# GIAMBATTISTA AND LORENZO BREGNO

# GIAMBATTISTA AND LORENZO BREGNO

## Venetian Sculpture in the High Renaissance

Anne Markham Schulz

The right of the
University of Cambridge
to print and publish
all kinds of books
was granted by law
in 1534.
The University has printed
and published continuously
since 1584.

CAMBRIDGE UNIVERSITY PRESS
CAMBRIDGE
NEW YORK   PORT CHESTER   MELBOURNE
SYDNEY

Published by the Press Syndicate of the University of Cambridge
The Pitt Building, Trumpington Street, Cambridge CB2 1RP
40 West 20th Street, New York, NY 10011, USA
10 Stamford Road, Oakleigh, Melbourne 3166, Australia

First published 1991

Printed in the United States of America

*Library of Congress Cataloging-in-Publication Data*

Shulz, Anne Markham, 1938–

Giambattista and Lorenzo Bregno : Venetian sculpture in the high
renaissance / Anne Markham Schulz.

p.    cm.

Includes bibliographical references and index.
ISBN 0-521-38406-0 (hardcover)
1. Bregno, Giovanni Battista, d. 1523 – Criticism and
interpretation.    2. Bregno, Lorenzo, d. 1524 or 5 – Criticism and
interpretation.    3. Sculpture, Renaissance – Italy – Venice.
I. Title.

NB623.B746S38    1991
730'.92 – dc20                                                        90–19996
                                                                          CIP

*British Library Cataloguing in Publication Data*

Schulz, Anne Markham 1938–

Giambattista and Lorenzo Bregno – Venetian sculpture in
the High Renaissance.

1. Italian sculptures, history
I. Title
730.945

ISBN 0-521-38406-0

for JUERGEN

ERRATA

Schulz: *Giambattista and Lorenzo Bregno*

ISBN 0-521-38406-0

p. 6, n. 28, *for* Paosletti *read* Paoletti
p. 28, line 29, *for* Figs. 80 *read* Figs. 80, 84
p. 105, col. 2, line 20, *for* promessa *read* promesso
p. 123, col. 2, line 5 from bottom, *for* del *read* dele
p. 126, col. 1, line 16, *for* Pancearie *read* Pancerie
p. 126, col. 1, line 9 from bottom, *for* libras b *read* libras 6
p. 135, col. 1, line 32, *for* PHILOSPHVS *read* PHILOSPHVS
p. 138, col. 1, line 15 from bottom, *for* (facebat) *read*
  (faciebat)
p. 140, col. 1, lines 12–13, *for* EIVS [*sic*] IN REM (publicam)
  VENETAM [*sic*] *read* EIVS IN REM(publicam) VENETAM [*sic*]
p. 167, col. 2, line 3, *for* epitaph *read* epigraph
p. 204, col. 1, line 10 from bottom, *for* incoporated *read*
  incorporated
p. 207, col. 2, lines 28–34 *The epitaph should read* MELCHIORI
  TRIVISANO QVI. FERDI(nandi). R(egis). / CLASSEM VENETO
  SINVDEPVLIT. CVM/ CAROLO. FR(anciae). R(ege). AD TARR(um).
  PROSPERE CO/NFLIXIT. CREMONAM VENETO ADIVNX/IT IMPERIO. III.
  MARIS. IMPERAT(or). OBIIT./ M.D.    FILII PIEN(tissimi).  POSVE(runt)
p. 212, col. 1, line 19, *for* DESTERREICHISCHES *read*
  OESTERREICHISCHES
p. 212, col. 2, n. 9, line 7, *for* Munnman *read* Munman
p. 212, col. 2, line 4 from bottom, *for* Księa *read* Księga

# CONTENTS

PREFACE     ix

INTRODUCTION     1

Chapter One
THE DOCUMENTS     15

Chapter Two
GIAMBATTISTA BREGNO     31

Chapter Three
LORENZO BREGNO     57

Chapter Four
CONCLUSION     83

Appendix A
DOCUMENTS     101

Appendix B
CATALOGUE     128

BIBLIOGRAPHY     217

LIST OF ILLUSTRATIONS     237

INDEX     247

FIGURES     261

PLATES     335

# PREFACE

The reader who has already made his way through my articles on Giambattista and Lorenzo Bregno has every right to wonder whether a fourth work on the subject by the selfsame author merits a new expenditure of time and effort. My assurance that it does is partly a confession of guilt – for sins of omission chiefly, but for sins of commission too. Questions of the Bregno's links with contemporary Venetian art and their debt to ancient sculpture that constraints of space deterred me from pursuing in my articles of 1980, 1983, and 1984, are examined here at length. The absence of a consideration of the artistic, economic, social, and political background to the Bregno's career on the mainland and in Venice has now been remedied. I am grateful for the opportunity to correct the transcription of a document I found at Treviso and the misattribution of three works to which formerly I gave but scant attention. Nonetheless, the fundamental distinctions between Giambattista's and Lorenzo's sculpture that I drew in 1980 have not been redefined: the core of works I established for each brother once, I believe, is valid still.

To the works found and reattributed before, however, I am now able to add a dozen more. In one case, a figure long hidden in an attic was placed on view within a church. In other cases – the vast majority, as it happened – the sculptures had always been there, but installed at such heights and so poorly lit that they were virtually invisible and quite unknown. Suffice it to mention the *Pages* above the frame of Titian's far-famed Pesaro Altar, published here for the first time. At Crema, Padua, Montagnana, and other sites, scaffolds were erected, which, for the first time, made the sculptures visually accessible. Thus was it possible to reconstitute the Bregno's oeuvre – one whose size alone establishes for the brothers a leading place among Venetian sculptors of the first quarter of the sixteenth century. New autoptic observations permitted the description of material, size, polychromy, and condition for every

piece. Research in libraries and archives yielded a wealth of circumstantial information concerning the commission and manufacture of the works and the vicissitudes of their preservation. Newly made photographs documented every sculpture in front and lateral views at least.

Here as elsewhere, it was my aim to produce the most accurate photographs possible by having sculptures dusted first, by calculating the position of the camera to eliminate distortions, and by manipulating reflected light to avoid cast shadows while registering the full range of shadow produced by the recession of the form. Nevertheless, even the best photographs taken from a multitude of vantage points cannot reproduce the experience of a mobile and sensible observer. It may therefore happen that my description of a work is not, in every respect, corroborated by its photographic record: both, I hope, are as faithful as they can be, but each reflects the different instruments and conditions by, and under, which it was made.

My work on Giambattista and Lorenzo Bregno was generously funded by the National Endowment for the Humanities. A Basic Research Grant from 1982 to 1985 paid for the construction of scaffolds at thirteen separate sites and for the photographic campaign, which produced most of the illustrations in this book, as well as the hundreds of other photographs, which contributed to the conclusions set forth here. An NEH Independent Study Grant in 1982/83 permitted an extended stay in Venice. Without the support of the NEH I should never have conceived this project, much less have finished it, and I am more grateful than I can say.

My work has been assisted in myriad ways by superintendents of monuments, archivists, librarians, photographers, curators, priests and sacristans, colleagues and friends; if I thank them all collectively, it is not because I have forgotten the contributions of any one. Among those to whom I am especially indebted are: Mons. Luigi Baldacci at the Cathedral of Cesena and my photographer there, Sig. Valerio Zangheri; at Crema, Padre Giuseppe Facchi, S. Trinità, and my photographers, Sig. Silvio Gamberoni and Sig. Paolo Marasca; at Creola, Sig. Enrico Tiso and members of his family; at Montagnana, Padre Zereich Princivalle, Zovon; at Padua, Padre Giovanni Luisetto, director of the Archivio dell'Arca, Padre Claudio Gottardello at the Convent of the Santo, Prof. Camillo Semenzato at the University of Padua, and Dott. Gianni Degan; at Treviso, Arciprete Lino Regazzo at the Duomo and sacristans Dionisio Sovernigo and Arturo Gasparini; Mons. Angelo Campagner, director of the Biblioteca Capitolare; Don Mario Bragognolo, S. Nicolò; Dott. Eugenio Manzato, director of the Museo Civico; Comm. Geom. Francesco Brandolin and Geom. Evelino Zamprognio; at Venice, Dott. Francesco Valcanover, former Soprintendente, and Dott.i Adriana Ruggieri and Sandro Sponza of the Soprintendenza ai Beni Artistici e Storici di Venezia; Dott.i Maria Elisa Avagnina Gostoli and Anna Maria Spiazzi of the Soprintendenza ai Beni Artistici e Storici del Veneto; Dott. Mario Piana of the Soprintendenza ai Beni Architettonici e Ambientali di Venezia; Geom. Giuseppe Fioretti at the Procuratoria di S. Marco; Dott.ssa Maria Francesco Tiepolo, former director of the Archivio di Stato di Venezia; Dott. Marino Zorzi, director of the Biblioteca Nazionale Marciana; Dott. Francomaria Colasanti, director of the Biblioteca della Fondazione Cini; Sig.i Nico Falconero and Urbano Pasquon at the Museo

Civico Correr; Sig. Silvano De Tuoni at the Istituto di Storia dell'Arte della Fondazione Cini; Padre Annibale Marini, Padre Silvio Bergamo, and sacristan Umberto Bognolo at S. Maria dei Frari and Padre Pio Camilotto at SS. Giovanni e Paolo; Don Antonio Niero at the Seminario Patriarcale; Sig. Paolo Pazzi at S. Giovanni Evangelista; Canc. Gracco Crevato-Selvaggi at the Scuola Grande di S. Rocco; Geom. Giorgio Lovato; and above all, my photographers, Sig.i Mario Polesel and Romano Feroli, as well as their technical assistants at Ditta Giacomelli – Sig.i Ivano Enzo, Silvano and Fabbio Martire, Massimo Sinibaldi, and Sig.ine Anna Fasolo and Morena Zulian – and Sig.a Giacomelli; at Budapest, Dr. Janos Eisler at the Szépművészeti Múzeum; at East Berlin, Dr. Michael Knuth at the Staatliche Museen; at Vienna, Dr. Christian Witt-Döring at the Oesterreichisches Museum für angewandte Kunst; and my friends and colleagues – Prof. Eric Apfelstadt, Sig.a Nike Barbati Hatfield, Prof.i Marino Berengo and Renata Berengo Segrè, Sir and Lady Ashley Clarke, Dott. Gino Corti, Prof. Franco Fido, Prof. Rona Goffen, Prof. Sir John Hale, Prof. Rab Hatfield, Prof. Ellen Longworth, Prof. Terisio Pignatti, Prof. Debra Pincus, Ms. Rona Roisman, Dott. Francesca Romanelli, Ms. Ruth Rubenstein, Dr. Wendy Stedman Sheard, Mr. Joachim Strupp, Prof. Manfredo Tafuri, Don Gastone Vio, Prof. Ivan Waldbauer, and Prof. Rolf Winkes. This manuscript has benefited from the attentive reading and courageous criticism of my editor at Cambridge University Press, Dr. Beatrice Rehl. To my husband, Juergen Schulz, whose support and help have lightened the burden of this book and made it better, I dedicate *Giambattista and Lorenzo Bregno*.

A.M.S.

Providence, R. I.

# Introduction

The fame of Venetian sculpture in the quarter century spanned by the Bregno's art has been eclipsed by the glorious achievements of High Renaissance Venetian painting, physically more accessible than sculpture and more widely celebrated in early and later literature. Indeed, so skewed is art historical research toward Venetian painting that, with the beginning of the Cinquecento, the manufacture of Venetian sculpture might seem to have lapsed, overwhelmed in the competition for patronage. Yet not only did early sixteenth century Venice support considerable activity in the field of sculpture, but the major artistic undertakings of the period – judged not by their novelty and beauty, but by their size and cost, by the length of time and number of craftsmen required for their execution – were not paintings at all, but rather sculptural ensembles made for public sites. There are no privately commissioned paintings to rival the facade Tomb of Benedetto Pesaro, for which the deceased bequeathed 1,000 ducats, or the bronze tomb and altar with life-size, free-standing figures, intended by Cardinal Zen to cost 5,000 ducats, and no painted decoration at all to equal the Chapel of St. Anthony in Padua, whose nine monumental reliefs alone took seventy-seven years to carve.

Why then has Venetian sculpture suffered such neglect? The answer lies partly in the difficulties presented by a field of study where few works are inscribed or documented and where the paucity of informative early secondary sources leaves the scholar stranded amidst countless undated and anonymous works. More important still, however, is the inaccessibility of so much Venetian sculpture. Almost always destined for public spaces, Venetian statuary and relief could not be pillaged with impunity, could not be traded, and therefore rarely found its way into accessible collections. In situ, however, embellishing the exterior of churches, tombs, and altarpieces at extraordinary heights, Venetian sculpture was hard to

see, impossible to attribute, and therefore generally ignored. Above all, has Venetian sculpture of the early and High Renaissance enjoyed the mixed blessing of remaining where originally placed.

During the auspicious period of the High Renaissance, when ever more complex and expensive projects were envisioned in bronze, marble, and semiprecious stone, a troop of sculptors was active in Venice and the Veneto. Most successful by far during most of the brief term of their careers were Giambattista and Lorenzo Bregno: to this, the number, magnitude, and range of their commissions, as well as the importance of their patrons, testify. The quality of the Bregno's work earns it a place among the finest sculpture of the epoch: whereas Giambattista's sculpture represents the culmination of Quattrocento realism and virtuosity, Lorenzo's classicizing figures qualify as the most advanced Venetian sculpture of the early Cinquecento. Yet until a few years ago, there existed but one short article essaying a synthetic view of Lorenzo's art;[1] as late as 1971 a connoisseur disclaimed responsibility for knowing nothing of Giambattista's style.[2] But for one egregious misattribution, the Bregno's names hardly appear in Venturi's twenty-five-volume history of Italian art[3] nor does a single work of theirs buttress Planiscig's speculations on Venetian Renaissance sculpture.[4] Indeed, it has recently been averred that the Bregno owed their careers to their kinship with the Venetian sculptor and architect Antonio Rizzo, not to their mediocre abilities.[5] Would contemporaries of the Bregno have called their talents mediocre? In 1520 a contract from the Arca del Santo at Padua described Lorenzo as "sculptor famossimus."[6] That this view was widespread, the Bregno's commissions show; that this view was merited will emerge, I hope, from an accurate appraisal of their work.

Despite the Bregno's evident success, few literary notices attest to it. This lack explains, at least in part, the oblivion the sculptors long endured. A survey of the Bregno literature begins with Francesco Sansovino's 1581 guide to Venice, where Lorenzo, only, figures as the author of four works – the High Altar of S. Marina, the *Effigies of Dionigi Naldi* and *Benedetto Pesaro*, and the Tomb of Bishop Lorenzo Gabriel – and as part author of figures finished by Antonio Minello for the Trevisan Altar in S. Maria Mater Domini.[7] As we shall see, only Sansovino's attribution of the High Altar of S. Marina withstands scrutiny. In the case of *Benedetto Pesaro*, Sansovino mistook Lorenzo for Giambattista Bregno. The *Naldi Effigy* is surely Antonio Minello's; the *Gabriel Effigy* is by a stonecarver so inept that he is not likely to emerge from anonymity. The Trevisan Altar does, indeed, reveal Minello's collaboration with another sculptor, but that sculptor was not Lorenzo Bregno.

For the next two hundred and fifty years nothing of any significance was published on the Bregno: at best, Venetian guidebooks copied Sansovino's attributions. But with the new investigation of archival material by nineteenth-century antiquarians and scholars, the Bregno's name was brought to light in a variety of contexts. Giambattista's commission for the

[1] Mariacher, *Arte ven.*, 1949, pp. 95–9.

[2] Pope-Hennessy, 1958, p. 355, idem,[2] 1971, p. 343.

[3] Venturi, vi, 1908, p. 1094, gave the Vendramin Tomb to Antonio and Tullio Lombardo together with Alessandro Leopardi and Lorenzo Bregno.

[4] Planiscig, 1921.

[5] Jestaz, 1986, pp. 71, 72.

[6] See Appendix A, Doc. XVII, B, C.

[7] Sans., 1581, pp. 12r, 20rf, 23r, 66r, 75r.

relief of *St. George* at the Convent of S. Giorgio Maggiore was published in 1834;[8] in 1852 a not entirely accurate report of Giambattista's involvement in the sculpture of the Cappella del Santo at Padua appeared.[9] Cecchetti's publication of the S. Marco documents in 1886 contained Lorenzo's commission for the Altar of the Cross.[10] In 1897 Biscaro made known Lorenzo's commission for the Trevisan statue of *St. Sebastian* and two years later, recounted the history of the Cappella del SS. Sacramento at Treviso.[11] All the more valuable did this last effort prove to be, when the documents from which Biscaro had quoted perished during World War II. In 1910 Grigioni found the commission to Lorenzo for the Altar of St. Leonard in the Duomo of Cesena;[12] in 1950 Burchi published notice of Giambattista's Altar of the Corpus Domini in the same church;[13] in 1983 I documented Giambattista's work for the Bettignoli Bressa at Treviso;[14] in 1986 Jestaz presented proof of Giambattista's contribution to the figures of the sarcophagus of Cardinal Zen.[15] To this account of the discovery of documented works must be added Terni de Gregory's reading of Lorenzo's name on the base of the *Effigy of Bartolino Terni* in Crema in 1949.[16]

In view of the considerable number of extant works secured to the Bregno by document or inscription, the disregard of their sculpture is astonishing. Of necessity, the Bregno figure in Thieme-Becker's *Künstler Lexikon*[17] and the *Dizionario biografico degli italiani*[18] and in Coletti's 1935 catalogue of Trevisan works of art.[19] But beyond Mariacher's 1949 four-page article on Lorenzo, which included a host of alien works,[20] and Vazzoler's 1962/63 thesis for the University of Padua, based on the critical judgments of Coletti and Mariacher, no attempt was made to discriminate between Giambattista's and Lorenzo's works or to define their styles, until my articles of the early 1980s.[21] The inability to differentiate between the art of Giambattista and Lorenzo resulted in the identification of both artists with a style that, in fact, is characteristic of Lorenzo only – an impersonal neoclassicism that critics found profoundly antipathetic. By the mid-nineteenth century, the neoclassical style of Canova and Thorwaldsen had been superseded by the quest for authenticity in individual expression, which has inspired most modern schools. Reverence toward a canon – the premise of Lorenzo's sculpture – is a sentiment that few experience today; want of originality – the virtue of a classicistic art – in the current system of artistic values is a fatal flaw. The disrepute of neoclassicism, combined with those factors that contributed to a neglect of Venetian sculpture in the first place, suffice to explain the absence of any proper study of the Bregno, despite the fact that a reconstruction of their life and works is vital to an understanding of

[8] Cicogna, iv, 1834, p. 322, n. 190.

[9] Gonzati, i, 1852, pp. 167f and xcvii, doc. LXXXVIII. Gonzati misidentified the subject of Giambattista's relief as the *Miracle of the Parrasio Boy*, an error carried forward to 1971 by Pope-Hennessy, [2]1971, p. 343.

[10] Cecchetti, in Ongania, pub., vii, 1886, p. 27, doc. 160. Giambattista's name also appeared in documents relating to the appraisal of sculpture for Cappella Zen: ibid., pp. 18f, doc. 124; p. 23, docs. 143b and d; p. 24, doc. 144b.

[11] Biscaro, *Atti ... dell'Ateneo di Treviso*, 1897, pp. 275, 279, n. 3; idem, *Arch. ven.*, ser. 2, xviii, pt. 1, 1899, pp. 179–88.

[12] Grigioni, *L'arte*, 1910, pp. 45f.

[13] Burchi, [1950], pp. 3–7.

[14] Schulz, *Arte cristiana*, 1983, p. 48, doc. 4.

[15] Jestaz, 1986, pp. 195–7, docs. 45, 46, 49, 56.

[16] G. Terni de Gregory, *Italia contemp.*, 1949, p. 249.

[17] Paoletti, T-B, iv, 1910, pp. 569–71, vocibus "Bregno, G. B.," "Bregno, L."

[18] Mariacher, DBI, xiv, 1972, pp. 113–15, vocibus "Bregno, G. B.," "Bregno, L."

[19] Coletti, 1935, ad indicem.

[20] Mariacher, *Arte ven.*, 1949, pp. 95–9.

[21] Schulz, BJ, 1980, pp. 173–202; eadem, *Arte cristiana*, 1983, pp. 35–48; eadem, BJ, 1984, pp. 143–179.

the artistic culture of High Renaissance Venice. In the service of an accurate historical appraisal, we must lay aside prejudices inculcated by the taste of the last century or so and attempt to view the Bregno's art with the eyes of those whose artistic sensibilities were formed by Venetian sculpture of the fifteenth century.

Despite the presence in Venice at the beginning of the Quattrocento of Florentine sculptors intimately acquainted with the art of Donatello and Ghiberti, the style of Venetian sculpture did not break with its Gothic past until the late 1450s. The greatest exponent of late Gothic sculpture in Venice was Bartolomeo Bon (d. ca. 1464), whose commission by the *Provveditori al Sal* in 1438 for the Porta della Carta – the monumental entrance to the Ducal Palace – testifies to the esteem with which the sculptor was regarded.[22] Indeed, its two most beautiful figures, *Temperance* and *Fortitude*, exemplify that rare phenomenon, the embodiment of a Gothic design by figures whose proportions and pose demonstrate an assimilation of Renaissance principles of anatomy and movement. Long and ample draperies of a malleable stuff establish a mellifluous pattern of curves that embraces the entire figure and suggests the easy sway of a late Gothic *Virgin*. But the unequal distribution of the body's weight that a sway implies is rationalized by the torsion of the head, the divergent axes of hips and shoulders, the alignment of flexed arm and tensed leg, and a distribution of folds that responds to the various positions of the limbs. Wistful, introverted expressions accord with the effortless gestures and the quietude of poses whose equilibrium of disparate forces suggests the potentiality, rather than the realization, of organic movement.

Between the Porta della Carta and the next great monument of Venetian Renaissance sculpture, the Tomb of Doge Francesco Foscari (d. 1457) in S. Maria dei Frari, there intervened Donatello's ten-year sojourn at nearby Padua. His art, which repudiated the placid moods, the comely grace, the careful finish of sculptures by Ghiberti or Bartolomeo Bon in favor of an intensely and heroically expressive sculpture, whose eccentric compositions and ragged modeling proclaimed the genius's indifference to convention, transformed Venetian sculpture. The drama enacted by the protagonists of Donatello's High Altar in the Santo, grown to life-size, modeled in the round, and liberated from their customary niches to occupy a real three-dimensional structure, are the precondition for the naturalistic grouping of *Virtues* around the recumbent *Effigy of Doge Francesco Foscari* from a tomb that I have recently ascribed to Niccolò di Giovanni Fiorentino. Here the individual figures of this mournful congregation are brought to life by momentary and unstable poses and active gestures that generate an excitement reinforced by convolutions of long, abundant drapery. Metamorphosed into persons, the *Virtues* have ceased functioning as personifications. Figures are carved with a license that betrays the habits of a sculptor accustomed to modeling in wax. Limbs are carved in the round; drapery is deeply excavated; borders are undercut, and forms, constantly in flux, are separated from one another by intervals of space.[23]

When Niccolò di Giovanni moved to Dalmatia in 1467, his place at Venice was taken by Antonio Rizzo, the uncle of Giambattista and Lorenzo Bregno. Born in Verona between ca. 1435 and 1440, evidently trained in Padua in the 1450s, Rizzo had settled in Venice by

[22] For Bartolomeo Bon, see Schulz, *Trans. APS*, June 1978, pp. 3–81.

[23] For Niccolò di Giovanni, see Schulz, 1978.

the mid-1460s.[24] His earliest documented works are the three altars made between ca. 1465 and 1469 for Doge Cristoforo Moro in the Basilica di S. Marco and dedicated to SS. James, Paul, and Clement. *Adam* and the inscribed *Eve*, originally installed on either side of the main opening of the Arco Foscari, probably were completed before the death of Doge Moro in 1471. Rizzo's colossal Tomb of Doge Niccolò Tron (d. 1473) in S. Maria dei Frari can be dated securely between 1476 and 1480. It is likely that the Tomb of Giovanni Emo (d. 1483), originally in S. Maria dei Servi, was begun before Rizzo's attention was fully claimed by work at the Ducal Palace. On September 14, 1483, fire destroyed most of the Palazzo del Doge in the east wing of the Ducal Palace. By the end of 1484 Rizzo had been placed in charge of its reconstruction. The northern half of the east wing, with the ducal apartments on the third floor and the Senato and Collegio on the fourth floor, was completed between that date and April 1498. The Scala dei Giganti, which gave access to the east wing, begun ca. 1490, was in use by 1497. With his own hands, Rizzo apparently executed most of the decorative sculpture on the staircase and four out of the eight *Victories*. The *Angel Bearing Attributes of Christ* in the Ca' d'Oro also can be assigned to this last period.

*Fig. 7*

*Fig. 24*

*Fig. 48*

Rizzo's career came to an abrupt and ignoble end in 1498, when a investigation by two senators resulted in an accusation of embezzlement of more than 10,000 ducats from funds allocated to the rebuilding of the Ducal Palace. Apprised of his impending indictment, Rizzo sold all his goods and property in April 1498 and fled to the Romagna. In February 1499, Rizzo was present at Cesena. From there, it seems, he traveled to Ferrara. On May 4, 1499, the sculptor was still alive. Nothing further is heard of him; probably he did not survive his disgrace by long.

Though Rizzo's early development, like Niccolò di Giovanni's, was influenced by the Paduan sculpture of Donatello, Rizzo's eclectic and obsessive style bore no resemblance to the art of Niccolò. Where the sculpture of the Foscari Tomb – large in scale, densely massed, and not confined by any architectural setting – dominates its architecture, sculpture in the Tron Tomb is subordinated to its frame. Characteristically, the architecture of that frame is extremely flat, sharply outlined, and strictly limited in its elevation to arcs and rectangles; instead of a few large units scaled to the height of the entire monument, as in the Foscari Tomb, a multitude of small units is scaled to the height of the statuary. But if Rizzo can be faulted, in his resolution of the whole, for its repetitive and unfocused design, it is because his interest lay rather in the execution of detail. In this respect, his technical virtuosity signals a new stage in the development of Venetian sculpture. The perfectly symmetrical and inexpressive face of the pedestrian *Effigy of Tron* reveals the habits of a goldsmith: no area of the surface remained unworked and details were carved with linear elegance on a minute scale. Distinctions in texture result not from a greater or lesser degree of surface polish, but rather from the various lines incised on the perfectly finished surface.

Rizzo's masterpiece is *Adam*, now removed to the interior of the Ducal Palace. Despite the subordination of the figure's pose to an expressive purpose, movements by which *Adam* conveys the anguish with which he confesses wrongdoing conform to the strictest rules of

*Fig. 7*

---

[24] For Antonio Rizzo, see Schulz, 1983.

*contrapposto*. The accuracy of *Adam's* anatomical structure was not surpassed in any sculpture of the fifteenth century. Rizzo's extraordinary advance in understanding of the organic structure of the human body, I believe, was due to the influence of Antonio Pollaiuolo, from whom Rizzo learned to imbue every part of the body with tension by the flexion of the muscles. Flexed muscles are more prominent and more precisely defined than muscles in a state of relaxation. Thus they produce a more richly articulated surface and more highly inflected contours. To the same end, *Adam's* pose is open and joints are accentuated by being made to protrude more sharply than they normally would do. That God is present to *Adam* is made clear by the inclination of the figure's head and the expression of his face; indeed, the urgency of *Adam's* communication has given life to every portion of the figure's body.

When Giambattista and Lorenzo Bregno began their professional careers around 1500 the artists canvassed above were either dead or settled far from Venice. Nevertheless, the sculptors among whom the Bregno made their way were not much younger than Antonio Rizzo. Indeed, Venetian sculptors of the early sixteenth century formed a gerontocracy. At its head stood Pietro Lombardo, his primacy assured by Rizzo's flight from Venice in April 1498;[25] on May 16, Pietro assumed Rizzo's post as *protomaestro* of the Ducal Palace,[26] retaining it until his death in the late spring of 1515.[27] A year before he died, Pietro was elected chief officer of the Venetian stonemasons' guild.[28] First documented as a sculptor in Bologna in 1462, then active in Padua, Pietro had established himself in Venice by the early 1470s.[29] Apparently he specialized in large-scale projects combining architecture, statuary, sculpture in relief, and ornamental carving: the range and complexity of his commissions are typified by the totality of the construction and embellishment of S. Maria dei Miracoli. But his shop was also known for its ducal tombs, altars, and private devotional reliefs of the *Madonna*. During the period of Pietro's activity that coincides with the debut of the Bregno, the

*Figs. 2–6* Cappella Giustiniani in S. Francesco della Vigna was incrusted with marble reliefs of the *Evangelists*[30] and furnished with an elaborate marble altar-piece dedicated to St. Jerome;[31] the interiors of the new wing of the Ducal Palace received their exquisite marble décor.[32] The number of overlapping projects, any one of which might have required a score of stone-masons,[33] suggests a workshop of extraordinary efficiency and size. If Pietro was not exempted from guild legislation of 1507, which limited the number of non-kindred apprentices to three,[34] he undoubtedly ignored it and paid the fines.

The characteristics of Pietro's style can be deduced from his early works, for whose execution he was largely responsible – the Roselli Tomb in the Santo at Padua, the portal lunette of S. Giobbe and the best sculpture of its choir, and the finest *Prophets* of the Frari choir screen. The format of the Roselli Tomb, based on Florentine tombs of humanists, and

[25] Schulz, 1983, pp. 134f.

[26] Lorenzi, 1868, pp. 121f, docs. 250, 251.

[27] Bertolotti, 1885, p. 75; Paoletti, 1893, ii, p. 249.

[28] Paosletti, 1893, ii, pp. 248f.

[29] Beck, *Flor. Mitt.*, 1967–8, p. 192, docs. I – V; Moschetti, Padua, Mus. Civ., *Boll.*, 1913, pp. 93–8, docs. xxiii–xxvii; idem, Ist. ven. SLA. *Atti*, 1927–8, pt. 2, p. 1514, doc. xxvi.

[30] Schulz, *Antichità viva*, Mar.–Apr. 1977, pp. 27–35.

[31] Ibid., p. 27. See also London, Victoria & Albert Mus. Cat, by Pope-Hennessy/Lightbown, 1964, i, pp. 351f, nos. 377, 378.

[32] Lorenzi, 1868, pp. 130–3, docs. 269, 272.

[33] In 1496 Pietro set a team of 25 stonemasons to work on an aedicule or framework for the Gonzaga Altar at Mantua: Luzio/Renier, *Arch. stor. dell'arte*, 1888, pp. 433f, doc. I.

[34] Maek-Gérard, *Wallraf-Richartz-Jahrb.*, 1980, pp. 123f.

the Roselli *Reggiscudo*, derived from Donatello's bronze *David*, warrant the widely held assumption that Pietro received his training at Florence ca. 1460. The relief technique, in which the contours of raised but otherwise flat relief are sharply undercut, adopted by Pietro for the lunette of the portal of S. Giobbe, was invented by Desiderio da Settignano; the *schiacciato* relief of the Roselli lunette also comes from Florence. The drapery of Pietro's figures, on the other hand, betrays the sculptor's Lombard origins. Typically, drapery seems made of a thin yet brittle cloth, which either adheres smoothly to the figure or, wrinkling, produces sharp, straight ridges that form angles when they change direction. By contrast, anatomical forms are stereometric, their regularity due not so much to a policy of idealization as to the artist's failure to proceed to the further stage of modulating the necessarily abstract form of the roughhewn block. Thus the *Reggiscudo* of the Roselli Tomb or the *putti* in the pendentives of the cupola of S. Giobbe show large, evenly rounded surfaces; neither hair nor drapery interrupts the sequence of regular arcs that compose the contours. Rarely do Pietro's autograph works show a highly finished surface: not only did Pietro fail to differentiate among the textures of cloth, skin, and hair, he often omitted to polish away traces of the claw chisel or drill. As a consequence, the quantity of detail, the range of values, and the variety of textures are limited, but the legibility of the tectonic structure and abstract symmetry of the design are correspondingly enhanced.

Throughout his life, Pietro was assisted by his elder son Tullio and, until Antonio's departure for Ferrara, by his younger son as well. Tullio and Antonio had made their debuts by 1475 in the sculptural decoration of the choir of S. Giobbe.[35] Though Antonio moved to Ferrara in 1506[36] and died probably in 1516,[37] Tullio continued to live and work in Venice until his death at an advanced age in 1532.[38] At the time of Giambattista's earliest documented works, the Lombardo brothers were engaged in carving the ornate marble fireplaces in the *Appartamenti dei Dogi* of the Ducal Palace.[39] In 1500, Tullio and Antonio contracted for two narratives for the Cappella del Santo at Padua; the reliefs were finished five years later.[40] Figs. 21, 22 Tullio's *Coronation of the Virgin* in S. Giovanni Crisostomo can be dated between 1500 and 1502.[41] In 1504 Antonio, together with Alessandro Leopardi, undertook to make in bronze an altar with a baldachin and statues of the *Madonna and Child Enthroned* and *SS. Peter* and *John the Baptist*, as well as a tomb chest surrounded by six female figures and surmounted by a recumbent effigy, for the funerary chapel of Cardinal Zen in S. Marco.[42]

The extent to which the art of Tullio and Antonio Lombardo was influenced by classical Roman sculpture makes their work unique in the context of late fifteenth century Italian sculpture: only Antico's bronze reproductions of famous Roman statues surpassed in faithfulness the Lombardo's redactions of antique style. That neoclassicm should have arisen in a city that was not antique in origin and possessed no antique relics of its own seems wonderful. Indeed, apart from isolated quotations, such as Pietro Lamberti's recollection of

[35] Schulz, *Antichità viva*, Mar.–Apr. 1977, pp. 35f.

[36] Sartori/Fillarini, 1976, p. 139.

[37] Cittadella, *Notizie*, 1868, ii, pt. 3, p. 193, repr. in idem, *Documenti*, 1868, p. 193. Cf. Bertolotti, 1885, p. 110, and Paoletti, 1893, ii, pp. 250, 251.

[38] Paoletti, 1893, ii, p. 254.

[39] Appendix A, Doc. III.

[40] Stepan, 1982, pp. 27–37, 287–92.

[41] Paoletti, 1893, ii, p. 111, doc. 90 and p. 179.

[42] Jestaz, 1986, pp. 185–9, no. 19.

a head of *Julius Ceasar*,[43] the adaptations by Bon and Niccolò di Giovanni of a *"Muse"* from the Teatro Berga at Vicenza,[44] Rizzo's copy of a panel from the *"Throne of Ceres"* at Ravenna,[45] or the heads of Roman emperors on the Tron and Giustiniani sarcophagi,[46] – quotations that can be counted on the fingers of one hand – classical antiquity had hardly played a role in the evolution of fifteenth-century Venetian sculpture. Nor can the Lombardo's susceptibility to the art of ancient Rome be explained by personal acquaintance with its monuments: indeed, there is no evidence that either brother ever ventured outside northern Italy. At Padua, however, the Lombardo's appreciation of antique art might have been fostered by the philological and literary studies of the humanist circle with which Tullio, at least, was on friendly terms.[47] Although the testimony at this early date is sparse, we may assume that works of ancient sculpture were regularly imported and collected by Paduan and Venetian connoisseurs. By 1465 the Paduan collection of Giovanni Marcanova contained an altar of Priapus.[48] The stock of casts owned by Mantegna's master, the Paduan painter Francesco Squarcione, undoubtedly included some of ancient sculpture.[49] Tullio himself possessed a classical draped female figure that frequently served him as paradigm.[50] From antique sculpture the Lombardo adopted ponderated stances, the proportions of their uniformly mature and robust figures, and the anatomical schemata of nudes. Classicizing garments were consistently draped in the Roman fashion, producing folds *all'antica* that consist of long, fine, parallel ridges, slightly bowed and evenly spaced in plan. Facial types and female coiffures, armor and sandals, imitated Roman prototypes. The Lombardo's nonpictorial relief, with its double row of closely spaced figures ranged isocephalically along the bottom of the relief, finds its closest parallel in the Hadrianic roundels of the Arch of Constantine.

As Antonio matured, his style came to resemble that of Tullio to such a degree that it is often difficult to tell their work apart. A comparison of the brothers' two Santo reliefs, executed contemporaneously, however, allows us to draw fine distinctions. The composition of Tullio's *Miracle of the Repentant Youth* reveals an almost mathematical consistency and orderliness and a high degree of abstraction in the service of decorative effects. The evenly spaced, upright figures, disposed as symmetrically as the narrative permitted against a neutral ground, produce an extremely tectonic composition. Spatially, figures are dispersed in discrete planes parallel to the relief plane. By preference, Tullio represented his figures frontally, while their limbs are nearly always shown in profile view; at the front of the relief space, the lamed youth, his torso twisted forward unnaturally, functions like a screen, preserving the integrity of the foremost plane of the relief. The surfaces of figures are flattened into low relief, even where the form in question occupies a plane at the front of the relief space and is deeply or entirely undercut; occasionally, however, flat relief gives way to excessively rounded forms whose perfect stereometry is no less abstract. Smooth, geometrically regular

*Fig. 22*

[43] Schulz, *Saggi e mem.*, 1986, pp. 34f.

[44] Schulz, *Trans. APS*, June 1978, pp. 26f; eadem, 1978, p. 24.

[45] Schulz, 1983, p. 49.

[46] Munman, *AB*, 1973, p. 81.

[47] Gauricus/ Chastel and Klein, (1504) 1969, p. 255.

[48] Huelsen, 1907, p. 19. For Venetian collections of antiquities, see Chapter Four of the present volume.

[49] Vas/ Mil, iii, (1568) 1878, pp. 385f.

[50] Michiel/ Frimmel, (1521–43) 1896, p. 82.

contours are as schematic as folds, whose arcs and straight lines never break the contours of figures and produce a highly ornamental linear pattern. Every surface was uniformly polished to an extraordinary degree. Within a design as manifestly indifferent to the narrative as this one, the expression of emotion by a few artificial and consistently repeated means, such as the opened mouth and furrowed brow, seems forced upon the figures rather than generated from within.

Although Tullio's art derived from antique sculpture, the extraordinary degree of abstraction and decorative linearity of his works carried him beyond the naturalistic and expressive goals of antique sculpture. A far more faithful classicist was Antonio, whose figures in the *Miracle of the Speaking Babe* match their antique prototypes in nearly all respects. In the more *Fig. 21* natural disposition of the figures and their responsiveness to one another, Antonio obeyed the dictates of the narrative, in which a newborn gives verbal testimony of his mother's marital fidelity. Here, in contrast to Tullio's relief, figures express feelings with far less vehemence but a great deal more conviction by a slight turn of the torso, the inclination of the head, or the focus of a glance. Recession into depth is gradual, abetted by the changing views and overlapping of figures composing the semicircle around the infant, but also by the gradual descent in the level of heads, which mitigates the isocephaly that Tullio so carefully maintained. Although the depth of the relief is no greater than that in Tullio's panel, forms seem a great deal more plastic because they are much more rounded; the full range of *mezzo rilievo*, keyed to location within the three-dimensional space, which Tullio abjured, is widely utilized by Antonio. As in antique statuary, drapery responds to the physical properties of its fabric, the mechanics of its draping, and the presence of underlying garments, as well as to the figure's anatomy and pose.

Probably a few years older than Tullio and Antonio Lombardo, the mediocre but prolific Giovanni Buora was born ca. 1455.[51] Documented first in 1476, his earliest securely datable sculpture, the relief of the *Madonna delle Biade*, was commissioned between 1481 and 1482. Between 1494 and 1513, Buora was responsible for the construction of the dormitory of S. Giorgio Maggiore. In 1502 he supplied the architectural framework and statuary of the portal of the Palazzo Vescovile at Verona. For the facade of the Cappella del Santo at Padua, he carved the figure of *St. Prosdocimus*, delivered by mid-1509 but commissioned many years before. He, too, continued active until his death between 1515 and 1519.

Though Buora's presence in the Lombardo workshop cannot be documented, his dependence on Pietro for the motives and style of his sculpture proves him to have been Pietro's creature. Typically, Buora's figures adhere to the density, axiality, and form of the block from which they come. Neither limbs, which adjoin the trunk, nor drapery, wrapped tightly around the body, are undercut; indeed, excavation of the mass is minimal. As a consequence, contours are closed, continuous, and uniform. The simplification of sharply delineated but unmodulated features, and poses, largely confined to unemphatic ponderations, in which the unequal distribution of weight fails to affect the axes of hips or shoulders, are

---

[51] For Giovanni Buora, see Schulz, *Arte lom.*, 1983, pt. 2, pp. 49–72.

further symptoms of an absence of articulation that makes Buora's figures appear archaic in the context of Quattrocento sculpture.

A fourth member of this generation was a Paduan, Antonio Minello (d. after January 1529), son of Giovanni, employed by Pietro Lombardo in the mid–1460s probably on the Paduan Tomb of Antonio Roselli.[52] The son is first heard of in 1483, associated with the father on the decoration of the Santo's choir screen. In the early sixteenth century, Antonio *Figs. 64, 85* was responsible for the least successful of the series from the *Miracles of St. Anthony* in the *Figs. 62, 63* Santo and three tombs to *condottieri* in SS. Giovanni e Paolo.[53] The clumsiness of the sculptor's inorganic figures, his travesty of antique style, and the bathos that resulted from his vain attempts to endow figures with expression would have relegated Minello to the ranks of artisans in a city less exorbitant in its demand for sculpture.

The bronze sculptor Alessandro Leopardi (d. 1522/23) entered the employ of the Venetian mint in 1484; he was still recorded there in 1521.[54] It is unlikely, therefore, that he was born much after 1460; possibly he was born considerably before. During his lifetime, the sculptor was chiefly known for having cast Andrea del Verrocchio's equestrian Monument of Colleoni. Out of gratitude, the government eventually entrusted Leopardi with a commission for the three bronze standards, which support the masts for banners in front of the Basilica di S. Marco. The standards were installed in 1505 and 1506.[55] No doubt, it was his mastery of bronze casting that led to Leopardi's association with Antonio Lombardo at the Cappella Zen between 1503 and 1505. But he also may have been intended to take charge of the chapel's architecture, for despite his probable training as a goldsmith, Leopardi was experienced in working stone.[56] The style of Leopardi's figures depends from that of Antonio Lombardo. Uniform figure and facial types are classicizing; the very sheer, adherent drapery, which forms long, fine, closely spaced, parallel folds, reflects Antonio's adaptations of classical models. But infelicities in foreshortening, and the excessively small and inorganic hands, suggest that Leopardi's forte was not the human figure. By contrast, the fanciful ornament shows exceptional proficiency.

Leopardi's colleague and superior at the mint was Vettor Gambello, called Camelio (d. 1537); like Leopardi, he was hired in 1484.[57] Although Camelio's father, Antonio Gambello, was a stonecarver and mason, Camelio made his career as medallist. Among his works are signed medals of Gentile and Giovanni Bellini, Cardinal Domenico Grimani, Doge Agostino Barbarigo, and Pope Julius II. It was under Camelio that medals struck from dies, formerly very rare, began to appear with a certain regularity.[58]

Other sculptors, among whom Giambattista and Lorenzo Bregno made their careers, included Zuan Zorzi Lascari, called Pyrgoteles (d. 1531), whose employment in Pietro Lombardo's shop in the late 1480s is confirmed by the half-length *Madonna and Child* in the

[52] Rigoni, Padua, Acc. SLA. *Atti e memorie*, 1932–3, pp. 213f, doc. VIII, repr. in eadem, 1970, pp. 134f, doc. VIII.

[53] For Antonio Minello, see Schulz, *Flor. Mitt.*, 1987, pp. 291–326.

[54] Cicogna, ii, 1827, p. 297, n. 1, and p. 300; Testolini, *Arch. ven.*, 1872, pp. 246–8; Paoletti, 1893, ii, p. 273.

[55] Jestaz, *Rev. de l'art*, 1982, p. 26.

[56] Ibid., p. 26.

[57] Paoletti, 1893, ii, pp. 263, 268f, 271; Cicogna, ii, 1827, p. 300; Sanuto, *Diarii*, xxxv, 1892, col. 269, Dec. 9, 1523.

[58] Hill, 1930, text, pp. 115–21; Weiss in *Rinascimento europeo*, ed. Branca, 1967, pp. 331–37.

*Fig. 33*

main portal of S. Maria dei Miracoli, inscribed with the artist's pseudonym.[59] Pyrgoteles' documented sculpture is either lost or not yet identified;[60] one attributed relief survives in the Cappella Giustiniani.[61] Remarkable in Pyrgoteles' *Madonna and Child* from the Miracoli is the violent torsion of the Christ Child, foreshadowing the *figura serpentinata*, which makes its wider appearance in Venetian sculpture only in the 1520s: like a springboard, the figure's means of support – the Virgin's hand – is a source of liberation rather than confinement or constraint. Where the Child's open pose projects limbs forward into space, Pyrgoteles carved the member in the round. Contours and surfaces are as smooth as those of Tullio's figures, but are more inflated. Thus forms are endowed with a balloonlike rotundity. The wide spacing and leisurely curve of folds, which hardly ever alter their velocity, accord with the ample curvature of contours; the idealized and uninflected surfaces are consonant with an assimilation of textures, a suppression of detail in the depiction of anatomy and costume, and an absence of expression.

When Antonio Lombardo moved to Ferrara in 1506, his place at the Cappella Zen was taken by Paolo di Matteo Savin. Savin was a woodcarver by profession, competent in the carving of ivory, and Antonio's intimate friend.[62] On the basis of his documented works in the Cappella Zen, the two *Mori* on the Torre dell' Orologio, installed on the newly finished clock tower in late 1497, have been persuasively attributed to him.[63]

Savin's art also derived from that of Antonio Lombardo. The deliberateness of its decorative effects, however, distinguishes Savin's version of a neoclassical style. With the regularity and rhythms of a copperplate hand, the prominent ridges of folds follow deep, geometric, and concentric curves, whose paths are never interrupted. Immutable contours at the outer edges of figures consist of intersecting arcs. The application to three dimensions of the principles that determined the two-dimensional pattern results in abstracted, perfectly rounded anatomical forms. Columnar, but open, figures adopt poses in which limbs clear the body. The thin projections that Savin's customary medium of wood allowed, account in his bronze figures for the bold underworking of forms and the cantilevered flanges so frequently found at the borders of his garments. Typical also is the frontality of Savin's figures and their patently tectonic structure, established chiefly by a central vertical axis, as firmly anchored as a pivot driven through the statue.

*Fig. 20*

Thus a survey of the Bregno's colleagues and rivals reveals that, with the possible exception of Paolo Savin, all were older than Giambattista and Lorenzo by one or two generations: wherever documents survive, they indicate that, by the 1480s, all had assumed important responsibilities. Most, moreover, shared a direct or indirect formation in Pietro Lombardo's shop. The hegemony of well-established senior colleagues, disciples of a single school, is likely to have had a bearing on the course of the Bregno's careers: to what extent is the competition of colleagues a factor to be reckoned with? We shall want to ask how often and to what degree the formats, motifs, and style of the Bregno's works were conditioned

[59] Boni, *Arch. ven.*, 1887, pp. 256f; Schulz, *Antichità viva*, Mar.–Apr. 1977, p. 44, n. 50.

[60] Sartori, *Il Santo*, 1964, pp. 184–7, 191f, docs. IV, V.

[61] Schulz, *Antichità viva*, Mar.–Apr. 1977, pp. 38f.

[62] Jestaz, 1986, pp. 71f.

[63] Planiscig, 1921, pp. 287–90.

by solutions arrived at decades earlier in the work of older sculptors. In responding, we shall attempt to distinguish from the achievements of their contemporaries, the Bregno's special contribution to the history of Renaissance Venetian sculpture.

Though rarely broached, an inquiry into the relationship of sculpture to contemporary Venetian painting offers valuable insights. In the first quarter of the sixteenth century, Venice witnessed the birth of a new technique and style that were to revolutionize the art of painting. At the same time, the style of later fifteenth-century painting not only survived, but flourished in the work of numerous notable, as well as minor, masters. On the one hand, members of an older generation, such as Giovanni Bellini, Cima da Conegliano, Bartolomeo Montagna, Vincenza Catena, and Vittore Carpaccio, continued to paint on gessoed panels, banishing, by a careful application of minute brushstrokes, all traces of their time-consuming method. The simulation of a bright, diffuse illumination justified the intense colors that they habitually employed, their precise delineation of contours, their graphic description of detail, the broken surfaces of bent limbs and angular folds conveyed by sharply delimited areas of light and shadow. By their side, Giorgone, Titian, Sebastiano del Piombo, and Palma il Vecchio worked rapidly on a canvas ground, reproducing more summarily fewer, but larger and more generalized, forms. Contours were blurred when not concealed by shadows enveloping the background; hues were muted except where a flash of light evoked forms from the surrounding dusk. Broad brushstrokes of thick impasto, imperfectly juxtaposed, left behind a record of the creator's spontaneous method. Was the Bregno's sculpture touched by any of these works? Can we identify particular schemas or motifs used by the Bregno that derived from painting? Where such derivations cannot be proved, does a rapport of style and method suggest the Bregno's affinity with one or the other school of painting?

While the art of the Bregno's predecessors and colleagues necessarily influenced the forms and style their own work assumed, their art also was affected by the political and economic situation of contemporary Venice. It is not often in the Renaissance that factors of a historical nature reveal their influence in change of style. But the effects of external events can be sought to good purpose in the vicissitudes of artists' careers. So much the more is this the case with artists like the Bregno, who lived at a time of extraordinary tumult.

On the face of it, the period and place in which the Bregno's activity unfolded would have seemed inimical to the prosperity of art. Between 1499 and 1503 Venice fought the Turks in the Peloponnesus, suffering a series of defeats at Lepanto in August 1499, at Zonchio in July 1500 and in August of the same year at Modon and Coron, key cities on the Venetian trade route to the Levant.[64] The mobilization of a fleet to counter the Turkish threat severely taxed the Venetian fisc, and in 1501 and 1502 the government was forced to cut official salaries. In addition, the Portuguese entry into the spice trade, consequent to Vasco da Gama's discovery of a sea route to India around the Cape of Good Hope, disrupted Venetian commerce of spices in the early years of the sixteenth century. But of far greater moment still was the War of the League of Cambrai.

[64] My survey of Venetian history has benefited chiefly from: Cessi, 1968, ii, pp. 32–99; Lane, in *Ren. Venice*, ed. Hale, 1973, pp. 146–73; Gilbert in ibid., pp. 274–92; Chabod, in *Storia della civiltà*, ed. Branca, 1979, ii, pp. 233–46; Finlay, 1980, pp. 163–226; Hale in Mallett/ Hale, 1984, pp. 221–7.

However victimized Venice may have been by the prosecution of the war, she was not entirely innocent of its provocation. After the death of Alexander VI Borgia in August 1503 caused the collapse of the duchy in the Romagna, which Cesare Borgia had usurped, Venice seized Faenza and Rimini. By doing so, the republic roused the enmity of Alexander's successor, Julius II, intent upon consolidating the papal states. In 1508 Venice also offended Emperor Maximilian, who wished to assume the imperial title at Rome, by refusing him passage through Venetian territory and by defeating his army at Pieve di Cadore when the emperor defiantly crossed the border. As a result of Maximilian's defeat, the Friulian cities of Pordenone, Gorizia, Trieste, and Fiume fell to Venice and the emperor was forced to conclude a truce in June 1508. Maximilian retaliated by joining King Louis XII of France in a league formed at Cambrai on December 10, 1508. Julius II entered the league soon afterward and in April 1509 excommunicated Venice. The three major powers were soon joined by Spain, England, Hungary, Savoy, Ferrara, Mantua, and Florence—that is, by virtually all of Western Europe. The goal of the league was the complete partition of Venice's mainland state.

French forces of the League of Cambrai met the Venetian army at Agnadello in the Ghiaradadda on May 14, 1509, and inflicted a crushing defeat: within a few days Venice had lost nearly her entire mainland dominion, with the exception of Treviso and the villages skirting the lagoon. France occupied the whole of Venetian Lombardy; papal forces recovered the Venetian cities of the Romagna; Maximilian retook cities in the Friuli lost the previous year and Verona, Vicenza, and Padua opened their gates to imperial representatives. Venice's struggle to regain her mainland state lasted until January 1517, but the war was characterized by constant reversals of fortune and changes of allegiance. On July 17, 1509, Padua was retaken and the imperial forces laid siege to the city. In February 1510, the pope became reconciled with Venice and lifted the ban against the city. In October 1511, the pope and Spanish king made an alliance with Venice, which at the moment augured well. But by summer 1513 the situation was desparate once again: Padua was under siege; the rest of the *terraferma* had been lost to Maximilian's troops; villages along the Brenta were looted and Mestre was burned. In January 1515, Francis I succeeded Louis XII and promised aid to the Venetians. Vicenza was recovered, and joint French and Venetian forces were victorious at Marignano on September 13–14, 1515. France thereby regained Milan, which assured Venetian recovery of most of its Lombard territories. Brescia surrendered in May 1516, and the rest of Venetian territory was regained through diplomacy. On December 3, 1516, Venice made peace with Maximilian and on January 17, 1517, reoccupied Verona. Thus Venice emerged from the War of the League of Cambrai with its dominion largely intact. But the republic's vulnerability had become manifest to all.

Needless to say, the War of the League of Cambrai created tremendous financial strains in Venice. Expenses of mercenary troops and leaders, armaments and fortifications, and support of refugees consumed vast quantities of money at the same time that sources of revenue were decreasing or disappearing altogether. As commerce declined, so did income from the indirect taxes levied on traded goods; during the war the mainland produced no revenue at all. The government could no longer pay interest on state bonds and the funded

debt, the *Monte vecchio* and *nuovo*, went bankrupt and were replaced by the *Monte nuovissimo*. The government sought to reduce its expenses by halting the payment of official salaries. Taxes were imposed at frequent intervals and appeals were made for loans. Emergency measures were instituted: lawbreakers and exiles were absolved of their crimes in exchange for payment; money bought underage patricians admittance to the *Maggior Consiglio*, and the offer of a low-interest loan to the state secured nomination to office. The Venetian patriciate accurately gauged the corrupting influence of these measures and rescinded them in 1517.

What effect, if any, did the disruptions of war and economic distress have on the patronage, commissions, functions, and destinations of Giambattista's and Lorenzo's sculptures? Did their careers suffer any more or less than the careers of other Venetian sculptors? Did sculpture in general suffer more or less than architecture or painting?

These are questions that link Giambattista and Lorenzo Bregno to their artistic and historical context. But before taking a distant view – one that permits a survey of field as well as object – we must focus on our objects from a nearer point of sight: we must reconstruct their biographies, establish their oeuvres, define their styles. To all that documents can teach us of the Bregno's life and works I have devoted Chapter One, as well as Appendix A, which contains transcriptions of all known documents that mention the Bregno or any of their works. Secondly, I have sought to identify all of the sculptors' surviving works and to characterize the Bregno's styles, sources, and development. My task has been greatly facilitated by the existence of numerous works either directly or indirectly documented as Giambattista's or Lorenzo's and by one sculpture inscribed with Lorenzo's name. These works have served as standards against which to judge those whose only claim to incorporation within the Bregno oeuvre is their style. If not every one of these has proved directly comparable to a documented work, I do not think I have transgressed the limits of a proper art historical method by using, as terms of comparison in such cases, works previously attributed to one or the other Bregno on the basis of their resemblance to documented works. I have tried to disencumber my text by relegating discussion of misattributed works to a catalogue of rejected attributions, where I argue their dis- or reattribution. Likewise, questions of documentation, patronage, provenance, and previous attributions are answered in the catalogue. Thus Chapters Two and Three are largely dedicated to formal analyses of Giambattista's and Lorenzo's works, in an attempt to chart the topography and boundaries of their art. At length, in the conclusion, I compare the art of the two brothers and set Giambattista's and Lorenzo's lives and works within the wider context of their age.

# CHAPTER ONE
# The Documents

Only the sparsest facts bear witness to the personal lives of Giambattista and Lorenzo Bregno. They were brothers;[1] not only documents but also the style of their works suggest that Giambattista was the older of the two. Their father was master Alberto of unknown profession, who was old and decrepit in 1502 and by 1505 had died.[2] The Bregno's dates of birth are not recorded; the dates of their careers, however, provide a basis for informed hypotheses. Giambattista's career opens around 1500 with commissions for the Bettignoli Bressa Altarpiece and the Verardi Altar of the Corpus Domini; their importance renders it unlikely that Giambattista was very young when he made his first surviving works. A birth date between 1467 and 1477 therefore seems plausible. Lorenzo's date of birth can be calculated within narrower limits. Documented for the first time in 1506 and apparently still a subordinate in his brother's shop until 1511, Lorenzo can be presumed to have been extremely young, perhaps not yet twenty, at his first appearance in the Shrine of the Three Martyrs in 1505–6. We can postulate, therefore, that Lorenzo was born between 1483 and 1488.

We do not know the origins of the Bregno family. One uncle was Veronese. Another hypothetical relative, the Ferrarese woodcarver Antonio di Pietro Bregno, for whom Giambattista was empowered to transact business in Venice, was from Milan,[3] as was the family of Lorenzo's wife.[4] But since Giambattista and Lorenzo are invariably described as residents of Venice without further qualification, it is likely that their family had settled there long before.[5]

Nor do we know if Giambattista was married. Lorenzo was wed to Maddalena di Giovanni Jacopo de' Liprandi da Milano; they had several children who apparently were minors at the time of Lorenzo's death. A son and daughter died not long after Lorenzo did himself. Lorenzo wrote his testament in Venice on December 22, 1523, and died there, from what

---

[1] Biscaro, *Arch. ven.*, ser. 2, xviii, pt. 1, 1899, p. 184.

[2] See Giambattista's commission for the *Miracle of the Goblet* (Appendix A, Doc. I, A) and his quittance for the Bettignoli Tomb (Appendix A, Doc. IV, D). The single instance of the name Roberto for Alberto (Lorenzo's commission for the Altar of St. Sebastian, Appendix A, Doc. XIV, A) is probably an error.

[3] Appendix A, Doc. XII.

[4] See Francesco de' Liprandi's account of his liquidation of Lorenzo's estate (Appendix A, Doc. XIX, D).

[5] In *Arte cristiana*, 1983, p. 37, I identified Giambattista's place of origin as Verona. This error derived from a misreading of "Breonis" as "Verona" in Giambattista's quittance for the Bettignoli Tomb (Appendix A, Doc. IV, D), an error that practice in deciphering archival documents eventually made plain to me.

appears to have been a brief and sudden illness, before January 4, 1524.[6] Giambattista is last
mentioned in the records of the *Arca del Santo*, Padua, for the year 1517.[7] Evidence of his
hand in a figure from the framework of the Pesaro Altar in S. Maria dei Frari suggests he
was still alive at least well into 1518.[8] Probably he had died by April 28, 1520, when the
relief for the Santo, which had been commissioned from him eighteen years earlier, was
reassigned to Giammaria Mosca.[9]

A newly discovered document reveals that Giambattista and Lorenzo were nephews of
the sculptor Antonio Rizzo; very likely it was through their mother that the Bregno and
Rizzo were related.[10] Ordinarily an uncle would have been entrusted with the training of
his nephews, if they were destined for the same profession. If Giambattista complied with
the rules of the Venetian stonemasons' guild, he was apprenticed for five years;[11] afterward
he may have remained in Rizzo's shop as *lavorante*. But Giambattista's name does not appear
among the records of Rizzo's many assistants at the Ducal Palace.[12] Nor is there any part
of the Scala dei Giganti, or any other work executed in Rizzo's shop, attributable to the
young Giambattista. Nevertheless, Rizzo's works repeatedly furnished Giambattista with
prototypes. More importantly, Rizzo's extraordinary technical refinement in the service of
subtle visual effects provided an aesthetic goal that guided Giambattista throughout his
career. A formative influence, however, also was exerted on the young Giambattista by Pietro
Lombardo. From Pietro came the facial types of Giambattista's male *Saints* and *Christ*, as well
as drapery patterns in his early works. Probably, by the later years of Giambattista's ap-
prenticeship, Rizzo was executing very little sculpture. Indeed, after Rizzo's flight, Giambattista
may have entered the employ of his uncle's successor at the Ducal Palace.

By contrast, Lorenzo can have worked with his uncle only briefly, if at all, before Rizzo's
flight from Venice in 1498: indeed, Lorenzo's style diverges radically from that of Rizzo.
Undoubtedly Lorenzo received most of his training from his brother, from whom, at an
early stage, he derived facial types and drapery, as well as particular motifs. On the other
hand, Lorenzo's works also reveal Pietro Lombardo's influence. But since Lorenzo drew on
the very works that inspired Giambattista and took from them the very things that Giam-
battista copied, we may suppose Lorenzo's appropriations largely guided, and possibly me-
diated, by his brother.

---

[6] See the sale of the contents of Lorenzo's shop (Appendix A,
Doc. XIX, A) and Francesco d' Liprandi's account of his liqui-
dation of Lorenzo's estate (Appendix A, Doc. XIX, D).
[7] See the payment to Giambattista for the *Prophet* of the Santo
(Appendix A, Doc. I, D, 9).
[8] See Catalogue no. 27 for the Pesaro Altar, S. Maria dei Frari,
Venice.
[9] Sartori/Fillarini, 1976, p. 172; Sartori/Luisetto, 1983, p. 361,
no. 441; Wilk in *Le sculture del Santo*, 1984, p. 134, n. 76.
[10] See the election of Giambattista as appraiser of works made
for the Cappella Zen (Appendix A, Doc. IX, A) first published
by Jestaz, 1986, pp. 196f, doc. 52. The Venetian word *nevodo*
used in the document means both nephew and grandson. In this
context, however, it cannot mean grandson, for Rizzo did not
have a son Alberto. (See Schulz, 1983, pp. 123f.) Moreover,
Rizzo and Alberto Bregno apparently belonged to the same

generation. Giambattista and Lorenzo are unlikely to have been
related to Rizzo through their father, since Rizzo never appears
in documents under the name of Bregno and the maiden name
of Rizzo's wife was Gibellino (ibid., p. 123). The name of Giam-
battista's and Lorenzo's mother is not known; therefore we do
not know whether she was related to Rizzo himself or to his
wife. The relationship between Rizzo and the Bregno may ac-
count for Sansovino's use in 1581 of the name Antonio Bregno
when he evidently meant Antonio Rizzo, and for the confusion
surrounding Rizzo's birthplace consequent to this misunder-
standing. (See Schulz, 1978, pp. 52f.)
[11] The Venetian *Arte degli scarpellini* prescribed an apprenticeship
of at least five years for all (Sagredo, 1856, p. 298, no. XLI),
but no more than five years for those apprenticed to relatives
(ibid., p. 290, no. XXI).
[12] Schulz, 1983, p. 94.

That Giambattista and Lorenzo shared a shop is suggested by their lifelong collaboration. This cannot have been Rizzo's shop, which evidently was sold before his flight from Venice.[13] At the end of his life, Lorenzo is known to have kept a shop at Venice in the parish of S. Severo;[14] presumably earlier references to S. Severo in connection with Giambattista also allude to the brothers' shop.[15] At Lorenzo's death his shop contained marble blocks and live stone, as well as implements; the outstanding salaries of an unspecified number of *garzoni* and *lavoranti* eventually were paid from his estate.[16] Unfortunately, the statutes of the Venetian stonemasons' guild devote far less space to the organization of the workshop than they do to matriculation and the payment of dues, the election of the *gastaldo*, and the attendance of members at funerals and masses,[17] and therefore shed little light on the daily exercise of the sculptor's profession in Renaissance Venice. The guild's *Mariegola* tells us that it was prohibited to continue work begun by a fellow mason who had not been paid, to work at night without a special license or on feast days, to mix different kinds of stone in a single work, and to keep more than three apprentices in addition to relatives[18] – but little else to our purpose. Moreover, the highly articulated system of penalties, in which the delinquent supervisor as well as the transgressor often shared, implies that regulations represented an ideal – not a reality.

Throughout their documented careers Giambattista and Lorenzo dwelt in the parish in which their uncle had lived[19] – S. Giovanni Nuovo[20] – bordering that of S. Severo. Despite extensive activity at Treviso, particularly in the first decade of the sixteenth century, Giambattista and Lorenzo do not seem to have set up shop there. In this respect their practice did not differ from that of Pietro or Tullio Lombardo, who also executed in Venice works delivered to several cities in northern Italy. Indeed, since unworked Carrara marble and Istrian limestone were regularly transshipped to the cities of the *terraferma* via Venice,[21] there would have been little advantage to such a move.

Giambattista is first documented in connection with his abortive commission for the marble relief of the *Miracle of the Goblet* for the new Cappella del Santo in the Basilica di S. Antonio at Padua. This chapel was intended as a more splendid re-creation of the medieval one, which housed the thaumaturgic remains of St. Anthony. Frescoed in the fourteenth century

[13] It is quite unlikely, as Jestaz, 1986, p. 71, n. 2, suggests, that the Bregno inherited the shop of their uncle, Antonio Rizzo. In the first place, Rizzo's shop was in the parish of S. Giovanni Nuovo, while the Bregno shop, at least from 1507, was in the parish of S. Severo. Secondly, Rizzo himself claimed to have abandoned his shop in 1485 because of pressure of work at the Ducal Palace (for which see Schulz, 1983, p. 128). Thirdly, before fleeing Venice in April 1498, Rizzo is supposed to have sold all his goods and property (for which see ibid., p. 135).

[14] See the sale of the contents of Lorenzo's shop (Appendix A, Doc. XIX, A).

[15] See the election of Giambattista as appraiser of works made for the Cappella Zen and payment to him for his estimate (Appendix A, Docs. IX, A and C); Giambattista's commission for the relief of *St. George* (Appendix A, Doc. X, A); payment to Giambattista for the *Prophet* of the Santo (Appendix A, Doc. I, D, 9).

[16] See Francesco de' Liprandi's account of his liquidation of Lorenzo's estate (Appendix A, Doc. XIX, D).

[17] Sagredo, 1856, pp. 281–310.

[18] Ibid., pp. 290f, nos XXII–XXIIII; p. 297, no. XXXVII; pp. 302f, no. XLVIIII; p. 306, no. LV.

[19] Schulz, 1983, pp. 124, 126, 136.

[20] See Giambattista's commission for the *Miracle of the Goblet* (Appendix A, Doc. I, A); Lorenzo's commission for the Altar of St. Sebastian (Appendix A, Doc. XIV, A); the sale of the contents of Lorenzo's shop (Appendix A, Doc. XIX, A).

[21] For example, in 1497 the Carrara marble to be used by Cristoforo Solari for the altar and Tomb of Beatrice d'Este destined for S. Maria delle Grazie, Milan, was sent from Venice. (Cantù, *Arch. stor. lom.*, 1874, pp. 483–5.) See also a contract of 1495 relating to the facade of the Certosa of Pavia (Magenta, 1897, p. 479) and various projects for the Santo, Padua (Sartori/Luisetto, 1983, p. 334, no. 32; pp. 685f, no. 18; pp. 975f, no. 25).

by Stefano da Ferrara with scenes of the saint's life, the chapel was in very poor repair by the end of the fifteenth century. Impetus for the chapel's reconstruction was provided in 1499 by the bequest of 3,000 ducats from Francesco Sansone da Brescia, Superior General of the Franciscan order. By early 1500, the design of the chapel, encircled by marble reliefs of the saint's miracles, was set. Along the rear wall, a blind arcade with five bays was to match an open arcade along the facade. Above the facade arcade there were to be life-size marble statues.[22] A few months later, the Paduan bronze sculptor, Andrea Riccio, was paid for having made wax figures and a relief for the last model of the chapel. On the basis of this document, it was long assumed that the decoration of the chapel was planned by Riccio. But it has been argued persuasively that, in fact, Riccio did no more on the model than what he was actually paid for and that the chapel's design was conceived by the younger generation of Lombardo jointly or by Tullio alone.[23] On June 19, 1500, Severo Calzetta da Ravenna, known chiefly as a sculptor of small bronzes, undertook to carve the statue of *John the Baptist* for a niche of the chapel facade. If the statue turned out well, Severo was promised the commission for two more statues and one relief.[24] On June 21, 1500, Giovanni Minello was named *protomaestro* of the new chapel and contracted for unspecified works of sculpture executed by himself and his son Antonio.[25] However, a month later, the first two reliefs were commissioned, not from Minello, but from Antonio and Tullio Lombardo.[26] On June 17, 1501, two more reliefs were ordered from the Lombardo and one from Giovanni and Antonio Minello.[27] Antonio Lombardo's partly finished relief of the *Miracle of the Speaking Babe*, or, more likely, his plaster model of it, had been exhibited temporarily at the Santo on the feast day of St. Anthony, 1501 (June 13),[28] but none of the reliefs had been finished and consigned when, on October 20, 1502, Giambattista Bregno was commissioned to supply the sixth relief of the *Miracle of the Goblet*.[29]

*Fig. 21*

In his contract, the stewards of the *Arca del Santo* obligated Giambattista to make the relief as large as the ones being made by Antonio Lombardo and to include as many figures in high and half relief. Work was to be finished within two years. The stewards promised to supply the marble and to pay Giambattista 150 ducats, in addition to the value of the stone. Sebastiano di Jacopo da Lugano stood guarantor to Bregno. At the same time, the marble perspective above Giambattista's relief – the intarsia lunette with an architectural panorama – was commissioned from Sebastiano da Lugano.[30] The stewards of the *Arca* would furnish the marble and promised Sebastiano 25 ducats at the conclusion of the work.

On December 22, 1502, Giambattista received an advance of 5 ducats for his relief.[31] The stewards took the opportunity to commission from Giambattista one of the twelve half-

---

[22] For the early history of the chapel, see Wilk in *Le sculture del Santo*, 1984, pp. 110–14.

[23] Stepan, 1982, pp. 17–22, 27, 217, 228–45; Wilk in *Le sculture del Santo*, 1984, pp. 114–17, 151–5.

[24] Sartori/Fillarini, 1976, p. 36; Sartori/Luisetto, 1983, p. 335, no. 38; Wilk in *Le sculture del Santo*, 1984, p. 125, n. 52.

[25] Sartori/Fillarini, 1976, pp. 155f; Sartori/Luisetto, 1983, p. 335, nos. 34, 39.

[26] Sartori/Fillarini, 1976, p. 137; Sartori/Luisetto, 1983, pp. 358f, no. 397; Wilk in *Le sculture del Santo*, 1984, p. 120, n. 40

(with the incorrect date of June 27).

[27] Sartori/Fillarini, 1976, pp. 137f, 156; Sartori/Luisetto, 1983, p. 359, no. 402, and p. 349, no. 262; Wilk in *Le sculture del Santo*, 1984, pp. 122–4, nn. 47, 49.

[28] Sartori/Fillarini, 1976, p. 137; Sartori/Luisetto, 1983, p. 359, no. 401. For Antonio's model, see Temanza, 1778, p. 118.

[29] Appendix A, Doc. I, A.

[30] Appendix A, Doc. I, B.

[31] Appendix A, Doc. I, C.

length *Prophets* in *tondi* immured in the full spandrels between the arches of the arcade surrounding the interior of the chapel. The *Prophet* was to match those by Giovanni Minello; indeed, the stewards hoped it would be better. For it, they would pay 7 ducats – the same amount Minello later received for a *Prophet* of his.[32] Bregno's guarantors were Minello and "maestro bastian suo compagno" – presumably Sebastiano di Jacopo da Lugano. Not till four and a half years later did Giambattista receive the marble block from which to carve the *Prophet*.[33]

Giambattista did not carve the *Miracle of the Goblet*; in 1520 it was commissioned anew from Giammaria Mosca and was largely executed by him, but was ultimately finished by Paolo Stella Milanese in 1529.[34] Bregno's debt to the *Arca del Santo* for his advance on the *Miracle of the Goblet* at length was extinguished by his delivery of the *Prophet*, conveniently appraised at the exact amount of Bregno's advance plus the value of the marble he had received for the *Prophet*, but less than had been agreed upon. In the *Arca's* account book for 1517, the *Prophet* is recorded as having been made and delivered and already installed on the wall towards the "capella di opici,"[35] the present-day Cappella della Madonna Mora, where it can still be seen.

*Pl. 113*

Despite his dilatoriness, Giambattista evidently was in the confidence of the stewards of the *Arca*, for there is record on December 13, 1504, in anticipation of the consignment of Antonio Lombardo's *Miracle of the Speaking Babe*, that they elected Bregno, along with Gian Cristoforo Romano chosen by Antonio, to evaluate the relief and its perspective.[36]

*Fig. 21*

The Sebastiano di Jacopo da Lugano, whose name is linked in the Santo documents with that of Giambattista Bregno and who apparently was Giambattista's partner in December 1502 – that is, before Lorenzo had begun to practice as a master carver – is a sculptor and architect who makes a brief appearance in his own right in the history of Venetian art.[37] We do not know when he was born; he died between December 18, 1515, and December 17, 1518. Four documents in the archive of the *Arca del Santo* appear to refer to Sebastiano; in two he figures as arbiter, in a third, as carver of an unidentified and perhaps unfinished figure for the facade of the Cappella del Santo. In the fourth Sebastiano was charged by the *Arca* on October 20, 1502, with making the perspective for Antonio Lombardo's *Miracle of the Speaking Babe*, along with the one for Bregno's relief.

A large part of Sebastiano's career was taken up with the construction of the *barco* for S. Antonio di Castello at Venice. Commissioned on January 7, 1505, it was still unfinished at Sebastiano's death. Completed by Guglielmo dei Grigi, it was demolished, along with the church and convent, in the early nineteenth century. But a drawing, incorporating alternate schemes for the plan and elevation of the *barco*, reveals a chaste and planar style, dependent upon elongated and attenuated members, incrustation, and fine, flat, uncarved moldings. The style revealed in the drawing accords with that of two extant works linked by document

---

[32] For Minello's payment of December 20, 1503, see Sartori/ Fillarini, 1976, p. 156; Sartori/ Luisetto, 1983, p. 337, no. 75.
[33] Appendix A, Doc. I, D, 4.
[34] Sartori/ Fillarini, 1976, pp. 172f, 206; Sartori/ Luisetto, 1983, pp. 361f, nos. 441–60; Wilk, in *Le sculture del Santo*, 1984, p. 134, n. 76.

[35] Appendix A, Doc. I, D, 9.
[36] Appendix A, Doc. II.
[37] For a conspectus of the documents concerning Sebastiano and a discussion of attributable works, see Schulz, *Arte ven.*, 1983, pp. 159–63.

with Sebastiano da Lugano – the Tomb of Pietro Guoro and the alcove in the Civran Chapel, S. Maria dei Carmini, Venice. These works can be dated between the death of Pietro Guoro on April 12, 1514,[38] and December 18, 1515, when Sebastiano tendered a receipt for money received for all work done in Guoro's chapel. At the same time and for the same chapel, Sebastiano probably executed the tomb of Guoro's uncle, Luca Civran (d. 1503), of which only the two *Reggiscudo* in the Staatliche Museen, East Berlin, survive. In November 1515, "maistro Sebastiano da Lugano taiapiera inzegner" examined Padua's fortifications for Doge Leonardo Loredan and gave advice on work of construction and repair derived principally from orders left by the late *Capitano Generale*, Bartolomeo d'Alviano, whose deputy Sebastiano had been. When in Padua, the architect may have provided a design for the new Basilica of S. Giustina, on the basis of foundations already sunk and in accordance with suggestions of d'Alviano. Sebastiano's project, drafted ca. 1513 to 1514, would have constituted the second of several plans for the rebuilding of the church. Our Sebastiano may or may not be identical with the "mistro Sebastian," named as *protomaestro* during the initial stages of construction at S. Fantin between March and June 1507 and again in January 1516[39] and with the author of a model for the new Scuola Grande della Misericordia presented in early 1504 in competition with Alessandro Leopardi.[40]

Partnerships between Venetian sculptors are known from other instances in the early sixteenth century. Giovanni Buora, for example, was called the former partner of Bartolomeo Duca when, in 1510, payment was made for the choir screen figures of S. Margherita, Treviso.[41] At Padua, Giammaria Mosca and Niccolò da Corte were named partners in an unpublished document of 1524 relating to a terracotta group for S. Maria del Carmine.[42] As in the case of Giambattista and Sebastiano, these notices reveal nothing more than the mere fact of association. The partnership of Antonio Minello and Bartolomeo Stampa, by contrast, is documented by contracts of 1522 and 1524, which specify the rights and obligations of each party and permit some general conclusions concerning the nature of artistic partnerships during the period of Bregno's activity.

Partnerships were temporary associations; Minello and Stampa's was made for two years and renewed for another three. Partnerships did not require participation in a common enterprise or the sharing of premises, assistants, tools, or materials. Indeed, partnerships could be formed between practitioners of different crafts, like Minello and Stampa, stone-carver and goldsmith, respectively, active in different cities. Undoubtedly many partnerships prescribed a division of labor, but the partnership between Minello and Stampa served a purely financial purpose: in return for Stampa's payment of the rent on a shop recently acquired by Minello in Venice and the salary of one assistant, Minello obligated himself to divide equally with Stampa, resident in Padua, whatever profits accrued from the former's work.[43] We do not know if Giambattista's association with Sebastiano da Lugano was of this kind. The absence of any work executed in Bregno's shop that can be attributed to Sebastiano,

[38] Sanuto, *Diarii*, xviii, 1887, col. 129, Apr. 13, 1514.

[39] Vio, *Arte ven.*, 1977, p. 226.

[40] Wurthmann, 1975, p. 167.

[41] Schulz, *Arte lom.*, 1983, pt. 2, pp. 50f, 71.

[42] ASP, Notarile, t. 2066 (not. Massimo Massimi), cc. 166r, 179r.

[43] Schulz, *Flor. Mitt.*, 1987, pp. 293–6.

permits – if it does not prove – the assumption of a partnership based on economic, rather than artistic, cooperation.

We do not know how long Bregno's association with Sebastiano lasted. Three documents, however, suggest the continuation of some sort of relationship, if not a formal partnership, long after 1502. On December 28, 1505, Giambattista and Sebastiano jointly appraised fireplace hoods in the *Appartamenti dei Dogi* at the Ducal Palace executed some years earlier by Tullio and Antonio Lombardo.[44] On August 23, 1507, Sebastiano and Giambattista were chosen jointly by Pietro Lombardo and the *Procuratori di S. Marco de citra*, the latter as executors of the testament of Cardinal Giovanni Battista Zen, to evaluate the works realized by Antonio Lombardo for the Cappella Zen.[45] The appraisal, however, was not made until September 24, 1510, by which time several works commissioned from Antonio, but not made by him, had been executed by his successor, Paolo Savin.[46] On the following day, Sebastiano and Giambattista were paid the extraordinarily high fee of 12 ducats for their expertise.[47]

The first work that can be linked by document to Giambattista Bregno – albeit only indirectly – is the Bettignoli Altar in S. Nicolò, Treviso. On July 9, 1505, Giambattista gave *Pl. 1* a quittance to the procurator of Giovanni Antonio Bettignoli's widow.[48] The work for which Bregno had received his final payment was the tomb of Giovanni Antonio's uncle, Venceslao Bettignoli, and the steps leading up to Venceslao's altar in the Franciscan Observant Church of S. Chiara, Treviso. Bregno also gave a quittance for everything received during Giovanni Antonio's lifetime, and, after his death, from his executor "for Venceslao's tomb in S. Chiara and for other works of whatever kind made by him [Bregno] for Giovanni Antonio." Tomb and altar had resulted from Venceslao's testament and codicil of August 22 and 23, 1499, respectively, in which he ordered that, within six months of his death, Giovanni Antonio erect the testator's tomb as well as an altar with figures of *Christ*, flanked by the *Virgin Mary* and *St. John the Evangelist* in S. Chiara.[49] We do not know when Venceslao died and work was started; tomb and altar were finished by December 30, 1503, when Giovanni Antonio indited his own testament.[50] Venceslao's tomb no longer exists, but the altar, greatly transformed, is currently installed in the right aisle of S. Nicolò. The fact that Giambattista made the tomb and altar steps encourages me to seek his hand in the remnants of Venceslao's altar. Indeed, the style of *Christ*, the *Angels* in medallions, and the relief of the *Madonna and* *Pls. 4, 10,* *Child* in the upper story agrees so well with that of Giambattista's documented sculptures, *13, 14* that we are justified in reckoning this altar among those "other works" commissioned from Giambattista by Giovanni Antonio Bettignoli in execution of his uncle's will.

Work for the Chapel of the Confraternity of the Holy Sacrament in the Duomo of Treviso, under Bishop Bernardo de' Rossi, occupied at least ten years in the careers of Giambattista and Lorenzo Bregno. The first stone of the new chapel at the east end of the church had been laid in 1501; construction took two years.[51] It was not until the chapel's

---

[44] Appendix A, Doc. III.
[45] Appendix A, Doc. IX, A.
[46] Jestaz, 1986, pp. 201–4, docs. 65, 66, 68, 69. See also Appendix A, Doc. IX, B.
[47] Appendix A, Doc. IX, C. One lira di grossi equaled 10 ducats.

[48] Appendix A, Doc. IV, D.
[49] Appendix A, Docs. IV, A, B.
[50] Appendix A, Doc. IV, C.
[51] Biscaro, *Arch. ven.*, ser. 2, xviii, pt. 1, 1899, pp. 182f.

*Pl. 46*

fabric, including interior pilasters and entablature and exterior revetment, was complete that Giambattista was engaged: it is clear, therefore, that he was responsible neither for the plan nor for the elevation of the chapel. This fact is consistent with the absence from Giambattista's (or Lorenzo's) oeuvre of any documented or hypothetical work of architecture. By contrast, the Lombardo shop had been entrusted with major work of construction as well as sculpture for the Duomo of Treviso twenty years before. Initially, Giambattista's tasks in the Cappella del SS. Sacramento were limited to those within the competence of any experienced stonemason. This, no doubt reflects the normal sequence of work there and not distrust of Giambattista's abilities. Four separate commissions to Giambattista provided for the chapel's veined marble cladding. The incrustation of the two lateral walls of the square room of the chapel was executed between April 28 and October 6, 1504;[52] the incrustation of the pendentives dates from June 12 to November 3, 1506. A payment on account of July 31, 1506 for the revetment of the pendentives contains our first reference to Lorenzo Bregno.[53] On November 3, 1506, Giambattista agreed to incrust the apse (exclusive of the half-dome later painted by Pietro Maria Pennacchi)[54] and on August 14, 1507, he promised to incrust the two lunettes and to make one oculus.[55] Meanwhile, on December 11, 1504, Giambattista had undertaken to make the black and white stone pavement.[56] He was commissioned to make the stairs that give access to the chapel on August 20, 1508.[57] Finally in 1514, Lorenzo was entrusted with the work of stonemasonry for the chapel's vestibule, then under construction.[58]

*Pl. 20*

While at work on the facing of the Chapel of the Holy Sacrament and before taking up the carving of its statuary, Giambattista was employed by the heirs of Carlo Verardi to execute the Altar of the Corpus Domini in the Duomo at Cesena. A contemporary chronicler reported that Verardi's chapel, erected in 1494, was furnished with marble figures in June 1505.[59] On January 10, 1506, Giambattista, present in Cesena, claimed his final payment for the completed statues.[60] Bregno's credit was acknowledged and, three days later, paid.[61] The figures had been commissioned from Giambattista by Carlo Verardi, canon and archdeacon of the cathedral, before his death on November 27, 1500.[62] By the time Giambattista came to be paid, Carlo's heir, his nephew Camillo, had died as well and payment was made by the guardians of Camillo's son and heir, Ptolomeo. The altar still exists under a dedication to St. John. Though moved, the altar is again in its original position in the right aisle of the church. While the figures seem to be preserved in their entirety, their arrangement within a segmental niche is probably the result of the altar's late nineteenth century reconstruction.

In his request for payment from the heirs of Carlo Verardi, Giambattista cited a second work which had not been fully paid – the Tomb of Ippolito Verardi, the young brother of Camillo and nephew of Carlo, in the Venetian Church of the Crociferi.[63] The tomb is lost and no descriptions of it survive. But its epitaph was often copied.[64]

[52] Appendix A, Docs. V, A, 1 and 2.
[53] Appendix A, Docs. V, B, 1, 3, 4.
[54] Appendix A, Doc. V, C, 1.
[55] Biscaro, *Arch. ven.*, ser. 2, xviii, pt. 1, 1899, p. 184.
[56] Ibid., p. 184.
[57] Ibid., p. 185.

[58] Ibid., p. 188.
[59] Appendix A, Docs. VI, B and D.
[60] Appendix A, Doc. VI, E.
[61] Appendix A, Doc. VI, F.
[62] Burchi, 1962, ii, p. 76.
[63] Appendix A, Doc. VI, E. See also Doc. VI, F.

From it we learn that Ippolito had died on April 5, 1503, and that the tomb had been erected by Ippolito's two brothers, Camillo and Sigismondo. Camillo died in June 1505.[65] Sigismondo was already dead when Camillo indited his testament on June 19, 1504.[66] Therefore we may assume that the tomb was commissioned between April 5, 1503 and June 19, 1504 — that is, between Ippolito's and Sigismondo's death. Work on the tomb was finished by January 10, 1506.

It is significant that, despite his documented residence in Venice, Giambattista's early activity was confined exclusively to the *terraferma* and was focused chiefly on Treviso and Cesena. Indeed, as we have seen, Giambattista's first documented Venetian commission, the Verardi Tomb in the Crociferi, was conferred, not by a Venetian but by the Cesenate relatives of the deceased, nephews of the patron of the Chapel of the Corpus Domini. It is not hard to imagine how Giambattista might have become known in cities of the Venetian *terraferma* like Treviso, a mere day's journey from the capital, where the Lombardo and Giovanni Buora had worked extensively. But that Giambattista should have become known in the small Romagnol city of Cesena in the papal states requires explanation. No doubt, the intermediary was Bregno's uncle. When, in April 1498, Rizzo was accused of having embezzled funds allocated to the rebuilding of the Ducal Palace, the sculptor fled to the Romagna. Testimony to his presence in Cesena in 1498 and early 1499 is contained in a contemporary chronicle and a notarial act, respectively.[67] In 1498 Carlo Verardi's chapel was standing, but still lacked an altar. There is no evidence that Rizzo agreed to carve, much less began, the Altar of the Corpus Domini; indeed, the chronicle reports that, after living in Cesena, Rizzo left for Ferrara. That Rizzo recommended his kinsman for the job, however, is more than likely. In fact, by November 1500 at the latest, Giambattista Bregno had been entrusted with the work.

Approximately six years after his debut, Giambattista received his first commission from a Venetian patron: on July 31, 1506, the *Procuratori di S. Marco de citra*, ordered the six bronze female figures for the sarcophagus of Cardinal Zen (d. 1501) for his funerary chapel in S. Marco jointly from Giambattista Bregno and Paolo Savin.[68] Savin had succeeded to Antonio's commission for the sculpture of the chapel when the latter moved to Ferrara in 1506.[69] Tomb chest and figures were to imitate those of the Tomb of ser Orsato Giustiniani (d. 1464) at S. Andrea della Certosa.[70] Payments to Giambattista for his figures date from October 30, 1506 and April 13, 1507.[71] Before October 14, 1507, four of the six figures, of which three probably were by Savin, were ready to be cast;[72] on March 28, 1508, casting was still under way, and apparently was finished by May 26, 1508.[73] On March 28, 1508, Giambattista received his final payment, bringing his total recompense to half the sum disbursed for the modeling of all the figures.[74] Giambattista's final payment, however, was explicitly made for four, rather than three, figures; evidently one of Bregno's figures was not used. The two

Pl. 63

---

[64] See Catalogue no. 18 for the Verardi Tomb, Church of the Crociferi, Venice.
[65] Fantaguzzi, (1460–1510) 1915, p. 217.
[66] Stat. Civ. Caes., 1589, p. 382.
[67] Schulz, 1983, pp. 134f, 138.
[68] Appendix A, Doc. VIII, A.

[69] Jestaz, 1986, pp. 71f.
[70] Ibid., p. 188, doc. 19, p. 190, doc. 24.
[71] Appendix A, Doc. VIII, B, 2.
[72] Jestaz, 1986, p. 197, doc. 55.
[73] Ibid., pp. 197f, docs. 56, 57.
[74] Appendix A, Docs. VIII, B, 1 and 2.

figures not ready to be cast on October 14, 1507, apparently were cast between May 26, 1508, and September 24, 1510.[75]

Pl. 48
Pls. 59, 61
54, 124
Pls. 129–
132

Pls. 133–
136

Not long after the commission for the Zen sarcophagus figures, Giambattista and Lorenzo took in hand the statuary for the Chapel of the Holy Sacrament at Treviso. This comprised the under life-size marble statues of the *Resurrected Christ* flanked by *Angels* in the niches of the apse, *St. Peter* in the niche of the left wall, *St. Paul* in the niche of the right wall, the altarpiece from which there survive four small compartments with high reliefs of *Angels*, now rearranged on the altar, and four high reliefs of *Evangelists* with their symbols in the pendentives of the dome. On November 3, 1506, Giambattista was entrusted with the *Resurrected Christ*; the commission for the statue is contained in Bregno's contract for the incrustation of the apse.[76] The figure was finished by April 30, 1508, when Bishop Rossi ordered from Giambattista four more figures – two *Angels* and the *Apostles Peter* and *Paul* – as perfect in workmanship and material as the figure of *Christ*, which Bregno had already made.[77] Since *St. Paul* was later paid for separately, the three finished figures for which Giambattista was paid on account on December 23, 1509, must be the two *Angels* and *St. Peter*.[78] On March 30, 1513, not Giambattista, but Lorenzo, was paid on account for the figure of *St. Paul*.[79] The altarpiece, altar, its pavement, and step were commissioned from Giambattista on March 20, 1510. But apart from an advance, all payments were made to Lorenzo, who signed the quittance.[80] A final contract for the four *Evangelists* of the pendentives was made with Lorenzo on March 13, 1511. Exactly one year later, two *Evangelists* were delivered to the chapel; the other two arrived on April 4, 1512.[81]

Pl. 84

While employed by the Confraternity of the SS. Sacramento at Treviso, Giambattista also carved a relief for the Convent of S. Giorgio Maggiore at Venice. On October 11, 1508, less than a month after the *bacino* facade of the dormitory of the Benedictine convent had been commissioned from Giovanni Buora,[82] Bregno was charged with making the relief of *St. George and the Dragon* for the summit of the facade. The sculpture was to be carved in half relief from Istrian stone and was to be finished by the end of the coming November. On July 25, 1509, Giambattista received his final payment.[83] But for nearly three years no provision was made for the installation of the facade's revetment[84] and the relief was not painted until June 9, 1513.[85] Its polychromy effaced and its surface worn by centuries of exposure, the relief of *St. George* survives in situ in the central lunette atop the dormitory facade.

Pl. 174

In the Duomo at Cesena are two altars that resulted from Verardi patronage. One, as we have seen, was the Altar of the Corpus Domini, executed by Giambattista for Carlo Verardi and his heirs. The other is the Altar of St. Leonard, erected for Carlo's nephew, Camillo, co-patron of Giambattista's Tomb of Ippolito Verardi, and for Camillo's heirs. In his testament

[75] Jestaz, 1986, p. 198, doc. 57, pp. 201f, docs. 65, 66.
[76] Appendix A, Doc. V, C, 1.
[77] Biscaro, *Arch. ven.*, ser. 2, xviii, pt. 1, 1899, pp. 184f.
[78] Ibid., p. 185.
[79] Ibid., p. 185.
[80] Ibid., p. 185f.

[81] Ibid., p. 186f.
[82] Cicogna, iv, 1834, p. 322, n. 190; Paoletti, 1893, ii, p. 256.
[83] Appendix A, Doc. X, A.
[84] Cicogna, iv, 1834, p. 323, n. 190; Paoletti, 1893, ii, p. 256.
[85] Appendix A, Doc. X, B.

of June 19, 1504, Camillo had instructed his executors to build a chapel dedicated to St. Leonard in the cathedral next to the baptismal font, in accordance with a contract that the testator had already made, and to install there marble figures of *SS. Leonard, Eustace,* and *Christopher,* within three years of his death.[86] Verardi died in June 1505; eventually his sister Giulia inherited his estate and with it, the obligation of implementing Verardi's testamentary decrees concerning his chapel.[87] Before she could see to the making of the altarpiece, however, Giulia was obliged to have the unfinished chapel, constructed during Camillo's lifetime in an inconvenient site, demolished and rebuilt nearby. The new chapel, meant to resemble Carlo's Chapel of the Corpus Domini, was built between May and November, 1508.[88] On May 25, 1510, Giulia commissioned the three statues of the altarpiece from the Lombard sculptor Tommaso Fiamberti, and the goldsmith and painter Vincenzo Gottardi.[89] Just how or why Giulia broke her contract with Fiamberti and Gottardi is not recorded. On March 18, 1514, at any rate, through the agency of her husband, she made a new agreement with Lorenzo Bregno, present in Cesena.[90] The marble figures of *SS. Leonard, Eustace,* and *Christopher,* three-quarters life-size, were to be carved in high relief and were to occupy three Istrian limestone niches faced with marble. The work that was to be finished within a year, instead took three years to complete: on February 9, 1517, Lorenzo, in Cesena once again, gave a receipt for his final payment.[91] Moved from their original location and despoiled of their architectural framework, the three figures are still preserved in the left aisle of the Duomo at Cesena.

The Bregno's employment at Treviso did not cease with completion of the Cappella del SS. Sacramento; on the contrary, there were few years when the Bregno did not have in hand some work or other destined for Treviso. According to its erstwhile inscription, Lorenzo's Altarpiece of St. Sebastian, originally in the Trevisan Church of S. Margherita, resulted from a testamentary decree of the jurist Vincenzo Zotti, which was implemented by his widowed mother and heir, Maddalena da Bavaria, in 1516.[92] On January 29, 1515, Maddalena ordered an altar with a marble statue of *St. Sebastian,* two-thirds life-size, from Lorenzo Bregno.[93] The sculptor had made a small model which he promised to follow. Work on the altar was under way on May 5, 1516;[94] presumably it was finished by Christmas 1516 – the change of the Trevisan year. Curiously, the commission makes no mention of the relief or reliefs of the *Madonna and Child* flanked by adoring *Angels,* which originally occupied the altar's attic. The altarpiece survives in entirety, although its parts are widely dispersed: the statue of *St. Sebastian* is currently installed in a pier in the Duomo of Treviso; the statue's niche, *Pl. 188* with its architectural surround, is immured in the left wall of S. Leonardo, Treviso; the *Pl. 194* *Madonna and Child* and *Angels* are in the Szépművészeti Múzeum, Budapest. *Pls. 190, 191, 193*

Presumably on the basis of a document known, but not published or cited, Paoletti reported that Lorenzo Bregno was supposed to deliver marble for Tullio Lombardo's work in the

---

[86] Appendix A, Doc. XIII, A.

[87] Fantaguzzi, (1460–1510) 1915, pp. 217, 270.

[88] Grigioni, *L'arte,* 1910, pp. 43f, n. 3; ASC, Archivio notarile, Volume 277 (not. no. 25, Gaspare Antonini, 1508), c. 197r, Nov. 2, 1508.

[89] Grigioni, *Felix Ravenna,* 1913, pp. 504–7.

[90] Appendix A, Doc. XIII, B.

[91] Appendix A, Doc. XIII, C.

[92] See Catalogue no. 10 for *St. Sebastian,* Duomo, Treviso.

[93] Appendix A, Doc. XIV, A.

[94] Appendix A, Doc. XIV, B.

Cappella Zen in 1516.[95] Jestaz's recent searches among the papers of the *Procuratori di S. Marco de citra* relating to the Cappella Zen uncovered no such document.

On March 3, 1518, the *Procuratori di S. Marco de supra* commissioned from Lorenzo Bregno the Altar of the Cross, as a tabernacle for the sacrament, for the Basilica di S. Marco.[96] The altarpiece was described in detail on the basis of a drawing; except for the greater height of the altarpiece as built, description and work correspond. The altarpiece was to contain a perspectival setting, two *Angels* in more than half relief flanking the repository for the Host, a figure of *God the Father* in half relief above the *sportello*, and freestanding figures of *SS. Francis* and *Anthony of Padua* in niches at either side. No time limit was set. Lorenzo's Altar of the Cross is located at the rear of the presbytery of S. Marco; it encloses a bronze *sportello* by Jacopo Sansovino with the *Allegory of the Redemption*.

The commission for the Altar of the Cross is unusual in assigning responsibility for the provision of material to the patrons: the procurators promised that marble, serpentine, and porphyry would be furnished by their *protomaestro*, Bartolomeo Bon. On only two other occasions were the Bregno supplied with their material: in 1507 and 1520 the stewards of the Arca del Santo gave Giambattista and Lorenzo the marble from which they were to carve a *Prophet* and the *Miracle of the Jealous Husband*, respectively. By contrast, the Bregno were held responsible for providing, at their own risk, labor, and expense, the necessary stone – whether Carrara marble, limestone from the Brioni Islands, black marble from Verona, or discs of porphyry or serpentine – for the relief of *St. George*, the St. Leonard and St. Sebastian Altars, and the incrustation of the Cappella del SS. Sacramento. There is no evidence that the Bregno personally oversaw the quarrying and transport of live stone; more likely, they ordered it from native masons or purchased it at Venice. Undoubtedly, a sculptor would be assumed to have easier access to the best material than would a private person, especially if the latter did not live at Venice. On the other hand, patrons like the stewards of the *Arca del Santo* or the procurators of St. Mark's, in charge of ongoing and extensive projects of construction and decoration, naturally would have found it expedient and cheaper to furnish the material themselves.

Lorenzo's pedestrian effigy of the Cremasque *condottiere*, Bartolino Terni, from his tomb in S. Trinità at Crema is the only work inscribed by either Giambattista or Lorenzo Bregno: the inscription on its base reads LAVRENTIVS BRENIVS FA.[97] It is interesting to note that where the artist himself wrote his surname, he called himself by the Latin equivalent of Bregno. Documents regarding the Terni Tomb do not survive. It is unlikely, however, that the monument was commissioned before Terni's death on July 1, 1518.[98]

During the first two decades of the sixteenth century, work on the reliefs of the *Miracles of St. Anthony* for the Cappella del Santo proceeded very slowly. Antonio Lombardo delivered his *Miracle of the Speaking Babe* and Tullio, his *Miracle of the Repentant Youth*, in 1505.[99] In 1519 the final payment was made for Antonio Minello's relief of the *Investiture of St. Anthony*, on

95  Paoletti, T–B, iv, 1910, p. 570, voce "Bregno, L."

96  Appendix A, Doc. XV, A.

97  See Catalogue no. 4 for the Terni Tomb, S. Trinità, Crema.

98  Terni, (1557) 1964, p. 309.

99  Sartori/Fillarini, 1976, pp. 138f; Sartori/Luisetto, 1983, p. 360, nos. 415–25.

which work had begun at least six years earlier.[100] But Antonio Lombardo had died in 1516 without having executed his second relief; nor had Tullio finished his. Giambattista Bregno too had defaulted on his commission for the *Miracle of the Goblet*. Thus, only three out of the nine reliefs had been consigned when, in the spring of 1520, a new effort to bring the cycle to completion was launched with the commissioning of four reliefs. On April 28, 1520, Giammaria Mosca undertook to carve Giambattista's relief of the *Miracle of the Goblet*.[101] And on June 16, 1520, the *Miracle of the Miser's Heart* was commissioned from Tullio Lombardo,[102] the *Miracle of the Parrasio Boy* from Antonio Minello,[103] and the *Miracle of the Jealous Husband* from Lorenzo Bregno.[104] Lorenzo's contract prescribed as many figures as in Antonio Lombardo's *Miracle of the Speaking Babe*. The marble for the relief had already been delivered to Lorenzo at Venice.[105] If the relief was not approved, Lorenzo was obligated to repay the *Arca del Santo* for the stone. For his work, Lorenzo was promised 250 ducats – the same fee offered Tullio Lombardo, but 10 ducats more than Antonio Minello would receive. No time limit was set. At the writing of the document, Lorenzo was absent, but was represented by a steward of the *Arca*, professor of philosophy at the University of Padua, protector of Andrea Riccio, and patron of Mosca's *Judgment of Solomon* – Giovanni Battista Leone.[106] On June 29, 1520, Lorenzo was in Padua and ratified his contract. Among the witnesses was Mosca's Paduan bronze founder and father of Tiziano Minio, Guido Lizzaro.[107] In the account book of the *Arca* for the fiscal year 1522–23, the treasurer observed that Lorenzo had had the marble for his relief, but had not yet begun to work on it.[108] It appears he never did.

On January 4, 1524, Lorenzo's widow Maddalena agreed to sell for 126 ducats the contents of Lorenzo's shop in the parish of S. Severo to Antonio Minello and to have the goods delivered to Minello's shop at S. Giovanni Nuovo.[109] As evidence of his good faith, Minello gave Maddalena a deposit of 25 ducats. The rest was to be paid in two installments at five-month intervals. The Paduan goldsmith Bartolomeo di Jacopo Stampa stood guarantor to Minello. Among the witnesses to this transaction were Maddalena's brother, Francesco de' Liprandi, mason at Treviso, and Marcantonio Michiel, future patron and owner of Minello's statuette of *Mercury* in the Victoria and Albert Museum, London.[110] From the document, we

[100] Sartori/Fillarini, 1976, pp. 157–60; Sartori/ Luisetto,1983, p. 339, no. 110; p. 340, no. 131; p. 349, nos. 263–71.

[101] Sartori/Fillarini, 1976, p. 172; Sartori/Luisetto, 1983, p. 361, no. 441; Wilk in *Le sculture del Santo*, 1984, p. 134, n. 76.

[102] Sartori/Fillarini, 1976, pp. 139f; Sartori/Luisetto, 1983, p. 360, no. 432; Wilk in *Le sculture del Santo*, 1984, p. 131, n. 69.

[103] Sartori/Fillarini, 1976, p. 161; Sartori/Luisetto, 1983, p. 349, no. 272.

[104] Appendix A, Doc. XVII, B. See below, n. 108.

[105] Appendix A, Doc. XVII, A and B.

[106] For Giovanni Battista Leone (d. 1528), see Scardeone, 1560, p. 219; [Michiel]/ Morelli, (1521–43) 1800, pps. 26f, 155, n. 52; Planiscig, 1927, pp. 182, 184, 243f, 248; Saxl, *WJ*, 1938–9, pp. 353–5; Cosenza, 1962, iii, pp. 1979f, ibid., v, p. 261, voce "Leonius, J. B."; ibid., Suppl. 1967, p. 159, with bibl.; Sartori/ Fillarini, 1976, pp. 198f, 261.

[107] Appendix A, Doc. XVII, C. For Guido Lizzaro (d. 1528), see [Planiscig], T–B, xxiv, 1930, p. 578, voce "Minio, G." with

bibl., and Rigoni, *Arte ven.*, 1953, pp. 119f, 121f, docs. I–IV, repr. in eadem, 1970, pp. 201f, 206, 210f, docs. I–III; p. 213, doc. IV.

[108] Appendix A, Doc. XVII, D. Records in the account book of the *Arca del Santo* for the fiscal year 1522/3 give June 16, 1516, as the date of Bregno's contract, as well as Tullio's contract for the *Miracle of the Miser's Heart*. Despite the care with which these extraordinarily neat entries were made, I am inclined to think that they do not refer to additional, earlier contracts, as is always assumed, but that the date of June 16, 1516, is a *lapsus calami* for June 16, 1520. The notary named is the very notary who drew up all the contracts on June 16, 1520. Among his numerous acts of 1516, preserved in ASP, Arch. not., vol. 4146 (not Sebastiano Balzan), no commissions for these reliefs appear in June 1516.

[109] Appendix A, Doc. XIX, A. For the date of this document, see Schulz, *BJ.*, 1980, p. 174, n. 6.

[110] For the patronage and ownership of *Mercury*, see Radcliffe in London, Royal Acad., *Genius of Venice*, 1983, pp. 367f, S12.

learn that Lorenzo had indited his testament on the previous December 22, naming his wife guardian of their children and his estate.

The sale of the contents of Lorenzo's shop was contingent upon Minello's promise to complete a figure of *S. Maria* for the church of Montagnana and to make an *Angel*, for which Minello was to use a marble block in Maddalena's possession. The *Angel* was to match one already made. In addition, Minello was obligated to repay Paolo di Andrea Trevisan the 25 ducats that Lorenzo had had from him.

Light is shed on this contract by the document of January 14, 1524, in which Antonio Minello and Bartolomeo Stampa renewed for three more years their partnership formed on May 5, 1522, and by the account of the partnership drawn up on August 20, 1526.[111] It is clear from these that Stampa guaranteed Minello's purchase of the contents of Bregno's shop because the two were partners. In the document of 1524, the partners declared that all expenses and profits resulting from the purchase were to be divided equally. In the reckoning of accounts in 1526, one of the partners — presumably Minello — reported having received 35 ducats from Paolo Trevisan.

*Fig. 76*

The 25 ducats that the contract with Maddalena obliged Minello to return to Paolo Trevisan undoubtedly constituted an advance to Lorenzo for Trevisan's altar in the first bay of the right aisle in the Venetian Church of S. Maria Mater Domini. It is commonly asserted that the terms of the sale of Bregno's shop obligated Minello to complete the altar begun by Bregno; as a consequence of this misreading of the document, the Trevisan Altar regularly figures as a joint work of Bregno and Minello.[112] But the fact that the sale agreement required Minello to return the money advanced for the work, rather than to execute or finish it, indicates that Lorenzo had not begun to carve the altar before he died. It would seem, however, that rather than return the money, Minello renegotiated the contract with Trevisan, transferring the commission, along with the advance of 25 ducats, to himself. By August 20, 1526, Minello had received from his patron one payment on account "for the altarpiece that is being made for him," raising Minello's debt to Trevisan to 60 ducats. By this time, work on the altar must have been well advanced, but evidently was not finished. We do not know

*Figs. 80,*

*Fig. 77*

*Fig. 83*

when or if it was ever finished under Minello: the lateral *SS. Peter* and *Paul* bear Minello's imprint, but *St. Andrew* and the hair of *St. Paul* testify to the collaboration of a more expert sculptor, while the *Trinity* in the lunette seems added later.

*Pls. 249,*
*250*

The "figure of S. Maria for the church of Montagnana," which, in contradistinction, Minello promised to complete, is the half-length relief of the *Madonna and Child* in a roundel incorporated into the exterior of the main portal of the Duomo at Montagnana. Work on the *Madonna* must have been finished by January 2, 1525, when, for the second time, Maddalena gave her brother power of attorney to liquidate the estate of her late husband.[113] This involved, among other things, collecting money due Bregno from the commune or citizens

[111] Sartori/ Fillarini, 1976, pp. 162f, corrected in Sartori/ Luisetto, 1983, p. 350, no. 275.
[112] See Catalogue no. 33 for the Trevisan Altar, S. Maria Mater Domini, Venice.
[113] Appendix A, Doc. XIX, C.

of Montagnana. An inscription below the *Madonna* assigns credit for the portal to Lodovico Basadonna, *Podestà* of Montagnana from 1517 to 1518.[114]

Ser Francesco de' Liprandi was empowered by his sister to collect payment for other work executed by Lorenzo before his death besides the *Madonna* for Montagnana. On August 3, 1524, Maddalena gave her brother power of attorney to represent her in all controversies, especially her suit with Broccardo Malchiostro, canon of Treviso.[115] When, on November 16, 1525, Francesco gave his sister an account of his liquidation of Bregno's estate, he reported having collected from Malchiostro 3 ducats and 13 *staia* of wheat.[116] What work for Malchiostro had incurred a debt to Bregno is never specified. It is known, however, that Malchiostro was responsible for the building and decoration of the Cappella della SS. Annunziata, directly opposite the Cappella del SS. Sacramento, in the Duomo of Treviso. Completed by 1519,[117] the chapel was frescoed by Giovanni Antonio Pordenone in 1520.[118] There are many stone objects in the chapel – an obliterated tomb slab, coats of arms in relief, a balustrade carved *à jour* – which Lorenzo could have executed. But only one bears traits identifiable as his and is of sufficient importance and expense to have warranted the attention of a foreign master – the frame of the altarpiece with Titian's *Annunciation*, finely carved and incrusted throughout with bronze and semiprecious marbles. The altar was consecrated on March 1, 1523[119] and two days later, a priest, Domenico da Bologna, was paid for the design of the lettering in the frame's entablature.[120]

*Pl. 246*

*Pl. 245*

In his final accounting of the liquidation of Bregno's estate on November 16, 1525, Francesco de' Liprandi reported to his sister that he had collected 35 ducats from the *primicerius* at Treviso – presumably Domenico Lamberti, named to that office in 1523,[121] for a tomb of his erected in the cathedral.[122] The money was then spent in having the tomb of the late *primicerius* completed. This must have been the tomb of Domenico's brother, Bertuccio – *primicerius* of the Cathedral of Treviso until his death in 1522 – which an early transcription of the epitaph credits to Domenico's patronage.[123] From the sum that was spent in the completion of the tomb, we infer that its execution was not far advanced at Lorenzo's death.

*Pl. 248*

Francesco de' Liprandi's account of his settlement of Lorenzo's estate on November 16, 1525, lists credits amounting to 98 ducats and 13 *staia* of wheat.[124] From Antonio Minello, Francesco had collected 50 ducats, from the *primicerius* at Treviso, 35 ducats, approximately 10 ducats from other people, and 3 ducats and 13 *staia* of wheat from Broccardo Malchiostro. But Francesco had spent more than 100 ducats altogether – in part for doctors and medicines needed during Lorenzo's final illness, and after his death, for candles and a tomb. Out of this sum, Francesco had paid the salaries of *lavoranti* and *garzoni* employed by Lorenzo, the

---

[114] See Catalogue no. 8 for the *Madonna and Child*, Duomo, Montagnana.

[115] Appendix A, Doc. XIX, B.

[116] Appendix A, Doc. XIX, D.

[117] See the inscription on the right wall of the chapel's vestibule, transcribed in the catalogue entry for the frame of Titian's *Annunciation*, Duomo, Treviso (Catalogue no. 14), n. 7.

[118] This is the year inscribed on his fresco of the *Adoration of the Magi*, for which, see ibid., n. 8.

[119] Liberali, 1963, p. 61, n. 198.

[120] Coletti, *Rass. d'arte*, 1921, pp. 414f, 420, doc. 2, quoted in Catalogue no. 14, n. 10.

[121] Campagner, 1956, p. 25.

[122] Appendix A, Doc. XIX, D.

[123] See Catalogue no. 11 for the Lamberti sarcophagus, Duomo, Treviso.

[124] Appendix A, Doc. XIX, D.

rent of 25 ducats for Maddalena's house, and the fees of doctors and the cost of medicine and funerals for two of Lorenzo's children, who died not long after their father. As we have seen, Francesco had also spent 35 ducats in having the Lamberti Tomb completed. Although Francesco had not kept precise accounts, and could not remember everything he had spent, Maddalena did not impugn her brother's honesty: she approved his administration of Lorenzo's estate and made him a quittance. Beyond this, the known documents regarding Giambattista and Lorenzo Bregno do not reach.

In summary, the documents collected here – all those that have come to light so far – show the Bregno to have run a busy and successful shop in Venice between 1500 and 1523. Their work was sought in Padua, Treviso, Cesena, Crema, and Montagnana, as well as Venice. Their patrons were among the most important personages of their respective cities. More significantly still, archival records identify several sculptures indisputably linked with Giambattista and Lorenzo, providing a body of documented work more extensive than the documented oeuvre of any Venetian sculptor before Jacopo Sansovino. Deducing from these recorded works the principal features of the Bregno's art, we have the means at hand to recover Giambattista's and Lorenzo's undocumented sculptures and to reconstruct the corpus of their surviving works.

# CHAPTER TWO
# Giambattista Bregno

en years ago a student in search of information on Giambattista Bregno would have found a sculptor without an oeuvre. Mariacher's entry for the *Dizionario biografico degli italiani* is indicative: apart from one fireplace in the *Appartamenti dei dogi* of the Ducal Palace, mistakenly credited to its appraisers rather than its makers, the author knew of no certain work by Bregno.[1] Two of his statues of the *Resurrected Christ* – one from the Cappella del SS. Sacramento, the other from the group of *Christ Appearing to the Holy Women* – on rare occasions had appeared in print as his, but the remainder of his works figured regularly as products of the hand of Tullio Lombardo, Paolo Savin, or, most often, Lorenzo Bregno. Even more to the point, however, is the fact that several of Giambattista's works were not known at all – under either his or any other sculptor's name. Only Paoletti had tried – without success – to identify Giambattista's Santo *Prophet*.[2] Although the figures of the Frari High Altar had not quite escaped all notice, they had not been photographed or examined at first hand. To be sure, Giambattista's unknown *Deacon Saint* lay hidden in an attic. But his equally unknown Pesaro *Reggiscudo* occupied as conspicuous a site as any offered by Venetian churches. In the task of reconstructing Giambattista's oeuvre, therefore, we must begin at the beginning: building outward from a core of certain works, we must patiently discover Giambattista's stylistic traits in order to arrive at last at a synthetic image of his art.

The earliest work by Giambattista, for which documents supply a date, is the Bettignoli Bressa Altarpiece in the Basilica of S. Nicolò, Treviso, executed between August 1499 and December 1503.[3] Made for S. Chiara della Cella in the outskirts of Treviso, the altarpiece

*Pl.* 1

---

[1] Mariacher, *DBI*, xiv, 1972, pp. 113f, voce "Bregno, G. B."
[2] Paoletti, 1893, ii, p. 275 and pl. 31, fig. 1.
[3] For a more circumstantial account of the commission, man-

ufacture, historical vicissitudes, and criticism of the monuments discussed in this chapter and Chapter Three, as well as the disattribution of individual figures belonging to these monu-

was reinstalled in 1591 in the new S. Chiara, built after the War of the League of Cambrai inside the city walls. After the Napoleonic suppression of S. Chiara in the early nineteenth century, the altarpiece was moved again to S. Nicolò, where it occupied three successive sites. An inscription informs us that, on the occasion of its removal to the new Church of S. Chiara, the altarpiece was restored: to this late sixteenth century campaign belong the work's present architectural arrangement, the full-length *Virgin*, the two *Reggiscudo*, and the inscription at the altarpiece's base.[4] The concrete fields, in which the medallions with Giambattista's heads of *Angels* are inserted, seem to belong to a later, less careful, reworking. By contrast, the statue of St. John *the Evangelist* appears original and very fine, but bears no evidence in its design or execution of Giambattista's hand.

*Pl. 2*

It is possible to reconstruct the general appearance of the original altarpiece. The outermost pilasters with their capitals belong to the epoch of the altar's origin and therefore probably correspond to the "ertis" – uprights – specified in Bettignoli's will. The consoles seem to have originated at the same time, but cannot have been intended for the purpose they now serve. Perhaps the consoles of the altar originally supported the *cassone* of Bettignoli's cenotaph, built in conjunction with the altar, and were incorporated into the reconstructed altarpiece when the cenotaph was abandoned in 1591. (No record of its appearance is preserved, but we may nonetheless surmise that its tomb chest sat on consoles, as in most Venetian tombs.) Bettignoli's testament informs us that there were arches in the altar; probably these crowned niches with the marble figures designated by the testator – *Christ* flanked by the *Virgin* and *John the Evangelist*. Therefore, there must have been an earlier *Virgin*, which the present late sixteenth century one replaced. The figures' bases suggest that lateral niches were curved, while the central niche was rectangular in plan. Three arched niches separated by uprights and containing figures would yield a design like that of the altarpiece of the

*Fig. 1*

Cappella Giustiniani in S. Francesco della Vigna of the same or a slightly later date.[5] If the extraneous pedestal beneath the relief of the *Madonna and Child* were removed and the relief set upon the cornice, and if the borders of the fields containing the roundels were replaced by the S-shaped volutes common in the early sixteenth century, the attic story would resemble the attics of the Giustiniani Altarpiece as well as the Altarpiece of the Virgin of 1480–6 in SS. Giovanni e Paolo, now framing Bartolomeo Bergamasco's *Mary Magdalene*.[6] Where there are now hypertrophic *Reggiscudo* of the late sixteenth century, presumably there once were smaller children bearing shields or candelabra.

*Pls. 4–6*

The *Resurrected Christ* is the first of four in the oeuvre of Giambattista Bregno – one of a genre, therefore, for which Bregno must have been renowned. Where earlier figures stand stolidly upon the covers of their tombs, Bregno's *Christ* appears to rise. The wind-whipped drapery, not constrained at any point, winds upward around the figure. The figure's pose is extraordinarily open: limbs are freestanding and the free foot barely touches the ground. The turn of the head, the opening of the eyes, the parting of the lips, seem a momentary

---

ments, the reader is referred to the respective catalogue entries, where all data are footnoted.
[4] Schulz, *Arte cristiana*, 1983, pp. 38f.
[5] For the dating of this work between 1495 and 1509, see

Schulz, *Antichità viva*, Mar.–Apr. 1977, p. 27.
[6] For this altar, see Schulz, in *Von Simson Festschrift*, ed. Grisebach/ Renger, 1977, pp. 197–208.

response to a sudden stimulus. The flexed muscles of *Christ's* thigh indicate that his motion is self-generated.

Giambattista's ability to render masculine anatomy owes little if anything to classical *exempla*, where a highly developed musculature divided the body more emphatically and more schematically into fewer parts. The extraordinarily prominent collarbones and tendons of the neck, the insistent probing of the torso's bony structure, the tensed muscles of the weight-bearing leg, recall Antonio Rizzo's prodigious treatment of anatomy in *Adam*, a figure *Fig. 7* from which Bregno learned the uses of anatomy in the portrayal of energized and transitory movement. *Adam's* open pose, the elevation of most of his free foot from the base, the sharp obliquity of the axis of his hips, his level shoulders, and the combination of these devices for the rendering of movement with focused gaze and parted lips, surely inspired Bregno's *Resurrected Christ*.

*Christ's* facial type and hair, on the other hand, were decisively influenced by Pietro Lom- *Pls. 7, 8* bardo, as a comparison with the face of *St. Mark* from the Cappella Giustiniani demonstrates.[7] *Fig. 3* From Pietro, Giambattista took the low placement of the eyes at approximately the middle of the face. In both, small, almond-shaped eyes are widely spaced. The small iris, contained nearly in its entirety, is indicated by an incision; the comparatively large pupil is made by a superficial drill hole. The nose is extraordinarily short; one indentation demarcates the high bridge, another isolates the tip. The prominent cheekbones are very low and do not quite occupy the outer edges of the short cheeks. The mustache curls around the narrow mouth and merges with the beard. The beard is composed of short curls of two strands each, stacked in rows of two or three curls each. Curls project from the surface of the face on a descending diagonal; the centers of curls are shallowly drilled. Like Pietro's *St. John the* *Fig. 5* *Evangelist* in the same chapel, *Christ's* curved hairline peaks in an ogee arch at the center of the forehead. The head of hair is endowed with an independent volume, yet its surface remains integral and smoothly rounded. Long, parallel strands are incised on the surface of the head of hair; the rhythm of slowly meandering waves continues in discrete locks that fall to the shoulders. Yet despite common traits, Giambattista distinguishes himself from Pietro by the greater delicacy of the features and refinement of their execution. In Bregno's figure the conjunction of forms is less abrupt because forms and contours are less highly differentiated and transitions are more gradual. Surfaces are smoother and more highly polished.

The relief of the *Madonna and Child* is probably the earliest portion of the altar and possibly *Pl. 10* is separated from the *Christ* by some time: at any rate, the baby's deficient neck and shoulders and oddly skewed genitals and the mother's inorganic hands are unexpected in the master of the *Resurrected Christ*. The figures occupy an exceptionally broad field, only partly filled by two *tondi* symmetrically disposed. The Christ Child seems to be standing – largely by virtue of his mother's support – on a parapet, which may have disappeared when the bottom

[7] Work on the chapel was in progress in 1498, for which, see Schulz, *Antichità viva*, Mar.–Apr. 1977, p. 27. Although documents do not suggest a *terminus ante quem* for the completion of the chapel until 1509, the stylistic evidence, it seems to me, justifies the interpretation of the resemblance of the two physiognomies propounded here. Indeed, Giambattista's apparent dependence on Pietro in the Bettignoli *Christ* testifies to Pietro's execution of the two *Evangelists* by winter, 1503, at the latest.

of the relief was truncated. The source of the motif was Giovanni Bellini's many realizations of the half-length Madonna supporting with both hands the infant Christ standing on a parapet — images that gave currency to the theme in late Quattrocento Venetian painting and sculpture.[8] Nevertheless, while a painting like Bellini's *Madonna degli Alberetti* of 1487 in the Accademia, Venice, may have inspired Bregno, neither it, nor any other painting by Bellini, can have supplied a model, for the relief conspicuously lacks the overlapping and foreshortening, the contrast of axes and stepping of the contour, that give such visual interest to Bellini's interpretations of the theme.

*Pls. 11, 12*    The Madonna's long and narrow egg-shaped face, with flattened skull, widely separated almond-shaped eyes hardly embedded in their sockets, long, straight, narrow nose that is not indented at the high bridge, flat cheeks, and recessive chin, not only has no parallel in Venetian sculpture of the time, but is diametrically opposed to the prevailing type, with spherical head and low-placed eyes, apparently derived from the S. Cassiano *Madonna* of Antonello da Messina. Bregno's facial type, as well as the pleated veil, which covers most of the Madonna's forehead, are Byzantine; Byzantine influence accounts also for the Madonna's serious expression and the absence of any display of maternal effection. Bregno's appreciation of Byzantine painting doubtless was encouraged by Giovanni Bellini, whose early *Madonnas* often make deliberate reference to their Byzantine counterparts. Byzantine icons influenced the physiognomy and coif, the draping of the mantle, the grave expression and austere comportment, of Bellini's *Madonnas* of the 1460s and 1470s; occasionally Greek initials appear in the background; gold striations sometimes model the Virgin's cloak.[9] These manifestations of Byzantine influence have been linked with the frequent use in late fifteenth century Venetian paintings of settings containing domes or semi-domes embellished by fictive Byzantine mosaics and with the revival from ca. 1490 of the Byzantine domed quincunx for newly built Venetian churches,[10] as a reflection of the sympathetic interest in Greek culture, excited by the Greek refugees who flocked to Venice after the fall of Constantinople. But Venetian interest in contemporary or medieval — as distinct from ancient — Greek culture was short-lived and of limited extent. Although Byzantinizing churches continued to be built in Venice until the 1530s, by the early sixteenth century those features that still characterize Giambattista's Madonna as Byzantine had disappeared from painting: his revival of a fashion laid aside some twenty years before proves Giambattista's high regard for the art of an earlier generation.

*Pls. 15–19*    Of approximately the same, or a slightly earlier, date than the Bettignoli Altar, I believe, is the *Visitation* in the Duomo of Treviso. The relief comes from an altar erected by Galeazzo Ostiani in his funerary chapel in S. Francesco, Treviso, and was transferred from the suppressed church to the city's cathedral in the early nineteenth century. Once attributed to Lorenzo Bregno, the *Visitation* proves to be the work of Giambattista. To analogies of proportions, anatomy, facial type, and costume between the figure of Joseph and Giambat-

---

[8] Sculptured examples of the theme include: *Madonna and Child*, Louvre, Paris (Inv. no. R. F. 783); *Madonna and Child*, Madonna dell'Orto, Venice; *Madonna and Child*, Institute of Arts, Detroit, (Inv. no. 36.80), all of which distantly echo the style of Pietro Lombardo. The influence of Bellini's invention can even be seen in Albrecht Dürer's *Haller Madonna*, Kress Collection, National Gallery, Washington, (Inv. no. K1835A).

[9] Goffen, *AB*, 1975, pp. 487–90; eadem, 1989, pp. 28, 34, 43.

[10] McAndrew, *AB*, 1969, pp. 15–17. See also Wilk, 1977/78, pp. 119–43.

tista's documented Sacrament Chapel *St. Peter,* adduced elsewhere,[11] can be added others, <span style="float:right">*Pls. 18, 19,*</span>
equally convincing, between Joseph and Giambattista's documented *Prophet* from the Santo. <span style="float:right">*54, 58*<br>*Pl. 113*</span>
Certain faults in the relief – the nonalignment of the pit of Joseph's neck with his weight-
bearing foot, the adherence of drapery to the side of his advancing leg, the subsidence,
below the surface of the background, of hollows in the pendant drape of the Virgin's cloak
– suggest that the relief belongs to Giambattista's early work.

Stylistic details of the *Visitation* can be traced to Pietro Lombardo's sculpture for the
Giustiniani Chapel. Though not as faithful an imitation as the Bettignoli *Resurrected Christ,*
the face of St. Joseph bears evident affinities to that of Pietro's *St. Mark.* Comparable also <span style="float:right">*Pl. 19,*<br>*Fig. 3*</span>
are the neckline of Joseph's tunic and the draping of the mantle on both shoulders. The <span style="float:right">*Pl. 18,*<br>*Fig. 2*</span>
gesture of St. Joseph's right hand, with its prolonged index figure – inexplicable here – makes
perfect sense in its Evangelistic context. Though the drapery of Bregno's figures contains
folds that vary widely in their shape and distribution, certain forms, like the small, shallow,
circular indentations, singly or in combination, in Zacharias' garments, or the larger, shallow,
leaf-shaped indentations in an otherwise flat surface in Joseph's bodice, repeat motifs found <span style="float:right">*Pls. 17, 18*</span>
in Pietro's *SS. Mark* and *John.*[12] <span style="float:right">*Figs. 2, 4*</span>

Relief was not a popular genre in Quattrocento Venice. Nevertheless, diverse approaches
coexisted, ranging from the spacious, circumstantial, pictorial relief of Rizzo's *Conversion of
St. Paul* in S. Marco, at one extreme, to Tullio Lombardo's condensed, non-pictorial, clas- <span style="float:right">*Fig. 13*</span>
sicizing *Baptism of St. Anianus* on the facade of the Scuola di S. Marco, at the other. Giambattista <span style="float:right">*Fig. 14*</span>
combined elements of both, producing a hybrid whose unhappy union of techniques had
no issue. In a field whose format was ideally suited to an iconic presentation of the theme,
Giambattista chose to treat the Visitation narratively, with subsidiary characters and a detailed
setting. But five figures could be accommodated in a narrow field only if their scale were
small. To occupy that portion of the relief's height that small figures would not fill, Bregno
introduced a transverse section – in the guise of a scarp – of the ground on which his figures
stand. The pictorial use of geological strata in elevation ultimately derives from Andrea
Mantegna's ubiquitous low earth walls and recurs in several of Giovanni Bellini's paintings,
such as the *St. Jerome* in the National Gallery, Washington. In Bellini's Naples *Transfiguration*
a low escarpment defines the front face of the stage on which figures in the middle ground
stand or kneel. But the use of geological strata to establish the foremost plane of a relief or
picture space is unprecedented; so, too, is the fact that the bluff's upper surface does not
slope. Where Rizzo or his Florentine sources would have employed the bottom of the relief
to elaborate a receding terrain on which rising but diminishing trees or figures provided a
measure of increasing depth, Bregno erected a two-dimensional barrier whose summit – the
ground on which his figures stand – also is portrayed *en face.* Thus, as in the *Baptism of St.
Anianus* and the Roman imperial examples that were its paradigm, Bregno's figures occupy a

---

[11] Schulz, *BJ,* 1980, pp. 189f

[12] It was the recurrence of silhouettes like those of Joseph and
Zacharias in the relief of *Pentecost* in the Giustiniani Chapel that
led me in *BJ,* 1980, pp. 198f, to suggest tentatively Giambattista's
authorship of the relief. But just those features I identified as
characteristic of Giambattista's faces are common also to Pietro

Lombardo's. It now seems to me that the face and figure of the
Madonna and the drapery of the Apostles in the *Pentecost* find
their closest analogies in the Loredan *Madonna and Child* in the
Ducal Palace (Fig. 15), and that the *Pentecost,* therefore, should
be viewed provisionally as a product of Pietro's hand.

stage fixed at a right angle to the background – a stage that, therefore, appears to recede no farther than the plane occupied by the second row of figures. As in that mode of relief adopted by Tullio from classical reliefs, Bregno's tightly grouped, upright figures, evenly spaced, fill the entire width of the field; the slight irregularity of the ground hardly affects the figures' isocephaly, which is the usual concomitant of an orthogonal view. From high relief for figures at the front, the gamut runs to very low relief for the woman in the farthest plane. Yet conjoined with this abstract and nonpictorial figural relief are elements of an illusionistic setting executed in *schiacciato* relief: overlapping trees diminish in scale and the shed, with its roof, which functions like a baldachin above the heads of Mary and Elizabeth, is represented perspectively from an area of sight to the left of Joseph's lowered arm.

*Pl. 20*

*Pl. 34*

*Pls. 35, 23*

*Pls. 26, 30*

*Pls. 38, 39*

*Pls. 40, 41*

The sculpture for Carlo Verardi's chapel in the Duomo of Cesena, now dedicated to the cathedral's patron, St. John the Baptist, and to St. John the Evangelist, was finished in June 1505. The chapel's sculptural decoration included the kneeling donor on the left, facing his nephew Camillo on the right. In the center stood *Christ as Man of Sorrows*, flanked by *St. John the Baptist* on the *Saviour's* right and *St. John the Evangelist* on the *Saviour's* left. In addition, there were two full-length *Angels*, against rectangular backgrounds once incrusted with black stone, and two half-length *Angels*, also against black incrusted grounds, within medallions. The chapel was moved in the late seventeenth century; toward the end of the nineteenth century it was moved back again to its original site.

*Pls. 23, 26, 30, 38, 39*

*Pl. 29*

It is doubtful that the original chapel comprised the curved niche we see today, for, to the extent they are preserved, the backgrounds of Bregno's figures are perfectly flat, and only by virtue of being pared down and surrounded by several smaller slabs of stone, do the original backgrounds combine to form a curve. More likely, the interior of the Chapel of the Corpus Domini consisted of a rectangular niche in which the three holy figures occupied the rear wall and the two kneeling patrons, the side walls at right angles to it. In evidence of this is the fact that, whereas the farther side of the *Baptist's* profile is finished, the farther sides of the two *Verardi* profiles are barely blocked out. If the *Baptist* had been located at the left of the rear wall, the farther side of his face, oriented toward the right, would have been partly visible from the entrance to the chapel. By contrast, the farther sides of the faces of two inward-looking donors affixed to lateral walls would have been entirely hidden and therefore could remain unworked. How the *Angels* were arranged in the original chapel cannot be determined; perhaps they were distributed as they are today. The inscribed bases beneath *Carlo* and *Camillo Verardi* and the neoclassical base beneath *Christ* are curved and therefore cannot have belonged to the original scheme. The scagliola conch, we know, was added in the early part of this century. The ornament of the frieze at the bottom of the niche duplicates the ornament in the semicircular frieze at the center of the conch and therefore probably was made at the same time. The two *Verardi* have been cropped below: in addition to their feet, they have lost the lower edge of folds heaped upon the ground.

*Pl. 20*

*Pls. 34, 35*

*Pl. 23*

The original dedication of the altar to the Corpus Domini explains the iconography of *Christ*, portrayed as the Eucharistic Man of Sorrows, who assures mankind of its redemption

through his sacrificial death and its reenactment in the Mass.[13] The barely parted lips, the eyelids, lowered but not quite shut, the disappearance of irises from the visible portion of the eyeball, are unmistakable signs of death. Yet his lithe pose proves *Christ* to be alive: he has risen, for he no longer wears the crown of thorns. Resurrected, Christ is eternally present at the performance of the Mass in transubstantiated Host and wine. With one hand *Christ* holds a chalice, symbolic of the Eucharistic wine, to a wound in his chest; with the other he displays his stigma. But the typical gesture of display – open palm pointing downward – is combined with the extended index and third fingers of a blessing hand.

*Pls. 22, 24, 25*

The two *SS. John* are represented in their customary guise. Yet despite the conventionality of their portrayal and the inclusion of symbolic attributes, the figures are anchored in a specific – if indefinable – time and place by the plots of real ground, which the bases of the figures simulate, by the figures' transitory poses and the intense concentration expressed by focused gazes and the *Baptist's* open mouth. The idea of transcience is conveyed above all, however, by the configuration of folds, which seems as mutable as the force of nature apparently producing them. It is rather the immobile and expressionless *Verardi*, who, abstracted by their profile view and conventionally portrayed in prayer, signify an existence outside of time.

*Pls. 26–33*

*Pl. 29*

*Pls. 34, 35*

Though figures are carved in relief, Bregno exploited few of the illusionistic advantages of his medium. As if figures were individual statues, *Christ* and the two *SS. John* stand on separate bases, whose upper surface is not perspectively inclined. Indeed, apart from cloudlets beneath the feet of hovering *Angels*, no setting of any sort intrudes. In *Christ*, surfaces are not flattened and many elements are either carved in the round or deeply undercut; at its intersection with the background, Giambattista merely eliminated the rear half or third of his figure. This type of high relief was less applicable to the highly foreshortened figures of the *Saints*, presented in three-quarter view: here limbs that occupy the most distant planes, are carved in low relief. Giambattista audaciously drilled the block, perforating the stone behind *Christ's* and the *Evangelist's* locks, behind the legs of *St. John's* eagle and even beneath the rear claw of its forward foot. As in the medallions with heads of *Angels* from the Bettignoli Altarpiece, the frames of half-length *Angels* take on, in part, the function of a setting as figures thrust through their openings. Here, especially, do figures forswear the appearance of relief.

*Pls. 23, 26, 30*

*Pls. 38, 39*

*Pl. 23*

*Pls. 26, 30*

*Pls. 24, 33, 21*

*Pls. 13, 14*

*Pls. 40, 41*

The drapery of the two *SS. John* and two *Verardi* has much in common with drapery in Giovanni Bellini's late paintings. Garments composed of more material than is strictly necessary to wrap the body, are loosely draped. Made of fabrics stiff enough to support their own weight, drapery takes leave of the body underneath, overrunning gaps between limbs and spreading out to either side, thus establishing a two-dimensional plane along the surface of relief or picture. Yet that plane is constantly broken by the innumerable sharply faceted wrinkles of an unpliant material. Relieved of its responsibility to disclose the structure of the body or the fabrication of the garment, drapery is free to pursue its own decorative ends. That these were ends shared by Pietro Lombardo is shown by a comparison of the

*Pls. 26, 30, 34, 35*

*Fig. 16*

---

[13] For similar images of the *Blood of the Redeemer* and the *Risen Christ* as foci of Altars of the Sacrament, see Cope, 1965/79, pp. 65–81, 87–9, 258f.

Pls. 23, 34 patterns created around the knees of *Carlo Verardi* or between the feet of *Christ* with the folds
Fig. 15 of the doge's cloak in Pietro's Loredan *Madonna* in the Ducal Palace.

Pls. 38, 39    By contrast, the *Angels* of the Cesena Altar owe their inspiration to the *Victories* of Antonio
Rizzo's Scala dei Giganti at the Ducal Palace. Both *Victories* and *Angels* are winged adolescents,
Pl. 38, dressed in chitons, with clouds beneath their feet. The pose and fluttering stole of Bregno's
Fig. 10 left-hand *Angel* was taken from the fifth *Victory* of Rizzo's series, on the front face of the
Pl. 39, right *avancorpo*. The drapery and pose of Bregno's other *Angel* were derived from the first
Figs. 11, 12 and last of the Scala dei Giganti *Victories* on the perpendicular faces of the *avancorpi*. But
Bregno's figures are not as flat as the *Victories*; nor are the contours of his figures undercut.

Between November 1506 and April 1508, Giambattista carved the *Resurrected Christ* for the
Pls. 46–52 central niche in the apse of the Cappella del SS. Sacramento in the Duomo of Treviso; it
was the first of the chapel's five statues to be commissioned and finished. Like the Bettignoli
Pls. 4, 23, 48 *Resurrected Christ* and the Cesena *Man of Sorrows*, the canon of the Sacrament Chapel *Christ* is
characterized by elongated legs, a slender torso, a long neck, and a small head. But still
thinner legs and narrower feet further reduce the statue's apparent weight. The figure's
*contrapposto* is more emphatic now as a result of the increased divergence of the axes of hips
and shoulders. A more perceptible revolution in space is abetted by the advance of *Christ's*
blessing hand. Yet the figure terminates in a perfectly vertical and frontal head. Here, where
Giambattista makes visible the actual bend and reversal of direction in the pliant swathes
of drapery encircling hip and leg, the movement of folds mirrors the movement of the body.
The figure is now approximately as deep as it is wide; indeed, the semicircular niche did
not suffice to hold the statue and had to be deepened below. Its dimensions, together with
its circular base, give the statue the semblance of a column.

Since Giambattista's three figures of *Christ* show a consistent development in the pon-
deration and spatial implications of the pose, it is not inconceivable that the sculptor arrived
at the composition of the Sacrament Chapel *Christ* quite independently. Yet Giambattista's
*Resurrected Christ* was preceded by a very similar bronze statuette of the *Resurrected Christ* in
the background of Vittore Carpaccio's *Vision of St. Augustine* in the Scuola di S. Giorgio degli
Fig. 17 Schiavoni. Lauts surmised that Carpaccio's statuette derived from an anonymous bronze
Fig. 18 statue of the *Resurrected Christ* in the Poldi-Pezzoli Museum, Milan,[14] though this one, unlike
Bregno's and Carpaccio's figures, does not revolve in space. Nonetheless, it is unlikely that
the pose of Bregno's *Christ* was totally unprecedented in Venetian sculpture.

Another hypothesis for the genesis of the Sacrament Chapel *Christ* is occasioned by the
existence of Roman bronze statuettes of male devotees, commonly represented like our
Fig. 19 *Resurrected Christ*.[15] From such a source as this may come the continuous draping of *Christ's*

---

[14] Lauts, 1962, pp. 30, 232, no. 14. Analogous figures appear in Carpaccio's preparatory drawing for the *Vision of St. Augustine* in the British Museum and in a drawing, also by Carpaccio, in the collection of Count P. de la Gardie at Borrestad, for which see ibid., pp. 271f, no. 27 and p. 265, no. 3.

Perhaps the bronze in the Poldi-Pezzoli Museum is to be identified with the "statua del Cristo de bronzo" on the altar of the chapel of the jeweler Domenico di Pietro, formerly in S. Maria della Carità, described by Marcantonio Michiel, as Friz-

zoni ([Michiel]/Frizzoni, [1521–43] 1884, pp. 231f) suggested. For the figure, see Sheard in *Roma e l'antico*, 1982/85, pp. 434–36, and Trenti Antonelli, in "Sculture" in Milan, Poldi-Pezzoli, Cat., vii, 1987, pp. 198f, no. 24.

[15] Reinach, i, 1897, p. 384, no. 2, p. 416, no. 3; ibid., ii, 1897, p. 110, no. 5, p. 122, no. 8, p. 501, no. 4, p. 502, nos. 5, 6; Babelon/Blanchet, 1895, pp. 166f, no. 371; New York, MMA. *Greek...Bronzes*, cat. by Richter, 1915, pp. 100f, no. 170.

shroud, from hip through opposite arm and shoulder, which matches neither that of Carpaccio's *Christ* nor that of the anonymous bronze. Such a source also would account for the classicizing pattern of the shroud's folds, unique in Giambattista's oeuvre. To be sure, such thin, cordlike or tubular folds, evenly and densely spaced throughout the drapery's surface, which follow long, parallel, segmental arcs, are also a hallmark of Tullio Lombardo's style. But it is unlikely that, on this occasion alone and only in the rendering of drapery, Bregno should have succumbed to Tullio's influence. Rather, such limited dependence is more likely to have been elicited by an object of greater rarity. Can it have been the "nudetto cun el vestito curto, pur de bronzo" that Marcantonio Michiel later saw in Pietro Bembo's house?[16]

Similarly, the delineation of musculature in the Sacrament Chapel *Christ* is Praxitelean now, rather than Rizzesque. The more highly developed pectoral muscles hide the upper ribs, and shallow grooves more consistently denote the waist and the protruding muscles of the lower abdomen. The inguinal ligament is more pronounced, the clavicles less so, than in Giambattista's preceding *Christs*. The nearer approach to a classical schemata confers upon the figure an ideality that serves as metaphor for the divinity of God incarnate. Purposely, no doubt, though disconcertingly, *Christ's* legs and feet show no influence of classical canons.

The high goal of idealization inspired the figure's execution as well as its design: no other work in Giambattista's oeuvre is as refined as this. Its smoother, more even surface is a result of very gradual transitions between extenuated projections and recessions. The surface is polished to translucence. Contours, too, are smoother. A comparison with the Bettignoli *Christ* shows how the beard has receded and features have shrunk. Cheekbones that hardly *Pls. 8, 52* protrude, eyes that are hardly recessed, pupils no longer drilled, produce a more nearly uniform surface. The contour of the nose and hairline now is regular; locks of hair no longer interrupt the even surface of the head.

Commissioned in April 1508, the statue of *St. Peter* on the left wall of the Cappella del *Pls. 53–58* SS. Sacramento was finished by the end of 1509. Archival sources explicitly document Giambattista's authorship: the import of the documents is confirmed by the figure's design. Folds in *St. Peter* drapery have numerous counterparts in the shroud of the Bettignoli *Christ*, *Pls. 4, 5, 54,* and the pattern formed by the mantle, where it swings around *St. Peter's* free leg, elaborates *55* motifs in the cloak of the Cesena *Evangelist*. *Pls. 31, 55*

The orthodox *contrapposto* of *St. Peter* implies potential mobility in the midst of actual repose. The slight withdrawal of right arm and leg and the advance of the left arm and shoulder produce the effect of revolution, despite the fact that the figure deviates very little from the plane. As Donatello had taught in his statue of *St. Mark* for Or San Michele, the pattern of folds diagrams the distribution of the body's weight. Folds are stretched taut over the projecting thigh and knee but loop where the lower leg recedes. Folds descend vertically over the weight-bearing foot, and the hem of the tunic occurs precisely where the body's weight is transferred from the vertical leg to the horizontal foot. The cloak is tied and thus held firm where the figure's weight is concentrated in the thrust-out hip. Curving transverse folds along the right leg of the figure and swinging folds on its torso reproduce the course

[16] Michiel/Frimmel, (1521–43) 1896, p. 24. For Bembo's collection, see Weiss, 1969, pp. 201f, and Low, 1973, pp 47,48,    50, 51, 56.

*Pls. 54–55*
*Pl. 124*

of the figure's apparent revolution. So effective is that revolution that a lateral view of the statue, from the entrance to the chapel, is as satisfactory as a front view. The figure's revolution, like the turn of *St. Paul's* head, is motivated by the *Saints'* focus in the Sacrament, housed at the center of the altar in a sculptured tabernacle.[17]

*Pls. 19, 58*
*Pl. 57*

In the head of *St. Peter*, Giambattista asserted with greater resolution principles already evident in the head of Joseph from the *Visitation. St. Peter's* face has become square; his head — as deep as it is wide — is more nearly cubic. The tectonic structure imposed by axially aligned or perpendicular features in Joseph, here is underscored by the horizontal wrinkles and vertical indentations of the forehead, the straightening of the lower lids, the level borders of the beard. With his drill, Bregno sounded the voids separating curls, endowing every lock with an independent plastic existence.

*Pl. 63*

The sarcophagus in the Chapel of Cardinal Giovanni Battista Zen (d. 1501) at S. Marco is surrounded by six bronze female figures. The figures were commissioned from Giambattista Bregno and Paolo Savin in July 1506; each sculptor eventually got half the total price. But when Giambattista received his final payment in March 1508, it was for four figures, not for three. Since Savin received half the sum due for six figures and the three figures on the east face of the sarcophagus are demonstrably by him, Giambattista's fourth figure represents an extra. In October 1507, four of the six figures were ready to be cast; indeed, the process of converting them to wax apparently had begun. These four may be supposed to have comprised Savin's three on the east face of the sarcophagus and the central figure on the

*Pl. 65,*
*Fig. 20*
*Pls. 69, 154*

west because, in terms of dress — himation and more than floor-length chiton cinched at the waist — they form a set, whereas the remaining two are each unique. By May 1508 the four figures had been cast. The last two figures evidently were cast between that date and September 1510.

The three figures along the sarcophagus's east face are uniform in style and motif and stylistically analogous to the *Effigy of Cardinal Zen, St. Peter,* and the antependium of the chapel's altar — works documented as Savin's. If the figures on the east can be attributed to Savin,

*Pl. 63*

Bregno's must be the figures in the west. But, as Jestaz recognized, these three figures differ so fundamentally among themselves that they must have been executed by three different sculptors.[18] Which, if any, is by Giambattista? We may exclude the figure at the southwest

*Pls. 153–*
*158*

corner of the sarcophagus, which is, I am convinced, Lorenzo Bregno's. More problematic is its mate at the other end of the sarcophagus, for the present assigned to an anonymous,

*Pls. 69–72*

but skilled, assistant.

*Pls. 64–68*

By far the finest of the six sarcophagus figures is the central figure of the west flank: this, above all, makes me suspect that it is Giambattista Bregno's. Unfortunately, the attribution is one I cannot prove to my total satisfaction, for despite its many links with other works by Giambattista, the Zen figure is essentially different: in the amplitude of its proportions, in its union of torsion and *contrapposto*, in its quietude and self-containment, it exemplifies the classicism of the High Renaissance. To be sure, both the medium and subject — or, rather, the lack of one — also were new to Giambattista: it may simply have been the accidents of the figure's commission that called forth so unusual a response. Or perhaps, as Ruhmer

---

[17] Cf. Timofiewitsch in Egg et al., 1965, p. 493.     [18] Jestaz, 1986, pp. 143–56.

thought, our figure originated in a model by Antonio Lombardo,[19] from whom, according to a document recently published by Jestaz, a figure of *Temperance* for the tomb actually was commissioned only three months before Savin and Bregno signed their contract for the Zen sarcophagus figures. Documents never refer to *Temperance* again: if it was begun, evidently it was not finished. Yet the small bowl held by our figure could have served as the vessel from which a hypothetical *Temperance* poured the water with which she diluted wine. In fact, in the Zen figure's dependence upon a classical prototype, in its matronly proportions and full anatomical forms, its classicizing coiffure, its evolved *contrapposto* that unfolds in space, and its sheer drapery, which makes fine, cordlike folds or else adheres to the body, explicitly revealing anatomical forms, the Zen figure is closer to the female bystanders in Antonio Lombardo's *Miracle of the Speaking Babe* than it is to any work by Bregno. How often in the Santo figures, as in ours, is a head in profile joined with a frontal view of the lower body. Yet the facial type and linear pattern of folds in the Zen figure are not Antonio's. Could a figure started by Antonio Lombardo and abandoned on his departure for Ferrara have been finished by Giambattista Bregno? Perhaps the similarity in dress between this figure and the three by Savin is to be accounted for by Savin's faithful imitation of a model by Antonio, rather than by Giambattista's adherence to Savin's example (which Bregno's collaborators, in any case, did not feel constrained to follow). Our present state of knowledge admits of no better hypothesis.

*Fig. 21*

*Pl. 64*

*Fig. 20*

From right foot to head, the Zen figure revolves consistently in one direction around an axis defined by the alignment of the pit of the neck with the heel of the weight-bearing foot and the elbow of the forward arm. Yet movement is brought to a full stop by the profile of the face and the vertical boundary of forehead and nose, while the horizontal axes of the features and the hairline at the nape ensure the ultimate stability of a composition largely dependent upon concordant curves. Like Giambattista's Sacrament Chapel *St. Peter*, the Zen figure's revolution and the correspondent pattern of folds produce an eminently satisfactory design from the vantage of the entrance, while the composition of the figures' opposite side, visible from the altar but probably rarely seen, was sacrificed. Over the Zen figure's free leg, drapery assumes a pattern that recalls, especially in side view, the treatment of the free leg of the *Saint*. In both, drapery inexplicably delineates the rear contour of the calf; looping folds toward the bottom of the leg follow the same elliptical course; analogous upward-curving folds are released by the flexion of the knee, and a fold forks in the same relative position on each thigh. As in *St. Peter*, a heavy swathe, loosely encircling one hip, is scored by numerous narrow grooves convulsed by intermittent spasms. An intricate and varied pattern of folds typical of Giambattista animates the highly generalized and smoothly rounded anatomy of what I take to have been Antonio Lombardo's model, as Antonio's own schematic folds never do. The ruffled border of the Zen figure's mantle recalls that of the Virgin of the *Visitation*. In both, tousled folds of the more than floor-length skirt flurry about the feet. The Zen figure's right breast is morphologically identical to that of the Virgin and from the nipple of each, a thin, quavering fold falls to the waist.

*Pl. 65*

*Pls. 67, 68, 55*

*Pls. 66, 56*

*Pls. 68, 55*

*Pls. 65, 67, 16*

[19] Ruhmer, *Arte ven.*, 1974, p. 60.

Pls. 64, 32 The Zen figure's head is comparable to that of *St. John the Evangelist* from Giambattista's Cesena Altar. The low foreheads of both are bounded by waves of the same amplitude. The bridge of the nose in each is identically formed. Straight, high brows are produced by fine, barely perceptible ridges, and identically lowered lids incorporate the upper halves of tear ducts. Lids are bounded above and below by incisions.

The pose and draping of the figure's torso and right arm have an antique source. In classical statuary and sarcophagi, comparable standing figures most often depict Terpsichore, some-times Urania or Clio, and, on one occasion, Erato, in representations of the *Muses*, and a female bystander in scenes of the *Death of Meleager*. The type recurs in *Victory* writing on a shield in the Column of Trajan and on the pedestal of the Arch of Constantine. The *Victories*, as well as several of the sarcophagi, were accessible in the Renaissance, but none of the antique figures matches the bronze in all respects.[20] Probably whatever prototype was used was changed substantially.

Pls. 77–82 The style of the *Effigy of Benedetto Pesaro* (d. 1503) from his tomb in S. Maria dei Frari warrants the statue's attribution to Giambattista Bregno. The tomb's architectural framework, Pl. 73 as well, seems to have been designed by Giambattista. For the dating of the tomb to 1508 there exists documentary evidence, but it is of dubious applicability, for it depends on Figs. 29, 30 Sansovino's attribution of one of the statues of the tomb – the *Mars* – to Baccio da Montelupo. If Baccio did carve *Mars*, he is most likely to have done so between April and November 1508, when documents attest to the presence of the Florentine in Venice. But the attribution to Baccio of *Mars*, or of any other figure on the tomb, has not been, and perhaps cannot be, demonstrated. Nonetheless, the style of the tomb's architecture and sculpture makes a date of 1508 entirely plausible. (1503 inscribed twice on the tomb undoubtedly refers to Pesaro's year of death). The tomb's patron was Benedetto's only son and heir, Girolamo.

Like the Tomb of Vittore Cappello at S. Elena, the monument incorporates a portal by means of columns on high pedestals flanking the opening, above which a projecting lintel, resting on the columns, supports tomb chest and effigy. In this case, however, the opening leads not from the exterior to the interior of the church, but rather from the basilica's right transept to the sacristy, which served as the funerary chapel for the Pesaro of S. Benetto. Pl. 74, Fig. 28 Roundels with reliefs of SS. *Benedict* and *Jerome in Penitence*, the patron saints of Benedetto and his son, are immured in the walls of the passage.

The appearance of the tomb was partly determined by instructions that Pesaro included in his testament of July 11, 1503. He charged that his tomb be made of marble, with marble columns,[21] and that it contain an epitaph recording his deeds. The prodigal sum of 1,000 ducats was allocated to the tomb. For its design, Giambattista – if it was he – adopted the scheme of the triumphal arch, first applied to Venetian funerary monuments by Pietro Lombardo in the Tomb of Doge Nicolò Marcello (d. 1474), formerly in S. Marina, and

---

[20] Reinach, i, 1897, p. 157, no. 5, p. 270, no. 7; Wegner, 1966, pls. 9b, 23a, 27a, 28, 31a, 31b, 35, 39, 54b, 65a, 99b, 100b, 101a, 102a, 102b, 103a, 104a, 104b, 127b, 130; Koch, 1975, pl. 101, no.120, pl.102, no.117, pl.107, no.116, p. 120, fig. 8;

Bober/Rubenstein, 1986, pp. 201f, no. 170. For Andrea Riccio's use of the motif, see Planiscig, 1927, p. 318 and figs. 363, 565.
[21] For the tomb's marble columns in the context of Venetian architecture, see Goffen, 1986, p. 68.

elaborated by Tullio Lombardo in 1493 in his Tomb of Doge Andrea Vendramin (d. 1478), *Fig. 27*
formerly in S. Maria dei Servi. But the designer of the Pesaro Tomb was more faithful to
his antique prototype, as a comparison with an arch that did not commemorate a triumph *Pl. 73,*
but nevertheless employed the triumphal format — the Arco dei Gavi at Verona[22] — shows. *Fig. 23*
Thus plinths, columns, and entablature at the edges of the tomb now are broken forward,
while the entire span of the entablature between the central columns also projects. In this
respect, the Pesaro Tomb participates in the general course of architectural development
around the turn of the century, not only at Venice but throughout Italy, characterized by
an increasingly accurate imitation of classical architectural vocabulary and syntax. From the
Vendramin Tomb come the roundels at the top of the lateral bays, the winged disc beneath *Fig. 27*
Pesaro's tomb chest, and the freestanding statues, as large as the life-size effigy and located
beyond the tomb's lateral boundaries. The center of the upper story, by contrast, derives in
large part from the Tomb of Giovanni Emo (d. 1483), formerly in S. Maria dei Servi, whose
design I have attributed to Tullio Lombardo. (The architectural framework of the Emo Tomb
no longer exists, but its appearance is preserved in a faithful eighteenth-century drawing by
Johannes Grevembroch.[23]) In the upper part of the Pesaro Tomb, as in the Emo Tomb, a *Fig. 24*
pedestrian effigy stands on a sarcophagus against a plain background and within an aedicule
framed by fluted columns of the composite order resting on tall, carved drums. The composition
of the *Madonna and Child* in the tympanum recalls Pyrgoteles's *Madonna and Child* in the *Figs. 33, 34*
tympanum of the portal of S. Maria dei Miracoli.

Despite the fact that most features of the Pesaro Tomb can be traced in earlier Venetian
works, its design is unique: not even the tomb of Benedetto's son Girolamo, built at the *Pl. 73*
opposite end of the transept, imitated it.[24] The unusual design of the Pesaro Tomb is due,
I believe, to its dual role as the sacristy's facade and monumental entrance and as tomb. This
duality is reflected in the disjunction between upper and lower stories. In the upper story are
found those elements proper to a tomb: *Madonna and Child*, tomb chest and effigy, freestanding
statuary and reliefs alluding to Pesaro's conquests in the Turkish War. Despite generic
correspondences of statues and reliefs, their inclusion leads to slight deviations from bilateral
symmetry. Below, are the inscriptions and conventionally emblematic or purely decorative
reliefs appropriate to architecture, like the lion of St. Mark,[25] cuirasses, and trophies, disposed
with almost perfect symmetry. Where the architectural design of the lower story has a well-
established pedigree, that of the upper story is ad hoc. Yet some attempt was made to
integrate upper and lower stories. The vertical accents and sequence of recessions and
projections, of planes and cylinders, initiated by the bay system of the lower story, are
continued in the upper. And the base of the upper story, with reliefs and pedestals, functions,

[22] G. Tosi, 1983.
[23] Venice, Mus. Correr, MS Gradenigo 228/III, Grevembroch,
*Mon. Ven.*, iii, 1759, c. 27. For the attribution of the architectural
design of the Emo Tomb, see Schulz, 1983, pp. 76–8. For the
sources of the Pesaro Tomb, see Munman, 1968, pp. 306f.
[24] Girolamo's tomb was engraved by Coronelli, [c. 1710], "De-
positi," n.p., for which see Catalogue no. 28, n. 15. McAndrew,

1980, pp. 483–7, discussed the architecture of the Benedetto
Pesaro Tomb at length.
[25] For the typical Venetian winged lion, portrayed in half-length
in foreshortened frontal view, holding an open or closed Gospel
of St. Mark between its forepaws, known as *Leon-molèca*, see
Erizzo, [2]1866, pp. 16f, n. 5.

*Fig. 26*

at the same time, as the attic of the lower triumphal arch. Indeed, the crowning of the later and more classicizing triumphal arch used by Tullio Lombardo for his Tomb of Doge Giovanni Mocenigo (d. 1485; tomb finished in 1522) in SS. Giovanni e Paolo is not so very different in its proportions or horizontal stepping from this intermediate register in the Pesaro Tomb.

*Pl. 73,*
*Fig. 27*

The decade or more that separates the Vendramin and Pesaro Tombs makes itself felt not only in a more faithful imitation of classical models. Areas devoted to decorative carving in the later work are fewer, smaller, and more discrete: the more reticent moldings of the architrave no longer compete with the ornament of the entablature and an ornamental frieze no longer crowns the plinths. There is a clear hierarchy of media: statuary is distinguished from relief by its subject matter — on the facade, only the former depicts the human figure — and by its relative independence from its architectural setting. Reliefs are simpler, less pictorial than in the Vendramin Tomb; by and large, the scale of objects in the Pesaro reliefs is larger and frames are as insistent as the reliefs they enclose. In short, relief is more subservient to the architectural design. In consonance with this is the greater simplicity and regularity of the whole due to the prevalence of rectangles and parallelepipeds, to the reduction in the number of major planes to two, and to the elimination of semicircular concavities and octagonal projections. The principle of repetition now replaces that of variation: where no element was repeated more than once in the Vendramin Tomb, here the major order and the drums and reliefs of the upper base recur four times. Pairs of reliefs on either side of the central vertical axis correspond more closely when not actually the same or mirror-images.

*Pl. 2*

*Pl. 75*

For proof of Giambattista's authorship of the design of the Pesaro Tomb, we must look to the single reasonably certain example of the artist's architecture — the two pilasters of the Bettignoli Altarpiece in Treviso. In the simplicity and openness of their design, the capitals of the Bettignoli Altarpiece are like the capitals of the upper story of the Pesaro Tomb. In both, acanthus leaves disposed in a single row beneath the volutes are widely spaced; the large amount of empty ground between them is only half filled by the double or triple sprays held fast between the diminutive ends of volutes. The height of the relief and the density and tectonic structure of the ornament on the shaft of the Bettignoli pilaster

*Pl. 76*

compare with the ornament on the pedestals of the Pesaro columns. Yet similarities are not so compelling that all doubt of Giambattista's authorship of the Pesaro Tomb is silenced: unfortunately, greater certainty requires more comparative material than we have at present.

*Pl. 73,*
*Fig. 25*

In July 1500, Pesaro was elected *Capitano Generale del Mar*, leader of the Venetian fleet in the war against the Turks; he died in that office three years later at Corfù. Like a renowned predecessor, *Capitano Generale* and later doge, Pietro Mocenigo (d. 1476), Pesaro was celebrated in his tomb as admiral of the Venetian fleet in the Turkish War: evidently Girolamo Pesaro was more concerned to obtain for his father that immortality conferred by eternal fame than to assure Benedetto's resurrection to eternal life in heaven by encouraging the prayers of passersby.[26] Pesaro's epitaph, like Mocenigo's, lists the defunct's military feats — his conquest

---

[26] The meaning of the Pesaro Tomb was expounded by Goffen,
1986, pp. 67f. To her discussion I do not have much to add.

of the islands of Cephalonia (Kefallinia) and Santa Maura (Levkas) and the city of Nauplia (Návplion) in the Morea, and his slaying of the pirate Enrichi. Like Mocenigo, Pesaro is dressed in the garb of *Capitano Generale* — armor (with the lion of St. Mark and a closed book emblazoned on his cuirass), *berretto*, and a mantle fastened on the right shoulder[27] — and holds the standard emblematic of his command. The dolphins, which flank his pedestal, serve to identify that command as naval. By the date of the Pesaro Tomb, an armor-clad pedestrian effigy had become standard for the commemoration of military heroes. The tradition had been established in Venetian funerary sculpture by the Tomb of Vittor Pisani (d. 1380), hero of the War of Chioggia (formerly in S. Antonio di Castello). Although the Pisani Tomb had no successors for nearly a century, examples of the type in tombs of *condottieri* and patrician captains followed in quick succession from the 1460s on.[28] On the front of the *cassone*, in low relief, are the sites of Pesaro's major conquests — the island of Cephalonia and Santa Maura, represented as fortresses and clearly labeled. They recall the scenes of *Mocenigo's Entry into Scutari* and *Mocenigo's Delivery of the Keys of Famagusta to Queen Caterina Cornaro* on the doge's tomb chest. To the left of the Pesaro sarcophagus is a relief of a light galley, to the right a carack — those ships on which the Venetian fleet chiefly relied during the Turkish War. *Mars* and *Neptune* flanking the *Effigy of Pesaro* symbolize Venetian domination of land and sea. Below are lions of St. Mark with closed books emblematic of the Venetian Republic, cuirasses and other military accoutrements represented *all'antica*. The triumphal arch, with its connotation of military victory, accords with the tomb's imagery, but the format probably was chosen for aesthetic, rather than iconographic, reasons. At any rate, Doge Nicolò Marcello and Doge Andrea Vendramin, tenants of earlier tombs derived from the triumphal arch, had no miliary achievements to their credit. Yet hope of a Christian immortality was not utterly relinquished in the quest for enduring fame. *Pesaro* stands on his sarcophagus in allusion to the risen Christ. The winged disc beneath the tomb chest symbolizes resurrection, while the *Madonna* in the crowning guides our prayer to Pesaro's most potent intercessor.

*Pl. 79*

*Fig. 27*

In 1581 Francesco Sansovino assigned the *Effigy of Pesaro* to Lorenzo Bregno; the attribution has never been disputed. But an authentic effigy, inscribed with Lorenzo's name — the *Effigy of Bartolino Terni* from his tomb in S. Trinità, Crema — is dissimilar enough to refute Lorenzo's authorship of *Pesaro*. Where the working out of *Pesaro's contrapposto* produces the impression of mobility, the outward swerve of *Terni's* knees and feet creates a stationary pose. Where *Pesaro's* cloak and belt modify an otherwise symmetrical design, the bilateral symmetry imposed by *Terni's* dress and figure remains intact. The refinement and variety of decorative details in *Pesaro's* armor contrast with the rote execution of the eyelets and bows of *Terni's* jack and the chain mail of his skirt. Faces, too, betray a different hand.

*Pls. 77–82*

*Pls. 239–241*

Since the statue of *Pesaro* is the only example of an armor-clad pedestrian effigy in Giambattista's oeuvre, points of contact between *Pesaro* and the sculptor's other works nec-

*Pls. 81, 242*

[27] Vecellio, 1590, p. 102v.
[28] They included the lost Tomb of the *condottiere* Cristoforo da Tolentino (d. 1462), formerly in S. Margherita, Treviso, as well as the surviving Tombs of Doge Pietro Mocenigo (d. 1476) in SS. Giovanni e Paolo, and of Jacopo Marcello (d. 1484) and Melchiore Trevisan (d. 1500) in the Frari. The Tombs of Dionigi Naldi da Brisighella (d. 1510) in SS. Giovanni e Paolo, of Pellegrino Baselli Grilli (d. 1515) in S. Rocco, 1517, and of Bartolino Terni (d. 1518) in S. Trinità, Crema, probably postdate the Pesaro Tomb.

essarily are few. Nevertheless, the protuberant eyeballs, the drilled tear duct, the irises formed by wide, drilled arcs, which do not reach the upper lid, also are traits of the Sacrament *Pls. 81, 58* Chapel *St. Peter*. To be sure, these techniques were copied by Lorenzo from his brother, but the hair of Lorenzo's figures is distinctive and wholly unlike *Pesaro's*. Conversely, the resem- blance to the Sacrament Chapel *Christ* of the smooth surface of *Pesaro's* hair, the rhythm of *Pls. 80, 51* its locks, and its finely chiseled strands, corroborates *Pesaro's* attribution to Giambattista. In neither *Christ* nor *Pesaro* is the head of hair, which swells very gradually, undercut at its *Pls. 37, 82* border with the face. Like the hair of *Camillo Verardi*, strands are separated mainly by narrow, chiseled, V-shaped troughs and occasionally by a short string of tiny drill-holes, so widely spaced that they do not form a channel. Where, at its termination, a lock curls up, its center is shallowly drilled.

Also characteristic of Giambattista at this period is the degree to which individual forms *Pls. 77–79* are freed from the matrix of the block: when not actually freestanding, as are most of the free leg and part of the engaged leg, the drapery that hangs over *Pesaro's* right arm, and the index finger of his upraised hand, receding forms are deeply excavated. Although *Pesaro* is *Pls. 23, 79* very robustly built, the figure's movement is as lithe as that of the Cesena *Christ*. In both, this is due largely to the wide spacing of the legs and feet and to the raising of all but a minute portion of the free foot from the ground. Here, as in almost all of Giambattista's figures, *Pesaro's* toes project beyond the edge of the base. The mantle — contracted into narrow pleats at its hem, expanding as it rises to envelop the figure's voluminous upper body — contributes to the impression of buoyancy, which the figure so conspicuously makes. As *Pl. 48* in the *Resurrected Christ* from the Sacrament Chapel at Treviso, the long folds of the more than floor-length mantle, slightly bowed at their commencement, straightening out as they ascend, visually counteract the gravitational pull exerted on the figure.

It is curious that no account was taken in the effigy of the distant and foreshortened view from below that a spectator would have had. Chain mail and armor were carved in minute detail and, as is true of all but one of Giambattista's works, the surface was polished to a remarkable degree of smoothness. While the back of the figure is flatter than the front and not as highly finished, it is more than just blocked out — Bregno had reached that stage at which the claw chisel would have replaced the point — and even in back, the head is fully *Pl. 81* finished. In the farther side of *Pesaro's* face, Bregno introduced perspectival distortions to accentuate the effects of foreshortening that would naturally have been produced by the turn of the effigy's head and the resultant three-quarter view of its face: this accounts for the tilting of the axis of right eye and brow, the contraction of the right half of nose and mouth. But from the ground, such distortions do not register. And so far from having emphasized the plasticity of *Pesaro's* features, Giambattista seems to have minimized their projection and recession in order to preserve the stereometric regularity of the spheroid head.

Only one other sculpture on the Pesaro Tomb bears evidence of Giambattista's hand.[29] *Pl. 74* It is the relief of the half-length *St. Benedict* in a roundel. Arcuated channels for irises could

---

[29] For a discussion of the style of the other sculpture of the tomb, see Catalogue no. 28.

testify as well to Lorenzo's authorship, but *St. Benedict's* squared beard, prominent cheekbones, short nose, and widely separated eyes – traits common also to *St. Peter* – speak in favor of *Pl. 58* the elder brother. Unlike the *Angels* in roundels from the Cesena Altar, however, the com- *Pls. 40, 41* position of *St. Benedict* respects both the two- and three-dimensional constraints imposed by the frame, which establishes simultaneously the borders of the field and the foremost plane of the relief's illusionistic space. This, no doubt, was a concession to the siting of the relief inside a relatively narrow passage.

In the central lunette at the top of the dormitory facade of the Convent of S. Giorgio Maggiore is Giambattista's relief of *St. George Slaying the Dragon*, carved between October *Pls. 83, 84* 1508 and July 1509. Quite exceptionally, the relief occupies the same plane as the facade yet is not framed. To be sure, there is a cornice at the bottom of the relief, but this is clearly a ledge, not part of a frame, for the cyma recta at the top causes the cornice to narrow below. Indeed, the relief could not have been framed easily, since it is not regular in shape: the straight edges of the background do not make a rectangle and, in any case, are interrupted in four places by horse and rider. Although the block from which the relief is carved is larger than the surrounding slabs of the lunette, its material is the same Istrian stone. In consequence, figures seem carved directly from the facade, rather than from a separate field incorporated within the lunette, thus securing the integrity of the wall as architectural surface. A setting of measurable depth would have counteracted that effect by creating the illusion that the plane were penetrated; here, on the other hand, no more of a setting exists than the princess's base line, defined as the top of a rock or cliff by a certain unevenness of the surface below her foothold. Indeed, Bregno did not even differentiate between the base lines of horse and dragon; thus both seem to inhabit a single plane. The dragon, horse, and much of the saint were represented in profile view; thus foreshortening and its attendant illusion of recession were circumvented. Because the action proceeds along a plane parallel to the relief ground, overlapping also was avoided. Here and there Bregno reduced the height of the relief, but for the most part he simply eliminated the rear of rounded forms at their intersection with the background. Thus, the princess's diminished scale alone acknowledges the effect of distance.

Bregno's relief of *St. George* was preceded by one, dated to the later Quattrocento, in the Victoria and Albert Museum, whose composition is extraordinarily similar. This relief comes *Fig. 36* from the exterior of a house in Venice at S. Marco 720–721 at the Ponte dei Baretteri.[30] Of no special artistic merit, the relief is not likely to have imposed itself independently on Giambattista as a model. Yet it documents the existence of a tradition, which Giambattista's patrons may have obligated him to follow (though his contract does not say so) and which accounts for much of what appears artless in his composition. Indeed, this conventional image probably was an emblem of the Benedictine monastery and, as such, served to identify its property throughout the city. We know that the Convent of S. Giorgio owned the houses at the Ponte dei Baretteri from which the London relief was prised.[31] And an undated relief

[30] "Il bassorilievo . . . ," *Il Veneto cattolico*, Aug. 22, 1883, [p. 3]; "Un bassorilievo . . . ," *La Venezia*, Mar. 24, 1885, [p. 3]; Ven., Bibl. Marc., MS it., Cl. VII, 2289 (=9125), Fapanni, 1870–88, fasc. 3, "Altarini di marmo," c. 64, no. 124 [no. 121]; London,

London, Victoria & Albert Mus., Cat. by Pope-Hennessy/Light-bown, 1964, i, pp. 358–60, no. 382; Rizzi, 1987, pp. 608f, no. 11.

*Fig. 37* in Campo Rusolo (also called Campo S. Gallo) at S. Marco 1076, nearly identical to ours, adorns houses donated to the convent in 1161.[32]

Bregno's unusually low fee for the relief of *St. George* may be explained in part by the absence of a setting. It is possible that the relief was never highly finished, perhaps because its surface was intended to be polychromed. The poorly proportioned and inorganic horse and the inelegant dragon suggest the collaboration of an assistant. In the design and execution of the princess, on the other hand — in the flatness of the folds of her bodice where they overhang her waistband, in the arabesques of the border of her fluttering peplum, in the undercut contour of her right leg, and in her extended foot, all of which can be paralleled in the full-length *Angel* on the left of the altar at Cesena — I sense Giambattista's hand. But the surface of the relief is far too worn to permit any definite conclusions regarding its autography.

A pair of marble *Angels*, now divided between the Staatliche Museen in East Berlin and the sacristy of SS. Giovanni e Paolo, once adorned the Altar of Verde della Scala in the former Church of S. Maria dei Servi. The framework of the altar was made between December 1523 and August 1524 by Guglielmo dei Grigi; it enclosed a statue of *Mary Magdalene* carved *Fig. 57* later that same year by Bartolomeo Bergamasco. During the construction of the altar, the *Angels* were given by the Servites to the patrons of the altar — the *Procuratori di S. Marco de citra*, as successors to the executors of Verde della Scala's will — for the decoration of the altar. For what altar the *Angels* originally were made and how they came into the possession of the convent, are subject to speculation. Before his death in October 1511, Girolamo Donato erected an altar in the Servi for a relic of wood from the inscription of the True Cross, given by him to the church in 1492. The altar was lavishly embellished with bronze reliefs by Andrea Riccio. Perhaps it was for this altar that the *Angels* were intended. It may be that, when Donato died in extreme poverty, the Servites undertook to pay for the *Angels*, which presumably had been begun but possibly not finished, and having done so, became their owners.

Plates 85 and 86 show the East Berlin *Angel* as it was before World War II. From shoulder to mid-bicep, the right arm was original; the left arm was preserved to the middle of the forearm. A fragment of the *Angel*'s original right hand was kept separately. In 1945 the *Angel* was severely burned in the *Flakturm* fire; recent attempts at restoration have proved only partially successful.

When I first ascribed the Servi *Angels* to Giambattista Bregno, my conviction of his authorship was based on a very limited number of the sculptor's works. Happily, Bregno's expanded oeuvre provides corroboration of his authorship. The hair of the East Berlin *Angel* recurs in the right-hand *Angel* in the Bettignoli Altar. The diadem worn by the Venetian *Angel* adorns both Bettignoli *Angels*; the headdress of the Venetian *Angel* is stippled like that of the left-hand Bettignoli *Angel*. In the ovoid shape of their faces, occasioned by high foreheads and pointed chins, in the brows created by a slight deflection in the plane of the

[31] Fees, 1988, p. 142.
[32] Tassini, (1863) [8]1970, p. 713, voce "S. Zorzi"; Rizzi, 1987, p. 108, no. 68; Fees, 1988, p. 166.

forehead and hairs etched so faintly that they are invisible except under artificial light, the physiognomies of the Venetian *Angel* and the bust-length *Angel* on the left of the Cesena Altar correspond. The uneven locks of hair, which, falling from the crown, curl inward toward the face, have the same morphology in both. The incisions and tiny drill-holes that define the irises and pupils in the *Angel* in East Berlin recur identically in the eyes of the Cesena *Angel*. Where folds amass in the *Angel* in East Berlin, drapery resembles the crumpled mantle of the Cesena *Baptist*.

*Pls. 96, 43*

*Pls. 95, 42*

*Pls. 85, 26*

Although both *Angels* were worked in entirety and appear to advantage in any view, they were meant to be seen in profile, facing one another — the East Berlin *Angel* on the left, the Venetian *Angel* on the right. Reverence influences every member of the *Angels'* bodies, determining the focused gaze and opened mouth, the tilt and inclination of the head, the position of the arms, the gesture of the hands, transfixed — no less than the expression of the face — in a momentary state. The strength of feeling has its physical correlative in the tension of the body: although the figures are at rest, they are not relaxed. The poses of the torsos of both *Angels*, bent forward and twisted slightly to one side, require a deliberate effort; foot and toes of extended legs are tensed; arms, half raised and suspended, strain the biceps, flexed to support the weight. Inanimate elements, such as drapery and hair, are hardly less informed with life than the body. Extremely puckered drapery produces patterns of folds that are various, complex, and as densely articulated as the surface of the flesh is smooth. But magically, the ruffled surface presents closed and even contours at major silhouettes.

*Pls. 85, 92*

The more painterly style of the *Angels*, the product of an extraordinarily sophisticated technique, suggests that these are the latest of Giambattista's works discussed so far. A comparison of the heads of the Venetian *Angel* and the Sacrament Chapel *Christ* reveals that, in the former, line has disappeared almost entirely, while contrasts of light and shade have assumed a more important role in the transmission of form. The hair of the brows has become much fainter, and only the closest observation discloses irises and pupils. On the other hand, ropelike locks of hair and tear ducts, drilled more deeply, create deeper shadows. Shapes appear abstracted, for modulations of the surface are so slight and forms merge so gradually that even features lose precise boundaries.

*Pls. 96, 52*

Above the frame enclosing Titian's *Assumption of the Virgin* on the High Altar of S. Maria dei Frari is a statue of the *Resurrected Christ*, flanked by the premier saints of the Franciscan order in the Veneto — *St. Francis* on *Christ's* right, *St. Anthony of Padua* on his left. On the basis of no evidence whatever, these figures, as well as the altar's framework, are generally assumed to be the work of Lorenzo Bregno. In fact, I shall seek to prove that Lorenzo was entirely responsible for *St. Francis* and, in part, also for the *Resurrected Christ*. But the framework is more likely to have been designed by Giambattista; *St. Anthony* certainly is his.

*Pl. 98*

*Pls. 195, 203*

*Pl. 103*

An inscription on the right pedestal of the frame names as patron of the altar Fra Germano, then prior of the Frari and the leading Franciscan Conventual in Venice. The year 1516 also is inscribed, but whether this refers to the commencement of the altarpiece, the completion of its framework, or some intermediate period, we do not know. It is most unlikely, however, that the altarpiece was begun before Fra Germano became prior. He is first recorded in that office in June 1516, but may have been elected some months earlier. Sanuto reported that

Titian's *Assunta* was installed in May 1518. By that time the framework of the altar must have been completed and installed. But the statuary need not have been in place.

The size of the *Assunta* is so exceptional – it is generally and reasonably held – that it must have been the painter's choice. If so, the dimensions of the altar's frame perforce were set by Titian. But its format, which imitates the wooden frame of 1503 for Alvise Vivarini's and Marco Basaiti's *Altarpiece of St. Ambrose* in the Cappella dei Milanesi in the Frari,[33] is more likely to have resulted from a decision of the patron, reassured by the appearance in his church of a successful prototype. However that may be, individual architectural members look sufficiently like those of the Pesaro Tomb to permit their tentative attribution to Giambattista Bregno. Columns are elevated on high, projecting plinths, whose front faces, like those of the Pesaro Tomb, are richly carved and framed. The dense and continuous ornamentation of the frieze at the altarpiece's base resembles the treatment of the Pesaro Tomb's main frieze. The central arch, by means of which the shape of the ancona was made to mirror the central opening of the basilica's choir screen across the fifth bay of the nave,[34] springs from lesenes, whose profiles match those of the central opening of the Pesaro Tomb. The bases supporting the *Resurrected Christ* and the *Effigy of Pesaro* are composed of truncated quadrilateral pyramids with curving faces. At the bottom of the frame is a small relief of *Christ as Man of Sorrows Adored by Two Angels.* The face and hair of the central figure are typical of Giambattista's *Christs,* as comparison with the Cesena *Christ* reveals, but the relief evinces no other traces of the sculptor's thought or hand.

Though there is no reason to suppose the statues unfinished, the surfaces of SS. *Francis* and *Anthony* were left extremely rough. Traces of tool marks – point, claw chisel, flat chisel, and drill – remain in many places: the final stage of refinishing with rasp and pumice apparently was skipped. At the rear, all three figures are flat and forms were merely roughhewn; indeed, at the back the bottom of *St. Anthony* was not even blocked out. Clearly, the statues were calculated for a very distant view, where refinishing would not tell. Designs are simple and repetitive; contours are regular and closed; individual forms are few and large in scale. Originally the figures were made still more legible by polychromy and gilding. Not only were pupils black, wounds red, and hair, cords, and the cover and clasps of *St. Anthony's* book gold, but the flesh in all three statues was painted naturalistically.

Archival records, as well as original remains, testify to the frequent polychromy of Italian marble sculpture in the Quattrocento. But it may come as a surprise that, as late as ca. 1516, when Roman antiquities, recently excavated in considerable numbers, had mistakenly persuaded connoisseurs that antique statuary was not polychromed and central Italians, therefore, had ceased applying color to their marble sculpture, Venetians should have continued to paint their statues – not only the decoration on dress and attributes, but flesh as well. In fact, the polychromy of the figures atop the Altar of the *Assunta*, where the desire to forge a link with Titian's painting might have accounted for the use of color, was not unique: traces of flesh color in one corner of *Pesaro's* mouth, in an upper lid, and inside his nostrils and in

[33] Steer, 1982, pp. 162f, 164f, cat. no. 36.
[34] Rosand, *AB,* 1971, p. 200, repr. in idem, 1982, p. 55. Rosand also observed that the gilded arabesques in the innermost frame
of the High Altar reflect the decoration of the pilasters and arch around the central opening of the choir screen.

*Fig. 38*

*Pls. 98, 73*

*Pl. 99*

*Pl. 22*

*Pls. 104, 198*

*Pls. 103, 195*

*Neptune's* right groin indicate that the flesh of the Pesaro Tomb statues also was polychromed. Probably many other statues of the period were painted in a similar fashion, but exposure to the elements or repeated cleaning has removed all trace of flesh color. It may be that the polychromy of sixteenth-century stone figures more frequently expressed the patron's taste than the artist's: the 1520 testament of Pietro Bernardo reveals that one patrician, at any rate, decidedly approved of it. Describing the tomb that he wished erected in the Frari, Bernardo charged that "above the sepulchre there be made and installed a most beautiful, freestanding marble figure of *God the Father*, with rays, completely gilded except the face and hands of flesh color."[35] That Venetians took so long to abandon a practice inherited from the Middle Ages is symptomatic of the innate conservatism that governed most aspects of Venetian cultural and political life.

A comparison of the head of *St. Anthony* with that of the Sacrament Chapel *St. Peter* makes manifest the same square shape and extraordinary depth from nose to ear. In both, the skeletal structure beneath the flesh insistently obtrudes, not only in the salient jaw- and cheekbones, but in the irregularities of the frontal bone and the protuberant chin. Features provide a firm tectonic structure because they are so large and plastic, and because eyes are so widely spaced. The high dome of the cranium is accentuated by the low placement of the features. The technique for the rendering of irises and tear ducts is the same in both and temples are similarly indented. In like manner, the flesh of the cheeks surges around the nostrils to subside beneath the cheekbones.

The block from which *St. Anthony* was carved is so shallow that the front face of the statue functions like relief. Limbs and drapery are spread out across the surface; right hand and book are pressed flat against the chest; left hand and forearm are sharply foreshortened. The recession of the upper torso is concealed by drapery, which fills the voids between arms and trunk. The surfaces of folds are relatively flat, even if their edges are cut back. At the base of the figure, neither feet nor tunic projects beyond the front plane of the narrow base.

Recently discovered in the attic of the Scuola di S. Giovanni Evangelista is a half life-size marble statuette of a *Deacon Saint*. The figure's attributes — vestments, tonsure, book, and youthful physiognomy — are not sufficient to permit its identification as St. Stephen, St. Lawrence, St. Leonard, or any of the less familiar deacon saints. The surface of the statue is so worn and, in places, mutilated, and its composition is necessarily so conventional, that it would be difficult to adjudicate between Giambattista and Lorenzo, were it not for the figure's face. But a comparison with the heads of *St. Peter* and *St. Anthony* reveals the same square jaws and straight chin, the same indentations at the temples, the same extraordinary depth from nose to ear. The large and plastic eyes, widely spaced, are morphologically identical to those of *Peter*; the folds of flesh on either side of the mouth recur in *Anthony*. The figure's robust proportions are magnified by the abundant and more than floor-length drapery, which bunches about the feet. The orthodox *contrapposto* is combined with a very slight torsion; the free foot extends just beyond the base. The fold, which sweeps up in one

*Pls. 105, 106*
*57, 58*

*Pl. 101*
*Pl. 103*

*Pl. 101*

*Pls. 107–111*

*Pls. 111, 58, 106*
*Pls. 110, 57, 105*

*Pl. 108*

---

[35] ASV, Archivio notarile, Testamenti, Busta 506 (not. Daniele Giordan), no. 565, c. 3r: "Voio sia fatta e messa di sopra la selputura [sic] vna belissima figura in malmoio di Idio padre; con razj tuta dora exceto volto con mano di carnaxon di tuto relievo ..."

Pls. 108, 48 continuous line from base to shoulder, recalls the means by which Giambattista made the Sacrament Chapel *Christ* appear to rise.

In the spandrels between the arches of the arcade surrounding the interior of the Cappella del Santo in the Basilica of St. Anthony are roundels containing *Prophets*. Although the *Prophets* are not documented individually, it is known that Giovanni Minello, *protomaestro* of the chapel, was generally responsible for their manufacture:[36] only one of the twelve *Prophets* has a different history.[37] In December 1502, the stewards of the *Arca del Santo* commissioned a *Prophet* from Giambattista Bregno; four and a half years later, Bregno was given the marble block from which to carve it. Sometime in 1517 the *Prophet* was delivered and installed in one of the two spandrels of the chapel's east wall. Its style proves Giambattista's to be the Pl. 113 *Prophet* to the left of the *Miracle of the Goblet* — the relief that Bregno originally was meant to carve.

With the single exception of this figure, the *Prophets* of the Cappella del Santo are worse than mediocre: by virtue of the proportionality and organic relationship of parts, correct foreshortening of the receding arm and attention to detail, our figure distinguishes itself from these. In design, too, it is different, for, considerably smaller in scale than the others, it is the only *Prophet* represented to the hips. The *Prophet's* physiognomy and dress recall Pl. 54 Giambattista's *St. Peter* from the Cappella del SS. Sacramento. With Joseph from Giambattista's Pl. 18 *Visitation*, the *Prophet* shares the draping of his mantle and the gesture of his right arm and hand. The neckband of his tunic resembles that of Joseph and secures a similar gathering Pls. 112, 17 of folds. The face and beard of the *Prophet* correspond to those of Zacharias; eyes conform to Giambattista's canon. But the pedantic notation of details in the carving of brows and wrinkles, the explicit and complete delineation of the borders of the features, and the straight edges and unmodulated surfaces of folds, reveal the plodding deliberation of a disciple.

Also from Giambattista's shop come the figures of Christ and the two Maries in S. Nicolò, Pls. 114, 116 Treviso, from the group of *Christ Appearing to the Holy Women*. Originally Christ's gaze was focused on a kneeling figure of Mary Magdalene, lost since the early nineteenth century. These four figures, together with some Angels, which may have been reliefs, and other ornaments, were set within a niche. Sources, which unfortunately date no farther back than 1630, suggest that the group was commissioned by Pileo, Aurelio, and Girolamo di Agostino d'Onigo for the altar of their chapel immediately to the left of the choir in S. Nicolò, but no proof of this has yet emerged.

That a design by Giambattista lies behind this group is confirmed by the many similarities between these and Bregno's figures. Christ's head copies that of the *Resurrected Christ* in the Pls. 115, 52 Cappella del SS. Sacramento. The draping of the upper part of the shroud and the gesture Pls. 114, 18, 113 of Christ's right arm and hand are analogous to those of Joseph from the *Visitation* and the Santo *Prophet*. The long neck, the slender and excessively low shoulders of the foremost Mary, as well as the delineation of her breast beneath her drapery, recur in the *Visitation's*

---

[36] Sartori/Luisetto, 1983, pp. 337–9, nos. 75, 86, 95, 101, 102, 105.

[37] Ibid., p. 338, no. 99, reported (without transcribing the document) that, on June 16, 1511, Giovanni Buora received a final payment of 24, out of 74, lire for the *Prophet* that he had made

for the *Arca*. I doubt that any one of the series of twelve *Prophets* in roundels is the *Prophet* referred to here, because the former were regularly paid for at the rate of 7 ducats or 43 lire, 8 soldi each. Furthermore, none of the twelve *Prophets* is attributable to Buora.

Virgin. Mary's gesture is also Elizabeth's; but Mary's pose, as well as the draping of her *Pls. 116, 16,*
tunic and mantle were based on *St. Mary Magdalene* from Lorenzo Bregno's High Altar of *17*
S. Marina, a statue patently imitated from classical draped female figures. A comparison *Pl. 213*
with Elizabeth from the *Visitation* reveals what a lifeless surface is produced in the Holy *Pl. 15*
Women by the smoothing of surfaces and the regularization of contours. In the face of Christ,
the compulsive definition of every form by means of stereometric surfaces and even borders *Pl. 115*
is incompatible with the extreme idealization of the type evolved by Giambattista and ends
in parody.

Although Christ and the Holy Women are freestanding, the group was conceived pic-
torially. A portion of the rear of both fragments is flat and unworked: evidently the figures
were intended to be seen against a backdrop of some sort. Bases simulate real ground. By
their very treatment, the figures are made to seem to inhabit different planes. Christ is 12
centimeters taller than the women and is carved in the round. By contrast, the Holy Women
are executed in relief of graduated height. The surface of the closer of the two women is
moderately uniform and flat, while the relief of the woman to the rear is lower still: only the
figure's face emerges into half relief.

Giambattista's final work is the right-hand *Reggiscudo* bearing a mitre and shield with the
arms of Bishop Jacopo Pesaro above Titian's Pesaro Altar in S. Maria dei Frari. The *Reggiscudo* *Pls. 117–*
must postdate the cession to Pesaro, his brothers, and descendants, of the altar and space *123*
nearby for burial in January 1518. Apparently altarpiece and framework were installed by
December 1526, when Sanuto reported the celebration of the Feast of the Immaculate
Conception at the altar. Although Giambattista's figure was surely finished, the two *Reggiscudo*
need not have been in place.

No archival records document the frame's history or authorship. Nevertheless, stylistic
considerations permit the attribution of the framework to Lorenzo Bregno. Strangely, the *Pl. 244*
left-hand *Reggiscudo* is not only not by either Bregno, but bears no traces of their influence: *Figs. 41–45*
indeed, right and left *Reggiscudo* are so different in figure type and pose that, were it not for
correspondences of size, material, arms, and mitre, we might think them destined for different
sites. Were the left-hand *Reggiscudo* attributable to Antonio Minello, I would identify it
unhesitatingly with the second of a pair of *Angels* that Minello promised to complete, when
he contracted to buy the contents of Lorenzo Bregno's shop. But there is nothing that the
figure resembles in Minello's oeuvre.[38]

The attribution of the right-hand *Reggiscudo* to Giambattista, by contrast, is supported by
numerous correspondences with other works of his. In arrangement and technique, the figure's *Pls. 120,*
hair repeats the hair of the East Berlin and right-hand Bettignoli *Angels*. In facial type, the *121, 123,*
*Reggiscudo* is comparable both to the latter *Angel* and to the right bust-length *Angel* from the *14, 89, 90*
Corpus Domini Altar at Cesena: contours are as sharply cut, edges as precisely defined, as *Pls. 122, 44*
in these early works. The figure's proportions and body type parallel those of Giambattista's

---

[38] Nor is it to be supposed that the figure was carved by Mi-
nello's partner, Bartolomeo Stampa, for Stampa was a goldsmith,
whose contribution to the partnership, as the documents make
clear, was purely financial. See Schulz, *Flor. Mitt.*, 1987, pp. 293–

6. For an attribution of the left-hand *Reggiscudo* to the author of
the 1523 altarpiece formerly in the Chapel of S. Nicolò in the
Ducal Palace and now in the Cappella di S. Clemente in S.
Marco, see Catalogue no. 27.

Pls. 117, 93, 94, 85–87 *Angel* in SS. Giovanni e Paolo. The pattern of folds of the Pesaro *Reggiscudo* recalls that of the *Angel* in East Berlin.

Pl. 117, Fig. 48 The source of the figure is Antonio Rizzo's *Angel Bearing Attributes of Christ* in the Ca' d'Oro, but how differently each artist treats the same motif. In contrast to the high-waisted chiton of Rizzo's *Angel*, the cinched waist of Giambattista's *Page* divides the figure's torso into geometric halves. The shoulders of the Pesaro *Reggiscudo*, unlike those of Rizzo's figure, are extremely broad and square. There is no hint of breasts; the waist is not indented; the hips do not expand. These differences in the figure's canon contrive to produce a much flatter, more even surface and straighter contours – an effect to which pose and drapery also tend. The pose of Rizzo's *Angel* is open: arms clear the body; even fingers are freestanding. By contrast, the Pesaro *Angel*'s arms adhere to the figure's torso. As voids between limbs and Pl. 103 trunk were filled to produce a uniform plane in *St. Anthony*, so, here, drapery introduced between widely separated legs guarantees the integrity of the surface. Neither undercutting nor deeply excavated cavities penetrate the surface, as they do in Rizzo's figure. Protuberances likewise are tempered, so that folds are carved in little more than *schiacciato* relief. The planarity of the surface conduces to even borders, as in the verge of drapery at the waist or the bottom of the peplum; curls that produce a broken outline in Rizzo's figure are subsumed within a common boundary in Bregno's *Reggiscudo*. Yet the integral and planar surface of Bregno's figure is continually tossed by small, irregular folds that leave no area of the drapery unruffled.

This tendency to articulate surfaces with a dense and overall pattern of small, constantly changing and ungraspable forms is a consistent feature of Giambattista's style. The chief vehicle for this decorative goal is drapery, typically as crumpled as used tissue paper. What distinguishes the *Reggiscudo* as a late work is not only the reduction in size and degree of relief of folds, but, more important, the participation of figure as well as drapery in a common Pls. 26, 4 enterprise. Where, in the Cesena *Baptist* or the Bettignoli *Christ*, the drapery, deployed across the foremost plane, to some extent stands free of the figure and therefore functions as a foil for the three-dimensional body behind it, in the Pesaro *Page*, figure and clinging drapery coalesce, creating relief of a figure in the round.

Pls. 100, 117 Thus Giambattista's late style, exemplified by the Frari *St. Anthony* and the Pesaro *Reggiscudo*, parallels to a remarkable degree the contraction of space and flattening of form characteristic of Giovanni Bellini's final *Fra Teodoro as St. Dominic* in the National Gallery of London and Fig. 15 Pietro Lombardo's late Loredan *Madonna* in the Ducal Palace.[39] Comparison between Pietro's Loredan *Madonna* and the *Reggiscudo* reveals as well a fracturing of the surface by minuscule folds in *schiacciato* relief, combined with smooth and continuous contours. Like Giambattista's *St. Anthony* and Pesaro *Reggiscudo*, Bellini's portrait and Pietro's *Madonna* were executed in the second decade of the sixteenth century. At the time, Bellini and Pietro were very old; Giambattista probably was middle-aged. Yet all three artists were working in a manner that was out of fashion and that, in the context of Venetian art, proved to be a cul-de-sac. In the art of Giovanni Bellini and Pietro Lombardo, their late style represents a significant

---

[39] Schulz, *Antichità viva*, Mar.–Apr. 1977, pp. 37f.

departure. By contrast, Bregno responded to artistic developments, which outstripped his capacity for assimilation and change, by a stricter conformity to the habits of his youth.

These habits prove Bregno to have been an exponent of late Quattrocento Italian sculpture who, like Andrea Ferrucci or Benedetto da Rovezzano at Florence, perpetuated a fifteenth-century style after High Renaissance art had acquired a prestige with which no other style could compete. Bregno's goal of endowing sculpture with the illusion of life through a mastery of the human figure and its movement, links the artist not only with Rizzo at Venice, but with Francesco di Giorgio at Siena and Antonio Pollaiuolo at Florence and Rome. Reality – not the art of ancient Rome – continued to provide for Bregno a valid standard against which to test his depiction of anatomy. His tall, lean figures expressed a preference that Bregno held in common with most late fifteenth century artists. Gestures and expressions describe states of active consciousness, in contrast to the reverie or sleep so often portrayed in the most progressive Venetian painting of the time. Poses characterized by disequilibria and shifting axes show figures in the midst of movement; even stationary poses, attained at the expense of muscular tension, imply imminent change. The response of folds to movement, or in its absence, to the play of natural forces, is as immediate and intense as if the weight of cloth offered no resistence.

In the small scale on which he worked and in the equal emphasis on every part of highly detailed compositions, Bregno declared his allegiance to the aesthetic that governed the painting of Giovanni Bellini, Bartolomeo Vivarini, and Cima da Conegliano, as it did the sculpture of Antonio Rizzo. The high degree of finish – the smooth, reflective surfaces of panel or marble – which usually follows from a lengthy and scrupulous procedure, is present in the work of all. Comparable to Venetian painting before the advent of Giorgione is the clarity effected by strong and rapid contrasts of meticulously defined areas of light and shadow – the result in Bregno's sculpture of drilling and undercutting and of the precise juxtaposition of projecting and receding forms. The linearity of Bregno's explicit contours is common also to late fifteenth century Italian painting before the revolution in taste that Leonardo's invention of *sfumato* brought about. Independent of underlying anatomical forms, drapery patterns composed of myriad, small, angular folds contribute as largely to the decorative appeal of Bregno's sculpture as of the sculpture of Rizzo and Pietro Lombardo and the paintings of late fifteenth century Venice.

For Bregno, as for the other great practitioners of late Quattrocento sculpture, beauty was defined by technical bravura – the ability to render minute detail, to simulate a wide variety of textures, to evoke the entire gamut of lights and shadows in defiance of the physical properties of stone. Art did not reside so much in the idea as in the execution, and the most artful execution was also the most demanding – one that rang most changes within the smallest area. In the refinement of his craft, Giambattista had no Venetian peer: the subtlety of visual effects attained in Bregno's sculptures by his suppression of etched line, by his constant but muted modulation of the surface, by the richness of his vocabulary of folds, surpasses that of every work but one by Rizzo. Unlike Rizzo, Giambattista consistently observed the same high standard of design and execution. In contrast to the works of Tullio and Antonio Lombardo, the decorative quality of Giambattista's sculpture was not dependent

upon decoration — the embroidered borders of garments, the stippled friezes and foliated jambs of architectural settings, the embellishment of attributes — but rather upon the design of larger as well as smaller forms, like the paths of ogee hairlines or serpentining locks, or the interplay of decisive mixtilineal contours with turbulent patterns of numerous small and variable folds. Behind Giambattista's achievement lay a century's advance in the conquest of the theoretical and technical means of reproducing visual reality. His art represents the culmination of that effort at a time when the majority of Italian sculptors had repudiated that goal in favor of a reevocation of the grandeur of antique sculpture. But the quality of Giambattista's art loses nothing by being *retardataire*: within the limits established by his aims, his sculpture stands among the preeminent creations of the Venetian Renaissance.

# CHAPTER THREE
# Lorenzo Bregno

If until this past decade Giambattista Bregno lacked an oeuvre, Lorenzo suffered from the opposite misfortune – the possession of an oeuvre that was not his. To be sure, it did include some works that properly belonged to him – the pendentive and altar reliefs of the Cappella del SS. Sacramento, the St. Sebastian Altar in Treviso, the St. Leonard Altar in Cesena, the Terni Tomb in Crema, the Altar of the Cross, *SS. Catherine* and *Mary Magdalene* from S. Marina, and the *Madonna* at Montagnana – all either documented, inscribed, or recorded as Lorenzo's in Sansovino's guide of 1581. The existence of so substantial a body of secure sculptures, one might have thought, would have stimulated the search for undocumented works of kindred style. But in fact, of the ten undocumented works discussed in this chapter, whose style – I shall argue – is demonstrably Lorenzo's, none had appeared in print as his. Instead, he was habitually given Giambattista's most important works – the Bettignoli Altar, the Sacrament Chapel *St. Peter*, the *Visitation* in Treviso, the Pesaro *Effigy*, and *St. Anthony* from the High Altar of the Frari. Antonio Minello's Naldi Tomb and Trevisan Altar were unanimously attributed to Lorenzo; the St. Luke Altar in S. Giobbe from the shop of Tullio and Antonio Lombardo and the anonymous and deficient Tombs of Melchiore Trevisan and Lorenzo Gabriel generally figured as his work. Lorenzo Bregno was widely credited with two monuments that, as I shall prove in another place, are Giammaria Mosca's – the Cenotaph of Alvise Pasqualigo in the Frari and the altarpiece with *SS. Mark* and *John the Evangelist* in S. Maria Mater Domini. Indeed, the frequency and indifference with which Lorenzo's name was applied to unpedigreed works of early sixteenth century Venetian sculpture suggest the play of an instinctive reflex: as an artist little studied and poorly known, he automatically was charged with High Renaissance Venetian works of problematic style. But Lorenzo's style is distinctive and, once described, difficult to mistake. Knowledge of its essential traits, gained

from an analysis of Lorenzo's documented works, will allow us to reconstruct his oeuvre, trace his sources and development, and define his meaning for Venetian sculpture of the Renaissance.

Pls. 124–
128
Lorenzo Bregno's first documented work is his statue of *St. Paul* in the Cappella del SS. Sacramento in the Duomo of Treviso, ordered in April 1508. Apparently still a subordinate of his brother's, Lorenzo was not charged with its execution: rather, together with *St. Peter* and the two *Angels* flanking *Christ, St. Paul* was commissioned from Giambattista. It was Lorenzo, however, who, five years later, was paid for it. Its style suggests that work on it was not nearly as protracted as the delay in payment would seem to indicate: indeed, *St. Paul* appears to be one of Lorenzo's earliest works. Attributed for a long time to the author of *St. Peter*, *St. Paul* distinguishes itself unequivocally, revealing even at this early stage Lorenzo's individual traits.

Pls. 124, 54
In opposition to *St. Peter*, garbed in the customary cloak and tunic of Apostles in late Quattrocento Venetian painting, *St. Paul* is oddly habited. The source of his dress is Roman statues of the *Priestess of Ceres* — a type commonly employed for full-length portraits of noblewomen of the Antonine period[1] — in which the himation, drawn diagonally across the body, wraps the right arm, bent at the elbow and extended slightly to one side. No exemplar of the more than fifty extant versions of this type is known to have been accessible in Venice at the time; nevertheless, whatever figure Lorenzo knew exerted an influence on Antonio Lombardo also, as his *Virtue* for Tullio's Tomb of Doge Andrea Vendramin,[2] under way in 1493, shows. In contrast to Antonio's relatively faithful copy are Lorenzo's alterations in the form and disposition of the folds and the length of the himation, as well as his radical adoption of a female mode of dress for an Apostle. The license evident in Bregno's treatment of his source bespeaks a lesser reverence bred, perhaps, by a greater familiarity with ancient art.

Fig. 49

Fig. 50

Pls. 124, 54
In his stocky proportions, too, *St. Paul* differs from *St. Peter*. The head of Lorenzo's figure, with its densely massed hair, is inordinately large. *St. Paul's* robust torso, square shoulders, bulging thigh and calf, thick joints at wrists, knuckles, knees, and ankles, endow the figure with a Herculean physique. His stature is enhanced by the diminutive proportions of his book.

Like *St. Peter*, *St. Paul's* pose is founded upon an unequal distribution of weight. But, with the exception of the disposition of *St. Paul's* free leg, the distribution of weight had no effect on the relationship of the individual members, ranged evenly on either side of a central vertical axis. Axes of hips and shoulders are horizontal; tensed and free limbs are aligned rather than opposed; the weight-bearing hip is retracted. The body responds neither to the turn of the head nor to the swerve of the foot. The free leg, with its vertical alignment of knee and heel and divergent orientation of knee and foot, is inorganic, while the elevation of the heel of the free foot produces the impression that the figure's lower leg is much too

---

[1] Kruse, 1968/ 75, pp. 229–59; Bieber, 1977, pp. 163–7.
[2] This persuasive attribution was made by Sheard, 1971, pp. 110f, 185f. For the derivation of the Vendramin *Virtue* from a *Kore* that entered the Venetian Statuario Pubblico in 1593 as

part of Federico Contarini's donation, see Pincus, *BM*, 1981, pp. 342–5. The difference in draping and gesture of the *Kore's* right arm, however, makes this an unlikely source for the Vendramin *Virtue*.

short. The trunk of drapery and several long descending folds make the figure seem not only stationary, but rooted to the ground.

Where *St. Peter* was worked in the round, *St. Paul* was treated like a high relief. The surface of the *Saint* was flattened and extended by the upraised arm sheathed in drapery, the frontal placement of the lowered hand and book, the pylon of drapery resting on the base. Vertical swathes bound the figure on either side: folds rarely disappear around its edge. Unlike *St. Peter*, Lorenzo's statue was not intended to be seen from any but a frontal point of sight.

*Pls. 125, 127*

A comparison of the faces of the *Saints* shows Lorenzo's dependence on *St. Peter*. But the cubic form of *St. Peter's* head is lengthened and flattened here: at either side a wide expanse of cheek and bushy hair increases the breadth of *St. Paul's* head. Features are smaller and more narrowly concentrated. Partly for this reason and partly because neither beard nor hairline is squared, *St. Paul's* face lacks the firm tectonic structure visible in *St. Peter*. In contrast to the formal integrity of each lock of *St. Peter's* beard, *St. Paul's* beard consists of a mass of hair whose locks are suggested, rather than defined, by channels so randomly scattered over the surface of the stone, so negligent of the actual boundaries of locks, as to seem as much the product of wear as of deliberate drilling.

*Pls. 126, 128, 57, 58*

Lorenzo's second work for the Cappella del SS. Sacramento was the chapel's altarpiece, allocated in March 1510. Although the work was commissioned from Giambattista, all payments, with the exception of an advance, were made to the younger brother. Unfortunately, the payments were not transcribed and now are lost. Therefore, we do not know when the altarpiece was finished. Nor, apart from the fact that it possessed a tabernacle for the Host, presumably at the center, do we know how the altarpiece was originally composed: we cannot reconstruct the relationship of tabernacle to the four surviving panels with *Angels*; nor can we be sure that four are all the panels that the altarpiece originally comprised. In 1629 the altarpiece was dismantled to make way for a new altar; the present altarpiece was fabricated from the remnants in 1948.

*Pls. 129– 132*

In the *Angels* from the Sacrament Altarpiece, Lorenzo appears before us fully formed. The plump figures would seem brawny if they were more muscular. Shoulders are immensely broad, necks extremely thick. The volume of relatively small heads is nearly doubled by the mass of hair. Simple kneeling or ponderated movements are organically correct, but contribute less to the effect of movement than the wildly fluttering drapery, whose momentum is greatly in excess of what the figures' movements warrant. The cadence of swinging folds recalls a neo-Attic relief of *Dancing Maidens*, then in Rome and often copied in the Renaissance.[3] In keeping with the momentary configuration of activated folds and swinging censers, is the transient response suggested by the inclination of the head, the focused glance and parted lips. By these devices, as well as gestures, the *Angels'* reverence is externalized and imbued with a dramatic force not quite compatible with the object of their adoration.

The facial type Lorenzo adopted for his *Angels* is a consistent and distinctive feature of his style. The curving, unpeaked hairline, which runs into the rounded contour of the jaw, makes faces virtually round. Beneath the remarkably low forehead, brows are formed by the

---

[3] Bober/ Rubenstein, 1986, p. 95, no. 59B.

tempered arc of a fine ridge low above the eyes. Large eyes are widely separated but barely indented. The nose is extremely thick and hardly contracted at its bridge. The distance between nose and mouth is short. The narrow mouth, with full lower lip, is enclosed on either side by a pad of flesh. Full cheeks and jaws conceal the skeleton. The hair is endowed with an independent mass; the part never penetrates the head of hair to reveal the scalp. The febrile vibration of kinky locks and the corkscrew curls, which descend to the shoulders, are hallmarks of Lorenzo's figures.

*Pl. 132,*
*Fig. 51*

The *Angels'* facial type is typical as well of figures by the the new generation of Venetian painters. It appears in the early works of Titian and Sebastiano del Piombo, but it is among the female saints and courtesans by Palma il Vecchio that we find hair and faces most like those of Lorenzo's figures. Although Lorenzo was the first to employ this physiognomy — as we shall see, it appears as early as 1505/6 — it is unlikely to have been introduced to High Renaissance Venetian painting through his agency: doubtless, both sculptor and painters derived their facial types from a common source in antique art.

Typical of Lorenzo's drapery style is the abundance of cloth from which the *Angels'* chitons are fashioned. At cinches and neckbands, folds are tightly gathered. At shoulders and elbows, the fabric is rolled up to create dense swathes much wider than the limbs they clothe. Thus swathes, like skirts, respond to the physical forces generated by the figures' movement. In contrast to the minute ripples that do not disrupt the surface of Giambattista's fluttering drapery, Lorenzo's drapery contributes to the dense layering and plastic differentiation of his relief; overlapping borders of drapery or limbs are undercut and the few, smooth passages, where drapery adheres to the body underneath, contrast with folds deeply scored by channels. These channels, like those in hair and beards, are singular in reproducing the effects of long outdoor exposure: broad and deep, channels are highly generalized in form, as though centuries of rain had worn away walls separating drill holes, had eliminated fine distinctions in the level of the surface, and had rounded edges of banks. Such effects are seen in Roman statuary and sarcophagi — often imperfectly preserved — where drilled channels were used almost indiscriminately. Thus, by imitating the effects of exposure on drilled channels, Lorenzo sought to give his sculpture an antique patina. Bregno was not the first to do this: in the beard of Antonio Lombardo's *St. Luke* from the Cappella Giustiniani in S. Francesco

*Fig. 6*

della Vigna channels also are drilled insistently and uniformly, without regard to intervening locks. But Lorenzo was the first to apply the technique widely and consistently enough to create the simulacrum of a relic of ancient art.

*Pls. 133–*
*136*

The last of the sculptures in the Cappella del SS. Sacramento, the four *Evangelists* in the pendentives, are the only works of sculpture in the chapel commissioned directly from Lorenzo. He was charged with the execution of the figures in March 1511; a year later they were finished and consigned.

*Figs. 2, 4, 6*
*Pls. 134, 133*
*Figs. 2, 6*
*Pl. 136*
*Fig. 4*

The format of the medallions, in which figures are truncated at waist or hips by sills behind which they stand, was derived from the reliefs of *Evangelists* in the Giustiniani Chapel. Lorenzo's *St. Luke* was taken from *St. Mark;* Lorenzo's *St. Mark* from *St. Luke.* The Trevisan *St. Matthew* reverses the composition of the Giustiniani *St. John,* while the right arm and, more distantly, the draping of the right half of the mantle of Lorenzo's *John the Evangelist* also was

inspired by the Giustiniani *St. John*. The eagle beneath the medallion of *St. John*, on the other hand, comes from the Lombardo shop's Tomb of Bishop Giovanni da Udine in the choir of the Duomo of Treviso. In contrast to the relatively succinct images of the Giustiniani Chapel, Lorenzo's figures expand to fill a greater proportion of the relief. This is due in part to the greater frontality of poses, in part to the extension of limbs and drapery to either side. Lorenzo was less concerned than Pietro to demonstrate the volume of individual forms or distinguish the several planes occupied by overlapping forms. Opened books are not foreshortened; straight folds gainsay the rotundity of arms or shoulders. The surface of Lorenzo's figures is evenly articulated by fewer kinds of folds worked on a larger scale. Indeed, faces and anatomical forms as well are less highly modulated, less finished; textures are less differentiated. While one might plead the distant siting of Lorenzo's *Evangelists*, which would have rendered most detail invisible, a certain degree of generalization, as we shall see, is a standard feature of Lorenzo's art.

The face of *St. Luke*, and to an even greater extent, *St. Mark*, derives from the face of Giambattista's Sacrament Chapel *Peter*. But the square contours of *St. Peter's* head yield to the continuously rounded contours of hair and beard in Lorenzo's two *Evangelists*. Where in *St. Peter's* beard, formal and graphic definition endows each lock with an independent existence, occasional and random drilling of an otherwise fairly uniform surface in the beards or heads of hair of Lorenzo's figures merely alludes to the existence of separate locks without identifying them.

Best calculated for a distant view, *St. John* seems the most accomplished of the four *Evangelists*. Not only is the figure larger in scale than its companions, but its constituent parts are worked more broadly. The composition, dependent upon the diagonals of bent limbs and the long, straight borders of drapery, is bolder in its simplicity and two-dimensionality. Folds are treated in a way that will prove idiosyncratic: straight-edged and flat-topped, they are separated by broad or narrow channels with flat beds and undercut sides. At their termination, channels often divide to produce two stunted and rounded ends like those of bones. Typical also are the *Evangelist's* low forehead and heavy-lidded eyes, with drilled tear ducts and flattened, arcuated channels for irises. Tumid cheeks and fleshy jaws hide all traces of a bony structure. The short, thick nose, the abbreviated space between nose and mouth, and the broad upper lip, whose wavy contour ends at either side with an upward curve, are recurrent traits, as is the massive head of matted hair, whose undercut border creates the illusion of a wig.

Our definition of Lorenzo's style enables us to recognize his hand in the Shrine of SS. Theonistus, Tabra, and Tabrata on the High Altar of the Duomo of Treviso. Probably it is the artist's earliest surviving work. The shrine owes its origin to the testament of Giovanni da Udine, Bishop of Treviso, indited on December 23, 1484. In January 1485, the executors of the bishop's testament commissioned the shrine from Pietro Lombardo. Pietro had submitted a drawing; a description of it proves that, in essential respects, the drawing determined the format of the completed urn. But the plain panels on either side of the reliefs of the three *Saints* at the front, specified in the contract, as well as the reliefs of *God the Father*, the *Virgin*, and *Angel Annunciate* and two further uncarved panels at the rear, were never made.

Pl. 135,
Fig. 4
Pl. 141,
Fig. 52
Pls. 133,
136,
Figs. 2, 4

Pls. 137,
138, 58

Pl. 135

Pl. 139

Pl. 144

Nor, apparently, were the tabernacle for the Host or the *cassone's* cover on which the tabernacle was to stand. Although in September 1486 Pietro Lombardo obligated himself once again to complete the urn, he never did so. Nineteen years later, at the end of October 1505, the shrine was finally delivered. The year 1506 is inscribed on it, but it was not until November 1507 that the three martyrs were entombed. The style of the reliefs suggests that, probably not long before the urn was actually delivered, Bernardo de' Rossi, then Bishop of Treviso, transferred the commission from the delinquent Pietro to the Bregno shop, employed in the Chapel of the Holy Sacrament, and that Giambattista delegated the reliefs' design and execution to his brother.

The severe decoration of the shrine's pilaster shafts contrasts forcibly with the luxuriant, winding tendrils typical of Pietro Lombardo's *all'antica* ornament: rather, lamp stands resemble the decoration of the lesenes flanking Giambattista's *Madonna and Child* in the Bettignoli Bressa *Pls. 145, 3* Altar, where the simple, geometric forms were determined by the inflexible medium of marble intarsia.

*Pls. 146,* Like the *Evangelists* of the Sacrament Chapel, the reliefs of *SS. Theonistus, Tabra,* and *Tabrata* *149, 151,* employ the scheme of the *Evangelists* in the Giustiniani Chapel. But unlike the latter, the *Figs. 2, 4, 6* embrasures of the shrine do not suggest a spatial ambience because the figures, which entirely occupy their fields, have become so large. It is as though the figures had been observed from a much closer point of sight – an effect accentuated by the broadening of the embrasures. The symmetrical disposition of almost identical deacon saints and the repetition in reverse of their glances and gestures tie together disparate components across the shrine's facade, further mitigating the effect of depth.

*Pl. 151,* In addition to the format of individual reliefs, particular motifs derive from Pietro's *Evan-* *Fig. 2* *gelists.* The pose of *St. Tabrata* reverses that of *St. Mark;* the gesture of *St. Tabra's* right arm *Pl. 146,* derives from that of *St. John the Evangelist.* The large, shallow, flat depressions, with their sharp *Fig. 4* edges, in *Tabrata's* sleeve are like the folds in *St. John's* cloak. *St. Mark's* face furnished the *Pl. 150,* model for *St. Theonistus.* The similarity of features, however, reveals differences of execution *Fig. 3* in *St. Theonistus'* wider, flatter face sufficient to refute Pietro's authorship of it. Where, in *St. Mark's* beard, curls, represented as complete and separate units, are stacked in orderly fashion, the tousled locks of *St. Theonistus'* beard lose their identity in the tangled mass of hair.

*Pls. 147,* Indeed, the faces of *SS. Tabra* and *Tabrata* are clearly recognizable as Lorenzo's, as com- *152, 131,* parison with the *Angels* of the Sacrament Altar shows. From a classical source, such as the *132* *Pl. 152,* head of an *Apollo* of the Anzio type, come *St. Tabrata's* low forehead, the segmental arc of *Fig. 53* the low, hairless brows formed by a mere deflection in the planes of brow and eyes, the rather long, broad nose neither pinched nor indented at its bridge, the narrowed separation of nose and mouth, the thickening of the lower of the curviform lips. Characteristic of both Lorenzo and his antique source are the full jaws and tempered swelling of the cheeks, which give no hint of the bony structure underneath; typically the wide, blunt, but nonetheless protuberant, chin is incorporated within the rounded contour of the face.

*Pls. 146,* In other respects, too, these figures are typical of Lorenzo. Proportions are Herculean: *149, 151* the breadth of torsos and shoulders is accentuated by small heads, hands, and attributes. *Pl. 124* Like *St. Paul,* not faces only, but entire figures are flattened and spread across the surface of

the relief. Large planes are preserved intact and the movement of limbs or folds rarely suggests the continuation of the form beyond the figure's visible boundary. The folds of SS. Tabra's and Tabrata's vestments resemble those of Pietro Lombardo's drapery more than any other work by Lorenzo does, but St. Theonistus' gown is furrowed by the regular drilled channels that are Lorenzo's trademark.

*Figs. 2, 4*

To the right of Giambattista's figure on the west flank of the Zen sarcophagus is a figure attributable to Lorenzo. Probably it is one of two not yet ready for casting in October 1507, but fully modeled when Giambattista received the final payment for his sarcophagus statuettes in March 1508 and cast by September 1510. In its *contrapposto* pose and the elevation of one arm above its head – a concession, no doubt, to the figure's intended but unrealized function as a caryatid – Lorenzo's bronze matches its companions. The figure's torsion and coiffure reflect Giambattista's model. But the figure's semi-nudity, better suited to a statuette of *Venus* than a personification, is unique.

*Pls. 154–158*

*Pl. 63*

If Lorenzo's, this would constitute his second work, executed between the Shrine of the Three Martyrs and *St. Paul*. Indeed, flaws in the depiction of anatomy – the inorganic juncture of frontal abdomen and twisted rib cage or the incongruous breasts – testify to the sculptor's immaturity. The heavy proportions of the figure are consistent with every one of Lorenzo's figures. An identical morphology of legs and feet, with prominent shins and tumid ankles, depressed arches and exceptionally long toes, is found later in the documented *St. Christopher* from the Altar of St. Leonard in Cesena. The draping of the figure's mantle, including the slightly ruffled, oblique hem and the regularly curving swathe at the hip, recurs in *St. Eustace* from Cesena. The rigidity of long, straight folds recalls the Sacrament Chapel *Paul*. But it is the figure's face, comparable in all respects to *St. Tabrata* and the *Angels* of the Sacrament Chapel Altar, that establishes Lorenzo's authorship beyond a doubt.

*Pls. 153–155, 178, 179*

*Pl. 182*

*Pl. 124*

*Pls. 157, 158, 131, 147, 152*

Nothing is known of the provenance of the statuette of *St. John the Evangelist* in East Berlin. Date and authorship, by contrast, can be inferred from the sculpture's style. The wiglike head of matted hair, undercut at its border with the face and falling to the shoulders in corkscrew locks, is unmistakable. Facial features closely resemble those of Lorenzo's *St. Mark;* the beard of the statuette is virtually identical to *St. Paul's*. The folds of the wide sleeves are thickly massed at the wrists and the mantle's hem is turned up between the feet, as in the statue of *St. Paul*. The composition of the figure, however, depends from prototypes by Giambattista. From Joseph in the *Visitation* come the *Evangelist's* relatively slender proportions, as well as the gesture of his right hand and the diagonal swathe of drapery that rises to his shoulder. So similar to Giambattista's *St. Peter* is *St. John's* pose and the configuration of folds where the mantle is wrapped around the legs and the tunic adheres to the chest, that we may posit for the *Evangelist* a *terminus post quem* of late 1509. Probably it is not much later.

*Pls. 159, 160*

*Pl. 137*

*Pl. 126*

*Pl. 127*

*Pl. 18*

*Pl. 54*

From approximately the same time dates Lorenzo's altarpiece with statuettes of *SS. Peter* and *John the Baptist*, currently installed in the baptismal chapel of the Venetian Church of S. Martino. The reredos, along with its altar table supported by four kneeling *Angels* inscribed with Tullio Lombardo's name, come from the former Venetian Church of S. Sepolcro, where the reredos occupied the altar of the simulacrum of Christ's sepulchre. Documents relating to the altar are not preserved; even the history of the grotto is obscure. Nevertheless, it

*Pls. 161–171*

seems likely that a cavelike burial chamber was erected between mid-1493 and spring 1496 and that it was completed, altered, or replaced by early 1511. By the time Marin Sanuto heard Mass inside the sepulchre on March 9, 1511, Lorenzo's altarpiece must have been in place.

At the center of the altarpiece were the Host and relics of the True Cross and of the column of the Flagellation, preserved behind a gilded bronze *sportello* with a relief of *Christ in Limbo*. The *sportello* no longer survives; nor does a statue of the *Risen Christ*, somewhat larger than the statuettes, located at the summit of the altarpiece. In the lunette is a relief of a half-length *Christ as Man of Sorrows* emerging from a disproportionately small sarcophagus in the form of a plinth; *St. John* occupies the left-hand niche, *St. Peter* the right. After a prolonged absence, during which they were cleaned and restored, the statuettes have finally been returned to their original positions.

Pl. 163

That the reredos was executed, not by Tullio Lombardo, as has generally been assumed, but by Lorenzo Bregno transpires from numerous analogies with the latter's works. The *Saints* are characteristically thickset. The *Baptist's* massive head of tightly waving hair is similar to that of Lorenzo's *St. John the Evangelist;* a later *Angel* from the documented Altar of the Cross wears an identical coiffure. *John's* facial type, by now, is familiar to us, as are the folds of his mantle, plastically defined by drilled trenches. Like *St. Paul* from the Sacrament Chapel, *St. Peter's* ponderation does not affect the axes of hips and shoulders, and the orientation of the knee, turned slightly too far forward, does not correspond to the orientation of the foot. *St. Peter's* free foot is planted firmly on the ground: by its stationary stance the figure rejects the implications of potential movement inherent in a *contrapposto* pose. Like *St. Paul*, *St. Peter* is flattened: the plasticity of forward surfaces is abridged, limbs extend to either side, and folds at the right or outer edge of the figure provide emphatic borders. The derivation from Giambattista's Sacrament Chapel *St. Peter* of the *Saint's* physiognomy, of the disposition of folds in gown and mantle, and the gesture of both arms, provides a *terminus post quem* of late 1509 for the S. Sepolcro figure. But minor differences are instructive. Giambattista's habitual boat-shaped neckline with its axial stress yields to the round one that Lorenzo consistently preferred. Folds are more densely massed in the statuette's widened cuffs and the pattern of the mantle's hem, greatly enriched, resembles that of the East Berlin *St. John*.

Pls. 167, 160
Pl. 230
Pls. 169, 124

Pl. 54

Pl. 159
Pl. 161

The S. Sepolcro Altarpiece is one of the earliest examples of that chastely spare yet monumental architectural style typical of the Venetian High Renaissance.[4] Lorenzo retained the tripartite division of earlier altars, like the Giustiniani Altar, but widened and heightened the central bay. Where the relief of the Giustiniani figures far exceeds that of the frame, minimally stepped, in the S. Sepolcro Altar figures in the round are contained within an equally plastic frame composed of shallow segmental niches and three-quarter engaged columns supporting broken entablatures. Decorative and figurative carving is severely restricted; ornament is limited to capitals, while statuettes are very small in proportion to the altar's total size. Simple geometric forms, plain surfaces, and framed slabs of projecting and variegated semiprecious stones succeed a riot of *putti*, tendrils, volutes, and rosettes. But while

Fig. 1

---

[4] The altarpiece predates by a year at least what Jestaz, 1986, pp. 97f, took to be a very early manifestation of the style – the southern exterior wall of the Cappella Zen, S. Marco, by Tullio Lombardo.

Lorenzo shared this architectural style with numerous other architects and sculptors of the 1510s and 1520s, his treatment of the order was unique. Unfluted columns are exceptionally elongated; Corinthian capitals are disproportionately small. Capitals are remarkable also for *Pl. 162* the amount of bell left exposed by the single row of identical acanthus leaves, set next to one another without overlapping. Volutes are detached from the bell by undercutting. The frieze is narrow in proportion to the whole entablature; the fasciae of the architrave are inclined. Lateral bays are crowned by inordinately low segmental pediments.

In the Cathedral of Belluno are statuettes of *SS. Martin of Tours* and *Joathas* from the shop *Pls. 172,* of Lorenzo Bregno. The statuettes originally belonged to an altarpiece that contained a relic *173* from Christ's crown of thorns. Construction of the altar commenced in March 1510. Presumably the altarpiece was finished by May 1514, when the altar was consecrated.

St. Joathas and Martin of Tours, along with St. Lucanus, were protectors of Belluno and patrons of its cathedral. Usually shown bestowing half his cloak upon a beggar, St. Martin figures here instead as Bishop of Tours, with crosier and mitre. St. Joathas, whose relics Belluno possessed, is represented as a young and beardless knight. At his feet is the spiked wheel on which he was tortured, in his hand the sword with which he was beheaded.

That the *Saints* were designed by Lorenzo Bregno and executed under his supervision does not need demonstration. The type of *St. Martin* derives from *St. Theonistus*, for whom the *Pls. 172,* former might be taken but for the absence of a beard. Cope, morse, stole, the draping of *149* the bodice of the gown, the blessing hand with beringed thumb, are very similar. But the unarticulated *contrapposto* and the insensitive carving of the folds disclose the intervention of an assistant, who seems to have finished everything but face and blessing hand. In the figure of *St. Joathas* the master evidently completed the lower part of both legs, whose anatomical *Pls. 173,* structure, beneath buskins, is comparable in every way to that of *St. Eustace* at Cesena. But *182* *St. Joathas'* inorganic arms, his undifferentiated ponderation, and the introduction of furrows that have no bearing on the structure of folds, are surely due to an assistant. The *Saint's* fleshy face recalls the faces of the freestanding *Angels* from the Trevisan Chapel of the Sacrament. *Pls. 60, 62* As there, brows are indicated not by projecting ridges, but by very faint incisions denoting hair.

The Altar of St. Leonard in the Duomo of Cesena resulted from Camillo Verardi's testament *Pl. 174* of June 19, 1504, but many misadventures supervened before Lorenzo Bregno was finally awarded the commission. The figures were executed between March 1514 and February 1517. The altarpiece's framework does not survive and clues to its reconstruction are few. Lorenzo's contract specified separate niches faced with Carrara marble for the figures. The flat ground visible at perimeters or between the figures' legs indicate that the rear walls of niches were straight, rather than curved, in plan. The rectangular shape of *St. Christopher's* slab suggests that niches were trabeated, not arched, but the slab may have been trimmed; trabeated compartments, at any rate, would have been unusual.

Unlike Tommaso Fiamberti, initially charged with execution of the altar, Lorenzo was not required by contract to imitate his brother's altar for Carlo Verardi. Nonetheless, it is apparent that Lorenzo adapted his design to it, perhaps as a means of alluding to the patrons' *Pl. 20* kinship. (Indeed, it may have been the same intention, that led Giulia Verardi to replace

Fiamberti by Giambattista's brother.) Lorenzo's figures are only marginally larger than Giambattista's. All are marble and stand on independent bases against neutral grounds. High relief predominates over rare passages carved in low relief as well as elements carved in the round. To the extent that their function and identity permit, figures in comparable positions correspond in pose and view. The diminutive attributes of the *Evangelist* and *St. Eustace* are disposed identically.

The similarity of design makes more vivid the contrast between Giambattista's late Quattrocento style and Lorenzo's classicism. Quite apart from literal quotations, like *St. Eustace*'s *Pl. 182* cuirass and the form and draping of his paludament, are the Roman weight and volume of *Pls. 178– 179* Lorenzo's *Saints*. The anatomy of *St. Eustace*'s torso and *St. Christopher*'s legs was conditioned by antique schemata. Lorenzo's figures gain in *gravitas* by his tendency to round off angles at chins and shoulders, knees and elbows. In Lorenzo's figures, drapery does not repudiate its obligation to reveal anatomy and pose in favor of purely decorative ends, as it does in Giambattista's figures. The long, narrow, and slightly bowed folds, disposed in parallel *Pl. 176* sequence, in the cloak of *St. Eustace* or the habit of *St. Leonard*, betray their classical ancestry. By contrast, the rippling surface of *St. Christopher*'s fluttering skirt and sash reflects the drapery *Pls. 178, 38 39* of Giambattista's hovering *Angels*. But however frantically line quivers, it does not abandon the course of the *Giant*'s abdomen and hips. A comparison of the faces of Lorenzo's *St. Eustace Pls. 184, 185, 32, 33* and Giambattista's *Evangelist*, reveals how the delicate features of the youth have been superseded by the man's inflated forms. Antithetical to Giambattista's customary care is Lo*Pls. 177, 181, 185* renzo's impressionistic treatment of hair and beards: random bumps and rough surfaces, drill holes and occasional incisions, combine to evoke, without actually defining, the density and texture of a beard or head of hair. The careful execution, the accurate distinction of shape *Pls. 175, 21* and texture evident in *St. John*'s eagle, contrast with the barely adumbrated deer and Crucifix of *St. Eustace*. The refinement of detail characteristic of Giambattista's figures, the completeness *Pl. 30* and precision of delineation evident in the decoration of the border of the *Evangelist*'s mantle, in his sandals, and the cover of his book, have no parallel in Lorenzo's figures. Nor has the *Pl. 27* undercutting of the flat relief of the *Baptist*'s farther leg by means of an inward slanting facet. By contrast, the forms of Lorenzo's figures gradually revolve until intercepted by the back*Pl. 183* ground, as they do in classical relief. In opposition to the plots of ground that Giambattista's bases simulate, are the abstracted bases of Lorenzo's figures, with their smooth vertical faces and geometric plans.

*Pls. 186– 189* The statue of *St. Sebastian* in the Duomo of Treviso, reliefs of the *Madonna and Child* and *Pls. 190, 191, 193* two *Angels* in the Szépművészeti Múzeum, Budapest, and the architectural framework of a *Pls. 192, 194* niche in the Trevisan Church of S. Leonardo come from an altar erected in execution of Vincenzo Zotti's testament in S. Margherita, Treviso, between 1515 and 1516. The thickset *Pl. 188* *Saint*, with broad neck and relatively short legs, is exemplary of Lorenzo's canon. The figure's corpulence blurs the structure of the torso, derived from Roman statuary. The lack of anatomical definition that more numerous and more emphatic protuberances, bounded by narrow grooves, would have articulated, conduces to the appearance of age observed in Lorenzo's treatment of hair and drapery, as though weathering had eroded the figure's corporeal landscape. Nevertheless, contours accurately chart the succession of muscles in

arms and legs and the bony structure *all'antica* of the feet. *St. Sebastian's* attitude combines an orthodox *contrapposto* with a slight but consistent revolution, to which the twist of the head contributes most. In accordance with the head's expressive turn and tilt are the furrowed brow, the creased forehead, and the opened mouth – reflections of the younger son of the *Laocoon*.[5] The *Saint's* low forehead, drilled irises, narrow mouth, thick lower lip, and heavy, round chin and jaws are typical of Lorenzo's figures. Channels force their way between matted locks. Hypertrophic corkscrew locks are so tightly twisted that individual coils touch. *St. Sebastian's* loincloth reveals Lorenzo's customary generosity and adds to the figure's Herculean bulk. Long and narrow folds, closely spaced and undercut by drilled channels, are formed in the antique manner. In the surfaces of folds, deep channels typically are widened at their termination by the use of a larger bit or the addition of a second drill hole, sometimes slightly behind the first.

Pl. 189,
Fig. 54

Pl. 188

Lorenzo's citation from the *Laocoon* marks the earliest dated instance of its influence in Venetian art. The *Laocoon* had been discovered in Rome on January 14, 1506. It was acquired by Pope Julius II in March of that year and by July, had been installed in the sculpture court of the Belvedere.[6] Through graphic and small sculptured reproductions of the work, its influence spread with extraordinary rapidity. Bregno's adaptation of the sculpture was shortly followed by that of Titian, who used the father for the Resurrected Christ and the head of St. Sebastian in his Averoldi Altar for SS. Nazaro e Celso, Brescia in 1519–22. In the S. Nicoletto Altarpiece of 1522(?) now in the Pinacoteca Vaticana, Titian borrowed the father's head for the upturned face of St. Nicholas.[7] Between ca. 1520 and 1524, Bartolomeo Bergamasco stamped the physiognomy of his *St. Sebastian* for the High Altar of S. Rocco with the features of the elder son.

Fig. 56

But despite Lorenzo's precocious response to the *Laocoon*, he remained untouched by the fundamental lesson that the work imparted to Renaissance art – the legitimacy of pain stoically endured as a theme in and of itself.[8] Bartolomeo Bergamasco's *St. Sebastian*, as well as Michelangelo's *Rebellious Slave* from which Bartolomeo's work derived, show to what extent – in the wake of the *Laocoon* – heroic suffering could be intensified by extremes of torsion applied to a nude and highly articulated body and make evident the extent to which the easy stance of Bregno's *Saint* and the languid gesture of his upraised arm – recalling Praxiteles' indolent *Apollo Lykeios* – eschew all reference to physical discomfort or exertion. The contraction of the abdominal muscles as an involuntary and spasmodic response to pain, in Bartolomeo's *St. Sebastian* and Michelangelo's *Slave*, contrast with the voluptuous relaxation of the muscles of Lorenzo's *St. Sebastian*. To the *Saint's* composure, the undisturbed configuration of the intricately twisted swathes of drapery bear final witness.

The inferior quality of the reliefs of the *Madonna and Child* and two *Angels*, now prised from their black-veined white marble ground, proves them the work of an assistant. In the *Angels* the design of the kneeling *Angels* from the Altar of the Sacrament returns, albeit much

Pls. 190,
191, 193
Pls. 131,
132

[5] Bober/ Rubenstein, 1986, pp. 151–5, no. 122. Ybl, *Évkönyv,* 1927–8, p. 65, repr. in idem, [1938], p. 40, compared *St. Sebastian's* expression to that of the *Niobids* or a son of Laocoon.
[6] Brummer, 1970, pp. 75–8.
[7] For Titian's adaptations of the *Laocoon*, see Beschi, *Aquileia*

*nostra*, 1976, coll. 24–31, and Favaretto, Ist. ven. SLA. *Atti*, 1982–3, pp. 81, 89.
[8] Ettlinger, *Essays . . . Panofsky*, ed. Meiss, 1960, i, pp. 121, 125f; Northampton, MA, Smith College Mus. of Art. *Antiquity in the Ren.*, cat. by Sheard, 1979, n.p., no. 103.

*Pls. 193, 11*

*Pls. 192, 194*

*Pls. 161, 162*

impoverished. The extent to which the face and veil of the Madonna echo the Madonna from the Bettignoli Altar suggests that the author of the former, lacking a model by Lorenzo, drew on whatever paradigms the Bregno workshop offered.[9] The architectural framework, now enclosing S. Leonardo's baptismal font, betrays many of the stylistic traits of the framework for the S. Sepolcro Altar. Plain architectural members are embellished chiefly by simple geometric incrustations of variegated marbles. Engaged columns are extremely elongated, capitals are short, the frieze is narrow, and the pediment very low. The niche, considerably less than semicircular in plan, and only a centimeter and a half taller than *St. Sebastian*, could not possibly have held the entire statue: like *SS. Peter* and *John the Baptist*, *St. Sebastian* must have projected in front of the niche's foremost plane.

*Pls. 200, 106, 184*

*Pl. 148*

*Pl. 196*

*Pl. 176*

*Pls. 197, 101*

If stylistic considerations support Giambattista's authorship of *St. Anthony* from the group crowning the High Altar of S. Maria dei Frari, differences between the heads of *SS. Anthony* and *Francis*, on the one hand, and similarities between the latter and *St. Eustace*, on the other, attest to Lorenzo's execution of *St. Francis*. Low, horizontally indented foreheads, arcuated brows with incised striations, and fleshy mouths, their corners succeeded by swellings at either side, are morphologically identical in the two *Saints*. But the unexpected drilling of *St. Francis's* pupils is known only from *St. Tabra* in Treviso. Typically, *St. Francis's* head is small in proportion to his body. The flexion of his free leg results in a disposition of folds very similar to that of the Cesena *St. Leonard*. While the upper part of *St. Francis* is as planar as Giambattista's *St. Anthony*, a transverse section of the lower part of the figure and its base would form half an ellipse.

*Pls. 201–205*

*Pls. 203, 182*

*Pls. 202, 203, 178, 179*

*Pls. 205, 200*

*Pls. 205, 8*

*Pls. 204, 7*

The *Resurrected Christ* stands on his base with the assurance of a conqueror: neither pose nor drapery hints at transit. Giambattista, therefore, is unlikely to have designed the figure. Rather, *Christ's* planar and stationary *contrapposto*, in which the extremely inclined axis of the hips contrasts with the tempered diagonal of the shoulders' axis, can be found in many of Lorenzo's works, most conspicuously in *St. Eustace*. Indeed, the classicizing anatomy of the torsoes of the two figures is virtually identical, despite the fact that *St. Eustace* wears a cuirass. *Christ's* classicizing legs and feet duplicate the complete linear articulation of the shank, distended ankle and depressed arch, the exceptionally high heel and curling little toe of *St. Christopher*. But there is nothing analogous to the shroud in the work of either Bregno. Nor are *Christ's* pupils, drilled like those of *St. Francis*, sufficient to justify an attribution to Lorenzo of the face. Elements of the statue's physiognomy and hair echo Giambattista's *Resurrected Christ* from the Bettignoli Altar. Tapered locks, similarly incised, fall to the chest with the same serpentine. In profile view, especially, the dependence of *Christ's* beard on that of the Bettignoli *Christ* is manifest. But the quality of execution fails to meet Giambattista's standards.

---

[9] Ybl, *Évkönyv*, 1927–8, p. 66, repr. in idem, [1938], p. 41, commented on the indubitable resemblance of the Budapest *Madonna and Child* to painted versions of the subject by Cima da Conegliano and his followers and called particular attention to Carpaccio's Madonna and Child above his *St. Thomas Aquinas Enthroned*, Stuttgart, Staatsgalerie (Lauts, 1962, pl. 140). In Budapest, Szépművészeti Múzeum. Cat. by Balogh, 1975, i, p. 156, no. 197, the author identified the source of the Budapest *Madonna* in Cima's *Madonna and Child with the Baptist and St. Jerome*, Leipzig, Museum der Bildenden Künste, of which replicas exist in the collection of Count Paolo Gerli, Milan, and the Museo del Castelvecchio, Verona (Humfrey, 1983, pls. 48, 49a, 196a). Among works related to the Budapest *Madonna*, the *Madonna and Child* from Cima's polyptych in the parish church at Ornica (ibid., pl. 89a) should also be included. But none of these paintings, or any other with which I am familiar, is sufficiently close to prove itself the source of the relief's design.

In sum, the statue gives the impression of having long been under way and of having been subjected at wide intervals, and different stages of its execution, to the intervention of different hands – among them, Giambattista and Lorenzo Bregno's. Considerably more finished than either flanking *Saint*, the statue may once have been intended for another site and therefore for another purpose. Perhaps these hypothetical vicissitudes were occasioned by the economic consequence of war. Unfortunately, conjectures are all that I can offer in explanation of this perplexing image.

An over-life-size bust of the *Saviour*, of the very highest quality yet practically unknown, occupies a pedestal on the first landing of the staircase currently used for storage, which leads to the treasury of the Scuola di S. Rocco. Facial type, kinky corkscrew locks carved in the round, and folds articulated by drilled channels establish Lorenzo's authorship of the work. The prominence of drilled holes and channels in the rough, but relatively even, surface of the beard creates the impression that the original plastic and linear form of individual locks has suffered centuries of exposure to inclement weather. That this effect is due to Bregno's conscious imitation of worn antique sculpture and not to the actual condition of the piece, is demonstrated by the perfect legibility of those fine incisions by which the texture of brows and vines is defined.

The *Saviour*'s format follows that of classical Roman portrait busts in the frontality and horizontality of the shoulders and in the termination of the bust in a flattened upward curve. Had the bust ended in a straight horizontal line, like the anonymous but approximately contemporary bust of the *Saviour* in S. Pantaleon, Venice, we could more easily conjure the figure's lower half, supposing it temporarily concealed by overlapping. But the oblique truncation of the *Savior*'s arms makes explicit the partialness, and therefore the artificiality, of the image. We are reminded of Tullio Lombardo's double portrait in the Ca' d'Oro, where the cropping of the figures in imitation of antique busts and herms, no less than the derivation of the composition of male and female sitters from Roman grave stelae, and the man's classicizing semi-nudity and paludament,[10] were determined by an aesthetic that aimed, not at the reproduction of reality, but at the re-creation of an antique work of art. As a consequence of the truncation of his arms, *Christ* does not bless; nonetheless, through parted lips, inclined head, and focused glance, he makes contact with a spectator beneath him. In this respect, as in the identity of *Christ*, the work paradoxically disavows its link with ancient portraiture.

From the High Altar of the demolished Venetian Church of S. Marina come the life-size statues of *SS. Marina, Catherine of Alexandria*, and *Mary Magdalene*. The altar's architectural framework is lost, but early descriptions record what appear to have been three niches in which the figures stood – *St. Marina* above the others – flanked by columns. The framework was made of Istrian stone and marble, with incrustations of semiprecious stones. Arms published the patronage of the Bragadin, buried in front of the altar. With the suppression of St. Marina in 1810, the figures were dispersed. Not long afterward, *SS. Catherine* and *Mary Magdalene* reappeared in SS. Giovanni e Paolo, where, since 1819, they have flanked Tullio

*Pls. 206– 208*

*Fig. 55*

*Pls. 209– 216*

---

[10] Wilk, 1977/8, pp. 67–73.

*Fig. 27*

Lombardo's Tomb of Doge Andrea Vendramin. Since the mid-nineteenth century, *St. Marina* has formed part of the collection of the Seminario Patriarcale at Venice.

Since the recapture of Padua during the War of the League of Cambrai on July 17, 1509 – the feast day of St. Marina – the saint has been especially revered in Venice. No doubt it was the new solemnization of her feast day, decreed and celebrated first in 1512, that inspired the commission of a new High Altar for her church. Whether the altar was executed immediately or some time later – perhaps after the cessation of hostilities in 1516 – we do not know.

*Pl. 211*

*St. Marina* is shown in monkish dress, whose disguise she wore from childhood; though she escaped detection until her death, her conspicuous breasts reveal her sex to us. By her

*Pls. 209, 210*

side is the boy whom she was wrongly accused of having fathered and whose care she

*Pls. 213– 214*

suffered to be thrust upon her. Originally *St. Marina* was flanked by *Mary Magdalene* with loosely flowing hair and unguent jar on the left and *St. Catherine* with a fragmentary spiked wheel on the right. In deliberate contrast to *St. Marina* are her companions' classicizing facial types and dress. Drapery analogous to that of the *Magdalene* is found in numerous antique figures of *Juno* and *Ceres*. No doubt, it was of Bregno's *Magdalene* that the *Procuratori di S. Marco de citra*, patrons of Verde della Scala's altar in the Servi, were thinking when, in August 1524,

*Fig. 57*

they commissioned from Bartolomeo Bergamasco an equally large *Magdalene* "vestida con drapi largi a lantiga."[11] But Bartolomeo dressed his figure instead in contemporary fashion, as painters had done habitually; his *Magdalene* is the first female *Saint* in Venetian sculpture to forswear timeless biblical, classical, or monastic dress.[12]

The attribution of the High Altar of S. Marina to Lorenzo Bregno goes back to Sansovino's guide of 1581. Though *SS. Catherine* and *Mary* were designed and closely supervised by Lorenzo, there is little doubt that an assistant collaborated in their execution. By contrast,

*Pl. 211*

*St. Marina*, though badly worn, appears entirely autograph: its characteristic style renders inexplicable the repeated denial of Lorenzo's authorship. *St. Marina*'s customary burly physique is accentuated by the small face, diminutive book, and tiny child. The orthodox and planar *contrapposto* is predicated on the emphatic flexion of the free leg. Abundant draperies conceal the figure's anatomy but increase its volume; garments that are too large and loose form folds that cluster at the cuffs, in the cowl, between the feet. Drilled channels in the

*Pls. 209, 190*

surfaces of folds end with a quaver. The child's fluttering skirt repeats rhythms familiar to us

*Pls. 212, 214*

from an *Angel* of the St. Sebastian Altar. If, in degree of modulation, the face of *St. Marina* surpasses that of *Mary Magdalene*, in type it hardly differs.

On either side of the altar at one end of the ground-floor hall of the Scuola Grande di S.

*Pls. 217– 224*

Rocco are two statuettes that guide books identify as the *Saviour* and *Justice*. In the stump of the male figure's right hand, however, is a hollow, which appears to be the matrix of a knife

*Pl. 217*

handle. The knife, with which the saint was flayed, is the symbol of St. Bartholomew, with

[11] Paoletti, 1893, ii, p. 282.

[12] In addition to Bregno's own *St. Apollonia/ Agatha*, examples of earlier Venetian or Paduan statues of female *Saints* dressed *all'antica* include: *St. Helen* from the Tomb of Vittore Cappello,

S. Elena, attributed to Niccolò di Giovanni Fiorentino; *St. Agnes* from the altarpiece of the Cappella Giustiniani, executed in the shop of Pietro Lombardo; Antonio Minello's *St. Justine* from the facade of the Cappella del Santo.

whom the figure's age and facial type, classicizing dress and sandals, accord. The female figure holds broken tongs. Tongs, as well as the figure's youth and Roman dress, characterize the virgin martyrs Apollonia and Agatha, who suffered injury by tongs to teeth and breasts, respectively. Although nothing is known of the figures' origins and their provenance can be traced no farther back than 1824, when they were already in the confraternity's possession, we need have no hesitation in assigning them to Lorenzo Bregno. <span>*Pl. 223*</span>

Facial type, expression, hair, and beard link *St. Bartholomew* with *John the Baptist* from the S. Sepolcro Altar. Proportions are typically robust. The figure's movement, however, is more developed than that of any figure examined hitherto and suggests that the *Saint* is a work of Lorenzo's maturity. *Contrapposto* now results in the correct divergence of oblique axes of hips and shoulders. Concomitantly, the figure revolves continuously from retracted left foot to retracted right shoulder. The lowered left arm, which crosses the body, initiates a revolution in the opposite direction. The twist and tilt of the shoulders is diametrically opposed by the dramatic movement of the head — turned, tilted, and inclined at once. Gaze and opened mouth express a state of exaltation in which the figure is carried beyond himself; the expression of the face is the culmination and warrant of the movement of the body. Drapery now explicates the dynamics of the pose. As in antique ponderated figures, the mantle is drawn up and pinned against the raised, weight-bearing hip; from this point folds fall over the weight-bearing leg. But there is no classical precedent for looping the mantle over the raised shoulder so that folds cascade to the figure's dependent hip. *Pls. 220, 167* *Pls. 217–219*

For *St. Bartholomew*, being clothed is not a passive state: the voluminous and heavy toga would fall to the ground were *St. Bartholomew* not clasping it; the disappearance of folds over his projecting leg reveals how tightly he has drawn the cloak. The *Saint* has just thrown the great rolled swathe of the toga's end over his shoulder; only the swiveling of his shoulder keeps it there. As actors know, the manipulation and control of long, loose, cumbrous garments endow characters with majesty; trains and mantles, therefore, are common attributes of kings and queens. The stature we grant instinctively to the bearer of such a superfluity of cloth and excess of weight, the dramatic flourishes permitted — indeed, almost compelled — by the draping of an unsewn garment, account here too for the effect of grandeur produced by Lorenzo's statuette.

*St. Apollonia/Agatha* finds an analogue in *St. Catherine* from the Altar of S. Marina. Heads show the same classicistic shape, features, and generalized surface; irises are drilled with the same semicircles; kinky locks are dressed in a similar fashion. The shirt, whose long, tight sleeve is creased throughout its length, the fold of the chiton that falls from the right shoulder, and the draping of the mantle over one arm and shoulder recur in *St. Mary Magdalene*. The disposition of *St. Apollonia's* legs and the drapery from hips to feet, on the other hand, faithfully copy Giambattista's Zen sarcophagus figure. But Lorenzo's adaptation is distinguished by the heaviness of the *Saint's* anatomical forms, the greater density of cloth, the lesser variety of folds. The planarity of the upper part of the marble statuette — a consequence of its frontal torso, the spreading of forms across the surface, and the descending folds that follow and frame the *Saint's* right edge, thus blocking the revolution of its form — contrast *Pls. 224, 216* *Pls. 223, 213* *Pl. 65*

with the three-dimensionality of the lower, borrowed portion of the figure. It is instructive

*Pls. 221, 67*  to note also how the tension in the parted toes of the Zen figure's free foot has been relaxed
in Lorenzo's statuette.

*Fig. 50*     Comparison with Antonio Lombardo's classicizing *Virtue* from the 1493 Tomb of Doge
Andrea Vendramin shows how much more mature is *St. Apollonia*'s assimilation of antique
style. Their different authorship, rather than the two decades that separate these works,
explains the evolutionary sequence inferred from their relationship. Measured against the
youthful proportions of Antonio's *Virtue*, Lorenzo's robust figure projects the image of a
matron. The potential movement evoked by the *Virtue*'s restful *contrapposto* is fully realized
by *St. Apollonia*'s active pose; limbs, spread farther apart, invade space more aggressively.
Drapery is heavier and more abundant: in Lorenzo's *Saint*, the *Virtue*'s linear folds assume
three-dimensional forms and swathes materially affect the plastic configuration of the figure.
The pattern of Lorenzo's folds is more complex, less repetitive and regular. Heavier drapery
clings less readily and therefore describes anatomical forms or the play of folds of an
underlying garment less explicitly. The sewn border, meticulously incised at the neckline of
the *Virtue*'s dress, gives way to a more summary gathering of folds. Indeed, the entire surface
of Lorenzo's figure is less precisely worked. Despite Antonio's more literal reproduction of
an antique model, it is Lorenzo's figure that more effectively conveys the ideal and heroic
quality of ancient art.

*Pl. 225*     Behind the High Altar of the Basilica of St. Mark's is the Altar of the Cross with a marble
altarpiece by Lorenzo Bregno. At the center of the altarpiece, a repository for the Host is

*Pl. 228*  closed by Jacopo Sansovino's gilded bronze *sportello* with the resurrected Christ. The *sportello*
functions illusionistically as the rear wall of a rectangular hall covered by a coffered barrel
vault. Rectangular openings at either side admit adoring *Angels* in relief. The rear lunette is

*Pl. 226*  filled by a relief of the half-length *Trinity*, in the guise of God the Father.[13] Flanking the

*Pls. 231,* central bay are segmental niches containing freestanding statuettes of *St. Francis* receiving
*232*    the stigmata and *St. Anthony of Padua* with book and lily. The altarpiece was commissioned
in March 1518 by three of four *Procuratori di S. Marco de supra*. Among them was Alvise Pisani,
whom we shall meet in connection with another of Lorenzo's works. Stone was to be supplied
at the procurators' expense by their *protomaestro*, Bartolomeo Bon.

Like the High Altar of the Frari, the Altar of the Cross contains images of those saints
most closely identified with the Conventual faction of the Franciscan order, which had split
from the Observants just the year before. Obligatory in the major altar of the major Con-
ventual Franciscan church in Venice, the choice of saints in the altar of a ducal chapel is
unexpected. They betray, I suspect, the personal preference of the procurator, Alvise Pisani,
whose confessor was Fra Germano, prior of the Frari.[14]

The Altar of the Cross served the dual function of tabernacle and altarpiece. Therefore
it is appropriate that Lorenzo should have fused the conventional formats of tripartite
altarpiece with niches, on the one hand, and tabernacle, composed of a foreshortened barrel-

---

[13] The Trinity appears in a similar guise in Tullio Lombardo's *Coronation of the Virgin*, 1500–1502, S. Giovanni Crisostomo, Ven-ice and his twin tabernacles in S. Maria dei Miracoli.

[14] Sanuto, *Diarii*, xxix, 1890, col. 381, Nov. 8, 1520. For *SS. Francis* and *Anthony* in the context of the High Altar of the Frari, see Catalogue no. 26.

vaulted chamber, framed by a pair of columns supporting an entablature, on the other. The *Pls. 225,*
chamber's own entablature is continuous with the entablature of the altarpiece's lateral bays, *227, 228*
which, therefore, are lower than the central bay. They are narrower as well. Central and
lateral bays are linked above the lateral entablatures by what appear to be inverted spandrels,
like those above the lateral bays of the approximately contemporary Venetian Church of S.
Maria Maggiore. A segmental pediment crowns the central bay. The result is a closed and
highly integrated composition, whose unequivocal focus is the tabernacle of the Host.

In style, the architecture of the Altar of the Cross agrees with that of Lorenzo's other *Pls. 161,*
altars. The order consists of engaged, unfluted columns carrying a broken entablature, in *194*
whose soffit are coffers with rosettes. Elongated shafts are missing less than half their diameter.
Corinthian capitals contain two rows of acanthus, rather than Lorenzo's customary single
row, but the upper part of the bell is nonetheless exposed and volutes are undercut. The
frieze of the entablature is narrow, the segmental pediment very low. Moldings of architraves
and cornices are plain; the fasciae of the major architrave are inclined. Walls are embellished,
not by carved ornament, but by a revetment of variegated marbles in simple geometric
shapes. As in Lorenzo's S. Sepolcro Altar, raised slabs are embedded in moldings, whose flat *Pls. 227,*
upper surface is continuous with that of the slabs. Vertical strips of the same extruded *161*
molding ornament the fronts of niches, as they do the jambs of the attic above the niche *Pls. 228,*
in S. Leonardo. Figures and their bases project beyond the front face of shallow niches. *194*
Thus the altar's architecture combines – to the mutual enhancement of each – a plastic order *Pls. 231,*
with a planar ground, a formal simplicity with precious colored stones and gilded marble. *232*

The jasper shaft of the column on the right is pieced, suggesting that, at least in part, *Pl. 228*
Lorenzo was furnished with *spolia*. Most exceptionally, SS. *Francis* and *Anthony* also are pieced; *Pls. 231,*
here too, apparently, the procurators practiced economies by issuing to Lorenzo stone once *232*
used for other purposes. Lorenzo exploited the limited plastic possibilities offered by standing
figures in Franciscan habits: shortened tunics that expose the feet and permit the undercutting
of the hem, voluminous sleeves gathered at the cuffs, and drapery that responds to the
engaged as well as the free leg, contribute to the figures' formal interest. Lorenzo contrasted
the advance of *St. Francis's* free foot, his open gesture, and upward gaze with the receding
foot, lowered eyes, downward tilted head, and introverted mien of *St. Anthony*. Though the *Pls. 229,*
*Angels* betray Lorenzo's type, comparison with the *Angels* from the Sacrament Altar in Treviso *230*
reveals the collaboration of an assistant. By contrast, the *Trinity* seems autograph. The stepped, *Pls. 129,*
forked, or hooked terminations of drilled channels in folds are idiosyncratic; hair is as luxuriant *130*
here as drapery. By its excessive scale and its halo, represented orthogonally, which overlaps *Pl. 226*
the foreshortened barrel vault, the *Trinity* largely negates the effect of recession produced
by the perspectival foreshortening of the setting.

A work not previously linked with Lorenzo is the Tomb of Benedetto Crivelli in the *Pl. 237*
Oratory of S. Maria del Carmine at Creola near Padua. Crivelli was a Milanese mercenary
leader of infantry. Present with his troops at Crema to reinforce its French occupiers during
the War of the League of Cambrai, he treacherously surrendered Crema to the Venetians
in September 1512, in exchange for an enormous sum of money, property in Padua and its
suburbs, and patrician status in Venice. In his testament of July 20, 1515, Crivelli decreed

that a church be built in the fields of his newly acquired estate at Creola. There a marble tomb with his name and arms was to be erected on four marble columns; for the tomb Crivelli bequeathed 150 ducats. On March 22, 1516 Crivelli died. He had named a friend, Alvise Pisani, executor and residual heir in the absence of legitimate male issue. In Venice, heirs customarily saw to the construction of their benefactor's tombs, as Crivelli's epitaph teaches us Pisani did. How long it took to build the sepulchre, we do not know. The epitaph calls Pisani Procurator of St. Mark's, an office he obtained in May 1516. The effigy, at least, was finished before Lorenzo's death at the end of 1523 or the beginning of 1524. Very likely, the entire tomb was finished by 1525 – the year inscribed in the exterior frieze of the oratory's portal – if not earlier.

*Fig. 58*

The oratory at Creola is an aisleless rectangular hall, approximately 11.5 meters long by 7 meters wide. Its interior is roofed by a lunette vault on corbels with four pairs of coves. Opposite the entrance is the narrower, five-sided apse, raised on two steps and covered with a rib vault.[15] The Crivelli Tomb is freestanding; it is aligned with the third pair of coves (counting from the entrance) and is oriented along the chapel's central longitudinal axis. At present, the effigy lies with its head toward the altar; when our photographs were taken, before the figure was moved for a temporary exhibition, *Crivelli's* head was oriented toward the entrance in what was probably the effigy's original position.[16]

*Pls. 235, 236*

Crivelli's sarcophagus is raised on four stunted, capitalless columns with enormous abaci, located at the corners of a low platform; two divided halves of a parallelepiped provide additional support at the center. Inscriptions on either face of the sarcophagus are flanked by plain, raised panels. At head and foot are coats of arms with a sieve for separating wheat from chaff – *crivello* in Paduan dialect and Italian. The effigy lies at a height slightly above eye-level on a richly profiled bier covered with a cloth. *Crivelli* is dressed in the armor of a knight, but is bare-headed and lacks gauntlets. His sword, in its scabbard, hangs by his side from a belt; his spurs are bent upward.

Apart from Andrea Riccio's undated and effigyless Tomb of Girolamo della Torre (d. 1506) and his son, Marcantonio (d. 1511) in S. Fermo Maggiore, Verona, I know of no surviving freestanding tomb in Italy as tall as the Crivelli Tomb and sited in exactly the same way – that is, in front of, and aligned with, the altar.[17] There exist numerous examples of tomb slabs placed like this – the Crivelli Tomb itself is preceded by the 1824 Tomb Slab of Alessandro Bonvecchiato[18] – for they created no obstruction. Indeed, burial in front of the altar was the traditional prerogative of the founders of churches and chapels. Raised tombs in front of altars, on the other hand, were liturgically impractical; of the few that

---

[15] A pastoral visitation of the oratory in 1572 made no mention of an altarpiece (Appendix A, Doc. XVI, B), while a visitation of 1587 ordered that a more decent altarpiece be provided for the altar (Padua, Archivio curia vescovile, Visite pastorali nella diocesi di Padova, xi, *Visitationum sub R.mo Federico Cornelio*, 1587, c. 345v).

[16] The *Effigies of Cardinal Zen* and *Pope Sixtus IV*, for which see Frommel, *Zts. f. Kstg.*, 1977, p. 31, fig. 3, were oriented in this way. Within his tomb, Sixtus was placed with his feet toward the altar: Beltrami, in *Atti del III Congresso*, 1935, ii, p. 373. Thus, on the Day of Judgment, the resurrected pope would face the

altar.

[17] The Della Torre Tomb was originally aligned with the altar of the family's chapel in the left transept of S. Fermo. See Perez Pompei, 1954, pp. 51–3, and pl. 1 opp. p. 16. Freestanding tombs as tall or taller than the Crivelli Tomb do exist, of course, but either their original position is not known or they were not axially related to an altar. Tombs of saints are very often freestanding, but are generally placed immediately behind the altar, above which they rise. An example is Lorenzo Bregno's own Shrine of SS. Theonistus, Tabra, and Tabrata.

[18] Grandis, 1983, p. 33.

remain, most are no higher than waist level.[19] By contrast, the Tomb of Francesco il Vecchio di Carrara (d. 1393; tomb 1398), though it lacked an effigy, may have been as tall as the Crivelli Tomb, for it was raised on four columns. Although an early source states that the tomb was lodged at the center of the square Baptistry at Padua, a location in front of the central baptismal font, yet still on axis with the altar, is more likely still. But there is reason to think that the Carrara Tomb was dismantled in 1443.[20] We must look elsewhere, therefore, for the prototype of the Crivelli Tomb.

In fact, there did exist in Padua another conspicuous freestanding tomb placed in front of, and on axis with, an altar. This was the Tomb of Raimondino de' Lupi, Marquis of Soragna (d. 1379), which stood at the center of the rectangular and aisleless Oratory of S. Giorgio. The Lupi Tomb consisted of an *arca* with sloping cover raised on four columns set on couchant wolves; the *arca* was enclosed by a vaulted baldachin set on six columns. Elevated on a platform of three steps and crowned by a pyramid, the tomb's baldachin almost reached the oratory's vault. Around the base of the pyramid were ten over-life-size, freestanding, upright figures of Raimondino and his relatives — all but his mother in armor.[21] Although today the *arca*, minus its baldachin, rests against the side wall of the oratory, in Crivelli's day and until 1596, the monument stood as originally built.[22] Since Raimondino, like Crivelli, had been a foreign *condottiere*, who chose to be buried in Padua in an oratory he founded for the purpose, his tomb might well have recommended itself as an appropriate model for the siting, if not the form or iconography, of Crivelli's Tomb.

In form, the Crivelli Tomb is not unusual. But dependent, as it is, upon a scheme identified almost exclusively with fourteenth-century Neapolitan tombs, in which a parallelepiped tomb chest is supported on fairly low columns or piers and is surmounted by an effigy in high relief,[23] the format of the Crivelli Tomb is as curious as its siting. The choice of model must

Pl. 237,
Fig. 59

---

[19] Examples of freestanding tombs in front of altars include the following low tombs: 1. Tomb of Martin V (d. 1431; tomb delivered 1445) at the head of the nave in S. Giovanni in Laterano, Rome (Valentini, 1836, i, pp. 59f, pls. VIII, XXXVII); 2. Antonio Pollaiuolo's Tomb of Sixtus IV (d. 1484; tomb finished 1493) at the center of the pope's small chapel dedicated to the Immaculate Conception in Old St. Peter's (Frommel, *Zts. f. Kstg.*, 1977, pp. 31f); 3. Tomb of Cardinal Christopher Bainbridge, Archbishop of York (d. 1514), in front of the High Altar of S. Tomaso di Canterbury, Rome (Longhurst, [1962], Z13, and Kenny in *The English Hospice*, 1962, pp. 229f). Somewhat higher, but still low enough to fit beneath a table, is the Tomb of Giovanni d'Averardo de' Medici (d. 1429) and his wife, Piccarda (d. 1433), at the center of the Old Sacristy, S. Lorenzo, Florence. *Cassoni* set on mounts or bases and surmounted by an effigy on a bier reached a spectator's chest. Among freestanding tombs of this type, there survives in entirety and in situ only the Tomb of Cardinal Zen. Those that partially survive include: 1. the Zen Tomb's prototype, the Tomb of Orsato Giustiniani (d. 1464; tomb ca. 1462–ca. 1466), from his funerary chapel in SS. Eufemia, Dorotea, Tecla, e Erasma in the minor cloister of S. Andrea della Certosa, Venice, attributed to Niccolò di Giovanni Fiorentino (Schulz, 1978, pp. 23–5); 2. Giovanni di Stefano's tomb for a member of another prominent Venetian family, Cardinal Pietro Foscari (d. 1485), from the Cappella Foscari, S. Maria del Popolo, Rome (Kühlenthal, *Flor. Mitt.*, 1982, pp. 47–

62); 3. Benedetto Briosco's Tomb of Ambrogio Grifo (d. 1493; tomb 1489–ca. 1493), from the Chapel of S. Ambrogio, S. Pietro in Gessate, Milan (Roth, *BM*, 1980, pp. 8–14).

[20] For the Carrara Tomb, see Saalman, *AB*, 1987, pp. 376–86.

[21] Edwards, *Ksth. tidskrift*, 1983, pp. 95–105. I am grateful to Prof. Sarah Wilk McHam for referring this monument to me.

[22] Gonzati, ii, 1853, p. vi, doc. CXLVII.

[23] There are eleven Trecento Neapolitan tombs of this type known to me: 1. Tomb of Filippo Minutolo, Archbishop of Naples (d. 1301), Duomo; 2. Tomb of Orso Minutolo, Archbishop of Salerno (d. 1327), Duomo; 3. Tomb of Raimondo Cabanis (d. 1334), S. Chiara; 4. Tomb of Guglielmo Tocco (d. 1335) and his son Nicola (d. 1347), Duomo; 5. Tomb of Giovanna d'Aquino (d. 1345), S. Domenico Maggiore; 6. Tomb of Antonino Manso, S. Lorenzo Maggiore; 7. Tomb of Niccolò Merloto (d. 1358), S. Chiara; 8. Tomb of a member of the Artus family, ca. 1350–70, S. Chiara; 9. Tomb of Ludovico Tocco (d. 1360), Duomo; 10. Tomb of Maria di Durazzo (d. 1371), S. Lorenzo Maggiore; 11. Tomb of Alessandro Favilla (d. 1404), S. Lorenzo Maggiore. For these tombs, see Longhurst, [1962], E1, E4, E7, E21, E23, E25, E36; Mormone, 1973, pp. 29f, cat. no. III, pp. 31f, cat. no. V, p. 41, cat. no. XXV, and Petito, ²1982, p. 91. Sometimes effigy, *cassone*, and supports are enclosed by a baldachin, sometimes they are not. None of these tombs is freestanding. The number of such tombs could be expanded vastly by adding examples in which effigies lie within curtained

have been Crivelli's, for his testament specifically enjoined that the *cassone* be elevated on four columns. Probably the exclusion of all figurative sculpture but the effigy reflects the executor's strict interpretation of Crivelli's instructions, which required that the defunct's name and arms be carved on the sepulchre, but said nothing of other images. In fact, apart from its siting in relation to the altar, there is not a Christian reference in the tomb.

*Pl. 236*

*Pl. 208*

Crivelli's wiglike head of kinky hair places the attribution of the effigy to Lorenzo Bregno beyond all reasonable doubt. Beard and mustache are almost identical to those of the *Saviour* in the Scuola di S. Rocco and in both, the hair of the brows is faintly etched by wavering incisions. The resemblance of Crivelli's physiognomy to that of Lorenzo's other male figures makes it unlikely that the *condottiere's* features derive from a portrait made from life or death. Indeed, the effigy seems asleep – poised, therefore, between life and death. *Crivelli's* hair fans out on the cushion. It is the only part of the figure to respond to its recumbent pose; the

*Pl. 235*

*Pl. 78*

disposition of plate armor and chain mail, by contrast, bespeaks an erect posture. Armor is depicted accurately, but in less detail than in Giambattista's *Effigy of Benedetto Pesaro*. Indeed, comparison with *Pesaro* shows how much ornament is missing, how contours have been generalized, and distinctions between the texture of flesh, leather straps, and armor have been eliminated. Traces of tool marks remain throughout. The figure's hands have been flattened, but other forms retain their normal volume: rather than contract naturally rounded surfaces, Lorenzo merely eliminated the rear third of the effigy.

*Pl. 237*

*Pls. 161, 227*

There are few traits by which to recognize Lorenzo's hand in the architectural members of the tomb. Yet the choice of gray-veined white marble for the tomb chest and supports is not uncharacteristic and the raised panels, which return to the plane of the *cassone* front by means of cavetto moldings, approximate the revetment on the S. Sepolcro Altar and the Altar of the Cross. The unusual lack of incrustation and the resultant uniformity of color probably are due to the exiguous sum allocated to the tomb by Crivelli's testament. But the plain surfaces, chaste moldings, the simple geometric shapes and purity of contours, undoubtedly reflect the sculptor's taste.

*Pl. 238*

Documents regarding the manufacture of the Tomb of Bartolino Terni in S. Trinità, Crema are not extant. The base of the pedestrian effigy, however, is inscribed "LAVRENTIVS BRENIVS FA (facebat)." The tomb therefore must have been completed by Lorenzo before his death at the end of 1523 or the beginning of 1524. Bartolino Terni was a Cremasque *condottiere*, a leader of infantry in Venetian service. After Crivelli's surrender of Crema, Terni was sent on an abortive mission to congratulate the *Signoria*. He died on July 1, 1518, at the age of eighty-seven. Whether the choice of the monument's author and format was Bartolino's or his executor's, we do not know, for Terni's final testament of 1516 does not survive. In any case, it is significant that the tomb of so loyal a Venetian subject should have been entrusted to a Venetian artist and that the latter should have adopted as his model a tomb that the Venetian Senate had recently erected, at its own expense, in honor of another *condottiere* – hero and victim of the siege of Padua in the War of the League of Cambrai. This was the Tomb of Dionigi Naldi da Brisighella (d. 1510), built between 1512 and ca.

cells or supports are caryatids.
   I know of only two examples of this type outside Naples: Tomb of Pope Gregory X (d. 1276), Duomo, Arezzo; Tomb of Cardinal

Branda Castiglione (d. 14443), Collegiata, Castiglione Olona. In the latter, however, the freestanding sarcophagus is borne by four caryatids.

1515 in the right transept of SS. Giovanni e Paolo. Traditionally ascribed to Lorenzo Bregno, the Naldi Tomb, as I have tried to prove, is by Antonio Minello.[24] Its artistic quality is not high. But the prestige of its tenant – like Terni, a leader of infantry in Venetian service – and the honor conferred publicly by the Senate's patronage, no doubt were given greater weight. From the Naldi Tomb, Lorenzo borrowed the pedestrian effigy holding a lance and the circular base. The poses of the two effigies are similar, gestures are identical; dress and armor – the mail skirt and the jack worn by the ordinary foot soldier[25] – correspond.

The foundation of the Naldi Tomb, with columns supporting a hybrid sarcophagus and attic, was conditioned by the incorporation of a portal within the tomb. The Terni Tomb also was installed above a doorway – one leading to the Baptistry, just outside the choir *in cornu Evangelii* – in the fifteenth century Church of S. Trinità; nonetheless the Terni Tomb makes explicit use of a sarcophagus. The pensile sarcophagus raised on corbels was a typical feature of Venetian tombs; so, too, was the introduction of the epitaph between the corbels. The design of the sarcophagus finds a close parallel in the Tomb of Jacopo Barbaro (d. 1511) in S. Maria dei Frari. The erect figure standing on his tomb inevitably evoked images of the *Resurrected Christ*. Crossed palm and laurel fronds flanking Terni's arms above the epitaph symbolize victory over death.

Evidently Lorenzo made some attempt to reproduce Terni's likeness, for the effigy's face is disfigured by rhinophyma. Yet this is not the portrait of an eighty-seven-year-old man. Can Lorenzo have wished to represent the defunct in his prime or was he merely ignorant of his subject's age and physiognomy? Terni's gaze is as fixed as his stance is stationary, in opposition to Giambattista's *Effigy of Pesaro*, where the turn of the figure's head and the sidelong glance suggest a momentary bestowal of attention. The drilled pupils and tear ducts, the carving of *Terni's* brows and hair, recall *St. Francis* from the High Altar of the Frari.

Whether by accident or design, Lorenzo's major architectural commissions are clustered toward the end of his career. Foremost among them is the framework of the Pesaro Altar in the Frari, for which Giambattista carved the right-hand *Reggiscudo*. The altar's site was ceded to Jacopo Pesaro in January 1518. In April 1519, the bishop commissioned from Titian a painting for his altar. Payments at irregular intervals were made to Titian between June 1519 and May 1526. The dimensions and shape of the frame's opening must have been fixed by September 1519, when Titian was paid for the painting's stretcher and canvas. The setting of an early version of the Pesaro *Madonna*, hypothetically linked with the campaign of work that resulted in payments to Titian between April and September 1522, is visible in X rays; pilasters, capitals, and entablature resemble those of the frame. By this stage, therefore, the frame's order must have been established. The coincidence of frame and setting encourages the speculation that Titian and Bregno collaborated; certainly they conferred and one may have stipulated the employment of the other. When Sanuto attended the commemoration of the Feast of the Immaculate Conception at the altar on December 8, 1526, the painting and framework were in place.

The format of the Pesaro Altar, with central arcade framed by a major order of columns

*Fig.* 63

*Pl.* 241,
*Fig.* 62

*Fig.* 63

*Pl.* 238

*Fig.* 61

*Pls.* 242,
243

*Pls.* 241, 79
*Pls.* 242,
200

*Pl.* 244
*Pl.* 117

---

[24] For the Naldi Tomb, see Catalogue no. 31, and Schulz, *Flor. Mitt.*, 1987, pp. 300–326.

[25] Blair, 1958, pp. 118, 138f. The resemblance of the two tombs was observed also by Zava Boccazzi, 1965, p. 179.

and minor order of pilasters or lesenes supporting a triangular pediment, makes its first appearance in Venice in the framework of the High Altar of S. Giovanni in Bragora with Cima da Conegliano's *Baptism of Christ*. Documents record the execution of the frame by a Master Sebastiano between 1492 and 1493; finishing touches were added in 1495.[26] After thirty years, the scheme had become common for the frames of large altarpieces in Venice and the Veneto.[27]

No documents or early sources record the Pesaro frame's creator: our criteria for its attribution to Lorenzo, therefore, necessarily are stylistic. In both the Pesaro Altar and the Altar of the Cross unfluted, Corinthian columns are elongated, while capitals are uncanonically short. Indeed, the same design served for the capitals of both, determining the double row of short acanthus, the exposure of the upper portion of the bell, the volutes carved *à jour*. In shape, the shields on the front faces of the Pesaro bases duplicate the shield on the Tomb of Bartolino Terni. The narrow friezes, low pediment, inclined fasciae, and soffit with rosettes in coffers are familiar elements of Lorenzo's architectural vocabulary; typical also are the plain moldings and the incrustation of variegated stone.

Lorenzo's most sumptuous work of architecture is the framework of another altarpiece by Titian – his *Annunciation* in the Cappella della SS. Annunziata in the Duomo of Treviso. The altar is not likely to have been begun much before completion of the chapel's construction in March 1519 or finished after the altar's consecration on March 1, 1523. Patron of the altar, as well as of the building and the decoration of the chapel, was Canon Broccardo Malchiostro, from whom Lorenzo's widow sought payment of a debt after her husband's death. The object of this payment is not specified, but only the framework of the altar, among the chapel's furnishings, reveals Lorenzo's hand.

Characteristic of Lorenzo are the unfluted, engaged three-quarter columns and the breaking of the entablature and base. If not as elongated as the members in the S. Sepolcro Altar or the S. Leonardo niche, columns nevertheless are slender and capitals are disproportionately short. In fact, the capitals are so similar to those of the St. Sebastian Altar, that this feature alone would suffice to prove Lorenzo's authorship. As there, the coloristic variety of materials compensates for plain moldings and uncarved frieze; common to both are small discs and horizontal rhomboids. In both, the frieze is narrow, the pediment is low, and the fasciae of the architrave are inclined. As in the Pesaro Altar, shields with coats of arms embellish the front faces of pedestals;[28] in both, frieze and architrave are apparently of equal height and the stepping of bases and entablature ensures a continuity of vertical accents at either side. Few frames of the period can vie with the altar of the Cappella della SS. Annunziata in

*Pls. 227, 228*

*Pl. 238*

*Pls. 245–247*

*Pls. 245, 161, 194*

*Pls. 247, 192*

*Pls. 245, 194*

*Pl. 244*

---

[26] Humfrey, *AB*, 1980, pp. 354–7; idem, 1983, pp. 157f, cat. no. 154.

[27] See, for example, the frame of the third altar on the right of the nave of S. Giobbe, which originally contained Carpaccio's *Presentation of Christ in the Temple*, 1510, Gallerie dell'Accademia, Venice; the frame of the Altar of the Madonna della Misericordia, 1519, fourth altar on the left in S. Corona, Vicenza; the frame of Vincenzo Catena's *Martyrdom of S. Cristina*, 1520, S. Maria Mater Domini; Lio Lupi's wooden frame for the High

Altar, 1524–7, S. Nicolò, Treviso; the frame of the undated Altare Nievo, the first altar on the left of S. Corona, Vicenza. Titian's *Assumption of the Virgin* in the first chapel on the left in the Duomo, Verona, is enclosed by a frame, attributed to Jacopo Sansovino, that copies the Pesaro Altar frame.

[28] On the left is the rampant lion of Bishop Bernardo de' Rossi; on the right are Broccardo Malchiostro's three sprays of thistle (*cardo* in Italian) held by a right hand.

opulence of material – veined marbles, porphyry, verd antique, and incrusted bronze – or expenditure of labor: the prodigality of effort, with which Lorenzo dissected moldings, chased capitals and blazons, and polished marble, shows that the frame was as highly valued as its contents.

Documents speak of two works left incomplete at Lorenzo's death and finished afterward. One of these is the tomb of the *primicerius* of the Cathedral at Treviso, Bertuccio Lamberti (d. 1522) erected by Lamberti's brother Domenico. The tomb has been dismembered and mutilated: the epitaph, which originally must have been immured between the corbels, later served as cover for the sarcophagus. Above, the tomb may have terminated like the Tomb of Jacopo Barbaro in the Frari. The *cassone*'s design, consisting of raised rectangular slabs of veined marble framed by cavetto moldings – three on the front face, one at either end – parallels the articulation of Terni's sarcophagus. Work of execution, however, probably had hardly started at Lorenzo's death.

Not long after Lorenzo died, his widow agreed to sell the contents of his shop to Antonio Minello. The sale, however, was contingent upon Minello's promise to complete a figure of *S. Maria* for the church of Montagnana. Presumably work was finished by January 1525, when Maddalena empowered her brother to collect money due Bregno from the commune. For want of any alternative, the work in question is generally assumed to be the relief of the *Madonna and Child* in a roundel incorporated into the exterior of the main portal in the Duomo at Montagnana. The style of the relief confirms this supposition.

In analyzing the respective shares of Lorenzo and Antonio Minello, we are hampered by the absence of a *Madonna and Child* indisputably by either. Nevertheless, comparison of the relief with *St. Mark* from a pendentive of the Cappella del SS. Sacramento proves Lorenzo's responsibility for the *Madonna*'s composition: in both, figures of comparable scale, posed identically, are truncated at approximately the level of their hips by a sill on the foremost plane. However, it is doubtful that the *Madonna and Child* was initially destined for a circular field like that of the *Evangelist*, for the single block, from which mother, child, their immediate background and the sill were carved, is more nearly rectangular than round and was made to fit a *tondo* only by the addition of slabs at either side and a stratum of concrete beneath the sill. The Madonna's monumental proportions enhanced by expansive gestures and a heavy, voluminous mantle, the round neckline, and the veil rolled into a thick swathe to form a halo, are features closely linked with Lorenzo's art. Through the turning and slight inclination of the heads, the gazes directed downward, the parted lips, and the gesture of Christ's blessing hand, the figures address the spectator from above with sovereign command. The easy *contrapposto* of the Christ Child has many parallels among Lorenzo's figures, but none among Minello's. The child's face, with its retroussé nose, so extraordinarily pinched and indented at the bridge, resembles that the Christ Child borne by *St. Christopher* in the Cesena Altar. But we must look to Minello's *St. Peter* from the Trevisan Altar in S. Maria Mater Domini for analogies with the child's tapered locks blown forward. That Minello also carved the Madonna's face and hair transpires from a comparison with *Prudence* and *Faith* from the Tomb of Nicolò Orsini in SS. Giovanni e Paolo and the woman in Minello's Santo

Pl. 248

Fig. 61

Pl. 238

Pl. 249

Pls. 250, 133

Pls. 252, 180

Fig. 79

Pl. 251,
Fig. 64
relief of the *Investiture of St. Anthony*.[29] Typical of the sculptor are the fleshy and amorphous features, the widely separated, heavy-lidded eyes, the short, thick nose, and the narrow, protuberant chin succeeded by a double chin. The hair that rises gradually from the surface of the forehead and makes a widow's peak, common to Minello's women, is very different from the arched and undercut hairline of Lorenzo's figures.

Our survey of Lorenzo's oeuvre reveals an extraordinarily consistent style: there is little to distinguish juvenilia from late works. To be sure, sculptures executed during the first lustrum of Lorenzo's career frequently depend from prototypes by Pietro Lombardo and Giambattista for compositions, poses and gestures, facial types and drapery; later works, on the other hand, manifest little interest on Lorenzo's part in the work of contemporary sculptors. By contrast, the enthusiasm for classical sculpture that conditioned Lorenzo's later work so fundamentally, affected his early work as well. Therefore, the differences between earlier and later works are determined chiefly by errors in the depiction of anatomy and the ponderation of figures that were later rectified. *St. Paul* is typical of a debutant in its pre-sumptuous claims of virtuosity at the expense of composition. But pressed by several exacting commissions, Lorenzo rapidly matured. In part, the consistency of the formed artist is explained by the brevity of Bregno's career, which did not exceed nineteen years, and by the overlapping of many of his works. More important still was the absence of any stimulus to change. During the period of Lorenzo's activity, most major works of Venetian sculpture not made by either Bregno were realized by sculptors older by at least a generation and still working in a Quattrocento idiom: unquestionably, Lorenzo's work represents the most advanced and progressive Venetian sculpture of his time. Not until shortly before Lorenzo's death did Mosca's statues for the High Altar of S. Rocco challenge the modernity of Bregno's art.

Pl. 124
Four years after Giambattista, Lorenzo made his first appearance in the documents; for the next several years, he seems to have held a subordinate position in his brother's shop. What the archival data suggest – that Lorenzo was Giambattista's junior – the stylistic data abundantly confirm: where Giambattista's sculpture belongs to the art of the late Quattro-cento, the proper context for Lorenzo's art is the High Renaissance. Lorenzo no longer sought to copy nature. Rather, his goal was the creation of works of art that could be judged by the standard of ancient Roman sculpture. Roman sculpture taught Lorenzo the virtues of monumentality and generalization, of maintaining a certain distance from reality by the depiction of a uniformly heroic figure type. His conscious imitation of antique dress and hair, facial types, masculine anatomy, and *contrapposto* produced works that emulated the best examples of Roman statuary. His relief with its fully rounded forms that recede gradually until intersected by the background, mirrors classical relief. In his disdain for linear and plastic definition, for virtuoso carving of details, or prodigious feats of undercutting, Lorenzo adapted his own technique to the limitations of ancient sculptors. His repetition of a limited repertory of types and compositions, which robbed the smallest elements, as well as larger forms, of their identity and singularity, corresponds to the restricted canon of subjects and

---

[29] For the attribution of the Orsini Tomb to Antonio Minello   312–19.
and a description of his art, see Schulz, *Flor. Mitt.*, 1987, pp.

motifs in Roman art. In his summary drilling of beards and folds, Lorenzo even tried to reproduce the kind of accidental effects of weathering that one might expect of forgeries.

Yet the creation of sculptures that could pass for works of classical antiquity was surely not Lorenzo's aim. In the first place is the conspicuous absence from his oeuvre of classical gods, personages, or events: invariably, antique motifs and styles were used to render Christian themes. Thus the bust of a Roman emperor was adapted to the *Saviour*, a Roman centurion to *St. Eustace*, a Roman matron to *St. Paul*, *Juno* or *Ceres* to the *Mary Magdalene*, *Venus* to a Zen personification. To be sure, this apparent lack of classical subject matter in Bregno's oeuvre may be due to the accidents of survival. More likely still, it reflects the taste of Venetian patrons, who eagerly collected antique marbles, but preferred their contemporary redactions of Roman history and myth in bronze.[30] In fact, until the small marble reliefs of classical heroes and heroines by Mosca and others, whose popularity is attested by the multiplicity of replicas, there were few marble specimens of classical subject matter carved in Venice by anyone.[31] But apart from the hypothetical demands of Venetian patrons is the fact that Lorenzo's works never copy their ancient prototypes in all, or even most, respects; much more faithful to their antique sources were the antiquarian sculptures of Tullio and Antonio Lombardo.

Despite the fidelity of their derivations, however, sculptures by Tullio and Antonio Lombardo look far less like their Roman archetypes than Bregno's freer adaptations do. The reasons for this are three. First, what ancient sculptors had rendered largely by plastic form, the Lombardo translated into line and contour. Secondly, by virtue of their planar, tectonic, and symmetrical structures, their geometric shapes and stereometric forms, and the frequent repetition of a single motif at equal intervals, the Lombardo's compositions acquired an abstract and schematic regularity that exceeded that of even the most formulaic and repetitive of Roman sculpture. Thirdly, the Lombardo's Quattrocento technique was vastly more subtle and refined, depended more on purely decorative details worked on a minute scale, brought surfaces to a higher polish, and distinguished a far greater variety of textures, than ancient sculptors could or ever cared to do. To be sure, these characteristics are more pronounced in Tullio's than Antonio's work; as a consequence, Antonio's sculpture distinguishes itself as the more truly classicizing. Nonetheless, even Antonio's simulations remind us of those fakes that deceive only at the moment of their creation, but that, at a little distance, appear part and parcel of the epoch that produced them.

---

[30] Franzoni, in *Storia della cultura veneta*, III, iii, 1981, pp. 236–9.

[31] Apart from small figures in the context of decorative reliefs, the only examples that come to mind are: heads of unidentifiable *Roman Emperors* on the lost sarcophagus of Orsato Giustiniani, ca. 1462–ca. 1466, and the sarcophagus of Doge Nicolò Tron, S. Maria dei Frari, 1476–80, on the wall bench of the Cappella Corner, S. Maria dei Frari, and in the Tomb of Doge Andrea Vendramin, SS. Giovanni e Paolo, 1493; the reliefs of *Hercules and the Hydra* and *Hercules and the Nemean Lion* in Pietro Lombardo's Tomb of Doge Pietro Mocenigo, SS. Giovanni e Paolo, ca. 1478; a lost *Hercules* by Antonio Rizzo, lauded by Raffaele Zovenzoni before 1485 (Schulz, 1983, p. 12); Antonio Rizzo's *Victories* for the Scala dei Giganti, Ducal Palace, ca. 1491; Tullio Lombardo's roundels of *Hercules Nessus, and Deianeira* and *Perseus with the Head of the Medusa* from the Vendramin Tomb; Cristoforo Solari's lost *Venus* and *Apollo*, the latter in the guise of the *Apollo Belvedere*, seen in the house of Giorgio Dragan by Bernardino Gadolo in 1494 (Meneghin, *Aten. ven.*, 1970, pp. 258, 261); Pyrgoteles' lost *Venus Flogging Cupid*, before 1496, and small *Hercules* (Schulz, *Antichità viva*, Mar.–Apr. 1977, p. 44, n. 50); *Mars* and *Neptune* from the Pesaro Tomb. The heads of *Hercules* and *Cybel* by Antonio Minello and the statue of *Mars* by Simone Bianco, seen by Marcantonio Michiel in 1532 in the house of Andrea Oddoni (Michiel/Frimmel, [1521–43] 1896, pp. 82, 86) probably post-dated Lorenzo's death.

In his more summary execution of plastic form, as well as his renunciation of line and detail, by contrast, Lorenzo Bregno thought and worked like a Roman sculptor. Having thoroughly assimilated the types and motifs of ancient sculpture, he did not need to copy. In these respects, Lorenzo's sculpture is comparable to that of Andrea Riccio or the mature Andrea Sansovino, whose classicism likewise was a question of mode rather than motifs. Yet Lorenzo's brand of neoclassicism was short-lived in Venice: although his commissions prove him to have been extremely successful among Venetian patrons, his example had little effect upon the younger generation of Venetian sculptors. In explanation is the change in taste apparent not only in Venice, but throughout the Italian peninsula, starting shortly before 1520. Though Bregno's figures breathe, move, speak – sometimes with rhetorical flourishes – they are not racked by pain or fury. Bregno's placid and benign interpretation of ancient art, however, was superseded in the 1520s by one that focused on antiquity's expressive traits, exemplified by the *Laocoon*. Chief in Venice among the disseminators of the new archeology were Giammaria Mosca and Bartolomeo Bergamasco. In their wake, even Tullio's aloof and undemonstrative figures were radically transformed, as his Santo relief of the *Miracle of the Miser's Heart* of 1525 and the Rovigo *Pietà* of 1526 disclose. Outside of Venice, Rosso Fiorentino, Pontormo, Giulio Romano, and other exponents of early Mannerism pursued the same expressive ends, even if their means were very different. Fueled by events that did not take place in Venice, the artistic revolution of the 1520s repudiated High Renaissance ideals of composure and decorum, harmony and balance, bringing to a close the unique and limited chapter in the history of Venetian art represented by the classicizing sculpture of Lorenzo Bregno.

# CHAPTER FOUR
## Conclusion

The activity of the Bregno shop can be documented through slightly more than two decades. Giambattista is first recorded in 1502, when he was commissioned to execute the relief of the *Miracle of the Goblet* and a *Prophet* for the Cappella del Santo at Padua, alongside Tullio and Antonio Lombardo and Giovanni and Antonio Minello. If the Trevisan Bettignoli Altar and Ostiani *Visitation* were finished by this time, they would have testified to Giambattista's extraordinary ability. They must, at any rate, have played a role in the decision of Bishop Rossi and the presidents of the Confraternity of the Holy Sacrament at Treviso to entrust the decoration of their chapel to the sculptor. Commissions to Giambattista for its incrustation, its pavement, and its steps run continuously from 1504 to 1508. Execution of the chapel's statuary occupied both Giambattista and Lorenzo between 1506 and 1512 at least. Lorenzo's Shrine of the Three Martyrs was made for the High Altar of the Cathedral at Treviso in 1505/6. In the midst of his Trevisan works, Giambattista undertook to execute the decoration of the Verardi Chapel of the Corpus Domini for the Duomo at Cesena; commissioned no later than November 1500, the sculpture was consigned in 1505. For the same Verardi family, Giambattista executed his first Venetian work – the lost Tomb of Ippolito Verardi in the Crociferi, finished by early 1506. Thus the first five years of the Bregno's activity were exclusively devoted to work for non-Venetians.

In July 1506, Giambattista received his first commission from a Venetian patron: he and Paolo Savin were charged jointly by the *Procuratori di S. Marco de citra* with the models for the six bronze female statuettes on the sarcophagus of Cardinal Zen. No doubt, Giambattista would have forfeited even this grudging commission had Antonio Lombardo not departed

for Ferrara a month before,[1] leaving many of his commissions unfulfilled. Jestaz surmised that Giambattista owed the commission for the Zen figures, not to his merit, but to the influence of his uncle's reputation.[2] But the course of Giambattista's career suggests that in Venice, at any rate, kinship with the notorious Rizzo was a decided disadvantage. To be sure, a younger man could hardly have rivaled such well-established sculptors as Pietro, Tullio, and Antonio Lombardo, and thus, is unlikely to have obtained the prestigious commissions for the decoration of the Giustiniani Chapel[3] or the sculpture for the Cappella Zen. But lesser orders executed in the Lombardo shop, such as the *Coronation of the Virgin* in S. Giovanni Crisostomo,[4] the St. Luke Altar in S. Giobbe,[5] the figures from the High Altar of S. Giustina,[6] might have been addressed to him. Giambattista might well have won from their deservedly anonymous authors the contracts for the Tombs of Melchiore Trevisan[7] or Benedetto Brugnolo in the Frari[8] or from the mediocre Giovanni Buora, the commissions for the Trevisan Altar in S. Cipriano, Murano or the *Page* on the facade of the Civran Palace.[9] That he did not do so suggests that, like Venetian patricians in the political arena, Giambattista suffered for a decade after Rizzo's flight from the taint of kinship with an outlaw.

In 1508 Giambattista was commissioned to carve the relief of *St. George and the Dragon* for the dormitory facade of S. Giorgio Maggiore. Although in terms of site, material, and fee the commission was a minor one, it seems to signal the end of Giambattista's ostracism. So too would the commission for the *Effigy of Benedetto Pesaro* and the framework of the tomb, were they to date from the same year. Yet the fact that the tomb's commission was not entrusted to Giambattista in its entirety may suggest a lingering reluctance on the part of Girolamo Pesaro to be known as Bregno's patron: indeed, the sculptor's identity may have been concealed by the cover of another contracting shop. However that may be, Giambattista's good fortune was short-lived, for within a year war broke out between Venice and virtually the rest of Western Europe, bringing to a halt all Venetian projects of construction and decoration. In fact, the relief of *St. George*, which Giambattista had completed in nine months, was not painted until four years later.

When Benedetto Crivelli wrote his testament in 1515, he was well aware of the disruptions war might cause and asked that his oratory and monument be built within a year of his death "unless the impediments of war should not permit it."[10] We are reminded of the inscription beneath Andrea Riccio's Paschal candlestick in the Santo, commissioned in 1507 but not installed until 1516, in which the artist expostulated that "it would have been completed in three years if Maximilian's most atrocious war with Venetian territories had not impeded it."[11] The loss of documents makes it difficult to trace the effects of war on the lives of individual artists, but the sudden appearance of Antonio Minello in 1510 in the service of the Fabbrica di S. Petronio, Bologna[12] and the return of Severo Calzetta da Ravenna

[1] Sartori/ Fillarini, 1976, p. 139.
[2] Jestaz, 1986, pp. 71, 72.
[3] Schulz, *Antichità viva*, Mar.–Apr. 1977, pp. 27–35.
[4] Paoletti, 1893, ii, p. 111, doc. 90.
[5] See Catalogue no. 30.
[6] Schulz, *Flor. Mitt.*, 1985, pp. 80–93.
[7] See Catalogue no. 32.
[8] Munman, 1968, p. 344.
[9] Schulz, *Arte lom.*, 1983, pt. 2, pp. 54, 61, 64.
[10] See Appendix A, Doc. XVI, A.
[11] Planiscig, 1927, pp. 243–5.
[12] Schulz, *Flor. Mitt.*, 1987, p. 292.

to his native city before early 1511[13] are surely to be traced to a lack of work in Padua, then under siege. In May 1514, Giovanni Minello's salary as *protomaestro* of the Cappella del Santo for the years 1508 through 1513 was reduced rectoactively from 200 to 50 lire *per annum*. It is evident from this that, for the past six years, Minello had received no salary at all and at last was forced to content himself with a lump sum of 300 lire. Furthermore, Minello's salary was to remain at the level of 50 lire *per annum*. In June 1515, however, Minello's services as *proto* were dispensed with altogether. He was not replaced; nor was he reinstated until December 1518.[14] In October 1510, Leopardi's salary at the Venetian mint was decreased from 80 to 40 ducats and Camelio's, from 80 to 60 ducats.[15] A petition in June 1515 to the Council of Ten from Camelio's brothers records the piteous state to which the sculptor had been reduced. The petition recounts how Camelio's salary had been lowered from 100 to 80 ducats, then to 60, and at last not paid at all, so that Camelio was owed 140 ducats. Having sold all his movable goods for the necessities of life, he was obliged to emigrate in order to feed his family.[16] Indeed, that very month we find Camelio appointed to the Roman mint.[17] From the spring of 1509 until March 1512 work ceased at the Cappella Zen. In June 1510 Sanuto reported that money from estates administered by the procurators was being diverted to pay the army; it is hardly likely that the patrimony of Cardinal Zen was spared.[18] Because of war, construction at the Scuola Nuova della Misericordia was arrested at its foundations;[19] more complete documentation, no doubt, would show that construction was halted at S. Geminiano, S. Sebastiano, S. Fantin, and S. Salvatore, as well.

During the War of the League of Cambrai painting does not seem to have suffered to the same degree as architecture and sculpture — if, indeed, any adverse effects are perceptible at all. No doubt this was due primarily to the fact that paintings required incomparably smaller expenditures than the construction of buildings or monuments and therefore were less vulnerable to economic catastrophe. Of secondary importance was the fact that because of their assumed expertise in the construction of war machines, in the planning of fortifications, in the casting of cannon, and the quarrying and dressing of stone for cannonballs, sculptors, bronze founders, and architects were liable to be called into service, whereas painters ordinarily were not. One is reminded of Antonio Rizzo's two stints at Scutari;[20] of Bartolomeo Bon, released from his post as *proto del Magistrato al Sal* in 1496 to serve as admiral under *Capitano del Mar* Melchiore Trevisan;[21] of Leopardi's manufacture of artillery at the Arsenal in 1499 and 1500[22] and his regulation of trenches and fortifications at Padua and Treviso between 1509 and 1511;[23] of Sebastiano da Lugano's consultations on Padua's fortifications in 1515, as deputy of the late Captain General Bartolomeo d'Alviano.[24]

[13] Winter, Cleveland, Mus. of Art. *Bull.*, 1986, p. 92.

[14] Sartori/Fillarini, 1976, pp. 158, 159; Sartori/Luisetto, 1983, p. 339, nos. 111, 119.

[15] Cicogna, ii, 1827, p. 297, n. 1.

[16] Papadopoli, *Arch. ven.*, 1888, p. 275, repr. in idem, *Riv. ital. di numismatica*, 1888, p. 356.

[17] Amati, *Arch. stor. ital.*, 1866, p. 221.

[18] Jestaz, 1986, p. 76.

[19] Paoletti, 1893, ii, p. 248.

[20] Schulz, 1983, p. 125.

[21] Lorenzi, 1868, p. 116, doc. 241.

[22] Sanuto, *Diarii*, ii, 1879, col. 473, Feb. 25, 1499; ibid., iii, 1880, coll. 413f, June 22, 1500.

[23] Paoletti, 1893, ii, p. 269, n. 1; Sanuto, *Diarii*, x, 1883, col. 26, Mar. 9, 1510, and col. 596, June 20, 1510; ibid., xii, 1886, col. 365, Aug. 12, 1511 and col. 496, Sept. 12, 1511.

[24] Predelli, vi, 1903, pp. 135f, no. 33; Rusconi, 1921, pp. 42–5, 91–4, docs. IV, V.

In April 1508, Giambattista had contracted for *SS. Peter* and *Paul* and the two large *Angels* for the Sacrament Chapel at Treviso; *St. Peter* and the *Angels* were finished by December 1509. It may well be that the *Angels* once in S. Maria dei Servi date from the period of the War of the League of Cambrai, but, in fact, between 1509 and 1516 – the year inscribed on the High Altar of S. Maria dei Frari and the year in which hostilities ended – there are no securely dated works by Giambattista. Was this the result of war or did it have some other cause? That Lorenzo fared rather better suggests that the responsibility may have been at least partly Giambattista's. Between 1508 and 1512, Lorenzo was occupied with the altarpiece, *Evangelists*, and *St. Paul* for the Sacrament Chapel at Treviso; his altarpiece for S. Sepolcro presumably was made not long before March 1511. Perhaps Lorenzo's commission for the High Altar of S. Marina can be connected with the modest revival of architectural and sculptural activity perceptible in Venice in 1512. In January 1512, work had resumed at the Cappella Zen.[25] In February a contract was made to install the facade of the dormitory of S. Giorgio Maggiore.[26] In March, the rebuilding of the summit of the Campanile of St. Mark's, damaged in the earthquake of March 26, 1511, was begun.[27] In July, the Council of Ten decided to erect tombs in SS. Giovanni e Paolo for three fallen *condottieri* – Nicolò Orsini, Dionigi Naldi, and Fra Leonardo da Prato – heroes of the siege of Padua. The 300 ducats allocated to the tombs – a sum more appropriate to tomb slabs than to tombs – are a measure of the severe financial constraints imposed by war.[28] From about the same time or not long afterward date several works by Lorenzo that were sent abroad: the Altarpiece of the Holy Thorn to Belluno, the Altar of St. Leonard to Cesena, the Altar of St. Sebastian to Treviso.

It is during the period of the War of the League of Cambrai that Lorenzo seems to have supplanted his brother as the dominant member of their workshop. When Lorenzo's name is first encountered in documents of the Cappella del SS. Sacramento four years after the earliest archival notice regarding Giambattista, Lorenzo apparently was subject to his brother's authority. For the first time in 1511, Lorenzo received a commission in his own name from the presidents of the Trevisan Confraternity of the Holy Sacrament. In 1514 Giulia Verardi ordered the Altar of St. Leonard, not from Giambattista but from Lorenzo, although apparently she meant it as a counterpart to Giambattista's Altar of the Corpus Domini. Why, in 1514, was the work of stonemasonry for the vestibule of the Cappella del SS. Sacramento entrusted to Lorenzo and not to Giambattista, responsible for the incrustation of the chapel? Indeed, this period roughly corresponds with what appears to be a hiatus in Giambattista's activity between the Servi *Angels* and the *Deacon Saint* or the High Altar of the Frari. The Santo *Prophet*, for which Giambattista received the stone in 1507, for example, was not delivered until 1517. To be sure, this hiatus may be due to the incorrect dating of undocumented works or to a purely fortuitous loss of works and documents. Or the hiatus, as well as the reversal of Giambattista's and Lorenzo's roles in the conduct of their shop, may reflect a partial or total retirement from the activity of the workshop on Giambattista's part, perhaps

[25] Jestaz, 1986, p. 76.
[26] Cicogna, iv, 1834, p. 323, n. 190.
[27] Paoletti, 1893, ii, p. 276.
[28] Schulz, *Flor. Mitt.*, 1987, p. 304.

as a result of illness, of employment far from Venice, or of wartime service of which no archival trace remains.

By the later teens the Bregno's success in Venice was assured. No doubt, this was partly due to the artistic vacuum created by Antonio Lombardo's departure for Ferrara in 1506 and by Pietro Lombardo's death at an advanced age in 1515.[29] Tullio's concerns at this time, moreover, were chiefly architectural.[30] To this period belong the Frari High Altar and the Pesaro Altar, possibly the High Altar of S. Marina, the Altar of the Cross, as well as the Crivelli and Terni Tombs and the framework for the Altar of the Annunciation at Treviso. Indeed, there were few commissions for marble sculpture that the Bregno did not receive. The exiguous sum, appropriated in 1512 to the manufacture of the three *condottieri* monuments in SS. Giovanni e Paolo, which necessitated the use of limestone and wood (instead of marble and bronze) and the re-use of secondhand material and which left the rear wall of the tombs without a facing, also precluded the employment of an artist of first rank and explains why Antonio Minello, rather than either Bregno, was chosen for the task.[31] The Tomb of Giovanni Mocenigo (d. 1485), finished only in 1522,[32] probably had been entrusted to Tullio Lombardo decades earlier. The one significant exception is Venturino Fantoni's commission for the High Altar of S. Rocco in 1517 – a commission that he was in no position to execute unaided. Indeed, the statuary was carved, not by Fantoni or by any member of his shop, but by two outsiders and newcomers – Giammaria Mosca of Padua and Bartolomeo di Francesco of Bergamo.[33]

No extant documents record the death of Giambattista Bregno; from his execution of the Pesaro *Page* and the reassignment of his Santo relief, I infer that he died between late 1518 and April 1520. About Lorenzo's death, we are better informed. When Lorenzo died suddenly at the end of 1523 or the beginning of 1524, he had three works in hand: the *Madonna* for Montagnana, the Lamberti Tomb for the Duomo of Treviso, and an *Angel*, which may have been the mate to Giambattista's Pesaro *Reggiscudo*. Lorenzo had received an advance from Paolo Trevisan, presumably for his altar in S. Maria Mater Domini, but apparently had not begun to work on it. Soon after Lorenzo's death, the contents of his shop were purchased by Antonio Minello, who had settled in Venice a year and a half before.[34] Minello is representative of a wave of immigration by foreign sculptors after the War of the League of Cambrai, among whom were Giammaria Mosca from Padua, Paolo Stella from Milan, Bartolomeo di Francesco, and the stonecutters, Guglielmo dei Grigi and Venturino Fantoni, from Bergamo. They were drawn by the relative abundance of sculptural commissions that resulted in the *Madonna* for Calle Fiubera, major altars in S. Maria dei Servi, S. Salvatore, S. Geminiano and the ducal

[29] Bertolotti, 1885, p. 75; Paoletti, 1893, ii, p. 249.

[30] In 1507, Tullio was appointed *protomaestro* of S. Salvatore; in 1509, together with his father, he took charge of the construction of the Scuola Nuova della Misericordia; from 1512 he was *proto* at the Cappella Zen; in 1517 he made a model for the Cathedral of Belluno. See Paoletti, 1893, ii, pp. 241, 248, 252; Jestaz, 1986, p. 204, doc. 72.

[31] Schulz, *Flor. Mitt.*, 1987, pp. 300–319.

[32] Sheard, *Yale Ital. Studies*, 1977, pp. 249f, n. 34.

[33] Schulz in *Interpretazioni ven.*, ed. Rosand, 1984, pp. 258–62. I am now persuaded that my initial attribution of *St. Sebastian* to Giammaria Mosca was wrong and that it is by Bartolomeo Bergamasco.

[34] Sartori/Fillarini, 1976, p. 161; Sartori/Luisetto, 1983, pp. 349f, no. 273.

Chapel of S. Nicolò and the Tombs of Giovanni Battista Bonzio and Guidarello Guidarelli, both of whom had died two decades before.[35]

The Bregno's patrons fall into several categories. Among ecclesiastics were the prior and friars of the Franciscan Conventual Church of S. Maria dei Frari, for whom the Bregno made the High Altar, and the prior of the Benedictine Convent of S. Giorgio Maggiore, for whom Giambattista carved *St. George*. The High Altar of S. Sepolcro was executed for the congregation of Observant Franciscan nuns, but was paid for by an anonymous donor. At Treviso, commissions for work in the Chapel of the Holy Sacrament were awarded by Bishop Rossi and the presidents of the Confraternity of the Holy Sacrament. Probably Bishop Rossi also promoted the completion of the Shrine of the Three Martyrs, which resulted from a testamentary decree of an earlier Trevisan bishop, Giovanni da Udine. Although intended for the altar of a confraternity, the framework for the altarpiece in the Chapel of the Annunciation in the Duomo of Treviso evidently was a private commission of Canon Broccardo Malchiostro's.

At Belluno, the Altar of the Holy Thorn was erected at the expense of the commune; we do not know to what extent the government was involved as well in establishing the terms, and choosing the recipient, of the commission. Nor is there record of the nature of the commune's participation in the commission of the *Madonna and Child* for the portal of the Duomo at Montagnana. In Venice, patronage dispensed by the procurators of St. Mark formed a customary part of their governmental duties. The *Procuratori di S. Marco de supra* had charge of the Basilica di S. Marco and the buildings in and around the Piazza S. Marco. Therefore, supervision of the manufacture of a new altar for S. Marco devolved on them. Hence, we might expect the *Procuratori de supra* to have taken charge of the construction and decoration of the Cappella Zen as well. That they did not do so reflects the fact that funds for its construction came, not from the government, as with the Altar of the Cross, but from a bequest of Cardinal Zen's. In Venice, the Procurators of St. Mark were routinely nominated in testaments to serve as fiduciaries of testators' legacies and succeeded under law to administration of legacies without fiduciaries. Estates of testators domiciled on the eastern side of the Grand Canal were administered by the *Procuratori de citra*; those on the western side by the *Procuratori de ultra*. Because the cardinal had named the procurators, among others, as his executors and the Zen family had resided in the parish of S. Fantin,[36] execution of Zen's testament and realization of his tomb devolved upon the *Procuratori de citra*.

But most of the Bregno's patrons, whether at Treviso, at Cesena, or at Venice, were private persons acting on their own behalf or as executors of the testament of a deceased relative or friend. In Venice, private patrons of the Bregno were uniformly members of the patriciate. In this, the Bregno's patrons were not exceptional. Rather, it was the nonpatrician private patron of an important work of sculpture who was exceptional.[37] But an unusually high

---

[35] See Paoletti, 1893, ii, p. 201, n. 1, pp. 243f; Schulz in *Interpretazioni ven.*, ed. Rosand, 1984, pp. 257, 262, 264; eadem, *Flor. Mitt.*, 1985, pp. 93–104; Grigioni, *Rass. bibl.*, 1914, pp. 123–8; Catalogue no. 27.

[36] Jestaz, 1986, pp. 13, 16, 178, doc. 5.

[37] I can think of only three at the end of the 15th century: the jeweler Domenico di Pietro, patron of the Cappella di S. Salvatore in S. Maria della Carità; Giorgio Dragan "da la nave," patron of Cristoforo Solari's Altar of St. George in the same church; the physician Jacopo Suriano, patron of a tomb and altar in S. Stefano. See Paoletti, 1893, ii, p. 184, n. 7, p. 185, n. 1, pp. 204, 233.

proportion of the Bregno's patrician patrons belonged to the powerful elite of Venice's inner ruling circle. For Girolamo Pesaro, senator at the remarkably early age of thirty and eventually procurator, Giambattista made the Tomb of Benedetto Pesaro, *Capitano Generale del Mar* and procurator himself;[38] for a different branch of the same family, both brothers executed the altar of Bishop Jacopo Pesaro. Lorenzo was employed by the Bragadin family at S. Marina, by Lodovico Basadonna, *Podestà* at Montagnana.[39] Though a religious, Giambattista's patron at S. Giorgio — its prior Benedetto Marin — belonged to the Venetian aristocracy. Paolo Trevisan, frequent head of the Council of Ten in the 1520s,[40] charged Lorenzo with the execution of an altar in S. Maria Mater Domini. From the procurator, Alvise Pisani,[41] Lorenzo received the commission for the Tomb of Benedetto Crivelli. By virtue of their lifetime office, procurators were second in rank only to the doge. Of the four procurators from whom Lorenzo received the commission for the Altar of the Cross, Lorenzo Loredan was the son of the reigning doge, while Antonio Grimani and Andrea Gritti each in turn eventually became doge himself.[42] Yet it appears to have been the fourth member of the group — Alvise Pisani — who exerted greatest influence. *Procuratori de citra* at the time of Giambattista's commission for the Zen sarcophagus figures were Domenico Morosini, Nicolò Michiel, and Domenico Marino;[43] in matters relating to the Chapel of Cardinal Zen, Morosini's voice prevailed.[44]

The exception that proves the rule of patrician patronage of the Bregno's art is the notable commission for the High Altar of S. Rocco. In June 1516, the Scuola Grande di S. Rocco resolved upon the manufacture of an altarpiece for the High Altar of the confraternity's church; models were ordered from several stonecarvers, not specifically named. In March 1517, the altar's commission was awarded to Venturino Fantoni, a stonemason from Bergamo by whom no other work is known.[45] Traditionally, the *scuola's* General Chapter, an ad hoc council generally comprising thirty to fifty men, many of whom had previously held office but were then without a post, authorized funds for artistic as well as charitable projects, while the executive control of artistic projects, including the choice of artist, devolved upon the *Banca*, composed of two members from each *sestiere* plus the *scuola's* four officers.[46] Since 1438, however, all offices in Venetian confraternities had been limited to the citizen class.[47] We may be certain, therefore, that the selection of Fantoni was due exclusively to non-patricians.

A survey of the Bregno's patrons yields a high proportion of individuals or families involved in more than one commission. Most conspicuous are the Verardi of Cesena. The Altar of the Corpus Domini was commissioned by Carlo Verardi; its execution was overseen by Verardi's heir and nephew, Camillo; after Camillo's death, Giambattista was paid by Camillo's wife and the husband of Camillo's sister, Giulia. The Tomb of Ippolito Verardi was commissioned by Ippolito's two brothers, Camillo and Sigismondo. The Altar of St. Leonard was commissioned by Giulia, sister of Camillo and niece of Carlo, in execution of the former's

[38] See Catalogue no. 28.
[39] See Catalogue no. 8.
[40] See Catalogue no. 33.
[41] See Catalogue no. 5.
[42] See Catalogue no. 24.

[43] Manfredi, 1602, pp. 69–72.
[44] Jestaz, 1986, pp. 52, 53.
[45] Paoletti, 1893, pp. 123f, docs. 142, 146.
[46] Wurthmann, 1975, pp. 195–202.
[47] Pullan, 1971, p. 108.

testament. Alvise Pisani was one of four procurators responsible for the commission of the Altar of the Cross; he also oversaw construction of the Crivelli Tomb at Creola. Pisani's confessor was Fra Germano, for whom the Bregno made the frame and figures of the High Altar of the Frari. The Bregno's services were sought repeatedly by the bishop and members of the chapter of the Cathedral of Treviso, including the bishop's trusted suffragan, Broccardo Malchiostro. From the fact that no fewer than three of Titian's major paintings – the *Assumption of the Virgin*, the Treviso *Annunciation*, and the Pesaro Altarpiece – were embellished by a frame by Giambattista or Lorenzo Bregno, we may surmise that Titian's support was effective in procuring commissions for the sculptors. In short, it would appear that the Bregno's patrons were highly satisfied and recommended the sculptors to their friends and relatives. The quality of the Bregno's work speaks for itself. The sequence of commissions and payments, where they survive, indicates that, with the exception of the Santo reliefs, the sculptors were relatively punctual as well.

Despite the different tastes their different styles may be assumed to have gratified, Giambattista and Lorenzo did not enjoy substantially different patronage. Although there is no documented instance in which one person commissioned works from both, members of the same institution or extended family, such as the Verardi or the stewards of the *Arca del Santo* and the Procurators of St. Mark, entrusted commissions first to one, then to the other, brother. Both were engaged by ecclesiastics, patricians, Trevisans, Cesenati, and Venetians. Indeed, because the brothers frequently collaborated, they often ended by serving the same patrons. Where they did not, a certain percentage of Giambattista's patrons prove to have been significantly older than Lorenzo's. Carlo Verardi died in 1500; Giovanni Antonio Bettignoli died in 1504; when Domenico Morosini commissioned the female figures for the Zen Tomb from Giambattista, he was eighty-eight years old.[48] By contrast, Alvise Pisani was in his late fifties when he charged Lorenzo with the execution of the Crivelli Tomb and the Altar of the Cross. Giulia Verardi, Lorenzo's patron, was the niece of Giambattista's patron Carlo. But the more progressive artist was not invariably patronized by members of a younger generation. Giambattista's patron in the Cappella del SS. Sacramento, Bernardo de' Rossi, was born at about the same time as Broccardo Malchiostro, Lorenzo's patron in the Cappella del SS. Annunziata; Girolamo Pesaro was born three years after his cousin Jacopo and was thirteen years younger, when he employed Giambattista, than Jacopo, when he employed Lorenzo. Although he did not die until a decade later, Paolo Trevisan was approximately seventy when he commissioned his altar for S. Maria Mater Domini from Lorenzo. What a survey of the Bregno's careers does disclose, however, is that Giambattista's commissions are most densely clustered in the earlier period of the shop's activity, Lorenzo's in the later. To a large extent, this was the natural consequence of Lorenzo's late debut and Giambattista's early death. But, like the reversal of the brothers' roles in the running of the shop during the War of the League of Cambrai, it also may reflect a growing preference for Lorenzo's modern style.

Where the history of a commission executed by the Bregno can be reconstructed, the

[48] Sanuto, *Diarii*, viii, 1882, col. 27, Mar. 20, 1509.

work generally proves to have been decreed by testament. This holds true both for altars, such as the two altars in Cesena and the St. Sebastian and Bettignoli Altars in Treviso, as well as the Zen, Pesaro, and Crivelli Tombs and the Shrine of SS. Theonistus, Tabra, and Tabrata. By contrast, only Broccardo Malchiostro's Annunciation Altar, Jacopo Pesaro's Altar of the Immaculate Conception, Paolo Trevisan's altar in S. Maria Mater Domini, and probably Galeazzo Ostiani's Visitation Altar were made at the expense and during the lifetime of private patrons. To be sure, it was customary in Venice for heirs to construct their benefactor's tombs, usually from sums specifically allotted to that purpose by the defunct's will. But this was not inevitable, for, in instances where male descendants did not exist, the patron himself often saw to the construction of his tomb before he died. The relatively high number of commissions undertaken by the Bregno that resulted from testamentary bequests is not unusual in the context of Venetian sculpture. It may bespeak a reluctance to spend large sums on enterprises that brought no financial return, as long as the patron was alive to reap the profits of invested capital. Indeed, it would be tempting to attribute this supposed parsimony to mental habits rooted in the canny mercantile activity on which Venetian wealth was founded, were our sample not drawn from works commissioned by natives of Cesena, Treviso, and Milan, as well as Venice, whose ranks included three churchmen, one *condottiere*, and one jurist, but only one erstwhile Venetian merchant. But after all, the prevalence of commissions that resulted from testamentary bequests may have quite another, nonutilitarian, explanation, such as conformity to recognized but unstated standards of honor and decorum.

Without exception, every sculpture executed by the Bregno was a public work destined for a church. Indeed, the public nature of the Bregno's sculpture obtains even when the Bregno's patrons were private people acting for themselves or for a second person. Two sculptures only – the *Madonna and Child* for the main portal of the Duomo at Montagnana and *St. George and the Dragon* for the dormitory facade of S. Giorgio Maggiore – ornamented an exterior: the rest were intended for interiors. By far the largest number of the Bregno's works were altarpieces. Those carved for the Bettignoli, Ostiani, Pesaro, Trevisan, and both Verardi were installed on altars of which the respective families enjoyed the juspatronage; in most of these cases, if not in all, family members had the right of burial before their altar. The altarpieces of the SS. Sacramento and SS. Annunziata at Treviso adorned chapels appropriated to religious confraternities. The altarpieces of S. Marina, S. Sepolcro, the Frari, and the Shrine of SS. Theonistus, Tabra, and Tabrata occupied the high altars of their respective churches. The Shrine of the Three Martyrs functioned as altarpiece, tomb, and reliquary shrine; the Altar of the Cross, the Altar of S. Sepolcro, and the Cesena Altar of the Corpus Domini served as altarpiece and repository for the Host. In the Chapel of the Corpus Domini sculptural decoration extended beyond the confines of the altar. The decoration of the Chapel of the Holy Sacrament ranks among the more lavish programs of chapel decoration of the epoch; that of the Cappella del Santo is one of the most ambitious ever realized.

Commissions for tombs were fewer but still considerable. Two of these – the Crivelli and Terni Tombs – commemorated *condottieri* active in the War of the League of Cambrai. Terni was a native and resident of Crema, who spent his life in Venetian service; Crivelli made

his mark in Venice late in life by handing over Crema to the Venetian enemy. The Pesaro Tomb honored a Venetian civilian commander, who lost his life in the Turkish War. The Tomb of Ippolito Verardi was dedicated to an adolescent – one of a class rarely honored by a tomb. The Zen and Lamberti Tombs housed the remains of ecclesiastics. The contrast between the two makes manifest the former's exceptional character: the Zen Tomb is the only monumental tomb dedicated to an ecclesiastic in fifteenth or early sixteenth century Venice. Even the Tomb of Beato Lorenzo Giustiniani, by comparison, was modest.[49] Further, the material of the Zen Tomb set it apart from every other Venetian Renaissance tomb, even ducal tombs, and most other Renaissance tombs erected elsewhere in Italy: in regard to medium and size, only the papal Tombs of Sixtus IV (d. 1484) and Innocent VIII (d. 1492) are comparable. The Tombs of Pope Sixtus and Cardinal Zen shared an additional attribute – also rare in Italy – of standing free. The allusion to the most recent papal tombs made by the format, material, and size of the Zen Tomb could hardly have been other than deliberate: his tomb presumptuously claimed for Cardinal Zen the stature of a pope.

The range of the Bregno's commissions is not unexpected in the context of Venetian sculpture: by far the vast majority of Venetian sculpture of the time also was destined for tombs and altars. Almost entirely lacking until the second half of the sixteenth century are Venetian portrait busts. Small marble statuettes and reliefs of classical subjects, such as those that Cristoforo Solari, Antonio Lombardo, Pyrgoteles, Giammaria Mosca, Antonio Minello, and Simone Bianco made for the private delectation of erudite patrons, seem to have enjoyed a better market on the mainland than at Venice, at least until the 1520s. The very few extant reliefs of the *Madonna and Child* from the shop of Pietro Lombardo or the hand of Antonio Rizzo or Giovanni Buora suggest that in Venice even private devotional reliefs were relatively rare. Indeed, the only genre of Venetian sculpture conspicuously absent from the Bregno's oeuvre is statuary for facades. This may be due partly to the fact that large campaigns of external decoration, like those of the Arco Foscari and the Scuola di S. Marco, had ended not long before the Bregno's debut, while contemporary church facades made do with little or no statuary at all. Nevertheless, Giovanni Buora counted among his numerous commissions statues for the portal of the Palazzo Vescovile at Verona, and for the facades of the Civran Palace, S. Rocco, and probably S. Maria dei Carmini at Venice and the Cathedral at Osor.[50] These works, as well as the unattributable figures atop the facade of the Venetian Church of S. Gerolamo dei Gesuati (S. Maria della Visitazione) make plain that the importance of such work had declined lamentably since the first half of the fifteenth century, when the

---

[49] In the Oratory of Beato Lorenzo Giustiniani in S. Pietro di Castello, Venice, Sans., 1581, p. 5v, recorded a "statua marmorea posta sul suo [Giustiniani's] sepolcro all'incontro del predetto [the oratory's] altare." The tomb chest, whose existence this passage implies, is lost, but the effigy survives in the form of a freestanding, half-length, marble figure of less than mediocre quality in the Lando Chapel. Meyer zur Capellen, 1980/81, pp. 6–20, 32, attributed the *Giustiniani Effigy* to Jacopo Bellini on the basis of payments of 1457 to the latter for "una figura" of Lorenzo Giustiniani "posto sopra la sua sepoltura" (pp. 11f). But nothing justifies the assumption that the documented "figura" was carved from marble, or, indeed, that Jacopo ever practiced

as a sculptor. Meyer zur Capellen also granted the possibility that Jacopo's "figura" constituted the design for a sculpture executed by someone else (p. 18). But a fee of at least 32 ducats suggests something far more ambitious than a preparatory drawing. In any case, it is most unlikely that the present *Effigy of Beato Lorenzo Giustiniani* existed in 1489, when Bernardo Giustiniani disposed by testament that his uncle's sepulchre be remade with marble sculptures (Labalme, 1969, p. 315). Indeed, the "figura" by Jacopo Bellini very probably is what the marble *Effigy of Beato Lorenzo Giustiniani* replaced.

[50] Munman, *Arte ven.*, 1979, pp. 23–5; Schulz, *Arte lom.*, 1983, pt. 2, pp. 56–61, 64; Štefanac, *Ven. arti*, 1989, pp. 42–5.

embellishment of the facades and roof line of S. Marco and the entrance to the Ducal Palace had engaged the city's foremost sculptors. The lack of such commissions to the Bregno may therefore be a reflection of the high esteem in which their work was held.

In every case where they are known or can be reconstructed, the formats of the Bregno's tombs and altars show themselves to be, if not traditional, not unprecedented. Probably Giambattista's Bettignoli Altar originally resembled the Altar of the Virgin in SS. Giovanni e Paolo and the altar of the Cappella Giustiniani. *St. George and the Dragon* apparently reproduced the emblem of the Convent of S. Giorgio. The format of the Frari High Altar represents an early quotation of the 1503 framework for the Altarpiece of St. Ambrose in the Frari. The composition of the Pesaro Tomb was thoroughly prepared by the Vendramin and Emo Tombs. That something new resulted was largely due to the uniqueness of the tomb's dual function as entrance to the sacristy and tomb: in fact, the monument was never copied. The relative restraint in the distribution of ornament, now subordinated to the structure, and the regularity and repetition of members presaged the new architectural style of the 1510s. But the later framework of the Frari High Altar reveals no further progress in this direction.

In his Shrine of the Three Martyrs and the Sacrament Chapel *Evangelists*, Lorenzo faithfully reproduced the scheme, as well as three of the compositions, of the Giustiniani *Evangelists*. Though the combination of tripartite altar and tabernacle with an illusionistic barrel-vaulted hall in the Altar of the Cross had no precedent in Venice, neither component was new. Similarly, the frameworks of the Pesaro and Annunciation Altars followed well-established conventions. The format of the Terni effigy, drawn from the Tomb of Dionigi Naldi, alluded to Terni's steadfast allegiance to Venice during the War of the League of Cambrai. The location of the Crivelli Tomb in front of the altar of S. Maria del Carmine testified, according to custom, to Crivelli's foundation of the oratory that housed his tomb; its siting alluded to what was probably the most conspicuous *condottiere* monument in all of Italy – the Tomb of Raimondino de' Lupi. But what can Crivelli have had in mind when he chose Trecento Neapolitan funerary monuments as the model for his tomb? Among these traditional works, which made no changes in their borrowed formats, Lorenzo's Altar for S. Sepolcro stands alone as the first securely dated example in Venice of the chaste yet monumental style that was to dominate Venetian church furniture for the next couple of decades. Niches, engaged columns, projecting entablatures and bases, replaced flat membering. Decorative carving was banished; even columns were unfluted. In contrast to the marble revetment of S. Maria dei Miracoli or the Chapel of the Holy Sacrament, small slabs of variegated marbles protruding from the surface and framed by plastic moldings here appear as ornament, rather than as ground.

The formative influence of antique sculpture on Lorenzo Bregno's art begs an attempt to identify those works that might have roused his interest. Unfortunately, the results of such an inquiry are meager. With a reasonable degree of certainty, we can exclude most of the antiquities of central and southern Italy: what evidence exists implies that Bregno traveled little. His derivation of *St. Sebastian*'s head from Laocoon's younger son might suggest a trip to Rome, were it not that plastic reductions and drawings of the Roman sculpture are known to have circulated at Venice: although he did not visit Rome until 1545, Titian cited the

*Laocoon* not long after Bregno did himself. Lorenzo's sojourns at Treviso, Padua, and Cesena are documented: the shortest route from Venice to Cesena lay through Ravenna, where Bregno might have seen fragments of the *"Thrones of Neptune"*[51] and *"Ceres"*[52] or the relief of *Augustus with his Family*, from which Titian took the statue of an emperor in his Paduan *Miracle of the Speaking Babe* of 1511.[53] Lorenzo must have known the marble kneeling *Hercules* with the hemisphere of the heavens on his shoulders that the Venetian *podestà* at Ravenna and possible patron of the Servi *Angels*, Girolamo Donato, had reinstalled in the *cortile* of the *podestà's* palace.[54] At Cesena was a relief dedicated to *Jove Dolichenus* that Giovanni Marcanova drew in 1465.[55] But it must have been primarily in Padua, Venice, and Treviso that Lorenzo made acquaintance with ancient sculpture.

We can identify few works of classical sculpture present in Venice, beyond the bronze horses of St. Mark's and the lion and *"St. Theodore"* on the columns in the Piazzetta, before the arrival from Rome in 1523 of Cardinal Domenico Grimani's collection of antiquities. The two reliefs in the Museo Archeologico from the so-called *Throne of Saturn* can be traced in Venice as early as 1335; in Bregno's day they were immured beneath an arcade of Piazza S. Marco that led to the Frezzaria.[56] Around 1493 a marble statue of a *Priest* was brought from Ravenna by Girolamo Donato and placed in his palace at S. Stin; the statue is still there.[57] In 1503 the bronze *Praying Boy* in East Berlin entered the collection of Andrea Martini, lodged in his house near the Church of the Angelo Raffaele. Discovered at Rhodes, the figure was particularly prized for its Greek origin.[58] In Padua, Lorenzo could have seen the funerary altar with *Dancing Maenads*, drawn by Jacopo Bellini.[59] In Treviso the relief of a *Dancing Bacchante* was immured in an exterior buttress of the cathedral's choir at the time of its construction under Bishop Giovanni da Udine.[60]

Despite the paucity of antique sculptures that can be securely identified, we know that in the first half of the sixteenth century, private collections in Padua and Venice abounded in specimens of ancient art. In 1498 the Venetian jeweler Zoan Andrea del Fiore acquired "tronchi marmorei de corpi antiqui" from the estate of his recently deceased Venetian colleague, Domenico di Pietro;[61] in 1503 Zoan Andrea's own estate contained one classical male head in marble and others – evidently casts – in plaster.[62] Giuliano Zancharol's testament of 1515 ordered that, after his death, his antiquities be sold.[63] But the fullest testimony to the presence of ancient sculpture is provided by Marcantonio Michiel, whose lists of the artistic contents of private palaces in Padua and Venice reveal how avidly antiquities were collected. Though the lists generally do not predate the late 1520s, many of the collections visited by Michiel undoubtedly were formed much earlier. None of the collectors named by Michiel can be identified as a patron of the Bregno. Nevertheless, many collectors came from the same stratum of patrician society as the Bregno's patrons; through the latter, no

[51] Bober/ Rubenstein, 1986, p. 90, no. 52A.
[52] Schulz, 1983, p. 49.
[53] Curtius, *Arch. f. Kulturgesch.*, 1938, pp. 233f.
[54] Low, 1973, pp. 18f, 20f.
[55] Huelsen, 1907, p. 19.
[56] Venice, Bibl. Marc., *Coll. di antichità*, cat. ed. Zorzi, 1988, pp. 11f; Sanuto, *Diarii*, lvii, 1902, col. 298, Nov. 31, 1532.
[57] Venice, Bibl. Marc., *Coll. di antichità*, cat. ed. Zorzi, 1988, p.

24, no. 2.
[58] Ibid., pp. 45f.
[59] Bober/ Rubenstein, 1986, p. 121, no. 88.
[60] Coletti, 1935, p. 151, nos. 282, 283.
[61] Bertolotti, *Arch. stor. lom.*, 1888, p. 280.
[62] Brown, *BM*, 1972, p. 404.
[63] Paoletti, 1893, ii, p. 112, doc. 94.

doubt, Giambattista and Lorenzo gained access to houses that ordinarily were closed to them. Notable for the frequency with which they occur in Michiel's register are bronze statuettes and portrait busts, sometimes identified as emperors. In addition to the many torsos, were a few life-size, full-length statues, including one female nude and another "che si strenge li panni alle gambe."[64] On two occasions Michiel traced works to Greece;[65] presumably all the rest were Roman. There were relatively few examples of reliefs and, remarkably, none at all of sarcophagi.

Although artists did not form proper collections of antique sculpture, they did occasionally own single pieces. The sometime partner of Bartolomeo Bon, the stonecarver Pantaleone di Paolo, possessed the upper part of a life-size male nude in marble.[66] The Bellini succeeded in selling to Isabella d'Este their marble head identified as Plato.[67] We are reminded of Lorenzo's figure for the Zen sarcophagus by Raffaele Zovenzoni's description of Gentile Bellini's statue of *Venus*, which showed the goddess standing, her breasts exposed.[68] Tullio Lombardo owned a "figura marmorea de donna vestita intiera, senza la testa et mani,"[69] that might have influenced Lorenzo's statue of *St. Paul*.

To a considerable degree, the contents of Venetian and Paduan collections, as described by Michiel, accord with the reflections of antique influence visible in the Bregno's art. The contorted poses, often depicted in rear view, that Quattrocento sculptors earlier, and Titian later, derived from antique sarcophagi are conspicuously absent from Giambattista's and Lorenzo's oeuvre; so too is the characteristic mode of sarcophagus relief, in which a multitude of figures, filling the entire height and width of the available surface, are compressed within a single plane. Nor did the Bregno adopt the layered relief common to Roman columns, though it might have suited the high and narrow format of the *Visitation* better than the odd composition devised by Giambattista. By contrast, examples of monumental relief, like *Augustus and his Family* in Ravenna, indubitably determined Lorenzo's high relief technique. But the majority of the sculptor's works betray the influence of statuary — fairly large in scale and carved from marble — from which Lorenzo appears to have evolved the classicizing anatomy, proportions, and poses of his figures, their Roman armor, the draping of antique garments, and the treatment of their folds. The surfaces of his sculptures imitate the weathering of the drilled channels typical of the drapery of Roman statues. From fragments of heads come Lorenzo's classicizing faces and coiffures.

*Fig. 60*

The Bregno's preferred medium was marble. The bronze figures modeled for the Zen sarcophagus are exceptional in the oeuvres of Giambattista and Lorenzo (as they are in the oeuvre of Antonio Lombardo). To be sure, other small bronzes by them may have escaped detection. But no literary or documentary trace of such works exists. On the contrary, when acts do not refer to Giambattista and Lorenzo as "sculptor," the brothers invariably are named "lapicida" or "taiapiera" — stonecarver or stonecutter, while the final accounting of the liquidation of Lorenzo's estate calls the artist "sculptor in marmoreis." In fact, unlike Padua,

[64] Michiel/ Frimmel, (1521–43) 1896, pp. 90, 92. For collections of antiquities in Venice, Padua, and elsewhere in the Veneto, see also Low, 1973, pp. 45–60, 62–9.
[65] Michiel/ Frimmel, (1521–43) 1896, p. 110.
[66] Paoletti, 1893, i, p. 42, n. 4.
[67] Brown, *AB*, 1969, pp. 372–7.
[68] [Michiel]/ Morelli, (1521–43) 1800, pp. 193f, n. 102.
[69] Michiel/ Frimmel, (1521–43) 1896, p. 82.

where the production of bronze sculpture seems to have been concentrated, Venice offered few significant commissions for work in bronze during the first quarter of the sixteenth century.[70] The Bregno's only sculpture carved from stone other than marble is the relief for the dormitory facade of S. Giorgio. The choice of Istrian limestone in this case was conditioned by the relief's location: Istrian stone is much more resistant to weathering than marble; moreover, the relief was an integral part of the facade, clad, like most Venetian buildings of any pretension, with slabs of Istrian stone. Bregno's low fee undoubtedly reflects in part the use of the less valuable material. By contrast, Lorenzo frequently employed expensive stones – porphyry, jasper, verd antique, veined and colored marbles – as incrustation in the architectural surrounds of his altarpieces. In this respect, Lorenzo's work exemplifies a general change in taste, which transformed the appearance of Venetian church furnishings in the early sixteenth century. Most of the Bregno's sculptures were single, freestanding figures, which range in size from the slightly over-life-size figures of the Frari High Altar to the figures for the S. Sepolcro Altar, less than half a meter high. The Bregno's oeuvre also contains a number of reliefs, but, with few exceptions, these too portray single figures, in bust- or full-length. Carved in high relief, set on independent bases against neutral grounds, and divided from one another by the compartments that enclose them, these figures in relief did not present problems of design and execution that differed from those of statuary in the round. On only two occasions – in the *Visitation* and *St. George and the Dragon* – did Giambattista produce in a relief effects not obtainable in freestanding statues. These are the only reliefs carved by either Bregno in which a narrative event involving more than a single figure occurs within a setting, despite commissions to both brothers for scenes of miracles from the life of St. Anthony. Yet even in Giambattista's most pictorial relief, spatial recession is limited, while the setting itself establishes a boundary between the spectator's space and the space of the relief. In Lorenzo's Altar of the Cross, the effect of recession created by the perspective foreshortening of the setting is largely negated by the figure of the *Trinity*. Clearly, it was never the intention of either sculptor to depict that receding background accidentally truncated, as though by a window frame, recommended by Alberti.[71] The Bregno were not alone in their rejection of this goal, for, unlike Tuscan or Lombard sculptors, Venetian sculptors showed little interest in relief, and, with few exceptions, none at all in relief's potential for the portrayal of panoramas executed in low or *schiacciato* relief.[72] Typically Venetian, rather, is the Bregno's concentration on the single figure: one need only think of

---

[70] In addition to the sculpture for the Cappella Zen there were: Leopardi's three standards for the banners outside S. Marco, 1505–6; the grille for the Barbarigo Altar in S. Maria della Carità, 1515; Andrea Riccio's reliefs for the Altar of the Holy Cross in S. Maria dei Servi. See Paoletti, 1893, ii, p. 268; Jestaz, *Rev. de l'art*, 1982, p. 26; Schulz in *Studies . . . Janson*, ed. Barasch/ Sandler/ Egan, 1981, p. 189, n. 15; Planiscig, 1927, pp. 211–220; Venice, Ca' d'Oro. *Guida-catalogo*, by Fogolari et al., 1929, pp. 87, 141.
[71] Alberti/ Grayson, (1435) 1972, p. 54 (*De pictura*, bk. 1, par. 19).
[72] The exceptions include: Antonio Rizzo, *Conversion of St. Paul*, S. Marco (Fig. 13); Rizzo, *The Miraculous Cure of St. Anianus*, Scuola dei Calegheri; Pietro Lombardo, *Job and St. Francis*, portal, S.

Giobbe; *Mocenigo's Entry into Scutari*, *Mocenigo's Delivery of the Keys of Famagusta to Caterina Cornaro*, and *The Three Maries at the Tomb* from Pietro Lombardo's Tomb of Doge Pietro Mocenigo, SS. Giovanni e Paolo; shop of Pietro Lombardo, including Tullio Lombardo, reliefs from the altar (Fig. 1) and mural decoration of the Cappella Giustiniani, S. Francesco della Vigna; shop of Tullio Lombardo, *Lamentation over the Dead Christ*, ante-sacristy, S. Maria della Salute; *St. Jerome in Penitence*, Tomb of Benedetto Pesaro, S. Maria dei Frari (Fig. 28); Paolo Savin, *Resurrection*, altar, Cappella Zen, S. Marco; *The Baptism of Christ* from Tullio Lombardo's Tomb of Doge Giovanni Mocenigo, SS. Giovanni e Paolo. Most of these works were delegated to assistants.

the customary embellishment of tombs with freestanding *Virtues, Warriors, Pages,* and standing effigy or of altars with their statues of *Saints* or of the troops of *Apostles, Saints,* or *Virtues* in the round crowning choir screens or church facades — none of which finds counterparts in later Quattrocento Florence — to realize how decidedly Venetian patrons preferred statuary to figurative or architectural relief. On the other hand, by the early sixteenth century, Italian sculptors generally, encouraged by the antique statuary excavated on Italian soil and by Michelangelo's example, had largely abandoned relief in favor of the freestanding, life-size figure.

The image of the *Resurrected Christ,* carved three times by Giambattista, once by a follower working to Giambattista's model, and once by both brothers with assistance, occurs most often in the Bregno oeuvre. The *Resurrected Christ* occupied the center of the chapel or altarpiece, where tradition might have led one to expect the Virgin. A full-length, freestanding *Virgin* originally occupied a lateral bay of the Bettignoli Altar, while three half-length *Madonnas* in relief took subordinate positions above a portal or atop an altarpiece. *Angels* accompany the *Resurrected Christ* and the *Madonna and Child,* worship at the tabernacle of the Host or bear shields with coats of arms. Statues of *Saints* abound, their identity determined by the dedication of the church or altar to which they belonged, by the convent's order or the patron's preference. Apart from the kneeling donor and his nephew in the Verardi Altar of the Corpus Domini, all portraits represent the deceased in the context of his tomb. While there is no evidence that either Bregno ever worked as architect, both brothers apparently did specialize in frames, fabricating them as settings, not only for their own figurative sculpture, but also for Titian's paintings.

Though the evidence indicates that Giambattista and Lorenzo shared a shop, they did not receive joint commissions, like Giambattista and Savin. Yet the Bregno did collaborate on large projects. In the Cappella del SS. Sacramento, the contracts for the altarpiece and the statue of *St. Paul* were made with Giambattista, but payments were disbursed to Lorenzo, to whose authorship the works themselves attest. Of the three Zen figures ordered from Giambattista, only one shows traces of his hand, while a second is attributable to Lorenzo and a third, to a member of the Bregno shop. Responsibility for frames, in contradistinction to the figures adorning them, is consistent with the contractor's wider responsibilities.[73] For Giambattista's frame for the Frari High Altar — if it is really his — Lorenzo supplied *St. Francis.* For Lorenzo's frame of the Pesaro Altar, Giambattista carved a *Page.* The only instance in which both brothers appear to have contributed to a single figure is the *Resurrected Christ* from the Frari Altar — a work that seems to have passed through other hands as well.

Several of the Bregno's assistants, like the carvers of Christ and the two Maries in Treviso, the *Prophet* in the Santo, the two large Sacrament Chapel *Angels, SS. Mary Magdalene* and *Catherine* from the High Altar of S. Marina or the figures from the Altar of the Holy Thorn at Belluno, show themselves faithful copyists of their masters' designs and styles. Other collaborators, like the sculptor of *St. John the Evangelist* in the Bettignoli Altarpiece or the authors of *Mars, Neptune,* the *Madonna and Child* and *St. Jerome* in the Pesaro Tomb, carved

---

[73] Cf. the history of the High Altar of S. Rocco: Schulz in *Interpretazioni ven.,* ed. Rosand, 1984, pp. 258–62.

figures that differ so thoroughly, not only from Giambattista's figures for the same monuments, but from one another's, that these collaborators are unlikely to have been working from Giambattista's models or to have been trained as his assistants. Probably they did not even come from a single shop. This division of labor could have resulted from the joint commission of the work to Giambattista and one or more other sculptors, like the sculpture of Cappella Zen. Or Giambattista could have subcontracted statues that he did not mean to execute himself, as Venturino Fantoni did the statuary of the High Altar of S. Rocco. While the latter explanation might fit the Bettignoli Altar, executed before Lorenzo's debut, I do not think it can apply to the Pesaro Tomb, for, if the tomb is as late as I suspect, Giambattista would surely have employed his brother. It is more likely, therefore, that, in this case, the choice of sculptors and their respective tasks was Girolamo Pesaro's. If so, Girolamo singled out Giambattista as the most important of the sculptors involved by assigning to him the effigy and probably the tomb's design. Subcontracted or commissioned jointly, the Pesaro Tomb is unusual but not unique in the annals of early Renaissance Venetian sculpture: of equally heterogeneous style are the Tombs of Doge Tomaso Mocenigo (d. 1423) in SS. Giovanni e Paolo and Niccolò Brenzoni (d. 1422) in S. Fermo Maggiore, Verona.

Despite the fact that Giambattista and Lorenzo worked together as long as each was active, their styles differed fundamentally. The goal that inspired Giambattista was that of most Italian marble sculptors of the second half of the fifteenth century — the translation of visual reality into a medium that would have seemed, on the face of it, utterly inimical. Giambattista was not a realist if by that is meant an artist who seeks to convey the physical appearance of a variety of individuals with anthropometrical exactitude; much less was Giambattista concerned to depict man's situation within his physical environment or his emotional response to violent stimuli. But his art was realistic in the sense that he sought to reproduce, with absolute fidelity, ever subtler visual effects. His path had been cleared by Antonio Rizzo, who introduced to Venetian sculpture movement defined by the response of a correct and highly articulated masculine anatomy to pose. Rizzo's use of *schiacciato* relief permitted the rendering of distant landscape; undercutting of the contours of superimposed layers disclosed intervals of space; suppression of relief and streamlining of contours simulated the effect of atmosphere on vision. A complete technical mastery of marble carving thus allowed Giambattista to reproduce in solid material the illusion of space and air and to make an object that was not only stable, but stationary, appear to move. Poses made transitory by the divergence of the axes of hips and shoulders, by arms that clear the body, the raising of a foot and its extension beyond the limits of the base, the turn of a head with its implication of a momentary fixing of attention, were enhanced by the long-limbed and slender canon of Giambattista's figures, their tensed muscles, and fluttering hair and garments. Imaginary gusts of wind furled drapery when figures did not move. Giambattista's compositions typically played dense patterns of tiny and constantly changing folds against the immutably straight inner borders of garments and smooth outer contours of figures. The high finish that Rizzo lavished on some works and Tullio, with even greater scrupulosity, gave to nearly all, was imitated by Giambattista. The degree to which Giambattista smoothed and polished his statues served not only to differentiate the textures of cloth, hair, and flesh, but to endow

the stone with a sensuous and gleaming surface. The range of values common to marble sculpture was extended at one end by the high polish of white marble, at the other by the undercutting of the borders of drapery, the drilling of locks of hair, the perforation of the stone between claws or fingers. Stippling served not only to define texture, but to mute the brilliancy of stone without creating shadow. Finely etched lines denoting strands of hair, irises and pupils, the decorative details of dress, graphically defined each element in its minutest permutations when, as in the armor of *Benedetto Pesaro*, Giambattista felt obliged to report on every detail of an artifact of which he probably had little practical experience. At other times, as in the face of the *Angel* from SS. Giovanni e Paolo, linear details were suppressed in order to produce the effect of vision baffled by a hazy atmosphere. Motifs were cherished by Giambattista for the opportunities they provided to demonstrate his technical bravura: the sculptor proved that what the eye could see the hand could carve.

Lorenzo, by contrast, conceived the ideal race of a more heroic age: so faithful to the style of a distant age and alien culture are his figures that the author's own voice is barely audible. Proportions, poses, garments, facial types, and hair were derived from antique Roman sculpture. Figures, invariably mature, adhere to a single canon: whether male or female, Lorenzo's figures are uniformly monumental – Herculean in their physique. The rounding and generalization of anatomical form stopped short of abstract stereometry, yet contrived to eliminate those accidental features that differentiate members of a single species. *Contrapposto* is pronounced, poses sometimes unwind in space; movement, in all events, is a permanently valid measure of figures' force, not – as in Giambattista's works – a sign of change. In contrast to the reticence and introversion of Giambattista's figures, Lorenzo's actors exhibit their emotion through open mouths, focused glances, and rhetorical posturings. Immeasurable lengths of heavy cloth lend to figures dignity and stature or play out dramas of drapery's own making; of little concern to Lorenzo was the illusion of a variety of textures or the disclosure of subtle modulations of anatomical form beneath a layer of transparent cloth. With an idiosyncratic shorthand that never varied, Lorenzo alluded to the physical properties of hair and cloth, without ever counterfeiting them. The high finish and technical refinement of Giambattista's sculptures were foreign to Lorenzo: for him, the idea was more important than its realization.

High finish – the laborious erasure of every tool mark – generally is found among a constellation of stylistic traits linked by the extraordinary skill and patience and length of time required for their realization: literal and complete linear definition of naturalistic detail, accurate distinction of textures, exquisite and minute embellishment. All are traits of a large proportion of later Quattrocento marble sculpture, as well as most of Giambattista's works. However antithetical to the classic art of the High Renaissance, a virtuoso treatment of minutiae did persist in northern Italy among sculptors of Lorenzo's own, and a later, generation, such as Bambaia, Giammaria Mosca, Francesco da Sant'Agata, Giovanni Rubino, and Simone Bianco. That Lorenzo did not feel himself bound by the same standard of high finish is explained by the influence of antique sculpture, typically less finely finished even when well preserved. But the sanction given Lorenzo's devaluation of surface finish by the paintings of Giorgione, Titian, and Sebastiano del Piombo, where brushstrokes retain their individual

identity, where the weave of the canvas support obtrudes, and forms that lack precise linear definition take shape only at a distance, also must have been decisive. In adopting for his sculpture the same standard of rapid execution at the expense of surface finish that characterized the most innovative of contemporary painting, Lorenzo paved the way in Venice for the revolutionary art of Bartolomeo Bergamasco, which actually sought to imitate, in the surface of marble sculpture, Titian's loose and spontaneous brushwork.[74]

In other respects as well, Lorenzo's sculpture belongs unqualifiedly to the current of style exemplified by Giorgione's late paintings, by the paintings of Palma il Vecchio and Sebastiano del Piombo before his move to Rome, and by Titian's early works. Common features include corpulent figures made monumental by small heads and abstracted anatomy, fully developed *contrapposto*, externalized emotion, abundant draperies. The facial type, with its curving hairline and low brow, is standard in the work of all. The crimped locks of Lorenzo's figures recur in the paintings of Palma il Vecchio and Bernardino Licinio. The relative increase in scale and generalization of form, characteristic of Lorenzo's compositions, are also typical of High Renaissance painting. The same degree of ideality informs the work of painters and sculptor alike. Probably influence moved in both directions, as well as outward from a common source in antique art.

If Giambattista's sculpture signals the end of a long tradition, Lorenzo's art betokens the appearance of something new. What was new in Lorenzo's sculpture was not merely its dependence on classical *exempla*, for Tullio and Antonio Lombardo were as much indebted to the sculpture of classical antiquity as Lorenzo was himself. But Tullio and Antonio rendered classical models in a Quattrocento idiom. Trained in an age that held sculptors to an ideal of rich embellishment and technical perfection, they did not relax their standard of detail or finish for the sake of the seeming inattention to the surface that age and wear had conferred on Roman sculpture, and that Lorenzo, encouraged by the example of contemporary painting, could accurately mirror. Nor were their adaptations free of the formulaic linearity and stereometry that offered Tullio and Antonio a program for translating what, for them, was still a foreign language. Lorenzo's accomplishment was to compose freely in the classical style — to speak Latin, as it were, without an accent. Where Giambattista earns a place in the history of Venetian sculpture by having done supremely well what had been done before, Lorenzo's place is equally secure for having done what had not been done before.

---

[74] Schulz in *Interpretazioni ven.*, ed. Rosand, 1984, pp. 269f; eadem in *Studies . . . Smyth*, ed. Morrogh et al., 1985, ii, pp. 421f.

# APPENDIX A
# Documents

## LIST OF DOCUMENTS

I. GIAMBATTISTA BREGNO, *MIRACLE OF THE GOBLET* AND *PROPHET*, CAPPELLA DEL SANTO, S. ANTONIO, PADUA

A. Commission to Giambattista Bregno for the *Miracle of the Goblet*, October 20, 1502

B. Commission to Sebastiano da Lugano for the perspective above the *Miracle of the Goblet*, October 20, 1502

C. Advance to Giambattista Bregno for the *Miracle of the Goblet* and his commission for a *Prophet*, December 22, 1502

D. Giambattista Bregno's account with the Arca del Santo for the *Miracle of the Goblet* and the *Prophet*, 1504 to 1517

II. ELECTION OF GIAMBATTISTA BREGNO TO APPRAISE ANTONIO LOMBARDO'S *MIRACLE OF THE SPEAKING BABE* IN THE CAPPELLA DEL SANTO, S. ANTONIO, PADUA, DECEMBER 13, 1504

III. GIAMBATTISTA BREGNO'S APPRAISAL OF TULLIO AND ANTONIO LOMBARDO'S FIREPLACE HOODS IN THE DUCAL PALACE, VENICE, DECEMBER 28, 1505

IV. GIAMBATTISTA BREGNO, BETTIGNOLI BRESSA ALTAR, S. NICOLÒ, TREVISO

A. Testament of Venceslao Bettignoli, August 22, 1499

B. Codicil to the above testament, August 23, 1499

C. Testament of Giovanni Antonio Bettignoli, December 30, 1503

D. Giambattista Bregno's quittance for the final payment for Venceslao Bettignoli's tomb and altar steps, July 9, 1505

V. GIAMBATTISTA BREGNO, MARBLE REVETMENT OF THE CAPPELLA DEL SS. SACRAMENTO, DUOMO, TREVISO

A. Revetment of the two interior lateral walls, April 28 to October 6, 1504

B. Revetment of the pendentives, June 12 to November 3, 1506

C. Revetment of the apse, November 3 to 5, 1506

VI. GIAMBATTISTA BREGNO, ALTAR OF THE CORPUS DOMINI, DUOMO, CESENA

A. Petition of Carlo Verardi to found a chapel in the Duomo, October 18, 1487

B. Construction of Carlo Verardi's chapel in the Duomo, 1494

C. Removal of the Tomb of Bishop Antonio Malatesta, 1496

D. Installation of the Altar of the Corpus Domini, June 1505

E. Confirmation of the debt of the heirs of Carlo and Camillo Verardi to Giambattista Bregno for the Altar of the Corpus Domini and the Tomb of Ippolito Verardi, Church of the Crociferi, Venice, January 10, 1506

F. Final payment to Giambattista Bregno for the Altar of the Corpus Domini and the Tomb of Ippolito Verardi, January 13, 1506

VII. LORENZO BREGNO, SHRINE OF SS. THEONISTUS, TABRA, AND TABRATA, DUOMO, TREVISO

A. Commission to Pietro Lombardo for the Shrine of the Three Martyrs, January 25, 1485

VIII. GIAMBATTISTA BREGNO, FIGURES FOR THE SARCOPHAGUS OF CARDINAL ZEN, CAPPELLA ZEN, S. MARCO, VENICE

A. Contract with Paolo Savin and Giambattista Bregno for the six figures of the Zen sarcophagus, July 31, 1506

B. Payments to Giambattista Bregno for four figures of the Zen sarcophagus, October 30, 1506 to March 28, 1508

IX. GIAMBATTISTA BREGNO'S APPRAISAL OF ANTONIO LOMBARDO'S WORK FOR THE CAPPELLA ZEN, S. MARCO, VENICE

A. Election of Giambattista Bregno as appraiser, August 23, 1507

B. Giambattista Bregno's appraisal, September 24, 1510

C. Payment to Giambattista Bregno for his appraisal, September 25, 1510

X. GIAMBATTISTA BREGNO, ST. GEORGE AND THE DRAGON, DORMITORY, CONVENT OF S. GIORGIO MAGGIORE, VENICE

A. Commission and payments to Giambattista Bregno for St. George and the Dragon, October 11, 1508 to July 25, 1509

B. Payment for painting St. George and the Dragon, June 9, 1513

XI. GIAMBATTISTA BREGNO AND OTHERS, TOMB OF BENEDETTO PESARO, S. MARIA DEI FRARI, VENICE

A. Testament of Benedetto Pesaro, July 11, 1503

XII. GIAMBATTISTA BREGNO RECEIVES POWER OF ATTORNEY FROM ANTONIO BREGNO DA MILANO, OCTOBER 10, 1509

XIII. LORENZO BREGNO, ALTAR OF ST. LEONARD, DUOMO, CESENA

A. Testament of Camillo Verardi, June 19, 1504

B. Commission to Lorenzo Bregno for the Altar of St. Leonard, March 18, 1514

C. Lorenzo Bregno's quittance for his final payment for the Altar of St. Leonard, February 9, 1517

XIV. LORENZO BREGNO, ALTAR OF ST. SEBASTIAN, S. MARGHERITA, TREVISO

A. Commission to Lorenzo Bregno for the Altar of St. Sebastian, January 29, 1515

B. Transfer of Lodovico Leone's debt from Maddalena Zotti to Lorenzo Bregno, May 5, 1516, and May 31, 1516

XV. LORENZO BREGNO, ALTAR OF THE CROSS, S. MARCO, VENICE

A. Commission to Lorenzo Bregno for the Altar of the Cross, March 3, 1518

## XVI. LORENZO BREGNO, TOMB OF BENEDETTO CRIVELLI, S. MARIA DEL CARMINE, CREOLA

A. Testament of Benedetto Crivelli, July 20, 1515

B. Pastoral visitation of S. Maria del Carmine, May 11, 1572

## XVII. LORENZO BREGNO, *MIRACLE OF THE JEALOUS HUSBAND*, CAPPELLA DEL SANTO, S. ANTONIO, PADUA

A. Consignment of marble to Lorenzo Bregno for the *Miracle of the Jealous Husband*, 1519/20

B. Commission to Lorenzo Bregno for the *Miracle of the Jealous Husband*, June 16, 1520

C. Lorenzo Bregno's ratification of the commission, June 29, 1520

D. Lorenzo Bregno's account with the Arca del Santo for the *Miracle of the Jealous Husband*, 1522/3

## XVIII. GIAMBATTISTA BREGNO, *ANGELS* FROM S. MARIA DEI SERVI, VENICE

A. Payment to Bartolomeo Garbin for polishing the *Angels*, July 30, 1524

B. Record of the gift of the *Angels* for the Altar of Verde della Scala, 1524

## XIX. LORENZO BREGNO'S ESTATE

A. Sale of the contents of Lorenzo Bregno's shop to Antonio Minello, January 4, 1524

B. Lorenzo's widow, Maddalena Bregno, empowers her brother to represent her in all suits and controversies, August 3, 1524

C. Maddalena Bregno renews her brother's power of attorney, January 2, 1525

D. Ser Francesco de' Liprandi renders a final account to his sister of his liquidation of Lorenzo Bregno's estate, November 16, 1525

# ARCHIVES CONSULTED AND THEIR ABBREVIATIONS

|       | Archivio curia vescovile, Cesena |
|-------|----------------------------------|
|       | Archivio curia vescovile, Cesena |
| ASC   | Archivio di stato, Cesena        |
| ASF   | Archivio di stato, Ferrara       |
|       | Archivio curia vescovile, Padua  |
| AdAP  | Archivio dell'Arca del Santo, Padua |
| ASP   | Archivio di stato, Padua         |
|       | Archivio curia vescovile, Treviso |
| AST   | Archivio di stato, Treviso       |
|       | Archivio curia patriarcale, Venice |
| ASV   | Archivio di stato, Venice        |

All extant documents have been checked against the originals; corrections have been incorporated in the transcriptions.

## I. GIAMBATTISTA BREGNO, *MIRACLE OF THE GOBLET* AND *PROPHET*, CAPPELLA DEL SANTO, S. ANTONIO, PADUA

A. Commission to Giambattista Bregno for the *Miracle of the Goblet*, October 20, 1502

> ASP, Arch. not., Volume 2835 (not. Alvise Scoin), c. 357v.
> Copies of the document appear in AdAP, Registro 182, c.
> 35r, and ASP, Archivio Clero Regolare, Busta 1415, filza
> "Sculture"

Millesimo quingentesimo secundo Indictione quinta die Iovis xx° mensis octobris padue in cancelleria comunis de supra

Reverendus pater ac sacre theologie minister dominus magister petrus Balota guardianus monasteri et convenctus sancti antonii confessoris padue nomine suo ac venerandi sacre theologie ministrij domini magistri petri moschardi absentis. Necnon Spectabiles dominus franciscus de bradiolo et dominus petrus de zabrielis nomine eorum proprio ac vice et nomine spectabilis equitis et egregij artium et Juris doctoris domini antonij de boromeis et domini Nicolai asavonarolla collegarum suorum absentium pro quibus promiserunt de rato etc. tanquam massarij Arce gloriosissimj Sancti antonii confessoris de padua et vice et nomine dicti arce ex una, et providus magister Joannes baptista bregnon filius magistri alberti habitator venetiis in contracta sancti Joannis novelli gerens se pro patrefamilias propter senetutem et impotentiam patris ex alia venerunt insimul ad infrascriptam compositionem et conventionem in hunc modum videlicet

Primo el dicto maestro Zuan Baptista si promete et se obliga de far uno quadro de lalteza et grandeza de li altri quadri li quali al presente se fano a Venetia per maestro antonio lombardo cum tante figure di tuto relievo et di mezo relievo quante sera nel quadro del dicto maestro antonio lumbardo et obligasse de farlo in quela perfectione et bonta di figure che serano quelle del quadro del dicto maestro antonio et etiam mejiore et cusi sera laudato da persone experte cercha di zo. nel qual quadro se contegna el miraculo del migliolo che fece misser sancto antonio el qual quadro lui promete de darlo fornido ala piu longa in termene de duj annj proximj hano avegnere scomenzando el termene nel di presente.

Ex Adverso autem prefati Signori massarj per nome so et per nome che e dito di sopra prometeno dar et consegnar primamente al dicto maestro Zuan Baptista el marmoro per far tal quadro in duj pecj oltra di

questo dar et exborsar al predicto maestro Zuan baptista per sua mercede ducati cento et cinquanta doro . . .

Insuper precibus et Instantia dicti magistri Joannis Baptisti ibi presentis etc. Sebastianus de Lugano q. Ser Jacobi habitator Venetiis in Contracta S. Benedicti pro predicto magistro Jo. Baptista penes prefatos dominos massarios presentes et dicto nomine recipientes exstitit fideiussor et se fideiussorem et principalem debitorem constituit promitens pro se etc. quod prefatus magister Jo. Baptista attendet et observabit omnia per eum ut supra promisa sub obligatione etc. renuntians beneficio de fideiussoribus et de pluribus eis debendis . . .

Item Ser antonius pavonus q. Ser nicolaj de Contracta Sancti petrj

franciscus de tarvisio q. betini habitator in domo spectabilis domini antonij de captibus. vace.

> Publ: Sartori/Fillarini, 1976, p. 28, Sartori/Luisetto, 1983, p. 362, doc. 463; Wilk, in *Le sculture del Santo*, 1984, p. 124, n. 50.

B. Commission to Sebastiano da Lugano for the perspective above the *Miracle of the Goblet*, October 20, 1502

> ASP, Arch. not., Volume 2835 (not. Alvise Scoin), c. 358r.
> The passage transcribed below is preceded by a draft of
> the document transcribed above in Doc. I., A.

Item ultrascripti domini massarij nominibus quibus ultra convenerunt cum magistro Sebastiano de Lugano q. Ser Jacopi habitatore ut ultra in hunc modum videlicet el dicto maestro sebastian si promete et se obliga de far una prospectiva marmorea sopra lo dicto quadro (*Miracle of the Goblet*) da fir facto per el dicto maestro zuan baptista bella et di bonta et grandeza che conviene si che la sia de la belleza et bonta: et piu presto de piu che sono quelle che son fate fin hora.

Ex adverso predicti d. massarij nominibus quibus supra promiserunt dare et consignare eidem magistri sebastiano marmur neccessarium per faciendam dictam prospectivam et pro eius mercede ducatos vigintiquinque aurj finito opere et non ante.

Item S. antonius pavonus q. Ser Nicolaj de contracta Sancti petri.

Ser franciscus de tarvisio q. betinj habitator in domo spectabilis domini antonii de captibus. vace.

> Unpubl.

C. Advance to Giambattista Bregno for the *Miracle of the Goblet* and his commission for a *Prophet*, December 22, 1502

AdAP, Registro 369, (massaro Nicolò da Savonarola), c. 39v

Item 1502 adi 22 dizembrio

Yesu maria et Santi antonj

Maestro Zuan bapthista dibrioni sta avenexia die dar per contadi alui adi dito ducati zinque da mi nicolo come casier de larcha de consentimento de masari el padre guardian et misser piero moschado misser franzescho de brazuolier questo per caparra et parte de pagamento de uno quadro come consta per mano de Ser alovixe Scoin adi 20 otubrio . . .

lire 31 soldi —

E nota come adi soprascritto el soprascrito maestro zuan battista ne promesse far uno profeta come quelli de Ser Zuan de minello e meio per prezio de ducati sete prexente la paternità e la spettabilità de i padri et nostri colegi soprascritti fideiussori maestro bastian suo compagno e Ser Zuan de minello . . .

Publ.: Sartori/Fillarini, 1976, p. 28; Sartori/Luisetto, 1983, p. 362 doc. 465.

D. Giambattista Bregno's account with the Arca del Santo for the *Miracle of the Goblet* and the *Prophet*, 1504–1517

1. AdAP, Registro 370 (massaro Pietro da Lio), c. 51v, 1504

Salariatj et debitores Arcae (1504)

Maestro zuan baptista de i brionj taglia pria sta in Venesia de dare per denarj contadj come appare a c. 39 in libro di messer niccolò e questi denarj glie fino datj per capara de un quadro come consta de mano di Ser Alovixe Scoin adj 20 octob. 1502

lire 31 soldi —

Nota como adj dito maestro zuan baptista ne promesse fare uno propheta como quilj de Ser zuan de minolo e meglior per pretio de ducati septe presenti li segnorj deputati

Unpubl.

2. AdAP, Registro 371 (massaro Bartolomeo da Soncin), c. 97 left, July 1, 1504

Maestro Zuan baptista di brionj tayapietra in Veniezia de dare adj primo luyo 1504 per resti trato ut supra a c. 51 per capara de uno quadro

lire 31 soldi —

Et nota che ha promesso far uno profeta come quellj de Maestro Zuanne de minelo e megore per ducati 7 appar ut supra

Unpubl.

3. AdAP, Registro 372, (massaro Jacopo Dondi dall'Orologio), c. 52 left, July 1, 1505

Maestro zuan baptista de j brionj taiapreda in Venesia de dare per resto trato ut supra a c. 97 e fu per capara de uno quadro     lire 31 soldi — denari —

Nota che luj ha promeso de fare uno propheta come quellj de maestro zuan de minello e megliore per ducatj sete appare ut supra

Unpubl.

4. AdAP, Registro 373 (massaro Giovanni Battista Leone), c. 49 left, July 1, 1506, and June 30, 1507

Maestro Zuanbatista di brioni taiapreda in venesia de dare per resto trato ut supra a carta 52 i quali lui have per capara di far un quadro di figure di marmo

lire 31 soldi — denari —

Nota che lui ha promessa di far un propheta come son quelli di maestro zuan di minello per ducati sete et ha habudo el marmoro da farlo pagado alui per zuan di minello adi 30 zugno 1507 per lire undese et ge lavora tuta via

Ibid., c. 33 left, July 1, 1507

Adi primo luio in un pezo di marmo a venetia per far un profeta a maestro battista brioni

a carta 86     lire 11 soldi — denari —

Ibid., c. 86 right, July 1, 1507

A di — dito (primo luio) per un pezo di marmo a venetia

a carta 33     lire 11 soldi — denari —

Unpubl.

5. AdAP, Registro 377 (massaro Marsilio Papafava), c. 74 left, 1513

jesus 1513

Zuan baptista di brioni taia pria in venetia de dar adi 20 oct. 1502 per contadi alui per messer niccolo dela Savonarola massaio per chapara di far uno quadro di marmor et non feze per libro dil dito messer niccolo

carta 40

reporta fin a messer Johannes Baptista de lion

carta 49     lire 31 soldi —

E per zerto marmor ge pago maestro zuane minello apar per libro di dito messer Johannes Baptista de Lion

<div align="right">

carta 49        lire 11 soldi —

</div>

Unpubl.

6. AdAP, Registro 378 (massaro Bartolomeo da Campolongo), c. 40 left, 1514

Zuan batista di brioni taiapria invenetia de dar adi 20 ott. 1502 per contanti alui per misser niccolo dala Savonarolla per far uno quadro di marmore, e per marmore pago maestro zuan de minello. In libro di messer marsilio papafava

<div align="right">

carta 74        lire 42 soldi —

</div>

Ibid., c. 40 right, Feb 1, 1515

Zuan baptista alincontro de avere adj primo febraio 1515 per resto porto debitor ut supra

<div align="right">

carta 96        lire 42 soldi —

</div>

Unpubl.

7. AdAP, Registro 379 (massaro Bonifacio da Soncino), c. 96 left, Feb. 1, 1515

Zuane baptista di beroni tayapria in Venetia de dare adi primo febraio 1515 per resti in monte trato ut supra a carta 40

<div align="right">

lire 42 soldi —

</div>

Ibid., c. 96 right, Feb. 1, 1516

Zuane baptista alincontro die haver adi primo februario 1516 per resto porto debitor in libro de mi Justo a carta 38

<div align="right">

lire 42 soldi —

</div>

Unpubl.

8. AdAP, Registro 380 (massaro Giusto de' Giusti), c. 38 left, 1516

<div align="center">

Jesus 1516

</div>

Zuan baptista di beroni tayapria in venetia die dar per resto tratto ut supra

<div align="right">

carta 96        lire 42 soldi —

</div>

Ibid., c. 38 right

Zuan Baptista Briony tayapria sta in Venexia die havere porto die dar in libro di messer Zuan baptista lion

<div align="right">

carta 58        lire 42 soldi —

</div>

Unpubl.

9. AdAP, Registro 381, (massaro Giovanni Battista Leone), c. 57v, 1517

Maestro Zuanbatista di brioni tagiapreda e sculptore sta in veneixa a san Sovero die dare alarcha del santo lire quarantado per resto tratto del libro di messer giusto a carte 38 val

<div align="right">

lire 42 soldi — denari —

</div>

Ibid., c 58r

Maestro Zuanbatista contrascritto die havere uno prophetta di marmo che ello ha fatto el lo dete, et è in opera verso la capella di opici per ditto precio di lire 42

<div align="right">

lire 42 soldi —

</div>

Unpubl.

## II. ELECTION OF GIAMBATTISTA BREGNO TO APPRAISE ANTONIO LOMBARDO'S *MIRACLE OF THE SPEAKING BABE* IN THE CAPPELLA DEL SANTO, S. ANTONIO, PADUA, DECEMBER 13, 1504

ASP, Arch. not., Volume 2859 (not. Alvise Zupponi), c. 65r

1504 Indictione VII die vero XIII mensis decembris Padue in sacristia ecclesie sancti antonii confessoris

Cum sit quod alias facta fuerit certa conventio inter spectabiles et reverendos dominos massarios Arce Sancti Antonii confessoris de padua ex una: et honorabiles viros magistrum Tulium et magistrum Antonium filios ser Petri Lombardi sculptores ex altera super sculptura certorum miraculorum prefati gloriossimi Sancti Antonij pro fabrica capelle Arce in dicta ecclesia Sancti Antonij et inter cetera conventum fuerit inter eos quod factis et perfectis quadris per eos faciendis dicta laboreria deberent estimari per duos estimatores per ipsas partes eligendos, et casu quo non essent concordes quod deberent elligere tercium, et secundum estimationem faciendam per ipsos estimatores debent satisfieri predictis sculptoribus . . .

Ideo Reverendus dominus Messer Nicolaus grassetus Inquisitor Reverendus dominus Messer petrus moscardus guardianus conventus dicte ecclesie sancti antonij confessoris, necnon Magnificus eques et clarissimus juris utriusque doctor dominus Jacobus de zabarellis, et nobilis vir dominus bonifatij de soncino omnes massarij antedicte arce sancti antonij, ac ipse dominus bonifatius et nomine Magnifici equitis domini hanibalis de Capiterliste, et nobilis viri domini Alexandri de sole et massariorum et collegarum suorum ex una parte: et predictus magister Antonius Lombardus nomine suo proprio ex altera in executione antedicti instrumenti concorditer ellegerunt

magistrum Iohannem Christophorum sculptorem habitatorem Mantue, ellectum pro parte dicti magistri Antonii Lombardi, et magistrum Iohannem Baptistam Bregnon sculptorem habitatorem Venetiis ellectum pro parte prefatorum dominorum commissariorum ad estimandum unum quadrum confectum et sculptum per ipsum magistrum Antonium in quo sculptum est miraculum sancti Antonii prefati ubi quidam infans marchionis estensis locutus fuit (et facta sua prospectiva ipsi quadro) dicti estimatores habeant etiam estimare dictam prospectivam: promittens antedictus magister Antonius dare perfectum et completum dictum quadrum et eius additionem cum sua prospectiva. Ita quod poterunt poni in opere pro festo Pasce resurrectionis dominice proxime future et prefati domini massarii promiserunt dare et solvere de presenti ipsi magistro Antonio ducati quinquaginta auri ad bonum computam dicti quadri et prospective.

Publ.: Sartori/Fillarini, 1976, p. 138; Sartori/Luisetto, 1983, p. 359, doc. 410.

## III. GIAMBATTISTA BREGNO'S APPRAISAL OF TULLIO AND ANTONIO LOMBARDO'S FIREPLACE HOODS IN THE DUCAL PALACE, VENICE, DECEMBER 28, 1505

ASV, Provveditori al Sal, Busta 61, filza 5, cc. 188r–v

Die XI Januarij 1505 (m. V.)

I magnifici Signori missier Maximo Valier, missier Zuan Gritti, missier Marco Dandolo el Kavalier et Doctor et missier Piero Lando dignissimi Provedadori al Sal, absenti i magnifici missier Zuan Surian et missier Priamo lhoro college dignissimi: Intesa la rechiesta de maistro Tulio et maistro Antonio Lombardo fiolli de maistro Piero rechiedendo, cum sit che za molti mexi et anni lhoro habino fatto una nappa de marmori cum figure de piu sorte in la spectante sala de la audientia nec non uno canton de la nappa de la audientia pur de marmoro cum figure et chavalli come ad oculum veder si pola et mai sono sta fatti creditori in loffitio del Sal de tal suo lavoro: et pareno debitori de certi che lhoro per questo conto hanno havutto: che per sue Magnificentie fusse fatto stimar esso lavoro per persone pratiche a questo et poi farli far creditori a caso che intendano el fato suo: Unde che i magnifici provedadori predicti fatto deponer a maistro Sebastian taiapiera sta a San Benetto et a maistro Zuanbatista taiapiera a San Zuane Novo, i qualli cum juramento hano deposto prima visto per lhoro esso lavoro che per suo conscientie

li ditti meritano ducati dusento et trentacinque, zoe 235, come in essa deposition inferius registrata appar: omnibus consideratis come dar hano termena et termenano che essi maistro Tulio et maistro Lombardo per conto de ditta nappa et del canton del altra dela audientia siano fatti creditori de ducati duxento et trentacinque, zoe 235, come hano justificato per la deposition deli prenominati a caso che sapiano come se ritrovano in debito over in credito: et hoc omni meliori etc, che sono ducati duxento et trentacinque.

maria 1505 adi. 28. decembrio in Venexia.

Io Sebastian taiapiera a San Beneto con Zuanbaptista taiapiera a San Zane Novo, et per comission del magnifico missier Marco Dandolo provedador al offitio del Sal come noi sopraditti habiamo a veder et estimar una nappa con la istoria et frixo con itagli del larchitravo de ditta nappa posta nel receto dila audientia picola: Et cussi habiamo aveder una zonta chomo dela istoria dela nappa laqual e in la ditta audientia pichola: Et noi sopraditti habiamo visto et examinato con ogni nostra diligentia habiamo considerato il merito e la faticha dila sopraditta opera per nostra conscientia judichemo et stimemo el merito dela sopraditta opera ducati dusento et trentacinque val ducati 235. Et io Sebastian soprascripto ho scripto de mia propria mano.

Io Zuanbaptista soprascripto confermo quanto e ditto di sopra.

Die 29 Decembris 1505 juraverunt coram magnificis Dominis Provisoribus Salis et interrogati super generalibus recte responderunt.

Publ.: Lorenzi, 1868, p. 138, doc. 283.

## IV. GIAMBATTISTA BREGNO, BETTIGNOLI BRESSA ALTAR, S. NICOLÒ, TREVISO

A. Testament of Venceslao Bettignoli, August 22, 1499

AST, Arch. not., 1ª serie, Busta 422 (not. Giovanni Leonardo di Marco Berenghi), Testamenti, 1482, 1490–1501, cc. 101r–108r

...Nobilis et Spectabilis Vir Dominus Vincilaus de bizignolis q. Spectabilis domini Joannis Antonij de bizignolis de brixia civis et habitator Tarvisij sanus per gratiam omnipotentis Dei mente sensu et intellectu...Jubans et mandans et ordinans quod quandocumque de hoc seculo sibi transmigrarj contigerit corpus suum sepellirj debere in ecclesia Sancte Clare

dela Cella extra et prope tarvisium. In qua ecclesia
debeat hedifficarj sepultura sive monumentum mar-
moris fini in muro dicte ecclesie a parte interiori penes
altare magnum a latere dextro intrando in ipsam ec-
clesiam, eminens et ad altum in ipso muro pulcra et
ornata cum armis et insignis dicti domini testatoris
et ibi prope fabricari et construi debeat unum altare
de marmore fino cum suis ertis et voltis de marmore
fino et in medio dicti altaris debeat fierj figura domini
nostrj Jesu Christi de marmore praedicto fino et a
latere superiori imago sive figura gloriosissime Vir-
ginis matris Marie de marmore fino: et ab alio latere
Sancti Joannis Evangelista pur de marmore fino pul-
cre, bene et sufficienter laborato cum pulcris figuris.
Et sub archa praedicta sive sepultura debeat fierj in
terra unus quadrus cum lapide de marmore fino cum
litteris et epithafio facientibus mentionem et me-
moriam dicti domini testatoris. In quo loco dictum
monumentum in terra sit factum debeat reponi ca-
daver dicti domini testatoris. Item debeat fieri subito
sub archa praedicta in muro unus epithafius de mar-
more fino cum litteris et carminibus facientibus men-
tionem dicti domini testatoris ad perpetuam
memoriam ipsius et domus suae . . .

Anno domini millesimo quadringentesimo nona-
gesimo nono: Indictione secunda: die Jovis vigesimo
secundo mensis augusti . . .

Publ.: Schulz, *Arte cristiana*, 1983, p. 48, doc. 1; Sartori/
Luisetto, 1988, pp. 1447, no. 20.

### B. Codicil to the above testament, August 23, 1499

AST, Arch. not., 1ª serie, Busta 422 (not. Giovanni Leo-
nardo di Marco Berenghi), Testamenti, 1482, 1490–1501,
cc. 108r–109r

Suprascriptis millesimo et Indictione: die Veneris
vigesimo tertio mensis augusti . . .

Item reliquit et ordinavit quod dictus eius heres
teneatur post eius dicti codicillatoris mortem fecisse
et construj ac fabricarj fecisse sepulturam et capellam
eius domini Vincilai in ecclesia sancte Clare per eum
ordinatam ut in suo testamento praedicto contentum
in termino sex mensium proxime futororum.

Publ.: Schulz, *Arte cristiana*, 1983, p. 48, doc. 2.

### C. Testament of Giovanni Antonio Bettignoli, December 30, 1503

AST, Arch. not., 1ª Serie, Busta 366 (not. Girolamo di
Gaspare da Pederobba), filza 5, cc. 84r–87r

Dominus Joannes Antonius de Bicignolis aequitus
quondam Spectabilis et Integrissimi Viri Do-
mini . . . Deiphebi de Bicignolis Nobilis tarvisinus . . .
jussit voluit et ordinavit quod quandocumque ipsi
divinae maiestati placuerit ipsum e vita migrare ca-
daver suum sepeliri debere in eclesia monasterij Ver-
ginarum Donnarum monialium S. Clarae a cella de
extra et prope tarvisium. Et quod quanto citius et
commodius fieri poterit ad arbitrium infrascriptorum
suorum heredum et commissariorum dicti sui heredes
et commissarij fabricari facere teneantur pro ipso
domino testatore in dicta eclesia unam archam de
lapide marmoreo a latere dextero prope altare q. spec-
tabilis et generosi Domini Vincilai de bicignolis eius
patrui ad instar et similitudinem in omnibus et per
omnia prout est archa dicti domini Vincilai a latere
sinistro dicti altaris . . .

Anno Nativitatis domini nostri Iesu Christi mil-
lesimoquingentesimoquarto Indictione septima die
Sabbati trigesimo mensis decembris.

Publ.: Schulz, *Arte cristiana*, 1983, p. 48, doc. 3; Sartori/
Luisetto, 1988, p. 1448, no. 22.

### D. Giambattista Bregno's quittance for the final payment for Venceslao Bettignoli's tomb and altar steps, July 9, 1505

AST, Arch. not., 1ª serie, Busta 366 (not. Girolamo di
Gaspare da Pederobba), filza 8, c. 59v.

In nomine domini nostri Jesu Christi amen. Anno
eiusdem Nativitatis millesimoquingentesimoquinto
Indictione octava die Jovis nono mensis Julij tarvisij
in Palatio comunalis ad banchum juris magnifici do-
mini Potestatis et Capitanibus Ser Jacobo Antonio q.
Ser Jo. Mathi de bononia nominato, magistro Da-
miano de Vincentia Verzario q. magistri Jacobi pic-
toris et Jo. Antonio Rubeo Caballario q. Gregorij
Magnani civibus et habitatoribus tarvisij testibus ro-
gatis et aliis. Magister Jo. Baptista q. magistri Alberti
de breonis lapicida habitator venetiarum habuit et
recepit in praesentia dictorum testium et mei notarii
a Ser Lazaro Bevilaqua q. magistri Gasparini Verzarij
cive tarvisino factore et procuratore generosae don-
nae Charae relictae q. magnifici Domini Io. Antonij
de bicignolis aequitis nobilis tarvisini manae et tu-
tricis filiorum suorum ac filiorum et heredum dicti q.
domini Io. Antonij et de denarijs eiusdem donnae
Charae dicto nomine ut dixit dictus Ser Lazarus libras
quadragintaquatuor soldos quatuor pro partim in auro

et partim in monetis argentis computatis libris septem per quas idem magister Jo. Baptista sponte libere certa scientia et non errore aliquo confessus est habuisse et recepisse proantea ab eodem Ser Lazaro nomine quo supra. Et omni exceptioni dictarum librarum septem sibi non datarum habitarum et receptarum speique futurae dationis habitionis et receptionis amplius faciendae pacto renuntiavit expresse. Et hoc pro resto pretij sepulturae q. nobilis domini Vincilai de bicignolis patrui praefati q. domini Io. Antonij et scalinorum quibus ascenditur eius altare fundatum in ecclesia S. Clarae a cella de extra et prope tarvisium. Et vocavit et dixit sibi bene fuisse solutus et integraliter satisffactus. Faciens per se et suos heredes dicto Ser Lazaro dicto nomine finem et quietationem amplius aliquod aliud non petendo causis praemissis particulariter nec in toto.

Insuper idem magister Jo. Baptista per se et suos heredes sponte libere certa scientia et non errore aliquo contentus confessus et manifestus fuit sibi bene fuisse solutus et integraliter satisfactus computatis receptis per eum tempore vitae praefati q. domini Io. Antonij de bicignolis: et post eius mortem ab eius comissaria pro archa marmorea praedicti q. domini Vincilai constructa in suprascripta eclesia S. Clarae et pro quibuscumque aliis laborerijs per eum factis eidem q. domino Vincilao (crossed out) Io. Antonio. Idem suprascriptus magister Io. Baptista et Ser Lazarus antedictus nomine quo supra per se et suos heredes fecerunt sibi invicem et vicissim finem remissionem quietationem et absolutionem plenariam et generalem pactumque de amplius alter ab altero aliquod aliud non petendo particulariter nec in toto. Laus deo.

Publ.: Schulz, *Arte cristiana*, 1983, p. 48, doc. 4.

## V. GIAMBATTISTA BREGNO, MARBLE REVETMENT OF THE CAPPELLA DEL SS. SACRAMENTO, DUOMO, TREVISO

A. Revetment of the two interior lateral walls

1. Commission to Giambattista Bregno, April 28, 1504*

Formerly Treviso, Archivio curia vescovile, Cattedrale, Busta 25. The *busta* is lost.

1504 — Conventio inter dominos praesidentes scholae sacratissimi Corporis Chr. Tarv. et magistrum Joh. Bapt. de Brionis lapicidam, occasione confectionis ipsius capellae.

In Ch. nomine A. Anni eiusdem Nat. 1504, indictione septima, die dominico 22* aprilis Tarv. in epāli pal. in cam. aurea, presentibus rev. artium et decr. doct. dño Bertutio Lamberto primicerio et rev. domino Francisco ab Angelo can. Cath. Eccl. Tarv. tt. rog. et aliis — Ibique cum sit quod per dominos Presidentes scholae Sacr.ᵐⁱ Corporis domini nostri Jesu Chr. nuncupatae erecta fuerit una Capella in Cath. Eccl. Tarv. prope Capellam Magnam dictae ecclesiae sub vocabulo et ad honorem dicti Sacr.ᵐⁱ Corporis Christi, quae capella ab intus perfecta nondum fuit et praedicti domini praesidentes videlicet vener. d. pbr. rev. decr. doct. d. Andreas Asquinus can. Tarv., vener. d. pbr. Nicolaus de Padua mansionarius dictae eccl., specialis doctor d. Petrus del Getto, egregius ser Lodovicus Fregona not., prudentes viri ser Hier. de Rizatis et ser Philippue a Lignamine cives tarv. facientes (prout dixerunt) pro se et suprascriptis suis ac (nomine ven. viri d. pbr. Nicolai de Padua mansionarii, dicte Cath. eccl. eorum collegae absentis tamen ad hoc vocati ac) nonine antedictae Scholae, cupientes dictam capellam ornari condecenter facere, prout convenit tanto Sacramento iuxta eiusdem scholae possibilitatem, ideo Christi auxilio implorato, de presentia licentia et auctoritate Rev.mi in Chr. patris et d. d. Bernardi de Rubeis. Dei et Ap. Sedis gratia Episcopi tarvisini (capitis praefate ecclesiae) eandem capellam perfici et ornari affectantis, iidem domini presidentes ex una et magister Joannes Baptista de Brionis habitans Venetiis in confinio S. Joannis novi lapicida ex altera, renunciantes omni et cuilibet suo juri legum auxilio statutis et reformationibus tam canonicis quam civilibus ubique factis et faciundis cum quibus possent se defendere vel tueri a presente instrumento cum expensis etc per se et successores ac heredes suos unanimiter et concorditer devenerunt ad hanc compositionem et pactum, videlicet quod dictus magister Joannes Bapt. promisit per se et suos heredes ac se obligavit investire antedictam capellam circum circa ab intus videlicet a cornice superiori usque ad cornicem inferiorem et ab uno pillastro ad alium de marmore fino avenato perpulcro ita quod venae insimul conveniant; quod petia magna quae erunt, subtus fenestra et sub casamento ficto pro posse dicti magistri Joannis Bapt. sint et esse debeant de uno pecio et integra, cum incastraturis et cornicibus suis et cum cornice superiori et cum casamento in medio fenestrarum iuxta formam designi per ipsum magistrum Joan. Bapt. facti et praefatis d. presentibus praesentati ac manu mei not. infrascripti subnotati de lapideis pulchris et bonis et duris de Breonis

de bona ac pulchra et dura sorte laboratis cum suis cornicibus et soletis pulchris, dignis et ad materiam condecentibus et correspondentibus iuxta formam designi supradicti; et quod pars illa in qua vadunt fenestrae sine luce, lux ipsa sit ficta et fingi debeat cum duobus lapidibus nigris pulcris et lucentibus de Verona unius pecii pro singula, videlicet uno pro qualibet fenestra: qui magister Jo. bapt. se similiter obligavit et obligat ad conducendum omnes lapides marmoreos de Breonis huc Tarvisium ad locum dictae capellae et ad ponendum eos in lavorerio omnibus suis periculis et expensis; praeter quod ad espensam murarii et calcinae ad quam predicti d. Presidentes et schola teneantur; et e converso ipsi d. presidentes per se et suos successores sub obligatione etc. promiserunt de bonis eiusdem scholae ipsi magistro Joanni Baptiste dare et solvere ducatos centum viginti auri pro omnibus dictis lapidibus et eorum pretio ac pro omni et tota eius mercede laborandi ut supra; et de presenti dicti d. Presidentes pro parte dictorum ducatorum centum viginti dederunt et exbursarunt ipsi m° Io. Bapt. duc. viginti quinque in auro pro quibus idem magr. Jo. Bapt. eis finem fecit et promisit pro dictis duc. 25 receptis amplius aliquid non petendo particulariter nec in toto; quam finem et ... quae omnia etc. in for.

Publ.: Liberali, 1963, pp. 87–89, doc. XX. My transcription of this and the following documents regarding the incrustation of the Cappella del SS. Sacramento has been taken from this source.

* Liberali's date, Sunday, April 22, 1504, was reported by Biscaro, *Arch. ven.*, ser. 2, xviii, pt. 1, 1899, p. 183, as April 28. Very likely Biscaro's dating is correct, since in 1504, April 28 did fall on a Sunday, while April 22 did not.

## 2. Final payment to Giambattista Bregno for the work commissioned above, October 6, 1504

1. Formerly Treviso, Archivio curia vescovile, Cattedrale, Busta 25. The *busta* is lost.

1504 – Indict. sept., die dominico sexto oct. Tarvisii loco quo supra magr. Joannes Bapt. de Brionis suprascriptus confessus fuit habuisse [a rev. d. Andrea Asquino can. Tarv. surrogato in locum rev. d. Paridis Concanonici Tarvisini presidentis etc., vener. viro d.] a ser Hieronimo de Patrarubea syndico scholae predictae exbursante nomine dictae scholae de comiss. dominorum presidentum etc. ducatos triginta quin-

que auri pro resto operis suprascripti. Item duc. unum auri pro fenestris nigris fictis ei promissum oretenus per ipsos d. Presidentes ultra pretium antedictum pro quibus finem fecit etc.

Presentibus ad promissa d. Jacobo Bevaloto et magr. Hanibale intaiatore testibus rogatis et all.

Publ.: Liberali, 1963, p. 89, doc. XX.

## B. Revetment of the pendentives

### 1. Commission to Giambattista Bregno, June 12, 1506

Formerly Treviso, Archivio curia vescovile, Cattedrale, Busta 25. The *busta* is lost.

In Christi nomine Amen. Noto sia a chi vederà al presente scripto, como nel anno del nostro Segnor misser Jesu Christo 1506, indiction nona adì ven. 12 zugno, in Treviso, in camera aurea del palazo episcopale, li segnori Gastaldi dela Schola del Sacr.mo Corpo de Chr. de Treviso, videlicet lo Rev. miser Andrea Asquino canonico Tarv., lo vener. miser prè Zuane da Bollogna, mansionario dela Giesa Cath. de Treviso, el spec. miser Francesco dal Legname doct. de medicina, mis. Hieronimo de Rizatis, mis. Alvise de Fregona et ser Philippo Rosolin constituti in presentia del Rev.mo Monsignor miser Bernardo dei Rossi episcopo Tarv. et conte de Berceto, volendo proceder ala perfection dela fabrica de la Capella de la predicta schola, conveneno con magistro Joan Bapt. dei Brioni sta in Venetia tagliapria ad far li cantoni de la dicta capella apresso la cuba, de li infrascripti marmori et pietre, videlicet de marmori da Pisa venadi, che siano belli con le soe cornise de pietra viva, condutte tute cosse ben lavorade et messe in opera a tute spese de esso m° Zuan Baptista, excepto pietre cocte, calcina, murari et armadure le qual cosse vadano a spese dela predicta schola; per precio et mercato del dicto lavorio, li prenominati segnori Gastaldi prometteno dare a dicto m° Zuambapt. ducati trenta octo doro et non altro, et al incontro esso m° Zuan Bapt. promette a dicti Gastaldi far dicto lavoro a sue spese ut supra, le qual tutte cosse, dicte parte promesseno attender et osservar etc.

Franc. Novello not. episcopatus Tarv. rogatus subscripsi.

Publ.: Liberali, 1963, pp. 89f, doc. XX.

## 2. Advance to Giambattista Bregno for the work commissioned above, June 12, 1506

Formerly Treviso, Archivio curia vescovile, Cattedrale, Busta 25. The *busta* is lost.

Eo die in Cancelleria Episcopatus Tarv. ser Augustinus de Strasio not. et massarius antescriptae scholae de mandato prenominatorum dominorum Gastaldionum exhibuit et numeravit in presentia mei not. libras centum decem parv. mº Joanni Bapt. lapicidae antescripto ad computum conventionis de qua ultra.

Publ.: Liberali, 1963, p. 90, doc. XX.

## 3. Payment on account to Lorenzo Bregno for the work commissioned above, July 31, 1506

Formerly Treviso, Archivio curia vescovile, Cattedrale, Busta 25. The *busta* is lost.

Die veneris ultimo julii Tarv. in audientia Episcopali, pres.bus hon. d. Brocchardo Malchiostro cancellario et ser Hier. de Fenerio not. et coadiutore Curiae Episcopatus Tarv. testibus rog. Ibique magr. Laurentius lapicida frater magr. Joannis Baptae supra scripti sponte confessus fuit recepisse prout recepit in presentia testium suprascriptorum et mei not. infrascr. a d. Augustino de Strasso Syndico antescripto ducatos decem auri in tot monetis, et hoc ad computum infrascr. compositionis pro quibus nomine predicti magistri Johanis Bapt.tae eius fratris sibi finem fecit etc. Rev...etc. exceptioni etc. et illico magr. Annibal intaiator Tarv. ad Hortatium sponte etc. — Rec. etc. cum except. etc. ac oblig. pro cautione prenominati d. Augustini syndici de predictis ducatis decem numeratis prefato mº Laurentio et libris centum* parv. numeratis dicto mº Joanni Bap. prout supra constituit se fideiussorem pro ipsis fratibus in forma etc.

Publ.: Liberali, 1963, p. 90, doc. XX.

* This stands in contradiction to the sum of 110 lire recorded as advanced to Giambattista Bregno in the previous document.

## 4. Final payment of Giambattista Bregno for the work commissioned above, November 3, 1506

Formerly Treviso, Archivio curia vescovile, Cattedrale, Busta 25. The *busta* is lost.

Die martis tertio novembris Tarv. in audientia episcopali: presentibus ser Hier. de Fenerio not. et cive Tarv., et mº Antonio de Como Bissono agnominato murario in Tarv. ac mº Laurentio murario fratre ipsius m. Antoni test. rogatis. Ibique prenominatus magister Joannes Bapt. suprascriptus sponte etc. confessus fuit habuisse, prout effectualiter habuit et recepit, a ser Augustino syndico supra nominato, libras septuagintatres, soldos duodecim par. de den. antescriptae scholae sibi numeratos in presentia dictorum testium et mei notarii infrascripti; et hoc pro resto et integrali solutione conventionis ultrascriptae pro quibus ei finem fecit in ampla forma.

Publ.: Liberale, 1963, p. 90, doc. XX.

## C. Revetment of the apse

### 1. Commission to Giambattista Bregno for the *Resurrected Christ* as well as the revetment of the apse, November 3, 1506

Formerly Treviso, Archivio curia vescovile Cattedrale, Busta 25. The *busta* is lost.

Nota sia a chi vederà lo presente scripto qualiter per li speciali segnori Presidenti della Schola del Sacr.ᵐᵒ Corpo di Chr., videlicet [ser Aloise Fregona] ms. Francesco dal Legname doctor de Medicina, ser Alvise Fregona, ser Hier. di Crespignaga, ser Hier. de Rizatis et ser Philippo Rosolin conduxeno a di 3* nov. 1506 magr. Zuan Bapt. dei Brioni tajapria in Venetia ad investir la meza cappa over cuba dela capella del Sacr.ᵐᵒ Corpo de Chr. in domo de Treviso, et dicto mº Zuan Bapt. se obligò ad investir quella de marmori zalli avenadi videlicet dela sorte che sono li altri de dicta capella verso la capella granda de dicta giesia del domo, et far li nichi et cornise como appar per lo desegno per mi not. subscripto, seguendo lordene de la capella zà commensado, at dicti marmori siano netti et belli. Item far una figura de un Christo in resurrectione de tuto relevo, et promette far dicto lavoro per tuto lo festo de Pascha proxime futuro, et dicti segnori Presidenti li promisseno dar per dicto lavoro duc. cento doro et non altro.

Presenti alle soprascripte cosse d. Bernardino de Nuceto et ser Sebastiano da Coneglliano familiari del rev.mo Monsignor Episcopo nostro, testes rogati. Franc. Novello not.

Publ.: Liberali, 1963, p. 89, doc. XX.

*Biscaro, *Arch. ven.*, ser. 2, xviii, pt. 1, 1899, p. 184, gives this date as November 4th.

## 2. Payment on account to Giambattista Bregno for the work commissioned above, November 5, 1506

Formerly Treviso, Archivio curia vescovile, Cattedrale, Busta 25. The *busta* is lost.

Nota qualiter adì 5 nov. in pal. episc. Tarv.no el suprascripto m° Zuan Bapt. have contà da ser Lodovigo da Zuchareda syndico de la prefata schola de mandato dei soprascripti sign. Presidenti L. 262 s. 2, a conto del soprascripto lavoro dei danari de dicta schola, como appar etiam de questa exbursatione de mia man in el libro dei computi de dicta schola, videlicet L. 262. s. 2.

Publ.: Liberali, 1963, p. 89, doc. XX.

## VI. GIAMBATTISTA BREGNO, ALTAR OF THE CORPUS DOMINI, DUOMO, CESENA

### A. Petition of Carlo Verardi to found a chapel in the Duomo, October 18, 1487

ASC, Arch. not., Volume 105 (not. no. 14, Gaspare Marzi, 1484–89) n.c.

1487    Indictione quinta die decima ottava octobris

Reverendi patres dominus hyeronimus blondus prepositus, dominus franciscus deronianinis, dominus blaxius de bondinis, dominus Nicolaus m. Antonii, Dominus Johannes nicolaj epirota, dominus Paulus baptiste, dominus Carolus de barardis, dominus petrus de amelia et dominus bartolinus de bondinis omnes Canonicj maioris ecclesie Cesene Capitulariter congregatj in sacristia episcopatus ad sonum Campanelle ut moris est: Coram quibus exposuit prefatus dominus Carolus quod pro sua devotione cum sit Canonicus dicte ecclesie vellet fabricare suis propriis sumptibus in ecclesia episcopatus Cesene in Introitu dicte ecclesie Iuxta portam parvulam versus violam de lapis alatere versus altare Sancti maurj ubi est sepulcrum domini Antonij de forosimfronio olim episcopus Cesene, et vellet eam aptare et amovere dictum sepulcrum et ponere illud in alio loco in quo dictis dominis Canonicis melius visum fuerit, et si opus esset claudere fenestram ibi existentem in totum vel in partem vel eam amovere, et frangere murum pro fabricando et edificando dictam capellam. Et propterea petijt sibj licentiam darj dictam Capellam

fabricandj et cum hoc quod ipse et filij M. tolomej etiam nepotes et eorum descendentes habeant jus patronatus in dictam capellam in perpetuum.

Qui domini Canonicj ut supra visis et auditis predictis unanimiter et concorditer et nemine eorum discrepante dictam capellam fabricandj ut supra et amovendj et aptandj prout sibi melius cum fatu et voluntate ipsorum Canonicorum visus fuerit . . .

Publ.: Grigioni, *Rass. bibl.*, 1909, p. 160.

### B. Construction of Carlo Verardi's chapel in the Duomo, 1494

Fantaguzzi, (1460–1510) 1915, p. 49

1494 La capella in San Giovanni magniffica del Corpus Domini fo principiata e fatta questo anno.

### C. Removal of the Tomb of Bishop Antonio Malatesta, 1496

Fantaguzzi, (1460–1510) 1915, p. 64

1496 L'Arca di miser Antonio, veschovo de Cesena, questo anno abiando mutato 3 volte loco, prima nel coro possa dove fatto la capella del Corpus Domini et hora sopra la porta, el corpo suo fo trovato tutto intero e saldo come ume [*sic*] uno santo.

### D. Installation of the Altar of the Corpus Domini, June 1505

Fantaguzzi, (1460–1510) 1915, p. 217

1505 Giugno. La capella del Corpus domini nel domo fo stabilita de le figure de marmore per ducati 300 . . .

### E. Confirmation of the debt of the heirs of Carlo and Camillo Verardi to Giambattista Bregno for the Altar of the Corpus Domini and the Tomb of Ippolito Verardi, Church of the Crociferi, Venice, January 10, 1506

Formerly Cesena, Archivio curia vescovile, Canonici 1, 1280–1527. The document is lost.

Creditum magistri Ioannis Baptiste de Venetiis et afinis eiusdem quondam domini Camilli de Verardis.

In Christi nomine. Amen. Anno a nativitate eiusdem domini millesimo quingentesimo sexto, indic-

tione nona, tempore pontificatus Sanctissimi in Christo patris et domini nostri Iulii divina providentia pape secundi et die decima mensis Ianuarii.

Cum hoc sit quod alias tempore recolende bone memorie Reverendi quondam patris quondam domini Caroli Verardi et domini Camilli quondam magistri Ptolomei similiter de Verardis de Cesena, magister Ioannes Baptista de Brenionis (or Bernionis) habitator Civitatis Venetiarum in contrata Sancti Ioannis novi scultor seu lapicida, convenerit cum predictis facere certas figuras de marmore scultas pro Capella Corporis Christi existente in ecclesia Sancti Ioannis Baptiste de Cesena, quam prefatus quondam Carolus instituit et ordinavit, pro mercede scilicet in totum ducatorum centum sexaginta auri prout infrascripte persone asserunt et desuper dicunt factum fuisse et etiam extare scriptum privatum in effectum manu dicti domini Caroli: Cumque dictus magister Ioannes Baptista compleverit opus promissum in dicta ecclesia et Capella, prout ex evidentia facti manifeste omnibus patet, restaveritque et restet adhuc creditor heredum dicti domini Caroli et dicti domini Camilli ex causa predicta et ex causa fabrice sepolture domini Ipoliti fratris dicti quondam domini Camilli per ipsum Ioannem Baptistam facte in Civitate Venetiarum in ecclesia nuncupata Crusachieri prout idem magister Ioannes Baptista et ipsius tutores declarantur fuisse factum et predicta omnia et singula supradicta et infrascripta vere fecisse, videlicet in summa et quantitate ducatorum quinquaginta auri et marchettis sexdecim auri: Volentes magnifica domina Camilla uxor quondam bone memorie dicti domini Camilli et clarissimi artium, medicineque doctores magister Pandulphus Morus, et magister Vincentius Tuschus de Cesena tutrix ac tutores testamentarii Ptolomei pupilli filii ac heredis in effectum dicti domini Camilli pium et laudabile opus ac laborem dicti magistri Ioannis Baptiste recognoscere prout debito convenit et honestati, et reddere cautum, et contentum de dicto suo credito et resto facere, dictis nominibus dederunt, concesserunt et legaverunt ipsi magistro Ioanni Baptiste presenti et pro se et suis heredibus stipulanti ac recipienti in debitorem dicti magistri Ioannis Baptiste Montem Novum civitatis Venetiarum, qui mediantibus eius suprastantibus habeat solvere et satisfacere dicto magistro Ioanni Baptiste.

Notary: Giacomo Ferri.

Publ.: Burchi [1950], pp. 4–7; idem, 1970, pp. 40f; Viroli in *Il mon.*, 1989, pp. 55–57. My transcription of this and the following document has been taken from Burchi.

## F. Final payment to Giambattista Bregno for the Altar of the Corpus Domini and the Tomb of Ippolito Verardi, January 13, 1506

Formerly, Cesena, Archivio curia vescovile, Canonici 1, 1280–1527. The document is lost.

Cautio pro Ioanne condam domini Camilli facta a magnifico comite Ioanne ser Absalonis.

In Christi nomine. Amen. Anno a nativitate eiusdem domini millesimo quingentesimo sexto, indictione nona, tempore pontificatus Sanctissimi in Christi patris et domini nostri domini Iulii divina providentia pape secundi, et die decima tertia mensis ianuarii.

Cum hoc sit quod Magnifica domina Camilla uxor quondam domini Camilli de Verardis de Cesena, et eximii artium et medicine doctores magister pandulphus de Moris et magister Vincentius Tuschus de Cesena tutrix et tutores Ptolomei filii et heredis quondam dicti domini Camilli solverint et satisfecerint egregio viro Ioanni Baptiste de Bernionis habitatori Venetiarum sculptori seu lapicide, ducatos quinquaginta et Marchettos sexdecim eidem debitos pro mercede ipsius magistri Ioannis Baptiste debita pro fabrica certarum figurarum marmorearum factarum ad Capellam Corporis Christi in ecclesia Sancti Ioannis Baptiste de Cesena, et pro mercede fabrice sepolture facte pro domino Ipolito fratre dicti quondam domini Camilli in Civitate Venetiarum in ecclesia nuncupata de Crusachieri prout de predictis latius constat manu mei notarii infrascripti et prout dicti tutores et magnificus comes dominus Ioannes quondam Ser Absalonnis Destel nomine et vice Galeacii filii et heredis quondam Sigismundi fratris dicti quondam domini Camilli pro interesse dicti Galeacii declaraverunt et confessi ruerant omnis infrascripta . . .

Publ.: Burchi, [1950], pp. 6f, n. 10; idem, 1970, pp. 41f; Viroli, in *Il mon.*, 1989, pp. 56f, n. 10.

## VII. LORENZO BREGNO, SHRINE OF SS. THEONISTUS, TABRA, AND TABRATA, DUOMO, TREVISO

### A. Commission to Pietro Lombardo for the Shrine of the Three Martyrs, January 25, 1485

AST, Arch. not., 1ª serie, Busta 287 (not. Bartolomeo Basso), filza 1483–85, cc. 107v–108v

1485. Indictione tertia: die lune vigesimo quarto [sic]* Januarij Tarvisij: in officio provisorie super ca-

nonica nova comunis tarvisini praesentibus ser gu-
glielmo de rido, ser Andrea de bladino et ser Antonio
de Vascono civibus tarvisinis et magistro petro an-
tonio de Mutina q. magistri Pauli Chori ecclesie
sancti francisci de tarvisio opifice testibus vocatis,
rogatis et aliis.

Ibique Spectabiles viri domini d. hieronimus de
Roverio Juris doctor, d. Raynaldus de Raynaldis, d.
bartolomeus de Cornuda Juris consultus, ser Alovisius
Sugana notarius et ser petrus de petrarubea, hono-
rabiles provisores Magnifice comunitatis Tarvisii suo
nomine et nomine aliorum eorum Collegarum in
dicto officio provisorie, Reverendi patres d. Pileus de
Vonico benemeritus decanus ecclesie cathedralis tar-
visine, d. franciscus novellus artium et decretorum
doctor, d. bertholomeus de Roverio et d. franciscus
de azalis canonici dicte ecclesie nomine et vice Ve-
nerandi Capituli Ecclesie antedicte et Magnificus
eques et doctor d. Augustinus de Vonico tamquam
gastaldio scole domine s. Marie de batutis de tarvisio
habens vices collegarum suorum omnes tamquam ex-
ecutores donationis seu dispensationis facte supra-
scriptis nominibus quibus supra per Reverendissimum
in christo patrem et d. d. Joannem dei et apostolice
sedis gratia Archiepiscopum Thebanum et Episcopum
tarvisinum ut dicitur constare publico Instrumento
scripto per Venerabilem d. presbiterum hieronymum
spezamolinum de Venetiis notarium parte ex una: Et
providus vir magister petrus lombardus q. ser martini
lapicida in civitate Venetiis in confinio S. Samuelis
suo nomine et vice et nomine filiorum suorum quos
more Veneto, ad infrascripta omnia et singula per eos
et quemlibet ipsorum simul principaliter et in solidum
attendenda et observanda una cum ipso magistro pe-
tro patre suo, solemniter et efficaciter obligavit et pro
habundantiori cautella promisit facere illos hec omnia
laudare et approbare: parte ex altera: Insimul con-
venerunt, videlicet quod dictus magister petrus dictis
nominibus renuncians omni et cuilibet suo Juri, pro-
visionibus, statutis, legum auxiliis et refformationibus
comunis tarvisini et cuiuslibet alterius civitatis, terre,
castri, fori et loci factis et de cetero faciendis, cum
quibus se dictis nominibus a presenti Instrumento et
contentis in eo quolibet tueri posset. Cum expensis,
damnis, interesse litis et extra integraliter refficiendis,
et obligatione omnium bonorum suorum presentium
et futurorum per se et suos heredes promisit et se
solemniter obligavit ipsis dominis executoribus fa-
cere, perficere et adimplere omnia et singula contenta
in capitulis in vulgari sermone anotatis, ibidem pre-
sentibus ipsis partibus et testibus per me notarium

lectis, modis, formis in terminis et precio, prout in
eisdem capitulis constat, et secundum tria designa
ibidem etiam ostensa et a tergo per me notarium
signata et anotata: Et . . . prefati domini executores
omni exceptione Juris et facti cessante promiserunt
dicto magistro petro nominibus quibus supra dare et
solvere ducatos quingentos viginti auri: et plaustra
duo vini: pro predictis omnibus et singulis in dictis
capitulis anotatis per ipsum magistrum petrum no-
minibus antedictis perficiendis et adimplendis: pro
parte quorum dictus magister petrus habuit et recepit
in presentia dictorum testium et mei notarii infra-
scripti ducatos centum in monetis argenti cuntatos et
numeratos per prefatum d. Raynaldum depositarium
de mandato prefatorum d. executorum: quos ducatos
centum idem d. d. Raynaldus asseruit habuisse in de-
positum a prefato Reverendissimo d. Episcopo ad re-
quisitionem dicti magistri petri, ut stipulato presenti
Instrumento idem d. Raynaldus illos dicto magistro
petro daret et solveret: Ressiduum vero dictorum du-
catorum quingentorum viginti auri et plaustrorum
duorum vini, idem magister petrus habere debeat, et
sic eidem dare et solvere promiserunt prefati domini
executores de tempus in tempus: prout ipse magister
petrus dabit et consignabit de laboreriis in eisdem
capitulis anotatis: que omnia dicte partes promiserunt
sibi invicem et vicissim firma, rata et grata habere,
tenere, attendere et observare et non contrafacere vel
contravenire, de jure aut de facto, pro se vel alios
pena ducatorum centum auri solemni stipulatione
promissa: quam tocies peti et lui possit pro parte
attendente a parte non attendente quocies fuerit con-
trafactum, Et pena promissa, petita, soluta, exacta vel
non, semel aut plures, contra predicta omnia suo spe-
ciali robore potiantur. Et voluerunt dicte partes pre-
sentem Instrumentum pro ejus inviolabili robore et
perpetua firmitate posse quandocumque confici de et
cum consilio sapientis: Tenor vero dictorum capitu-
lorum infra sequitur.

Jesus. 1485. di 22 Zener.

. . .

La sepultura de sancto Theonisto, Tabra, et Ta-
bratta cum quattro colone cum quatro pedistalli: longi
tanto avanti de sopra la palla del altar grando tuta
lalteza de li capitelli: et sopra quelle una piana granda
sia de la man grossa da i brionj de la più perfecta, Et
sopra quella sia fatto cinque campi davanti: tre cum
le figure de li dicti Sancti: do de Tavole del dicto
marmo cornesade intorno: come sta el desegno, et
de drieto sia altri cinque campi: tre cum figure zoe

dio padre: la nunciata: e lo Angiolo: et do de dicto marmo: et in le teste lavorate le arme del dicto monsignor: Et sopra intorno intorno comenza una cornixe cum lo suo coperto schaiado sopra el qual sia uno sacrifficio dove stia el corpo de christo, el qual habia da uno ladi una portella de ramo, et da laltr.º uno vedro rosso, e dalaltre due, duo epigramj cum uno vaso de sopra, tuto lavorado segondo la forma del desegno. Item die far una schaleta da driedo che sia dopia cum uno patto al mezo proporcionada segondo el luogo.

. . .

Et die haver dicto maistro piero per suo pagamento ducati cinquecentovinti e opere over fachinj numero centotrenta: et sia obligado dicto maistro dar dicti lavori tuti cargi in burchio a soi pericoli e spexe. La conducta sia a spexe de esso monsignor, over suo executorj, siando maistro piero al descargar, e meter in opera dicti lavori tuti. Et oltra dicti cinquecento e vinti ducati dicto monsignor promette donar cari do de vin e quelo piu parera ala coscientia de esso monsignor segondo la perfection del opera, obligandose esso maistro piero dar tuti dicti lavori fatti e messi in opera compidamente, zoe de la cuba per tuto el mese de Aprile proximo seguente 1485. et tuto el resto per tuto Aprile . . . del anno 1486 segondo Treviso: Et non attendando possa far de suo danno ducati cento. Io piero lombardo son contento de zo de sora se contien.

Publ.: Biscaro, *Arch. stor. dell'arte*, 1897, pp. 151–3, doc. I; idem, *Arch. ven.*, ser. 2, xvii, pt. 2, 1899, pp. 185–9, doc. F

* January 24, 1485, was a Sunday. The correct date probably is January 25.

## VIII. GIAMBATTISTA BREGNO, FIGURES FOR THE SARCOPHAGUS OF CARDINAL ZEN, S. MARCO, VENICE

A. Contract with Paolo Savin and Giambattista Bregno for the six figures of the Zen sarcophagus, July 31, 1506

ASV, Procuratori di S. Marco de citra, Busta 242, fasc. Z XXV 4, fol. 51 right–fol. 52 left

Domini Dominicus Mauroceno et Nicolaus Michael doctor et eques dignissimi Procuratores . . . uti commissarii . . . et magister Paulus de Savia, incisor ligniaminum in Sancta Justina, et Joannes Baptista lapicida in Sancto Joanne Novo . . . convenerunt . . . hoc modo videlicet: che li dicti magistri Polo et Zuan-

baptista prometeno et se obligano simul et in solidum . . . de far a tute sue spese si de creda come di cera sei figure de quela bonta et perfection sono quele di la sepultura del quondam messer Orsato Justignan poste su la predicta sua sepultura in Sancto Andrea de Lio, le qual se hano meter su la sepultura del predicto quondam Reverendissimo Cardenal Zen ita et taliter chel [pia]xano ali predicti magnifici signori procuratori, [pia]xando dicte figure . . . loro se obligano dar et pagar per dicte sei figure . . . ducati octanta et quelo piu parera ale sue magnificentie fina a la summa de ducati cento: Ita che dicte figure stiano ben et di contento di sue magnificentie . . .

Publ.: Jestaz, 1986, p. 195, doc. 45.

B. Payments to Giambattista Bregno for four figures of the Zen sarcophagus, October 30, 1506 to March 28, 1508

1. ASV, Procuratori di S. Marco de citra, Busta 249A, fasc. VIIIb, no. 17

mº Paulo intaiador e mº Zuan Batista taiapiera die aver adi 31 luio 1506 per ser Antonio Lombardo per uno marchado fato con loro per el far de 6 figure. . . . duc. 80 . . . . . . . . . . . . . . . . . . . . . . . . . . . . . Lire 8
[en face] mº Paulo e Zuan Batista die dar che l'ano abudo contadi . . . duc. 40 . . . . . . . . . . . . . . . . . . Lire 4
e per contadi ano abudo mº Paulo intaiador duc. 195 de li qual meto a questo conto duc. 40 . . . . . . Lire 4

Publ.: Jestaz, 1986, p. 195, doc. 46.

2. ASV, Procuratori di S. Marco de citra, Busta 242, fasc. Z XXV 4, fol. 38 left

1509 die 22 Junij dedimus magistro Joanni Baptiste lapizide sub die 30 oct. 1506 ducatos 15 et sub die 13 aprilis 1507 ducatos 15 et sub die 28 martii 1508 pro suo resto duc. decem pro quatuor figuris ponendis ad archam . . . in totum . . . . . . . . . . . . . . . . . . . . Lire IIII

Publ.: Jestaz, 1986, p. 196, doc. 49.

## IX. GIAMBATTISTA BREGNO'S APPRAISAL OF ANTONIO LOMBARDO'S WORK FOR THE CAPPELLA ZEN, S. MARCO, VENICE

A. Election of Giambattista Bregno as appraiser, August 23, 1507

ASV, Procuratori di S. Marco de citra, Busta 242, fasc. Z XXV 4, fol. 52 right–54 left

...prudens vir magister Petrus Lombardus, architectus, tam suo proprio nomine et in sua propria specialitate quam uti...procurator...magistri Antonii lapicide eius filii:

I magnifici Signori Procuratori...et ser Piero Lombardo padre de Antonio Lombardo...sum rimasti da cordo...di far stimar tute le opere facte per el dicto Antonio fin sto di et altri fate far per lui al prexio quel che cadaun di esse monta al prexio che ultimamente iera rimasto da cordo el dito Antonio suo fio cum i Signor Procuratori predicti azoche el se possa veder el resto di quel che Antonio predicto sera credador over debitor. I stimadori...sono sta electi per primo magistro Sabastian taiapiera da Lugam sta a S. Benedetto, l'altro veramente magistro Baptista taiapiera nevodo fo de magistro Antonio Rizzo sta a S. Sovero.

Publ.: Jestaz, 1986, pp. 196f, doc. 52.

B.  Giambattista Bregno's appraisal, September 24, 1510

ASV, Procuratori di S. Marco de citra, Busta 249A, fasc. VIII b, no. 11

...tute opere prenominato visti per nui chon quela diligenzia che a nui esta posibele,

...

e cosi io Sabastian taia piera confermo quanto per noi e sopraschrito.

Io Zuanbatista di Brioni eschultore fezo da chordo chon maistro Sabastian tuto zio e soprascrito.

Publ.: Cecchetti, in Ongania, ed., VII, 1886, pp. 18f, doc. 124; Jestaz, 1986, p. 201, doc. 65.

C.  Payment to Giambattista Bregno for his appraisal, September 25, 1510

ASV, Procuratori di S. Marco de citra, Busta 242, fasc. Z XXV 4, fol. 38 right

...dedimus magistro Sebastiano lapicide in Sancto Angelo et magistro Joannibaptiste lapicide in Sancto Sovero qui extimaverunt laboreria facta pro archa... Lire 1, soldi 4

Publ.: Jestaz, 1986, p. 202, doc. 67.

## X.  GIAMBATTISTA BREGNO, *ST. GEORGE AND THE DRAGON*, DORMITORY, CONVENT OF S. GIORGIO MAGGIORE, VENICE

A.  Commission and payments to Giambattista Bregno for *St. George and the Dragon*, October 11, 1508 to July 25, 1509

ASV, S. Giorgio Maggiore, Busta 26, Processo 13B, Libro di conti 1507–1510, c. 35 left

✠ Jesus 1508

Notta come adj 11 octubrio 1508 el p. prior e convegnudo cum maistro zuan Baptista taiapiera sta a s. severo de far un S. Zorzi a cavallo de mezo relievo cum el dragon e la donzella in una pria Istriana da rovigno de alteza de pie 4 ¼ e de largeza pie 5. che stia ben et habia gratia in se et sia ben lavorado per ducati 28 computando la pria et ogni altra spexa. La qual opera die dar per tutto el mese de novembrio. Ha hauto a bon conto ducati 8 doro val. lire 49 soldi 12 presente alo acordo soprascritto et danari sborsadi maistro Zuan buora et maistro francesco taiapiera et dun gasparo col io

(c. 35 right: Maistro zuan Baptista taiapiera sta a s. Severo alincontro die haver per haver facto uno cavallo de piera distria el qual va sula fazada sopra el canal grando sul dormittorjo nouo monta dacordo ducati 28                                    lire 173 soldi 12)

adj 26 hoctubrio per cassa contanti per mj D. Zuan Anttonio al sopradicto ducati 6. abon contto et fo presente maistro Zuan buora in Cellerja
               a carta 34          lire 37 soldi 4
(c. 34 right: adj dicto [26 October]
      per maistro Zuan baptista tajapiera a S. Severo
               va a carta 35          lire 37 soldi 4)

adj 11 novembre per cassa conttanti per mj D. Zuan Anttonio a maistro Zuan buora per suo nome ducati 4 de orro a bon conto
               a carta 38          lire 24 soldi 16
(c. 38 right: adj dicto [11 November 1508] per maistro Zuan baptista taiapiera
               a carta 35          lire 24 soldi 16)

1509 adj 10 marzo per cassa contanti a lui per d. Gasparo lire 24 soldi 16 a bon conto
               a carta 39          lire 24 soldi 16
(c. 39 right: adj 10 dicto [March] per maistro Zuan Baptista taiapiera
               a carta 35          lire 24 soldi 16)

adj 31 dicto [March] per Cassa contanti aluj per d.
Gasparo lire 18 soldi 12 a bon contto

     a carta 39   lire 18 soldi 12
(c. 39 right: adj dicto [31 March] per maistro Zuan
Baptista taiapiera

     a carta 35   lire 18 soldi 12)
adj per Cassa contanti aluj per suo resto del sopra-
dicto Cavallo  a carta 39   lire 18 soldi 12
    tutto lire 173 soldi 12
(c. 39 right: adj 25 lujo per maistro Zuan Baptista
tajapiera   a carta 35   lire 18 soldi 12)

> Publ. in part: Cicogna, iv, 1834, p. 322, n. 190; Paoletti,
> 1893, ii, p. 256.

### B. Payment for painting *St. George and the Dragon*, June 9, 1513

> ASV, S. Giorgio Maggiore, Busta 26, Processo 13B, Libro
> di conti 1513, "Libreto per la fasada del dormitorio novo,"
> c. 5 left

Conto del depinger dela fazada die dar adj 9 zugno
contanti al depintor per depinger el S. Zorzi val.
         lire 37 soldi 4

> Publ. in part: Cicogna iv, 1834, p. 323, n. 190; Paoleti,
> 1893, ii, p. 256.

### XI. GIAMBATTISTA BREGNO AND OTHERS, TOMB OF BENEDETTO PESARO, S. MARIA DEI FRARI, VENICE

### A. Testament of Benedetto Pesaro, July 11, 1503

> ASV, Arch. not., Testamenti, Busta 1227 (not. Cristoforo
> Rizzo), no. 74 (protocol and copy)

. . . Anno Nativitatis eiusdem millesimo quingen-
tesimo tertio die xj^mo Julij Indicatione vj^ta . . . Ego Be-
nedictus dechadepesaro procurator Sancti marci,
capitaneus generalis maris Serenissimi Dominii Ve-
netiarum infirmus corpore sed sanus mente et intel-
lectu . . . volo ac ordino quod casu quo placuerit
altissimo Domino nostro Jesu Christo me ad se vocare
quod corpus meum imprimis sepeliatur in ecclesia
sancti Francisci Venetiarum ordinis minorum in ca-
pella nostra que est in sacristia eiusdem ecclesie fra-
trum minorum, et pro memoria volo quod commis-
sarij mei hic inferius nominandi et describendi fieri
faciant super portam eiusdem sacristie unum nobile
monumentum marmoreum cum collumnis marmoreis,

ubi corpus meum postea reponatur. Et fieri faciant
epitaphium rerum per me gestarum super ipso mon-
umento, in quo expendant usque ad summam duca-
torum mille, et de hoc onero conscientias eorum. Et
intentio mea est quod porta eiusdem sacristie desti-
netur et reducatur in forma convenienti, non acci-
piendo ob hoc aliquid eiusdem ecclesie et postea
super ipsam portam conficiatur superscriptum mon-
umentum marmoreum cum eis collumnis, prout su-
perius dictum est: Insuper volo et ordino necnon rogo
commissarios meos infrascriptos quod superscripti
denarij exbursandi quod conficiendo ipso monu-
mento vadant ad computum fraterne societatis. Et ita
volo, quod quodcumque lucrum per me factum in
presenti capitanaria vadat ad computum fratrum so-
cietatis cum hoc sit maximi honoris et decoris domus
nostre: verum si aliquis commissariorum meorum es-
set retrosus et nolet quod ipsum monumentum fieret
de fraterna societate quidem non credo, volo et or-
dino quod fiat de mea specialitate.

> Publ.: Schulz, *BJ*, 1984, p. 151, n. 35; Goffen, 1986, p. 200,
> n. 113.

### XII. GIAMBATTISTA BREGNO RECEIVES POWER OF ATTORNEY FROM ANTONIO BREGNO DA MILANO, OCTOBER 10, 1509

> ASF, Arch. not. antico, Not. Alessandro Benasciutti, ma-
> tricola 360, pacco n. 4, schede 1504–12

In Christi nomine amen. anno eiusdem nativitatis
millesimo quingentesimo nono Indictione duode-
cima. die decimo mensis octobris. Ferrarie. imbancho
Cambij egregij Caroli de Strocis Campsoris posito
super plateis Civitatis Ferrarie, presentibus testibus
vocatis et rogatis egregiis magistro Antonio Lom-
bardo sculptore de contracta bucecanalium. magistro
Michaele filio magistri Ioannis Coste pictore de con-
tracta Sancti Nicolaj et aliis.

Providus magister Antonius filius quondam ma-
gistri Petri Brignoni mediolanensis intaiator ligna-
minum ad presens trahens in Civitate Ferrarie in con-
tracta bucecanalium, non revocando propter hoc
aliquem alium suum procuratorem sed potius confir-
mando fecit constituit creavit et soleniter ordinavit
providum virum magistrum baptistam brignonum
sculptorem absentem tamquam presentem eius pro-
curatorem specialem specialiter etiam expresse ad
renunciandum spectabili et eximio juris consulto
domino Marino Quirino veneto unam apotecham

positam in Civitate venetiarum in contracta Sancte Marie Formose quam dictus constituens una cum magistro Paulo de Lanzano intaiatore lignaminum conducebant ad affictum a predicto domino Marino sub anua solutione ducatorum undecim auri. eo maxime quia dictus constituens non intendit amplius perseverare in locatione nisi nonquam ad medesimum mensem decembris proxime futurum ita postea sit in libertatem ipsius domini Marini posse desponere de ea apotecha pro suo libito voluntate quantum est respectu dicti constituentis. Et generaliter etc. . . .

Ego alexander bonasciuti notarius.

Publ.: Cittadella, 1868, ii, pt. 3, p. 193, repr. in idem, *Documenti*, 1868, p. 193.

## XIII. LORENZO BREGNO, ALTAR OF ST. LEONARD, DUOMO, CESENA

### A. Testament of Camillo Verardi, June 19, 1504

ASC, Arch. not., Volume 212 (not. no. 22, Baldassare Albertini), no. 70

. . .Magnificus eques auratus Dominus Camillus quondam clarissimi artium et medicinae doctoris magistri Ptholomei de Verardis de Cesena sanus gratia Domini Nostri Iesu Christi mente, sensu, intellectu, et corpore . . .

Item reliquit voluit disposuit et mandavit fieri debere et construi ac edificari pro anima ipsius testatoris in Ecclesia Cathedrali Caesenae iuxta et prope fontem baptismi unam capellam dicandam divo Leonardo secundum pacta et conventiones facta et factas per ipsum testatorem cum magistro dominico de bononia muratore, et magistro Ioannebaptista de castro bononiense carpentario de quibus pactis et conventionibus idem testator latius constare asserit ex instrumento super inde facto scripto et rogato manu ser Baptistae Gemati notarij publici Caesenae.

Item reliquit voluit et disposuit quod ultra praedicta fiant et fieri debeant sumptibus dictae suae hereditatis tres figure marmoree cum ornamentis eis convenientibus saltem infra terminum trium annorum proxime futurorum incipiendorum a die obitus dicti testatoris et prout sequitur finiendorum quarum una sit Sancti Leonardi quae in medio aliarum duarum collocetur et ponatur alia vero Sancti Eustachij tertia vero Sancti Christophori in quibus expendantur et expendi voluit et mandavit ad minus ducati quinquaginta auri.

Publ.: *Stat. civ. Caes.*, 1589, pp. 378–84; Grigioni, *L'arte*, 1910, pp. 42f.

### B. Commission to Lorenzo Bregno for the Altar of St. Leonard, March 18, 1514

ASC, Arch. not., Volume 161 (not. no. 18, Francesco Bucolini, 1514), n.c.

#### 1514 die 18 mensis martii

In Christi nomine amen

Magister Laurentius quondam Alberti Braniosus Lapicida et schultor habitator venetiis presens per se etc. solemniter se obligando promisit magistro vincentio tusco marito coniuncte parti magnifice domine Iulie verarde eius uxoris ac heredis olim domini Camilli verardi de cesena presenti eius nomine stipulanti facere tres statuas marmoreas ex marmore dicto de Carara finissimo videlicet unam Sancti leonardi alteram Sancti Christofori gerentis Ihesum Christum super eius humeris alteram vero Sancti Eustachii equitis cum Cerva ad pedes et in habitibus suis in dui tertii de relevo et plus et minus prout melius erit que sit tante pulcritudinis et pretii prout eis dabitur pro dictis figuris et prout melius fieri potest altitudinis 4 pedum cum dimidio que sint unius peccii pro qualibet et habeant Sub pedibus suas bassas cum tribus Casis lapidis de Briono de la man biancha de Istria cum tribus Casis al desegno existente penes me notarium foderatis ex marmore de Carara cum suis ornamentis competentibus prout dicto magistro Laurentio videbitur: omnibus sumptibus dicti magistri Laurentii et eas cum suis omnibus lapidibus neccessariis conducere usque ad portum et exonerare in terra suis sumptibus quas dictus magister vincentius teneatur conducere Cesenam suis sumptibus et dictus magister Laurentius promisit ponere in operam in capella dicti Sancti leonardi existente in episcopatu cesene omnibus suis laboribus operibus et sumptibus etc. Infra terminum unius anni proxime venturi inchoandi hac presenti die et ut sequitur finiendo etc. Et hoc pro mercede ducatorum Centum auri in auro: de qua summa dictus magister vincentius prefatus dedit et soluit dicto magistro laurentio presenti et ad se trahenti ducatos decem auri et ressiduum dare et soluere promisit eidem magistro laurentio modis et terminis infrascriptis videlicet finita una prima figura ducatos 20 finita 2.a figura ducatos 20 et finita tertia figura alios ducatos 20 et ressiduum dicte summe quod est de ducatis 30 finito toto opere et posito in opere.

Et dictus magister laurentius promisit dare unam

fideiussionem in venetiis ad omnem dicte domine Iulie petitionem tam de pecuniis receptis quam recipiendis et de opere perficiendo etc.

Actum Cesene in contrata Crucis marmoris in domo dicte domine Iulie presentibus Ibidem magistro Dominico Bengolo aurifice et magistro tomasio quondam antonii de mediolano lapicida cesene testibus.

Et ego franciscus Bucchulinus notarius de Cesene predictus omnibus presens fui ea quod rogatus scribere scripsi et publicavi.

Publ.: Grigioni, *L'arte*, 1910, pp. 45f.

## C. Lorenzo Bregno's quittance for his final payment for the Altar of St. Leonard, February 9, 1517

ASC, Arch. not., Volume 160 (not. no. 18, Francesco Bucolini, 1512–17), n.c.

In Christi nomine amen anno ab eiusdem nativitate millesimo quingentesimo decimo septimo indictione quinta tempore pontificatus sanctissimi in Christo patris et domini nostri domini Leonis divina providente clementia papa decimi et die nona mensis februarius.

Magister Laurentius quondam albertinis [sic] de benionis lapicida et schultor habitator veneciis presens per se et suos heredes in presentia mei notarii testiumque infrascriptorum non vi non dolo etc. dixit et confessus fuit se habuisse et recepisse ac sibi datos solutos et numeratos fuisse ducatos Centum auri in auro a Clarissimo medicine doctore magistro vincentio Tusco cesenate computatis ducatis viginti tribus auri quos dictus magister vincentius dedit et soluit dicto magistro laurentio in presentia mei notarii testiumque infrascriptorum pro resto dicte summe in monetis argenti et quatrenis in quibus tenebatur dicto magistro Laurentio pro eius mercede et factura trium figurarum cum earum ornamentis factarum et positarum in opere in ecclesia episcopatus cesene in capella Sancti Leonardi erecta per quondam dominum Camillum verardum et iuxta ordinationem testamenti dicti domini Camilli scripti et rogati ut dicitur manu Ser baldasaris albertini notarii publici cesene.

Actum Cesene in contrata Sancti Genonis in domo mei notarii infrascripti presentibus ibidem Magistro Tomasio quondam antonii de fiambertis de mediolano lapicida et habitatore cesene Dominico quondam merchioris de Bucchulinis et Cesare quondam Ioannis hercolani mazerio dominorum conservatorum cesene testibus.

Publ.: Grigioni, *L'arte*, 1910, p. 46.

## XIV. LORENZO BREGNO, ALTAR OF ST. SEBASTIAN, S. MARGHERITA, TREVISO

### A. Commission to Lorenzo Bregno for the Altar of St. Sebastian, January 29, 1515

AST, Arch. not., 1ª serie, Busta 356 (not. Giovanni Matteo Zibetto), filza 12 (1514–15), cc. 120 left–121 left

1515 Indictione 3 die Lunae 29 mensis Januarij Tarvisii In contracta Scorzariarum In domo habitationis infrascriptae domina magdalenae de claudis Presentibus m. Francesco q. Melchioris de Resane et Thomeo q. Dominici Boldrini de Belpago Scorzarijs et habitatoribus Tarvisij testibus rogatis et aliis.

Ibique prudentissima domina magdalena Relicta q. egregii Ser Nicolae de claudis civis et habitator Tarvisij ex una et providus Magister Laurentius Bregnonus q. Ruberti de Venetijs lapicida habitator in confinio S. Joannis novi ex alia omni meliori modo et forma quibus melius potuerunt venerunt ad pacta et conventiones infrascriptas videlicet dictus Magister Laurentius per se et heredes suos promisit et se obligavit ipsi dominae magdalenae ipsi presenti pro se et heredibus recipienti et stipulanti facere et construere et factum et constructum perfecte praebere unum altare seu ornamentum unius altaris nuncupati Sancti Sebastiani in ecclesia Sanctae Margaritae de Tarvisio latitudinis 4ᵒʳ pedum cum dimidio ad mensuram venetam in sportis in quibus maior latitudo est, cum figura Beati Sebastiani longitudinis quattuor pedum Venetorum scilicet ad magnitudinem similitudinis Sancti Sebastiani nunc existentis in dicto loco proportionaliter in reliquis omnibus prout et ad similitudinem modelli parvi existentis penes ipsam dominam magdalenam ex optimis et sufficientibus marmoribus, exceptis duobus scalinis qui fierent ex petra viva, quod laborerium dare promisit et se obligavit perfectum integraliter conductum ad dictum locum et positum ordinatim circa dictum altare omnibus expensis dicti magistri Laurentij, prout stare debet. Dante iam solum ipsa domina magdalena lapides coctos, calcem, plumbum et arpesetos circa dictum altare occurrentes et non altera. in reliquis vero dictus magister Baptista [sic] se obligat ut supra omnibus suis expensis et periculis facere, declarato quod petra altaris plane quae de presenti est supra ipso altari, debeat reponi supra altari novo, et habeat terminum dandi dictum laborerium perfectum, ut supra, usque ad unum annum proxime futurum. Et ipsa domina magdalena per se et suos heredes pro eius mercede et expensis alijs omnibus dare promisit dicto magistro

Laurentio ibi presenti ducatos centum auri hoc modo, videlicet ex nunc dedit, cessit et renuntiavit ipsi magistro Laurentio ad computum dictorum ducatorum centum iura sua omnia quae habet contra dominum Luduvicum de leono civem patavinum ad presens habitatorem venetiis debitorem suum de ducatorum quinquaginta auri, quem debitum dictus magister Laurentius acceptavit et acceptat in debitum ad suum computum et pro parte ut supra, et de presenti in presentia testium suprascriptorum et mei notarij infrascripti dedit et numeravit ducatos decem auri in monetis et ducatos decem auri dare promisit dicta domina magdalena ipsi magistro Laurentio in progressu operis ad omne beneplacitum ipsius magistri Laurentij, et reliquos ducatos triginta auri quum expedierit et opus erit perfectum, et positum circa dictum altare ordinatim. Et pro dictis ducatis sexaginta habitis in denarijs et debito predicto fecit dictus magister Laurentius dictae dominae Magdalenae finem et remissionem ac pactum quoscumque de eis non petendo in parte vel in toto. Et ambae partes promiserunt sicut suprascripta omnia et singulam habere firma rata et grata sub obligatione omnium suorum bonorum presentium et futurorum.

[*In the margin:*] 1516 die Lunae 5 mensis maij loco suprascripto presentibus infrascriptis ibique suprascripta domina Magdalena in executione mercati facti cum suprascripto Magistro Laurentio pro manifactura altaris lapidei quod construit ad presens in ecclesia Sanctae Margaritae ad ipsius dominae magdalenae instantiam ut in suprascripto instrumento continetur omni meliori modo quo potuit per presens instrumentum dedit libertatem ipsi magistro Laurentio exigendi ducatos quinquaginta auri a Spectabili doctore domino Luduvico de leono cive patavino ipsius dominae magdalenae debitore. Et eidem eius nomine finem de dictis ducatis L.^ta faciendi in forma. Et hoc quod computum mercedis suae suprascriptae...

Publ.: Biscaro, *Atti...dell'Ateneo di Treviso*, 1897, p. 279, n. 3.

B.  Transfer of Lodovico Leone's debt from Maddalena Zotti to Lorenzo Bregno, May 5, 1516, and May 31, 1516

1. AST, Arch. not., 1ª serie, Busta 356 (not. Giovanni Matteo Zibetto), filza 14 (1515–16), c. 142 left

1516 Indictione 4 die lunae 5 mensis maij Tarvisii in contracta Scorzariarum

Hic cedit Instrumentum libertatis datae per dominam magdalenam de claudis magistro Laurentio Bregnono lapicide exigendi ducati L^ta quod est in margine alterius instrumenti ipsius dominae magdalenae in libro anni 1515 die 29 Januarij.

Unpubl.

2. AST, Arch. not., 1ª serie, Busta 356 (not. Giovanni Matteo Zibetto), filza 12 (1514–15), cc. 120 right–121 left

1516 Indictione 4 die sabbati ultimo maij Tarvisii in plathea sub palatio ad apothecam suprascripti mei notarii...suprascriptus Magister Laurentius lapicida habuit et recepit a Ser francesco de bavaria notario ibi presente dante et consignante nomine suprascriptae dominae magdalenae chirographum suum nominantem ducatos quinquaginta auri subnotatum manu suprascripti domini Luduvici de Leono iuris utriusque doctoris cum eius sigillo diei 21 novembris 1503 usque notificans habuisse denarios de dicto millesimo et die et cui Ser francesco dicto nomine fecit finem dictus Magister Laurentius.

Unpubl.

## XV.  LORENZO BREGNO, ALTAR OF THE CROSS, S. MARCO, VENICE

A.  Commission to Lorenzo Bregno for the Altar of the Cross, March 3, 1518

ASV, Proc. di S. Marco de supra, Chiesa, Affitanze, registro 173, cc. 6r–6v

### Iesu Christi tertia martij 1518

Clarissimi domini Andreas griti, laurentius lauredano, et aloysius pisani: absente Clarissimo Domino Antonio grimani, procuratores de supra ecclesie Sancti marci: Volentes removere locum ubi ad presens reconditur preciosum Corpus Domini nostri Jesu christi propter inreverentiam habitam ab hominibus inde transeuntibus: et condere alium locum: ut devotius illud a fidelibus adoretur. Per la qual cosa sue Magnificentie sono convenute et acordatosi cum maistro Lorenzo brignon taiapiera in questo modo Videlicet chel se faci uno ornamento et opera a laltar de la Croce secundo el desegno monstrato in procuratia a li prefati signori, tuto de marmi, Serpentini, et profidi et altre piere fine et in tuta belleza. De le qual tute piere provederasi per maistro bon protho de la procuratia per conto di quella. El qual maistro Lorenzo promette in dicto ornamento far la sua pros-

pectiva che intre dentro mezo piede, cum do anzoli un per banda de la portella del Corpo de Christo piu che de mezo relievo. far etiam uno dio padre i nel mezo volto sopra la portella de mezo relievo et piu presto piu che mancho. far etiam do figure de tuto relievo Videlicet san francesco et sancto antonio da padoa, una per banda intro i nichi, cum li suo ve-stimente conveniente a dicte figure scossi fuori i dicti drapi piu che se puol. Far insuper duo Colonne una per banda fuora cum i suo do terzi de relievo Cum le suo basse, et capitelli, i quali siano fuori et scossi piu che se puol la qual opera et ornamento die esser alta 7 piede, et altrotanto larga promettendo el pre-fato maistro Lorenzo tute le altre opere intrano in dicto ornamento far cum summa diligentia, bonta, et belleza, Lavorando quelle incassando, impiobando, arpesando come bisognera. Et li prefati Clarissimi procuratori prometteno al dicto maistro Lorenzo per faticha et mercede sua, dar ducati Cento. Hoc mer-catum actum fuit in nostra procuratia presentibus nos-tris gastaldionibus et alijs, et me notario infrascripto

Ego Victor griti plebanus sancti Johannis baptista in bragora et notarius dicte procuratie.

Publ.: Cecchetti, in Ongania, ed., vii, 1886, p. 27, doc. 160; Paoletti, 1893, ii, pp. 274f, n. 6.

## XVI. LORENZO BREGNO, TOMB OF BENEDETTO CRIVELLI, S. MARIA DEL CARMINE, CREOLA

### A. Testament of Benedetto Crivelli, July 20, 1515

ASV, Arch. not., Testamenti, Busta 50 (not. Girolamo de Bossis), no. 214, cc. 192r–193v. (protocol) and ASV, Arch. not., Testamenti, Busta 51 (not. Girolamo de Bossis), no. 78 (copy).

...Anno ab Incarnatione domini nostri Jesu Christi millesimo quingentesimo quinto decimo in-dictione tertia die vero vigesimo mensis Julij Rivoalti ...Ego Benedictus Cribellus q. Domini Gulielmi civis mediolani ad presens habitator civitatis padue, pa-triciusque Venetiarum ac capitaneus peditum Illus-trissimi Domini Venetiarum sanus Dei gratia mente, intellectu et corpore iturus de proximo in Castris prelibati illustrissimi Dominij volens dum tempus da-tur rebus meis providere et eas debito ordine dis-ponere accessi personaliter ad Hieronymum de Bossis Venetiarum notarium ipsumque rogavi ut hoc meum scriberet testamentum ipsumque post meum obitum

compliret et roboraret cum suis clausulis et addition-ibus novis et oportunis juxta ritum Civitatis Venetia-rum...Commissarium voco et huius mei testamenti executorem ordino et esse volo Magnificum et Clar-issimum Dominum Alovisium Pisani abanco q. M. D. Joannis quem rogavi sicuti ordinabo fideliter exequa-tur. Item volo et ordino quod super illis campis duo-bus terre quos habeo in Villa Credule vicariatus tituli agri patavinj et qui sunt intermedii inter pischeriam et palatium meum existentem in dicta Villa Credule et in quibus Campis duobus solebat esse quidam Cur-tivus alaboratoribus edificetur una ecclesia talis qualis est ecclesia ante Villam Credule, necnon una domus comoda habitationi unius sacerdotis. Et in qua eccle-sia construi debeat unum monumentum lapideum marmoreum super quatuor colonnis marmoreis, in quo monumento excisa sit arma mea cum nomine meo. Et in quo sepulcro cadaver meum humari debeat et in constructione cuius monumenti expendi debeant ducati centemquinquaginta. In qua quidem ecclesia infrascriptus meus heres et eius heredes et descen-dentes inperpetuum ponere et ospitare debeant unum mansionarium bone et probate vite qui qualiter dire et inperpetuum celebrare debeat unam missam pro anima mea cum quodam mansionario dari volo quam-libet renditam ex impresto ducatorum trigintasex auri habendos et exequendos per dictum mansion-arium de et ex introitibus meis possessionis mee per me empte in Villa Arquate agri patavini...Quantum quandam superscriptam ecclesiam cum monumento et domo per habitationem mansionarij construi volo intra annum a die mortis mee nisi bellorum impedi-menta hec fare non permitterent....Si vero nulli mihi superessent filij vel descendentes ex eis eo casu re-linquo totum dictum meum residuum prefato Mag-nifico Domino Alovisio pisani abanco.

Unpubl.

### B. Pastoral visitation of S. Maria del Carmine, May 11, 1572

Padua, Archivio curia vescovile, Visite pastorali nella di-ocesi di Padova, viii, Visitationum sub. R.mo Nicolao Or-manetto, 1572, c. 14r

#### Die XI Maij 1572

Visitavit oratorium erectum ex testamento quon. Benedicti Cribelli nuncupatum l'oratorio di ipatina positum in villa credula'. Hoc oratorium habet altare unum non consecratum ab oriente et portam unam

ab occidente, non habet cimiterium, necque sacrestiam.

Habet fenestras duas vel oculam ab occidente, et fenestram abaastro sine specularibus campanile cum una campana ab occidente.

In medio dicti oratorij est sepulchrum marmoreum super 4.ᵒʳ columnis aedificatum ubi iacent ossa quon. Benedicti Cribelli; in quo sunt marmore incisa haec verba videlicet:

Benedicto Cribelo fortissimo peditum ductori ob eximia eius in rem Venetam magnis muneribus donato simulque a Senatu Veneto in patritium ordinem ascito, Aloysius Pisanus d. Marci procurator heres ex testamento benefitij memoria obijt anno 1516.

Habet domum pro habitatione capellani prope oratorium satis comodam.

Unpubl.

## XVII. LORENZO BREGNO, *MIRACLE OF THE JEALOUS HUSBAND*, CAPPELLA DEL SANTO, S. ANTONIO, PADUA

### A. Consignment of marble to Lorenzo Bregno for the *Miracle of the Jealous Husband*, 1519/20

AdAP, Registro 384 (massaro Pietro Barbaro da Soncin), c. 47 right, 1519/20

In the name of the Arca del Santo Maestro Pietro Curti da Carrara consigned "duj quadri da Istorie uno ...a maestro Tulio ... maestro lapicida laltro a maestro Lorenzo bragnon maestro lapicida ... "

Publ.: Sartori / Fillarini, 1976, p. 29. Most of this document is illegible.

### B. Commission to Lorenzo Bregno for the *Miracle of the Jealous Husband*, June 16, 1520

ASP, Arch. not., Volume 4150 (not. Sebastiano Balzan), cc. 245r–245v

1520 Indictione octava. Die Sabbati xvj Iunij padue in medio pallatij. Iuris

Reverendi patres dominus magister Laurentius de padua, sacre pagine professor et dominus frater Joannes Aregina Guardianus conventus et dominorum fratrum Sancti Antonij confessoris ordinis minorum, Magnificus eques dominus Gaspar de obicis. Spectabilis artium doctor, dominus Jacobus de fabrianis. Spectabilis juris doctor dominus Nicolaus bonisonus. Et nobilis civis patavinus dominus Petrus

de barbobus de Soncino capserius, honorabiles deputati ad regimen bonorum et fabrice ac massarij et gubernatores arce domini Antonij confessoris paduae presentes etc. ac nomine et vice dicte arce parte ex una; Et Spectabilis artium doctor dominus Johannes Baptista de leone nobilis civis padue. Interveniens nomine et vice famossimi sculptoris magistri Laurentij brignon quondam Ser Alberti habitatoris venetiis inconfinio Sancti Zaninovo absentis aquo dixit habere comissionem ad infrascripta peragenda. Et pro quo nihilominus de rato promisit et sub obligatione omnium suorum bonorum ex alia ad invicem ut infra convenerunt et pacierunt nominibus quibus supra quia prefactus Spectabilis dominus Johannes Baptista dicto nomine sponte etc. dixit et confessus fuit prefactum Magistrum Laurentium habuisse et penes se habere a prefactis Dominis massarijs nomine dicte Arce unum quadrum marmoreum extimatum et apretiatum inter ipsas partes concorditer ducatorum vigintiocto qui quadrus marmoreus in presentiam extat deonerater in domo dicti Magistri Laurentii venetiis et est dicte arce, in quo quidem quadro teneatur dictus magister Laurentius et ita ipse Spectabilis dominus Johannes Baptista suo nomine promisit sculptare et perficere Miraculum divi antonij confessoris predicti sive Istoriam Equitis ocidentis eius uxorem cum tot figuris quot sunt in quadro alias facto per quondam magistrum Antonium Lombardum possito in dicta Capella prefacte arce. Et alijs circumstantijs convenientibus ipsi miraculo ad suficientiam pulchritudinem perfectionem et bonitatem iuxta alias laudabiles et famosissimas operas magistri Tulij Lombardj et aliorum famosissimorum sculptorum facientium alios quadros et potius immeliorando. Et si culpa vel negligentia aut defectu dicti Magistri Laurentij dictus quadrus marmoreus devastabitur et si non fecerit et sculptaverit in eo operam pro ut sperant se facturum in meliorando et laudabiliorem alijs eo tunc teneatur dictus Magister Laurentinus ipsum quadrum solvere pro dictis ducatis 28. E converso autem prefacti Reverendi domini patres et spectabiles domini massarij nomine dicte arce dare et solvere promiserunt ipsi magistro Laurentio pro eius mercede et pro dicto opere et quadro reducto in perfectione ut supra Ducatos ducentos quinquaginta auri ad earum tantum librarum sex, et solidorum quatuor pro quomodocumque ducato. Ex quo quidem precio seu ducatis Ducentis quinquaginta dicti domini deputati exbursare debeant de tempore in tempus partem ipsius et ratam prout eis videbitur ipsum magistrum Laurentium mererj secundum opus seu laborerium in eo

quadro factum. Et ipso perfecto ut supra habeat dictos suos ducatos ducentos quinquaginta integraliter: Que omnia etc. sub pena etc. sub pena etc. pro quibus etc.

M. Franciscus confinens orologia filius M. . . . habitator padue in contracta strati maioris penes platheam dominationis

Ser Franciscus vigonza filius q. habitator in villa monte eartone sub consilue.

Publ.: Sartori / Fillarini, 1976, p. 29; Wilk, in *Le sculture del Santo*, 1984, p. 130, n. 67; Sartori / Luisetto, 1989, p. 176, no. 92.

C. Lorenzo Bregno's ratification of the commission, June 29, 1520

ASP, Arch. not., Volume 4150 (not. Sebastiano Balzan), c. 245v

1520 Indictione 8 die xxviiij lunij padue in domo mei notarij in contracta burgi rogatorum

Suprascriptus magister Laurentius brignon sculptor famosissmus: qui tempore stipulantis suprascripti instrumenti absens erat et pro quo intervenit suprascriptus spectabilis dominus Joannes Baptista de Leone et pro eo promiserat declarate ut supra. et sponte etc. audito et sane intelecto tenore suprascripti instrumenti. Eidem lectum per me notarium dictum verbo ad verbum prout jacet: illud et omnia in eo contenta laudavit approbavit et ratificavit sibique placere dixit: ac se obligavit in omnibus et per omnia prout in eo contenta promitens etc. sub obligatione etc.

Ser Lucas de ragusio predictus filius q. Ser Stefani habitator padue in contracta Sancte marie de avantio

M. guido Lizarius filius q. Ser gratioxij de bononia habitator padue in contracta strate maiores

Unpubl.

D. Lorenzo Bregno's account with the Arca del Santo for the *Miracle of the Jealous Husband*, 1522/3

AdAP, Registro 387 (massaro Giovanni de' Barisoni), c. 54 right, 1522/23

Maistro Lorenzo brignon q. Ser Alberto die haver per manifatura di un quadro di marmore nel quale luj ha afare el miracolo de un cavaliere che amazava sua mogliere a li dinarj se li die dare de tempo in tempo secondo il lavorera apar de mano de Ser Sabastian balzan adi 16 Zugno 1516 [*sic*] lire 1550 soldi —

Nota chel soprascritto ha il quadro stima ducati 28 e non ha anchora principia a lavorare

Publ.: Sartori / Fillarini, 1976, p. 28; Sartori / Luisetto, 1983, p. 362, doc. 467.

XVIII. GIAMBATTISTA BREGNO, *ANGELS* FROM S. MARIA DEI SERVI, VENICE

A. Payment to Bartolomeo Garbin for polishing the *Angels*, July 30, 1524

ASV, Procuratori di S. Marco, Commissarie, Misti, Busta 98A, filza 1523–24, c. 11 left

1524 dito [30 luio] contadj a bortolomio garbin segador per zornade 5 fate questa settimana in fregar i anzollj et renovarllj. Fregar la figura de la sepoltura et altro fusarete a soldi 16 al dj monta a . . . . . . . . . . .
. . . . . . . . . . . . . . . . . . . . . . . . . . lire 4, soldi . . .

Unpubl. but paraphrased by Caffi, *Arch. ven.*, n.s. xxviii, pt. 1, 1884, pp. 36f, repr. in idem, *Arch. ven.*, ser. 2, iii, pt. 1, 1892, p. 171.

B. Record of the gift of the *Angels* for the Altar of Verde della Scala, 1524

ASV, Procuratori di S. Marco, Commissarie, Misti, Busta 98A, filza 1523–24, c. 18 right

1524
Suma lo amonta dela spexa fata pel far de lo altar et sepoltura nela giexia de i Servi de Venexia per conto de la commissaria di madonna Verde de la Schalla como destinto al incontra apar ducati 422, lire 5, soldi 9.

Dechiarando che oltra la sopraschrita spexa abiamo avuto che sono sta messo in dita opera dal monesterio et frati de i Servi da Venexia gratis senza algun pagamento per averlla donata per sua cortexia, azo se fati dita opera, le sotoschrite piere et prima:

do colone de marmoro venade. Uno pezo grando de serpentin bastardo meso nel antipeto del altar. Item algunj pezi de alabastro rosi et bianchj adoperatj nel foro et nela gozola del altar. Item algunj pezi di serpentin bastardo et de porfido mesi nei quadrixelj dele colone. Item tavolle n.º 8 de marmoro de una meschia rosa et biancha del qual e fato 100 frixj di sopra et incasadj nelj pilastronj da baso. Item algunj pezi di . . . mese nel antipeto del altar et fato el tondo e nel frontespizo de sora. Item ne ano dato lj do anzollj di marmoro con algunj pezi de marmoro del

qual son sta fati i lidj et base dele colone et ladornamento che e di marmoro atorno el nichio dela figura. Qual dichiaracion se fa con inteligencia et volunta dei supraditi frati dei Servi azo che in ognj tempo se sapia la verita.

Unpubl. but paraphrased by Caffi, *Arch. ven.*, n.s. xxviii, pt. 1, 1884, p. 42, doc. B, repr. in idem, *Arch. ven.*, ser. 2, iii, pt. 1, 1892, p. 178, doc. B.

## XIX. LORENZO BREGNO'S ESTATE

### A. Sale of the contents of Lorenzo Bregno's shop to Antonio Minello, January 4, 1524

ASV, Arch not., Atti, Busta 3346 (Giovanni Maria Cavagnis), cc. 496v–497r

Quod compromissus durare debeat per dies octo ad libitum per alios 8 dies...Nicolaus...ser Sebastianus.

Die dicta.

Honesta domina Magdaliena relicta qm. magistri Laurentii Brignono scultoris habitatrix Venetiis in confinio Sancti Iohannis Novi tamquam gubernatrix filiorum bonorum et filiorum suorum et dicti qm. magistri Laurentii viri sui ut constat testamenti breviario per manus dominorum de nocte propter vacantiam curiarum scripto et in publicam formam redacto manu ser Aloisii Perarotto in . . . et dicti offitii de nocte notarii sub die 22 decembris proximi decursi, sponte et libere dedit vendidit et tradidit prestanti viro magistro Antonio Minello sculptori magistri Iohannis de Padua presenti et pro se et suis heredibus et successoribus stipulanti ementi et aceptanti omnia et singula bona seu . . . massaritias et fulcimenta apothece dicti magistri Laurentii quam tenebat in dicto confinio Sancti Severi cum inviamento apothece quam conducebat a nobilibus dominis Francisco et Hieronimo Zane Sancti Iohannis Novi, per magistrum Petrum Marono magistrum Andream Buora et magistrum Antonium de Abondis protho in offitio salis lapidicis pretio et . . . ducatorum centum viginti sex a libris 6 soldis 4 pro ducato, cum conditione quod teneatur complere unam imaginem sancte Marie pro ecclesia Montagnane et unum angelum iuxta formam alterius angeli in adaptandam dicta domina Magdalena unam petram marmuream et cum conditione quod teneatur dictus emptor dare et solvere magnifico domino Paulo Trivisano qm. magnifici domini Andree ducatos 25 per . . . per ipsum quondam magistrum Laurentium a pre-

fato domino Paulo Trivisano; item quod dictus magister Antonius Minello est debitor prefate gubernatrici de dictis ducatis 126, de quibus ducatis domina Magdalena habuit a prefato magistro Antonio auri ducatos 25 in prompto et mutuo favore . . . restum vero in duas pagas videlicet singulis quinque mensibus . . . sine ulla conditione, cum hoc quod si dicta domina Magdalena aut commissus suus venisset venisset [*sic*] post dies octo, lapsis terminis, possessiones suas hic venderet et dictum emptorem solveret omnia singula unum quintum ducatorum singulo die promisit etiam quod de bonis venditis et illa que de tempore in tempus . . . et . . . et . . . dict. domin. Magdalen. usque in integram solutionem dictorum ducatorum 101. Ad hec autem magister Bartholameus Stampa aurifex qm. ser Iacobi de Padua precibus et instantia dicti magistri Antonii Minelli se constituit plegium et principalem solutorem eius, promittens dicte domine Magdalene dare restum et . . . diffinitum et . . . a quibusdam usque. . . . Hec facta fuerunt magistri Francisci de Librandis murarii de Tarvisio fratris dicte domine Magdalene et ad cancellum consuetum.

Actum Venetiis in dicto confinio et in dicta apotheca presentibus dominis nobili viro Marco Antonio Michael domini Victori et ser Fantino Basaiti qm. domini Francisci et ser Michaele qm. ser Pauli provisionati Porte Sanct. Th . . .

Publ.: Paoletti, 1893, ii, p. 116, doc. 106.

### B. Lorenzo's widow, Maddalena Bregno, empowers her brother to represent her in all suits and controversies, August 3, 1524

AST, Arch. not., 1ª serie, Busta 439 (not. Giovanni Matteo Spilimbergo), filza "1524 die nono Julii," cc. 28v–29r

1524, indictione 12, die Mercurii tertio mensis Augusti, Tarvisii, in camera anteriori domus habitationis infrascipti ser Francisci, posita in contrata Pancerie, presentibus magistro Nicolao de Crema biretario quondam ser Antonii fornaserii, et magistro Ypollito de Marostica scartezino quondam ser G[i]ambartholomei de Fabris, testibus rogatis etc.

Ibique honesta mulier domina Magdalena, relicta ser Laurentii sculptoris in marmore, soror infrascipti ser Francisci, omni meliori modo, tam in sua specialitate quam gubernatorio nomine filiorum suorum, filiorum et heredum dicti ser Laurentii, fecit constituit creavit et ordinavit procuratorem suum generalem et specialem, taliter quod specialitas generalitati non deroget et e contra, ser Franciscum de Liprandis, fra-

trem suum presentem et acceptantem, ad omnes et
singulas lites causas querellas et controversias quas
habet et habitura esset cum quibuscumque personis,
tam ecclesiasticis quam secularibus, quacumque ra-
tione et causa et tam in civitate Tarvisii quam in
quacumque alia terra, castro et loco ubi opus esset,
et specialiter in causa quam habet cum Reverendo
domino Brocchardo Malchiostro Canonico Tarvisii.
Et pro predictis ad comparendum coram magnifico
domino potestate et capitaneo Tarvisii, suo vicario
et quocumque alio officio, et coram quibuscumque
magnificis dominis iudicibus cuiuscumque officii in-
clyte civitatis Venetiarum, et precipue pro causa dicti
domini Brocardi, coram magnificis dominis iudicibus
iustitie veteris Venetiarum, ad agendum, defenden-
dum, opponendum etc. ad iurandum etc., ad substi-
tuendum etc. in forma. Promittens mihi notario uti
publice persone etc. habere firma etc.

Unpubl.

## C. Maddalena Bregno renews her brother's power of attorney, January 2, 1525

AST, Arch. not., 1ª serie, Busta 439 (not. Giovanni Matteo
Spilimbergo), filza "1524 die XXVII octobris 1525," cc.
166v–168r

1525, Indictione XIII, die Lune, secundo mensis Ian-
uarii, Tarvisii, in domo habitationis infrascripte dom-
ine constituentis, posita in contrata Pancerie,
presentibus magistro Galeatio fusario quondam ser
Michaelis, et magistro Gulielmo fabro quondam ser
Antonii, testibus rogatis et aliis.
Ibique honestissima domina Magdalena, relicta
magistri Laurentii sculptoris, tamquam tutrix filiorum
suorum, filiorum et heredum dicti quondam magistri
Laurentii, ut de tutela sua dixit extare publicum in-
strumentum celebratum Venetiis, citra revocationem
alterius instrumenti procure scripti per me notarium
infrascriptum de mense Augusti anni preteriti 1524,
omni meliori modo via iure et forma quibus melius
potuit ac potest, fecit constituit creavit et ordinavit
procuratorem suum generalem et specialem, taliter
quod specialitas generalitati non deroget et e contra,
et quicquid melius dici potest, probum virum ser Fran-
ciscum de Liprandis, civem Tarvisii, dicte consti-
tuentis fratrem, presentem et acceptantem, ad omnes
et singulas littes, causas, questiones, querellas et con-
troversias, quas habet et habitura est dicto nomine,
etiamque suo proprio nomine, hic Tarvisii, Venetiis
et alibi, quacumque ratione et causa, cum quibus-

cumque personis tam ecclesiasticis quam secularibus
…specialiter et expresse ad exigendum quascumque
denariorum quantitates, quas habere debet nomine
filiorum suorum, filiorum et heredum dicti magistri
Laurentii, tutorio nomine quo supra etiamque suo
proprio nomine, et tam in hac civitate Tarvisii quam
Venetiis et alibi, et specialiter a magistro Antonio
Minello sculptore habitatore in Venetiis, omnem
quantitatem denariorum quam habet debet dicto
nomine ex forma et tenore instrumenti scripti in Ve-
netiis manu notarii publici. Item de exactis quietan-
dum et finem faciendum etc. Item ad componendum,
concordandum et paciscendum cum quibuscumque
personis tam dare debentibus quam ex alia qua-
cumque causa, prout melius placuerit dicto procurato-
ri. Item, si opus esset, consentendum in iudices et
arbitros, et iudices eligendum et eligi videndum et
electis opponendum et alios non suspectos eligi in-
standum. Et salvis premissis, etiam ad exigendum in
castro Montagnane, omnes denariorum summas quas
habere debet a civibus dicti castri sive a comunitate
dicti castri vel a quibus reperientur debitores, et de
exactis quietandum ut supra, et cum eis decidendum
[et] componendum ut supra, si opus erit. Et pro pre-
dictis ad comparendum coram magnifico domino po-
testate et capitaneo Tarvisii presente et successoribus
suis et suo spectabili domino vicegerente et alio
quovis iudice huius civitatis Tarvisii, et tam eccle-
siastico quam secullari, et coram quibuscumque aliis
dominis rectoribus, potestatibus et vicariis iudicisque
cuiuscumque alterius terre, castri et loci, et coram
quibuscumque dominis iudicibus et ius reddentibus,
consiliis, collegiisque civitatis Venetiarum, etiam et
ecclesiasticis, delegatis et subdelegatis, presentibus et
futuris, prout opus erit. Et si opus esset, coram emi-
nentissimo principe Venetiarum eiusque excellentis-
simo collegio, et tam ad agendum quam ad
defendendum, opponendum, audiendum, libellum
dandum et recipiendum, lites contestandum, contes-
tationes videndum, examinas dandum sibique dari pe-
tendum, de callumnia et veritate iurandum, et testes,
litteras, instrumenta et iura quelibet producendum et
producta videndum, …opponendum et opposita
probandum ad … in animam dicti constituentis prout
expediet, ad substituendum unum et plures procur-
atores loco sui si fuerit opportunum, et substitutos
revocandum, nihilominus presens mandatum in se re-
tinendo; sententiam et sententias audiendum et illam
vel illas executioni mandari petendum ab eo vel ab
eis, appellationem [et] appellationes prosequendum
eisque renuntiandum. Et generaliter ad omnia alia et

singula que in predictis et circa predicta necessaria fuerint et opportuna, faciendum et exercendum prout quilibet procurator facere potest et prout ipsamet constituens facere posset si personaliter interesset, etiam si talia forent que exigerent magis specialis mandatum. Dans et concedens etc. in forma solita, promittens in forma etc.

Unpubl.

D. Ser Francesco de' Liprandi renders a final account to his sister of his liquidation of Lorenzo Bregno's estate, November 16, 1525

AST, Arch. not., 1ª serie, Busta 440 (not. Giovanni Matteo Spilimbergo), filza "1525 die xxiii octobris," cc. 80r–82r

1525 Indictione 13, die Iovis 16 mensis novembris, Tarvisii, in camera anteriori domus habitationis infrascripti ser Francisci, posita in contrata Pancearie . . . de domo, presentibus magistro Nicolao biretario quondam ser Antonii de Crema fornaserii, et magistro Alberto fornario quondam Bernardini de Citadella, testibus rogatis et vocatis [et] aliis.

Cum a tempore mortis quondam ser Laurentii Brignoni, sculptoris in marmoreis, citra, ser Franciscus de Liprandis quondam Magistri Ioannis Iacopi de Mediolano, murarii, civis, et sororius dicti quondam ser Laurentii, quia est frater domine Magdalene relicte uxoris dicti magistri Laurentii, se exercuerit in negotiis dicte quondam domine Magdalene, sororis sue, etiamque et in negotiis hereditatis dicti quondam ser Laurentii tam hic quam in civitate Venetiarum, et presertim in exigendo a dare debentibus dicte hereditati et sue dicte domine Magdalene, matri et tutrici filiorum suorum filiorum et heredum dicti quondam ser Laurentii, et quod in solvendo et satisfaciendo habere debentibus hic et Venetiis, computando medicos et medicinas, duos funerales unius filie et unius filii dicti quondam magistri Laurentii, mortuorum post ipsum ser Laurentium, tamen in domo dicte domine Magdalene; et computando affictus domus pro habitatione dicte domine Magdalene, posite in Venetiis, pro qua solvit ducatos XXV a libras ♭, solidos 4 pro ducato; et computando denarios solutos laborantibus et famulis dicti quondam ser Laurentii, quibus ipse quondam ser Laurentius tenebatur; et computando etiam salaria medicorum pro infirmitate dicti quondam magistri Laurentii, per quam mortuus fuit in civitate Venetiarum, et medicinas et donum propter cereos et sepulturam illius. In quibus omnibus et aliis que memorie non tenet, expendidit ultra summam

ducatorum centum, sed in rei veritate de bonis dicti quondam ser Laurentii non pervenerint ad manus dicti ser Francisci nisi ducati quin [sic] quinquaginta, quos habuit ab Antonio Minello, habitatore in Venetiis, debitore dicti quondam ser Laurentii. Item a Reverendo domino primicerio tarvisino, pro una sua sepultura posita in ecclesia de domo, ducatos trigintiquinque. Item in aliis partitis a certis personis, circa ducatos decem. Item staria tredecim frumenti, . . . a Reverendo domino Brocardo canonico Tarvisii, et ducatos tres. Tamen ducati trigintaquinque predicti fuerunt expenditi in perficiendo sepulturam dicti quondam domini primicerii. Item staria 13 frumenti et ducatos tres, de quibus supra ea et eos. . . . Item domina Magdalena, ut coram me et omnibus confessa fuit, habuit et recepit et non pervenerunt in manus dicti ser Francisci, sed conducta fuerunt in domum dicte domine Magdalene. Nunc vero dicta domina Magdalena, mater et tutrix filiorum suorum predictorum, ut de tutoria sua apparet in officio Magnificorum Dominorum de nocte, ex instrumento publico per me viso, manu ser Alovisii Fu . . . to, notarii et scribe ad officium Magnificorum Dominorum de nocte, de anno 1523, die 22 decembris, de omnibus premissis veram noticiam habens, ut mihi notario et testibus affirmavit, et omnia notificans et laudans per se et suos heredes, et nomine dictorum suorum filiorum, sponte, libere, ex certa scientia et non per errorem, non coacta, non subducta, sed ex sua mera, libera et spontanea voluntate, dixit, confessa et manifesta fuit a predicto ser Francisco fratre suo, ibi presenti, danti pro se et heredibus suis usque in presentem diem ei fuisse integ [sic] integre persoluta et satisfacta de omni et toto eo quod quovis modo, tam hic quam Venetiis, pervenit ad manus dicti ser Francisci ex hereditate dicti quondam ser Laurentii. Quia de omnibus per eum de tempore in tempus exactis et e contra expenditis de eius consensu et scientia, semper eidem domine Magdalene redditum fuerit per ipsum ser Franciscum bonum computum, fidele et legale. Et propterea quia ipse ser Franciscus de expenditis pro ea et dicta hereditate precise et distincte non tenuit computum, quia de vice in vicem prout ipse exigebat et expendebat, oretenus inter se fatientibus eorum computis, ei consignabat restantem, et ipsa domina Magdalena cognoscebat nullam esse deceptionem, recipiebat id quod in manibus dicti ser Francisci reperiebatur. Cognoscens et indubitata sciens eum de omnibus ipsi mulieri bonum computum reddidisse usque in diem presentem, et quod potius est creditor quam debitor, consideratis omnibus con-

siderandis, eidem ser Francisco, ibi presenti, recipienti per se et heredibus suis, ipsa domina Magdalena per se et suos heredes et gubernatorio nomine quo supra, fecit finem, remissionem, liberationem, quietationem et plenariam absolutionem et protestationem de amplius aliquid ei nec heredibus suis non petendo particulariter nec in to[to], de aliquibus gestis, pertractatis, habitis et exactis ex bonis et denariis hereditatis dicti quondam ser Laurentii usque in diem presentem. Quam finem et omnia predicta ipsa domina Magdalena dicto nomine promisit habere firma etc., et non contravenire etc., pena librarum 50 soldorum, totiens quotiens etc.

Unpubl.

# APPENDIX B
# Catalogue

Entries are arranged alphabetically according to their present location (or their former location in the case of lost works); works by Giambattista and Lorenzo Bregno have been interspersed. A catalogue of authentic works is succeeded by a catalogue of rejected attributions. In the individual entries the following topics are considered in sequence:

1. Location. Directions refer to the spectator's left and right.

2. Material.

3. Measurements. Dimensions are metric. Height precedes width; width precedes depth.

4. Polychromy and gilding.

5. Condition, including elements missing or replaced. Directions, when used to describe body parts of figures, refer to the figure's own left and right.

6. Inscriptions.

7. Bibliography. Only those works that mention the specific sculpture under consideration are cited. Items are arranged in chronological order. Unpublished manuscripts have been included, but archival references have not. Books are referred to by the author's name followed by the date of publication, articles by the author's name followed by the abbreviated title of the book, catalogue, encyclopedia, or periodical in which the article appears. Superscribed Arabic numerals preceding the date of publication indicate edition. Dates within parentheses indicate the date of composition or first publication. Brackets indicate facts not conveyed by the work in question, but known from other sources. Dates precede volume numbers when all volumes of a work were published concurrently; dates follow volume numbers when individual volumes were published consecutively.

The following abbreviations have been used in the catalogue and notes:

| | |
|---|---|
| *AB* | *Art Bulletin* |
| ASC | Archivio di Stato, Cesena |
| ASP | Archivio di Stato, Padua |
| AST | Archivio di Stato, Treviso |
| ASV | Archivio di Stato, Venice |
| *BJ* | *Jahrbuch der Berliner Museen* |
| *BM* | *Burlington Magazine* |
| *DBI* | *Dizionario biografico degli italiani* |
| *Enc. ital.* | *Enciclopedia italiana di scienze, lettere ed arti* |
| *JpK* | *Jahrbuch der königlich preuszischen Kunstsammlungen* |
| *MJ* | *Münchner Jahrbuch der bildenden Kunst* |
| *RIS* | *Rerum Italicarum scriptores* |
| T-B | *Allgemeines Lexikon der bildenden Künstler*, ed. U. Thieme and F. Becker |
| TCI | Touring Club Italiano |
| Sans. | Sansovino |
| Vas/Mil | Vasari/Milanesi |

## 1. BELLUNO, DUOMO (SS. MARIA ASSUNTA E MARTINO): *ST. MARTIN* AND *ST. JOATHAS*

### LORENZO BREGNO AND SHOP

Pls. 172, 173

*SS. Martin* and *Joathas* currently occupy the Altar of the Madonna delle Grazie, the first altar in the left aisle of the cathedral (*in cornu Evangelii*).

The figure of *St. Martin*, together with its base, is carved from a single block of white, black-veined marble. The figure of *St. Joathas*, together with its base, is carved from a single block of white, golden-spotted marble.

*St. Martin*: ca. 101.5 cm high × 35 cm wide; *St. Joathas*: ca. 98 cm high × 40 cm wide.

There are no traces of polychromy or gilding in either of the statuettes.

A crack across *St. Martin's* neck has been repaired with plaster. The borders of the cope, especially around the figure's neck, are badly damaged. The *Saint's* right eyebrow, chin, and the ornament of his mitre are chipped; the peaks of the mitre have been restored. *St. Martin* is missing the last joint of the third finger of his right hand. There are mortar repairs around the right cuff and wrist; chips remain in the drapery of the right arm. At its right corner, the cope is cracked; its border has been repaired with mortar. *St. Martin* is missing the end of his right foot. The *Saint's* wooden crosier is not original: fragments of the top of another — presumably original — one of stone were hidden behind the statuette several years ago.

*St. Joathas's* neck has suffered two major cracks; the hilt of the *Saint's* sword is also cracked. The knot on the *Saint's* right shoulder and the curl nearest it, the tip of his left foot, and the teeth of the wheel are chipped. The figure's nose and the third and fourth fingers of his right hand have been restored. The lining of his cloak was never polished and the wheel

was not completely realized. The wooden blade of the *Saint*'s sword is not original.

Bibl.: Delai, 1673, pp. 9, 17; Miari, 1843, p. 43; Alvisi, in *Grande illus.*, ii, 1858 (1859), p. 762; Guernieri, 1871, p. 33; Brentari, 1887, p. 71; Paoletti, 1893, ii, p. 252; Monti, *Studi bellunesi*, July 10, 1896, p. 56; Zanetti-Persicini, 1906, pp. 37f; Pellegrini, 1908, p. 17; [Ricci], *L'amico del popolo*, Jan. 19, 1929, [p. 2]; Fontana, 1951, p. 146; Rossi, 1958, p. 10; Timofiewitsch, in Egg et al., 1965, p. 81; Tamis, 1971, pp. 29, 42, 78, 93–5; Sirena, 1972, p. 32; Boranga et al., 1973, p. 18; De Bortoli/Moro/Vizzutti, 1984, p. 253; Schulz, *BJ*, 1984, pp. 173–8.

The statuettes of SS. *Martin* and *Joathas* belonged to the Altar of the Holy Thorn in the Cathedral of Belluno. The relic from Christ's crown of thorns was brought to the church on October 5, 1471.[1] A tabernacle for the thorn was decreed by the *Maggior Consiglio* of Belluno on April 3, 1472, and April 6, 1490, but the altar from which our figures come seems to have resulted from the council's decision of March 31, 1508, to erect a more decorous altar for the relic.[2] Construction of the altar at the commune's expense commenced on March 27, 1510.[3] The altar was consecrated in May 1514.[4]

The church in which the Altar of the Holy Thorn stood at first was erected between 1471 and 1497, when the previous cathedral was reconstructed in the Gothic style. After the War of the League of Cambrai, it was decided to rebuild the Duomo yet again, on a larger scale. On December 16, 1517, Tullio Lombardo was paid for a model of the new church. Construction began in the aisles in May 1525. Not until 1557 had work advanced sufficiently to permit construction of the choir. The fabric was not finished until 1587; indeed, the church still lacks a proper facade.[5] In the Gothic church, the Altar of the Holy Thorn took the place of the Altar of the Cross; sources do not situate the altars more precisely.[6] In the new church, the Holy Thorn occupied the fourth altar in the right aisle (*in cornu Epistolae*), now the Altar of the Pietà.[7] In 1732 the relic of the Holy Thorn was moved to the chapel to the left of the cathedral's choir,[8] while the statuettes, which originally flanked the relic, were reinstalled on the Altar of the Ma-

donna delle Grazie – the first altar in the left aisle of the church – where they are found today.[9]

The original project for the Altar of the Holy Thorn was described on the basis of the artist's drawing in a book dedicated to the thorn and its miracles. A casket with the relic was to repose in the center of the marble altar; in front of the relic a light was to burn perpetually. Both light and case were to be protected by a grille. Freestanding statues of SS. *Blaise* and *Joathas*, of the same marble as the altar, were to flank the relic.[10] In the 17th century, freestanding figures of the *Virgin Mary* and *John the Evangelist*, flanking the *Crucified Christ*, stood at the top of the altar;[11] they were not necessarily original. The altar was closed off by balustrades.[12] Of the original altar there survive only the two statuettes of *Saints*. To the right of the reliquary stood *St. Joathas* who, along with SS. Lucanus and Martin of Tours, was a patron saint of Belluno and titular saint of the cathedral.[13] Represented as a young knight, he is shown with the instruments of his martyrdom, the spiked wheel and sword. His companion is not St. Blaise, as was initially intended, or St. Lucanus, as is generally claimed, but the third of Belluno's three protectors and patron of the cathedral – St. Martin of Tours.[14] In identical guise, St. Martin appears among Belluno's patron saints in a *Sacra conversazione* by Matteo Cesa in East Berlin.[15]

Few mentions of the statuettes occur outside guidebooks to the cathedral or city of Belluno; not unexpectedly, local *ciceroni* credited the designer of the church, Tullio Lombardo, with SS. *Martin* and *Joathas* as well.[16] Sometimes the statuettes were more cautiously assigned to Lombardo or the Lombardi, or to the "scuola lombardesca."[17] Paoletti thought them by a pupil or son of Tullio.[18] Despite his acknowledgment of apparent links with sculpture from the Lombardo workshop, Timofiewitsch disputed the attribution to Tullio, without suggesting an alternative.[19] In 1984 I reconstructed the history of the Altar of the Holy Thorn and attributed the figures to Lorenzo Bregno and an assistant supervised by him.[20]

---

[1] Delai, 1673, pp. 8f; Tamis, 1971, p. 86.

[2] Belluno, Bibl. civ., MS 537, Alpago, 1742–4, iii, cc. 484vf, voce "Spina"; Belluno, Bibl. civ., MS 1099, Bucchi, 19th cen., iii, fasc. XXIIc, cc., 3f, voce "Spina"; Tamis, 1971, p. 86.

[3] Pellegrini, 1908, p. 9.

[4] Tamis, 1971, p. 30.

[5] Paoletti, 1893, ii, p. 252; Tamis, 1971, pp. 26–36.

[6] Delai, 1673, p. 17.

[7] Pellegrini, 1908, p. 23, n. 2; Tamis, 1971, pp. 42, 70. The altar now contains Palma Giovane's *Deposition from the Cross*.

[8] Belluno, Bibl. civ., MS 537, Alpago, 1742–4, iii, c. 485v, voce "Spina"; Belluno, Bibl. civ., MS 1099, Bucchi, 19th cen., iii, fasc. XXIIc, c. 5, voce "Spina"; Pellegrini, 1908, pp. 14f. The relic displaced Cesare Vecellio's *Madonna in Glory with Saints and Donor*.

[9] Ibid., p. 17; Tamis, 1971, p. 78. They flank a *Madonna and Child* attributed to the 18th-century painter Agostino Ridolfi.

[10] Delai, 1673, p. 9: "fù anco deliberato, che si fabricasse un'altare di marmo finissimo con una finestra nel mezo craticolata, & à drittura dell'armaro, ove la Spina si conserva; trà le quali ardesse un lume eterno, con doi statue del medesimo marmo di tutto rilievo dalle bande di S. Biasio, e di S. Gioatà martiri, e tutelari della Città, e della Chiesa, & con altri lavori, come nel disegno, che fù fatto da un perito di quell'arte."

[11] Ibid., p. 26: "E perche di sopra il medesimo Altare con artificiosa manifattura scolpite, & erette si vedono à piedi del Crocifisso le Imagini di tutto rilievo della Santissima Vergine sua diletta Madre, e di San Giovanni suo ben amato Discepolo...."

[12] Pellegrini, 1908, p. 15.

[13] Doglioni, Arch. stor. di Belluno, 1958, pp. 88, 90; Kaftal/Bisogni,

[14] 1978, coll. 505–8, no. 148.

[14] Ibid., coll. 692–704, no. 200.

[15] Doglioni, Arch. stor. di Belluno, 1958, pp. 88, 90.

[16] Brentari, 1887, p. 71; Monti, Studi bellunesi, July 10, 1896, p. 56; Zanetti-Persicini, 1906, pp. 37f; [Ricci], L'amico del popolo, Jan. 19, 1929, [p. 2]; Fontana, 1951, p. 146; Rossi, 1958, p. 10.

[17] Guernieri, 1871, p. 33; Pellegrini, 1908, p. 17; Tamis, 1971, pp. 42, 78, 94; Sirena, 1972, p. 32; Boranga et al., 1973, p. 18.

[18] Paoletti, 1893, ii, p. 252.

[19] Timofiewitsch, in Egg et al., 1965, p. 81.

[20] Schulz, BJ, 1984, pp. 173–8.

## 2. CESENA, DUOMO (S. GIOVANNI BATTISTA): ALTAR OF THE CORPUS DOMINI

### GIAMBATTISTA BREGNO

Pls. 20–45

The figural components of the original altarpiece are separately immured in a segmental niche containing the Altar of the Corpus Domini in the fourth bay of the Cathedral's right aisle (in cornu Epistolae).

The figure of Christ together with its uppermost base, which simulates ground, and its flat background, is carved from a single block of black-veined white marble. The background is as wide as the base and roughly follows Christ's contour, except for an inward jog on the spectator's left at the level of Christ's thigh. Around Christ's halo the edges of the background are covered by the strip, which divides the compartments of the niche. The figure of John the Baptist together with its base and its flat background is carved from a single block of a similar, but less highly veined, white marble. The background of the figure is considerably narrower than its base, particularly on the spectator's left, and closely adheres to the Saint's contours except toward the bottom of the figure. The figure of John the Evangelist together with its base, the eagle standing on a book, and the flat background, is carved from a single block of white marble; the background is lightly veined. It is as wide as the figure's base and rectangular in shape. The crossed palm and laurel branches on the cover of the book held by the Evangelist are filled with niello. The figure of Carlo Verardi on the spectator's left and its base are carved from separate blocks of white marble; the seam between the two blocks is filled with mortar. The slightly concave, high, rectangular background of the figure is stucco painted to imitate black-veined white marble. The figure of Camillo Verardi on the right and its base are carved from separate blocks of black-veined white marble; between figure and base is a thick stratum of mortar. The figure's stucco background matches that of Carlo Verardi. The flying Angels and their immediate flat, stippled backgrounds are carved from single blocks of white marble. Tiny traces of black-painted stucco remain in the crook of the right Angel's inner arm and behind the fluttering sleeve of the left Angel's outer arm. Backgrounds are approximately rectangular in shape, but edges are irregular. The two half-length Angels, their immediate backgrounds, their circular frames, and a portion of the flat grounds beyond the frames are carved from single blocks of white marble, approximately square in shape. In the tondo on the left, the Angel's immediate background retains its original black marble facing. What seems to remain of the facing in the background of the Angel on the right is stucco painted black.

Christ: 167 cm high (including its 6.5- to 7.5-cm-high first base); St. John the Baptist: 164.5 cm high (including its 7- to 13-cm-high base); St. John the Evangelist: 162 cm high (including its 11- to 14.5-cm-high base); Carlo Verardi: 122.5 cm high (excluding its base); Camillo Verardi: 117 cm high (excluding its base); slab of left half-length Angel: 56 cm × 56 cm; slab of right half-length Angel: 65 cm × 60 cm; left flying Angel: 102 cm high; right flying Angel: 96 cm. high.

There are no traces of polychromy or gilding in Christ or St. John the Evangelist, but traces of gilding are preserved in the Baptist's cross and the cinch at his waist. There are no traces of color or gilding in either of the Verardi portraits. A trace of black paint is visible on the inner eyeball of the flying Angel on the spec-

tator's left, a trace of gold on the sash of the flying *Angel* on the right. The immediate backgrounds of both *Angels* give evidence of once having been painted, probably blue, although one can no longer be sure. Bits of stucco applied to the background were painted black. Larger areas of stucco painted black cover the background of the half-length *Angel* on the right.

The figure of *Christ* is perfectly preserved. A chip is missing from the border of the *Baptist*'s mantle above his pointing hand. The crossbar of his cross is badly chipped. There are chips in the ridges of folds along the *Evangelist*'s back. Some of the niello has fallen out of the pattern incised on the cover of his book. The farther cover of the book is chipped in three places. The tip of the big toe of the *Evangelist*'s right foot is broken off, while the tip of his left big toe is nicked. The front edge of the upper cover of the book at the *Saint*'s feet is chipped and a shallow fissure runs diagonally across the cover from chip to spine. The edges of the figure of *Carlo Verardi* are besmirched with stucco. A large chip is missing from the edge of the cowl on the figure's shoulder. The tip of the figure's third finger is chipped; the fingernail of the fourth finger is nicked. A short, shallow fissure runs obliquely through the bottom of the figure's cuff. The lower extremity of the figure has been truncated: extended feet as well as the edge of folds, which rested on the ground, are lost. The borders of the figure of *Camillo Verardi* are spattered with stucco. There are chips missing from the tip of his fourth finger, the corner of the stiff border of the mantle at the top of the figure's shoulder, and the edge of the mantle at about the level of the figure's groin. There is a shallow fissure in the drapery which gathers about the figure's knee and another in the drapery toward the rear of its thigh. Here, too, the bottom of the figure as well as a portion of the extended leg appear to have been cropped. The rufous hue of *Camillo*'s surface suggests that it was once cleaned with hydrochloric acid. In the half-length *Angel* on the spectator's left, the only damage is a small nick in the drapery covering the figure's chest. In the right *tondo*, the *Angel*'s jaw and projecting shoulder are nicked. The original black marble facing of the background of the half-length *Angel* on the right is lost. So too is the black marble facing of the background of the two full-length *Angels*. In both cases, the reshaping of the block resulted in the truncation of a few edges of the drapery. A large chip is missing from the forward toe of the *Angel* on the left; the tip of the big

right toe of the *Angel* on the right is chipped as well.

Inscribed in the base beneath *Carlo Verardi*: CAROLVS VERARDVS HIC/ PRIMVS ARCHIDIACONVS. Inscribed in the base beneath *Camillo Verardi*: CAMILLVS VERARDVS/ EQVES PONTIFICIVS.

Bibl.: Fantaguzzi, (1460–1510) 1915, pp. 49, 64, 217; Cesena, Bibl. com., MS 164.45, Bucci, 1728, pt. 1, cc 24, 38; Braschi, 1738, pp. 332f, no. 31; Oretti, 1777, in *Il patrimonio culturale... di Forlì, I. Gli edifici*, 1973, p. 186; Cesena, Bibl. com., MS 164.33, Andreini, *Cesena sacra*, i, 1807, cc. 48, no. IX, 136, 196; ibid., *Suppl.*, i, 1808, c. 69; ibid., *Suppl.*, iii, 1810, cc. 100f, 113–15; Cesena, Bibl. com., 164.31, Andreini, *Memorie*, xii, 1808, cc. 183f, 188f; Sassi, 1865, in *Il patrimonio culturale... di Forlì, I. Gli edifici*, 1973, pp. 188f; Lübke, ²1871, ii, pp. 563f; Bode, *Rev. archéol.*, Jan.–June 1879, p. 102; Burckhardt/ Bode, ⁴1879, ii, pt. 2, p. 407c; idem, ⁵1884, ii, pt. 1, pp. 162gf, ii, pt. 2, p. 437h; Zazzeri, 1890, p. 356, n. 2; Paoletti, 1893, ii, pp. 233f, n. 6 [Trovanelli], *Il cittadino*, May 17, 1896, [p. 2]; [Zazzeri], *Il Savio*, Dec, 17, 1899, [p. 2]; [idem], ibid., Dec. 31, 1899, [p. 1]; Grigioni, *Rass. bibl.*, 1909, pp 160f, idem, *L'arte*, 1910, pp. 43, n. 2, 48; idem, "L'altare," *Rass. bibl.*, 1911, pp. 11–18, repr. in idem, *Il cittadino*, June 11, 1911, [pp. 1f]; idem, "Ancora dell'altare," *Rass. bibl.*, 1911, p. 84; idem, *Felix Ravenna*, 1913, pp. 504, 505, 507–10; idem, *Rass. bibl.*, 1915, p. 2; Bazzocchi/ Galbucci, 1915, p. 131; Burchi, [1950]; idem, *Studi romagnoli*, 1954, pp. 257–63, 269, 275, 277, and fig. 5; Bagnoli, *Boll. Camera di commercio*, May 1961, p. 41; Dradi-Maraldi, [1962], p. 28; Fabbri, [1965], pp. 363/ 366; Burchi, 1970, pp. 40–2; Sirotti, 1974, pp. 110–16; ibid., ²1982, pp. 113–16; Ortalli, in *Storia di Cesena*, ii, pt. 2, 1985, p. 149, n.64; Viroli, in *Il mon.*, 1989, pp. 55–60, 165f.

Carlo Verardi, canon of the Cathedral of Cesena and patron of the Altar of the Corpus Domini, was born in 1440. He is noted in Cesenate history as the cathedral's first archdeacon. Resident at the Curia, he filled the office of *Cubicularius* under Popes Paul II, Sixtus IV, Innocent VIII, and Alexander VI. Verardi was author of a *Libro delle cose memorabili di Cesena* and a drama entitled *Historia Baetica*, which recounted the conquest of Granada by Ferdinand V, King of Aragon, and his expulsion of the Moors from Spain; the latter was published in Rome in 1493, with a dedication to Cardinal Raffaello Riario.[1] Verardi died in Rome shortly before November 27, 1500,[2] and was buried in S. Agostino, in a tomb erected by his brother's sons, Camillo, Sigismondo, and Ippolito di Ptolomeo Verardi.[3]

On October 18, 1487, Carlo Verardi requested permission from the chapter of the Cathedral of Cesena to erect there, on the site of the lateral portal, a chapel of which he, the sons of his brother Ptolomeo, and their descendants in perpetuity would have the juspatronage. The canon would bear all costs of construction. Verardi asked leave to move the

Tomb of Bishop Antonio Malatesta and to close or move the window and to break the wall, if that should prove necessary. Verardi's petition was granted.[4] The Cesenate chronicler, Giuliano Fantaguzzi, reported that the Cappella del Corpus Domini was erected in 1494, that the Malatesta Tomb was moved in 1496, and that the chapel was furnished with marble figures at a (total?) cost of 300 ducats in June 1505.[5] This information is partly confirmed by a document of January 10, 1506, in which payment from Verardi's heirs was requested. Recapitulating the conditions of an initial contract, the document states that Carlo Verardi had founded the chapel and commissioned the figures from Giambattista Bregno for 160 ducats. Bregno now claimed 50 ducats and 16 marchetti from the heirs of Carlo and Camillo (who had died in June 1505)[6] for the figures duly completed, as well as for the tomb of Camillo's brother, Ippolito Verardi, which Giambattista had constructed in the Venetian Church of the Crociferi. Bregno's credit was acknowledged by the guardians of Camillo's son and heir Ptolomeo: Camillo Verardi's widow Camilla, Pandolfo Moro, and Vincenzo Toschi.[7] On January 13, 1506, the three paid Giambattista the money due him.[8]

As Fantaguzzi's entries and the documents of payment show, at first the Verardi Chapel was dedicated to the Corpus Domini. Apparently, the chapel did not continue to house the sacrament for long: between 1523 and 1525, Giacomo Bianchi and Rocco Poltri were employed in the construction of another chapel at the choir end of the cathedral's right aisle dedicated to the Corpus Christi. By the late 16th century, the sacrament had migrated once again.[9]

The Chapel of the Corpus Domini (later called the Cappella della Prepositura and now the Cappella di S. Giovanni) originally occupied the fourth bay of the right aisle of the cathedral (in cornu Epistolae), that is, the site it occupies today. There is reason to think that the original chapel consisted of a rectangular recess, in which Christ as Man of Sorrows and the two SS. John occupied the rear wall, while the two kneeling donors were affixed to lateral walls.[10] During the thorough restoration of the church, undertaken between 1681 and 1683 by Cardinal Francesco Vincenzo Maria Orsini, Bishop of Cesena, the chapel and altarpiece were moved to the third bay on the right, displacing once again the lateral portal and the Tomb of Bishop Malatesta. The chapel and altar were cleaned at least twice, in 1778 and 1810.[11] In 1810–11, the sarcophagus of Vincenzo Toschi, from the suppressed church of S. Francesco, was relieved of

its contents, fitted up with relics, and adapted to serve as the altar table of the Chapel of the Corpus Domini. Between 1886 and 1892 the chapel was returned to its original position. The niche's shell by Paolo Grilli dates from the beginning of the twentieth century.[12] The Toschi sarcophagus was eventually replaced by the casket of S. Mauro, visible in the Alinari photograph beneath the altar table; the casket was removed in 1960.

The explicitness with which the document of January 10, 1506, defines Giambattista Bregno's commission as "facere certas figuras de marmore scultas pro Capella Corporis Christi" makes it most unlikely that the sculptor also was entrusted with the architectural framework, begun and finished, as Fantaguzzi tells us, in 1494. Indeed, neither its style nor its quality is Bregno's: evidently its author was a provincial sculptor of little talent.

Among early critics, Oretti and Lübke thought the altar was the work of a Lombardo;[13] Sassi, of Alfonso Lombardi Ferrarese.[14] Zazzeri ascribed the sculptures to the school of Donatello and the framework to Alfonso Lombardi.[15] Meanwhile, Bode traced the altarpiece, which he dated ca. 1510, to the shop of Antonio or Tullio Lombardo.[16] Paoletti tentatively advanced the name of Severo da Ravenna for the figures of the altar.[17] In an article dedicated to the altar, Grigioni claimed for its figures a terminus ante quem of May 25, 1510, by reference to a document of that date requiring that Tommaso Fiamberti's prospective statues for the Altar of St. Leonard in the Duomo of Cesena be of the height of the "figurarum marmorearum capelle Corporis Cristi posite in dicta Ecclesia Cathedrali." Grigioni observed an indisputable similarity between the structure of the altar and the Tomb of Cardinal Bartolommeo Roverella (d. 1476) in S. Clemente, Rome, attributed to Giovanni Dalmata – a resemblance that only to a slight extent depends on the altar's present segmental niche. On the basis of this resemblance, Grigioni assigned execution of most of the Altar of the Corpus Domini to Giovanni Dalmata in 1499–1500, excluding only the cornices, the background of the niche, perhaps also the conch, and the candelabra of the pilasters and bases, left incomplete at Giovanni's hypothetical departure from Cesena. The candelabra certainly and possibly other things as well, Grigioni believed, were carved by Tommaso Fiamberti. The architectural framework of the altar, however, was supposed to have been finished only between 1523 and 1525 by Giacomo Bianchi and Rocco Poltri.[18] In a pamphlet printed privately in 1950, Burchi published the two

documents of 1506, which proved Giambattista's authorship of the figures and provided for them a *terminus ante quem* of January 1506. Burchi also brought to bear on the dating of the altar the entries in Fantaguzzi's chronicle.[19] In a subsequent article, Burchi elucidated the various transpositions of the altar.[20] Burchi's discoveries were incorporated in descriptions of the Duomo of Cesena by Bagnoli, Fabbri, and

Dradi-Maraldi.[21] Viroli distinguished between the principal sculptures, certainly by Giambattista Bregno, and the decorative portions of the chapel, due to another hand.[22] But Sirotti fantasized that Giambattista had delegated *Christ* and the *Baptist* to Antonio Rizzo, perhaps reserving to himself the figure of the *Evangelist*.[23]

---

[1] Forcella, v, 1874, p. 27, no. 74; Braschi, 1738, pp. 332f, no. 31; Zazzeri, 1890, p. 356, n. 2; Sirotti, 1982, p. 113, and esp. Ortalli, in *Storia di Cesena*, ii, pt. 2, 1985, pp. 147–9, with bibliography. Cf. Cesena, Bibl. com., MS 164.45, Bucci, 1728, pt. 1, c. 37, who legitimately doubted whether Verardi were the first archdeacon of the Cathedral of Cesena.

[2] Burchi, 1962, ii, p. 76, according to whom the vacancy in the cathedral's archdeaconate, caused by Verardi's death, was filled on November 27, 1500, by the nomination of Don Agapito Geraldini. The document of election is preserved in Cesena, Archivio curia vescovile, Canonici 1, 1280–1527, cc. 56r–57v. A death date in November 1500 is confirmed by Fantaguzzi, (1460–1510) 1915, p. 133. Therefore the deathdate of December 13, 1500, given by Verardi's epitaph, for which see below n.3, must be mistaken.

[3] Forcella, v, 1874, p. 27, no. 27, no. 74. The epitaph, crowned by a relief of the half-length seated Madonna, the Christ Child, John the Baptist and an adoring Angel, is illustrated in Courtauld Institute illustration archives, Archive 2, pt. 3, 1977, figs. 16–18.

[4] See Appendix A, Doc. VI A.

[5] See Appendix A, Doc. VI, B, C, D.

[6] Fantaguzzi, (1460–1510) 1915, p. 217.

[7] See Appendix A, Doc. VI, E.

[8] See Appendix A, Doc. VI, F.

[9] Grigioni, *Rass. bibl.*, 1911, pp. 16–18; Burchi, [1950], p. 8; idem, *Studi romagnoli*, 1954, pp. 262f, no. 7.

[10] See Chapter Two, p. 36.

[11] Cesena, Bibl. com., MS 164.33, Andreini, *Suppl.*, iii, 1810, cc. 100f.

[12] All the basic information on the chapel's transpositions is provided by Burchi, *Studi romagnoli*, 1954, pp. 257–62, nos. 4, 6, and fig. 5. See also Cesena, Bibl. com., MS 164.45, Bucci, 1728, pt. 1, cc. 24f; Cesena,

Bibl. com., MS 164.31, Andreini, *Memorie*, xii, 1808, cc. 183f, 188f; Cesena, Bibl. com., MS 164.33, Andreini, *Suppl.*, i, 1808, c. 69; ibid., *Suppl.*, iii, 1810, cc. 113–15; Bagnoli, *Boll. Camera di commercio*, May 1961, p. 41.

[13] Oretti, 1777, in *Il patrimonio culturale . . . di Forlì, I. Gli edifici*, 1973, p. 186; Lübke, [2]1871, ii, p. 564.

[14] Sassi, 1865, in *Il patrimonio culturale . . . di Forlì, I. Gli edifici*, 1973, pp. 188f.

[15] Zazzeri, 1890, p. 356, n. 2; idem, *Il Savio*, Dec. 31, 1899, [p. 1].

[16] Bode, *Rev. archéol.*, Jan.–June 1879, p. 102; Burckhardt/Bode, [4]1879, ii, pt. 2, p. 407c; idem, [5]1884, ii, pt. 2, p. 437h.

[17] Paoletti, 1893, ii, pp. 233f, n. 6. Although Paoletti called the altar ambiguously the Verardi Altar, we may be sure he did not mean the Altar of St. Leonard, whose Verardi patronage was discovered only in 1910.

[18] Grigioni, "L'altare," *Rass. bibl.*, 1911, pp. 12–16, repr. in idem, *Il cittadino*, June 11, 1911, [pp. 1f] and summarized in idem, *Rass. bibl.*, 1915, p. 2. The documents of 1523 and 1525, as it happens, refer to a different altar, for which see n. 9. Grigioni's attribution to Giovanni Dalmata was repeated by Bazzocchi/Galbucci, 1915, p. 131.

[19] Burchi, [1950], pp. 3–7.

[20] Burchi, *Studi romagnoli*, 1954, pp. 257–62, nos. 4, 6.

[21] Bagnoli, *Boll. Camera di commercio*, May 1961, p. 41; Dradi-Maraldi, [1962], p. 28; Fabbri, [1965], pp. 363/6.

[22] Viroli, in *Il mon.*, 1989, pp. 59f.

[23] Sirotti, 1974, pp. 111–14; idem, [2]1982, pp. 113–15. Sirotti's mention of other collaborators hired by Bregno to execute the altar — among whom, Tommaso Fiamberti — in the 1974 mimeographed, but already posthumous, edition (p. 112), along with the chapter to which it belonged, was dropped from the printed book of 1982.

---

## 3. CESENA, DUOMO (S. GIOVANNI BATTISTA): ALTAR OF ST. LEONARD
### LORENZO BREGNO

Pls. 174–185

The figural components of the original altarpiece are separately immured within a common frame considerably above eye-level in the tract of wall spanning part of the second and third bays of the cathedral's left aisle (*in cornu Evangelii*).

The figure of *St. Leonard*, its upper base, and a small portion of the background between the base and the *Saint's* left sleeve are carved from a single block of white marble. *St. Christopher*, his staff and base, the Christ Child with his globe, and that part of the background contained within the borders of the group, are carved from a single block of white marble. *St. Eustace*, his base, the deer, sword, bow, and tree trunk, as well as a small portion of the background between the *Saint's* two legs and between his right leg and his attributes, are carved from a single block of white marble.

*St. Leonard*: 164.5 cm high (including its uppermost base); *St. Christopher*: 175 cm high (including its base); *St. Eustace*: 167.3 cm high (including its base).

In none of the figures are there any traces of polychromy or gilding.

There is a nick in the outer part of *St. Leonard*'s left sleeve; above the nick the stone is finely fissured. The miniature metal wrist irons, attached through a hole in the stem held in the *Saint*'s right hand and visible in a very old photograph, are missing now. Otherwise the figure is perfectly preserved. The upper half of the Christ Child's globe is broken off; its upper surface is flat but not smooth. The pitted surface of the hemisphere seems to be due to lack of finish, rather than to damage. The tip of the last toe of *St. Christopher*'s right foot is chipped. The vertical edge of the *Saint*'s mantle on the spectator's left is slightly chipped in several places. At the rear of *St. Eustace*'s left elbow and forearm, a large chip appears to have broken off while the figure was being carved, and to have been reattached and finished along with the rest of the arm. A chip is missing from the border of the mantle that crosses the *Saint*'s right upper arm; two chips are missing from the border of the mantle that crosses the *Saint*'s legs. One of the straps on the *Saint*'s left shoulder is nicked. The knob of the sword hilt has been truncated vertically, but not smoothed. Here, as in the Christ Child's globe, the planar but rough surface appears to signal the edge of the relief.

In the late nineteenth century the following inscription existed beneath the base of *St. Leonard*: VIN-CENTIVS TVSCVS PHILOSPHVS/ ET MEDICVS AC IVLIA VERARDA EIVS VXOR/ DILLECTISSIMA IVSSV CAMILLI VERARDI/ EQVITIS PONTIFICII DIVO LEONARDO/ SACELLVM HOC DEDICAVIT. The inscription no longer exists.[1]

Bibl.: Cesena, Bibl. com., MS 164.66, Masini, late 16th cen., in Ceccaroni, ii, c. 167; *Stat. civ. Caes.*, 1589, p. 379; Oretti, 1777, in *Il patrimonio culturale…di Forlì*, I. *Gli edifici*, 1973, p. 186; Cesena, Bibl. com., MS 164.33, Andreini, *Cesena sacra*, i, 1807, cc. 46f, no. VII, c. 111; ibid., *Suppl.*, i, 1808, cc. 66f; ibid., *Suppl.*, iii, 1810, c. 99; Sassi, 1865, in *Il patrimonio culturale…di Forlì*, I. *Gli edifici*, 1973, p. 188; Lübke, [2]1871, ii, p. 706; Bode, *Rev. archéol.*, Jan.–June, 1879, p. 102; Burckhardt/ Bode, [4]1879, ii, pt. 2, p. 407c; idem, [5]1884, ii, pt. 2, p. 437h; Zazzeri, 1890, pp. 356f, n. 2; [Zazzeri], *Il Savio*, Dec. 31, 1899, [p. 1]; Grigioni, *L'arte*, 1910, pp. 42–8; [Trovanelli], *Il cittadino*, Apr. 10, 1910, [pp. 2f]; Grigioni, "L'altare," *Rass. bibl.*, 1911, pp. 14f, repr. in idem, *Il cittadino*, June 11, 1911, [p. 2]; idem, *Felix Ravenna*, 1913, pp. 504–7; idem, *Rass. bibl.*, 1913, p. 4; K., T-B, xi, 1915, p. 526, voce "Fiamberti"; Bazzocchi/ Galbucci, 1915, pp. 128, n. 2, 131; "Gottardi," T-B, xiv, 1921, p. 420; Mariacher, *Arte ven.*, 1949, pp. 95, 96; Burchi,

*Studi romagnoli*, 1954, pp. 266f, 269, 276, 277, 278, and fig. 5; Bagnoli, *Boll. Camera di commercio*, May 1961, p. 44; Dradi-Maraldi, [1962], p. 31; Vazzoler, 1962/63, pp. 156, 242–246, 265; Fabbri, [1965], p. 368; Munman, 1968, p. 309, n. 4; Mariacher, *DBI*, xiv, 1972, p. 114, voce "Bregno, L."; Sirotti, [2]1982, pp. 123f; Schulz, *BJ*, 1984, pp. 145, 179; Mariacher, 1987, p. 232, voce "Bregno."

Camillo di Ptolemo Verardi, pontifical knight and nephew of Carlo Verardi in whose altar he is portrayed, indited his testament in Cesena on June 19, 1504. In it he appointed as his executors his wife Camilla, his brother-in-law Vincenzo Toschi, Pandolfo Moro, and Marcello Verardi, rector of S. Severo, Cesena. As his residual heirs, he named his minor son Ptolomeo and any other legitimate male offspring he might have and their legitimate male issue; in their absence, the legitimate male issue of his late brother Sigismondo Verardi; and in their absence, the most closely related female issue of the Verardi house. Camillo instructed his executors to have a chapel dedicated to St. Leonard built in the cathedral, next to the baptismal font, in accordance with the contract, notarized by Battista Gemati, which the testator had made with Domenico da Bologna mason and Giovanni Battista da Castel Bolognese carpenter. Camillo also charged his executors to commission three marble figures with appropriate attributes, to be made within three years of his death at his estate's expense. The figures were to represent St. Leonard, flanked by SS. Eustace and Christopher, and were to cost no less than 50 ducats.[2]

Verardi died in exile in Rimini in June 1505.[3] Apparently his only son, Ptolomeo, alive on January 13, 1506,[4] did not survive for long. Nor, apparently, had Camillo's brother any surviving male issue. For on October 20, 1507, the *Collegio della Roba* of Pavia awarded the Verardi inheritance of 20,000 ducats, which had been contested by Bastiano Martellino da Ravenna, to Giulia Verardi, Camillo's sister and wife of Vincenzo Toschi.[5] With the inheritance, Giulia seems to have assumed responsibility for construction of Camillo's chapel and altar, for which she engaged the mason Giovanni di Bartolino da Palazzolo on May 15, 1508. Their contract recounts how, during his lifetime, Camillo Verardi had had work begun on a chapel dedicated to St. Leonard in the corner of the Duomo near the baptismal font, how this chapel had extended into the cemetery, which was both unsightly and inconvenient, and how the Bishop of Cesena, through his vicar, had ordered Giulia to de-

molish what had already been erected and rebuild the chapel in a better place. Therefore Giulia, with the permission of her husband and Pandolfo Moro, as Verardi's executors, was now commissioning Giovanni di Bartolino to build the chapel in the same corner of the church but not on the foundations begun by Camillo. The structure of brick was to resemble the Chapel of the Corpus Domini in the Duomo of Cesena, in accordance with a drawing made by Master Giovanni. Work on the chapel was to be finished by the end of the coming August, and Giovanni's fee was set at 90 Bolognese lire.[6] On November 2, 1508, the mason presented his final quittance for 70 Bolognese lire.[7]

On May 25, 1510, with the consent of her husband, Giulia commissioned the three statues for the Verardi Chapel altar from the Lombard sculptor Tommaso Fiamberti, and the goldsmith and painter Vincenzo Gottardi. The statues were to represent St. Leonard, St. Christopher with the Christ Child on his shoulder, and St. Eustace with a deer at his feet. The figures were not to be pieced, but were to be made of single blocks of marble, of the same kind and quality as the sample Fiamberti and Gottardi had brought to Giulia's house. The figures were to be as tall as those in the Chapel of the Corpus Domini (162–7 cm). Fiamberti and Gottardi promised that, before executing the marble figures, they would make a clay model, which the marble figures should follow. The statues were to be finished and installed by February 28, 1511. Completed figures were to be submitted to the judgment of two or more expert sculptors. Work was to be done at the expense of the artists, with the exception of the transport of the marble from the quarry to Fiamberti's house at Cesena, to be carried out at Giulia's expense. In recompense, Giulia undertook to pay Fiamberti and Gottardi, in addition to one *salma* of grain and one of wine, 25 ducats in cash and 25 ducats' worth of immovable goods previously appraised. Of the total 50 ducats, one-third was to be paid before completion of the statues, and two-thirds after completion and installation. If Fiamberti and Gottardi did not fulfill their obligations, they would return to Giulia all the money and goods received from her and pay all damages and interest.[8] On October 12, 1510, the two artists received their first payment on account.[9]

We do not know why or when Fiamberti and Gottardi were dismissed. In any event, on March 18, 1514, through the agency of her husband, Giulia made a new agreement with Lorenzo Bregno. The contract again specified statues of *St. Leonard, St. Chris-topher* bearing Christ on his shoulder, and *St. Eustace* with the deer at his feet. The figures, with bases, were to be made of single blocks of the finest Carrara marble; they were to be four and a half feet high (156.15 cm) and carved in approximately two-thirds relief. The figures were to stand in three compartments of white Istrian limestone from the Brioni Islands, as shown in a drawing in the possession of the notary; the compartments were to be faced with Carrara marble and ornamented as Lorenzo might choose. The sculptor was to see to the installation of the figures himself. The work was to be finished and the figures installed within a year. For his labor and material Bregno was awarded a fee of 100 ducats, of which he received 10 ducats as an advance. Upon the completion of each statue, he would receive another 20 ducats and the remaining 30 would be paid him upon the installation of the finished altarpiece. The expense of the transport of the statues (presumably from Venice) to the port (Cesenatico) and their unloading was to be borne by the sculptor, but the expense of transport from the port to the cathedral would be paid for by the patron. Bregno promised to provide a guarantor in Venice for the money received and the work to be accomplished. Among the witnesses to the contract was Tommaso Fiamberti.[10]

The figures having been finished and installed, Bregno gave a quittance for his final payment of 23 ducats on February 9, 1517. Again Tommaso Fiamberti was present as witness.[11] At the same time, Fiamberti returned to Vincenzo Toschi the 17 ducats that the sculptor had been paid on account in 1510.[12]

Until its dismemberment and the dispersal of its components during the cathedral's restoration of 1886–92, the Altar of St. Leonard occupied its original site in the first bay of the left aisle. An Alinari photograph shows the altarpiece as it stood before its disassembly (Pl. 174). Its architectural setting of scagliola[13] imitates colored marbles and therefore may have been intended to allude to the original marble revetment called for by Bregno's contract. But the scagliola setting cannot have preserved the design of the original, for the flat backgrounds of Bregno's reliefs do not accord with the setting's segmental curve, and the rectangular shape of *St. Christopher's* slab does not agree with the arched compartments. In 1810 the statues were cleaned; the altar table was replaced by a wooden mensa taken from the suppressed church of S. Francesco and painted to imitate marble. In 1887 the Chapel of St. Leonard was transformed into the church's baptistry. The relief of *St. Leonard* was moved to the altar in the third bay of

the right aisle; the reliefs of *SS. Christopher* and *Eustace* were installed on the altar in the sixth bay of the right aisle.[14] The three figures were reunited in the left aisle of the Duomo between 1957 and 1960.[15]

In his *Vita di Domenico Malatesta,* Niccolò II Masini (1533–1602) wrote, "In questo stesso anno (1498) lo Ecc.te Scultore Pietro [*sic*] Riccio Venetiano, che fece lo Adamo, et Eva nel Palazzo di S. Marco, essendo fugito di prigione dove era stato posto di ordine della Signoria di Vinegia, se ne venne ad habitare in Cesena, e partitosi fra certo tempo se ne andò a Ferrara: Tiensi per fermo che le tre figure di marmo poste nella p.a Capella del Duomo a mano sinistra, cioè il S. Leonardo, il S. Eustachio, et il S. Cristofuro fossero fatte con sua partecipatione da uno degl'Allievi suoi."[16] Although Rizzo's temporary presence in Ce-

sena has been confirmed,[17] there is nothing in the figures that can be attributed to him; indeed, it is likely that he died not long after witnessing a document in Cesena in 1499. Oretti claimed the three statues for a Lombardo,[18] Sassi, for a mythical Pier Lombardo Ferrarese,[19] and Lübke, for Alfonso Lombardi,[20] while Bode ascribed the altar to the shop of Antonio [*sic*] or Tullio Lombardo and dated it ca. 1520–5.[21] Masini's account evidently influenced Zazzeri, who gave the altar to "Pietro Riccio nicknamed Tribolo,"[22] and Bazzocchi and Galbucci, who gave it to Rizzo.[23] In 1910 Grigioni explicated the circumstances of the altar's commission and manufacture.[24] Since then, the altar has figured regularly among Lorenzo Bregno's works.[25]

---

[1] The inscription was transcribed by Grigioni, *L'arte,* 1910, p. 47, n. 1.

[2] The testament was published in entirety in *Stat. civ. Caes.,* 1589, pp. 378–84. For passages concerning the chapel and altar, see Appendix A, Doc. XIII, A. The acts of the Cesenate notary, Battista Gemati, do not survive.

[3] Fantaguzzi, (1460–1510) 1915, p. 217; Sirotti,[2]1982, p. 115.

[4] See Appendix A, Doc. VI, F.

[5] Fantaguzzi, (1460–1510) 1915, p. 270.

[6] ASC, Archivio notarile, Volume 277 (not. no. 25, Gaspare Antonini, 1508), cc. 123rf, published by Grigioni, *L'arte,* 1910, pp. 43f, n. 3.

[7] ASC, Archivio notarile, Volume 277 (not. no. 25, Gaspare Antonini, 1508), c. 197r.

[8] ASC, Archivio notarile, Volume 554 (not. no. 50, Stefano Toschi, 1511), n.c., published by Grigioni, *Felix Ravenna,* 1913, pp. 504–7.

[9] Ibid., p. 507.

[10] See Appendix A, Doc. XIII, B.

[11] See Appendix A, Doc. XIII, C.

[12] ASC, Archivio notarile, Volume 160 (not. no. 18, Francesco Bucolini, 1512–17), n.c.

[13] [Trovanelli], *Il cittadino,* Apr. 10, 1910, [p. 2].

[14] Ibid., [p. 2]; Burchi, *Studi romagnoli,* 1954, pp. 266, no. 14, 277f, and fig. 5; Cesena, Bibl. com., 164.33, Andreini, *Suppl.* iii, 1810, c. 99.

[15] Sirotti,[2]1982, p. 124.

[16] Cesena, Bibl. com., MS 164.66, Masini, late 16th cen., in Ceccaroni, ii, c. 167.

[17] Grigioni, *L'arte,* 1910, pp. 44f.

[18] Oretti, 1777, in *Il patrimonio culturale ... di Forlì, I. Gli edifici,* 1973, p. 186.

[19] Sassi, 1865, in *Il patrimonio culturale ... di Forlì, I. Gli edifici,* 1973, p. 188.

[20] Lübke,[2]1871, ii, p. 706.

[21] Bode, *Rev. archéol.,* Jan.–June 1879, p. 102; Burckhardt/Bode,[4]1879, ii, pt. 2, p. 407c; idem,[5]1884, ii, pt. 2, p. 437h.

[22] Zazzeri, 1890, pp. 356f, n. 2; [idem], *Il Savio,* Dec. 31, 1899, [p. 1].

[23] Bazzocchi/Galbucci, 1915, p. 131.

[24] Grigioni, *L'arte,* 1910, pp. 42–48.

[25] [Trovanelli], *Il cittadino,* Apr. 10, 1910, [p. 2], K., T-B, xi, 1915, p. 526, voce "Fiamberti", "Gottardi," T-B, xiv, 1921, p. 420; Mariacher, *Arte ven.,* 1949, p. 95; Burchi, *Studi romagnoli,* 1954, p. 266, no. 14; Bagnoli, *Boll. Camera di commercio,* May 1961, p. 44; Dradi-Maraldi, [1962], p. 31; Vazzoler, 1962/63, pp. 156, 246; Fabbri, [1965], p. 368; Munman, 1968, p. 309, n. 4; Mariacher, *DBI,* xiv, 1972, p. 114, voce "Bregno, L."; Sirotti,[2]1982, p. 124; Schulz, *BJ,* 1984, pp. 145, 179; Mariacher, 1987, p. 232, voce "Bregno."

---

## 4. CREMA, S. TRINITÀ: TOMB OF BARTOLINO TERNI
### LORENZO BREGNO

Pls. 238–243

The Tomb of Bartolino Terni is affixed to the internal facade of the church above its main portal.

The front and lateral faces of the sarcophagus are incrusted with slabs of black-veined white marble. Most of the letters of the epitaph are filled with niello.

The pedestrian effigy, its base, and the tree stump, which functions as a support, were carved from a single block of white marble. A portion of the puffed sleeve immediately above the effigy's projecting left elbow, however, has been pieced; evidently the piecing is original. The effigy holds a wooden lance with a metal tip.

Effigy: 183.5 cm high (including its 11-cm-high base).

The effigy's pupils are battleship gray. The outer rim of its left iris is red. Traces of gilding are preserved in its hair. A broad black strip cuts diagonally across the heel of the outer side of the figure's left shoe. No other remains of polychromy or gilding are visible in the figure. The two incised letters and sign contained within the O of BARTO in the epitaph are painted red; the rest of the letters are black. The figure's lance – staff as well as tip – is painted silver.

*Terni* has lost the ends of the last four fingers of his left hand. A chip is missing in the edge of the skirt of chain mail beneath the broken hand. The middle ribbon, which ties the figure's jack, is nicked just below the bow. The ornament at the dangling end of the belt is rather badly chipped. There is a short fissure in the stone of the effigy's left sleeve, visible at the front near the armhole. The pockmarked surface of the effigy is most likely due to its relative lack of finish, not to damage. Indeed, tool marks are visible all over. While the figure is sketched out in back, details of armor are lacking: the skirt of chain mail is smooth and the jack is merely stippled with a punch. At the rear, the chain and locks of hair are not as finely carved as they are in front. The figure's engaged leg is not entirely excavated from the block, while the raised part of the effigy's free foot remains attached to the base. The apex of A in FA, inscribed in the base, is chipped.

Beneath the sarcophagus, the epitaph reads: QVI VE-NETAS INTER COPIAS ANN / XL FLORVIT · BAR-TOLIÒ · TERNVS · GENERE . AEQVESTRIQ₃ DIGNI-TATE CLARVS · / HIC FIDE · MARTE · ET · PATRIA PLO / RANTIR̥TEGITVR · DIE P IVLII M D IIXX

The upper rim of the base is inscribed on its vertical face: · LAVRENTIVS · BRENIVS · FA · (f a c e b a t)

Bibl.: P. Terni, (1557) 1964, p. 309; Crema, Bibl. Sem. Vesc., CR. 7 ms, Zucchi, ii, 1737–45, cc. 41 vf; Crema, Bibl. com., MS 182.2, Racchetti, 1848–50, c. 262, voce "Terni, Bartolino"; Sforza Benvenuti, in *Grande illus.*, v, pt. 1, 1859, p. 743; Crema, S. Trinità, Arch. parrocchiale, MS, c. 11; Sforza Benvenuti, 1888, pp. 278f, voce "Terni, Bartolino il Vecchio"; Franceschini, 1871, c. 11; Gelera, n.d., p. 10; Crema, S. Trinità, Arch. parrocchiale, MS, Zavaglio, 1922, c. 72; G. Terni de Gregory, *Italia contemp.*, 1949, p. 249; Mariacher, *Arte ven.*, 1949, p. 97; Piantelli, 1951, p. 67; Bombelli, 1953, p. 34; W. Terni de Gregory, 1955, pp. 13, 57; Vazzoler, 1962/63, pp. 156, 159f, 251f; Zava Boccazzi, 1965, p. 179; Munman, 1968, pp. 298f, 302, 303–6, 308; Mariacher, *DBI*, xiv, 1972, p. 115, voce "Bregno, L."; Perolini, 1978, p. 73; Facchi, 1983, pp. 36, 38, 39; Schulz, *BJ*, 1984, p. 146; Mariacher, 1987, pp. 52, 232, voce "Bregno."

The Cremasque knight Bartolino di Antonio Terni il Vecchio was born in 1431. During the Ferrarese war, Bartolino valorously led 400 mercenary infantry troops in the Venetian defense of Crema. Having acquired Cremona in 1499, the Venetians gave its fort in charge to Bartolino. As a reward for service on behalf of Venice, Terni received exemptions from taxation and land at Crema where the Castello di Porta Ombriano had formerly stood, on condition that he construct his residence there. After Benedetto Crivelli handed over French-held Crema to the Venetians in September 1512, Bartolino and three other Cremasque ambassadors were sent to congratulate the *Signoria* and ask for confirmation of the city's privileges. At Verona the four were taken hostage by the Germans; although the others were soon liberated, Bartolino remained imprisoned for 86 days in the Castel Vecchio and was released only upon payment of 400 ducats, eventually reimbursed by Crema. In 1513 Bartolino lent 3,000 ducats, refusing repayment until the war had ended, in order to support mercenaries in Venetian employ garrisoned at Crema. At an advanced age Bartolino married Aloisa Terni, who bore him Serafina and Marcantonio. Bartolino died on July 1, 1518, at the age of 87, having served the *Serenissima* for forty years.[1]

The Church of S. Trinità, in which Bartolino's tomb was erected – the third of four on the site – had been built by Giuliano Ogliaro between 1479 and 1485, to replace one of the 12th century. The length and width of the 15th-century church were not much less than those of the present church, but the 15th-century church was only a little less than half as high. The orientation of the 15th-century church was not changed afterward and altars were disposed and dedicated as they are today. S. Trinità was the seat of Benedictine nuns from 1493 to 1518, after which the church was transferred to parish use.[2] The Tomb of Bartolino Terni was erected in the 15th-century church immediately outside the choir, above the door to the Baptistry, *in cornu Evangelii*. The monument was moved to the position it occupies today when the present church was built by Andrea Nono between 1737 and 1740.[3] In fact, the internal facade of S. Trinità, with its bowed cornice surmounting a niche, which embraces Terni's effigy, was clearly designed to house the tomb (Pl. 238). In November 1797, during the Napoleonic occupation of Crema, the Terni family was condemned to remove the tomb of their ancestor. Bartolino's ashes were temporar-

ily interred in a family grave in the Church of the Capuccines (Madonna di Lourdes); his tomb was preserved in the family palace. Once the French had been expelled and Lombardy was under Austro-Russian control, the Terni applied to the interim government of Crema for permission to reinstall Bartolino's tomb. License was granted on July 27, 1799, and the tomb, with Bartolino's remains, was erected

once again over the church's central portal.[4]

Although the Tomb of Bartolino Terni found frequent mention in histories of Crema, it was not until G. Terni de Gregory read the inscription on the pedestal of the effigy in 1949 that any thought was given to its authorship.[5] Since then, the attribution of the tomb to Lorenzo Bregno has never been disputed.[6]

---

[1] P. Terni, (1557) 1964, ad indicem; Fino/Terni, (1566), i, 1844, pp. 217–96; Sforza Benvenuti, 1859, i, pp. 276–362; idem, 1888, pp. 276–8, voce "Terni, Bartolino il Vecchio." Bartolino is known to have made two testaments – one on November 13, 1502, notarized by Matteo Bravio, and another of August 14, 1516, notarized by Luigi Patrini: Crema, Bibl. com., MS 193.2, *Rubrica de' testamenti*, ii, c. 340. Only the former is extant: Lodi, Archivio notarile della Bibl. com. Laudense, shelf 13A (not. Matteo Bravio, 1502). It makes no reference to the testator's burial.

[2] Crema, S. Trinità, Arch. parrocchiale, MS, Franceschini, 1871, cc. 10, 12; Crema, S. Trinità, Arch. parrocchiale, MS, Zavaglio, 1922, cc. 67–71; Facchi, 1983, pp. 20, 34–6.

[3] Crema, Bibl. com., MS 182.2, Racchetti, 1848–50, c. 262, voce "Terni, Bartolino": "Morì (Bartolino Terni) il primo Luglio 1518, e fù sepolto nella Chiesa della SS. Trinità in un monumento di marmo, posto fuori del Coro a man destra dell'altar maggiore." More explicit still is a contemporary report of the tomb's removal contained in Crema, Bibl. Sem. Vesc., CR 7 ms, Zucchi, ii, 1737–45, cc. 41vf: "Nella chiesa che si costruisce della S.S.ma Trinità alli 27 d.° [June

1738] venne levata la statua di marmo con il deposito sotto il valoroso Bartolin Terni nostro Concittadino fu generale dell'armi della Ser.ma nostra Republica, dal luogo sopra della porta de Battisterio in cornu Evang. immediate fuori del Presbiterio del gran Altare, e quella e questo collocati sopra la porta maggiore intieramente con la sua antica iscrizione e nella stessa figura e sistema di prima." For the present church of S. Trinità, see Facchi, 1983, pp. 43f.

[4] Crema, Bibl. com., MS 182.2, Racchetti, 1848–50, c. 262, voce "Terni, Bartolino", Sforza Benvenuti, 1888, pp. 278f; Crema, S. Trinità, Arch. parrocchiale, MS, Zavaglio, 1922, c. 72.

[5] G. Terni de Gregory, *Italia contemp.*, 1949, p. 249.

[6] The attribution recurs in: Mariacher, *Arte ven.*, 1949, p. 97; Piantelli, 1951, p. 67; Bombelli, 1953, p. 34; W. Terni de Gregory, 1955, pp. 13, 57; Vazzoler, 1962/63, pp. 156, 251f; Zava Boccazzi, 1965, p. 179; Munman, 1968, pp. 298f, 302, 303–6; Mariacher, *DBI*, xiv, 1972, p. 115, voce "Bregno, L."; Perolini, 1978, p. 73; Facchi, 1983, pp. 36, 38; Schulz, *BJ*, 1984, p. 146. Mariacher, 1987, pp. 52, 232, voce "Bregno."

---

## 5. CREOLA (SACCOLONGO), S. MARIA DEL CARMINE (ORATORY OF THE SS. TRINITÀ): TOMB OF BENEDETTO CRIVELLI

LORENZO BREGNO

Pls. 235–237; Fig. 58

The freestanding tomb is located in the nave of the aisleless church, equidistant from either lateral wall, beneath the third of four pairs of ceiling lunettes. The effigy is currently oriented so that its head points to the altar, its feet to the entrance.

Bier and effigy are carved from a single block of white marble. The sarcophagus consists of six slabs of gray-veined white marble – one each for the head and foot and two more for the sides, plus two for upper and lower cornices. The stunted columns and square pedestals beneath the sarcophagus are made of the same gray-veined white marble, as is the border around the floor of the tomb. The central rectangle

of the floor is paved with red tiles set in a pattern of lozenges.

Effigy: 188 cm long; bier: 20.4 cm high × 203 cm long × 99.2 cm wide; sarcophagus: 81.8 cm high × 218.2 cm long × 88.9 cm wide; columns: 58.6 cm high; floor: 13.6 cm high × 239.7 cm long × 108.1 cm wide.

There are no traces of polychromy or gilding.

A chip is missing from *Crivelli's* beard; the tip of his nose is chipped and nicked. The wrist of his right hand is chipped; beneath his right hand the surface is nicked. Here and there, but particularly on and around *Crivelli's* left knee, the plate armor is nicked. On the effigy's right, the border of the bier cloth is chipped in the center. On the opposite side, the border of the bier cloth is nicked through most of its length.

There are two cracks in the lower cornice of the sarcophagus on the Epistle side. The seams at the foot of the sarcophagus are gaping and damaged. The

escutcheon at the foot of the sarcophagus is badly defaced: crowning scrolls are broken off, lateral scrolls are mutilated; ribbons at the top are chipped; the top of the stem and the blossom of the flower, which rises from the center of the escutcheon, are truncated; the lower border of the shield is chipped. The corners of some of the abaci and bases of the columns are chipped. The inner faces of the square pedestals are unworked.

On the Epistle side of the sarcophagus is the following inscription: BENEDICTO CRIBELLO / FORTISSIMO PEDITVM / DVCTORI OB EXIMIA / EIVS [sic] IN REM (publicam) VENETAM [sic] / MAGNIS MVNERIBVS / DONATO. On the Gospel side is the following inscription: SIMVLQ(ue) A SENATV VENETO / IN PATRITIVM ORDINEM / ASCITO(ascripto) ALOYS PISANVS / D MARCI PROC(urator) HAERES / EX TEST(amento) BENEFICII M(emoria) / OBIIT ANNO · M · D · XVI.

Bibl.: Scardeone, 1560, p. 437; Padua, Bibl. civ., MS B. P. 324, [Cittadella], 1605, c. 171; Venice, Bibl. Marc., MS lat., Cl. X, 144 (= 3657); Palferio, 17th cen., c. 303v; Venice, Mus. Correr, MS Cicogna 2331, *Famiglie venete*, 17th cen., cc. 360f; Salomoni, 1696, p. 191; Venice, Bibl. Marc., MS. it., Cl. VII, 167 (= 8184); Gradenigo, 18th cen., i, c. 145v; Brandolese, 1793–1808, in Fantelli, *Padova e la sua provincia*, Feb. 1981, p. 30; Padua, Bibl. civ., MS B. P. 3202; Manetti, 19th cen., cc. 355rf; Meneghini, in *Grande illus.*, iv, 1859 (1861), p. 240; Gloria, 1862, ii, p. 92; F. Sartori, 1876, p. 33; idem, 1883, p. 21; Paoletti, 1893, ii, p. 146; "Contributo al cat. gen.," in Berchet, 1895 (1896), p. 21; *Elenco degli edifici*, 1930, p. 126; Prosdocimi, in Padua, Pal. della Ragione. *Dopo Mantegna*, 1976, p. 132, no. 93; Scarpitta, 1978, p. 108; Degan, in Degan/Rubini, 1980, pp. 47–50; Degan, 1981, pp. 3–5, 9, n. 7; Grandis, 1983, pp. 31–33; Condé, 1986, pp. 97–9; Sandro Zanotto, in Cuoghi et al., 1987, p. 91; Scalini, *Gazz. antiquaria*, 1987, p. 57, n. 4

Benedetto di Guglielmo Crivelli was descended from an ancient and noble Milanese family; like many of his relatives, he was a *condottiere*,[1] a leader of infantry. In June 1512, Crivelli brought 500 soldiers to Crema to reinforce the French, besieged by the Venetians in the War of the League of Cambrai. Within a short time, Crivelli was holding secret negotiations with both the Venetians and the Milanese. In return for the city, he asked from the former 7,000 ducats, an additional 1,000 ducats from the income of the Padovano, a house in Padua, and patrician status in Venice. These conditions were accepted, and on September 9, 1512, Crivelli surrendered Crema to the Venetians. Five days later, he and his legitimate male issue were ennobled. On January 5, 1513, the Venetian *Signoria* gave Crivelli a house in Padua at the Eremitani, which had belonged to Bertuzi Bagaroto,

and "la possession a Creola fo di Arturo Conte fo fiol di domino Prosdozimo, qual è mia 6 lontan di Padoa sora l'aqua, va atorno mia 10, e si cavalcha tre mia in mezo dite possession, qual danno de intrada ducati 1000."[2] Crivelli entered Venetian employ, but because he was suffering from syphilis, his *condotta* from the Venetian *Signoria* was canceled; nevertheless the *condottiere* was awarded a monthly salary of 100 ducats. On March 22, 1516, Crivelli died in Padua of pleurisy.[3]

Crivelli's testament of July 20, 1515, and its protocol survive among the papers of the Venetian notary Girolamo de' Bossis.[4] In his testament, Crivelli ordered that there be built on his estate at Creola (Saccolongo), in the untilled fields between the fishpond and his palace, a church like the church in front of his estate, in which Mass for his soul was to be celebrated by a priest whose salary and house Crivelli also provided for. A marble tomb, on which Crivelli's name and arms were to be carved, was to be erected on four marble columns in Crivelli's new church; 150 ducats were to be spent on the tomb's construction. The church with its monument, as well as the priest's house, were to be built within a year of Crivelli's death, unless war should prevent it. Crivelli named his great friend Alvise Pisani executor and, in the absence of legitimate male descendants, his residual heir.

Alvise Pisani dal Banco, son of Giovanni q. Almorò, entered the *Maggior Consiglio* in 1484.[5] He was *Savio del Consiglio* when, on May 18, 1516, not long after learning of Crivelli's bequest, Pisani pledged 10,000 ducats as a low interest loan to the state if elected procurator. Successful in his candidature, he was elected *Procuratore di S. Marco de supra*. In 1526 Pisani was *Provveditore* of the Venetian army and in 1527, ambassador to Pope Clement VII. Pisani was *Provveditore* of the army again when, in 1527, Aquila and other towns in the Abruzzo and in Puglia were taken. In 1528 his army participated in the siege of Naples, where Pisani died of the plague on June 30, at the age of 60.[6]

Crivelli's epitaph informs us that his tomb was erected by Pisani, Procurator of St. Mark's and testamentary heir, as the *condottiere* had disposed. The terms of Crivelli's will make clear that the commission for tomb and church postdates Crivelli's death. Its style proves the effigy to have been completed before Lorenzo Bregno's death, between December 22, 1523, and January 4, 1524. "M · D · XXV" inscribed in the exterior frieze of the oratory's portal,[7] probably designates the year of the facade's erection and there

fore the end of work on the fabric of the church.

In 1816 the church, together with the estate, passed from the Pisani to the Bonvecchiato who, in turn, ceded it in 1837 to the Collegio Armeno Moorat. The estate and oratory passed to the Gallo Adelchi family before becoming the property of the Fabris brothers in 1924. A beneficed priest remained in attendance until ca. 1930, after which the abandoned church was used as chicken house, cellar, and lumber room. Eventually the estate was divided and sold at auction. Crivelli's tomb was vandalized, his sarcophagus pried open, and his bones strewn about.[8] Since 1974 S. Maria del Carmine and the Crivelli Monument have belonged to Sig. Enrico Tiso of Selvazzano, by whom the church has been protected against trespassers. In 1976 the effigy was exhibited in the Palazzo della Ragione at Padua.[9] When the effigy was returned to the church, its head was placed where its feet had previously been.

In the third annual report of the regional superintendency of monuments, the name of Dentone was tentatively attached to the Crivelli Tomb; presumably the author of the report meant Giovanni, not the mythical Antonio, Dentone.[10] Paoletti disputed the attribution to both Antonio and Giovanni Dentone, but failed to offer an alternative.[11] In his entry for the effigy in the catalogue of the 1976 exhibition, Prosdocimi recalled Fiocco's verbal attribution of the tomb to Giammaria Mosca. With this attribution, Prosdocimi, Degan, Zanotto, Condé, and Scalini fully concurred.[12]

[1] Morigia, 1595, pp. 219f.

[2] Sanuto, *Diarii*, xv, 1887, coll. 453f, Jan. 5, 1513.

[3] Ibid., xiv, 1886, col. 627, Aug. 28, 1512; ibid., xv, 1887, coll. 52, 69–76, Sept. 11 and 14, 1512; ibid., xxii, 1887, col. 61, Mar. 22, 1516; P. Terni, (1557) 1964, pp. 273–86; Sforza Benvenuti, 1859, i, pp. 322–36.

[4] ASV, Archivio notarile, Testamenti, Busta 50 (not. Girolamo de Bossis), no. 214, cc. 192r–193v; ibid., Busta 51 (not. Girolamo de Bossis), no. 78. For relevant portions of the text, see Appendix A, Doc. XVI, A.

[5] ASV, Misc. Cod. I, Stor. ven. 22, Barbaro, 1733–43, vi, c. 123, voce "Pisani, F."

[6] Sanuto, *Diarii*, xxii, 1887, coll. 220, 223, May 18, 1516; ibid., xlviii, 1897, coll. 232, 234, 236f, July 10, 11, and 12, 1528; ASV, Avogaria di Comun, Busta 159, *Necrologia dei nobili*, filza 1, n.c., see under July 12, 1528, the date on which the news of Pisani's death was received.

ASV, Misc. Cod. I, Stor. ven. 22, Barbaro, 1733–43, vi, cc. 102, 123, voce "Pisani F"; Venice, Bibl. Marc., MS it., Cl. VII, 17 (= 8306), Cappellari Vivaro, 18th cen., iii, c. 218r.

[7] M⁽ᶜⁱ⁾ (Magnifici) · D(omini) · BENEDITI · CRIBELLI · EQVIT(is) · D · XXV.

[8] Brandolese, 1793–1808, in Fantelli, *Padova e la sua provincia*, Feb. 1981, p. 30; Degan, 1981, pp. 4, 9, n. 7; Grandis, 1983, pp. 31, 33; Condé, 1986, pp. 99f.

[9] Prosdocimi, in Padua, Pal. della Ragione. *Dopo Mantegna*, 1976, p. 132, no. 93.

[10] "Contributo al cat. gen.," in Berchet, 1895 (1896), p. 21.

[11] Paoletti, 1893, ii, p. 146.

[12] Prosdocimi, in Padua, Pal. della Ragione. *Dopo Mantegna*, 1976, p. 132, no. 93; Degan, in Degan/ Rubini, 1980, p. 47; Degan, 1981, pp. 4, 7f, nn. 3, 4; Condé, 1986, p. 97; Sandro Zanotto, in Cuoghi et al., 1987, p. 91; Scalini, *Gazz. antiquaria*, 1987, p. 57, n. 4.

## 6. EAST BERLIN, STAATLICHE MUSEEN: *ANGEL*
## VENICE, SS. GIOVANNI E PAOLO, SACRISTY: *ANGEL*
### GIAMBATTISTA BREGNO

Pls. 85–97

One *Angel* was acquired in 1902 by the Staatliche Museen, Berlin (Inv. no. 2943) from the Adolf von Beckerath Collection, Berlin.[1] Its present condition prevents it from being exhibited. The other *Angel* is currently located on the altar of the sacristy in SS. Giovanni e Paolo.

Both *Angels*, together with their respective bases, are carved from single blocks of white marble.

*Angel*, East Berlin: 77.8 cm high (including its base: 8.8 cm high × 53.7 cm wide × 26 cm deep); *Angel*, Venice: 78.2 cm high (including its base: 8.8 cm high × 56 cm wide × 22.5 cm deep).

In its present condition, it is not possible to discover traces of polychromy or gilding in the East Berlin *Angel*. Rust-colored speckles found in profusion on the surface of the *Angel* in Venice could be remnants of polychromy or bole for gilding.

The *Angel* in East Berlin has lost a large portion of both arms and one hand. The figure's right arm is broken off in the area of the elbow; the left arm is broken off at mid-forearm. On the figure's left breast, the last joints of two fingers – probably right and left thumbs – remain. Restored arms and hands recorded in photographs from 1933, therefore, may be as-

sumed to reproduce the *Angel's* original gesture. Both upper arms are cracked through and repaired with mortar: the seam in the left arm is thick and irregular, no doubt because pieces on either side of the break were lost. The *Angel's* right hand, together with the wrist and a bit of the arm but minus all fingers, exists as a separate fragment. Curls framing the *Angel's* left cheek and forehead are largely lost; above the figure's forehead, curls are less seriously mutilated. There are disfiguring nicks in both lids of the *Angel's* left eye. The lower third of her nose, including most of her nostrils and septum, is missing. The surface of her lower lip is rough. There are nicks in her forehead just above her left brow, in her nose, and in her left cheek. Most of the *Angel's* left big toe and the tip of her second toe – those parts of her left foot that overhung the base – are lost. The tip of her fifth right toe is chipped and her right heel is pitted on its upper surface. Drapery has suffered relatively little from chipping: here and there a few small chips are missing from the border of the peplum and the hem of the chiton; very occasionally there are nicks in the projecting ridges of folds. During World War II, the *Angel* was stored in the Bunker Berlin-Friedrichshain, where a fire in May 1945 turned a large part of the figure's surface dark brown. In 1979–80 an unsuccessful attempt was made to clean half of the surface: the application of hydrogen peroxide produced an ash-colored surface (Pls. 87–90).[2]

The Venetian *Angel*, by contrast, is well preserved. A large chip is missing from the figure's diadem, while the end of the figure's left big toe has broken off. There are smaller chips in the second and third toes of the statue's left foot, the folds of its right sleeve, the hem of its skirt, and the lower edge of its base.

Bibl.: Soravia, i, 1822, pp. 47, 185f; Zanotto, 1856, p. 287; Caffi, *Arch. ven.*, xxviii, 1884, pp. 35–37, 42, doc. B, repr. in *Arch. ven.*, ser. 2, iii, pt. 1, 1892, pp. 168–71, 178, doc. B; Venice, Bibl. Marc., MS it., Cl. VII, 2283 ( = 9121), Fapanni, 1884–9, fasc. 8, "Chiesa de SS. Giovanni e Paolo," c. 73v; Paoletti, 1893, ii, p. 282, n. 2; Berlin, Kstge. Gesellschaft. Ausstellung, 1898, cat., p. 42, no. 212; Tschudi, in Berlin, Kstge. Gesellschaft. Ausstellung, 1899, pp. 86f; Burckhardt/ Bode/ Fabriczy, [8]1901, ii, pt. 2, p. 499c; Venturi, vi, 1908, p. 467, n. 1; Rambaldi, 1913, pp. 20f; Berlin, Königl. Mus. Cat. by Schottmüller, 1913, pp. 124f; no. 303; Vicentini, 1920, p. 83, n. 2; Valentiner, *Art in Amer.*, 1925, p. 319; Berlin, Staatl. Mus., Kaiser-Friedrich-Mus. Cat. by Schottmüller, [2]1933, pp. 122f, no. 2943; Zava Boccazzi, 1965, pp. 96, 97, fig. 41; Munman, 1968, p. 234, n. 5; Sheard, 1971, p. 403, n. 48 and pls. 130, 131; Venice, Procuratie Nuove. *Arte a Ven.*, cat. by Mariacher, 1971, pp. 154f, nos. 73, 74; East Berlin, Alten Mus., Staatl. Mus. *Restaurierte Kunstwerke*, 1979 (1980), pp. 156f, no. 63; Schulz, *BJ*, 1980, pp. 191–7; eadem, *Arte cristiana*, 1983, p. 45; eadem, in *Interpretazioni ven.*, 1984, p. 266

In his 1822 guide to SS. Giovanni e Paolo, Soravia recorded that our two *Angels* had stood atop the Altar of Verde della Scala, flanking a Crucifix.[3] The Altar of Verde della Scala, dedicated to St. Mary Magdalene, originally formed the fifth altar from the entrance along the right wall of the nave (*in cornu Epistolae*) in the Venetian Church of S. Maria dei Servi.[4] Documents inform us that the Altar of Verde della Scala was commissioned on December 6, 1523, from Guglielmo dei Grigi Bergamasco by the *Procuratori di S. Marco de citra* as successors to the executors of the will of Verde della Scala (d. 1393).[5] The framework was finished by August 24, 1524, when its gilding was commissioned. Bartolomeo di Francesco da Bergamo was charged with execution of the statue of the *Magdalene* on August 21, 1524; apparently it was completed three months later (Fig. 57). The *Angels* that crowned the altarpiece, however, did not form part of this commission: rather, they were donated by the Servites to the executors of Verde della Scala's testament for the adornment of the altar during its construction[6] and were merely polished by Bartolomeo Garbin, marble sawyer, between July 25 and 30, 1524.[7]

For what site were these *Angels* made? Vicentini plausibly surmised that the figures once belonged to the Servi's Altar of the Holy Cross,[8] decorated at about the time of the *Angels'* manufacture. Facing west and thus accessible to the laity, the Altar of the Cross was set against the *tramezzo*, which crossed the entire church near the eastern end of the nave; the altar stood between the partition's central and right-hand portals.[9] Erected by order of the orator and statesman Girolamo Donato, the altar housed a relic of wood from the inscription of the True Cross, which Donato had given to the Servi in 1492.[10] Besides a silver and jasper reliquary,[11] the altar contained five bronze reliefs by Andrea Riccio, four with scenes of the *Discovery and Miracles of the True Cross*, plus double doors of a tabernacle with the *Glorification of the Cross*.[12] Donato died on October 20, 1511,[13] in a state of extreme poverty.[14] Therefore, if the *Angels* had been commissioned by Donato, he might have been unable to pay for them; by assuming the burden of their expense, the Servites would have become their owners.

Ca. 1812 the Altar of Verde della Scala was transported from the Servi, suppressed only shortly before, to SS. Giovanni e Paolo.[15] Apparently, at that time the *Angels* were removed from the altar and installed on the altar of the Cappella di S. Domenico (the last chapel from the entrance in the right or Epistle aisle

of SS. Giovanni e Paolo). There they were seen in 1822 and 1856.[16] By the early 1880s one of the *Angels* had been sold;[17] the other occupied the last altar in the right aisle just before the crossing, or possibly the last altar in the left and right aisles successively, at least between 1884 and 1920.[18] Since 1965 at least the *Angel* has adorned the altar of the church's sacristy.[19] Its mate had entered the Berlin collection of Adolf von Beckerath by 1898,[20] whence it was acquired by the Kaiser-Friedrich-Museum in 1902.[21]

On the basis of Temanza's documented attribution of the Altar of Verde della Scala,[22] Soravia – and after him, Zanotto – assigned the two *Angels* to Guglielmo Bergamasco.[23] For Paoletti,[24] Schottmüller,[25] and

Zava Boccazzi,[26] they recalled the style of Tullio Lombardo; Mariacher evinced no hesitation in attributing the Venetian *Angel* to Tullio.[27] In 1898 the Berlin *Angel* was catalogued under the Master of the S. Trovaso altar frontal (Antonio Rizzo?);[28] in the accompanying text, however, Tschudi expressed doubts about its attribution.[29] Not dissuaded, Fabriczy gave the Venetian *Angel* to the Master of S. Trovaso,[30] while Valentiner cited it in connection with other works that he attributed to Pietro Lombardo.[31] Sheard tentatively proposed Lorenzo Bregno as author of the *Angel* in SS. Giovanni e Paolo.[32] In 1980 I explicated the history of the two *Angels* and assigned them to the later career of Giambattista Bregno.[33]

---

[1] Letter of January 23, 1979 from Dr. Edith Fründt.

[2] East Berlin, Alten Mus., Staatl. Mus. *Restaurierte Kunstwerke*, 1979 (1980), pp. 156f, no. 63.

[3] Soravia, i, 1822, pp. 185f.

[4] Vicentini, 1920, p. 83 and plan oppos. p. 48.

[5] For the documents concerning the Altar of Verde della Scala, see Caffi, *Arch. ven.*, xxviii, 1884, pp. 37f, 41f, docs. A, C, repr. in idem, *Arch. ven.*, ser. 2, iii, pt. 1, 1892, pp. 171–4, 176–9, docs. A, C, and Schulz, in *Interpretazioni ven.*, 1984, p. 264.

[6] Appendix A, Doc. XVIII, B. See also Schulz, in *Interpretazioni ven.*, 1984, pp. 264–6.

[7] Appendix A, Doc. XVIII, A.

[8] Vicentini, 1920, p. 83, n. 2.

[9] Corner, 1749, ii, p. 24; Vicentini, 1920, pp. 49f and plan oppos. p. 48.

[10] Corner, 1749, ii, p. 34; Cicogna, i, 1824, pp. 89–91, no. 202.

[11] The relic was contained within a silver casket placed within a cross of jasper, 2 Venetian feet high (69.4 cm): Corner, 1749, ii, p. 34 The reliquary was drawn by Johannes Grevembroch, Venice, Mus. Correr, MS Gradenigo 65, *Varie venete curiosità*, ii, 1760, c. xxvi. Another drawing of it can be found in Venice, Mus. Correr, MS Gradenigo 200, *Commemoriali*, 18th cen., xx, c. 115r.

[12] The reliefs are in the Ca'd'Oro. Those with the *Discovery and Miracles of the True Cross* measure 38 × 30 cm. The doors of the tabernacle measure 88 cm high × 22 cm wide. For the reliefs, see Planiscig, 1927, pp. 211–20 and Venice, Ca' d'Oro. *Guida-catalogo*, by Fogolari et al., 1929, pp. 87, 141.

[13] Agostini, ii, 1754, p. 222; Paoletti, 1893, ii, p. 270.

[14] On November 31, 1511, the *Signoria* undertook to provide for Donato's heirs: Agostini, ii, 1754, p. 223.

[15] Caffi, *Arch. ven.*, xxviii, 1884, pp. 34f, repr. in idem, *Arch. ven.*, ser. 2, iii, pt. 1, 1892, pp. 166f. The architectural framework of the altar now houses Alessandro Vittoria's statue of *St. Jerome* in the first bay of the left aisle of SS. Giovanni e Paolo, while the figure of the *Magdalene* is installed in the altarpiece of the first chapel to the right of the *cappella maggiore*. For further transformations of the Altar of Verde della Scala, see Schulz, in *Interpretazioni ven.*, 1984, p. 266.

[16] Soravia, i, 1822, pp. 47, Zanotto, 1856, p. 287. Tschudi, in Berlin, Kstge. Gesellschaft. Ausstellung, 1899, p. 87, stated that until the

Cappella del Rosario in SS. Giovanni e Paolo was devastated by fire in 1867, the *Angels* stood there. This location cannot be confirmed.

[17] Caffi, *Arch. ven.*, xxviii, 1884, p. 36, repr. in idem, *Arch. ven.*, ser. 2, iii, pt. 1, 1892, p. 169.

[18] Caffi, *Arch. ven.*, xxviii, 1884, p. 36, repr. in idem, *Arch. ven.*, ser. 2, iii, pt. 1, 1892, p. 169, and Paoletti, 1893, ii, p. 282, n. 2, located the *Angel* on the Altarino di S. Giuseppe. For the location of the Altar of S. Giuseppe at the end of the left aisle in 1856 at least, see Zanotto, 1856, pp. 287, 299. Venturi, vi, 1908, p. 467, n. 1; Rambaldi, 1913, pp. 20f, and Vicentini, 1920, p. 83, n. 2, located the *Angel* on the last altar of the right aisle. Either the dedication of the *altarino* in the right aisle was changed to that of S. Giuseppe between 1856 and 1884 or the *Angel* was moved from left to right *altarino* between 1893 and 1908.

[19] Zava Boccazzi, 1965, p. 96.

[20] Berlin, Kstge. Gesellschaft. Ausstellung, 1898, cat., p. 42, no. 212.

[21] See above, n. 1.

[22] Temanza, 1778, pp. 126f.

[23] Soravia, i, 1822, p. 47, Zanotto, 1856, p. 287.

[24] Paoletti, 1893, ii, p. 282, n. 2.

[25] In the first edition of her catalogue, Schottmüller, Berlin, Königl. Mus., 1913, pp. 124f, no. 303, was disposed to claim the Berlin *Angel* as a late work of Tullio Lombardo's. Less certain of her attribution twenty years later, she assigned it to the later Lombardo workshop: Berlin, Staatl. Mus., Kaiser-Friedrich-Mus. Cat. by Schottmüller, [2]1933, p. 122, no. 2943.

[26] Zava Boccazzi, 1965, pp. 96, 97, fig. 41, seconded by Munman, 1968, p. 234, n. 5, likened the Venetian *Angel* to the *Virtues* of Tullio Lombardo's Tomb of Doge Andrea Vendramin in SS. Giovanni e Paolo, although she cautiously labeled the *Angel* "scuola dei Lombardo."

[27] Venice, Procuratie Nuove. *Arte a Ven.*, cat. by Mariacher, 1971, pp. 154f, nos. 73, 74.

[28] Berlin, Kstge. Gesellschaft. Ausstellung, 1898, cat., p. 42, no. 212.

[29] Tschudi, in Berlin, Kstge. Gesellschaft. Ausstellung, 1899, p. 87.

[30] Burckhardt/Bode/Fabriczy, [8]1901, ii, pt. 2, p. 499c, contested by Venturi, vi, 1908, p. 467, n. 1.

[31] Valentiner, *Art in Amer.*, 1925, p. 319.

[32] Sheard, 1971, p. 403, n. 48. The captions to pls. 130 and 131 show, however, that Sheard entertained the possibility of Giam-

battista's authorship.

[33] Schulz, BJ, 1980, pp. 191–197.

## 7. EAST BERLIN, STAATLICHE MUSSEN: ST. JOHN THE EVANGELIST

LORENZO BREGNO

Pls. 159, 160

St. John the Evangelist was acquired by the Staatliche Museen, Berlin (Inv. no. 2928) as a gift from Emperor Wilhelm II in 1904. Before that, the statuette was kept in Potsdam.

Statuette, eagle, and base are carved from a single block of white marble.

St. John the Evangelist: 97.5 cm high. Its base is 29 cm wide × 22 cm deep.

There are no traces of polychromy or gilding.

The figure, especially its hair and beard, the upper surface of its left cuff, and its shoulders, are badly weathered. The surface is very dirty. The nose is cracked through; the original tip has been reattached with mortar. Both hands are nicked. The drapery is nicked and chipped in several places; losses are most serious in the folds descending St. John's right shoulder and traversing his right elbow. The edge of the Saint's book is chipped in several places. The front of the eagle's head is missing and its left wing is broken off toward its termination. A large piece of

stone is missing from the front of the base. Most of both of the figure's big toes are lost, as is the eagle's left claw and that portion of the base on which it rested. The rear of the base also is mutilated. At the rear, the figure is only very slightly rounded and no more than roughhewn. Behind the figure's left foot, a broad piece of stone linking drapery and base, functions as a strut.

Bibl.: Berlin, Königl. Mus. Cat. by Schottmüller, 1913, p. 128, no. 311; Berlin, Staatl. Mus., Kaiser-Friedrich-Mus. Cat. by Schottmüller, [2]1933, p. 123, no. 2928; Middeldorf, R. d'arte, 1938, p. 101; Schulz, BJ, 1984, pp. 171–3.

In Schottmüller's first edition of the catalogue of the Berlin museum, St. John the Evangelist was classed among Venetian works of the end of the fifteenth century.[1] In the catalogue's second edition, Schottmüller labeled the work "Venetian? Beginning of the 16th century."[2] Reviewing the later catalogue, Middeldorf acknowledged the statuette's kinship with Trevisan sculpture of the Bregno school.[3] Despite the accuracy of Middeldorf's observation, St. John was not incorporated into the literature on the Bregno until my publication of the statuette in 1984 as a work of Lorenzo Bregno's from the beginning of the second decade of the 16th century.[4]

[1] Berlin, Königl. Mus. Cat. by Schottmüller, 1913, p. 128, no. 311.

[2] Berlin, Staatl. Mus., Kaiser-Friedrich-Mus. Cat. by Schottmüller,

1933, p. 123, no. 2928.

[3] Middeldorf, R. d'arte, 1938, p. 101.

[4] Schulz, BJ, 1984, pp. 171–3.

## 8. MONTAGNANA, DUOMO (S.MARIA): MADONNA AND CHILD

LORENZO BREGNO AND ANTONIO MINELLO

Pls. 249–252

The relief of the Madonna and Child is inserted in the center of the attic, which surmounts the main portal, on the exterior of the Duomo.

The Madonna and Child are carved from white marble. The Madonna, Christ Child, and balustrade, together with the background directly behind them, constitute one block. Two more slabs fill out the background of the tondo at either side. The slab with Madonna and Child is set at a very slight angle with

respect to the horizontal axis of the tondo; between the bottom of the balustrade and the frame of the tondo is a thick stratum of concrete. The tondo's frame is Istrian limestone.

Inside of tondo: 94.5 cm high × 95.5 cm wide.

There are no traces of polychromy or gilding.

A long chip is missing from the border of the Madonna's mantle where it falls from her wrist. In her veil there is a chip opposite her left cheekbone and a nick opposite her right jaw. Most of the cloak clothing the Madonna's left arm and the left part of the balustrade is covered with rust, as though a vein of iron ran through the marble. The Christ Child has lost all the fingers of his raised hand. Surfaces exposed

to rain are extremely worn. They are: the child's locks of hair, the features of his face, the knuckles of his left hand, his penis, and the ends of the toes of his weight-bearing foot. The surface of the cushion between Christ's feet has begun to flake.

The frieze of the main entablature of the portal is entirely filled by the following inscription: LVDOVICO · BASADONAE · LVD · F(ilio) · POSTHVMO · PRAETORI/ CLARISS · CONCILIO · MVNICIPII · HVIVS ·/BELLORVM · CVLPA · DE · PACTIONE · VETERI · SEIVNCTO · PER · SENTENTIAM · DECENVIRALI · DE/ CRETO/ APPROBATAM · IN · PRISTINAM · LIBERTATEM · VINDICATO · PRAEDIIS · ETIAM · COMMVNIBVS ·/ABALIENATIS · PVBLICIS · VTILITATIBVS · EADEM · SANCTIONE · RESTITVTIS · PORTA · HAC · CELEBRI ·/ERECTA · OMNIVMQ · APPLAVSV · IVRISDICTIONE · FVNCTO · DEBET · POSTERITAS ·

Bibl.: Brandolese, 1793–1808, in Fantelli, *Padova e la sua provincia*, Apr. 1981, p. 24; Montagnana, Arch. Casa Antonio Giacomelli, MS Bazzoni, 1850–60, filza, "Montagnana, cenni storici, epoca moderna, Duomo," n.c.; Gloria, 1862, ii, p. 302; G. Foratti, pt. 3, 1863, p. 122; Paoletti, 1893, ii, p. 116, doc. 106, p. 275; Moschetti, T-B, ii, 1908, p. 486, voce "Bardi, Ant."; Paoletti, T-B, iv, 1910, p. 570, voce "Bregno, Lor."; A. Foratti, *Arte e storia*, 1911, pp. 140f; Callegari, *Dedalo*, 1928–9, pp. 360, 362; Giacomelli, in *Acta eccl. Mont.*, 1936, pp. 57f; Pope-Hennessy, *BM*, 1952, p. 27; Vazzoler, 1962/63, p. 155; Timofiewitsch, in Egg et al., 1965, p. 261; *Il Duomo di Mont.*, 1965, p. 6; Princivalle, 1981, pp. 160, 161–3; Schulz, *BJ*, 1984, pp. 147, 149f.

The inscription in the entablature beneath the *Madonna and Child* avows posterity's debt to Lodovico Basadonna for the erection of the portal, implying that it resulted from Basadonna's patronage. Lodovico (or Alvise) Basadonna was a Venetian nobleman, posthumous son of Alvise Basadonna and Andrianna di Lorenzo Loredan.[1] Between January 31, 1517 and May 3, 1518, Alvise di Alvise was *Podestà* at Montagnana[2] – to the applause of all, as the inscription magniloquently claims. It also records that under Basadonna the liberty of the city council was defended by means of a sentence approved by the Council of Ten. This refers, no doubt, to Basadonna's sentence of August 27, 1517, by which the city council was reorganized, 30 members thenceforth to be chosen by the citizens of the city proper, 30 more by the inhabitants of its suburbs.[3] The epigraph further states that, under Basadonna, communal properties that had been sold, were restored to public use. After serving at Montagnana, Basadonna was *Provveditore alla Sanità* at Venice and died probably in December 1543.[4]

Yet there is also reason to think that the *Madonna and Child* was paid for by the commune. On January 2, 1525, Lorenzo Bregno's widow gave her brother, the mason Francesco de' Liprandi of Milan, a new and ampler power of attorney in order to liquidate the estate of her late husband, which involved, among other things, collecting money due Bregno from the commune or citizens of Montagnana.[5] That this money was owed the estate for a *Madonna* transpires from a previous document of January 4, 1524, according to which Maddalena sold to Antonio Minello the contents of her late husband's shop at S. Severo on the condition, among others, that they – presumably Minello and his partner, the goldsmith Bartolomeo Stampa – complete "an image of S. Maria for the church of Montagnana."[6] There is no reason to doubt that the *Madonna* referred to is that incorporated in the exterior of the Duomo's main portal. Thus documents prove the *Madonna and Child* a joint work of Bregno and Antonio Minello – as far as we know, Stampa did not work in stone – and indicate that the relief was finished by early January 1525.

The discrepant testimony to the portal's patronage suggests that the portal's expense was divided by Basadonna and the commune of Montagnana. Perhaps a commission, bestowed by Basadonna, was overseen by the commune after the *Podestà's* departure from Montagnana. In token of joint patronage, two coats of arms flank the *Madonna* – Basadonna's to the *Virgin's* right (the place of honor), the commune's to her left.

Around 1800 Brandolese recorded the traditional attribution of the portal – both architecture and sculpture – to Jacopo Sansovino.[7] This attribution, so far as it applied to the portal in general, remained current throughout the 19th century,[8] although Foratti did ascribe the *Madonna and Child* to an anonymous master.[9] With Paoletti's publication in 1893 of the conditions of sale of Lorenzo's shop[10] and Moschetti's identification of the "imaginis sancte marie pro ecclesia montagnane" with the portal relief,[11] the *Madonna and Child* was widely recognized as having been started by Bregno and finished by Antonio Minello.[12] The portal, however, continued to be assigned to Sansovino, despite the fact that his arrival in Venice considerably postdated Bregno's death, not to mention Basadonna's tenure as *Podestà*. As a consequence, it was necessary to assume that the relief originally had been destined for an earlier portal or another part of the church altogether and was later adapted to Sansovino's portal.[13] Whether or not the

portal is Sansovino's, the relief, as Callegari and Principalle have remarked, gives every indication of having been intended for a different field than the medallion it occupies.[14]

[1] ASV, Misc. Cod. I, Stor. ven. 17, Barbaro, 1733–43, i, c. 261, voce, "Basadonna D." In 1523 Alvise di Alvise Basadonna married Margherita di Anzolo Sanudo, who bore him three sons – Piero, Niccolò, and Anzolo.

[2] ASV, Segretario alle voci, Serie mista, Busta 8, *Reggimenti 1492–1523*, c. 33. Although it is almost invariably asserted that Basadonna was *Podestà* at Montagnana again in 1540, in fact he never served a second term. (For the *Podestàs* of Montagnana up to 1552, see ibid., c. 33; Venice, Bibl. Marc., MS it., Cl. VII, 818 (= 8897), *Raccolta dei Consegi*, vi, cc. 87r, 187r, 272r; idem, MS it., Cl. VII, 819 (= 8898), *Raccolta dei Consegi*, vii, c. 68r; ASV, Segretario alle voci, Elezioni del Maggior Consiglio, Registro 1 (1526–40), cc. 110v, 111r [cc. 113v, 114r]; idem, Registro 2 (1541–52), cc. 129v, 130r [cc. 132v, 133r]. In 1540 *Podestàs* were Francesco Malipiero (to April 8, 1540) and Nicolò Contarini (from April 25, 1540 to August 24, 1541). The error may have originated in Venice, Bibl. Marc., MS it., Cl. VII, 15 (= 8304), Cappellari Vivaro, 18th cen., c. 125r.

[3] G. Foratti, 1862, pt. 1, p. 161.

[4] Venice, Mus. Cor., MS Cicogna 510, Barbaro, 18th cen., c. 162v, voce "Basadona D." ASV, Misc. Cod. I, Stor. ven., 17, Barbaro, 1733–43, i, c. 261, voce "Basadonna D," by contrast, gives 1549 as Alvise Basadonna's year of death. This must be a mistake of the copyist's since ASV, Avvogaria del Comun, Busta 159, filza *Necrologia nobili*

*1526–1616* does not list Basadonna among those nobles who died in 1549. Because the lists from October 1542 to August 1545 are missing from the necrology, Basadonna's death in 1543 could not be confirmed.

[5] See Appendix A, Doc. XIX, C.

[6] See Appendix A, Doc. XIX, A.

[7] Brandolese, 1793–1808, in Fantelli, *Padova e la sua provincia*, Apr. 1981, p. 24.

[8] Magrini, 1845, p. 60; Montagnana, Arch. Casa Antonio Giacomelli, MS Bazzoni, 1850–60, filza, "Montagnana, cenni storici, epoca moderna, Duomo," n. c.; Meneghini, in *Grande illus.*, iv, 1859 (1861), p. 259; Gloria, 1862, ii, p. 302; G. Foratti, pt. 3, 1863, p. 122.

[9] G. Foratti, pt. 3, 1863, p. 122.

[10] Paoletti, 1893, ii, p. 116, doc. 106.

[11] Moschetti, T-B, ii, 1908, p. 486, voce "Bardi, Ant."

[12] A. Foratti, *Arte e storia*, 1911, p. 141; Callegari, *Dedalo*, 1928/29, p. 383, n. 5; Giacomelli, in *Acta eccl. Mont.*, 1936, p. 57; Princivalle, 1981, p. 162; Schulz, *BJ*, 1984, pp. 146–50. Timofiewitsch, in Egg et al., 1965, p. 261, recorded only the attribution to Antonio Minello.

[13] Callegari, *Dedalo*, 1928/29, pp. 360, 362; Giacomelli, in *Acta eccl. Mont.*, 1936, p. 57; Princivalle, 1981, p. 162.

[14] Callegari, *Dedalo*, 1928/29, p. 362; Princivalle, 1981, p. 162.

## 9. PADUA, S. ANTONIO, CAPPELLA DEL SANTO: *PROPHET*
### GIAMBATTISTA BREGNO AND SHOP

Pls. 112, 113

Twelve *Prophets* fill each of the full spandrels formed by the interstices between the arches of the arcade, which surrounds the interior of the Cappella del Santo on four sides. Giambattista Bregno's *Prophet* is located on the east wall of the chapel, in the spandrel between the opening to the Cappella della Madonna Mora on the right and the bay of the arcade with Giammaria Mosca's and Paolo Stella's relief of the *Miracle of the Goblet* on the left.

The *Prophet* is carved from a single block of white marble. The background is composed of black marble.

*Prophet*: 56.5 cm high.

There are no traces of polychromy or gliding.

A fissure traverses the *Prophet's* left forearm and the adjacent portion of the scroll in an irregular course. The stone is fissured again above and to the spectator's left of the lower end of the scroll. A crack in the background runs slightly downward from the figure's right shoulder to the edge of the field. The figure is completely finished except for a strut at the rear of the *Prophet's* head and neck.

Bibl.: Gonzati, i, 1852, pp. 167f, XCVII, doc. LXXXVIII; Paoletti, 1893, ii, p. 147, n. 4, p. 275; Biscaro, *Arch. ven.*, ser. 2, xviii, pt. 1, 1899, p. 194; Paoletti, T-B, iv, 1910, p. 569, voce "Bregno, G. B."; Lorenzetti, *Enc. ital.*, vii, 1930, p. 793, voce "Bregno", Vazzoler, 1962/63, pp. 152, 202; Mariacher, *DBI*, xiv, 1972, p. 113, voce "Bregno, G. B."; Sartori/Fillarini, 1976, p. 28; Schulz, *BJ*, 1980, pp. 174, 200; Sartori/Luisetto, 1983, p. 337, nos. 83, 87, p. 362, nos. 465, 466; Schulz, *Arte cristiana*, 1983, pp. 44f.

In 1497 Francesco Sansone da Brescia, Superior General of the Franciscan Order, asked to sponsor a complete reconstruction of the Trecento chapel, which housed the thaumaturgic remains of St. Anthony, in the Basilica del Santo at Padua. At Sansone's death two years later, a bequest of 3,000 ducats was put at the disposal of the *Massari* of the *Arca del Santo* for that end. By January 2, 1500, plans for the relief decoration of the chapel's walls had matured, and on June 22, 1500, Andrea Riccio was paid for having made wax figures and a relief for a wooden model, which embodied a design plausibly ascribed to Tullio

Lombardo. The nine marble reliefs with scenes from the life of St. Anthony were executed between 1500 and 1577. The first two reliefs were commissioned from Tullio and Antonio Lombardo on June 27, 1500. On June 17, 1501, two more reliefs were ordered from them and one from Giovanni and Antonio Minello. When the relief of the *Miracle of the Goblet* was commissioned from Giambattista Bregno on October 20, 1502, none of the reliefs was finished.[1] Meanwhile, on June 21, 1500, Giovanni Minello had been named *protomaestro* of the new chapel and had contracted for unspecified works of sculpture executed by himself and his son Antonio.[2]

On December 22, 1502, Giambattista Bregno received from the *Arca del Santo* an advance of 31 lire for his relief of the *Miracle of the Goblet*. On that occasion, Giambattista also undertook to execute one *Prophet* for the chapel, like those by Giovanni Minello if not better, for what appears to have been the standard price of 7 ducats (43 lire, 8 soldi at 6 lire, 4 soldi per ducat).[3] Giovanni and "maestro bastian suo compagno" – undoubtedly Sebastiano di Jacopo da Lugano – stood guarantors for Bregno. On July 1, 1507, Bregno received the marble block from which the *Prophet* was to be carved. At a cost of 11 lire, the stone had been paid for by Giovanni Minello. In account books of 1513, 1514, 1515, and 1516 there is record of Bregno's debt to the *Arca* for the sum of 42 lire – the advance the sculptor had received for the narrative relief, which he would never deliver, plus the value of the marble he had been given for

the *Prophet*. Finally in 1517 (*sine die*), Bregno's debt was extinguished, because the sculptor had delivered his *Prophet*, valued at 42 lire; it had been installed in the Cappella del Santo on the side towards the "capella di opici."[4] That side must be the eastern one, for the Obizzi family acquired the juspatronage of the Cappella della Madonna Mora in 1458 and retained it for several centuries thereafter.[5]

In 1852 Gonzati published part of the commission for the *Prophet* (with the incorrect year of 1503)[6] and in 1976 Sartori reported Bregno's receipt of the marble block,[7] but the document which proves Bregno's *Prophet* to have been consigned and installed, I found only in 1984 and have not published before. Nevertheless, both Paoletti and I sought to identify Bregno's *Prophet* among the series of twelve. Paoletti thought Bregno's was the *Prophet* between the second and third arches counting from the west on the internal facade (south inside wall) of the Cappella del Santo.[8] I attributed to Bregno the *Prophet* illustrated here, on the east wall of the chapel, immediately to the right of the *Miracle of the Goblet*, finally executed between 1520 and 1529 by Giammaria Mosca and Paolo Stella Milanese.[9] My attribution is now virtually corroborated by the document of 1517, which locates Giambattista's figure on the side of the chapel next to the Cappella degli Obizzi where there are only two *Prophets*. Thus it would appear that Bregno's relief of the *Miracle of the Goblet* and his *Prophet* were intended to stand together.

---

[1] For the history of the decoration of the Cappella del Santo, see Wilk, in *Le sculture del Santo*, 1984, pp. 109–71.

[2] Sartori/Fillarini, 1976, pp. 155f; Sartori/Luisetto, 1983, p. 335, nos. 34, 39.

[3] On December 20, 1503, Giovanni Minello was also paid 7 ducats for a *Prophet*. See Sartori/Fillarini, 1976, p. 156; Sartori/Luisetto, 1983, p. 337, no. 75.

[4] See Appendix A, Docs. I, C, D.

[5] Sartori/Luisetto, 1983, p. 535, nos. 7, 22, 26.

[6] Gonzati, i, 1852, p. XCVII, doc. LXXXVIII.

[7] Sartori/Fillarini, 1976, p. 28.

[8] Paoletti, 1893, ii, p. 275 and pl. 31, fig. 1; idem, T-B, iv, 1910, p. 569, voce "Bregno, G. B."

[9] Schulz, *Arte cristiana*, 1983, pp. 44f.

## 10. TREVISO, DUOMO (S. PIETRO): *ST. SEBASTIAN*

TREVISO, S. LEONARDO: NICHE WITH ARCHITECTURAL SURROUND

BUDAPEST, SZÉPMŰVÉSZETI MÚZEUM: *MADONNA AND CHILD* AND *TWO ANGELS*

LORENZO BREGNO AND SHOP

Pls. 186–194

The statue of *St. Sebastian* occupies a niche in the first pier on the left of the Duomo's nave (*in cornu Evangelii*). The niche is excavated from the north face of the pier and thus faces the aisle.

The niche with its architectural surround is immured in the first bay of the left wall of the aisleless Church of S. Leonardo (*in cornu Evangelii*). The niche encloses a baptismal font.

The reliefs of the *Madonna and Child* and two *Angels* are exhibited in the sculpture galleries of the Budapest Museum of Fine Arts (Inv. no. 1108).

*St. Sebastian*, its base and the tree trunk are carved from an integral block of white marble. The *Saint's* upraised elbow and part of his forearm were formed from a separate piece of marble, evidently by Bregno himself. Arrows and halo are metal.

The architectural members of the niche are white marble. The ground of the attic reliefs is black-veined white marble. The triangles in the spandrels of the arch and the rhomboid in the frieze are verd antique. The disc in the lunette of the pediment is verd antique.

The *Madonna and Child* and the two *Angels* are each made of white marble.

*St. Sebastian*: 153.5 cm high (including its 5.8-cm-high base); architectural framework: ca. 294 cm high (from the bottom of the shallow plinths immediately beneath the columns to the apex of the pediment) × 158.6 cm wide; interior of the niche: 155 cm. high; *Madonna and Child*: 48 cm high; left *Angel*: 43 cm high; right *Angel*: 42 cm high.

The hair, loincloth, and band encircling *St. Sebastian's* right wrist are heavily gilded; the gilding probably is not original. The tree stump is painted black, although there seem to be traces of gold underneath. There are no traces of polychromy or gilding in the architectural framework or the reliefs of the *Madonna and Child* and *Angels*.

A very fine fissure runs horizontally across the right half of *St. Sebastian's* rib cage. A large chip is missing from the edge of the hanging swathe of the *Saint's* loincloth. In the figure's upraised hand, only the tip and the beginning of the index finger are preserved. *St. Sebastian's* left big toe is broken off at its tip. The tree stump behind the *Saint* is very badly damaged. A large chip is missing from the stump of the branch behind the figure's upraised arm. About 10 cm from its end, a crack severs the stump. The upper piece is kept precariously attached by a metal rod inserted in it and by wire wound around it and *Sebastian's* wrist. A second crack severs the stump at the level of the top of the figure's buttocks. Presumably a metal rod has been inserted here, too, to keep the pieces joined. The surface of the tree stump on either side of the fracture is not continuous: the circumference of the upper piece of the tree trunk is smaller than that of the piece below. The *Saint's* halo has fallen off.

The reliefs of the *Madonna and Child* and *Angels* in the niche in S. Leonardo are stucco copies of the original marbles in Budapest. The reliefs' marble ground has been reduced to fragments eked out with stucco. The left corner of the pediment has broken off. The bottom of the left lesene and the bottom of the shaft of the right column have been repaired with stucco. The three-quarter rounds at the bottom left and upper right of the niche are chipped.

The contour of the *Madonna's* left upper arm is quite badly chipped. There are small chips and nicks in the surface of her drapery; the drapery on her left arm is scored. There is a nick in the tip of the *Christ Child's* nose. His right forearm is cracked through and the tips of the second and third fingers of his right hand are missing. The top of the *Christ Child's* head is barely roughhewn. The rear arm of the left *Angel* has been hacked off. Her inner contour is chipped. The lower part of what is visible of the rear wing is unfinished. There are a number of nicks in the surface of the right *Angel's* face, in her left upper lid, the bridge of her nose, and her chin. Two corkscrew ringlets, which flow back from her nape, are badly chipped. The tip of the fifth finger of her left hand is chipped. The *Angel's* shoulder is nicked and a chip is missing from the swathe of drapery that sweeps back around her shoulder. Here and there, the surface of the peplum is nicked. The top of the *Angel's* rear wing is truncated; a rough patch mars the surface of her forward wing.

In the base of the altarpiece, between two coats of arms, there once was the following inscription: VIN-CENTIVS CLAVDIVS I. C. (jurisconsultus)/ SEBASTIANO MARTYRI T. F. I. (testamento fieri iussit)/ MAGDALENA DE BAVARIA MATER, ATQ;/ HÆRES F. C. (fieri curavit)/ AN. M D X V I.[1]

Bibl.: Burchelati, [1583], p. 330; Treviso, Bibl. com., MS 1341, Mauro, 16th cen., c. 355r, voce "Zotti"; Burchelati, 1616, pp. 375, 482; Treviso, Bibl. com., MS 643, Cima, iii, 1699, cc. 217, 226; Temanza, 1778, p. 118; Federici, 1803, ii, p. 17, no. 23; Crico, 1829, p. 13, no. 18, p. 40, no. 7; idem, 1833, pp. 17, 56f, 302; Pietrucci, 1858, pp. 50f, voce, "Briosco"; Sernagiotto, 1871, pp. 89f; [Bailo], 1872, pp. 61, 84; Milanesi, in Vas/ Mil, ii, (1568) 1878, p. 609, n. 2; Treviso, Bibl. com., MS 1355, Fapanni, i, 1891, c. 35, ii, 1892, c. 51; Burckhardt/ Bode, [6]1893, ii, pt. 2. p. 408a; Santalena, 1894, pp. 103f, 148; Budapest, Szépművészeti Múzeum. Cat. by Pulszky/ Peregriny, 1896, p. 3; Biscaro, *Atti ... dell'Ateneo di Treviso*, 1897, pp. 274–9; idem, *Gazz. di Treviso*, May 7–8, 1898, [p. 3], repr. in idem, 1910, pp. 11f; idem, *Arch. ven.*, ser. 2, xviii, pt. 1, 1899, p. 195; Burckhardt/ Bode, [8]1901, ii, pt. 2, p. 499l; Paoletti, T-B, iv, 1910, p. 570, voce "Bregno, L."; Burckhardt/ Bode/ Fabriczy, [10]1910, ii, pt. 2, p. 538e, f; Serena, 1912, p. 299, n. 1; Budapest, Szépművészeti Múzeum, MS Budapest 10/ 3, Schubring, *Katalog*, 1913, n.c., no. 68; Budapest, Szépművészeti Múzeum. Cat. by Peregriny, 1915, p. 3, no. 1108; Budapest, Szépművészeti Múzeum. Cat. by Meller, 1921, p. 12, no. 2; Coletti, [1926], p. 81; Planiscig, 1927, p. 408; Ybl, *Évkönyv*, 1927–8, pp. 59–

67, repr. in idem, [1938], pp. 35–43; Lorenzetti, *Enc. ital.*, vii, 1930, p. 793, voce "Bregno", Balogh, *L'arte*, 1932, p. 80, no. 40; Coletti, 1935, p. 183, no. 336, p. 295, no. 580; Balogh, *Magyar Női Szemle*, 1936, pp. 203f; Tiepolo, 1936, p. 67; [Planiscig], *Corvina*, 1938, p. 603; Mariacher, *Arte ven.*, 1949, p. 98; Balogh in *A Szépművészeti Múzeum 1906–1956*, 1956, p. 125; idem, *A Régi Szoborosztály kiállítása*, 1956, p. 20; Vazzoler, 1962/63, pp. 164, 239–41, 264f; Timofiewitsch, in Egg et al., 1965, p. 493; Mariacher, *DBI*, xiv, 1972, p. 114, voce "Bregno, L.", Budapest, Szépművészeti Múzeum. Cat. by Balogh, 1975, i, p. 156, no. 197; Schulz, *BJ*, 1984, pp. 145f; Bellieni, in Barzaghi et al., 1986, p. 118; Netto, 1988, p. 179.

The inscription, which once adorned the base of the altarpiece of St. Sebastian, informs us that the altarpiece resulted from a testamentary disposition of the jurist Vincenzo Zotti, which was implemented by his mother and heir, Maddalena da Bavaria, in 1516. Vincenzo di Nicola Zotti was born in 1480[2] and died at Padua before May 13, 1512.[3]

On January 29, 1515, Lorenzo Bregno was commissioned by Maddalena, widow of Ser Nicola Zotti, to construct an altar dedicated to St. Sebastian for S. Margherita, Treviso, church of the Augustinian Eremites. In his contract, Lorenzo promised to build an altar 4.5 Venetian feet wide (156.15 cm), with a marble figure of *St. Sebastian*. In design the statue was to follow the small model in Maddalena's possession; in height Lorenzo's statue was to match the 4-foot (138.8 cm) image of *St. Sebastian* it would replace. The finished work was to be delivered within a year. Work was to be executed and the figure installed at the artist's expense; bricks, lime, lead, and clamps, however, would be supplied by Maddalena. For the altar Lorenzo was to earn 100 ducats, of which half was in the form of a credit from Doctor Lodovico Leone of Padua, then resident in Venice. Lorenzo received immediately an advance of 10 ducats. Another 10 ducats would be paid at Lorenzo's pleasure when work was under way, and the final 30 when work was finished. On May 5, 1516, Maddalena legally transferred to Lorenzo credit for the 50 ducats owed her by Lodovico Leone. At this time work on the altar was in progress, but not yet finished. On May 31, 1516, Bregno was given Lodovico Leone's promissory note.[4]

In the Church of S. Margherita, the nave was di-

vided from flanking aisles by two rows of six piers. To one of the two piers nearest the entrance (whether right or left is not recorded), the Altar of St. Sebastian was affixed. Some time before 1629/30, the place of the altar was taken by the Altar of the Holy Thorn, while the Altar of St. Sebastian was moved to the sacristy.[5] There the altar continued to stand as long as it remained in S. Margherita.[6]

S. Margherita was suppressed by Napoleonic decree and in 1808 was turned over to the *Ufficiali della Finanza*.[7] By 1829 *St. Sebastian* had been reerected in the pier of the Duomo of Treviso that the figure occupies today.[8] The framework of the altar was recorded in S. Leonardo in the same year.[9] Some time before July 1894, the *Madonna* and *Angels*, which till then had remained in the attic of the altar's framework, were sold and replaced by stucco copies.[10] The *Madonna and Child* and two *Angels* were acquired in Venice from the dealer Antonio Marcato by Károly Pulszky for the Budapest Museum of Fine Arts on July 10, 1894.[11]

Although Cima gave the statue of *St. Sebastian* to Gerolamo Campagna,[12] and Temanza to Tullio Lombardo,[13] through nearly the whole of the 19th century *St. Sebastian* figured qualifiedly or unqualifiedly as the work of Andrea Riccio.[14] The documents published by Biscaro in 1897 established unequivocally the authorship of Lorenzo Bregno.[15] In 1898 Biscaro recognized, in the niche of the baptismal font in S. Leonardo, the framework of the altar of St. Sebastian,[16] and in 1910 he traced the alienated reliefs of the *Madonna* and *Angels* to the museum at Budapest.[17] Prior to Ybl's 1927–8 article, which made Biscaro's researches available to a Hungarian public and confirmed the provenance of the Budapest figures in the St. Sebastian Altar,[18] the *Madonna* and *Angels* had appeared in catalogues of the Szépművészeti Múzeum as the work of Antonio and Tullio Lombardo,[19] in the style of the Lombardos, but possibly Sienese,[20] or simply as Venetian, ca. 1500.[21] While Ybl thought the *Madonna and Child* autograph, he perceived the collaboration of Lorenzo's workshop in the *Angels*.[22] The autography of *St. Sebastian*, by contrast, has never been doubted.[23]

---

[1] The inscription no longer exists, but was recorded by Burchelati, [1583], p. 330; Treviso, Bibl. com., MS 1341, Mauro, 16th cen., c. 355r, voce "Zotti," (who added GLORIOSO after MARTYRI); Burchelati, 1616, p. 375 (from whom my transcription is taken); Treviso, Bibl. com., MS 643, Cima, iii, 1699, c. 217, (who gave SEBASTIANO MAR-

TYRI GLORIOSO ARAM); Federici, 1803, ii, p. 17.

[2] Treviso, Bibl. com., MS 1341, Mauro, 16th cen., cc. 355rf, voce "Zotti."

[3] Serena, 1912, p. 299, n. 1; AST, Archivio notarile, 1a serie, Busta 355 (not. Giovanni Matteo Zibetto), filza 8 (1512), c. 98v.

⁴ See Appendix A, Docs. XIV, A, B.

⁵ Sernagiotto, 1871, pp. 89f. (The dating comes from idem, 1870, p. 78, and Michieli, Ven., Ist. ven. SLA. Atti, 1953–4, p. 337.) See also Treviso, Bibl. com., MS 643, Cima, iii, 1699, cc. 199, 215, 217, 226.

⁶ Treviso, Arch. curia vescovile, Monasteri soppressi, Agostiniani di S. Margherita, Visita pastorale del 21 dic. 1768, Bishop Paolo Francesco Giustiniani, n.c.; Temanza, 1778, p. 118; Federici, 1803, ii, p. 17.

⁷ Agnoletti, i, 1897, p. 429.

⁸ Crico, 1829, p. 13, no. 18.

⁹ Ibid., p. 40, no. 7.

¹⁰ Biscaro, Gazz. di Treviso, May 7–8, 1898, n.p. [p. 31], repr. in idem, 1910, pp. 11f; Budapest, Szépművészeti Múzeum. Cat. by Peregriny, 1915, p. 3, no. 1108.

¹¹ Ybl, Évkönyv, 1927–28, pp. 59, 60, repr. in idem, [1938], pp. 35, 36.

¹² Treviso, Bibl. com., MS 643, Cima, iii, 1699, cc. 217, 226.

¹³ Temanza, 1778, p. 118.

¹⁴ Federici, 1803, ii, p. 17; Crico, 1829, p. 13, no. 18; idem, 1833, pp. 17, 302; Pietrucci, 1858, pp. 50f, voce "Briosco"; Sernagiotto, 1871, pp. 89f; [Bailo], 1872, p. 61; Milanesi, in Vas / Mil, ii, (1568) 1878, p. 609, n. 2; Treviso, Bibl. com., MS 1355, Fapanni, i, 1891, c. 35; Burckhardt / Bode, ⁶1893, ii, pt. 2, p. 408a; Santalena, 1894, pp. 103f.

¹⁵ Bicaro, Atti . . . dell'Ateneo di Treviso, 1897, pp. 274–279.

¹⁶ Biscaro, Gazz. di Treviso, May 7–8, 1898, n.p. [p. 3], repr. in idem, 1910, pp. 11f.

¹⁷ Ibid., p. 11. This information is missing from Biscaro's original article.

¹⁸ Ybl, Ékönyv, 1927–8, pp. 59–67, repr. in idem, [1938], pp. 35–43.

¹⁹ Budapest, Szépművészeti Múzeum. Cat. by Pulszky / Peregriny, 1896, p. 3; Budapest, Szépművészeti Múzeum. Cat. by Peregriny, 1915, p. 3, no. 1108.

²⁰ Budapest, Szépművészeti Múzeum, MS Budapest 10/ 3, Schubring, Katalog, 1913, n.c., no. 68.

²¹ Budapest, Szépművészeti Múzeum. Cat. by Meller, 1921, p. 12, no. 2.

²² Ybl, Évkönyv, 1927–8, pp. 66, 67, repr. in idem [1938], pp. 41, 42.

²³ Burckhardt / Bode / Fabriczy, ⁸1901, ii, pt. 2, p. 499l; Paoletti, T-B, iv, 1910, p. 570, voce "Bregno, L."; Serena, 1912, p. 299, n. 1; Coletti, [1926], p. 81; Planiscig, 1927, p. 408; Lorenzetti, Enc. ital., vii, 1930, p. 793, voce "Bregno"; Balogh, L'arte, 1932, p. 80, no. 40; Coletti, 1935, p. 183, no. 336, p. 295, no. 580; Tiepolo, 1936, p. 67; Mariacher, Arte ven., 1949, p. 98; Vazzoler, 1962/63, pp. 239–41; Timofiewitsch, in Egg et al., 1965, p. 493; Mariacher, DBI, xiv, 1972, p. 114, voce "Bregno, L."; Schulz, BJ, 1984, pp. 145f; Bellieni, in Barzaghi et al., 1986, p. 118; Netto, 1988, p. 179.

## 11. TREVISO, DUOMO (S. PIETRO): SARCOPHAGUS OF CANON BERTUCCIO LAMBERTI
### BREGNO SHOP AND AN ANONYMOUS STONECARVER

Pl. 248

The Lamberti Tomb is located in the Chiostro delle Canoniche Vecchie, contiguous to the Duomo, now the Museo Diocesano of Treviso. The corbels are immured separately in the ground floor portico; the sarcophagus and crowning are installed together in the upper portico. The epitaph is currently in storage.

The sarcophagus, as well as what remains of its cover, are carved from a single block of Istrian limestone. The sarcophagus is still incrusted on its front face and left side with oblong panels of black-veined white marble. Corbels were carved from separate blocks of Istrian limestone. The crowning consists of two pieces of Istrian limestone; its incrustation is lost. When examined in the crypt, the material of the stone epitaph was not identifiable.

Sarcophagus: 49.4 cm high × 219.5 cm wide; epi-

taph: 68 cm high × 174.5 cm wide; crowning: 72.7 cm high × 155 cm wide.

The damaged ground of the patera in the crowning is painted in imitation of porphyry. Before the tomb's recent restoration, the vertical face of the upper molding of the sarcophagus gave abundant evidence of having been gilded. The letters of the epitaph were also gilded once.¹

Originally the crowning was incrusted in the areas left vacant by the volutes, in the patera, and between the sprays of the palmette. The palmette and the left volute immediately beneath it are mutilated. The inner frame of the patera is badly chipped. The edge of the long volute on the left is also chipped. When the epitaph, which initially must have been suspended between the corbels, served as cover to the sarcophagus, its edges appeared badly damaged. Its place atop the sarcophagus has now been taken by a simple rectangular slab intended to cover the cassone's opening. The top of the sarcophagus is severely cracked on the spectator's right and the edges of the sarcophagus are badly chipped. Slabs of incrusted marble were prised from the right end of the sarcophagus and the outer side of both corbels, in the course of which surrounding moldings were muti-

lated. The inner corner of the top of the left corbel has broken off.

The following inscription is incised in the epitaph:
BERTVCIO LAMBERTO PRIMICERIO / TARVISINO PROTQ (Protonotarioque) · APOSTOLICO / PLVRES ANNOS PONTIFICVM TAR(visinorum) · / VICA-RIATV IVSTISSIME AC / SAPIENTISSIME FVNCTO / M · D · XXII · / (DOMINICVS LAMBERTVS I. C. CANON.)[2]

Bibl.: Treviso, Bibl. com., MS 1341, Mauro, 16th cen., c. 227v, voce "Lamberti"; Burchelati, 1616, p. 250; Treviso, Bibl. com., MS 643, Cima, ii, 1695, cc. 136f; Federici, 1803, ii, p. 19; Treviso, Bibl. com., MS 1355, Fapanni, i, 1891, cc. 112f, no. 33; Biscaro, Atti...dell'Ateneo di Treviso, 1897, p. 276; idem. Arch. ven., ser. 2, xviii, pt. 1, 1899, p. 195; Burckhardt/Bode/Fabriczy, [8]1901, ii, pt. 2, p. 499k; Paoletti, T-B, iv, 1910, p. 571, voce, "Bregno, L."; Coletti, [1926], p. 81; idem, 1935, p. 192, no. 355; Campagner, 1956, p. 25; Vazzoler, 1962/63, pp. 266f; Mariacher, DBI, xiv, 1972, p. 115, voce, "Bregno, L."; Schulz, BJ, 1984, p. 150; Viroli, in Il mon., 1989, p. 63

A member of the Trevisan nobility, Bertuccio di Domenico Lamberti was a doctor of arts and canon law. In 1487 he was named Canon of Concordia; in that year he was celebrated in a Latin oration by Cassandra Fedele.[3] Lamberti was vicar to Nicolò Franco, Bishop of Treviso, and apostolic protonotary when, on November 1, 1495, he was invested with the third highest office of the chapter of the Cathedral of Treviso, that of primicerius; he was the first to assume that dignity. On May 12, 1511, Bishop Rossi, successor to Bishop Franco, constituted Lamberti his Vicar General with full episcopal authority, including the power of awarding benefices.[4] Lamberti indited his testament in 1521 and died the following year.[5] Bertuccio's brother was Domenico Marino. Appointed primicerius in 1523, Domenico was a doctor of law and a member of the Collegio dei Giudici of Treviso. He died in 1560.[6]

A document of November 16, 1525, reports that, in settlement of Lorenzo Bregno's estate, Francesco de' Liprandi, mason at Treviso and brother of Lorenzo's widow, for whom he was acting, obtained 35 ducats from the Trevisan primicerius, then Domenico Lamberti, for a tomb of his erected in the cathedral. This money was then spent in having the tomb of the late primicerius completed.[7] This must have been the Tomb of Bertuccio Lamberti, which Burchelati's transcription of the epitaph credits to the patronage of Domenico.[8] From the sum that was spent in the completion of the tomb, we infer that its execution cannot have been very far advanced at Lorenzo's death, between December 22, 1523, and January 4, 1524.

The combined testimony of Mauro, Burchelati, and Cima reveals that, at one time, the Lamberti sarcophagus was set high against the wall to the left of the Altar of the Cross, the third altar from the entrance of the Duomo, in cornu Epistolae.[9] In the first half of the nineteenth century [?] Cicogna saw the tomb in the crypt;[10] probably the tomb was transferred when the body of the Romanesque church was rebuilt from 1760 on.[11] Biscaro and Paoletti thought the tomb was lost.[12] In 1935 the sarcophagus was recorded in the Cappella della Madonna di Loreto, the right-hand chapel (in cornu Epistolae) at the east end of the crypt.[13] Until recently, the tomb formed the first in a series affixed to the right wall (in cornu Epistolae) at the west end of the Duomo's crypt: it is in this location that it was photographed.

Federici tentatively assigned the tomb to Tullio and Martino Lombardo.[14] Since Biscaro's publication of the documents, however, the Lamberti Tomb has figured regularly among the works of Lorenzo Bregno.[15]

---

[1] Burchelati, 1616, p. 250; Treviso, Bibl. com., MS 643, Cima, ii, 1695, cc. 136f, quoted below, n. 9.

[2] The transcription made by Burchelati, 1616, p. 250, is unique in containing the last line of the epitaph. It is not present in the transcriptions of Treviso, Bibl. com., MS 1341, Mauro, 16th cen., c. 227v, voce, "Lamberti," and Treviso, Bibl. com., MS 643, Cima, ii, 1695, c. 137. Fapanni (Treviso, Bibl. com., MS 1355, i, 1891, c. 113, no. 33) could not find the last line transcribed by Burchelati, nor could I.

[3] Cicogna, iii, 1830, p. 503.

[4] Liberali, 1963, p. 19.

[5] For Bertuccio Lamberti, see Treviso, Bibl. capitolare, MS I/66, Scotti, 18th cen., cc. 529r–531r; Campagner, 1956, p. 25.

[6] For Domenico Marino Lamberti, see Campagner, 1956, p. 25.

[7] See Appendix A, Doc. XIX, D.

[8] See above, n. 2.

[9] Treviso, Bibl. com., MS 1341, Mauro, 16th cen., c. 227v, voce "Lamberti": "Di Bertuccio si trova memoria in una magnifica arca affissa al muro della chiesa del domo dalla parte delle canoniche (in cornu Epistolae)." Burchelati, 1616, p. 250: "Tarvisii in T. Cathed. in muro sursum post Organum speciosum sepulchrum his praecipue in auro clarum notis." Treviso, Bibl. com., MS 643, Cima, ii, 1695, cc. 136f: "Al lato sinistro del predetto Altare della Croce nobile Deposito in marmo con sotto Cassa sepolcrale, memoria in lapida ad oro di Bertuccio Lamberto Protonotario Apostolico, Primicerio della Cattedrale, e Vicario Episcopale."

[10] Reported in Treviso, Bibl. com., MS 1355, Fapanni, i, 1891, c. 113,

no. 33. The work to which Fapanni referred without citation was probably Cicogna's *Iscrizioni trevigiane*, Treviso, Bibl. Capitolare, MS II/90, destroyed during World War II. Apparently the sarcophagus was not moved to the crypt before 1803: Federici, 1803 ii, p. 19.

11 Coletti, 1935, p. 150.

12 Biscaro, *Atti . . . dell'Ateneo di Treviso*, 1897, p. 276; Paoletti, T-B, iv, 1910, p. 571, voce "Bregno, L."

13 Coletti, 1935, p. 192, no. 355.

14 Federici, 1803, ii, p. 19.

15 Biscaro, *Arch. ven.*, ser. 2, xviii, pt. 1, 1899, p. 195; Burckhardt/Bode/Fabriczy, 8 1901, ii, pt. 2, p. 499k; Coletti, [1926], p. 81; idem, 1935, p. 192, no. 355; Vazzoler, 1962/63, pp. 266f; Mariacher, *DBI*, xiv, 1972, p. 115, voce "Bregno, L."; Schulz, *BJ*, 1984, p. 150; Viroli, in *Il mon.*, 1989, p. 63.

## 12. TREVISO, DUOMO (S. PIETRO): SHRINE OF SS. THEONISTUS, TABRA, AND TABRATA

LORENZO BREGNO

Pls. 144–152

The shrine rests on the High Altar of the cathedral.

The base of the shrine is made of Istrian limestone. The three white marble figures of *Saints* are set against black slate backgrounds; architectural members enframing the reliefs are also white marble. At the right end of the shrine, the inscription is incised in two slabs, the upper one of which is a greenish-brownish breccia, the lower one limestone. The seam occurs a fifth of the way up and divides the year from the rest of the inscription. Some of the letters still contain a yellowish paste. At the left end of the shrine, the escutcheon is carved from white marble. The element crowning the escutcheon is inlaid with black marble. The escutcheon is affixed to a slab of gray breccia, which occupies the upper four-fifths of the field; the rest is limestone. The remainder of the shrine is made of Istrian limestone.

Sarcophagus: 127 cm high × 280.5 cm wide × 72.5 cm deep; relief of *St. Tabra*: 98.5 cm high × 75.7 cm wide; relief of *St. Theonistus*: 98 cm high × 75 cm wide; relief of *St. Tabrata*: 97.8 cm high × 75.5 cm wide; inscription: 87 cm high × 33 cm wide.

The embrasures of the reliefs and the outermost border around each field are gilded, as are elements in relief on the shafts and capitals of flanking pilasters. There is gilding also in the moldings and frieze of the entablature. In the relief of *St. Tabra*, the following elements are gilded: the pages, clasps, and ornament of the cover of the book; the borders of the deacon's tunicle and dalmatic; the crosses on the collar of the tunicle; the crosses and border of the stole; the halo; the navicula. In the relief of *St. Theonistus*, the following elements are gilded: the pages, clasps, and ornament of the cover of the book; the stole; the borders of the bishop's alb; the cuff and button of the sleeve beneath the alb; the broad, carved border of the cope; the morse; the ornament of the mitre; the crosier; the ring. In the relief of *St. Tabrata*, the following elements are gilded: the censer and its chain; the borders of the deacon's tunicle and dalmatic; the crosses on the collar of the tunicle; the crosses, border, and fringe of the stole; the halo. The background behind the escutcheon is painted what now appears to be black, but may once have been blue.

In the relief of *St. Tabra*, the volute at the right end of the navicula and the end of the index finger, which supports it, are missing. The lower half of the figure's nose is badly mutilated and both eyelids and the right tear duct are chipped. There is a nick between the brow and left upper eyelid. The perpendicular edge of the figure's right collar is quite badly chipped. The upraised fingers of *St. Theonistus*'s blessing hand are broken off; the break is smooth and pierced by a mortise, indicating that, at one time, the fingers were pieced. One chip is missing from the top edge of the *Saint*'s book, another from its corner. The tip of the figure's nose is abraded. The corner of *St. Tabrata's* right collar is chipped. The seam dividing breccia from limestone at the left end of the shrine is extremely untidy. A wooden door, inserted at the center of the rear face, is not original.

Inscribed below the *Saints*: THABRAE MARTYR; THEONISTVS MARTYR; THABRATA MARTYR. On the right end of the shrine is the following inscription: THEONISTO/ THABRAE ET/ THABRATAE/ MARTYRIB/ IOANNES/ VTINENSIS/ ARCHI/ EPISCOPVS/ THEBANVS/ ET TAVRISII/ ANTISTES DE/ SVA PECVNIA/ T F I (testamento fieri iussit)/ M D VI.

Bibl.: Burchelati, 1616, p. 218; Treviso, Bibl. com., MS 1046A–1046B, Burchelati, 1630 (typescript, p. 26); Treviso, Bibl. com., MS 643,

Cima, ii, 1695, cc. 113f; Azzoni Avogaro, 1760, pt. 1, pp. 204f, pt. 2, pp. 154–6; Temanza, 1778, p. 86; Federici, 1803, i, p. 230; [Crico], 1822, p. 40; idem, 1829, pp. 7f, no. 2; idem, 1833, pp. 6f, 301; Sernagiotto, 1870, p. 77; [Bailo], 1872, p. 57; Treviso, Bibl. com., MS 1355, Fapanni, i, 1891, pp. 31, 57, no. 4; Paoletti, 1893, ii, p. 229; Santalena, 1894, pp. 100f; Biscaro, Arch. stor. dell' arte, 1897, pp. 142–6, 148, 149, 151–4; idem, Arch. ven., ser. 2, xvii, pt. 2, 1899, pp. 137f, 140, 143, 156–62; 168f; Burckhardt/Bode/Fabriczy, [8]1901, ii, pt. 2, p. 501k; Venturi, vi, 1908, p. 1092; Serena, 1912, p. 288; Bouchaud, 1913, p. 169; Coletti, [1926], p. 78; Paschini, Arch. Fran. his., 1933, p. 123; Coletti, 1935, pp. 180f, no. 332; Tiepolo, 1936, p. 67; Venturi, x, pt. 2, 1936, p. 688, n. 1; Mazzotti, 1952, pp. 42f; Menegazzi, in Treviso nostra, 1964, p. 202; Timofiewitsch, in Egg et al., 1965, p. 493; Sheard, 1971, pp. 147, 393, n. 6; Wilk, 1977/78, p. 141; Renucci, in Treviso nostra, [2]1980, i, p. 285; Menegazzi, in ibid., i, p. 312; Schulz, BJ, 1984, pp. 154–59; Bellieni, in Barzaghi et al., 1986, p. 118; Manzato, in ibid., p. 34; M. Cervellini, 1986, pp. 42f, no. 10; Netto, 1988, p. 174; Beltramini, 1989, p. 54, n. 1.

Giovanni, called Zanetto, was born at Udine of humble parentage probably in 1427. At a very early age he entered the Franciscan Convent of S. Francesco, Udine, and was ordained in May 1441. In 1454 he obtained a doctorate in theology from the University of Padua. He was elected Minister of the Franciscan Order for the Veneto in 1465, after having served as the order's Procurator General at the Roman Curia from 1461. From May 19, 1469 to May 13, 1475 Giovanni was Minister General of the Franciscan Order. On July 23, 1473, Sixtus IV named Giovanni, Archbishop of Split; though it is doubtful that he ever went to Split, he retained that dignity until appointed Bishop of Treviso on February 27, 1478. Not long afterward, Giovanni received as well the honorific title of Archbishop of Thebes. During his tenure as Bishop of Treviso, Giovanni restored and enlarged the Palazzo Vescovile and the cathedral, and built from its foundation the cathedral's *cappella maggiore*, dedicated to the Immaculate Conception, at the east end of the church. Throughout his life, Bishop Giovanni enjoyed the affection and patronage of Francesco della Rovere, later Sixtus IV, and the esteem of the Venetian Senate. Giovanni died on February 14/15, 1485.[1]

On December 23, 1484, Giovanni, lying ill at Venice, indited his testament, in which he stipulated that his estate be distributed before his death – a means of ensuring that it not pass by *jus spolii* to the *Camera apostolica*. For his own tomb in the Duomo, he allotted 300 ducats; for an oculus above the cathedral's main portal, 200 ducats; and 500 ducats for vestments. As the last item of his testament, Bishop Giovanni des-

tined the residue of his patrimony for the decoration of the Chapel of the Immaculate Conception – for vestments, altarpieces, and other ornaments – in accordance with the views of his executors.[2]

On January 25, 1485, the bishop's executors – the *Provveditori* Gerolamo di Rovero, Rinaldo dei Rinaldi, Bartolomeo da Cornuda, Alvise Sugana, and Ser Pietro da Pederobba, acting in the name of the entire college of *Provveditori* of Treviso, the canons Pileo d'Onigo, Francesco Novello, Bartolomeo di Rovero, and Francesco degli Azzalli, in the name of the chapter of the cathedral, and Agostino d'Onigo as *gastaldo* of the Trevisan Confraternity of S. Maria dei Battuti – commissioned from Pietro Lombardo, contracting in his own name and that of his sons, Tullio and Antonio, the bishop's tomb, the oculus, the domed bay immediately to the west of the Chapel of the Immaculate Conception, a pulpit, and the Shrine of SS. Theonistus, Tabra, and Tabrata. Pietro's fee was set at 520 ducats plus two wagonloads of wine, from which the sculptor received an advance of 100 ducats. Transport of material was to be undertaken at the patrons' expense, but Pietro was to supervise installation. Pietro obligated himself to complete and install the cupola of the chancel bay by April 30, 1485, and to finish the rest of the work by April 30, 1486.[3]

Appended to the contract are complete descriptions of the work commissioned. These clauses had been drawn up on the previous January 22 and were accompanied by three drawings, at least one of which represented the Shrine of the Three Martyrs. The shrine was to stand on four columns on bases. The columns were to rise above the top of the altarpiece on the High Altar, so that their capitals would be visible from all sides; columns were to support a slab of Istrian stone from the Brioni Islands. The urn was to be articulated by five fields in front and back. On the front, three of the fields were to contain figures of SS. *Theonistus*, *Tabra*, and *Tabrata*, while the other two were to consist of plain framed limestone panels. On the rear, the three figurated fields were to depict *God the Father*, and the *Virgin* and *Angel Annunciate*; the other two fields were to correspond to the plain panels in front. At either end, the arms of Bishop Giovanni were to be carved. On an imbricated cover supported by a cornice there was to rest a tabernacle for the Host; presumably the front and back of it were to be occupied by a red glass window and a small copper door respectively, the sides by two epigrams, and the top by a vase. At the rear of the shrine,

Pietro was to install a double-ramp staircase with a landing in the center.

The western bay of the chancel and its cupola were soon erected, collapsed, and were eventually rebuilt, but apparently little, if anything, was done on the Shrine of the Three Martyrs. In the contract of September 15, 1486, in which Pietro obligated himself, in his own name and that of his sons, to rebuild the shattered bay, only passing mention of the shrine was made: Pietro was to complete and install the two tombs (i.e., of Bishop Giovanni and the three martyrs) as well as the other works previously commissioned from him, at his own expense.[4] On May 6, 1488, in his own name and that of Antonio, Tullio Lombardo ratified his father's contract of 1486.[5] But it was not until the end of October 1505 that the urn was transported to the church.[6] The inscription at the right end of the sarcophagus bears the year 1506. The bodies of the three martyrs were entombed on November 22, 1507.[7] Evidently, the tabernacle for the Host, which was to repose on top of the shrine, was never made — probably because need of it was obviated by construction of the Cappella del Santissimo Sacramento, begun in 1501. In 1692 the bodies of SS. Fiorenzo and Vincemmiale were added to the tomb.[8] In 1694 another reliquary shrine was set on top of the Shrine of the Three Martyrs. At the same time marble statues of the *Virgin Mary*, flanked by *St. Peter* on her right and *St. Prosdocimus* on her left, were placed on top of the new reliquary shrine.[9] In 1712 the body of Beato Enrico da Bolzena, as well as the relics of the original urn, were placed in the new reliquary shrine.[10] By 1829 the three statues had been joined by two more of *Angels*, standing on little pi-

lasters at either side of the altar.[11] In the 19th century, the High Altar with its shrine was located in a niche at the rear of the apse at the east end of the chancel.[12] In 1911 the Shrine of the Three Martyrs was moved to the altar in the Chapel of St. Sebastian in the left aisle of the church, where it was exhibited without ulterior adornment.[13] By 1952 the shrine had been returned to the High Altar located between the two bays of the chancel.[14]

In 1760 Azzoni Avogari recorded Pietro Lombardo's commission for the monument.[15] Very likely it was knowledge of this contract that induced Temanza to assign to Pietro the three reliefs of the shrine.[16] Attributions to Pietro or the Lombardo family prevailed until the end of the 19th century,[17] when Paoletti cast doubt upon the Lombardo's authorship.[18] Paoletti did not dissuade Fabriczy[19] or Venturi,[20] for whom the shrine was evidence of the diffusion of Pietro Lombardo's art, but Paoletti did convert Biscaro.[21] In 1926, Coletti, followed by Manzato, ascribed the urn to Antonio Lombardo;[22] in 1935, Coletti hesitantly proposed Tullio as its author.[23] The latter attribution, which Timofiewitsch and Cervellini tentatively adopted,[24] was accepted unquestioningly by Netto.[25] Reconciling all views, Renucci wrote that the shrine had been designed by Pietro and executed with the collaboration of his sons.[26] Tiepolo is unique in having assigned the work to Antonio Maria da Milano, putative architect of the Cappella del Santissimo Sacramento.[27] In 1984 I gave the shrine to Lorenzo Bregno, possibly acting as an assistant to Pietro Lombardo.[28] Unbeknownst to me, Sheard had long suspected Lorenzo's participation in the carving of the shrine.[29]

[1] Biscaro, *Arch. ven.*, ser. 2, xvii, pt. 2, 1899, pp. 135–45; Paschini, *Arch. Fran his.*, 1933, pp. 105–26; Sartori, 1958, p. 331.

[2] Biscaro, *Arch. ven.*, ser. 2, xvii, pt. 2, 1899, pp. 151–6, 181–5, doc. E.

[3] See Appendix A. Doc. VII. For a transcription of the entire contract, see Biscaro, *Arch. stor. dell'arte*, 1897, pp. 151–3, doc. I; idem, *Arch. ven.*, ser. 2, xvii, pt. 2, 1899, pp. 185–9, doc. F.

[4] Biscaro, *Arch. stor. dell'arte*, 1897, pp. 153–4, doc. II; idem, *Arch. ven.*, ser. 2, xvii, pt. 2, 1899, pp. 189–91, doc. G.

[5] Biscaro, *Arch. stor. dell'arte*, 1897, p. 154, doc. III; idem, *Arch. ven.*, ser. 2, xvii, pt. 2, 1899, p. 194, doc. I.

[6] Ibid., 1899, pp. 168f.

[7] Azzoni Avogaro, 1760, pt. 2, pp. 154–6.

[8] Ibid., pt. 1, p. 205.

[9] Treviso, Bibl. com., MS 643, Cima, ii, 1695, c. 113.

[10] Azzoni Avogaro, 1760, pt. 1, p. 205.

[11] Crico, 1829, pp. 7f, no. 2.

[12] Crico, 1833, pp. 6f; Biscaro, *Arch. stor. dell'arte*, 1897, p. 144.

[13] Coletti, 1935, p. 181, no. 332.

[14] Mazzotti, 1952, pp. 42f.

[15] Azzoni Avogaro, 1760, pt. 1, p. 205.

[16] Temanza, 1778, p. 86.

[17] Federici, 1803, i, p. 230; Crico, 1829, p. 7, no. 2; idem, 1833, p. 301; Sernagiotto, 1870, p. 77; [Bailo], 1872, p. 57.

[18] Paoletti, 1893, ii, p. 229.

[19] Burckhardt/Bode/Fabriczy, [8]1901, ii, pt. 2, p. 501k.

[20] Venturi, vi, 1908, p. 1092, followed by Bouchaud, 1913, p. 169. However, twenty-eight years later, Venturi, x, pt. 2, 1936, p. 688, n. 1, opted for the authorship of Aurelio Lombardo, with the collaboration of his brothers, Girolamo and Ludovico.

[21] Biscaro, *Arch. ven.*, ser. 2, xvii, pt. 2, 1899, p. 169.

[22] Coletti, [1926], p. 78; Manzato, in Barzaghi et al., 1986, p. 34.

[23] Coletti, 1935, p. 181, no. 332.

[24] Timofiewitsch, in Egg et al., 1965, p. 493; M. Cervellini, 1986, pp. 42f, no. 10.

[25] Netto, 1988, p. 174.

[26] Renucci, in *Treviso nostra*, [2]1980, i, p. 285.

[27] Tiepolo, 1936, p. 67.

[28] Schulz, *BJ*, 1984, pp. 157–9.

[29] Sheard, 1971, p. 393, n. 6.

## 13. TREVISO, DUOMO (S. PIETRO): *VISITATION*

### GIAMBATTISTA BREGNO

Pls. 15–19

The *Visitation* is immured in the second pier on the right of the Duomo's nave (*in cornu Epistolae*). The relief occupies the south face of the pier and thus faces the aisle.

The relief is carved from a single piece of veined white marble. The carving does not include a frame. The base and the last 4 cm or so of the relief's rocky ground are stucco.

Relief: 178 cm high × 109 cm wide.

There are no traces of gilding or polychromy.

The fourth toe of Joseph's right foot is chipped and its upper surface is worn. The end of his staff is chipped. A chip is missing from the hem of the tunic above Joseph's left foot and from the bottom of his cuff below his left hand. There is a nick in the surface of the Virgin's headdress and in the edge of her veil above her right eye. The second toe of the Virgin's left foot is chipped at its tip. The fold, which overhangs the wrist of the women behind the Virgin, is nicked. A rather large chip is missing from the hem of Elizabeth's cloak. The end of Zacharias's mantle is broken off and his boot is nicked. The foremost diagonal beam of the shed is badly chipped along its lower edge, less badly along its upper edge. The surface of the rocks is nicked in several places and the head of the salamander has broken off.

An inscription, now lost, was placed at the foot of the altarpiece in 1565. It read: "Hanc Aram quae post Galeatij Hostani Veronen./ Ac Reginae Vxoris Dedicationem/ Diu male materiata, ac ruinosa jacuit/ Nunc Antonius Hostianus de Verona Vir pientiss./ Vna cum Innocentia Vxore/ Ad Dei Opt. Max. et Divae Mariae laudem,/ Et sempiternam sui, suorumque memoriam/ In hanc pulchriorem formam/ Ære proprio restit.(uerunt)/ Anno Dom. MDLXV. IX. Novemb."[1]

Bibl.: Burchelati, [1583], p. 236; Treviso, Bibl. com., MS 1089, Mauro, 16th cen., cc. 61rf, voce "Hostiani"; Burchelati, 1616, pp. 349, 483; Treviso, Bibl. com., MS 643, Cima, iii, 1699, p. 164; Federici, 1803, ii, p. 68; Crico, 1829, p. 14, no. 22; idem, 1833, p. 23; Giovanelli, 1858, pp. 33f; Sernagiotto, *Gazz. di Treviso*, July 15, 1869, p. 2, repr. in idem, *S. Franc.*, 1869, pp. 11f; [Bailo], 1872, p. 61; Burckhardt/ Zahn, [3]1874, ii, p. 677; Bailo, *Boll. del Museo Trivigiano*, no. 1, Sept. 8, 1888, p. 5, no. 68; Treviso, Bibl. com., MS 1355, Fapanni, i, 1891, c. 37; Santalena, 1894, p. 104; Burckhardt/Bode/Fabriczy, [8]1901, ii, pt. 2, p. 499i; Bailo, *Gazz. di Treviso*, May 2–3, 1905, [p. 2]; idem, *Gazz. di Treviso*, May 5–6, 1905, [p. 2]; Serra, [1921], p. 76; Coletti, [1926], p. 81; idem, *La vita del popolo*, Oct. 4, 1928, [p. 3], repr. in ibid., Oct. 7, 1928, [p. 2]; M., *La vita del popolo*, Oct. 4, 1928, [p. 3], repr. in ibid., Oct. 7, 1928, [p. 1]; Benvenuti, 1930, pp. 23f; Lorenzetti, *Enc. ital.*, vii, 1930, p. 793, voce "Bregno"; Coletti, 1935, p. 186, no. 342; Tiepolo, 1936, p. 70; Venturi, x, pt. 2, 1936, p. 688, n. 1; Mariacher, *Arte ven.*, 1949, p. 98; Vazzoler, 1962/63, pp. 164f, 256f; Menegazzi, in *Treviso nostra*, 1964, p. 202; Timofiewitsch, in Egg et al., 1965, p. 492; Mariacher, *DBI*, xiv, 1972, p. 115, voce "Bregno, L."; Schulz, *BJ*, 1980, pp. 186–91; Menegazzi, in *Treviso nostra*, [2]1980, i, p. 312; M. Cervellini, 1986, pp. 48f, no. 13; Sartori/Luisetto, 1986, pt. 2, p. 1624, nos. 152, 153, p. 1631, no. 251; Bellieni, in Barzaghi et al., 1986, p. 121; Manzato, in ibid., p. 34; Mariacher, 1987, p. 52; Netto, 1988, pp. 179f.

The relief of the *Visitation* comes from the homonymous chapel in the Trevisan Conventual Church of S. Francesco. The inscription, which recorded the restoration of the Altarpiece of the Visitation in 1565 by Antonio Ostiani and his wife, Innocenza,[2] informs us that it was originally erected by Galeazzo Ostiani and his wife, Regina. Galeazzo di Francesco Ostiani da Verona (b. 1457)[3] indited his testament on September 1, 1505; it is known only from a later summary of certain conditions. In it, Ostiani provided for his burial in his chapel in S. Francesco – the chapel in which his father was interred – but apparently made no reference to an altar,[4] perhaps because it was already in existence, as its early style would suggest. The Ostiani Chapel of the Visitation was immediately to the right of the *cappella maggiore* (*in cornu Epistolae*).[5] To the right of the chapel's altar, the tomb that Galeazzo erected for his mother and brother was affixed to the wall. The tomb consisted of a marble sarcophagus, within an arch surmounted by two escutcheons, and a dedicatory epitaph below. In the pavement of the chapel was the family grave.[6]

In 1806 S. Francesco was suppressed by Napoleonic decree and made into a stable.[7] The relief of the *Visitation* was moved to the Duomo, where it was first recorded in 1829.[8] Four carved pilasters of Istrian stone, removed from the Ostiani Chapel in 1858 and exhibited in the Museo Trivigiano, first on the ground floor of the cloister, then on the facade, were thought to have come from the framework of the altarpiece.[9] If these are the four pilasters with Corinthian capitals and shafts with vases and Lombardesque scrolls now in the lapidarium of the Casa Da Noal at Treviso — an identification that is not at all certain — then for reasons of style they are unlikely ever to have belonged to the Altar of the Visitation.[10]

Misdating the *Visitation* to the time of its restoration, early connoisseurs attributed the relief to Jacopo Sansovino[11] or Alessandro Vittoria.[12] Nineteenth-century guides routinely assigned it to an unknown sculptor.[13] Crico proposed the Paduan Bonazza, without specifying which of the numerous family he meant.[14] As long ago as 1699, Cima credited a Lombardo with its manufacture.[15] In the third edition of the *Cicerone*, the relief was ascribed to Antonio Lombardo.[16] In 1899 Biscaro cited the documents pertaining to the Cappella del SS. Sacramento.[17] Hypothesizing that the *Visitation* might have belonged to the original décor of that chapel, Fabriczy transferred the relief to the Bregno.[18] An attribution to Lorenzo was championed on other grounds by Coletti.[19] With the exception of Mariacher, who temporarily ascribed the work to Antonio Lombardo or his assistants,[20] Venturi, who gave it to Aurelio Lombardo,[21] and Lorenzetti, who labeled an illustration of the relief Lorenzo and Giambattista Bregno,[22] the *Visitation* was regularly assigned thereafter to Lorenzo Bregno.[23] In 1980 I attributed the relief to Giambattista Bregno and dated it hypothetically before Ostiani's testament of September 1505.[24]

---

[1] The inscription was transcribed in Treviso, Bibl. com., MS 643, Cima, iii, 1699, c. 139. It was published by Burchelati, [1583], p. 236, where the year of restoration was given as 1575. The year was corrected to 1565 by Burchelati in his later *Commentariorum*, 1616, p. 349. Neither of Burchelati's transcriptions records the day or month of restoration.

[2] The Antonio di Palamino di Antonio Ostiani, responsible for the sculpture's restoration, was descended from the brother of Galeazzo's father and was Galeazzo's first cousin twice removed: Treviso, Bibl. com., MS 1089, Mauro, 16th cen., cc. 61rf, voce "Hostiani."

[3] Treviso, Bibl. com., MS 1341, Mauro, 16th cen., c. 257r, voce "Ostigliani."

[4] AST, Corporazioni religiose soppresse, S. Francesco di Treviso, Busta 9, Processo segnato del nr. 113, c. 1r: "Et sic testando animam suam Altissimo creatori devote commendavit, jussit, et ordinavit corpus suum ubi fuerit exanimatum, sepeliri in capella sua in Ecclesia Sancti Francisci ubi sepultus fuit q. Dominus Franciscus Pater suus" (Not. Girolamo da Bologna).

[5] Treviso, Bibl. com., MS 1355, Fapanni, iii, 1892, c. 94, quoted in Sartori/Luisetto, 1986, pt. 2, p. 1632, no. 257 and pl. 29.

[6] Treviso, Bibl. com., MS 643, Cima, iii, 1699, cc. 139f: "A lato sinistro di questo Altare Cassa sepolcrale di marmo grande con nobile arco, e nelle sommità due Armi gentilizie con Iscrizione in lapida di Bartolomea Azzoni, e Pietro Maria Ostiano da Verona." For Cima, left signified *in cornu Epistolae* (cf. ibid., ii, 1695, cc. 116, 119), that is, on the right hand of a spectator facing the altar. See also Treviso, Bibl. com., MS 1341, Mauro, 16th cen., c. 256v, voce "Ostigliani": "Vedesi nella chiesa di S. franc.º de' fratti minori una capella dedicata alla Visitatione di Maria Vergine dove è nel muro affissa una arca di marmo, et in terra u' sepolcro per la famiglia, ma sotto l'arca in una tavola di marmo intagliato si legge il seguente epitaffio." The epitaph was transcribed by Cima as well as Burchelati, [1583], p. 237, and idem, 1616, p. 349. It read: BARTHOLOMÆÆ AZZONIAE MATRI / ET PETRO MARIAI HOSTIANO VERONENSI FRATRI / STEMMATIS ANTIQVI, MOERORE/ PVB. (publico) ELATIS, GALEAT. HOSTIANVS FRANC. / F. (filius) PIETATIS ERGO V.P. (vivus posuit)." See also

Sartori/Luisetto, 1986, pt. 2, p. 1632, no. 257.

[7] Coletti, 1935, p. 370.

[8] Crico, 1829, p. 14, no. 22.

[9] Bailo, *Boll. del Museo Trivigiano*, no. 1, Sept. 8, 1888, p. 5, no. 68; Treviso, Bibl. com., MS 1355, Fapanni, iii, 1892, c. 116, quoted in Sartori/Luisetto, 1986, pt. 2, p. 1634, no. 257; Bailo, *Gazz. di Treviso*, May 2–3, 1905, n.p. [p. 2]; idem, *Gazz. di Treviso*, May 5–6, 1905, n.p. [p. 2].

[10] The pilasters are now exhibited in the ground floor of the loggia of the Museo della Casa Trevigiana (Casa Da Noal). They are carved from a soft yellowish stone, not from Istrian limestone. The pilasters measure 189.5 cm in total height, and therefore are 11.5 cm higher than the relief of the *Visitation*. At the shafts, the pilasters measure 25.5 cm in width; at the capital, between 33.5 and 36 cm in width. Their joint width, therefore, would have exceeded that of the relief. At the shaft, the pilasters measure 13.5 cm in depth. The inferior quality of their carving bespeaks the authorship of a local craftsman.

[11] Treviso, Bibl. com., MS 643, Cima, iii, 1699, c. 164, records the attribution of the work by "altri" to Sansovino — an attribution to which Cima did not subscribe. A pastoral visitation of 1769 enumerates "un relievo sansovinesco" on the Altar of the Visitation: M., *La vita del popolo*, Oct. 4, 1928, [p. 3], repr. in ibid., Oct. 7, 1928, [p. 1].

[12] Federici, 1803, ii, p. 68; Giovanelli, 1858, pp. 33f.

[13] [Bailo], 1872, p. 61; Treviso, Bibl. com., MS 1355, Fapanni, i, 1891, c. 37; Santalena, 1894, p. 104.

[14] Crico, 1829, p. 14, no. 22; idem, 1833, p. 23.

[15] Treviso, Bibl. com., MS 643, Cima, iii, 1699, c. 164.

[16] Burckhardt/Zahn, ³1874, ii, p. 677.

[17] Biscaro, *Arch. ven.*, ser. 2, xviii, pt. 1, 1899, pp. 181–8.

[18] Burckhardt/Bode/Fabriczy, ⁸1901, ii, pt. 2, p. 499i.

[19] Coletti, [1926], p. 81; idem, *La vita del popolo*, Oct. 4, 1928, [p. 3] and Oct. 7, 1928, [p. 2]; idem, 1935, p. 186, no. 342.

[20] Mariacher, *Arte ven.*, 1949, p. 98.

[21] Venturi, x, pt. 2, 1936, p. 688, n. 1.

[22] Lorenzetti, *Enc. ital.*, vii, 1930, p. 793, voce "Bregno."

[23] Benvenuti, 1930, p. 24; Tiepolo, 1936, p. 70; Vazzoler, 1962/63, pp. 165, 257; Menegazzi, in *Treviso nostra*, 1964, p. 202; Mariacher,

*DBI*, xiv, 1972, p. 115, voce "Bregno, L."; Menegazzi, in *Treviso nostra*, 1980, i, p. 312; Bellieni, in Barzaghi et al., 1986, p. 121; M. Cervellini, 1986, pp. 48f, no. 13; Mariacher, 1987, p. 52; Netto, 1988, p. 179.

[24] Schulz, *BJ*, 1980, pp. 186–91.

## 14. TREVISO, DUOMO (S. PIETRO), CAPPELLA DELLA SS. ANNUNZIATA: FRAME OF TITIAN'S *ANNUNCIATION*
### LORENZO BREGNO

Pls. 245–247

Titian's *Annunciation* and its frame occupy the altar in the apse of the Cappella della SS. Annunziata, the chapel to the right of the *cappella maggiore* (*in cornu Epistolae*), in the Duomo, Treviso.

The white marble frame is incrusted with black-veined white marble. The shafts of the columns are brown- and gray-veined breccia. The lunette is gray-veined white marble. Within the inner frame are strips of purple breccia. Rhomboids are verd antique; discs are porphyry. The letters of the inscription in the frieze and the base are incrusted bronze.

Titian's *Annunciation*: 176 cm high × 199 cm wide.

Gilding is preserved in the acanthus leaves and volutes of the capitals and in the grounds of the rosettes in the soffit of the architrave.

The frame was restored after the bombardment of the chapel on April 7, 1944. Restoration was complete by 1947. The frame now shows no signs of damage.[1]

BM (Broccardo Malchiostro) is inscribed in the base of the frame. ECCE ANCILLA DOMINI is inscribed in the frieze.

Bibl. Crico, 1829, pp. 15f, no. 26; [Bailo], 1872, p. 60; Biscaro, *Atti ... dell'Ateneo di Treviso*, 1897, pp. 276f; idem, *Arch. ven.*, ser. 2, xviii, pt. 1, 1899, p. 195; Paoletti, T-B, iv, 1910, p. 571, voce "Bregno, L."; Coletti, *Rass. d'arte*, 1921, pp. 414f, 420, doc. 2; idem, 1935, p. 162, no. 303; Forlati, *Arte ven.*, 1947, p. 57; Vazzoler, 1962/63, p. 254; Liberali, 1963, pp. 47f; Bernini, 1969, p. 52; Avagnina Gostoli, in Treviso, Duomo. *Pordenone e Tiziano*, 1982–3, p. 3.

Broccardo Malchiostro, son of the notary Antonio, was born at Berceto near Parma. He was almost the same age as his compatriot Bernardo de Rossi,[2] under whose aegis Malchiostro exercised power over

church and clergy in Treviso, enriching himself immoderately. Soon after Rossi's arrival in Treviso, at the beginning of 1500, Malchiostro was recorded as the bishop's chancellor and member of his household. Between 1500 and 1502 Malchiostro received sacred orders at Rossi's hands and in 1502 was granted Trevisan citizenship. From October 13, 1509 on, Malchiostro administered the bishopric's temporal affairs. On May 12, 1511, in consideration of his imminent departure for Rome, Bishop Rossi made Malchiostro his procurator; on May 9, 1514, Malchiostro succeeded also to the canonicate of the cathedral vacated by the bishop. Malchiostro was the first *gastaldo* of the Scuola del SS. Sacramento, rector of the Church of Salgareda, and parish priest of S. Biagio di Callalta. In 1509, 1516, and 1520 he was the bishop's surrogate Vicar General and in 1519 and 1520, the bishop's Vicar General. By virtue of a diploma of September 12, 1518, Malchiostro was named Count Palatine by Emperor Maximilian. Infirm from 1525, the canon died on April 12, 1527 and was buried beneath the pavement of the Cappella della SS. Annunziata before the altar he had commissioned and in which he was portrayed.[3]

Work on the fabric of the Cappella della SS. Annunziata is first documented in April 1518.[4] The chapel was to serve as seat of the Compagnia dell'Annunziata. Members of the confraternity contributed to the cost of the chapel, but its expense was borne largely by its first president – Canon Malchiostro. Building seems to have been completed by March 25, 1519 – the date of the official founding of the sodality, for its charter described the chapel as "costructa per el rev. d. Brochardo Malchiostro."[5] Nevertheless, the ceremonial laying of the first stone took place only on May 5, 1519.[6] An inscription on the right wall of the chapel's vestibule, dated October 1519, states that Malchiostro was responsible for the chapel and its decoration, implying that all work was complete by then.[7] Yet Pordenone's fresco of the *Adoration of the Magi* on the left wall is inscribed 1520; work on it must have been finished by August of that year, when Pordenone took up residence at Cremona.[8] Thus there is no certainty that the altar was

completed either, until its consecration by Bishop Rossi on March 1, 1523.[9] From March 3, 1523 comes notice of a payment to the priest Domenico da Bologna for the lettering of ECCE ANCILLA DOMINI in the frame's entablature, at the rate of one soldo per letter.[10]

An inscription at the end of the vestibule, now lost but transcribed by Burchelati, transmits the name of the chapel's architect – an otherwise unidentifiable Martinus architectus,[11] but not the name of the author of the altar. That he might have been Lorenzo Bregno was suspected long ago from two documents recording an attempt by the widow of Bregno, not long deceased, to secure payment from Malchiostro. By an act of August 3, 1524, Maddalena appointed her brother, the mason Francesco de' Liprandi da Milano, Trevisan citizen, to represent her in a lawsuit against Malchiostro, among other controversies. On November 16, 1525, Liprandi gave his sister an account, which she approved, of his liquidation of Bregno's estate. Among the debts he had succeeded in collecting was one of three ducats and 13 *staia* of wheat from Malchiostro.[12]

In his publication of the documents, Biscaro argued that Malchiostro's debt to Bregno's heirs was incurred by work executed by the sculptor for the chapel, whose construction and decoration the canon had funded and overseen. While no one has disputed this assumption, there is disagreement about the nature of Bregno's work. Biscaro proposed assigning to Bregno the altar, parapet at the entrance to the chapel, shields with Rossi and Malchiostro arms flanking the chapel's entrance arch, and the terracotta *Bust of Bishop Rossi* (misidentified as Malchiostro) in the drum.[13] Paoletti adopted the attribution to Lorenzo of the bust and altar;[14] Fabriczy, only of the bust.[15] In 1921 Coletti argued persuasively for the attribution of the bust to Andrea Riccio; Malchiostro's pay-

ment to Bregno's heirs, Coletti thought, related to the arms of the triumphal arch.[16] In 1926 Coletti added the balustrade,[17] but in 1935 he excluded the arms, now labeled "opera locale," and was doubtful of Bregno's execution of the balustrade.[18] Chimenton thought the balustrade probably by Bregno.[19] Vazzoler gave to Bregno, not only the shields at the entrance arch, but all the other arms scattered throughout the chapel and its vestibule, the balustrade, Malchiostro's tomb slab, the *Bust of Bishop Rossi* and, with a certain hesitancy, the altar as well.[20] Menegazzi summarily rejected the bust's attribution to Riccio, opting instead for Bregno's authorship.[21]

The attribution to Lorenzo Bregno of the superb *Bust of Bishop Rossi* does not need refutation: there is nothing in Lorenzo's oeuvre that resembles it and we must assume that the attribution survived only because Bregno's works were unknown. It is harder to disprove the attribution of the inferior balustrade, various arms, and deteriorated tomb slab: while it is hardly likely that Bregno carved these works himself, he might have delegated them to an assistant. By the same token, however, these works would not have exceeded the ability of a local mason. Since none bears traits identifiable as Bregno's, I think it more prudent to refrain from ascribing any author to them. The case is otherwise, however, with the *Annunciation*'s framework. Its costly materials attest to Malchiostro's concern and explain why, in this case, the patron might not have been content to hire local craftsmen. That it is, in fact, by Bregno can be demonstrated by the several parallels between its architectural details and those of the documented niche for the statue of *St. Sebastian*, now in S. Leonardo, Treviso, as well as those of the altar from S. Sepolcro, now in S. Martino, Venice, whose figures are unquestionably Lorenzo's.

[1] Forlati, *Arte ven.*, 1947, p. 57.

[2] For Rossi's biography, see Catalogue no. 15.

[3] Coletti, *Rass. d'arte*, 1921, pp. 407f; Liberali, 1963, pp. 37–54, 60, 68.

[4] Liberali, 1963, pp. 44f.

[5] Ibid., pp. 51, 93, doc. XXIVa.

[6] Ibid., p. 51.

[7] BROCCARDVS MALCHIOSTRVS PARMENSIS/ CANONICVS TARVISINVS/ SACELLVM MARIAE VIRGINI SANCTISSIMAE/ DEDICATVM VNA CVM FORNICE/ CAETEROQ. ORNATV SVA IMPENSA FECIT// BERNARDO RVBEO ANTISTITE TARVISINO/ BENE DE SE MERITO/ TVNC BONONIAM SAPIENTER AC FORTITER/ PROLEGATO REGENTE//ANNO/ DN. MDXIX. MEN. OCTOBRIS.

[8] BROCCARDI MAL/ CANO: TAR:/ CVRA ATQVE/ SVMPTV:/ IO: ANTˢ CORTI/ CELLVS. P. / M. D. XX. See J. Schulz, in *Studies... Blunt*, 1967, p. 46, n. 16; Goi, in Passariano, *Villa Manin*, et al., *Pordenone*, ed. Furlan, 1984, pp. 270f.

[9] Liberali, 1963, p. 61, n. 198.

[10] Coletti, *Rass. d'arte*, 1921, pp. 414f, 420, doc. 2. The relevant passages read: "Infrascriptae partitae sunt illae quas habere et consequi intendit presbyter Dominicus Bolognatus pro laboribus, sudoribus et mercede suis a dno. Brochardo Malchiostro . . .

—Pro uno versu supra altare dictae capellae dicente: Ecce ancilla Domini – de litteris magnis ut sunt numero decem septem ad soldum unum pro una quaque littera valet L. – s. 17."

[11] Burchelati, 1616, p. 481: CONDITORIS IVSSV MARTINVS ARCHIT(ectvs) · EXTRVX(it) ·

[12] See Appendix A, Doc. XIX, B, D. Coletti, *Rass. d'arte*, 1921, p. 419, calculated that, at the time, a *staio* of wheat was worth 4 lire. Thus 13 *staia* were worth a little over 8⅓ ducats.

[13] Biscaro, *Atti... dell'Ateneo di Treviso*, 1897, p. 277; idem, *Arch. ven.*, ser. 2, xviii, pt. 1, 1899, p. 195.

[14] Paoletti, T-B, iv, 1910, p. 571, voce "Bregno, L."

[15] Burckhardt/Bode/Fabriczy, [10]1910, ii, pt. 2, p. 538d, and Register, p. 138.

[16] Coletti, *Rass. d'arte*, 1921, pp. 417–19.

[17] Idem, [1926] p. 105.

[18] Idem, 1935, pp. 168f, no. 309, p. 174, no. 318. Coletti did not identify the author of the altar: ibid., p. 162, no. 303.

[19] Chimenton, 1947, p. 8.

[20] Vazzoler, 1962/63, pp. 162f, 254, 272.

[21] Menegazzi, in *Treviso nostro*, 1964, p. 202; idem, ibid., [2]1980, pp. 309/12.

## 15. TREVISO, DUOMO (S. PIETRO), CAPPELLA DEL SS. SACRAMENTO: STATUARY AND RELIEFS
### GIAMBATTISTA AND LORENZO BREGNO AND SHOP

Pls. 46–62, 124–143

The Cappella del SS. Sacramento is located at the east end of the church, to the left of the chancel (*in cornu Evangelii*). The chapel consists of a square room vaulted by a fenestrated drum on pendentives and a hemispherical dome with lantern. Two arched windows, flanking a lower round-headed niche with frame and triangular pediment on the left wall are paired with an identical niche flanked by two false windows on the right wall. To the east is a semicircular apse with three niches like those on the lateral walls; the apse is vaulted by a half-dome. To the west is a long, lunette-vaulted vestibule.

In the pendentives of the dome are four high reliefs of *Evangelists* in medallions; below each medallion is the *Evangelist's* emblem. Clockwise, starting in the northeast corner, are *St. John*, *St. Matthew*, *St. Luke*, and *St. Mark*. The *Resurrected Christ* occupies the central niche of the apse; in niches to either side are statues of *Angels* – the one holding a swathe of drapery on the spectator's left, the one holding a stole on the spectator's right. *SS. Peter* and *Paul* occupy the niches in the center of the lateral walls of the chapel, *St. Peter* on the left, *St. Paul* on the right. Four small compartments with high reliefs of *Angels* are combined with one central empty compartment to form a segmental altarpiece on the chapel's altar: paired *Angels* fill the outer compartments, single *Angels* the intermediate ones.

*SS. Luke, Matthew,* and *John the Evangelist*, along with their respective parapets, were carved from single blocks of white marble. By contrast, *St. Mark* and his parapet constitute separate blocks of marble. The background of each of the *Evangelists* was incrusted with two, three, or four slabs of black slate. Symbols were carved from separate slabs of white marble. The eagle of *St. John*, however, is composed of two slabs, while an additional piece of white marble furnished the cloud below the feet of the angel of *St. Matthew*.

The *Resurrected Christ*, together with its base, was carved from a single block of Carrara marble; Christ's banner and halo are metal. The freestanding *Angels*, including their wings, together with their respective bases and supports, were carved from single blocks of white marble. *St. Peter*, together with its base and support, was carved from a single block of white marble; keys proper are wood. *St. Paul*, together with its base, was carved from a single block of white marble.

The compartments belonging to the altarpiece were carved from white marble; backgrounds are black slate. Front, lateral, and rear faces of terminal compartments were carved from single slabs of marble. Front and rear faces of intermediate compartments were also carved from single slabs. Pilasters dividing terminal and intermediate compartments belong to the latters' slabs. The entablature is Istrian limestone.

Medallions with *Evangelists*: 72 cm in diameter (maximum opening of frame); angel below *St. Matthew*: 58 cm high; *Resurrected Christ*: 118.5 cm high (including its 3.5 cm–high base); left-hand *Angel*: 116 cm high (including its 3.3-cm-high base); right-hand *Angel*: 119 cm high (including its 3.7-cm-high base); *St. Peter*: 111.2 cm high (including its 1.9-cm-high base); *St. Paul*: 113.5 cm high (including its 2-cm-high base); compartments with *Angels*: 69.3 cm high × 37.6–39 cm wide.

There are traces of gilding in the inscription of the Gospel of *St. Luke*; there are no other vestiges of gilding or polychromy visible in the *Evangelists*. No traces of polychromy or gilding remain in the *Resurrected Christ* or *St. Peter*, or in the compartments of

the altarpiece. However, *Christ's* banner and halo were painted red and gold and *St. Peter's* wooden keys were gilded. In *St. Paul* remnants of gilding can be found on the cover, clasps, and pages of the book, on the hilt of the sword, and on both sandals and their bows. In the left *Angel*, traces of gilding are preserved in the sash. In the *Angel* on the right, the border, cross, and fringe of the stole were once gilded.

*St. Luke* is undamaged, but his bull has lost its forward horn and its head is marred by two cracks, the longer one of which extends into the animal's wings, on one side, and the background, on the other. Where badly corroded, the surface of *St. Matthew* is turning into gypsum. This process has advanced furthest in the locks of hair, the swathe of drapery on the *Saint's* right shoulder, and the tips of his right fingers. The left sleeve and hand are slightly less corroded, while the rest has been spared till now. The *Saint's* book is fissured. A small wedge is missing at the mouth of the crack in the book's left edge; a much larger wedge has been lost at the top of the book. The latter loss was once repaired by piecing, but the piece has fallen out. The folds of the *Saint's* left sleeve are nicked. A chip is missing from the slate background above *Matthew's* left elbow. The angel beneath *Matthew* has lost most of the upper surface of both feet along with the upper surface of the cloud on which they are planted. The fingers of both hands were truncated in order to permit the insertion of the angel beneath the *tondo*. *St. John the Evangelist* has lost most of his left thumb. In the background to his right, the slate has disintegrated. The *Evangelist's* eagle is undamaged. The lower edge of the seam in the medallion with *St. Mark* is chipped, particularly in the folds of the *Saint's* left sleeve. In his right sleeve and the last joint of his right thumb, the process of corrosion has begun. The exposed upper corner of the Gospel is chipped and the edge of the left sleeve is nicked. The slate revetment of the background to the figure's left is missing. The lion beneath is undamaged.

Christ's right upraised arm is badly damaged. The figure's thumb is cracked through and badly reattached with stucco. The last joints of the two upraised fingers are missing. A crack penetrates the forearm and its surface is badly scored. The drapery between arm and torso is cracked; behind *Christ's* elbow, a chip is missing from the edge of the swathe. The tips of the first, fourth, and fifth fingers of *Christ's* left hand are missing.

A diagonal fissure penetrates the left *Angel's* left upper arm, just above her elbow. There are several nicks on the inner surface of the upper arm just below the sleeve. A chip is missing from the *Angel's* right index finger at its juncture with the hand. A fold, which runs around her right shoulder, is nicked in two places. A fold at the right edge of the *Angel* opposite her calf is badly chipped. The hem is nicked and chipped in several places. The tip of her right big toe is broken off, while the tips of her next two toes are worn. Large pieces of stone are missing from the *Angel's* base behind her advancing foot.

The right *Angel's* right wing is badly mutilated: a large wedge is missing from the wing and the wing is fissured from the point of the wedge to the middle of the *Angel's* upper arm. The drapery around her right elbow is chipped. There is a nick in the edge of the stole, where it crosses the figure's left hip. The *Angel* is missing most of her left thumb and the end of her left index finger. The hanging edge of her left cuff is chipped. The point of the *Angel's* headdress is broken off. The hem is nicked in a few places. The second toe of the *Angel's* right foot and the fourth toe of her left foot are chipped. A bad crack runs through most of the base on the spectator's right.

*St. Peter's* base is severely damaged. There are cracks thoughout and a large wedge is missing behind the figure's right foot. A large piece of stone to one side of *St. Peter's* left foot has been crudely replaced with stucco. The toes of the figure's left foot have broken off and been reattached with stucco. The big toe is almost entirely missing and the tip of the second toe, as well as the sole of the sandal beneath the two toes, is chipped. A crack at the ankle completely separates foot from garment. The big toe of *St. Peter's* right foot is chipped. Large chips are missing from the hem of the *Saint's* tunic above both feet. For about 23.5 cm the edge of the mantle, where it crosses the figure's left leg, is missing. The edge of the book is nicked; a chip is missing from its outer upper corner. The ribbon of *St. Peter's* keys is badly worn.

*St. Paul* is in rather better condition. The figure's right shoulder is cracked horizontally. His right thumb and index finger are cracked and the back of his right hand is nicked. The fold over his left elbow is chipped. A large chip is missing from the edge of the mantle beneath the *Saint's* left sleeve; the border of the mantle is nicked continuously down to the level of his knee. A fine fissure follows the juncture of the *Saint's* left foot and toes. The blade of his sword is missing.

The recomposition of the altarpiece in 1948 ap-

parently involved the addition of a new central compartment and an Istrian stone entablature. In the first compartment on the left some of the slate is missing from the background. There is a small chip in the hem of the chiton of the kneeling *Angel* above her left foot and a nick in the edge of the swathe that sweeps under her armpit. The tip of the nose of the *Angel* in the second compartment from the left is mutilated. There are nicks in the fold that sweeps over her right shoulder and in the hem between her legs; the swathe of drapery covering her crotch is chipped in several places. The big toe of the figure's left foot is badly chipped. In the second compartment from the right, the end of the *Angel*'s right big toe has broken off. In the first compartment on the right the slate background has cracked in three places. Pilasters are nicked and chipped in several places, particularly in the outer edges of the front face of the altarpiece. There is a bad crack at the bottom of the pilaster at the right end; its capital, from which the outer volute is missing, is mutilated.

Inscribed in the open book of *St. Luke* is POST / QVAM / CONSV / MATI / SVNT (Luke 2:21).

At the west end of the right wall of the vestibule, above stairs leading to the Duomo's crypt, is a shield with Bernardo de' Rossi's arms. A stole draped around the shield is inscribed with the initials B R. At the bottom, the year M · D//XIIII is incised. Underneath this is the following inscription: SACRATISSIMAE / EVCHARISTIAE / SACELLVM / CVM OMNI CVLTV / EX PIIS / EROGATIONIBVS / FACTVM / BERNARDO RVBEO / ANTISTITE OPT / ANNO SAL. / MDXV.

Bibl.: Burchelati, 1616, p. 482; Treviso, Bibl. com., MS 1046A–1046B, Burchelati, 1630 (typescript, pp. 26, 36); Treviso, Bibl. com., MS 643, Cima, ii, 1695, cc. 118–20; Temanza, 1778, p. 118; Federici, 1803, ii, pp. 16f; [Crico], 1822, p. 39; idem, 1829, pp. 10f, nos. 10, 11; idem, 1833, pp. 9f, 301; Mothes, ii, 1860, pp. 65, 115; Semenzi, in *Grande illus.*, v, pt. 2, 1861, p. 621; idem, ²1864, pp. 166f; Perkins, 1868, p. 197, n. 1; Sernagiotto, 1870, p. 78; [Bailo], 1872, pp. 56, 58f; Treviso, Bibl. com., MS 1355, Fapanni, i, 1891, pp. 32f; Paoletti, 1893, ii, p. 248; Santalena, 1894, p. 102; Burckhardt/Bode/Fabriczy, ⁷1898, register, p. 105; Biscaro, *Arch. ven.*, ser. 2, xviii, pt. 1, 1899, pp. 179–97; [Fabriczy], *Rep. f. Kstw.*, 1900, pp. 259f; Paoletti, T-B, iv, 1910, pp. 569, 570, vocibus, "Bregno, G. B." and "Bregno, L."; Serena, 1912, pp. 298f; Coletti, [1926], pp. 80f; Ybl, *Évkönyv*, 1927–28, pp. 65f, repr. in idem, [1938], pp. 40f; Coletti, 1935, pp. 149, 155f, nos. 291–3, p. 177, no. 325, pp. 181f, no. 333; Tiepolo, 1936, pp. 67, 68; Venturi, x, pt. 2, 1936, p. 688, n. 1; Chimenton, (1947) 1948; Mariacher, *Arte ven.*, 1949, pp. 97f; Mazzotti, 1952, pp. 39–43; Vazzoler, 1962/63, pp. 203, 210f, 213–18, 232–4, and passim; Liberali, 1963, pp. 41, 87–90, doc. XX; Timofiewitsch, in Egg et al., 1965, p. 493; TCI, *Veneto*, 1969, p. 503; Bernini, 1969, pp. 33–5; Sheard, 1971, p. 393, n. 6; Mariacher, *DBI*, xiv, 1972, pp. 113, 114, vocibus, "Bregno, G. B.," and "Bregno, L."; Maek-Gérard, 1974, pp. 298f; Schulz, *BJ*, 1980, pp. 174–86; eadem, *BJ*, 1984, pp. 144f and passim; Bellieni, in Barzaghi et al., 1986, p. 118; Manzato, in ibid., p. 34; M. Cervellini, 1986, pp. 38–41, no. 9; Jestaz, 1986, pp. 149f; Wolters, in Huse/Wolters, 1986, p. 180; Mariacher, 1987, pp. 52, 232, voce "Bregno"; Netto, 1988, p. 172; Beltramini, 1989, pp. 27–63.

The Confraternity of the SS. Sacramento was founded on February 2, 1496, through the initiative of Nicolò Franco, Bishop of Treviso. Upon his death, Franco was succeeded by Bishop Bernardo de' Rossi, through whose disposal of funds, as the inscription in the vestibule informs us, the construction and decoration of the chapel was realized. Bernardo de' Rossi was born at Corniglio di Parma on August 26, 1468, son of Guido, Count of Berceto, whose title Bernardo inherited. Count Guido had faithfully served Venice as *condottiere*; Bernardo's brother Filippo eventually succeeded to his father's command. On the death of Bishop Zanetto in February 1485, Bernardo was elected Bishop of Treviso by the Venetian Senate, but the nomination of the 16-year-old was rejected by Pope Innocent VIII. Two years later — on January 31, 1487 — Bernardo received in compensation the bishopric of Belluno, where he promoted the rebuilding of the cathedral. During this period Rossi took sacred orders, earned his doctorate in canon law at the University of Padua, and was canon at Treviso, archdeacon at Padua, and Abbot of S. Grisogono at Zadar. On August 15, 1499, Rossi became Bishop of Treviso. There he strenuously sought to reform ecclesiastical finances and clerical and monastic discipline. This gained him such enmity that in 1503 an attempt was made on his life and the lives of his closest collaborators. During his Trevisan residence, in addition to the building and decoration of the Cappella del SS. Sacramento, Rossi furthered the execution of the Shrine of SS. Theonistus, Tabra, and Tabrata and acted as patron to Lorenzo Lotto, who painted for Rossi, among other things, the bishop's portrait now in the Museo di Capodimonte, Naples. Largely as the result of his brother's defection to the cause of Emperor Maximilian early in the War of the League of Cambrai, Bernardo was arrested and confined in Venice through most of 1510. Liberated through the influence of Pope Julius II, Rossi betook himself to Rome, returning to Treviso only for rare visits — his duties there performed by suffragans. At Rome, he twice held the post of the city's governor (1513–14; 1523–7); in 1517 he was sent as President General to the Romagna, and from 1519 to 1523 was

responsible for the forcible pacification of Bologna. Rossi died at Parma on June 23, 1527.[1]

The chapel, which had occupied the site of the Chapel of the Confraternity of the Holy Sacrament and likewise was dedicated to the sacrament, was demolished in March 1501.[2] The laying of the first stone of the new chapel took place two months later. By the middle of June 1503, the chapel's fabric, including the interior pilasters and entablature and the exterior revetment, was finished. Between July and December 1503, the outside of the dome was sheathed with lead. On April 28, 1504, the five presidents of the Scuola del SS. Sacramento, with the permission of the bishop, commissioned the veined marble revetment of the two interior lateral walls of the square room of the chapel, at a price of 120 ducats, from Giambattista Bregno. Bregno had made a drawing, which he was to follow. The transport of the stone from the Brioni Islands and the installation of the dressed marbles were to be undertaken at the sculptor's expense; the confraternity would pay for lime and the services of a mason. On this occasion, Giambattista received an advance of 25 ducats. On October 6, 1504, Bregno was paid 35 ducats as the remainder due him for the incrustation of the walls. The sculptor received an extra ducat for the two fictive windows filled with black Veronese stone (now missing) on the right wall of the chapel. A contract with Giambattista for the black and white stone pavement according to a drawing, at a price of 60 ducats, followed on December 11, 1504. Giambattista also promised to furnish at his own expense two roundels of prophyry or serpentine for the pilasters inside the apse. A contract of June 12, 1506 with Giambattista provided for the incrustation of the pendentives with veined marble from Pisa for a fee of 38 ducats. The sculptor received 110 lire on account immediately. A payment on account of 10 ducats was made to Lorenzo Bregno on July 31, 1506. On November 3, 1506, Giambattista received his final payment of 73 lire, 12 soldi for the incrustation of the pendentives. The incrustation of the apse with veined yellow marble, following the arrangement already established in the chapel and incorporating three niches, but apparently not the half-dome which was later painted, was commissioned from Giambattista on the same day. For this work, as well as for a statue of the *Resurrected Christ*, the sculptor would receive 100 ducats. Everything was to be finished by Easter (April 4, 1507). On November 5, 1506, Giambattista received 262 lire, 2 soldi on account for the afore-

mentioned work. For a price of 90 ducats, Giambattista agreed, on August 14, 1507, to incrust the two lunettes and two bands (*fasse*), the latter with veined yellow marble, and to make one oculus. A payment on account, of 50 lire, was made to Lorenzo Bregno on October 10, 1507. On August 20, 1508, Giambattista was charged with making the stairs that lead to the chapel's vestibule, for 70 ducats. On March 2, 1511, Pietro Maria Pennacchi promised to paint the vault of the chapel's apse. The last contract with either of the two Bregno for masonry dates from 1514: it is a commission to Lorenzo for the work of stonemasonry required by construction of the vestibule.

Included in Giambattista's commission of November 3, 1506, for the facing of the apse, was the commission for a statue of the *Resurrected Christ*. Giambattista was adjured to use fine marble and to make the figure as beautiful as his talent would permit. This figure was finished by April 30, 1508, when Bishop Rossi commissioned from Giambattista four marble figures, two *Angels* and the *Apostles Peter* and *Paul*, as perfect in workmanship and material as the figure of *Christ* that Bregno had made. The four new figures were to be transported to Treviso and installed in the chapel at the artist's expense. For them, he was to receive 150 ducats. Three of the statues — apparently the two *Angels* and *St. Peter* — were finished by December 23, 1509, when Giambattista was paid on account 158 lire, 18 soldi (at 6 lire, 4 soldi the ducat) for the figures he had made. *St. Paul* was paid for separately: for its execution, Lorenzo Bregno received on account 49 lire, 12 soldi on March 30, 1513. There are no further mentions of it.

On March 20, 1510, a contract was stipulated at Venice between Giambattista and the presidents of the Scuola del SS. Sacramento for the making of the altarpiece, the altar, and the pavement and step beneath it, according to Giambattista's drawing, for a price of 85 ducats. On that occasion, Giambattista received an advance of 74 lire, 8 soldi. All remaining payments, however, were made to Lorenzo, who signed the final quittance.

On March 13, 1511, the stewards of the confraternity charged Lorenzo with the execution of the four marble *Evangelists* of the pendentives for 100 ducats. Two of the *Evangelists*, along with other marbles, were transported to the chapel on March 13, 1512. On April 4, 1512, the last two *Evangelists* were brought to the chapel.

In the context of the chapel's decoration, it is dif-

ficult to understand a commission of June 6, 1512, from the presidents of the Confraternity of the Holy Sacrament to "maestro Simone Biancho citadin de Vienesia sculptor e com m.° Martin dal vedello," resident in the Venetian parish of S. Maurizio, for four reliefs in Carrara marble of Old Testament prefigurations of the Last Supper and the Eucharist.[3] These included "la perfiguration de Abram," by which was meant, no doubt, the *Visit of the Three Angels to Abraham*, the *Meeting of Abraham and Melchizedek*, and the *Gathering of Manna*. The price of 350 ducats suggests fairly large reliefs – too large, at any rate, for the Chapel of the Holy Sacrament, where lateral walls were interrupted by niches and windows. Probably the reliefs were intended for the vestibule. To be sure, the vestibule was built only two years later,[4] but its size and shape, conditioned by the location of the chapel and the dimensions and disposition of the church, were easily determined. Why the confraternity should have chosen the debutant Simone Bianco,[5] and the stonemason Martino dal Vedello,[6] for such an ambitious enterprise is inexplicable. In any case, the reliefs were never executed.

The compartments with *Angels* belonged to an altarpiece which had – in an elevated position and presumably at the center – a tabernacle for the preservation of the Host.[7] In 1629 the altarpiece was taken down and partially destroyed to make way for a new altar constructed between 1629 and 1630.[8] Divided, the compartments with *Angels* were displayed in the vestibule of the Cappella della SS. Annunziata. In 1911 the components of the altar were transferred to the Cappella di S. Sebastiano, where they were still in 1935.[9]

Since the large Baroque altar hid the statues of *Christ* and the two *Angels*, these, too, were moved. In 1644 the *Angels* were installed in two niches excavated from the blind windows on either side of *St. Paul*;[10] they were still there in 1935.[11] When Crico described the chapel in 1829, the statue of *Christ* had been transferred to the rooms of the Fabbriceria. In the three niches at the rear were "tre piccole statue informi."[12] Between 1872 and 1893, the *Resurrected Christ* was moved to the vestibule of the Cappella del SS. Annunziata,[13] where the statue could still be seen in 1935.[14]

On April 7, 1944, the Duomo of Treviso was bombed. Fortunately, the statuary and the fragments of the altar of the Holy Sacrament Chapel had been removed. Though the incrustation of the chapel was shattered, the *Evangelists* in the pendentives were not

harmed. Work of salvage began almost immediately. By September 1947 the chapel had been restored and the statues returned to their original and current positions.[15] In 1948 a new altarpiece was composed of the four extant reliefs and installed on the altar;[16] there they remain.

In 1778 Temanza assigned the sculpture of the chapel to Tullio Lombardo;[17] his attribution was adopted by Federici and Mothes.[18] In 1822 Crico claimed the works for the Lombardo in general,[19] but in 1829 he distinguished between the *Apostles, Evangelists*, and the reliefs of the altar attributed to the Lombardo or to Tullio Lombardo, in particular, and the *Resurrected Christ* and the two freestanding *Angels*, believed to be by Sansovino.[20] Bailo concurred in all but the attribution of *Christ*, which he gave to the Lombardi.[21] In 1893 Paoletti attributed to Tullio the *Evangelists* and the fragments of the altar, and to an assistant of Tullio's, *Christ* and *SS. Peter and Paul*. The two *Angels*, he thought, were later.[22] In the seventh edition of Burckhardt's *Cicerone*, the *Resurrected Christ* figured as a work of Antonio Lombardo's.[23] On the basis of the documents, which he found and partly published, Biscaro gave *Christ* to Giambattista and the *Evangelists* to Lorenzo. He opined that *SS. Peter and Paul* were predominantly, if not exclusively, by Lorenzo; that the fragments of the altar were probably Lorenzo's; and that the *Angels* were by a pupil of Lorenzo's.[24] Writing of the chapel again in 1910, Paoletti skirted the question of the brothers' respective contributions to the *Resurrected Christ, St. Peter*, and *St. Paul*, but characterized the two *Angels* as the work of weak assistants. The altar, he thought, had been designed by Giambattista and probably completed with Lorenzo's assistance. The four *Evangelists* by Lorenzo revealed to Paoletti an intimate acquaintance with similar works by Tullio.[25] Coletti credited Giambattista with the *Resurrected Christ*, whose high quality he remarked. The rest of the sculpture, including the altar, he ascribed, with more or less assurance, to Lorenzo.[26] Ybl assigned the *Evangelists* and the reliefs from the altar to Lorenzo, and the freestanding *Angels* to an assistant.[27] Tiepolo gave the fragments of the altar to Giambattista and the *Evangelists* to Lorenzo.[28] Venturi proposed the authorship of Aurelio Lombardo with the collaboration of his brothers, Girolamo and Ludovico, for some of the statues and the panels from the altar.[29] To Giambattista, Mariacher gave the statues of *Christ* and the flanking *Angels*, and to his brother, the *Evangelists* and *SS. Peter and Paul*.[30] Bernini allotted the *Resurrected Christ* and *St. Peter* to

Giambattista, *St. Paul* and the two freestanding *Angels* to Lorenzo, and the *Evangelists*, to the Bregno shop.[31] In 1980 I argued for the attribution of *St. Peter* and the *Resurrected Christ* to Giambattista, *St. Paul* to Lorenzo, and the *Angels* to assistants. To Lorenzo, I also gave the altarpiece and four *Evangelists*.[32] In response, Jestaz peremptorily declared the separation of hands in works he did not analyze "unwarranted" and "rash."[33]

Despite a commission and payment to the master of the shop, the freestanding *Angels* are recognizable as works of an assistant. Face and body types, hair and folds, are those elaborated by Giambattista and Lorenzo Bregno, but the execution of the *Angels* manifests a scrupulous and obsessive finish that betokens an imitator's laborious retracing of the creator's more impulsive strokes.

---

[1] Carrari, 1583, pp. 190–6, 201–203; Agnoletti, 1897, i, pp. 162f; Coletti, *Rass. d'arte*, 1921, pp. 410, 412; Liberali, 1963, pp. 10–35, 52–7, 61, 68, and passim; idem, Ven., Ist. ven. SLA. *Atti*, 1971–2, pp. 283f; idem, 1978, pp. 11, 22–7, 34, 50f, and passim; Beltramini, 1989, pp. 7–25.

[2] For the history of the chapel, see Biscaro, *Arch. ven.*, ser. 2, xviii, pt. 1, 1899, pp. 179–88. A few of the documents excerpted by Biscaro were published in full by Liberali, 1963, pp. 87–90, doc. XX. See Appendix A, Docs. V, A–C.

[3] Biscaro *Arch. ven.*, ser. 2, xviii, pt. 1, 1899, p. 188.

[4] Ibid., p. 188.

[5] Simone is known to the history of art as a virtuoso carver of classicizing busts. Simone di Nicolò Bianco came from Loro, in the province of Arezzo (Ludwig, 1911, p. 21), but at an early stage of his career settled permanently in Venice (Vas/Bettarini and Barocchi, iii, text, p. 625). On November 20, 1547, Simone indited his testament (Ludwig, 1911, pp. 21f), but was still alive in December 1553 (Aretino, ii, 1957, p. 438, DCLXV, 1553). Male busts inscribed with Simone's name in Greek are preserved in the Nationalmuseum at Stockholm, the Kunsthistorisches Museum at Vienna, the Château de Compiègne, and the Louvre, where there are two; one inscribed female bust is in the Statens Museum for Kunst in Copenhagen. Marcantonio Michiel listed a marble foot and a freestanding statue of the nude *Mars* in the Venetian collection of Andrea Oddoni in 1532 (Michiel/Frimmel, [1521–43] 1896, pp. 82, 86); in 1548 Pietro Aretino described a portrait of the wife of Nicolò Molino (Aretino, ii, 1957, pp. 244f, CDLIV, 1548), and there were seen on the Paris art market a *Bust of a Man* inscribed with Simone's name in Greek (Héron de Villefosse, *Bull. mon.*, 1880, pp. 379f) and, in a Munich private collection, a marble *Amor* bearing a torch, on whose base Simone's name was written in Italian (Planiscig, *Belvedere*, 1924, p. 161) — works all since lost. But nothing in Simone's oeuvre is even remotely comparable to large reliefs of Old Testament scenes. (For Simone, see the fundamental article by Meller, *Flor. Mitt.*, 1977, pp. 199–210, with bibl. Recent publications on Simone include: Schlegel, *Flor. Mitt.*, 1979, pp. 187–96; Androsow, *Acta historiae artium*, 1980, p. 147; Schlegel in Münster, Westfälisches Landesmuseum, *Bronzen*, 1983, p. 136, no. 70; Favaretto, *Quaderni ticinesi*, 1985, pp. 405–22.

[6] By contrast with Simone Bianco, Martino dal Vedello's activity was limited to stonemasonry. "Maestro Marttin dal vedell" was paid on July 8, 1499, for having carved two capitals for the Bernabò Chapel in S. Giovanni Crisostomo and on January 1, 1500, for two pilasters made by his brother. (Paoletti, 1893, ii, pp. 110f, doc. 90.) On August 8, 1515, Martino was named in the testament of Luca di Pietro da Cattaro. (Ibid., p. 121, doc. 131.) On August 31, 1515, Martino, resident in the parish of S. Vidal (contiguous to that of S. Maurizio), was commissioned by the Guardian Grande of the Scuola di S. Marco

to make the pulpit for the confraternity's chapter hall, to replace the one by Antonio Rizzo destroyed in the fire of 1485. The pulpit was to be ornamented chiefly by framed and incrusted slabs of porphyry. Martino's fee, set at 23 ducats, was to include the Istrian stone used for the fabric of the pulpit, but not the porphyry or marble for the frames. The stonecutter was given a month to complete the work. (Ibid., p. 106, doc. 82.) On August 21, 1534 and September 1, 1534, Martino was again documented in the employ of the Confraternity of St. Mark, whose *scuola* was being extended toward the lagoon. The latter document indicates that Martino was working on the windows, which fronted the canal. (Ibid., p. 107, doc. 84. Paoletti, 1893, ii, p. 179, unjustifiably identified our Martino dal Vedello, or "a Vitello" in Latin, with a Martino di Bartolomeo named in the Bernabò Chapel documents.)

[7] Biscardo, *Arch. ven.*, ser. 2, xviii, pt. 1, 1899, p. 186, quoting Burchelati's *Gli sconci & diroccamenti di Trevigi* of 1630 (Treviso, Bibl. com., MS 1046, IV, version B, c. 26v). See also Burchelati, 1616, p. 482: "... preter Reclinatorium, seu tabernaculum dicas, quatuor [sic] suffultum marmoreis Angelis," and Treviso, Arch. curia vescovile, Visite pastorali antiche, Busta 7, filza iii, "Visite di Francesco Corner, 1579–80," cc. 2rf.

[8] Biscaro, *Arch. ven.*, ser. 2, xviii, pt. 1, 1899, pp. 190f, 196.

[9] Paoletti, 1893, ii, p. 248; Coletti, 1935, pp. 181f, no. 333.

[10] Biscaro, *Arch. ven.*, ser. 2, xviii, pt. 1, 1899, pp. 185, 191; Treviso, Bibl. com., MS 643, Cima, ii, 1695, c. 119.

[11] Coletti, 1935, p. 156, no. 293.

[12] Crico, 1829, p. 11, no. 11.

[13] [Bailo], 1872, p. 59; Paoletti, 1893, ii, p. 248.

[14] Coletti, 1935, p. 177, no. 325.

[15] Chimenton, (1947) 1948, pp. 10, 13–21, 34; Mazzotti, 1952, pp. 39–43.

[16] Chimenton, (1947) 1948, p. 35; TCI, *Veneto*, 1969, p. 503.

[17] Temanza, 1778, p. 118.

[18] Federici, 1803, ii, pp. 16f; Mothes, ii, 1860, pp. 65, 115.

[19] [Crico], 1822, p. 39, followed by Semenzi, [2]1864, pp. 166f; Perkins, 1868, p. 197, n. 1 (SS. *Peter* and *Paul* and the four *Evangelists* perhaps by the Lombardi); Sernagiotto, 1870, p. 78 (Tullio and Antonio).

[20] Crico, 1829, pp. 10f, no. 11; idem, 1833, pp. 9f, 301, followed by Santalena, 1894, p. 102.

[21] [Bailo], 1872, p. 59.

[22] Paoletti, 1893, ii, p. 248.

[23] Burckhardt/Bode/Fabriczy, [7]1898, register, p. 105.

[24] Biscaro, *Arch. ven.*, ser. 2, xviii, pt. 1, 1899, pp. 195f, followed by [Fabriczy], *Rep. f. Kstw.*, 1900, p. 260, and summarized by Serena, 1912, pp. 298f.

[25] Paoletti, T-B, iv, 1910, pp. 569, 570, vocibus "Bregno, G. B." and "Bregno, L."

[26] Coletti, [1926], pp. 80f; idem, 1935, p. 155, no. 291, p. 177, no. 325, p. 182, no. 333.

[27] Ybl, Évkönyv, 1927–8, pp. 65f, repr. in idem, [1938], pp. 40f.

[28] Tiepolo, 1936, pp. 67, 68.

[29] Venturi, x, pt. 2, 1936, p. 688, n. 1.

[30] Mariacher, Arte ven., 1949, pp. 97f, followed by Vazzoler, 1962/

63, pp. 203, 214, 218, 233, for whom the altar, as well, was Lorenzo's work. In DBI, xiv, 1972, pp. 113, 114, vocibus "Bregno, G. B," and "Bregno, L.," Mariacher refrained from committing himself to specific attributions.

[31] Bernini, 1969, p. 34.

[32] Schulz, BJ, 1980, pp. 175–86; eadem, BJ, 1984, p. 144.

[33] Jestaz, 1986, pp. 149f, n. 48.

## 16. TREVISO, S. NICOLÒ: BETTIGNOLI BRESSA ALTAR
GIAMBATTISTA BREGNO AND AN ANONYMOUS SCULPTOR

Pls. 1–14, Figs. 8, 9

The altar is affixed to the wall of the third bay of the right aisle of S. Nicolò (in cornu Epistolae).

The statuary and most architectural members are white marble; statues and bases constitute single blocks. The relief of the Madonna and Child is black-veined white marble. The cornice of the main entablature is a yellowish black-veined marble. The plaques on either side of the inscription and the flat, rear wall of the central arch are composed of black marble slabs. The two roundels of the main entablature above terminal pilasters and the roundel in the pediment are verd antique; the two roundels of the main entablature above the central pilasters and the single remaining roundel in the background of the Madonna and Child are verd antique. The fields incorporating the medallions with heads of angels are concrete. Lesenes flanking the relief of the Madonna and Child contain intarsias of white and black marble; the incised ornament of the relief's entablature is filled with niello. The staff of Christ's banner is metal.

The epigraph of Venceslao Bettignoli is white marble. The two lateral roundels are verd antique. The incised letters of the inscription, olive branch, and palm frond are filled with niello. Beneath the volutes, at the top of the epigraph, is an intarsia of white and black marble. The band connecting the volutes is pointed with niello. The ground behind the coat of arms is black marble.

*Resurrected Christ:* 110 cm high (including its 6.3-cm-high base); *St. John the Evangelist:* 110 cm high (including its 5-cm-high base); *Virgin Mary:* 108.5 cm high (including its 5.5-cm-high base); *Madonna and Child:* 78 cm high × 53 cm wide (minus its frame);

epigraph of Venceslao Bettignoli: ca. 152 cm high × 115.2 cm wide.

There are no traces of polychromy or gilding in the *Resurrected Christ.* The pupils of *St. John the Evangelist* were painted black. Traces of black paint are preserved in the pupils of the Madonna and Christ Child of the relief. There are traces of black in the eyeballs of the left-hand *Angel.* The backgrounds of both medallions with *Angels* are black; the paint, carelessly applied, is probably not original.

The stone of *Christ's* torso is fissured vertically on the right. What seems to have been a wound on the left side of *Christ's* chest was filled in with mortar. The elbow of his upraised arm is chipped. The first three fingers of *Christ's* right hand are lost; the damaged ends of the remaining fingers were repaired with mortar. The figure's left hand is cracked through at the wrist and was repaired with mortar. The ends of the first, fourth, and fifth fingers of *Christ's* left hand are chipped, as are the tips of the first two toes of the statue's right foot and the second toe of its left foot.

At the rear, the base of *St. John the Evangelist* is badly chipped. The border of the *Saint's* mantle and right cuff and the tip of the third toe of his left foot are also slightly chipped. Otherwise, the statue is well preserved.

In the relief, the Madonna's dress, the inside of her cloak behind the Christ Child, and the infant's rear leg are unfinished. The tip of the Madonna's nose, the index finger of the baby's left hand, and the end of his penis are chipped. The inner corner of the Christ Child's front foot has broken off. The bottom edge of the entire relief is uneven and appears to have been truncated. A crack in the background runs long the Madonna's left contour. The *tondo* on the left is missing its original incrustation.

The lower portion of the nose of the left-hand *Angel* is badly chipped. Two nicks mar the surface of forehead and neck. The peak of the figure's headdress

has broken off. The projecting portions of the right *Angel's* face are very badly damaged, as though the head had fallen, face down: half of the nose has broken off and the upper lip is entirely missing, while the lower lip and chin are chipped. Areas of damage appear to have been uniformly roughened with a point, as though in preparation for the application of mortar.

The inscription in the base reads: FRANC · BETHI- GNOLO · BRIXIA · PHOEBI · EX · LAVRA · POLA · F · QVI · MVNIF · AC · LIBERAL · INSIGNIS · NECNON · SCIENT · / ET · ART · PRAESTAN · SPLENDORE · QVAS · IN · CELEB · ITALIAE · ACAD · FREQVENTI · DOCT · HOMIN · CONSVET · / DIDIC · CVM · NVLLA · IN · EO · NEC · POL · NEC · MOR · NEC · CHRIST · VIRTVS · DESIDER- ARETVR · NOBIL · A · PATRIB · / ACCEP · LONGE · CLARIOR · POST · RELINQ · ET · ILLVSTRATA · ETIAM · IISDEM · VIRT · PATRIA · V · A · XLV · MEN · VII · / D · XXVIII · MORTVVS · M · D · XCI · VII · KAL · MAII · FRANCISCHINA · SVGANA · VX · ET · CARA · F · VNICA · PIENT · P ·

The epigraph of Venceslao Bettignoli to the left of the altar reads: D · M · [Deo maximo]/VINCILAO · BI- CIGNOLLO · /PATRVO · MERITISSIMO · /IOANNES- ANTONIVS · B · / NEPOS · SIBI · ET · / POSTERIS ·

The inscription to the right of the altar reads: D · O · M · (Deo optimo maximo) / HANC · ARAM · IAMPRIDEM · ALIBI/ COLLAPSAM · FRANCI- SCHINA · SVGANA/ FRANCISCO · BETHIGNOLO · BRIXIA/ VXOR · DILECTISS · ET · CARA · EX · EODEM/ VNICA · FILIA · INSTAV · HIC · CVR · / M · D · XCI · MENS · SEPT · DIE · XV

Bibl.: Treviso, Bibl. com., MS 1089, Mauro, 16th cen., c. 50r, voce "Bethinioli qui est Brixii"; Burchelati, 1616, pp. 353f, 483; Treviso, Bibl. com., MS 1046 A – 1046B, Burchelati, 1630, (typescript, p. 30); Treviso, Bibl. com., MS 643, Cima, iii, 1699, cc. 322–4; Federici, 1803, ii, pp. 68f; Pulieri/Marchesan, (1813–25) 1911, pp. 264f; [Crico], 1822, p. 20; Pesce ed., (1826–27) 1969, p. 30; Crico, 1829, p. 66, no. 20; idem, 1833, pp. 35f, 301; Semenzi, in *Grande illus.*, v, pt. 2, 1861, p. 649; idem, ² 1864, p. 195; Perkins, 1868, p. 197, n. 1; [Sernagiotto], *Gazz. di Treviso*, Jan. 29, 1869, pp. 1–3; idem, *Gazz. di Treviso*, Jan. 30, 1869, pp. 1f; idem, 1869, p. 28; [Bailo], 1872, p. 69; Caccianiga, ²1874, p. 69; Milanese, 1889, p. 13; Treviso, Bibl. com., MS 1355, Fapanni, ii, 1892, cc. 234f, 257–63, iii, 1892, c. 291; Paoletti, 1893, ii, p. 229, n. 4; Santalena, 1894, p. 176; Biscaro, *Gazz. di Treviso*, May 7–8, 1898, [p.3], repr. in idem, 1910, p. 11; Milanese, ²1904, pp. 34f; Brenna in *Solenni feste*, 1904, [p. 5]; Serena, 1912, p. 298; "Appunti storici," *La vita del popolo*, Feb. 17, 1923, [p. 4]; Coletti, [1926], pp. 80, 118; idem, *L'illus. veneta*, Apr. 1928, p. 72; idem, 1935, pp. 424f, no. 836; Venturi, x, pt. 2, 1936, p. 688, n. 1; Tiepolo, 1936, p. 55; Patrizio, 1962, pp. 9f, no. 10; Vazzoler, 1962/63, pp. 165, 262–5; Timofiewitsch, in Egg et al., 1965, p. 508; Renucci, *Le Venezie francescane*, 1962 (1965), pp. 37f, 44, 48f; Mun-

man, 1968, pp. 305, 309, n. 8; Mariacher, *DBI*, xiv, 1972, p. 114, voce "Bregno, L."; Schulz, *BJ*, 1980, p. 185, n. 14; Renucci, in *Treviso nostra*, ²1980, i, p. 285; Schulz, *Arte cristiana*, 1983, pp. 35–48; Bellieni, in Barzaghi et al., 1986, pp. 141–3; Netto, 1988, p. 409; Sartori/Luisetto, 1988, p. 1448, nos. 22, 23.

In his testament of August 22, 1499, Venceslao di Giovanni Antonio Bettignoli da Brescia ordered his burial in the Franciscan Observant Church of S. Chiara della Cella, just beyond the walls of Treviso, in a tomb to be erected to the right of the High Altar. Beneath the tomb, one epigraph was to be laid in the pavement and another immured in the wall. Near the tomb there was to be constructed "unum altare de marmore fino cum suis ertis et voltis de marmore fino et in medio dicti altaris debeat fierj figura domini nostrj Jesu Christi de marmore praedicto fino et a latere superiori imago sive figura gloriossime Virginis matris Marie de marmore fino: et ab alio latere Sancti Joannis Evangelista pur de marmore fino." Venceslao bequeathed to the Convent of S. Chiara 120 fields at the Villa di Monestier del Pero. The nuns, in turn, were obligated to elect a priest responsible for celebrating daily Mass for the soul of the testator at the aforementioned altar. In addition, Bettignoli left to the convent his garments of silk to be made into vestments, a silver chalice with its paten, a manuscript missal, and a silk vestment, in exchange for which the nuns were to recite a Paternoster and an Ave Maria daily for the testator's soul. Finally, Bettignoli designated as his residual heir the son of his late brother Deifebo, Giovanni Antonio Bettignoli, and after him, Giovanni Antonio's legitimate male issue.[1] In a codicil of August 23, 1499, Venceslao charged that his tomb and altar be constructed by Giovanni Antonio within six months of the testator's death.[2] We do not know when Venceslao died, but presumably it was not long afterward.

On December 30, 1503, Giovanni Antonio Bettignoli wrote his own testament. From it we learn that Venceslao's heir had seen to the construction of the tomb and altar of his uncle. Giovanni Antonio, in turn, ordained that he be buried in "unam archam de lapide marmoreo a latere dextero prope altare q. spectabilis et generosi Domini Vincilai de bicignolis eius patrui ad instar et similitudinem in omnibus et per omnia prout est archa dicti domini Vincilai a latere sinistro dicti altaris."[3] By March 14, 1504, Giovanni Antonio was dead.[4] In the event, he was buried, not in S. Chiara, but in the Eremite Church of S. Margherita, where his father's body lay.[5]

On July 9, 1505, the stonemason "Magister Jo. Baptista q. Alberti de breonis," resident in Venice, gave a quittance to ser Lazaro Bevilacqua, steward and procurator of Chiara, widow of Giovanni Antonio, for whom ser Lazaro was acting. The quittance was for 44 lire, 4 soldi due Giambattista "pro resto pretij sepulturae q. nobilis domini Vincilai de bicignolis patrui praefati q. domini Io. Antonij et scalinorum quibus ascenditur eius altare fundatum in ecclesia S. Clarae a cella." Giambattista renounced his claim to a further 7 lire about which evidently there was some dispute. Bregno also gave a quittance for everything he had received during the lifetime of Giovanni Antonio and, after his death, from his executor, "pro archa marmorea praedicti q. domini Vincilai constructa in suprascripta eclesia S. Clarae et pro quibuscumque aliis laborerijs per eum factis eidem q. domino Io. Antonio."[6]

The quittance explicitly credits Giambattista with the manufacture of the tomb of Venceslao Bettignoli and the steps to his altar. But it also mentions "other works of whatever kind made by him [Bregno] for Giovanni Antonio," for which the sculptor was paid before his patron's death. That the Bettignoli Altar was intended here we may deduce from the stylistic correspondence between most of the extant figures of the altar and Giambattista's other works. The documents supply an approximate date for the tomb and altar. While the quittance establishes a *terminus ante quem* of July 9, 1505, for the altar steps, Venceslao's and Giovanni Antonio's testaments fix the execution of Venceslao's tomb and altar between August 23, 1499, and December 30, 1503.

Altar, tomb, and epigraphs stood to the right of the High Altar (*in cornu Epistolae*) of the mid-15th-century Church of S. Chiara della Cella. In 1512, during the War of the League of Cambrai, S. Chiara was razed; once hostilities had ended, the convent of Poor Clares was transferred to the city proper.[7] There a new single-naved, apseless, rectangular church with raised choir was constructed between 1516 and 1519.[8] Nevertheless, enough of the old church remained standing to continue to shelter, however inadequately, the Bettignoli Altar and epigraphs: the inscription currently installed to the right of the altar in S. Nicolò informs us that the altar was transferred from the old, to the new, Church of S. Chiara only on September 15, 1591. At this time the altar was restored and rededicated to the grandson of Giovanni Antonio, Francesco Bettignoli Bressa, recently deceased, by his widow and daughter. In ad-

dition to the altar, Franceschina Bettignoli Bressa Sugana and Cara Bettignoli Bressa saw to the reinstallation of the epitaph that Venceslao had ordered immured beneath his tomb, recording Giovanni Antonio's dedication of the tomb to his uncle, and the epigraph that Venceslao intended for the pavement of the church. The former is still preserved to the left of the altar in S. Nicolò (Pl. 9); the latter, described by Burchelati in 1616,[9] has since disappeared. Twice in the 17th century the altar and its inscriptions were observed at the left of the *cappella maggiore* of S. Chiara (*in cornu Evangelii*).[10] From the absence of any later mention of Venceslao's tomb, we infer that it alone succumbed to the ravages of war.

On April 25, 1810, S. Chiara was suppressed by Napoleonic decree; transformed, it served for many years as a post office.[11] Meanwhile, the Bettignoli Altar was removed to the Dominican Church of S. Nicolò, where it was installed by 1822 opposite the Altar of the Madonna del Rosario at the west end of the south wall (*in cornu Epistolae*).[12] There it remained at least until 1864.[13] Probably in consequence of a rearrangement of the altars of the side walls planned in 1864,[14] the Bettignoli Altar was moved to the second chapel on the left at the east end of the church (*in cornu Evangelii*).[15] By 1889 the Bettignoli Altar had been set up in the position it occupies today on the south wall opposite the lateral portal of the church.[16]

The altar's present sculpture and architectural members are apparently the result of three separate campaigns. To the altar commissioned by Giovanni Antonio Bettignoli belong the *Resurrected Christ, John the Evangelist,* the *Madonna and Child* and the pair of angel heads, as well as the outermost pilasters. The statue of the *Virgin*, which evidently replaced one by Giambattista, and the two *Reggiscudo* must date from the altar's reconstruction in 1591. So too does the rearrangement of the architectural framework, in which a new base, inscription, lesenes, and entablature were combined with older elements, including some, like the consoles, possibly pillaged from the Bettignoli Tomb. To a third, and probably relatively recent campaign, belong the concrete fields embracing the medallions with *Angels.*

The first attempt at attribution was made by Federici: from an incomplete knowledge of the documents, he deduced that the altar was commissioned in 1493 by Venceslao from Pietro Lombardo, who had finished only the statue of *Christ* when the patron's death supervened. It was not until 1591, wrote Federici, that the altar was completed under Fran-

cesco Bettignoli and his widow, apparently by Gero-lamo Campagna.[17] Federici's story was given currency by Crico and Sernagiotto.[18] Semenzi, followed by Bailo and Fapanni, gave the altar *tout court* to Tullio Lombardo,[19] while Milanese, endorsed by Santalena, adopted the Lombardi/Campagna attribution of Crico.[20] In an aside, Paoletti disputed the authorship of the Lombardo. Though he considered the sculpture of the altar "mediocre," he correctly perceived that the *Virgin*, among other things, was a later addition.[21] In Federici's wake, Coletti stated that the *Virgin* and *St. John* had been added at the end of the 16th century to an altar of Pietro Lombardo's.[22] With further thought, however, Coletti concluded that the two *Reggiscudo*, the *Madonna and Child*, and the angel heads belonged, not to the Lombardi, but to the Lombard school of the end of the 15th century: these, he supposed, might have been those parts of the altar commissioned by Venceslao Bettignoli. *Christ*, the *Virgin*, and *St. John*, on the other hand, he gave to Lorenzo Bregno and dated two or three decades later.[23] Coletti convinced Patrizio, Vazzoler, Bellieni, and Netto,[24] and influenced Timofiewitsch, who appropriated Coletti's dating of the altar's various parts, but refrained from assigning them an author.[25] Venturi attributed the *Risen Christ* to Aurelio Lombardo,[26] while Munman gave the entire altar, without discussion, to Giambattista Bregno.[27]

In 1983, I published the documents just discussed and recounted the altar's moves and transforma-tions.[28] To Giambattista Bregno, working for Giovanni Antonio Bettignoli between 1499 and 1503, I assigned the *Resurrected Christ*,[29] the *Madonna and Child*, and the heads of *Angels*. With the exception of *St. John the Evangelist*, the remaining figures were dated to 1591, but I could not name their author.

Even before an autograph figure of *St. John the Evangelist* by Giambattista had come to light, I was sure that the Bettignoli *Evangelist* (Figs. 8, 9) was not by him. Comparison with the Cesena *Evangelist* (Pls. 30–33) now makes doubly evident the Treviso figure's classicizing figure type and face, draping of the cloak and structure of the folds, which find no parallel in Giambattista's work. The figure's stable pose and settled folds contrast with the illusion of transience conveyed by the pose and drapery of the Cesena *Evangelist*. I would be tempted to identify the author of the Treviso *St. John* as Sebastiano da Lugano, Giambattista's partner in 1502, were it not that the only works that have any documentary claim, however indirect, to Sebastiano's paternity – the Civran *Pages* in East Berlin[30] – are so different in quality and style. The author of *St. John* clearly knew the sculpture of Tullio and Antonio Lombardo without being a slavish imitator; conversely, he took nothing from Giambattista Bregno. When he came to execute this work he was a fully trained and accomplished master – not vastly inferior to Bregno himself. Yet I do not know another work by him.

---

[1] See Appendix A, Doc. IV, A.

[2] See Appendix A, Doc. IV, B. A summary of the testament and codicil are found in AST, Corporazioni religiose soppresse, S. Chiara di Treviso, Busta 1, Catastico, cc. 2–5.

[3] See Appendix A, Doc. IV, C. A summary of the testament is found in AST, Corporazioni religiose soppresse, S. Chiara di Treviso, Busta 1, Catastico, c. 7.

Giovanni Antonio's testament is dated December 30, 1504, *stile Nativitatis*, according to whose use at Treviso, the new year was advanced to December 25. In the modern style (*stile Circumcisionis*), December 30, 1504, *modo Tarvisino* is thus December 30, 1503.

[4] AST, Archivio notarile, 1ª serie, Busta 366, filza 6, c. 23r.

[5] Treviso, Bibl. com., MS 643, Cima, iii, 1699, cc. 201f; AST, Corporazioni religiose soppresse, S. Chiara di Treviso, Busta 1, Catastico, c. 7.

[6] See Appendix A, Doc. IV, D.

[7] Renucci, *Le Venezie francescane*, 1962 (1965), pp. 33–8; Agnoletti, i, 1897, pp. 412f; Sartori/Luisetto, 1988, pp. 1448f, nos. 26–34.

[8] Treviso, Bibl. com., MS 643, Cima, iii, 1699, c. 322; Renucci, *Le Venezie francescane*, 1962 (1965), pp. 42f; Sartori/Luisetto, 1988, p. 1448f, nos. 32, 35, 39, 40. The church was consecrated on May 27, 1534: ibid., p. 1449, no. 46.

[9] Burchelati, 1616, p. 353: "Cum nihilominus infra Virginium tale quadratum comperiatur elegans marmor. VINCISLAI BICIGNOLI TERREVM" Cima (Treviso, Bibl. com., MS 643, iii, 1699, cc. 323f) does not mention it.

[10] Burchelati, 1616, pp. 353f; Treviso, Bibl. com., MS 643, Cima, iii, 1699, cc. 322–4. That both Burchelati and Cima used "right" to mean *in cornu Evangelii* is clear from their location of monuments still *in situ*, such as the Tomb of Agostino Onigo in S. Nicolò. See Catalogue no. 13, n. 6, and Burchelati, 1616, p. 323.

[11] Renucci, *Le Venezie francescane*, 1962 (1965), pp. 40f, 42.

[12] [Crico], 1822, p. 20; Pesce ed., (1826–7) 1969, p. 30.

[13] Semenzi, ²1864, p. 195.

[14] Treviso, Bibl. com., MS 1356, Fapanni, 1851–90, c. 32.

[15] [Sernagiotto], *Gazz. di Treviso*, Jan. 30, 1869, p. 1; [Bailo], 1872, p. 69.

[16] Milanese, 1889, p. 13.

[17] Federici, 1803, ii, pp. 68f.

[18] Crico, 1833, pp. 35f; [Sernagiotto], *Gazz. di Treviso*, Jan. 29, 1869, pp. 1f.

[19] Semenzi, in *Grande illus.*, v, pt. 2, 1861, p. 649; idem, ²1864, p. 195; [Bailo], 1872, p. 69; Treviso, Bibl. com., MS 1355, Fapanni, ii, 1892,

cc. 234f. Perkins, 1868, p. 197, n. 1, thought the altar was probably by the Lombardi.

[20] Milanese, 1889, p. 13; Santalena, 1894, p. 176.

[21] Paoletti, 1893, ii, p. 229, n. 4.

[22] Coletti, [1926], pp. 80, 118.

[23] Coletti, 1935, p. 425, no. 836.

[24] Patrizio, 1962, pp. 9f, no. 10; Vazzoler, 1962/63, pp. 264f; Bellieni, in Barzaghi et al., 1986, pp. 141/3; Netto, 1988, p. 409.

[25] Timofiewitsch, in Egg et al., 1965, p. 508.

[26] Venturi, x, pt. 2, 1936, p. 688, n. 1.

[27] Munman, 1968, pp. 305, 309, n. 8.

[28] Schulz, Arte cristiana, 1983, pp. 35–48.

[29] In BJ, 1980, p. 185, n. 14, I rashly rejected the attribution of the Resurrected Christ to either Giambattista or Lorenzo Bregno.

[30] For these figures, see Schulz, Arte ven., 1983, pp. 159f.

## 17. TREVISO, S. NICOLÒ: CHRIST APPEARING TO THE HOLY WOMEN
### GIAMBATTISTA BREGNO AND SHOP

Pls. 114–116

The Risen Christ and the two Holy Women are situated to the left and right, respectively, of the altarpiece of the *Doubting Thomas* in the Cappella Monigo, the first chapel to the right of the *cappella maggiore* (*in cornu Epistolae*) in S. Nicolò.

The statue of Christ and its base are carved from a single block of white marble. The figures of Holy Women with their joint base are carved from a second block of white marble.

Christ: 117 cm high (including its base); Holy Women: 105 cm high (including their base).

Apart from irises and pupils tinted black, there are no traces of polychromy or gilding in the Risen Christ. Polychromy and gilding are entirely absent from the Holy Women.

The upper half of Christ's left hand, which at one time was pieced, is missing now. The big toe of Christ's left foot and the third and fifth toes of his right foot are chipped. Along the outer contour of the figure's left leg, the edge of the shroud is chipped in a couple of places; a fold running into the crotch is nicked. Otherwise the work is well preserved.

A horizontal crack runs through the further of the Holy Women at the level of her neck and shoulders; at the right edge the crack has been repaired with mortar. The right border of the group is chipped throughout its length. The nose of the rear figure and the thumb of the foremost figure's lowered hand are badly chipped. Smaller chips are missing from the upper lip and nose of the forward figure, from the edge of its book, and from the folds and edge of its mantle. To the left of the engaged foot of this figure, a large piece is missing from the base.

Bibl.: Burchelati, 1616, p. 482; Treviso, Bibl. com., MS 1046A–1046B, Burchelati, 1630 (typescript, p. 38); Federici, 1803, ii, pp. 66f; [Crico], 1822, p. 24; idem, 1829, p. 63, no. 3; Sernagiotto, 1871, pp. 31f; [Bailo], 1872, p. 74; Milanese, 1889, p. 17; Treviso, Bibl. com., MS 1355, Fapanni, ii, 1892, c. 227; Santalena, 1894, p. 177; Milanese, [2]1904, p. 42; Coletti, [1926], p. 80; idem, 1935, p. 404, nos. 795, 796; Tiepolo, 1936, p. 57; Treviso, Seminario Vescovile: *Mostra d'arte sacra*, [1947], p. 12, no. 144; Patrizio, 1962, p. 16, no. 24; Vazzoler, 1962/63, pp. 205f; Timofiewitsch, in Egg et al., 1965, p. 510; Schulz, BJ, 1980, p. 185, n. 14; eadem, Arte cristiana, 1983, pp. 42–4.

In addition to the Risen Christ and the Holy Women, this group originally included a statue of the kneeling Magdalene;[1] undoubtedly it was this figure, located to Christ's right and balancing the Holy Women on his left, on which Christ focused his attention. Thus, the scene of the "Noli me tangere" (St. John 20:14–17) was conflated with Christ's appearance to the two Maries (St. Matthew 28:9–10). Not much before 1803 the Magdalene vanished, replaced by a plaster copy.[2] Neither original nor copy survives.

Christ and the three Maries within a niche, plus some Angels and ornaments, not more precisely enumerated or described, belonged to an altar that in 1630 and the first part of the 19th century occupied the first chapel to the left of the *cappella maggiore* (*in cornu Evangelii*), once dedicated to the Saviour, then to the SS. Nome di Dio, in the Dominican Church of S. Nicolò.[3] By 1871 the two remaining parts of the ensemble had been removed to the small sacristy of the church; the head of the woman at the rear of the group of two was lost.[4] By 1889 Christ and the two Maries had been placed in their present positions.[5] In September 1947, the missing head, which had passed in the meantime to the Museo Civico, Treviso, was reunited with its torso.[6]

In 1803 Federici reported, without citing a source, that the altar to which our statuary belonged had been commissioned by the Counts d'Onigo.[7] In fact, Pileo di Bonsembiante d'Onigo (d. 1438) and Gio-

vanni Paolo d'Onigo (tomb slab 1579) were buried in the first chapel to the left of the *cappella maggiore*,[8] suggesting that, from the mid-15th century on, at least, the chapel was under the juspatronage of the Onigo. If we could be sure that *Christ Appearing to the Three Maries* was made initially for the altar it adorned in 1630, we would be tempted to credit Federici's assertion of Onigo patronage and, indeed, to identify his "Conti d'Onigo" with the sons of Senator Agostino d'Onigo – Pileo (d. August 26, 1502), Aurelio, and Girolamo – who erected a monument to their father on the left wall of S. Nicolò's choir between 1490 and 1492. But proof is wanting.

Federici assigned the two extant fragments of *Christ Appearing to the Three Maries* to Jacopo Sansovino;[9] his attribution was still current in 1962.[10] Coletti is unique in having questioned this egregious misattribution. In 1926 he assigned both fragments to Pietro Lombardo but labeled the figures of Holy Women a

"Virgin Annunciate" (an understandable mistake in view of the fact that only the foremost figure was intact).[11] In his catalogue of 1935, Coletti explained that the Resurrected Christ and what he took to be the Virgin Annunciate did not belong together: the statue of Christ, he thought, was probably by Giambattista Bregno, while the "Virgin" was closer to the Quattrocento and the art of Pietro Lombardo.[12] Although Timofiewitsch did not adopt Coletti's attribution and failed to name an author, he did borrow Coletti's erroneous identification of the main female figure and consequently assumed that the two fragments were not related. He dated the "Virgin" ca. 1500.[13] Aware of the reintegration of the Two Maries, Vazzoler, by contrast, catalogued both fragments among Giambattista's works.[14] In 1980 I summarily rejected the attribution of Christ to Giambattista Bregno.[15] I now believe that the group was executed in Giambattista's shop, probably to his design.[16]

---

[1] Burchelati, 1616, p. 482; Treviso, Bibl. com., MS 1046A–1046B, Burchelati, 1630 (typescript, p. 38); Federici, 1803, ii, p. 67.

[2] Federici, 1803, ii, p. 67.

[3] Treviso, Bibl. com., MS 1046A–1046B, Burchelati, 1630 (typescript, p. 38); Federici, 1803, ii, p. 66; [Crico], 1822, p. 24; Crico, 1829, p. 63, no. 3.

[4] Sernagiotto, 1871, p. 32, n. 1; [Bailo], 1872, p. 74.

[5] Milanese, 1889, p. 17.

[6] Treviso, Seminario Vescovile. *Mostra d'arte sacra*, [1947], p. 12, no. 144; Patrizio, 1962, p. 16, no. 24.

[7] Federici, 1803, ii, p. 66.

[8] Treviso, Bibl. com., MS 1089, Mauro, 16th cen., n.c., voce "Vonici", Burchelati, 1616, p. 342, for whom "à dextris" signified *in cornu Evangelii* (see Cat. no. 16, n. 10). In 1882 the Tomb Slab of Pileo

Onigo passed to the Museo Civico, Treviso: Cervellini, 1933, pp. 90f, no. 162.

[9] Federici, 1803, ii, pp. 66f.

[10] [Crico], 1822, p. 24; idem, 1829, p. 63, no. 3; Sernagiotto, 1871, pp. 31f; [Bailo], 1872, p. 74; Milanese, 1889, p. 17; Treviso, Bibl. com., MS 1355, Fapanni, ii, 1892, c. 227; Santalena, 1894, p. 177; Tiepolo, 1936, p. 57; Treviso, Seminario Vescovile. *Mostra d'arte sacra*, [1947], p. 12, no. 144; and doubtfully, Patrizio, 1962, p. 16, no. 24.

[11] Coletti, [1926], p. 80.

[12] Coletti, 1935, p. 404, nos. 795, 796.

[13] Timofiewitsch, in Egg et al., 1965, p. 510.

[14] Vazzoler, 1962/63, pp. 205f.

[15] Schulz, *BJ*, 1980, p. 185, n. 14.

[16] Schulz, *Arte cristiana*, 1983, pp. 42–4.

---

## 18. FORMERLY VENICE, CHURCH OF THE CROCIFERI (S. MARIA ASSUNTA DEI GESUITI): TOMB OF IPPOLITO VERARDI

GIAMBATTISTA BREGNO

Epitaph: HIPPOLITO VERARDO CESENNATI RARISSIMAE INDOLIS PUERO IN QUO EXORNANDO DUM NATURA CUM ARTE, ET VIRTUS CUM DOCTRINA CERTATIM CONTENDUNT, FATI VIS INVIDA PULCHERRIMUM ORNAMENTUM MALA DISPARAVIT MANU. VIXIT ANNOS 17. MENSES 3. DIES 4. HORAS 2. OBIIT NONAS APRIL(is). 1503. CAMILLUS AEQUES PONTIFICIUS, ET SIGISMUNDUS MOESTISSIMUS FRATRES NON SINE LACRIMIS P(osuerunt) STEMMATA FAMILIAE, PUDOR, FA-

CUNDIA, GRATIA, VIRTUS, CLAUSA SUB HOC TENUI MARMORE JACENT.[1]

Bibl.: Schrader, 1592, p. 307r; Venice, Bibl. Marc., MS lat., Cl. X, 144 (=3657), Palferio, 17th cen., c. 89v; idem, MS lat., Cl. XIV, 26 (=4268), *Inscriptiones*, 18th cen., cc. 397f; Venice, Mus. Correr, MS Gradenigo 201/II, *Iscrizioni*, 18th cen., c. 199v; idem, MS Cicogna 2010, Cicogna, 19th cen., no. 6, c. 4r, no. 42; Burchi, [1950], pp. 5–7, idem, 1970, pp. 41f; Viroli, in *Il mon.*, 1989, pp. 56f, n. 10.

The epitaph transcribed above informs us that Ippolito Verardi died on April 5, 1503, at the age of 17. Ippolito's father was Ptolomeo; Ippolito's brothers were Camillo, pontifical knight and patron of Lorenzo Bregno's Altar of St. Leonard in the Duomo of Cesena,[2] and Sigismondo. The inscription identifies

the two brothers as the patrons of Ippolito's tomb. Camillo died in June 1505.[3] Sigismondo was already dead when Camillo indited his testament on June 19, 1504.[4] We may posit that the tomb was commissioned before Sigismondo's, but after Ippolito's, death, that is, between April 5, 1503, and June 19, 1504.

By January 10, 1506, the tomb was finished. On that day Giambattista Bregno requested payment from the heirs of Carlo Verardi and of his deceased nephew Camillo for the tomb of Camillo's brother Ippolito, which the sculptor had constructed in the Venetian Church of the Crociferi, as well as payment for the statues of the Altar of the Corpus Domini carved by Bregno for Carlo's chapel in the Duomo at Cesena.[5] On January 13, 1506, Giambattista was paid the money due him by the guardians of Camillo's son and heir Ptolomeo – Camillo Verardi's widow Camilla, Pandolfo Moro, and Vincenzo Toschi.[6]

The Tomb of Ippolito Verardi was located in the second Church of the Crociferi, constructed after a fire had consumed the first church on the site in 1214.[7] In 1656 the Convent of the Crociferi was suppressed; in 1657 the church passed to the Jesuits.[8] In 1715 the second Church of the Crociferi was demolished and rebuilt in a new and ampler form by the architect Domenico Rossi.[9] The fabric of the third church was complete by 1728; its decoration was finished one year later.[10] It was presumably on the occasion of the rebuilding of the church that the Verardi Tomb was lost. Despite the fact that its epitaph was transcribed several times, there survives no description of the tomb's appearance or site.

Giambattista Bregno's responsibility for the Verardi Tomb came to light only in 1950 with Burchi's publication of the relevant documents.[11] However, Burchi's privately printed pamphlet, available only at Cesena, was not known to Mariacher, Vazzoler, or to me when we wrote on Giambattista Bregno.[12]

---

[1] The epitaph is lost, but was transcribed by: Schrader, 1592, p. 307r; Venice, Bibl. Marc., MS lat., Cl. X, 144 (= 3657), Palferio, 17th cen., c. 89v; idem, MS lat., Cl. XIV, 26 (= 4268), Inscriptiones, 18th cen., cc. 397f; Venice, Mus. Correr, MS Gradenigo 201/II, Iscrizioni, 18th cen., c. 199v; idem, MS Cicogna 2010, Cicogna, 19th cen., no. 6, c. 4r, no. 42. There are substantial differences among the various transcriptions. Schrader is unique in having omitted DIES 4, HORAS 2. He transcribed FRATRES as FRATER; all the others transcribed the word as PATER. MS Gradenigo 201/II gave MALA as MOLA. MS lat., Cl. XIV, 26 (= 4268), transcribed FACUNDIA as JACUNDIA and DIES 4 as DIES III. My conflation of these sources has been governed by the sense of the inscription, which I would translate thus: "To Ippolito Verardi, Cesenate, boy of rarest character, in whom nature contended in rivalry with art, virtue with learning, about to be honored, a malevolent and evil force of destiny cut off the most beautiful ornament by force [or unnaturally]. He lived 17 years, 3 months, 4 days, 2 hours. He died on April 5, 1503. Camillo, pontifical knight and Sigismondo, saddest brothers, not without tears, erected [this tomb]. Lineage of the family, honor, eloquence, grace, virtue lie enclosed beneath this thin marble."

[2] See Camillo's testament of June 19, 1504 (ASC, Arch. not., Volume 212 [no. 22, Baldassare Albertini], no. 70, published in Stat. civ. Caes.,

1589, p. 378. See Appendix A, Doc. XIII, A) and the epitaph from Carlo Verardi's tomb in S. Agostino, Rome (Forcella, v, 1874, p. 27, no. 74).

[3] Fantaguzzi, (1460–1510) 1915, p. 217.

[4] ASC, Arch. not., Volume 212 (not. no. 22, Baldassare Albertini), no. 70, published in Stat. civ. Caes., 1589, p. 382.

[5] The document, formerly Cesena, Archivio curia vescovile, Canonici 1, 1280–1527, is lost. It was first published by Burchi, [1950], pp. 4–7. See Appendix A, Doc. VI, E.

[6] The document, formerly Cesena, Archivio curia vescovile, Canonici 1, 1280–1527, is lost. It was first published by Burchi, [1950], pp. 6f, n. 10. See Appendix A, Doc. VI, F.

[7] Corner, 1749, ii, p. 174.

[8] Bianchini, 1891, p. 12.

[9] Franzoi/Di Stefano, 1975, p. 153.

[10] Corner, 1749, ii, p. 179.

[11] Burchi, [1950], pp. 4–7.

[12] Mariacher, DBI, xiv, 1972, pp. 113f, voce "Bregno, G. B."; Vazzoler, 1962/63; Schulz, BJ, 1980, pp. 173–202; eadem, Arte cristiana, 1983, pp. 35–48.

---

## 19. VENICE, CONVENT OF S. GIORGIO MAGGIORE, DORMITORY: ST. GEORGE AND THE DRAGON
GIAMBATTISTA BREGNO AND SHOP

Pls. 83, 84

The relief is immured in the central lunette atop the main dormitory facade, fronting the Bacino di S. Marco, of the former Convent of S. Giorgio Maggiore.

The relief is composed of a single block of Istrian limestone. The separate base is carved from two blocks of Istrian limestone.

St. George and the Dragon: 168 cm high (including its base) × 188.6 cm wide.

There are no traces of polychromy or gilding.

The relief is fixed to the masonry of the facade by two long clamps covered by concrete and four short exposed clamps. Between relief and base is a thick, uneven stratum of gray concrete. The surface of the relief is extremely worn and is fissured throughout. A crack penetrates both rear pasterns of the horse. The fetlock of the nearer of the horse's hind legs has broken off. The tips of the dragon's ears also seem to be missing. A large piece of stone has been lost from the princess's forward silhouette between waist and upper thigh. St. George's lance has broken off at the point at which it emerges from the dragon's mouth: about a third of it is missing.

Bibl.: Cicogna, iv, 1834, pp. 322f, n. 190; Ven., Bibl. Marc., MS it., Cl. VII, 2283 (=9121), Fapanni, 1884–9, fasc. 5, "Monastero... di S. Giorgio Maggiore," Apr. 23, 1874, c. 26v; Paoletti, 1893, ii, p. 256; Biscaro, *Arch. ven.*, ser. 2, xviii, pt. 1, 1899, p. 195; Paoletti, T-B, iv, 1910, p. 570, voce "Bregno, G. B."; Lorenzetti, 1926, p. 727; idem, *Enc. ital.*, vii, 1930, p. 793, voce "Bregno"; Damerini, 1956, p. 61; Perocco, 1960, p. 62; Vazzoler, 1962/63, pp. 154, 204; London, Victoria & Albert Mus. Cat. by Pope-Hennessy/ Lightbown, 1964, i, p. 360, nos. 382–4; Mariacher, *DBI*, xiv, 1972, p. 114, voce "Bregno, G. B."; Menegazzi, *DBI*, xv, 1972, pp. 359f, voce "Buora, G."; Niero, in Niero et al., 1972, p. 236; Lauritzen, *Apollo*, July 1976, p. 4, fig. 1; Schulz, *BJ*, 1980, pp. 174, 190f, 201; eadem, *Arte cristiana*, 1983, p. 45; eadem, *Arte lom.*, 1983, pt. 2, p. 70; Mariacher, 1987, p. 232, voce "Bregno"; Beltramini, 1989, pp. 54, 55.

The relief of *St. George and the Dragon* is an integral part of the *bacino* facade of the dormitory of the Benedictine Convent of S. Giorgio Maggiore. Construction of the dormitory began under Abbot Cipriano Rinaldini ca. 1449, but work was interrupted and no progress was made for many years. Work was taken up again in 1494 under Abbot Leonardo da Vicenza. On June 16, 1494, a first agreement to build the dormitory was made with Pasqualin Boneto, stonecutter, and Andrea Cirabelli, mason. On October 22, 1494, the partners, Giovanni Buora and Bartolomeo di Domenico Duca, made a second contract for the dormitory; Buora was named *protomaestro*.

On September 28, 1508, Buora, Andrea mason and Francesco stonecarver, specifically contracted for the dormitory facade fronting the canal, according to the design of Buora or his son; on February 16, 1512, Master Christin was commissioned to install the facade's facing.[1]

Giambattista's commission for the relief of *St. George* succeeded by less than a month the commission for the facade. On October 11, 1508, Giambattista promised the convent's prior, Benedetto Marin,[2] to carve "S. Zorzi a cavallo... cum el dragon e la donzella" in half relief from Istrian stone from the quarries of Rovigno, 4.25 Venetian feet high (147.475 cm) by 5 feet wide (173.5 cm). Bregno's fee of 28 ducats was to include the cost of the stone and every other expense. Work was to be finished by the end of the coming November. At the making of the contract, Bregno received an advance of 8 ducats. Among the witnesses was Giovanni Buora. Bregno was paid 6 ducats on October 26; 4 ducats on November 11; 4 ducats on March 10, 1509; 3 ducats on March 31; and the final 3 ducats on July 25, 1509.[3] Documents suggest, therefore, that the relief was finished considerably before the rest of the facade, work on which undoubtedly was halted by the disruptions at S. Giorgio consequent to the War of the League of Cambrai.[4] Thus may one account for the fact that the relief was not polychromed for another four years: on June 9, 1513, an unnamed painter received 6 ducats for painting the relief.[5]

Because not adequately photographed and visible only at steep angle from very far below, *St. George and the Dragon* was not widely known, despite the publication of Bregno's contract for it in 1834 and again in 1893.[6] Pope-Hennessy referred to the relief as though it were anonymous,[7] while Lauritzen mistook it for a work of Lorenzo Bregno's.[8] In my 1980 article on Giambattista Bregno, I discussed the relief in the context of the artist's other sculpture.[9] Otherwise modern art historical literature contains no more than mere citations of the work.

---

[1] Schulz, *Arte lom.*, 1983, pt. 2, p. 70.

[2] Cicogna, iv, 1834, p. 262; Damerini, 1956, pp. 137f.

[3] See Appendix A, Doc. X, A.

[4] Cicogna, iv, 1834, p. 321, n. 187.

[5] See Appendix A, Doc. X, B.

[6] Cicogna, iv, 1834, p. 322, n. 190; Paoletti, 1893, ii, p. 256.

[7] London, Victoria & Albert Mus. Cat. by Pope-Hennessy/Lightbown, 1964, i, p. 360, nos. 382–4.

[8] Lauritzen, *Apollo*, July 1976, p. 4, fig. 1.

[9] Schulz, *BJ*, 1980, pp. 190f.

## 20. VENICE, SCUOLA GRANDE DI S. ROCCO: BUST OF THE *SAVIOUR*
LORENZO BREGNO

Pls. 206–208

The bust occupies a pedestal on the first landing of the staircase leading to the treasury of the Scuola di S. Rocco.

The *Saviour* is carved from a single block of white Carrara marble.

*Saviour*: 54.5 cm high.

There are no traces of polychromy or gilding.

The lower border of the bust is slightly chipped in a few places. There are a small chip in the lock of hair that traverses the figure's right forehead and two nicks in the crown of thorns. The stone of *Christ's* left upper arm is scratched. Otherwise the bust is

extremely dirty but excellently preserved. The *Saviour* is unfinished in back: the arms are hollow, but the rest of the figure exists in its entirety.

Bibl.: Urbani de Gheltof, 1901, p. 2, no. 8; Schulz, *BJ*, 1984, p. 171.

Nothing is known of the *Saviour's* patronage or provenance: the bust is not mentioned in any published document or early secondary source. Since the staircase, on whose landing the sculpture stands, is used for storage and is not accessible to the public, very little altogether has been written on the work. A pamphlet guide to the confraternity's treasury of 1901 assigned the bust to Tullio Lombardo and dated it to the 16th century.[1] In 1984, I published photographs and a description of the bust with an unequivocal attribution to Lorenzo Bregno.[2] There is no other literature on the work.

---

[1] Urbani de Gheltof, 1901, p. 2, no. 8.

[2] Schulz, *BJ*, 1984, p. 171.

## 21. VENICE, SCUOLA GRANDE DI S. ROCCO: *ST. BARTHOLOMEW* AND *ST. APOLLONIA* OR *AGATHA*
LORENZO BREGNO

Pls. 217–224

The statuettes, part of a group of four, are mounted on the wall on either side of the altar of the confraternity's ground-floor hall, *St. Bartholomew* on the far left, *St. Apollonia/Agatha* on the far right.

The figures, together with their bases, are carved from integral blocks of white marble.

*St. Bartholomew*: 87.2 cm high (including its base); *St. Apollonia/Agatha*: 92.1 cm high (including its base).

*St. Batholomew's* irises show traces of black pigment; there are no signs of gilding. In *St. Apollonia/Agatha*, there are traces of red bole preparation in the grooves of irises and the cavities of nostrils as well as vestiges of gilding in the hair.

The tip of *St. Bartholomew's* nose is chipped. The figure has lost most of its right hand and the attribute it held. The knob of drapery, which the *Saint* held in its left hand, has broken off. The edges of the gown and mantle are chipped in several places, most conspicuously in the hem of the gown on the specta-

tor's left. The statuette has suffered the loss of the first two toes of its right foot and the big toe of its left foot. The base is severely damaged on all sides. The rear of the figure is flattened and only partly smoothed.

*St. Apollonia/Agatha* has lost its left hand; the smooth break gives no evidence of piecing. The index finger of the *Saint's* right hand and the upper part of the attribute she held have broken off. A large chip is missing from a fold on the figure's left upper arm; here and there other folds are nicked. The statuette's rear is unfinished.

The statuettes were cleaned in 1987.[1]

Bibl.: Soravia, iii, 1824, p. 108; E. Paoletti, iii, 1840, p. 108; Selvatico/Lazari, 1852, p. 191; Zanotto, 1856, p. 451; Fulin/Molmenti, 1881, p. 306; Ven., Bibl. Marc., MS it., Cl. VII, 2398 (=10527), Fapanni, fasc. 1, "Confraternite," ca. 1884–9, c. 3; Bernardi, 1885, p. 35; Lorenzetti, 1926, p. 563; Bisacco, 1931, p. 48; *La Scuola Grande*, [1949] p. 11; Mazzucato, [2]1950, p. 11; Hubala, in Egg et al., 1965, pp. 832f; [Crevato-Selvaggi/Mignozzi], 1983, p. 12; Schulz, *BJ*, 1984, pp. 167–71, "Attività," *Arte ven.*, 1987, p. 247.

Nothing is known of the statuettes' patronage or provenance: the *Saints* do not appear in any published document or early secondary source. The sculptures are currently exhibited with statuettes of *SS. Jerome* and *John the Baptist* of approximately the same size,

but later in date, and by a different sculptor. Since first mentioned in guides to the confraternity, all four figures have stood together. Between 1824 and 1885 they were recorded above the cupboards of the room, known as the *piccolo archivio*, that opened off the Cancelleria on the *scuola's piano nobile*;[2] by August 1884 they seem to have been installed where they are found today.[3]

Early references to the statuettes described them as exemplary of Tullio's style,[4] or gave them to Tullio outright;[5] later attributions more cautiously assigned them to a Lombardesque or Lombard sculptor active at the beginning of the 16th century.[6] Hubala was unique in having distinguished between pairs of figures, but mistakenly grouped them by their location to the right or left of the altar: those on the right, he thought, were later than the statues on the left.[7] In 1984 I identified the saints portrayed and unhesitatingly ascribed *SS. Bartholomew* and *Apollonia/Agatha*, dated after 1510, to Lorenzo Bregno.[8]

---

[1]  "Attività," *Arte ven.*, 1987, p. 247.

[2]  Soravia, iii, 1824, p. 108; E. Paoletti, iii, 1840, p. 108; Selvatico/Lazari, 1852, p. 191; Zanotto, 1856, p. 451; Fulin/Molmenti, 1881, p. 306; Bernardi, 1885, p. 35.

[3]  Venice, Bibl. Marc., MS it., Cl. VII, 2398 (= 10527), Fapanni, fasc. 1, "Confraternite," ca. 1884–9, c. 3. On the following page, Fapanni stated that he had examined the paintings of the *scuola* on August 16, 1884.

[4]  Soravia, iii, 1824, p. 108; E. Paoletti, iii, 1840, p. 108; Zanotto,

1856, p. 451.

[5]  Bernardi, 1885, p. 35.

[6]  Selvatico/Lazari, 1852, p. 191; Fulin/Molmenti, 1881, p. 306; Lorenzetti, 1926, p. 563; Bisacco, 1931, p. 48; *La Scuola Grande*, [1949], p. 11; Mazzucato, [2]1950, p. 11; [Crevato-Selvaggi/Mignozzi], 1983, p. 12.

[7]  Hubala, in Egg et al., 1965, pp 832f.

[8]  Schulz, *BJ*, 1984, pp. 168–71.

## 22. VENICE, SS. GIOVANNI E PAOLO: *ST. MARY MAGDALENE* AND *ST. CATHERINE*
## VENICE, SEMINARIO PATRIARCALE, LAPIDARIUM: *ST. MARINA*

LORENZO BREGNO AND SHOP

Pls. 209–216

SS. *Mary Magdalene* and *Catherine* occupy plinths at the edges of Tullio Lombardo's Tomb of Doge Andrea Vendramin on the left wall of the *cappella maggiore*, SS. Giovanni e Paolo (*in cornu Evangelii*) — *Mary Magdalene* on the right, *St. Catherine* on the left. *St. Marina* is located in the lapidarium installed in a ground-floor hall of the Seminario Patriarcale.

SS. *Mary Magdalene* and *Catherine*, together with their respective bases, are carved from integral blocks of white marble. *St. Marina*, together with the child and their common base, also is carved from a single block of white marble.

*St. Marina*: 169 cm high (including its 4.3-cm-high base); *St. Catherine*: 164.1 cm high (including its 5-cm-high base); *St. Mary Magdalene*: 157.8 cm high (including its 2.5-cm-high base).

The *Magdalene's* book is gilded. The fragment of *St. Catherine's* wheel is prepared with bole for gilding.

The surface of *St. Marina* is so dirty that any traces of polychromy or gilding would be hidden.

The rear of the *Magdalene* is flat. On the left side of the figure's head, a large piece of stone, from which the hair was carved, has broken and been reattached. Another large piece of stone is missing from her right elbow. The *Saint's* right forearm and hand are badly cracked. The tip of the figure's right thumb is lost. The jar that she held in her left hand has broken off just above the level of her hand. A crack runs through the first joint of the figure's left thumb into the back of her hand. A large horizontal chip cuts across folds in the swathe of the *Magdalene's* mantle that falls over her left forearm. The front of the base is badly chipped and is missing several pieces. The stone from which the figure was carved is badly veined; most noticeable is the vein that traverses the left half of the statue at the level of its thigh. Around the figure's feet, veins are chipped. The hem of the figure's skirt and the ends of her toes are worn. A patch on the *Magdalene's* right upper arm documents the condition of the figure before its cleaning in 1986.

The rear of *St. Catherine* is flat and only roughhewn. Her wheel has broken off above and below her hand. The pieces of drapery to which the attribute was attached below are chipped. There are chips in the figure's skirt and in the edge of her mantle along her left leg. At the center of the base is a hole into which a metal rod — now truncated — was inserted. A dirty

patch on the figure's left arm shows the state of the surface before the statue's cleaning in 1986.

The rear of *St. Marina* is flat and only roughhewn. At the top of her head is a fairly large unworked knob. In it is a hole for the attachment of a halo, no longer preserved. Except where recently chipped, *St. Marina* is black with soot. Its projecting or flat upper surfaces, such as the top of the child's head, its shoulder, arm, and hand, *St. Marina's* hand, the upper surface of her left sleeve, and her toes, are very worn. Around the *Saint's* face, the edge of the hood is chipped in many places, and her lower lip is nicked. The figure's left hand, including her wrist, is missing; the broken edge is smooth, but the absence of a mortise suggests that the hand was never pieced. The edge of drapery around the vanished wrist is badly chipped. A chip is missing from the nadir of the swathe falling from *St. Marina's* right elbow. Three large chips are missing from the front cover of her book. The borders of the scapular are nicked. The fold over the *Saint's* projecting knee is badly chipped. A large wedge is missing from the fold beyond the figure's free foot. A considerable part of the second toe of the figure's right foot is missing and the upper surface of the first two toes of its left foot are badly chipped. The upper edge of the base is chipped almost throughout. The child's foot and the hem of its dress, where it crosses the buttock, is badly chipped.

Bibl.: Sans., 1581, p. 12r; Sans./Stringa, ²1604, p. 110r; Venice, Arch. di S. Maria Formosa, MS d'Amadeni, 1676, cc. 51f; Martinelli, 1684, p. 133; Pacifico, 1697, p. 168; Corner, 1749, iii, p. 255; Gradenigo/Livan, (1748–74) 1942, p. 157, July 17, 1767; Zucchini, i, 1785, p. 457; Cicognara, ii, 1816, pp. 152, 153; Moschini, 1819, p. 40; Soravia, i, 1822, p. 86; Cicogna, i, 1824, p. 333; [Quadri], 1835, p. xv; E. Paoletti, ii, 1839, p. 236; Moschini, 1842, p. 89, no. 8; Selvatico, 1847, p. 228; Mothes, ii, 1860, p. 153; Fulin/Molmenti, 1881, p. 224; Ven., Bibl. Marc., MS it., Cl. VII, 2283 (= 9121), Fapanni, 1884–9, fasc. 8, "Chiesa de' SS. Giovanni e Paolo," c. 79r; Ven., Bibl. Marc., MS it., Cl. VII, 2289 (= 9125), Fapanni, 1870–88, fasc. 3, "Altarini," c. 62, no. 115 [no. 112], and fasc. 7, "Oggetti d'arte ... del Seminario," Aug. 28, 1886, "Marmi moderni anepigrafi," no. 11; Paoletti, 1893, ii, p. 231, n. 8, p. 274; Conti, 1896, p. 151; Burckhardt/Bode/Fabriczy, ⁷1898, ii, pt. 2, pp. 123f, 127a; Paoletti, T-B, iv, 1910, p. 570, voce "Bregno, L."; *Guida*, 1912, p. 57, no. 22; Rambaldi, 1913, p. 26; Planiscig, 1921, p. 239; Lorenzetti, 1926, pp. 332, 505, no. 22; idem, *Enc. ital.*, vii, 1930, p. 793, voce "Bregno"; Fogolari, 1931, p. opp. pl. 41; V. Moschini, 1940, p. 8; Mariacher, *Arte ven.*, 1949, pp. 96, 98; Lorenzetti, ²1956, p. 694; Caccin, 1959, p. 38; Zangirolami, 1962, p. 72; Vazzoler, 1962/63, pp. 207–9, 275f; Zava Boccazzi, 1965, pp. 132, 134; Hubala, in Egg et al., 1965, p. 791; Munman, 1968, pp. 227, 304; TCI, *Venezia*, ²1969, p. 336; Sheard, 1971, pp. 44f; Zorzi, 1972, ii, pp. 370, 371, 373; Mariacher, *DBI*, xiv, 1972, p. 114, voce "Bregno, L."; Cetti, *Arte cristiana*, 1982, p. 35; Pedrocco, in Ven., Bibl. Marc. *Servi*, [1983], p. 111; Schulz, *BJ*, 1984, pp. 150, 158f; Romano, 1985, p. 7; Wolters, in Huse/Wolters, 1986, p. 179; Lippini, [1989] p. 42.

*SS. Marina, Mary Magdalene,* and *Catherine* originally adorned the High Altar of the Venetian parish Church of S. Marina. On September 18, 1810, the church was suppressed by Napoleonic decree. After serving as a tavern, S. Marina was demolished in 1820.[1] The statues of *SS. Mary Magdalene* and *Catherine* were removed to SS. Giovanni e Paolo, where, sometime after 1816,[2] they were installed on the balustrade of the *cappella maggiore*. On the night of April 18, 1819, the figures were moved to either side of Tullio Lombardo's Tomb of Doge Andrea Vendramin inside the choir. The plinths they occupied there had originally provided bases for Tullio's two *Warriors*, shifted on the same night to niches previously occupied by statues of *Adam* and *Eve*; this complicated rearrangement was occasioned by the secret removal of the nude figures of *First Parents*, considered inappropriate to the sanctuary of a church.[3] Meanwhile, the "statua d'intaglio rappresentante Santa Marina" had been sold on April 28, 1812.[4] The statue disappeared from view until 1842, when it was recorded among the relics of suppressed churches collected by Canon Moschini at the Seminario Patriarcale.[5] There, between 1912 and at least 1969, the statue was exhibited in a portico of the courtyard.[6] Recently *St. Marina* was moved to an interior ground-floor hall.

Two early descriptions record the appearance of the High Altar of S. Marina.[7] The three figures apparently stood in niches flanked by columns. The framework was made of Istrian stone and marble, with incrustations of porphyry and what was probably verd antique. *St. Marina* was elevated in the center; below and to either side stood *Mary Magdalene* and *St. Catherine*. The altarpiece was not inscribed. Nevertheless, the presence of arms bore witness to the patronage of the Bragadin family, members of which were buried before the altar.[8]

The prestige of the Church of S. Marina enjoyed an enormous and sudden increase when, during the War of the League of Cambrai, Venice wrested the city of Padua from imperial forces on July 17, 1509 – the feast day of the saint: the victory was widely attributed to St. Marina's intervention. On June 25, 1512, a decree of the Venetian Senate established a holiday on the saint's anniversary: work was to cease and shops to close. The same decree prescribed a ritual according to which the doge, accompanied by the *Signoria*, Venetian nobles, and the chapter of S. Marco, was to visit the Church of S. Marina, where tierce would be said.[9] Very likely, it was the new celebration of the saint, decreed in June of 1512 and

given public expression for the first time on July 17 of that year, that provoked the commission of S. Marina's elaborate and costly High Altar. But it is also possible that its execution, like that of so many artistic projects in Venice and the Veneto, suffered some delay and that work did not actually begin until the cessation of hostilities in 1516. The altarpiece must have been finished before Lorenzo Bregno's death, but in 1593 the High Altar of S. Marina was still not consecrated.[10]

No documents concerning the High Altar of S. Marina have come to light. The attribution of its figures to Lorenzo Bregno goes back to Sansovino's guidebook of 1581.[11] The attribution was respected as long as the altarpiece remained intact.[12] Even afterward, Lorenzo Bregno's authorship of SS. Mary Magdalene and Catherine was rarely doubted.[13] Almost unique is the dissent of Vazzoler, who attributed the

two Saints to Giambattista Bregno.[14] A very different fate, however, attended the attribution of St. Marina. In 1893 and 1910, Paoletti reported that the statue of St. Marina had disappeared after the suppression of the church.[15] Perhaps it was this misinformation that made modern critics so loath to recognize in the statue of the Seminario Patriarcale evident affinities with other works by Lorenzo Bregno.[16] V. Moschini, endorsed by Zorzi, dated St. Marina to the end of the 16th century.[17] Mariacher, followed by Vazzoler and Lorenzetti's widow in her emendations to Venezia e il suo estuario, believed that, if the seminary's St. Marina did come from the High Altar of the church – itself rather doubtful – the statue might have been a later copy of Bregno's original.[18] In 1984, I emphatically reasserted Lorenzo Bregno's authorship of St. Marina and the statue's provenance in the High Altar of S. Marina.[19]

---

[1] Zorzi, 1972, ii, pp. 371, 373.

[2] Cicognara, ii, 1816, p. 152, says nothing of the removal of SS. Mary Magdalene and Catherine to SS. Giovanni e Paolo. The statues are not listed among the sights of SS. Giovanni e Paolo by Moschini, 1815, i, pt. 1, pp. 146–9, but do appear in Moschini, 1819, p. 40.

[3] Venice, Bibl. Marc., MS it., Cl. VII, 2283 (= 9121), Fapanni, 1884–9, fasc. 8, "Chiesa de' SS. Giovanni e Paolo," c. 79r.

[4] Zorzi, 1972, ii, p. 371.

[5] Moschini, 1842, p. 89, no. 8. The statue does not yet appear in Moschini's Ragguaglio delle cose notabili nella Chiesa e nel Seminario Patriarcale di Santa Maria della Salute in Venezia of 1819. Again in 1886, 1912, and 1926, St. Marina was recorded among the objects brought together at the seminary: Venice, Bibl. Marc., MS it., Cl. VII, 2289 (= 9125), Fapanni, 1870–88, fasc. 7, "Oggetti d'arte ... del Seminario patriarcale," Aug. 28, 1886, "Marmi moderni anepigrafi," no. 11; Guida, 1912, p. 57, no. 22; Lorenzetti, 1926, p. 505, no. 22.

[6] Guida, 1912, pp. 45, 57, no. 22; TCI, Venezia,[2] 1969, p. 336.

[7] Sans./Stringa, [2] 1604, p. 110r: "Ha questa Chiesa altari sette, tra i quali il maggiore è di nobili, & ricchi marmi fabricato, & per suo maggior ornamento vi sono molti pezzi di porfido finissimo, con le sue colonne, nicchi, figure, lavori, partimenti, & corniciamenti, che formano in bel modo il disegno della pala di esso altare, sopra il quale vi sono collocate tre figure di marmo al naturale, scolpite da Lorenzo Bregno. È serrato questo altare da due parapetti della medesima pietra, con colonnelle finissime, che formano il coro di questa Chiesa in assai pulita maniera." and Venice, Arch. di S. Maria Formosa, MS, d'Amadeni, 1676, cc. 51f: "In eodem choro conspicitur altare maius, S. Marinae dedicatum, in quo eiusdem Virginis corpus requiescit. Machina magna est ex Istrio, Pario, Porphyretico, Lacedemonio viridi, ac Tiberiaco marmore uersicolore erecta, ac speciosis coruscorum et muscosorum lapidum segmentis conspicua: cuius medium occupat S. Marinae statua maior ex alabastro efformata, ad utrumque latus aliae duae statuae SS. Mariæ Magdalenæ et Catharinæ Virg. Martyr. ex alabastro eiusdem magnitudinis cum priore, inferiori tamen loco positæ admirantur, ac earum sculptor Laurentius Bregno laudatur. Bragadenorum antiquissimorum Patriciorum opus est, utpote, qui illud erigi mandarunt, et ante aram sibi ac successoribus suis sepeliendi

locum delegerunt. Altare et sepultura inscriptione carent, arma tamen Bragadena cum dignam uetustà prosapià munificentiam tacitè loquuntur et apertè demonstrant."

[8] Ibid., cc. 51cf, for which, see above, n. 7; Corner, 1749, iii, p. 255. The altar was endowed with three mansionaries of 24 ducats each by members of the Bragadin family: Venice, Arch. curia patriarcale, Visitationes ecclesiae, 1591, bk. II, c. 397r, January 31, 1593.

[9] Sanuto, xiv, 1886, coll. 418, 420f, June 25, 1512; col. 486, July 17, 1512; ibid., xxxi, 1891, coll. 62f, July 17, 1521; Sanuto/ Monticolo, RIS, n.s. xxii, pt. 4, 1900, p. 88. For further bibliography, see Muir, 1981, pp. 213f, n. 4.

[10] Venice, Arch. curia patriarcale, Visitationes ecclesiae, 1591, bk. II, c. 397r, January 31, 1593.

[11] Sans., 1581, p. 12r: "Su l'altar grande sono collocate tre figure di marmo al naturale, scolpite da Lorenzo Bregno."

[12] Martinelli, 1684, p. 133; Pacifico, 1697, p. 168; Gradenigo/Livan, (1748–74) 1942, p. 157, July 17, 1767; Zucchini, i, 1785, p. 457; Cicognara, ii, 1816, p. 152.

[13] Soravia, i, 1822, p. 86; [Quadri], 1835, p. xv; E. Paoletti, ii, 1839, pp. 235f; Fulin/Molmenti, 1881, p. 224; Paoletti, 1893, ii, p. 231, n. 8, p. 274; Conti, 1896, p. 151; Burckhardt/Bode/Fabriczy, [7]1898, ii, pt. 2, pp. 123f, 127a; Paoletti, T-B, iv, 1910, p. 570, voce "Bregno, L."; Rambaldi, 1913, p. 26; Planiscig, 1921, p. 239; Lorenzetti, 1926, p. 332; Fogolari, 1931, p. opp. pl. 41; Caccin, 1959, p. 38; Hubala, in Egg et al., 1965, p. 791; Zava Boccazzi, 1965, pp. 132, 134; Zorzi, 1972, ii, pp. 371, 373; Cetti, Arte cristiana, 1982, p. 35; Pedrocco, in Ven., Bibl. Marc. Servi, [1983], p. 111; Schulz, BJ, 1984, p. 150; Romano, 1985, p. 7; Lippini, [1989], p. 42. Cicogna, Diario, Apr. 21, 1819, quoted in Venice, Bibl. Marc., MS it., Cl. VII, 2283 (= 9121), Fapanni, 1884–9, fasc. 8, "Chiesa de' SS. Giovanni e Paolo," c. 79r, believed them to be works of Tullio Lombardo.

[14] Vazzoler, 1962/63, p. 208. Mariacher, Arte ven., 1949, p. 98, hesitantly proposed that the two Saints be assigned to Giambattista's circle. In his entry on Lorenzo Bregno for the DBI, xiv, 1972, p. 114, however, Mariacher betrayed no doubt of Lorenzo's authorship of the two Saints.

[15] Paoletti, 1893, ii, p. 274; idem, T-B, iv, 1910, p. 570, voce "Bregno, L."

[16] Yet the tradition of *S. Marina's* provenance in Bregno's High Altar of S. Marina remained alive at the Seminario Patriarcale: *Guida*, 1912, p. 57, no. 22.

[17] V. Moschini, 1940, p. 8; Zorzi, 1972, ii, pp. 371, 373.

[18] Mariacher, *Arte ven.*, 1949, p. 96, n. 1; idem, *DBI*, xiv, 1972, p. 114, voce "Bregno, L.", Vazzoler, 1962/63, pp. 275f; Lorenzetti, ²1956, p. 694.

[19] Schulz, *BJ*, 1984, pp. 158f.

## 23. VENICE, S. GIOVANNI EVANGELISTA: *DEACON SAINT*
### GIAMBATTISTA BREGNO

Pls. 107–111

The *Deacon Saint* stands immediately to the right of the altar in the Cappella di Lourdes, the first chapel on the right (*in cornu Epistolae*) in S. Giovanni Evangelista.

Statuette and base are carved from a single block of white marble.

*Deacon Saint*: 76.7 cm high (including its ca. 2 cm–high base).

The *Deacon Saint* manifests no traces of polychromy or gilding.

The statuette is very poorly preserved. Its surface is extremely worn, as though the figure had stood outside for many years. A large chip is missing from the locks of hair above the *Saint's* right temple. Eyelids, the tip of the nose, the upper lip, the chin, and the right ear are nicked. So, too, is the drapery along the outer contour of both arms. The loss of the lower corner of the book along with most of the fingers of the *Saint's* left hand, the loss of the upper surface of the right index finger, and the chipping of the border of the right cuff of dalmatic and tunicle is of long standing. Chipping in the border of the left cuff of the *Saint's* dalmatic and at the bottom of his tunicle is of a more recent date. Toward the rear on the spectator's left, a crack runs from the lower part of the statue through its base. The vertical face of the base is chipped throughout. The rear of the *Deacon Saint* is roughhewn and flat.

Bibl.: None.

The statuette was found in the attic of the neighboring Scuola di S. Giovanni Evangelista by Sig. Piero Pazzi and was installed in its present location on the occasion of the reopening of the church in September 1985.

## 24. VENICE, S. MARCO: ALTAR OF THE CROSS
### LORENZO BREGNO AND SHOP

Pls. 225–234

The Altar of the Cross is located behind the High Altar, at the rear of the basilica's central apse.

Most of the statuette of *St. Francis* is integral with the central core and rear of its base; altogether, however, figure and base are made of five separate pieces of white marble (see under "condition"). The statuette of *St. Anthony*, together with its support and base, is made of two pieces of white marble. The two *Angels*, together with their immediate architectural setting, that is, lateral and rear walls, entablature and floor, are carved from a single block of black-veined white marble. The lunette with coffered vault and relief of the *Trinity*, plus the spandrels at either side of the arch, are carved from another block of white marble.

The architectural framework of the altarpiece is mainly white marble. The shafts of the columns are red jasper. The shaft on the spectator's right is pieced 3.5 cm above its base. The frieze of the upper entablature and the curved triangles in the compartments above the *Saints'* niches are also red jasper. The spandrels on either side of the lateral niches are incrusted with prophyry; the spandrels above the central arch are incrusted with white-veined red marble. The frieze of the base contains four pieces of white-spotted red marble. Jacopo Sansovino's *sportello* with a relief of the *Allegory of the Redemption* is gilded bronze.

Altar: 262 cm high × 247.5 cm wide; *St. Francis*: 74.1 cm high (including its 3.4 cm–high base); *St. Anthony*: 76.2 cm. high (including its 3.2 cm–high base); left-hand *Angel*: 54 cm high; right-hand *Angel*: 54 cm high; *Trinity*: 29 cm high.

The *Trinity's* halo is gilt. Gilding was also applied to the capitals of the jasper columns, and to rosettes in the coffers in the central barrel vault and in the soffit of the main entablature. The ground of these coffers is black.

The statuette of *St. Francis* appears originally to have been pieced. Pieces of marble were added for the projecting portion of the *Saint*'s left foot, a skirt around the front and sides of the base, the bottom of the central fold of the *Saint*'s tunic, and the *Saint*'s head. The figure is missing its left thumb. The hem of the tunic on the spectator's left is badly chipped. The first four toes of *St. Anthony*'s left foot constitute a separate piece of marble; it is not attached to the base with a clamp or mortise and tenon, but was probably glued. The hem of the *Saint*'s tunic is chipped in a few places. A fissure runs from the hem up the narrower of the two folds between the *Saint*'s feet. The central petal of the lily's central blossom is chipped. The left-hand *Angel* is undamaged. In the *Angel* on the right, both forearms are cracked through; hands are fixed to the chest by means of an iron clamp. The outer edges of both hands are chipped. Most of the little finger of the figure's left hand is missing and the tops of the third and fourth fingers are chipped. There is a chip in the edge of the peplum beyond the figure's left thigh. The *Trinity* has lost its right thumb; the smooth surface of the break suggests that the thumb originally was pieced. The corner of the *Trinity*'s cloak on the spectator's right is slightly chipped. The right side of the vault is fissured and chipped.

A chip is missing from the base of the left column and the upper cornice of the pediment. The lower left corner of *St. Francis*'s niche is very badly cracked; the inner corner of the base of the left-hand lesene is built up with mortar. At the rear of the niche, moldings were cut away to permit the insertion of the statue's base. Another crack runs diagonally through the top of *St. Anthony*'s niche. Here, too, moldings were cut away behind the statuette's base.

Bibl.: Sans., 1581, p. 37r; Moryson, (1594) 1907, i, p. 168; Stringa, 1610, pp. 23f; Onofri, 1655, pp. 84f; Martinelli, 1684, p. 10; [Albrizzi], 1740, p. 13; Corner, 1749, x, p. 137; [Meschinello], ii, 1753, p. 108; [Zatta], 1761, p. 22; Zucchini, ii, 1784, p. 97; Maier, i, 1787, p. 137; Moschini, 1815, i, pt. 1, p. 301; Piazza, 1833, pp. 7f; E. Paoletti, ii, 1839, p. 34; Cadorin, *Esercitazioni . . . Aten. di Ven.*, 1846, pp. 283f; Zanotto, in *Ven. e le sue lagune*, 1847, ii, pt. 2, p. 43; Selvatico, 1847, p. 312; Selvatico/Lazari, 1852, p. 22; Cappelletti, iii, 1853, pp. 294f; Zanotto, 1856, pp. 45f; Moroni, xc, 1858, p. 265, no. 4, voce "Venezia"; Fulin/Molmenti, 1881, p. 76; Cecchetti, in Ongania, pub., vii, 1886, p. 27, doc. 160, p. 45, doc. 230, p. 87, doc. 365; Saccardo, in Ongania, pub., vi, 1888, pt. 3 [1893], pp. 274, 275; A. P. Zorzi, in "Presbiterio e Cappella Zen" in Ongania, pub., vi, 1888, pt. 3 [1893], p. 417; Pasini, 1888, p. 169f; Paoletti, 1893, ii, pp. 274f; idem, T-B, iv, 1910, p. 570, voce "Bregno, L."; Lorenzetti, 1926, p. 195; Musolino, 1955, pp. 90, 91; Caccin, 1962, p. 95; Vazzoler, 1962/63, pp. 218, 248–50; Caspary, 1964, pp. 86f; Hubala, in Egg et al., 1965, p. 717; Mariacher, *DBI*, xiv, 1972, pp. 114f, voce "Bregno, L."; Sinding-Larsen, *Acta ad archaeologiam*, 1974, pp. 104f, 189; Boucher, *BM*, 1979, p. 165; idem *Apollo*, Sept. 1981, p. 160; Schulz, *BJ*, 1984, pp. 146, 158, 165, fig. 17, pp. 166, 172, 178.

Maintenance and decoration of the Basilica di S. Marco and church property in and around the Piazza di S. Marco were superintended by one of the three Venetian procuracies, the *Procuratori di S. Marco de supra*. Procurators held the second most prestigious office in Venice: like the doge, they were elected for life. Of the four *Procuratori de supra* in 1518, Lorenzo Loredan was son of the reigning doge, while Antonio Grimani and Andrea Gritti became doge in 1521 and 1523, respectively. Andrea Gritti had been elected procurator on April 12, 1509, Antonio Grimani on December 24, 1510, and Marco Bolani on June 17, 1513. On May 15, 1516, the *Maggior Consiglio* decided to increase to four the traditional number of three procurators in each procuracy. For the first time, procurators were elected chiefly on the basis of an offer to the state – impoverished by the War of the League of Cambrai – of a financial contribution in the form of a low interest loan. On May 18, 1516, Alvise Pisani was elected *Procuratore de supra*, having pledged 10,000 ducats. On June 1, 1516, it was decided to add still another procurator to each of the three procuracies and Lorenzo Loredan was elected *Procuratore de supra* against a promise of 14,000 ducats. When after the war, however, Marco Bolani died on July 13, 1517, it was decided not to replace him, in order to reduce the number of procurators eventually to the original three.[1]

On March 3, 1518, the *Procuratori di S. Marco de supra*, Andrea Gritti, Lorenzo Loredan, and Alvise Pisani (in the absence of their fourth colleague, Antonio Grimani), commissioned from Lorenzo Bregno an altarpiece with a tabernacle for the sacrament.[2] The sacrament was to be moved from its former site. The new altarpiece was to measure 7 square feet (242.9 sq. cm) and was to conform to a drawing already shown the procurators. The altarpiece was to contain a perspective setting one-half-foot deep (17.35 cm), two *Angels* in more than half relief flanking the repository for the host, a figure of *God the Father* in approximately half relief in the lunette above the *sportello*, and on either side, in niches, figures of *SS. Francis* and *Anthony of Padua* in full relief, and columns in two-thirds relief. Lorenzo was not asked to supply the stone: rather, marble, serpentine, and porphyry would be furnished by the *protomaestro*, Bartolomeo Bon, at the procurators' expense. Lorenzo's fee was

set at 100 ducats; no time limit was prescribed.

The repository for the Host is closed by Jacopo Sansovino's gilded bronze relief of the resurrected Christ borne aloft by *putti* and displaying his wounds. One *putto* raises a chalice as though to catch the blood from the wound in Christ's chest; another carries a cross. The relief, it would appear, was finished between February 1545 and March 1565. On March 20, 1565, Jacopo Sansovino asked the *Procuratori de supra* to be credited for works executed on their behalf; among them figured "la portella di bronzo per me similmente fatta posta in chiesia di San Marco allo altare del Sagramento."[3] By this date, therefore, the *sportello* of Bregno's tabernacle was completed and installed. Lorenzetti deduced from the absence of any mention of the *sportello* from a similar petition of February 10, 1545, that the relief had not yet been delivered.[4] Nevertheless, there are reasons for thinking that its composition had already been worked out. On September 2, 1542, Lorenzo Lotto paid for the casting of "la storia del basso rilevo de la gloria del Cristo del Sansovino."[5] Apparently from this cast, or from a common source, Lotto painted for Federico Priuli the "quadretto piccolo con un trionpho del Salvator Yesu in atto del sacramento sparger el sangue in aria con molti anzoleti" recorded in the painter's book of expenses the following year.[6] This written record is linked to Lotto's little painting of *Christ Dispensing His Blood* in the Kunsthistorisches Museum, Vienna.[7] Because Lotto's painting compares very closely with the relief of Sansovino's *sportello*, as well as with the two other extant versions of the relief, we may deduce that Jacopo's composition of the *Allegory of Redemption* was already fixed by the time Lotto took a cast of Sansovino's "gloria del Cristo."[8]

The commission to Bregno for the altar specified the depiction of SS. Francis and Anthony of Padua, with whom the facial types and Franciscan habits of the two statuettes, the stigma of one and the book and lily of the other, respectively, accord. Despite no physical resemblance, however, Bregno's figure of *St. Anthony* is frequently misidentified as St. Bernar-

dino; originator of this mistake evidently was Meschinello.[9] It is ironic that Meschinello should have substituted the leader of the Franciscan Observant movement for the spiritual patron of its rival Conventual faction. The central bay of the altar, with rectangular, barrel-vaulted hall, adoring *Angels* flanking the *sportello*, and a half-length *God the Father* in the lunette, is typical of early Renaissance tabernacles of the Host.[10] But the triangular halo indicates that it is actually the Trinity that is represented in the guise of God the Father.[11]

The antependium of the Altar of the Cross is incrusted with slabs of Oriental jasper. The altar is screened by four spiral columns, the central two of Oriental alabaster, the outer two of African marble; behind the outer pair are two more, unfluted, of verd antique: to judge by their capitals, all of them are *spolia*.[12] These capitals support an entablature on which, at least from the mid-18th century, rested an umbrella dome of gilded metal, shaped like a pear and surmounted by a cross.[13] This dome replaced a crowning pointed in the manner of crenellations.[14] From the entablature there hung two lamps – of silver on holidays, of copper at other times.[15] The cupola was removed in 1810;[16] at the same time the altarpiece ceased to house the Eucharist.[17]

In his guide of 1581, Francesco Sansovino ascribed the *sportello* of the altar to his father Jacopo.[18] Apparently from this, Moschini, followed by E. Paoletti and Moroni inferred that the altar, too, was Jacopo's.[19] In 1846, Cadorin assigned the marble portions of the altarpiece to Lorenzo Bregno on the basis of its 1518 document of commission.[20] Cadorin's discovery was acknowledged almost immediately by Zanotto and Cappelletti.[21] But in 1847 Selvatico hypothesized that the Altar of the Cross was what Vasari had had in mind when listing as Pietro da Salò's, "alcune opere assai buone...nella tribuna di San Marco."[22] In 1886, Cecchetti published the commission for the altarpiece;[23] thenceforth Lorenzo Bregno's authorship was universally accepted. Paoletti, Vazzoler, and I suggested the intervention of assistants in the execution of the work.[24]

---

[1] Sanuto, *Diarii*, viii, 1882, coll. 82f, Apr. 12, 1509; ibid., xi, 1884, coll. 692f, Dec. 24, 1510; ibid., xvi, 1887, coll. 382f, June 17, 1513; ibid., xxii, 1887, coll. 219f, 223, May 18, 1516, coll. 257f, June 1, 1516; ibid., xxiv, 1889, col. 470, July 13, 1517. See also Manfredi, 1602, pp. 73f.

[2] See Appendix A, Doc. XV, A.

[3] The document was published by Cecchetti in Ongania, pub., vii, 1886, p. 45, doc. 230.

[4] Lorenzetti, *L'arte*, 1909, pp. 291f. The document was published by Cecchetti in Ongania, pub., vii, 1886, p. 51, doc. 248.

[5] Lotto/Zampetti, 1969, p. 243.

[6] Ibid., p. 56, under the date of ca. May 31, 1543. See also, ibid., p. 57, under the date of July 29, 1544.

[7] Frizzoni, *VJ*, 1911/12, pp. 52f. But cf. Vertova, in *Lor. Lotto*, 1980/81, pp. 408f, 409f.

⁸ For the dating, order of precedence, and attribution of the re-liefs of the *Allegory of Redemption*, see Lorenzetti, *L'arte*, 1909, pp. 288–301; Planiscig, 1921, pp. 374f; Weihrauch, 1935, pp. 63–7; Pope-Hennessy, *Ital. High Ren. Sc.*, 1963, cat., pp. 107f; Boucher, *BM*, 1979, pp. 165f; idem, *Apollo*, Sept. 1981, pp. 157–61.

⁹ [Meschinello], ii, 1753, p. 108. The mistake has persisted to the present day: Boucher, *Apollo*, Sept. 1981, p. 160.

¹⁰ Caspary, 1964, p. 86. The composition of the central bay has numerous precedents in Florence; in Venice only the two twin tab-ernacles in S. Maria dei Miracoli are comparable. These contain a hall, whose barrel vault has coffers with rosettes. From the lunette a figure of the *Trinity* in the guise of God the Father emerges, overlap-ping a portion of the vault. Angels, however, are lacking. For these tabernacles see ibid., pp. 48f.

¹¹ Sinding-Larsen, *Acta ad archaeologiam*, 1974, p. 104.

¹² Caspary, 1964, p. 161, n. 188.

¹³ A. P. Zorzi, in "Presbiterio e Cappella Zen," in Ongania, pub., vi, 1888, pt. 3 [1893], p. 417. See also [Zatta], 1761, p. 22 and pls. IX, XI.

The arrangement of steps preceding the altar and the screening columns reminded Caspary, 1964, pp. 86f, of the Shrine of St. Peter, which was demolished in 1592. The reconstruction of the shrine as it was ca. 600 A.D. by Ward Perkins, *Journ. of Rn. Studies*, 1952, pp. 23f and fig. 2, cited by Caspary, reveals a structure that has a few features in common with the precinct enclosing the Altar of the Cross. They are: the elevation of the level of the pavement of the apse and

of the rectangular area immediately preceding it; a screen of spiral columns in front of the altar; an entablature extended backward at either extremity of the screen of columns to the corners of the apse. It cannot be maintained, however, that the two precincts look very much alike. Caspary also suggested that both precincts alluded to the *Sanctum Sanctorum* of the Temple of Jerusalem from which, according to legend, the six columns of the Shrine of St. Peter came.

¹⁴ [Zatta], 1761, p. 22.

¹⁵ Moryson, (1594) 1907, i, p. 168.

¹⁶ A. P. Zorzi, in "Presbiterio e Cappella Zen," in Ongania, pub., vi, 1888, pt. 3 [1893], p. 417.

¹⁷ E. Paoletti, ii, 1839, p. 34.

¹⁸ Sans., 1581, p. 37r.

¹⁹ Moschini, 1815, i, pt. 1, p. 301; E. Paoletti, ii, 1839, p. 34; Moroni, xc, 1858, p. 265, no. 4, voce, "Venezia".

²⁰ Cadorin, *Esercitazioni . . . Aten. di Ven.*, 1846, p. 283.

²¹ Zanotto, in *Ven. e le sue lagune*, 1847, ii, pt. 2, p. 43; idem, 1856, p. 46; Cappelletti, 1853, iii, p. 295.

²² Selvatico, 1847, p. 312, Vas/ Mil, vii, (1568) 1881, pp. 516f. Not long after, however, Selvatico withdrew the attribution: Selvatico/ Lazari, 1852, p. 22, followed by Fulin/ Molmenti, 1881, p. 76, assigned the marble figures to an "ignoto."

²³ Cecchetti, in Ongania, pub., vii, 1886, p. 27, doc. 160.

²⁴ Paoletti, T-B, iv, 1910, p. 570, voce "Bregno, L."; Vazzoler, 1962/ 63, p. 250; Schulz, *BJ*, 1984, p. 165, fig. 17.

## 25. VENICE, S. MARCO, CAPPELLA ZEN: THREE FEMALE FIGURES FROM THE ZEN SARCOPHAGUS
### GIAMBATTISTA AND LORENZO BREGNO AND SHOP

Pls. 63–72, 153–158

The freestanding sarcophagus of Cardinal Zen oc-cupies the center of the chapel at the southwest cor-ner of the atrium of S. Marco. The figures with which we are concerned are set against the west face of the sarcophagus, opposite the chapel's window. Giam-battista's figure appears to be the one at the center of the sarcophagus; Lorenzo's is at the south end, nearest the altar. An anonymous assistant in the Bregno shop probably was responsible for the figure at the north end, toward the chapel's entrance.

All statuettes are made of bronze. The patina of the west central figure is greenish brown with golden highlights; that of the southwest figure, brown; that of the northwest figure, brown with a slight tinge of green.

Giambattista's figure: 99 cm high (including its own base); Lorenzo's figure: 99.5 cm high (including its

own base); assistant's figure: 95.5 cm high (including its own base).

Quite a large piece, approximately trapezoidal in shape, is missing from the base of Giambattista's stat-uette. Another, approximately trapezoidal, piece is inserted into the base in front of the figure's left foot. The figure's nose is nicked; the shin of the weight-bearing leg and the thigh of the free leg are dented. The surface of the figure's right forearm is rough. At the rear, the figure is hollow from the waist down to the base.

In the base of Lorenzo's statuette, one wedge-shaped piece has been inserted between the figure's right foot and the drapery at the rear and another in front of its left foot. The rough casting of the upraised forearm and hand has produced a pitted surface. The thumb is badly nicked, while the ends of the third and fourth fingers are missing altogether. There is a hole at the side of the figure's right leg, just below its knee, and a flaw in the surface of the genitals just above the drapery. At the rear, a small irregular area in the middle of the figure is hollow.

In the base of the northwest statuette, a wedge-shaped hole behind the figure's right foot has been plugged; the roughened surface of the base helps

conceal the seams. A fairly large hole on the figure's right shoulder also has been plugged, but one in her left side at the level of her hip, invisible from the front, has not. There are two casting flaws on the figure's right thigh. The tress, which descends from her nape, does not appear to have been reworked.

The statuettes were cleaned once in 1604[1] and again in 1981–82.

At the head of the sarcophagus, facing the entrance to the chapel, is the following inscription: IOANNI · BAPTISTAE · ZENO · PAVLI · / SECVMDI · EX · SORORE · NEPOTI · / S · S · ROMANAE · ECCLESIAE · CAR-/DINALI · MERITISSIMO · SENATVS · / VENETVS · CVM · PROPTER · EXIMI-/AM · EIVS · SAPIENTIAM · TVM · SIN-/GVLAREM · PIETATEM · AC · MVNI-/FICENTIAM · INPATRIAM · QVAM · / AMPLISSIMO · LEGATO · MORI-/ENS · PRO-SECVTVS · EST · / · M · P· P · C · (monumentum ponendum pie curavit[2]) AETATIS · ANN · LXIII · OBIIT · / · M · D · I · DIE · VIII · MAII · HORA · XII ·

Bibl.: Sanuto, *Diarii*, iv, 1880, col. 19, Apr. 10, 1501; coll. 34f, May 8, 1501; ibid., v, 1881, col. 184, Oct. 20, 1503; coll. 387f, Nov. 25, 1503; col. 620, Dec. 29, 1503; ibid., vii, 1882, col. 639, Sept. 21, 1508; ibid., xiv, 1886, col. 20, May 8, 1512; ibid., xxv, 1889, col. 202, Jan. 16, 1518; col. 417, May 18, 1518; ibid., xxx, 1891, col. 71, Mar. 29, 1521; coll. 267f, May 27, 1521; coll. 272f, May 27, 1521; col. 276, May 28, 1521; Sans., 1581, pp. 32vf; Stringa, 1610, pp. 17vf; Coryat, (1611) 1905, i, p. 351; Onofri, 1655, pp. 108f; Chacón, 1677, ii, col. 1112, no. IX; Martinelli, 1684, p. 18; Palazzi, ii, 1701, col. 354; Ughelli, v, 1720, col. 1064; [Albrizzi], 1740, pp. 16f; Quirini, 1750, p. 35; [Meschinello], i, 1753, p. 68; Venice, Mus. Correr, MS Gradenigo 200/XIII, *Commemoriali*, 18th cen., c. 65r; Venice, Mus. Correr, MS Gradenigo 228/ III, Grevembroch, iii, 1759, c. 55r; [Zatta], 1761, p. 46; Temanza, 1778, pp. 88f; [Giampiccoli], 1779, p. 35; Zucchini, ii, 1784, p. 43; Milizia, [4]1785, i, p. 172; Riccardi, 1786, pp. 180, 182; Maier, i, 1787, p. 132; Moschini, 1815, i, pt. 1, pp. 348f; [Labus], in *Chiese principali*, 1824, pp. 11f, [pl. 13]; Piazza, 1833, p. 12; Cicogna, iv, 1834, p. 204, no. 36; Zanotto, in Diedo/ Zanotto, [1839], n.p.; n. pl.; E. Paoletti, ii, 1839, pp. 44f; Selvatico, 1847, pp. 190f; Selvatico/ Lazari, 1852, p. 34; Cappelletti, iii, 1853, pp. 332f; Burckhardt, 1855, p. 625b; Zanotto, 1856, pp. 86f; Cicognara/ Diedo/ Selva, 1858, pl. 2; Moroni, xc, 1858, p. 280, voce "Venezia"; ibid., ciii, 1861, p. 469, voce "Zeno, Battista"; Mothes, ii, 1860, pp. 109f; Lübke, 1863, p. 509; Perkins, 1868, p. 197; Milanesi in Vas/Mil, iii, (1568) 1878, p. 675; Fulin/Molmenti, 1881, p. 93; Cecchetti, in Ongania, pub., vii, 1886, pp. 17–26, docs. 122–153, p. 88, doc. 365; Saccardo, in ibid., vi, 1888, pt. 3, [1893], p. 275; Barozzi, in ibid., vi, 1888, pt. 3, [1893], pp. 417–419; Pasini, 1888, p. 233; Paoletti, 1893, ii, pp. 244–7; Burckhardt/ Bode, [6]1893, ii, pt. 2, p. 429; Merzario, 1893, ii, pp. 46, 48; Marangoni, 1910, p. 12; Bouchaud, 1913, pp. 184, 185, 206; Berti, [1916], pl. 19; Schubring, 1919, p. 249; Planiscig, 1921, pp. 218–22, 284–6, 290–3; Bode, *Kunstwanderer*, 1922, p. 426; Lorenzetti, 1926, p. 212; Planiscig, 1927, p. 416; idem, *Dedalo*, Jan.–June 1932, p. 52; Venturi, x, pt. 1, 1935, pp. 406f; "Savin," T-B, xxix, 1935, pp. 508f; Mariacher/ Pignatti, 1950, p. 42; Musolino, 1955, pp. 89f; Pope-Hennessy, 1958, pp. 116, 356f; Caccin, 1962, pp. 114f; Pope-Hennessy, *BM*, 1963, p. 22, repr. in idem, 1968, p. 181; Hubala, in Egg et al., 1965, p. 726; Munman, 1968, p. 350; Ruhmer, *Arte ven.*, 1974, p. 60; Jestaz, 1986, pp. 34, 62, 65, 67, 71, 73, 74, 143–156, 160, 163, 165–7, 188, 190, 194–202, 204, 211.

Giovanni Battista Zen was born in 1439 into a noble Venetian family. His father was Nicolò di Tomà Zen; his mother, Elisabetta Barbo, was the sister of Pope Paul II Barbo. In 1460, Zen was admitted to the *Maggior Consiglio*.[3] He was Apostolic Protonotary when, on November 21, 1468, Pope Paul II named him Cardinal Deacon, with the title of S. Maria in Porticu. With the resignation of another uncle, Zen was appointed Bishop of Vicenza in 1471, but because of the opposition of the Venetian government he did not make his entry until September 28, 1477: for the most part his duties there were performed by suffragans. During Zen's episcopate, the Monte di Pietà was founded in Vicenza and the Jews were expelled from the city. In 1479, Zen also was named Bishop of Frascati (Tusculum). As Papal Legate the cardinal was sent to Perugia and Venice. Zen's patronage was not limited to his own tomb and chapel. He restored and embellished S. Zeno at Verona, of which he held the benefice. The magnificent palace that he built for himself in the Borgo at Rome bore the year 1483. He had his mother buried in an oratory that he founded in St. Peter's, of which he was archpriest; the chapel was finished in 1484.[4] The High Altar of the Cathedral at Vicenza also was erected at the cardinal's expense. On these and other works, Zen was said to have spent 50,000 scudi.[5]

Cardinal Zen died at Padua on May 8, 1501.[6] His body was brought from Padua to Venice, where it was laid in the Church of S. Teodoro, behind S. Marco.[7] The cardinal's exequies were repeated daily in S. Marco from June 16 through June 23. A platform, with tapers and benches around it, was erected for the coffin in the middle of the church. The funeral was attended by the members of the *Scuole piccole* and *Grandi*, the clergy, the chapter of St. Mark's, four bishops, sailors, and the doge, together with the *Signoria* and *Pregadi*, in addition to 152 mourners. Angelo Gabriel gave the funeral oration, which was published soon afterward.[8] The eight ceremonies cost the government 3,000 ducats.[9] The cardinal's body remained in S. Teodoro until his tomb and chapel were finished two decades later.[10]

On April 29, 1501, shortly before his death, Car-

dinal Zen indited his testament, as well as the codicil pertaining to his tomb and altar.[11] As executors, Zen named the doge together with his six Councillors, the three heads of the Council of Ten, the three procurators of St. Mark, and the three senior male members of the Zen family, but only the *Procuratori di S. Marco de citra* actually performed that function.[12] The cardinal wished his tomb and altar to be constructed on the east side of St. Mark's right transept, in front of the arcade that gives access to the choir on the south. But because it was forbidden to erect tombs inside S. Marco, Zen's tomb and altar were eventually ceded a site at the southwest extremity of the basilica's atrium.[13] The cardinal's sarcophagus was to rest on the pavement, on four gilded bronze apples six fingers high. At the head and foot of the sarcophagus there were to be Zen arms. The sarcophagus was to contain an inscription and, on its front face, the cardinal's effigy in pluvial, rochet, and mitre; the rest of the sarcophagus was to be embellished with figures of saints and classical garlands. The *cassone* was to stand beneath a broad bronze altar table, on which were to rest three life-size, freestanding statues – the *Virgin* holding the *Christ Child* in the center, flanked by *St. Peter* on the right and *St. John the Baptist* on the left. In his reconstruction, Jestaz plausibly shows four square fluted piers supporting a vault in whose lunette is a relief with *God the Father* and *Angels*, which Zen specified as standing above the statues. The sarcophagus, figures, and ciborium were to be made of gilded bronze. Finally, the cardinal charged that "it be as classical as possible."[14] For the construction of his tomb and altar, Zen bequeathed 5,000 ducats. In addition, he destined another 1,600 ducats for liturgical vessels, candelabra, and a cross. A lamp was to burn night and day before the statue of the *Madonna*.

The Tomb of Cardinal Zen, as eventually built, consists of a bronze, freestanding tomb chest surmounted by a bier, cushions, and the *Effigy of the Cardinal*, vested in pluvial, rochet, and mitre. Along each of the long sides of the tomb chest are a pair of decorative panels in low relief. They are framed by six draped or semi-draped freestanding female figures. At the head of the sarcophagus is the inscription transcribed above; at the foot, two *putti* support a shield with Zen arms and a cardinal's hat, all modeled in relief.

The documentation concerning the six bronze female figures, which articulate the long sides of the sarcophagus, is incomplete and to some extent con-

tradictory. Nevertheless, the following history can be deduced. In the first contract made with Alessandro Leopardi and Antonio Lombardo on January 19, 1504, the *Procuratori de citra* specified that the tomb be made of bronze in the form of ser Orsato Giustiniani's tomb in S. Andrea della Certosa. The Zen Tomb was to be embellished by figures similar in pose and form to the figures of the Giustiniani Tomb. But where the Giustiniani figures were detachable, the Zen figures were to be fixed to the sarcophagus. And where the Giustiniani figures did not function as caryatids, the Zen figures were to appear to support the cover of the sarcophagus with their heads. In the second contract of May 23, 1505, in which Leopardi was replaced by Zanin Alberghetto and Pietro dalle Campane, mention again was made of the six figures, which were to surround the Zen sarcophagus like those in the Giustiniani Tomb. On May 2, 1506, the procurators contracted with Antonio Lombardo specifically for one of these figures, called here for the first and last time by the name of a Virtue – *Temperance*. Antonio's fee of 13 ducats was to include casting as well as modeling, but the procurators would supply the necessary copper. Apparently this figure was not finished – indeed, by June Antonio was settled in Ferrara[15] – for on July 31, 1506, the procurators made another contract for all six figures with the woodcarver Paolo Savin and Giambattista Bregno, called "Joannes Baptista, lapicida in Sancto Joanne Novo." The two men were to be held jointly responsible for the six figures; clay and wax were to be supplied at their own expense. Savin and Giambattista were promised at least 80 ducats (13⅓ ducats per figure), but if the procurators were particularly well pleased, they might add as much as 20 ducats to the sculptors' fee. Two payments to Giambattista of 15 ducats each were registered on October 30, 1506, and April 13, 1507. On April 30, 1507, Savin received 15 ducats for "the figures which he is making for the tomb," and on October 12, 1507, he was paid another 25 ducats, for a sum of 40 ducats, or half the total price. Two days after Savin's last payment, on October 14, 1507, a contract was drawn up with Pietro dalle Campane for the casting of four wax figures for the tomb made by "master Paolo carver and others." The contract informs us that casting had previously been entrusted to Zanin Alberghetto, who had begun work on the four figures.[16] But Zanin had left Venice, abandoning the work in its initial stages. For his efforts Pietro was to receive at least 30 ducats, along with the metal needed for casting; work was

to be finished by the end of the coming December. On March 28, 1508, when Pietro was paid for the casting of the four figures, however, work was still in progress. Casting apparently was finished by May 26, 1508. The two figures missing in October 1507, when the contract for casting had been made, evidently were complete by March 28, 1508, when Giambattista received his final payment of 10 ducats, for a total equivalent to Savin's of 40 ducats. Giambattista's payment, however, was made explicitly, not for three figures, but for four. The last two figures of the tomb were cast between May 26, 1508 and September 24, 1510.[17]

While the documents shed light on the figures of the tomb by demonstrating the equal responsibility of Paolo Savin and Giambattista Bregno and by fixing termini for the modeling of the figures between July 31, 1506, and March 28, 1508, the figures, in turn, shed light on the documents. It has long been recognized that the three figures on the east face of the Zen sarcophagus are uniform in style and motif; stylistically related to the *Effigy of Cardinal Zen, St. Peter*, and the altar's antependium – works documented as Savin's – they can be indentified with that half of the group of six, for which Savin was paid. By contrast, the three figures on the opposite face are different in style, not only from Savin's figures, but from each other. The central figure alone bears features attributable to Giambattista Bregno. The figure at the right-hand corner of the sarcophagus evidently was modeled by Lorenzo, while the figure at the left-hand corner seems to belong to an anonymous member of Giambattista's shop.

Which of the six figures are the four that were waiting to be cast before the contract with Pietro dalle Campane was signed on October 14, 1507? There are four – namely, Savin's three and the one by Giambattista Bregno – which form a set because they, unlike the other two, are dressed identically in chitons and himations; we may assume hypothetically that these four, therefore, are the ones that were cast first. Giambattista's final payment, in which a fee initially stipulated for three figures, was made to cover four, poses another problem. I suspect that the extra figure was Antonio Lombardo's *Temperance*, which apparently Giambattista finished and set in the center of the sarcophagus. If so, one of the figures modeled *ex novo* in Bregno's shop eventually was discarded.

The document of January 19, 1504, which fixed the form and dimensions of the cardinal's sepulchre, prescribed that the six figures resemble those of the Tomb of Orsato Giustiniani (d. 1464). The Giustiniani Tomb attributed to Niccolò di Giovanni Fiorentino was erected between ca. 1462 and ca. 1466 in the Church of SS. Eufemia, Dorothy, Tecla, and Erasma in the minor cloister of the Venetian Church of S. Andrea della Certosa. The tomb was apparently destroyed at the beginning of the 19th century: only five of its six statuettes survive.[18] Fortunately, the tomb's appearance is preserved in a drawing by Johannes Grevembroch.[19] It proves the Giustiniani Tomb to have influenced the Tomb of Cardinal Zen in more than just the employment of female figures: in fact, the Zen and Giustiniani Tombs are unique in Venetian funerary sculpture in consisting of freestanding sarcophagi set on the ground, in the manner of northern European tombs. Both stood at the center of a richly ornamented funerary chapel. In both, on either side of the parallelipiped sarcophagus, three freestanding female figures on circular bases framed two rectangular decorative panels in relief.[20] Above the sarcophagus, the three-dimensional effigy rested on a low bier with two cushions at the head, one at the feet. However, in contrast to the *Virtues* of the Giustiniani Tomb, only one of the figures of the Zen Tomb bears an identifiable attribute – four bear none at all – and therefore the Zen figures cannot be construed as Virtues. (The single exception is a figure holding what appears to be a mirror – an attribute of Prudence.[21]) Indeed, with the exception of Antonio Lombardo's abortive *Temperance*, the documents never call the Zen statuettes anything but "figure" or "figurete." Nevertheless, in a quest for specificity, evidently alien to the mentality of Venetian patrons of the Renaissance, writers on the tomb since Stringa have preferred to name them Faith, Hope, Charity, Prudence, Mercy, and Munificence – those virtues, it was supposed, preeminently possessed by Cardinal Zen.[22]

Until 1778, when Temanza reported on the documents he had found in the archive of the Procurators of St. Mark with the names of Antonio Lombardo, Alessandro Leopardi, Giovanni (or Zanin) Alberghetto and Pietro dalle Campane, no attempt was made to attribute the sculpture of the Cappella Zen. Temanza compounded the problems of attribution by assigning to Pietro Lombardo a decisive role in the design and execution of the chapel's sculpture on the basis of a document that shows Pietro acting as Antonio's procurator, after the latter's departure for Ferrara. On the other hand, Temanza introduced Paolo Savin, as responsible in some measure for the tomb chest and its figures, to the literature.[23] Te-

za's account was adopted, if sometimes abridged, by Moschini, Cicognara, E. Paoletti, Selvatico, Zanotto, Mothes, Perkins, and others.[24] Selvatico, however, was skeptical of Pietro Lombardo's actual participation in the manufacture of the sculpture and found that, in their pagan attitudes and dress, the six female figures of the tomb seemed a good deal later than the epoch of the Lombardi. Burckhardt, Mothes, and Lübke proposed the authorship of Leopardi for the figures.[25] Much previous speculation was invalidated by Cecchetti's publication of the documents in 1886 – partial and faulty though it was,[26] and by Paoletti's exposition of Pietro Lombardo's legal role in 1893.[27] Thenceforth, Savin's exclusive authorship of the female figures of the sarcophagus was generally acknowledged;[28] curiously, no notice was ever taken of the phrase "figure quatro de bronzo fate per maistro paulo jntaiador ed altri" in the contract for their casting.[29] On other grounds, Venturi distinguished between the figures on either side of the sarcophagus: those on the east he ascribed to Paolo Savin, but those on the west, which he thought much superior, he tentatively gave to Leopardi.[30] Hubala could not reconcile the six figures with his notion of early 16th century style and suggested that they were made, or at least reworked, on the occasion of the restoration of the chapel in 1604.[31] Ruhmer singled out the very figures I attribute to the Bregno, commending Giambattista's as the most beautiful of all. Where the other four had been modeled by Savin in 1507, these two, he thought, were executed by an anonymous sculptor considerably later – perhaps only toward 1519. Probably all had made use of models by Antonio Lombardo, but only in our two figures was Antonio's influence still discernible to him.[32]

In 1986, Jestaz dedicated a monograph to the Cappella Zen. To the document published by Cecchetti, Jestaz added a host of others, including those that most nearly interest us – the contract with Savin and Giambattista Bregno for the six figures of the tomb and the payments to Bregno for half the total sum disbursed for the modeling of the figures. Like Venturi, Jestaz attributed to Paolo Savin the three figures facing the Baptistry. Jestaz perceived that the figures on the other side of the sarcophagus differed not only from Savin's, but also from one another. Although clearly prey to doubt, the critic assigned the figure on the northwest corner of the sarcophagus to Giambattista and the central figure to his assistant. Jestaz thought the claims of Paolo Savin, working in Giambattista's style, to the authorship of the southwest figure marginally stronger than those of a second anonymous assistant in the Bregno shop, but hesitated to declare himself for either one.[33]

In his attribution of the figure at the northwest corner of the sarcophagus (Pls. 69–72) to Giambattista Bregno, Jestaz pointed to analogies with the large *Angels* of the Holy Sacrament Chapel (Pls. 59, 61). Undeniably, the configuration of folds about the legs, particularly in the left-hand Sacrament Chapel *Angel*, is very similar to that of the Zen sarcophagus figure (Pls. 61,70): in both it is the fluttering of folds, where the sheer and clinging drapery clears the legs, that produces the effect of supple movement. But in respect of pose, proportions, facial type, and, above all, the linear design created by the play of folds, the figures are very different. To be sure, this does not invalidate Jestaz's attribution, since the *Angels* are probably not by Giambattista: where the inferior quality of the *Angels* proves them products of the shop, the quality of the Zen figure is not unworthy of the master. But there is nothing comparable in Giambattista's documented oeuvre. I conclude, therefore, that the figure at the northwest corner belongs to a very creditable assistant, by whom I know no other work.

[1] Jestaz, 1986, p. 215, doc. 118.

[2] Ibid., p. 157, n. 50.

[3] ASV, Misc. Cod. I, Stor. ven. 23, Barbaro, vii, c. 373, voce "Zen, R."

[4] Steinmann, i, 1901, p. 42.

[5] For Zen's biography, see Chacón, 1677, ii, coll. 1112–1113, no, IX; Quirini, 1750, pp. 34–6, no. VIII; Barbarano de' Mironi, iv, 1760, pp. 68–71; Riccardi, 1786, pp. 180–4; Castellini, xii, 1821, pp. 230, 232, 237, 272; Gams, 1873, pp. xx, 807; Soranzo, *Riv. di storia della chiesa in Italia*, 1962, pp. 249–74.

[6] Sanuto, *Diarii*, iv, 1880, col. 34, May 8, 1501.

[7] Ibid., col. 50, June 16, 1501.

[8] *Oratio magnifici d. Angeli Gabrielis*, [1501], repr. in Valerio, 1719, pp. 226–33.

[9] Sanuto, *Diarii*, iv, 1880, col. 50, June 16, 1501; col. 53, June 23, 1501; coll. 63–5, n.d.

[10] Ibid., xxv, 1889, col. 202, Jan. 16, 1518; col. 417, May 18, 1518; ibid., xxx, 1891, col. 276, May 28, 1521.

[11] For the cardinal's testament and codicils, see Jestaz, 1986, pp. 14–27, 175–9, docs. 1–6. Sanuto, *Diarii*, xxx, 1891, coll. 272–6, May 27, 1521, summarized those dispositions pertaining to the cardinal's tomb and chapel, as well as to the celebration of the anniversary of his death. Barozzi, in Ongania, pub., vi, 1888, pt. 3, [1893], pp. 417f, and Paoletti, 1893, ii, p. 245, n. 1, transcribed only those provisions relating to the cardinal's tomb and chapel.

[12] Jestaz, 1986, p. 29.

[13] Ibid., pp. 29f, 184f, docs. 12, 13, 16, 17, p. 200, doc. 62.

[14] For the cardinal's intentions regarding his tomb and altar, see ibid., pp. 22–7.

[15] Sartori/Fillarini, 1976, p. 139.

[16] The documents say "inzirade da una banda," which Jestaz, 1986, p. 73, n. 9, interprets as "set in wax on one side."

[17] Ibid., pp. 188–211, docs. 19, 24, 41, 45, 46, 49, 50, 53–8, 60, 65, 66, 69, 105 and Appendix A, Doc. VIII, A, B.

[18] For the Giustiniani Tomb, see Schulz, 1983, pp. 186–8, no. 23.

[19] Venice, Mus. Correr, MS Gradenigo 228/I, Grevembroch, i, 1754, c. 92.

[20] Jestaz, 1986, p. 156, observed that, in contrast to the Giustiniani figures, corner figures of the Zen Tomb are not set on a diagonal, but rather are aligned with the lateral faces of the sacrophagus.

[21] Zanotto, in Diedo/Zanotto, [1839], n.p.

[22] Stringa, 1610, pp. 17vf.

[23] Temanza, 1778, pp. 88f, 114.

[24] Moschini, 1815, i, pt. 1, pp. 347–9; Cicognara, ii, 1816, pp. 162, 164; Zanotto, in Diedo/Zanotto, [1839], n.p.; E. Paoletti, ii, 1839, pp. 44f; Selvatico, 1847, pp. 190f; Selvatico/Lazari, 1852, p. 34; Cappelletti, iii, 1853, pp. 332f; Zanotto, 1856, pp. 86f; Mothes, ii, 1860, pp. 109f; Perkins, 1868, pp. 197f; Fulin/Molmenti, 1881, pp. 93f.

[25] Burckhardt, 1855, p. 625b; Mothes, ii, 1860, pp. 109f; Lübke, 1863, p. 509.

[26] Cecchetti, in Ongania, pub., vii, 1886, pp. 17–26, docs. 122–53.

[27] Paoletti, 1893, ii, pp. 244f.

[28] Saccardo, in Ongania, pub., vi, 1888, pt. 3, [1893], p. 275; Barozzi, in ibid., p. 419; Paoletti, 1893, ii, p. 246; Burckhardt/Bode,⁶1893, ii, pt. 2, p. 429; Bouchaud, 1913, p. 184; Berti, [1916], pl. 19; Planiscig, 1921, pp. 220, 222, 286, 290f; Bode, Kunstwanderer, 1922, p. 426; Lorenzetti, 1926, p. 212; Planiscig, 1927, p. 416; idem, Dedalo, Jan.–June 1932, p. 52; "Savin," T-B, xxix, 1935, p. 509; Musolino, 1955, p. 89; Pope-Hennessy, 1958, p. 357; Caccin, 1962, pp. 114f; Pope-Hennessy, BM, 1963, p. 22, repr. in idem, 1968, p. 181.

[29] Cecchetti, in Ongania, pub., vii, 1886, p. 22, doc. 141.

[30] Venturi, x, pt. 1, 1935, pp. 406f. Munman, 1968, p. 350, also observed a difference in the quality of design between figures on the east and west flanks of the sarcophagus. He, too, preferred the figures on the west.

[31] Hubala, in Egg et al., 1965, p. 726. Cf. Jestaz, 1986, p. 148.

[32] Ruhmer, Arte ven., 1974, p. 60.

[33] Jestaz, 1986, pp. 143–55, 160.

## 26. VENICE, S. MARIA DEI FRARI: FRAME OF THE HIGH ALTAR WITH THE *RESURRECTED CHRIST*, *ST. FRANCIS*, AND *ST. ANTHONY*

### GIAMBATTISTA AND LORENZO BREGNO AND SHOP

Pls. 98–106, 195–205

The High Altar of S. Maria dei Frari is located at the rear of the choir. Statues stand above the cornice of the frame at the top of the altar – the *Resurrected Christ* in the center, *St. Francis* on the spectator's left, *St. Anthony* on his right. The frame encloses Titian's *Assumption of the Virgin*. Each of the two spandrels contains a frescoed *Victory*. In the center, below the painting, the innermost frame is interrupted, and the painting partially overlapped, by a relief of *Christ as Man of Sorrows Adored by Angels*.

Each statue, together with its respective base, as well as the relief, are carved from integral blocks of white marble. *Christ's* halo is metal. The banner he holds in his left hand has a wooden staff and a metal flag and finial. *St. Francis's* cross and *St. Anthony's* lily are also metal. The framework of the altar is made of limestone. The lowest plinths at either side are incrusted with verd antique (in the triangles) and porphyry (in the roundels).

*Resurrected Christ*: 195 cm high (including its 10.3-cm-high base); *St. Francis*: 193 cm high (including its 4.1-cm-high base); *St. Anthony*: 198 cm high (including its 9.5-cm-high base); *Christ as Man of Sorrows*: 46.5 cm high × 40 cm wide × 20.6 cm deep (with frame); 28.8 cm high × 31.3 cm wide (without frame); Titian's *Assumption of the Virgin*: 668 cm high × 344 cm wide; frame to the cornice: 1250 cm × 725 cm.[1]

In the *Resurrected Christ* there are traces of gilding in the hair. Pupils are black. Remains of flesh-colored paint are visible between the first two toes of the figure's right foot. The blood from wounds in hands, feet, and chest is red. The upper and lower borders of the shroud are gilded. The metal flag, finial, and halo are gilded; the staff of the banner is painted red.

Numerous traces of flesh color remain on *St. Francis's* skull and right ear. Blood issuing from wounds in the chest and the right hand is red. The pupils of the eyes are black. Traces of the preparatory red bole, as well as gilding, are visible in the knots of the *Saint's* belt. The figure's hair also was once gilded.

There are traces of flesh color on *St. Anthony's* skull and left index finger. Pupils were black. Traces of red bole in the hair indicate that it was once gilded. The cover and clasps of the book, the cord belt, and the metal lily also were gilded.

In *Christ as Man of Sorrows* the following elements

were gilded: Christ's hair, crown of thorns, and loin
cloth; the Angels' hair, wings and chitons; ceiling
beams and jambs of lateral openings; fillets and mold-
ings of the frame. The coffers of the ceiling are
brown.

The following elements of the frame were gilded:
carved relief in the base, capitals, and plinths beneath
the columns; the heads of cherubim, bucrania, and
festoons in the frieze; the tendril of the inner frame;
the carved moldings of cornice and architrave; fillets
in the moldings of lesenes and base and between the
channels of the fluted columns.

A crack in *Christ's* left wrist penetrates the entire depth
of the stone. The crack has been repaired with mortar
painted gray to match the stone. Large portions of
the statue's shroud are covered with graffiti. At the
rear, the statue is only roughhewn.

The surface of *St. Francis* is slightly scarred and
pitted; this is probably due to its imperfect state of
finish rather than to damage to the finished work.
The contour of the figure's right ear is chipped. The
rear half of the figure is only roughhewn. The skull
is finished in back, but the belt, cowl, and tonsure
are only blocked out. At their rear, the ears have not
been excavated.

Like *St. Francis*, the surface of *St. Anthony* is scarred
and pitted. The bottom corner of the front cover of
the *Saint's* book is badly chipped; a small chip is
missing from the upper front corner as well. The rear
half of the statue is roughhewn, except at the bottom
of the figure, where the form has not been blocked
out. The figure's tonsure, belt, and cowl have been
blocked out, but the ears have not been excavated
behind.

The relief of *Christ as Man of Sorrows* is perfectly
preserved, but its frame is chipped in a few places.
A large chip is missing from the front left corner of
the upper, horizontal surface of the frame. On that
surface are remnants of the irregular base of an object
– probably a Crucifix with its ground – that once
stood on the relief. The relief is wedged into the
inner border of the altarpiece with pieces of wood
and at either side the relief's frame is truncated. From
this I deduce that the relief was not originally in-
tended for this place; nor was the altarpiece originally
intended to contain it.

Inscribed in the pedestal of the left column: AS-
SVMPTAE IN/ COELVM VIRGI/ NI AETERNI O/ PI-
FICIS MATRI · Inscribed in the pedestal of the right
column: FRATER · GER/ MANVS · HANC · A/ RAM ·
ERIGI · CV/ RAVIT · M · D · XVI ·

Bibl.: Sanuto, *Diarii*, xxv, 1889, col. 418, May 20, 1518; Moschini,
1815, ii, pt. 1, p. 183; Soravia, ii, 1823, pp. 89f; E. Paoletti, iii, 1840,
p. 91; Selvatico/Lazari, 1852, p. 179; Zanotto, 1856, p. 465; Fulin/
Molmenti, 1881, p. 291; Paoletti, 1893, p. 270, n. 1; idem, T-B, iv,
1910, p. 570, voce "Bregno, L."; Lorenzetti, 1926, p. 554; Fogolari,
1931, p. opp. pl. 8; Sartori, 1949, p. 90; Hubala, in Egg et al., 1965,
pp. 821, 822; Meyer zur Capellen, *MJ*, 1971, pp. 125f; Rosand, *AB*;
1971, p. 200, repr. in idem, 1982, pp. 55–8; Mariacher, *DBI*, xiv,
1972, p. 114, voce "Bregno, L."; Meller, in *Tiziano*, 1977, p. 140; *Venice
restored* [1978?], p. 69; Marini, 1979, p. 28; Gilbert, *AB*, 1980, p. 53,
n. 74; Steer, 1982, p. 165, cat. no. 36; Goffen, 1986, pp. 82–91, 112;
Humfrey, *Saggi e memorie*, 1986, pp. 71, 74; Sartori/Luisetto, 1986, pt.
2, p. 1977, no. 129.

The inscription on the right pedestal of the frame
of the Frari's High Altar names as patron Frater Ger-
manus. Fra Germano came from Casale, but whether
Casale sul Sile in the province of Treviso, or Casale
di Scodosia in the province of Padua, or some other
Casale, we do not know. Fra Germano was a Fran-
ciscan Conventual and doctor of theology.[2] In 1475
he was mentioned as living at S. Giacomo del Paludo
in the Venetian lagoon, a dependency from 1470 of
the Convent of S. Maria dei Frari; later he was
procurator of the Convent of S. Giacomo.[3] In 1480,
Fra Germano founded the Franciscan Conventual
Church of S. Rocco at Mestre;[4] his name recurs as
superior of the convent on several occasions.[5] In this
capacity he may have commissioned from Cima da
Conegliano the *Triptych of St. Catherine of Alexandria*,
now divided between the Wallace Collection, Lon-
don, and the Musée des Beaux-Arts, Strasbourg, but
formerly on the church's High Altar.[6] On July 10,
1497, Fra Germano was temporarily appointed to
fulfill the duties of Magister Gabriel Bruno as In-
quisitor of heretical practices at Mestre, while the
latter was making a visitation of the Holy Land,
whose Minister he was.[7] Fra Germano is mentioned
as *Guardiano* of S. Maria dei Frari in documents of
June and July 1516, February and March 1517, Jan-
uary 1518, October 1519, and February 1521,[8] while
Sanuto calls him *Guardian* twice in 1518.[9] Between
February 1512 and February 1521, at least, Fra Ger-
mano was also Minister of the province of Cyprus
and the Holy Land.[10] On February 9, 1517, Fra Ger-
mano was deputed to represent the Frari in a dispute
with S. Stefano over a legacy of Andrea Zane's.[11] On
November 8, 1520, Sanuto recorded how Fra Ger-
mano, confessor to ser Alvise Pisani, acted as inter-
mediary in the restitution to Pisani of 1,900 ducats
in cash and gold stolen from the latter's bank.[12] The
Alvise Pisani mentioned here has been encountered
already on two occasions as Lorenzo Bregno's patron

– in relation to the Tomb of Benedetto Crivelli at Creola and the Altar of the Cross in S. Marco. On February 21, 1521, Fra Germano was elected *Guardiano* of S. Nicoletto dei Frari by the *Procuratori di S. Marco de citra*, succeeding Fra Urbano Bolzano da Belluno, who had resigned on account of age and debility; Fra Germano was installed in office on April 11th.[13] He retained the post of *Guardiano* until his death.[14] The High Altar of S. Nicoletto with Titian's altarpiece of the *Madonna and Child in Glory with Six Saints*, now in the Pinacoteca Vaticana, was once inscribed: "Almae Virgini Mariae, Redemptoris Matri, Hanc Aram Frater Germanus Divi Nicolai Guardianus dicavit M. D. XXII."[15] On May 4, 1525, at the chapter held at Treviso, Fra Germano was named Minister for the province of S. Antonio;[16] he was succeeded by Fra Gianfranco Marini in October 1528.[17] Germano died on December 1, 1533;[18] at his death he was once again *Custode* of S. Rocco di Mestre, as well as *Guardiano* of S. Nicoletto.[19]

From these data, we may infer that Fra Germano was the leading member of the Franciscan Conventuals in Venice, at least from 1516 until his death. When the Abbess of S. Chiara lamented to the *Collegio* that her nuns had not received their provisions and were starving, Fra Germano was present,[20] and when the Minister General of the Franciscans came to Venice to pay homage to the doge, the head of the order was accompanied by "maistro Zerman et altri di primi di la religion."[21] Theologian and Inquisitor, Fra Germano must have been more than commonly learned. His interference in the painting of the *Assunta*, recounted by Ridolfi,[22] suggests that he took a keen interest in art, and his commission of a second altarpiece from Titian shortly after the completion of the first, gives the lie to Ridolfi's report of the dissatisfaction with which the Franciscan friars, in general, and Fra Germano, in particular, greeted the *Assunta*.

As patron of the work, Fra Germano's contribution cannot have been financial, for Franciscans did not possess private property. But a convent and its prior naturally had discretionary use of unrestricted bequests. These can be documented as having been used to fund high altarpieces in other Franciscan churches and undoubtedly did so in this case too.[23]

The High Altar of the Frari was consecrated on February 13, 1469.[24] The frame is dated by inscription to 1516. This could refer to the commencement of the altarpiece, the completion of its framework, or some intermediate period. Sanuto reported that Titian's *Assumption of the Virgin* was installed on May 19, 1518; Sanuto added that the framework was made before the picture.[25] This does not necessarily mean that the framework was entirely finished before the painting was thought of.[26] On the contrary, the fact that the High Altar of the Frari was the first ever to encompass a painting on so colossal a scale suggests that the painter's ideas fundamentally influenced the conception of the frame.[27]

Modern scholars generally attribute the frame's execution together with its statuary, to Lorenzo Bregno, with or without assistance.[28] Although I hope to demonstrate that this is partially correct, the attribution rested on no more than an assertion of Paoletti's – not supported by documents, stylistic analysis, or even photographs.[29] That Paoletti's attribution was so readily accepted is a measure of the prevailing lack of interest in the frame.

Above the frame, the *Resurrected Christ* is flanked by SS. *Francis* and *Anthony*. While a theological text, in which St. Anthony commented on Christ's glorification of the Virgin, has been adduced as justification for the inclusion of the saint,[30] it suffices for our purpose to note that in the Veneto St. Anthony was the second saint of the Franciscan Order and the *exemplum virtutis* of its Conventual faction.[31] The Resurrection of Christ is thematically related, in the most obvious way, to the Assumption of the Virgin. The death of Christ, represented by the relief of the *Man of Sorrows* at the bottom of the altarpiece, is the precondition of Christ's resurrection at the top; the dead Christ in his tomb was symbolized by the sacrifice of the Eucharist offered daily at the altar.[32] On the pedestals of the frame is the Franciscan *stemma*, the crossed arms of Christ and St. Francis showing stigmatized palms.[33]

---

[1] Sartori/Luisetto, 1986, pt. 2, p. 1977, no. 129.

[2] ASV, Conventi religiosi soppressi, S. Maria dei Frari, Busta 106, filza XXXIII–5.q.

[3] Sartori/Luisetto, 1986, pt. 2, pp. 2077f, nos. 27, 36, 37; ASV, Deputazione ad pias causas, Busta 58, filza "Minori Conventuali di S. Antonio," no. 1, c. 4v; Sartori, 1958, pp. 298f.

[4] ASV, Conventi religiosi soppressi, S. Maria dei Frari, Busta 91, filza III, 56. On November 18, 1480, at the request of Fra Francesco Albizoto, Doge Giovanni Mocenigo accorded the Franciscan Conventuals the privilege of erecting a place for the increase of the divine cult under the title of S. Rocco and a place for their habitation in a vacant site in the city of Mestre. (Wadding, xiv, ³1933, p. 287;

P. Ridolfi, 1586, p. 272.) The head of the convent of S. Rocco di Mestre, with the title of *Custode*, was chosen by the council of priests of the Frari, generally from among their number. (ASV, Deputazione ad pias causas, Busta 58, filza "Minori Conventuali di S. Antonio," no. 1, c. 4r.)

[5] ASV, Conventi religiosi soppressi, S. Maria dei Frari, Busta 91, filza III, 56; Sartori/Luisetto, 1986, pt. 1, pp. 940f, nos. 3, 9; ibid., pt. 2, p. 2078, no. 36.

[6] Sartori, *Il Santo*, 1962, pp. 281–4; Humfrey, 1983, pp. 115f, no. 73, p. 145, no. 133; Sartori/Luisetto, 1986, pt. 1, p. 952, nos. 12, 15–17.

[7] Sartori/Luisetto, 1988, pt. 1, p. 429, no. 89.

[8] ASV, Conventi religiosi soppressi, S. Maria dei Frari, Busta 106, filza XXXIII–5.q; ASV, Conventi religiosi soppressi, Busta 5, *Cathastico incomincia 1502. 28 luglio*, c.5r; ASV, Conventi religiosi soppressi, S. Maria dei Frari, Busta 96, xi, no. 3; Sartori/ Luisetto, 1986, pt. 2, p. 1805, no. 34, p. 1865, no. 23, p. 1893, no. 61, p. 1928, nos. 32, 33, p. 2030, no. 21; Sartori/ Luisetto, 1988, pt. 1, p. 429, no. 89.

[9] Sanuto, *Diarii*, xxv, 1889, col. 418, May 20, 1518, for which see below, n. 25; ibid., xxvi, 1889, col. 102, Oct. 3, 1518.

[10] Sartori, *Il Santo*, 1962, p. 283; Sartori/Luisetto, 1986, pt. 2, p. 2030, no. 21, p. 2078, no. 37; Sartori/Luisetto, 1988, pt. 1, p. 429, no. 89; ASV, Conventi religiosi soppressi, S. Maria dei Frari, Busta 106, filza XXXIII–5.q; ASV, Conventi religiosi soppressi, S. Maria dei Frari, Busta 5, c.5r; ASV, Conventi religiosi soppressi, S. Maria dei Frari, Busta 96, xi, no. 3.

[11] Sartori/Luisetto, 1988, pt. 1, p. 429, no. 89.

[12] Sanuto, *Diarii*, xxix, 1890, col. 381.

[13] ASV, Conventi religiosi soppressi, S. Maria dei Frari, Busta 96, xi, no. 3; Sartori/Luisetto, 1986, pt. 2, p. 2030, no. 21; Sartori/Luisetto, 1988, pt. 1, p. 429, no. 89.

[14] Ibid., p. 675, no. 236.

[15] Vio, *Arte ven.*, 1980, p. 210; Sartori/Luisetto, 1986, pt. 2, p. 2016, no. 69.

[16] Sanuto, *Diarii*, xxxviii, 1893, col. 348, May 26, 1525; Sartori/ Luisetto, 1988, pt. 1, p. 429, no. 89.

[17] Sartori, 1958, pp. 331f; Sartori/Luisetto, 1988, pt. 1, p. 430,

[18] Sartori, 1958, p. 331.

[19] ASV, Conventi religiosi soppressi, S. Maria dei Frari, Busta 113, no. XXXVII (parchment); Sartori/Luisetto, 1986, pt. 1, p. 941, no. 9; ibid., pt. 2, p. 2030, no. 23; Sartori/Luisetto, 1988, pt. 1, p. 430, no. 89.

[20] Sanuto, *Diarii*, xxxi, 1891, col. 162, Aug. 2, 1521.

[21] Ibid., xl, 1894, coll. 164f, Oct. 31, 1525.

[22] Ridolfi/von Hadeln, i, (1648) 1914, p. 163.

[23] Goffen, 1986, pp. 84–86.

[24] Sartori, 1949, p. 90.

[25] Sanuto, *Diarii*, xxv, 1889, col. 418: "A di 20 . . . Et eri fu messo la palla granda di l'altar di Santa Maria di Frati Menori suso, depenta per Ticiano, et prima li fu fato atorno una opera grande di marmo a spese di maistro Zerman, ch'è guardian adesso."

[26] Cf. Gilbert, *AB*, 1980, p. 53, n. 74.

[27] Hubala, in Egg et al., 1965, p. 822; Rosand, *AB*, 1971, p. 200, repr. in idem, 1982, pp. 57f; *Venice restored*, [1978?], p. 69; Goffen, 1986, p. 214, n. 69; Humfrey, *Saggi e memorie*, 1986, pp. 71, 74.

[28] Sartori, 1949, p. 90; Meyer zur Capellen, *MJ*, 1971, p. 130, n. 33; Rosand, *AB*, 1971, p. 200, repr. in idem, 1982, pp. 57f; Mariacher, *DBI*, xiv, 1972, p. 114, voce "Bregno, L."; Meller in *Tiziano*, 1977, p. 140; Marini, 1979, p. 28.

[29] Paoletti, T-B, iv, 1910, p. 570, voce "Bregno, L." The frame had previously been ascribed to an "ignoto": Selvatico/Lazari, 1852, p. 179; Fulin/ Molmenti, 1881, p. 291.

[30] Meyer zur Capellen, *MJ*, 1971, pp. 125f, viewed the presence of *St. Anthony* as an oblique reference to his commentary on Isaiah 60:13, according to which, having received his human form from the Virgin Mary, Christ glorified her by raising her corporeally above the choirs of angels to a place at his feet. Correspondingly, in the High Altar of the Frari, the Virgin of Titian's panel, elevated corporeally by a host of angels, appears at the feet of the sculptured *Risen Christ*.

[31] Goffen, 1986, pp. 90f.

[32] Ibid., pp. 86f.

[33] Bracaloni, *Studi francescani*, 1921, pp. 221–6.

## 27. VENICE, S. MARIA DEI FRARI: FRAME AND TWO REGGISCUDO OF THE PESARO ALTER
### GIAMBATTISTA AND LORENZO BREGNO AND AN ANONYMOUS SCULPTOR

Pls. 117–123, 244, Figs. 41–45

The Pesaro Altar is affixed to the wall of the fourth bay of the Frari's left aisle (*in cornu Evangelii*). The frame encloses Titian's *Madonna and Child Enthroned, with Saints and Members of the Pesaro Family*. Giambattista's *Reggiscudo* occupies the right slope of the pediment; the *Reggiscudo* on the left is by an anonymous sculptor.

Figures, together with their bases, escutcheons, and bishop's mitres, are carved from single blocks of white marble.

The shafts of columns, pilasters, and lesenes, the friezes of both entablatures, and the background of the pediment are made of highly veined and spotted reddish marble. The bases and capitals of the columns are white marble. The remaining architectural members are limestone. Roundels in the spandrels of the arch and in the shafts of the pilasters behind the free-standing columns are incrusted with porphyry. Roundels in the lesenes and triangles in the spandrels of the arch are incrusted with verd antique. In the base, discs are porphyry; triangles are verd antique. The fields on either side of the discs are incrusted with

reddish-violet breccia. White-speckled purple marble was used for the central square of the base, the front faces of the bases of terminal pilasters, and the receding faces of the bases of the columns.

Left *Reggiscudo*: 92 cm high (including its 4.3-cm-high base); right *Reggiscudo*: 92 cm high (including its 5.6-cm-high base); Titian's *Madonna and Child Enthroned*: 478 cm high × 266.5 cm wide.

In the left *Reggiscudo* traces of gilding are preserved in the hair. Gilding provided the neckline of the dress with a broad border; the pattern of gilding, however, did not take account of pleats. The bow at the center of the neckline also was gilded. Traces of red bole preparation indicate former gilding in what would have been the cuff of the rolled-up left sleeve. There is gilding on the uppermost molding of the base. The border and rear of the shield show remnants of gilding; the recessed rays on the face of the shield were painted blue or black. The raised ornament of the mitre was gilded; the stippled ground on its front face was polychromed – whether blue or black, I cannot tell. On the inside of the mitre are traces of red.

In the right *Reggiscudo* the cuff of the long right sleeve was gilded, but the neckline of the chiton was not. In all other respects the pattern of gilding and polychromy in this figure was identical to that of its mate.

In the right hand of the left *Reggiscudo*, the last finger is almost entirely missing and the tip of the fourth finger is nicked. Most of the last two joints of the third finger of the figure's left hand are lost. The crook of the *Reggiscudo*'s left elbow is nicked. The upper surface of the two central folds of the skirt are chipped. The drapery above the figure's extended foot is badly chipped and the stone is corroded. The tip of the extended left foot is chipped. The nadir of the shield has broken off; the forward volute is missing. There are numerous chips in the vertical face of the figure's base. Toward the center of the base, a metal rod has been driven through a hole in order to fix the statuette to the pedestal provided by the roof of the altar's pediment. A hole at the rear of the figure permits the insertion of a metal clamp through which the rod attaching figure to wall is hooked. At the rear, a portion of the *Reggiscudo* was not finished; there the skirt is not even roughhewn.

The tip of the right *Reggiscudo*'s nose is corroded and there are nicks in the left cheek and beneath the left jaw. The edge of the figure's short right sleeve is missing a chip. In the figure's right hand, nearly all of the fifth finger is lost, while the end of the fourth finger is slightly chipped. The tip of the third finger of the *Reggiscudo*'s left hand has broken off. The tips of both big toes are lost. Midway between the two feet, the hem of the dress is chipped. At the rear of the figure, a little above the level of the knees, vertical folds are chipped and the stone is fissured. Both points of the mitre have broken off. The lower border of the shield is chipped along its farther edge. The upper surface of the base is chipped in several places, particularly near the figure's right foot. The statue is entirely finished in back.

A large piece of stone is missing from the cornice of the upper entablature above the letters E G. The right corner, and receding portions of the cornice, of the pediment are also damaged. A piece is missing from the ribbon on the left base.

The frieze of the upper entablature is inscribed: GREGORIANO

Bibl.: Soravia, ii, 1823, p. 135; Zanotto, 1856, p. 470; Sartori, 1949, p. 51; Valcanover, *Quaderni della Sopr. Ven.*, 1979, p. 61; Marini, 1979, p. 16; Meyer zur Capellen, *Pantheon*, 1980, p. 150; Goffen, 1986, pp. 112, 120; Sartori/Luisetto, 1989, p. 12, no. 46.

The patron of the Pesaro Altar, Jacopo Pesaro of the "dal Carro" branch of the Pesaro family, was born in 1464.[1] His father Leonardo was a cousin of Benedetto Pesaro. Active as a youth in the family business at Constantinople, Jacopo subsequently entered the Dominican Order and on July 3, 1495, was named Bishop of Paphos in Cyprus.[2] In May 1501 Pesaro was Apostolic Legate. Under a commission from Pope Alexander VI Borgia, on June 28, 1502, Pesaro assumed command of the papal fleet marshalled against the Turks at Santa Maura (Levkas). There papal galleys, reenforced by the Spanish and Venetian armadas – the latter led by Benedetto Pesaro as *Capitano del Mar* – were victorious on August 30, 1502. That Benedetto took credit for the victory engendered in Jacopo animosity that lasted till his death. Ironically, only one year after its conquest, Santa Maura was returned to the Turks by treaty. In 1530 Pesaro was made Keeper of the Clementine Bull at Venice;[3] in that capacity he supervised the election of Venetian parish priests by their parishioners. Though Jacopo aspired to a bishopric on the *terraferma* and was considered for the sees of Vicenza and Cremona, as well

as for the patriarchate of Venice, he remained Bishop of Paphos until his death. Pesaro died on April 24, 1547 and was buried in a tomb affixed to the wall immediately to the right of the Pesaro Altar.

On January 3, 1518, Fra Germano, prior of the Franciscan Convent of S. Maria dei Frari, and its chapter ceded to Jacopo Pesaro and his brothers and descendants in perpetuity the chapel or altar of the Immaculate Conception. The altar was located on or near the site it occupies today in the left aisle of the Frari, between the Cappella di S. Pietro and the lateral portal of the church. There an altar dedicated to the Immaculate Conception had stood since 1361 and members of the newly founded Scuola della Concezione had worshiped since 1498.[4] The chapel or altar was to be constructed and adorned by the Pesaro at their own expense. One tomb in the pavement of the chapel and another in the wall to one side of the altar might also be erected. In exchange for these privileges, Bishop Pesaro was obligated to endow a mansionary with land that would yield between 25 and 30 ducats *per annum* for daily celebration of the Mass and to pay 2 ducats every year for the convent's meal on the feast day of the Immaculate Conception. For their part, the friars undertook to illumine the tomb with two tapers at Mass, Vespers, and Matins.[5] On January 17, 1519, the agreement between the chapter and the Pesaro was repeated and provisions regarding the annual donation of 30 ducats were clarified. On September 7, 1524, the contract was renewed again.[6]

Meanwhile, on April 28, 1519, Jacopo Pesaro commissioned from Titian an altarpiece for his newly acquired "Altar della Concettione a i Frari" and gave the painter a deposit of 10 ducats. Further payments on account of 10 and 15 ducats respectively followed on June 12, 1519, and September 23, 1519. On the latter date Titian also received from Pesaro 6 ducats for the altarpiece's stretcher and canvas. After a hiatus of nearly three years, Titian was paid a further 10 ducats each on April 13, May 5, and September 9, 1522. Not until June 20, 1525, did Titian receive another payment of 15 ducats. On April 30, 1526 Titian received 16 ducats and on May 29, 1526, he acknowledged his final payment for the altarpiece.[7] Undoubtedly the framework was complete and the altarpiece was installed when, on December 8, 1526, Sanuto recorded the celebration of the feast of the Immaculate Conception "ai Frari menori a l'altar hanno fatto i Pexari in chiesia."[8]

From the payments to Titian, we can infer that, by September 23, 1519, when the altarpiece's stretcher and canvas were paid for, at the very least the shape and dimensions of the frame's aperture had been established. The frame's order must have been designed, when, in what appears to have been a very early version of the painting's architectural setting visible in X rays, Titian approximated the frame's combination of columns and pilasters, Corinthian capitals, and entablature.[9] This version of the setting has been linked hypothetically with the campaign of work that resulted in payments to Titian between April and September 1522.[10] When Sanuto attended the celebration of the Immaculate Conception at the Pesaro Altar on December 8, 1526, the frame was in place.[11] It may well have been nearly or entirely finished before the death of its author, Lorenzo Bregno, between December 22, 1523, and January 4, 1524.

We do not know when the *Reggiscudo* were finished and installed. Giambattista, responsible for the right-hand one, is last documented in an account book of the *Arca del Santo* for the year 1517; we do not know precisely when he died. Unfortunately, Sanuto's notice of December 8, 1526, from which we infer the completion and installation of the framework, has no real bearing on the completion and installation of the *Reggiscudo*, for Sanuto can hardly be expected to have observed their absence (if, indeed, they were not there), despite plinths emerging from the upper surface of the altar's pediment.

Although I cannot name the author of the left-hand *Reggiscudo* (Figs. 41–45), I can identify another work by him. It is the relief with SS. James and Andrew and Doge Andrea Gritti (1523–38) kneeling before St. Nicholas of Bari, currently incorporated into the altarpiece in the Cappella di S. Clemente in S. Marco (Fig. 39).[12] The relief comes from the early sixteenth century Cappella di S. Nicolò in the Cortile dei Senatori of the Ducal Palace.[13] Mass was heard in the chapel for the first time on December 5, 1523, when Sanuto noted the frescoes by Titian and the gilded altar and, on the following day, reported that the doge had had the chapel almost completely finished.[14] Andrea Gritti was elected doge on May 20, 1523. The altarpiece, therefore, must have been commissioned, designed, executed, and gilded within a span of hardly more than six months at most. Indeed, the work itself gives signs of hasty execution. This must be borne in mind when comparing the relief with the left-hand *Reggiscudo*, which evidently was

wrought with considerable care. Both works are archaic in the minimal excavation of the block and the lack of differentiation of figure and garment (Figs. 40, 41). Thus, the surface remains uniform and contours are regular and closed. No more of the figures' anatomy is revealed beneath their clothing than the position of the knee and the form of the toes, much generalized, beneath the soft footwear. Despite the difference in identity, the figure type of St. James and the *Reggiscudo* are very similar. Beneath the square neckline, the shoulders run into the chest along a continuous slope that rounds the contour of the shoulders and inclines the surface of the chest; in consequence, the pit of the neck seems much too low. The waist is not indented and the figure gradually expands downward with as little articulation as an upholstered cushion. The only visible effect of the unequal distribution of weight is the slight projection of the free knee and the advance of the free foot. Although much sketchier and possibly unfinished, the hair of St. James shows the same idiosyncratic treatment (Figs. 44, 45, 47) in which separate clusters of short, pointed locks flop forward onto the

forehead, producing a very ragged hairline. In both, drill holes at the first turning of the limp, S-shaped locks contribute to the very bumpy surface, against which the feeble part makes little headway. The large irises of both, bounded by a fine incision, are invaded nearly in their entirety by the immense, hollow pupil. With the face of St. Nicholas (Figs. 44, 46) the features of our *Page* share a highly concentrated and tectonic organization, low, straight brows, a short, straight, flat nose with flaring nostrils and a broad mouth.

Notwithstanding the attention focused on the Pesaro Altar since its erection, references to the frame are exiguous in the extreme. Sartori thought it the work of the Lombardo; Valcanover called the altar "lombardesco," and Padre Marini assigned it to Tullio and Antonio Lombardo.[15] Of the *Reggiscudo*, there are no previous studies at all.

"GREGORIANA" incised in the entablature of the frame is a later addition. No doubt it refers to the indulgences granted the Pesaro Altar at the instance of Carlo Pesaro, Bishop of Torcello, by Pope Gregory XIII on August 23, 1582.[16]

---

[1] Valcanover, *Quaderni della Sopr. Ven.*, 1979, p. 58, n. 4. Unless otherwise annotated, biographical facts have been taken from Goffen, 1986, pp. 122f, 132–36.

[2] Meyer zur Capellen, *Pantheon*, 1980, pp. 144f.

[3] Crowe/ Cavalcaselle, ²1881, i, p. 73.

[4] Goffen, 1986, pp. 107–10.

[5] Ibid., pp. 118f, 228f, n. 30.

[6] Ibid., p. 119.

[7] Scrinzi, *Venezia*, 1920, pp. 258f.

[8] Sanuto, *Diarii*, xliii, 1895, col. 396, Dec. 8, 1526.

[9] Valcanover, *Quaderni della Sopr. Ven.*, 1979, pp. 59–61.

[10] Hope, *BM*, 1973, p. 810.

[11] See above, n. 8.

[12] The relief was installed on the Altar of St. Clement between 1795 and 1815, probably ca. 1810. (Schulz, 1983, pp. 167, 169, no. 15.) The relief is crowned by Antonio Rizzo's relief of the *Madonna and Child* at the center and his statuettes of *SS. Mark* and *Bernardino* at the sides.

The relief proper is made of a single block of white marble. It measures 123 cm high × ca. 117 cm wide × 18 cm deep. No traces of polychromy or gilding remain. At the right corner of the relief a large wedge has broken off; indeed, the entire right edge of the base is missing. A large piece of stone is missing behind the right elbow of St. James; the hem of his tunic is chipped. The hem of St. Nicholas's tunic also is chipped. At St. Andrew's outer contour the drapery is badly nicked in several places. A crack runs vertically through the

doge's bonnet, neck, and into his shoulder, then jogs sharply to the spectator's left. The surface of the doge is nicked in a couple of places. There is a long nick in the background of the relief behind St. Nicholas's right shoulder.

The sole attempt to attribute this relief was made by Selvatico, 1847, pp. 239f, who, assuming that the Altar of St. Clement originated as a single unit, called the whole ensemble Lombardesque. Urbani de Gheltof, *Bull. di arti*, 1877–8, pp. 72f, identified the principal saint as St. Peter and the doge as Pietro Lando (1539–45).

[13] Saccardo, in Ongania, pub., vi, 1888, pt. 3 [1893], p. 275; Wolters, 1983, p. 98.

[14] Sanuto, *Diarii*, xxxv, 1892, coll. 254f, Dec. 6, 1523.

[15] Sartori, 1949, p. 51; Valcanover, *Quaderni della Sopr. Ven.*, 1979, p. 61; Marini, 1979, p. 16; Sartori/Luisetto, 1989, p. 12, no. 46.

[16] A Latin inscription affixed to the fourth pier on the left of the Frari (opposite the Tomb of Jacopo Pesaro) reads in translation: "At the entreaty of Carlo Pesaro, Bishop of Torcello, Pope Gregory XIII conceded to the Altar of the Conception of the Virgin Mary, dedicated a long time ago at the expense of his [Pesaro's] outstanding family, the perpetual privilege of liberating a soul from Purgatory by anyone celebrating [Mass] here and as often as [he does so] and also [Pope Gregory conceded] that the Confraternity of the same Conception be aggregated to the Archiconfraternity of the Conception at Rome with the same indulgences. Wherefore and in order that it should become known to everybody, he had [this inscription] carved. 1582, August 23." For the original inscription, see Soravia, ii, 1823, p. 133.

## 28. VENICE, S. MARIA DEI FRARI: TOMB OF BENEDETTO PESARO
### GIAMBATTISTA BREGNO AND ANONYMOUS SCULPTORS

Pls. 73–82, Figs. 28–32, 34–35

The tomb is constructed around the entrance to the sacristy at the end of the right arm of the transept (*in cornu Epistolae*) in S. Maria dei Frari.

Most of the architectural members of the tomb were carved from gray-veined white Carrarese marble. The columns of the second story and the pilasters behind them are Istrian limestone. White-veined purple marble was used for the spandrels of the central opening and the uppermost frieze. The backgrounds of the two reliefs of cities are red porphyry; the backgrounds of the two reliefs of ships are verd antique. The stone of the black disc beneath the sarcophagus and the black background of the *Madonna and Child* has not been identified. The shield affixed to the pendant volute, which serves as keystone to the central opening, is gold, blue, and red mosaic. The incised design at the top of the intrados of the central opening and the incised names of the cities in the reliefs on the sarcophagus are filled with niello. The *Madonna and Child* and the statues of *Pesaro, Mars,* and *Neptune* were carved from white Carrara *statuario*. Freestanding figures, bases, and supports were carved from single blocks. *Neptune's* right foot and shell, however, were pieced. *Pesaro* holds a metal banner, *Neptune* a wooden staff. The reliefs of *SS. Benedict* and *Jerome* were carved from integral blocks of white marble.

Tomb: 860 cm high × 470 cm wide;[1] *Effigy of Pesaro:* 185 cm high (including its 7.5-cm-high base); *Neptune:* 184 cm high (including its base); *Mars:* 188 cm high (including its base); *Madonna and Child:* 50 cm high × 45.5 cm wide × 42.5 cm deep; relief of *Levkas:* 44.8 cm high × 82 cm wide (exclusive of its frame); relief of *Kefallinia:* 46.3 cm high × 82 cm wide (exclusive of its frame); left-hand relief of light galley: 51 cm high × 65.5 cm wide (exclusive of its surrounding strips); right-hand relief of carack: 51.3 cm high × 68.5 cm wide (exclusive of its surrounding strips); *St. Benedict:* 39.6 cm in diameter (exclusive of its frame); *St. Jerome:* 39.6 cm in diameter (exclusive of its frame).

Numerous architectural details, including most borders and elements in relief, were gilded. In the *Effigy of Pesaro,* traces of gilding were preserved in the chain

mail, the narrow plates of armor on the figure's right foot, the broad borders of the *fiancali,* the edges of the lappets, plates, and *alette* of the poleyns, and in the border of the right avambrace. Originally the ribbons and clasps fastening adjacent plates of armor and the boss on the figure's right shoulder were gilded. Traces of flesh color remained in the right corner of *Pesaro's* mouth, beneath his left upper lid, and inside his nostrils. There were vestiges of black paint in *Pesaro's* right eyeball and pupil and on both upper lids. His banner was gilded. In *Neptune* traces of gilding were preserved in the underside of the shell that the figure holds in its left hand. *Neptune's* irises and pupils showed traces of black pigment. Traces of flesh color existed in the figure's right inguinal cavity. Remnants of black pigment were preserved in *Mars's* eyes. The visible portions of the *Madonna and Child* were entirely gilded. The ships and cities (but not the ground on which the latter stand) were gilded. In the relief of *St. Benedict,* the entire figure as well as its attributes and the innermost frame were gilded. In the relief of *St. Jerome,* the entire figure as well as its halo, the crucifix, and the innermost frame were gilded.

Apart from the pitting of the surface of the cloak in the area of *Pesaro's* left elbow, the figure is perfectly preserved. Except for its head, the effigy is flattened, and not quite finished in back. The rear of *Neptune's* upraised hand is sliced off vertically. The edge is very neat, suggesting that the break occurred during carving; the hand was not pieced, probably because, in front view, the break could not be seen. Both the crown of the shell and the end of *Neptune's* right foot were formerly pieced; the pieces are missing now. A metal trident, which the figure presumably once held, is also lost. A leaf of the wreath at *Neptune's* right temple is chipped. When I examined the tomb in the autumn of 1982, a helmet – presumably *Neptune's* – was lying on the sarcophagus. Probably *Mars* originally held a lance, now lost, which was threaded through the cylinder hidden in the figure's left hand. An area along the figure's contour above its right thumb is unfinished: presumably an attribute held in the figure's right hand rested here, against the figure's hip. The lower rim of *Mars's* visor is badly chipped and the top of the acanthus leaf at the helmet's crest has broken off. Otherwise the figure is well preserved and is very nearly as highly finished in back as it is in front. Most of the *Christ Child's* left foot is missing: that part below the horizontal fissure at the base of

the group is a stucco repair. The *Madonna*'s rear and the top of her head are flat. The stippling of her cloak was discontinued toward the rear. The *Madonna*, as well as the ships and water in the lateral reliefs, are covered with brown oxidized oils over gilding, which the recent cleaning of the tomb could not remove. The tip of *St. Benedict*'s nose has recently broken off. In the relief of *St. Jerome*, the projecting arm of the crucifix is truncated.

The tomb was repaired in 1826 and cleaned in 1984.[2]

The following inscription appears in the left-hand intercolumniation: BENEDICTVS / PISAVRVS / V. CLASSIS IMP. / TVRCORVM / CLASS. ALTERA / EX IONIO IN / HELLESPON / TVM FVGATA / ALTERA IN / AMBRACIO SINV / VI CAPTA / LEVCADE ET / CEPHALENIA and is continued in the right-hand intercolumniation: EXPVGNATIS ALI / IS QVE RECV / PERATIS INSV / LIS NAVPLIA / OBSIDIONE LI / BERATA / RICHIO SAE / VISS. PIRATA / INTER- FECTO / DIVI M. PROC. / CREATVS / PACE COM- POSITA / CORCIRAE OBIIT.

The following inscription appears between the pedestals on the right: HIERONYMVS F. / PARENTI OPTIME / DE PATRIA MERITO / POSVIT.

Both inner socles flanking the central opening are inscribed: M. D. III. The outer city wall in the relief on the left of the sarcophagus is inscribed: LEVCAS. The outer city wall in the relief on the right is in- scribed: CEPHALENIA.

Bibl.: Sans., 1581, pp. 66rf, 68vf; Schrader, 1592, p. 303v; Henninges, 1598, iv, p. 1156, no. 53; Superbi, 1629, ii, pp. 75f; Crasso, 1652, p. 85; Zabarella, 1659, pp. 56f; Martinelli, 1684, pp. 337f; Coronelli, [ca.1710], "Depositi," n. pp.; [Albrizzi], 1740, p. 211; Moschini, 1815, ii, pt. 1, p. 178; Cicognara, ii, 1816, pp. 152, 297; Moschini, 1819, pp. 269f; Cicognara, in Cicognara et al., ii, 1820, [pp. 74rf, 76r]; Soravia, ii, 1823, pp. 46–9; Zenier, 1825, p. 4; *Collezione*, 1831, n.p.; "Descrizioni," pl. VI; Zanotto, in Diedo/Zanotto, [1839], n.p., n. pls.; E. Paoletti, iii, 1840, p. 88; Selvatico, 1847, pp. 227f; Zanotto, in *Ven. e le sue lagune*, 1847, ii, pt. 2, pp. 126f; Selvatico/Lazari, 1852, p. 176; Burckhardt, 1855, ii, pp. 611b, 622b; Zanotto, 1856, p. 462; Cico- gnara/Selva/Diedo, 1858, pls. 77, 78; Moroni, xci, 1858, p. 149, voce "Venezia"; Mothes, ii, 1860, pp. 152f; Perkins, 1868, p. 209; Burck- hardt/Zahn, [2]1869, ii, pp. 610c, 621c, 662, n. 1; Burckhardt/Bode, [4]1879, ii, pp. 400f, 413b, 430, n. 1; Milanesi, in Vas/Mil, iv, 1879, p. 540, n. 1*; Fulin/Molmenti, 188   p. 289; Cecchetti, *Arch. ven.*, xxxiv, 1887, p. 280; Merzario, 1893, ii, p. 25; Paoletti, 1893, ii, pp. 273f; Conti, 1896, p. 151; Biscaro, *Atti ... dell'Aten. di Treviso*, 1897, pp. 275f, 277; idem, *Gazz. di Treviso*, May 7–8, 1898, [p. 3], repr. in idem, 1910, p. 11; Burckhardt/Bode/Fabriczy, [7]1898, ii, pt. 1, pp. 123e, 135k, 152, n. 1; Polverosi, 1899, p. 9; Burckhardt/Bode/Fabriczy, [8]1901, ii, pt. 2, pp. 499e, 514o, 532, n. 1; Fabriczy, *JpK*, 1907, p. 84; Moschetti, T-B, ii, 1908, p. 485, voce "Bardi, Antonio"; Gottschewski and Gronau in Vasari/Gottschewski and Gronau, vii, pt. 1, (1568)

1910, pp. 123f, n. 1; Paoletti, T-B, iv, 1910, p. 570, voce "Bregno, L."; Bouchaud, 1913, p. 205; Berti, [1916], pl. 5; Coletti, *Rass. d'arte*, 1921, p. 419; Planiscig, 1921, pp. 201, 206; Lorenzetti, 1926, p. 552; Tosi, *Enc. ital.*, v, 1930, p. 785, voce, "Baccio da Montelupo"; Lo- renzetti, *Enc. ital.*, vii, 1930, p. 793, voce "Bregno"; Kriegbaum, T-B, xxv, 1931, p. 86, voce "Montelupo, Baccio da"; Venturi, x, pt. 1, 1935, p. 411; Mariacher, *Arte ven.*, 1949, pp. 96f; Sartori, 1949, pp. 127f; Weinberger, *GBA*, 1952, pt. 1, pp. 107, 111; Muraro, 1953, p. 280; Vazzoler, 1962/63, pp. 160f, 222f; Lisner, in *Stil u. Ueberlieferung*, (1964) 1967, ii, p. 83; Hubala, in Egg et al., 1965, pp. 818f; Zava Boccazzi, 1965, p. 179; Munman, 1968, pp. 295–7, 302, 303–7; Sheard, 1971, pp. 258f; Mariacher, *DBI*, xiv, 1972, pp. 114, 115, voce "Bregno, L."; Cetti, 1973, p. 129; Meller, in *Tiziano*, 1977, p. 146; McAndrew, 1980, pp. 483–7; Meyer zur Capellen, *Pantheon*, 1980, p. 152, n. 48; Cetti, *Arte cristiana*, 1982, p. 35; Rearick, *Artibus et historiae*, 1984, p. 73; Schulz, *BJ*, 1984, pp. 150f; Petrucci, *Paragone*, Nov. 1984, p. 20, n. 38; Valcanover, *Arte ven.*, 1984, p. 277; Goffen, 1986, pp. 30, 64–72, 135f, 147; Sartori/Luisetto, 1986, pt. 2, pp. 1979f, no. 146; Adriana Ruggeri Augusti, in "Restauri," *Quaderni della Sopr. Ven.*, 1986, p. 142; Mariacher, 1987, pp. 52, 232, voce "Bregno".

Benedetto di Pietro Pesaro, of the S. Benetto branch of the Pesaro family, was born in 1433.[3] Ad- mitted to the *Maggior Consiglio* in 1450,[4] Pesaro spent his early career in London and was fleet commander of the Flemish galleys. In 1491, 1498, and 1499 he was elected one of the three heads of the Council of Ten, and on July 28, 1500, he was chosen *Capitano Generale del Mar* in the war against the Turks.[5] Pesaro's epitaph records his feats as leader of the Venetian fleet, his conquest of the Islands of Cephalonia (Ke- fallinia) and Santa Maura (Levkas) and the city of Nauplia (Návplion) in the Morea, and his killing of the pirate Enrichi.[6] On October 6, 1501, the captain was elected *Procuratore di S. Marco de supra*.[7] Pesaro died on August 10, 1503, on his galley at Corfù. News of his death reached Venice on August 22, 1503;[8] his body followed on September 3.[9] On September 4, 1503, Pesaro's funeral was held in S. Maria dei Frari, in the presence of the doge, the *Signoria*, and nu- merous patricians. The funeral oration was delivered by Gabriele Moro. Pesaro was buried – presumably beneath the pavement – in the sacristy.[10]

Pesaro indited his testament on July 11, 1503. As executors, he nominated his sister Elizabetta Tiepolo; his sister-in-law Madalena Pesaro; his nephews Pietro di Nicolo Pesaro and Francesco di Marco Pesaro; his brother-in-law Girolamo Duodo; his son-in-law La- zaro di Giovanni Mocenigo, and finally his only son, Girolamo. Girolamo was also named Benedetto's re- sidual heir. Pesaro disposed that his body be interred temporarily in his family chapel in the sacristy of the Franciscan Church of S. Maria dei Frari, Venice, while

his executors build in his memory a monument where his body afterward would rest, over the sacristy portal. The monument was to be made of marble, with marble columns, and was to contain an epitaph recording Pesaro's achievements. Up to a thousand ducats were to be spent on construction of the tomb. In addition, Benedetto charged that daily masses for his soul be celebrated in perpetuity, for which he left 25 ducats to the Frari.[11]

An inscription on Benedetto's tomb states that it was erected by his son Girolamo. Girolamo was born in 1467.[12] At the age of only 30, when his father's popularity was at its peak, Girolamo was elected to the Senate.[13] In 1511 he served as *Podestà* and Captain of Treviso.[14] He was named *Capitano Generale da Mar* once in 1529 against Charles V and again in 1536 against the Turks. He died on January 7, 1550, having been elected *Procuratore di S. Marco de ultra* shortly before. In his testament of November 7, 1549, Girolamo asked to be buried in a tomb built over the portal at the end of the Frari's left transept, directly opposite his father's tomb. In some essential respects his tomb was to match that of his father. On February 2, 1550, Benedetto Pesaro, Girolamo's son and heir, requested permission to erect his father's tomb on the desired site. The tomb was built there in 1551 but no longer exists, having been demolished to relieve pressure on the wall.[15]

Documents naming the author of Benedetto's tomb do not survive. In 1581, however, Sansovino assigned the pedestrian effigy to Lorenzo Bregno and the statue of *Mars* to Baccio da Montelupo Fiorentino (1469 – dead by 1536) (Figs. 29, 30).[16] The authority of this early source was widely acknowledged.[17] Soravia perceived no distinction in style between *Mars* and *Neptune* (Figs. 30, 32) and therefore ascribed both to Baccio.[18] Biscaro also thought the two works by a single hand, but identified that hand as Lorenzo Bregno's.[19] Mothes gave *Neptune* to an anonymous sculptor, whose name was best forgotten.[20] In 1931 Kriegbaum asserted that Baccio had carved, not *Mars*, but *Neptune*.[21] Germanophone critics by and large concurred.[22] Zahn's edition of Burckhardt's *Cicerone* informed readers that Antonio Minello had worked with Baccio on the tomb.[23] This notice was repeated in all successive editions of the *Cicerone* until Fabriczy observed that it was quite unfounded.[24]

In 1921, Planiscig, hypothetically attributed to Prygoteles the *Madonna and Child* in the tympanum (Figs. 33, 34).[25] This attribution found no adherents;[26] indeed, Planiscig himself soon abandoned his recon-

struction of Pyrgoteles's oeuvre.[27] Several critics entertained the possibility of Giambattista's collaboration on the tomb, but none identified his contribution.[28]

"M. D. III," inscribed twice on the socles flanking the opening to the sacristy, was widely assumed to refer to the year of execution of the tomb.[29] The second edition of Burckhardt's *Cicerone* dated Antonio Minello's supposititious activity on the Pesaro Tomb between 1503 and 1506.[30] In the eighth edition of the *Cicerone*, Fabriczy amended the date of Baccio's *Mars* from 1503 to 1506;[31] thenceforth, Baccio's participation on the Pesaro Tomb was dated to 1506 in the works of German-reading scholars.[32] McAndrew surmised that Baccio was engaged to complete the tomb only after Lorenzo Bregno's death in 1523 – an epoch with which the architectural style of the tomb's pediment, he thought, accorded.[33] In a lecture at the University of Padua in April 1983, I presented the reasons for dating Baccio's *Mars* to 1508 (for which, see below).[34] Though following my dating of *Mars*, Rearick, like Selvatico more than a century before, believed *Neptune* to have been added considerably after Bregno's death.[35] Meyer zur Capellen dated the completion of the tomb to 1537 on the basis of an inscription published by Zabarella in 1659.[36] But the inscription appears nowhere on the tomb. In any case, the year of 1537 undoubtedly refers to Girolamo's leadership of the Venetian fleet in the war against the Turks – an honor to which the text specifically alludes.

In his *Memoriale di Firenze*, dedicated on August 30, 1510 to Baccio da Montelupo, Francesco Albertini wrote: "et anchora per esser tu stato più tempo nella riccha ciptà di Venectia, nella quale hai lasciato memoria in marmo et bronzo degna di fama, laude et assai commendatione."[37] As long ago as 1816, Cicognara deduced from this a *terminus ante quem* of 1510 for Baccio's contribution to the Pesaro Tomb.[38] In fact, Baccio's presence in Venice can be dated precisely between April and November 1508, at least, by documents concerning Fra Bartolommeo della Porta's *God the Father with SS. Mary Magdalene and Catherine of Siena* of 1508 in the Pinacoteca, Lucca. The most informative of these documents comes from the *Libro di ricordanze* of the Florentine Convent of S. Marco and records a letter of January 15, 1512 (s.C.), to the Dominican Convent of S. Pietro Martire at Murano, protesting the latter's delinquency in paying for Fra Bartolommeo's completed painting. The letter recounts that, when the Dominican painter was vis-

iting Venice in April 1508, he was commissioned to execute a painting by the prior of the convent at Murano. At the time, Fra Bartolommeo was given an advance with which to purchase paints in Venice and was promised further payment, presumably in Florence, of a deposit of up to 25 ducats, to be remitted in part "per mano di Bart.° de Monte Lupo dipinctore ovvero sculptore, che si trovava alora a Venetia."[39] By November or December 1508, Fra Bartolommeo had received three ounces of blue pigment, sent to Florence by Baccio da Mountelupo.[40] Thus, Baccio's presence in the lagoon between April and ca. November 1508 is certain. But the date of his sojourn can be applied to *Mars*, and by extension, to the Pesaro Tomb, only hypothetically, for Baccio's authorship of *Mars*, not so far confirmed by stylistic analogies with his attested works,[41] must be taken *cum grano salis*.

The graphic definition of *Mars'* musculature does point, however, to a Florentine. (Fig. 30). By contrast, there is no reason to doubt the Venetian authorship of *Neptune*. (Figs. 31, 32). The figure's pose and facial type recur in Antonio Lombardo's *Forge of Vulcan* in the Hermitage, and an almost identical figure appears atop a column in the background of Carpaccio's painting from the St. Ursula cycle in the Accademia, Venice of *The Engaged Couple Being Greeted by the Pope in Rome*. Though I recently claimed *Neptune* for Lorenzo,[42] I am now persuaded I was wrong. *Neptune* is not corpulent; in proportion to his legs and head, his torso is very short. Note the strangely elevated division between hips and thighs, the exceptionally contracted pelvis, and the odd location of genitals and navel. *Neptune's* pose, which combines an exaggerated thrust of the hip with an immobile stance and a planar disposition of the torso and arms with a nearly profile head, finds no analogy in Lorenzo's work. The nodulose bony structure of *Neptune's* face, derived from an antique figure of the resting *Hercules*,[43] contrasts with the smooth, inflated forms of Lorenzo's physiognomies. The small eyes with their protruding

rims and flat, recessed eyeballs, which lack any plastic definition of iris or pupil, are unusual in Venetian sculpture of the period. Locks of hair composed of half tubes with tapered ends, coiled in perfect arcs or circles, contrive to form an even surface and a regular contour; the technique that Lorenzo evolved for making hair could not be more dissimilar.

The composition of the Pesaro Madonna (Fig. 34) is almost unique among examples of early Renaissance Venetian sculpture: Pyrgoteles' *Madonna and Child* from S. Maria dei Miracoli (Fig. 33), finished by 1489, alone, can be compared with it. Technically, both works are hybrid: flattened and unworked in back and partly attached to the background, the forms are not at all abridged in front, while the Madonna's upper body and the Christ Child, almost in entirety, are carved in the round. In both, the Madonna's head tilts forward to accommodate a spectator on the ground, while the urgency of the Christ Child's movement results in an extraordinarily unstable and transitory pose. I should be tempted to concur in Planiscig's attribution of the Pesaro *Madonna* to Pyrgoteles, were the physiognomies of the two women not so very different (Fig. 35). Comparison with Giambattista's Bettignoli *Madonna* or the *Madonna* from the St. Sebastian Altar (Pls. 11, 193) disproves as well the authorship of Giambattista and Lorenzo – an attribution I myself espoused.[44] Could the *Madonna and Child* be by the author of *Neptune*? The Madonna's small eyes conspicuously rimmed and her flat, recessed, unmarked eyeballs are identical to *Neptune's* (Figs. 31, 35). The rounded contour of the *Madonna's* face, head, and shoulders, and the circular rhythms of her folds accord with the aesthetic that determined the configuration of *Neptune's* beard. But these common traits, I think, are not sufficient to warrant attribution to a single master. Nor do I recognize the hand of the carver of the relief of *St. Jerome* (Fig. 28), whose capabilities, unfortunately, were not equal to his ambition.

[1] Adriana Ruggeri Augusti, in "Restauri," *Quaderni della Sopr. Ven.*, 1986, p. 142.

[2] Goffen, 1986, p. 201, n. 115; Adriana Ruggeri Augusti, in "Restauri," *Quaderni della Sopr. Ven.*, 1986. p. 142.

[3] A good treatment of Pesaro's life is to be found in Goffen, 1986, pp. 62–4. Unless otherwise noted, the details of Pesaro's biography have been taken from that source.

[4] Vienna, Oesterr. Natbibl., MS 6156, Barbaro, 1538, ii, c. 323v, voce "Pesari."

[5] Sanuto, *Diarii*, iii, 1880, col. 555, July 28, 1500.

[6] Lane, in *Ren. Ven.*, ed. Hale, 1973, p. 165.

[7] Sanuto, *Diarii*, iv, 1880, col. 147, Oct. 6, 1501.

[8] Ibid., v, 1881, col. 67, Aug. 22, 1503.

[9] Nani Mocenigo, 1937, p. 138.

[10] Sanuto, *Diarii*, v, 1881, coll. 78f, Sept. 4, 1503.

[11] ASV, Archivio notarile, Testamenti, Busta 1227 (not. Cristoforo Rizzo), no. 74. See Appendix A, Doc. XI, A.

[12] Vienna, Oesterr. Natbibl., MS 6156, Barbaro, 1538, ii, c. 323v, voce "Pesari."

[13] Lane, in *Ren. Ven.*, ed. Hale, 1973, p. 173, n. 98.

[14] For Girolamo Pesaro, see Goffen, 1986, pp. 69f.

[15] Girolamo's tomb was engraved by Coronelli, [ca. 1710], "Depositi," n.p., inscribed "PORTA DI S. CARLO NELLA CHIESA DE' FRARI," For the tomb, see Sartori, 1949, p. 62; Goffen, 1986, pp. 69–72; Sartori/ Luisetto, 1986, pt. 2, p. 1807, no. 46, p. 1820, no. 7.

[16] Sans., 1581, pp. 66rf: "la statua pedestre di Benedetto da Pesaro fu fatta da Lorenzo Bregno. Et il Marte di marmo lo scolpì Baccio da Monte Lupo Fiorentino."

[17] Moschini, 1819, p. 269; Cicognara, ii, 1820, n.p. [p. 74v]; Soravia, ii, 1823, p. 47; Zenier, 1825, p. 4; Collezione, 1831, n.p., "Descrizioni," pl. VI; Zanotto, in Diedo/Zanotto, [1839], n.p.; Zanotto, in Ven. e le sue lagune, 1847, ii, pt. 2, p. 127; Selvatico, 1847, p. 227; Selvatico/ Lazari, 1852, p. 176; Zanotto, 1856, p. 462; Moroni, xci, 1858, p. 149, voce "Venezia"; Mothes, ii, 1860, pp. 152f; Paoletti, 1893, ii, p. 273; Lorenzetti, 1926, p. 552; Muraro, 1953, p. 280; Vazzoler, 1962/ 63, pp. 160f, 223; Hubala, in Egg et al., 1965, p. 819; Mariacher, DBI, xiv, 1972, p. 114, voce "Bregno, L."; Schulz, BJ, 1984, p. 150.

[18] Soravia, ii, 1823, pp. 47f.

[19] Biscaro, Atti . . . dell'Ateneo di Treviso, 1897, pp. 275f.

[20] Mothes, ii, 1860, p. 153.

[21] Kriegbaum, T-B, xxv, 1931, p. 86, voce "Montelupo, Baccio da."

[22] Weinberger, GBA, 1952, pt. 1, pp. 107, 111; Lisner, in Stil u. Ueberlieferung, (1964) 1967, ii, p. 83; Meller, in Tiziano, 1977, p. 146; also Petrucci, Paragone, Nov. 1984, p. 20, n. 38.

[23] Burckhardt/Zahn, ²1869, ii, p. 662, n. 1.

[24] Fabriczy, JPK, 1907, p. 84, n. 2, repeated by Moschetti, T-B, ii, 1908, p. 485, voce, "Bardi, Antonio." Nevertheless, this misinformation reappeared in Paoletti, T-B, iv, 1910, p. 570, voce "Bregno, L." and Venturi, x, pt. 1, 1935, p. 411.

[25] Planiscig, 1921, pp. 201, 206. Planiscig, however, ascribed Mars to Baccio da Montelupo and the rest of the tomb to Lorenzo Bregno.

[26] Vazzoler, 1962/63, p. 223, and Schulz, BJ, 1984, p. 150, assigned the Madonna and Child explicitly to Lorenzo Bregno, as Biscaro, Gazz. di Treviso, May 7–8, 1898, [p. 3], repr. in idem, 1910, p. 11, had done before.

[27] Planiscig, T-B, xxvii, 1933, pp. 480f, voce "Pyrgoteles."

[28] Paoletti, T-B, iv, 1910, p. 570, voce "Bregno, L."; Lorenzetti, Enc. ital., vii, 1930, p. 793, voce "Bregno"; Sartori, 1949, p. 128; McAndrew, 1980, p. 484; Valcanover, Arte ven., 1984, p. 277.

[29] Moschini, 1815, ii, pt. 1, p. 178; Collezione, 1831, n.p., "Descrizione," pl. VI; Paoletti, 1893, ii, p. 273; Conti, 1896, p. 151; Polverosi, 1899, p. 9; Berti, [1916], pl. 5; Tosi, Enc. ital., v, 1930, p. 785, voce "Baccio da Montelupo"; Sartori, 1949, p. 128.

[30] Burckhardt/Zahn, ²1869, ii, p. 662, n. 1. Venturi, x, pt. 1, 1935, p. 411, adopted the date along with the notice of Minello's activity.

[31] Burckhardt/Bode/Fabriczy, ⁸1901, ii, pt. 2, p. 514o. Cf. Burckhardt/Bode/Fabriczy, ⁷1898, ii, pt. 1, p. 135k.

[32] Gottschewski and Gronau in Vasari/Gottschewski and Gronau, vii, pt. 1, (1568) 1910, pp. 123f, n. 1; Weinberger, GBA, 1952, pt. 1, p. 107; Lisner, in Stil u. Ueberlieferung, (1964) 1967, ii, p. 83; Meller, in Tiziano, 1977, p. 146; Kriegbaum, T-B, xxv, 1931, p. 86, voce "Montelupo, Baccio da," dated what he supposed to have been Baccio's second sojourn in Venice to 1506.

[33] McAndrew, 1980, p. 487.

[34] Schulz, "Contributi alla storia della scultura veneziana del primo Cinquecento," April 21, 1983, Istituto di Storia dell'Arte, Università di Padova, Padua.

[35] Rearick, Artibus et historiae, 1984, p. 73; Selvatico, 1847, pp. 227f.

[36] Meyer zur Capellen, Pantheon, 1980, p. 152, n. 48, quoted Zabarella, 1659, p. 57: HIERONYMVS PISAVRVS IMPERATOR/ CLASSIS VENE-TAE CONTRA TVRCAS [sic]/ ANNO CHRISTI M. D. XXXVII/ PATRI MONVMENTVM POSVIT. The tomb does contain an inscription, which tells of the monument's construction by Benedetto's son but omits Girolamo's title and gives no year. In fact, Zabarella's factitious epigraph was taken verbatim from Henninges, 1598, p. 1156, no. 53.

[37] Albertini, (1510) 1863, pp. 7, 8.

[38] Cicognara, ii, 1816, pp 152, 297.

[39] The document was published by Marchese, ii, 1846, pp. 415f, doc. III, and Frantz, 1879, pp. 244–6, doc. III.

[40] Borgo, 1968/76, pp. 523–5, doc. 14. As for Fra Bartolommeo's painting, the Convent of S. Pietro Martire defaulted on its payment and eventually Fra Bartolommeo gave the work to Padre Sante Pagnini, alternately prior of S. Marco, Florence, and the Dominican Convent of S. Romano, Lucca. For this, see ibid., pp. 377–9, cat. no. II, 2.

[41] Baccio's attested, extant works, in chronological order are: 1. Po-lychromed, terracotta figures of the Virgin Mary, Mary Magdalene, a Holy Woman, and Joseph of Arimathea from a Lamentation over the Dead Christ, S. Domenico, Bologna, 1495: Supino, 1910, p. 112; Sighinolfi, Il resto del carlino della sera, Sept. 19, 1921, [p. 2]; 2. Wooden Crucifix, Convent of S. Marco, Florence, 1496: Filippini, Dedalo, 1927/ 8, pp. 532/534; 3. Wooden Crucifix, Cappella della Pura, S. Maria Novella, Florence, before 1501: Mesnil, R. d'arte, 1904, p. 72; Paatz, Flor. Mitt., 1919–32, pp. 360f; 4. Wooden figure of St. Sebastian, Badia, S. Goden-zo, 1506: Fabriczy, Misc. d'arte, 1903, p. 67, doc. 2; [Poggi], R. d'arte, 1909, pp. 134f; 5. Bronze statue of St. John the Evangelist, Or San Michele, Florence, 1515: Vas/Mil, iv, (1568) 1879, p. 540; 6. Marble Tabernacle of the Host, S. Lorenzo, Segromigno Monte (Lucca), 1518–19: Guidi, Arte cristiana, 1915, pp. 68–70.

[42] Schulz, BJ, 1984, p. 150.

[43] For antique representations of Hercules in Repose, see Moreno, Mé-langes d'archéologie, 1982, pt. 1, pp. 379–526.

[44] Schulz, BJ, 1984, p. 150.

## 29. VENICE, S. MARTINO: RETABLE WITH ST. JOHN THE BAPTIST AND ST. PETER

LORENZO BREGNO

Pls. 161–171

The altar is situated in the part of S. Martino that serves as Baptistry, at the left of the large central bay in the lei. .lank of the church (in cornu Evangelii). Removed for restoration after the flood of 1966 by the Soprintendenza ai Beni Artistici e Storici di Venezia, the statuettes have only recently been returned to

the altar. *St. Peter* occupies the right-hand niche; *St. John the Baptist*, the niche on the left.

The altarpiece with the relief of *Christ as Man of Sorrows* in the lunette is made from several blocks of white marble. The framework is incrusted with slabs of verd antique, porphyry, and dark red-purple marble with white veins, and purple breccia, in various geometric shapes.

The figure of *St. Peter*, together with its base, was carved from a single piece of white Carrara marble. The figure of *St. John* is also white Carrara marble, but it is no longer possible to tell the number of pieces from which the statuette was carved.

Altarpiece: 230 cm high × 184.8 cm wide (at the lowest cornice); interior of niches: 53.7 cm high; lunette: 19.5 cm high × 4 cm deep; *St. Peter*: 48.5 cm high (including its base); *St. John the Baptist*: 47.5 cm high (including its base).

The following elements of the framework of the altarpiece were once gilded: the faces of narrow moldings, those parts of the capitals carved in relief, and the borders of incrusted slabs. In the lunette above the *sportello* there was gilding on the borders of the frame, on the moldings of Christ's sarcophagus, and on the hair and wings of the cherubim.

When I examined the two statuettes in the restoration laboratory of the Soprintendenza in the summer of 1978, I found traces of gilding in *St. Peter* in the neckband and hem of the tunic, its cinch, and the edges of its sleeves, the borders and inner face of the cloak, the cover and clasps of the book, the key, and the bows of the sandals. In the *Baptist*, traces of gilding remained in the covers of the book, the furry lining of the goatskin tunic, the inside of the cloak, and the girdle.

The original bronze *sportello* with a relief of *Christ in Limbo* and a statue of the *Resurrected Christ* from the summit of the altarpiece are missing.[1] The central *tondo* of painted wood at the top of the altarpiece evidently replaced one of porphyry. At the base of both niches, the molding has been cut away in the rear to permit the insertion of the statuettes; the moldings have been repaired with plaster. A piece is missing from the center of the altarpiece's base, where there was once a clamp. The projecting edges of the bases beneath the columns on the left are chipped.

The end of *St. Peter's* key is broken off and chips are missing from the corner of the *Saint's* book, the toes of his right foot, and the base beneath it. The

rear of the figure is flat and smooth, but otherwise unworked. A hole in the top of the head once served for the attachment of a halo.

The *Baptist* is gravely damaged. When examined in 1978, the lower part was in pieces, not all of which survived. A large portion of the bottom of the drapery, which formed a support behind the figure, was missing. The feet are preserved, but toes are badly chipped. The hair also is chipped and a crack runs through the face. The rear of the figure on the spectator's left is unfinished: forms have not been excavated and the surface is extremely rough. A hole toward the bottom rear of the statuette once served to fix it to its niche. A second hole in the top of the head permitted the attachment of a halo. The statuettes were cleaned in 1969 by the Soprintendenza ai Beni Artistici e Storici di Venezia[2] and were returned to the altar in June 1989.

The following inscriptions were found on the altar or within its precinct. At the top of the antependium of the altar: "Surrexit victa Christus de morte triumphans." At the bottom of the antependium: "Exurgat Domino iam pia turba comes." In the entablature of the altarpiece: "Hic intus est corpus Iesu Christi." In the altarpiece's base; "Hic Deus est, veræq; Crucis pars, atq; columnæ." On the parapet at the spectator's left: "Conscia vulneribus Domini hic crucis, atque columnæ." On the parapet at the spectator's right: "Portio & ipse parens rerum prostratus adora." On the grille of the altar: "Quis jacet hic? Rerum Dominus, cur mersus acerbo/ funere? Quo lectis gentibus astra daret."[3] Since they no longer exist, the altar's inscriptions are likely to have been painted.

Bibl.: Sans./ Stringa, ²1604, pp. 131rf; Sans./ Martinioni, ³1663, pp. 77f; Martinelli, 1684, pp. 109f; Pacifico, 1697, p. 203; [Albrizzi], 1740, pp. 109f; Corner, 1749, xi, pp. 280f; Zucchini, i, 1785, pp. 206f; Maier, i, 1787, p. 65; Moschini, 1815, i, pt. 1, p. 66; idem, 1819, p. 11; E. Paoletti, ii, 1839, p. 203; Selvatico/ Lazari, 1852, p. 103; Zanotto, 1856, p. 236; Moroni, xci, 1858, p. 11, voce "Venezia"; Mothes, ii, 1860, p. 87; Tassini, *Arch. ven.*, 1879, pp. 275, 280f; Fulin/ Molmenti, 1881, p. 191; Ven., Bibl. Marc., MS it., Cl. VII, 2283 (= 9121), Fapanni, 1884–9, fasc. 37, "Chiesa del Sepolcro," c. 301r; Ven., Bibl. Marc, MS it., Cl. VII, 2510 (= 12215), Fapanni, before 1889, c. 14r; Paoletti, 1893, ii, p. 231; Moro, 1897, p. 8; Planiscig, 1921, p. 228; Lorenzetti, 1926, p. 303; Mariacher, *BM*, 1954, p. 373; Zangirolami, 1962, p. 122; Hubala, in Egg et al., 1965, p. 912; Hellmann, *Aten. ven.*, 1967, p. 200; Sheard, 1971, pp. 137, 393, n. 6; Ven., Procuratie Nuove. *Arte a Ven.*, cat. by Mariacher, 1971, p. 154, nos. 73, 74; Zorzi, 1972, ii, pp. 382–4; *Venice restored*, 1973, pp. 13, 18; Maek-Gérard, 1974, pp. 285–91, 298–301; Franzoi/ Di Stefano, 1975, p. 490; *Venice restored*, [1978?], pp. 49, 58; Schulz, *BJ*, 1984, pp. 159–67; Sandro Sponza, in "Restauri," *Quaderni della Sopr. Ven.*, 1986, p. 64.

Bregno's altarpiece with statuettes of *SS. John the Baptist* and *Peter* and a relief of *Christ as Man of Sorrows*, surmounts an altar supported by four kneeling *Angels* inscribed on their bases with Tullio Lombardo's name. The altar comes from the former Venetian Franciscan Observant Church of S. Sepolcro, so called from the model of Christ's burial chamber, which stood in the center of the church, filling most of it. Made of rough blocks of Istrian limestone, the counterfeit sepulchre was hollow. Hung about the interior were small paintings of the Passion of Christ. It was here that the Altar of S. Martino stood. Within the grotto, on either side, two flights of eight marble steps led to a crypt below, where a miraculous life-size wooden image of the *Dead Christ* was preserved on another altar.[4]

Several early sources describe the altar of the sepulchre; the earliest and most detailed occurs in Stringa's 1604 edition of Sansovino's guide of 1581. It reads:

> Qui dentro [the grotto] vi è un'altare di marmo molto ricco, e bello così per disegno, come per finezza di pietre. Egli è da quattro Angioli scolpiti in marmo assai belli, sostenuto in aria. Nel suo parapetto [antependium] vi si vede una lastra lunga, e larga di porfido, in cui vi si specchia, tanto è bella, & fina; ve ne sono altri sei pezzi fuori di esso altare della medesima bellezza, & finezza, attaccati al muro. Sopra la detta lastra vi si legge nel marmo:
>
> > Surrexit victa Christus de morte triumphans.
>
> Et di sotto di lei.
>
> > Exurgat Domino iam pia turba comes.
>
> La pala di quest'altare è tutta di marmo intersiata, & lavorata vagamente di pietre fine di più colori; quattro colonnelle di finissimo marmo la formano; nel cui mezo vedesi una portella, che chiude il corpo del Signore, tutta di bronzo, & indorata con figurine di mezo rilievo, che rappresentano la liberation delle anime de' Santi Padri, che fece Christo, dal Limbo, quando nella sua morte colà discese; e da' lati in due nicchi piccioli vi sono due figurine di San Gio. Battista, e di S. Pietro, scolpite in marmo assai belle: e nella cima ne apparisce un'altra più grande di un Christo risuscitato. Nella sua cornice ad alto è scritto:
>
> > Hic intus est corpus Iesu Christi.
>
> Et a basso:
>
> > Hic Deus est, veræq; Crucis pars, atq; columnæ.
>
> È serrato quest'altare da' lati, e davanti da due parapetti di pietra viva, intersiate con pietre fine col suo adito in mezo. . . .[5]

In its present state the S. Sepolcro Altar does not correspond in all particulars with its description. There no longer exists the gilded bronze *sportello* with

a relief of *Christ in Limbo*, behind which the Host and relics of the True Cross and of the column of the Flagellation were preserved. The statue of the *Resurrected Christ* is missing from the summit of the altar. The medallion of the attic is painted wood instead of porphyry. Verses, probably painted, once ran along the top and bottom of the frame of the antependium, the base of the reredos, and the broken entablature above.

The vicissitudes of S. Sepolcro bear crucially on the history of our altarpiece. The convent resulted from a testamentary decree of January 2, 1410, of Elena Celsi, widow of Marco Vioni, which ordained that, after her death, her house on the Riva degli Schiavoni serve in part for the reception of female pilgrims to the Holy Land. There two refugees from Negroponte, which had fallen to the Turks in 1471 – Beatrice Venier and Polissena Premarin – obtained permission to make their home in 1475. Gathering about them other pious women, they embraced the third order of St. Francis in 1482. A small chapel dedicated to the Presentation of the Virgin was added to the hospice, and it was there, as a beacon to the pilgrims who took refuge in the hospice, that a replica of the Holy Sepulchre in Jerusalem was erected.[6]

At the entrance to the grotto of S. Sepolcro was a door of serpentine above which was inscribed SE-PUL. IHU XPI MCCCCLXXXIIII.[7] Stringa referred this year to the construction of the grotto.[8] Alleging that the church, in which the grotto stood, postdated 1500 and was consecrated only in 1582, Franzoi and Di Stefano denied that the simulacrum of Christ's sepulchre was built so early. The authors justly observed that Jacopo de' Barbari's view of Venice of 1500 does not show a church on the site of S. Sepolcro and that the process by which the hospice for pilgrims to the Holy Land was transformed into the convent for Franciscan tertiaries, to whom the hospice was ceded in perpetuity on April 13, 1493, commenced only in that year.[9] Franzoi and Di Stefano may be right to date the Church of S. Sepolcro after 1500, but it does not follow that the sepulchre did not already exist in some form. In fact, there is reason to believe that a sepulchre was constructed there between mid-1493 and spring 1496. A manuscript history of the convent, relating events up to 1593, records that, in execution of the concession of April 13, 1493, a chapel and altar under the title of the Presentation of the Virgin were built and that in the chapel "vi fabricarono un sepolcro a' simiglianza del Santissimo Sepolcro del Nostro Signor Giesu

Christo."[10] In the first edition of his *De situ urbis Venetae*, composed by April 1491, Marc'Antonio Sabellico made no mention of the sepulchre. But in the version of *De situ urbis Venetae* included in the edition of his *Opera* of 1502 there is specific reference to the Sepulchre of Christ the King with a convent of virgins on the Riva degli Schiavoni just beyond the Ponte della Pietà.[11] Internal evidence indicates that *De situ urbis Venetae* was revised in the spring of 1496.[12] Finally, a petition to Pope Alexander VI probably of November 7, 1499, on behalf of the nuns of the Convent of S. Sepolcro, requesting permission to observe perpetual *clausura*, cites the Chapel of the Presentation of the Virgin, "in qua certum sepulcrum ad instar & similitudinem Sepulcri Dominici Jerosolimitani hujusmodi constructum fuit."[13]

But the completion of Christ's burial chamber was precisely dated by Marin Sanuto to March 9, 1511. On the following day he recorded in his diary:

> Noto, che eri da matina, hessendo compito lo edificio, facto in la chiesia dil santo Sepulcro, de marmo, una montagna con il sepulcro dentro, è stà fato per uno che fa la spexa, e non si sa chi, costa ducati 1000 e più, et fu dito messa ivi, et posto Cristo dentro, et vi concorse assa' persone a vederlo.[14]

This suggests that the date of 1484 on the grotto entrance marked the founding of the Holy Sepulchre, which was actually erected or re-erected in a more conspicuous form between 1493 and 1496, and that the grotto was completed, altered, or replaced yet again by March 1511.

In agreement with the hypothesis of successive campaigns inferred from written testimony, is the change in plan evidenced by the altar itself. The altar proper must originally have been freestanding, for it is incrusted with porphyry on all four sides and is supported by a centralized pedestal and four identical *Angels*, presumably meant to face in opposite directions. But the reredos could only have stood against a wall. Very likely, the altar supported by *Angels* constituted the Altar of the Presentation of the Virgin erected by the Franciscan tertiaries once the hospice had been ceded to them in perpetuity in 1493. Though the inscription of Tullio's name on the *Angels'*

bases is not authentic[15] and the *Angels* themselves do not seem worthy of so great a master, there is no doubt that the *Angels* and, therefore, the altar proper come from Tullio's circle; a date between 1493 and 1496 is entirely plausible. The reredos, by contrast, could not have originated in Tullio's shop: rather, all stylistic indices point to the authorship of Lorenzo Bregno ca. 1511. It is tempting to suppose, therefore, that, when Mass was said on March 9, 1511, the reredos had only recently been set upon the altar, now shoved up against the wall. Possibly the reredos's commission and the final reconstruction of the grotto are to be related to concessions of 1500, according to which the nuns of S. Sepolcro were exempted from entertaining pilgrims in future and were authorized to enlarge their quarters.[16]

In 1808 the Church and Convent of S. Sepolcro were suppressed by Napoleonic decree; subsequently church and convent were made over into barracks. The grotto was demolished in 1832.[17] By 1815 the altar already occupied its present site in S. Martino.[18] After the flood of 1966, the *Angels* and *Saints* were removed for restoration. The restored *Angels* were soon returned to S. Martino, but *SS. Peter* and *John the Baptist* languished for a long time at the laboratory of the Soprintendenza ai Beni Artistici e Storici di Venezia at S. Gregorio before being restored and returned to their original position.

In the secondary literature, the Altar of S. Martino was almost always treated globally as Tullio Lombardo's work:[19] on only five occasions was the reredos distinguished from the altar with *Angels*. In the guides of Selvatico and Lazari, and Fulin and Molmenti, the four *Angels* were assigned to Tullio, while the remainder of the altar was given to an unknown sculptor of the 16th century.[20] Paoletti concurred in this estimate: nothing in the dossal, he thought, betrayed the hand of Tullio.[21] In his dissertation of 1974, Maek-Gérard assigned the statuettes of *SS. Peter* and *John the Baptist* to Lorenzo Bregno and dated them and the retable to ca. 1511.[22] Independently of him, I arrived at the same conclusion, attributing the two figures to Lorenzo Bregno and dating them to 1510.[23]

---

[1] The *sportello* was lost between 1787 and 1815. (Maier, i, 1787, p. 65; Moschini, 1815, i, pt. 1, p. 66.) Descriptions of the altar do not allow us to date with certainty the disappearance of the *Resurrected Christ*.

[2] Sandro Sponza, in "Restauri," *Quaderni della Sopr. Ven.*, 1986, p. 64.

[3] All except the last inscription on the grille were transcribed by Sans./Stringa, ²1604, p. 131v; Martinelli, 1684, p. 110; Corner, 1749,

xi, p. 281; Zucchini, i, 1785, pp. 206f; Tassini, *Arch. ven.*, 1879, pt. 1, pp. 280f, nos. 8–11. The last inscription was published by Tassini, ibid., p. 281, no. 12.

[4] Sans./Stringa, ²1604, pp. 131r–132r; Martinelli, 1684, pp. 109f; Pacifico, 1697, p. 203; [Albrizzi], 1740, pp. 109f; Corner, 1749, xi, pp. 280f; Zucchini, i, 1785, pp. 206–8.

[5] Sans./Stringa, ²1604, pp. 131rf.

[6] Tassini, *Arch. ven.*, 1879, pt. 1, p. 274.

[7] Ibid., p. 279, no. 5.

[8] Sans./Stringa, [2]1604, pp. 131r, 132r.

[9] Franzoi/Di Stefano, 1975, p. 490.

[10] ASV, Conventi religiosi soppressi, S. Sepolcro, Catastico, Busta 1, "Catastico delli beni del venerando monasterio del Santo Sepolcro di Venetia," n.c. [cc. 4rf]: "In essecutione della qual concessione [of Apr. 13, 1493] dette Venerande donne riddotte in detto hospitale fabricarono una Capella, et altare sotto titolo della Presentatione della Beata Vergine Maria, et in essa Cappella vi fabricarono un sepolcro a' simiglianza del Santissimo Sepolcro del Nostro Signor Giesu Christo … onde dette Venerande donne furno chiamate le donne del Santo Sepolcro, et doppo haver grandemente ampliata detta Cappella, et hospitale mandarono un loro procurator a' supplicar la Santità di Papa Alessandro Sesto [Nov. 7, 1499], che si dignasse di concederli in gratia speciale, che potessero ritirarsi in perpetua clausura … sotto la Regola delle Monache del terzo Ordine di San Francesco et sotto la custodia et governo delli Reverendi Fratti Minori de osservantia del detto terzo ordine di S. Francesco…" I assume that this is the MS to which Maek-Gérard, 1974, p. 290, n. 1, referred with an incomplete citation. The history related in this MS is confirmed by [Grandis], iii, 1762, pp. 148f.

[11] Sabellico, 1502, p. 88r: "ædem occurrit fundamenta tenentibus dexterum christi regis sepulchrum cum virginio: pons inde lapideus a proxima pietatis domo nūcupatus occurrit." Cf. Sabellico, (1491–2) n.d., n.p. [p. 29]. For the composition of *De situ urbis Venetae* before Girolamo Donato's departure for Rome in April 1491 and its publication by 1492, see Mercati, 1939, ii, pp. 13f.

[12] The 1502 edition of *De situ urbis Venetae* contains a reference to the Monument of Bartolomeo Colleoni (pp. 87rf), unveiled on March 21, 1496 (Sanuto, *Diarii*, i, 1879, coll. 96f), but none to the Torre dell'Orologio (p. 89v), on which construction began on June 10, 1496 (Sanuto, *Diarii*, i, 1879, coll. 205f).

[13] Corner, 1749, xi, pp. 297f. Corner's heading of Sept. 7, 1499 contradicts his transcription of the document itself which is dated "Septimo Novembris." This error was corrected in his supplement, ibid., xiv, p. 441. The petition is also preserved in an 18th-century copy in Venice, Mus. Correr, MS Gradenigo 179/I, *Monache*, cc. 337r–338v, with the date of "septimo kalendas novembris," viz. Oct. 26. This exemplar was partly published by Schulz, *BJ*, 1984, p. 163, n. 69. Pope Alexander's consent to the petition is dated Nov. 26, 1499, and was published by Corner, 1749, xi, pp. 298f.

[14] Sanuto, *Diarii*, xii, 1886, col. 35.

[15] Sheard, 1971, p. 137. Luchs, *AB*, 1989, p. 232, n. 9, suggested that one inscription was original and that the other three were added around 1828. But none of the inscriptions distinguishes itself by a Renaissance style or facture. On the other hand, the signatures already existed in 1815: Moschini, 1815, i, pt. 1, p. 66. Probably they were incised when the altar was moved to S. Martino after the suppression of S. Sepolcro in 1808.

[16] Tassini, *Arch. ven.*, 1879, p. 275.

[17] Ibid., pp. 275, 280, no. 6.

[18] Moschini, 1815, i, pt. 1, p. 66.

[19] Ibid., p. 66; idem, 1819, p. 11; E. Paoletti, ii, 1839, p. 203; Zanotto, 1856, p. 236; Moroni, xci, 1858, p. 11, voce "Venezia"; Mothes, ii, 1860, p. 87; Tassini, *Arch ven.*, 1879, p. 275; Ven., Bibl. Marc., MS it., Cl. VII, 2510 (=12215), Fapanni, before 1889, c. 14r; Moro, 1897, p. 8; Lorenzetti, 1926, p. 303; Mariacher, *BM*, 1954, p. 373, n. 13; Hubala, in Egg et al., 1965, p. 912; Zorzi, 1972, ii, p. 384; *Venice restored*, 1973, p. 13. Sandro Sponza, in "Restauri," *Quaderni della Sopr. Ven.*, 1986, p. 64, gave the statuettes to Tullio Lombardo's shop.

[20] Selvatico/Lazari, 1852, p. 103; Fulin/Molmenti, 1881, p. 191.

[21] Paoletti, 1893, ii, p. 231.

[22] Maek-Gérard, 1974, pp. 291, 298f, 300f.

[23] Schulz, *BJ*, 1984, p. 166.

## 30. VENICE, S. GIOBBE: ALTAR OF *ST. LUKE*

### LOMBARDO SHOP

Figs. 65, 66, 68–71

The Altar of St. Luke is located at the center of the end wall of the Cappella Grimani, the first chapel on the left of S. Giobbe (*in cornu Evangelii*).

*St. Luke*, together with its base and support, was carved from a single block of white marble. The *Angels*, with their respective bases, were carved from single blocks of white marble.

*St. Luke*: 131.5 cm high (including its 4.2-cm-high base); left *Angel*: 84 cm high (including its 3.2-cm-high base); right *Angel*: 86 cm high (including its 3.2 cm–high base).

The border of *St. Luke*'s mantle, the hem of his tunic, and the cover of his book are gilded. There are traces of gilding in the *Angels*' cinches, where they dip beneath the abdomen, and in the sides of the two bases.

In *St. Luke*'s mantle, folds are chipped over the figure's right foot, near the bottom of the cloak on the spectator's right, and in the swathe that forms a sleeve around the figure's left wrist. There are a nick and a small crack in the fold over *St. Luke*'s left groin. The upper surface of the third toe of the figure's right foot is also nicked. In the *Angel* on the left, a large hole in the base, at the inside of the figure's left foot, once permitted the clamping of the circular base to the pedestal beneath. Where the figure's chiton is contiguous with the hole, its hem is damaged. The edges of the base are chipped here and there. A chip is missing from a fold of the peplum over the figure's left leg and the tip of the *Angel*'s right toe is nicked. In the right *Angel*, the hole in the base is much smaller, neater, and less disfiguring. At the rear of the figure, a large wedge is missing from the bottom of the

drapery on the spectator's right. The tips of the first three toes of the *Angel's* forward foot are nicked. In the thinnest part of the marble, where the folds of the chiton fly back behind the figure's legs, there are two holes.

Bibl.: Sans., 1581, p. 57r; Martinelli, 1684, p. 271; Pacifico, 1697, p. 329; [Albrizzi], 1740, p. 174; Bottari, in Vasari/Bottari, i, (1568) 1759, "Giunta alle note," p. 40, voce, "Ant., e Bern. Rossellino"; Moschini, 1815, ii, pt. 1, p. 65; Cicognara, ii, 1816, pp. 76f; E. Paoletti, iii, 1840, p. 40; Selvatico, 1847, pp. 235f; Zanotto, in *Ven. e le sue lagune*, 1847, ii, pt. 2, pp. 166f; Selvatico/Lazari, 1852, p. 161; Zanotto, 1856, p. 338; Mothes, ii, 1860, pp. 32f, 80; Fulin/Molmenti, 1881, p. 267; Paoletti, 1893, ii, pp. 202, 274; Biscaro, *Arch. ven.*, ser. 2, xviii, pt. 1, 1899, p. 196; Paoletti, T-B, iv, 1910, p. 570, voce "Bregno, L."; Lorenzetti, 1926, pp. 425f; idem, *Enc. ital.*, vii, 1930, p. 793, voce "Bregno"; Mariacher, *Arte ven.*, 1949, p. 96; Muraro, 1953, p. 248; Vazzoler, 1962/63, pp. 214, 226f, 257; Finotto, 1971, pp. 48f; Mariacher, *DBI*, xiv, 1972, p. 115, voce "Bregno, L."; Ruhmer, *Arte ven.*, 1974, pp. 53f; McAndrew, 1980, p. 50; Viroli, in *Il mon.*, 1989, pp. 63f.

In S. Giobbe the Altar of St. Luke occupies the first chapel on the left, known as the Grimani Chapel. The history of the chapel's construction is not known. Erection of the Observant Franciscan church was due largely to the benefactions of Doge Cristoforo Moro (1462–71). In 1451 the land on which the choir stands was donated to the church and Moro undertook to build there, at his own expense, a magnificent chapel in honor of St. Bernardino. In his testament of September 1, 1470, Moro bequeathed 10,000 ducats for the extension of the church and for the construction of its chapels. Presumably work was finished before the church's consecration on April 14, 1493.[1] But it would seem that the original church did not include the Grimani Chapel, for in 1493 Sanuto described the Martini Chapel – the chapel immediately to the liturgical east of the Grimani Chapel – as the first chapel in S. Giobbe.[2] Jacopo de' Barbari's bird's-eye view of Venice of 1500 shows structures to the left of the church's nave, which may represent the series of lateral chapels to which the Grimani Chapel belongs.[3] But it is impossible to deduce from this depiction the existence of the Grimani Chapel in particular.

By 1539 the chapel had been built, for in that year Pietro Grimani (d. 1553) was granted its juspatronage.[4] Both in this document of cession and in Grimani's will of 1548,[5] in which the testator asked to be buried in his chapel in S. Giobbe, the Grimani Chapel is called by the name of its patron saint – St. Luke. The earliest recorded dedication of the chapel makes it likely that at least by 1539 – that is, at the acquisition of the chapel by Grimani – our altarpiece was on the chapel's altar. Dedication of chapel and altar are bound up with the history of S. Giobbe, recipient of a donation from Doge Moro of what was claimed to be the body of the Evangelist, St. Luke. In August 1463 the body, brought from Bosnia by Franciscan friars, was given to Doge Moro, who had it placed in the Church of S. Nicolò al Lido. It was his intention to have it transferred to S. Giobbe, where it might be exhibited to the veneration of the faithful. But the authenticity of the relic was immediately challenged by other claimants to possession of St. Luke's remains – the Benedictines of S. Giustina, Padua. The dispute was submitted to Pope Pius II, who delegated Cardinal Bessarion, Apostolic Legate at Venice, to investigate the question. Bessarion's sentence in favor of the Venetian relic was appealed to Paul II, who named Cardinals Giovanni Caravajel and Bernardo Erulo da Narni Apostolic Judges in the case. In an instrument of March 21, 1465, Caravajel and Erulo prohibited the veneration of the Venetian relic, pending a final verdict. Meanwhile, soon after the promulgation of Bessarion's decision, on December 17, 1463, Doge Moro and the *Signoria*, in solemn procession, had brought the body to S. Giobbe, where it was deposited above the altar in the little chapel at the head of the sacristy. In the event, a definitive sentence in favor of one or the other body was never pronounced and the Venetian relic remained in the sacristy of S. Giobbe until January 14, 1986.[6]

In 1581, Francesco Sansovino wrote: "Vi [in S. Giobbe] si vede di scoltura in marmo di mezzo rilievo, la palla della capella di Pietro Grimani Procurator di San Marco fatta da Antonio Rosselli Fiorentino. Et un'altra palla pur di marmo con un San Giovanni Battista di mano di buon maestro."[7] As it happens, the altarpiece with figures of SS. *John the Baptist, Francis* and *Anthony of Padua*, in the adjacent Martini Chapel, is consonant with works from the shop of Antonio Rossellino. But it was a long time before Sansovino's confusion of the Grimani and Martini Chapels was recognized as such: his attribution of the Altar of St. Luke to Antonio Rosselli continued to be repeated until 1847.[8] Meanwhile, in his notes to Vasari's lives of the painters, Bottari had identified Sansovino's Antonio Rosselli Fiorentino, active at S. Giobbe, with the Florentine Quattrocento sculptor Antonio Rossellino.[9] Cicognara found too wide an abyss between Rossellino's certain works – executed, in any case, before the decoration of the

Cappella Grimani — and the Altar of St. Luke, and therefore rejected Sansovino's attribution.[10] Cicognara's objections convinced Selvatico, Zanotto, Mothes, and others.[11] Indeed, Mothes thought the author of the St. Luke Altar a Florentine-trained pupil of the Lombardi. In 1893 Paoletti dated the altarpiece around the beginning of the 16th century and assigned it to Lorenzo Bregno.[12] His view was accepted almost universally.[13] Even Ruhmer, who gave the left-hand *Angel* to Antonio Lombardo and its mate to Tullio (ca. 1484–8), did not dispute Paoletti's attribution of St. Luke.[14]

Amid so many works by Lorenzo Bregno erroneously claimed for one or another of the Lombardo, the Altar of St. Luke stands alone as the only work by the Lombardo and their shop credited to Bregno. St. Luke's stance and drapery closely resemble that of the woman on the far right in Antonio Lombardo's *Miracle of the Speaking Babe* in the Santo (Figs. 21, 65). The *Saint's* hair and facial type recur identically in the Lombardo school *St. Peter Martyr* from the High Altar of S. Giustina, ascribed by Sansovino to Antonio and Paolo Stella Milanese[15] (Figs. 66, 67). Though *St. Luke* testifies to collaboration in its later stages — hands are particularly weak and the folds of cuffs atypical — it is superior to standard Lombardo shop work. That the statue is unfinished is surely relevant. *St. Luke's* left foot is not fully excavated from the block; neither his sandals nor the sides of his head are completely worked and only the most cursory incisions in his beard suggest the course of locks. It would appear, therefore, that the work was abandoned by Antonio and continued, but never entirely finished, by an assistant.

The *Angels*, by contrast, are more closely linked to Tullio's sculpture. The hair of the *Angel* on the right, in facture and composition, matches that of a youth in Tullio Lombardo's *Miracle of the Repentant Youth* in the Santo (Figs. 70–72). The drapery of chitons, articulated by the long, parallel arcs of cordlike folds, regularly spaced, that do not interrupt the even contours, is typical of Tullio (Figs. 68, 69). Yet schemata imposed on folds are inordinately simple and repetitive, while flesh lacks that subtlety of modullation we expect of Tullio. Since the *Angels'* proportions, anatomy, and poses leave little to desire, I conjecture that figures designed and possibly begun by Tullio were left to an assistant for completion. I perceive no differences between the *Angels* that would warrant attribution to different hands.

The documented works by Antonio and Tullio Lombardo, which the figures from the Altar of St. Luke approach most closely, date from the first lustrum of the 16th century. Perhaps St. Luke's unfinished state is due to its having been commenced not long before Antonio's departure for Ferrara in mid-1506.[16]

In 1893 Paoletti observed that the architectural framework of the altar had been altered. (Indeed, the shafts of the pilasters framing *St. Luke* are truncated below.) Paoletti thought that the changes might have been made when the juspatronage of the chapel passed to Pietro Grimani.[17] But the plaster keystones and shells of the *Angels'* niches suggest, rather, an 18th-century reconstruction. Elements from the Cinquecento framework, retained when the altar was remodeled, show Lombardesque ornament: these include the base, which runs beneath lateral niches and pilasters, and the pedestals and pilasters flanking *St. Luke*. Their idiosyncratic capitals, with a narrow band of fluting beneath an egg-and-dart molding and volutes, recur in the Tabernacles for the Host in S. Maria dei Miracoli.

[1] Cicogna, vi, pt. 1, 1853, pp. 530, 533f, 728–32, doc. 5.

[2] Sanuto, (1493) 1980, p. 226.

[3] Franzoi/Di Stefano, 1975, pp. 109f.

[4] Cicogna, vi, pt. 1, 1853, p. 604, no. 35, referring to ASV, Conventi religiosi soppressi, S. Giobbe, Busta 8, "Stampa al taglio," 1770, p. 2.

[5] Cicogna, vi, pt. 1, 1853, pp. 603f, no. 35.

[6] For the history of the relic and the controversy surrounding it, see Sanuto, RIS, xxii, (1490–1530) 1733, coll. 1176f; Cavacio, 1606, pp. 230–49; Corner, 1749, xii, pp. 90–2; Cicogna, vi, pt. 1, 1853, pp. 534f; Wadding, xiii, ³1932, pp. 312–22; Sartori/Luisetto, 1988, pt. 2, pp. 1660–1707, nos. 3–73. In 1986 the remains were taken to the Palazzo Patriarcale.

[7] Sans., 1581, p. 57r.

[8] Martinelli, 1684, p. 271; Pacifico, 1697, p. 329; [Albrizzi], 1740, p. 174; Moschini, 1815, ii, pt. 1, p. 65; E. Paoletti, iii, 1840, p. 40; Zanotto, in Ven. e le sue lagune, 1847, ii, pt. 2, pp. 166f.

[9] Bottari, in Vasari/Bottari, i, (1568) 1759, "Giunta alle note," p. 40, voce "Ant. e Bern. Rossellino."

[10] Cicognara, ii, 1816, pp. 76f.

[11] Selvatico, 1847, pp. 235f; Selvatico/Lazari, 1852, p. 161; Zanotto, 1856, p. 338, n. 3; Mothes, ii, 1860, pp. 32f, 80; Fulin/Molmenti, 1881, p. 267.

[12] Paoletti, 1893, ii, pp. 201f, 274; idem, T-B, iv, 1910, p. 570, voce "Bregno, L."

[13] Biscaro, Arch. ven., ser. 2, xviii, pt. 1, 1899, p. 196; Lorenzetti, 1926, pp. 425f; idem, Enc. ital., vii, 1930, p. 793, voce "Bregno"; Mariacher, Arte ven., 1949, p. 96; Muraro, 1953, p. 248; Vazzoler, 1962/63, pp. 214, 227; Finotto, 1971, pp. 48f; Mariacher, DBI, 1972, xiv,

p. 115, voce "Bregno, L."; McAndrew, 1980, p. 50; Viroli, in *Il mon.*, 1989, p. 63.

[14] Ruhmer, *Arte ven.*, 1974, pp. 53f.

[15] Sans., 1581, p. 12v.

[16] Antonio was settled in Ferrara by June 9, 1506: Sartori/Fillarini, 1976, p. 139.

[17] Paoletti, 1893, ii, p. 202; idem, T-B, iv, 1910, p. 570, voce "Bregno, L."

## 31. VENICE, SS. GIOVANNI E PAOLO: TOMB OF DIONIGI NALDI DA BRISIGHELLA
### ANTONIO MINELLO

Figs. 62, 63

The Tomb of Dionigi Naldi surrounds and surmounts the portal at the end of the right arm of the transept (*in cornu Epistolae*) in SS. Giovanni e Paolo.

The pedestrian effigy, base, and support are carved from a single block of highly compact, yellowish limestone. The columns appear to be made of Greek marble. The remainder of the tomb is Istrian limestone, including a reused piece with inscription on the left side of the sarcophagus.[1]

Effigy: 199.5 cm high (including its 11.6-cm-high base).

In the effigy the following elements were gilded: the figure's hair, beard, and mustache; in the jack, studs, belt, the border of the central vertical opening, and the neckband. The skirt of chain mail showed traces of an unidentifiable dark pigment; at the bottom, a border ca. 4 cm wide was originally gilded. At the rear of the statue, gilding was applied only to the hair.

The area around the effigy's left eye is badly nicked; a fairly large chip is missing from above the center of the eye. The figure's neck is scratched. The left sleeve is chipped in several places, especially near the elbow. In *Naldi's* left hand, the last two fingers in entirety, as well as most of the second and third fingers, and a bit of the hand itself, have broken off. The effigy has lost all the fingers of its upraised hand, along with whatever he was holding.[2] *Naldi's* sword breaks off neatly about 20 cm beyond the lower border of the hilt. The top of the hilt is chipped around its edge. The border of the skirt of chain mail is chipped in a few places, particularly at the rear. Nicks mar the surface of both legs. The upper edge of the base is chipped. Graffiti were scratched into the vertical face of the base, the tree stump, and the figure's left leg. At the rear of the figure, the jack with its studs, chain mail, and locks of hair are fully carved, but with less care than they are in front. By contrast, the rear of the base and the bottom of the tree stump are only roughhewn. At the center of the statue's back, just above its waist, is a hole for the clamp by means of which the figure is hooked to the central colonnette of the window.

The tomb was cleaned in 1986.[3]

The epitaph inscribed on the sarcophagus reads: IM-PERATOR · DVCTOR · EQVES · MILESQ · DIO-NYSII · NALDI · CONDVNTVR · / HIC · OSSA · HIC · IVNIOREM · FERDINANDVM · REGNO · A · GALLIS · PVLSVM · RES / TITVIT · FLORENT · REM · PEDITATVI · PRAEFEC · ORNAVIT · VENETI · DI / GNITATEM · IMPERII · SVSTINVIT · FIDE · AC · FORTITVDINE · INCOMPAR / · INTER · ALIOS · DVCES · PEDIT · PRAEFECTVS · PATAVIVM · SER-VAVIT · / MORIENS · EX · NIMIIS · VIGILIIS · HOC · VIRTVTIS · SVAE · PERPETVVM · / MONVMENTVM · CLARISSIMO · LAVREDANO · PRINC · EX · AMPLISS · / SENAT · AVCTORITATE · MERVIT · OBIIT · AETATIS · ANNO · XLV · M · D · X ·

In the cornice beneath the epitaph is the following inscription: DIVI GEMELLI · QVI · PRO · FIDE · ARMATI · REM · GESSISTIS · PROTEGITE · QVAE · ET HOC · OPERE · VOS · PIE · VENERATA · EST · VENET · R · P ·

Bibl.: Sanuto, *Diarii*, x, 1883, col. 839, July 24, 1510; ibid., xv, 1887, col. 90, Sept. 17, 1512; ibid., xix, 1887, col. 331, Dec. 24, 1514; ibid., xx, 1887, col. 67, Mar. 21, 1515; Sans., 1581, pp. 20rf; Garzoni, 1585, p. 696; Schrader, 1592, p. 297v; Moryson, (1594) 1907, i, p. 177; Henninges, 1598, iv, p. 1363; Onofri, 1655, p. 141; Tonduzzi, 1675, pp. 585f; Martinelli, 1684, pp. 141f; [Albrizzi], 1740, p. 146; Corner, 1749, vii, p. 275; Ven., Mus. Correr, MS Gradenigo 228/I, Gre-vembroch, i, 1754, c. 104; Ven., Mus. Correr, MS Gradenigo 200/XVI, *Commemoriali*, 18th cen., c. 111r; Ven., Bibl. Marc., MS it., Cl. VII, 167 ( = 8184), Gradenigo, 18th cen., i, c. 140r; [Giampiccoli], 1779, pp. 23f; Zucchini, i, 1785, pp. 381, 419; Maier, i, 1787, p. 108; Moschini, 1815, i, pt. 1, p. 142; Cicognara, ii, 1816, pp. 152f; Soravia, i, 1822, pp. 54f; [Quadri], 1835, pp. xi, 18, no. 9 and pl. VII; Zanotto, in Diedo/Zanotto, [1839], n.p., n.pl.; E. Paoletti, ii, 1839, p. 233; Zanotto, in *Ven. e le sue lagune*, 1847, ii, pt. 2, p. 97; Selvatico, 1847, p. 228; Selvatico/Lazari, 1852, p. 122; Burckhardt, 1855, p. 622d; Cappelletti, iv, 1855, p. 432; Zanotto, 1856, p. 288; Cicognara/Selva/Diedo, 1858, pl. 47; Moroni, xci, 1858, p. 139, voce "Venezia";

Mothes, ii, 1860, p. 153; Perkins, 1868, p. 209; Metelli, 1869, pt. 1, ii, p. 30; Fapanni, *Bull. di arti*, 1880, p. 84; Paoletti, 1893, ii, p. 274; idem, T-B, iv, 1910, p. 570, voce "Bregno, L."; Rambaldi, 1913, pp. 21, 43; Zauli-Naldi, 1925, pp. 94–6; Lorenzetti, 1926, p. 329; idem, *Enc. ital.*, vii, 1930, p. 793, voce "Bregno"; Mariacher, *Arte ven.*, 1949, p. 97; Muraro, 1953, p. 239; Caccin, 1959, p. 31; Vazzoler, 1962/63, pp. 161, 235f; Zava Boccazzi, 1965, pp. 176–80; Munman, 1968, pp. 298, 302, 303–6, 307f, 311, n. 13; Mariacher, *DBI*, xiv, 1972, p. 114, voce "Bregno, L."; Cetti, 1973, p. 130; idem, *Arte cristiana*, 1982, p. 35; Puppi, in *La grande vetrata*, 1982, pp. 31–4; Romano, in ibid., p. 66; Hale, in Mallett/Hale, 1984, pp. 292f; Schulz, *BJ*, 1984, p. 151; Puppi, 1985, pp. 25–31; "Attività," *Arte ven.*, 1986, p. 314; Sandro Sponza, in "Restauri," *Quaderni della Sopr. Ven.*, 1986, p. 62; Wolters, in Huse/Wolters, 1986, p. 184; Schulz, *Flor. Mitt.*, 1987, pp. 300–326; Lippini, [1989], p. 32.

Dionigi di Giovanni Naldi was born in 1465 in Brisighella, south of Faenza. In the mid-1490s, he served Ferdinand II of Naples against the French. In 1495 he assisted Ottaviano di Carlo Manfredi, supported by the Florentines, in Ottaviano's abortive attempt to regain Faenza. In 1500 Dionigi subdued Brisighella in the name of Duke Valentino Borgia.[4] A captain of infantry, Dionigi entered Venetian employ in 1504.[5] Under Bartolomeo d'Alviano, he and his troops fought at Agnadello on May 14, 1509 against the army of the League of Cambrai.[6] On May 17, 1509, the Senate placed Naldi in charge of all infantry.[7] Naldi reconquered Castelfranco from Spanish forces[8] and, in November 1509, helped retake Vicenza.[9] Garrisoned at Padua with his 800 troops, Dionigi died of a fever, brought on by exhaustion, a couple of hours after midnight on July 24, 1510. News of the *condottiere*'s death reached Venice later the same day. The *Collegio* determined that Naldi's body be brought from Padua and placed in a coffin in SS. Giovanni e Paolo. Ser Giorgio Emo, who had arranged the funeral of the late *Capitano Generale*, Nicolò Orsini, Count of Pitigliano (d. Jan. 26, 1510 [10]), was ordered to arrange similar exequies for Naldi. Emo had Naldi's coffin, draped with black velvet, set up in SS. Giovanni e Paolo, near that of Nicolò Orsini; beneath Naldi's coffin was an epitaph whose text was later incoporated in his tomb. But because of the extraordinary heat and fear of epidemic, a funeral was not held.[11] The Council of Ten granted Dionigi's widow 100 ducats from income from possessions confiscated from Paduan rebels.[12]

On July 31, 1512, the Council of Ten with its Giunta decided that there be erected in SS. Giovanni e Paolo three tombs in honor of Orsini, Naldi, and Fra Leonardo da Prato, leader of Venice's light cavalry, who had died in the field toward the end of March 1511.[13] The exiguous sum of three hundred ducats was allocated to the tombs; two of the three heads of the Council of Ten were to attend to the matter. In payment for the tomb sites, the council moved that the friars of SS. Giovanni e Paolo be given the gold and velvet cloths then covering the caskets of Orsini and Naldi respectively, in order to make two vestments.[14] On August 19, 1512, the friars of SS. Giovanni e Paolo granted Giorgio Emo's petition to be allowed to erect three tombs in the church in honor of Orsini, Naldi, and Fra Leonardo; Emo was permitted to choose the tombs' sites.[15] Thus it would appear that Emo had charge of the project. From Sanuto we learn that Fra Leonardo's coffin, draped in black velvet, was set up in SS. Giovanni e Paolo ca. September 17, 1512, on the opposite side of the church from the coffin of Nicolò Orsini.[16] Work of construction was under way on January 5, 1513, when, at Emo's instance, the convent ceded four marble columns for the (unnamed) tomb then being built.[17] Describing indulgences granted SS. Giovanni e Paolo by Pope Leo X, Sanuto reported on December 24, 1514, that the Tombs of the Count of Pitigliano and of Fra Leonardo da Prato had been erected on either side of the choir, and that the Tomb of Dionigi Naldi was being made over the door.[18] Naldi's tomb was still not finished on March 21, 1515, when Sanuto included, among the works undertaken by Giorgio Emo for the embellishment of SS. Giovanni e Paolo (whose procurator he had become at the end of 1513[19]), the construction of the portal in the choir, above which Naldi's tomb was to be installed. Until some of the tombs outside were removed, on which work had begun that very day, the portal could not be breached. Nor was the great stained-glass window behind Naldi's effigy, which Emo intended to have completed, quite finished.[20] There is no reason to suppose that work on the window, portal, and tomb was greatly protracted after this.[21]

The epitaphs of Naldi's tomb and coffin make clear that monument and lying-in-state were accorded the *condottiere* by a grateful Senate for the loyalty and fortitude with which he had served at Padua.[22] Indeed, Naldi's tomb and lying-in-state were clearly part of a programmatic effort by the Senate and Council of Ten to remember and honor, publicly and permanently, those *condottieri* who had died in Venetian service at the siege of Padua.[23] But the chief motive of this display – one that had a greater weight even than gratitude – was the desire of the Venetian *Signoria* to ensure the allegiance of future mercenary

replacements, at a moment of critical vulnerability, by its public reward of those who had already fallen.[24] No doubt, it was because doges were buried in such numbers in SS. Giovanni e Paolo that that basilica was chosen as the site of the *condottieri's* tombs. (Indeed, Orsini's catafalque imitated ducal catafalques.[25]) And though not as prestigious as the *cappella maggiore*, the arms of the transept provided more honorific sites than the nave. Perhaps such consequential sites were intended to compensate for the tombs themselves. For, made chiefly of limestone including *spolia*, with little decorative carving and limited incrustation composed mostly of small, miscellaneous slabs, with equestrian figures of wood, and backgrounds formed by the stuccoed wall of the church, the monuments bear witness to the fact that the Council of Ten allocated to the tombs a sum better suited to tomb slabs.[26] Even the sites cost the government nothing. That these are probably the cheapest tombs for their size in 16th-century Venice is a measure, not of the state's illiberality, but rather of the poverty to which the burdens of the War of the League of Cambrai had reduced the Venetian fisc.

Despite the identity of patron, purpose, and date of the Naldi, Orsini, and Leonardo da Prato Tombs, only two of the three are related to one another and these, only loosely. The monuments to Orsini and Leonardo da Prato occupy corresponding positions in opposite arms of the transept; both contain wooden equestrian portraits.[27] In both, horse and rider are framed by one bay of an arcade. To be sure, an equestrian portrait would hardly have suited a captain of infantry. Nonetheless, by placing the pedestrian *Effigy of Naldi* over a portal and in front of a window, Giorgio Emo precluded any visual accommodation between the structure of the Naldi Tomb, on the one hand, and that of the Orsini and Fra Leonardo Tombs, on the other. Indeed, the difference in design of the three monuments may have been intended as an acknowledgment of the individual contributions of the three to the achievement of a common goal.

Naldi's effigy was conditioned by a long-standing tradition of pedestrian effigies in armor, in Venetian tombs of generals and *condottieri*. The earliest example

is that of Vittor Pisani (d. 1380) in SS. Giovanni e Paolo (originally in S. Antonio di Castello). After a lapse of nearly a century, the type reappeared in the Tomb of the *condottiere* Cristoforo da Tolentino (d. 1462), formerly in S. Margherita, Treviso, in the Tomb of Doge Pietro Mocenigo (d. 1476) in SS. Giovanni e Paolo and in the Tombs of Jacopo Marcello (d. 1484), Melchiore Trevisan (d. 1500), and Benedetto Pesaro (d. 1503), all in S. Maria dei Frari. To the definition of the type, figures of guardian *Warriors* on tombs, like Antonio Rizzo's left-hand *Warrior* from the Tomb of Doge Nicolò Tron (d. 1473) in S. Maria dei Frari, no doubt, contributed. The *Effigy of Dionigi Naldi*, in turn, evidently inspired Lorenzo Bregno's *Effigy of Bartolino Terni* in S. Trinità, Crema, which matches the former, not only in gesture and, to a lesser degree, in pose, but also in accoutrements. Like the Naldi Tomb, both the Tomb of Vittore Cappello (d. 1467), S. Elena, Venice, and the Tomb of Benedetto Pesaro incorporated a portal within the structure of the tomb by means of freestanding or engaged columns on high pedestals flanking the opening, above which a projecting lintel, resting on the columns, supported tomb chest and effigy. But the Naldi Tomb is unique in its lack of a frame enclosing the effigy.

The style of their architecture and figures persuades me that the author of all three tombs (with the exception of wooden equestrian portraits) was Antonio Minello.[28] On two counts Minello was a logical choice. Not only was he a native Paduan, but, to judge from comparative rates of pay for the reliefs of the Santo and the low esteem in which Minello was held by its stewards, we may surmise that he was content with a very low fee or perhaps none at all.[29] Despite their common authorship, however, the three tombs have enjoyed very different critical fortunes: until recently, the Tomb of Dionigi Naldi alone was almost unanimously assigned to Lorenzo Bregno on the basis of Sansovino's testimony of 1581.[30] In 1984 I argued that the inferior quality of the effigy belied its attribution to Lorenzo Bregno.[31] Newly made photographs of Bregno's *Bartolino Terni* now prove how very different an authentic effigy is (Pl. 241, Fig. 62).

---

[1] Information kindly supplied by the restorer Dott.ssa Giovanna Bortolaso, who examined the tomb in 1986.

[2] This was probably a lance, the weapon carried by Naldi's troops. It was already missing by 1754: Venice, Mus. Correr, MS Gradenigo 228/I, Grevembroch, i, 1754, c. 104.

[3] "Attività," *Arte ven.*, 1986, p. 314.

[4] Venice, Bibl. Marc., MS it., Cl. VII, 167 ( = 8184), Gradenigo, 18th cen., i, c. 141vf; Zanotto in Diedo/Zanotto, [1839], n.p.

[5] Mallett, in Mallett/Hale, 1984, p. 197.

[6] Porto/Bressan, 1857, p. 41, letter 8; Romanin, v, ³1973, p. 149.

[7] Zauli-Naldi, 1925, pp. 91–3.

[8] Venice, Bibl. Marc., MS it., Cl. VII, 167 ( = 8184), Gradenigo, 18th cen., i, cc. 140vf; Zanotto in Diedo/Zanotto, [1839], n.p.

[9] Porto/Bressan, 1857, p. 143, letter 36.

[10] Sanuto, *Diarii*, ix, 1883, coll. 491, 496, Jan. 27, 1510.

[11] Ibid., x, 1883, col. 802, July 17, 1510; coll. 809, 811, July 18, 1510; col. 815, July 19, 1510; col. 819, July 21, 1510; col. 826, July 22, 1510; col. 834, July 23, 1510; col. 839, July 24, 1510.

[12] Bonardi, in Venice, Dep. ven. di stor. pat., *Misc.*, ser. 2, viii, 1902, pp. 419f.

[13] Sanuto, *Diarii*, xii, 1886, coll. 85f, Mar. 27, 1511.

[14] ASV, Consiglio dei X, Misto, Registro 35 (1512–13), c. 70v, published by Schulz, *Flor. Mitt*, 1987, pp. 322f, n. 66. This decision superseded one passed by the Senate on Apr. 12, 1511, according to which a tomb, costing between 150 and 200 ducats, was to be built for Leonardo da Prato in whichever convent church his relatives should choose. See ASV, Senato, Deliberazioni Secrete, Registro 44 (1511–12), c. 7v, published by Schulz, *Flor. Mitt.*, 1987, p. 322, n. 64, and Sanuto, *Diarii*, xii, 1886, col. 114, Apr. 12, 1511.

[15] ASV, Conventi religiosi soppressi, SS. Giovanni e Paolo, Serie registri XI, filza C, c. 61v, for which, see Puppi, in *La grande vetrata*, 1982, p. 30, repr. in idem, 1985, p. 25, with the incorrect date of August 17.

[16] Sanuto, *Diarii*, xv, 1887, col. 90, Sept. 17, 1512.

[17] ASV, Conventi religiosi soppressi, SS. Giovanni e Paolo, Serie registri XI, filza C, c. 64v, for which, see Puppi in *La grande vetrata*, 1982, p. 31, repr. in idem, 1985, p. 26. Apparently only two columns were actually used – those flanking the portal in the Tomb of Dionigi Naldi.

[18] Sanuto, *Diarii*, xix, 1887, col. 331, Dec. 24, 1514.

[19] Puppi, in *La grande vetrata*, 1982, p. 24, repr. in idem, 1985, p. 16.

[20] Sanuto, *Diarii*, xx, 1887, col. 67, Mar. 21, 1515.

[21] Puppi, in *La grande vetrata*, 1982, p. 34, repr. in idem, 1985, pp. 30f.

[22] For the epitaph of Naldi's coffin, see Sanuto, *Diarii*, x, 1883, col. 839, July 24, 1510.

[23] Ibid., xix, 1887, col. 331, Dec. 24, 1514: "In la qual è stà fata in choro l'arca marmorea dil conte di Pitiano fo capitanio zeneral nostro da una banda, da l'altra di domino frate Leonardo da Prato governador di cavalli lizieri, e sora la porta si fa di Dyonisio di Naldo di Brixighella capitanio nostro di le fantarie; tutti tre fidelissimi et stati in la obsidion di Padoa."

[24] Indeed, the preamble to the Council of Ten's decision to erect the three tombs justifies the motion thus: "et dar causa a' li altri che serveno di exponer la vita sua a' beneficio & commodo de la signoria nostra." (ASV, Consiglio dei X, Misto, Registro 35 [1512–13], c. 70v, published by Schulz, *Flor. Mitt.*, 1987, p. 322, n. 66.)

[25] Sanuto, *Diarii*, ix, 1883, col. 502, Jan. 31, 1510.

[26] Schulz, *Flor. Mitt.*, 1987, pp. 304f.

[27] The equestrian portrait of Orsini, which dates only from 1726, replaced an earlier one: see Venice, Bibl. Marc., MS it., Cl. VII, 323, ( = 8646), *Cronaca veneta*, 16th cen., c. 232v, and Venice, Mus. Correr, MS Gradenigo 228/III, Grevembroch, iii, 1759, c. 56.

[28] See Schulz, *Flor. Mitt.*, 1987, pp. 312–19, where this attribution is argued *in extenso*.

[29] Ibid., p. 319.

[30] Sans., 1581, p. 20r: "Di sopra alla porta per fianco dalla parte dove è l'Orsino, si vede la statua pedestre di Dionisio Naldo da Brisighella, scolpita da Lorenzo Bregno, & posta per ordine del Senato."

Sansovino's attribution was repeated by: Garzoni, 1585, p. 696; Martinelli, 1684, p. 141; Venice, Mus. Correr, MS Gradenigo 228/I, Grevembroch, i, 1754, c. 104; Venice, Bibl. Marc., MS it., Cl. VII, 167 ( = 8184), Gradenigo, 18th cen., i, c. 140r; Zucchini, i, 1785, p. 381; Moschini, 1815, i, pt. 1, p. 142; Cicognara, ii, 1816, pp. 152f; Soravia, i, 1822, p. 54; [Quadri], 1835, p. xi, no. 9; Zanotto in Diedo/Zanotto, [1839], n.p.; E. Paoletti, ii, 1839, p. 233; Selvatico, 1847, p. 228; Zanotto, in *Ven. e le sue lagune*, 1847, ii, pt. 2, p. 97; Selvatico/Lazari, 1852, p. 122; Burckhardt, 1855, p. 622d; Zanotto, 1856, p. 288; Moroni, xci, 1858, p. 139, voce "Venezia"; Mothes, ii, 1860, p. 153; Perkins, 1868, p. 209; Metelli, 1869, pt. 1, ii, p. 30; Fapanni, *Bull. di arti*, 1880, p. 84; Fulin/Molmenti, 1881, pp. 221f; Merzario, 1893, ii, pp. 24f; Paoletti, 1893, ii, p. 274; idem, T-B, iv, 1910, p. 570, voce "Bregno, L."; Rambaldi, 1913, p. 21; Zauli-Naldi, 1925, p. 95; Lorenzetti, 1926, p. 329; idem, *Enc. ital.*, vii, 1930, p. 793, voce "Bregno"; Mariacher, *Arte ven.*, 1949, p. 97; Muraro, 1953, p. 239; Caccin, 1959, p. 31; Vazzoler, 1962/63, pp. 161, 235; Zava Boccazzi, 1965, pp. 176, 179; Munman, 1968, pp. 298, 302, 303–6, 307f; Mariacher, *DBI*, xiv, 1972, p. 114, voce "Bregno, L."; Cetti, 1973, p. 130; idem, *Arte cristiana*, 1982, p. 35; Puppi, in *La grande vetrata*, 1982, p. 31, repr. in idem, 1985, p. 26; Sandro Sponza, in "Restauri," *Quaderni della Sopr. Ven.*, 1986, p. 62; Lippini, [1989], p. 32.

[31] Schulz, *BJ*, 1984, p. 151.

## 32. VENICE, S. MARIA DEI FRARI: TOMB OF MELCHIORE TREVISAN
### VENETIAN SCHOOL, BEGINNING OF THE SIXTEENTH CENTURY

Figs. 73–75

The Tomb of Melchiore Trevisan is elevated on the right wall of the Chapel of St. Michael, the second chapel to the left of the *cappella maggiore* (*in cornu Evangelii*) in S. Maria dei Frari.

The tomb is made mostly of white marble. The *tondo* at the bottom of the tomb is porphyry; the *tondo* supported by the *putti* is gray-spotted red marble. The rectangular areas on the either side of the epitaph, the triangular areas on either side of the *putti*, the two intervals between the feet of the sarcophagus, the two rectangular plaques on the front and one on either side of the sarcophagus, and the frieze of the *Effigy*'s pedestal are incrusted with slabs of black-veined white marble. *Pages*, their bases and supports, are carved from single blocks of white marble. The pedestrian *Effigy* together with its base is carved from

a single block of white marble. The figure's helmet is metal. The background of the tomb is frescoed.

Tomb overall: 575 cm high × 290 cm wide;[1] *Effigy*: 191 cm high (including its helmet; excluding its base); left *Page*: 113 cm high (including its base); right *Page*: 114.5 cm high (including its base); left flying *putto*: 55.5 cm wide; right flying *putto*: 52 cm wide.

Throughout, fillets, raised borders, and relief ornament are gilded. The incised letters of the epitaph are painted black. In the relief with flying *putti*, the following elements are gilded: wings and hair, the ribbon, the flat border of the field, and the fluted border of the disc. The acanthus leaf and wings at the top of the feet of the sarcophagus and fillets in its cornice are gilded. In the *Effigy* the following elements are gilded: the edges of the plate armor, the studs of sollerets, jambs, and poleyns, the straps of jambs at the back of the thighs, the bottom edge of the chain mail, the borders and straps of the avambraces, the stippled bands on the chest, the scalloped border at armholes and neck, the discs of the pallettes, the medal, the helmet, and portions of the sword – the border of the pommel, the band wound around the hilt, all of the cross guard and whatever remains of the blade. The cylinder, which the figure's right hand grips, is painted red. In both *Pages* the following elements are gilded: hair, the borders of the cuirass, the straps of sleeves and skirt in their entirety, laces and boots but not their flaps, the truncated ends of branches of the tree stumps, the background of the shield hung from the tree stump. In addition, the medallion of the right *Page* possesses a black ground and a gilded rim, lion, and book.

Behind *Trevisan*'s torso and the lower half of his head, the wall is hollowed out to permit insertion of the figure. The banner, which Grevembroch depicted[2] and which was threaded through the cylinder in the effigy's right hand, is missing. The inner, lower edge of the cylinder is broken off. The left elbow down to the bottom of the couter is composed of a separate piece of stone, the top of which is clamped to the upper arm, while the bottom is fixed with mortar. The top of the left couter is chipped. Where it joins the hand, the left little finger is fissured and repaired with mortar. The left strap holding the sword, just below the figure's waist, is chipped, as is the edge of the disc on the figure's left pallette. The metal blade of the sword is broken off at its commencement. In the rear, the statue is almost completely smoothed;

only toward the bottom of the skirt of taces do marks of a point remain. However, links of chain mail were omitted in the rear.

The nose of the left-hand *Page* is badly chipped. The figure's left forearm is cracked through; the two pieces were reattached with iron clamps and the crack was filled with mortar. There are further cracks in the left wrist and the first joint of the thumb; a continuous crack runs through the first joint of the next three fingers. The cracks in the thumb and first knuckle of the last finger have been repaired with mortar. The tip of the left index finger is chipped. The figure's right forearm is also cracked; the two pieces were reattached with iron clamps. There are multiple cracks at the wrist. Half of the right index finger has broken off. The medallion is a replacement; it is fixed to the hands with mortar.[3] The right foot is cracked at the ankle. A long fissure runs through the tree stump, across the left foot at the level of the ankle, down the outside of the foot, and through the base. The inside of the *Page*'s right hand and the top of the figure's head were not entirely finished. At the rear, the form was carefully blocked out with a point; the hair was completely finished but details of costume were omitted. The right *Page* is in much better condition. The separate piece from which most of its left thumb was carved, however, is missing.

The epitaph is inscribed: MELCHIORI TRIVISIANO QVI. FERDI(nandi). R(egis). / CLASSEM VENETO SINVDEPVLIT. CVM / CAROLO. FR(atre). R (egis). AD TARR(um). PROSPERE CO / NFLIXIT. CREMONAM VENETO ADIVNX / IT IMPERIO. III. MARIS. IMPERAT(or). OBIIT. / M. D. FILII PIEN. POSVE(runt)

Bibl.: Sans., 1581, p. 67v; Schrader, 1592, p. 303r; Superbi, 1629, ii, pp. 71f; Onofri, 1655, p. 176; Martinelli, 1684, p. 336; Coronelli, [ca. 1710], "Depositi," n.p.; [Albrizzi], 1740, p. 211; Venice, Mus. Correr, MS Gradenigo 228/III, Grevembroch, iii, 1759, c. 74; Moschini, 1815, ii, pt. 1, p. 187; Cicognara, in Cicognara et al., ii, 1820, [pp. 74r–75r]; Soravia, ii, 1823, pp. 106f; Zenier, 1825, p. 6; Zanotto, in Diedo/Zanotto, [1839], n.p., n. pl.; E. Paoletti, iii, 1840, pp. 93f; Selvatico, 1847, p. 229, n. 1, p. 244f; Zanotto, in *Ven. e le sue lagune*, 1847, ii, pt. 2, p. 126; Selvatico/Lazari, 1852, p. 179; Burckhardt, 1855, p. 628a; Zanotto, 1856, p. 466; Cicognara/Selva/Diedo, 1858, pl. 86; Mothes, ii, 1860, p. 157; Lübke, 1863, p. 510; Fulin/Molmenti, 1881, pp. 291f; Paoletti, 1893, ii, pp. 145, 202, 274; Burckhardt/Bode/Fabriczy, [7]1898, ii, pt. 1, p. 125d; Venturi, vi, 1908, p. 1092; Paoletti, T-B, iv, 1910, p. 570, voce "Bregno, L."; Berti, [1916], pl. 8; Schubring, 1919, p. 248; Lorenzetti, 1926, pp. 555f; Fogolari, 1931, p. opp. pl. 26; Mariacher, *Arte ven.*, 1949, p. 96; Sartori, 1949, p. 82; Muraro, 1953, pp. 281f; Vazzoler, 1962/63, pp. 160, 219–21; Zava Boccazzi, 1965, p. 179; Hubala, in Egg et al., 1965, p. 825; Munman,

1968, pp. 294f, 302–6, 301f, n. 13; Mariacher, *DBI*, xiv, 1972, p. 114,
voce "Bregno, L.", Marini, 1979, p. 25; Sartori/Luisetto, 1986, pt. 2,
p. 1980, no. 147; Wolters, in Huse/Wolters, 1986, pp. 165, 183;
Mariacher, 1987, p. 232, voce "Bregno," Viroli, in *Il mon.*, 1989, p. 63.

A member of the Venetian patriciate, Melchiore
di Paolo Trevisan was admitted to the *Maggior Con-
siglio* in 1451.[4] An inscription in the pilaster of the
Trevisan Chapel in S. Maria dei Frari records that,
when Trevisan commanded the galleys of Romania
(1479), he received at Constantinople a relic of
Christ's blood in the Magdalene's unguent. Upon his
return to Venice, Trevisan gave it to the convent of
the Frari. In gratitude, on April 14, 1480 the friars
ceded to Trevisan and his descendants the Chapel
of St. Michael Archangel, the second chapel to the
left of the basilica's choir. By 1488 a tabernacle for
the relic by Tullio Lombardo had been erected; it is
now in the church's sacristy.[5] But the epitaph of Trev-
isan's tomb commemorates him, not as benefactor to
the Frari, but rather as military leader: as *Capitano
generale* following the death of Jacopo Marcello in
1484, in command of the Venetian fleet arrayed off
Puglia against King Ferdinand of Naples;[6] as *Provve-
ditore generale* of Venetian troops at the rout of Charles
VIII, King of France, on July 6, 1495, at Fornovo on
the River Taro;[7] as *Provveditore generale* in Lombardy
from October 9, 1498, when Cremona was ceded to
Venice by the king of France as a condition of the
treaty of April 15, 1499;[8] as leader of the Venetian
fleet from September 15, 1499, succeeding Antonio
Grimani, in the war against the Turks.[9] It was in this
office that Trevisan died at Cephalonia (Kefallinia)
on July 17, 1500.[10] His body did not arrive in Venice
until October; his funeral was held in S. Maria dei
Frari on October 21, 1500.[11] The epitaph gives credit
for construction of the tomb to Trevisan's sons. These
were Vincenzo and Marino, whose names were for-
merly inscribed in the second step leading to the
altar of the Trevisan Chapel.[12]

No documents or early sources provide evidence
of authorship or date for the Trevisan Tomb. Yet no
one has ever doubted that the monument was made
shortly after the captain died – a date to which its
style points. Indeed, Vincenzo and Marino Trevisan's
dedication of the chapel as a place of burial for them-
selves and their descendants in 1500, which the in-
scription on the altar step recorded, might well have

coincided with the erection of their father's tomb.
By contrast, the tomb's paternity has been disputed.
In 1820, Cicognara tentatively proposed an attribu-
tion to the apparently mythical Antonio Dentone,
by false analogy with the Tomb of Vittore Cappello
at S. Elena, then ascribed to the undocumented sculp-
tor.[13] This attribution was unqualifiedly endorsed by
Zanotto, so far as it applied to the effigy and *Pages*;
flying *putti*, however, he held to be the product of a
different hand.[14] Burckhardt ascribed the effigy to
Dentone, the *Pages* to his shop.[15] Selvatico, on the
other hand, explicitly rejected the attribution of
the Trevisan Tomb to Dentone,[16] while major 19th-
century guidebooks, including Zanotto's, gave the
tomb to an anonymous Lombardesque sculptor.[17] In
1860, Mothes hypothetically advanced the name of
Lorenzo Bregno.[18] Espoused by Paoletti, this attri-
bution has had considerable success.[19] Fabriczy, Ven-
turi, Schubring, and Muraro assigned the tomb to the
Lombardo or their shop.[20]

Comparison with autograph works disproves Lo-
renzo Bregno's authorship of the Trevisan Tomb: dif-
ferences are so obvious that it is unnecessary to de-
scribe them. Nor can any of the Lombardo have been
responsible for the tomb. In fact, I cannot name its
author: in the history of Venetian sculptured por-
traiture the physiognomy of *Trevisan* is unique.

The use of a pedestrian effigy for the tomb of a
*condottiere* or civilian commander was traditional in
Venetian funerary sculpture. (For a discussion of its
origins and development, see Catalogue no. 31.)
Young *Pages* supporting shields with the arms of the
defunct often flank the standing effigy. Suffice it to
mention the Tombs of Doge Pietro Mocenigo (d.
1476) in SS. Giovanni e Paolo, of Giovanni Emo (d.
1483), formerly in S. Maria dei Servi, of Jacopo Mar-
cello (d. 1484) in S. Maria dei Frari, and of Agostino
Onigo (d. 1490) in S. Nicolò, Treviso. For the first
time, however, Trevisan's *Pages* wear Roman armor.
And rather than support the shield – here suspended
from truncated limbs of tree stumps – the *Pages* dis-
play roundels with the lion of St. Mark. Roman garb
and roundels were taken over in almost identical form
for the *Pages* of the Cenotaph of Alvise Pasqualigo,
erected between 1523 and 1530, also in the Frari. In
its architectonic form, as well, the Pasqualigo Ceno-
taph derives most directly from the Tomb of
Trevisan.

---

[1] Sartori/Luisetto, 1986, pt. 2, p. 1980, no. 147.

[2] Venice, Mus. Correr, MS Gradenigo 228/III, Grevembroch, iii,
1759, c. 74.

[3] Arms were already damaged in 1820; in the engraving subscribed
"Chevalir dis./Dolcetti inc." in Cicognara et al., ii, 1820, [p. 75r], the
arms of the left-hand *Page* end in stumps just before the wrists.

[4] Vienna, Oesterr. Natbibl., MS 6156, Barbaro, 1538, ii, c. 399v.

[5] Sabellico, (1491–2), [p. 12]. For Trevisan's gift of the relic and the concession of the chapel, see Corner, 1749, vi, pp. 282–4.

[6] Malipiero, Arch. stor. ital., vii, pt. 1, 1843, p. 295.

[7] Romanin, v, ³1973, p. 57.

[8] Sanuto, Diarii, ii, 1879, col. 24, Oct. 9, 1498; Romanin, v, ³1973, p. 78.

[9] Sanuto, Diarii, ii, 1879, col. 1305, Sept. 15, 1499; Malipiero, Arch. stor. ital., vii, pt. 1, 1843, pp. 180, 181; Romanin, v, ³1973, p. 100; Lane, in Ren. Venice, ed. Hale, 1973, pp. 162f.

[10] Soravia, ii, 1823, p. 107; Kretschmayr, ii, 1964, p. 413.

[11] Sanuto, Diarii, iii, 1880, col. 953, Oct. 21, 1500.

[12] The inscription, transcribed by Soravia, ii, 1823, p. 108 read: VINCENTIVS . ET MARINVS . TRIVISANI . MELCHIORIS . F . SIBI . ET POSTERIS, M. D. The inscription no longer exists, having been removed in February 1824 when the chapel was rededicated to St. Thomas: Venice, Mus. Correr, MS Cicogna 2009, Cicogna, 19th cen., no. 10, "Note alle inscrizioni nella Chiesa di S. Maria . . . dei Frari," c. 28v, no. 31.

[13] Cicognara et al., ii, 1820, [pp. 74rf].

[14] Zanotto, in Zanotto/Diedo, [1839], n.p.

[15] Burckhardt, 1855, p. 628a.

[16] Selvatico, 1847, p. 229, n.1, pp. 244f.

[17] Selvatico/Lazari, 1852, p. 179; Zanotto, 1856, p. 466; Fulin/Molmenti, 1881, pp. 291f. See also, Sartori/Luisetto, 1986, pt. 2, p. 1980, no. 147.

[18] Mothes, ii, 1860, p. 157.

[19] Paoletti, 1893, ii, p. 274; idem, T-B, iv, 1910, p. 570, voce "Bregno, L."; Berti, [1916], pl. 8; Lorenzetti, 1926, pp. 555f (with a question mark); Mariacher, Arte ven., 1949, p. 96; Sartori, 1949, p. 82; Vazzoler, 1962/63, pp. 160, 219f; Zava Boccazzi, 1965, p. 179; Hubala, in Egg et al., 1965, p. 825; Munman, 1968, pp. 294 f, 302–6; Mariacher, DBI, xiv, 1972, p. 114, voce "Bregno, L."; idem, 1987, p. 232, voce "Bregno"; Viroli, in Il mon., 1989, p. 63.

[20] Burckhardt/Bode/Fabriczy, ⁷1898, ii, pt. 1, p. 125; Venturi, vi, 1908, pp. 1091f; Schubring, 1919, p. 248; Muraro, 1953, pp. 281f.

## 33. VENICE, S. MARIA MATER DOMINI: TREVISAN ALTAR
### ANTONIO MINELLO AND ANONYMOUS SCULPTORS

Figs. 76–81, 83, 84

The Trevisan Altar occupies the first bay of the right aisle (in cornu Epistolae) in S. Maria Mater Domini.

The freestanding statuette of St. Andrew, together with its base and that part of the cross contained between the tip of the figure's right thumb and third finger, are carved from a single block of purplish marble; the remainder of St. Andrew's cross is composed of a second piece of lighter gray marble. Behind St. Andrew, the niche consists of five separate pieces of white or black-veined, white marble – one for the floor, two for the walls, and two for the cornice, whose right upper corner is pieced. In contradistinction to St. Andrew, SS. Peter and Paul are high reliefs. The white marble slab from which the relief of St. Peter was carved includes the background to the level of the architrave, but makes a dog's leg in front of the figure's feet. The rest of the floor is composed of a second piece of marble neatly inserted. The entablature of the Saint's niche is carved from a third piece. The white marble slab from which the relief of St. Paul is carved includes all of the entablature above the niche. Here, too, another piece of marble was inserted to complete the floor. The blade of the Saint's sword is wood. The central part of the lunette with a relief of the Trinity is carved from a separate slab of gray marble. The coffered barrel vault is composed of a further slab of black-veined, white marble.

The architectural framework of the altar is richly incrusted. In the pediment the black disc is flanked by jasper triangles. The upper frieze, as well as the triangles of the spandrels, seem to be verd antique. The frieze of that portion of the entablature supported by columns and pilasters and the shafts of the columns are black-veined, white marble. Incorporated in the altar's base are pieces of porphyry, serpentine, verd antique and a mustard-colored stone. At the center of the base, the Trevisan arms are worked in gray, black, golden, and speckled orange stones. The rest of the architectural framework is composed of Istrian limestone.

St. Andrew: 114.5 cm high (including its 8.3-cm-high base); St. Peter: 106.5 cm high; St. Paul: 105 cm high.

The following elements are gilded: the Trinity's halo; the wings and hair of the cherubim; the rosettes and borders of coffers in the vault, and the capitals (where all traces of gilding seem to have disappeared in the recent cleaning). The blade of St. Paul's sword is painted to simulate marble.

The lower part of St. Andrew's cross is attached to the figure with a metal clamp. At their juncture the edges of upper and lower parts of the cross are very neat,

as though the cross were originally pieced, but the upper piece is skewed in relation to the lower. The front upper corner of the *Saint*'s book is chipped. The stone is badly fissured at the bottom of the *Saint*'s cloak on the spectator's left. There are two chips in the base at the spectator's left. *St. Peter* shows nicks in the surface of his right index finger and a few small chips in the edge of his mantle and the hem of his tunic. The upper left corner of his book is chipped. The stone from which the skirt of his tunic is carved, shows several fissures. The original blade of *St. Paul*'s sword is lost and the upper front cover of his book is chipped.

The architectural framework is chipped and cracked in many places. The entablature and outer wall of the niche of *St. Peter* is badly fissured. Everywhere pieces are ill-joined. The seam between the relief with the *Trinity* and the entablature beneath is filled with a particularly wide stratum of mortar.

Bibl.: Sans., 1581, p. 75r; Martinelli, 1684, p. 306; Pacifico, 1697, pp. 391f; [Albrizzi], 1740, p. 221; Ven., Bibl. Marc., MS it., Cl. VII, 18 (= 8307), Cappellari Vivaro, 18th cen., iv, c. 130v; Gradenigo/ Livan, (1748–74) 1942, pp. 74f, July 24, 1761; Maier, i, ²1795, pp. 419f; Moschini, 1815, ii, pp. 136f; Cicognara, 1816, ii, p. 152; E. Paoletti, iii, 1840, p. 177; Selvatico, 1847, p. 228; Zanotto, in *Ven. e le sue lagune*, 1847, ii, pt. 2, p. 191; Selvatico/Lazari, 1852, p. 195; Zanotto, 1856, p. 385; Moroni, xci, 1858, p. 45, voce "Venezia"; Pietrucci, 1858, p. 191, voce "Minello de Bardi, A."; Perkins, 1868, p. 209; Fulin/Mol- menti, 1881, p. 311; Bianchini, 1893, p. 13; Paoletti, 1893, ii, p. 116, doc. 106, pp. 202, 257, 275; Biscaro, *Gazz. di Treviso*, May 7–8, 1898, [p. 3], repr. in idem, 1910, p. 11; idem, *Arch. ven.*, ser. 2, xviii, pt. 1, 1899, p. 196; Burckhardt/Bode/Fabriczy, ⁸1901, ii, pt. 2, p. 499h; eidem, ⁹1904, ii, pt. 2, p. 506m; Fabriczy, *JpK*, 1907, p. 85; Moschetti, T-B, ii, 1908, pp. 485f, voce "Bardi, Ant."; Burckhardt/Bode/Fabriczy, ¹⁰1910, ii, pt. 2, pp. 512n, 538c; Paoletti, T-B, iv, 1910, p. 570, voce "Bregno, L."; Lorenzetti, 1926, p. 445; Vardanega, *Rivista Mariana 'Mater Dei,'* May–June 1929, pp. 53f; Lorenzetti, *Enc. ital.*, vii, 1930, p. 793, voce "Bregno"; Carpi, *Padova*, Jan.–Apr. 1931, p. 10; Venturi, x, pt. 1, 1935, p. 411; Mariacher, *Arte ven.*, 1949, p. 96; Pope-Hennessy, *BM*, 1952, p. 27; Muraro, 1953, p. 268; Tramontin, 1962, p. 37; Vazzoler, 1962/63, pp. 156, 214, 247, 257, 260, 273f; London, Vic- toria & Albert Mus. Cat. by Pope-Hennessy/Lightbown, 1964, ii, p. 510; Hubala, in Egg et al., 1965, p. 905; Munman, 1968, pp. 303, 309, n. 4; Sheard, 1971, p. 262; Mariacher, *DBI*, xiv, 1972, p. 115, voce "Bregno, L."; Sartori/Fillarini, 1976, p. 163; Radcliffe, in London, Royal Acc., *Genius of Venice*, 1983, p. 367; Schulz, *BJ*, 1984, pp. 147, 149, 150; Mariacher, 1987, pp. 52, 66, 232, voce "Bregno"; Viroli, in *Il mon.*, 1989, p. 63.

The tomb slab at the foot of the Altar of SS. Andrew, Peter, and Paul in the Venetian parish Church of S. Maria Mater Domini was dedicated by Paolo di Andrea Trevisan to his deceased two-year-old son, Andrea, his six-year-old daughter, Elena, and

Anna, his wife of thirteen years.[1] Paolo was son of Andrea di Paolo Trevisan and father of Gio- vanni Trevisan, Patriarch of Venice from 1559. In 1477, Paolo was admitted to the *Maggior Consiglio*.[2] His marriage to Anna di Giovanni Emo took place in 1501.[3] Trevisan was castellan at Nauplia (Návplion) in the Morea between 1501 and 1503, at the fortress of Legnago in 1509, and at Cividale di Belluno in 1511.[4] On December 21, 1516, he was elected one of the six Ducal Councillors.[5] In 1520, Trevisan be- came *Provveditore sopra le fabbriche di Rialto*, a post he held for many years.[6] Between 1521 and 1533, Tre- visan frequently served monthly terms as one of the three heads of the Council of Ten.[7] Trevisan was elected *Podestà* of Padua on December 20, 1528[8] and *Provveditore sopra la fabbrica del Palazzo Ducale* in 1533.[9] He died the following year and was buried in S. Maria Mater Domini.[10]

Construction of the present Church of S. Maria Mater Domini began in 1504: on March 16 and 17, 1504, S. Maria Mater Domini celebrated a jubilee granted by Pope Julius II "per compir la chiesia ch'è ruinata."[11] No doubt the church was finished by the time the Filomato Altar with Vincenzo Catena's *Martyrdom of S. Cristina* was incised with the year 1520.[12] I suspect that the precise dates of the church's construction are to be deduced from a record that the 28 biannual interest payments made by the *Monte Vecchio*, intended for the purchase of an annual Christ- mas candle, were not withdrawn from March 1504 through September 1518;[13] probably there was no use for such a candle because work of construction prevented Christmas services from being held in the church. S. Maria Mater Domini was consecrated on July 25, 1540.[14]

The Trevisan Altar was commissioned before Lo- renzo Bregno's death at the end of 1523 or the be- ginning of 1524. On January 4, 1524, Lorenzo's widow, Maddalena, sold Antonio Minello the con- tents of Lorenzo's shop for 126 ducats, on condition, among other things, that Minello repay Paolo di An- drea Trevisan the 25 ducats that Lorenzo had re- ceived from him.[15] In a financial reckoning on August 20, 1526, Minello and his partner, the Paduan gold- smith Bartolomeo Stampa, listed a payment of 217 lire (35 ducats) to one of them – presumably Minello – from messer Trevisan for an altarpiece, which was being made for him.[16] That the sale agreement of 1524 required Minello to return the money advanced for the altarpiece implies that Bregno had not begun to carve it before he died: if Bregno had begun it,

presumably Minello would have been obliged to finish it, as he was the *Madonna* of Montagnana. It would seem, however, that, rather than return the money, Minello renegotiated the contract with Trevisan, transferring the commission, along with the advance of 25 ducats to himself. By August 1526, Minello had received from his patron one payment of 35 ducats, raising Minello's debt to Trevisan to 60 ducats. By this time, work on the altar must have been well advanced, but evidently was not yet finished.

The framework of the Trevisan Altar matches that of the Contarini Altar with Francesco Bissolo's *Transfiguration*, located directly opposite in the church's left aisle; it is not known which precedes the other or whether both were made concurrently.[17] In any case, by the 1520s, the form was standard for Venetian altar frames. In the early 19th century, the figure on the left of the Trevisan Altar held the keys of St. Peter[18] – that saint with whom St. Paul is generally paired. Although the attribute – of iron – apparently was not original, it was probably correct.

In 1581, Sansovino reported that Lorenzo Bregno had carved the three figures of the Trevisan Altar, but that Antonio Minello had finished them.[19] Sansovino's attribution has rarely been challanged.[20] Lorenzetti specifically assigned *SS. Peter* and *Paul* to Bregno, *St. Andrew* to Minello.[21] Mariacher, followed by Vazzoler, claimed that, if the ensemble of the

altarpiece was not complete at Bregno's death, the sculptor certainly had finished the three *Saints*, as well as *God the Father* in the lunette.[22]

In my opinion, *St. Peter* in its entirety and *St. Paul*, with the exception of its hair, are by Antonio Minello. In pose, facial type, and beard, *St. Paul* is a debased, but otherwise faithful, replica of the figure to the spectator's right of the armor-clad man in Minello's documented Santo relief of the *Investiture of St. Anthony* (Figs. 84, 85). *St. Peter* is analogous in style to *St. Paul*. (Figs 80); his face, sparse beard, and mustache, although not finished, look very like those in Minello's inscribed *Mercury* in the Victoria and Albert Museum, London (Figs. 81, 82). *St. Andrew*, however, differs from both lateral figures not only in material and technique – it is carved in the round rather than in high relief (Figs. 77, 78). In its greater massiveness, in the more decisive twist of its head, in the freer excavation of the block visible above all in the extremities of limbs, its author displays a bolder temperament. Facial type and beard find no analogies in Minello's work. Hair, bored through repeatedly with a large-gauge drill, consists of spiky, tousled locks; for so idiosyncratic a treatment, I know no parallels at all, except the hair of *St. Paul* (Figs. 78, 84). The relief of the *Trinity* in the guise of God the Father is not by Minello or his collaborator (Fig. 83). Its exceedingly crude seams suggest a later addition.

---

[1] ANDREAE · TRIVISANO · FILIO · ET/ HELENAE · FILAE · ILLI · BIMO · HVIC/ SEXENNI · VTRISQ(ue) ACERBE · DEFVNCTIS/ ET · ANNAE · VXORI · INCOMPARABILI/ CVM · QVA · IVCVNDISS · VIXIT · ANN · XIII/ PAVLVS · TRIVISAN · ANDREAE · F(ilius) · ET · SIBI/ ET · POSTERIS · VVLT · FIERI.

[2] ASV, Misc. Cod. I, Stor. ven. 23, Barbaro, 1733–43, vii, c. 114, voce "Trevisan A."

[3] ASV, Avogaria di Comun, Registro 106/ 1, *Cronaca matrimoni*, i, c. 132v and Registro 107/ 2, *Cronaca matrimoni*, ii, c. 319r.

[4] Sanuto, *Diarii*, iii, 1880, coll. 1625f, Mar. 29, 1501, ibid., v, 1881, col. 360, Nov. 21, 1503; ibid., viii, 1882, col. 137, Apr. 27, 1509; ibid., xiii, 1886, col. 279, Nov. 30, 1511.

[5] Ibid., xxiii, 1888, coll. 354, 355, Dec. 21, 1516.

[6] Ibid., xxviii, 1890, col. 243, Feb. 8, 1520; ibid., xxxvi, 1893, col. 389, June 5, 1524.

[7] Ibid., xxxi, 1891, col. 116, July 30, 1521; ibid., xxxiv, 1892, col. 116, Apr. 29, 1523 and col. 338, July 31, 1523; ibid., xxxvii, 1893, col. 118, Oct. 31, 1524 and col. 649, Feb. 25, 1525; ibid., xxxviii, 1893, col. 7, Mar. 1, 1525, and col. 380, May 31, 1525; ibid., xxxix, 1894, col. 5, June 1, 1525, and col. 371, August 31, 1525; ibid., xliv, 1895, col. 169, Feb 27, 1527; ibid., xlv, 1896, col. 225, May 31, 1527, and col. 561, July 31, 1527; ibid., lvii, 1902, col. 474, Jan. 30, 1533; ibid., lviii, 1903, col. 238, May 31, 1533, and col. 513, Aug. 1, 1533.

[8] Ibid., xlix, 1897, col. 262, Dec. 20, 1528.

[9] Ibid., lviii, 1903, col. 175, May 17, 1533.

[10] ASV, Misc. Cod. I, Stor. ven. 23, Barbaro, 1733–43, vii, c. 114, voce "Trevisan, A."

[11] Sanuto, *Diarii*, v, 1881, col. 1000, Mar. 16, 1504.

[12] The year 1512, widely accepted for another altar in S. Maria Mater Domini – the Contarini Altar – and therefore adopted as a *terminus ante quem* for the completion of the church, in fact, is very insecurely founded on Sans., 1581, p. 74v: "In questo Tempio [S.Maria Mater Domini] la palla dell'altare di Hieronimo Contarini Dottor che visse l'anno 1512. fu di mano di Francesco Bissuola."

[13] Ven., Mus. Correr, MS Cicogna 1654, Pallazzi et al., 1664–1776, c. 29v: "Notta, che si deve scuoder ducato uno d'oro lasciata dalla quondam Signora Vielma d'Elia per illuminar il corpus Domini nella Chiesa di Santa Maria Mater Domini; come appar nel testamento della suddetta sotto li 16 Maggio 1389. Pagava la Commessaria d'Ultra, ed essendo andata deffetiva, comparve sotto il 1603. 21 Decembre il Piovano pro tempore dimandando d'esser risarcito, e fu giudicato à suo favore, ut infra-

Comparse inanzi l'Illustrissimi Signori Procuratori il Reverendo Piovan di Santa Maria Mater Domini, esponendo, che attrovandosi beneficiata dalla Comisaria di Madonna Vielma d'Elia d'uno dopiero ogni anno da natale di ducati uno d'oro per levar, et illuminar il corpus Domini nella sua Chiesa l'entrata della qual Comisaria è fondata sopra il Sestier di S. Polo monte Vecchio; ne havendo li suoi Piovani antecesori ricercato tal Elemosina dalla paga Marzo 1504 fina Settembre

1518 inclusive, che sono paghe no. 28 ne' quello pagato per essa procuratia; però richiede che sue Signorie Illustrissime cometano farli sodisfar tal legato . . ."

14 Paoletti, 1893, ii, p. 257; Tramontin, 1962, pp. 18, 19f.

15 See Appendix A, Doc. XIX, A.

16 Sartori/Fillarini, 1976, p. 163.

17 See above n. 12.

18 Moschini, 1815, ii, pt. 1, pp. 136f.

19 Sans., 1581, p. 75r: "Lorenzo Bregno scolpì tre figure di tutto tondo, & le finì Antonio Minello, nella palla della famiglia Trivisana, fatta gia da Paolo padre di Giovanni Patriarca di Venetia."

20 It was repeated by: Pacifico, 1697, pp. 391f; [Albrizzi], 1740, p. 221; Moschini, 1815, ii, pt. 1, p. 136; E. Paoletti, iii, 1840, p. 177; Selvatico, 1847, p. 228; Zanotto, in Ven. e le sue lagune, 1847, ii, pt. 2, p. 191; Selvatico/Lazari, 1852, p. 195; Zanotto, 1856, p. 385; Moroni, xci, 1858, p. 45, voce "Venezia"; Pietrucci, 1858, p. 191, voce "Minello de Bardi, A."; Fulin/Molmenti, 1881, p. 311; Paoletti, 1893, ii, pp. 202, 257, 275; Bianchini, 1893, p. 13; Burckhardt/Bode/Fabriczy,

9 1904, ii, pt. 2, p. 506m; Fabriczy, JpK, 1907, p. 85; Moschetti, T-B, ii, 1908, pp. 485f, voce "Bardi, Ant."; Paoletti, T-B, iv, 1910, p. 570, voce "Bregno, L."; Vardanega, Rivista Mariana 'Mater Dei,' May–June 1929, p. 53; Carpi, Padova, Jan.–Apr. 1931, p. 10; Venturi, x, pt. 1, 1935, p. 411; Pope-Hennessy, BM, 1952, p. 27; Tramontin, 1962, p. 37; London, Victoria & Albert Mus. Cat. by Pope-Hennessy/Lightbown, 1964, ii, p. 510; Munnman, 1968, p. 309, n. 4; Sheard, 1971, p. 262; Radcliffe, in London, Royal Acc., Genius of Venice, 1983 p. 367; Mariacher, 1987, p. 66. The omission of Minello's name from discussions of the Trevisan Altar by Cicognara, ii, 1816, p. 152, and Perkins, 1868, p. 209, clearly reflects inattention, rather than a judgment regarding the work's authorship.

21 Lorenzetti, 1926, p. 445, followed by Muraro, 1953, p. 268. Hubala, in Egg et al., 1965, p. 905, gave the central statue to Bregno and Minello and St. Andrew to Minello alone, not realizing that the two statues were one and the same.

22 Mariacher, Arte ven., 1949, p. 96; idem, DBI, xiv, 1972, p. 115, voce "Bregno, L."; Vazzoler, 1962/63, pp. 156, 214, 273f.

## 34. VIENNA, DESTERREICHISCHES MUSEUM FUER ANGEWANDTE KUNST: EFFIGY OF BISHOP LORENZO GABRIEL VENETIAN SCHOOL (?), EARLY SIXTEENTH CENTURY

Figs. 86, 88

The Effigy of Bishop Lorenzo Gabriel, along with the architectural member supporting it, is exhibited in a ground-floor hall of the Oesterreichisches Museum für angewandte Kunst, Vienna (Inv. no. Pl. 278). The rest of the tomb has disappeared.

The effigy, cushions, and bier cloth are carved from a single block of white marble. The member on which the effigy rests contains incrustations of darker and lighter gray and white breccia. Moldings are Istrian limestone.

Effigy: 207 cm wide × 34.5 cm deep.

There are no traces of polychromy or gilding.

The Effigy of Lorenzo Gabriel is poorly preserved. Most of the figure's nose, including its tip, and most of its nostrils, are restored. The surface of the face is nicked; the right cheekbone is pitted. There is a chip in the upper contour of the left little finger, where it joins the hand. Large chips are missing from the foremost border of the chasuble; smaller chips are missing from every one of the garments' borders. The edge of the bier cloth is chipped nearly throughout. The tassle of the cushion beneath the statue's foot has broken off. The marble is fissured in a great many

places. The paths of two fissures cross one another in the figure's forward leg. There are two fissures in the effigy's left forearm, and two in its left hand. A fissure runs from the left shoulder, down the chest to approximately the level of the abdomen. Folds are chipped along the course of this fissure. Another fissure descends from the left hand to the bottom of the chasuble. The stone at the rear of the effigy is barely dressed; even the farther ear is unfinished.

The epitaph read: HEUS BERGOMAS TUUM LAURENTIUM/ GABRIELEM REPOSCIS/ EXCUMBANS HIC SUM/ SAT CLYSMUM ANNIS TIBI TRIGINTA/ REDDIDI PONTIFICATUM/ NUNC VIRGINI FAMULARI PACIFICE CUPIO/ TE ROGO NE VEXES/ MDXII.[1]

Bibl.: Venice, Mus. Correr, MS Cicogna 1976, Luciani, 1521, cc. 106f, voce "Gabriel"; Sans., 1581, p. 23r; Schrader, 1592, p. 298v; Superbi, 1629, i, p. 136; Tagliapietra, 1646, p. 9; Venice, Bibl. Marc., MS lat., Cl. X, 144 (= 3657), Palferio, 17th cen., cc., 44rf; Martinelli, 1684, p. 157; [Albrizzi], 1740, pp. 136f; Corner, 1749, vii, p. 270; Venice, Mus. Correr, MS Gradenigo 201/I, Iscrizioni, 18th cen., c. 144r [c. 65]; Venice, Bibl. Marc., MS lat., Cl. XIV, 26 (= 4268), Inscriptiones, 18th cen., cc. 246f; Zucchini, i, 1785, pp. 402, 428; E. Paoletti, ii, 1839, p. 224; Venice, Mus. Correr, MS Cicogna 1874, Arrigoni, 19th cen., n.c., voce "Gabriel"; Venice, Mus. Correr, MS Cicogna 3006, Antiquaria, 19th cen., fasc. 3, c. gg; "Neue Ankäufe," Mitt. des k.k. Oesterreich. Mus. für Kst. u. Industrie, 1880–1, p. 476; Bołoz Antoniewicz, Prace Komisji Historii Sztuki, 1919, p. xxv; Hornung, PAU, Krakow. Spraw. z czynności i posiedzeń, 1935 (1936), p. 277, trans. in idem, PAU, Krakow. Bull. internat., 1935, p. 163, repr. in idem, Prace Komisji Historii Sztuki, 1937–8, p. 24*; Venice, Conv. di SS. Giovanni e Paolo, MS, Tapparini, 1936, c. 243, voce "Gabriel"; Hornung, in Księga . . . Pinińki, 1936, i, p. 394; idem, Rosprawy Komisji Historii Sztuki, i, 1949, p. 131; Zorzi, 1972, ii, p. 299; Mariacher, DBI, xiv, 1972, p. 115, voce "Bregno, L."; Schulz, BJ, 1984, pp. 151f.

Lorenzo Gabriel belonged to the Venetian patriciate. His father was Giacomo di Zaccaria da S. Polo; his mother, Maddalena, was daughter of Doge Pasquale Malipiero.[2] On October 15, 1484, Lorenzo Gabriel was named Bishop of Bergamo, succeeding Lodovico Donato; Gabriel retained the office until his death.[3] On August 5, 1508, Gabriel indited his testament at Rome, but made no provision for his burial. As residual heir he named his cousin's son, Marco di Zaccaria di Marco Gabriel.[4] Lorenzo died at Padua on July 5, 1512.[5]

On August 3, 1515, Lorenzo's brother, Zaccaria, obtained the juspatronage of the Cappella della Madonna della Pace, along with the right of construction and alteration in the chapel. The chapel belonged to the Dominican Convent of SS. Giovanni e Paolo and was located to the west of the church's cloister, near the site of the present pharmacy of the Ospedale Civile. Zaccaria endowed the chapel with 1,200 ducats, obligating the friars to celebrate two daily Masses and one anniversary Mass on July 1 in perpetuity for the souls of the late Lorenzo Gabriel and the deceased members of the Gabriel family.[6] No doubt, Lorenzo's tomb was erected only after the appropriation of the chapel to Gabriel. The tomb was finished by September 25, 1519, when Zaccaria Gabriel decreed by testament that he be buried "in la archa in santa maria della pase nel monestier di santi zuane et polo doue ho fato far una sepoltta in terra per mi et per queli vorano farse poner dentro sia [purchè siano] dela Casa da cha gabriel et quella [sepoltta] del Reverendissimo messer Lorenzo mio fradelo fo episcopo bergomazo."[7] From this passage we also learn that Zaccaria was responsible for construction of his brother's tomb.

Zaccaria Gabriel pursued a career in Venetian politics that materially benefited during the War of the League of Cambrai from money inherited from Lorenzo. In July 1499, Zaccaria was recorded as an official of the *Rason Vecchia*;[8] in January 1509, as a senator;[9] in December 1510, as *Governador de l'intrade*;[10] in August 1512, as one of the three *Capi* of the *Consiglio dei Dieci*.[11] On May 17, 1513, Gabriel was elected one of six Ducal Councillors.[12] On June 8, 1513, Sanuto reported that Zaccaria was being harassed by the nuncios of the current Bishop of Bergamo on account of money inherited from Lorenzo. The sum, we learn, was upward of 20,000 ducats, of which Zaccaria had lent the state 6,000. As security, he had been given silver belonging to the late Cardinal Zen.[13] On April 28, 1516, Zaccaria was chosen *Procuratore di S. Marco de ultra*, having promised, if elected, to lend the state 7,000 ducats.[14] On the following day, Gabriel delivered 1,000 ducats, but demanded that the state accept the Zen silver in lieu of the remaining 6,000 ducats.[15] Gabriel died on July 27, 1525 at the age of 85 and was buried two days later in his chapel at SS. Giovanni e Paolo.[16]

The Tomb of Lorenzo Gabriel was elevated on the right wall (*in cornu Epistolae*) of the Chapel of the Madonna della Pace. The tomb was incrusted with marbles of different colors. A carved effigy of the bishop rested on the cover; two small boys, presumably at either side, held coats of arms. Beneath the epitaph were insignia.[17] In the pavement at the center of the chapel was the Tomb Slab of Zaccaria Gabriel with arms but no epitaph.[18]

The Chapel of the Madonna della Pace was suppressed in 1810 and demolished a couple of years later.[19] In 1850 and 1861 the recumbent effigy was recorded in the workshop of the stonemason Resegati on the Rio Marin.[20] On September 5, 1881, the statue was acquired for the Oesterreichisches Museum für angewandte Kunst for 1,500 florins by U. Barizh.[21] The epitaph and *Pages* with shields are lost.

The attribution of the Gabriel Tomb to Lorenzo Bregno, adopted by the museum at Vienna, derives from Sansovino's guide of 1581.[22] No study of the effigy exists: indeed, most writers on Lorenzo Bregno were unaware of its survival.[23]

The *Effigy of Lorenzo Gabriel*, with raised torso and head resting on one hand – a conventional sign of melancholic meditation[24] – was the first of its type in Venice. The funerary *statue accoudée* had made its first appearance in Renaissance Italy not long before in Andrea Sansovino's Tomb of Cardinal Ascanio Sforza (d. 1505), completed by June 3, 1509, in S. Maria del Popolo, Rome. Andrea's Tomb of Cardinal Girolamo Basso della Rovere (d. 1507) in the same church, probably constructed concurrently and also finished by June 3, 1509, presents an effigy similar in all respects except that its head rests upon its forearm.[25] The effigy in the Tomb of Cardinal Pietro da Vicenza (d. 1504) in S. Maria in Aracoeli, Rome, from the Sansovino shop, was based on the *Effigy of Ascanio Sforza*; doubtless this example, too, antedates the Gabriel Tomb. Sansovino's reclining figures were derived from the effigies on Etruscan and Roman sarcophagi; reclining effigies in Spanish tombs of the last quarter of the 15th century may have aroused the sculptor's interest in the motif.[26] The influence of Sansovino's monuments to cardinals accounts for the frequent association in northern and central Italy of the accumbent effigy with tombs of prelates.

The reclining effigy was introduced to northern Italy in Bartolommeo Spani's Tomb of Bishop Buonfrancesco Arlotti (d. 1508) in the Duomo at Reggio Emilia[27] and in the Tomb of Bassiano da Ponte in the Duomo, Lodi, attributed to Andrea Fusina and dated by inscription to 1510.[28] The author of the *Effigy of Lorenzo Gabriel* probably knew neither these nor their Roman precedents, where poses of accumbent figures respond to the unequal distribution of weight no less than do the poses of contemporary standing figures: *Lorenzo Gabriel*, by contrast, is as rigid as a conventional recumbent effigy. But there does exist an effigy nearly identical in pose to the *Effigy of Lorenzo Gabriel* – the *statue accoudée* from Andrea Fusina's Tomb of Battista Bagarotti (d. 1522), Bishop of Bobbio, from S. Maria della Pace, Milan, now in the Castello Sforzesco. (Figs. 86, 87). Its inscription informs us that the tomb was erected by the bishop himself in 1519.[29] Thus, it might be contemporaneous with, and, in any case, is not much later than, the *Effigy of Gabriel*. Which of the two tombs derives from the other cannot be determined; indeed, it is more likely that both derive from a common source, not yet identified.

Unusual, if not unique to the *Effigy of Lorenzo Gabriel* are the figure's opened eyes.[30]

The motif of the reclining effigy did not become popular in Venice until the end of the 16th century.[31] In the seventy years that succeeded construction of the Gabriel Tomb, only the Tomb of Bishop Jacopo Pesaro (d. 1547) in S. Maria dei Frari contains a *statue accoudée*. Nevertheless, the pose of *Lorenzo Gabriel* was adopted, virtually unchanged, in Jacopo Sansovino's 1527 effigy from the Tomb of Galese Nichesola, Bishop of Belluno (d. 1527) in the Cathedral at Verona.

Sansovino's attribution of the Gabriel Tomb to Lorenzo Bregno is confuted by the style of the effigy. The quality of its execution is vastly inferior to anything by the master. Nor does the effigy's design – its elongated proportions, its undifferentiated pose, its uniform contour, and emaciated face – find an analogue in any figure ever linked with either Bregno. Despite his idiosyncratic treatment of the flat surface, arbitrarily dented throughout, the author of the effigy is not identifiable in any other work.

[1] The epitaph no longer exists, but was transcribed by: Venice, Mus. Correr, MS Cicogna 1976, Luciani, 1521, c. 107; Tagliapietra, 1646, p. 9; Venice, Bibl. Marc., MS lat., Cl. X, 144 (= 3657), Palferio, 17th cen., cc. 44rf; Corner, 1749, vii, p. 270; Venice, Bibl. Marc., MS lat., Cl. XIV, 26 (= 4268), *Inscriptiones*, 18th cen., cc. 246f; Zucchini, i, 1785, p. 428; Venice, Mus. Correr, MS Cicogna 1874, Arrigoni, 19th cen., n.c., voce "Gabriel." The following transcriptions contain HUNC in place of NUNC: Sans., 1581, p. 23r; Schrader, 1592, p. 298v; Superbi, 1629, i, p. 136; Palferio, c. 44v, transcribed HUIC. Martinelli, 1684, p. 157, gave the year as 1516 instead of 1512.

[2] ASV, Misc. Cod., I, Stor. ven. 18, Barbaro, 1733–43, ii, c. 186, voce "Gabriel, A"; Venice, Conv. di SS. Giovanni e Paolo, MS, Tapparini, 1936, c. 243, voce "Gabriel."

[3] Gams, 1873, p. 778.

[4] ASV, Procuratori di S. Marco de ultra, Busta 139, fasc. XII, cc. 1r–1v, copied in Venice, Bibl. Marc., MS it., Cl. VII, 480 (= 7785), *Testamenti vari*, cc. 193rf. For the genealogy of Marco Gabriel, see ASV, Procuratori di S. Marco de ultra, Busta 139, fasc. XII, c. 7r, and ASV, Misc. Cod. I, Stor. ven. 18, Barbaro, 1733–43, ii, c. 186, voce "Gabriel, A."

[5] Sanuto, *Diarii*, xiv, 1886, col. 459, July 5, 1512.

[6] ASV, Conventi religiosi soppressi, SS. Giovanni e Paolo, Registro Testamenti 1234–1745, c. 71: "1515, 3 Agosto, Zaccaria Gabriel con Instrumento in atti del Reverendo Alessandro Facolni acquistata la Capella della Pace con Padronia e jus di fabbricare e mutare a sua piacimento diede a Padri per dote e per elemosina ducati 1200 – con obbligo di due Messe al giorno ed un Anniversario nel primo di Luglio in perpetuo in detta Capella per l'anima del quondam Lorenzo Gabriel, fù Vescovo di Bergamo, e de suoi Morti."

[7] ASV, Procuratori di S. Marco de ultra, Busta 139, fasc. XII, cc. 15rf. Neither the testator's codicil of May 25, 1523, nor that of Feb. 2, 1524 (ibid., cc. 17v–18r) mentions burial or tombs.

[8] Sanuto, *Diarii*, ii, 1879, col. 987, July 31, 1499.

[9] Ibid., vii, 1882, col. 735, Jan. 31, 1509.

[10] Ibid., xi, 1884, col. 700, Dec. 29, 1510.

[11] Ibid., xiv, 1886, col. 322, June 13, 1512; col. 527, July 31, 1512, and col. 538, Aug. 1, 1512.

[12] Ibid., xvi, 1887, col. 267, May 17, 1513, and col. 318, June 1, 1513.

[13] Ibid., xvi, 1887, col. 340, June 8, 1513, and col. 383, June 17, 1513.

[14] Ibid., xxii, 1887, coll. 169, 171f, Apr. 28, 1516.

[15] Ibid., xxii, 1887, col. 175, Apr. 29, 1516; col. 219, May 18, 1516, and coll. 231f, May 22, 1516.

[16] Ibid., xxxix, 1894, col. 249, July 28, 1525, and col. 260, July 29, 1525.

[17] Venice, Mus. Correr, MS. Cicogna 1976, Luciani, 1521, c. 106: "Sepultura Reverendissimi Domini Laurentii Gabriele episcopi Bergomasis est in dicta Capella ad murum parte sinistra pulcra equidem ornata figuris et lapidibus marmorinis diversi coloris cum episcopo sculpto super copertorio et duobus puerulis tenentibus insignia tali insuper insignito epitaphio," and Corner, 1749, vii, p. 270: "In Sacello Pacis ad dexteram parietem sublime visitur Laurentii Gabrielis Episcopi Bergomatis Sarcophagum." For Corner's use of left and right, which is that adopted in this book, cf. his location of the Grimani Chapel in S. Francesco della Vigna: ibid., viii, p. 22.

[18] Venice, Mus. Correr, MS Gradenigo 201/I, *Iscrizioni*, 18th cen., c. 144r [c. 65].

[19] Zorzi, 1972, ii, p. 299.

[20] Venice, Mus. Correr, MS Cicogna 1874, Arrigoni, 19th cen., n.c., voce "Gabriel," n. 1; Venice, Mus. Correr, MS Cicogna 3006, *Antiquaria*, 19th cen., fasc. 3, c. gg.

[21] Letter from Dr. Christian Witt-Döring, Vienna, July 12, 1982.

[22] Sans., 1581, p. 23r: "Presso poi alla scuola di san Marco, è situato un' altro Oratorio, dedicato alla famiglia Gabriella, & consacrato al nome della Beata Vergine della Pace. Vi sono figure di mano di Lorenzo Bregno, in memoria di Lorenzo Gabriello Vescovo di Bergamo, con queste parole . . ." Sansovino's attribution recurs in Zucchini, i, 1785, p. 402: "Neue Ankäufe," *Mitt. des k.k. Oesterr. Mus. für Kst. u. Industrie*, 1880–1, p. 476; Bołoz Antoniewicz, *Prace Komisji Historii Sztuki*, 1919, p. xxv; Hornung, PAU, Krakow. *Spraw. z czynności i posiedzeń*, 1935, p. 277, trans. in idem, PAU, Krakow. *Bull. internat.*, 1935 (1936), p. 163, repr. in idem, *Prace Komisji Historii Sztuki*, 1937–8, p. 24*; idem in *Księga . . . Pinińki*, 1936, i, p. 394.

[23] Paoletti, T-B, iv, 1910, pp. 570f, voce "Bregno, L."; Vazzoler, 1962/63; Munman, 1968; Zorzi, 1972, ii, p. 299; Mariacher, *DBI*, xiv, 1972, p. 115, voce "Bregno, L."

[24] Panofsky, [1964], p. 82.

[25] For the two tombs, see Pope-Hennessy, *Ital. High Ren. Sc.*, 1963, cat., pp. 47f.

[26] Panofsky, [1964], pp. 81–3. For the accumbent effigy in general, see s'Jacob, 1954, pp. 185–90, no. 54.

[27] First noted by Hornung, PAU, Krakow. *Spraw. z czynności i posiedzeń*, 1935, p. 277.

[28] For the tomb, see Caretta et al., 1966, pp. 120f.

[29] For the tomb, see Vigezzi, 1934, p. 181, no. 562, and Raponi, *DBI*, v, 1963, p. 169, voce, "Bagarotti, Batt." A fourth accumbent effigy, now lost, but known from a description and a sketch, also seems related to this group. It is Alfonso Lombardi's *Effigy of Galeazzo Bottrigari*, Bishop of Gaeta (d. 1518; tomb 1520–2), formerly in S. Francesco, Bologna, for which see Gramaccini, 1980, pp. 115–17, no. 15.

[30] The eyes of the *Effigy of Bassiano da Ponte* are half opened, but incised pupils and irises are lacking.

[31] E.g., Tomb of Caterina Cornaro (d. 1510), S. Salvatore, Venice; Tomb of Cardinals Marco, Francesco, and Andrea Cornaro, S. Salvatore; Tomb of Doge Pasquale Cicogna (d. 1595), Church of the Croceiferi, Venice; Tomb of Doge Marino Grimani (d. 1605) and Dogaressa Morosina Morosini, S. Giuseppe di Castello, Venice.

# Bibliography

## MANUSCRIPTS

Belluno, Biblioteca civica, MS 537, Francesco Alpago, *Dizionario delle cose bellunesi tratto dai libri delle provisioni del Consiglio* . . . , 1742–4, iii

Belluno, Biblioteca civica, MS 1099, Giuseppe Bucchi, *Dizionario storico bellunese*, 19th cen., iii

Budapest, Szépművészeti Múzeum, MS Budapest 10/3, P. Schubring, *Katalog der Bildwerke der italienischen Renaissance des Museums der Bildenden Künste*, 1913 (typescript)

Cesena, Biblioteca comunale, MS 164.31, Carl'Antonio Andreini, *Memorie di Cesena*, August 1, 1808–December 31, 1812, xii, 1808

Cesena, Biblioteca comunale, MS 164.33, Carl'Antonio Andreini, *Cesena sacra*, i, *Cattedrale*, 1807

Cesena, Biblioteca comunale, MS 164.33, Carl'Antonio Andreini, *Supplemento delle cose ommese in questa storia di Cesena sacra*, i, 1808; iii, 1810

Cesena, Biblioteca comunale, MS 164.45, Ettore Bucci, *Memorie ecclesiastiche de la citta di Cesena*, begun March 18, 1728

Cesena, Biblioteca comunale, MS 164.66, Niccolò Masini, "Vita di Domenico Malatesta," late 16th cen., in Giovanni Ceccaroni, *Raccolta di memorie cesenati: notizie delle famiglie principali e biografie degli uomini più illustri*, ii, cc. 1–180

Crema, Biblioteca comunale, MS 182.2, Giuseppe Racchetti, *Storia genealogica delle famiglie cremasche*, 1848–50

Crema, Biblioteca comunale, MS 193.2, *Rubrica de' testamenti rogati da notai cremaschi*, ii

Crema, Biblioteca del Seminario Vescovile, CR 7 ms, Bernardo Nicola Zucchi, *Alcune annotazioni di ciò che giornalmente è succeduto nella città e territorio di Crema incominciate a registrarsi l'anno 1710*, 1710–82, ii, 1737–45

Crema, S. Trinità, Archivio parrocchiale, MS, Cesare Franceschini, *Storia della parocchia*, 1871

Crema, S. Trinità, Archivio parrocchiale, MS, Angelo Zavaglio, *Storia della Chiesa e della Parocchia della SS. Trinità in Crema*, 1922

Montagnana, Archivio Casa Antonio Giacomelli, MS, Augusto Bazzoni, *Carte su Montagnana*, 1850–60, filza, "Montagnana, cenni storici, epoca moderna, Duomo"

Padua, Biblioteca civica, MS B. P. 324, [Andrea Cittadella, *Descrittione di Padoa e suo territorio con l'inventario ecclesiastico*, 1605

Padua, Biblioteca civica, MS B. P. 3202, Alfredo Manetti, *Territorio della diocesi di Padova*, 19th cen.

Treviso, Biblioteca capitolare, MS I/66, Antonio Scotti, *Tarvisinorum episcoporam series*, 18th cen.

Treviso, Biblioteca comunale, MS 643, Niccolò Cima, *Le tre faccie di Trivigi*, ii, 1695; iii, 1699

Treviso, Biblioteca comunale, MSS 1046A–1046B, Bartolommeo Burchelati, *Gli sconci, & diroccamenti di Trevigi, nel tempo di mia vita . . .*, 1630. Typed transcription by Giovanni Netto, 1964 (Treviso, Biblioteca comunale, Misc. 3886.26)

Treviso, Biblioteca comunale, MS 1089, Nicolò Mauro, *Genealogie trevigiane*, 16th cen.

Treviso, Biblioteca comunale, MS 1341, Nicolò Mauro, *Genealogie trevigiane*, 16th cen.

Treviso, Biblioteca comunale, MS 1355, Francesco Fapanni, *La città di Treviso esaminata nelle chiese, luoghi pubblici e privati, . . .*, i, 1891; ii, 1892; iii, 1892; iv, 1892

Treviso, Biblioteca comunale, MS 1356, Francesco Fapanni, *Sconvenienze e spropositi artistici, nonchè ammiglioramenti, osservati in molte chiese di campagna ed urbane, . . . nella Diocesi di Treviso*, 1851–90

Venice, Archivio di S. Maria Formosa, MS, Teodoro d'Amadeni, *Biologia S. Marinæ monachum indutæ virginis*. Venice, 1676

Venice, Archivio di Stato, Miscellanea Codici I, Storia veneta 17–23, Marco Barbaro, *Arbori de' patritii veneti*, 1733–43, 7 vols.

Venice, Biblioteca nazionale Marciana, MSS it., Cl. VII, 15–18 (= 8304–8307), Girolamo Alessandro Cappellari Vivaro, *Campidoglio veneto*, 18th cen., 4 vols.

Venice, Biblioteca nazionale Marciana, MS it., Cl. VII, 167 (= 8184), Pietro Gradenigo, *Memorie istoriche de' Generali da terra ch'erano al serviggio della Sereniss. Republica di Venezia*, 18th cen., i

Venice, Biblioteca nazionale Marciana, MS it., Cl. VII, 323 (= 8646), *Cronaca veneta sino al 1528*, 16th cen.

Venice, Biblioteca nazionale Marciana, MS it., Cl. VII, 480 (= 7785), *Testamenti vari*, collected by Pietro Gradenigo, 18th cen.

Venice, Biblioteca nazionale Marciana, MSS it., Cl. VII, 813–871 (= 8892–8950), *Raccolta dei Consegi*, 59 vols., 16th–18th cen.

Venice, Biblioteca nazionale Marciana, MS it., Cl. VII, 2283 (= 9121), Francesco Fapanni, *Chiese claustrali e Monasteri di Venezia*, 1884–9

Venice, Biblioteca nazionale Marciana, MS it., Cl. VII, 2289 (= 9125), Francesco Fapanni, *Marmi sparsi*, 1870–88,

Venice, Biblioteca nazionale Marciana, MS it., Cl. VII, 2398 (= 10527), Francesco Fapanni, *Memorie veneziane d'arte, di religione e di beneficenza*, late 19th cen.

Venice, Biblioteca nazionale Marciana, MS it., Cl.

Venice, Biblioteca nazionale Marciana, MS it., Cl. VII, 2510 (= 12215), Francesco Fapanni, *Chiese e conventi in Venezia e nelle isole, esistenti e demolite*, before 1889

Venice, Biblioteca nazionale Marciana, MS lat., Cl. X 144 (= 3657), Giangiorgio Palferio, *Memorabilia Venetiarum monumenta antiquis recentioribusque lapidibus insculpta*, 17th cen.

Venice, Biblioteca nazionale Marciana, MS lat., Cl. XIV, 26 (= 4268), *Inscriptiones sepulchrales Venetae*, 18th cen.

Venice, Convento di SS. Giovanni e Paolo, MS, Cesare Agostino Tapparini, *San Zanipolo a traverso la repubblica di Venezia. Iscrizioni lapidarie illustrate*, 1936

Venice, Museo civico Correr, MSS Cicogna 510–517, Marco Barbaro, *Discendenze patrizie*, 18th cen., 6 vols.

Venice, Museo civico Correr, MS Cicogna 1654, Giovanni Pallazzi et al., *Catastico di S.a M.a Mater Domini, anno 1664*, 1664–1776

Venice, Museo civico Correr, MS Cicogna 1874, Onorio Arrigoni, *Lapidi sepolcrali esistenti o che esistevano nella chiesa e chiostri dei SS. Giovanni e Paolo*, 19th cen.

Venice, Museo civico Correr, MS Cicogna 1976, Marcantonio Luciani, *Inscrizioni nella chiesa e monastero dei Santi Giovanni e Paolo di Venezia*, 1521, copied by Emmanuele Cicogna in 1828

Venice, Museo civico Correr, MSS Cicogna 2009–2010, Emmanuele Cicogna, *Inscrizioni veneziane nelle chiese e luoghi pubblici*, 19th cen.

Venice, Museo civico Correr, MS Cicogna 2331, *Famiglie venete*, 17th cen.

Venice, Museo civico Correr, MS Cicogna 3006, *Antiquaria e belle arti veneziane e forastiere*, 19th cen., fasc. 3

Venice, Museo civico Correr, MS Gradenigo 65, Johannes Grevembroch, *Varie venete curiosità sacre e profane*, i, 1755; ii, 1760; iii, 1764

Venice, Museo civico Correr, MS Gradenigo 179/I, *Monache*, 18th cen.

Venice, Museo civico Correr, MS Gradenigo 200, *Commemoriali*, 18th cen., xiii, xvi, xx

Venice, Museo civico Correr, MS Gradenigo 201, *Iscrizioni sepolcrali, ed altre, nelle chiese di Venezia*, i, Sestier di Castello; ii, Sestieri di S. Marco e Canalreggio, 18th cen.

Venice, Museo civico Correr, MS Gradenigo 228, Johannes Grevembroch, *Monumenta Veneta ex antiquis ruderibus*, i, 1754; ii, 1754; iii, 1759

Venice, Museo civico Correr, MS P.D. 2d, Antonio Vucetich, *Pietre e frammenti storici e artistici della città*

*di Venezia,* early 20th cen.

Vienna, Oesterreichische Nationalbibliothek, MSS 6155–6156, Marco Barbaro, *Famiglie nobili venete,* 1538, 2 vols.

## BOOKS AND ARTICLES

Agnoletti, Carlo. *Treviso e le sue pievi.* Treviso, i, 1897; ii, 1898

Agostini, Giovanni degli. *Notizie istorico-critiche intorno la vita, e le opere degli scrittori viniziani.* Venice, i, 1752; ii, 1754

Alberti, Leon Battista. *On Painting and On Sculpture,* ed. and trans. Cecil Grayson. London, (1435) 1972

Albertini, Francesco. *Memoriale di molte statue e pitture della città di Firenze,* (per nozze Mussini-Piaggio), ed. Gaetano Milanesi, Cesare Guasti, and Carlo Milanesi. Florence. (1510) 1863

Albrizzi, Giovanni Battista. *Forestiere illuminato intorno le cose più rare, e curiose, antiche, e moderne della città di Venezia, e dell'isole circonvicine.* Venice, 1740

Alvisi, Giuseppe. "Belluno e sua provincia," in *Grande illustrazione del Lombardo-Veneto,* ed. Cesare Cantù. Milan, ii, 1858 (1859), pp. 579–807

Amati, G. "Notizia di alcuni manoscritti dell'Archivio Secreto Vaticano," *Archivio storico italiano,* series 3, iii, pt. 1, 1866, pp. 166–236

Androsow, S. O. "Bemerkungen zu Kleinplastiken zweier Ausstellungen," *Acta historiae artium,* xxvi, 1980, pp. 143–157

"Appunti storici. La monumentale di S. Nicolò," *La vita del popolo* (Treviso), xxxi, no. 7, February 17, 1923, [p. 4]

Aretino, Pietro. *Lettere sull'arte,* ed. Ettore Camesasca, commentary by Fidenzio Pertile. Milan, ii, 1957

"Attività della Soprintendenza ai Beni Artistici e Storici di Venezia nel 1986," *Arte veneta,* xl, 1986, pp. 310–17

"Attività della Soprintendenza ai Beni Artistici e Storici di Venezia nel 1987," *Arte veneta,* xli, 1987, pp. 244–9

Avagnina Gostoli, Maria Elisa. "La cappella Malchiostro nel Duomo di Treviso: architettura e decorazione," in Treviso, Duomo. *Pordenone e Tiziano nella Cappella Malchiostro: problemi di restauro,* exhibition, October 23, 1982–January 31, 1983, (typescript)

Azzoni Avogari, Rambaldo degli. *Memorie del Beato Enrico . . . con una dissertazione sopra San Liberale e sopra gli altri santi.* Venice, 1760

Babelon, Ernest, and Blanchet, J.-Adrien. *Catalogue des bronzes antiques de la Bibliothèque Nationale.* Paris, 1895

Bagnoli, Leo. "La Cattedrale di Cesena: notizie storico-artistiche," Forlì, Camera di commercio, industria, agricoltura. *Bollettino mensile,* n.s. xv, no. 5, May 1961, pp. 38–48

[Bailo, Luigi]. *Guida della città di Treviso.* Treviso, 1872

Bailo, Luigi. "Cenni storici," *Bollettino del Museo Trivigiano,* no. 1, September 8, 1888, pp. 1–8

Bailo, Luigi. "La chiesa di S. Francesco. Lo strazio sotto il Governo Austriaco," *Gazzetta di Treviso,* xx, no. 119, May 2–3, 1905, [pp. 1–2]; xx, no. 122, May 5–6, 1905, [pp. 1–2]

Balogh, Jolán. Notice of E. Ybl in *A Szépművészeti Múzeum évkönyvei,* 1929, *L'arte,* xxxv, 1932, p. 80, no.40

Balogh, Jolán. "Die alten Bildwerke des Ungarischen Museums der Bildenden Künste," *Magyar Női Szemle* (Budapest), ii, 1936, pp. 197–206

Balogh, Jolán. "A Régi Szoborosztály," in *A Szépművészeti Múzeum 1906–1956,* ed. B. Bacher and Ö. G. Pogány. Budapest, 1956

Balogh, Jolán. *A Régi Szoborosztály kiállítása. Vezető.* Budapest, 1956

Barbarano de' Mironi, Francesco. *Historia ecclesiastica della città, territorio e diocese di Vicenza.* Vicenza, iv, 1760

Barozzi, Nicolò. "Presbiterio e Cappella Zen," in Ferdinando Ongania, pub., *La Basilica di San Marco in Venezia illustrata nei riguardi dell'arte e della storia da scrittori veneziani,* ed. Camillo Boito. Venice, vi, 1888, pt. 3 [1893], pp. 415–19

"Il bassorilievo . . . ," *Il Veneto cattolico* (Venice), xvii, no. 188, August 22, 1883, [p. 3]

"Un bassorilievo," *La Venezia, giornale politico-quotidiano,* x, no. 83, March 24, 1885, [p. 3]

Bazzocchi, Dino, and Galbucci, Piero. *Cesena nella storia.* Bologna, 1915

Beck, James H. "A Notice for the Early Career of Pietro Lombardi," *Mitteilungen des Kunsthistorischen Institutes in Florenz,* xiii, 1967–8, pp. 189–92

Bellieni, Andrea. "Treviso," in Antonio Barzaghi et al., *Treviso: guida ritratto di una provincia.* Padua, 1986, pp. 103–47

Beltrami, Giuseppe. "Il monumento sepolcrale di Sisto IV e sue vicende," Istituto di studi romani. *Atti del III Congresso nazionale di studi romani,* ed. C. Galassi Paluzzi. Bologna, 1935, ii, pp. 369–79

Beltramini, Guido. *Studi su Tullio Lombardo,* Tesi di laurea, Istituto universitario di architettura, Dipartimento di storia dell'architettura, Venice, 1989 (computer printout)

Benvenuti, Giacomo. *Il Tempio monumentale di S. Francesco d'Assisi in Treviso dei frati minori conventuali.* Assisi,

1930

Berchet, Federico. *IIIa relazione annuale (1895) dell'Ufficio regionale per la conservazione dei monumenti del Veneto.* Venice, 1896, "Contributo al catalogo generale," pp. 14–29

Berlin, Königliche Museen. *Die italienischen und spanischen Bildwerke der Renaissance und des Barocks in Marmor, Ton, Holz und Stuck,* catalogue by Frida Schottmüller. Berlin, 1913

Berlin, Kunstgeschichtliche Gesellschaft. *Ausstellung von Kunstwerken des Mittelalters und der Renaissance aus Berliner Privatbesitz,* May 20–June 25, 1898, catalogue. Berlin, n.d.

Berlin, Staatliche Museen, Kaiser-Friedrich-Museum. *Die italienischen und spanischen Bildwerke der Renaissance und des Barock, i. Die Bildwerke in Stein, Holz, Ton und Wachs,* catalogue by Frida Schottmüller. Berlin/Leipzig, ²1933

Bernardi, Jacopo. *La Scuola di S. Rocco, il suo ordinamento e i suoi monumenti; cenni storici.* Venice, 1885

Bernini, Giovanni Pietro. *Profilo storico di Bernardo Rossi vescovo di Treviso e Conte di Berceto, e Broccardo Malchiostro bercetano canonico di Treviso.* Parma, 1969

Berti, Giuseppe. *L'architettura e la scultura a Venezia attraverso i secoli. Il rinascimento.* Turin, [1916]

Bertolotti, Antonino. *Artisti in relazione coi Gonzaga signori di Mantova,* Modena, 1885 (extract from *Atti e memorie delle Deputazioni di storia patria per le Provincie Modenesi e Parmensi,* ser. 3, iii, pt. 1)

Bertolotti, Antonino. "Le arti minori alla corte di Mantova nei secoli xv, xvi e xvii," *Archivio storico lombardo,* ser. 2, v, 1888, pp. 259–318, 491–590, 980–1075

Beschi, Luigi. "Collezioni d'antichità a Venezia ai tempi di Tiziano," *Aquileia nostra,* xlvii, 1976, coll. 2–43

Bianchini, Giuseppe. *La Chiesa di Santa Maria Assunta de' Gesuiti in Venezia; cenni illustrativi.* Venice, 1891

Bianchini, Giuseppe. *La Chiesa di S. Maria Mater Domini in Venezia; cenni illustrativi.* Venice, 1893

Bieber, Margarete. *Ancient Copies. Contributions to the History of Greek and Roman Art.* New York, 1977

Bisacco, D. A. *La Scuola Grande di S. Rocco: guida storico-artistica-illustrata.* Venice, 1931

Biscaro, Gerolamo. "Pietro Lombardo e la cattedrale di Treviso," *Archivio storico dell'arte,* ser. 2, iii, 1897, pp. 142–54

Biscaro, Gerolamo. "Per la storia delle belle arti in Treviso, II. Una statua ed altre opere di Lorenzo Bregno," *Atti e memorie dell'Ateneo di Treviso,* 1897, pp. 274–9

Biscaro, Gerolamo. "Lorenzo Bregno e l'Altare di S. Sebastiano," *Gàzzetta di Treviso,* xv, no. 124, May 7–8, 1898, [p. 3], repr. in idem, *Per la storia dell'arte in Treviso, appunti e documenti.* Treviso, 1910, pp. 11f

Biscaro, Gerolamo. "Note storico-artistiche sulla Cattedrale di Treviso, I. Il Vescovo Zanetto e la Cappella maggiore," *Archivio veneto,* ser. 2, xvii, pt. 2, 1899, pp. 135–94

Biscaro, Gerolamo. "Note storico-artistiche sulla Cattedrale di Treviso, II. La Cappella del Santissimo," *Archivio veneto,* ser, 2, xviii, pt. 1, 1899, pp. 179–97

Blair, Claude. *European Armour, circa 1066 to circa 1700.* London, 1958

Bober, Phyllis Pray, and Rubenstein, Ruth. *Renaissance Artists and Antique Sculpture.* London, 1986

Bode, Wilhelm. "L'exposition rétrospective au Trocadéro," *Revue archéologique,* n.s. xxxvii, January–June 1879, pp. 94–103

Bode, Wilhelm. Review of L. Planiscig, *Die Venezianische Bildhauer der Renaissance,* 1921, *Der Kunstwanderer,* iv, May 15–31, 1922, pp. 425–7

Bołoz Antoniewicz, Jan. "Posiedzenie z dnia 14 stycznia 1913" (Conference of January 14, 1913), *Prace Komisji Historii Sztuki,* i, 1919, pp. xxiii–xxvi

Bombelli, Andrea. *Crema bella; guida artistica di Crema e dintorni.* Cremona, 1953

Bonardi, Antonio. "I padovani ribelli alla repubblica di Venezia (a. 1509–1530)," Venice, R. Deputazione veneta di storia patria. *Miscellanea di storia veneta,* ser. 2, viii, 1902, pp. 303–614

Boni, Giacomo. "Santa Maria dei Miracoli in Venezia," *Archivio veneto,* xxxiii, 1887, pp. 237–74

Boranga, Pierina, et al. *Guida alla Cattedrale di Belluno e alle Chiese di S. Pietro, della B. V. della Salute, del Battistero o M. delle Grazie.* Belluno, 1973

Borgo, Ludovico. *The Works of Mariotto Albertinelli,* Ph. D. dissertation, Harvard University, 1968; repr. Garland Series of Outstanding Dissertations in the Fine Arts. New York/London, 1976

Bouchaud, Pierre de. *La sculpture vénitienne.* Paris, 1913

Boucher, Bruce. "Jacopo Sansovino and the Choir of St. Mark's: the Evangelists, the Sacristy Door and the Altar of the Sacrament," *Burlington Magazine,* cxxi, 1979, pp. 155–68

Boucher, Bruce. "Sansovino's Medici Tabernacle and Lotto's Sacramental Allegory: New Evidence on their Relationship," *Apollo,* n.s. cxiv, no. 235, September 1981, pp. 156–61

Bracaloni, Leone. "Lo stemma francescano nell'arte," *Studi francescani,* n.s. vii, 1921 (numero speciale, VII centenario del Terz'Ordine Francescano), pp. 221–6

Brandolese, Pietro. "Le cose più notabili . . .," 1793–1808, in Pier Luigi Fantelli, " 'Le cose più notabili riguardo alle belle arti che si trovano nel territorio di Padova,' " *Padova e la sua provincia*, n.s. xxvi, no. 3, March 1980, pp. 11–23; xxvi, no. 11/ 12, November – December 1980, pp. 16–21; xxvii, no. 2, February 1981, pp. 27–34; xxvii, no. 4, April 1981, pp. 21–6; xxvii, no. 5, May 1981, pp. 22–8; xxvii, no. 6, June 1981, pp. 28–32; xxvii, no. 7, July 1981, pp. 28–33

Braschi, Giovanni Battista. *Memoriæ Cæsenates sacræ, et profanæ*. Rome, 1738

Brenna, Gina. "S. Nicolò e Treviso," *Solenni feste centenarie in onore di Papa B. Benedetto XI*. Treviso, 1904, [pp. 4–6]

Brentari, Ottone. *Guida storico-alpina di Belluno, Feltre, Primiero, Agordo, Zoldo*. Bassano, 1887

Brown, Clifford Malcolm. " 'Una testa de Platone antica con la punta dil naso di cera': Unpublished Negotiations between Isabella d'Este and Niccolò and Giovanni Bellini," *Art Bulletin*, li, 1969, pp. 373–7

Brown, Clifford Malcolm. "Giovanni Bellini and Art Collecting," *Burlington Magazine*, cxiv, 1972, pp. 404f

Brummer, Hans Henrik. *The Statue Court in the Vatican Belvedere* (Stockholm Studies in History of Art, 20). Stockholm, 1970

Budapest, Szépművészeti Múzeum. *A Szépművészeti Múzeum részére vásárolt festmények, plasztikai művek és graphicai lapok lajstroma*, catalogue by K. Pulszky and J. Peregriny. Budapest, 1896

Budapest, Szépművészeti Múzeum. *As Országos Magyar Szépművészeti Múzeum állagai*, pt. 3, fasc. 3, catalogue by J. Peregriny. Budapest, 1915

Budapest, Szépművészeti Múzeum. *A közép– és újabbkori szobrászati gyűjtemény*, catalogue by Simon Meller. Budapest, 1921

Budapest, Szépművészeti Múzeum. *Katalog der ausländischen Bildwerke des Museums der Bildenden Künste in Budapest, IV–XVIII. Jahrhundert*, by Jolán Balogh. Budapest, 1975, 2 vols.

Burchelati, Bartolommeo. *Epitaphiorum dialogi septem*. Venice, [1583]

Burchelati, Bartolommeo. *Commentariorum memorabilium multiplicis hystoriæ Tarvisinæ locuples promptuarium*. Treviso, 1616

Burchi, Pietro. *Un'opera ignorata di Giovanni Battista Bregno nel duomo di Cesena*. Rome, [1950]

Burchi, Pietro. "Il Duomo di Cesena," *Studi romagnoli*, v, 1954, pp. 255–78

Burchi, Pietro. *Storia delle parrocchie di Cesena*. Cesena, 1962, ii

Burchi, Pietro. *Le antiche pievi e le chiese di Cesena nella storia*. Forlì, 1970 (extract from Forlì, Camera di commercio, industria, artigianato e agricoltura. *Bollettino mensile*, April, May, June, July, August, 1970)

Burckhardt, Jacob. *Der Cicerone*. Basel, 1855

Burckhardt, Jacob. *Der Cicerone*, with A. von Zahn. Leipzig, [2]1869, [3]1874

Burckhardt, Jacob. *Der Cicerone*, with W. Bode. Leipzig, [4]1879, [5]1884, [6]1893

Burckhardt, Jacob. *Der Cicerone*, with W. Bode and C. von Fabriczy. Leipzig, [7]1898, [8]1900–1901, [9]1904. [10]1909–10

Caccianiga, Antonio. *Ricordo della provincia di Treviso*. Treviso, [2]1874

Caccin, Angelo M. *La Chiesa dei SS. Giovanni e Paolo in Venezia*. Bologna, 1959

Caccin, Angelo M. *San Marco: la basilica d'oro*. Venice, 1962

Cadorin, Guiseppe. "I miei studi negli archivi," Venice. Ateneo di Venezia. *Esercitazioni scientifiche e letterarie*, v, 1846, pp. 269–85

Caffi, Michele. "Guglielmo Bergamasco ossia Vielmo Vielmi di Alzano," *Archivio veneto*, xxviii, 1884, pp. 30–42

Caffi, Michele. "Guglielmo Bergamasco ossia Vielmo Vielmi di Alzano, architetto e scultore del secolo xvi," *Archivio veneto*, ser. 2, iii, pt. 1, 1892, pp. 157–79

Callegari, Adolfo. "Pietro Lombardo e il lombardismo nel basso padovano," *Dedalo*, ix, 1928/29, pp. 357–85

Campagner, Antonio. *Canonici trevigiani, notizia di uno schedario*. Treviso, 1956 (mimeograph)

Cantù, Cesare. "Aneddoti di Lodovico il Moro," *Archivio storico lombardo*, i, 1874, pp. 483–7

Cappelletti, Giuseppe. *Storia della chiesa di Venezia dalla sua fondazione sino ai nostri giorni*. Venice, iii, 1853; iv, 1855

Caretta, Alessandro; Degani, Alessandro; Novasconi, Armando. *La Cattedrale di Lodi*, ed. Novasconi. Lodi, 1966

Carpi, Piera. "Giovanni Minello e la sua opera nella Cappella del Santo," *Padova*, v, nos. 1–2, January–April 1931, pp. 3–23

Carrari, Vincenzo. *Historia de' Rossi parmigiani*. Ravenna, 1583

Caspary, Hans. *Das Sakramentstabernakel in Italien bis zum*

*Konzil von Trient: Gestalt, Ikonographie und Symbolik, kultische Funktion,* dissertation, Ludwig-Maximilians-Universität, Munich, 1964

Castellini, Silvestro. *Storia della città di Vicenza.* Vicenza, xii, 1821

Cavacci, Giacomo. *Historiarum Coenobii D. Iustinae Patavinae, libri sex.* Venice, 1606

Cecchetti, Bartolomeo. *Documenti per la storia dell'augusta ducale Basilica di San Marco,* in Ferdinando Ongania, pub., *La Basilica di San Marco in Venezia illustrata nei riguardi dell'arte e della storia da scrittori veneziani,* ed. Camillo Boito. Venice, vii, 1886

Cecchetti, Bartolomeo. "Funerali e sepolture dei veneziani antichi," *Archivio veneto,* xxxiv, 1887, pp. 265–84

Cervellini, G. B. *Inventario dei monumenti iconografici d'Italia, no. 3, Treviso.* Trent, 1933

Cervellini, Marco. *Guida al Duomo di Treviso.* Treviso, 1986

Cessi, Roberto. *Storia della Repubblica di Venezia.* Milan/Messina, 1968, ii

Cetti, Battista. *Artisti vallintelvesi.* Como, 1973

Cetti, Battista. "Scultori comacini: i Bregno," *Arte cristiana,* lxx, 1982, pp. 31–44

Chabod, Federico. "Venezia nella politica italiana ed europea del Cinquecento," *Storia della civiltà veneziana,* ii, *Autunno del medioevo e rinascimento,* ed. Vittore Branca. Florence, 1979, pp. 233–46

Chacón, Alfonso. *Vitae, et res gestae Pontificum Romanorum et S. R. E. Cardinalium ab initio nascentis Ecclesiae usque ad Clementem IX. P. O. M.* Rome, 1677, ii

Chimenton, Costante. *Nella Cattedrale di Treviso: come si è salvata la Cappella dell'Annunziata.* Treviso, 1947, repr. from *Osservatore romano,* March 2, 1947

Chimenton, Costante. *La Cappella del Santissimo nella Cattedrale di Treviso: danni di guerra e restauri.* Vedelago (TV), (1947) 1948

Cicogna, Emmanuele Antonio. *Delle inscrizioni veneziane.* Venice, i, 1824; ii, 1827; iii, 1830; iv, 1834; v, 1842; vi, 1853

Cicognara, Leopoldo. *Storia della scultura dal suo risorgimento in Italia sino al secolo di Napoleone.* Venice, ii, 1816

Cicognara, Leopoldo; Diedo, Antonio; Selva, Giovanni Antonio. *Le fabbriche più cospicue di Venezia.* Venice, ii, 1820

Cicognara, Leopoldo; Diedo, Antonio; Selva, Giovanni Antonio. *Monumenti sepolcrali cospicui eretti alla memoria degli uomini celebri in Venezia.* Turin, 1858

Cittadella, Luigi Napoleone. *Notizie amministrative, storiche, artistiche relative a Ferrara, ricavate da documenti ed illustrate.* Ferrara, 1868, ii, pt. 3, repr. as idem, *Documenti ed illustrazioni risguardanti la storia artistica ferrarese.* Ferrara, 1868

Coletti, Luigi. "Intorno ad un nuovo ritratto del vescovo Bernardo de' Rossi," *Rassegna d'arte antica e moderna,* xxi, 1921, pp. 407–20

Coletti, Luigi. *Treviso* (Italia artistica, 90). Bergamo, [1926]

Coletti, Luigi. "Il Tempio monumentale di S. Nicolò," *L'illustrazione veneta,* iii, no. 4, April 1928, pp. 69–72

Coletti, Luigi. "Il Tempio di S. Francesco e le sue opere d'arte," *La vita del popolo* (Treviso), xxxvi, no. 41, October 4, 1928 (special edition), [pp. 2–3], repr. in ibid., xxxvi, no. 41, October 7, 1928, [pp. 1–2]

Coletti, Luigi. *Catalogo delle cose d'arte e di antichità d'Italia. Treviso.* Rome, 1935

*Collezione de' migliori ornamenti antichi sparsi nella città di Venezia.* Venice, 1831

Condé, Erminio. *Creola, chiesa di San Pietro Apostolo.* Tencarola (PD), 1986

Conti, Pietro. *Memorie storiche della vall'Intelvi: arte, ingegno, patriottismo degli Intelvesi.* Como, 1896

Cope, Maurice Erwin. *The Venetian Chapel of the Sacrament in the Sixteenth Century: A Study in the Iconography of the Early Counter-Reformation,* Ph.D. dissertation, University of Chicago, 1965; repr. as idem, *The Venetian Chapel of the Sacrament in the Sixteenth Century,* Garland Series of Outstanding Dissertations in the Fine Arts, New York/London, 1979

Corner, Flaminio. *Ecclesiae Venetae antiquis monumentis nunc etiam primum editis illustratae.* Venice, 1749

Coronelli, Vincenzo. "Depositi più singolari di Venezia," *Singolarità di Venezia e del serenissimo suo dominio.* Venice, [ca. 1710]

Coryat, Thomas. *Coryat's Crudities.* Glasgow, (1611) 1905

Cosenza, Mario Emilio. *Biographical and Bibliographical Dictionary of the Italian Humanists and of the World of Classical Scholarship in Italy, 1300–1800.* Boston, MA, ²1962 and *Supplement A–Z,* 1967

Courtauld Institute Illustration Archives. Archive 2, 15th and 16th century sculpture in Italy, pt. 3, *Rome: S. Agostino, S. Giacomo Maggiore, Vicovaro,* ed. Constance Hill. London, 1977

Crasso, Niccolò. *Pisaura gens.* Venice, 1652

[Crevato-Selvaggi, Mario, and Mignozzi, Claudio]. *La Scuola Grande e la Chiesa di San Rocco a Venezia.* Venice, 1983

[Crico, Lorenzo]. *Viaggetto pittorico da Venezia a Possagno*. Venice, 1822

Crico, Lorenzo. *Indicazione delle pitture ed altri oggetti di belle arti degni d'osservazione esistenti nella R. città di Treviso*. Treviso, 1829

Crico, Lorenzo. *Lettere sulle belle arti trivigiane*. Treviso, 1833

Crowe, J. A., and Cavalcaselle, G. B. *The Life and Times of Titian*. London, ²1881

Cuoghi, Nemo, et al. *La provincia di Padova, la natura, l'arte e la cultura di una terra antica*, ed. Camillo Semenzato. Padua, 1987

Curtius, Ludwig. "Zum Antikenstudium Tizians," *Archiv für Kulturgeschichte*, xxviii, 1938, pp. 233–41

Damerini, Gino. *L'Isola e il Cenobio di San Giorgio Maggiore*. Venice, 1956

De Bortoli, Gigetto; Moro, Andrea; Vizzutti, Flavio. *Belluno, storia, architettura, arte*. Belluno, 1984

Degan, Gianni. "Appunti di storia e arte sul territorio di Saccolongo e Creola," in Degan and Lino Rubini, *Saccolongo, l'onorevole del mondiale*. [Padua], 1980, pp. 9–58

Degan, Gianni. *S. Maria del Carmine a Creola: storia e arte*. Padua, 1981

Delai, Giovanni. *Relatione del transporto, e miracoli della Santissima Spina, che si conserva nella Chiesa Cathedrale di Belluno*. Venice, 1673

Diedo, Antonio, and Zanotto, Francesco. *I monumenti cospicui di Venezia*. Milan, [1839]

Doglioni, Virginio A. "Un codice del 1458 del pittore Matteo Cesa e alcuni suoi disegni. Notizie sulla famiglia Cesa, sulla vita e sull'arte di Matteo. La 'Sacra Conversazione' Musei Statali di Berlino," *Archivio storico di Belluno Feltre e Cadore*, xxix, 1958, pp. 87–94

Dradi-Maraldi, Biagio. *Cesena: guida artistica illustrata*. Milan/Rome, [1962]

*Il Duomo di Montagnana*. Padua, 1965

East Berlin, Alten Museum, Staatliche Museen zu Berlin. *Restaurierte Kunstwerke in der Deutschen Demokratischen Republik*, April–June 1980. Leipzig, 1979

Edwards, Mary D. "The Tomb of Raimondino de' Lupi, its Form and its Meaning," *Konsthistorisk tidskrift*, lii, 1983, pp. 95–105

Egg, Erich; Hubala, Erich; Tigler, Peter; Timofiewitsch, Wladimir; Wundram, Manfred. *Oberitalien Ost* (Reclams Kunstführer, ed. Wundram, *Italien*, ii). Stuttgart, 1965

*Elenco degli edifici monumentali*, xxi, *Provincia di Padova*, compiled by Ugo Nebbia et al., (Ministero della pubblica istruzione). Rome, 1930

Erizzo, Nicolò. *Relazione storico-artistica della Torre dell'Orologio di S. Marco in Venezia*. Venice, ²1866

Ettlinger, Leopold D. "Exemplum Doloris. Reflections on the Laocoön Group," *De artibus opuscula XL. Essays in Honor of Erwin Panofsky*, ed. Millard Meiss. Zurich, 1960, pp. 121–6

Fabbri, Angela. *L'Appennino Tosco-Romagnolo e la riviera adriatica: guida turistica storico-illustrata*. Borello/Cesena, [1965]

[Fabriczy, Cornelius von]. "Mittheilungen über neue Forschungen," *Repertorium für Kunstwissenschaft*, xxiii, 1900, pp. 259–61

Fabriczy, Cornelius von. "Sculture in legno di Baccio da Montelupo," *Miscellanea d'arte*, i, 1903, pp. 67–8

Fabriczy, Cornelius von. "Giovanni Minello, ein Paduaner Bildner vom Ausgang des Quattrocento," *Jahrbuch der königlich preuszischen Kunstsammlungen*, xxviii, 1907, pp. 53–89

Facchi, Giuseppe. *La Chiesa della Trinità in Crema*. Crema, 1983

Fantaguzzi, Giuliano. *'Caos': cronache cesenati del sec. xv*, ed. Dino Bazzocchi. Cesena, (1460–1510) 1915

Fapanni, Francesco. "Delle statue equestri erette a' suoi capitani generali di terra dalla repubblica di Venezia," *Bullettino di arti, industrie e curiosità veneziane*, iii, 1880, pp. 72–84

Favaretto, Irene. "La tradizione del Laocoonte nell'arte veneta," Venice, Istituto veneto di scienze, lettere ed arti. *Atti* (Classe di scienze morali, lettere ed arti), cxli, 1982–3, pp. 75–92

Favaretto, Irene. "Simone Bianco: uno scultore del xvi secolo di fronte all'antico," *Quaderni ticinesi di numismatica e antichità classiche* (Lugano), xiv, 1985, pp. 405–22

Federici, Domenico Maria. *Memorie trevigiane sulle opere di disegno*. Venice, 1803

Fees, Irmgard. *Reichtum und Macht in mittelalterlichen Venedig. Die Familie Ziani*. Tübingen, 1988

Filippini, Francesco. "Baccio da Montelupo in Bologna," *Dedalo*, viii, 1927/28, pp. 527–42

Finlay, Robert. *Politics in Renaissance Venice*. New Brunswick, NJ, 1980

Fino, Alemanio. *Storia di Crema dagli annali di M. Pietro Terni*, notes by Giuseppe Racchetti, ed. Giovanni Solera. Crema, (1566) 1844–5

Finotto, Ferdinando. *San Giobbe: la Chiesa dei Santi Giobbe e Bernardino in Venezia*. Venice, 1971

Fogolari, Gino. *I Frari e i SS. Giovanni e Paolo a Venezia* (Il fiore dei musei e monumenti d'Italia, 14). Milan, 1931

Fontana, Giuseppe. *Guida di Belluno*. Belluno, 1951

Foratti, Aldo. "Un arco sansovinesco," *Arte e storia*, ser. 5, xxx, 1911, pp. 139–41

Foratti, Giacinto. *Cenni storici e descrittivi di Montagnana con alcune notizie dei principi estensi e carraresi che ne ebbero il dominio*. Venice, pt. 1, 1862; pt. 2, 1863; pt. 3, 1863

Forcella, Vincenzo. *Iscrizioni delle chiese e d'altri edificii di Roma dal secolo xi fino ai giorni nostri*. Rome, v, 1874

Forlati, Ferdinando. "Il restauro dei monumenti danneggiati dalla guerra nel Veneto orientale," *Arte veneta*, i, 1947, pp. 50–60

Frantz, Erich. *Fra Bartolommeo della Porta. Studie über die Renaissance*. Regensburg, 1879

Franzoi, Umberto, and Di Stefano, Dina. *Le chiese di Venezia*. Venice, 1975

Franzoni, Lanfranco. "Antiquari e collezionisti nel Cinquecento," in *Storia della cultura veneta*, iii. *Dal primo Quattrocento al Concilio di Trento*, ed. Girolamo Arnaldi and Manlio Pastore Stocchi. Vicenza, pt. 3, 1981, pp. 207–66

Frizzoni, Gustavo. "Ein bisher nicht erkanntes Werk Lorenzo Lottos in der Kaiserlichen Gemäldegalerie," *Jahrbuch der Kunsthistorischen Sammlungen der allerhöchsten Kaiserhauses*, xxx, 1911–12, pp. 49–57

Frommel, Christoph Luitpold. " 'Capella Iulia': Die Grabkapelle Papst Julius' II in Neu-St. Peter," *Zeitschrift für Kunstgeschichte*, xl, 1977, pp. 26–62

Fulin, R., and Molmenti, P. G. *Guida artistica e storica di Venezia e delle isole circonvicine*. Venice, 1881

Gabriel, Angelo. *Oratio magnifici d. Angeli Gabrielis q. clariss. d. Silvestri: in laudem reverendissimi Cardinalis d. B. Zeni patritii Veneti*. Venice, [1501], repr. in Agostino Valerio, *De cautione adhibenda in edendis libris*. Padua, 1719, pp. 226–33

Gams, Pius Bonifacius. *Series episcoporum Ecclesiae Catholicae, quotquot innotuerunt a Beato Petro Apostolo*. Regensburg, 1873–86

Garzoni, Tommaso. *La piazza universale di tutte le professioni del mondo, e nobili et ignobili*. Venice, 1585

Gauricus, Pomponius. *De sculptura (1504)*, annot. and trans. by André Chastel and Robert Klein. Geneva/Paris, (1504) 1969

Gelera, Riccardo. *Crema e il santuario di S. Maria della Croce* (Le cento città d'Italia illustrate, 50). Milan, n.d.

Giacomelli, Antonio. "Notizie di storia e di cronaca sul Duomo di Montagnana," in *Acta Ecclesiae Montaneanensis quinta saecularia feliciter celebrantis*. Padua, 1936, pp. 35–115

[Giampiccoli, Marco Sebastiano]. *Notizie interessanti, che servono a far conoscere in tutti i suoi sestieri l'inclita città di Venezia*. Belluno, 1779

Gilbert, Creighton E. "Some Findings on Early Works of Titian," *Art Bulletin*, lxii, 1980, pp. 36–75

Gilbert, Felix. "Venice in the Crisis of the League of Cambrai," in *Renaissance Venice*, ed. J. R. Hale. London, 1973, pp. 274–92

Giovanelli, Benedetto. *Vita di Alessandro Vittoria, scultore trentino*. Trent, 1858

Gloria, Andrea. *Il territorio padovano illustrato*. Padua, 1862, ii

Goffen, Rona. "Icon and Vision: Giovanni Bellini's Half-Length Madonnas," *Art Bulletin*, lvii, 1975, pp. 487–518

Goffen, Rona. *Piety and Patronage in Renaissance Venice: Bellini, Titian, and the Franciscans*. New Haven/London, 1986

Goffen, Rona. *Giovanni Bellini*. New Haven/London, 1989

Goi, Paolo. "I documenti," in Passariano, Villa Manin, and Pordenone, ex Convento di S. Francesco, *Il Pordenone*, July 21–November 11, 1984, catalogue ed. by Caterina Furlan. Milan, 1984, pp. 265–82

Gonzati, Bernardo. *La Basilica di S. Antonio di Padova*. Padua, i, 1852; ii, 1853

"Gottardi, Vincenzo," *Allgemeines Lexikon der bildenden Künstler*, ed. U. Thieme and F. Becker. Leipzig, xiv, 1921, p. 420

Gradenigo, Pietro. *Notizie d'arte tratte dai notatori e dagli annali del N. H. Pietro Gradenigo*, ed. Lina Livan (Venice, R. Deputazione veneta di storia patria. Miscellanea di studi e memorie, v). Venice, 1942

Gramaccini, Norberto. *Alfonso Lombardi*, (Neue kunstwissenschaftliche Studien, ed. A. Perrig, 9). Frankfurt a. M., 1980

Grandis, Claudio. *Il Bacchiglione, un fiume e la sua terra*. Tencarola/Selvazzano Dentro (PD), 1983

[Grandis, Domenico]. *Vite, e memorie de' santi spettanti alle chiese della diocesi di Venezia*. Venice, iii, 1762

Grigioni, Carlo. "Ancora del sepolcro del Vescovo Antonio Malatesta ne la Cattedrale di Cesena," *Rassegna bibliografica dell'arte italiana*, xii, 1909, pp. 160–1

Grigioni, Carlo. "Un opera ignota di Lorenzo Bregno," *L'arte*, xiii, 1910, pp. 42–8

Grigioni, Carlo. "L'altare del Sacramento o di S. Giovanni Battista nella Cattedrale di Cesena," *Rassegna bibliografica dell'arte italiana*, xiv, 1911, pp. 11–18, repr. in *Il cittadino, giornale della domenica* (Cesena), xxiii, no. 24, June 11, 1911, [pp. 1–2]

Grigioni, Carlo. "Ancora dell'altare di S. Giovanni

Battista nel Duomo di Cesena," *Rassegna bibliografica dell'arte italiana*, xiv, 1911, p. 84

Grigioni, Carlo. "Nota su l'arte e gli artisti in Ravenna. Tommaso Fiamberti," *Felix Ravenna*, Oct. 1913, fasc. 12, pp. 497–514

Grigioni, Carlo. "Per la storia della pittura in Cesena nel primo quarto del secolo xvi," *Rassegna bibliografica dell'arte italiana*, xvi, 1913, pp. 3–14, repr. in Orlando Piraccini, *La Pinacoteca Comunale di Cesena*. Cesena, 1984, pp. 248–56

Grigioni, Carlo. "L'autore della statua di Guidarello Guidarelli in Ravenna," *Rassegna bibliografica dell'arte italiana*, xvii, 1914, pp. 123–8

Grigioni, Carlo. "Giacomo Bianchi a Cesena," *Rassegna bibliographica dell'arte italiana*, xviii, 1915, pp. 1–5

Guernieri, Angelo. *Guida alla città di Belluno*. Belluno, 1871

*Guida del visitatore artista attraverso il Seminario patriarcale di Venezia*. Venice, 1912

Guidi, P. "La 'Pietà' di Lammari e la 'Pietà' di Segromigno," *Arte cristiana*, iii, 1915, pp. 66–78

Hellmann, Mario. "Ca' Molin dalle due Torri, la Chiesa della Presentazione e il Santo Sepolcro," *Ateneo veneto*, n.s. v, 1967, pp. 197–203

Henninges, Hieronymus. *Theatrum genealogicum ostentans omnes omnium ætatum familias*. Magdeburg, 1598, iv, "Appendix primi regni quartae monarchiae Italiae, Venetiarum ducum catalogus et familiae generosae," pp. 1133–68, and "Siciliam, Neapolem, Calabriam vel Brutios, Magnam Graeciam etc.," pp. 1169–1528

Héron de Villefosse, Antoine. "Demande de renseignements sur un sculpteur italien," *Bulletin monumental*, xlvi, 1880, pp. 379–80

Hill, George Francis. *A Corpus of Italian Medals of the Renaissance before Cellini*. London, 1930, 2 vols.

Hope, Charles. "Documents concerning Titian," *Burlington Magazine*, cxv, 1973, pp. 809–10

Hornung, Zbigniew. "Jan Marja zwany il Mosca albo Padovano. Próba charakterystyki," Polska Akademia Umiejętności, Krakow. *Sprawozdania z czynności i posiedzeń*, xl, 1935, pp. 274–7, trans. as idem, "Gianmaria, genannt il Mosca oder Padovano. Versuch einer Charakteristik," Polska Akademia Umiejętności, Krakow. *Bulletin international* (Classe de philologie, Classe d'histoire et de philosophie), 1935 (1936), pp. 159–64, no. 33, and repr. in *Prace Komisji Historii Sztuki*, vii, 1937–8, pp. 23*–25*

Hornung, Zbigniew. "Pomnik ostatnich Jagiellonów w Kaplicy Zygmuntowskiej na Wawelu," *Księga pamiątkowa ku czci Leona Pinińskiego*, Lwow, 1936, i, pp. 379–402

Hornung, Zbigniew. "Mauzoleum króla Zygmunta i w katedrze krakowskiej," Towarzystwo Naukowe Warszawskie. *Rozprawy Komisja Historii Sztuki i Kultury*, i, 1949, pp. 69–150

Huelsen, Christian. *La Roma antica di Ciriaco d'Ancona*. Rome, 1907

Humfrey, Peter. "Cima da Conegliano, Sebastiano Mariani, and Alvise Vivarini at the East End of S. Giovanni in Bragora in Venice," *Art Bulletin*, lxii, 1980, pp. 350–63

Humfrey, Peter. *Cima da Conegliano*. Cambridge, 1983

Humfrey, Peter. "The Venetian Altarpiece of the Early Renaissance in the Light of Contemporary Business Practice," *Saggi e memorie di storia dell'arte*, xv, 1986, pp. 63–82, 223–33

s'Jacob, Henriette. *Idealism and Realism: A Study of Sepulchral Symbolism*. Leiden, 1954

Jestaz, Bertrand. "Requiem pour Alessandro Leopardi," *Revue de l'art*, 1982, no. 55, pp. 23–34

Jestaz, Bertrand. *La Chapelle Zen à Saint-Marc de Venise: d'Antonio à Tullio Lombardo*. Stuttgart, 1986

K., B. C. "Fiamberti, Tommaso," *Allgemeines Lexikon der bildenden Künstler*, ed. U. Thieme and F. Becker. Leipzig, xi, 1915, p. 526

Kenny, Anthony. "From Hospice to College 1559–1579," in *The English Hospice in Rome*. Exeter, 1962, pp. 218–73

Koch, Guntram. *Die mythologischen Sarkophage*, pt. 6, *Meleager* (*Die antiken Sarkophagreliefs*, ed. Friedrich Matz and Bernard Andreae, xii, pt. 6). Berlin, 1975

Kretschmayr, Heinrich. *Geschichte von Venedig*. Darmstadt, 1964, ii

Kriegbaum, F. "Montelupo, Baccio," *Allgemeines Lexikon der bildenden Künstler*, ed. U. Thieme and F. Becker. Leipzig, xxv, 1931, pp. 86–7

Kruse, Hans-Joachim. *Römische weibliche Gewandstatuen des zweiten Jahrhunderts n. Chr.*, dissertation, Georg-August Universität, Göttingen, (1968) 1975

Kühlenthal, Michael. "Das Grabmal Pietro Foscaris in S. Maria del Popolo in Rom, ein Werk des Giovanni di Stefano," *Mitteilungen des Kunsthistorischen Institutes in Florenz*, xxvi, 1982, pp. 47–62

Labalme, Patricia H. *Bernardo Giustiniani, a Venetian of the Quattrocento*. Rome, 1969

[Labus, Giovanni]. "Descrizione della I. R. Basilica di S. Marco," in *Chiese principali d'Europa; dedicate a Sua Santità Leone XII. Pon. Mas*. Milan, 1824–

Lane, Frederic C. "Naval Actions and Fleet Organization, 1499–1502," in *Renaissance Venice*, ed. J. R.

Hale. London, 1973, pp. 146–73

Lauritzen, Peter Lathrop. "The Architectural History of San Giorgio," *Apollo*, n.s. civ, no. 173, July 1976, pp. 4–11

Lauts, Jan. *Carpaccio: Paintings and Drawings*. London, 1962

Liberali, Giuseppe. *Lotto, Pordenone e Tiziano a Treviso; cronologie, interpretazioni ed ambientamenti inediti* (Venice, Istituto veneto di scienze, lettere ed arti. *Memorie* [Classe di scienze morali e lettere], xxxiii, fasc. 3). Venice, 1963

Liberali, Giuseppe. "La sfortunata adolescenza di Bernardo Rossi (1468–1486), Conte di Berceto e Vescovo di Belluno e di Treviso," Venice, Istituto veneto di scienze, lettere ed arti. *Atti* (Classe di scienze morali, lettere ed arti), cxxx, 1971–2, pp. 261–314

Liberali, Giuseppe. *L'episcopato bellunese di Bernardo de Rossi (1487–1499)*. Vicenza, 1978

Lippini, Pietro. *La Basilica dei SS. Giovanni e Paolo*. Milan, [1989]

Lisner, Margrit. "Das Quattrocento und Michelangelo," *Stil und Ueberlieferung in der Kunst des Abenlandes. Akten des 21. Internationalen Kongresses für Kunstgeschichte in Bonn, 1964*, ii. *Michelangelo*. Berlin, 1967, pp 78–89

London, Victoria & Albert Museum. *Catalogue of Italian Sculpture in the Victoria and Albert Museum*, catalogue by John Pope-Hennessy, assisted by Ronald Lightbown. London, 1964, 3 vols.

Longhurst, Margaret H. *Notes on Italian Monuments of the 12 to 16th Centuries*. [London], [1962] (photostat)

Lorenzetti, Giulio. "Di alcuni bassorilievi attribuiti a Jacopo Sansovino," *L'arte*, xii, 1909, pp. 288–301

Lorenzetti, Giulio. *Venezia e il suo estuario*. Venice et al., 1926, ²1956

Lorenzetti, Giulio. "Bregno, Lorenzo e Giovanni Battista," *Enciclopedia italiana di scienze, lettere ed arti*. Rome, vii, 1930, p. 793

Lorenzi, Giambattista. *Monumenti per servire alla storia del Palazzo Ducale di Venezia*. Venice, 1868, i

Lotto, Lorenzo. *Il 'Libro di spese diverse' con aggiunta di lettere e d'altri documenti*, ed. Pietro Zampetti, (Civiltà veneziana. Fonti e testi ix, series 1, 6). Venice/Rome, 1969

Low, P. Jane S. *The Knowledge and Influence of Classical Sculpture in Venice and Padua c. 1460–1530*, M. A. report, Courtauld Institute of Art, University of London, 1973 (typescript)

Lübke, Wilhelm. *Geschichte der Plastik von den ältesten Zeiten bis auf die Gegenwart*. Leipzig, 1863, ²1871, ii

Luchs, Alison. "Tullio Lombardo's Ca' d'Oro Relief: A Self-Portrait with the Artist's Wife?" *Art Bulletin*, lxxi, 1989, pp. 230–6

Ludwig, Gustav. *Archivalische Beiträge zur Geschichte der Venezianischen Kunst aus dem Nachlass Gustav Ludwigs*, ed. Wilhelm Bode, Georg Gronau, Detlev von Hadeln, (Florence, Kunsthistorisches Institut. Italienische Forschungen, 4). Berlin, 1911

Luzio, Alessandro, and Renier, Rodolfo. "Di Pietro Lombardo architetto e scultore veneziano," *Archivio storico dell'arte*, i, 1888, pp. 433–8.

M., P. G. "La Chiesa di S. Francesco nell'anno 1769 da preziose memorie del Vescovo Paolo Francesco Giustiniani," *La vita del popolo* (Treviso), xxxvi, no. 41, October. 4, 1928 (special edition), [p. 3], repr. in ibid., xxxvi, no. 41, October. 7, 1928, [p. 1]

Maek-Gérard, Michael. *Tullio Lombardo, ein Beitrag zur Problematik der Venezianischen Werkstatt bis zu den Auswirkungen des Krieges gegen die Liga von Cambrai*, dissertation, Johann-Wolfgang-Goethe-Universität, Frankfurt a.M., 1974 (typescript)

Maek-Gérard, Michael. "Die 'Milanexi' in Venedig. Ein Beitrag zur Entwicklungsgeschichte der Lombardi-Werkstatt," *Wallraf-Richartz-Jahrbuch*, xli, 1980, pp. 105–130

Magenta, Carlo. *La Certosa di Pavia*. Milan, 1897

Magrini, Antonio. *Memorie intorno la vita e le opere di Andrea Palladio*. Padua, 1845

Maier, Johann Christoph. *Beschreibung von Venedig*. Frankfurt/Leipzig, i, 1787; Leipzig, i, ²1795

Malipiero, Domenico. "Annali veneti dall'anno 1457 al 1500," ed. Francesco Longo, notes by Agostino Sagredo, *Archivio storico italiano*, vii, pt. 1, 1843; vii, pt. 2, 1844

Mallett, Michael. E., and Hale, John. R. *The Military Organization of a Renaissance State: Venice c. 1400 to 1617*. Cambridge, 1984

Manfredi, Fulgenzio. *Degnità procuratoria di San Marco di Venetia*. Venice, 1602

Manzato, Eugenio. "Le arti figurative nella Marca Trevigiana: presenze nei secoli," in Antonio Barzaghi et al., *Treviso: guida ritratto di una provincia*. Padua, 1986, pp. 32–44

Marangoni, Luigi. *La basilica di S. Marco in Venezia*. Milan, 1910

Marchese, Vincenzo. *Memorie dei più insigni pittori, scultori e architetti domenicani*. Florence, ii, 1846

Mariacher, Giovanni. "Problemi di scultura veneziana, 1) Opere poco note di Lorenzo Bregno,"

*Arte veneta*, iii, 1949, pp. 95–9

Mariacher, Giovanni. "Tullio Lombardo Studies," *Burlington Magazine*, xcvi, 1954, pp. 366–74

Mariacher, Giovanni. "Bregno, Giovanni Battista," *Dizionario biografico degli italiani*. Rome, xiv, 1972, pp. 113–14

Mariacher, Giovanni. "Bregno, Lorenzo," *Dizionario biografico degli italiani*. Rome, xiv, 1972, pp. 114–15

Mariacher, Giovanni. *La scultura del Cinquecento* (*Storia dell'arte in Italia*, ed. Ferdinando Bologna). Turin, 1987

Mariacher, Giovanni and Pignatti, Terisio. *La Basilica di San Marco a Venezia*. Florence, 1950

Marini, Luciano. *La Basilica dei Frari*. Venice, 1979

Martinelli, Domenico. *Il ritratto di Venezia*. Venice, 1684

Mazzotti, Giuseppe. *Treviso, Salone dei Trecento. Mostra della ricostruzione degli edifici storici ed artistici danneggiati dalla guerra*. N.p., 1952

Mazzucato, Alessandro. *La Scuola Grande e la Chiesa di San Rocco in Venezia*. Venice, ²1950

McAndrew, John. "Sant'Andrea della Certosa," *Art Bulletin*, li, 1969, pp. 15–28

McAndrew, John. *Venetian Architecture of the Early Renaissance*. Cambridge, MA/London, 1980

Meller, Peter. "Tiziano e la scultura," *Tiziano nel quarto centenario della sua morte 1576–1976*, lessons held at the Ateneo veneto, Venice, between November 15, 1975 and May 15, 1976. Venice, 1977, pp. 123–56

Meller, Peter. "Marmi e bronzi di Simone Bianco," *Mitteilungen des Kunsthistorischen Institutes in Florenz*, xxi, 1977, pp. 199–210

Menegazzi, Luigi. "Le cose d'arte," in *Treviso nostra: ambiente, storia, arte, tradizione*, ed. Lucio Polo. Treviso, 1964, pp. 195–219; ²1980, i, pp. 305–31

Menegazzi, Luigi. "Buora," *Dizionario biografico degli italiani*. Rome, xv, 1972, pp. 359–60

Meneghin, Vittorino. "Un grande artista del rinascimento giudicato da alcuni illustri contemporanei," *Ateneo veneto*, n.s. viii, 1970, pp. 255–61

Meneghini, Augusto. "Padova e sua provincia," in *Grande illustrazione del Lombardo-Veneto*, ed. Cesare Cantù. Milan, iv, 1859 (1861), pp. 9–304

Mercati, Giovanni. *Ultimi contributi alla storia degli umanisti* (*Studi e testi*, 90–1). Vatican City, 1939, ii

Merzario, Giuseppe. *I maestri comacini*. Milan, 1893

[Meschinello, Giovanni]. *La Chiesa ducale di S. Marco*. Venice, i, 1753; ii, 1753

Mesnil, Jacques. "La Compagnia di Gesù Pellegrino," *Rivista d'arte*, ii, 1904, pp. 64–73

Metelli, Antonio. *Storia di Brisighella e della Valle di Amone*. Faenza, pt. 1, ii, 1869

Meyer zur Capellen, Jürg. "Ueberlegungen zur 'Pietà' Tizians," *Münchner Jahrbuch der bildenden Kunst*, xxii, 1971, pp. 117–32.

Meyer zur Capellen, Jürg. "Beobachtungen zu Jacopo Pesaros Exvoto in Antwerpen," *Pantheon*, xxxviii, 1980, pp. 144–52

Meyer zur Capellen, Jürg. *La 'Figura' del San Lorenzo Giustinian di Jacopo Bellini* (Centro tedesco di studi veneziani. *Quaderni*, 19 [lecture of December 16, 1980]). Venice, 1981

Miari, Florio. *Dizionario storico, artistico, letterario bellunese*. Belluno, 1843

[Michiel, Marcantonio]. *Notizia d'opere di disegno*, ed. Jacopo Morelli. Bassano, (1521–43) 1800

[Michiel, Marcantonio]. *Notizia d'opere di disegno*, ed. Gustavo Frizzoni. Bologna, (1521–43) 1884

Michiel, Marcantonio. *Der Anonimo Morelliano* (*Marcanton Michiel's Notizia d'opere del disegno*), ed. and trans. Theodor Frimmel. Vienna, (1521–43) 1896

Michieli, A. A. "Vaniloqui e scorribande erudite d'un secentista trivigiano (Bartolomeo Burchelati)," Venice, Istituto veneto di scienze, lettere ed arti. *Atti* (Classe di scienze morali e lettere), cxii, 1953–4, pp. 307–52

Middeldorf, Ulrich. Review of Berlin, Staatliche Museen, Kaiser-Friedrich-Museum. *Die italienischen und spanischen Bildwerke . . . i, Die Bildwerke . . .*, catalogue by F. Schottmüller, ²1933, *Rivista d'arte*, xx, 1938, pp. 94–104

Milan, Museo Poldi-Pezzoli. Catalogue of the collection, vii, *Tessuti, sculture, metalli islamici*, by Alessandra Mottola Molfino, Maria Grazia Trenti Antonelli et al. Milan, 1987

Milanese, Giovanni. *La chiesa monumentale di San Nicolò in Treviso*. Treviso, 1889, ²1904

Milizia, Francesco. *Memorie degli architetti antichi e moderni*. Bassano, ⁴1785, i

Monti, Osvaldo. "Elenco degli oggetti d'arte nella provincia di Belluno," *Studi bellunesi*, i, no. 7, July 10, 1896, pp. 55–6

Moreno, Paolo. "Il Farnese ritrovato ed altri tipi di Eracle in riposo," *Mélanges de l'École française de Rome. Antiquité* (*Mélanges d'archéologie et d'histoire*), lxxxxiv, pt. 1, 1982, pp. 379–526

Morigia, Paolo. *La nobiltà di Milano*. Milan, 1595

Mormone, Raffaele. *Sculture trecentesche in S. Lorenzo Maggiore a Napoli*. Naples, 1973

Moro, Marco. *Cenni storici sulla Chiesa di S. Martino Vescovo in Venezia*. Venice, 1897

Moroni, Gaetano. *Dizionario di erudizione storico-ecclesiastica da S. Pietro sino ai nostri giorni*. Venice, xci 1858; xc, 1858; ciii, 1861

Moryson, Fynes. *An Itinerary containing his Ten Yeeres Travell through the Twelve Dominions of Germany, Bohmerland, Sweitzerland, Netherland, Denmarke, Poland, Italy, Turky, France, England, Scotland & Ireland*. Glasgow, i, (1591–6) 1907

Moschetti, Andrea. "Bardi, Antonio di Giovanni Minelli de'," *Allgemeines Lexikon der bildenden Künstler*, ed. U. Thieme and F. Becker. Leipzig, ii, 1908, pp. 485–6

Moschetti, Andrea. "Un quadriennio di Pietro Lombardo a Padova (1464–67) con una appendice sulla data di nascita e di morte di Bartolommeo Bellano," Padua, Museo Civico. *Bollettino*, xvi, 1913, pp. 1–99; xvii, 1914, pp. 1–43

Moschetti, Andrea. "Pietro e altri lapicidi lombardi a Belluno," Venice, Istituto veneto di scienze, lettere ed arti. *Atti*, lxxxvii, pt. 2, 1927–8, pp. 1481–1515

Moschini, Giannantonio. *Guida per la città di Venezia*. Venice, 1815

Moschini, Giannantonio. *Itinéraire de la ville de Venise et des îles circonvoisines*. Venice, 1819

Moschini, Giannantonio. *La Chiesa e il Seminario di Santa Maria della Salute in Venezia*. Venice, 1842

Moschini, Vittorio. *Le raccolte del Seminario di Venezia* (Itinerari dei musei e monumenti d'Italia, 76). Rome, 1940

Mothes, Oscar. *Geschichte der Baukunst und Bildhauerei Venedigs*. Leipzig, ii, 1860

Muir, Edward. *Civic Ritual in Renaissance Venice*. Princeton, NJ, 1981

Munman, Robert. *Venetian Renaissance Tomb Monuments*, Ph.D. dissertation, Harvard University, 1968 (typescript)

Munman, Robert. "Antonio Rizzo's Sarcophagus for Nicolò Tron: A Closer Look," *Art Bulletin*, lv, 1973, pp. 77–85

Munman, Robert. "The Sculpture of Giovanni Buora: a Supplement," *Arte veneta*, xxxiii, 1979, pp. 19–28

Muraro, Michelangelo. *Nuova guida di Venezia e delle sue isole*. Florence, 1953

Musolino, Giovanni. *La Basilica di San Marco in Venezia*. Venice, 1955

Nani Mocenigo, Mario. *Glorie mediterranee italiane*. Venice, 1937

Netto, Giovanni. *Guida di Treviso: la città, la storia, la cultura e l'arte*. Trieste, 1988

"Neue Ankäufe," *Mittheilungen des k. k. Oesterreichischen Museums für Kunst und Industrie*, viii, Jg. 15/ 16, 1880–1, p. 476

New York, Metropolitan Museum of Art. *Greek, Etruscan and Roman Bronzes*, catalogue by Gisela M. A. Richter. New York, 1915

Niero, Antonio. "Il culto dei santi nell'arte popolare," in Niero, G. Musolino, S. Tramontin, *Santità a Venezia*. Venice, 1972, pp. 231–89

Northampton, MA, Smith College Museum of Art. *Antiquity in the Renaissance*, April 6–June 6, 1978, exhibition catalogue by Wendy Stedman Sheard. Northampton, MA, 1979

Onofri, Fedele. *Cronologia veneta*. Venice, 1655

Oretti, Marcello. "Le pitture di Cesena," 1777 in *Il patrimonio culturale della provincia di Forlì*, i. *Gli edifici di culto del territorio delle diocesi di Cesena e Sarsina*, ed. Orlando Piraccini, (*Rapporto della Soprintendenza alle Gallerie di Bologna*, ed. Cesare Gnudi, 18). Bologna, 1973, pp. 179–86

Ortalli, Gherardo. "Malatestiana e dintorni. La cultura cesenate tra Malatesta Novello e il Valentino," in *Storia di Cesena*, ii. *Il medioevo*, ed. Augusto Vasina. Rimini, pt. 2, 1985, pp. 129–65

Paatz, Walter. "Ein wiedergefundener Kruzifixus von Baccio da Montelupo," *Mitteilungen des Kunsthistorischen Institutes in Florenz*, iii, 1919–32, pp. 360–1

Pacifico, Pietro Antonio. *Cronica veneta, overo succinto racconto di tutte le cose più cospicue, & antiche della Città di Venetia*. Venice, 1697

Palazzi, Giovanni. *Fasti cardinalium omnium Sanctæ Romanæ Ecclesiæ* . . . Venice, ii, 1701

Panofsky, Erwin. *Tomb Sculpture*, ed. H. W. Janson. New York, [1964]

Paoletti, Ermolao. *Il fiore di Venezia*. Venice, i, 1837; ii, 1839; iii, 1840; iv, 1840

Paoletti, Pietro. *L'architettura e la scultura del rinascimento in Venezia*. Venice, 1893

Paoletti, Pietro. "Bregno, Giovanni Battista di Roberto," *Allgemeines Lexikon der bildenden Künstler*, ed. U. Thieme and F. Becker. Leipzig, iv, 1910, pp. 569–70

Paoletti, Pietro. "Bregno, Lorenzo di Roberto," *Allgemeines Lexikon der bildenden Künstler*, ed. U. Thieme and F. Becker. Leipzig, iv, 1910, pp. 570–1

Papadopoli, Nicolò. "Alcune notizie sugli intagliatori della Zecca di Venezia," *Archivio veneto*, xxxv, 1888, pp. 271–7, repr. in *Rivista italiana di numismatica*, i, 1888, pp. 351–9

Paschini, Pio. "Frate Zanetto da Udine, Generale dei Frati Minori e Vescovo di Treviso (†1485): cenni biografici," *Archivum Franciscanum historicum*, xxvi, 1933, pp. 105–26

Pasini, Antonio. *Guide de la Basilique St. Marc à Venise.* Schio, 1888

Patrizio, Giovanni. *Piccola guida del Tempio monumentale di S. Nicolò, Treviso.* Treviso, 1962

Pedrocco, Filippo. "Il patrimonio artistico disperso dei Servi di Maria a Venezia," in Venice, Biblioteca nazionale Marciana, Sala sansoviniana. *Fra Paolo Sarpi e i Servi di Maria a Venezia nel 750° anniversario dell'ordine,* October 28–November 19, 1983. Venice, [1983], pp. 104–25

Pellegrini, Francesco. *Appunti storici sulla Cattedrale di Belluno* (per nozze Prosdocimi-Palatini). Belluno, 1908

Perez Pompei, Carla. *La Chiesa di S. Fermo Maggiore* (Collana 'Le guide', 11). Verona, 1954

Perkins, Charles C. *Italian Sculptors: Being a History of Sculpture in Northern, Southern, and Eastern Italy.* London, 1868

Perocco, Guido. *Tutta la pittura del Carpaccio.* Milan, 1960

Perolini, Mario. *Compendio cronologico della storia di Crema.* Crema, 1978

Pesce, Luigi, ed. *La visita pastorale di Giuseppe Grasser nella diocesi di Treviso (1826–1827)* (Centro studi per le fonti della storia della chiesa nel Veneto, 2). Rome, 1969

Petito, Luigi. *Guida del Duomo di Napoli.* Naples, ²1982

Petrucci, Francesca. "Baccio da Montelupo a Lucca," *Paragone,* xxxv, no. 417, November 1984, pp. 3–22

Piantelli, Francesco. *Folclore cremasco.* Crema, 1951

Piazza, Guiseppe. *La R. Basilica di S. Marco, esposta in sei tavole.* Venice, 1833

Pietrucci, Napoleone. *Biografia degli artisti padovani.* Padua, 1858

Pincus, Debra. "An Antique Fragment as Workshop Model: Classicism in the Andrea Vendramin Tomb," *Burlington Magazine,* cxxiii, 1981, pp. 342–6

Planiscig, Leo. *Venezianische Bildhauer der Renaissance.* Vienna, 1921

Planiscig, Leo. "Simon Bianco," *Belvedere,* v, January–July 1924, pp. 157–63

Planiscig, Leo. *Andrea Ricco.* Vienna, 1927

[Planiscig, Leo]. "Minio, Guido," *Allgemeines Lexikon der bildenden Künstler,* ed. U. Thieme and F. Becker. Leipzig, xxiv, 1930, p. 578

Planiscig, Leo. "Maffeo Olivieri," *Dedalo,* xii, pt. 1, January–June 1932, pp. 34–55

[Planiscig, Leo]. "Pyrgoteles," *Allgemeines Lexikon der bildenden Künstler,* ed. U. Thieme and F. Becker.

Leipzig, xxvii, 1933, pp. 480–1

[Planiscig, Leo]. Review of E. Ybl, *Mesterek és mesterművek, Corvina,* n.s. i, 1938, pp. 603–4

[Poggi, Giovanni]. "Un san Sebastiano di Baccio da Montelupo nella Badia di san Godenzo," *Rivista d'arte,* vi, 1909, pp. 133–5

Polverosi, Manfredi. *Uno scultore del secolo xvi: Baccio Sinibaldi da Montelupo.* Florence, 1899

Pope-Hennessy, John. "A Statuette by Antonio Minelli," *Burlington Magazine,* xciv, 1952, pp. 24–8

Pope-Hennessy, John. *Italian Renaissance Sculpture.* London, 1958, ²1971

Pope-Hennessy, John. "Italian Bronze Statuettes – I," *Burlington Magazine,* cv, 1963, pp. 14–23, repr. in idem, "An Exhibition of Italian Bronze Statuettes," *Essays on Italian Sculpture.* London/New York, 1968, pp. 172–98

Pope-Hennessy, John. *Italian High Renaissance and Baroque Sculpture.* London, 1963

Porto, Luigi da. *Lettere storiche . . . dall'anno 1509 al 1528,* ed. Bartolommeo Bressan. Florence, 1857

Predelli, Riccardo. *I libri commemoriali della Republica di Venezia. Regesti* (Venice, R. Deputazione veneta di storia patria. Monumenti storici, series 1, Documenti, xi). Venice, vi, 1903

Princivalle, Zereich. *Il Duomo di Montagnana.* Montagnana, 1981

Prosdocimi, Alessandro, in Padua, Palazzo della Ragione. *Dopo Mantegna: arte a Padova e nel territorio nei secoli xv e xvi,* June 26–November 14, 1976. Milan, 1976

Pulieri, Marco. *Miscellanea di memorie trivigiane dal 1813 al 1825,* ed. Angelo Marchesan. Treviso, 1911

Pullan, Brian. *Rich and Poor in Renaissance Venice.* Oxford, 1971

Puppi, Lionello. "Il tempio e gli eroi," in *La grande vetrata di San Giovanni e Paolo: storia, iconologia, restauro.* Venice, 1982, pp. 21–35

Puppi, Lionello. *La grande vetrata della Basilica dei Santi Giovanni e Paolo.* Venice, 1985

[Quadri, Antonio]. *I due Templi de' SS. Giovanni e Paolo e di Santa Maria Gloriosa detta de' Frari in Venezia.* Venice, 1835

Quirini, Angelo Maria. *Tiara et purpura Veneta.* Rome, 1750

Radcliffe, Anthony, in London, Royal Academy of Arts. *The Genius of Venice, 1500–1600,* November 25, 1983–March 11, 1984, catalogue ed. by Jane Martineau and Charles Hope. London, 1983

Rambaldi, P. L. *La Chiesa dei Ss. Gio. e Paolo e la Cappella del Rosario in Venezia.* Venice, 1913

Raponi, Nicola. "Bagarotti, Battista," *Dizionario biografico degli italiani.* Rome, v, 1963, pp. 168–9

Rearick, William Roger. "Observations on the Venetian Cinquecento in the Light of the Royal Academy Exhibition," *Artibus et historiae,* v, no. 9, 1984, pp. 59–75

Reinach, Salomon. *Répertoire de la statuaire grecque et romaine.* Paris, i, 1897; ii, pt. 1, 1897; ii, pt. 2, 1898; iii, 1904

Renucci, Giorgio. "Il Monastero di Santa Chiara in Treviso (memorie storiche)," *Le Venezie francescane* (Venice), xxix, nos. 1–4, 1962 (1965), pp. 26–54

Renucci, Giorgio. "Le chiese e i conventi," in *Treviso nostra.* Treviso, ²1980, i, pp. 263–303

"Restauri a Venezia, 1967–1986," *Quaderni della Soprintendenza ai Beni Artistici e Storici di Venezia,* xiv, 1986

Riccardi, Tommaso. *Storia dei vescovi vicentini.* Vicenza, 1786

[Ricci, Ettore]. "Le opere d'arte della Cattedrale," *L'amico del popolo* (Belluno), xx, no. 3, January 19, 1929, [p. 2]

Ridolfi, Carlo. *Le maraviglie dell'arte ovvero le vite degli illustri pittori veneti e dello stato,* ed. Detlev von Hadeln. Berlin, i, 1914; ii, 1924

Ridolfi, Pietro. (Petrus Rodulphus Tossinianus). *Historiarum seraphicae religionis libri tres.* Venice, 1586

Rigoni, Erice. "Notizie riguardanti Bartolomeo Bellano e altri scultori padovani," Padua, Accademia di scienze, lettere ed arti. *Atti e memorie,* n.s. xlix, 1932–3, pp. 199–219, repr. in eadem, *L'arte rinascimentale in Padova: studi e documenti (Medioevo e umanesimo,* 9). Padua, 1970, pp. 123–39

Rigoni, Erice. "Notizie sulla vita e la famiglia dello scultore Tiziano Aspetti detto Minio," *Arte veneta,* vii, 1953, pp. 119–22, repr. in eadem, *L'arte rinascimentale in Padova, studi e documenti (Medioevo e umanesimo,* 9). Padua, 1970, pp. 201–15

Rizzi, Alberto. *Scultura esterna a Venezia.* Venice, 1987

Romanin, S. *Storia documentata di Venezia.* Venice, iv, ³1973

Romano, Serena. "La vetrata: i maestri e gli artefici," in *La grande vetrata di San Giovanni e Paolo: storia, iconologia, restauro.* Venice, 1982, pp. 51–71

Romano, Serena. *Tullio Lombardo, il monumento al Doge Andrea Vendramin.* Venice, 1985

Rosand, David. "Titian in the Frari," *Art Bulletin,* liii, 1971, pp. 196–213

Rosand, David. *Painting in Cinquecento Venice: Titian, Veronese, Tintoretto.* New Haven/London, 1982

Rossi, Piero. *I monti di Belluno: la città e gli itinerari. Guida per il turista, lo sciatore e l'alpinista.* Belluno, 1958

Roth, Anthony. "The Lombard Sculptor Benedetto Briosco: Works of the 1490s," *Burlington Magazine,* cxxii, 1980, pp. 7–22

Ruhmer, Eberhard. "Antonio Lombardo: Versuch einer Charakteristik," *Arte veneta,* xxviii, 1974, pp. 39–74

Rusconi, Giacomo. *Le mura di Padova.* Bassano, 1921

Saalman, Howard. "Carrara Burials in the Baptistry of Padua," *Art Bulletin,* lxix, 1987, pp. 376–94

Sabellico, Marc'Antonio. *De situ urbis Venetae libri tres.* N.p., [Venice], (1491–2) n.d.

Sabellico, Marc'Antonio. "De situ Venetæ urbis: libri tres," in *Opera.* Venice, 1502, pp. 82v–94r

Saccardo, Francesco. "Sculture diverse," in Ferdinando Ongania, pub., *La Basilica di San Marco in Venezia illustrata nei riguardi dell'arte e della storia da scrittori veneziani,* ed. Camillo Boito. Venice, vi, 1888, pt. 3 [1893], pp. 269–75

Sagredo, Agostino. *Sulle consorterie delle arti edificative in Venezia.* Venice, 1856

Salomoni, Jacopo. *Agri Patavini inscriptiones sacræ, et prophanæ.* Padua, 1696

Sansovino, Francesco. *Venetia, citta nobilissima et singolare, descritta in xiiii. libri.* Venice, 1581

Sansovino, Francesco. *Venetia città nobilissima, et singolare; descritta già in xiiii. libri,* ed. and enlarged by Giovanni Stringa. Venice, ²1604

Sansovino, Francesco. *Venetia citta nobilissima, et singolare, descritta in xiiii. libri,* additions by Giustiniano Martinioni. Venice, ³1663

Santalena, Antonio. *Guida di Treviso.* Treviso, 1894

Sanuto, Marin. "Vite de' duchi di Venezia" in Lodovico Antonio Muratori, *Rerum Italicarum scriptores.* Milan, xxii, (1490–1530) 1733, coll. 399–1252

Sanuto, Marin. "Le vite dei dogi," ed. Giovanni Monticolo, in *Rerum Italicarum scriptores,* n.s. xxii, pt. 4, Città di Castello, 1900

Sanuto, Marin. *I diarii.* Venice, 1879–1903, 58 vols.

Sartori, Antonio. *Guida storico-artistica della Basilica di S. M. Gloriosa dei Frari in Venezia.* Padua, 1949

Sartori, Antonio. *La provincia del Santo dei frati minori conventuali: notizie storiche.* Padua, 1958

Sartori, Antonio. "Giambattista Cima da Conegliano e i suoi Sant'Antonio di Padova," *Il Santo,* n.s. ii, 1962, pp. 275–87

Sartori, Antonio. "Le acquasantiere della Basilica del Santo," *Il Santo,* n.s. iv, 1964, pp. 177–95

Sartori, Antonio. *Documenti per la storia dell'arte a Padova,* ed. Clemente Fillarini. Vicenza, 1976

Sartori, Antonio. *Archivio Sartori. Documenti di storia e*

*arte francescana*, i. *Basilica e Convento del Santo*, ed. Giovanni Luisetto. Padua, 1983

Sartori, Antonio. *Archivio Sartori. Documenti di storia e arte francescana*, ii, pts. 1 and 2. *La provincia del Santo dei Frati Minori Conventuali*, ed. Giovanni Luisetto. Padua, 1986

Sartori, Antonio. *Archivio Sartori. Documenti di storia e arte francescana*, iii, pts. 1 and 2. *Evoluzione del francescanesimo nelle tre Venezie*, ed. Giovanni Luisetto. Padua, 1988

Sartori, Antonio. *Archivio Sartori. Documenti di storia e arte francescana*, iv. *Guida della Basilica del Santo, varie, artisti e musici al Santo e nel Veneto*, ed. Giovanni Luisetto. Padua, 1989

Sartori, Francesco. *Cronistoria del comune di Selvazzano*. Padua, 1876

Sartori, Francesco. *Memorie storiche delle chiese parrocchiali ed oratorii oggidì spettanti alla forania di Selvazzano*. Padua, 1883

Sassi, Gioacchino. "Ecclesiografia Cesenate," 1865 in *Il patrimonio culturale della provincia di Forlì*, i. *Gli edifici di culto del territorio delle diocesi di Cesena e Sarsina*, ed. Orlando Piraccini, (*Rapporto della Soprintendenza alle Gallerie di Bologna*, ed Cesare Gnudi, 18). Bologna, 1973, pp 187–204

"Savin, Paolo." *Allgemeines Lexikon der bildenden Künstler*, ed. U. Thieme and F. Becker. Leipzig, xxix, 1935, pp. 508–9

Saxl, Fritz. "Pagan Sacrifice in the Italian Renaissance," *Journal of the Warburg and Courtauld Institutes*, ii, 1938–9, pp. 346–67

Scalini, Mario. "Isabella d'Este e Francesco Gonzaga: gli amanti regali rimasti senza una tomba attesa vent'anni," *Gazzetta antiquaria*, n.s. i, autumn 1987, pp. 56–62

Scardeone, Bernardino. *De antiquitate urbis Patavii*. Basel, 1560

Scarpitta, Giancarlo. *La provincia di Padova*. Avellino, 1978

Schlegel, Ursula. "Simone Bianco und die Venezianische Malerei," *Mitteilungen des Kunsthistorischen Institutes in Florenz*, xxiii, 1979, pp. 187–96

Schlegel, Ursula, in Münster, Westfälisches Landesmuseum für Kunst und Kulturgeschichte; Saarbrücken, Saarland-Museum; Hannover, Kestner-Museum. *Bronzen von der Antike bis zur Gegenwart*, March 14–November 13, 1983, catalogue ed. by Peter Bloch. Berlin, 1983

Schrader, Lorenz. *Monumentorum Italiae, quae hoc nostro sæculo & à Christianis posita sunt, libri quatuor*. Helmstadt, 1592

Schubring, Paul. *Die italienische Plastik des Quattrocento* (Handbuch der Kunstwissenschaft). Berlin, 1919

Schulz, Anne Markham. "The Giustiniani Chapel and the Art of the Lombardo," *Antichità viva*, xvi, no. 2, March–April 1977, pp. 27–44

Schulz, Anne Markham. "A New Venetian Project by Verrocchio: the Altar of the Virgin in SS. Giovanni e Paolo," *Festschrift für Otto von Simson zum 65. Geburtstag*, ed. L. Grisebach and K. Renger, Berlin/Frankfurt a.M./Vienna, 1977, pp. 197–208

Schulz, Anne Markham. *Niccolò di Giovanni Fiorentino and Venetian Sculpture of the Early Renaissance* (Monographs on Archaeology and Fine Arts sponsored by the Archaeological Institute of America and the College Art Association of America, 33). New York, 1978

Schulz, Anne Markham. "The Sculpture of Giovanni and Bartolomeo Bon and their Workshop," *Transactions of the American Philosophical Society*, lxviii, pt. 3, June 1978, pp. 3–81

Schulz, Anne Markham. "Giambattista Bregno," *Jahrbuch der Berliner Museen*, n.s. xxii, 1980, pp. 173–202

Schulz, Anne Markham. "Pietro Lombardo's Barbarigo Tomb in the Venetian Church of S. Maria della Carità," *Art the Ape of Nature, Studies in Honor of H. W. Janson*, ed. M. Barasch, L. F. Sandler, P. Egan. New York, 1981, pp. 171–92

Schulz, Anne Markham. *Antonio Rizzo, Sculptor and Architect*. Princeton, NJ, 1983

Schulz, Anne Markham. "The Bettignoli Bressa Altar and other Works by Giambattista Bregno," *Arte cristiana*, lxxi, 1983, pp. 35–48

Schulz, Anne Markham. "Giovanni Buora lapicida," *Arte lombarda*, lxv, 1983, pt. 2, pp. 49–72

Schulz, Anne Markham. "Sebastiano di Jacopo da Lugano," *Arte veneta*, xxxvii, 1983, pp. 159–63

Schulz, Anne Markham. "Bartolomeo di Francesco Bergamasco," *Interpretazioni veneziane. Studi di storia dell'arte in onore di Michelangelo Muraro*, ed. David Rosand. Venice, 1984, pp. 257–74

Schulz, Anne Markham. "Lorenzo Bregno," *Jahrbuch der Berliner Museen*, n.s. xxvi, 1984, pp. 143–79

Schulz, Anne Markham. "Paolo Stella Milanese," *Mitteilungen des Kunsthistorischen Institutes in Florenz*, xxix, 1985, pp. 79–110

Schulz, Anne Markham. "The Cenotaph of Alvise Trevisan in SS. Giovanni e Paolo," *Renaissance Studies in Honor of Craig Hugh Smyth*, ed. A. Morrogh, F. Superbi Gioffredi, P. Morselli, E. Borsook. Florence, 1985, ii, pp. 413–27

Schulz, Anne Markham. "Revising the History of

Venetian Renaissance Sculpture: Niccolò and Pietro Lamberti," *Saggi e memorie di storia dell'arte*, xv, 1986, pp. 7–61, 137–222

Schulz, Anne Markham. "Four New Works by Antonio Minello," *Mitteilungen des Kunsthistorischen Institutes in Florenz*, xxxi, 1987, pp. 291–326

Schulz, Juergen. "Pordenone's Cupolas," *Studies in Renaissance and Baroque Art Presented to Anthony Blunt on his 60th Birthday*. London, 1967, pp. 44–50

Scrinzi, Angelo. "Ricevute di Tiziano per il pagamento della Pala Pesaro ai Frari," *Venezia. Studi di arte e storia*, i, 1920, pp. 258–9

*La Scuola Grande e la Chiesa di San Rocco in Venezia*. Venice, [1949]

Selvatico, Pietro. *Sulla architettura e sulla scultura in Venezia dal medio evo sino ai nostri giorni*. Venice, 1847

Selvatico, Pietro, and Lazari, V. *Guida artistica e storica di Venezia e delle isole circonvicine*. Venice/Milan/Verona, 1852

Semenzi, Giovanni Battista Alvise. "Treviso e la sua provincia," in *Grande illustrazione del Lombardo-Veneto*, ed. Cesare Cantù. Milan, v, pt. 2, 1861 (1862), pp. 605–780

Semenzi, Giovanni Battista Alvise. *Treviso e sua provincia*. Treviso, ²1864

Serena, Augusto. *La cultura umanistica a Treviso nel secolo decimoquinto* (Venice, R. Deputazione veneta di storia patria. Miscellanea di storia veneta, ser. 3, iii). Venice, 1912

[Sernagiotto, Matteo]. "Il prezioso Altarino Bettignuoli da Brescia ora in S. Nicolò," *Gazzetta di Treviso*, iv, no. 29, January 29, 1869, pp. 1–3; iv, no. 30, January 30, 1869, pp. 1–2

Sernagiotto, Matteo. "Il Tempio e Convento di San Francesco in Treviso soppressi nel 1810: memoria letta al nostro Ateneo la sera del 20 aprile 1869," *Gazzetta di Treviso*, iv, no. 193, July 14, 1869, pp. 1–2; iv, no. 194, July 15, 1869, pp. 1–2; iv, no. 195, July 16, 1869, pp. 1–2; iv, no. 196, July 17, 1869, pp. 1–3; iv, no. 197, July 18, 1869, pp. 1–2; iv, no. 199, July 20, 1869, pp. 1–2, repr. as idem, *Il Tempio e Convento di San Francesco in Treviso . . . .* Treviso, 1869

Sernagiotto, Matteo. *Passeggiata per la città di Treviso verso il 1600*. Treviso, 1869

Sernagiotto, Matteo. *Seconda passeggiata per la città di Treviso verso l'anno 1600*. Treviso, 1870

Sernagiotto, Matteo. *Terza ed ultima passeggiata per la città di Treviso verso l'anno 1600*. Treviso, 1871

Serra, Luigi. *Alessandro Vittoria*. Rome, [1921]

Sforza Benvenuti, Francesco. "Crema e il suo terri-

torio," in *Grande illustrazione del Lombardo-Veneto*, ed. Cesare Cantù. Milan, v, pt. 1, 1859, pp. 717–88

Sforza Benvenuti, Francesco. *Storia di Crema*. Milan, 1859, 2 vols.

Sforza Benvenuti, Francesco. *Dizionario biografico cremasco*. Crema, 1888

Sheard, Wendy Stedman. *The Tomb of Doge Andrea Vendramin in Venice by Tullio Lombardo*, Ph.D. dissertation, Yale University, 1971 (typescript)

Sheard, Wendy Stedman. "Sanudo's List of Notable Things in Venetian Churches and the Date of the Vendramin Tomb," *Yale Italian Studies*, i, 1977, pp. 219–68

Sheard, Wendy Stedman. "Il torso antico nell'arte veneziana tra Quattro e Cinquecento. Una nuova lettura del torso," in *Roma e l'antico nell'arte e nella cultura del Cinquecento*, ed. Marcello Fagiolo (Corso internazionale di alta cultura, Rome, October 19–30, 1982). Rome, 1985, pp. 407–36

Sighinolfi, Lino. "Il culto di S. Domenico a Bologna e Nicolò dell'Arca," *Il resto del carlino della sera* (Bologna), xxxvii, no. 226, September 19, 1921, [p. 2]

Sinding-Larsen, Staale. *Christ in the Council Hall. Studies in the Religious Iconography of the Venetian Republic*, with a contribution by A. Kuhn, *Acta ad archaeologiam et artium historiam pertinentia*, v, 1974

Sirena, Franco. *Belluno, guida turistica*. Belluno, 1972

Sirotti, Giuseppe. *Cesena: diciotto secoli di storia dall'arrivo del cristianesimo alla cattedrale odierna*, ed. Gian Angelo Sirotti. Cesena, 1974 (mimeograph), ²1982

Soranzo, Giovanni. "Giovanni Battista Zeno, nipote di Paolo II, Cardinale di S. Maria in Portico (1468–1501)," *Rivista di storia della chiesa in Italia*, xvi, 1962, pp. 249–74

Soravia, Giambattista. *Le chiese di Venezia*. Venice, i, 1822; ii, 1823; iii, 1824

*Statuta civitatis Caesenae cum additionibus ac reformationibus, pro tempore factis*. Cesena, 1589

Steer, John. *Alvise Vivarini, his Art and Influence*. Cambridge, 1982

Štefanac, Samo. "Le sculture di Giovanni Buora a Ossero," *Venezia arti*, iii, 1989, pp. 41–5

Steinmann, Ernst. *Die Sixtinische Kapelle*. Munich, i, 1901

Stepan, Peter. *Die Reliefs der Cappella del Santo in Padua. Quellenstudien und Untersuchungen zu ihrer Ikonographie*, dissertation, Ludwig-Maximilians-Universität, Munich, 1982

Stringa, Giovanni. *La chiesa di S. Marco*. Venice, 1610

Superbi, Agostino. *Trionfo glorioso d'heroi illustri, et emi-*

nenti dell'inclita, & maravigliosa città di Venetia. Venice, 1629, i, ii

Supino, Igino Benvenuto. La scultura in Bologna nel secolo xv. Bologna, 1910

Tagliapietra, Paolo Maria. Templum Pacis, divinissima chiesa posta in SS. Giovanni et Paolo. Venice, 1646

Tamis, Ferdinando. La cattedrale di Belluno. Belluno, 1971

Tassini, Giuseppe. Curiosità veneziane, ed. Lino Moretti. Venice, (1863) ⁸1970

Tassini, Giuseppe. "Iscrizioni dell'ex Chiesa e Monastero del S. Sepolcro in Venezia," Archivio veneto, xvii, 1879, pp. 274–300

Temanza, Tommaso. Vite dei più celebri architetti, e scultori veneziani che fiorirono nel secolo decimosesto. Venice, 1778

Terni, Pietro. Historia di Crema 570–1557, ed. Maria and Corrado Verga. Crema, (1557) 1964

Terni de Gregory, Ginevra. "Un uomo d'affari cremasco del quattrocento," Italia contemporanea (Crema), 1949, no. 9, pp. 248–9

Terni de Gregory, Winifred. Crema monumentale e artistica. Crema, 1955, ²1960

Testolini, Marco. "Ricerche intorno ad Alessandro Leopardo," Archivio veneto, iii, 1872, pp. 246–50

Tiepolo, Piero. Treviso e la sua provincia: guida turistica. Treviso, 1936

Tonduzzi, Giulio Cesare. Historie di Faenza. Faenza, 1675

Tosi, Giovanna. L'Arco dei Gavi (La Fenice, 1). Rome, 1983

Tosi, Luigia Maria. "Baccio da Montelupo," Enciclopedia italiana di scienze, lettere ed arti. Rome, v, 1930, pp. 785–7

Touring Club Italiano. Guida d'Italia. Veneto. Milan, ⁵1969

Touring Club Italiano. Guida d'Italia. Venezia. Milan, ²1969

Tramontin, Silvio. S. Maria Mater Domini, storia e arte (Venezia sacra, 3). Venice, 1962

Treviso, Seminario Vescovile. Mostra d'arte sacra, Seminario di Treviso, September 13–21, 1947. Vedelago (TV), [1947]

[Trovanelli, Nazzareno]. "Artisti celebri italiani e stranieri a Cesena," Il cittadino, giornale della domenica (Cesena), viii, no. 20, May 17, 1896, [p. 2]

[Trovanelli, Nazzareno]. "Per una locale opera d'arte scomposta e da ricomporsi," Il cittadino, giornale della domenica (Cesena), xxii, no. 15, April 10, 1910, [pp. 2–3]

Tschudi, Hugo von. "Italienische Plastik des xv. und xvi. Jahrhunderts: grössere Bildwerke in Stein, Thon und Stuck," in Berlin, Kunstgeschichtliche Gesellschaft. Ausstellung von Kunstwerken des Mittelalters und der Renaissance aus Berliner Privatbesitz, May 20–July 3, 1898. Berlin, 1899, pp. 81–8

Ughelli, Ferdinando. Italia sacra; sive de episcopis Italiæ et insularum adjacentium. Venice, v, 1720

Urbani de Gheltof, Giuseppe Marino. "Una scoltura contrastata," Bullettino di arti, industrie e curiosità veneziane, i, 1877–8, pp. 72–3

Urbani de Gheltof, Giuseppe Marino. Tesoro della Scuola Grande di San Rocco in Venezia. Guida al visitatore. Venice, 1901

Valcanover, Francesco. "La Pala Pesaro," Quaderni della Soprintendenza ai Beni Artistici e Storici di Venezia, viii, 1979, pp. 57–67

Valcanover, Francesco. "Attività della Soprintendenza ai Beni Artistici e Storici di Venezia nel 1984," Arte veneta, xxxviii, 1984, pp. 267–77

Valentiner, Wilhelm Reinhold. "The Clarence H. Mackay Collection of Italian Renaissance Sculptures, pt. 2," Art in America, xiii, 1925, pp. 315–31

Vardanega, Alessandro. "Le chiese di Venezia dedicate alla Vergine. Santa Maria Mater Domini," Rivista Mariana 'Mater Dei', i, no. 3, May–June 1929, pp. 51–9

Vasari, Giorgio. Vite de' più eccellenti pittori scultori e architetti, ed. Giovanni Bottari. Rome, i, (1568) 1759

Vasari, Giorgio. Le vite de' più eccellenti pittori scultori ed architettori, ed. Gaetano Milanesi. Florence, (1568) 1878–85, 9 vols.

Vasari, Giorgio. Die Lebensbeschreibungen der berühmtesten Architekten, Bildhauer und Maler, ed. A. Gottschewski and G. Gronau. Strasbourg, vii, pt. 1, (1568) 1910

Vasari, Giorgio. Le vite de' più eccellenti pittori scultori e architettori, nelle redazioni del 1550 e 1568, ed. by Rosanna Bettarini, commentary by Paola Barocchi. Florence, 1966–

Vazzoler, Giancarla. Antonio, Lorenzo e Giambattista Bregno, Tesi di laurea, Università degli Studi di Padova, Facoltà di Magistero. Padua, 1962/63 (typescript)

Vecellio, Cesare. De gli habiti antichi, et moderni di diverse parti del mondo libri due. Venice, 1590

Venice, Biblioteca nazionale Marciana, Libreria Sansoviniana. Collezioni di antichità a Venezia nei secoli della repubblica (dai libri e documenti della Biblioteca Marciana), May 27–July 31, 1988, exhibition catalogue ed. by Marino Zorzi. Rome, 1988

Venice, Ca' d'Oro. La R. Galleria Giorgio Franchetti alla Ca' d'Oro. Guida-catalogo, by Fogolari, Nebbia, Mos-

chini. Venice, 1929

Venice, Procuratie Nuove. *Arte a Venezia dal medioevo al settecento*, June 26–October 31, 1971, catalogue by Giovanni Mariacher. Venice, 1971

*Venice Restored*. Paris, United Nations Educational Scientific and Cultural Organization, 1973

*Venice Restored*. [Paris], United Nations Educational Scientific and Cultural Organization, n.d. [1978?]

Venturi, Adolfo. *Storia dell'arte italiana*. Milan, vi, 1908; x, pt.1, 1935; x, pt. 2, 1936

Vertova, Luisa. "Lorenzo Lotto: collaborazione o rivalità fra pittura e scultura?" in *Lorenzo Lotto. Atti del Convegno internazionale di studi per il V centenario della nascita*, Asolo, September 18–21, 1980, ed. Pietro Zampetti and Vittorio Sgarbi. N.p. [Venice], 1981, pp. 401–14

Vicentini, Antonio M. *S. Maria de' Servi in Venezia*. Treviglio, 1920

Vigezzi, Silvio. *La scultura in Milano*. Milan, 1934

Vio, Gastone. "I 'mistri' della Chiesa di S. Fantin in Venezia," *Arte veneta*, xxxi, 1977, pp. 225–31

Vio, Gastone. "La pala di Tiziano a S. Nicolò della Lattuga (S. Nicoletto dei Frari)," *Arte veneta*, xxxiv, 1980, pp. 210–13

Viroli, Giordano, in *Il monumento a Barbara Manfredi e la scultura del rinascimento in Romagna*, ed. Anna Colombi Ferretti and Luciana Prati. Bologna, 1989

Wadding, Luke. *Annales Minorum seu trium ordinum a S. Francisco institutorum*, ed. Giuseppe Maria Fonseca. Florence, xiii, ³1932; xiv, ³1933

Ward Perkins, John Bryan. "The Shrine of St. Peter and its Twelve Spiral Columns," *Journal of Roman Studies*, xlii, 1952, pp. 21–33

Wegner, Max. *Die Musensarkophage (Die antiken Sarkophagreliefs*, ed. Friedrich Matz, v, pt. 3). Berlin, 1966

Weihrauch, Hans R. *Studien zum bildnerischen Werke des Jacopo Sansovino*. Strasbourg, 1935

Weinberger, Martin. "A Bronze Statuette in the Frick Collection and its Connection with Michelangelo," *Gazette des beaux-arts*, xciv (ser. 6, xxxix), 1952, pt. 1, pp. 103–114

Weiss, Roberto. "Vittore Camelio e la medaglia veneziana del rinascimento," *Rinascimento europeo e rinascimento veneziano*, ed. Vittore Branca (Civiltà europea e civiltà veneziana, Aspetti e problemi, 3). Florence, 1967, pp. 327–37

Weiss, Roberto. *The Renaissance Discovery of Classical Antiquity*. Oxford, 1969

Wilk, Sarah Blake. *Iconological Problems in the Sculpture of Tullio Lombardo*, Ph.D dissertation, New York University, 1977; repr. as eadem, *The Sculpture of Tullio Lombardo: Studies in Sources and Meaning*, Garland Series of Outstanding Dissertations in the Fine Arts. New York/London, 1978

Wilk, Sarah Blake. "La decorazione cinquecentesca della Cappella dell'Arca di S. Antonio," in *Le sculture del Santo di Padova*, ed. Giovanni Lorenzoni. Vicenza, 1984, pp. 109–71

Winter, Patrick M. de. "Recent Accessions of Italian Renaissance Decorative Arts. Part 1: Incorporating Notes on the Sculptor Severo da Ravenna," Cleveland, Museum of Art. *Bulletin*, lxxiii, 1986, pp. 75–138

Wolters, Wolfgang. *Der Bilderschmuck des Dogenpalastes. Untersuchungen zur Selbstdarstellung der Republik Venedig im 16. Jahrhundert*. Wiesbaden, 1983

Wolters, Wolfgang. "Skulptur," in Norbert Huse and Wolfgang Wolters, *Venedig. Die Kunst der Renaissance: Architektur, Skulptur, Malerei, 1460–1590*. Munich, 1986, pp. 146–202

Wurthmann, William B. *The Scuole Grandi and Venetian Art, 1260–c. 1500*, Ph.D. dissertation, University of Chicago, 1975 (typescript)

Ybl, Ervin. "Lorenzo Bregno márványdomborművei a Szépművészeti Múzeumban," *Az Országos Magyar Szépművészeti Múzeum évkönyvei*, v, 1927–8, pp. 59–67

Ybl, Ervin. *Mesterek és mestermüvek*. Budapest, [1938]

Zabarella, Giacomo. *Il Carosio, overo origine regia et augusta della serenissima fameglia Pesari di Venetia*. Padua, 1659

Zanetti-Persicini, Italia. *Bellune et ses environs: notes d'un amateur d'art et d'histoire*. Belluno, 1906

Zangirolami, Cesare. *Storia delle chiese, dei monasteri, delle scuole di Venezia rapinate e distrutte da Napoleone Bonaparte*. Venice, 1962

Zanotto, Francesco. "Descrizione della città," in *Venezia e le sue lagune*. Venice, 1847, ii, pt. 2, pp. 1–482

Zanotto, Francesco. *Nuovissima guida di Venezia e delle isole della sua laguna*. Venice, 1856

[Zatta, Antonio]. *L'augusta ducale Basilica dell'evangelista San Marco nell'inclita dominante di Venezia*. Venice, 1761

Zauli-Naldi, Dionigi. *Dionigi e Vincenzo Naldi in Romagna (1495–1504)*. Faenza, 1925

Zava Boccazzi, Franca. *La Basilica dei Santi Giovanni e Paolo in Venezia*. Padua, 1965

Zazzeri, Raimondo. *Storia di Cesena dalla sua origine fino ai tempi di Cesare Borgia*. Cesena, 1890

[Zazzeri, Raimondo]. "La Cattedrale di Cesena," *Il*

*Savio* (Cesena), i, no. 29, December 17, 1899, [pp. 1–2]; i, no. 31, December 31, 1899, [pp. 1–2]; ii, no. 1, January 6, 1900, [pp. 2–3]

Zenier, Vincenzo. *Guida per la Chiesa di S. Maria Gloriosa dei Frari di Venezia.* Venice, 1825

Zorzi, A. P., in Nicolò Barozzi, "Presbiterio e Cappella Zen," in Ferdinando Ongania, pub., *La Basilica di San Marco in Venezia illustrata nei riguardi dell'arte e della storia da scrittori veneziani,* ed. Camillo Boito. Venice, vi, 1888, pt. 3 [1893], pp. 415–17

Zorzi, Alvise. *Venezia scomparsa.* Milan, 1972, 2 vols.

Zucchini, Tommas'Arcangelo. *Nuova cronaca veneta, ossia descrizione di tutte le pubbliche architetture, sculture e pitture della città di Venezia ed isole circonvicine.* Venice, i, 1785; ii, 1784

# LIST OF ILLUSTRATIONS

FIGURES

1. Shop of Pietro Lombardo, Altar of St. Jerome, Cappella Giustiniani, S. Francesco della Vigna, Venice (Alinari, Florence)

2. Pietro Lombardo, *St. Mark*, Cappella Giustiniani, S. Francesco della Vigna, Venice (Böhm, Venice)

3. Pietro Lombardo, detail, *St. Mark*, Cappella Giustiniani, S. Francesco della Vigna, Venice (Böhm, Venice)

4. Pietro Lombardo, *St. John the Evangelist*, Cappella Giustiniani, S. Francesco della Vigna, Venice (Böhm, Venice)

5. Pietro Lombardo, detail, *St. John the Evangelist*, Cappella Giustiniani, S. Francesco della Vigna, Venice (Böhm, Venice)

6. Antonio Lombardo, *St. Luke*, Cappella Giustiniani, S. Francesco della Vigna, Venice (Böhm, Venice)

7. Antonio Rizzo, *Adam*, Ducal Palace, Venice (Rossi, Venice. Courtesy of Debra Pincus)

8. Detail, *St. John the Evangelist*, Bettignoli Bressa Altarpiece, S. Nicolò, Treviso (Fini, Treviso)

9. *St. John the Evangelist*, Bettignoli Bressa Altarpiece, S. Nicolò, Treviso (Fini, Treviso)

10. Assistant of Antonio Rizzo, fifth *Victory*, Scala dei Giganti, Ducal Palace, Venice (Böhm, Venice)

11. Assistant of Antonio Rizzo, first *Victory*, Scala dei Giganti, Ducal Palace, Venice (Böhm, Venice)

12. Antonio Rizzo and assistant, eighth *Victory*, Scala dei Giganti, Ducal Palace, Venice (Böhm, Venice)

13. Antonio Rizzo, *Conversion of St. Paul*, Altar of St. Paul, S. Marco, Venice (Alinari, Florence)

14. Tullio Lombardo, *Baptism of St. Anianus*, facade, Scuola Grande di S. Marco, Venice (Böhm, Venice)

15. Pietro Lombardo, *Madonna and Child Enthroned with Doge Leonardo Loredan*, Ducal Palace, Venice (Böhm, Venice)

16. Giovanni Bellini, *Madonna of the Meadow*, National Gallery, London (National Gallery, London)

17. Vittore Carpaccio, detail, *Vision of St. Augustine*, Scuola di S. Giorgio degli Schiavone, Venice (Böhm, Venice)

18. *Resurrected Christ*, Museo Poldi-Pezzoli, Milan (Museo Poldi-Pezzoli, Milan)

19. Roman, *Devotee*, Bibliothèque Nationale, Paris (Bibliothèque Nationale, Paris)

20. Paolo Savin, Female figure, Sarcophagus of Cardinal Zen, Cappella Zen, S. Marco, Venice (Giacomelli, Venice)

21. Antonio Lombardo, *Miracle of the Speaking Babe*, Cappella del Santo, S. Antonio, Padua (Alinari, Florence)

22. Tullio Lombardo, *Miracle of the Repentant Youth*, Cappella del Santo, S. Antonio, Padua (Alinari,

Florence)

23. Roman, 1st century A.D., Arco dei Gavi, Verona (Alinari, Florence)

24. Johannes Grevembroch, drawing of the Tomb of Giovanni Emo formerly in S. Maria dei Servi, Venice, in MS Gradenigo 228/ III, c. 27, Museo Correr, Venice (Museo Correr, Venice)

25. Pietro Lombardo, Tomb of Doge Pietro Mocenigo, SS. Giovanni e Paolo, Venice (Anderson, Florence)

26. Tullio Lombardo, Tomb of Doge Giovanni Mocenigo, SS. Giovanni e Paolo, Venice (Fiorentini, Florence)

27. Tullio Lombardo, Tomb of Doge Andrea Vendramin, SS. Giovanni e Paolo, Venice (Anderson, Florence)

28. St. Jerome in Penitence, Tomb of Benedetto Pesaro, S. Maria dei Frari, Venice (Giacomelli, Venice)

29. Baccio da Montelupo (?), detail, Mars, Tomb of Benedetto Pesaro, S. Maria dei Frari, Venice (Giacomelli, Venice)

30. Baccio da Montelupo (?), Mars, Tomb of Benedetto Pesaro, S.Maria dei Frari, Venice (Giacomelli, Venice)

31. Detail, Neptune, Tomb of Benedetto Pesaro, S. Maria dei Frari, Venice (Giacomelli, Venice)

32. Neptune, Tomb of Benedetto Pesaro, S. Maria dei Frari, Venice (Giacomelli, Venice)

33. Pyrgoteles, Madonna and Child, main portal, S. Maria dei Miracoli, Venice (Giacomelli, Venice)

34. Madonna and Child, Tomb of Benedetto Pesaro, S. Maria dei Frari, Venice (Giacomelli, Venice)

35. Detail, Madonna and Child, Tomb of Benedetto Pesaro, S. Maria dei Frari, Venice (Giacomelli, Venice)

36. St. George and the Dragon, Victoria & Albert Museum, London (Victoria & Albert Mus., London)

37. Antonio Vucetich, drawing of St. George and the Dragon at S. Marco 1076, Venice, in MS P. D. 2d, i, c. 2, no. 6, Museo Correr, Venice (Museo Correr, Venice)

38. Frame, Altar of St. Ambrose, Cappella dei Milanesi, S. Maria dei Frari, Venice (Giacomelli, Venice)

39. Altarpiece of St. Nicholas of Bari with Doge Andrea Gritti, Cappella di S. Clemente, S. Marco, Venice (Giacomelli, Venice)

40. St. James, Altarpiece of St. Nicholas of Bari with Doge Andrea Gritti, Cappella di S. Clemente, S. Marco, Venice (Giacomelli, Venice)

41. Left-hand Reggiscudo, Pesaro Altar, S. Maria dei Frari, Venice (Giacomelli, Venice)

42. Left-hand Reggiscudo, Pesaro Altar, S. Maria dei Frari, Venice (Giacomelli, Venice)

43. Left-hand Reggiscudo, Pesaro Altar, S. Maria dei Frari, Venice (Giacomelli, Venice)

44. Detail, left-hand Reggiscudo, Pesaro Altar, S. Maria dei Frari, Venice (Giacomelli, Venice)

45. Detail, left-hand Reggiscudo, Pesaro Altar, S. Maria dei Frari, Venice (Giacomelli, Venice)

46. Detail, St. Nicholas of Bari, Altarpiece of St. Nicholas of Bari with Doge Andrea Gritti, Cappella di S. Clemente, S. Marco, Venice (Giacomelli, Venice)

47. Detail, St. James, Altarpiece of St. Nicholas of Bari with Doge Andrea Gritti, Cappella di S. Clemente, S. Marco, Venice (Giacomelli, Venice)

48. Antonio Rizzo, Angel Bearing Attributes of Christ, Galleria Giorgio Franchetti alla Ca' d'Oro, Venice (Sopr. ai Beni Artistici e Storici di Venezia, Venice)

49. Roman, 2nd century A.D., Roman Woman as Priestess of Ceres, Ny Carlsberg Glyptotek, Copenhagen (Ny Carlsberg Glypt., Copenhagen)

50. Antonio Lombardo, Virtue, Tomb of Doge Andrea Vendramin, SS. Giovanni e Paolo, Venice (Böhm, Venice)

51. Palma il Vecchio, detail, Madonna and Child with SS. John the Baptist and Mary Magdalene, Accademia Carrara, Bergamo (Anderson, Florence)

52. Shop of Pietro Lombardo, eagle, Tomb of Bishop Giovanni da Udine, Duomo, Treviso (Böhm, Venice)

53. Roman, 1st century A.D., Apollo (of the Anzio type), Museo Archeologico, Venice (Sopr. Archeol. per il Veneto, Padua)

54. Agesandros, Polydoros, and Athenodoros of Rhodes, 1st century B.C. — 1st century A.D., detail, Laocoon, Cortile del Belvedere, Musei Vaticani, Vatican City (Deutsch. Archeol. Inst., Rome)

55. Tullio Lombardo, Double Portrait, Galleria Giorgio Franchetti alla Ca' d'Oro, Venice (Giacomelli, Venice)

56. Bartolomeo Bergamasco, St. Sebastian, High Altar, S. Rocco, Venice (Giacomelli, Venice)

57. Bartolomeo Bergamasco, St. Mary Magdalene from the Altar of Verde della Scala, SS. Giovanni e

Paolo, Venice (Giacomelli, Venice)

58. Plan of S. Maria del Carmine, Creola

59. Tomb of Niccolò Merloto, S. Chiara, Naples (Alinari, Florence)

60. Roman, 1st century A.D., *Augustus and his Family*, Museo Nazionale, Ravenna (Anderson, Florence)

61. Tomb of Jacopo Barbaro, S. Maria dei Frari, Venice (Giacomelli, Venice)

62. Antonio Minello, *Effigy*, Tomb of Dionigi Naldi da Brisighella, SS. Giovanni e Paolo, Venice (Giacomelli, Venice)

63. Engraving of the Tomb of Dionigi Naldi da Brisighella in SS. Giovanni e Paolo, Venice, in Diedo/Zanotto, [1839], pl. 67a (Bibl. Marciana, Venice)

64. Antonio Minello, detail, *Investiture of St. Anthony*, Cappella del Santo, S. Antonio, Padua (Giacomelli, Venice)

65. Lombardo shop, *St. Luke*, Altar of St. Luke, S. Giobbe, Venice (Giacomelli, Venice)

66. Lombardo shop, detail, *St. Luke*, Altar of St. Luke, S. Giobbe, Venice (Giacomelli, Venice)

67. Antonio Lombardo and assistant, detail, *St. Peter Martyr* from the High Altar of S. Giustina, SS. Giovanni e Paolo, Venice (Giacomelli, Venice)

68. Lombardo shop, left-hand *Angel*, Altar of St. Luke, S. Giobbe, Venice (Giacomelli, Venice)

69. Lombardo shop, right-hand *Angel*, Altar of St. Luke, S. Giobbe, Venice (Giacomelli, Venice)

70. Lombardo shop, detail, right-hand *Angel*, Altar of St. Luke, S. Giobbe, Venice (Giacomelli, Venice)

71. Lombardo shop, detail, right-hand *Angel*, Altar of St. Luke, S. Giobbe, Venice (Giacomelli, Venice)

72. Tullio Lombardo, detail, *Miracle of the Repentant Youth*, Cappella del Santo, S. Antonio, Padua (Giacomelli, Venice)

73. Tomb of Melchiore Trevisan, S. Maria dei Frari, Venice (Böhm, Venice)

74. *Effigy*, Tomb of Melchiore Trevisan, S. Maria dei Frari, Venice (Giacomelli, Venice)

75. Detail, *Effigy*, Tomb of Melchiore Trevisan, S. Maria dei Frari, Venice (Giacomelli, Venice)

76. Antonio Minello and others, Trevisan Altar, S. Maria Mater Domini, Venice (Böhm, Venice)

77. *St. Andrew*, Trevisan Altar, S. Maria Mater Domini, Venice (Giacomelli, Venice)

78. Detail, *St. Andrew*, Trevisan Altar, S. Maria Mater Domini, Venice (Giacomelli, Venice)

79. Antonio Minello, detail, *St. Peter*, Trevisan Altar, S. Maria Mater Domini, Venice (Giacomelli, Venice)

80. Antonio Minello, *St. Peter*, Trevisan Altar, S. Maria Mater Domini, Venice (Giacomelli, Venice)

81. Antonio Minello, detail, *St. Peter*, Trevisan Altar, S. Maria Mater Domini, Venice (Giacomelli, Venice)

82. Antonio Minello, detail, *Mercury*, Victoria & Albert Museum, London (Victoria & Albert Mus., London)

83. *Trinity*, Trevisan Altar, S. Maria Mater Domini, Venice (Giacomelli, Venice)

84. Antonio Minello and collaborator, *St. Paul*, Trevisan Altar, S. Maria Mater Domini, Venice (Giacomelli, Venice)

85. Antonio Minello, detail, *Investiture of St. Anthony*, Cappella del Santo, S. Antonio, Padua (Giacomelli, Venice)

86. *Effigy*, Tomb of Bishop Lorenzo Gabriel, Oesterreichisches Museum für angewandte Kunst, Vienna (Oester. Mus. für angewandte Kst., Vienna)

87. Andrea Fusina, *Effigy*, Tomb of Bishop Battista Bagarotti, Castello Sforzesco, Milan (Alinari, Florence)

88. Detail, *Effigy*, Tomb of Bishop Lorenzo Gabriel, Oesterreichisches Museum für angewandte Kunst, Vienna (Oester. Mus. für angewandte Kst., Vienna)

PLATES

1. Bettignoli Bressa Altarpiece, S. Nicolò, Treviso (Alinari, Florence)

2. Giambattista Bregno, pilaster, Bettignoli Bressa Altarpiece, S. Nicolò, Treviso (Giacomelli, Venice)

3. Giambattista Bregno, lesene, Bettignoli Bressa Altarpiece, S. Nicolò, Treviso (Böhm, Venice)

4. Giambattista Bregno, *Resurrected Christ*, Bettignoli Bressa Altarpiece, S. Nicolò, Treviso (Fini, Treviso)

5. Giambattista Bregno, *Resurrected Christ*, Bettignoli Bressa Altarpiece, S. Nicolò, Treviso (Fini, Treviso)

6. Giambattista Bregno, *Resurrected Christ*, Bettignoli Bressa Altarpiece, S. Nicolò, Treviso (Fini, Treviso)

7. Giambattista Bregno, detail, *Resurrected Christ*, Bettignoli Bressa Altarpiece, S. Nicolò, Treviso (Fini, Treviso)

8. Giambattista Bregno, detail, *Resurrected Christ,* Bettignoli Bressa Altarpiece, S. Nicolò, Treviso (Fini, Treviso)

9. Giambattista Bregno, Bettignoli Bressa Epigraph, S. Nicolò, Treviso (Fini, Treviso)

10. Giambattista Bregno, detail, *Madonna and Child,* Bettignoli Bressa Altarpiece, S. Nicolò, Treviso (Fini, Treviso)

11. Giambattista Bregno, detail, *Madonna and Child,* Bettignoli Bressa Altarpiece, S. Nicolò, Treviso (Fini, Treviso)

12. Giambattista Bregno, detail, *Madonna and Child,* Bettignoli Bressa Altarpiece, S. Nicolò, Treviso (Fini, Treviso)

13. Giambattista Bregno, left-hand *Angel,* Bettignoli Bressa Altarpiece, S. Nicolò, Treviso (Fini, Treviso)

14. Giambattista Bregno, right-hand *Angel,* Bettignoli Bressa Altarpiece, S. Nicolò, Treviso (Fini, Treviso)

15. Giambattista Bregno, *Visitation,* Duomo, Treviso (Giacomelli, Venice)

16. Giambattista Bregno, detail, *Visitation,* Duomo, Treviso (Giacomelli, Venice)

17. Giambattista Bregno, detail, *Visitation,* Duomo, Treviso (Giacomelli, Venice)

18. Giambattista Bregno, detail, *Visitation,* Duomo, Treviso (Giacomelli, Venice)

19. Giambattista Bregno, detail, *Visitation,* Duomo, Treviso (Giacomelli, Venice)

20. Altar of the Corpus Domini, Duomo, Cesena (Alinari, Florence)

21. Giambattista Bregno, detail, *St. John the Evangelist,* Altar of the Corpus Domini, Duomo, Cesena (Zangheri, Cesena)

22. Giambattista Bregno, detail, *Christ as Man of Sorrows,* Altar of the Corpus Domini, Duomo, Cesena (Zangheri, Cesena)

23. Giambattista Bregno, *Christ as Man of Sorrows,* Altar of the Corpus Domini, Duomo, Cesena (Zangheri, Cesena)

24. Giambattista Bregno, detail, *Christ as Man of Sorrows,* Altar of the Corpus Domini, Duomo, Cesena (Zangheri, Cesena)

25. Giambattista Bregno, detail, *Christ as Man of Sorrows,* Altar of the Corpus Domini, Duomo, Cesena (Zangheri, Cesena)

26. Giambattista Bregno, *St. John the Baptist,* Altar of the Corpus Domini, Duomo, Cesena (Zangheri, Cesena)

27. Giambattista Bregno, *St. John the Baptist,* Altar of the Corpus Domini, Duomo, Cesena (Zangheri, Cesena)

28. Giambattista Bregno, detail, *St. John the Baptist,* Altar of the Corpus Domini, Duomo, Cesena (Zangheri, Cesena)

29. Giambattista Bregno, detail, *St. John the Baptist,* Altar of the Corpus Domini, Duomo, Cesena (Zangheri, Cesena)

30. Giambattista Bregno, *St. John the Evangelist,* Altar of the Corpus Domini, Duomo, Cesena (Zangheri, Cesena)

31. Giambattista Bregno, *St. John the Evangelist,* Altar of the Corpus Domini, Duomo, Cesena (Zangheri, Cesena)

32. Giambattista Bregno, detail, *St. John the Evangelist,* Altar of the Corpus Domini, Duomo, Cesena (Zangheri, Cesena)

33. Giambattista Bregno, detail, *St. John the Evangelist,* Altar of the Corpus Domini, Duomo, Cesena (Zangheri, Cesena)

34. Giambattista Bregno, *Carlo Verardi,* Altar of the Corpus Domini, Duomo, Cesena (Zangheri, Cesena)

35. Giambattista Bregno, *Camillo Verardi,* Altar of the Corpus Domini, Duomo, Cesena (Zangheri, Cesena)

36. Giambattista Bregno, detail, *Carlo Verardi,* Altar of the Corpus Domini, Duomo, Cesena (Zangheri, Cesena)

37. Giambattista Bregno, detail, *Camillo Verardi,* Altar of the Corpus Domini, Duomo, Cesena (Zangheri, Cesena)

38. Giambattista Bregno, left-hand *Angel,* Altar of the Corpus Domini, Duomo, Cesena (Zangheri, Cesena)

39. Giambattista Bregno, right-hand *Angel,* Altar of the Corpus Domini, Duomo, Cesena (Zangheri, Cesena)

40. Giambattista Bregno, left-hand half-length *Angel,* Altar of the Corpus Domini, Duomo, Cesena (Zangheri, Cesena)

41. Giambattista Bregno, right-hand half-length *Angel,* Altar of the Corpus Domini, Duomo, Cesena (Zangheri, Cesena)

42. Giambattista Bregno, detail, left-hand half-

length *Angel*, Altar of the Corpus Domini, Duomo, Cesena (Zangheri, Cesena)

43. Giambattista Bregno, detail, left-hand half-length *Angel*, Altar of the Corpus Domini, Duomo, Cesena (Zangheri, Cesena)

44. Giambattista Bregno, detail, right-hand half-length *Angel*, Altar of the Corpus Domini, Duomo, Cesena (Zangheri, Cesena)

45. Giambattista Bregno, detail, right-hand *Angel*, Altar of the Corpus Domini, Duomo, Cesena (Zangheri, Cesena)

46. Cappella del SS. Sacramento, Duomo, Treviso (Böhm, Venice)

47. Giambattista Bregno, *Resurrected Christ*, Cappella del SS. Sacramento, Duomo, Treviso (Giacomelli, Venice)

48. Giambattista Bregno, *Resurrected Christ*, Cappella del SS. Sacramento, Duomo, Treviso (Giacomelli, Venice)

49. Giambattista Bregno, *Resurrected Christ*, Cappella del SS. Sacramento, Duomo, Treviso (Giacomelli, Venice)

50. Giambattista Bregno, detail, *Resurrected Christ*, Cappella del SS. Sacramento, Duomo, Treviso (Giacomelli, Venice)

51. Giambattista Bregno, detail, *Resurrected Christ*, Cappella del SS. Sacramento, Duomo, Treviso (Giacomelli, Venice)

52. Giambattista Bregno, detail, *Resurrected Christ*, Cappella del SS. Sacramento, Duomo, Treviso (Giacomelli, Venice)

53. Giambattista Bregno, detail, *St. Peter*, Cappella del SS. Sacramento, Duomo, Treviso (Giacomelli, Venice)

54. Giambattista Bregno, *St. Peter*, Cappella del SS. Sacramento, Duomo, Treviso (Giacomelli, Venice)

55. Giambattista Bregno, *St. Peter*, Cappella del SS. Sacramento, Duomo, Treviso (Giacomelli, Venice)

56. Giambattista Bregno, *St. Peter*, Cappella del SS. Sacramento, Duomo, Treviso (Giacomelli, Venice)

57. Giambattista Bregno, detail, *St. Peter*, Cappella del SS. Sacramento, Duomo, Treviso (Giacomelli, Venice)

58. Giambattista Bregno, detail, *St. Peter*, Cappella del SS. Sacramento, Duomo, Treviso (Giacomelli, Venice)

59. Bregno shop, left-hand *Angel*, Cappella del SS. Sacramento, Duomo, Treviso (Giacomelli, Venice)

60. Bregno shop, detail, left-hand *Angel*, Cappella del SS. Sacramento, Duomo, Treviso (Giacomelli, Venice)

61. Bregno shop, right-hand *Angel*, Cappella del SS. Sacramento, Duomo, Treviso (Giacomelli, Venice)

62. Bregno shop, detail, right-hand *Angel*, Cappella del SS. Sacramento, Duomo, Treviso (Giacomelli, Venice)

63. West face, Sarcophagus of Cardinal Zen, Cappella Zen, S. Marco, Venice (Giacomelli, Venice)

64. Giambattista Bregno and Antonio Lombardo (?), detail, Female figure, Sarcophagus of Cardinal Zen, Cappella Zen, S. Marco, Venice (Giacomelli, Venice)

65. Giambattista Bregno and Antonio Lombardo (?), Female figure, Sarcophagus of Cardinal Zen, Cappella Zen, S. Marco, Venice (Giacomelli, Venice)

66. Giambattista Bregno and Antonio Lombardo (?), Female figure, Sarcophagus of Cardinal Zen, Cappella Zen, S. Marco, Venice (Giacomelli, Venice)

67. Giambattista Bregno and Antonio Lombardo (?), Female figure, Sarcophagus of Cardinal Zen, Cappella Zen, S. Marco, Venice (Giacomelli, Venice)

68. Giambattista Bregno and Antonio Lombardo (?), Female figure, Sarcophagus of Cardinal Zen, Cappella Zen, S. Marco, Venice (Giacomelli, Venice)

69. Bregno shop, Female figure, Sarcophagus of Cardinal Zen, Cappella Zen, S. Marco, Venice (Giacomelli, Venice)

70. Bregno shop, Female figure, Sarcophagus of Cardinal Zen, Cappella Zen, S. Marco, Venice (Giacomelli, Venice)

71. Bregno shop, Female figure, Sarcophagus of Cardinal Zen, Cappella Zen, S. Marco, Venice (Giacomelli, Venice)

72. Bregno shop, detail, Female figure, Sarcophagus of Cardinal Zen, Cappella Zen, S. Marco, Venice (Giacomelli, Venice)

73. Tomb of Benedetto Pesaro, S. Maria dei Frari, Venice (Böhm, Venice)

74. Giambattista Bregno, *St. Benedict*, Tomb of Benedetto Pesaro, S. Maria dei Frari, Venice (Giacomelli, Venice)

75. Giambattista Bregno (?), capital, Tomb of Benedetto Pesaro, S. Maria dei Frari, Venice (Böhm, Venice)

76. Giambattista Bregno (?), detail of pedestal, Tomb of Benedetto Pesaro, S. Maria dei Frari, Venice (Böhm, Venice)

77. Giambattista Bregno, *Effigy*, Tomb of Benedetto Pesaro, S. Maria dei Frari, Venice (Giacomelli, Venice)

78. Giambattista Bregno, *Effigy*, Tomb of Benedetto Pesaro, S. Maria dei Frari, Venice (Giacomelli, Venice)

79. Giambattista Bregno, *Effigy*, Tomb of Benedetto Pesaro, S. Maria dei Frari, Venice (Giacomelli, Venice)

80. Giambattista Bregno, detail, *Effigy*, Tomb of Benedetto Pesaro, S. Maria dei Frari, Venice (Giacomelli, Venice)

81. Giambattista Bregno, detail, *Effigy*, Tomb of Benedetto Pesaro, S. Maria dei Frari, Venice (Giacomelli, Venice)

82. Giambattista Bregno, detail, *Effigy*, Tomb of Benedetto Pesaro, S. Maria dei Frari, Venice (Giacomelli, Venice)

83. Giambattista Bregno and assistant, detail, *St. George and the Dragon*, dormitory facade, Convent of S. Giorgio Maggiore, Venice (Giacomelli, Venice)

84. Giambattista Bregno and assistant, *St. George and the Dragon*, dormitory facade, Convent of S. Giorgio Maggiore, Venice (Giacomelli, Venice)

85. Giambattista Bregno, *Angel*, Staatliche Museen, East Berlin (Staatl. Mus., East Berlin)

86. Giambattista Bregno, *Angel*, Staatliche Museen, East Berlin (Staatl. Mus., East Berlin)

87. Giambattista Bregno, *Angel*, Staatliche Museen, East Berlin (Staatl. Mus., East Berlin)

88. Giambattista Bregno, *Angel*, Staatliche Museen, East Berlin (Staatl. Mus., East Berlin)

89. Giambattista Bregno, detail, *Angel*, Staatliche Museen, East Berlin (Staatl. Mus., East Berlin)

90. Giambattista Bregno, detail, *Angel*, Staatliche Museen, East Berlin (Staatl. Mus., East Berlin)

91. Giambattista Bregno, *Angel*, sacristy, SS. Giovanni e Paolo, Venice (Giacomelli, Venice)

92. Giambattista Bregno, *Angel*, sacristy, SS. Giovanni e Paolo, Venice (Giacomelli, Venice)

93. Giambattista Bregno, *Angel*, sacristy, SS. Giovanni e Paolo, Venice (Giacomelli, Venice)

94. Giambattista Bregno, *Angel*, sacristy, SS. Giovanni e Paolo, Venice (Giacomelli, Venice)

95. Giambattista Bregno, detail, *Angel*, sacristy, SS. Giovanni e Paolo, Venice (Giacomelli, Venice)

96. Giambattista Bregno, detail, *Angel*, sacristy, SS. Giovanni e Paolo, Venice (Giacomelli, Venice)

97. Giambattista Bregno, detail, *Angel*, sacristy, SS. Giovanni e Paolo, Venice (Giacomelli, Venice)

98. Giambattista Bregno (?), frame of the High Altar, S. Maria dei Frari, Venice (Giacomelli, Venice)

99. Bregno shop, *Christ as Man of Sorrows*, High Altar, S. Maria dei Frari, Venice (Giacomelli, Venice)

100. Giambattista Bregno, *St. Anthony*, High Altar, S. Maria dei Frari, Venice (Giacomelli, Venice)

101. Giambattista Bregno, *St. Anthony*, High Altar, S. Maria dei Frari, Venice (Giacomelli, Venice)

102. Giambattista Bregno, detail, *St. Anthony*, High Altar, S. Maria dei Frari, Venice (Giacomelli, Venice)

103. Giambattista Bregno, detail, *St. Anthony*, High Altar, S. Maria dei Frari, Venice (Giacomelli, Venice)

104. Giambattista Bregno, detail, *St. Anthony*, High Altar, S. Maria dei Frari, Venice (Giacomelli, Venice)

105. Giambattista Bregno, detail, *St. Anthony*, High Altar, S. Maria dei Frari, Venice (Giacomelli, Venice)

106. Giambattista Bregno, detail, *St. Anthony*, High Altar, S. Maria dei Frari, Venice (Giacomelli, Venice)

107. Giambattista Bregno, *Deacon Saint*, S. Giovanni Evangelista, Venice (Giacomelli, Venice)

108. Giambattista Bregno, *Deacon Saint*, S. Giovanni Evangelista, Venice (Giacomelli, Venice)

109. Giambattista Bregno, detail, *Deacon Saint*, S. Giovanni Evangelista, Venice (Giacomelli, Venice)

110. Giambattista Bregno, detail, *Deacon Saint*, S. Giovanni Evangelista, Venice (Giacomelli, Venice)

111. Giambattista Bregno, detail, *Deacon Saint*, S. Giovanni Evangelista, Venice (Giacomelli, Venice)

112. Assistant of Giambattista Bregno, detail, *Prophet*, Cappella del Santo, S. Antonio, Padua (Giacomelli, Venice)

113. Assistant of Giambattista Bregno, *Prophet*, Cappella del Santo, S. Antonio, Padua (Giacomelli, Venice)

114. Assistant of Giambattista Bregno, *Resurrected Christ*, S. Nicolò, Treviso (Fini, Treviso)

115. Assistant of Giambattista Bregno, detail, *Resurrected Christ*, S. Nicolò, Treviso (Fini, Treviso)

116. Assistant of Giambattista Bregno, *Holy Women*, S. Nicolò, Treviso (Fini, Treviso)

117. Giambattista Bregno, right-hand *Reggiscudo*, Pe-

saro Altar, S. Maria dei Frari, Venice (Giacomelli, Venice)

118. Giambattista Bregno, right-hand *Reggiscudo*, Pesaro Altar, S. Maria dei Frari, Venice (Giacomelli, Venice)

119. Giambattista Bregno, right-hand *Reggiscudo*, Pesaro Altar, S. Maria dei Frari, Venice (Giacomelli, Venice)

120. Giambattista Bregno, detail, right-hand *Reggiscudo*, Pesaro Altar, S. Maria dei Frari, Venice (Giacomelli, Venice)

121. Giambattista Bregno, detail, right-hand *Reggiscudo*, Pesaro Altar, S. Maria dei Frari, Venice (Giacomelli, Venice)

122. Giambattista Bregno, detail, right-hand *Reggiscudo*, Pesaro Altar, S. Maria dei Frari, Venice (Giacomelli, Venice)

123. Giambattista Bregno, detail, right-hand *Reggiscudo*, Pesaro Altar, S. Maria dei Frari, Venice (Giacomelli, Venice)

124. Lorenzo Bregno, *St. Paul*, Cappella del SS. Sacramento, Duomo, Treviso (Giacomelli, Venice)

125. Lorenzo Bregno, *St. Paul*, Cappella del SS. Sacramento, Duomo, Treviso (Giacomelli, Venice)

126. Lorenzo Bregno, detail, *St. Paul*, Cappella del SS. Sacramento, Duomo, Treviso (Giacomelli, Venice)

127. Lorenzo Bregno, *St. Paul*, Cappella del SS. Sacramento, Duomo, Treviso (Giacomelli, Venice)

128. Lorenzo Bregno, detail, *St. Paul*, Cappella del SS. Sacramento, Duomo, Treviso (Giacomelli, Venice)

129. Lorenzo Bregno, *Angel* from the altarpiece, Cappella del SS. Sacramento, Duomo, Treviso (Giacomelli, Venice)

130. Lorenzo Bregno, *Angel* from the altarpiece, Cappella del SS. Sacramento, Duomo, Treviso (Giacomelli, Venice)

131. Lorenzo Bregno, *Angels* from the altarpiece, Cappella del SS. Sacramento, Duomo, Treviso (Giacomelli, Venice)

132. Lorenzo Bregno, *Angels* from the altarpiece, Cappella del SS. Sacramento, Duomo, Treviso (Giacomelli, Venice)

133. Lorenzo Bregno, *St. Mark*, Cappella del SS. Sacramento, Duomo, Treviso (Giacomelli, Venice)

134. Lorenzo Bregno, *St. Luke*, Cappella del SS. Sac-

ramento, Duomo, Treviso (Giacomelli, Venice)

135. Lorenzo Bregno, *St. John the Evangelist*, Cappella del SS. Sacramento, Duomo, Treviso (Giacomelli, Venice)

136. Lorenzo Bregno, *St. Matthew*, Cappella del SS. Sacramento, Duomo, Treviso (Giacomelli, Venice)

137. Lorenzo Bregno, detail, *St. Mark*, Cappella del SS. Sacramento, Duomo, Treviso (Giacomelli, Venice)

138. Lorenzo Bregno, detail, *St. Luke*, Cappella del SS. Sacramento, Duomo, Treviso (Giacomelli, Venice)

139. Lorenzo Bregno, detail, *St. John the Evangelist*, Cappella del SS. Sacramento, Duomo, Treviso (Giacomelli, Venice)

140. Lorenzo Bregno, detail, *St. Matthew*, Cappella del SS. Sacramento, Duomo, Treviso (Giacomelli, Venice)

141. Lorenzo Bregno, eagle beneath *St. John the Evangelist*, Cappella del SS. Sacramento, Duomo, Treviso (Giacomelli, Venice)

142. Lorenzo Bregno, detail, angel beneath *St. Matthew*, Cappella del SS. Sacramento, Duomo, Treviso (Giacomelli, Venice)

143. Lorenzo Bregno, angel beneath *St. Matthew*, Cappella del SS. Sacramento, Duomo, Treviso (Giacomelli, Venice)

144. Lorenzo Bregno, Shrine of SS. Theonistus, Tabra, and Tabrata, High Altar, Duomo, Treviso (Giacomelli, Venice)

145. Lorenzo Bregno, pilaster, Shrine of SS. Theonistus, Tabra, and Tabrata, High Altar, Duomo, Treviso (Giacomelli, Venice)

146. Lorenzo Bregno, *St. Tabra*, Shrine of SS. Theonistus, Tabra, and Tabrata, High Altar, Duomo, Treviso (Giacomelli, Venice)

147. Lorenzo Bregno, detail, *St. Tabra*, Shrine of SS. Theonistus, Tabra, and Tabrata, High Altar, Duomo, Treviso (Giacomelli, Venice)

148. Lorenzo Bregno, detail, *St. Tabra*, Shrine of SS. Theonistus, Tabra, and Tabrata, High Altar, Duomo, Treviso (Giacomelli, Venice)

149. Lorenzo Bregno, *St. Theonistus*, Shrine of SS. Theonistus, Tabra, and Tabrata, High Altar, Duomo, Treviso (Giacomelli, Venice)

150. Lorenzo Bregno, detail, *St. Theonistus*, Shrine of SS. Theonistus, Tabra, and Tabrata, High Altar,

Duomo, Treviso (Giacomelli, Venice)

151. Lorenzo Bregno, St. Tabrata, Shrine of SS. Theonistus, Tabra, and Tabrata, High Altar, Duomo, Treviso (Giacomelli, Venice)

152. Lorenzo Bregno, detail, St. Tabrata, Shrine of SS. Theonistus, Tabra, and Tabrata, High Altar, Duomo, Treviso (Giacomelli, Venice)

153. Lorenzo Bregno, Female figure, Sarcophagus of Cardinal Zen, Cappella Zen, S. Marco, Venice (Giacomelli, Venice)

154. Lorenzo Bregno, Female figure, Sarcophagus of Cardinal Zen, Cappella Zen, S. Marco, Venice (Giacomelli, Venice)

155. Lorenzo Bregno, Female figure, Sarcophagus of Cardinal Zen, Cappella Zen, S. Marco, Venice (Giacomelli, Venice)

156. Lorenzo Bregno, Female figure, Sarcophagus of Cardinal Zen, Cappella Zen, S. Marco, Venice (Giacomelli, Venice)

157. Lorenzo Bregno, detail, Female figure, Sarcophagus of Cardinal Zen, Cappella Zen, S. Marco, Venice (Giacomelli, Venice)

158. Lorenzo Bregno, detail, Female figure, Sarcophagus of Cardinal Zen, Cappella Zen, S. Marco, Venice (Giacomelli, Venice)

159. Lorenzo Bregno, St. John the Evangelist, Staatliche Museen, East Berlin (Staatl. Mus., East Berlin)

160. Lorenzo Bregno, detail, St. John the Evangelist, Staatliche Museen, East Berlin (Staatl. Mus., East Berlin)

161. Lorenzo Bregno, Altarpiece from S. Sepolcro, S. Martino, Venice (Giacomelli, Venice)

162. Lorenzo Bregno, capital, Altarpiece from S. Sepolcro, S. Martino, Venice (Giacomelli, Venice)

163. Lorenzo Bregno, Christ as Man of Sorrows, Altarpiece from S. Sepolcro, S. Martino, Venice (Giacomelli, Venice)

164. Lorenzo Bregno, St. John the Baptist, Altarpiece from S. Sepolcro, S. Martino, Venice (Giacomelli, Venice)

165. Lorenzo Bregno, St. John the Baptist, Altarpiece from S. Sepolcro, S. Martino, Venice (Giacomelli, Venice)

166. Lorenzo Bregno, St. John the Baptist, Altarpiece from S. Sepolcro, S. Martino, Venice (Giacomelli, Venice)

167. Lorenzo Bregno, detail, St. John the Baptist, Al-

tarpiece from S. Sepolcro, S. Martino, Venice (Giacomelli, Venice)

168. Lorenzo Bregno, St. Peter, Altarpiece from S. Sepolcro, S. Martino, Venice (Giacomelli, Venice)

169. Lorenzo Bregno, St. Peter, Altarpiece from S. Sepolcro, S. Martino, Venice (Giacomelli, Venice)

170. Lorenzo Bregno, St. Peter, Altarpiece from S. Sepolcro, S. Martino, Venice (Giacomelli, Venice)

171. Lorenzo Bregno, detail, St. Peter, Altarpiece from S. Sepolcro, S. Martino, Venice (Giacomelli, Venice)

172. Lorenzo Bregno and assistant, St. Martin of Tours, Duomo, Belluno (Sopr. ai Beni Artistici e Storici del Veneto, Venice)

173. Lorenzo Bregno and assistant, St. Joathas, Duomo, Belluno (Sopr. ai Beni Artistici e Storici del Veneto, Venice)

174. Lorenzo Bregno, Altar of St. Leonard, Duomo, Cesena (Alinari, Florence)

175. Lorenzo Bregno, detail, St. Eustace, Altar of St. Leonard, Duomo, Cesena (Zangheri, Cesena)

176. Lorenzo Bregno, St. Leonard, Altar of St. Leonard, Duomo, Cesena (Zangheri, Cesena)

177. Lorenzo Bregno, detail, St. Leonard, Altar of St. Leonard, Duomo, Cesena (Zangheri, Cesena)

178. Lorenzo Bregno, St. Christopher, Altar of St. Leonard, Duomo, Cesena (Zangheri, Cesena)

179. Lorenzo Bregno, St. Christopher, Altar of St. Leonard, Duomo, Cesena (Zangheri, Cesena)

180. Lorenzo Bregno, detail, St. Christopher, Altar of St. Leonard, Duomo, Cesena (Zangheri, Cesena)

181. Lorenzo Bregno, detail, St. Christopher, Altar of St. Leonard, Duomo, Cesena (Zangheri, Cesena)

182. Lorenzo Bregno, St. Eustace, Altar of St. Leonard, Duomo, Cesena (Zangheri, Cesena)

183. Lorenzo Bregno, St. Eustace, Altar of St. Leonard, Duomo, Cesena (Zangheri, Cesena)

184. Lorenzo Bregno, detail, St. Eustace, Altar of St. Leonard, Duomo, Cesena (Zangheri, Cesena)

185. Lorenzo Bregno, detail, St. Eustace, Altar of St. Leonard, Duomo, Cesena (Zangheri, Cesena)

186. Lorenzo Bregno, St. Sebastian, Altar of St. Sebastian, Duomo, Treviso (Giacomelli, Venice)

187. Lorenzo Bregno, St. Sebastian, Altar of St. Sebastian, Duomo, Treviso (Giacomelli, Venice)

188. Lorenzo Bregno, St. Sebastian, Altar of St. Sebastian, Duomo, Treviso (Giacomelli, Venice)

189. Lorenzo Bregno, detail, St. Sebastian, Altar of St.

Sebastian, Duomo, Treviso (Giacomelli, Venice)

190. Assistant of Lorenzo Bregno, left-hand *Angel*, Altar of St. Sebastian, (Szépművészeti Múzeum, Budapest (Szépművészeti Múz., Budapest)

191. Assistant of Lorenzo Bregno, right-hand *Angel*, Altar of St. Sebastian, (Szépművészeti Múzeum, Budapest (Szépművészeti Múz., Budapest)

192. Lorenzo Bregno, capital, Altar of St. Sebastian, S. Leonardo, Treviso (Giacomelli, Venice)

193. Assistant of Lorenzo Bregno, *Madonna and Child*, Altar of St. Sebastian, Szépművészeti Múzeum, Budapest (Szépművészeti Múz., Budapest)

194. Lorenzo Bregno, frame, Altar of St. Sebastian, S. Leonardo, Treviso (Giacomelli, Venice)

195. Lorenzo Bregno, detail, *St. Francis*, High Altar, S. Maria dei Frari, Venice (Giacomelli, Venice)

196. Lorenzo Bregno, *St. Francis*, High Altar, S. Maria dei Frari, Venice (Giacomelli, Venice)

197. Lorenzo Bregno, *St. Francis*, High Altar, S. Maria dei Frari, Venice (Giacomelli, Venice)

198. Lorenzo Bregno, detail, *St. Francis*, High Altar, S. Maria dei Frari, Venice (Giacomelli, Venice)

199. Lorenzo Bregno, detail, *St. Francis*, High Altar, S. Maria dei Frari, Venice (Giacomelli, Venice)

200. Lorenzo Bregno, detail, *St. Francis*, High Altar, S. Maria dei Frari, Venice (Giacomelli, Venice)

201. Bregno shop, *Resurrected Christ*, High Altar, S. Maria dei Frari, Venice (Giacomelli, Venice)

202. Bregno shop, *Resurrected Christ*, High Altar, S. Maria dei Frari, Venice (Giacomelli, Venice)

203. Bregno shop, *Resurrected Christ*, High Altar, S. Maria dei Frari, Venice (Giacomelli, Venice)

204. Bregno shop, detail, *Resurrected Christ*, High Altar, S. Maria dei Frari, Venice (Giacomelli, Venice)

205. Bregno shop, detail, *Resurrected Christ*, High Altar, S. Maria Frari, Venice (Giacomelli, Venice)

206. Lorenzo Bregno, detail, *Bust of the Saviour*, Scuola Grande di S. Rocco, Venice (Giacomelli, Venice)

207. Lorenzo Bregno, *Bust of the Saviour*, Scuola Grande di S. Rocco, Venice (Giacomelli, Venice)

208. Lorenzo Bregno, detail, *Bust of the Saviour*, Scuola Grande di S. Rocco, Venice (Giacomelli, Venice)

209. Lorenzo Bregno, detail, *St. Marina*, High Altar of S. Marina, Seminario Patriarcale, Venice (Giacomelli, Venice)

210. Lorenzo Bregno, detail, *St. Marina*, High Altar of S. Marina, Seminario Patriarcale, Venice (Giaco-melli, Venice)

211. Lorenzo Bregno, *St. Marina*, High Altar of S. Marina, Seminario Patriarcale, Venice (Giacomelli, Venice)

212. Lorenzo Bregno, detail, *St. Marina*, High Altar of S. Marina, Seminario Patriarcale, Venice (Giacomelli, Venice)

213. Lorenzo Bregno and assistant, *St. Mary Magdalene*, High Altar of S. Marina, SS. Giovanni e Paolo, Venice (Giacomelli, Venice)

214. Lorenzo Bregno and assistant, detail, *St. Mary Magdalene*, High Altar of S. Marina, SS. Giovanni e Paolo, Venice (Giacomelli, Venice)

215. Lorenzo Bregno and assistant, *St. Catherine of Alexandria*, High Altar of S. Marina, SS. Giovanni e Paolo, Venice (Giacomelli, Venice)

216. Lorenzo Bregno and assistant, detail, *St. Catherine of Alexandria*, High Altar of S. Marina, SS. Giovanni e Paolo, Venice (Bőhm, Venice)

217. Lorenzo Bregno, *St. Bartholomew*, Scuola Grande di S. Rocco, Venice (Giacomelli, Venice)

218. Lorenzo Bregno, *St. Bartholomew*, Scuola Grande di S. Rocco, Venice (Giacomelli, Venice)

219. Lorenzo Bregno, *St. Bartholomew*, Scuola Grande di S. Rocco, Venice (Giacomelli, Venice)

220. Lorenzo Bregno, detail, *St. Bartholomew*, Scuola Grande di S. Rocco, Venice (Giacomelli, Venice)

221. Lorenzo Bregno, *St. Apollonia* or *St. Agatha*, Scuola Grande di S. Rocco, Venice (Giacomelli, Venice)

222. Lorenzo Bregno, *St. Apollonia* or *St. Agatha*, Scuola Grande di S. Rocco, Venice (Giacomelli, Venice)

223. Lorenzo Bregno, *St. Apollonia* or *St. Agatha*, Scuola Grande di S. Rocco, Venice (Giacomelli, Venice)

224. Lorenzo Bregno, detail, *St. Apollonia* or *St. Agatha*, Scuola Grande di S. Rocco, Venice (Giacomelli, Venice)

225. Altar of the Cross, S. Marco, Venice (Bőhm, Venice)

226. Lorenzo Bregno, *Trinity*, Altar of the Cross, S. Marco, Venice (Giacomelli, Venice)

227. Lorenzo Bregno, detail, Altar of the Cross, S. Marco, Venice (Giacomelli, Venice)

228. Lorenzo Bregno, assistant, and Jacopo Sansovino, detail, Altar of the Cross, S. Marco, Venice (Giacomelli, Venice)

229. Assistant of Lorenzo Bregno, left-hand *Angel*, Altar of the Cross, S. Marco, Venice (Giacomelli,

Venice)

230. Assistant of Lorenzo Bregno, right-hand *Angel*, Altar of the Cross, S. Marco, Venice (Giacomelli, Venice)

231. Lorenzo Bregno, *St. Francis*, Altar of the Cross, S. Marco, Venice (Giacomelli, Venice)

232. Lorenzo Bregno, *St. Anthony*, Altar of the Cross, S. Marco, Venice (Giacomelli, Venice)

233. Lorenzo Bregno, detail, *St. Francis*, Altar of the Cross, S. Marco, Venice (Giacomelli, Venice)

234. Lorenzo Bregno, detail, *St. Anthony*, Altar of the Cross, S. Marco, Venice (Giacomelli, Venice)

235. Lorenzo Bregno, *Effigy*, Tomb of Benedetto Crivelli, S. Maria del Carmine, Creola (Mus. Civico, Padua)

236. Lorenzo Bregno, detail, *Effigy*, Tomb of Benedetto Crivelli, S. Maria del Carmine, Creola (Mus. Civico, Padua)

237. Lorenzo Bregno, Tomb of Benedetto Crivelli, S. Maria del Carmine, Creola (Mus. Civico, Padua)

238. Lorenzo Bregno, Tomb of Bartolino Terni, S. Trinità, Crema (Marasca, Crema)

239. Lorenzo Bregno, *Effigy*, Tomb of Bartolino Terni, S. Trinità, Crema (Gamberoni, Bergamo)

240. Lorenzo Bregno, *Effigy*, Tomb of Bartolino Terni, S. Trinità, Crema (Gamberoni, Bergamo)

241. Lorenzo Bregno, *Effigy*, Tomb of Bartolino Terni, S. Trinità, Crema (Gamberoni, Bergamo)

242. Lorenzo Bregno, detail, *Effigy*, Tomb of Bartolino Terni, S. Trinità, Crema (Gamberoni, Bergamo)

243. Lorenzo Bregno, detail, *Effigy*, Tomb of Bartolino Terni, S. Trinità, Crema (Gamberoni, Bergamo)

244. Lorenzo Bregno, frame, Pesaro Altar, S. Maria dei Frari, Venice (Giacomelli, Venice)

245. Lorenzo Bregno, frame, Altarpiece of the *Annunciation*, Cappella della SS. Annunziata, Duomo, Treviso (Giacomelli, Venice)

246. Cappella della SS. Annunziata, Duomo, Treviso (Alinari, Florence)

247. Lorenzo Bregno, capital, Altarpiece of the *Annunciation*, Cappella della SS. Annunziata, Duomo, Treviso (Giacomelli, Venice)

248. Bregno shop and an anonymous stonecarver, Tomb of Bertuccio Lamberti, formerly crypt, Duomo, Treviso (Giacomelli, Venice)

249. Main portal, Duomo, Montagnana (Frick Art Reference Library, New York)

250. Lorenzo Bregno and Antonio Minello, *Madonna and Child*, main portal, Duomo, Montagnana (Giacomelli, Venice)

251. Lorenzo Bregno and Antonio Minello, detail, *Madonna and Child*, main portal, Duomo, Montagnana (Giacomelli, Venice)

252. Lorenzo Bregno and Antonio Minello, detail, *Madonna and Child*, main portal, Duomo, Montagnana (Giacomelli, Venice)

# Index

Abbondi, Antonio (Scarpagnino), 124
Agnadello, 13, 204
Alberghetto, Zanin, founder, 182, 183
Alberti, Leon Battista, 96
Albertini, Francesco, 194
Albizoto, Fra Francesco, 187f n. 4
Alexander VI, Pope, 13, 132, 189, 199, 200 n. 13
Alviano, Bartolomeo d', *condottiere*, 20, 85, 204
Andrea, mason, 172
Antico (Pier Jacopo Alari-Bonacolsi), 7
Antonello da Messina; Vienna, Kunsthistorisches Museum:
    S. Cassiano *Madonna*, 34
Antonio Maria da Milano, 154
*Apollo* of the Anzio type, 62; Venice, Museo Archeologico
    (Roman, 1st cen. A.D.), Fig. 53
*Apollo Lykeios* (Praxiteles), 67
Aquila, 140
Aretino, Pietro, 164 n. 5
Azzalli, Francesco degli, 153

Baccio da Montelupo, 194, 194f, 196 n. 25
    WORKS. Bologna, S. Domenico: *Lamentation*, 196 n.
    41; Florence, Convent of S. Marco: *Crucifix*, 196 n. 41;
    Or San Michele: *St. John the Evangelist*, 196 n. 41; S.
    Maria Novella: *Crucifix*, 196 n. 41; S. Godenzo, Badia:
    *St. Sebastian*, 196 n. 41; Segromigno Monte, S. Lo-
    renzo: tabernacle, 196 n. 41; Venice, S. Maria dei
    Frari: Tomb of Benedetto Pesaro, *Mars*, 42, 45, 81 n.
    31, 97f, 192, 194, Figs. 29, 30
Bagaroto, Bertuzi, 140
Balzan, Sebastiano, 27 n. 108

Bambaia (Agostino Busti), 99
Barbari, Jacopo de', 198, 201
Barbarigo, Doge Agostino, medal of (Camelio), 10
Bartolomeo Bergamasco, 82, 87, 100
    WORKS. Venice, S. Geminiano (formerly): High Al-
    tar, 87; SS. Giovanni e Paolo: *St. Mary Magdalene* from
    the Altar of Verde della Scala, 32, 48, 70, 142, Fig. 57;
    S. Rocco: High Altar, 87; *St. Sebastian*, 67, 87 n. 33,
    Fig. 56
Bartolomeo da Cornuda, 153
Basadonna, Lodovico, 29, 89, 145
Bellini, family, 95
Bellini, Gentile, 95; medal of (Camelio), 10
Bellini, Giovanni, 12, 37, 55; Byzantine influence in paintings
    of the Madonna, 34; medal of (Camelio), 10
    WORKS. London, National Gallery: *Fra Teodoro as St.
    Dominic*, 54; *Madonna of the Meadow*, Fig. 16; Naples,
    Museo di Capodimonte: *Transfiguration*, 35; Venice,
    Gallerie dell'Accademia: *Madonna degli Alberetti*, 34;
    Washington, D.C., National Gallery of Art: *St. Jerome*,
    35
Bellini, Jacopo, 92 n. 49, 94
Belluno, 88, 161; Duomo, history of its construction, 130,
    161; model of (T. Lombardo), 87, 130; Altar of the Holy
    Thorn (lost; L. Bregno), 65, 86, 88, 97, 130f; *Deposition
    from the Cross* (Palma il Giovane), 130 n. 7; *Madonna and
    Child* (Agos. Ridolfi), 130 n. 9; *Madonna in Glory* (Cesare
    Vecellio), 130 n. 8; *SS. Martin* and *Joathas* from the Altar
    of the Holy Thorn (L. Bregno), 65, 129–131 Cat. no. 1,
    Pls. 172, 173
Bembo, Pietro, 39

Benedetto da Rovezzano, sculptor, 55

Berceto, 157

Bergamo, 87, 89, 213; Accademia Carrara: *Madonna and Child with SS. John the Baptist and Mary Magdalene* (Palma il Vecchio), Fig. 51

Berlin, Beckerath Collection (former), 141, 143

Bernardo, Pietro, 51

Bessarion, Cardinal, 201

Bettignoli, Chiara, 108, 167

Bettignoli, Deifebo, 108, 166

Bettignoli, Giovanni Antonio, 21, 90, 108f, 166, 167, 168

Bettignoli, Venceslao, 21, 32, 107f, 166

Bettignoli Bressa, Cara, 166, 167, 167f

Bettignoli Bressa, Franceschina Sugana, 166, 167

Bettignoli Bressa, Francesco, 166, 167, 167f

Bevilacqua, ser Lazaro, 108f, 167

Bianchi, Giacomo, 133

Bianco, Simone, 92, 99, 163; *Mars* (lost), 81 n. 31
    WORKS. Compiègne, Château: *Bust of a Man*, 164 n. 5; Copenhagen, Statens Museum for Kunst: *Bust of a Woman*, 164 n. 5; Munich, private collection (formerly): *Amor*, 164 n. 5; Paris, art market (formerly): *Bust of a Man*, 164 n. 5; Louvre: two *Busts of Men*, 164 n. 5; Stockholm, Nationalmuseum: *Bust of a Man*, 164 n. 5 Vienna, Kunsthistorisches Museum: *Bust of a Man*, 164 n. 5

Bissolo, Francesco; Venice, S. Maria Mater Domini: *Transfiguration*, 211, 211 n. 12

Bolani, Marco, procurator, 178

Bologna, 6, 162

————, S. Domenico: *Lamentation* (Baccio da Montelupo), 196 n. 41

————, S. Francesco: Tomb of Bishop Galeazzo Bottrigari (lost; Alfonso Lombardi), 215 n. 29

————, S. Petronio, *Fabbrica di*, 84

Bolzano, Fra Urbano, 187

Bon, Bartolomeo, architect, 26, 72, 85, 120, 178f

Bon, Bartolomeo, sculptor, 4, 8, 95; Venice, Ducal Palace, Porta della Carta, 4, 93

Bonazza, family, 156

Boneto, Pasqualin, stonecutter, 172

Bonzio, Giovanni Battista, 88

Borgia, Cesare (Duke Valentino), 13, 204

Borrestad, Collection of Count P. de la Gardie: figure studies (Carpaccio), 38 n. 14

Bosnia, 201

Bossis, Girolamo de', notary, 140

Bragadin, family, 69, 89, 175

Bregno, Alberto, 15, 16 n. 10, 104

Bregno, Antonio, 16 n. 10

Bregno, Antonio di Pietro, 15, 117f

Bregno, family, 15

Bregno, Giambattista, appraisals by, 19, 21, 106f Doc. II, 107 Doc. III; 115f Doc. IX; critical fortune, 2–4, 31; date of birth, 15; date of death, 16, 87; nephew of Rizzo, 16, 116; partner of Sebastiano da Lugano, 19, 20f; proxy of Antonio di Pietro Bregno, 15, 117f Doc. XII; residence

of, 17; training of, 16; workshop of, 15, 17, 80, 86f, 90, 97f
    WORKS. Cesena, Duomo: Altar of the Corpus Domini, 3, 15, 22, 23, 24, 25, 36–38, 65f, 83, 86, 89, 91, 112f Doc. VI, 131–134 Cat. no. 2, 136, 171, Pl. 20; *Angels* (full-length), 36, 37, 38, 66, Pls. 38, 39, 45; *Angels* (half-length), 36, 37, 47, 48f, 53, Pls. 40–44; *Christ as Man of Sorrows*, 36, 36f, 38, 39, 50, 97, Pls. 22–25; *St. John the Baptist*, 36, 37, 49, 54, 66, Pls. 26–29; *St. John the Evangelist*, 36, 37, 39, 42, 66, 168, Pls. 21–33; *Camillo Verardi*, 36, 37, 46, 97, Pls. 35, 37; *Carlo Verardi*, 36, 37, 38, 97, Pls. 34, 36

    WORKS. East Berlin, Staatliche Museen: *Angel from Altar of Verde della Scala*, 48f, 53f, 86, 94, 123f Doc. XVIII, 141–144 Cat. no. 6, Pls. 85–90; Padua, S. Antonio, Chapel of St. Anthony: *Miracle of the Goblet*, commission for, 3, 16, 17, 18f, 27, 52, 83, 90, 104–106 Doc. I, 147; *Prophet*, 18f, 26, 31, 35, 52, 83, 86, 97, 105f Doc. I, 146f Cat. no. 9, Pls. 112, 113

    WORKS. Treviso, Duomo: *Visitation*, 34–36, 40, 41, 52f, 57, 63, 83, 91, 95, 96, 155–157 Cat. no. 13, Pls. 15–19; Cappella del SS. Sacramento, 3, 83, 88, 90, 91, 159–165 Cat. no. 15, Pl. 46; *Angels*, 24, 58, 65, 86, 97, 184, Pls. 59–62; incrustation, 22, 24, 26, 83, 93, 109–112 Doc. V; pavement, 22, 83; *Resurrected Christ*, 24, 31, 38f, 46, 48, 52, 58, 97, 111 Doc. V, C, Pls. 47–52; *St. Peter*, 24, 35, 39f, 41, 46, 47, 51, 52, 57, 58f, 61, 63, 64, 86, Pls. 53–58; stairs, 22, 83

    WORKS. Treviso, S. Chiara (formerly): Bettignoli Bressa Altar, see Bregno, G.B.; Treviso, S. Nicolò: Bettignoli Bressa Altar; Cenotaph of Venceslao Bettignoli (lost), 21, 32, 107–109 Doc. IV, 166, 167; S. Nicolò: Bettignoli Bressa Altar, 3, 15, 21, 31–34, 57, 83, 91, 93, 98, 107–109 Doc. IV, 165–169 Cat. no. 16, Pl. 1; *Angels*, 21, 32, 37, 48, 53, Pls. 13, 14; frame, 32, 44, 62, Pls. 1–3; *Madonna and Child*, 21, 32, 33f, 68, 97, Pls. 10–12; *Resurrected Christ*, 21, 32f, 38, 39, 54, 68, 97, Pls. 4–8; Bettignoli Epigraph, 165, 166, 167, Pl. 9; *Christ Appearing to the Holy Women*, 31, 52f, 97, 169–170 Cat. no. 17, Pls. 114–116

    WORKS. Venice, Church of the Crociferi: Tomb of Ippolito Verardi (lost), 22f, 24, 83, 89, 92, 113 Docs. VI, E, F, 133, 170f Cat. no. 18; Convent of S. Giorgio Maggiore: *St. George and the Dragon*, 2f, 24, 26, 47f, 84, 88, 89, 91, 93, 96, 116f Doc. X, 171f Cat. no. 19, Pls. 83, 84

    WORKS. Venice, SS. Giovanni e Paolo: *Angel from Altar of Verde della Scala*, 48f, 53f, 86, 94, 99, 123f Doc. XVIII, 141–144 Cat. no. 6, Pls. 91–97; S. Marco, Cappella Zen: female figures from Tomb of Cardinal Zen, 3, 23f, 40–42, 71f, 83f, 90, 95, 97, 115 Doc. VIII, 180–185 Cat. no. 25, Pls. 63–72; S. Giovanni Evangelista: *Deacon Saint*, 31, 51, 86, 177 Cat. no. 23, Pls. 107–111

    WORKS. Venice, S. Maria dei Frari: High Altar, 72, 86, 87, 88, 90, 91, 93, 96, 185–188 Cat. no. 26, Pl. 98; *Christ as Man of Sorrows*, 50, Pl. 99; frame, 49, 50,

86, 93, 97, Pl. 98; *Resurrected Christ*, 31, 49, 68f, 90, 96, 97, Pls. 201–205; *St. Anthony*, 31, 49, 50, 51, 54, 57, 68, 69, 72, 90, 96, Pls. 100–106; Pesaro Altar, right-hand *Reggiscudo*, 16, 31, 53f, 77, 87, 89, 97, 188–191 Cat. no. 27, Pls. 117–123

WORKS. Venice, S. Maria dei Frari: Tomb of Benedetto Pesaro, 1, 42–47, 89, 91, 92, 98, 117 Doc. XI, 192–196 Cat. no. 28, Pl. 73; *Effigy*, 2, 42, 43, 45, 45f, 50, 57, 76, 77, 84, 98, 99, 205, Pls. 77–82; frame, 42, 42–44, 45, 50, 84, 93, 98, 205, Pls. 73, 75, 76; *St. Benedict*, 42, 46f, Pl. 74; S. Maria dei Servi (formerly): *Angels* from Altar of Verde della Scala, 48f, 53f, 86, 94, 99, 123f Doc. XVIII, 141–144 Cat. no. 6, Pls. 85–97

Bregno, Lorenzo, children of, 15, 28, 30, 124, 125, 126; critical fortune, 2–4, 57; date of birth, 15; death of, 15, 29, 30, 87, 126; estate of, 27–30, 124–127 Doc. XIX, 145, 151, 158; first notice of, 22, 111; nephew of Rizzo, 16; residence of, 17; surname of, 26; testament of, 15, 28, 124, 126; training of, 16; workshop of, 17, 27, 28, 53, 86f, 87, 90, 97f, 124, 126, 145, 210f

WORKS. Belluno, Duomo: Altar of the Holy Thorn (lost), 65, 86, 88; *SS. Martin* and *Joathas* from Altar of the Holy Thorn, 65, 97, 129–131 Cat. no. 1, Pls. 172–173; Budapest, Szépművészeti Múzeum: *Angels* from Altar of St. Sebastian, 25, 66, 67f, 70, 97, 147–150 Cat. no. 10, Pls. 190, 191; *Madonna and Child* from Altar of St. Sebastian, 25, 66, 67, 68, 97, 147–150 Cat. no. 10, Pl. 193

WORKS. Cesena, Duomo: Altar of St. Leonard, 3, 24f, 26, 57, 65f, 86, 89f, 91, 118f Doc. XIII, 133, 134 n. 17, 134–137 Cat. no. 3, 170f, Pl. 174; *St. Christopher*, 63, 65, 66, 68, 79, Pls. 178–181; *St. Eustace*, 63, 65, 66, 68, 81, Pls. 175, 182–185; *St. Leonard*, 66, 68, Pls. 176, 177

WORKS. Crema, S. Trinità: Tomb of Bartolino Terni, 26, 57, 76f, 78, 79, 87, 91, 93, 137–139 Cat. no. 4, Pl. 238; *Effigy*, 3, 45, 45 n. 28, 77, 205, Pls. 239–243; Creola, S. Maria del Carmine: Tomb of Benedetto Crivelli, 73–76, 84, 87, 89, 90, 91, 93, 121f Doc. XVI, 139–141 Cat. no. 5, 187, Pls. 235–237; East Berlin, Staatliche Museen: *St. John the Evangelist*, 63, 64, 144 Cat. no. 7, Pls. 159, 160; Montagnana, Duomo, portal: *Madonna and Child*, 28f, 57, 79f, 87, 88, 89, 91, 97, 124 Doc. XIX, 144–146 Cat. no. 8, 211, Pls. 250–252; Padua, S. Antonio, Chapel of St. Anthony: *Miracle of the Jealous Husband*, commission for, 2, 26, 27, 90, 122f Doc. XVII

WORKS. Treviso, Duomo: *St. Sebastian* from Altar of St. Sebastian, 3, 25, 66f, 68, 93, 119 Doc. XIV, A, 147–150 Cat. no. 10, Pls. 186–189; Sarcophagus of Canon Bertuccio Lamberti, 29, 30, 79, 87, 92, 126 Doc. XIX, D, 150–152 Cat. no. 11, Pl. 248; Shrine of SS. Theonistus, Tabra, and Tabrata, 15, 61–63, 65, 68, 74 n. 17, 83, 88, 91, 93, 113–115 Doc. VII, 152–155 Cat. no. 12, 161, Pls. 144–152

WORKS. Treviso, Duomo: Cappella del SS. Sacra-

mento, 159–165 Cat. no. 15, Pl. 46; altarpiece, 24, 57, 59f, 62, 63, 67f, 73, 91, 97, Pls. 129–132; *Evangelists*, 24, 57, 60f, 62, 63, 79, 86, 93, Pls. 133–143; *St. Paul*, 24, 40, 58f, 62, 63, 64, 80, 81, 86, 95, 97, Pls. 124–128; vestibule, 22, 86; Cappella della SS. Annunziata: frame for Titian's *Annunciation*, 29, 78f, 87, 88, 90, 91, 93, 157–159 Cat. no. 14, Pls. 245–247

WORKS. Treviso, S. Leonardo: frame for Altar of St. Sebastian, 25, 66, 68, 73, 78, 147–150 Cat. no. 10, 158, Pls. 192, 194; S. Margherita (formerly): Altar of St. Sebastian, 3, 25, 26, 57, 66–68, 70, 73, 78, 86, 91, 93, 97, 119f Doc. XIV, 147–150 Cat. no. 10, Pls. 186–194

WORKS. Venice, SS. Giovanni e Paolo: *St. Catherine* from High Altar of S. Marina, 57, 69f, 71, 97, 174–177 Cat. no. 22, Pls. 215, 216; *St. Mary Magdalene* from High Altar of S. Marina, 53, 57, 69f, 71, 81, 97, 174–177 Cat. no. 22, Pls. 213, 214

WORKS. Venice, S. Marco: Altar of the Cross, 3, 26, 57, 64, 72f, 76, 78, 87, 88, 89, 90, 91, 93, 96, 97, 120f Doc. XV, 177–180 Cat. no. 24, 187, Pls. 225–234; Cappella Zen: female figure from Tomb of Cardinal Zen, 40, 63, 81, 95, 97, 180–185 Cat. no. 25, Pls. 153–158

WORKS. Venice, S. Maria dei Frari: High Altar, 185–188 Cat. no. 26, *Resurrected Christ*, 31, 49, 68f, 90, 96, 97, Pls. 201–205; *St. Francis*, 31, 49, 50, 68, 69, 72, 77, 90, 96, 97, Pls. 195–200; Pesaro Altar, frame, 53, 77f, 78, 87, 89, 90, 91, 93, 97, 188–191 Cat. no. 27, Pl. 244

WORKS. Venice, S. Maria Mater Domini: Altar of Paolo Trevisan, commission for, 28, 87, 89, 90, 91, 210f; S. Marina (formerly): High Altar, 2, 53, 57, 69f, 71, 81, 86, 87, 89, 91, 97, 174–177 Cat. no. 22, Pls. 209–216; S. Martino: Altarpiece from S. Sepolcro, 63–65, 68, 71, 73, 76, 78, 86, 88, 91, 93, 96, 158, 196–200 Cat. no. 29, Pls. 161–171; S. Sepolcro (formerly): Altarpiece, see Bregno, L.; Venice, S. Martino: Altarpiece from S. Sepolcro

WORKS. Venice, Scuola di S. Rocco: *Bust of the Saviour*, 69, 76, 81, 173 Cat. no. 20, Pls. 206–208; *SS. Bartholomew and Apollonia/Agatha*, 70–72, 173f Cat. no. 21, Pls. 217–224; Seminario Patriarcale: *S. Marina* from High Altar of S. Marina, 69, 70, 174–177 Cat. no. 22, Pls. 209–212

Bregno, Maddalena, 15, 27, 28, 29, 30, 78, 79, 124–127, 145, 151, 158, 210

Bregno, Roberto, 15 n. 2, 119

Brescia, 13; SS. Nazaro e Celso: Altar of Altobello Averoldi (Titian), 67

Briosco, Benedetto; Milan, S. Pietro in Gessate: Tomb of Ambrogio Grifo, 75 n. 19

Brisighella, 204

Bruno, Fra Gabriel, 186

Budapest, Szépművészéti Múzeum: *Angels* from Altar of St. Sebastian (L. Bregno), 25, 66, 67f, 70, 97, 147–150 Cat. no. 10, Pls. 190, 191; *Madonna and Child* from Altar of St.

Sebastian (L. Bregno), 25, 66, 67, 68, 97, 147–150 Cat. no. 10, Pl. 193

Buonarroti, Michelangelo, see Michelangelo Buonarroti

Buora, Andrea, stonemason, 124, 172

Buora, Giovanni, 9, 20, 23, 92, 116
    WORKS. Murano, S. Cipriano (formerly): Altar of Abbot Giovanni Trevisan, 84; Osor, Cathedral: statuary of the facade, 92; Padua, S. Antonio: *Prophet*, 52 n. 37; Chapel of St. Anthony: *St. Prosdocimus*, 9; Treviso, S. Margherita (formerly): *Apostles, Virgin Mary*, and *St. John the Evangelist* from the choir screen, 20; S. Nicolò: Tomb of Senator Agostino Onigo, 168 n. 10, 170, 208; Venice, Convent of S. Giorgio Maggiore, dormitory, 172; facade, 9, 24; Ducal Palace: *Madonna delle Biade*, 9; Palazzo Civran, facade: *Page*, 84, 92; S. Maria dei Carmini: statuary of the facade, 92; S. Maria dei Frari: Tomb of Jacopo Marcello, 45 n. 28, 205, 208; S. Rocco (formerly), facade: *St. Roch*, 92; S. Stefano: Tomb of Jacopo Suriano, 88 n. 37; Verona, Palazzo Vescovile: portal, 9; statuary of the portal, 92

Byzantine influence in Venetian art, 34

Calzetta, Severo, 84f, 133; Padua, S. Antonio, Chapel of St. Anthony: *St. John the Baptist*, 18

Cambrai, 13

Camelio (Vettor Gambello), 10, 85

Campagna, Gerolamo, 149, 168; Venice, Church of the Crociferi: Tomb of Doge Pasquale Cicogna, 215 n. 31; S. Giuseppe di Castello: Tomb of Doge Marino Grimani and Dogaressa Morosina Morosini, 215 n. 31

Canova, Antonio, 3

Caravajel, Cardinal Giovanni, 201

Carpaccio, Vittore, 12
    WORKS. Borrestad, Collection of Count P. de la Gardie: figure studies, 38 n. 14; London, British Museum: drawing for the *Vision of St. Augustine*, 38 n. 14; Stuttgart, Staatsgalerie: *St. Thomas Aquinas Enthroned*, 68 n. 9; Venice, Gallerie dell'Accademia: *The Engaged Couple Being Greeted by the Pope*, 195; Scuola di S. Giorgio degli Schiavoni: *Vision of St. Augustine*, 38, 39, Fig. 17;

Carrara, marble from, 17, 25, 26, 65, 110, 118, 122, 136, 159, 162, 163, 173, 192, 197, 204

Catena, Vincenzo, 12; Venice, S. Maria Mater Domini: *Martyrdom of St. Cristina*, 78 n. 27, 210

Celsi, Elena, 198

Cephalonia (Kefallinia), 45, 192, 193, 208

*Ceres*, 70, 81

Cesa, Matteo; East Berlin, Staatliche Museen: *Sacra Conversazione*, 130

Cesena, 5, 22, 23, 25, 30, 88, 94
———, Duomo: Altar of the Corpus Domini (G. B. Bregno), 3, 15, 22, 23, 24, 25, 36–38, 65f, 83, 86, 89, 91, 112f Doc. VI, 131–134 Cat. no. 2, 136, 171, Pl. 20; *Angels* (full-length), 36, 37, 38, 66, Pls. 38, 39, 45; *Angels* (half-length), 36, 37, 47, 48f, 53, Pls. 40–44; *Christ as Man of Sorrows*, 36, 36f, 38, 39, 50, 97, Pls. 22–25; *St. John the Baptist*, 36, 37, 49, 54, 66, Pls. 26–29; *St. John the*

*Evangelist*, 36, 37, 39, 42, 66, 168, Pls. 30–33; *Camillo Verardi*, 36, 37, 46, 97, Pls. 35, 37; *Carlo Verardi*, 36, 37, 38, 97, Pls. 34, 36
———, Duomo: Altar of St. Leonard (L. Bregno), 3, 24f, 26, 57, 65f, 86, 89f, 91, 118f Doc. XIII, 133, 134 n. 17, 134–137 Cat. no. 3, 170f, Pl. 174; *St. Christopher*, 63, 65, 66, 68, 79, Pls. 178–181; *St. Eustace*, 63, 65, 66, 68, 81, Pls. 175, 182–185; *St. Leonard*, 66, 68, Pls. 176, 177
———, Duomo: Tomb of Bishop Antonio Malatesta, 112, 132, 133
———, S. Francesco, 136; Sarcophagus of Vincenzo Toschi, 133

Cesenatico, 136

Charles V, Holy Roman Emperor, 194

Charles VIII, King of France, 207, 208

Christin, Master, 172

Cima da Conegliano, Giovanni Battista, 12, 55
    WORKS. Leipzig, Museum der bildenden Künste: *Madonna and Child with the Baptist and St. Jerome*, 68 n. 9; Mestre, S. Rocco (formerly): Triptych of St. Catherine of Alexandria, 186; Milan, Collection of Count Paolo Gerli: *Madonna and Child with the Baptist and St. Jerome*, 68 n. 9; Ornica, parish church: *Madonna and Child*, 68 n. 9; Verona, Museo del Castelvecchio: *Madonna and Child with the Baptist and St. Jerome*, 68 n. 9

Cirabelli, Andrea, mason, 172

Cividale di Belluno, 210

classical influence in Venetian architecture, 43, 44

classical influence in Venetian painting, 60, 100

classical influence in Venetian sculpture, 35f, 38f, 41, 42, 53, 56, 58, 59, 60, 62, 63, 66, 67, 69, 70, 71, 72, 80–82, 93–95, 99, 100, 182, 195, 208

Clement VII, Pope, 140

Compiègne, Château: *Bust of a Man* (Simone Bianco), 164 n. 5

Constantinople, 34, 189, 208

Contarini, Federico, 58 n. 2

Contarini, Girolamo, 211 n. 12

Conte, Arturo, 140

Contino, Bernardino; Venice, S. Salvatore: Tomb of Caterina Cornaro, 215 n. 31; Tomb of Cardinals Marco, Francesco, and Andrea Cornaro, 215 n. 31

Copenhagen, Ny Carlsberg Glyptotek: *Roman Woman as Priestess of Ceres* (Roman, 2nd cen. A.D.), Fig. 49; Statens Museum for Kunst: *Bust of a Woman* (Simone Bianco), 164 n. 5

Corfù, 44, 193

Corniglio di Parma, 161

Coron, 12

Coronelli, Vincenzo, 196 n. 15

Corte, Niccolò da, 20

Crema, 30, 73, 76, 91, 92, 138, 139, 140
———, Church of the Capuccines, 139
———, S. Trinità, history of its construction, 138; Tomb of Bartolino Terni (L. Bregno), 26, 57, 76f, 78, 79, 87, 91, 93, 137–139 Cat. no. 4, Pl. 238; *Effigy*, 3, 45, 45 n. 28, 77, 205, Pls. 239–243

Cremona, 138, 157, 189, 207, 208
Creola, S. Maria del Carmine, 74, 84, 121f, 141, Fig. 58;
    Tomb of Benedetto Crivelli (L. Bregno), 73–76, 84, 87,
    89, 90, 91, 93, 121f Doc. XVI, 139–141 Cat. no. 5, 187,
    Pls. 235–237; Tomb slab of Alessandro Bonvecchiato, 74
Crivelli, Benedetto, 73f, 75f, 84, 91f, 121, 122, 138, 140
Cyprus, 186

Dalmata, Giovanni, 133; Rome, S. Clemente: Tomb of Car-
    dinal Bartolommeo Roverella, 133
Dalmatia, 4
Dentone, Antonio, 141, 208
Dentone, Giovanni, sculptor, 141
Desiderio da Settignano, sculptor, 7
Detroit, Institute of Arts: Madonna and Child (Venetian, late
    15th cen.), 34 n. 8
Domenico da Bologna, mason, 118, 135
Domenico da Bologna, priest, 29, 158
Domenico di Pietro, jeweler, 38 n. 14, 88 n. 37, 94
Donatello, 4, 5; Florence, Museo Nazionale: bronze David,
    7; Or San Michele: St. Mark, 39; Padua, S. Antonio: High
    Altar, 4
Donato, Girolamo, 48, 94, 142, 200 n. 11
Donato, Bishop Lodovico, 213
Dragan, Giorgio, captain, 81 n. 31, 88 n. 37
Duca, Bartolomeo, 20; Venice, Convent of S. Giorgio
    Maggiore, dormitory, 172
Duodo, Girolamo, 193
Dürer, Albrecht; Washington, D.C., National Gallery of
    Art: Haller Madonna, 34 n. 8

East Berlin, Staatliche Museen: Angel from Altar of Verde
    della Scala (G. B. Bregno), 48f, 53f, 86, 94, 123f Doc.
    XVIII, 141–144 Cat. no. 6, Pls. 85–90; Praying Boy (Boi-
    das), 94; Reggiscudo from Tomb of Luca Civran (Seb. da
    Lugano), 20, 168; Sacra Conversazione (Matteo Cesa), 130;
    St. John the Evangelist (L. Bregno), 63, 64, 144 Cat. no. 7,
    Pls. 159, 160
Elia, Vielma d', 211 n. 13
Emo, Giorgio, 204, 205
England, 13
Enrichi, pirate, 45, 193
Erulo, Cardinal Bernardo, 201
Este, Isabella d', 95

Faenza, 13, 204
Fantaguzzi, Giuliano, chronicler, 22, 23, 112, 133, 134 n. 2,
    137 nn. 3, 5, 171 n. 3
Fantoni, Venturino, 87; Venice, S. Rocco: High Altar, 87,
    89, 97 n. 73, 98
Fedele, Cassandra, 151
Ferdinand I, King of Naples, 207, 208
Ferdinand II, King of Naples, 203, 204
Ferdinand V, King of Aragon, 132
Ferrara, 5, 7, 11, 13, 23, 41, 84, 87, 117, 137, 182, 183,
    202
Ferrucci, Andrea, sculptor, 55

Fiamberti, Tommaso, sculptor, 25, 65, 66, 119, 133, 134 n.
    23, 136
figura serpentinata, 11, 195
Fiore, Zoan Andrea del, jeweler, 94
Fiume, 13
Florence, 7, 13, 55, 180 n. 10, 195
——, Convent of S. Marco, 194, 196 n. 40; Crucifix (Bac-
    cio da Montelupo), 196 n. 41
——, Museo Nazionale: bronze David (Donatello), 7
——, Or San Michele: St. John the Evangelist (Baccio da
    Montelupo), 196 n. 41; St. Mark (Donatello), 39
——, S. Lorenzo, Old Sacristy: Tomb of Giovanni and
    Piccarda de' Medici, 75 n. 19
——, S. Maria Novella: Crucifix (Baccio da Montelupo),
    196 n. 41
Fornovo, 208
Francesco, stonecarver, 172
Francesco da Sant'Agata, 99
Francesco di Giorgio, 55
Francis I, King of France, 13
Franco, Bishop Nicolò, 151, 161,
Frascati, 181
Fusina, Andrea; Lodi, Duomo: Tomb of Bassiano da Ponte,
    214, 215 n. 30; Milan, Castello Sforzesco: Tomb of
    Bishop Battista Bagarotti, 214, Fig. 87

Gabriel, Angelo, 181
Gabriel, family, 213
Gabriel, Bishop Lorenzo, 212, 213
Gabriel, Marco, 213
Gabriel, Zaccaria, procurator, 213
Gadolo, Don Bernardino, 81 n. 31
Gama, Vasco da, 12
Gambello, Antonio, stonemason, 10
Gambello, Vettor, see Camelio
Garbin, Bartolomeo, marble sawyer, 123, 142
Gemati, Battista, notary, 135, 137 n. 2
Geraldini, Don Agapito, 134 n. 2
Germano, Fra, prior of the Frari, 49, 50, 72, 88, 90, 186f,
    190
Ghiberti, Lorenzo, 4
Gian Cristoforo Romano, sculptor, 19, 106f
Gibellino, 16 n. 10
gilding of Venetian sculpture, see polychromy of Venetian
    sculpture
Giorgione, 12, 55, 99, 100
Giovanni da Udine, Bishop, 61, 88, 94, 114, 153, 161
Giovanni di Bartolino, mason, 135, 136
Giovanni di Stefano; Rome, S. Maria del Popolo: Tomb of
    Cardinal Pietro Foscari, 75 n. 19
Giovanni Battista da Castel Bolognese, carpenter, 118, 135
Giulio Romano, 82
Giustiniani, Bernardo, 92 n. 49
Gorizia, 13
Gottardi, Vincenzo, goldsmith and painter, 25, 136
Greece, 95
Gregory XIII, Pope, 191

Grevembroch, Johannes, 43, 143 n. 11, 183, 205 n. 2, 206 n. 27, 207, Fig. 24

Grigi, Guglielmo dei, 87, 143; Venice, S. Antonio di Castello: *barco* (demolished), 19; S. Maria dei Servi (formerly): frame for Altar of Verde della Scala, 48, 70, 87, 142, 143; S. Salvatore: frame for Altar of St. Jerome, 87

Grilli, Paolo, 133

Grimani, Doge Antonio, 89, 120, 178, 208

Grimani, Cardinal Domenico, 94; medal of (Camelio), 10

Grimani, Pietro, procurator, 201, 202

Gritti, Doge Andrea, 89, 120, 121, 178, 190

Guidarelli, Guidarello, *condottiere*, 88

*Hercules*, 195

Hungary, 13

India, 12

Innocent VIII, Pope, 132, 161

Istria, limestone from, 17, 24, 25, 26, 47, 69, 96, 109f, 114, 116, 118, 136, 144, 150, 152, 153, 156, 159, 161, 162, 164 n. 6, 171, 172, 175, 192, 198, 203, 209, 212

Jerusalem, Temple (demolished), 180 n. 13

*Jove Dolichenus*, 94

Julius II, Pope, 13, 67, 161, 210; medal of (Camelio), 10

*Juno*, 70, 81

Lamberti, Canon Bertuccio, 29, 79, 109, 151

Lamberti, Doctor Domenico, 29, 79, 126, 151

Lamberti, Pietro, 7f; Venice, SS. Giovanni e Paolo: Tomb of Doge Tomaso Mocenigo, 98

Lando, Doge Pietro, 191 n. 12

Lanzano, Paolo, woodcarver, 118

*Laocoon* (Agesandros, Polydoros, and Athenodoros of Rhodes), 67, 82, 93, 94, Fig. 54

Lascari, Zuan Zorzi, see Pyrgoteles

Legnago, 210

Leipzig, Museum der bildenden Künste: *Madonna and Child with the Baptist and St. Jerome* (Cima da Conegliano), 68 n. 9

Leningrad, Hermitage: *Forge of Vulcan* (A. Lombardo), 195

Leo X, Pope, 204

Leonardo da Prato, Fra, *condottiere*, 204

Leonardo da Vicenza, Abbot, 172

Leonardo da Vinci, 55

Leone, Giovanni Battista, professor, 27, 105, 106, 122, 123

Leone, Lodovico, 120, 149

Leopardi, Alessandro, 2 n. 3, 7, 10, 85, 183, 184; at the Cappella Zen, S. Marco, 7, 10, 182

    WORKS. Venice, Campo SS. Giovanni e Paolo: Monument of Bartolomeo Colleoni, 10, 200 n. 12; Piazza S. Marco: standards, 10, 96 n. 70; Scuola Nuova della Madonna della Misericordia, model of, 20

Lepanto, 12

Licinio, Bernardino, painter, 100

Liprandi, Francesco de', mason, 27, 28, 29, 30, 124–127, 145, 151, 158

Lizzaro, Guido, founder, 27, 123

Lodi, Duomo: Tomb of Bassiano da Ponte (And. Fusina), 214, 215 n. 30

Lombardi, Alfonso, 133, 137; Bologna, S. Francesco: Tomb of Bishop Galeazzo Bottrigari (lost), 215 n. 29

Lombardo, Antonio, 2 n. 3, 7, 10, 11, 23, 55, 81, 83, 83f, 84, 87, 92, 95, 100, 106f, 114, 115, 116, 117, 133, 137, 147, 149, 153, 154, 156, 163, 168, 182, 183, 184, 191

    WORKS. Leningrad, Hermitage: *Forge of Vulcan*, 195; Padua, S. Antonio, Chapel of St. Anthony, design of, 18; *Miracle of the Speaking Babe*, 7, 8f, 18, 19, 26, 27, 41, 104, 106f, 122, 147, 202, Fig. 21

    WORKS. Venice, Ducal Palace: fireplaces in east wing, 7, 21, 31, 107 Doc. III; S. Francesco della Vigna, Cappella Giustiniani: *St. Luke*, 60, 93, Fig. 6; S. Giobbe, Altar of St. Luke, 57, 84, 200–203 Cat. no. 30, Figs. 65, 66, 68–71; *St. Luke*, 7; SS. Giovanni e Paolo: *St. Peter Martyr* from High Altar of S. Giustina, 84, 202, Fig. 67; Tomb of Doge Andrea Vendramin, *Virtue*, 58, 72, Fig. 50; S. Giustina (formerly): High Altar, 84, 202

    WORKS. Venice, S. Marco, Cappella Zen: ciborium, 182; furnishings, 1, 11, 182; appraisal of, 3 n. 10, 21, 115f Doc. IX; contract for, 7, 10, 84; *Madonna and Child*, 7, 182; *Temperance* for Tomb of Cardinal Zen, 41, 182, 183, Pls. 64–68

Lombardo, Aurelio, sculptor, 154 n. 20, 156, 163, 168

Lombardo, family, 23, 208

Lombardo, Girolamo, sculptor, 154 n. 20, 163

Lombardo, Ludovico, sculptor, 154 n. 20, 163,

Lombardo, Martino, 151

Lombardo, Pietro, 6, 9, 10, 11, 16, 17, 21, 37, 55, 61, 62, 80, 84, 87, 87 n. 30, 92, 116, 143, 153, 154, 167, 168, 170, 183, 184, commission for Shrine of SS. Theonistus, Tabra, and Tabrata, 61f, 113–115 Doc. VII; 153f

    WORKS. Mantua, Duomo, Cappella dell'Incoronata: frame for the Gonzaga Altar (lost), 6 n. 33; Padua, S. Antonio: Tomb of Antonio Roselli, 6f, 10; Treviso, Duomo: Tomb of Bishop Giovanni da Udine, 61, 153, 154, Fig. 52

    WORKS. Venice, Ducal Palace, 6, 16; *Loredan Madonna*, 35 n. 12, 38, 54, Fig. 15; S. Francesco della Vigna, Cappella Giustiniani, 84, 96 n. 72; altarpiece, 6, 32, 64, 70 n. 12, 93, 96 n. 72, Fig. 1; *SS. Mark and John the Evangelist*, 6, 33, 35, 60f, 62, 63, 93, Figs. 2–5; narrative reliefs, 96 n. 72; *Pentecost*, 35 n. 12

    WORKS. Venice, S. Giobbe, *putti* in the choir, 6f; portal: *Job and St. Francis*, 6f, 96 n. 72; SS. Giovanni e Paolo: Tomb of Doge Nicolò Marcello, 42, 45; Tomb of Doge Pietro Mocenigo, 44f, 45 n. 28, 81 n. 31, 96 n. 72, 205, 208, Fig. 25; S. Maria dei Frari: *Prophets* of choir screen, 6f; S. Maria dei Miracoli, 6

Lombardo, Tullio, 7, 11, 17, 31, 36, 39, 55, 64, 81, 82, 83, 84, 87, 87 n. 30, 95, 98, 100, 106, 114, 122, 130, 133, 137, 143, 147, 149, 151, 153, 154, 163, 168, 173, 174, 191, 199

    WORKS. Belluno, Duomo, model of, 87, 130; Padua,

S. Antonio, Chapel of St. Anthony, design of, 18, 146; *Miracle of the Miser's Heart*, 27, 27 n. 108, 82; *Miracle of the Repentant Youth*, 7, 8f, 18, 26, 106, 122, 147, 202, Figs. 22, 72; Ravenna, Galleria dell'Accademia: *Effigy of Guidarello Guidarelli*, 88; Rovigo, S. Francesco: *Pietà*, 82

WORKS. Venice, Ducal Palace: fireplaces in east wing, 7, 21, 31, 107 Doc. III; Galleria Giorgio Franchetti alla Ca' d'Oro: *Double Portrait*, 69, Fig. 55; S. Francesco della Vigna, Cappella Giustiniani: *Lamentation*, 96 n. 72; S. Giobbe: Altar of St. Luke, 57, 84, 200–203 Cat. no. 30, Figs. 65, 66, 68–71; *St. Mark*, 7; S. Giovanni Crisostomo: *Coronation of the Virgin*, 7, 72 n. 13, 84

WORKS. Venice, SS. Giovanni e Paolo: Tomb of Doge Giovanni Mocenigo, 44, 87, 96 n. 72, Fig. 26; Tomb of Doge Andrea Vendramin, 2 n. 3, 43, 45, 69f, 81 n. 31, 93, 143 n. 26, 174, 175, Fig. 27, see also Lombardo, Antonio

WORKS. Venice, S. Marco, Cappella Zen: architecture, 25f, 64 n. 4, 87 n. 30; S. Maria dei Frari: Tomb of Pietro Bernardo, 51; sacristy, Tabernacle of the Holy Blood, 208; S. Maria dei Miracoli: tabernacles, 72 n. 13, 180 n. 10, 202; S. Maria dei Servi (formerly): Tomb of Giovanni Emo, design of frame, 43, 93, Fig. 24; S. Maria della Salute, ante-sacristy: *Lamentation*, 96 n. 72; S. Martino: *Angels* from Altar from S. Sepolcro, 63, 198, 199; Scuola di S. Marco: *Baptism of St. Anianus*, 35, Fig. 14

London, 193
———, British Museum: drawing for the *Vision of St. Augustine* (Carpaccio), 38 n. 4
———, National Gallery: *Fra Teodoro as St. Dominic* (Gio. Bellini), 54; *Madonna of the Meadow* (Gio. Bellini), Fig. 16
———, Victoria & Albert Museum: *Mercury* (Ant. Minello), 27, 211, Fig. 82; *St. George and the Dragon* (Venetian, 15th cen.), 47, Fig. 36
———, Wallace Collection: *St. Catherine of Alexandria* (Cima da Conegliano), 186
Loredan, Doge Leonardo, 20, 89, 120, 121
Loredan, Lorenzo, procurator, 178, 203
Loro, 164 n. 5
Lotto, Lorenzo, 161, 179; Naples, Museo di Capodimonte: *Portrait of Bishop Rossi*, 161; Vienna, Kunsthistorisches Museum: *Christ Dispensing his Blood*, 179
Louis XII, King of France, 13
Luca di Pietro, 164 n. 6
Lucca, Convent of S. Romano, 196 n. 40; Pinacoteca Nazionale: *God the Father with SS. Mary Magdalene and Catherine of Siena* (Fra Bartolommeo), 194f
Lupi, Lio; Treviso, S. Nicolò: frame of High Altar, 78 n. 27
Lupi, Marquis Raimondino de', *condottiere*, 75
Maddalena da Bavaria, see Zotti, Maddalena
Malchiostro, Canon Broccardo, 29, 78, 78 n. 28, 88, 90, 91, 111, 125, 126, 157, 158
Malipiero, Domenico, chronicler, 209 nn. 6, 9
Malipiero, Doge Pasquale, 213

Manfredi, Ottaviano, 204
Mannerism, 82
Mantegna, Andrea, 35
Mantua, 13; Duomo, Cappella dell'Incoronata: frame for the Gonzaga Altar (lost; P. Lombardo), 6 n. 33
Marcanova, Giovanni, 8, 94
Marcello, Jacopo, 208
Marignano, 13
Marin, Abbot Benedetto, 88, 89, 116, 172
Marini, Fra Gianfranco, 187
Marino, Domenico, procurator, 89
Martellino, Bastiano, 135
Martini, Andrea, 94
Martino, architect, 158
Martino di Bartolomeo, 164 n. 6
Masini, Niccolò II, 137
Maximilian I, Holy Roman Emperor, 13, 84, 157, 161
Mestre, 13; S. Rocco, 186, 187; S. Rocco (formerly): Triptych of St. Catherine of Alexandria (Cima da Conegliano), 186
Michelangelo Buonarroti, 97; Paris, Louvre: *Rebellious Slave*, 67
Michiel, Marcantonio, 27, 38 n. 14, 39, 81 n. 31, 94f, 124, 164 n. 5
Michiel, Nicolò, procurator, 89, 115
Milan, 13, 15, 87
———, Castello Sforzesco: Tomb of Bishop Battista Bagarotti (And. Fusina), 214, Fig. 87
———, Collection of Count Paolo Gerli: *Madonna and Child with the Baptist and St. Jerome* (Cima da Conegliano), 68 n. 9
———, Museo Poldi-Pezzoli: *Resurrected Christ* (Venetian, late 15th cen.), 38, 39, Fig. 18
———, S. Maria della Pace (formerly): Tomb of Bishop Battista Bagarotti (And. Fusina), 214, Fig. 87
———, S. Maria delle Grazie: Altar of Beatrice d'Este (lost; Crist. Solari), 17 n. 21; S. Maria delle Grazie (formerly): Tomb of Beatrice d'Este (Crist. Solari), 17 n. 21
———, S. Pietro in Gessate: Tomb of Ambrogio Grifo (Ben. Briosco), 75 n. 19
Minello, Antonio, 10, 18, 29, 53, 83, 84, 92, 147, 194; *Head of Cybel* (lost), 81 n. 31; *Head of Hercules* (lost), 81 n. 31; partner of Bartolomeo Stampa, 20, 28, 53 n. 38; purchase of L. Bregno's shop, 27f, 79, 87, 124 Doc. XIX, A, 125, 126, 145, 210f

WORKS. London, Victoria & Albert Museum: *Mercury*, 27, 211, Fig. 82; Montagnana, Duomo, portal: *Madonna and Child*, 28f, 57, 79f, 87, 88, 89, 91, 124 Doc. XIX, A, 144–146 Cat. no. 8, 211, Pls. 250–252; Padua, S. Antonio: choir screen, 10; Chapel of St. Anthony: *Investiture of St. Anthony*, 10, 18, 26f, 79f, 147, 205, 211, Figs. 64, 85; *Miracle of the Parrasio Boy*, 3 n. 9, 27; *St. Justine*, 70 n. 12

WORKS. Venice, SS. Giovanni e Paolo: Tomb of Fra Leonardo da Prato, 10, 86, 87, 204f; Tomb of Dionigi Naldi, 2, 10, 45 n. 28, 57, 76f, 86, 87, 93, 203–206

Cat. no. 31, Figs. 62, 63; Tomb of Count Nicolò Or-
sini, 10, 79, 86, 87, 204f; S. Maria Mater Domini: Al-
tar of Paolo Trevisan, 2, 28, 57, 79, 87, 89, 90, 91,
209–212 Cat. no. 33, Figs. 76–81, 83, 84

Minello, Giovanni, 10, 19, 83, 105, 106, 147; *protomaestro* of
the Chapel of St. Anthony, 18, 85, 147; Padua, S. Anto-
nio: choir screen, 10; Chapel of St. Anthony: *Prophets*, 19,
52, 105, 147

Minio, Tiziano, 27

Mocenigo, Doge Giovanni, 187f n. 4

Mocenigo, Lazaro, 193

Mocenigo, Doge Pietro, 44

Modon, 12

Molino, Nicolò, 164 n. 5

Montagna, Bartolomeo, 12

Montagnana, 28f, 30, 79, 88, 125, 145; *Podestà* of, 145, 146
n. 2; Duomo, portal, Pl. 249; *Madonna and Child* (L.
Bregno; Ant. Minello), 28f, 57, 79f, 87, 88, 91, 97, 124
Doc. XIX, A, 144–146 Cat. no. 8, 211, Pls. 250–252

Morea, 45

Moro, Doge Cristoforo, 5, 201

Moro, Gabriele, 193

Moro, Pandolfo, 113, 133, 135, 136, 171

Morosini, Domenico, procurator, 89, 90, 115

Mosca, Giammaria (Padovano), 16, 20, 81, 82, 87, 92, 99,
141
WORKS. Padua, S. Antonio, Chapel of St. Anthony:
*Miracle of the Goblet*, 19, 27, 146, 147; Paris, Louvre:
*Judgment of Solomon*, 27; Venice, Calle Fiubera (for-
merly): *Madonna* of the Scuola della Madonna della
Carità, 87; S. Maria dei Frari: Cenotaph of Alvise Pas-
qualigo, 57, 208; S. Maria Mater Domini: altarpiece,
57; S. Rocco: High Altar, 80, 87

Munich, private collection (formerly): *Amor* (Simone
Bianco), 164 n. 5

Murano, Convent of S. Pietro Martire, 194f, 196 n. 40; S.
Cipriano (formerly): Altar of Abbot Giovanni Trevisan
(Gio. Buora), 84

Naldi, Dionigi, *condottiere*, 77, 203, 204

Nanni di Bartolo; Verona, S. Fermo Maggiore: Tomb of
Niccolò Brenzoni, 98

Naples, 140
———, Duomo: Tomb of Archbishop Filippo Minutolo, 75
n. 23; Tomb of Archbishop Orso Minutolo, 75 n. 23;
Tomb of Guglielmo and Nicola Tocco, 75 n. 23; Tomb
of Ludovico Tocco, 75 n. 23
———, Museo di Capodimonte: *Portrait of Bishop Rossi*
(Lotto), 161; *Transfiguration* (Gio. Bellini), 35
———, S. Chiara: Tomb of a member of the Artus family,
75 n. 23; Tomb of Raimondo Cabanis, 75 n. 23; Tomb
of Niccolò Merloto, 75 n. 23, Fig. 59
———, S. Domenico Maggiore: Tomb of Giovanna d'A-
quino, 75 n. 23
———, S. Lorenzo Maggiore: Tomb of Maria di Durazzo,
75 n. 23; Tomb of Alessandro Favilla, 75 n. 23; Tomb of
Antonino Manso, 75 n. 23

Nauplia (Návplion), 45, 193, 210

Negroponte, 198

Neoclassicism, 3f, 7–9, 10, 11

Niccolò di Giovanni Fiorentino, 5, 8
WORKS. Venice, S. Andrea della Certosa (formerly):
Tomb of ser Orsato Giustiniani, 8, 23, 75 n. 19, 81 n.
31, 115, 182, 183; S. Elena: Tomb of Vittore Cap-
pello, 42, 70 n. 12, 205, 208; S. Maria dei Frari: Tomb
of Doge Francesco Foscari, 4, 5

*Niobids*, 67 n. 5

Nono, Andrea, architect, 138

Novello, Francesco, 153

Obizzi, family, 147

Oddoni, Andrea, collector, 81 n. 31

Ogliaro, Giuliano, architect, 138

Onigo, Agostino d', Senator, 114, 153

Onigo, Aurelio d', 52, 170

Onigo, Giovanni d', 169f

Onigo, Girolamo d', 52, 170

Onigo, Pileo di Agostino d', 52, 114, 153, 170

Onigo, Pileo di Bonsembiante di, 169f

Ornica, parish church: *Madonna and Child* (Cima da Conegli-
ano), 68 n. 9

Orsini, Cardinal Francesco Vincenzo Maria, 133

Orsini, Count Nicolò, *condottiere*, 204

Osor, Cathedral: statuary of the facade, 92

Ostiani, Antonio, 155

Ostiani, Galeazzo, 34, 91, 155, 156 n. 2

Ostiani, Innocenza, 155

Ostiani, Regina, 155

Padua, 4, 6, 8, 13, 27, 30, 70, 73, 76, 85, 86, 87, 94, 95f,
121, 140, 149, 161, 175, 181, 203, 204, 210, 213; fortifi-
cations, 85
———, Baptistry: Tomb of Francesco il Vecchio di Carrara,
75
———, Convent of S. Giustina, 201
———, Museo Civico: *Dancing Maenads* (Roman, 1st–2nd
cen. A.D.), 94
———, Oratory of S. Giorgio: Tomb of Marquis Raimon-
dino de' Lupi, 75, 93
———, Palazzo della Ragione, 141
———, S. Antonio, *Arca del Santo*, 16, 17 n. 21, 19, 26, 27,
52, 52 n. 37, 90, 104, 106, 106f, 122, 146, 147, 190;
choir screen (Gio. and Ant. Minello), 10; High Altar
(Donatello), 4; *Prophet* (Gio. Buora), 52 n. 37; Tomb of
Antonio Roselli (P. Lombardo), 6f, 10; Cappella della
Madonna Mora, 19, 146, 147
———, S. Antonio, Chapel of St. Anthony, 1, 91; history
of its construction, 17f, 26f, 146f; *Investiture of St. Anthony*
(Ant. Minello), 10, 18, 26f, 79f, 147, 205, 211, Figs. 64,
85; *Miracle of the Goblet* (Mosca; Stella), 19, 27, 146, 147;
commission for (G. B. Bregno), 3, 16, 17, 18f, 27, 52, 83,
90, 104–106 Doc. I, 147; *Miracle of the Jealous Husband* (L.
Bregno), 2, 26, 27, 90, 122f Doc. XVII; *Miracle of the Mi-
ser's Heart* (T. Lombardo), 27, 27 n. 108, 82; *Miracle of the*

*Parrasio Boy* (Ant. Minello; Jac. Sansovino), 3 n. 9, 27;
*Miracle of the Repentant Youth* (T. Lombardo), 7, 8f, 18, 26,
   106, 122, 147, 202, Figs. 22, 72; *Miracle of the Speaking
   Babe* (A. Lombardo), 7, 8f, 18, 19, 26, 27, 41, 104, 106f,
   122, 147, 202, Fig. 21; *Prophet* (G. B. Bregno), 18f, 26, 31,
   35, 52, 83, 86, 97, 105f Doc. I, 146f Cat. no. 9, Pls. 112,
   113; *Prophets* (Gio. Minello), 19, 52, 105, 147; *St. John the
   Baptist* (Calzetta), 18; *St. Justine* (Ant. Minello), 70 n. 12;
   *St. Prosdocimus* (Gio. Buora), 9
———, S. Giustina, design of (Seb. da Lugano), 20
———, S. Maria del Carmine, 20
———, Scuola di S. Antonio: *Miracle of the Speaking Babe* (Ti-
   tian), 94
———, University of, 27, 153, 161
Pagnini, Padre Sante, 196 n. 40
painting, Venetian Renaissance, 12, 54f, 60, 85, 99f
Palma il Giovane, Jacopo; Belluno, Duomo: *Deposition from
   the Cross*, 130 n. 7
Palma il Vecchio, Jacopo, 12, 60, 100; Bergamo, Accademia
   Carrara: *Madonna and Child with SS. John the Baptist and
   Mary Magdalene*, Fig. 51
Pantaleone di Paolo, stonecarver, 95
Paphos, 189, 190
Paris, art market (formerly): *Bust of a Man* (Simone Bianco),
   164 n. 5
———, Bibliothèque Nationale: *Devotée* (Roman), Fig. 19
———, Louvre: two *Busts of Men* (Simone Bianco), 164 n. 5;
   *Dancing Maidens* (Roman, 1st cen. B.C.–1st cen. A.D.), 59;
   *Judgment of Solomon* (Mosca), 27; *Madonna and Child* (Vene-
   tian, late 15th cen.), 34 n. 8; *Rebellious Slave* (Michelan-
   gelo), 67
Parma, 162
partnerships in Venice and Padua, 20f
Paul II, Pope, 132, 181, 201
Pavia, Certosa: Tomb of Beatrice d'Este (Crist. Solari), 17 n.
   21; facade, 17 n. 21
Pennacchi, Pietro Maria, painter, 22, 162
Perugia, 181
Pesaro, Benedetto di Girolamo, 194
Pesaro, Benedetto di Pietro, 42, 44, 89, 117, 189, 193f
Pesaro, Bishop Carlo, 191
Pesaro, family, 42, 190, 191 n. 16
Pesaro, Francesco, 193
Pesaro, Girolamo, 42, 44, 84, 89, 90, 98, 193, 194, 196 n.
   36
Pesaro, Bishop Jacopo, 53, 77, 89, 90, 91, 189f
Pesaro, Maddalena, 193
Pesaro, Pietro, 193
Pietro da Pederobba, 153
Pietro da Salò, sculptor, 179
Pietro dalle Campane, founder, 182, 182f, 183
Pieve di Cadore, 13
Pisani, Alvise, procurator, 72, 74, 76, 89, 90, 120, 121, 122,
   140, 178, 186f
Pius II, Pope, 201
*Plato, Head of*, 95
Pollaiuolo, Antonio, 6, 55; Rome, St. Peter's: Tomb of Pope

Innocent VIII, 92; Tomb of Pope Sixtus IV, 74 n. 16, 75
   n. 19, 92
Poltri, Rocco, 133
polychromy and gilding in Venetian sculpture, 24, 48, 50f,
   84, 117, 131f, 138, 141, 148, 150, 152, 157, 159f, 165,
   169, 172, 173, 174, 185f, 189, 192, 197, 200, 203, 207,
   209
Pontormo, Jacopo, 82
Pordenone, Giovanni Antonio, 13, 29; Treviso, Duomo,
   Cappella della SS. Annunziata: *Adoration of the Magi*, 157
Porta, Fra Bartolommeo della, 194f; Lucca, Pinacoteca Na-
   zionale: *God the Father with SS. Mary Magdalene and Catherine
   of Siena*, 194f
Porto, Luigi da', 205 n. 6, 206 n. 9
Potsdam, 144
Premarin, Polisena, 198
*Priestess of Ceres*, 58
Priuli, Federico, 179
Puglia, 208
Pyrgoteles (Zuan Zorzi Lascari), 10f, 92, 194; *Hercules* (lost),
   81 n. 31; *Venus Flogging Cupid* (lost), 81 n. 31; Venice, S.
   Francesco della Vigna, Cappella Giustiniani: *Christ Carry-
   ing the Cross*, 11; S. Maria dei Miracoli, portal: *Madonna
   and Child*, 10f, 43, 195, Fig. 33

Quirini, Marino, 117

Ravenna, 85, 94
———, Galleria dell'Accademia: *Effigy of Guidarello Guidarelli*
   (T. Lombardo), 88
———, Museo Nazionale: *Augustus and his Family* (Roman,
   1st cen. B.C. – 1st cen. A.D.), 8, 94
———, Palazzo Arcivescovile: *"Throne of Ceres"* (Roman, 1st
   cen. B.C. – 1st cen. A.D.), 8, 94
———, Palazzo dei Podestà: *Hercules* (lost), 94
———, S. Vitale: *"Throne of Neptune"* (Roman, 1st cen. B.C.–
   1st cen. A.D.), 94
Reggio Emilia, Duomo: Tomb of Bishop Buonfrancesco Ar-
   lotti (Bart. Spani), 214
relief sculpture in Venice, 35f, 37, 44, 73, 95, 96, 97
Resegati, stonemason, 213
Rhodes, 94
Riario, Cardinal Raffaello, 132
Riccio, Andrea, 27, 42 n. 20, 82, 149
   WORKS. Padua, S. Antonio: *Paschal Candlestick*, 84;
      Chapel of St. Anthony, model of, 18, 146; Treviso,
      Duomo, Cappella della SS. Annunziata: *Bust of Bishop
      Rossi*, 158; Venice, Galleria Giorgio Franchetti alla Ca'
      d'Oro: reliefs from the Altar of the True Cross, 48, 96
      n. 70, 142; Verona, S. Fermo Maggiore: Tomb of Gi-
      rolamo and Marcantonio della Torre, 74
Ridolfi, Agostino; Belluno, Duomo: *Madonna and Child*, 130
   n. 9
Rimini, 13, 135
Rinaldi, Rinaldo dei, 153
Rinaldini, Abbot Cipriano, 172

Rizzo, Antonio, 2, 4f, 6, 8, 16, 17, 23, 39, 55, 84, 85, 92, 98, 116, 134, 137, 143; *Hercules* (lost), 81 n. 31
    WORKS. Venice, Ducal Palace: *Adam*, 5, 5f, 33, Fig. 7; *Eve*, 5; east wing, 5; Scala dei Giganti, 5, 16, 38, 81 n. 31, Figs. 10–12; Galleria Giorgio Franchetti alla Ca' d'Oro: *Angel Bearing Attributes of Christ*, 5, 54, Fig. 48; S. Marco: Altars of SS. James, Paul, and Clement, 5; *Conversion of St. Paul*, 35, 96 n. 72, Fig. 13; *Madonna and Child* and SS. *Mark* and *Bernardino*, 191 n. 12; S. Maria dei Frari: Tomb of Doge Nicolò Tron, 5, 8, 81 n. 31, 205; S. Maria dei Servi (formerly): Tomb of Giovanni Emo, 5, 93, 208, Fig. 24, see also Lombardo, Tullio; Scuola dei Calegheri: *Miraculous Cure of St. Anianus*, 96 n. 72; Scuola di S. Marco: pulpit (lost), 164 n. 6
Romagna, 5, 13, 161
Rome, 13, 55, 93, 161, 213; Archiconfraternity of the Immaculate Conception, 191 n. 16; mint, 85
———, Arch of Constantine: Hadrianic roundels, 8; *Victory Writing on a Shield*, 42
———, Column of Trajan: *Victory Writing on a Shield*, 42
———, Musei Vaticani, Cortile del Belvedere: *Apollo Belvedere*, 81 n. 31; *Laocoon*, 67, 82, 93, 94, Fig. 54; Pinacoteca Vaticana: S. Nicoletto Altarpiece (Titian), 67, 187
———, Palazzo Zen (demolished), 181
———, S. Agostino: Tomb of Carlo Verardi, 132, 171 n. 2
———, S. Clemente: Tomb of Cardinal Bartolommeo Roverella (Gio. Dalmata), 133
———, S. Giovanni Laterano: Tomb of Pope Martin V, 75 n. 19
———, S. Maria del Popolo: Tomb of Cardinal Girolamo Basso della Rovere (And. Sansovino), 213; Tomb of Cardinal Pietro Foscari (Gio. di Stefano), 75 n. 19; Tomb of Cardinal Ascanio Sforza (And. Sansovino), 213
———, S. Maria in Aracoeli: Tomb of Cardinal Pietro da Vicenza (And. Sansovino), 213
———, St. Peter's 181; Shrine of St. Peter (demolished), 180 n. 13; Tomb of Pope Innocent VIII (Ant. Pollaiuolo), 92; Tomb of Pope Sixtus IV (Ant. Pollaiuolo), 74 n. 16, 75 n. 19, 92
———, S. Tomaso di Canterbury: Tomb of Cardinal Christopher Bainbridge, 75 n. 19
Rossellino, Antonio, 201f; Venice, S. Giobbe: Altarpiece of St. John the Baptist, 201
Rossi, Bishop Bernardo de', 21, 24, 62, 83, 88, 90, 109, 110, 151, 157, 158, 158 n. 7, 161f, 162
Rossi, Domenico, architect, 171
Rossi, Filippo de', *condottiere*, 161
Rossi, Count Guido de', *condottiere*, 161
Rosso Fiorentino, Giovanni Battista, 82
Rovero, Bartolomeo di, 153
Rovero, Gerolamo di, 153
Rovigo, S. Francesco: *Pietà* (T. Lombardo), 82
Rubino, Giovanni, sculptor, 99
Sabellico, Marcantonio, historian, 199, 209 n. 5
Salgareda, 157
S. Biagio di Callalta, 157

S. Godenzo, Badia: *St. Sebastian* (Baccio da Montelupo), 196 n. 41
Sansone, Fra Francesco, 18, 146
Sansovino, Andrea, 82; Rome, S. Maria del Popolo: Tomb of Cardinal Girolamo Basso della Rovere, 213; Tomb of Cardinal Ascanio Sforza, 213; S. Maria in Aracoeli: Tomb of Cardinal Pietro da Vicenza, 213
Sansovino, Francesco, 2, 16 n. 10, 42, 45, 57, 70, 176, 179, 194, 198, 201, 202, 205, 211, 211 n. 12, 213, 214
Sansovino, Jacopo, 30, 145, 146, 156, 163, 170, 179; Venice, S. Marco: *Allegory of the Redemption* from Altar of the Cross, 26, 177, 179, Pl. 228; Verona, Duomo: frame for Titian's *Assumption of the Virgin*, 78 n. 27; Tomb of Bishop Galese Nichesola, 214
Santa Maura (Levkas), 45, 189, 192, 193
Sanuto, Marin, 10 n. 57, 49, 53, 64, 72, 77, 85, 85 nn. 22, 23, 90 n. 48, 94 n. 56, 176 n. 9, 179 n. 1, 184 nn. 6, 7, 9, 11, 186, 186f, 187, 188 nn. 9, 12, 16, 20, 21, 25, 190, 195 nn. 5, 7, 8, 10, 199, 200 n. 12, 201, 202 n. 6, 204, 206 nn. 10, 11, 13, 14, 22, 23, 25, 209, nn. 8, 9, 11, 211, nn. 4–9, 11, 213, 214, nn. 5, 8–16
Savin, Paolo, 11, 31, 97, 183, 184
    WORKS. Venice, S. Marco, Cappella Zen, altar: *Resurrection of Christ*, 40, 96 n. 72, 183; *St. John the Baptist*, 7, 182; *St. Peter*, 7, 40, 182, 183; furnishings, 1; appraisal of, 3 n. 10, 21; Tomb of Cardinal Zen, 7, 75 n. 19, 91, 92, 182, 183, Pl. 63; *Effigy*, 40, 74 n. 16, 182, 183; female figures, 23, 40f, 83f, 90, 115 Doc. VIII, 182–185, Fig. 20; Torre dell'Orologio: *Mori*, 11
Savoy, 13
Scala, Verde della, 48, 123
Sebastiano, Master; Venice, S. Giovanni in Bragora: frame for High Altar, 78
Sebastiano da Lugano, 18, 19f, 85, 104, 147, 168; appraisals by, 19, 21, 107, 116; partner of G. B. Bregno, 19, 20f, 105; *protomaestro* of S. Fantin, 20
    WORKS. East Berlin, Staatliche Museen: *Reggiscudo* from Tomb of Luca Civran, 20, 168; Padua, S. Giustina, design of, 20; Venice, S. Antonio di Castello: *barco* (demolished), 19; S. Maria dei Carmini, Cappella Civran: alcove, 19f; Tomb of Luca Civran (lost), 20; Tomb of Pietro Guoro, 19f; Scuola Nuova della Madonna della Misericordia, model of, 20
Sebastiano del Piombo, 12, 60, 99, 100
Segromigno Monte, S. Lorenzo: tabernacle (Baccio da Montelupo), 196 n. 41
Severo da Ravenna, see Calzetta, Severo
Siena, 55
Sixtus IV, Pope, 74 n. 16, 132, 153
Solari, Cristoforo, 92; *Apollo* (lost), 81 n. 31; *Venus* (lost), 81 n. 31; Milan, S. Maria delle Grazie: Altar of Beatrice d'Este (lost), 17 n. 21; Pavia, Certosa: Tomb of Beatrice d'Este, 17 n. 21; Venice, S. Maria della Carità: frame of Altar of St. George (lost), 88 n. 37
Spain, 13
Spani, Bartolommeo; Reggio Emilia, Duomo: Tomb of Bishop Buonfrancesco Arlotti, 214

Split, 153

*spolia*, use of, 73, 87, 179, 203, 205

Squarcione, Francesco, 8

Stampa, Bartolomeo, goldsmith, 27, 124; partner of Antonio Minello, 20, 28, 53 n. 38, 145, 210

Stefano da Ferrara, painter, 17f

Stella, Paolo, 87; Padua, S. Antonio, Chapel of St. Anthony: *Miracle of the Goblet*, 19, 146, 147; Venice, SS. Giovanni e Paolo: Tomb of Giovanni Battista Bonzio, 88; S. Giustina (formerly): High Altar, 84, 202

Stockholm, Nationalmuseum: *Bust of a Man* (Simone Bianco), 164 n. 5

Strasbourg, Musée des Beaux-Arts: *SS. Sebastian and Roch* (Cima da Conegliano), 186

Stuttgart, Staatsgalerie: *St. Thomas Aquinas Enthroned* (Carpaccio), 68 n. 9

Sugana, Alvise, 153

Suriano, Jacopo, physician, 88 n. 37

Terni, Aloisa, 138

Terni, Bartolino, 76, 77, 91, 93, 138

Terni, Marcantonio, 138

Terni, Serafina, 138

Thorwaldsen, Bertel, sculptor, 3

Tiepolo, Elizabetta, 193

Titian, 12, 50, 60, 77, 90, 93f, 95, 97, 99, 100
    WORKS: Brescia, SS. Nazaro e Celso: Altar of Altobello Averoldi, 67; Padua, Scuola di S. Antonio: *Miracle of the Speaking Babe*, 94; Rome, Musei Vaticani, Pinacoteca Vaticana: S. Nicoletto Altarpiece, 67, 187; Treviso, Duomo, Cappella della SS. Annunziata: *Annunciation*, 29, 90, 157; Venice, Ducal Palace, Cappella di S. Nicolò: frescoes (lost), 190; S. Maria dei Frari: *Assumption of the Virgin* from High Altar, 49, 49f, 50, 90, 185, 187, 188 n. 30; *Madonna and Child Enthroned* from Pesaro Altar, 53, 77, 90, 188, 189, 190

Toschi, Vincenzo, 25, 89, 113, 118, 119, 133, 135, 136, 171, 210

Trevisan, Anna, 210

Trevisan, Elena, 210

Trevisan, Patriarch Giovanni, 210, 212 n. 19

Trevisan, Marino, 207, 208

Trevisan, Melchiore, 85, 207, 208

Trevisan, Paolo, 28, 87, 89, 90, 91, 124, 210

Trevisan, Vincenzo, 207, 208

Treviso, 13, 17, 23, 30, 88, 94, 161, 168 n. 3, 187, 194; Confraternity of the Holy Sacrament, 83, 86, 91, 109, 111, 112, 157, 161, 162; Confraternity of S. Maria dei Battuti, 153; fortifications, 85
——, Casa Da Noal: pilasters from Cappella Ostiani, S. Francesco, 156
——, Duomo, history of its construction, 22; *St. Sebastian* from Altar of St. Sebastian (L. Bregno), 3, 25, 66f, 68, 93, 119 Doc. XIV, A, 147–150 Cat. no. 10, Pls. 186–189; Sarcophagus of Canon Bertuccio Lamberti (L. Bregno), 29, 30, 79, 87, 92, 126 Doc. XIX, D, 150–152 Cat. no. 11, Pl. 248; Shrine of SS. Theonistus, Tabra, and Tabrata

(L. Bregno; commission to P. Lombardo), 15, 61–63, 65, 68, 74 n. 17, 83, 88, 91, 93, 113–115 Doc. VII, 152–155 Cat. no. 12, 161, Pls. 144–152; Tomb of Bishop Giovanni da Udine (Lombardo shop), 61, 153, 154, Fig. 52; *Visitation* (G. B. Bregno), 34–36, 40, 41, 52f, 57, 63, 83, 91, 95, 96, 155–157 Cat. no. 13, Pls. 15–19; buttress: *Dancing Bacchante*, 94
——, Duomo, Cappella del SS. Sacramento, 3, 83, 88, 90, 91, 154, 156, 159–165 Cat. no. 15, Pl. 46; history of its construction, 21f, 162f; altarpiece (L. Bregno), 24, 57, 59f, 62, 63, 67f, 73, 91, 97, Pls. 129–132; *Angels* (Bregno shop), 24, 58, 65, 86, 97, 184, Pls. 59–62; *Evangelists* (L. Bregno), 24, 57, 60f, 62, 63, 79, 86, 93, Pls. 133–143; fresco (lost; Pennacchi), 22, 162; incrustation, 22, 24, 26, 83, 93, 109–112 Doc. V; pavement, 22, 83; *Resurrected Christ* (G. B. Bregno), 24, 31, 38f, 46, 48, 52, 58, 97, 111 Doc. V, C, Pls. 47–52; *St. Paul* (L. Bregno), 24, 40, 58f, 62, 63, 64, 80, 81, 86, 95, 97, Pls. 124–128; *St. Peter* (G. B. Bregno), 24, 35, 39f, 41, 46, 47, 51, 52, 57, 58f, 61, 63, 64, 86, Pls. 53–58; stairs, 22, 83; vestibule, 22, 86
——, Duomo, Cappella della SS. Annunziata, 29, 163, Pl. 246; history of its construction, 157f; *Adoration of the Magi* (Pordenone), 157; altarpiece, 91; *Annunciation* (Titian), 29, 90, 157; *Bust of Bishop Rossi* (Riccio), 158; frame for Titian's *Annunciation* (L. Bregno), 29, 78f, 87, 88, 90, 93, 157–159 Cat. no. 14, Pls. 245, 247; furnishings, 29, 78, 158; *cappella maggiore*, 153
——, Museo Civico, 156, 169, 170 n. 8
——, Palazzo Vescovile, 153
——, S. Chiara, 31f, history of its construction, 167; Bettignoli Bressa Altar, see Treviso, S. Nicolò: Bettignoli Bressa Altar; Cenotaph of Venceslao Bettignoli (lost; G. B. Bregno), 21, 32, 107–109 Doc. IV, 166, 167
——, S. Francesco, Cappella Ostiani, 34, 155f
——, S. Leonardo: frame for Altar of St. Sebastian (L. Bregno), 25, 66, 68, 73, 78, 147–150 Cat. no. 10, 158, Pls. 192, 194
——, S. Margherita, 166; S. Margherita (formerly): Altar of St. Sebastian (L. Bregno), 3, 25, 26, 57, 66–68, 70, 73, 78, 86, 91, 93, 97, 119 Doc. XIV, 147–150 Cat. no. 10, Pls. 186–194; *Apostles, Virgin Mary,* and *St. John the Evangelist* from the choir screen (Gio. Buora), 20; Tomb of Cristoforo da Tolentino (lost), 45 n. 28, 205
——, S. Nicolò: Bettignoli Bressa Altar, 3, 15, 21, 31–34, 57, 83, 91, 93, 98, 107–109 Doc. IV, 165–169 Cat. no. 16, Pl. 1; *Angels* (G. B. Bregno), 21, 32, 37, 48, 53, Pls. 13, 14; frame (G. B. Bregno), 32, 44, 62, Pls. 1–3; *Madonna and Child* (G. B. Bregno), 21, 32, 33f, 68, 97, Pls. 10–12; *Reggiscudo*, 32; *Resurrected Christ* (G. B. Bregno), 21, 32f, 38, 39, 54, 68, 97, Pls. 4–8; *St. John the Evangelist*, 32, 97f, Figs. 8, 9; *Virgin Mary*, 32; Bettignoli Epigraph (G. B. Bregno), 165, 166, 167, Pl. 9; *Christ Appearing to the Holy Women* (G. B. Bregno), 31, 52f, 97, 169–170 Cat. no. 17, Pls. 114–116; frame of High Altar (Lio Lupi), 78 n. 27; Tomb of Senator Agostino d'Onigo (Gio. Buora), 168 n. 10, 170, 208; Cappella Onigo, 52, 170

Trieste, 13

Turkish War with Venice, 12, 43, 44, 45, 92, 189, 193, 194, 196 n. 36, 198, 208

Udine, Convent of S. Francesco, 153

Vasari, Giorgio, 179, 196 n. 41
Vatican City, see Rome
Vecellio, Cesare; Belluno, Duomo: *Madonna in Glory*, 130 n. 8
Vedello, Martino dal, 163; Venice, S. Giovanni Crisostomo, Cappella Bernabò: capitals, 164 n. 6; Scuola di S. Marco, canal facade, 164 n. 6; pulpit, commission for, 164 n. 6
Venice, Council of Ten, 85, 86, 89, 145, 182, 193, 204, 205, 210, 213; history of, 12–14; mint, 10, 85; *Procuratori di S. Marco*, 85, 88, 89, 90; *de citra*, 21, 23, 26, 48, 70, 83, 88, 89, 142, 182, 187; *de supra*, 26, 72, 88, 89, 90, 140, 178, 179, 193; *de ultra*, 88, 194, 213; *Provveditori al Sal*, 107; Senate, 76, 77, 153, 161, 175, 181, 194, 204, 206 n. 14, 213; stonemasons' guild, 6, 16, 17
——, Calle Fiubera (formerly): *Madonna of the Scuola della Madonna della Carità* (Mosca), 87
——, Campo Rusolo (Campo S. Gallo), S. Marco 1076: *St. George and the Dragon*, 47f, Fig. 37
——, Campo SS. Giovanni e Paolo: Monument of Bartolomeo Colleoni (Verrocchio; Leopardi), 10, 200 n. 12
——, Church of the Crociferi, history of its construction, 171; Tomb of Doge Pasquale Cicogna (Campagna), 215 n. 31; Tomb of Ippolito Verardi (lost; G. B. Bregno), 22f, 24, 83, 89, 92, 113 Docs. VI, E, F, 133, 170–171 Cat. no. 18
——, Convent of S. Chiara, 187
——, Convent of S. Giorgio Maggiore, 47f, 93; dormitory (Gio. Buora), 9; history of its construction, 172; facade, 24, 86; *St. George and the Dragon* (G. B. Bregno), 2f, 24, 26, 47f, 84, 88, 89, 91, 93, 96, 116f Doc. X, 171f Cat. no. 19, Pls. 83, 84
——, Ducal Palace, 16; *Adam* (Rizzo), 5, 5f, 33, Fig. 7; *Eve* (Rizzo), 5; *Loredan Madonna* (P. Lombardo), 35 n. 12, 38, 54, Fig. 15; *Madonna delle Biade* (Gio. Buora), 9; Arco Foscari, 92; Cappella di S. Nicolò (formerly): altarpiece (Venetian, 1523), 53 n. 38, 87f, 190f, Figs. 39, 40, 46, 47; frescoes (lost; Titian), 190; east wing (Rizzo), 5, 6, 16, 17 n. 13; fireplaces (A. and T. Lombardo), 7, 21, 31, 107 Doc. III; Porta della Carta (Bart. Bon), 4, 93; Scala dei Giganti (Rizzo), 5, 16, 38, 81 n. 31, Figs. 10–12
——, Frezzaria, 94
——, Galleria Giorgio Franchetti alla Ca' d'Oro: *Angel Bearing Attributes of Christ* (Rizzo), 5, 54, Fig. 48; *Double Portrait* (T. Lombardo), 69, Fig. 55; reliefs from the Altar of the True Cross (Riccio), 48, 96 n. 70, 142
——, Gallerie dell'Accademia: *The Engaged Couple Being Greeted by the Pope* (Carpaccio), 195; *Madonna degli Alberetti* (Gio. Bellini), 34
——, Madonna dell'Orto: *Madonna and Child* (Venetian, late 15th cen.), 34 n. 8
——, Museo Archeologico: *Apollo of the Anzio type* (Roman, 1st cen. A.D.), Fig. 53; *Kore*, 58 n. 2; "Throne of Sat-

urn" (1st cen. B.C.–1st cen. A.D.), 94
——, Palazzo Civran, facade: *Page* (Gio. Buora), 84, 92
——, Palazzo Donà: *Priest* (Roman), 94
——, Piazza S. Marco, 88, 178; Campanile, 86; standards (Leopardi), 10, 96 n. 70
——, Piazzetta: columns with the *Lion of St. Mark* and "*St. Theodore*," 94
——, Ponte dei Baretteri, 47
——, S. Andrea della Certosa (formerly): Tomb of ser Orsato Giustiniani (Nic. di Gio. Fiorentino), 8, 23, 75 n. 19, 81 n. 31, 115, 182, 183
——, S. Antonio di Castello: *barco* (demolished; Seb. da Lugano and Gugl. dei Grigi), 19
——, S. Cassiano (formerly): *Madonna and Child Enthroned* (Antonello da Messina), 34
——, S. Elena: Tomb of Vittore Cappello (Nic. di Gio. Fiorentino), 42, 70 n. 12, 205, 208
——, S. Fantin, 85, 88; history of its construction, 20
——, S. Francesco della Vigna, Cappella Grimani, 214 n. 17; Cappella Giustiniani, 84, 96 n. 72; altarpiece (Lombardo shop), 6, 32, 64, 70 n. 12, 93, 96 n. 72, Fig. 1; *Christ Carrying the Cross* (Pyrgoteles), 11; *Lamentation* (T. Lombardo), 96 n. 72; *Pentecost* (P. Lombardo), 35 n. 12; *St. Luke* (A. Lombardo), 60, 93, Fig. 6; *SS. Mark* and *John the Evangelist* (P. Lombardo), 6, 33, 35, 60f, 62, 63, 93, Figs. 2–5; narrative reliefs, 96 n. 72
——, S. Geminiano, 85; S. Geminiano (formerly): High Altar (Bart. Bergamasco), 87
——, S. Gerolamo dei Gesuati: statuary of the facade, 92
——, S. Giacomo del Paludo, 186
——, S. Giobbe, history of its construction, 201; Altar of St. Luke (Lombardo shop), 57, 84, 200–203 Cat. no. 30, Figs. 65, 66, 68–71; frame for Carpaccio's *Presentation of Christ in the Temple*, 78 n. 27; choir: *putti* (P. Lombardo), 6f; *St. Luke* (A. Lombardo), 7; *St. Mark* (T. Lombardo), 7; portal: *Job and St. Francis* (P. Lombardo), 6f, 96 n. 72
——, S. Giovanni Crisostomo, Cappella Bernabò: capitals (Vedello), 164 n. 6; *Coronation of the Virgin* (T. Lombardo), 7, 72 n. 13, 84
——, SS. Giovanni e Paolo, 204, 205; Altar of the Virgin (Venetian, ca. 1482–6), 32, 93; *St. Catherine* from High Altar of S. Marina (L. Bregno), 57, 69f, 71, 97, 174–177 Cat. no. 22, Pls. 215, 216; *St. Jerome* (Ales. Vittoria), 143 n. 15; *St. Mary Magdalene* from Altar of Verde della Scala (Bart. Bergamasco), 32, 48, 70, 142, Fig. 57; *St. Mary Magdalene* from High Altar of S. Marina (L. Bregno), 53, 57, 69f, 71, 81, 97, 174–177 Cat. no. 22, Pls. 213, 214; *St. Peter Martyr* from High Altar of S. Giustina (A. Lombardo), 84, 202, Fig. 67; Tomb of Giovanni Battista Bonzio (Stella), 88; Tomb of Fra Leonardo da Prato (Ant. Minello), 10, 86, 87, 204f; Tomb of Doge Nicolò Marcello (P. Lombardo), 42, 45; Tomb of Doge Giovanni Mocenigo (T. Lombardo), 44, 87, 96 n. 72, Fig. 26; Tomb of Doge Pietro Mocenigo (P. Lombardo), 44f, 45 n. 28, 81 n. 31, 96 n. 72, 205, 208, Fig. 25; Tomb of Doge Tomaso Mocenigo (P. Lamberti), 98; Tomb of Dionigi Naldi (Ant. Minello), 2, 10, 45 n. 28, 57, 76f,

86, 87, 93, 203–206 Cat. no. 31; Figs. 62, 63; Tomb of Count Nicolò Orsini (Ant. Minello), 10, 79, 86, 87, 204f; Tomb of Vittor Pisani, 45, 205; Tomb of Doge Andrea Vendramin (T. Lombardo), 2 n. 3, 43, 45, 69f, 81 n. 31, 93, 143 n. 26, 174, 175, Fig. 27; *Virtue* from Vendramin Tomb (A. Lombardo), 58, 72, Fig. 50

———, SS. Giovanni e Paolo, Cappella del Rosario, 143 n. 16; Cappella della Madonna della Pace, 213; Cappella della Madonna della Pace (formerly): Tomb of Bishop Lorenzo Gabriel, 2, 57, 212–215 Cat. no. 34, Figs. 86, 88; sacristy: *Angel* from Altar of Verde della Scala (G. B. Bregno), 48f, 53f, 94, 99, 123f Doc. XVIII, 141–144 Cat. no. 6, Pls. 91–97

———, S. Giovanni Evangelista: *Deacon Saint* (G. B. Bregno), 31, 51, 86, 177 Cat. no. 23, Pls. 107–111

———, S. Giovanni in Bragora: frame for High Altar (Master Sebastiano), 78

———, S. Giuseppe di Castello: Tomb of Doge Marino Grimani and Dogaressa Morosina Morosini (Campagna), 215 n. 31

———, S. Giustina (formerly): High Altar (A. Lombardo; Stella), 84, 202

———, S. Marco, 88, 178, 181, 182; Altar of the Cross (L. Bregno; Jac. Sansovino), 3, 26, 57, 64, 72f, 76, 78, 87, 88, 89, 90, 91, 93, 96, 97, 120f Doc. XV, 177–180 Cat. no. 24, 187, Pls. 225–234; Altars of SS. James, Paul, and Clement (Rizzo), 5; *Conversion of St. Paul*, 35, 96 n. 72, Fig. 13; *Madonna and Child* and SS. *Mark* and *Bernardino*, 191 n. 12; four bronze *Horses*, 94; statuary of the facade, 93

———, S. Marco, Cappella di S. Clemente: altarpiece from Cappella di S. Nicolò, Ducal Palace (Venetian, 1523), 53 n. 38, 87f, 190f, Figs. 39, 40, 46, 47; Cappella Zen, 85, 86, 89; altar: *Madonna and Child* (A. Lombardo), 7, 182; *Resurrection of Christ* (Savin), 40, 96 n. 72, 183; *St. John the Baptist* (Savin), 7, 182; *St. Peter* (Savin), 7, 40, 182, 183; architecture (Leopardi; T. Lombardo), 10, 25f, 64 n. 4; 87 n. 30; ciborium (A. Lombardo), 182; furnishings, 1, 11, 88, 96 n. 70, 98; appraisal of, 3 n. 10, 21, 115f Doc. IX; contract for, 7, 10, 84: Tomb of Cardinal Zen (Savin), 7, 75 n. 19, 91, 92, 182, 183, Pl. 63; *Effigy* (Savin), 40, 74 n. 16, 182, 183; female figures from Tomb of Cardinal Zen (G. B. and L. Bregno; Savin), 3, 23f, 40–42, 63, 71f, 81, 83f, 90, 95, 97, 115 Doc. VIII, 180–185 Cat. no. 25, Fig. 20, Pls. 63–72, 153–158; *Temperance* (A. Lombardo), 41, 182, 183

———, S. Maria dei Carmini: statuary of the facade (Gio. Buora), 92; Cappella Civran: alcove (Seb. da Lugano), 19f; Tomb of Luca Civran (lost; Seb. da Lugano), 20; Tomb of Pietro Guoro (Seb. da Lugano), 19f

———, S. Maria dei Frari, 186, 193, 208; Cenotaph of Alvise Pasqualigo (Mosca), 57, 208; choir screen (P. Lombardo), 50 n. 34; *Prophets*, 6f; High Altar, 72, 86, 87, 88, 90, 91, 96, 185–188 Cat. no. 26, Pl. 98; *Assumption of the Virgin* (Titian), 49, 49f, 50, 185, 187, 188 n. 30; *Christ as Man of Sorrows* (Bregno shop), 50, Pl. 99; frame (G. B. Bregno?), 49, 50, 86, 93, 97, Pl. 98; *Resurrected Christ* (Bregno shop),

31, 49, 68f, 90, 96, 97, Pls. 201–205; *St. Anthony* (G. B. Bregno), 31, 49, 50, 51, 54, 57, 68, 69, 72, 90, 96, Pls. 100–106; *St. Francis* (L. Bregno), 31, 49, 50, 68, 69, 72, 77, 90, 96, 97, Pls. 195–200; Pesaro Altar, 87, 89, 91, 188–191 Cat. no. 27; frame (L. Bregno), 53, 77f, 78, 90, 93, 97, Pl. 244; *Madonna and Child Enthroned* (Titian), 53, 77, 90, 188, 189, 190; left-hand *Reggiscudo*, 53, Figs. 41–45; right-hand *Reggiscudo* (G. B. Bregno), 16, 31, 53f, 77, 87, 89, 97, Pls. 117–123; Tomb of Jacopo Barbarigo, 77, 79, Fig. 61; Tomb of Pietro Bernardo (T. Lombardo), 51; Tomb of Benedetto Brugnolo, 84; Tomb of Doge Francesco Foscari (Nic. di Gio. Fiorentino), 4, 5; Tomb of Jacopo Marcello (Gio. Buora), 45 n. 28, 205, 208

———, S. Maria dei Frari, Tomb of Benedetto Pesaro, 1, 42–47, 89, 91, 92, 98, 117 Doc. XI, 192–196 Cat. no. 28, Pl. 73; *Effigy* (G. B. Bregno), 2, 42, 43, 45, 45f, 50, 57, 76, 77, 84, 98, 99, 205, Pls. 77–82; frame (G. B. Bregno?), 42, 42–44, 45, 50, 84, 93, 98, 205, Pls. 73, 75, 76; *Madonna and Child*, 43, 45, 97f, Figs. 34, 35; *Mars* (Baccio da Montelupo?), 42, 45, 81 n. 31, 97f, Figs. 29, 30; *Neptune*, 45, 50f, 81 n. 31, 97f, Figs. 31, 32; *St. Benedict* (G. B. Bregno), 42, 46f, Pl. 74; *St. Jerome*, 42, 96 n. 72, 97f, Fig. 28; Tomb of Girolamo Pesaro (demolished), 43, 194; Tomb of Bishop Jacopo Pesaro, 190, 191 n. 16, 214; Tomb of Melchiore Trevisan, 45 n. 28, 57, 84, 205, 206–209 Cat. no. 32, Figs. 73, 74, 75; Tomb of Doge Nicolò Tron (Rizzo), 5, 8, 81 n. 31, 205

———, S. Maria dei Frari, Cappella Corner: wall bench, 81 n. 31; Cappella dei Milanesi: frame for Altar of St. Ambrose, 50, 93, Fig. 38; sacristy, 42, 93, 117, 193, 193f; Tabernacle of the Holy Blood (T. Lombardo), 208

———, S. Maria dei Miracoli, 6, 93; tabernacles (T. Lombardo), 72 n. 13, 180 n. 10, 202; portal: *Madonna and Child* (Pyrgoteles), 10f, 43, 195, Fig. 33

———, S. Maria dei Servi (formerly): Altar of the True Cross, 48, 142; reliefs (Riccio), 48, 96 n. 70, 142; Altar of Verde della Scala (Gugl. dei Grigi; Bart. Bergamasco), 48, 70, 87, 142, 143; *Angels* (G. B. Bregno), 48f, 53f, 86, 94, 99, 123f Doc. XVIII, 141–144 Cat. no. 6, Pls. 85–97; Tomb of Giovanni Emo (Rizzo; T. Lombardo), 5, 43, 93, 208, Fig. 24

———, S. Maria della Carità (formerly): frame of Altar of St. George (lost; Crist. Solari), 88 n. 37; grille from Barbarigo Altar, 96 n. 70; Cappella di S. Salvatore: altar (lost), 38 n. 14, 88 n. 37

———, S. Maria della Salute, ante-sacristy: *Lamentation* (Lombardo shop), 96 n. 72

———, S. Maria Maggiore, 73

———, S. Maria Mater Domini, history of its construction, 210; altarpiece (Mosca), 57; Contarini Altar, frame for Bissolo's *Transfiguration*, 211, 211 n. 12; Filomato Altar, frame for Catena's *Martyrdom of St. Cristina*, 78 n. 27, 210; Trevisan Altar (Ant. Minello), 2, 28, 57, 79, 87, 89, 90, 91, 209–212 Cat. no. 33, Figs. 76–81, 83, 84

———, S. Marina, 175f; S. Marina (formerly): High Altar (L. Bregno), 2, 53, 57, 69f, 71, 81, 86, 87, 89, 91, 97, 174–177 Cat. no. 22, Pls. 209–216

————, S. Martino: Altarpiece from S. Sepolcro (L. Bregno), 63–65, 68, 71, 73, 76, 78, 86, 88, 91, 93, 96, 158, 196–200 Cat. no. 29, Pls. 161–171; *Angels* from S. Sepolcro Altar (T. Lombardo), 63, 198, 199

————, S. Nicoletto dei Frari, 187; S. Nicoletto dei Frari (formerly): *Madonna and Child in Glory* (Titian), 67, 187

————, S. Nicolò al Lido, 201

————, S. Pantaleon: *Bust of the Saviour* (Venetian, ca. 1500), 69

————, S. Pietro di Castello: Tomb of Beato Lorenzo Giustiniani, 92

————, S. Rocco: High Altar (Fantoni; Mosca; Bart. Bergamasco), 80, 87, 89, 97 n. 73, 98; *St. Sebastian* (Bart. Bergamasco), 67, 87 n. 33, Fig. 56; Tomb of Pellegrino Baselli Grilli, 45 n. 28; S. Rocco (formerly), facade: *St. Roch* (Gio. Buora), 92

————, S. Salvatore, 85, 87 n. 30; frame of Altar of St. Jerome (Gugl. dei Grigi), 87; Tomb of Caterina Cornaro (Bernardino Contino), 215 n. 31; Tomb of Cardinals Marco, Francesco, and Andrea Cornaro (Bernardino Contino), 215 n. 31

————, S. Sebastiano, 85

————, S. Sepolcro, history of its construction, 198f; S. Sepolcro (formerly): altarpiece (L. Bregno), 63–65, 68, 71, 73, 76, 78, 86, 88, 91, 93, 96, 158, 196–200 Cat. no. 29, Pls. 161–171; *Angels* from altar (T. Lombardo), 63, 198, 199

————, S. Stefano, 186; Altar of Jacopo Suriano, 88 n. 37; Tomb of Jacopo Suriano (Gio. Buora), 88 n. 37

————, S. Teodoro, 181

————, Scuola dei Calegheri: *Miraculous Cure of St. Anianus* (Rizzo), 96 n. 72

————, Scuola di S. Giorgio degli Schiavoni: *Vision of St. Augustine* (Carpaccio), 38, 39, Fig. 17

————, Scuola di S. Giovanni Evangelista, 177

————, Scuola di S. Marco, 92; *Baptism of St. Anianus* (T. Lombardo), 35, Fig. 14; pulpit (lost; Rizzo), 164 n. 6; commission for (Vedello), 164 n. 6; canal facade (Vedello), 164 n. 6

————, Scuola di S. Rocco, 89; *Bust of the Saviour* (L. Bregno), 69, 76, 81, 173 Cat. no. 20, Pls. 206–208; SS. *Bartholomew* and *Apollonia/Agatha* (L. Bregno), 70–72, 173f Cat. no. 21, Pls. 217–224; SS. *Jerome* and *John the Baptist* (Venetian, mid-16th cen.), 173f

————, Scuola Nuova della Madonna della Misericordia, 85, 87 n. 30; models of (Leopardi; Seb. da Lugano), 20

————, Seminario Patriarcale: S. Marina from High Altar of S. Marina (L. Bregno), 69, 70, 174–177 Cat. no. 22, Pls. 209–212

————, Torre dell'Orologio, 200 n. 12; *Mori* (Savin), 11

Venier, Beatrice, 198

*Venus*, 63, 81, 95

Verardi, Camilla, 89, 113, 133, 135, 171

Verardi, Camillo, 22, 23, 24f, 36, 65, 89, 112, 112f, 118, 119, 132, 133, 135, 136, 170, 171

Verardi, Carlo, 22, 23, 24, 25, 36, 65, 89, 90, 112f, 132,

133, 135, 171

Verardi, family, 83, 90

Verardi, Giulia, 25, 65f, 86, 89, 90, 118, 119, 135, 135f

Verardi, Ippolito, 22f, 112, 132, 170, 171

Verardi, Marcello, 135

Verardi, Ptolomeo, 22, 113, 133, 135, 171

Verardi, Sigismondo, 23, 89, 112, 132, 135, 170, 171

Verona, 4, 13, 15 n. 5, 138; marble from, 26, 110, 162

————, Arco dei Gavi, 43, Fig. 23

————, Duomo: frame for Titian's *Assumption of the Virgin* (Jac. Sansovino), 78 n. 27; Tomb of Bishop Galese Nichesola (Jac. Sansovino), 214

————, Museo del Castelvecchio: *Madonna and Child with the Baptist and St. Jerome* (Cima da Conegliano), 68 n. 9

————, Palazzo Vescovile, portal (Gio. Buora), 9; statuary, 92

————, S. Fermo Maggiore: Tomb of Niccolò Brenzoni (Nanni di Bartolo), 98; Tomb of Girolamo and Marcantonio della Torre (Riccio), 74

————, S. Zeno, 181

Verrocchio, Andrea del; Venice, Campo SS. Giovanni e Paolo: Monument of Bartolomeo Colleoni, 10, 200 n. 12

Vicenza, 13, 181, 189, 204

————, Duomo: High Altar, 181

————, Museo Civico: *"Muse"* from Teatro Berga, 8

————, S. Corona: frame for Altar of the Madonna della Misericordia, 78 n. 27; frame for Nievo Altar, 78 n. 27

Vienna, Kunsthistorisches Museum: *Bust of a Man* (Simone Bianco), 164 n. 5; *Christ Dispensing his Blood* (Lotto), 179; S. Cassiano *Madonna* (Antonello da Messina), 34

————, Oesterreichisches Museum für angewandte Kunst: *Effigy of Bishop Lorenzo Gabriel*, 2, 57, 212–215 Cat. no. 34, Figs. 86, 88

Villa di Monestier del Pero, 166

Vittoria, Alessandro, 156; Venice, SS. Giovanni e Paolo: *St. Jerome*, 143 n. 15

Vivarini, Bartolomeo, 55

War of Chioggia, 45

War of the League of Cambrai, 13f, 32, 69, 70, 73, 76, 84–87, 87, 90, 91, 93, 121, 138, 140, 161, 167, 172, 175, 178, 204, 204f, 213

Washington, D.C., National Gallery of Art: *Haller Madonna* (Dürer), 34 n. 8; *St. Jerome* (Gio. Bellini), 35

Wilhelm II, Emperor, 144

World War II, 48, 142, 152 n. 10, 157, 163

Zadar, S. Grisogono, 161

Zancharol, Giuliano, 94

Zane, Andrea, 186

Zen, Cardinal Giovanni Battista, 85, 88, 181f, 183, 213

Zonchio, 12

Zotti, Maddalena da Bavaria, 25, 119, 120, 148, 149

Zotti, Vincenzo, jurist, 25, 66, 148, 149

Zovenzoni, Raffaele, 81 n. 31, 95

# FIGURES

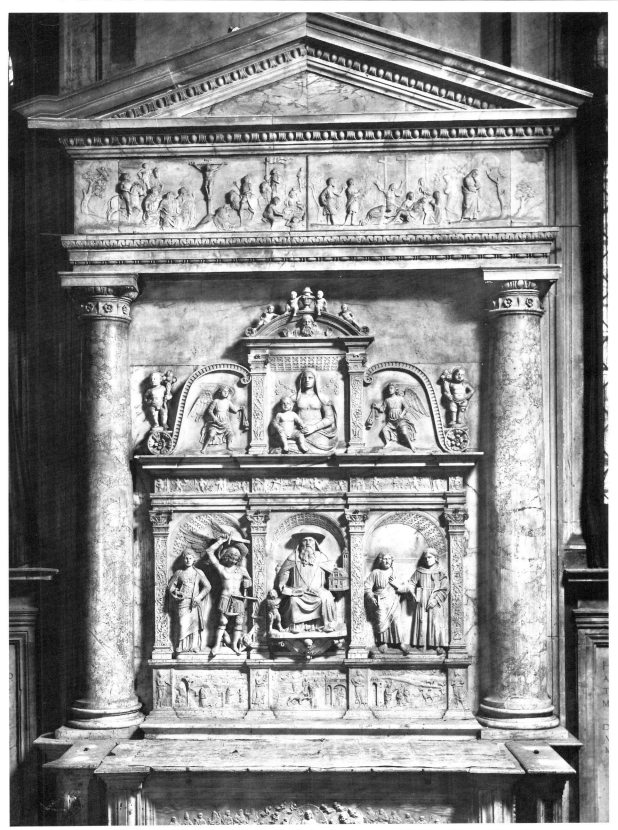

Fig. 1. Shop of Pietro Lombardo, Altar of St. Jerome, Cappella Giustiniani, S. Francesco della Vigna, Venice (Alinari, Florence)

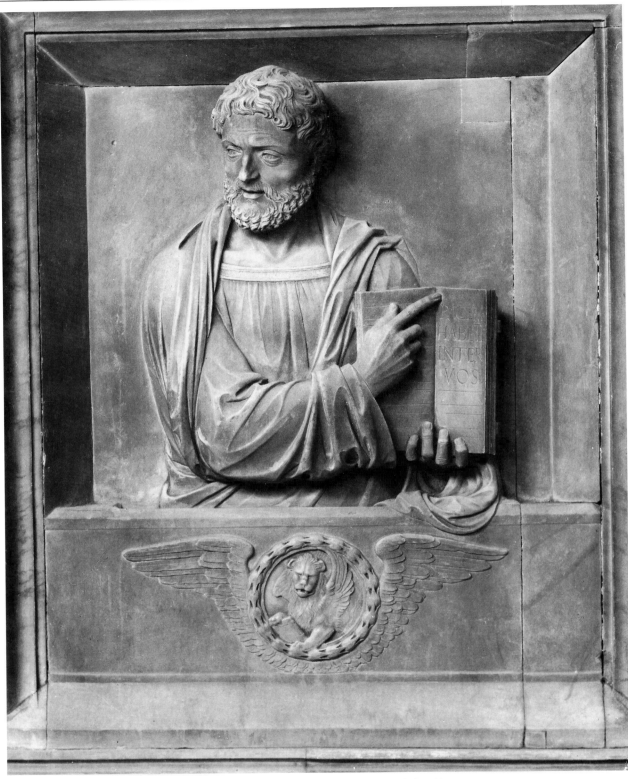

Fig. 2. Pietro Lombardo, *St. Mark*, Cappella Giustiniani, S. Francesco della Vigna, Venice (Böhm, Venice)

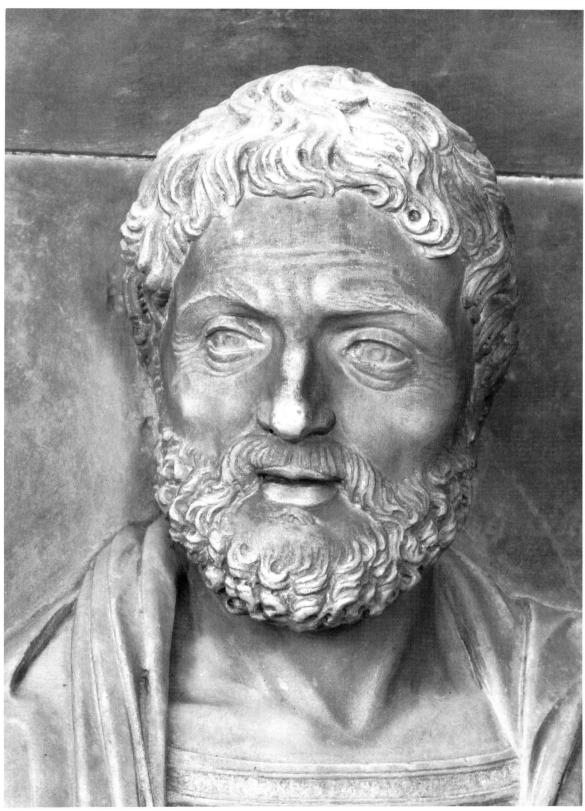

Fig. 3. Pietro Lombardo, detail, *St. Mark*, Cappella Giustiniani, S. Francesco della Vigna, Venice (Böhm, Venice)

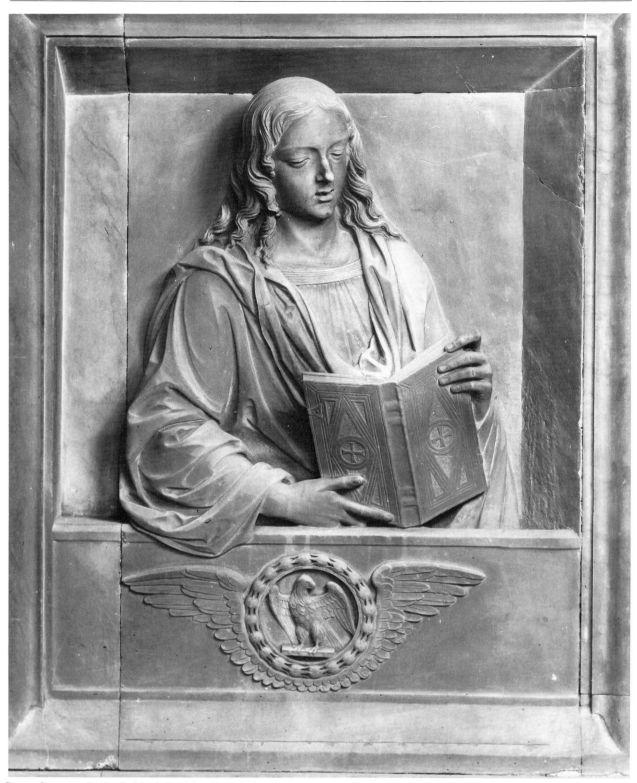

Fig. 4. Pietro Lombardo, *St. John the Evangelist*, Cappella Giustiniani, S. Francesco della Vigna, Venice (Böhm, Venice)

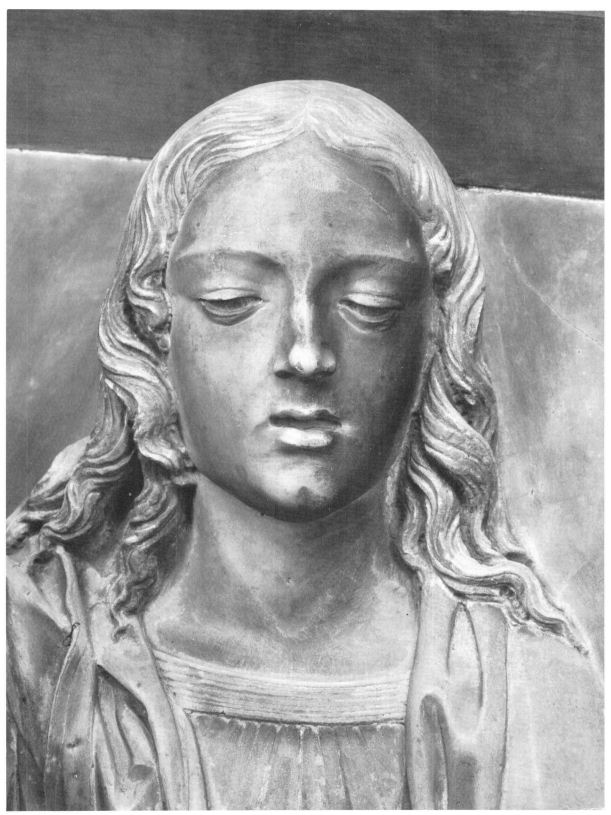

Fig. 5. Pietro Lombardo, detail, *St. John the Evangelist*, Cappella Giustiniani, S. Francesco della Vigna, Venice (Böhm, Venice)

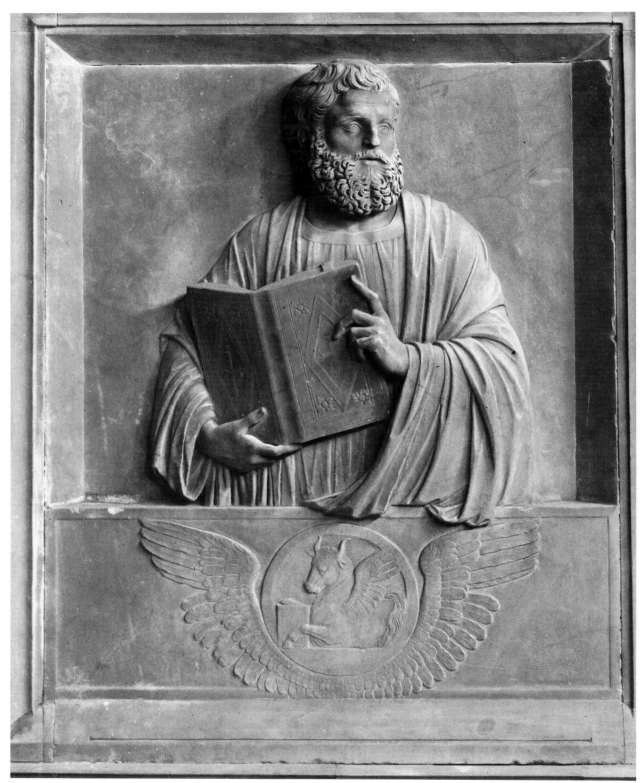

Fig. 6. Antonio Lombardo, *St. Luke*, Cappella Giustiniani, S. Francesco della Vigna, Venice (Böhm, Venice)

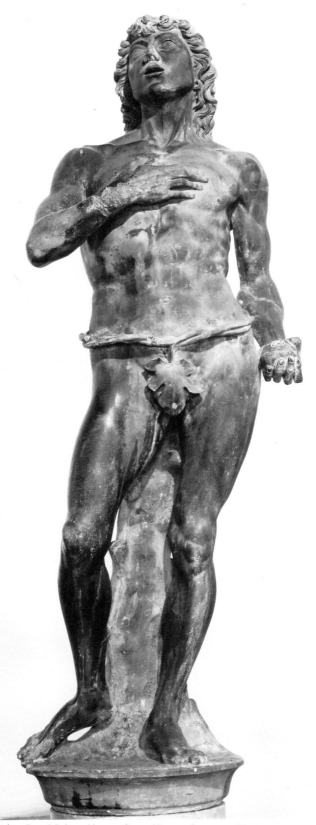

Fig. 7. Antonio Rizzo, *Adam*, Ducal Palace, Venice (Rossi, Venice. Courtesy of Debra Pincus)

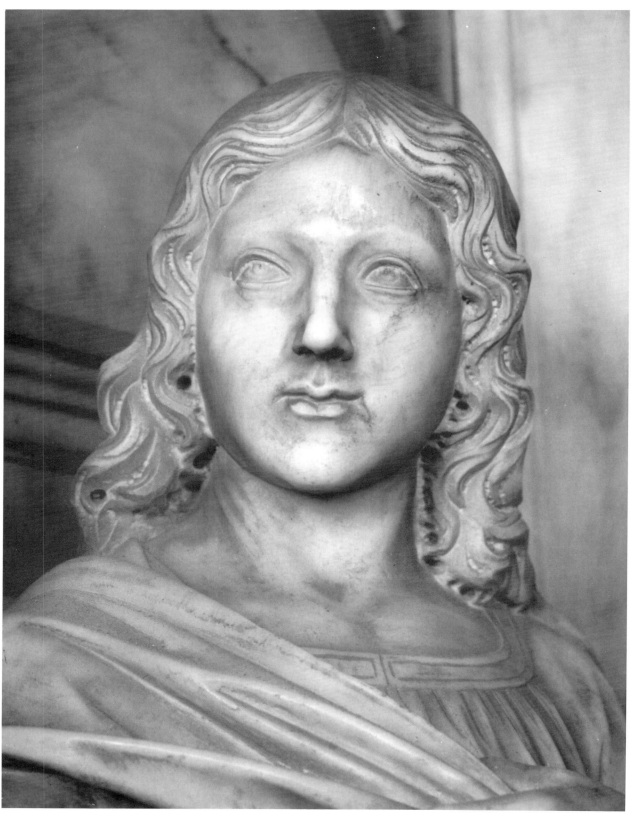

Fig. 8. Detail, *St. John the Evangelist*, Bettignoli Bressa Altarpiece, S. Nicolò, Treviso (Fini, Treviso)

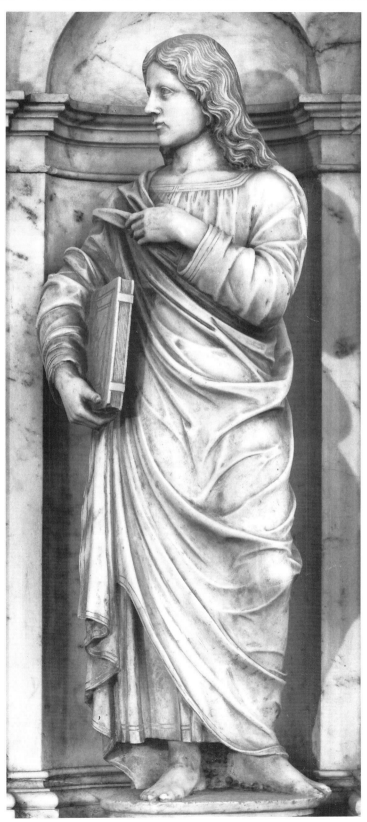

Fig. 9. *St. John the Evangelist*, Bettignoli Bressa Altarpiece, S. Nicolò, Treviso
(Fini, Treviso)

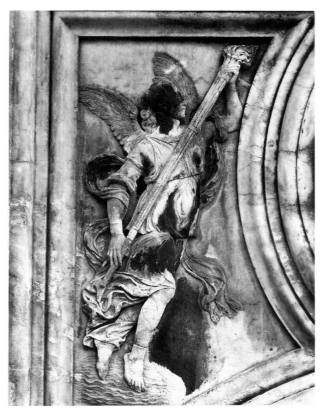

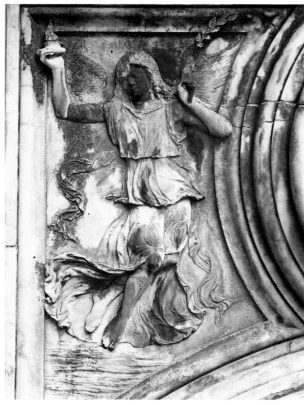

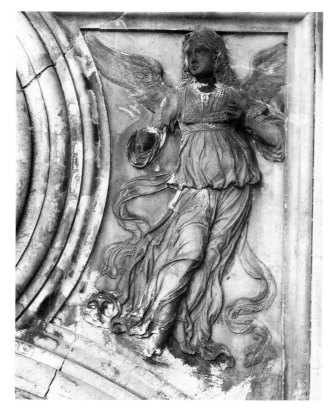

Fig. 10. (Above, left) Assistant of Antonio Rizzo, fifth *Victory*, Scala dei Giganti, Ducal Palace, Venice (Böhm, Venice)

Fig. 11. (Above, right) Assistant of Antonio Rizzo, first *Victory*, Scala dei Giganti, Ducal Palace, Venice (Böhm, Venice)

Fig. 12. (Opposite) Antonio Rizzo and assistant, eighth *Victory*, Scala dei Giganti, Ducal Palace, Venice (Böhm, Venice)

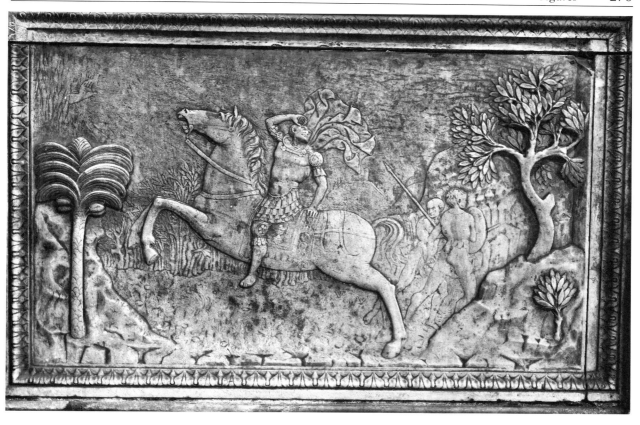

Fig. 13. (Above) Antonio Rizzo, *Conversion of St. Paul*, Altar
of St. Paul, S. Marco, Venice (Alinari, Florence)

Fig. 14. (Opposite) Tullio Lombardo, *Baptism of St. Anianus*,
facade, Scuola Grande di S. Marco, Venice (Böhm,
Venice)

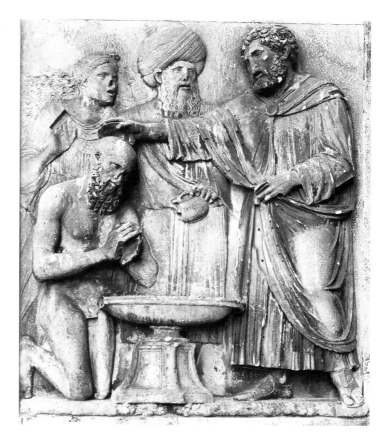

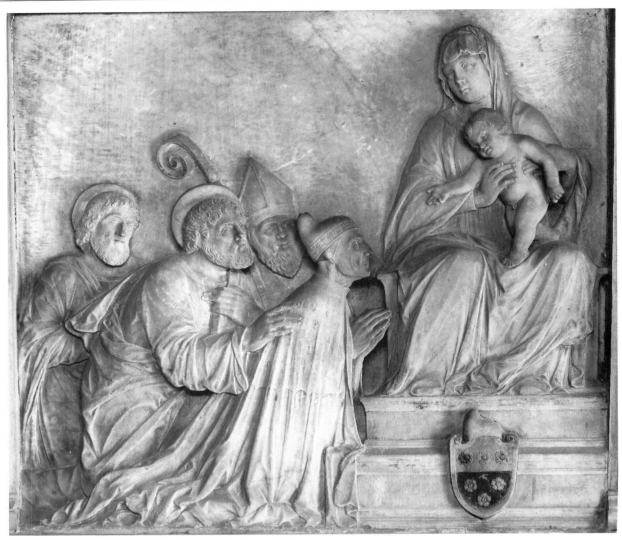

Fig. 15. Pietro Lombardo, *Madonna and Child Enthroned with Doge Leonardo Loredan*, Ducal Palace, Venice (Böhm, Venice)

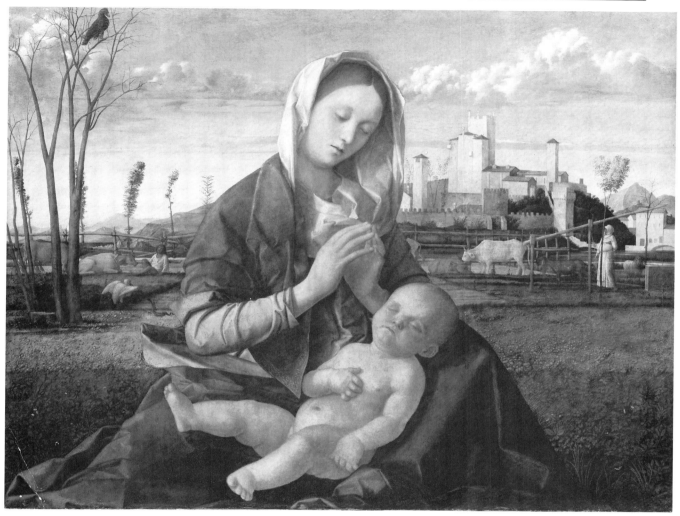

Fig. 16. Giovanni Bellini, *Madonna of the Meadow*, National Gallery, London (National Gallery, London)

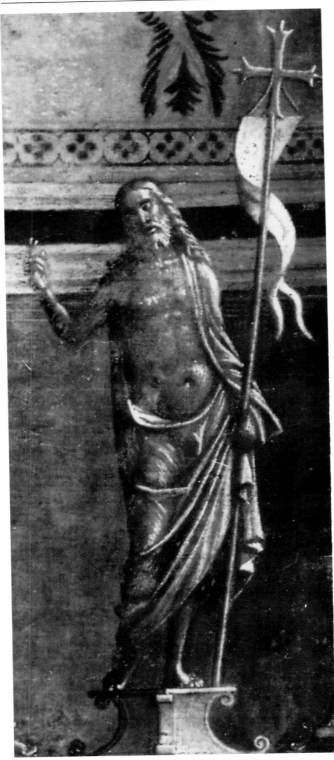

Fig. 17. Vittore Carpaccio, detail, *Vision of St. Augustine*, Scuola di S. Giorgio degli Schiavone, Venice (Böhm, Venice)

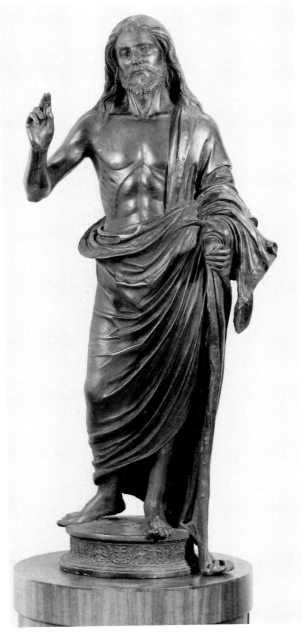

Fig. 18. *Resurrected Christ*, Museo Poldi-Pezzoli, Milan (Museo Poldi- Pezzoli, Milan)

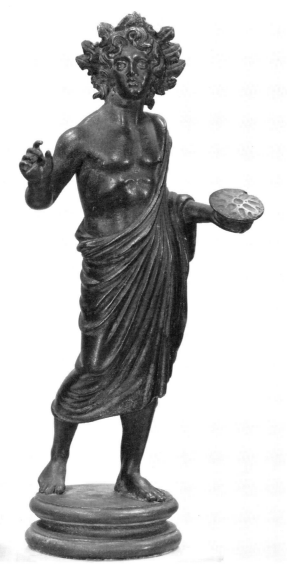

Fig. 19. Roman, *Devotee*, Bibliothèque Nationale, Paris (Bibliothèque Nationale, Paris)

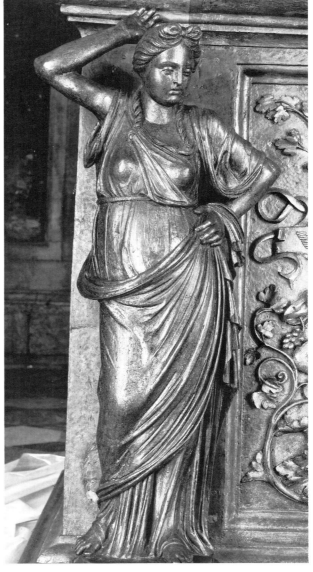

Fig. 20. Paolo Savin, Female figure, Sarcophagus of Cardinal Zen, Cappella Zen, S. Marco, Venice (Giacomelli, Venice)

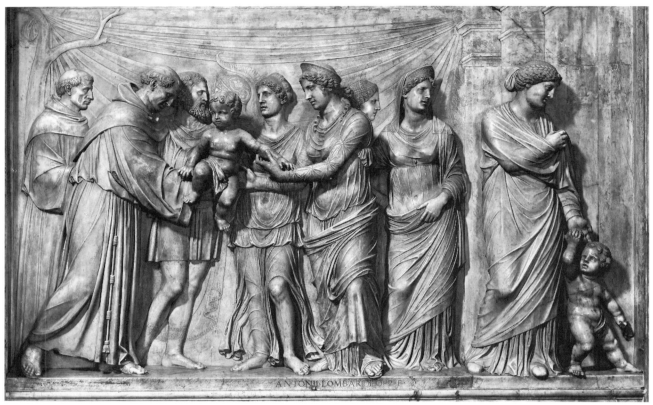

Fig. 21. Antonio Lombardo, *Miracle of the Speaking Babe*, Cappella del Santo, S. Antonio, Padua (Alinari, Florence)

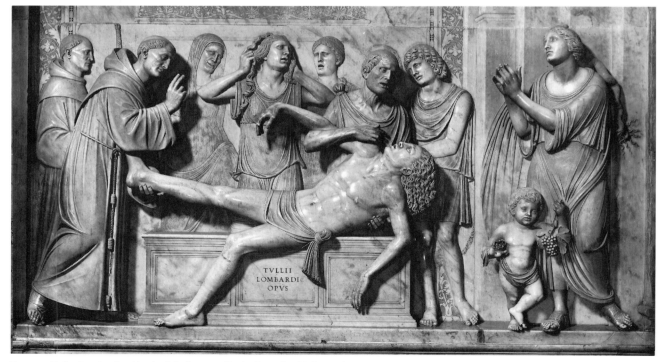

Fig. 22. Tullio Lombardo, *Miracle of the Repentant Youth*, Cappella del Santo, S. Antonio, Padua (Alinari, Florence)

Fig. 23. (Above) Roman, 1st century A.D., Arco dei Gavi, Verona (Alinari, Florence).

Fig. 24. (Opposite) Johannes Grevembroch, drawing of the Tomb of Giovanni Emo formerly in S. Maria dei Servi, Venice, in MS Gradenigo 228/ III, c. 27, Museo Correr, Venice (Museo Correr, Venice)

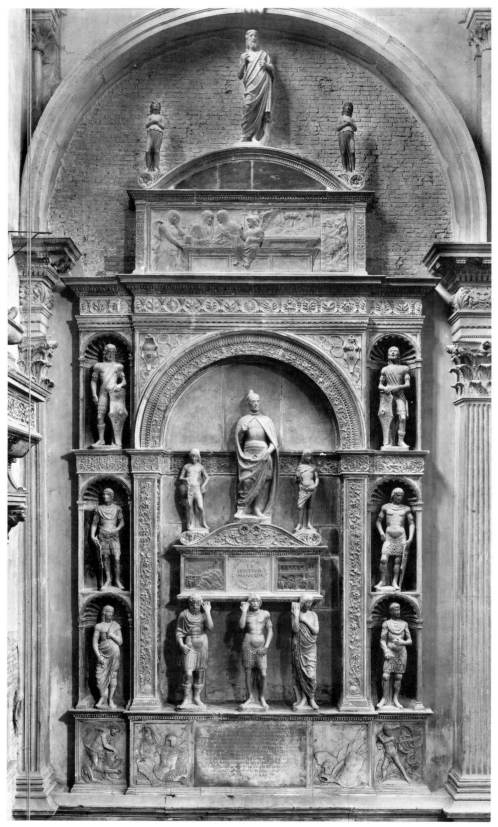

Fig. 25. Pietro Lombardo, Tomb of Doge Pietro Mocenigo, SS. Giovanni e Paolo, Venice (Anderson, Florence)

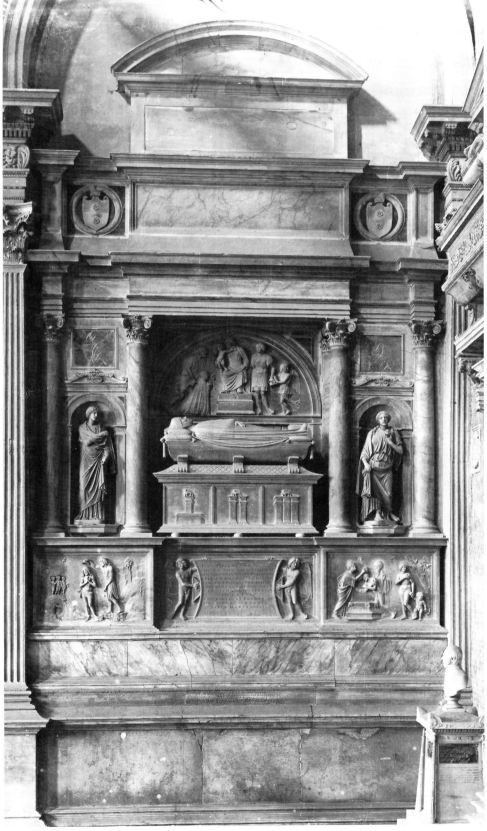

Fig. 26. Tullio Lombardo, Tomb of Doge Giovanni Mocenigo, SS. Giovanni e Paolo, Venice (Fiorentini, Florence)

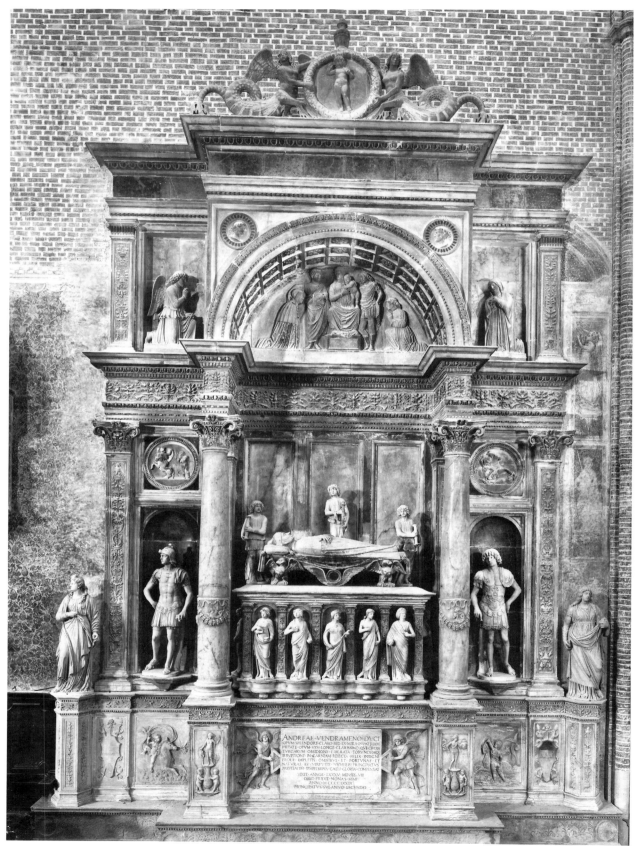

Fig. 27. Tullio Lombardo, Tomb of Doge Andrea Vendramin, SS. Giovanni e Paolo, Venice (Anderson, Florence)

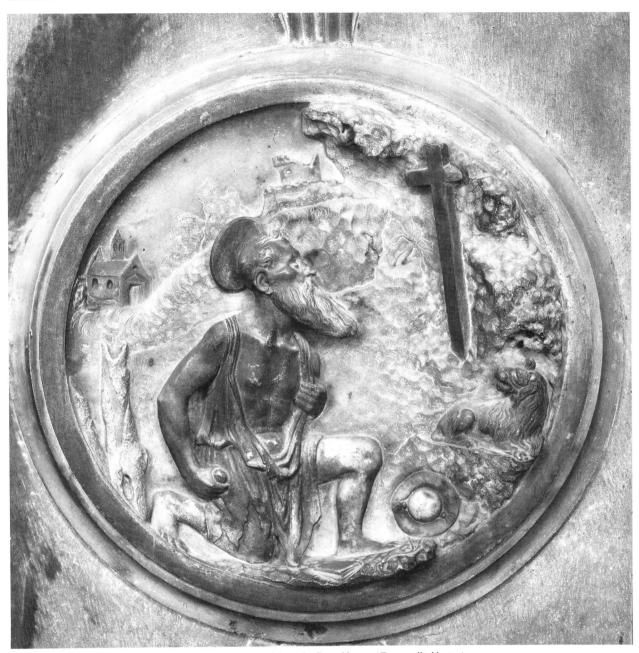

Fig. 28. *St. Jerome in Penitence*, Tomb of Benedetto Pesaro, S. Maria dei Frari, Venice (Giacomelli, Venice)

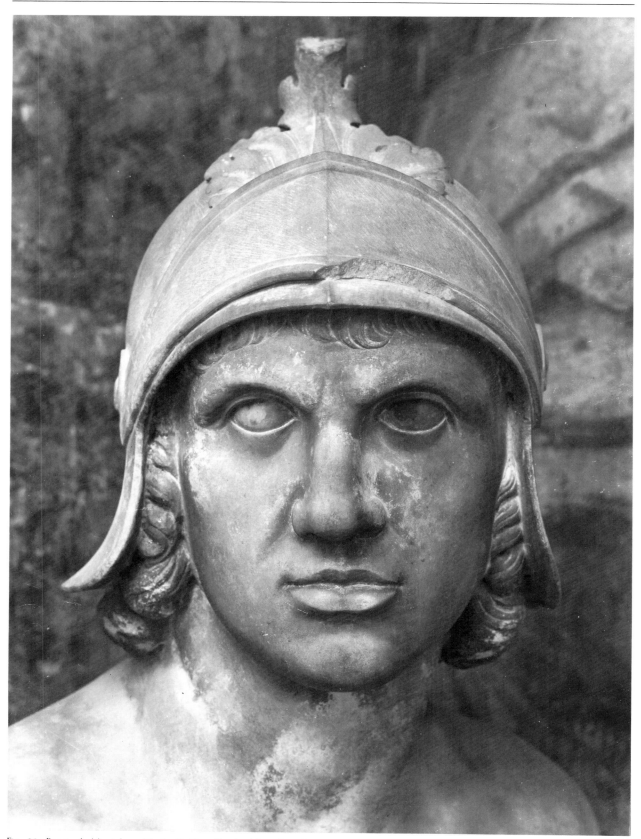

Fig. 29. Baccio da Montelupo (?), detail, *Mars*, Tomb of Benedetto Pesaro, S. Maria dei Frari, Venice (Giacomelli, Venice)

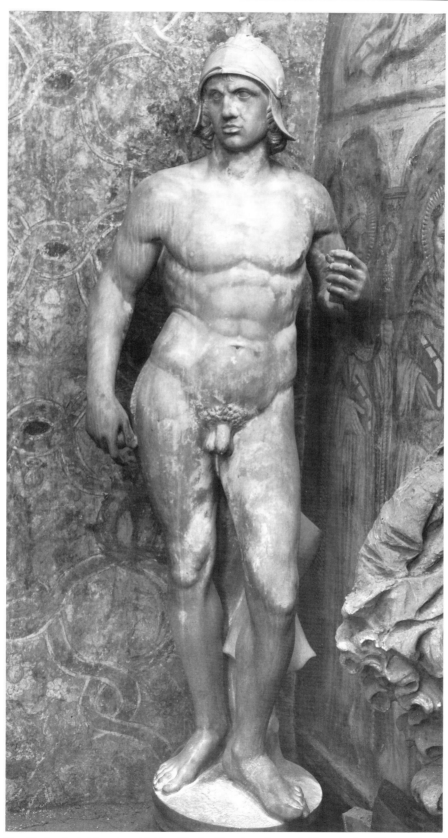

Fig. 30. Baccio da Montelupo (?), *Mars*, Tomb of Benedetto Pesaro, S. Maria dei Frari, Venice (Giacomelli, Venice)

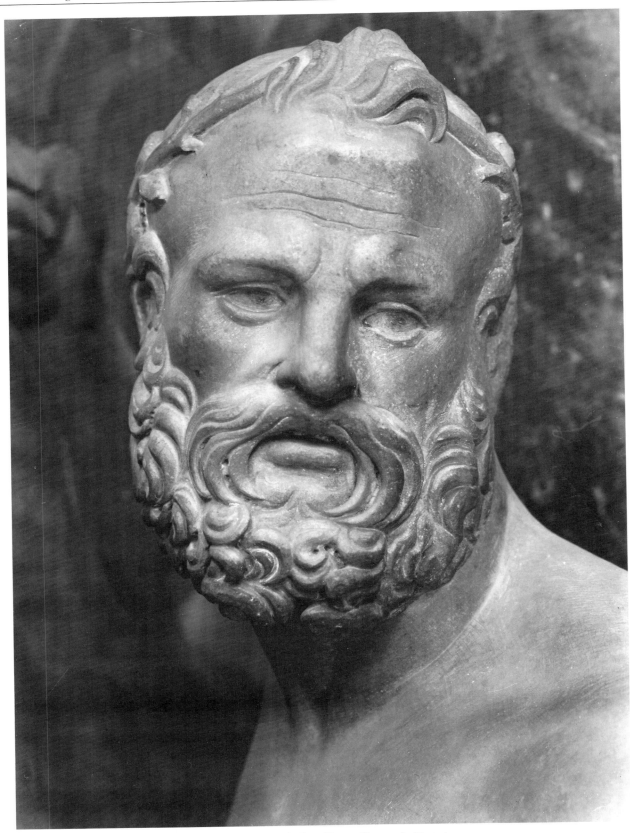

Fig. 31. Detail, *Neptune*, Tomb of Benedetto Pesaro, S. Maria dei Frari, Venice (Giacomelli, Venice)

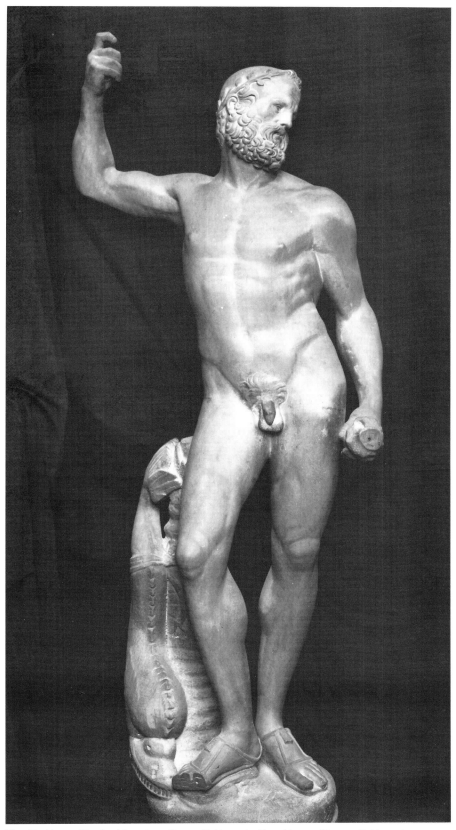

Fig. 32. *Neptune*, Tomb of Benedetto Pesaro, S. Maria dei Frari, Venice (Giacomelli Venice)

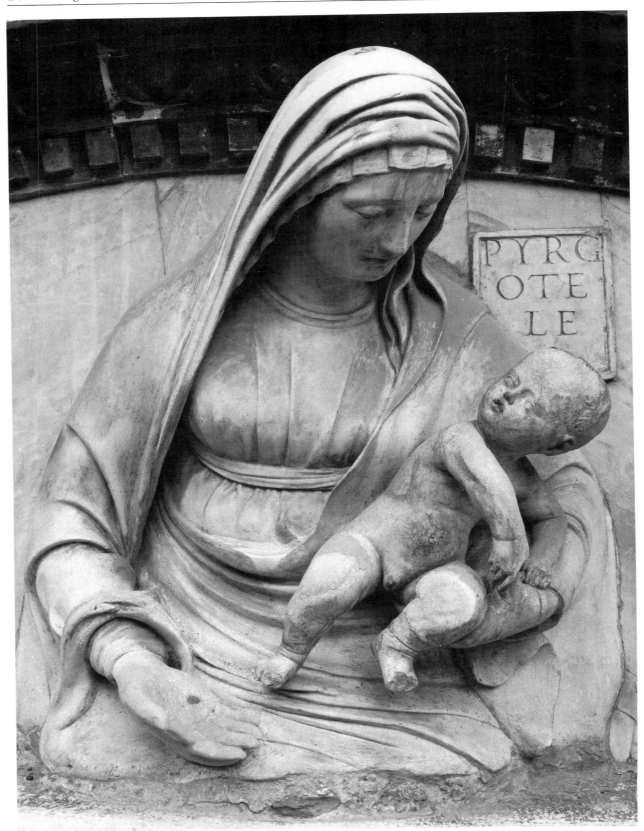

Fig. 33. Pyrgoteles, *Madonna and Child*, main portal, S. Maria dei Miracoli, Venice (Giacomelli, Venice)

Fig. 34. *Madonna and Child*, Tomb of Benedetto Pesaro, S. Maria dei Frari, Venice (Giacomelli, Venice)

Fig. 35. Detail, *Madonna and Child*, Tomb of Benedetto Pesaro, S. Maria dei Frari, Venice (Giacomelli, Venice)

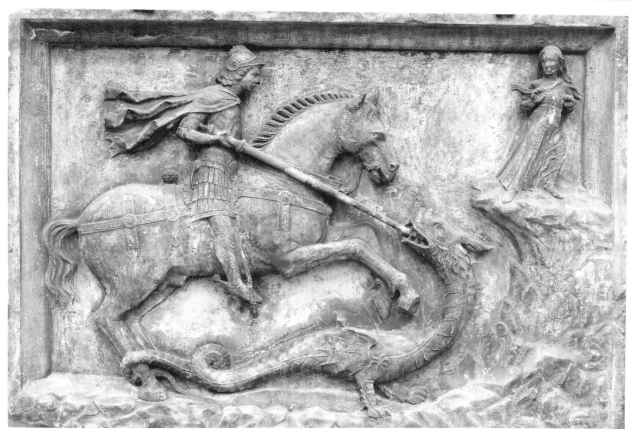

Fig. 36. *St. George and the Dragon*, Victoria & Albert Museum, London (Victoria & Albert Mus., London)

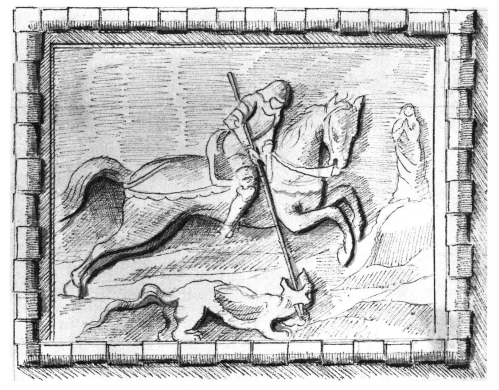

Fig. 37. Antonio Vucetich, drawing of *St. George and the Dragon* at S. Marco 1076, Venice, in MS P. D. 2d, i, c. 2, no. 6, Museo Correr, Venice (Museo Correr, Venice)

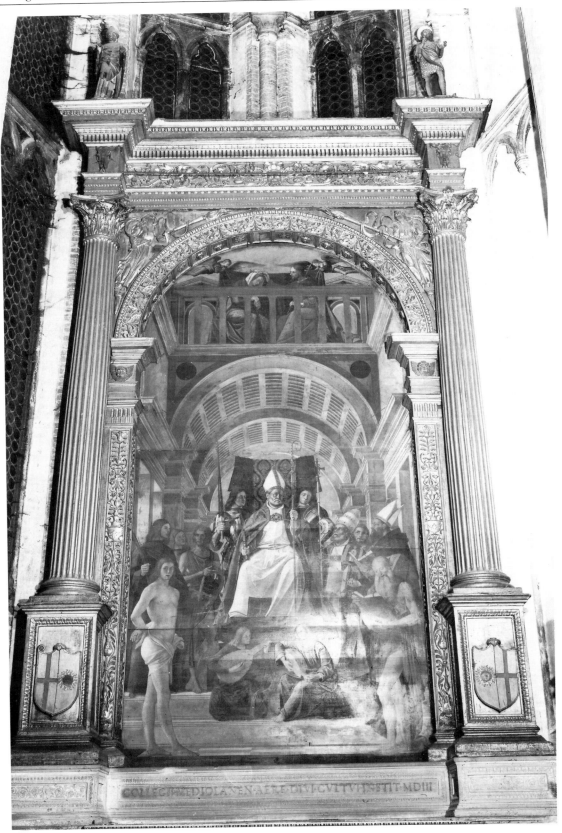

Fig. 38. Frame, Altar of St. Ambrose, Cappella dei Milanesi, S. Maria dei Frari, Venice (Giacomelli, Venice)

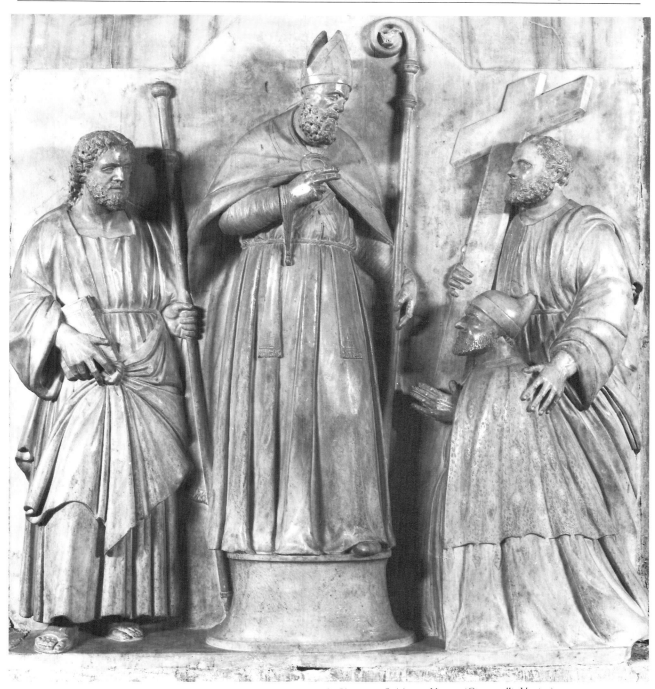

Fig. 39. *Altarpiece of St. Nicholas of Bari with Doge Andrea Gritti*, Cappella di S. Clemente, S. Marco, Venice (Giacomelli, Venice)

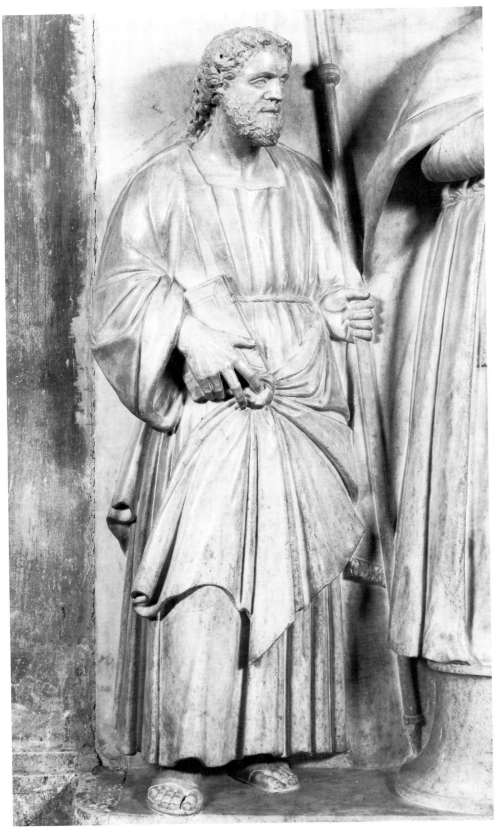

Fig. 40. St. James, *Altarpiece of St. Nicholas of Bari with Doge Andrea Gritti*, Cappella di S. Clemente, S. Marco, Venice (Giacomelli, Venice)

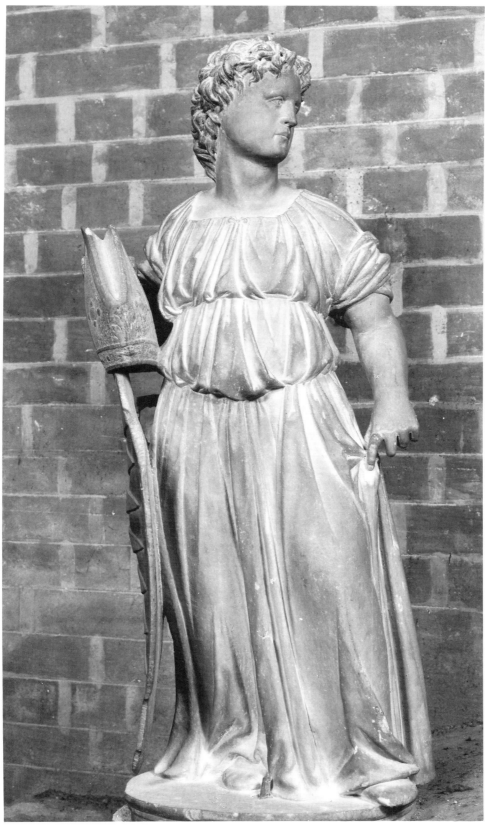

Fig. 41. Left-hand *Reggiscudo*, Pesaro Altar, S. Maria dei Frari, Venice (Giacomelli, Venice)

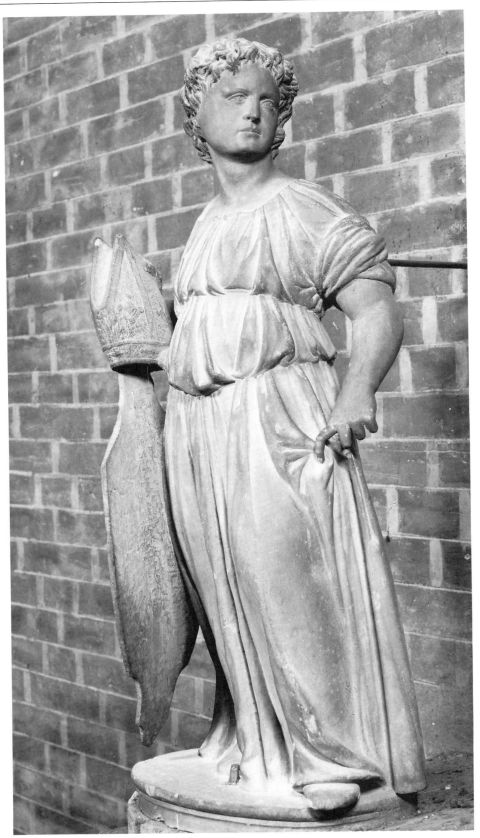

Fig. 42. Left-hand *Reggiscudo*, Pesaro Altar, S. Maria dei Frari, Venice (Giacomelli, Venice)

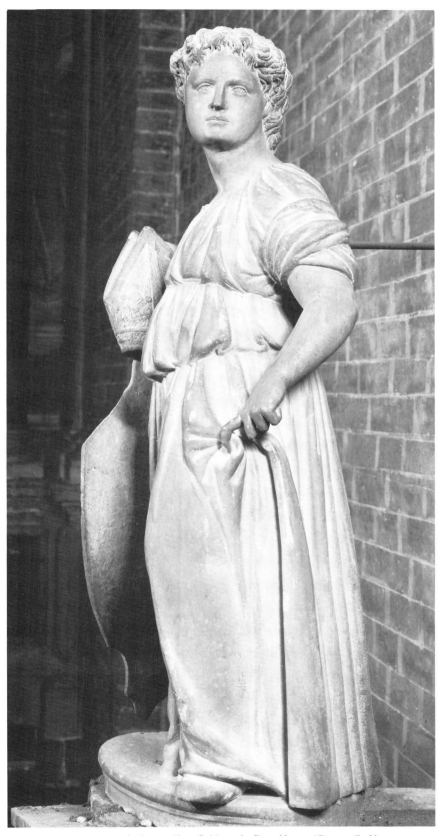

Fig. 43. Left-hand *Reggiscudo*, Pesaro Altar, S. Maria dei Frari, Venice (Giacomelli, Venice)

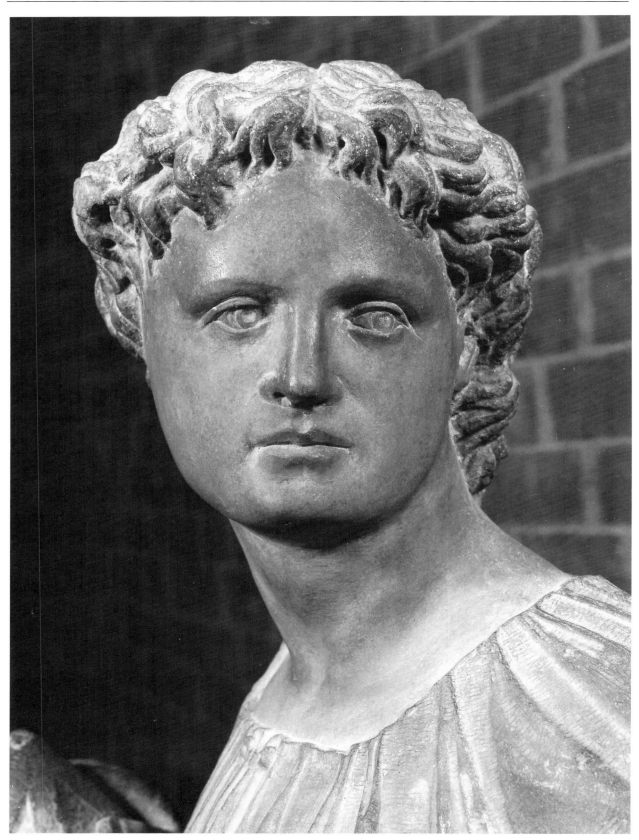

Fig. 44. Detail, left-hand *Reggiscudo*, Pesaro Altar, S. Maria dei Frari, Venice (Giacomelli, Venice)

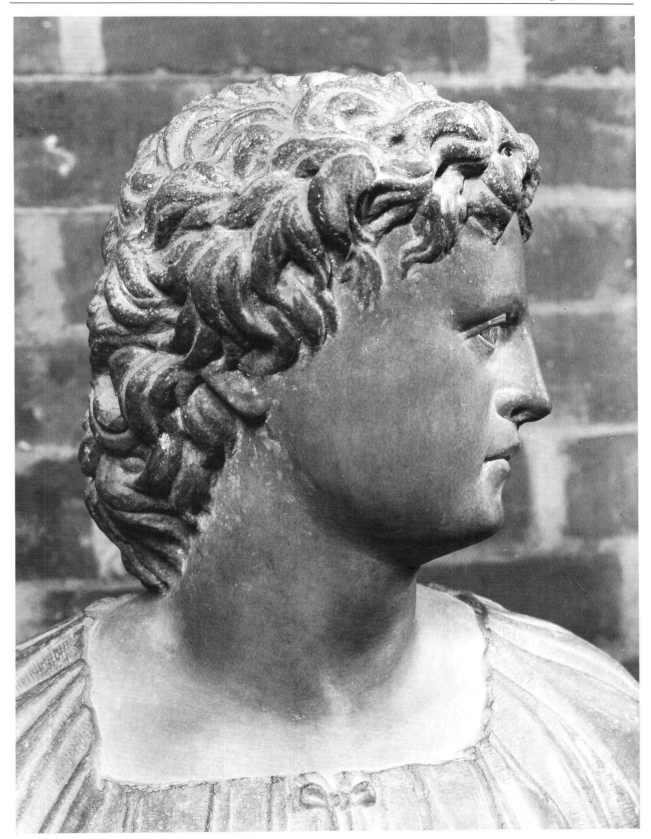

Fig. 45. Detail, left-hand *Reggiscudo*, Pesaro Altar, S. Maria dei Frari, Venice (Giacomelli, Venice)

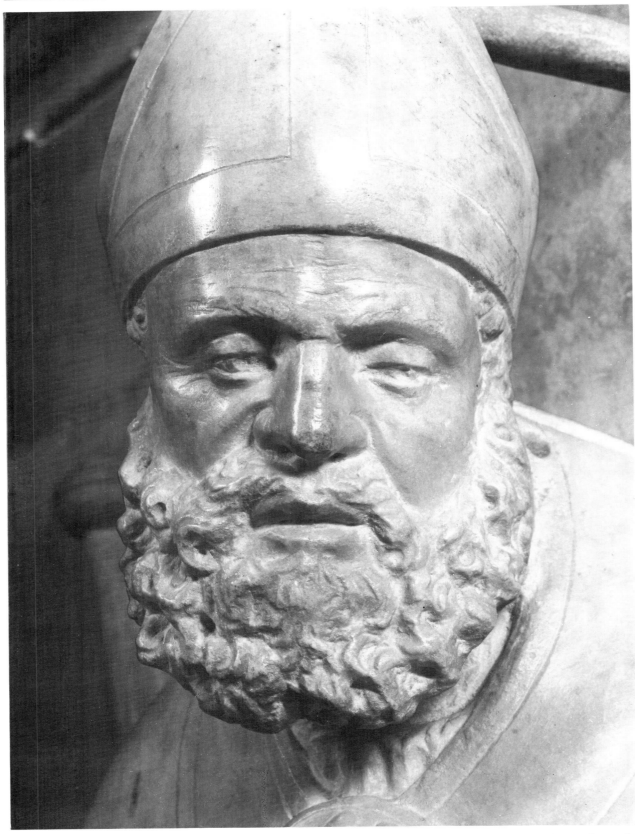

Fig. 46. Detail, St. Nicholas of Bari, *Altarpiece of St. Nicholas of Bari with Doge Andrea Gritti*, Cappella di S. Clemente, S. Marco, Venice (Giacomelli, Venice)

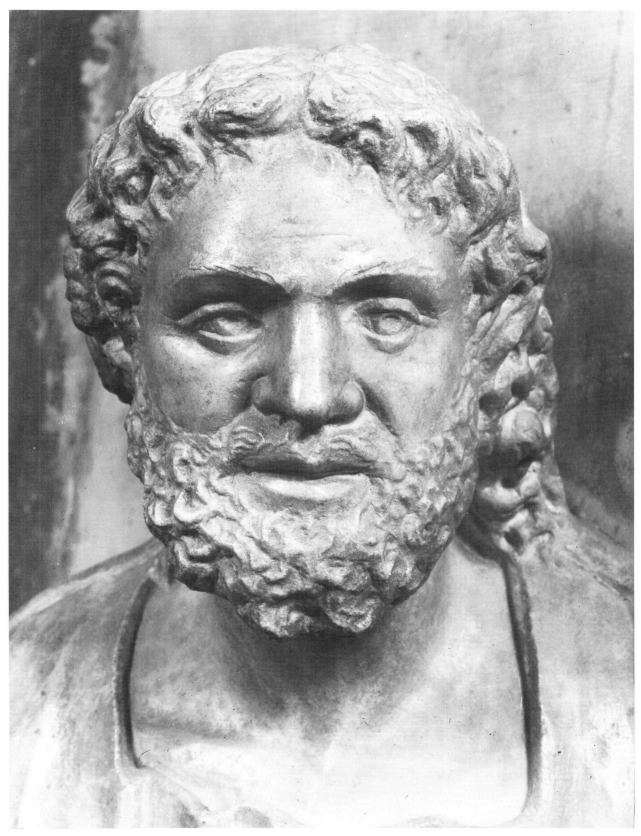

Fig. 47. Detail, St. James, *Altarpiece of St. Nicholas of Bari with Doge Andrea Gritti*, Cappella di S. Clemente, S. Marco, Venice (Giacomelli, Venice)

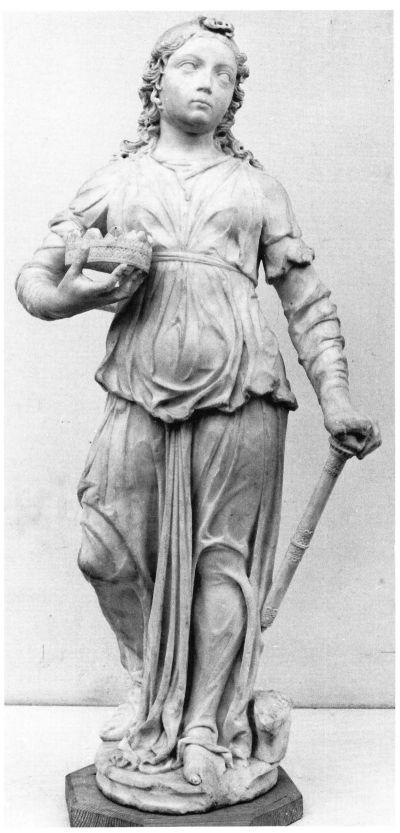

Fig. 48. Antonio Rizzo, *Angel Bearing Attributes of Christ*, Galleria Giorgio Franchetti alla Ca'
d'Oro, Venice (Sopr. ai Beni Artistici e Storici di Venezia, Venice)

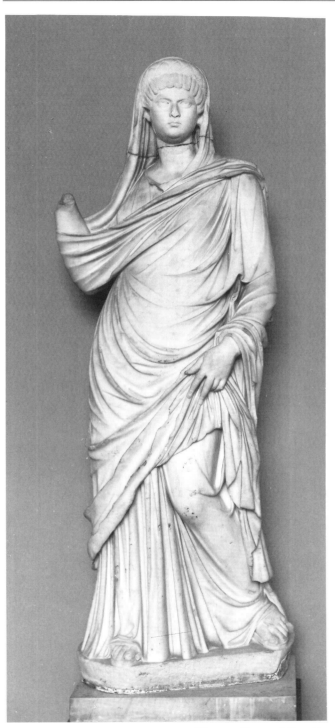

Fig. 49. Roman, 2nd century A.D., *Roman Woman as Priestess of Ceres*, Ny Carlsberg Glyptotek, Copenhagen (Ny Carlsberg Glypt., Copenhagen)

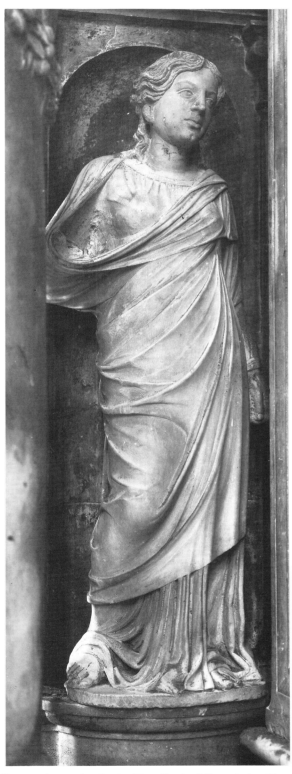

Fig. 50. Antonio Lombardo, *Virtue*, Tomb of Doge Andrea Vendramin, SS. Giovanni e Paolo, Venice (Böhm, Venice)

Fig. 51. Palma il Vecchio, detail, *Madonna and Child with SS. John the Baptist and Mary Magdalene*, Accademia Carrara, Bergamo (Anderson, Florence)

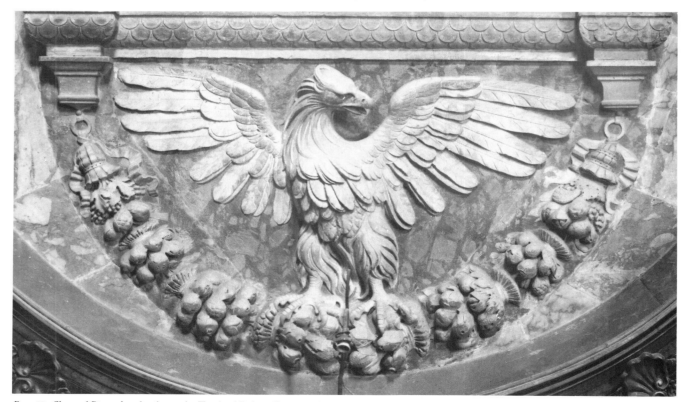

Fig. 52. Shop of Pietro Lombardo, eagle, Tomb of Bishop Giovanni da Udine, Duomo, Treviso (Böhm, Venice)

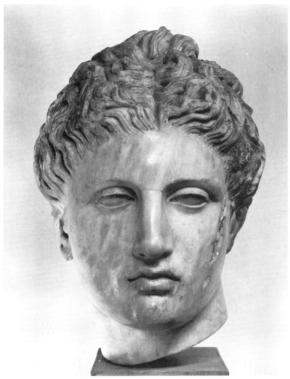

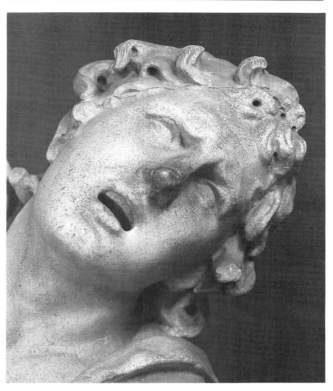

Fig. 53. Roman, 1st century A.D., *Apollo* (of the Anzio type), Museo Archeologico, Venice (Sopr. Archeol. per il Veneto, Padua)

Fig. 54. Agesandros, Polydoros, and Athenodoros of Rhodes, 1st century B.C.–1st century A.D., detail, *Laocoon*, Cortile del Belvedere, Musei Vaticani, Vatican City (Deutsch. Archeol. Inst., Rome)

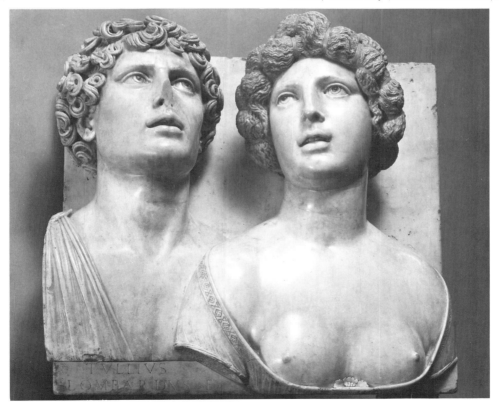

Fig. 55. Tullio Lombardo, Double Portrait, Galleria Giorgio Franchetti alla Ca' d'Oro, Venice (Giacomelli, Venice)

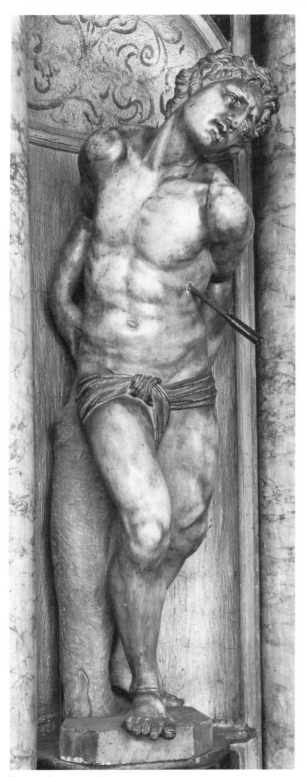

Fig. 56. Bartolomeo Bergamasco, *St. Sebastian*, High Altar, S. Rocco, Venice (Giacomelli, Venice)

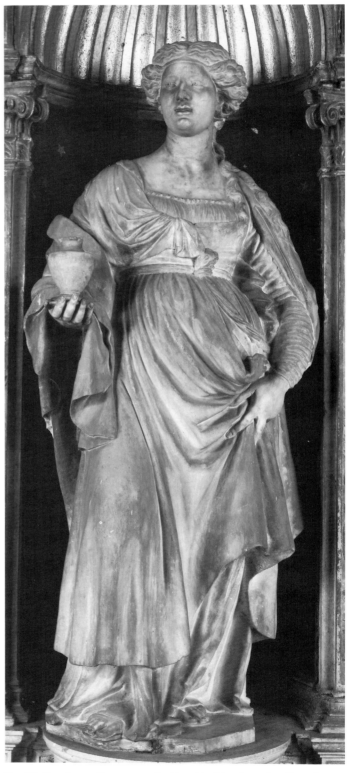

Fig. 57. Bartolomeo Bergamasco, *St. Mary Magdalene* from the Altar of Verde della Scala, SS. Giovanni e Paolo, Venice (Giacomelli, Venice)

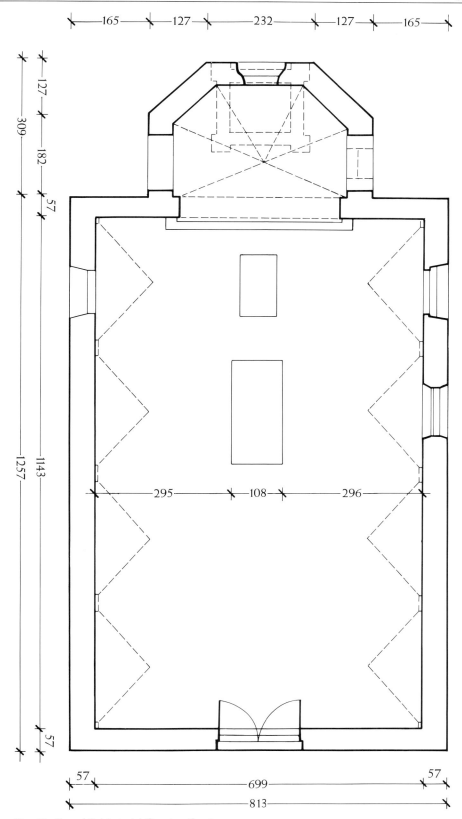

Fig. 58. Plan of S. Maria del Carmine, Creola.

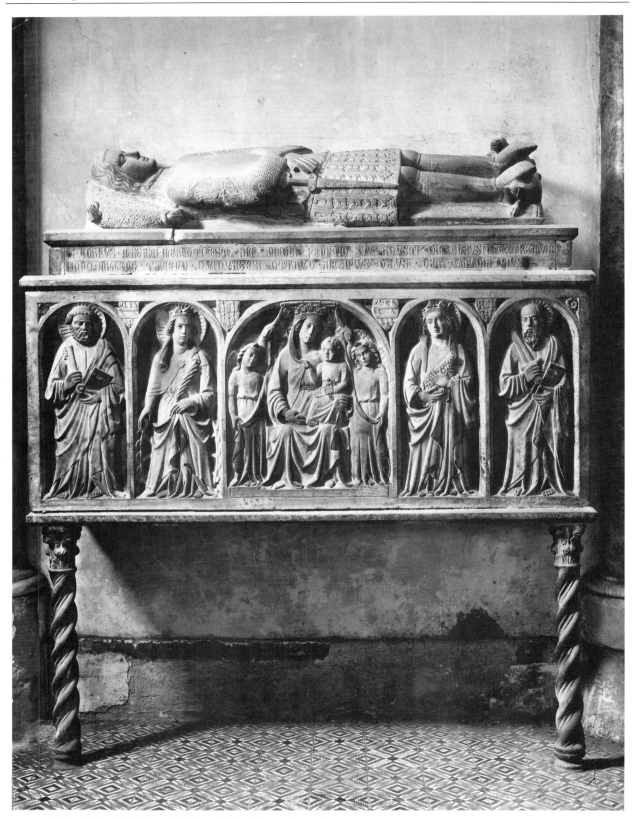

Fig. 59. Tomb of Niccolò Merloto, S. Chiara, Naples (Alinari, Florence)

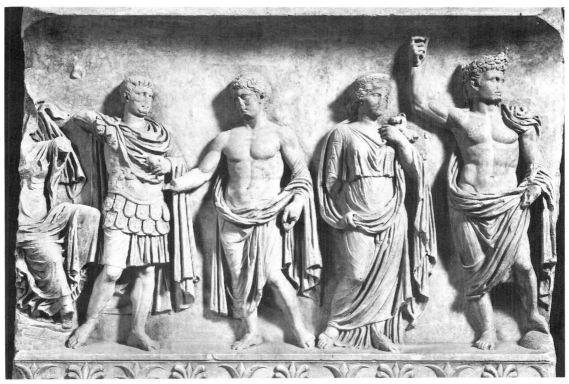

Fig. 60. Roman, 1st century A.D., *Augustus and his Family*, Museo Nazionale, Ravenna (Anderson, Florence)

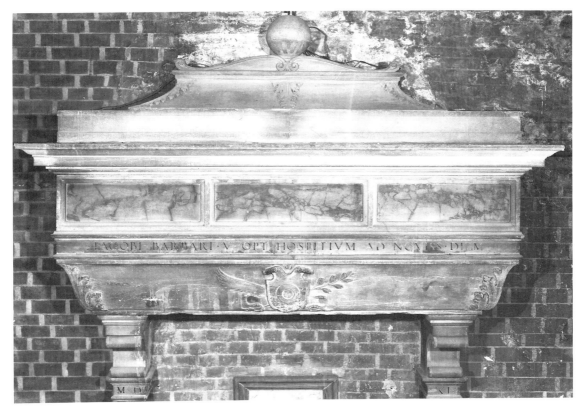

Fig. 61. Tomb of Jacopo Barbaro, S. Maria dei Frari, Venice (Giacomelli, Venice)

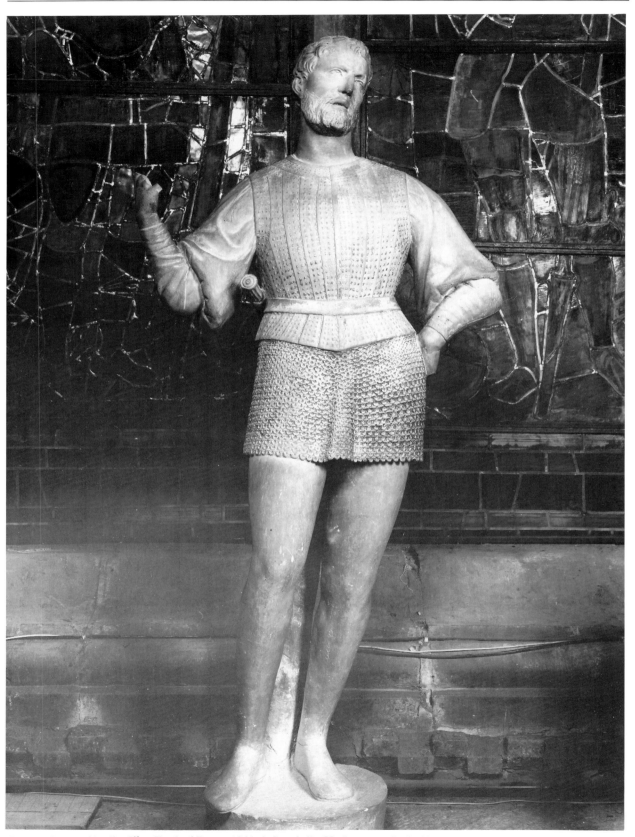

Fig. 62. Antonio Minello, *Effigy*, Tomb of Dionigi Naldi da Brisighella, SS. Giovanni e Paolo, Venice (Giacomelli, Venice)

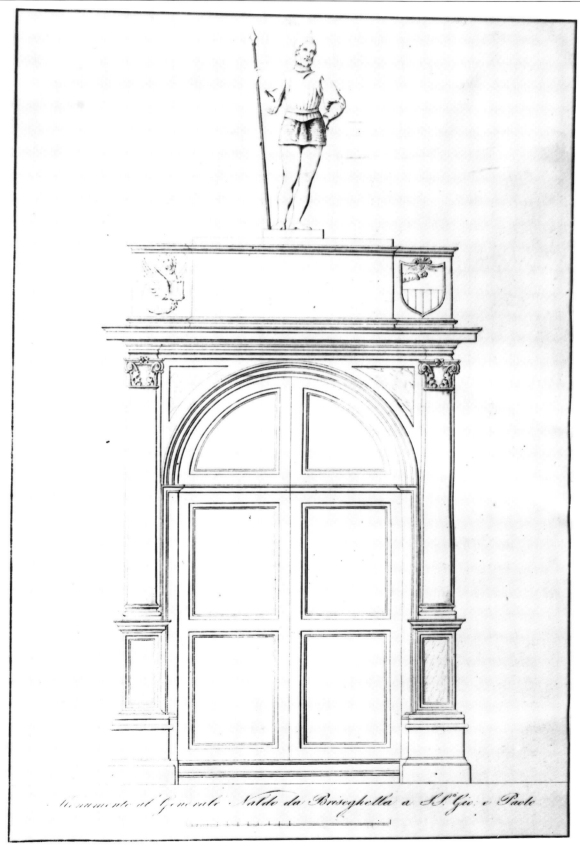

Fig. 63. Engraving of the Tomb of Dionigi Naldi da Brisighella in SS. Giovanni e Paolo, Venice, in Diedo/Zanotto, [1839], pl. 67a (Bibl. Marciana, Venice)

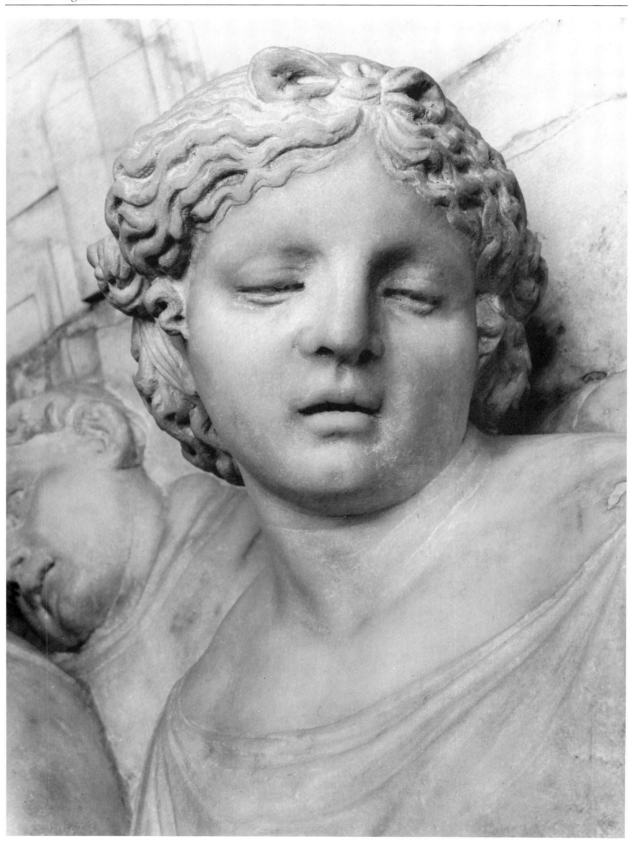

Fig. 64. Antonio Minello, detail, *Investiture of St. Anthony*, Cappella del Santo, S. Antonio, Padua (Giacomelli, Venice)

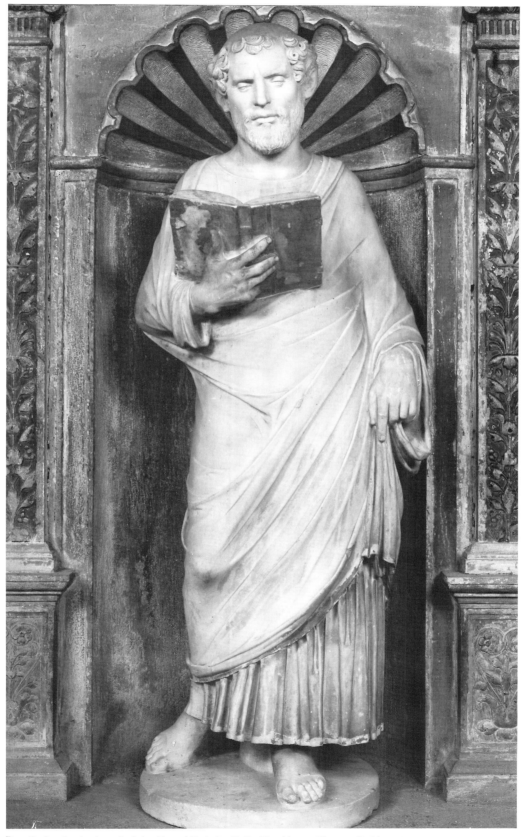

Fig. 65. Lombardo shop, *St. Luke*, Altar of St. Luke, S. Giobbe, Venice (Giacomelli, Venice)

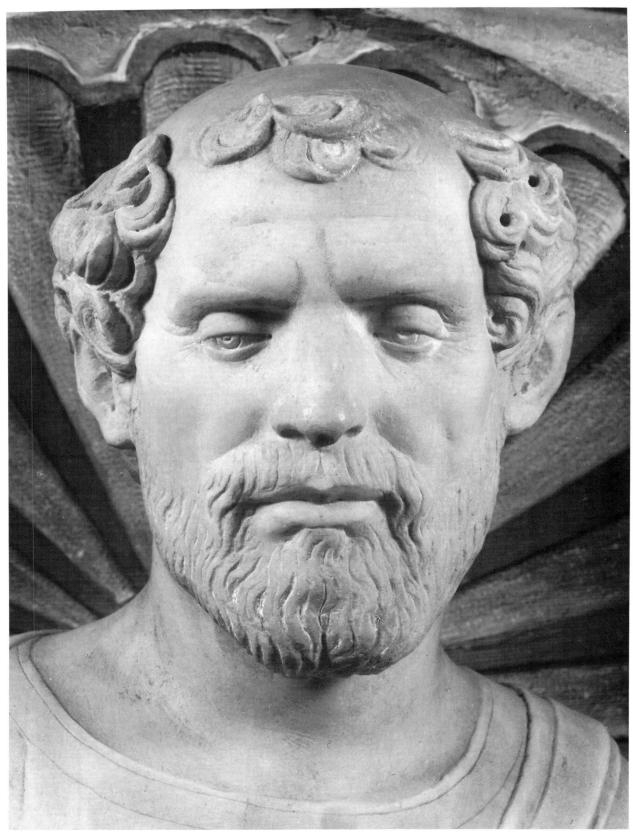

Fig. 66. Lombardo shop, detail, *St. Luke*, Altar of St. Luke, S. Giobbe, Venice (Giacomelli, Venice)

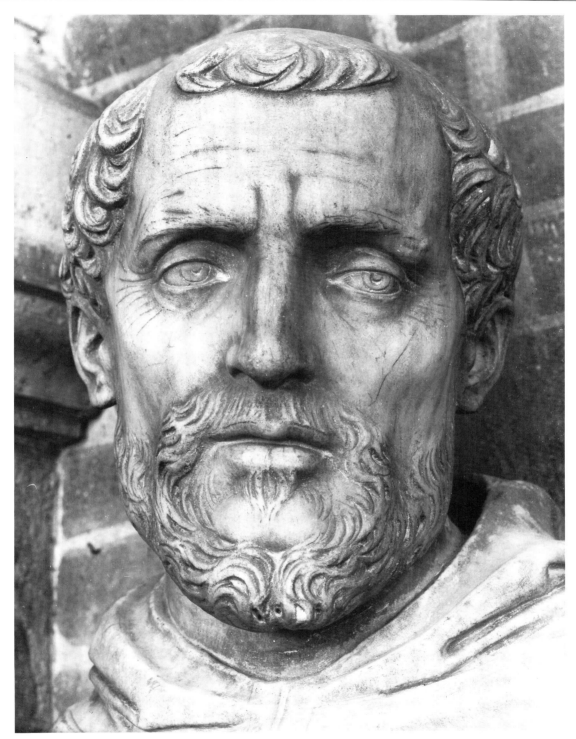

Fig. 67. Antonio Lombardo and assistant, detail, *St. Peter Martyr* from the High Altar of S. Giustina, SS. Giovanni e Paolo, Venice (Giacomelli, Venice)

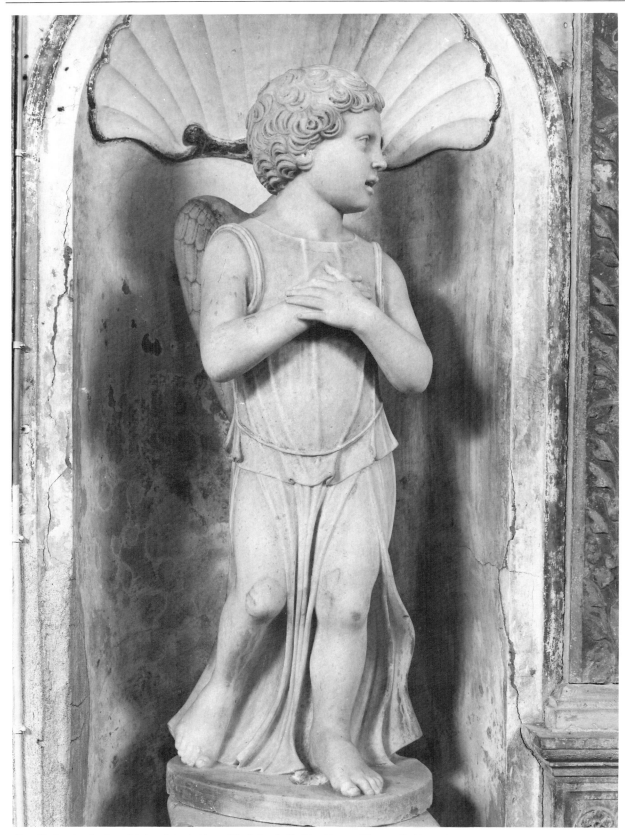

Fig. 68. Lombardo shop, left-hand *Angel*, Altar of St. Luke, S. Giobbe, Venice (Giacomelli, Venice)

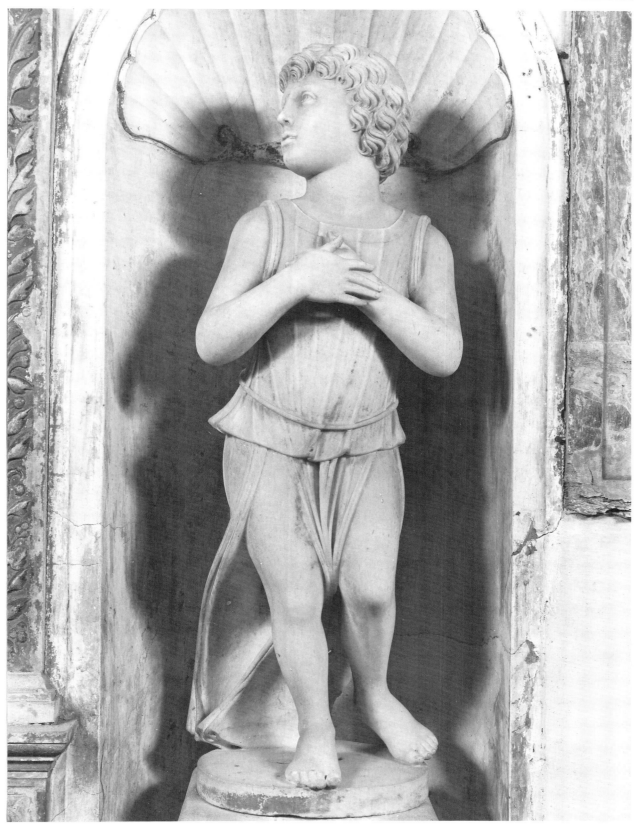

Fig. 69. Lombardo shop, right-hand *Angel*, Altar of St. Luke, S. Giobbe, Venice (Giacomelli, Venice)

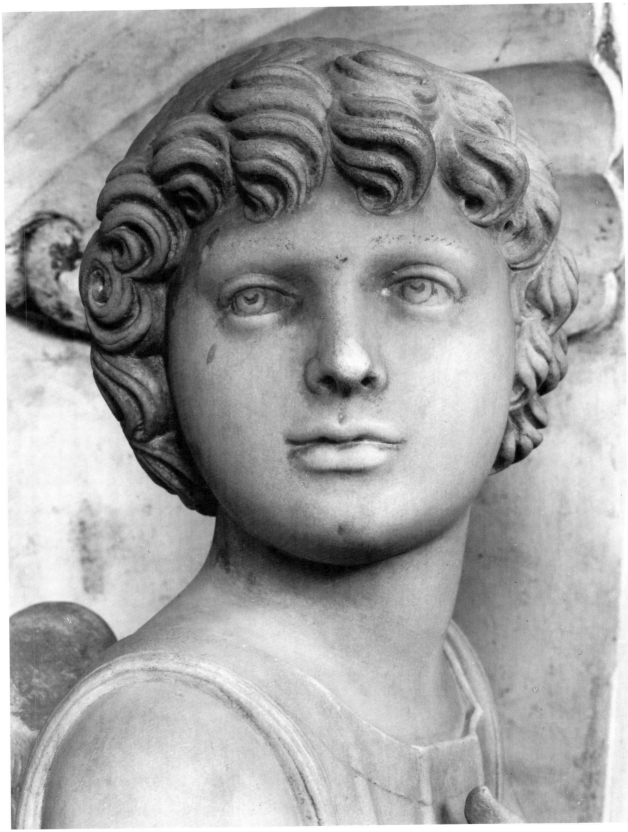

Fig. 70. Lombardo shop, detail, right-hand *Angel*, Altar of St. Luke, S. Giobbe, Venice (Giacomelli, Venice)

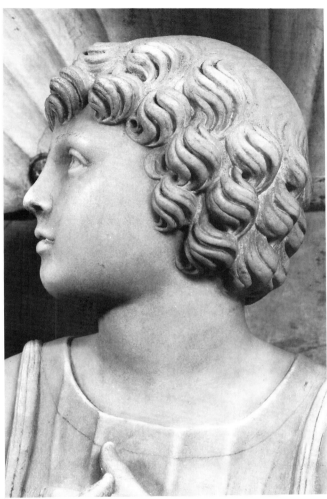

Fig. 71. Lombardo shop, detail, right-hand *Angel*, Altar of St. Luke, S. Giobbe, Venice (Giacomelli, Venice)

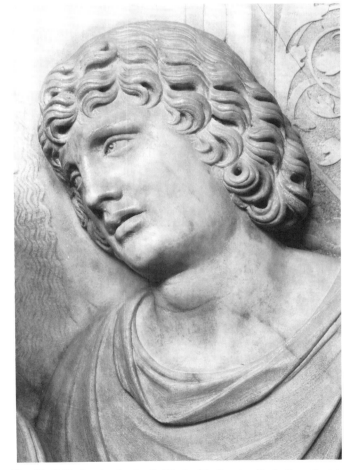

Fig. 72. Tullio Lombardo, detail, *Miracle of the Repentant Youth*, Cappella del Santo, S. Antonio, Padua (Giacomelli, Venice)

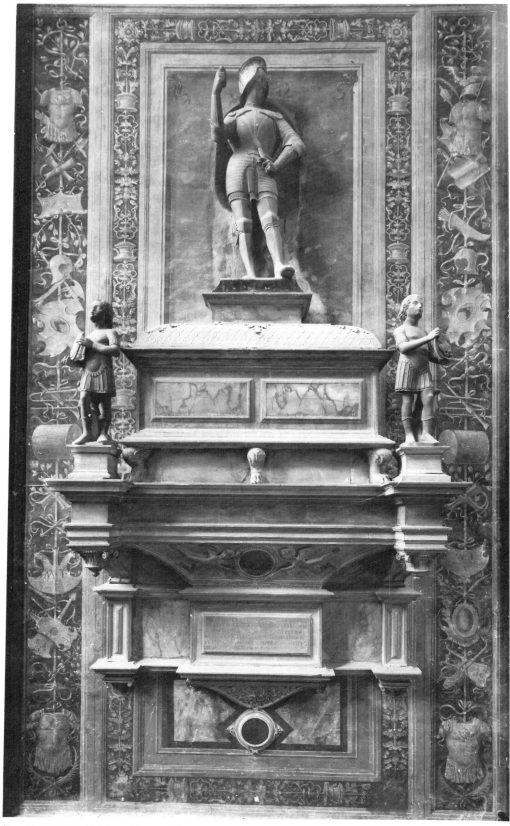

Fig. 73. Tomb of Melchiore Trevisan, S. Maria dei Frari, Venice (Böhm, Venice)

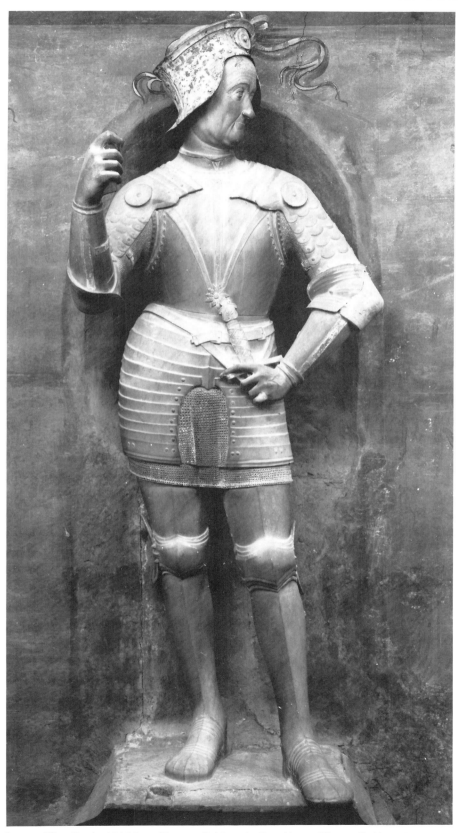

Fig. 74. *Effigy*, Tomb of Melchiore Trevisan, S. Maria dei Frari, Venice (Giacomelli, Venice)

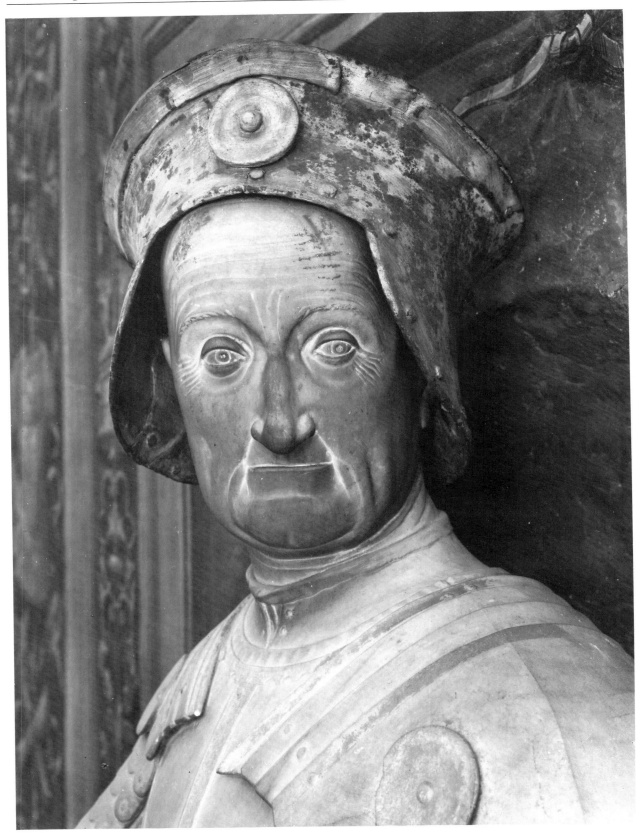

Fig. 75. Detail, *Effigy*, Tomb of Melchiore Trevisan, S. Maria dei Frari, Venice (Giacomelli, Venice)

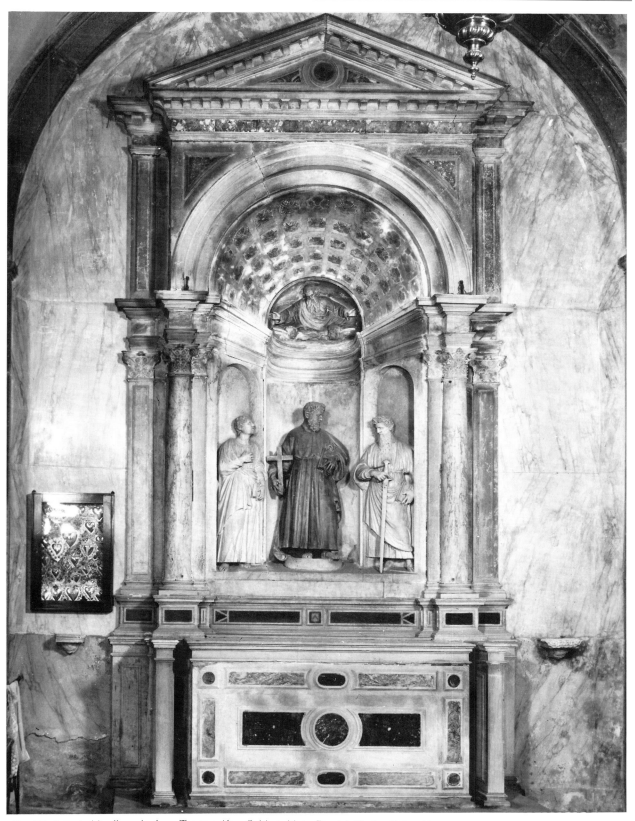

Fig. 76. Antonio Minello and others, Trevisan Altar, S. Maria Mater Domini, Venice (Böhm, Venice)

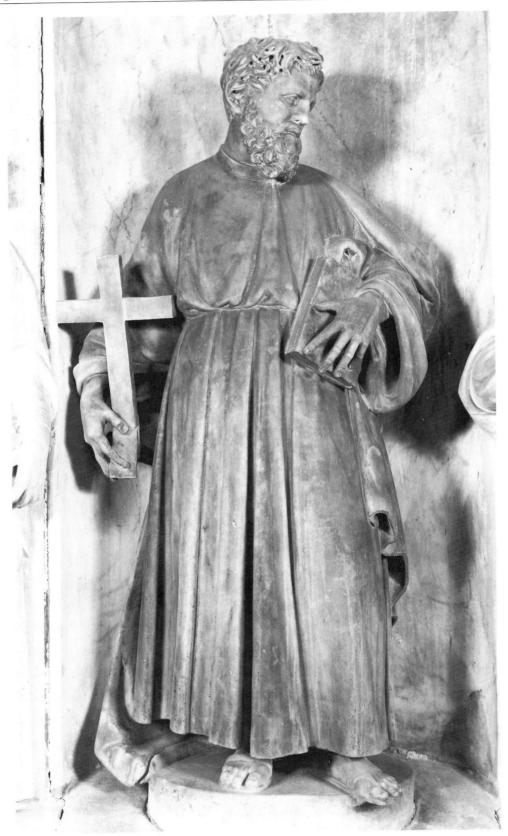

Fig. 77. *St. Andrew*, Trevisan Altar, S. Maria Mater Domini, Venice (Giacomelli, Venice)

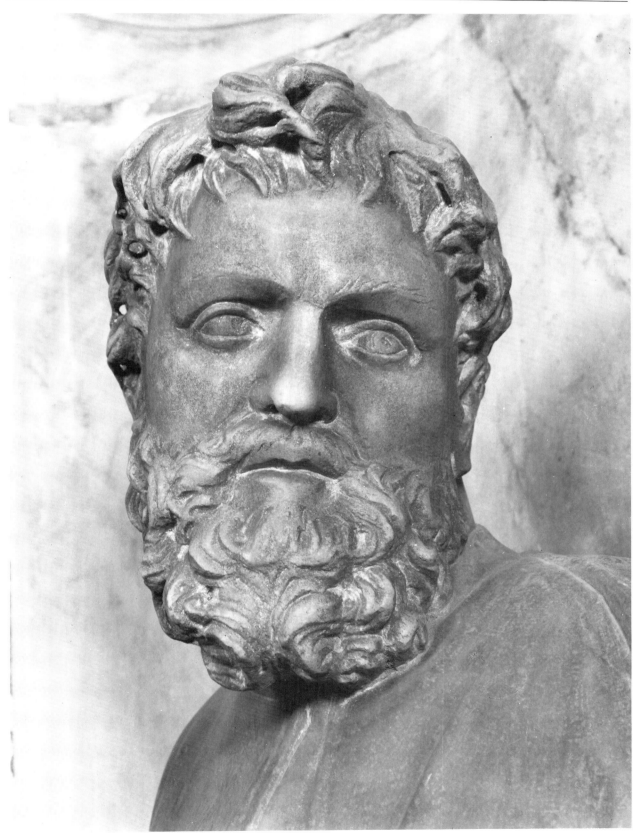

Fig. 78. Detail, *St. Andrew*, Trevisan Altar, S. Maria Mater Domini, Venice (Giacomelli, Venice)

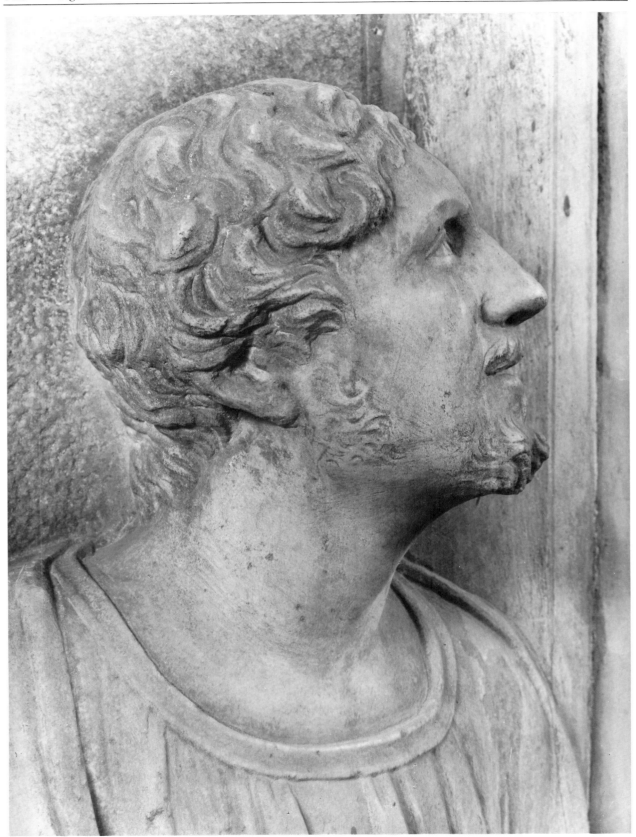

Fig. 79. Antonio Minello, detail, *St. Peter*, Trevisan Altar, S. Maria Mater Domini, Venice (Giacomelli, Venice)

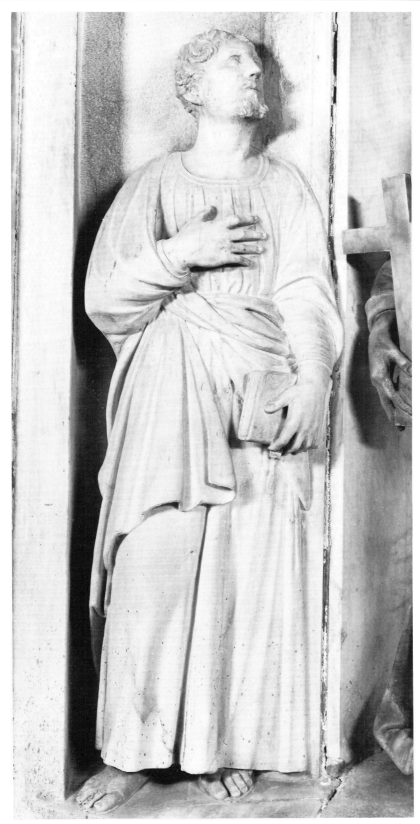

Fig. 80. Antonio Minello, *St. Peter*, Trevisan Altar, S. Maria Mater Domini, Venice (Giacomelli, Venice)

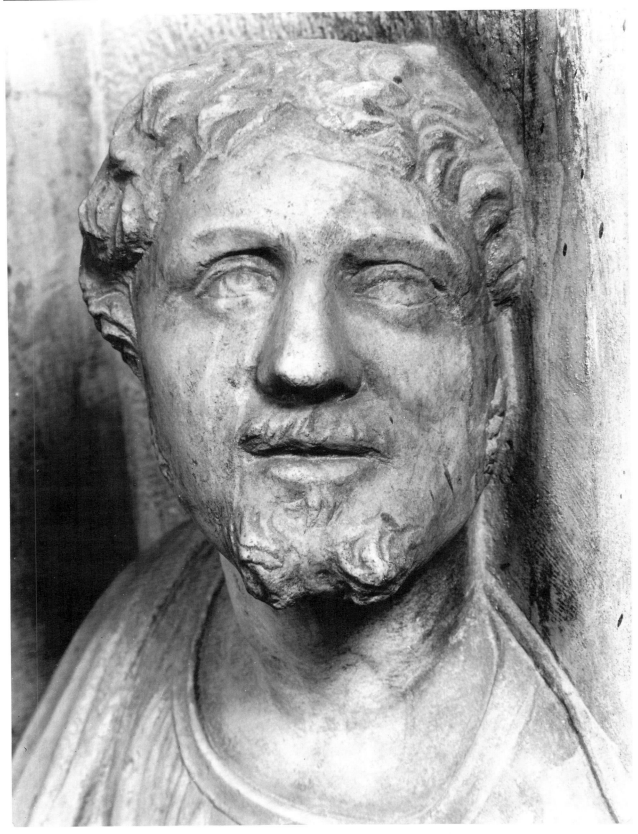

Fig. 81. Antonio Minello, detail, *St. Peter*, Trevisan Altar, S. Maria Mater Domini, Venice (Giacomelli, Venice)

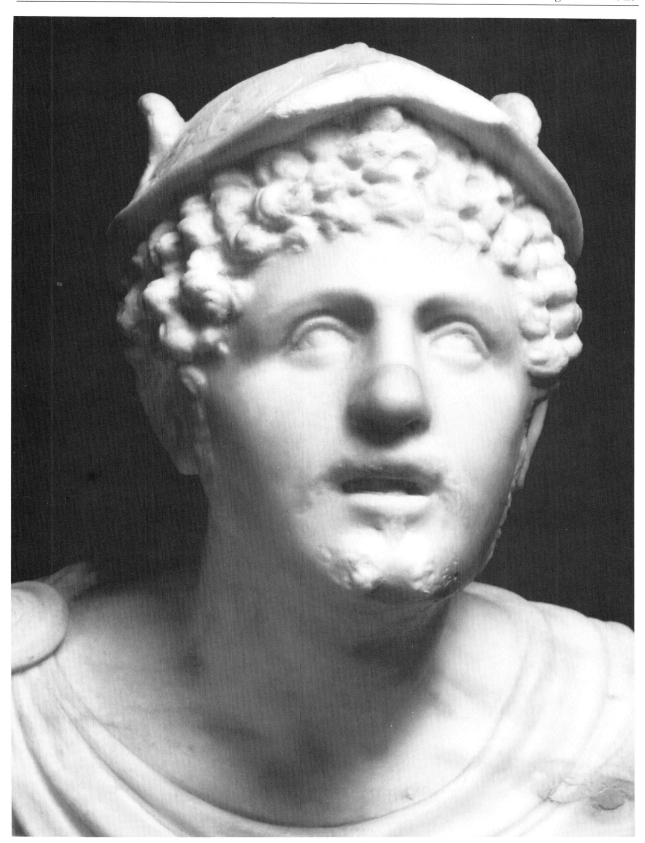

Fig. 82. Antonio Minello, detail, *Mercury*, Victoria & Albert Museum, London (Victoria & Albert Mus., London)

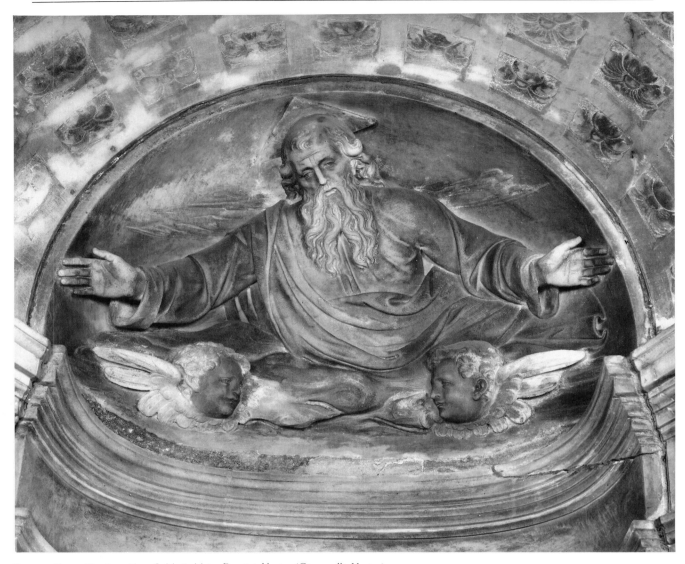

Fig. 83. *Trinity*, Trevisan Altar, S. Maria Mater Domini, Venice (Giacomelli, Venice)

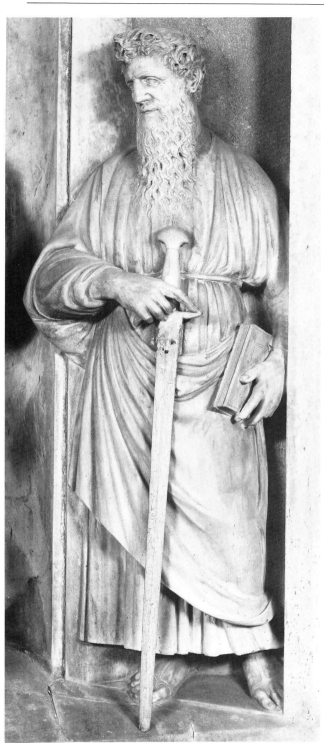

Fig. 84. Antonio Minello and collaborator, *St. Paul*, Trevisan Altar, S. Maria Mater Domini, Venice (Giacomelli, Venice)

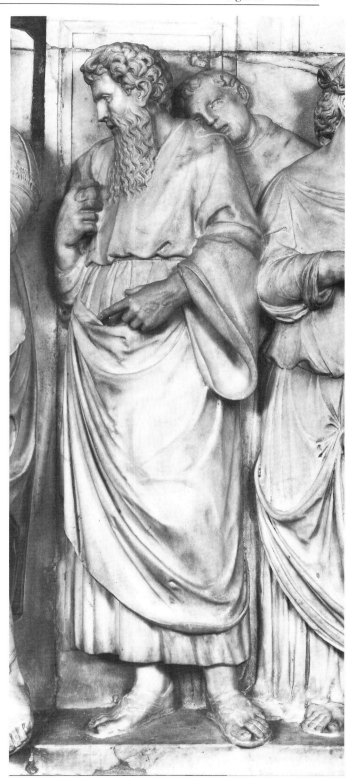

Fig. 85. Antonio Minello, detail, *Investiture of St. Anthony*, Cappella del Santo, S. Antonio, Padua (Giacomelli, Venice)

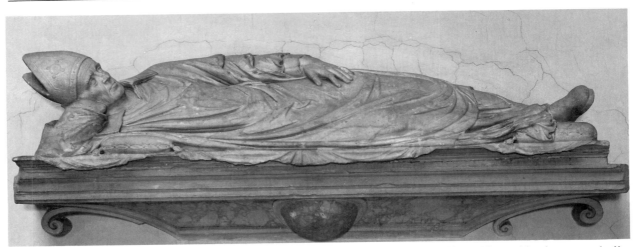

Fig. 86. *Effigy*, Tomb of Bishop Lorenzo Gabriel, Oesterreichisches Museum für angewandte Kunst, Vienna (Oester. Mus. für angewandte Kst., Vienna)

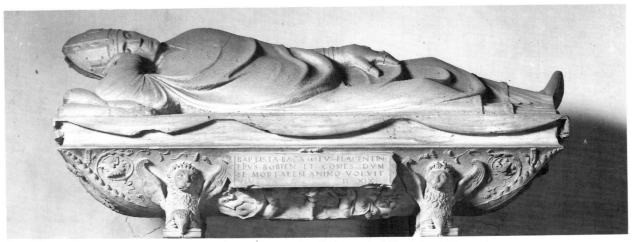

Fig. 87. Andrea Fusina, *Effigy*, Tomb of Bishop Battista Bagarotti, Castello Sforzesco, Milan (Alinari, Florence)

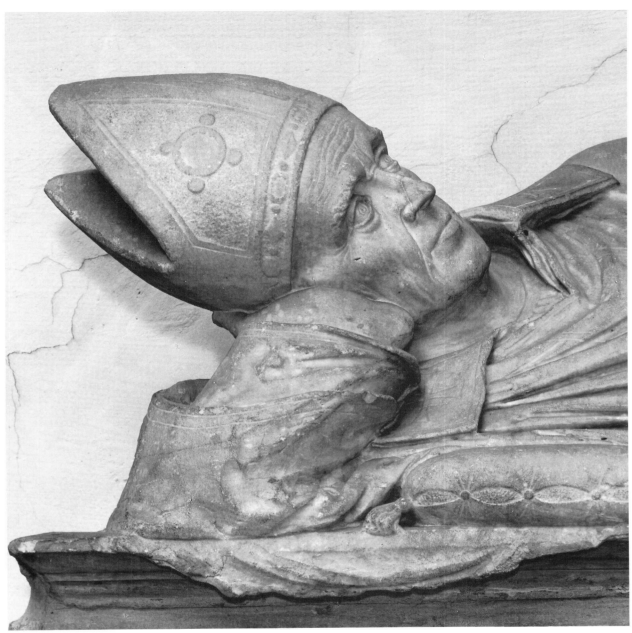

Fig. 88. Detail, *Effigy*, Tomb of Bishop Lorenzo Gabriel, Oesterreichisches Museum für angewandte Kunst, Vienna (Oester. Mus. für angewandte Kst., Vienna)

# PLATES

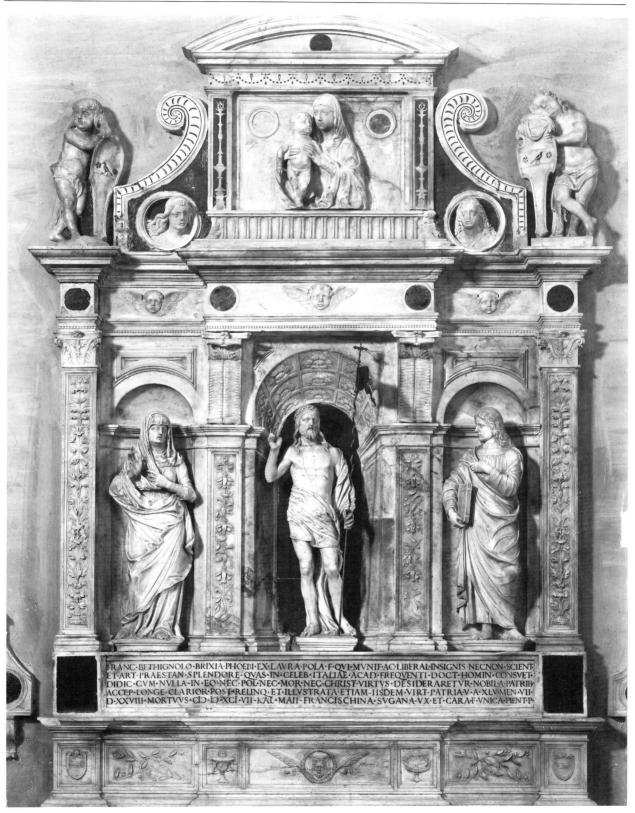

Pl. 1. Bettignoli Bressa Altarpiece, S. Nicolò, Treviso (Alinari, Florence)

Pl. 2. Giambattista Bregno, pilaster, Betti-
gnoli Bressa Altarpiece, S. Nicolò, Treviso
(Giacomelli, Venice)

Pl. 3. Giambattista Bregno, lesene, Bettigno-
li Bressa Altarpiece, S. Nicolò, Treviso
(Böhm, Venice)

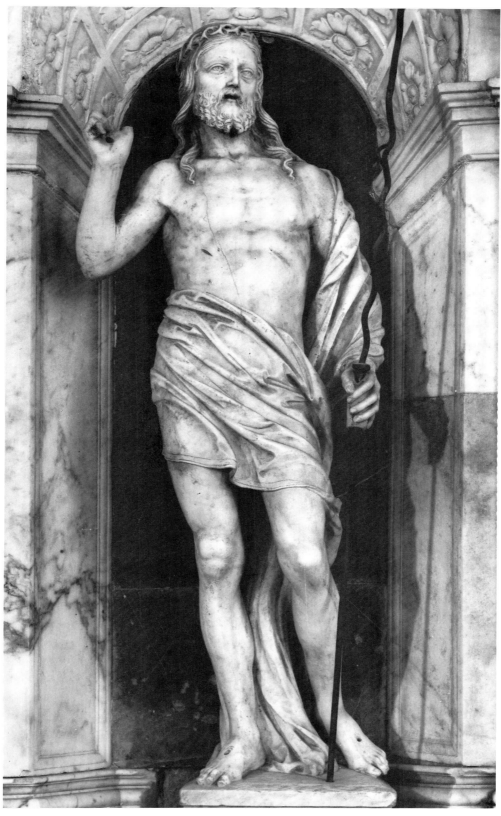

Pl. 4. Giambattista Bregno, *Resurrected Christ*, Bettignoli Bressa Altarpiece, S. Nicolò, Treviso (Fini, Treviso)

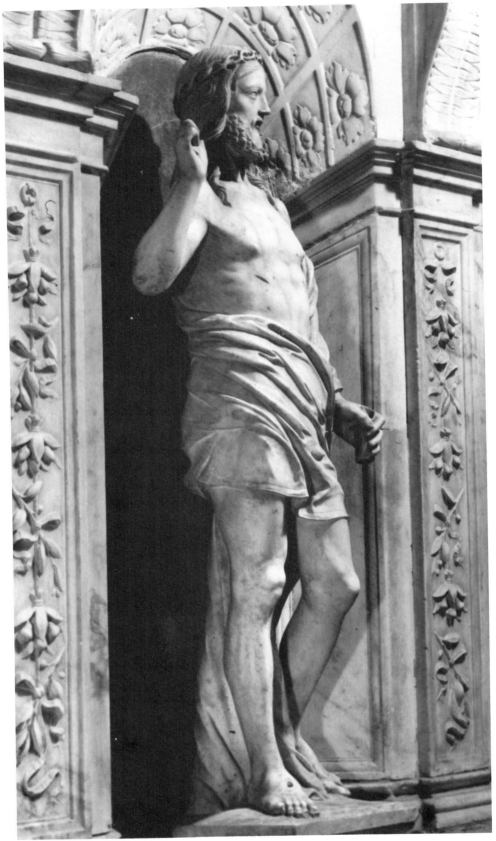

Pl. 5. Giambattista Bregno, *Resurrected Christ*, Bettignoli Bressa Altarpiece, S. Nicolò, Treviso (Fini, Treviso)

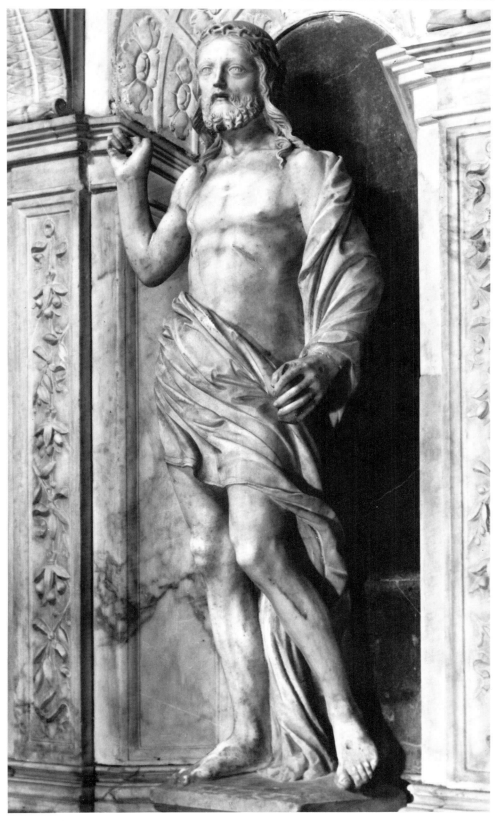

Pl. 6. Giambattista Bregno, *Resurrected Christ*, Bettignoli Bressa Altarpiece, S. Nicolò, Treviso (Fini, Treviso)

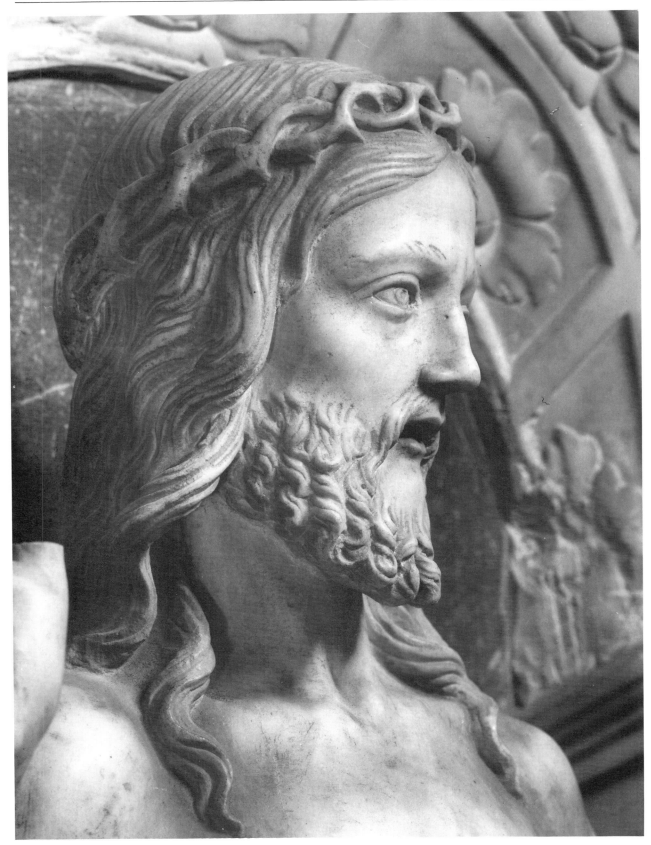

Pl. 7. Giambattista Bregno, detail, *Resurrected Christ*, Bettignoli Bressa Altarpiece, S. Nicolò, Treviso (Fini, Treviso)

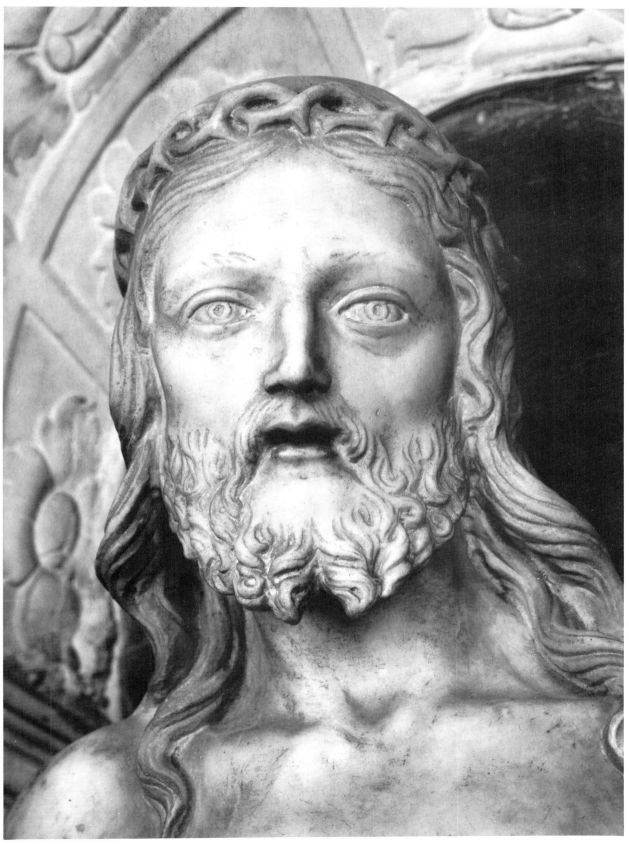

Pl. 8. Giambattista Bregno, detail, *Resurrected Christ*, Bettignoli Bressa Altarpiece, S. Nicolò, Treviso (Fini, Treviso)

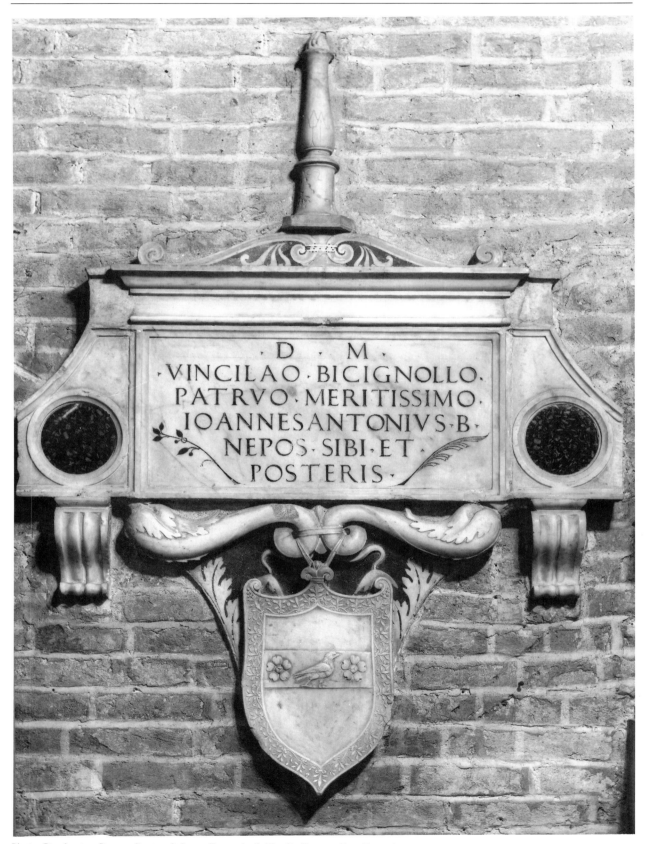

Pl. 9. Giambattista Bregno, Bettignoli Bressa Epigraph, S. Nicolò, Treviso (Fini, Treviso)

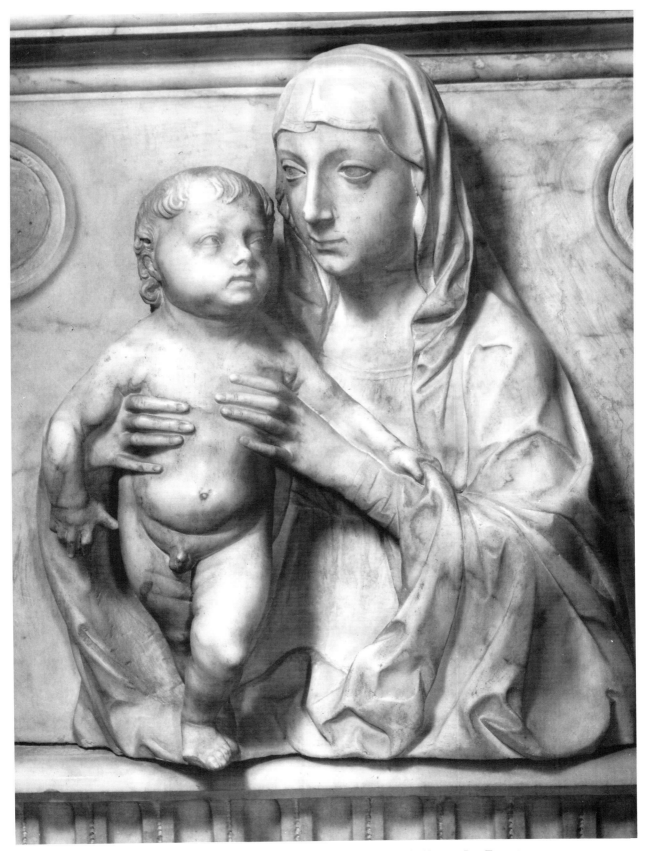

Pl. 10. Giambattista Bregno, detail, *Madonna and Child*, Bettignoli Bressa Altarpiece, S. Nicolò, Treviso (Fini, Treviso)

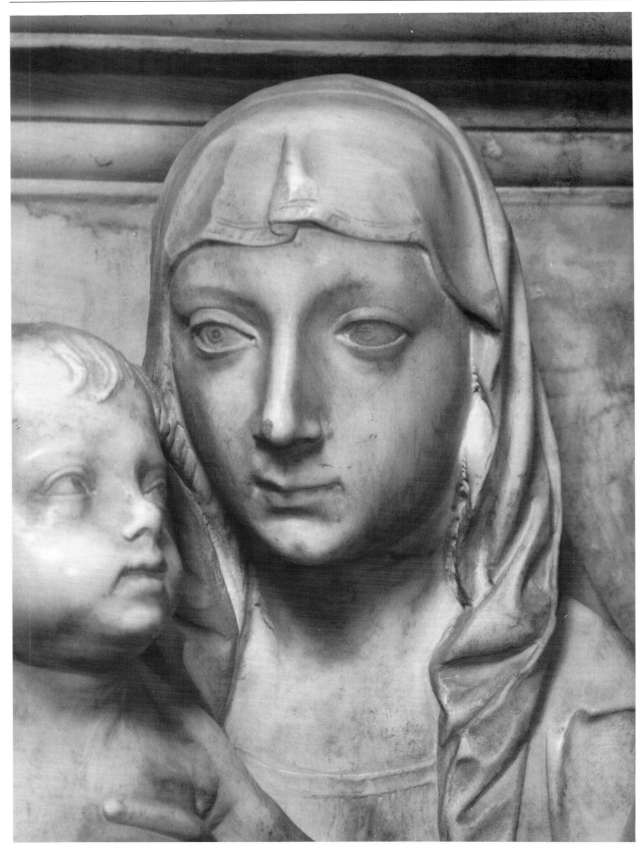

Pl. 11. Giambattista Bregno, detail, *Madonna and Child*, Bettignoli Bressa Altarpiece, S. Nicolò, Treviso (Fini, Treviso)

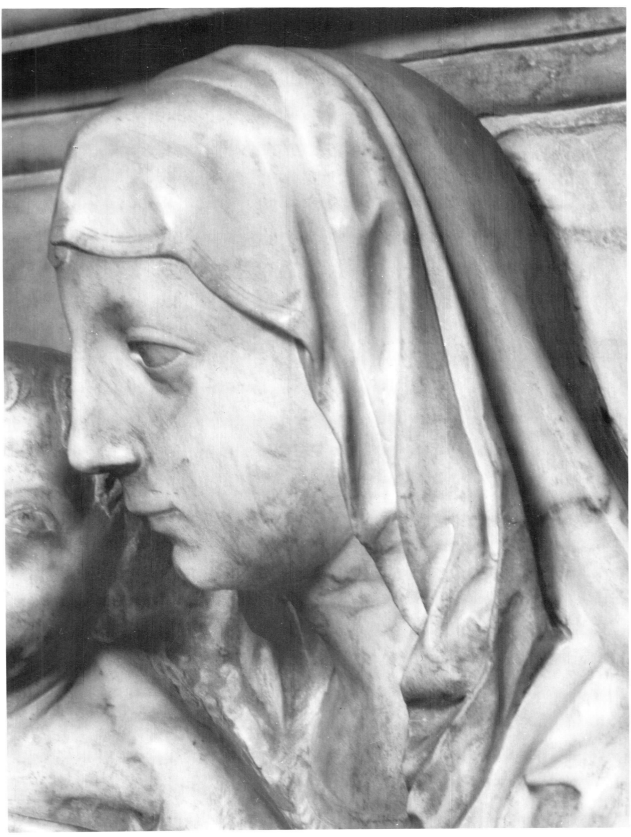

Pl. 12. Giambattista Bregno, detail, *Madonna and Child*, Bettignoli Bressa Altarpiece, S. Nicolò, Treviso (Fini, Treviso)

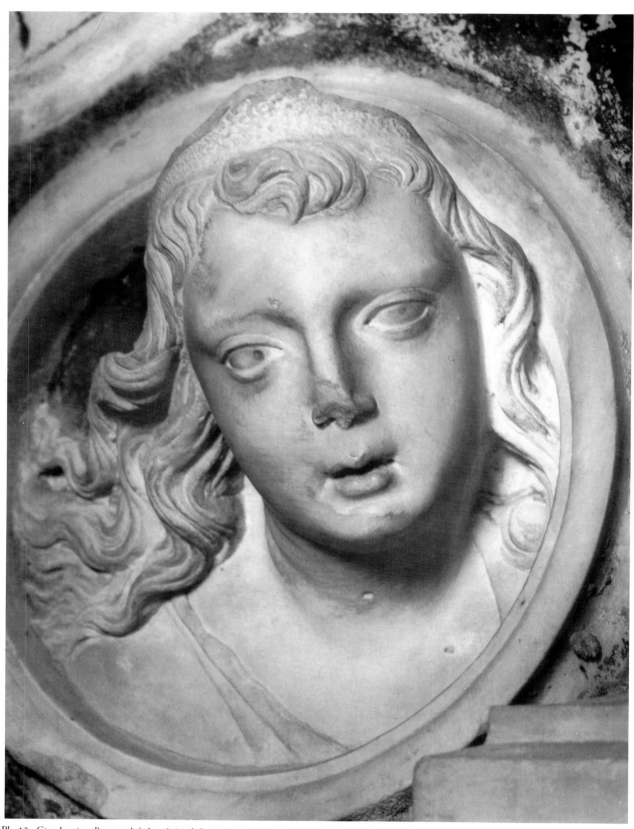

Pl. 13. Giambattista Bregno, left-hand *Angel*, Bettignoli Bressa Altarpiece, S. Nicolò, Treviso (Fini, Treviso)

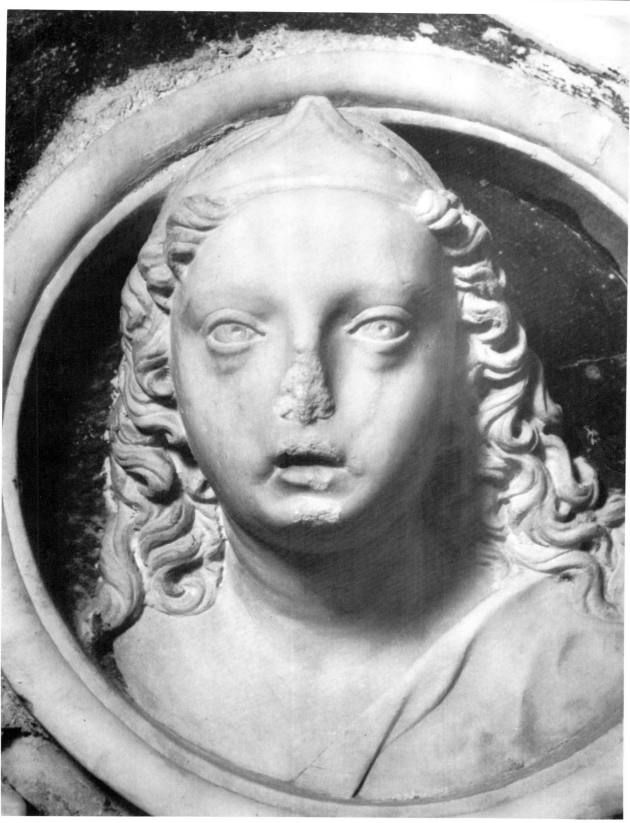

Pl. 14. Giambattista Bregno, right-hand *Angel*, Bettignoli Bressa Altarpiece, S. Nicolò, Treviso (Fini, Treviso)

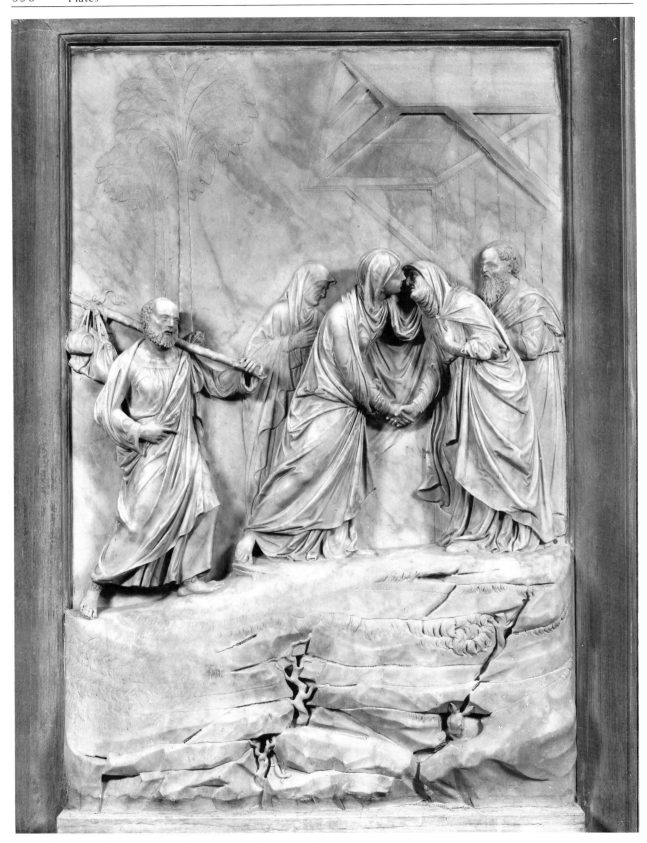

Pl. 15. Giambattista Bregno, *Visitation*, Duomo, Treviso (Giacomelli, Venice)

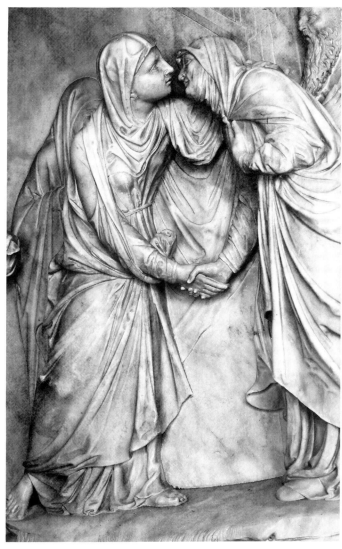

Pl. 16. Giambattista Bregno, detail, *Visitation*, Duomo, Treviso (Giacomelli, Venice)

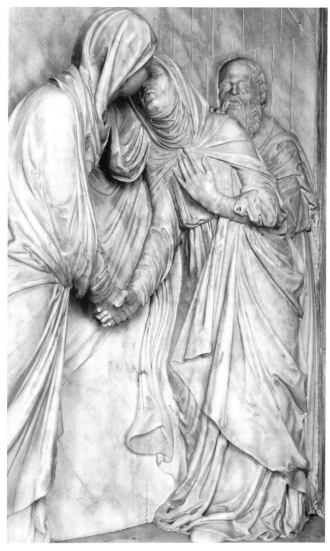

Pl. 17. Giambattista Bregno, detail, *Visitation*, Duomo, Treviso (Giacomelli, Venice)

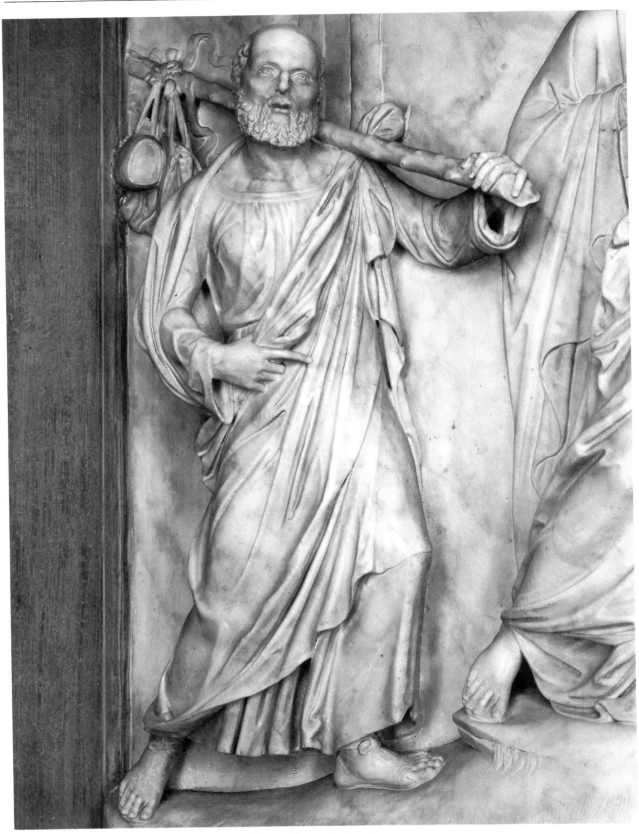

Pl. 18. Giambattista Bregno, detail, *Visitation*, Duomo, Treviso (Giacomelli, Venice)

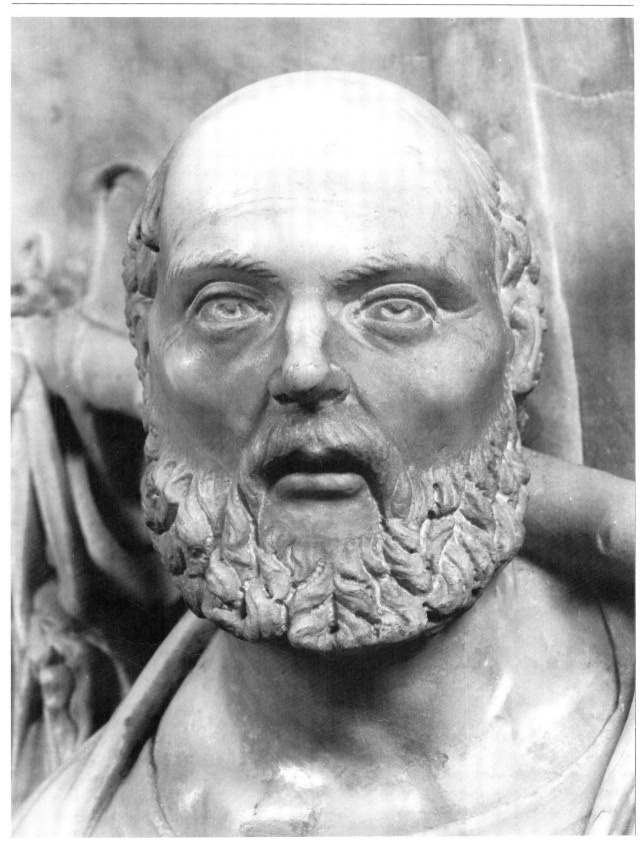

Pl. 19. Giambattista Bregno, detail, *Visitation*, Duomo, Treviso (Giacomelli, Venice)

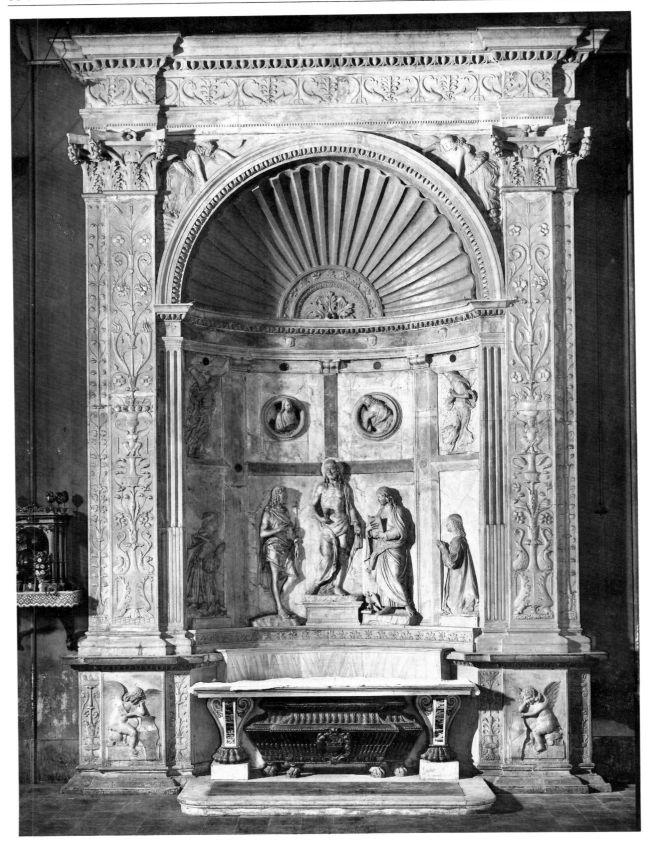

Pl. 20. Altar of the Corpus Domini, Duomo, Cesena (Alinari, Florence)

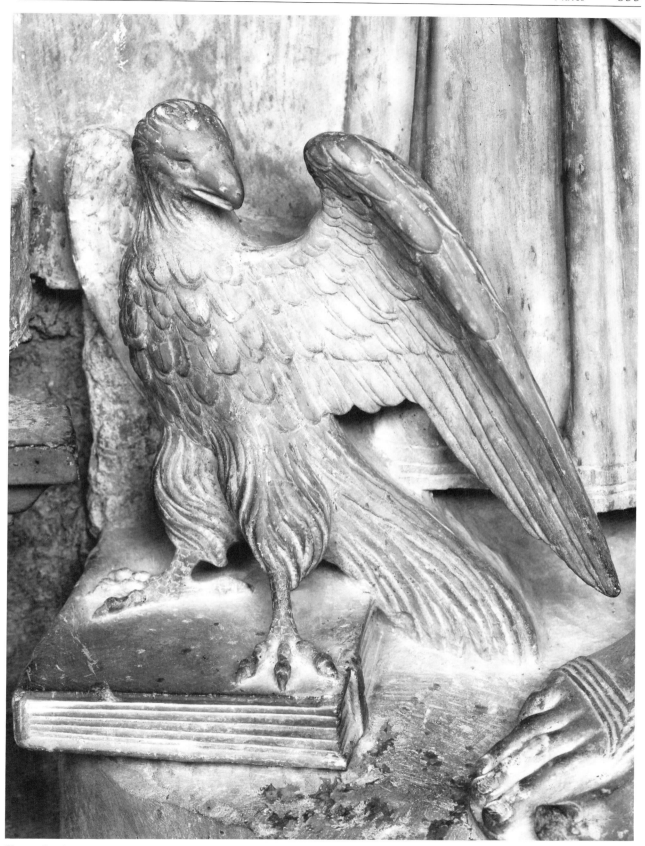

Pl. 21. Giambattista Bregno, detail, *St. John the Evangelist*, Altar of the Corpus Domini, Duomo, Cesena (Zangheri, Cesena)

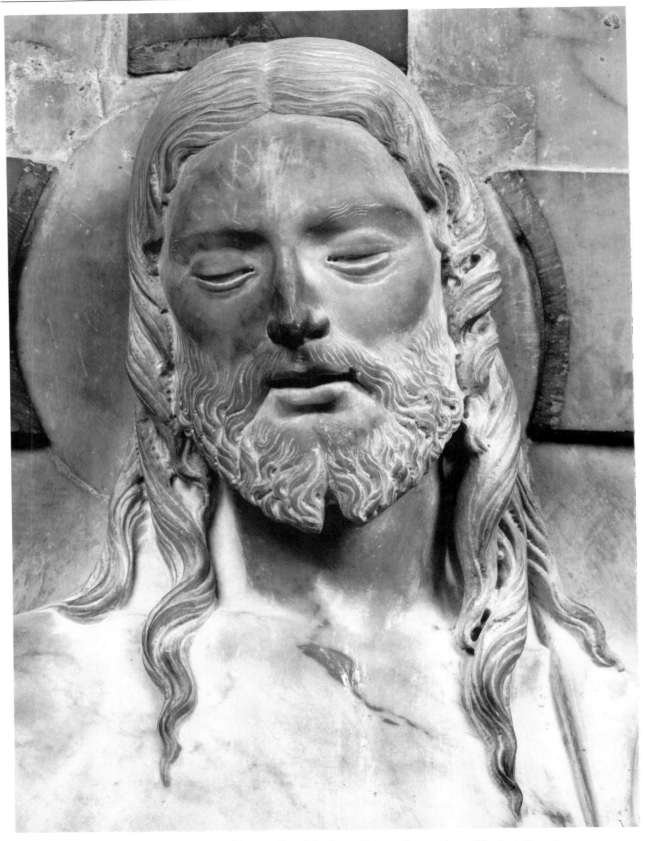

Pl. 22. Giambattista Bregno, detail, *Christ as Man of Sorrows*, Altar of the Corpus Domini, Duomo, Cesena (Zangheri, Cesena)

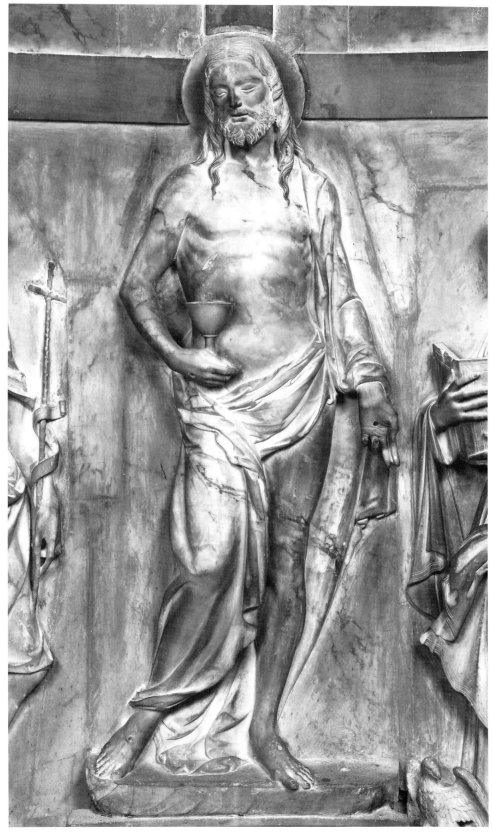

Pl. 23. Giambattista Bregno, *Christ as Man of Sorrows*, Altar of the Corpus Domini, Duomo, Cesena (Zangheri, Cesena)

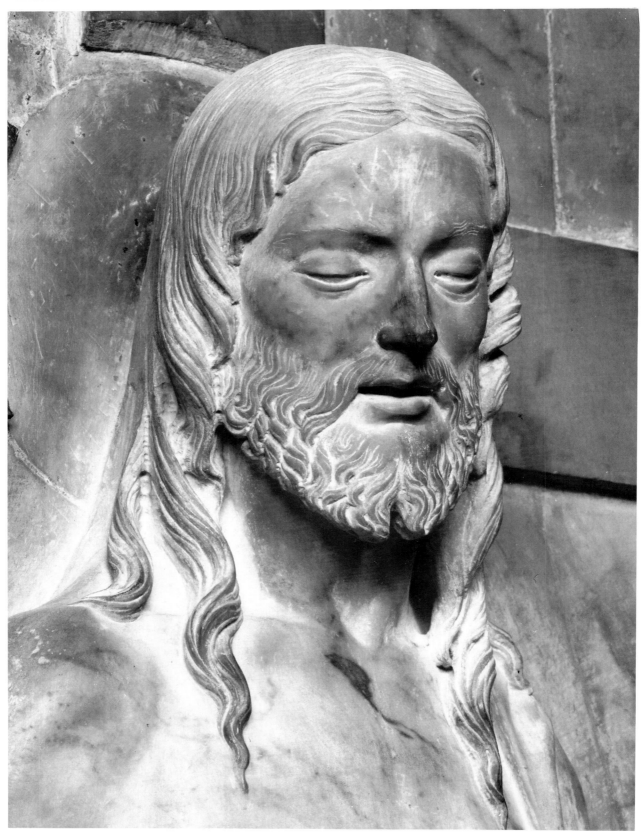

Pl. 24. Giambattista Bregno, detail, *Christ as Man of Sorrows*, Altar of the Corpus Domini, Duomo, Cesena (Zangheri, Cesena)

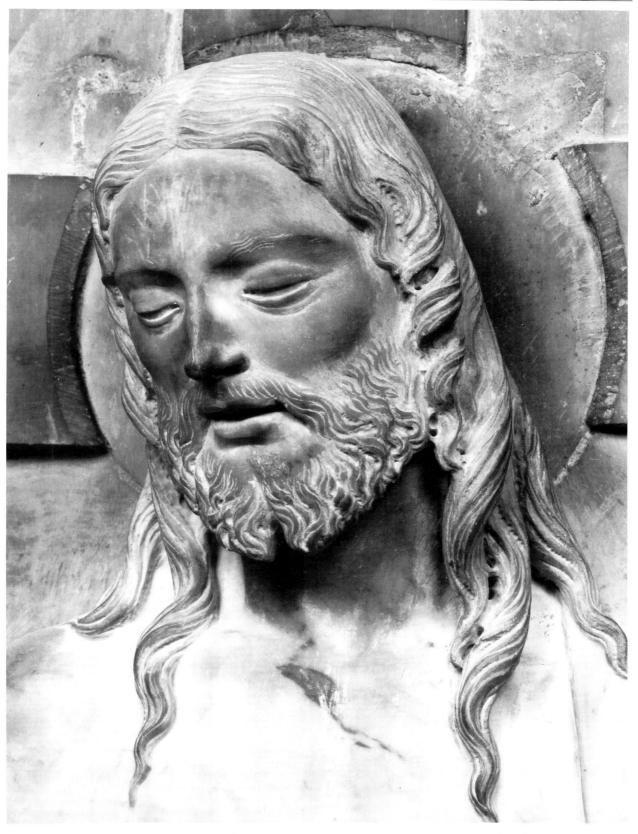

Pl. 25. Giambattista Bregno, detail, *Christ as Man of Sorrows*, Altar of the Corpus Domini, Duomo, Cesena (Zangheri, Cesena)

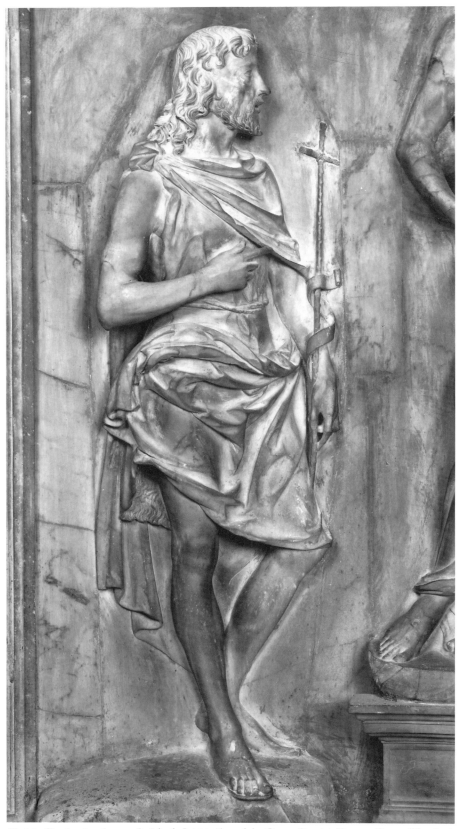

Pl. 26. Giambattista Bregno, *St. John the Baptist*, Altar of the Corpus Domini, Duomo, Cesena (Zangheri, Cesena)

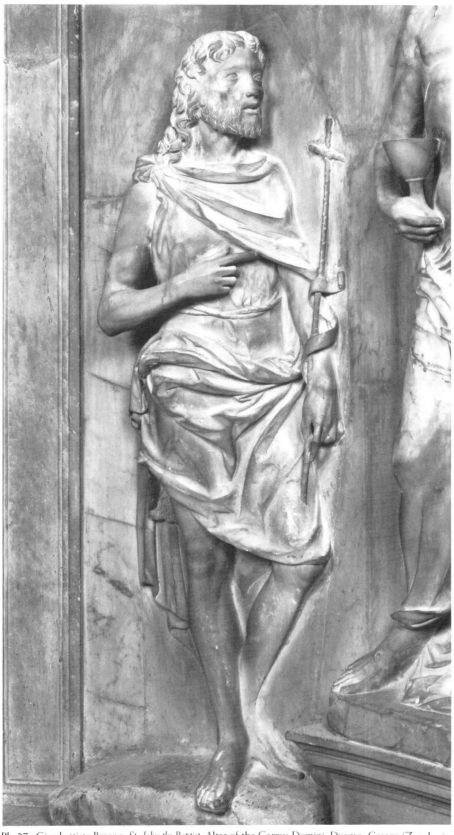

Pl. 27.  Giambattista Bregno, *St. John the Baptist*, Altar of the Corpus Domini, Duomo, Cesena (Zangheri, Cesena)

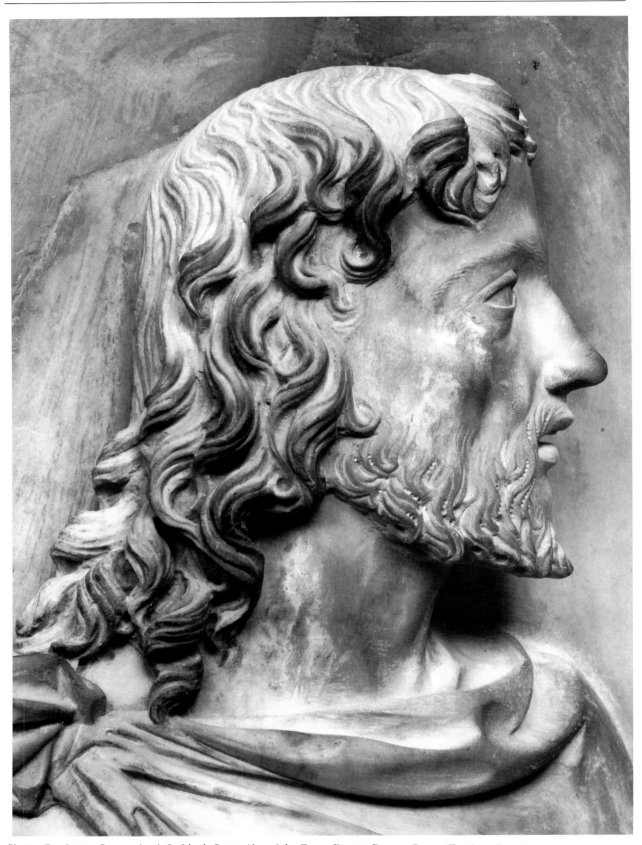

Pl. 28. Giambattista Bregno, detail, *St. John the Baptist*, Altar of the Corpus Domini, Duomo, Cesena (Zangheri, Cesena)

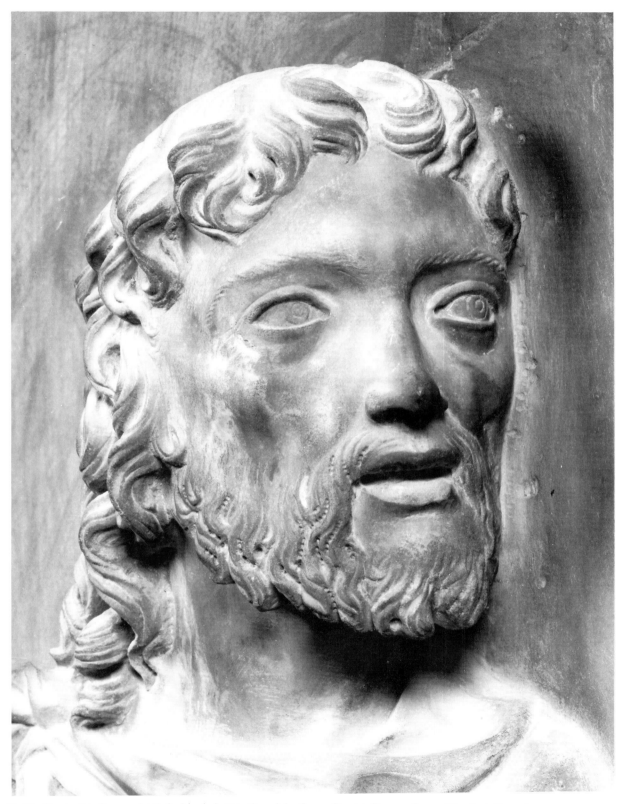

Pl. 29.  Giambattista Bregno, detail, *St. John the Baptist*, Altar of the Corpus Domini, Duomo, Cesena (Zangheri, Cesena)

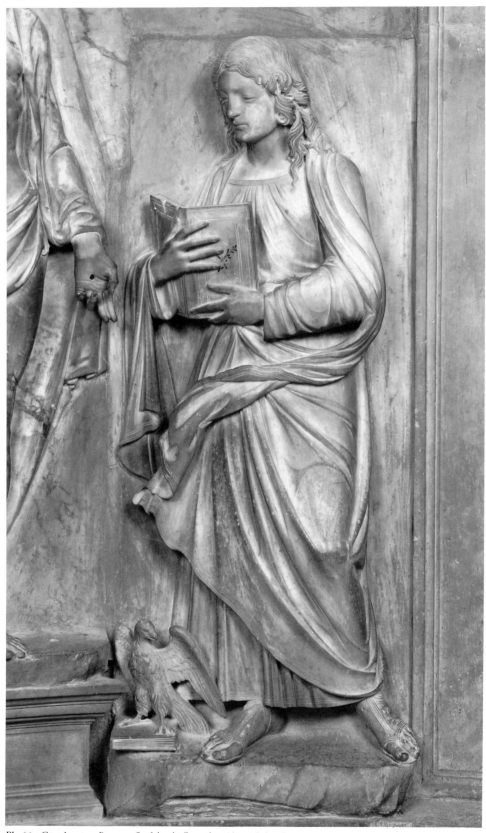

Pl. 30.  Giambattista Bregno, *St. John the Evangelist*, Altar of the Corpus Domini, Duomo, Cesena (Zangheri, Cesena)

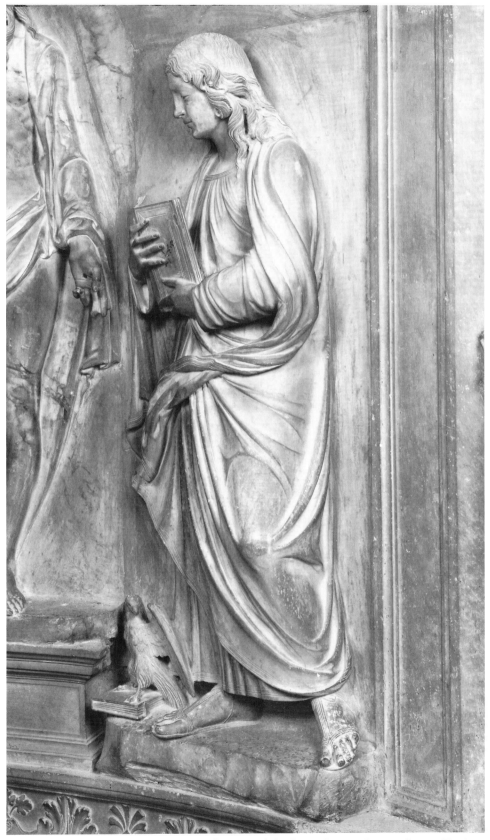

Pl. 31. Giambattista Bregno, *St. John the Evangelist*, Altar of the Corpus Domini, Duomo, Cesena (Zangheri, Cesena)

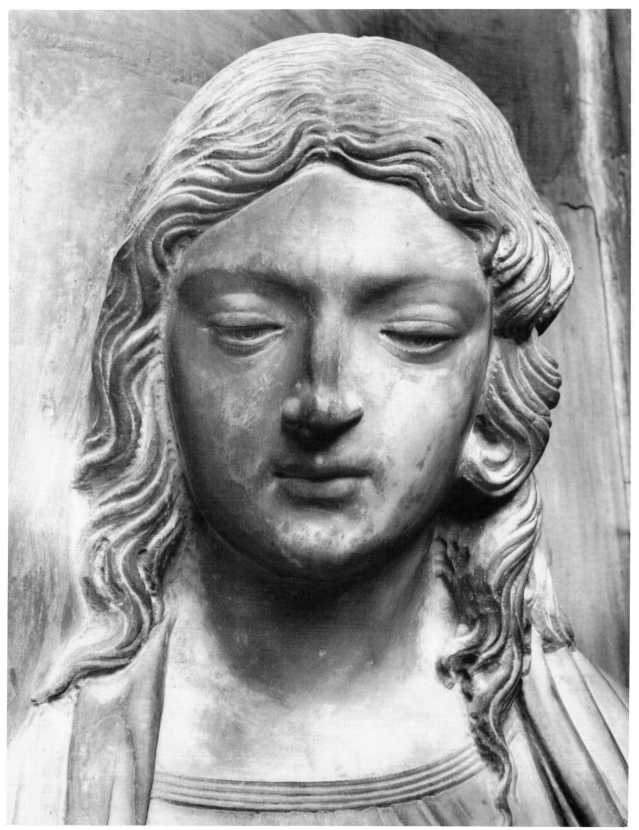

Pl. 32. Giambattista Bregno, detail, *St. John the Evangelist*, Altar of the Corpus Domini, Duomo, Cesena (Zangheri, Cesena)

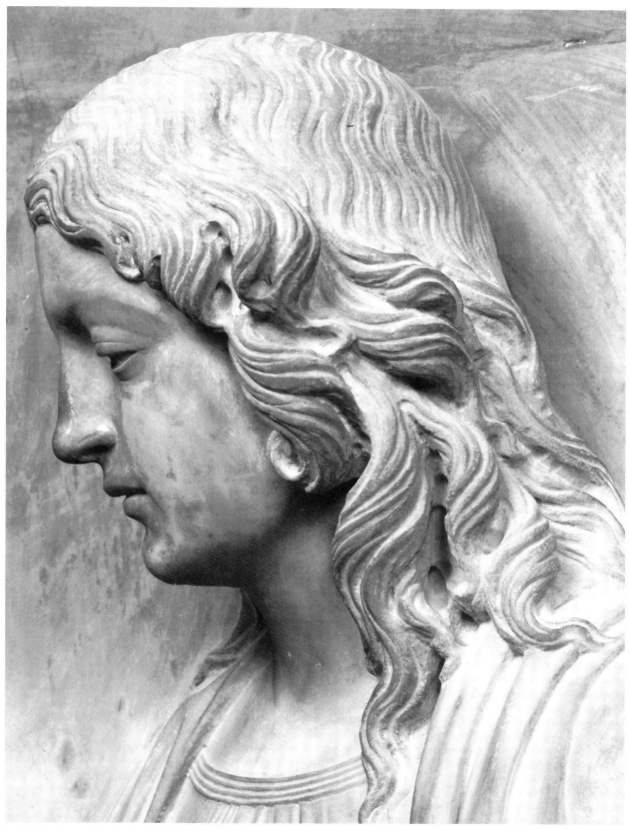

Pl. 33. Giambattista Bregno, detail, *St. John the Evangelist*, Altar of the Corpus Domini, Duomo, Cesena (Zangheri, Cesena)

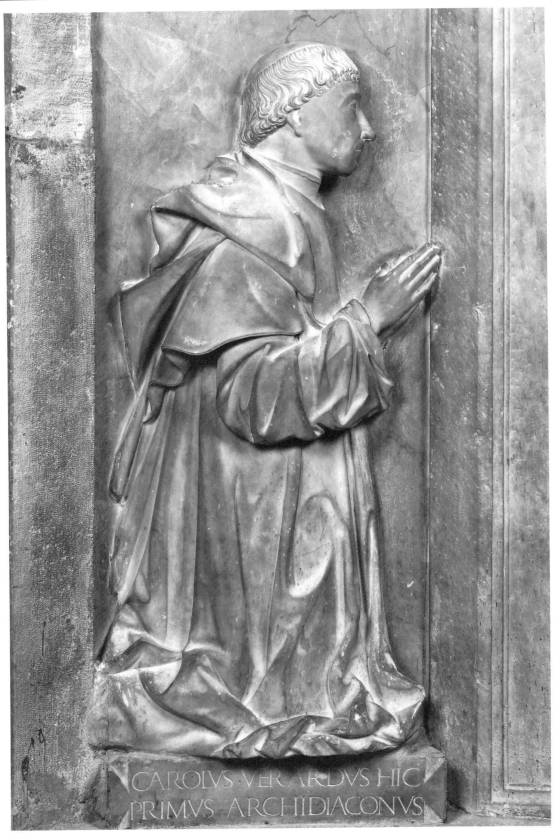

Pl. 34. Giambattista Bregno, *Carlo Verardi*, Altar of the Corpus Domini, Duomo, Cesena (Zangheri, Cesena)

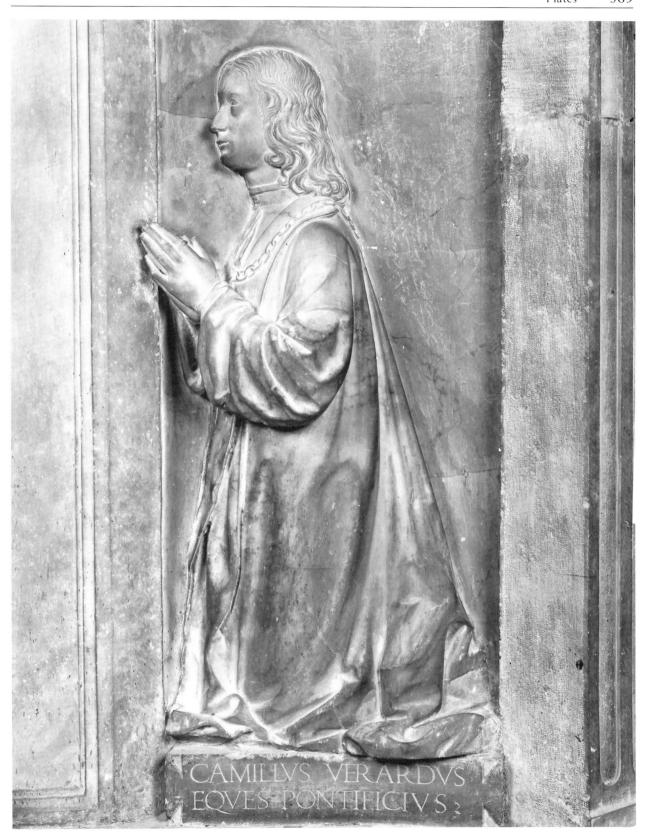

CAMILLVS VERARDVS
EQVES PONTIFICIVS

Pl. 35. Giambattista Bregno, *Camillo Verardi*, Altar of the Corpus Domini, Duomo, Cesena (Zangheri, Cesena)

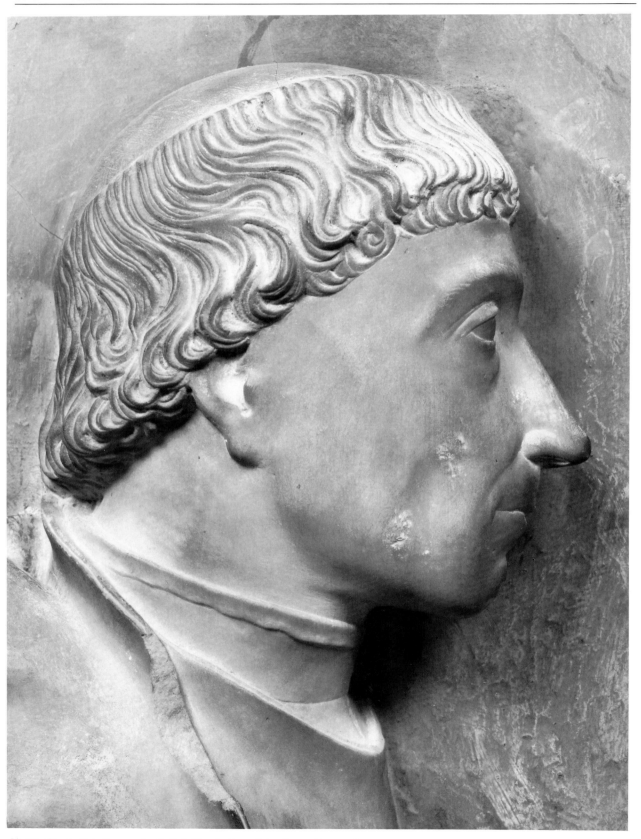

Pl. 36. Giambattista Bregno, detail, *Carlo Verardi*, Altar of the Corpus Domini, Duomo, Cesena (Zangheri, Cesena)

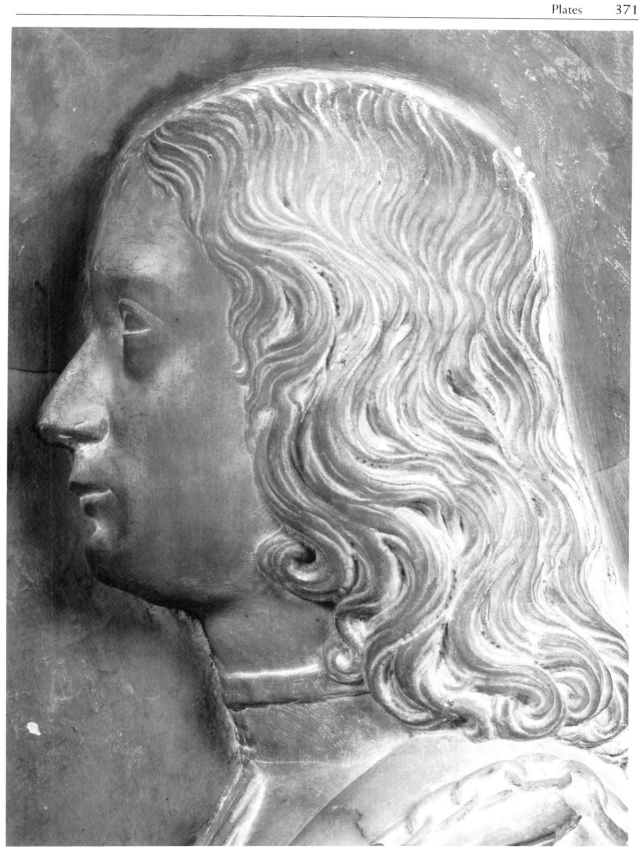

Pl. 37. Giambattista Bregno, detail, *Camillo Verardi*, Altar of the Corpus Domini, Duomo, Cesena (Zangheri, Cesena)

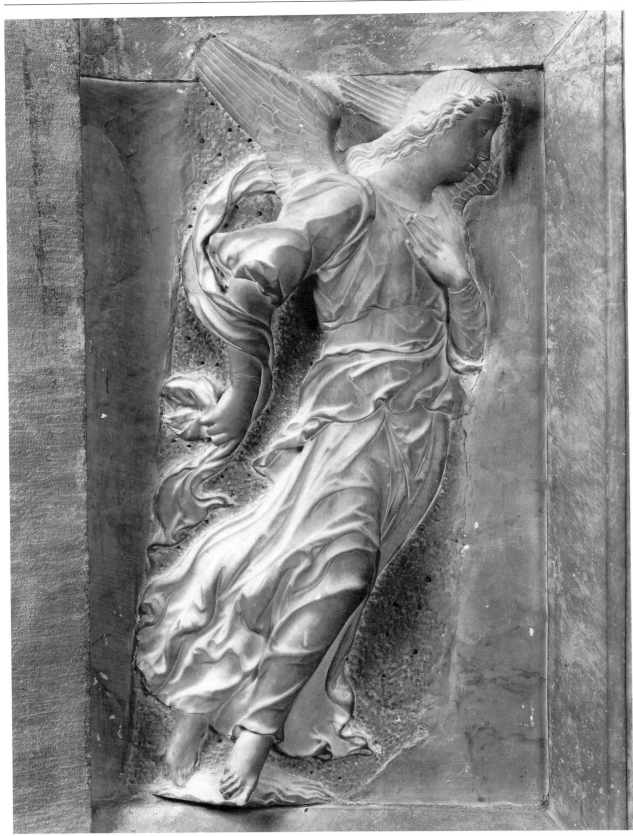

Pl. 38. Giambattista Bregno, left-hand *Angel*, Altar of the Corpus Domini, Duomo, Cesena (Zangheri, Cesena)

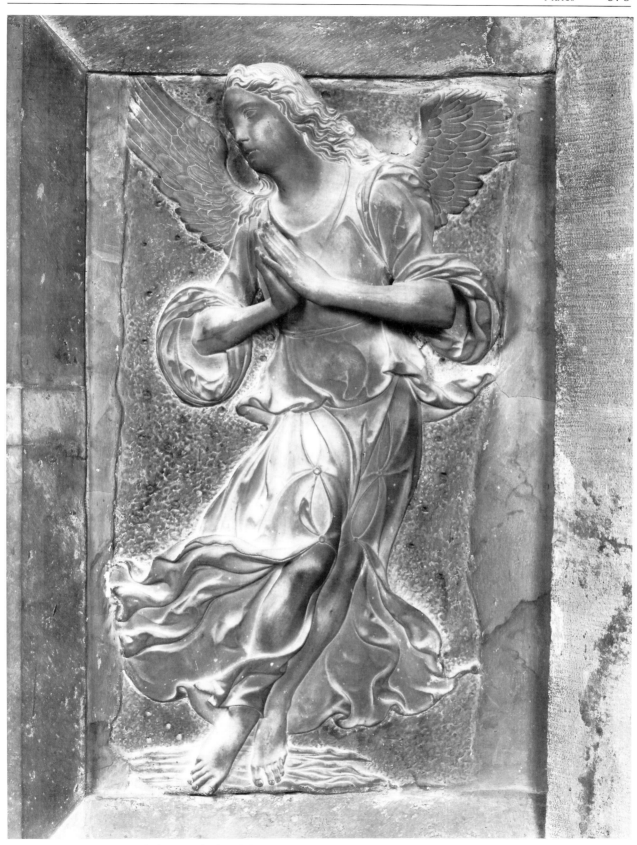

Pl. 39. Giambattista Bregno, right-hand *Angel*, Altar of the Corpus Domini, Duomo, Cesena (Zangheri, Cesena)

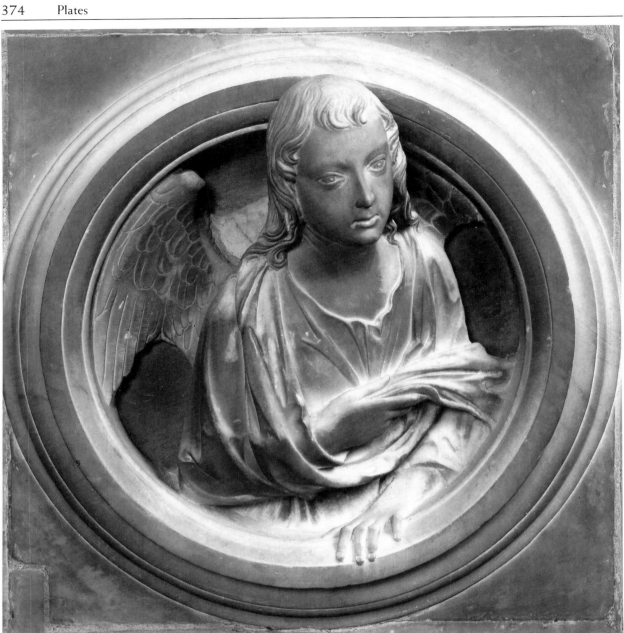

Pl. 40. Giambattista Bregno, left-hand half-length *Angel*, Altar of the Corpus Domini, Duomo, Cesena (Zangheri, Cesena)

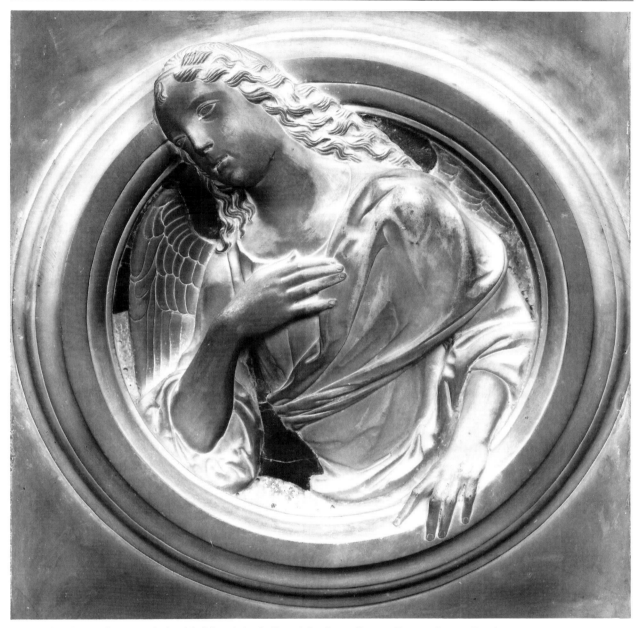

Pl. 41. Giambattista Bregno, right-hand half-length *Angel*, Altar of the Corpus Domini, Duomo, Cesena (Zangheri, Cesena)

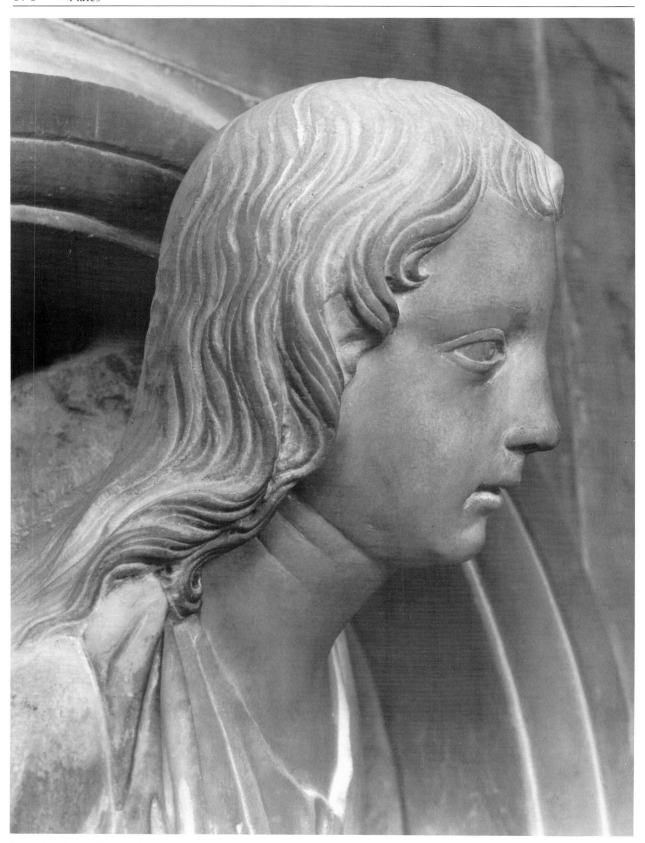

Pl. 42. Giambattista Bregno, detail, left-hand half-length *Angel*, Altar of the Corpus Domini, Duomo, Cesena (Zangheri, Cesena)

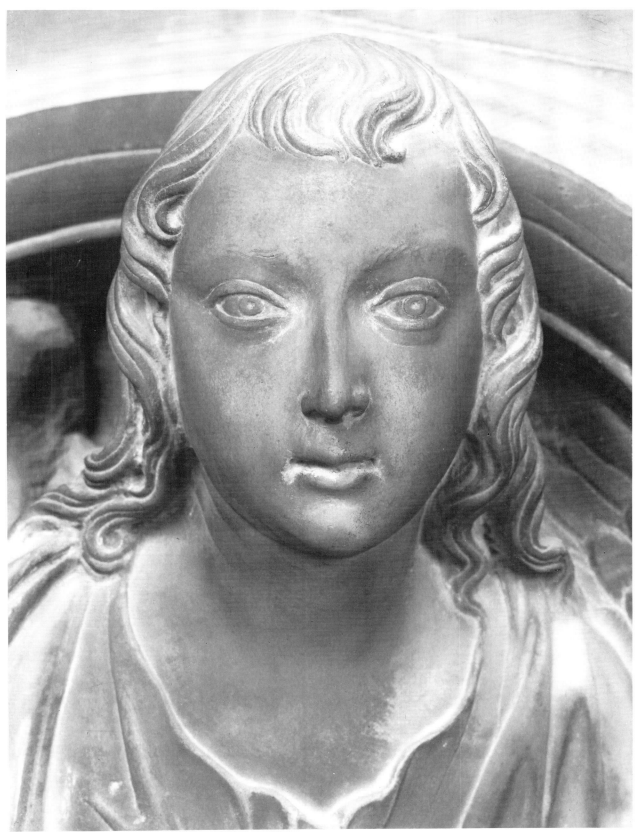

Pl. 43. Giambattista Bregno, detail, left-hand half-length *Angel*, Altar of the Corpus Domini, Duomo, Cesena (Zangheri, Cesena)

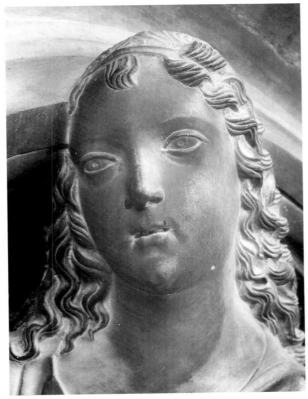

Pl. 44. Giambattista Bregno, detail, right-hand half-length *Angel*, Altar of the Corpus Domini, Duomo, Cesena (Zangheri, Cesena)

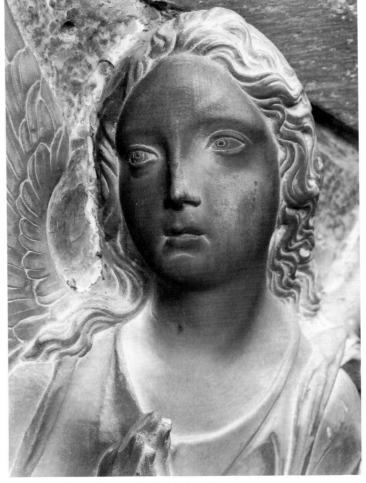

Pl. 45. Giambattista Bregno, detail, right-hand *Angel*, Altar of the Corpus Domini, Duomo, Cesena (Zangheri, Cesena)

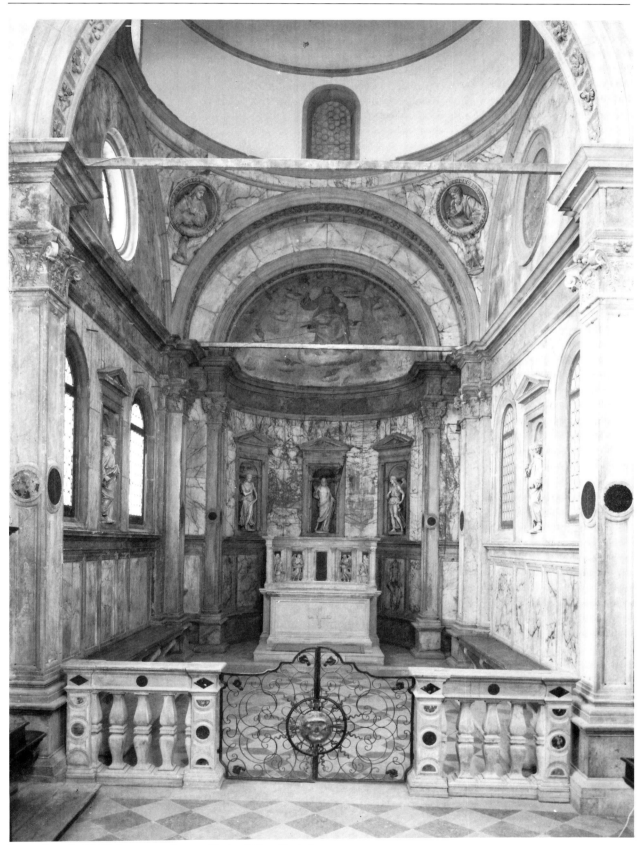

Pl. 46. Cappella del SS. Sacramento, Duomo, Treviso (Böhm, Venice)

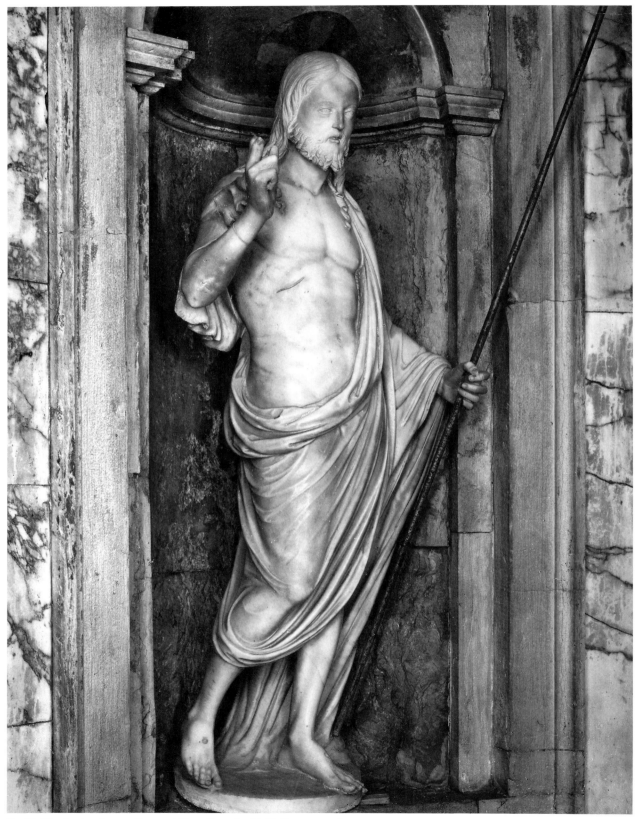

Pl. 47. Giambattista Bregno, *Resurrected Christ*, Cappella del SS. Sacramento, Duomo, Treviso (Giacomelli, Venice)

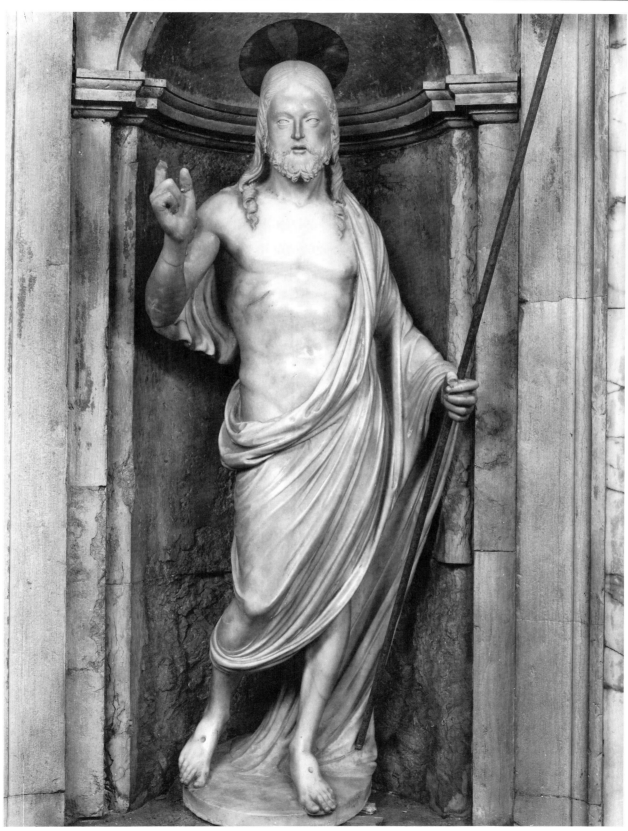

Pl. 48. Giambattista Bregno, *Resurrected Christ*, Cappella del SS. Sacramento, Duomo, Treviso (Giacomelli, Venice)

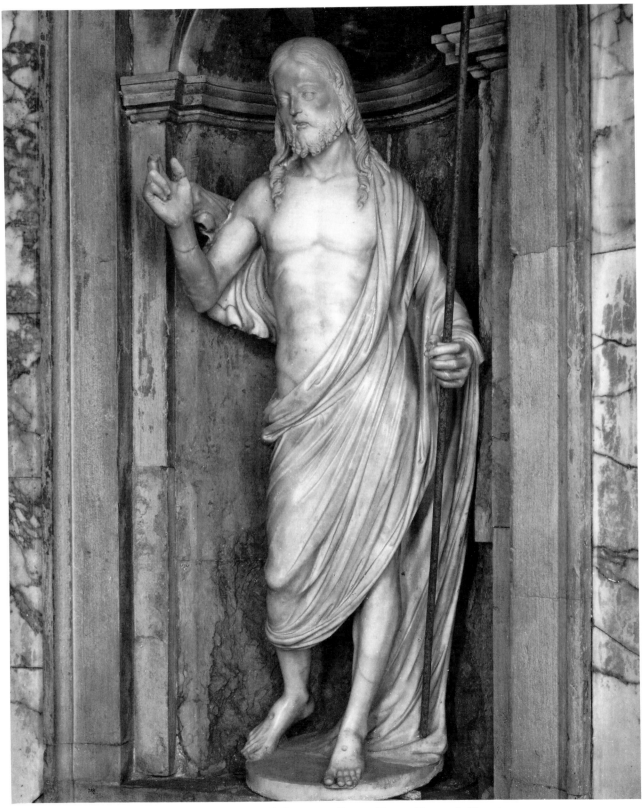

Pl. 49. Giambattista Bregno, *Resurrected Christ*, Cappella del SS. Sacramento, Duomo, Treviso (Giacomelli, Venice)

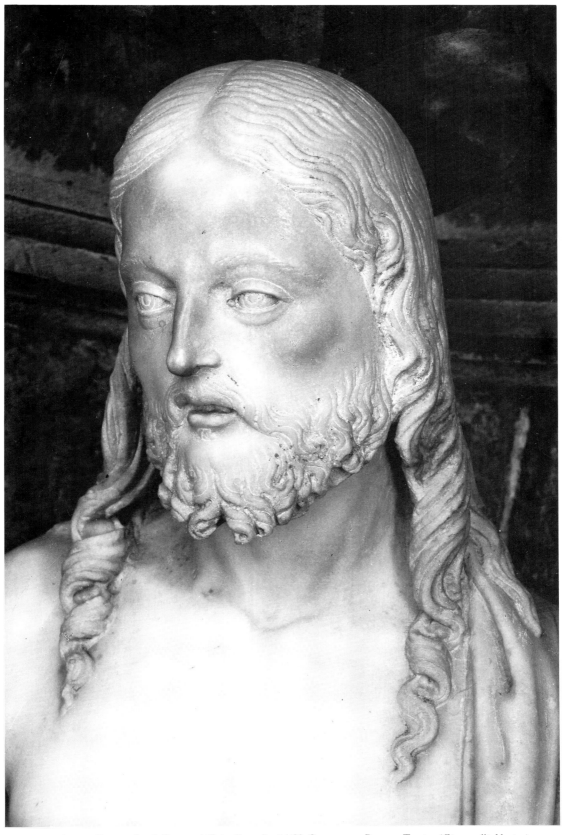

Pl. 50. Giambattista Bregno, detail, *Resurrected Christ*, Cappella del SS. Sacramento, Duomo, Treviso (Giacomelli, Venice)

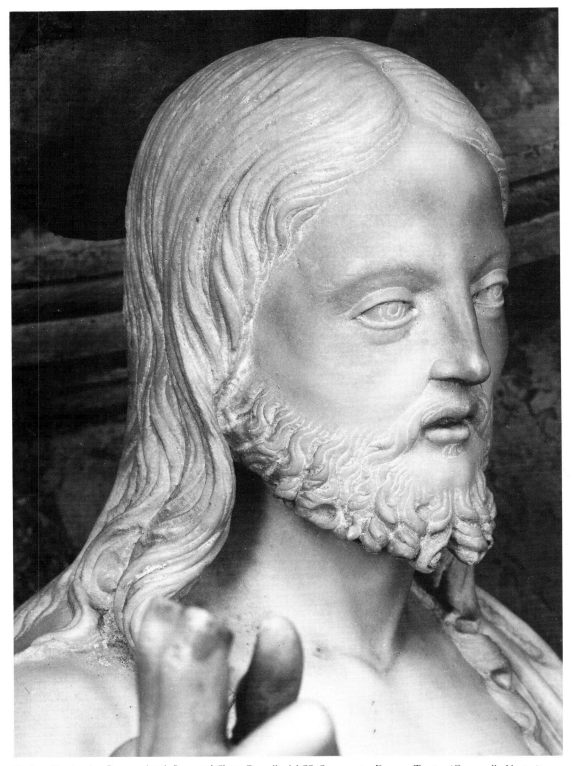

Pl. 51. Giambattista Bregno, detail, *Resurrected Christ*, Cappella del SS. Sacramento, Duomo, Treviso (Giacomelli, Venice)

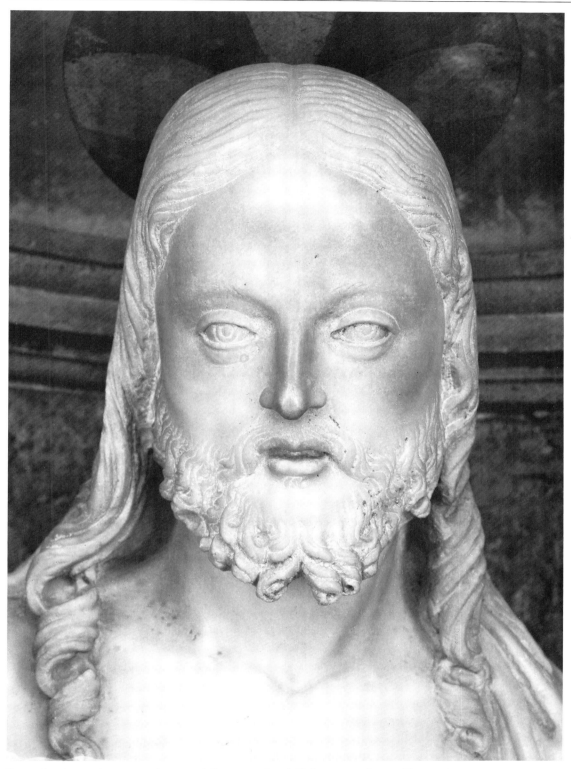

Pl. 52.  Giambattista Bregno, detail, *Resurrected Christ*, Cappella del SS. Sacramento, Duomo, Treviso (Giacomelli, Venice)

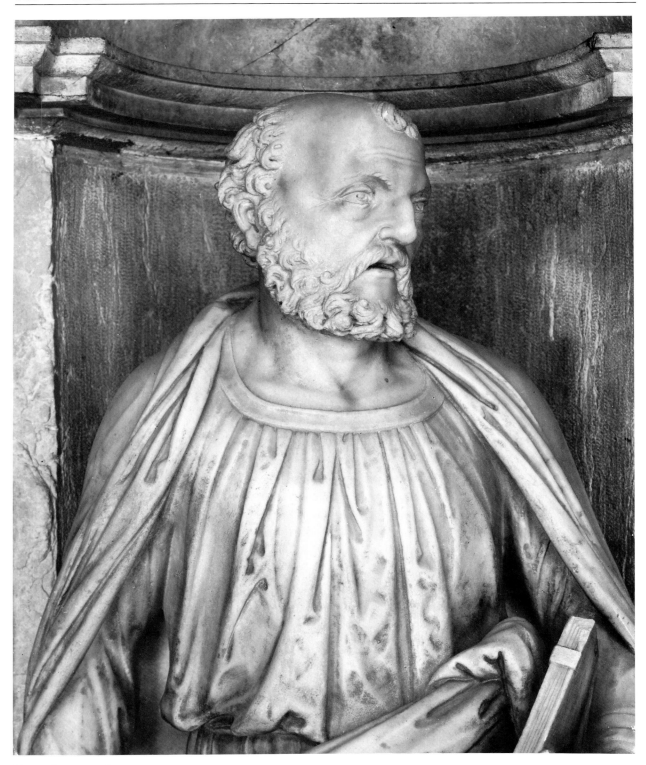

Pl. 53. Giambattista Bregno, detail, *St. Peter*, Cappella del SS. Sacramento, Duomo, Treviso (Giacomelli, Venice)

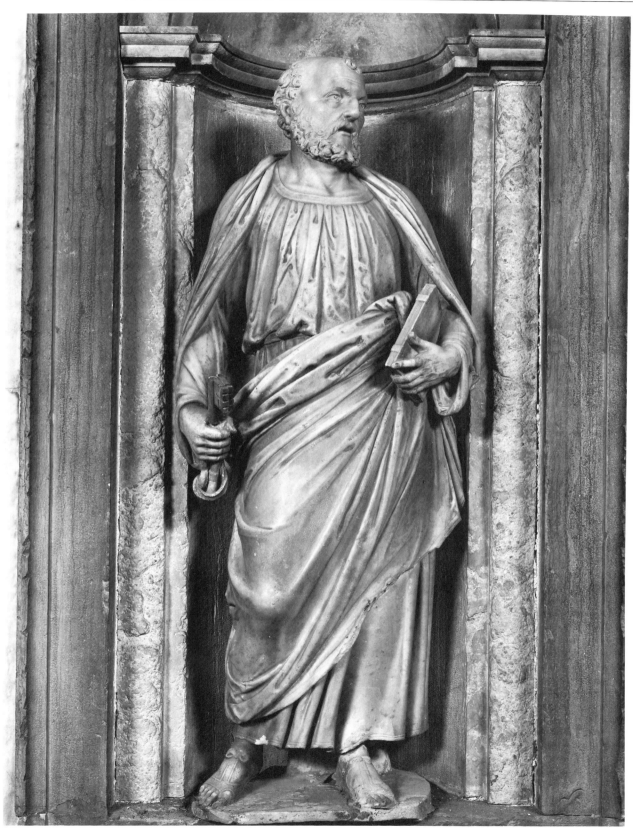

Pl. 54. Giambattista Bregno, *St. Peter*, Cappella del SS. Sacramento, Duomo, Treviso (Giacomelli, Venice)

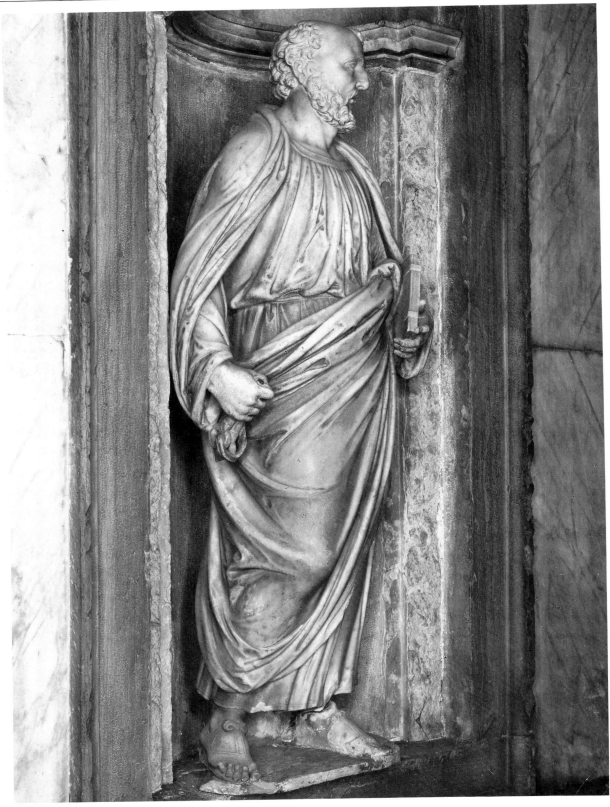

Pl. 55. Giambattista Bregno, *St. Peter*, Cappella del SS. Sacramento, Duomo, Treviso (Giacomelli, Venice)

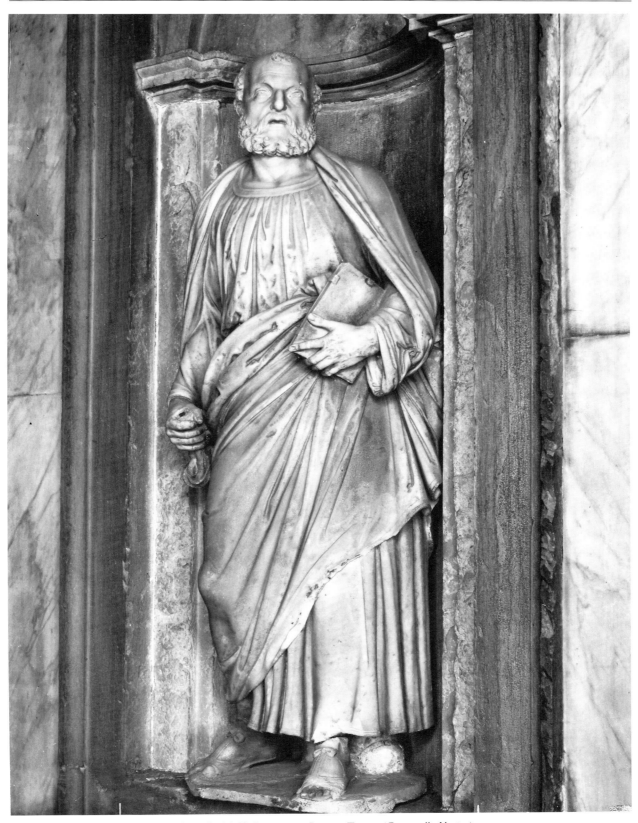

Pl. 56. Giambattista Bregno, *St. Peter*, Cappella del SS. Sacramento, Duomo, Treviso (Giacomelli, Venice)

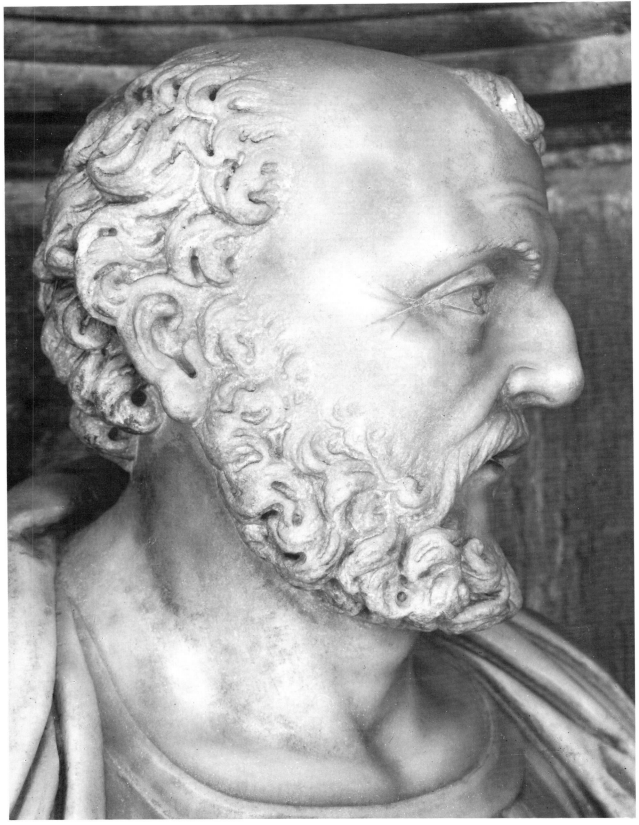

Pl. 57. Giambattista Bregno, detail, *St. Peter*, Cappella del SS. Sacramento, Duomo, Treviso (Giacomelli, Venice)

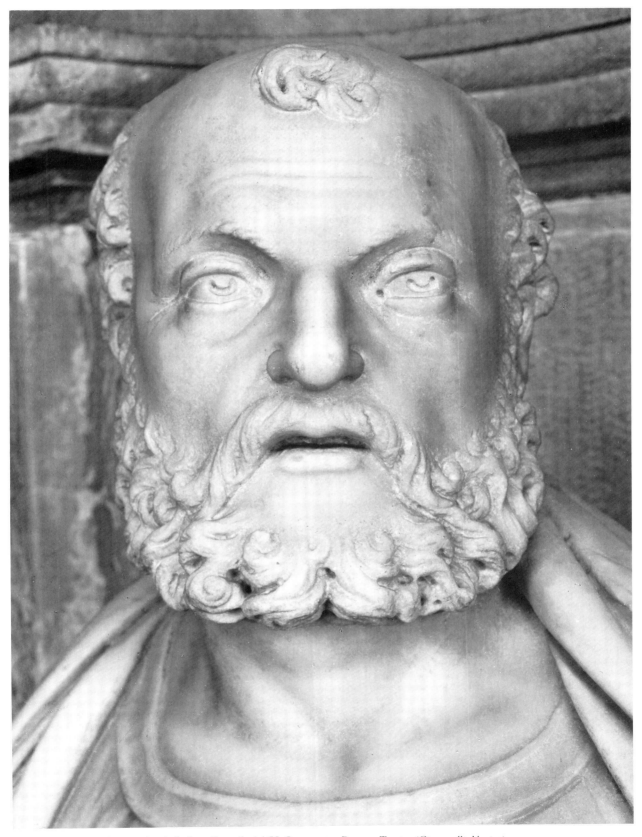

Pl. 58. Giambattista Bregno, detail, *St. Peter*, Cappella del SS. Sacramento, Duomo, Treviso (Giacomelli, Venice)

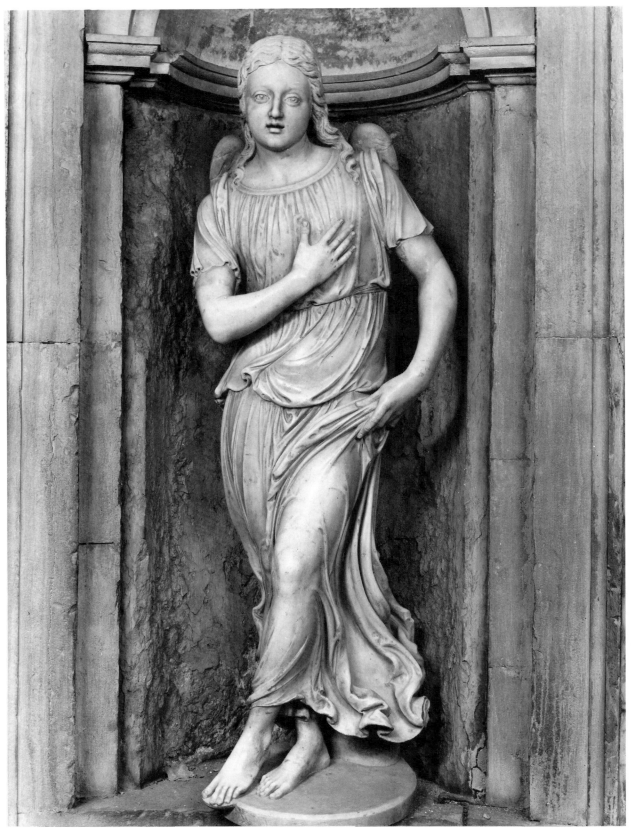

Pl. 59. Bregno shop, left-hand *Angel*, Cappella del SS. Sacramento, Duomo, Treviso (Giacomelli, Venice)

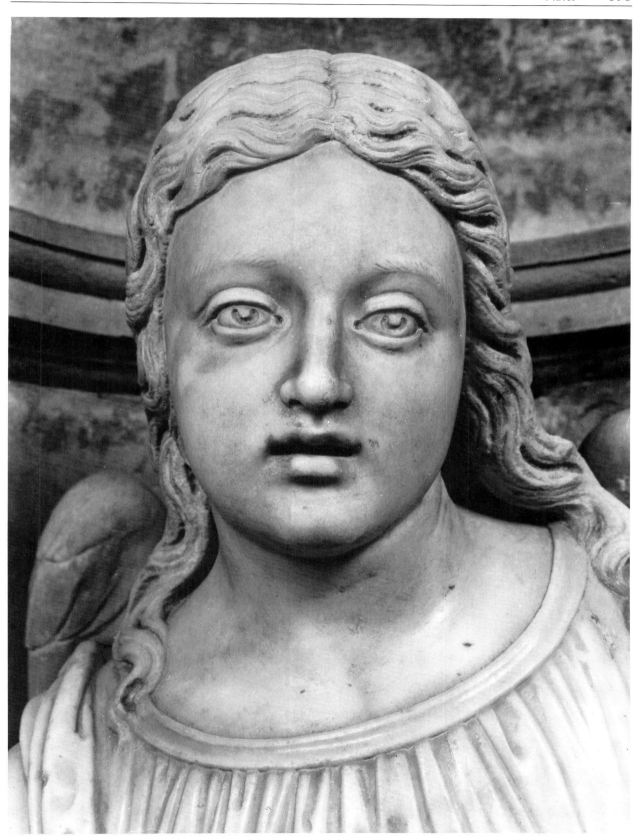

Pl. 60. Bregno shop, detail, left-hand *Angel*, Cappella del SS. Sacramento, Duomo, Treviso (Giacomelli, Venice)

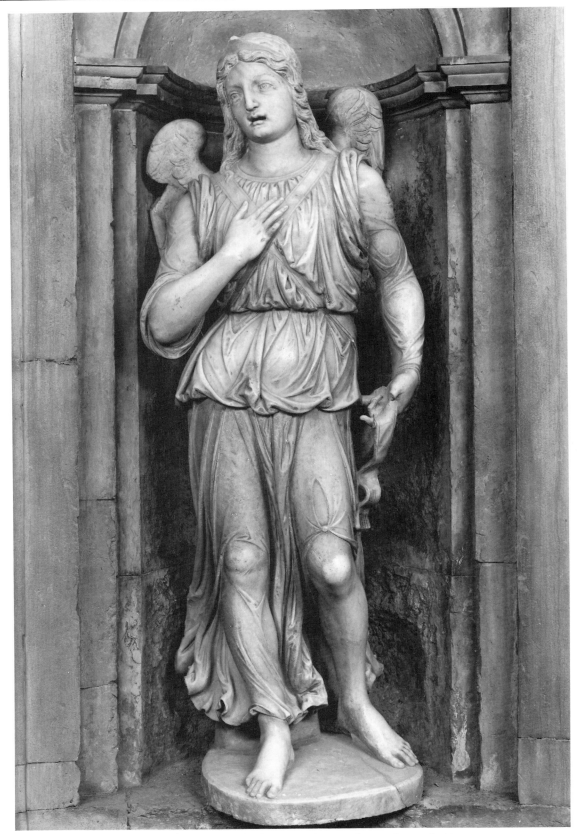

Pl. 61. Bregno shop, right-hand *Angel*, Cappella del SS. Sacramento, Duomo, Treviso (Giacomelli, Venice)

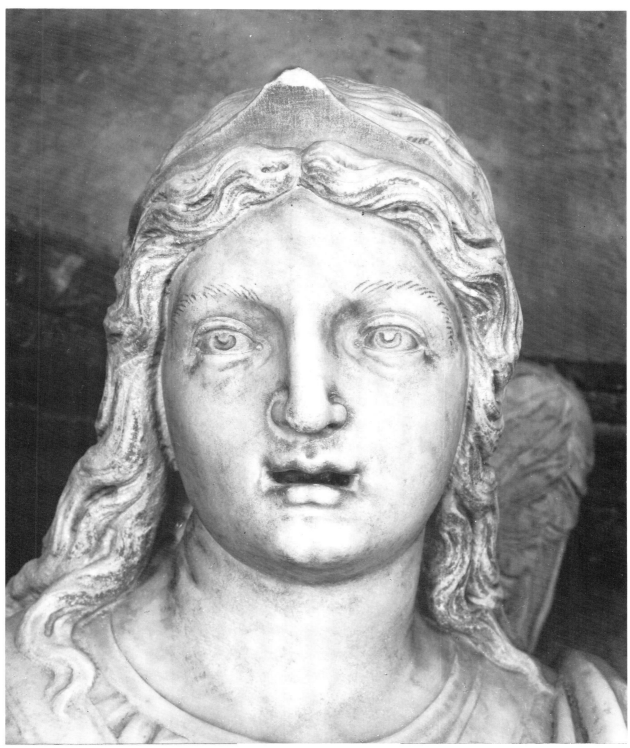

Pl. 62. Bregno shop, detail, right-hand *Angel*, Cappella del SS. Sacramento, Duomo, Treviso (Giacomelli, Venice)

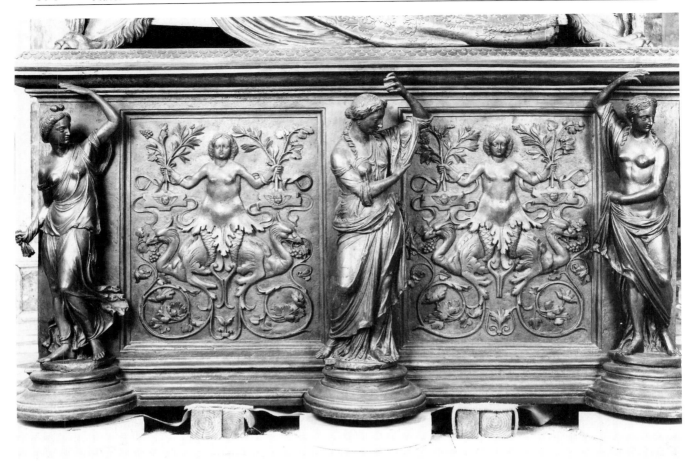

Pl. 63. West face, Sarcophagus of Cardinal Zen, Cappella Zen, S. Marco, Venice (Giacomelli, Venice)

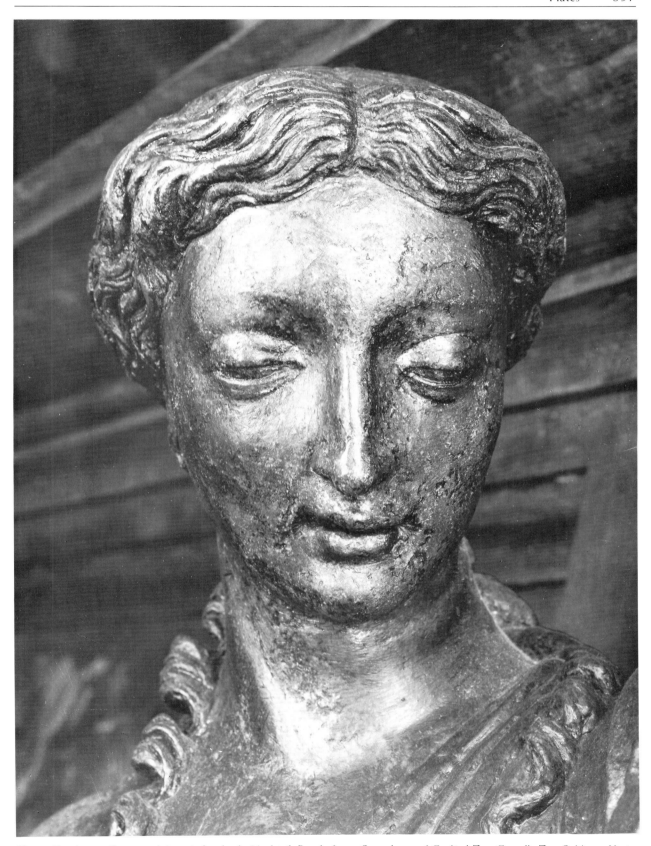

Pl. 64. Giambattista Bregno and Antonio Lombardo (?), detail, Female figure, Sarcophagus of Cardinal Zen, Cappella Zen, S. Marco, Venice (Giacomelli, Venice)

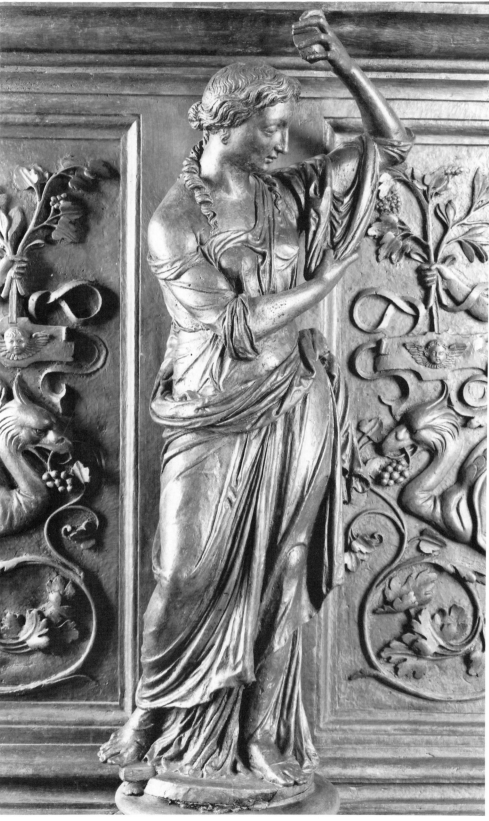

Pl. 65. Giambattista Bregno and Antonio Lombardo (?), Female figure, Sarcophagus of Cardinal Zen, Cappella Zen, S. Marco, Venice (Giacomelli, Venice)

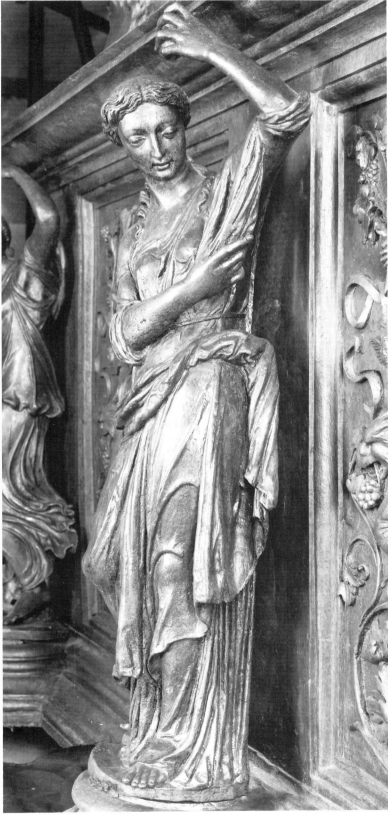

Pl. 66. Giambattista Bregno and Antonio Lombardo (?), Female figure, Sarcophagus of
Cardinal Zen, Cappella Zen, S. Marco, Venice (Giacomelli, Venice)

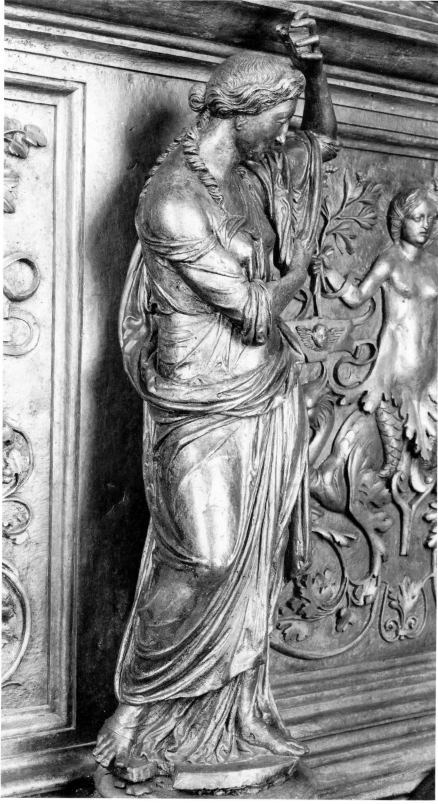

Pl. 67. Giambattista Bregno and Antonio Lombardo (?), Female figure, Sarcophagus of Cardinal
Zen, Cappella Zen, S. Marco, Venice (Giacomelli, Venice)

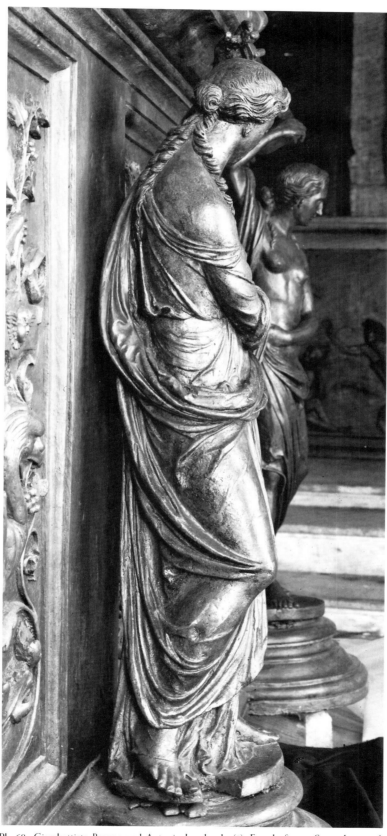

Pl. 68. Giambattista Bregno and Antonio Lombardo (?), Female figure, Sarcophagus of Cardinal Zen, Cappella Zen, S. Marco, Venice (Giacomelli, Venice)

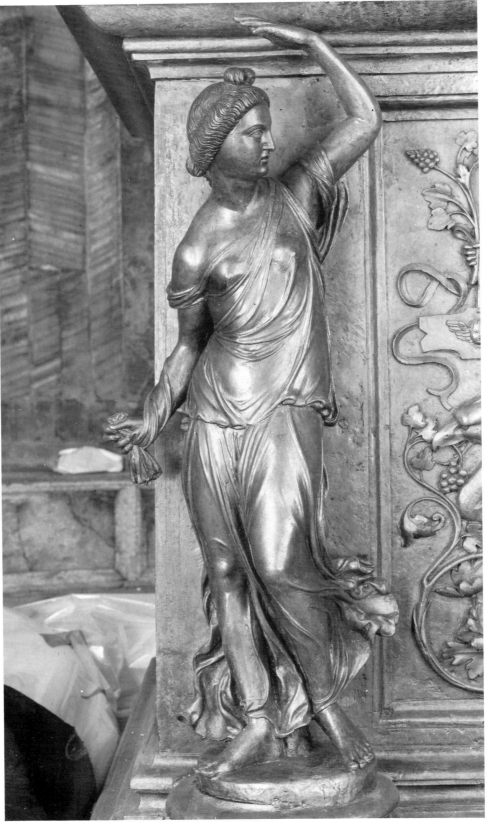

Pl. 69. Bregno shop, Female figure, Sarcophagus of Cardinal Zen, Cappella Zen, S. Marco, Venice (Giacomelli, Venice)

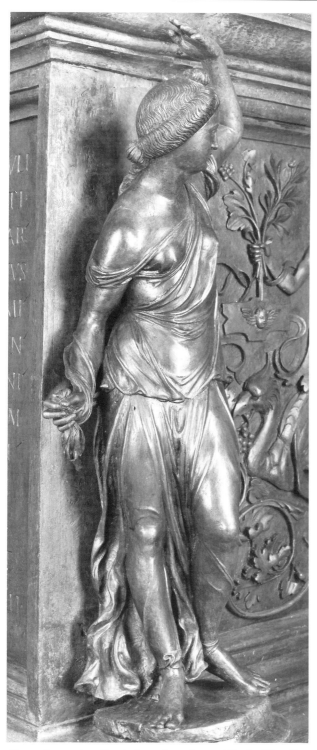

Pl. 70. Bregno shop, Female figure, Sarcophagus of Cardinal Zen, Cappella Zen, S. Marco, Venice (Giacomelli, Venice)

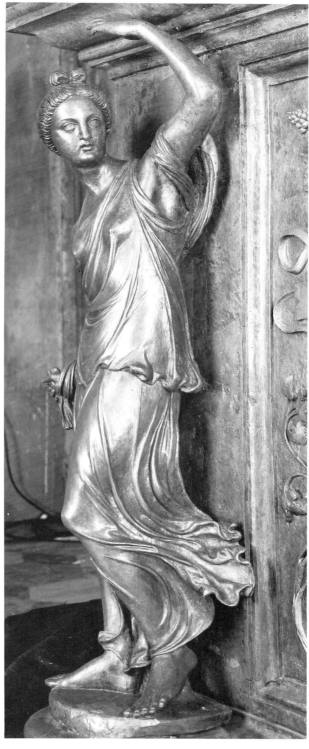

Pl. 71. Bregno shop, Female figure, Sarcophagus of Cardinal Zen, Cappella Zen, S. Marco, Venice (Giacomelli, Venice)

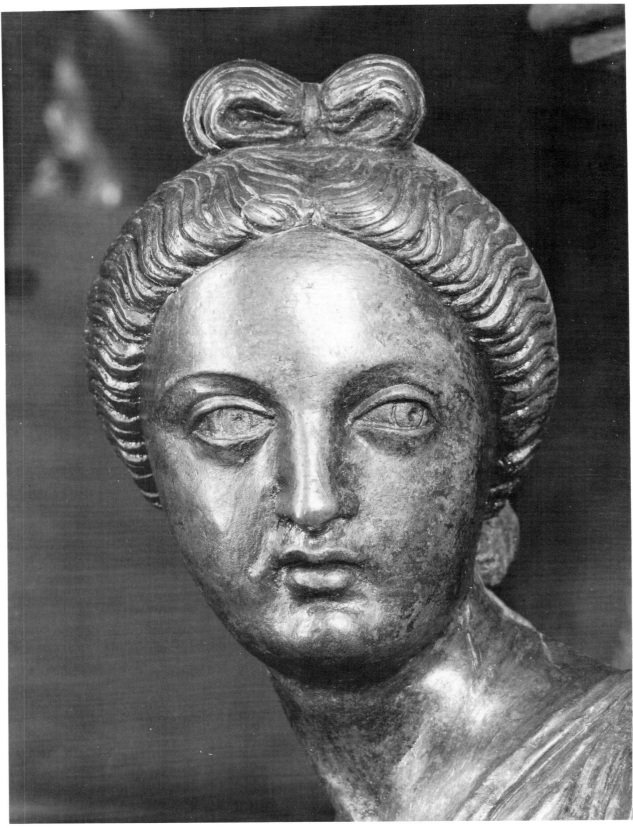

Pl. 72. Bregno shop, detail, Female figure, Sarcophagus of Cardinal Zen, Cappella Zen, S. Marco, Venice (Giacomelli, Venice)

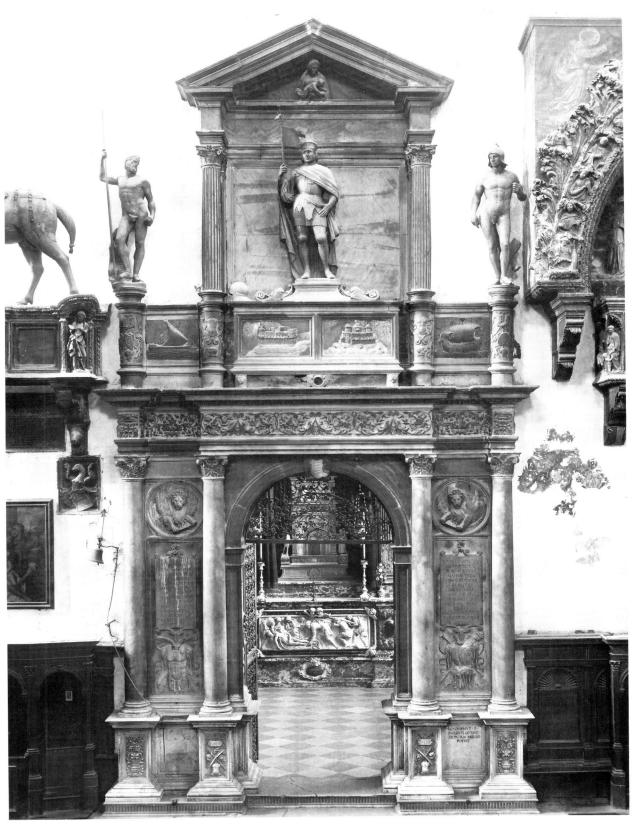

Pl. 73. Tomb of Benedetto Pesaro, S. Maria dei Frari, Venice (Böhm, Venice)

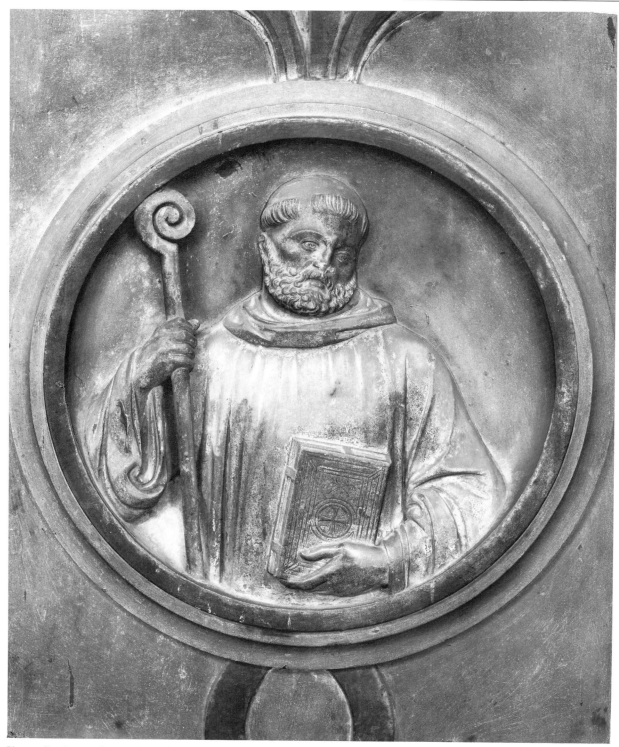

Pl. 74. Giambattista Bregno, *St. Benedict*, Tomb of Benedetto Pesaro, S. Maria dei Frari, Venice (Böhm, Venice)

Pl. 75. Giambattista Bregno (?), capital, Tomb of Benedetto Pesaro, S. Maria dei Frari, Venice (Böhm, Venice)

Pl. 76. Giambattista Bregno (?), detail of pedestal, Tomb of Benedetto Pesaro, S. Maria dei Frari, Venice (Böhm, Venice)

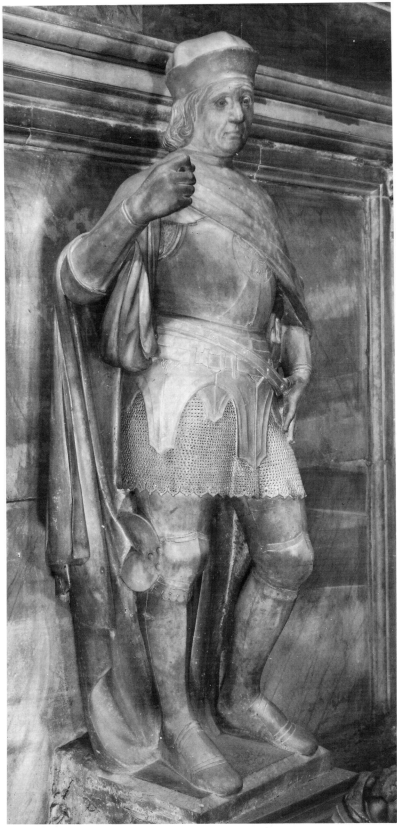

Pl. 77. Giambattista Bregno, *Effigy*, Tomb of Benedetto Pesaro, S. Maria dei Frari, Venice (Giacomelli, Venice)

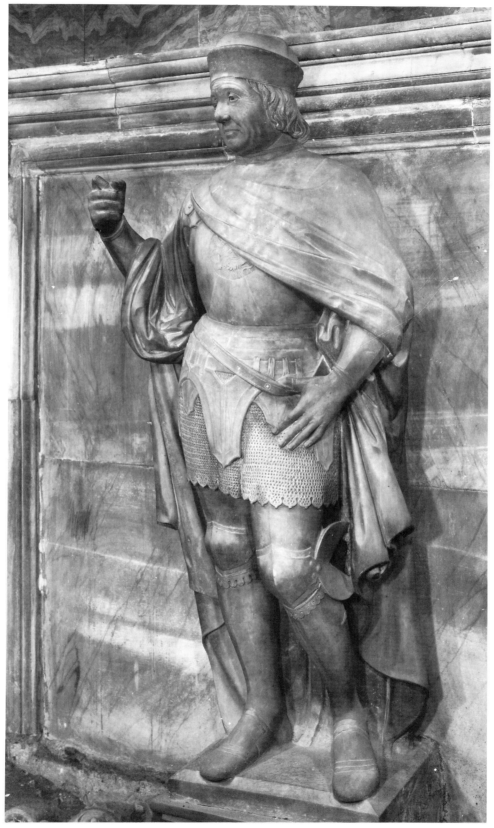

Pl. 78. Giambattista Bregno, *Effigy*, Tomb of Benedetto Pesaro, S. Maria dei Frari, Venice (Giacomelli, Venice)

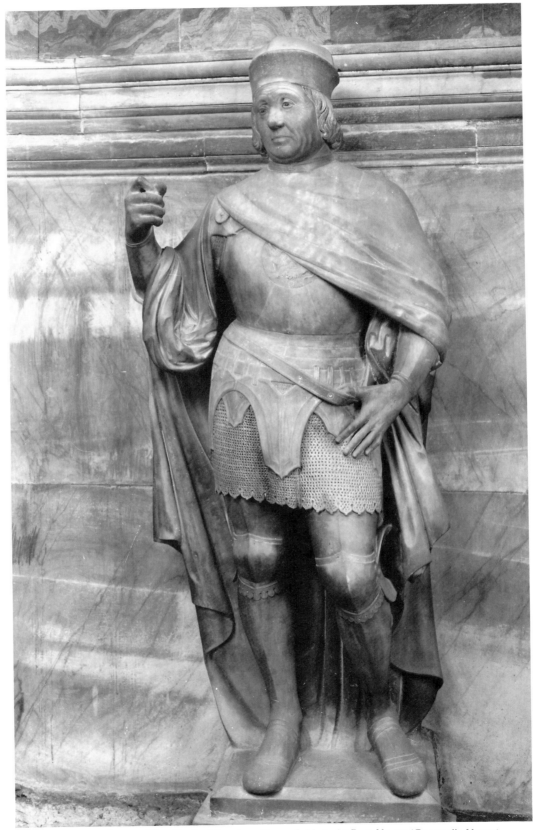

Pl. 79. Giambattista Bregno, *Effigy*, Tomb of Benedetto Pesaro, S. Maria dei Frari, Venice (Giacomelli, Venice)

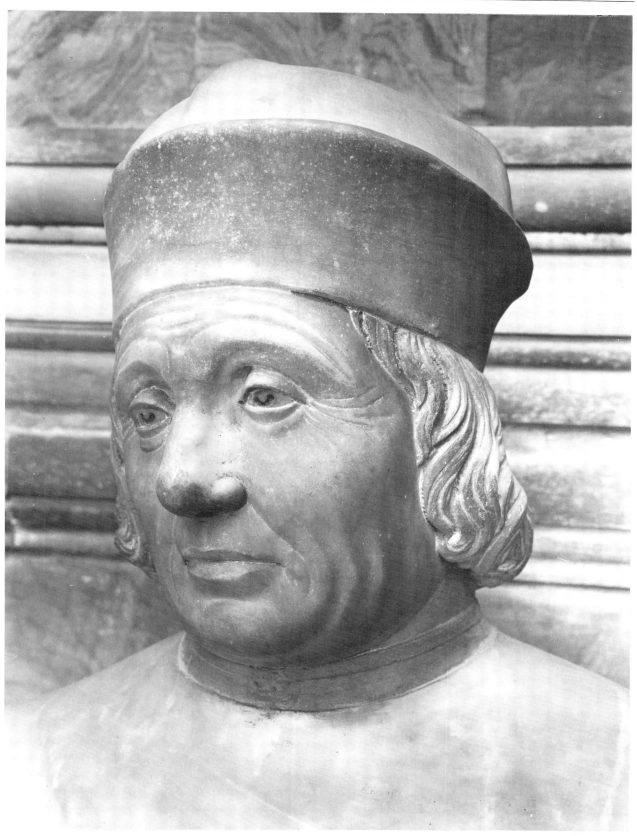

Pl. 80. Giambattista Bregno, detail, *Effigy*, Tomb of Benedetto Pesaro, S. Maria dei Frari, Venice (Giacomelli, Venice)

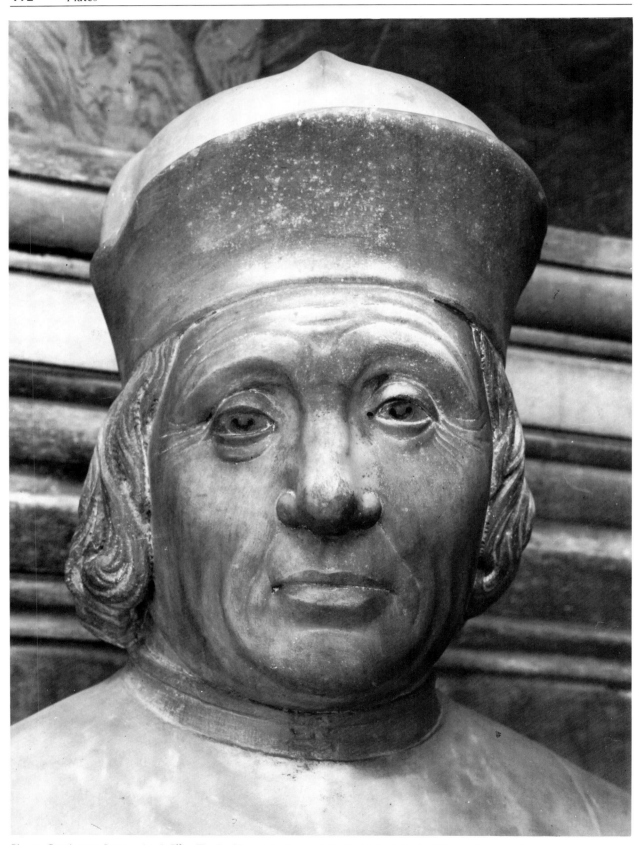

Pl. 81. Giambattista Bregno, detail, *Effigy*, Tomb of Benedetto Pesaro, S. Maria dei Frari, Venice (Giacomelli, Venice)

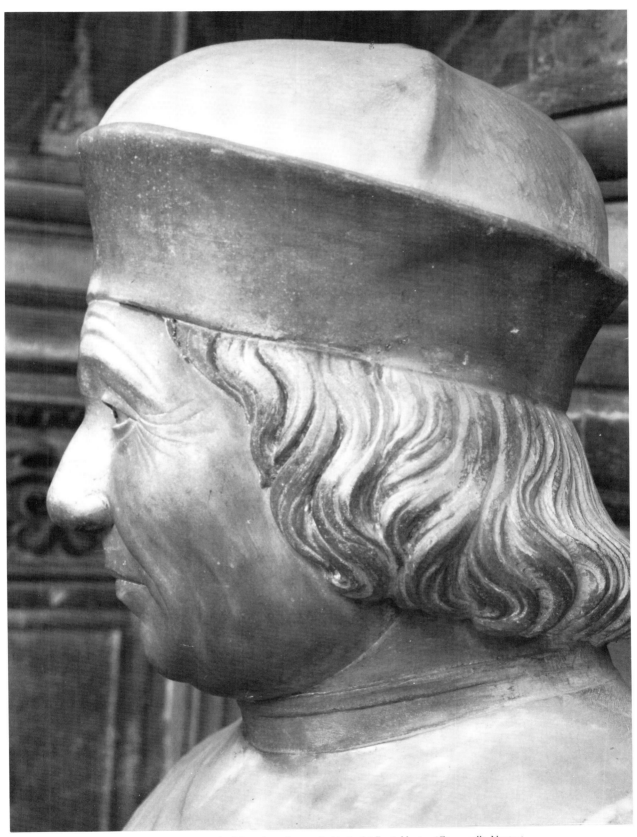

Pl. 82. Giambattista Bregno, detail, *Effigy*, Tomb of Benedetto Pesaro, S. Maria dei Frari, Venice (Giacomelli, Venice)

Pl. 83. Giambattista Bregno and assistant, detail, *St. George and the Dragon*, dormitory facade, Convent of S. Giorgio Maggiore, Venice (Giacomelli, Venice)

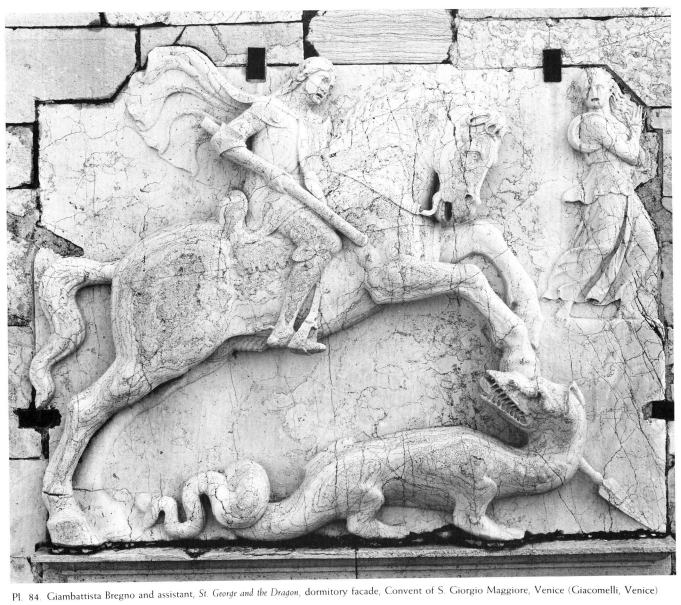

Pl. 84. Giambattista Bregno and assistant, *St. George and the Dragon*, dormitory facade, Convent of S. Giorgio Maggiore, Venice (Giacomelli, Venice)

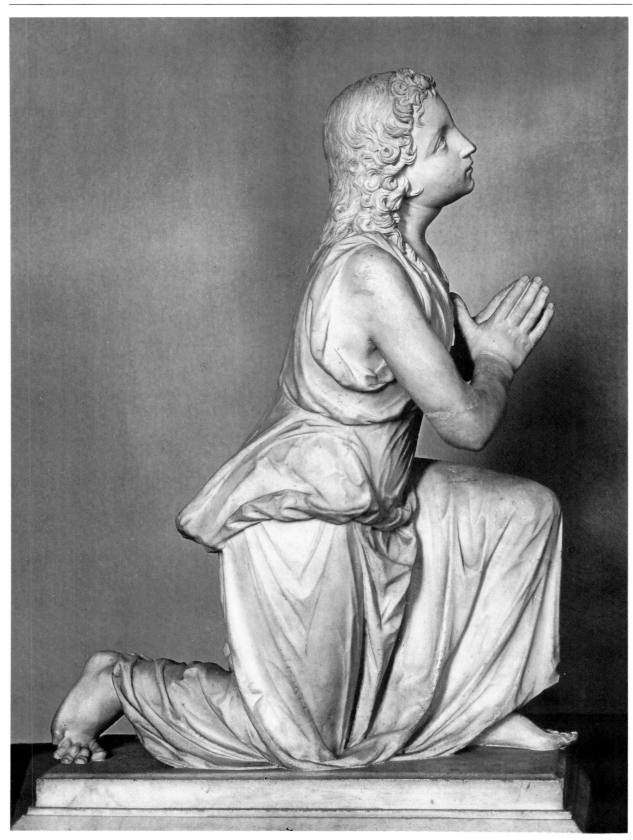

Pl. 85. Giambattista Bregno, *Angel*, Staatliche Museen, East Berlin (Staatl. Mus., East Berlin)

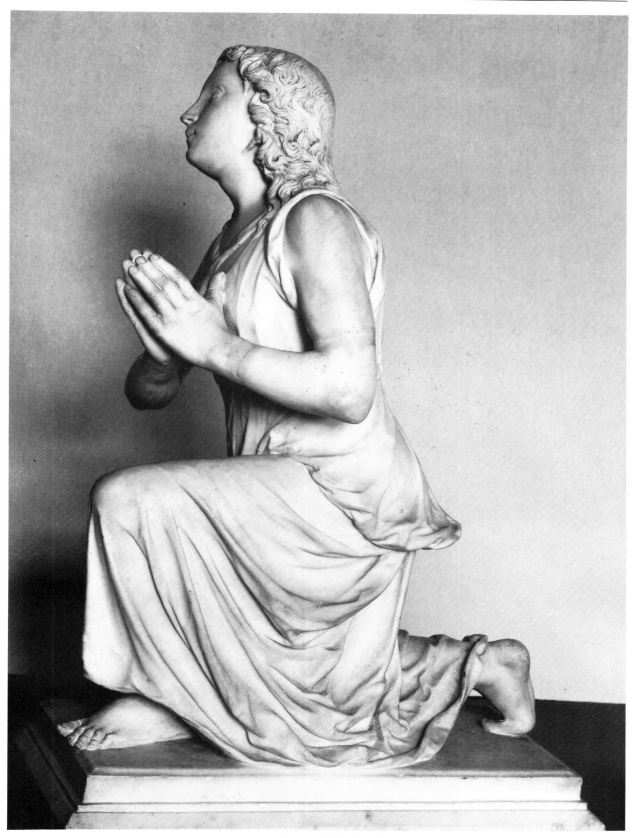

Pl. 86. Giambattista Bregno, *Angel*, Staatliche Museen, East Berlin (Staatl. Mus., East Berlin)

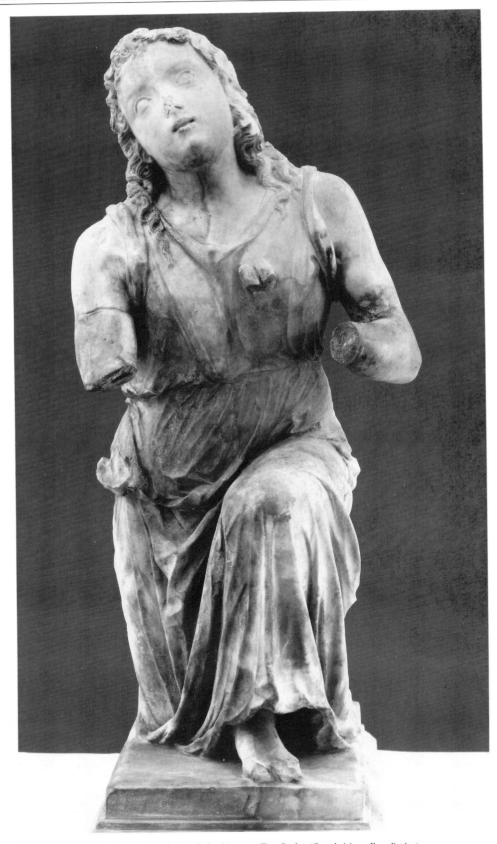

Pl. 87. Giambattista Bregno, *Angel*, Staatliche Museen, East Berlin (Staatl. Mus., East Berlin)

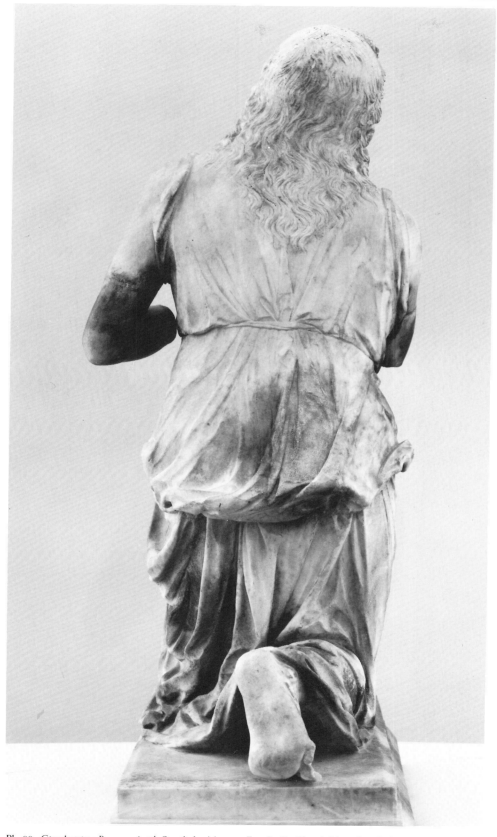

Pl. 88. Giambattista Bregno, *Angel*, Staatliche Museen, East Berlin (Staatl. Mus., East Berlin)

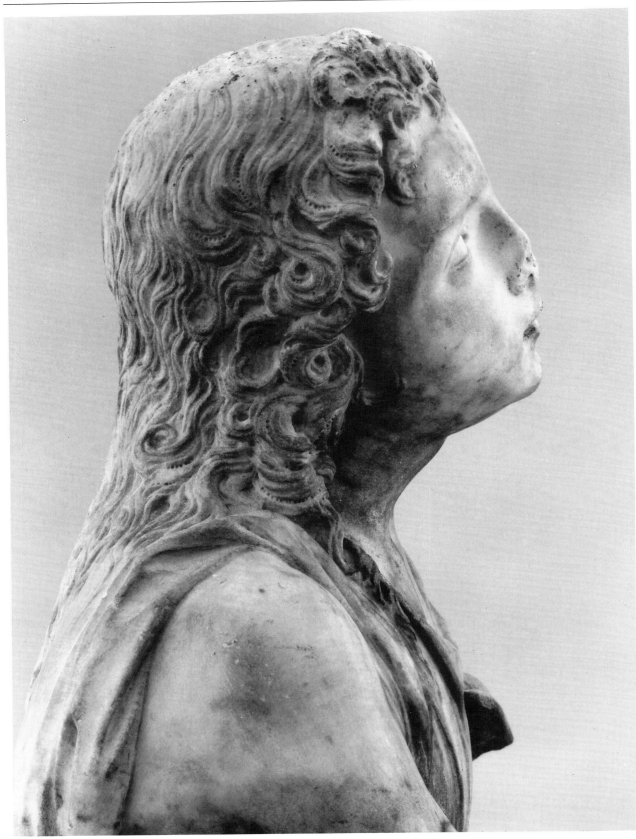

Pl. 89. Giambattista Bregno, detail, *Angel*, Staatliche Museen, East Berlin (Staatl. Mus., East Berlin)

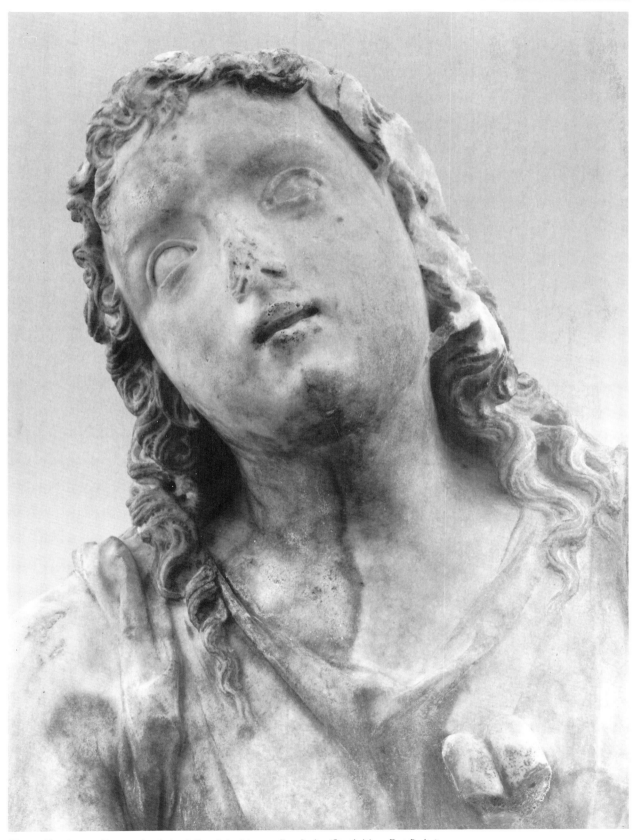

Pl. 90. Giambattista Bregno, detail, *Angel*, Staatliche Museen, East Berlin (Staatl. Mus., East Berlin)

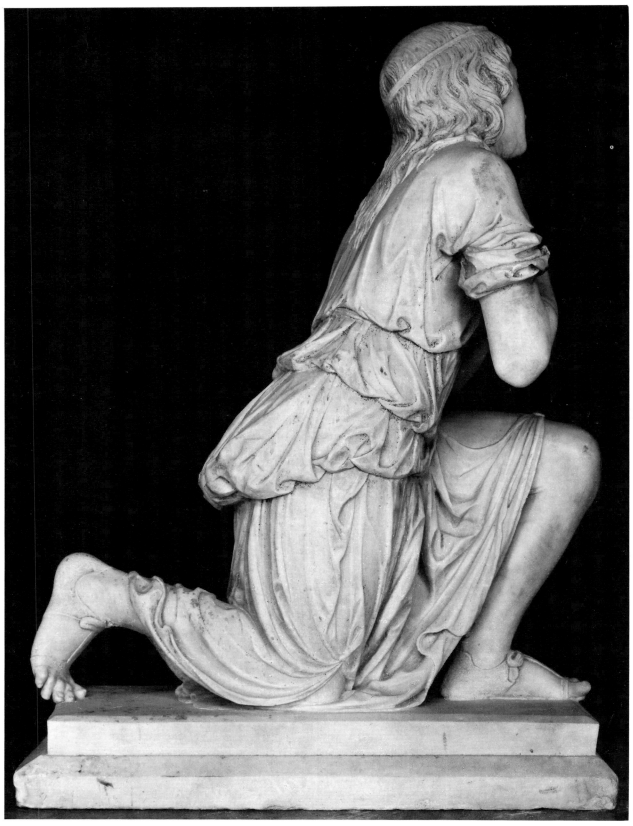

Pl. 91. Giambattista Bregno, *Angel*, sacristy, SS. Giovanni e Paolo, Venice (Giacomelli, Venice)

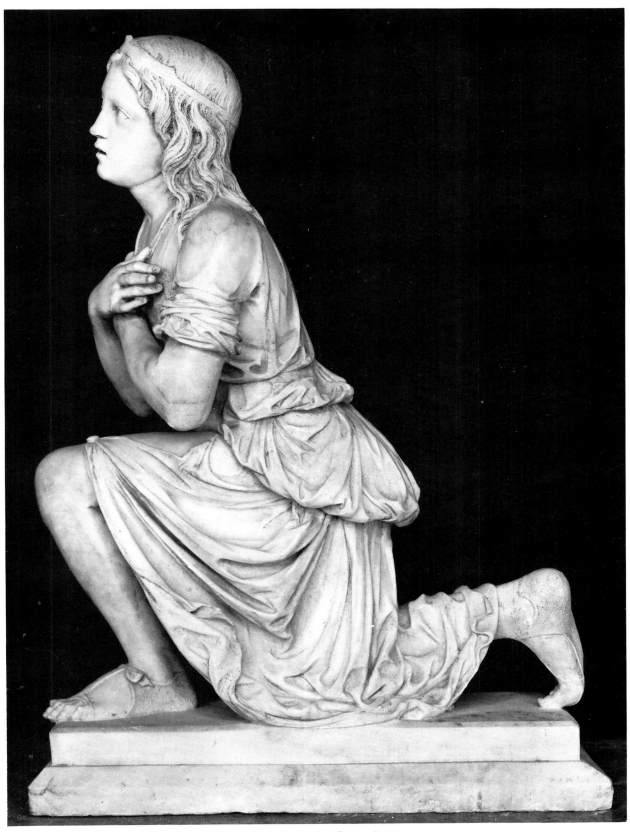

Pl. 92. Giambattista Bregno, *Angel*, sacristy, SS. Giovanni e Paolo, Venice (Giacomelli, Venice)

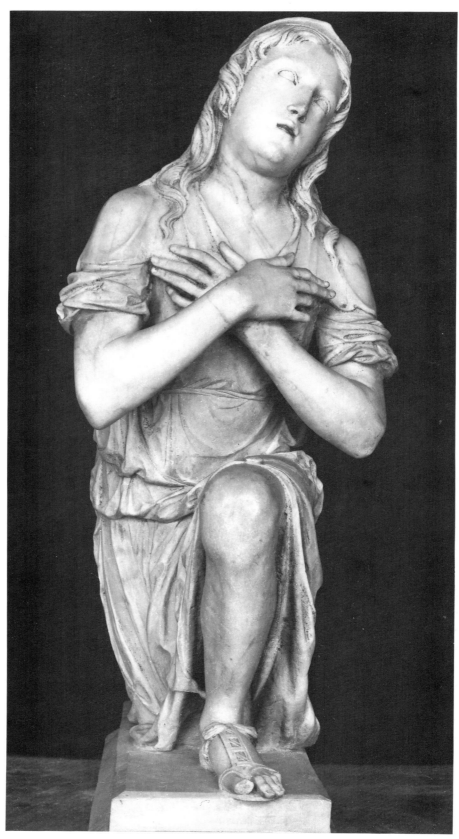

Pl. 93. Giambattista Bregno, *Angel*, sacristy, SS. Giovanni e Paolo, Venice (Giacomelli, Venice)

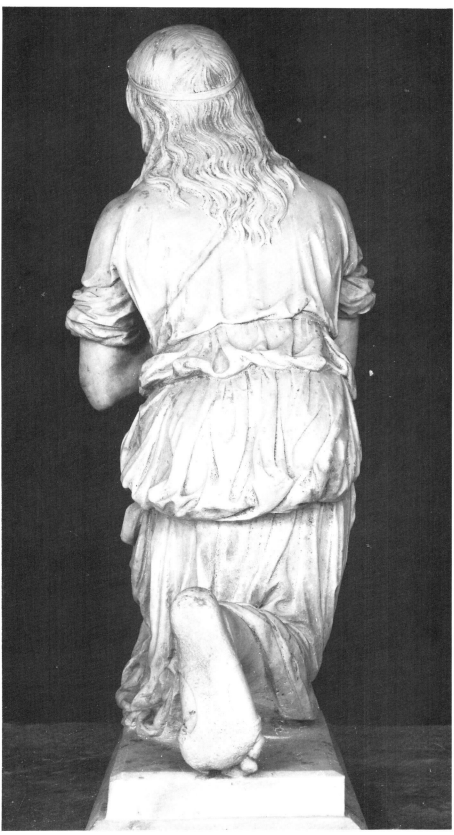

Pl. 94. Giambattista Bregno, *Angel*, sacristy, SS. Giovanni e Paolo, Venice (Giacomelli, Venice)

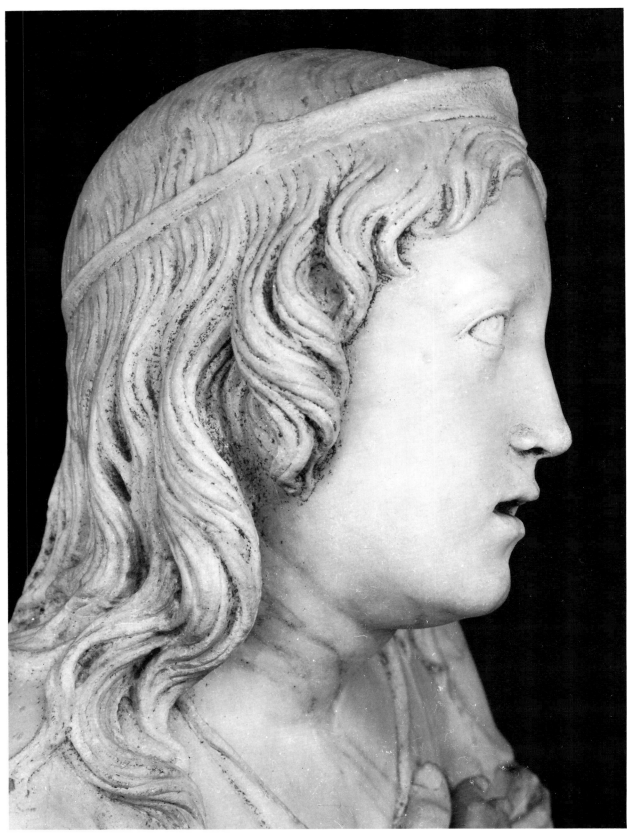

Pl. 95. Giambattista Bregno, detail, *Angel*, sacristy, SS. Giovanni e Paolo, Venice (Giacomelli, Venice)

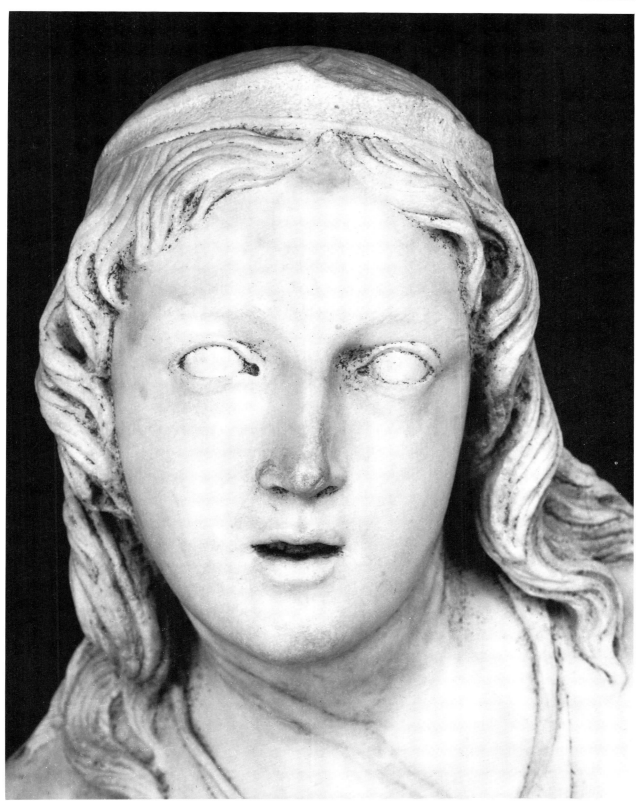

Pl. 96  Giambattista Bregno, detail, *Angel*, sacristy, SS. Giovanni e Paolo, Venice (Giacomelli, Venice)

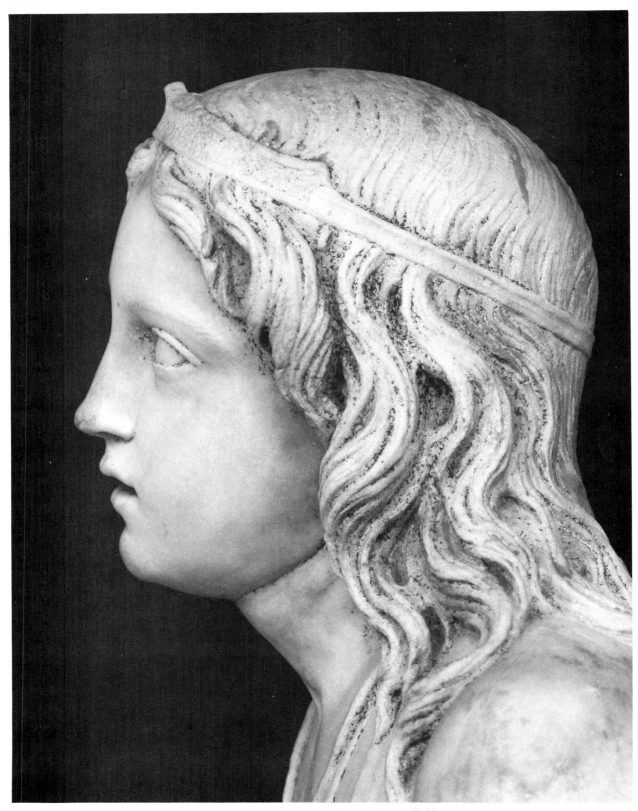

Pl. 97. Giambattista Bregno, detail, *Angel*, sacristy, SS. Giovanni e Paolo, Venice (Giacomelli, Venice)

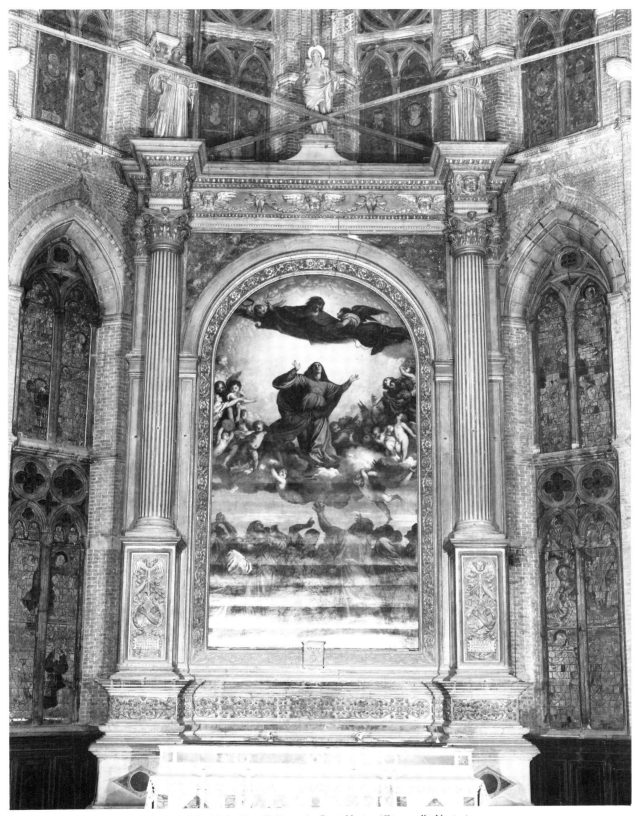

Pl. 98. Giambattista Bregno (?), frame of the High Altar, S. Maria dei Frari, Venice (Giacomelli, Venice)

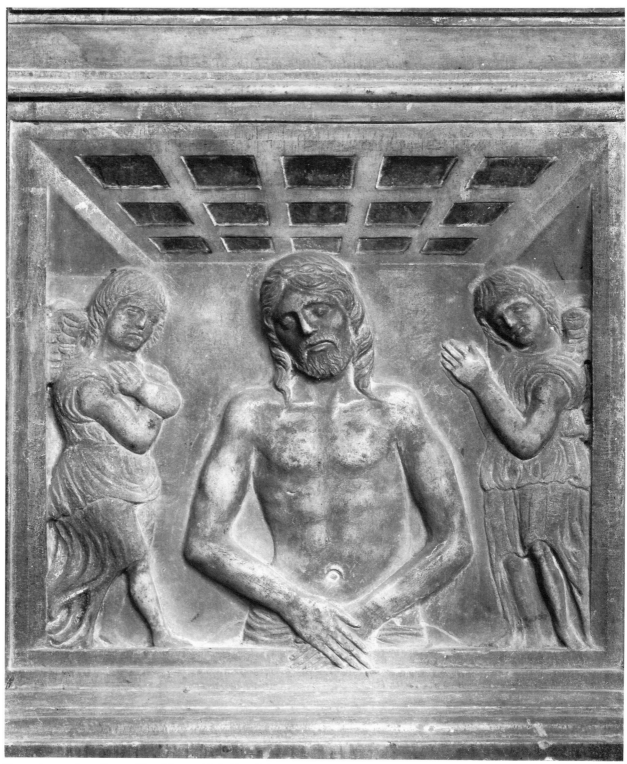

Pl. 99. Bregno shop, *Christ as Man of Sorrows*, High Altar, S. Maria dei Frari, Venice (Giacomelli, Venice)

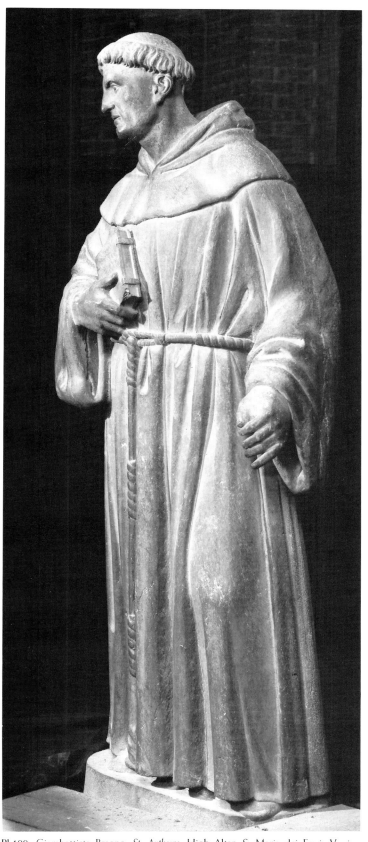

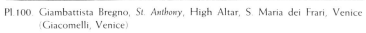

Pl.100. Giambattista Bregno, *St. Anthony*, High Altar, S. Maria dei Frari, Venice (Giacomelli, Venice)

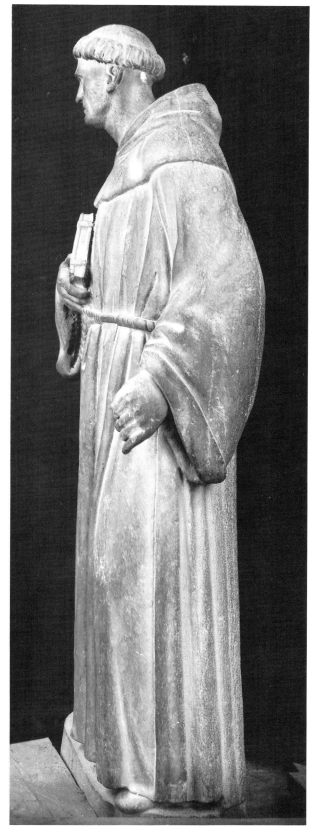

Pl.101. Giambattista Bregno, *St. Anthony*, High Altar, S. Maria dei Frari, Venice (Giacomelli, Venice)

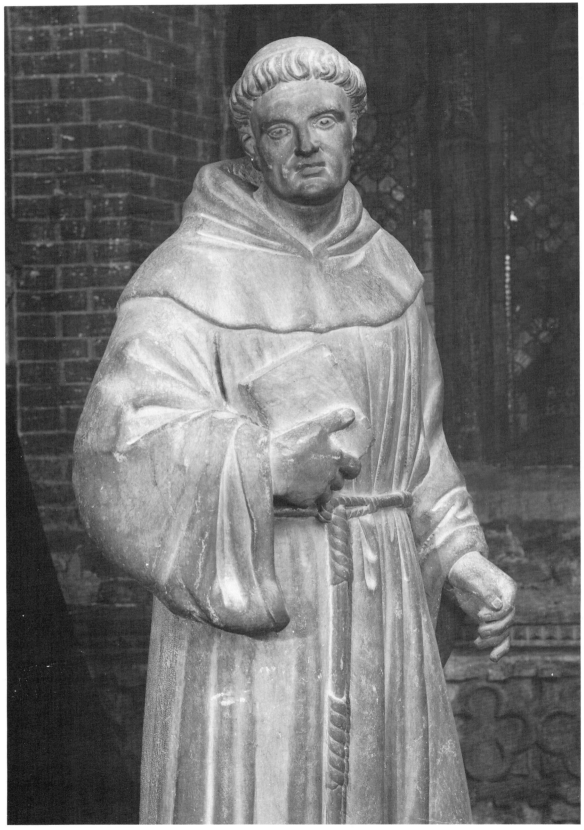

Pl. 102. Giambattista Bregno, detail, *St. Anthony*, High Altar, S. Maria dei Frari, Venice (Giacomelli, Venice)

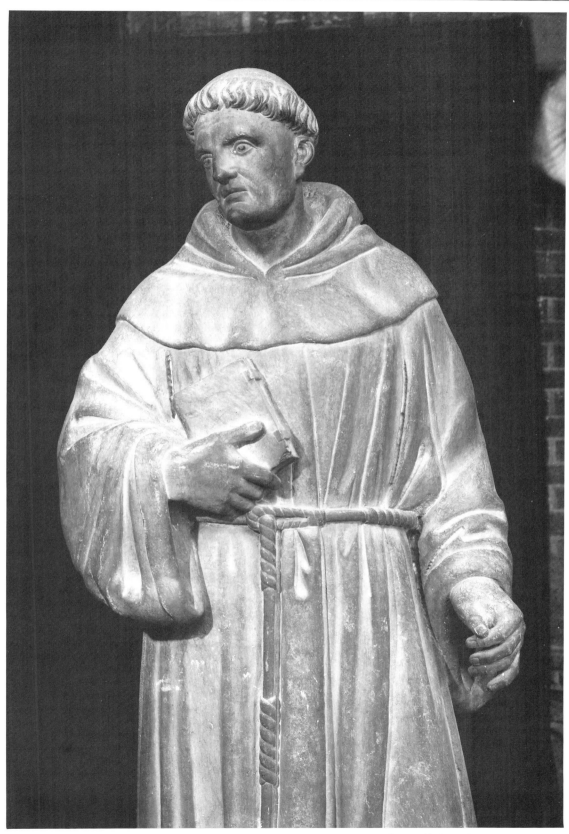

Pl. 103. Giambattista Bregno, detail, *St. Anthony*, High Altar, S. Maria dei Frari, Venice (Giacomelli, Venice)

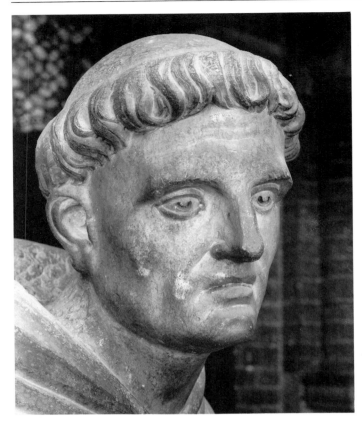

Pl.104. (Above) Giambattista Bregno, detail, *St. Anthony*, High Altar, S. Maria dei Frari, Venice (Giacomelli, Venice)

Pl.105. (Opposite) Giambattista Bregno, detail, *St. Anthony*, High Altar, S. Maria dei Frari, Venice (Giacomelli, Venice)

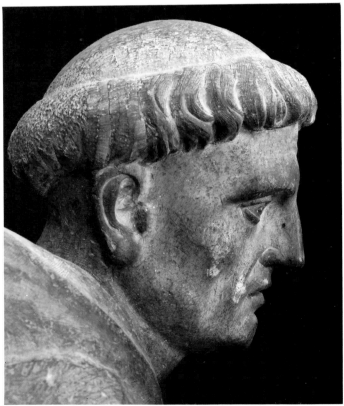

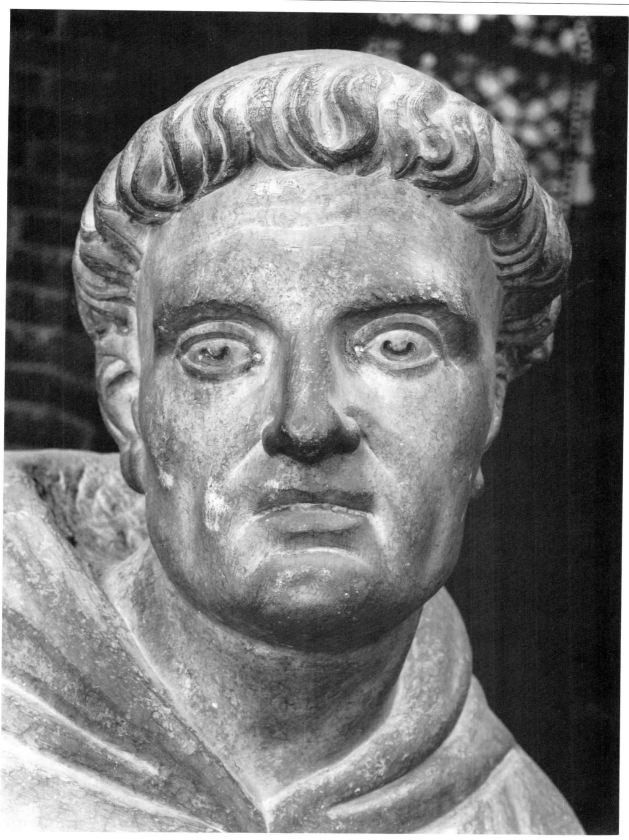

Pl.106. Giambattista Bregno, detail, *St. Anthony*, High Altar, S. Maria dei Frari, Venice (Giacomelli, Venice)

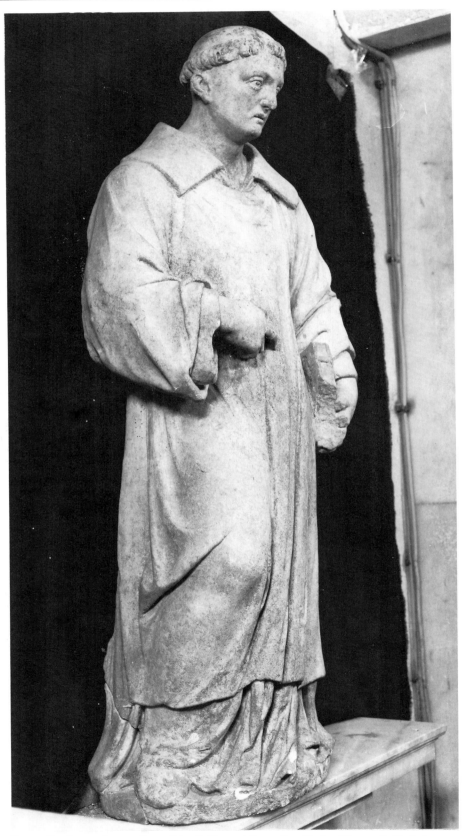

Pl.107. Giambattista Bregno, *Deacon Saint*, S. Giovanni Evangelista, Venice (Giacomelli, Venice)

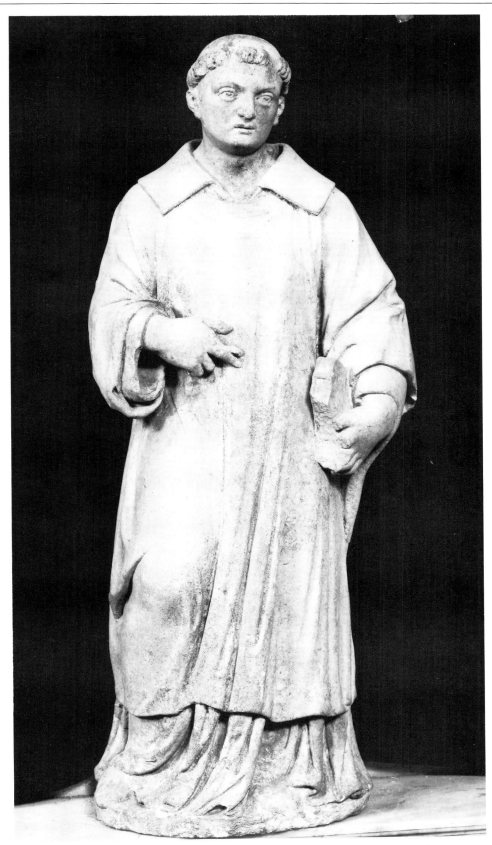

Pl.108.  Giambattista Bregno, *Deacon Saint*, S. Giovanni Evangelista, Venice (Giacomelli, Venice)

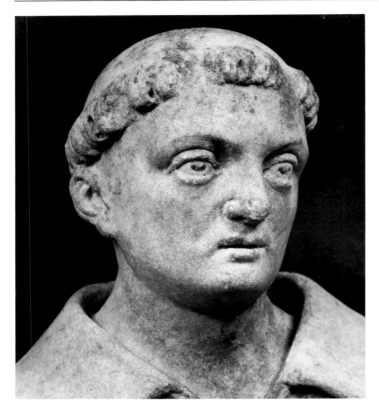

Pl. 109. (Above) Giambattista Bregno, detail, *Deacon Saint*, S. Giovanni Evangelista, Venice (Giacomelli, Venice)

Pl. 110. (Opposite) Giambattista Bregno, detail, *Deacon Saint*, S. Giovanni Evangelista, Venice (Giacomelli, Venice)

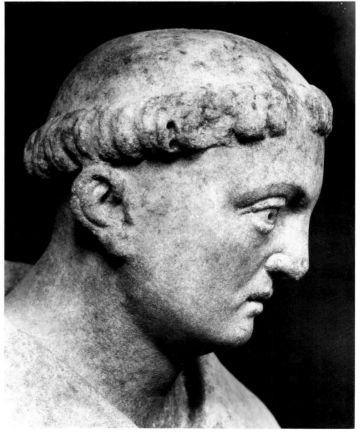

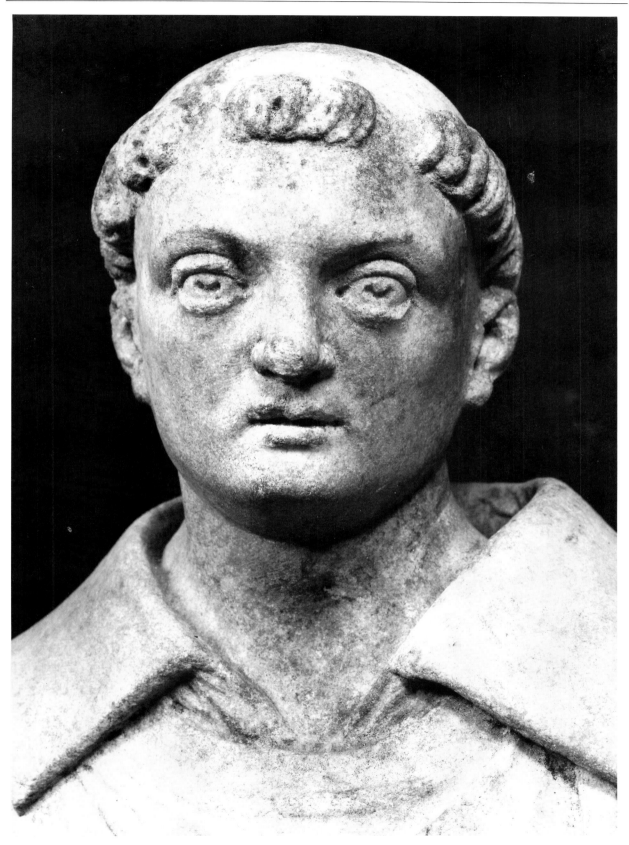

Pl.111. Giambattista Bregno, detail, *Deacon Saint*, S. Giovanni Evangelista, Venice (Giacomelli, Venice)

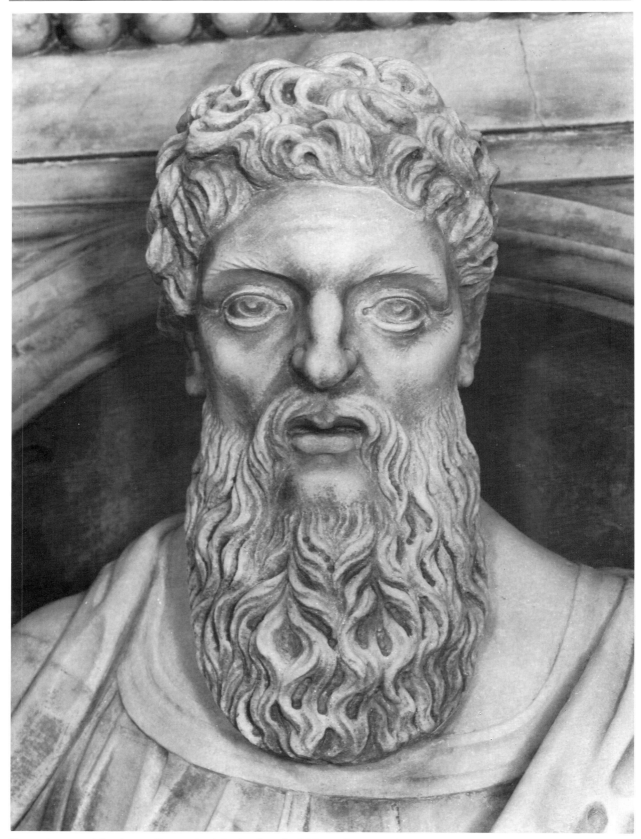

Pl.112. Assistant of Giambattista Bregno, detail, *Prophet*, Cappella del Santo, S. Antonio, Padua (Giacomelli, Venice)

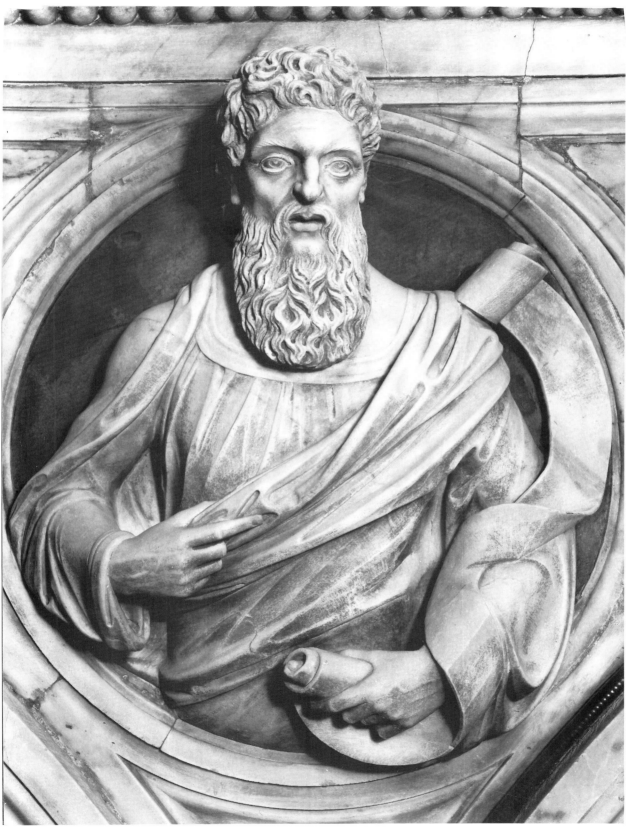

Pl.113. Assistant of Giambattista Bregno, *Prophet*, Cappella del Santo, S. Antonio, Padua (Giacomelli, Venice)

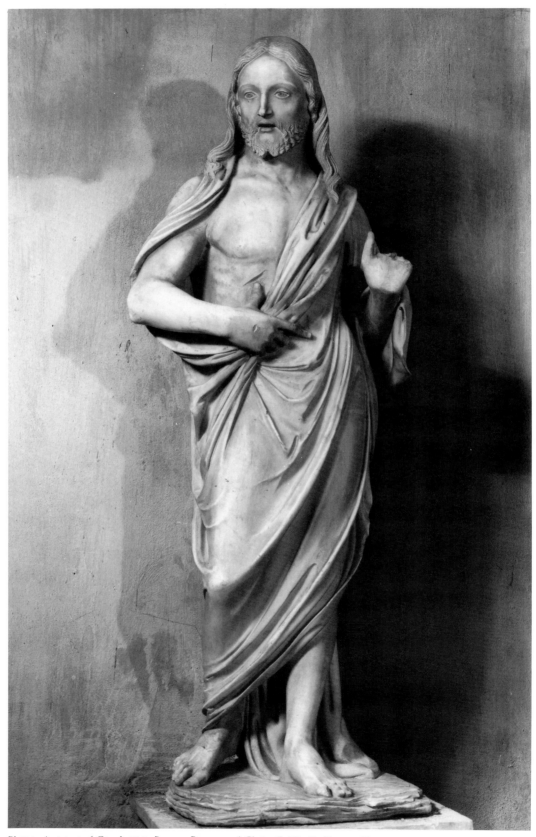

Pl.114. Assistant of Giambattista Bregno, Resurrected Christ, S. Nicolò, Treviso (Fini, Treviso)

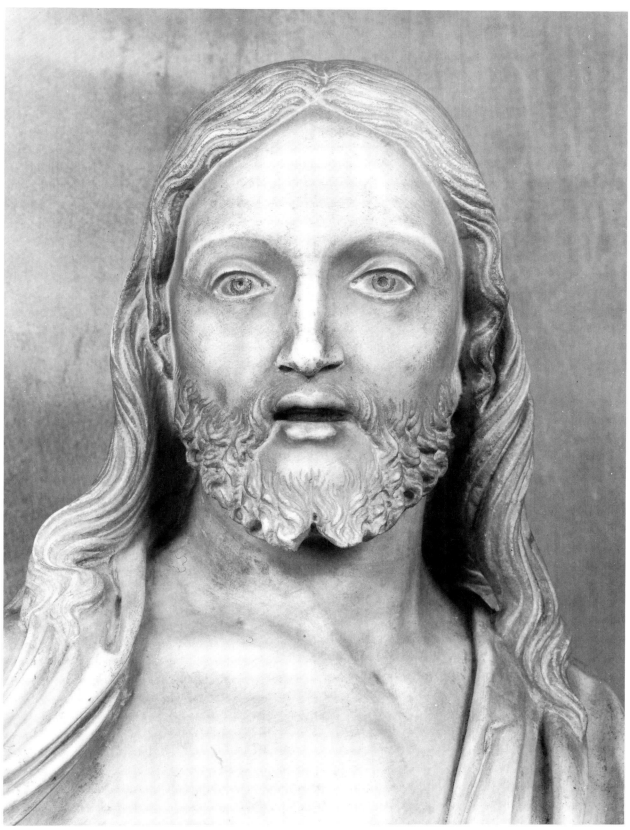

Pl.115. Assistant of Giambattista Bregno, detail, Resurrected Christ, S. Nicolò, Treviso (Fini, Treviso)

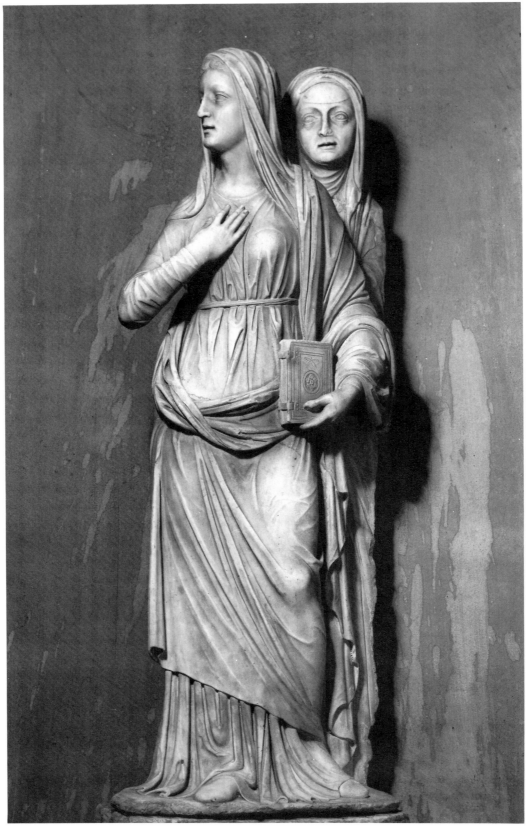

Pl.116. Assistant of Giambattista Bregno, Holy Women, S. Nicolò, Treviso (Fini, Treviso)

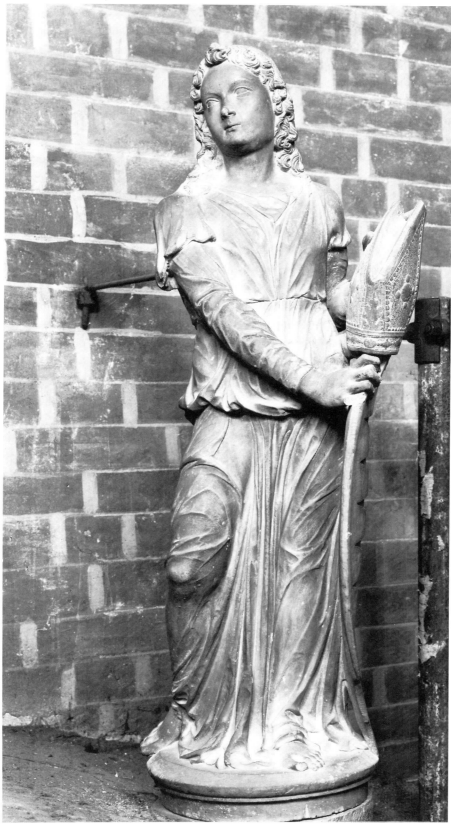

Pl.117.  Giambattista Bregno, right-hand *Reggiscudo*, Pesaro Altar, S. Maria dei Frari, Venice (Giacomelli, Venice)

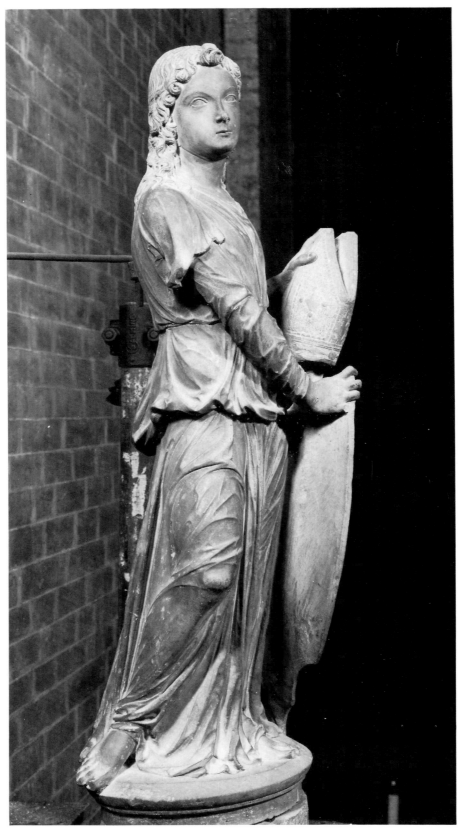

Pl.118.  Giambattista Bregno, right-hand *Reggiscudo*, Pesaro Altar, S. Maria dei Frari, Venice (Giacomelli, Venice)

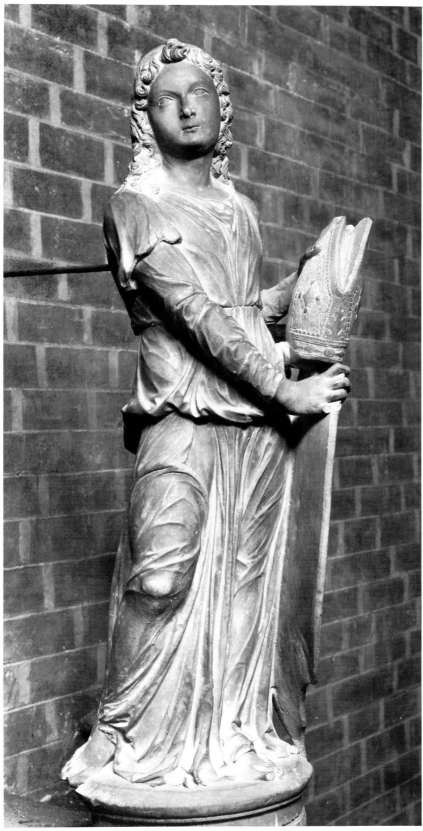

Pl.119.  Giambattista Bregno, right-hand *Reggiscudo*, Pesaro Altar, S. Maria dei Frari, Venice (Giaco-
melli, Venice)

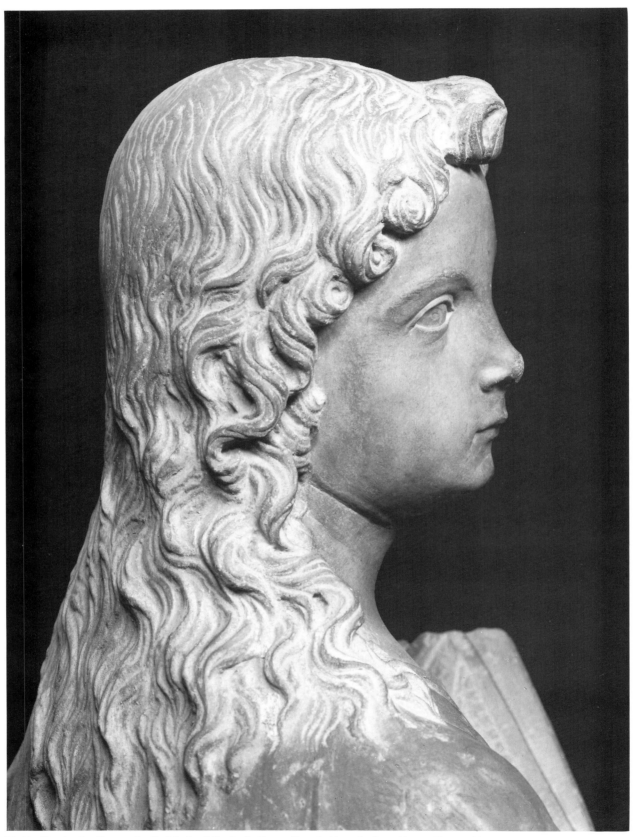

Pl.120. Giambattista Bregno, detail, right-hand *Reggiscudo*, Pesaro Altar, S. Maria dei Frari, Venice (Giacomelli, Venice)

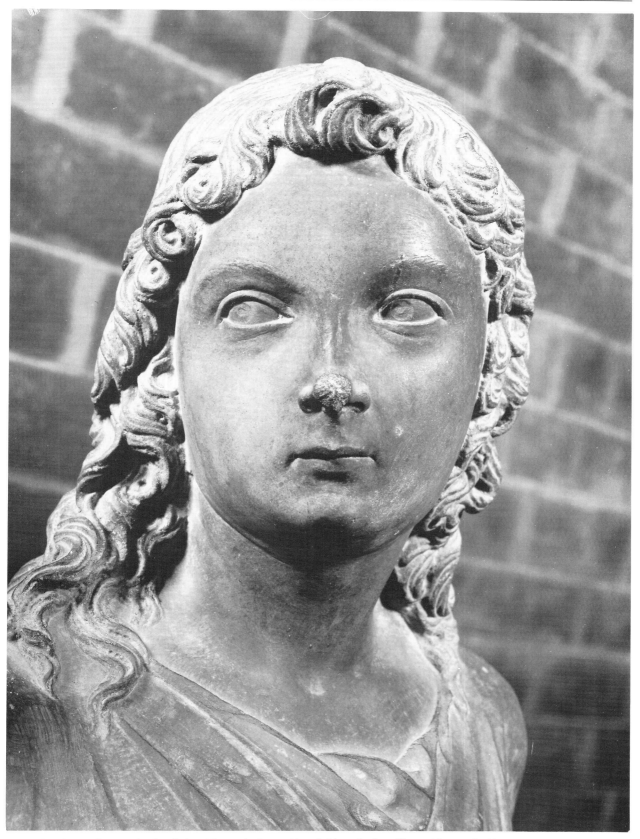

Pl.121. Giambattista Bregno, detail, right-hand *Reggiscudo*, Pesaro Altar, S. Maria dei Frari, Venice (Giacomelli, Venice)

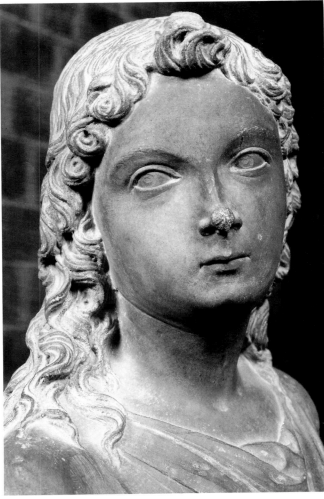

Pl.122. Giambattista Bregno, detail, right-hand *Reggiscudo*, Pesaro Altar, S. Maria dei Frari, Venice (Giacomelli, Venice)

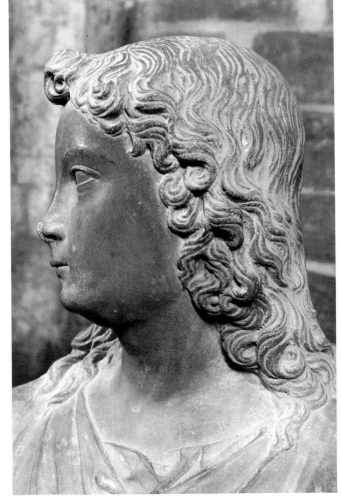

Pl.123. Giambattista Bregno, detail, right-hand *Reggiscudo*, Pesaro Altar, S. Maria dei Frari, Venice (Giacomelli, Venice)

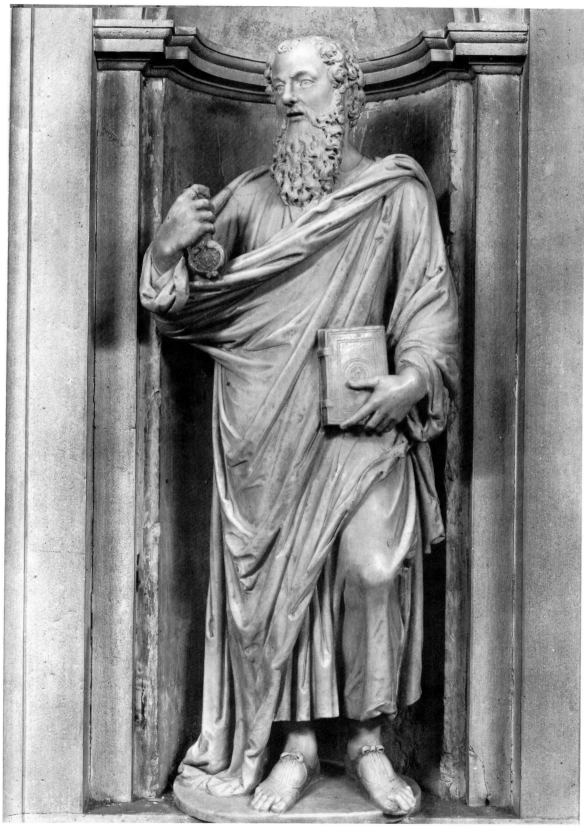

Pl.124. Lorenzo Bregno, *St. Paul*, Cappella del SS. Sacramento, Duomo, Treviso (Giacomelli, Venice)

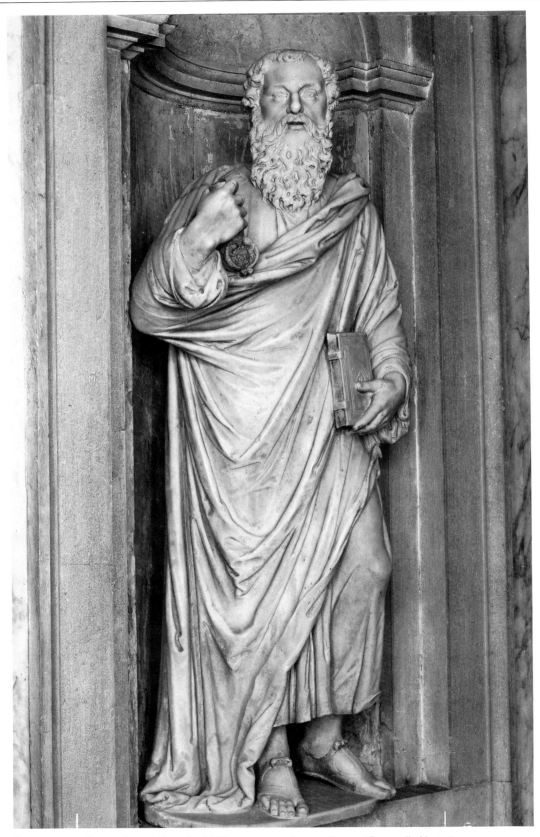

Pl.125. Lorenzo Bregno, *St. Paul*, Cappella del SS. Sacramento, Duomo, Treviso (Giacomelli, Venice)

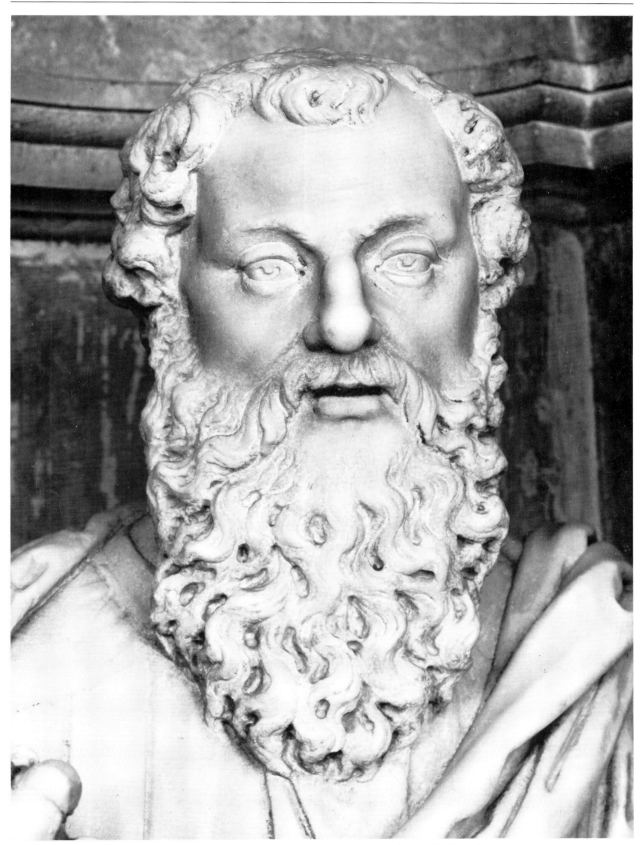

Pl.126. Lorenzo Bregno, detail, *St. Paul*, Cappella del SS. Sacramento, Duomo, Treviso (Giacomelli, Venice)

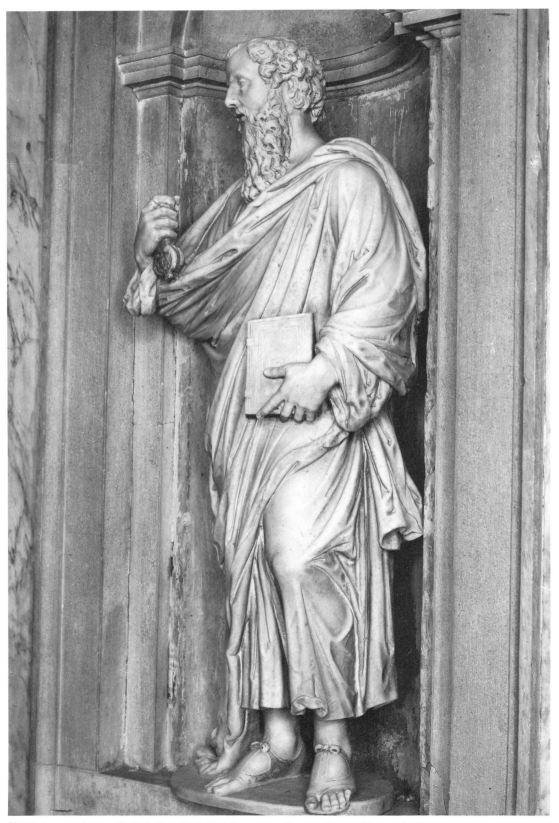

Pl.127. Lorenzo Bregno, *St. Paul*, Cappella del SS. Sacramento, Duomo, Treviso (Giacomelli, Venice)

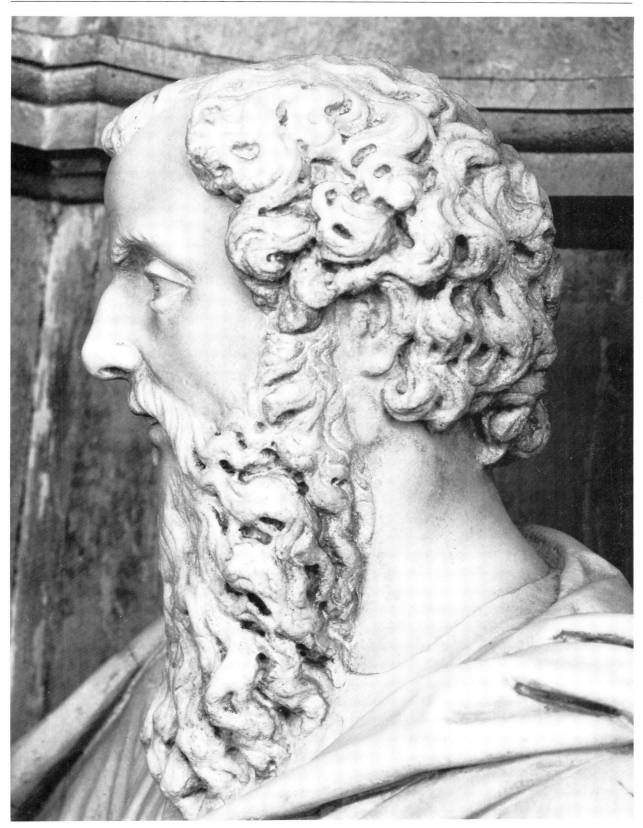

Pl.128. Lorenzo Bregno, detail, *St. Paul*, Cappella del SS. Sacramento, Duomo, Treviso (Giacomelli, Venice)

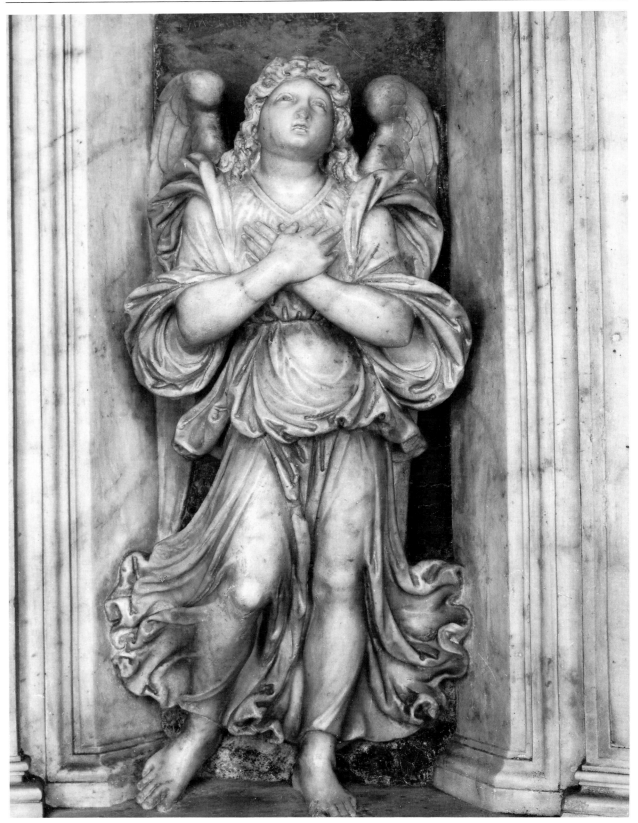

Pl.129.  Lorenzo Bregno, *Angel* from the altarpiece, Cappella del SS. Sacramento, Duomo, Treviso (Giacomelli, Venice)

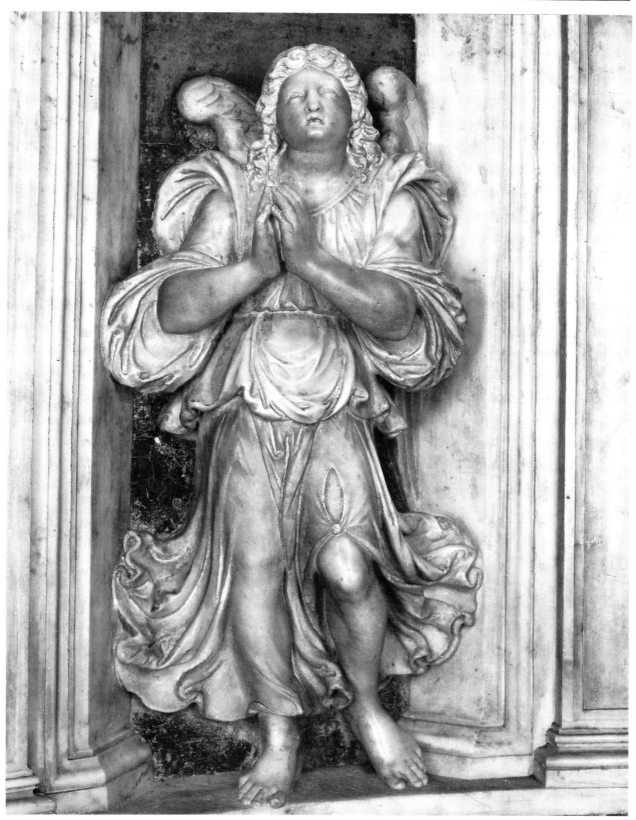

Pl.130. Lorenzo Bregno, *Angel* from the altarpiece, Cappella del SS. Sacramento, Duomo, Treviso (Giacomelli, Venice)

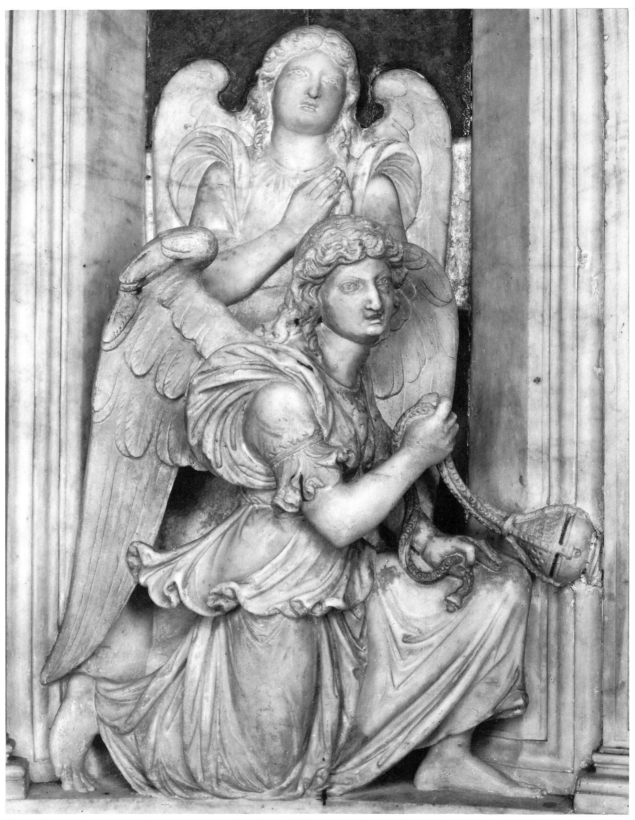

Pl.131. Lorenzo Bregno, *Angels* from the altarpiece, Cappella del SS. Sacramento, Duomo, Treviso (Giacomelli, Venice)

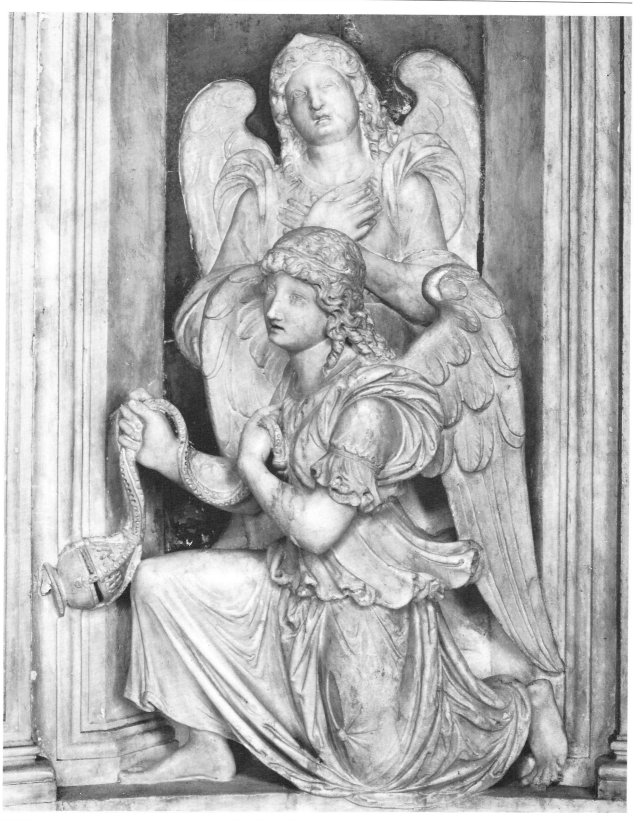

Pl.132. Lorenzo Bregno, *Angels* from the altarpiece, Cappella del SS. Sacramento, Duomo, Treviso (Giacomelli, Venice)

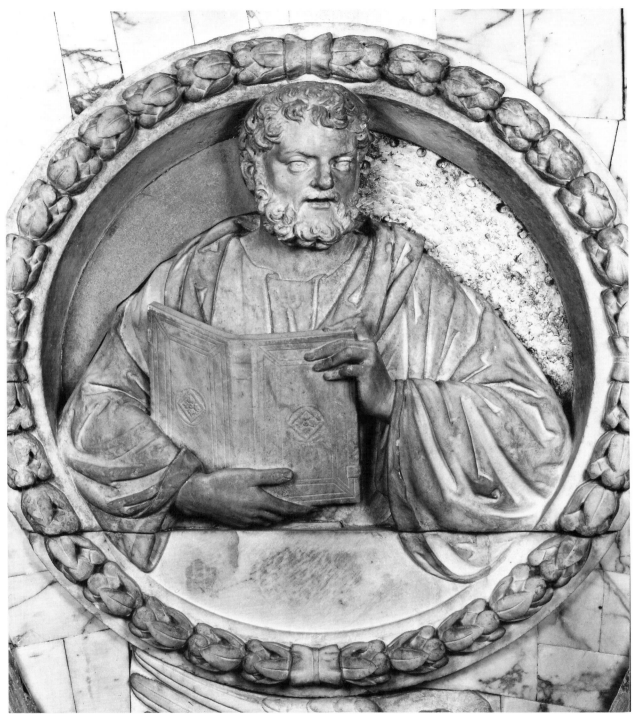

Pl.133. Lorenzo Bregno, *St. Mark*, Cappella del SS. Sacramento, Duomo, Treviso (Giacomelli, Venice)

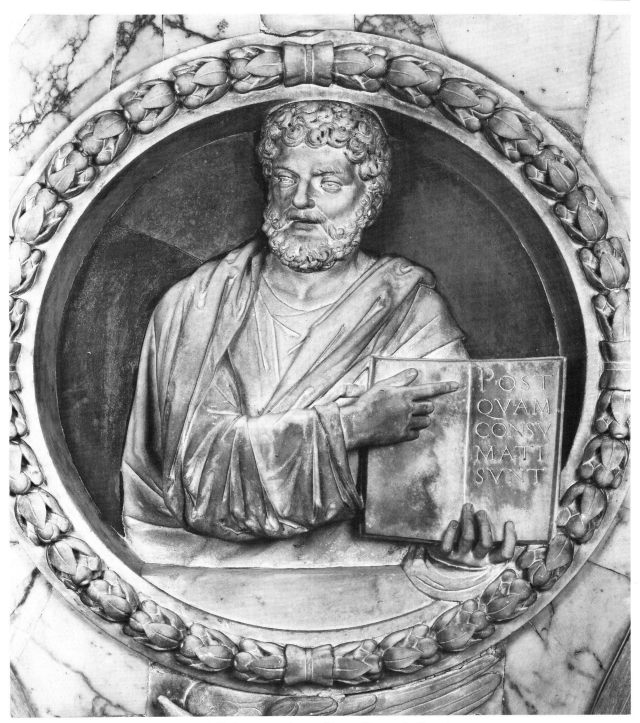

Pl.134. Lorenzo Bregno, *St. Luke*, Cappella del SS. Sacramento, Duomo, Treviso (Giacomelli, Venice)

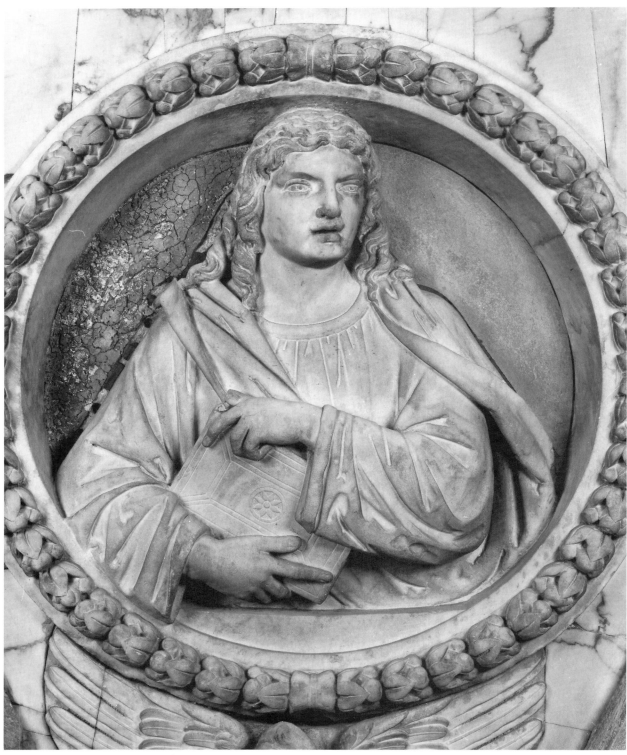

Pl.135. Lorenzo Bregno, *St. John the Evangelist*, Cappella del SS. Sacramento, Duomo, Treviso (Giacomelli, Venice)

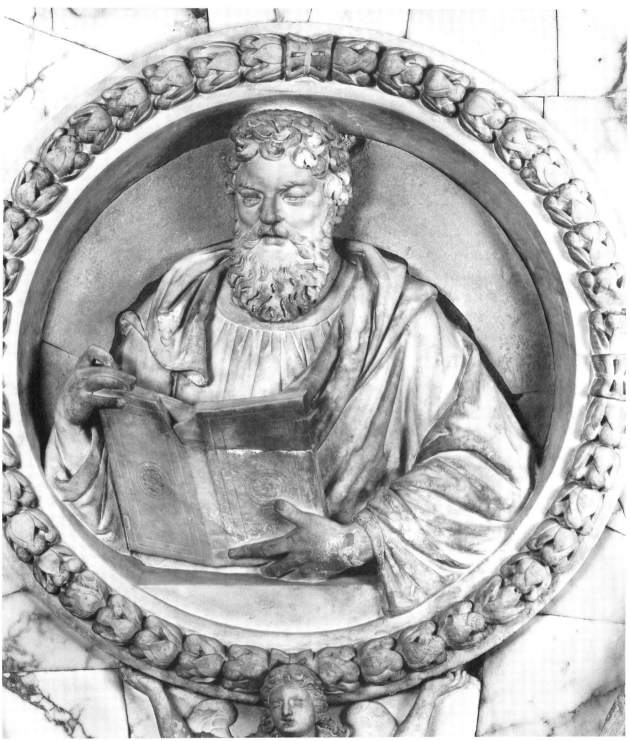

Pl.136. Lorenzo Bregno, *St. Matthew*, Cappella del SS. Sacramento, Duomo, Treviso (Giacomelli, Venice)

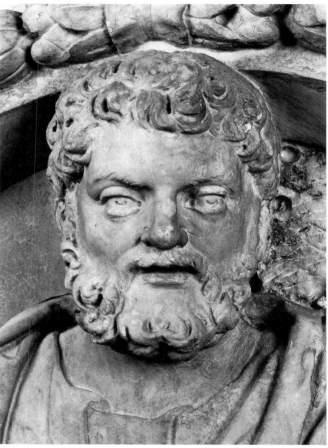

Pl.137. Lorenzo Bregno, detail, *St. Mark*, Cappella del SS. Sacramento, Duomo, Treviso (Giacomelli, Venice)

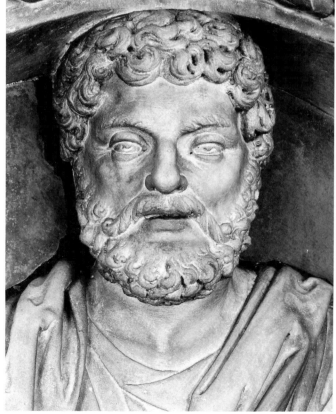

Pl.138. Lorenzo Bregno, detail, *St. Luke*, Cappella del SS. Sacramento, Duomo, Treviso (Giacomelli, Venice)

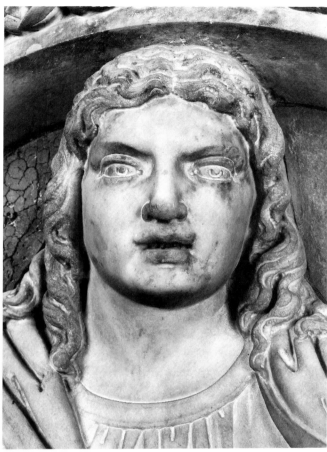

Pl.139. Lorenzo Bregno, detail, *St. John the Evangelist*, Cappella del SS. Sacramento, Duomo, Treviso (Giacomelli, Venice)

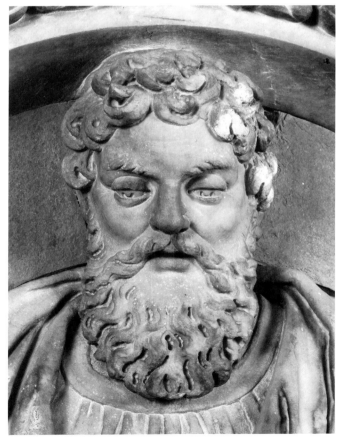

Pl.140. Lorenzo Bregno, detail, *St. Matthew*, Cappella del SS. Sacramento, Duomo, Treviso (Giacomelli, Venice)

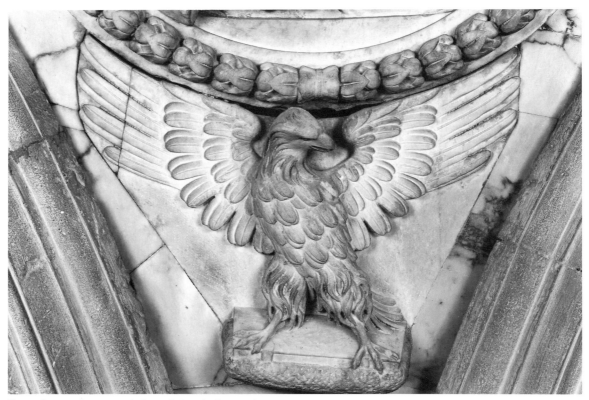

Pl.141. Lorenzo Bregno, eagle beneath *St. John the Evangelist*, Cappella del SS. Sacramento, Duomo, Treviso (Giacomelli, Venice)

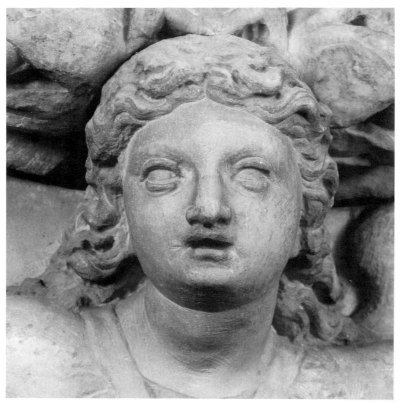

Pl.142. Lorenzo Bregno, detail, angel beneath *St. Matthew*, Cappella del SS. Sacramento, Duomo, Treviso (Giacomelli, Venice)

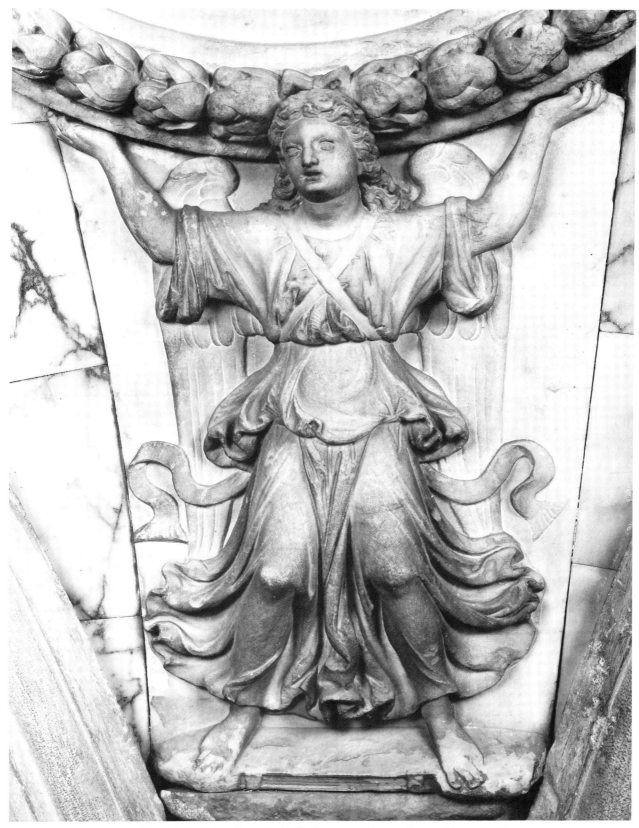

Pl.143. Lorenzo Bregno, angel beneath *St. Matthew*, Cappella del SS. Sacramento, Duomo, Treviso (Giacomelli, Venice)

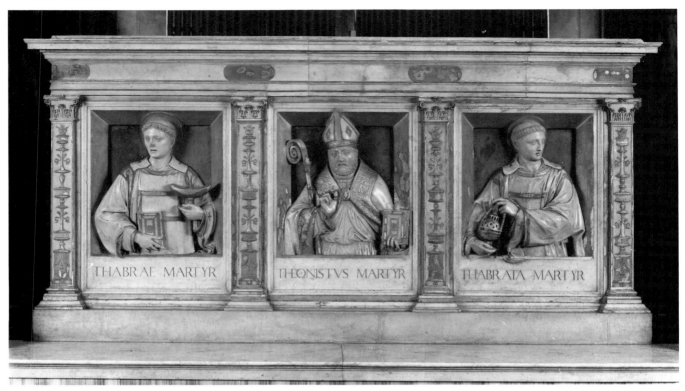

THABRAE MARTYR    THEONISTVS MARTYR    THABRATA MARTYR

Pl.144.  (Above) Lorenzo Bregno, Shrine of SS. Theonistus, Tabra, and Tabrata, High Altar, Duomo, Treviso (Giacomelli, Venice)

Pl.145.  (Opposite) Lorenzo Bregno, pilaster, Shrine of SS. Theonistus, Tabra, and Tabrata, High Altar, Duomo, Treviso (Giacomelli, Venice)

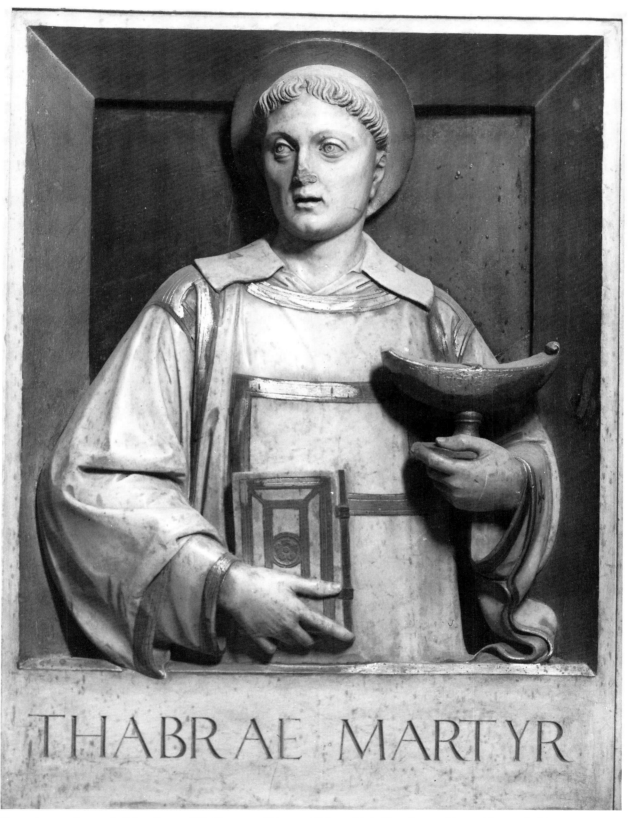

THABRAE MARTYR

Pl.146. Lorenzo Bregno, *St. Tabra*, Shrine of SS. Theonistus, Tabra, and Tabrata, High Altar, Duomo, Treviso (Giacomelli, Venice)

Pl.147. Lorenzo Bregno, detail, *St. Tabra*, Shrine of SS. Theonistus, Tabra, and Tabrata, High Altar, Duomo, Treviso (Giacomelli, Venice)

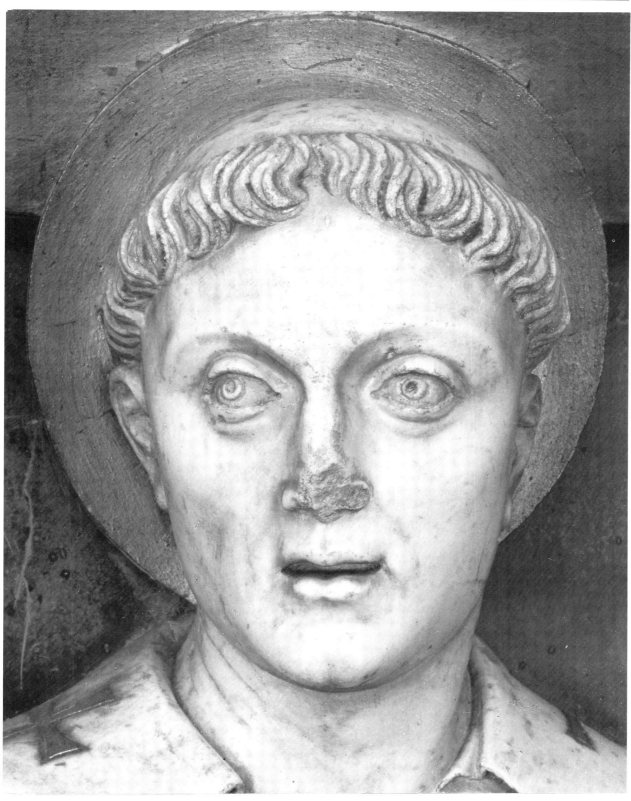

Pl.148. Lorenzo Bregno, detail, *St. Tabra*, Shrine of SS. Theonistus, Tabra, and Tabrata, High Altar, Duomo, Treviso (Giacomelli, Venice)

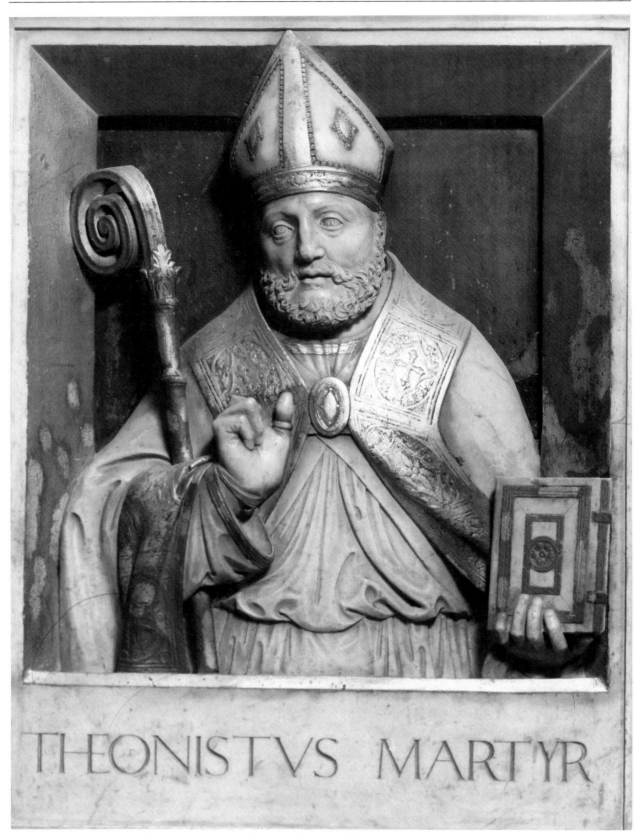

Pl.149. Lorenzo Bregno, *St. Theonistus*, Shrine of SS. Theonistus, Tabra, and Tabrata, High Altar, Duomo, Treviso (Giacomelli, Venice)

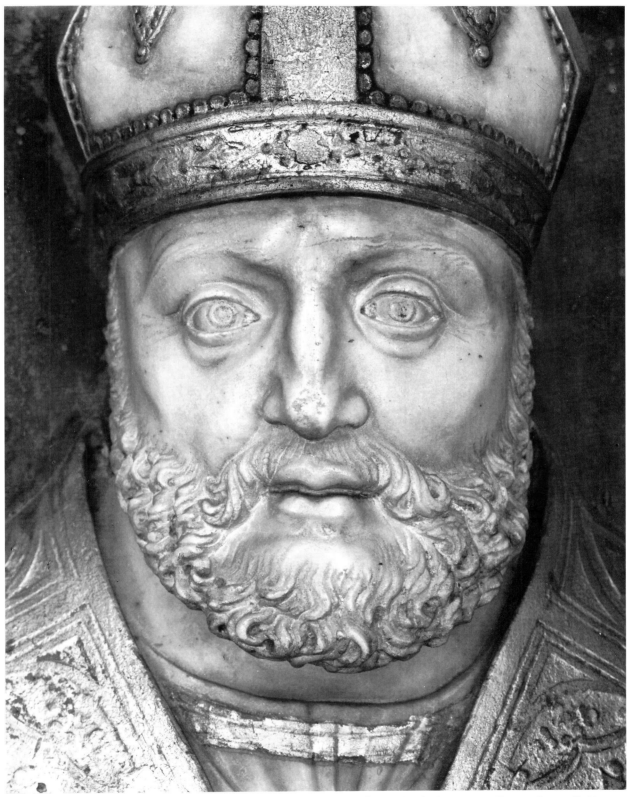

Pl.150. Lorenzo Bregno, detail, *St. Theonistus*, Shrine of SS. Theonistus, Tabra, and Tabrata, High Altar, Duomo, Treviso (Giacomelli, Venice)

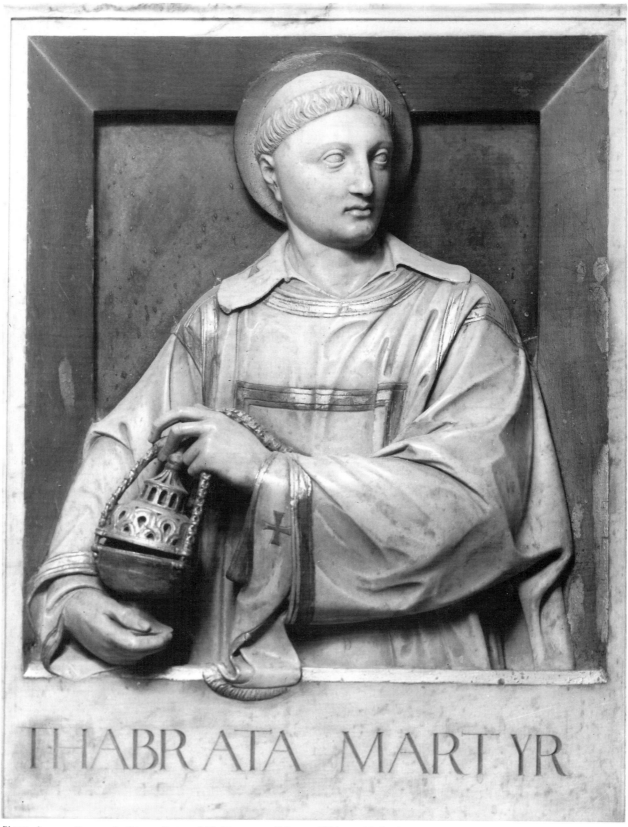

Pl.151. Lorenzo Bregno, *St. Tabrata*, Shrine of SS. Theonistus, Tabra, and Tabrata, High Altar, Duomo, Treviso (Giacomelli, Venice)

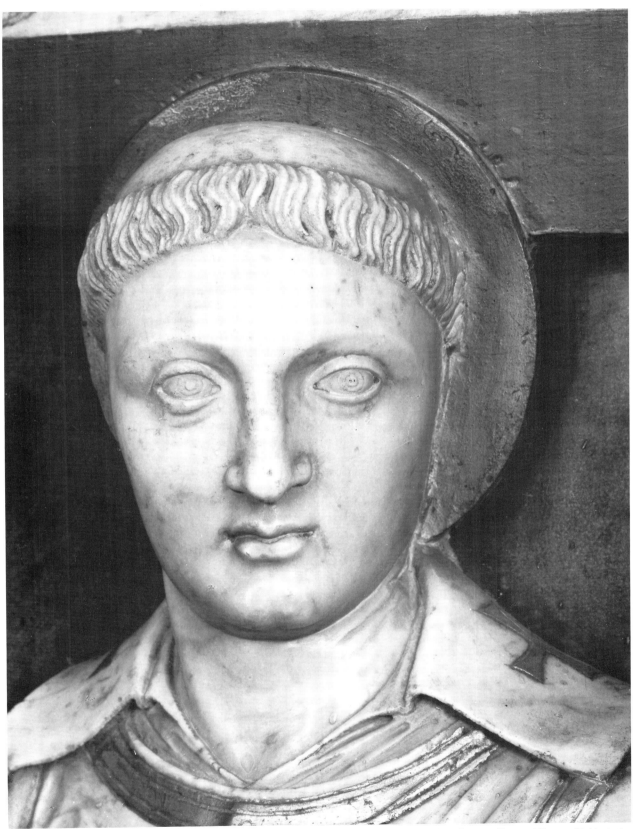

Pl.152. Lorenzo Bregno, detail, *St. Tabrata*, Shrine of SS. Theonistus, Tabra, and Tabrata, High Altar, Duomo, Treviso (Giacomelli, Venice)

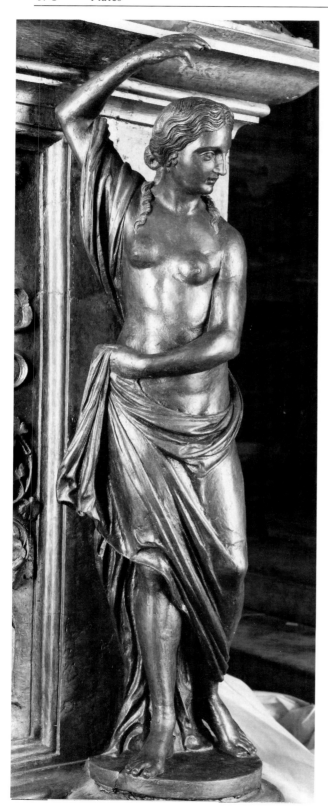

Pl.153. Lorenzo Bregno, Female figure, Sarcophagus of Cardinal Zen, Cappella Zen, S. Marco, Venice (Giacomelli, Venice)

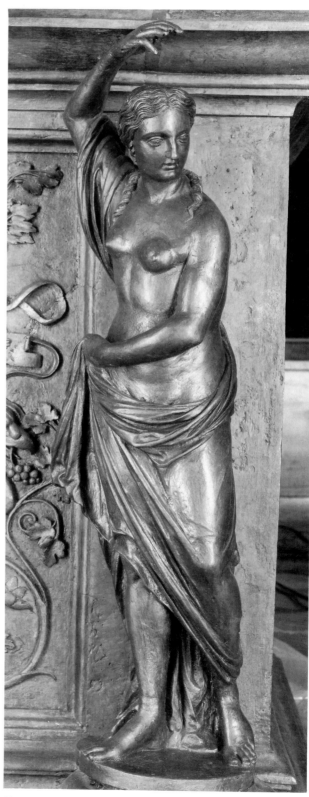

Pl.154. Lorenzo Bregno, Female figure, Sarcophagus of Cardinal Zen, Cappella Zen, S. Marco, Venice (Giacomelli, Venice)

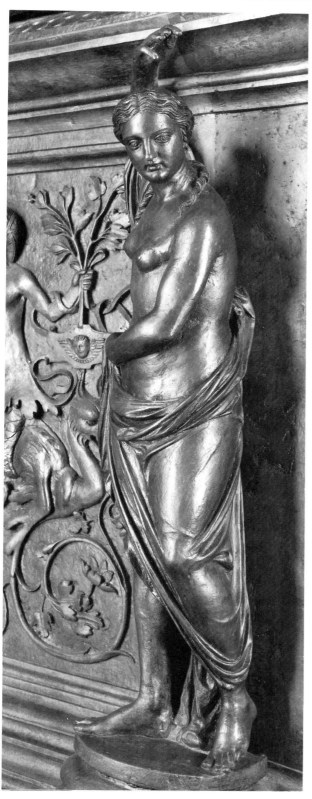

Pl.155.  Lorenzo Bregno, Female figure, Sarcophagus of Cardinal Zen,
Cappella Zen, S. Marco, Venice (Giacomelli, Venice)

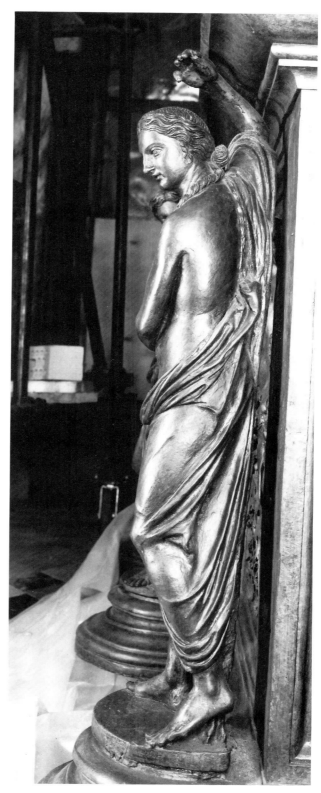

Pl.156.  Lorenzo Bregno, Female figure, Sarcophagus of Cardinal Zen,
Cappella Zen, S. Marco, Venice (Giacomelli, Venice)

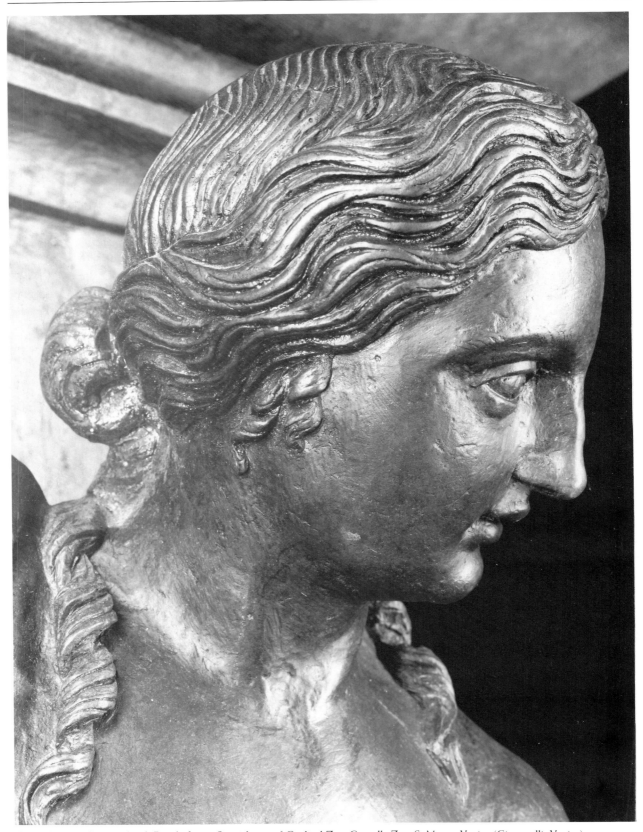

Pl.157. Lorenzo Bregno, detail, Female figure, Sarcophagus of Cardinal Zen, Cappella Zen, S. Marco, Venice (Giacomelli, Venice)

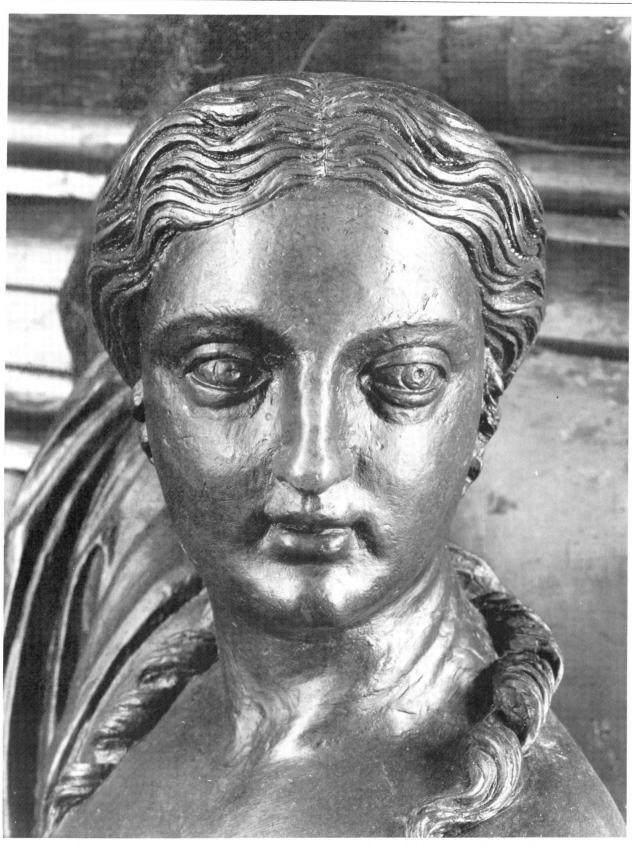

Pl.158. Lorenzo Bregno, detail, Female figure, Sarcophagus of Cardinal Zen, Cappella Zen, S. Marco, Venice (Giacomelli, Venice)

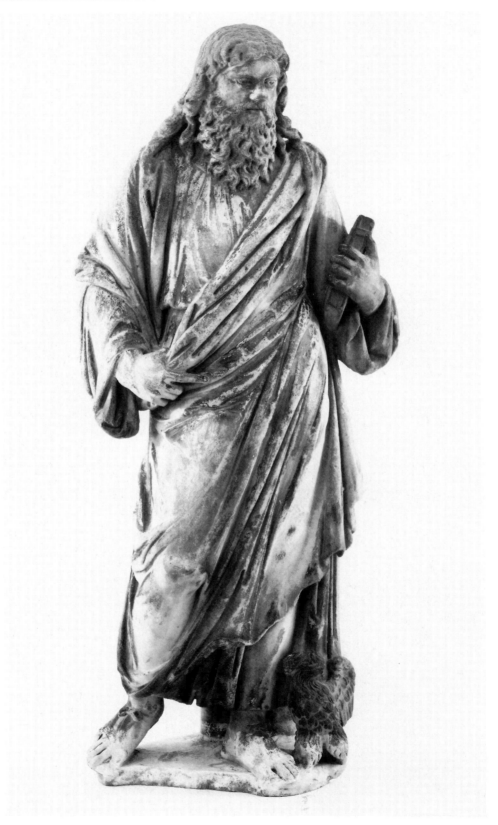

Pl.159. Lorenzo Bregno, *St. John the Evangelist*, Staatliche Museen, East Berlin (Staatl. Mus., East Berlin)

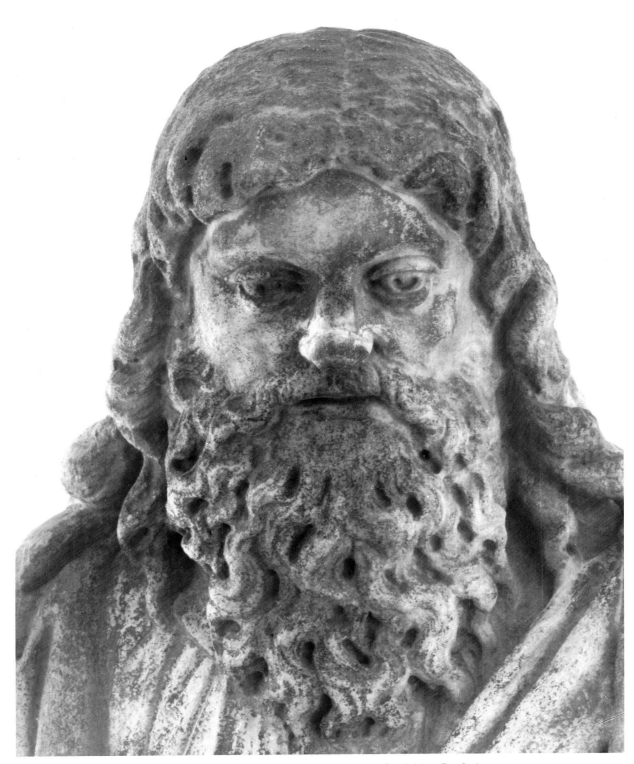

Pl.160. Lorenzo Bregno, detail, *St. John the Evangelist*, Staatliche Museen, East Berlin (Staatl. Mus., East Berlin)

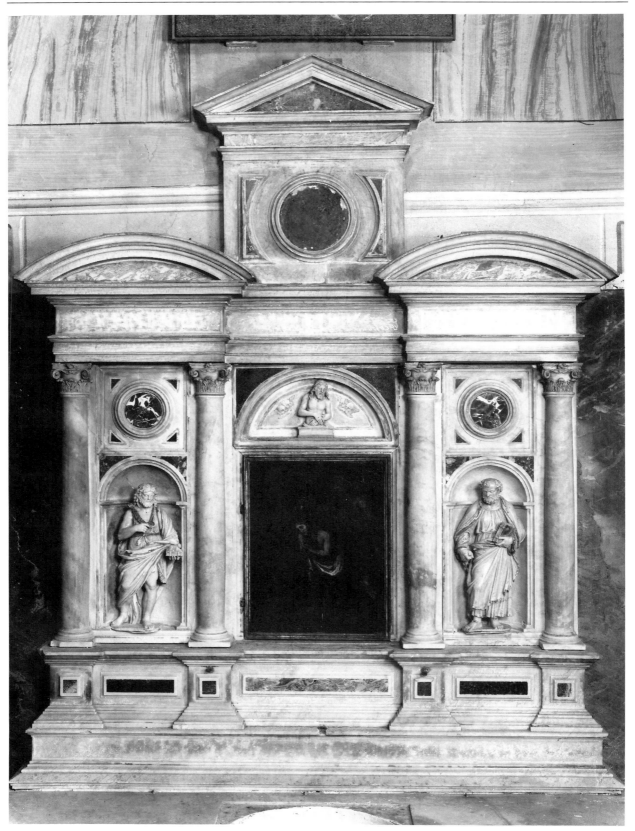

Pl.161. Lorenzo Bregno, Altarpiece from S. Sepolcro, S. Martino, Venice (Giacomelli, Venice)

Pl.162. Lorenzo Bregno, capital, Altarpiece from S. Sepolcro,
S. Martino, Venice (Giacomelli, Venice)

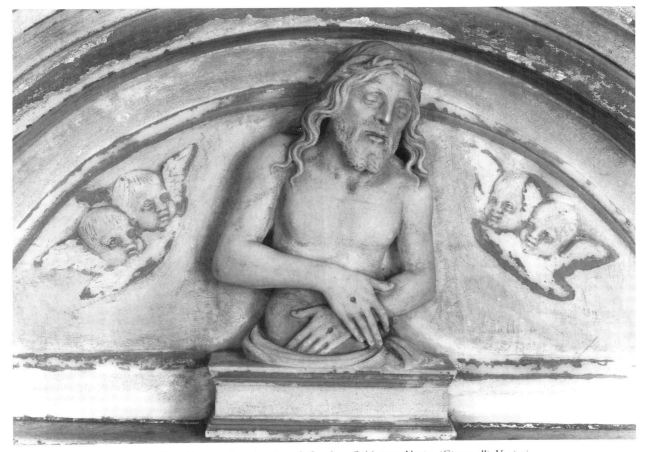

Pl.163. Lorenzo Bregno, *Christ as Man of Sorrows*, Altarpiece from S. Sepolcro, S. Martino, Venice (Giacomelli, Venice)

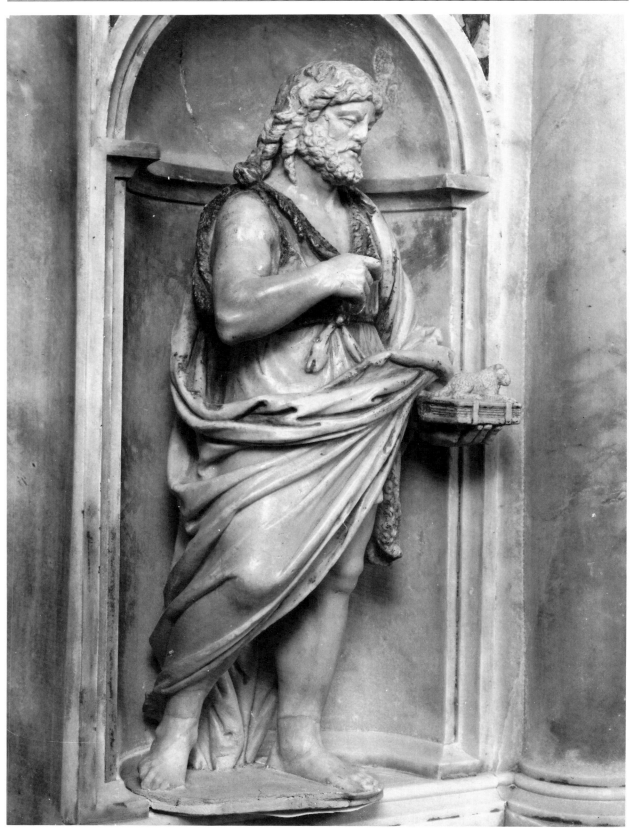

Pl.164. Lorenzo Bregno, *St. John the Baptist*, Altarpiece from S. Sepolcro, S. Martino, Venice (Giacomelli, Venice)

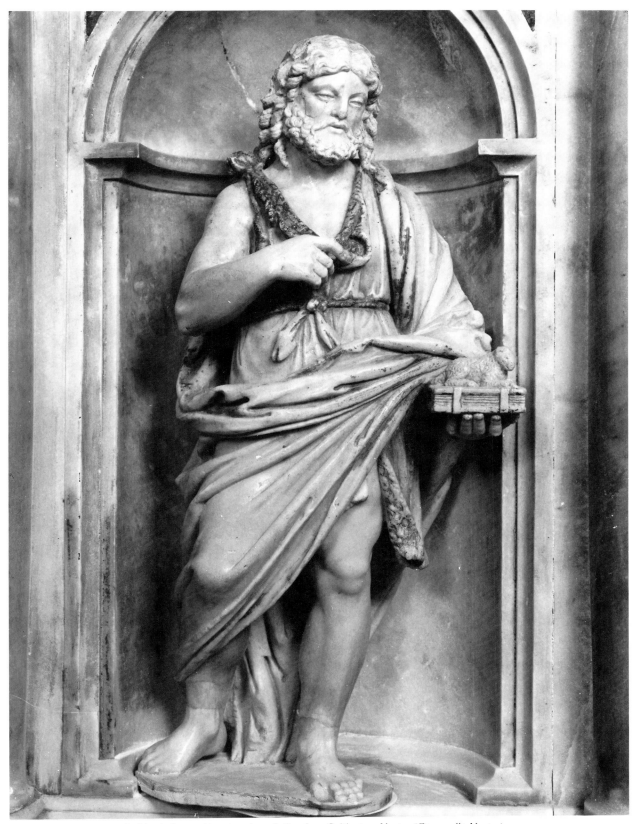

Pl.165. Lorenzo Bregno, *St. John the Baptist*, Altarpiece from S. Sepolcro, S. Martino, Venice (Giacomelli, Venice)

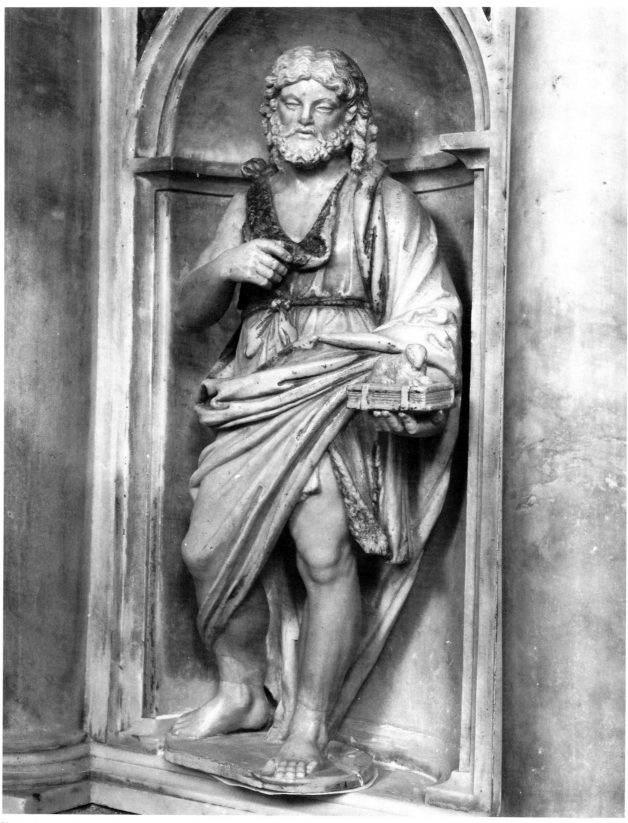

Pl.166. Lorenzo Bregno, *St. John the Baptist*, Altarpiece from S. Sepolcro, S. Martino, Venice (Giacomelli, Venice)

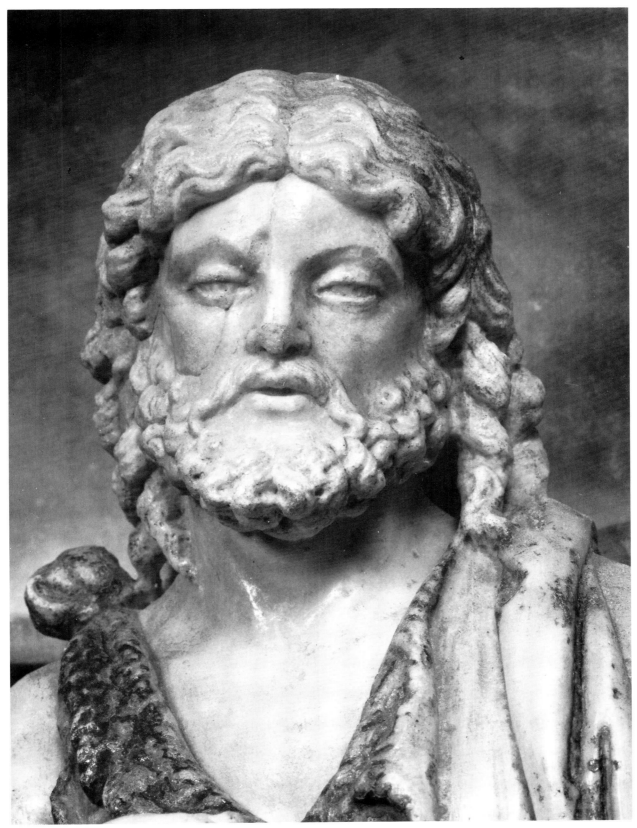

Pl.167. Lorenzo Bregno, detail, *St. John the Baptist*, Altarpiece from S. Sepolcro, S. Martino, Venice (Giacomelli, Venice)

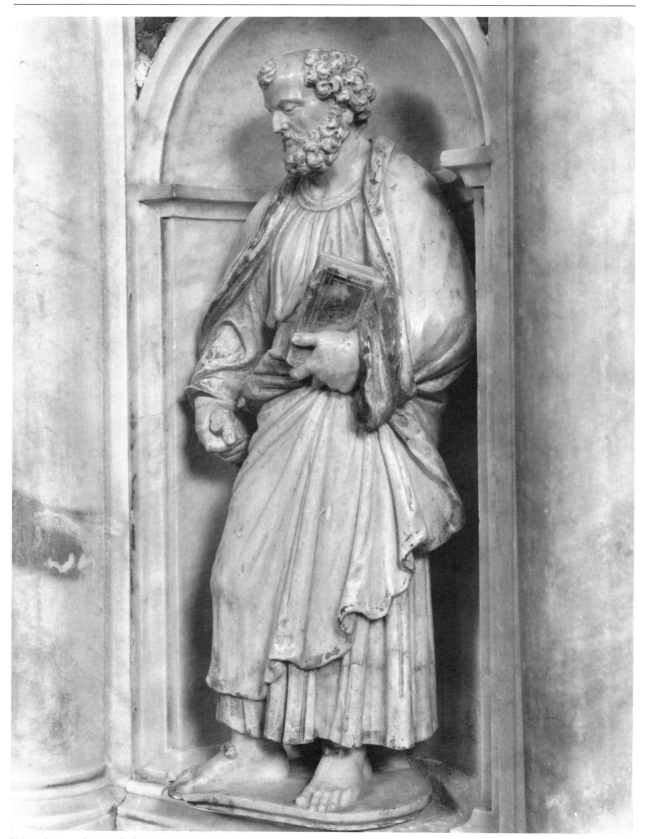

Pl.168. Lorenzo Bregno, *St. Peter*, Altarpiece from S. Sepolcro, S. Martino, Venice (Giacomelli, Venice)

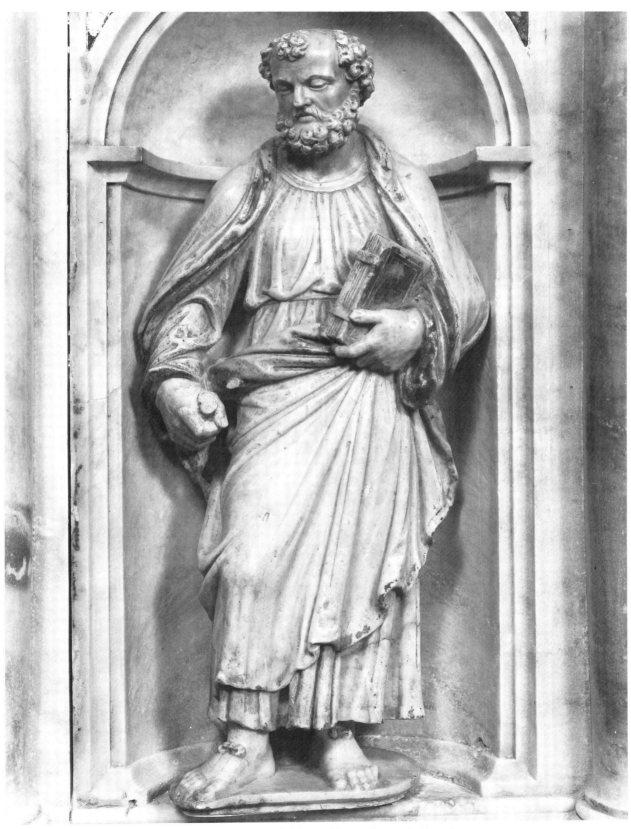

Pl.169. Lorenzo Bregno, *St. Peter*, Altarpiece from S. Sepolcro, S. Martino, Venice (Giacomelli, Venice)

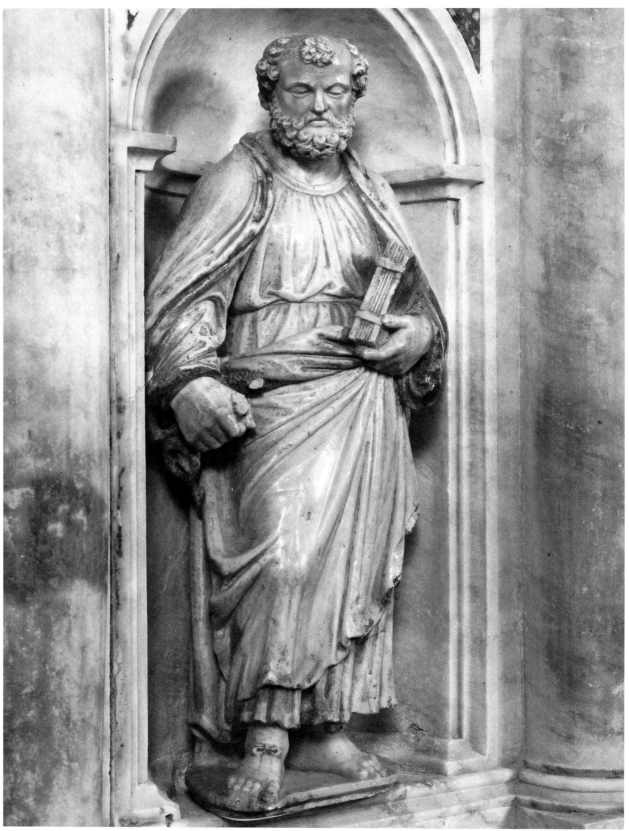

Pl.170. Lorenzo Bregno, *St. Peter*, Altarpiece from S. Sepolcro, S. Martino, Venice (Giacomelli, Venice)

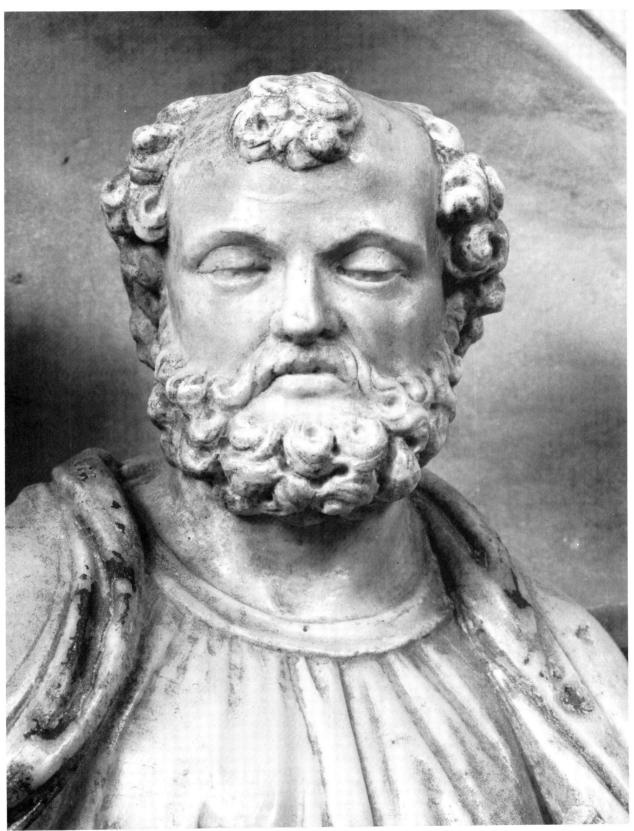

Pl.171. Lorenzo Bregno, detail, *St. Peter*, Altarpiece from S. Sepolcro, S. Martino, Venice (Giacomelli, Venice)

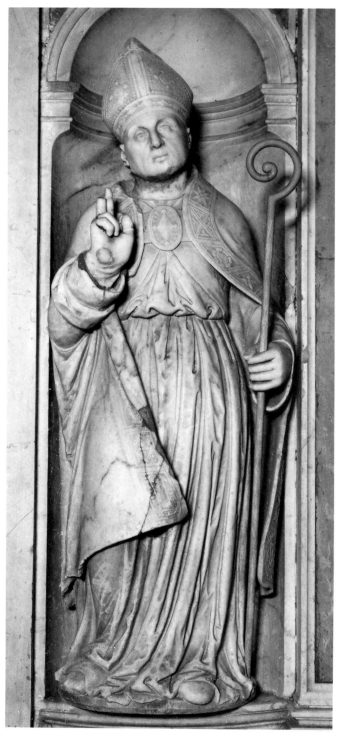

Pl.172. Lorenzo Bregno and assistant, *St. Martin of Tours*, Duomo, Belluno
(Sopr. ai Beni Artistici e Storici del Veneto, Venice)

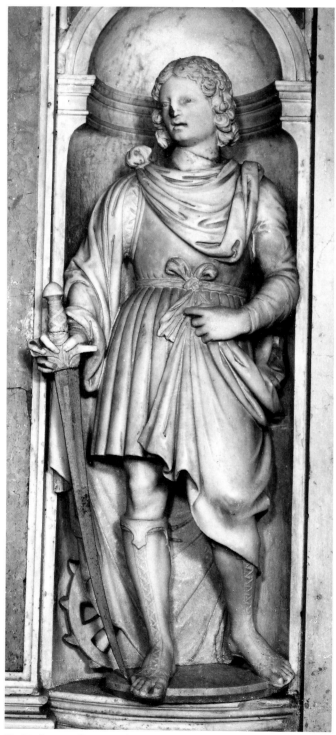

Pl.173. Lorenzo Bregno and assistant, *St. Joathas*, Duomo, Belluno (Sopr. ai
Beni Artistici e Storici del Veneto, Venice)

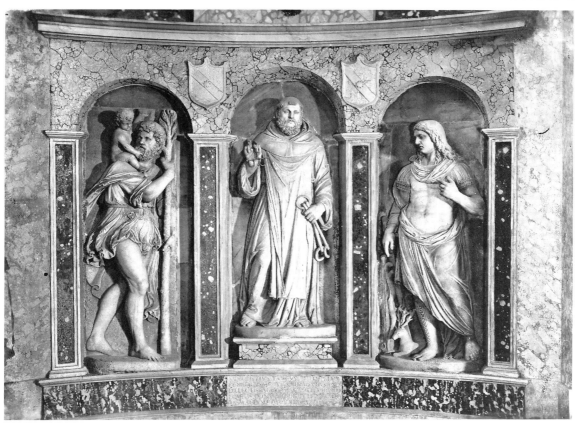

Pl.174. (Above) Lorenzo Bregno, Altar of St. Leonard, Duomo, Cesena (Alinari, Florence)

Pl.175. (Opposite) Lorenzo Bregno, detail, *St. Eustace*, Altar of St. Leonard, Duomo, Cesena (Zangheri, Cesena)

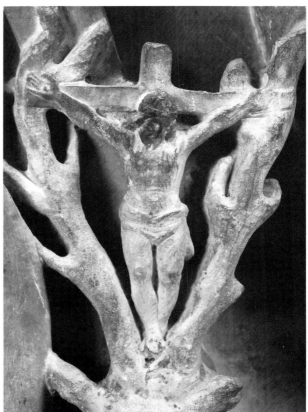

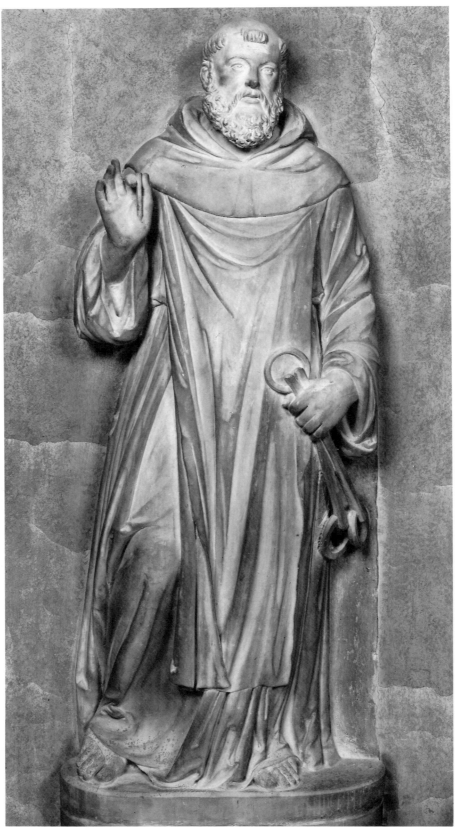

Pl.176. Lorenzo Bregno, *St. Leonard*, Altar of St. Leonard, Duomo, Cesena (Zangheri, Cesena)

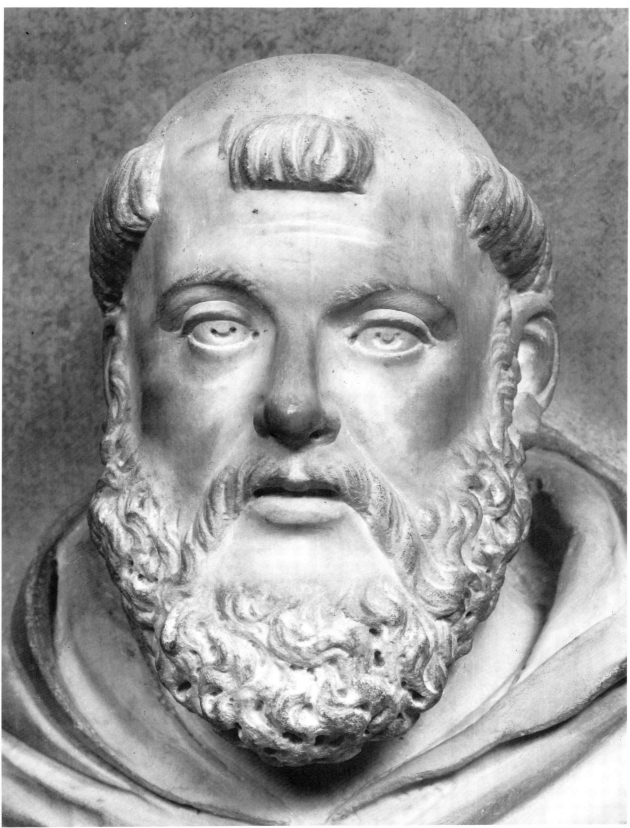

Pl.177. Lorenzo Bregno, detail, *St. Leonard*, Altar of St. Leonard, Duomo, Cesena (Zangheri, Cesena)

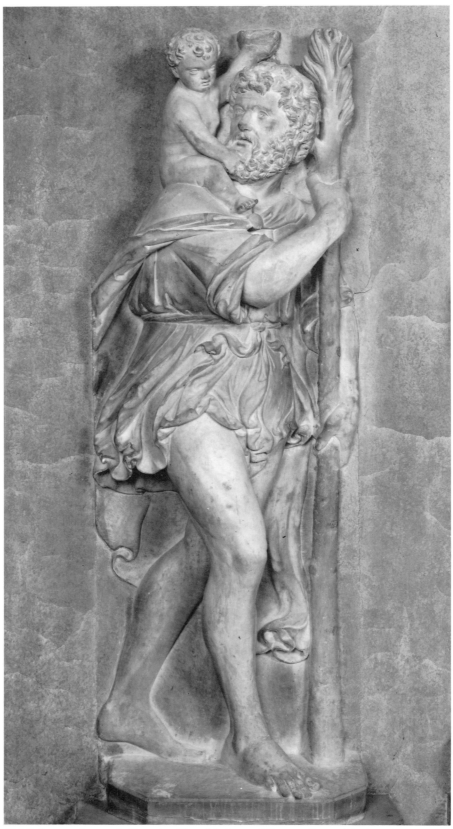

Pl.178. Lorenzo Bregno, *St. Christopher*, Altar of St. Leonard, Duomo, Cesena (Zangheri, Cesena)

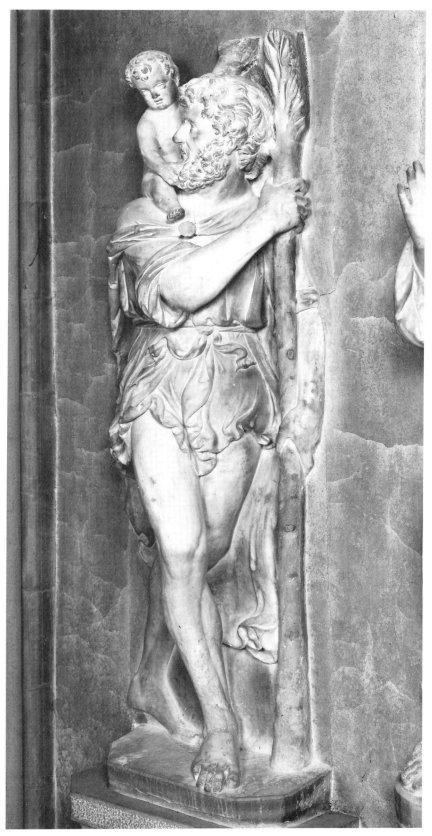

Pl.179. Lorenzo Bregno, *St. Christopher*, Altar of St. Leonard, Duomo, Cesena (Zangheri, Cesena)

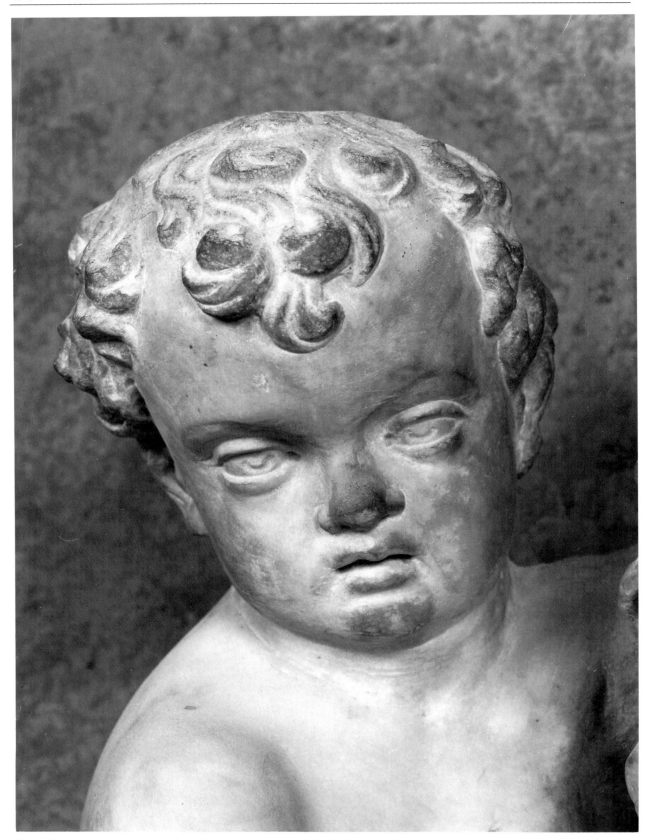

Pl.180. Lorenzo Bregno, detail, *St. Christopher*, Altar of St. Leonard, Duomo, Cesena (Zangheri, Cesena)

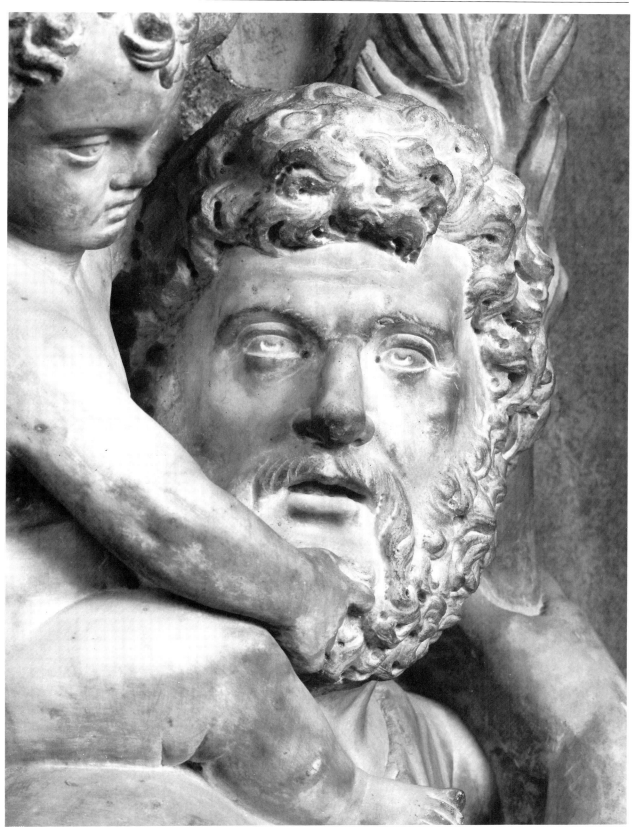

Pl.181. Lorenzo Bregno, detail, *St. Christopher*, Altar of St. Leonard, Duomo, Cesena (Zangheri, Cesena)

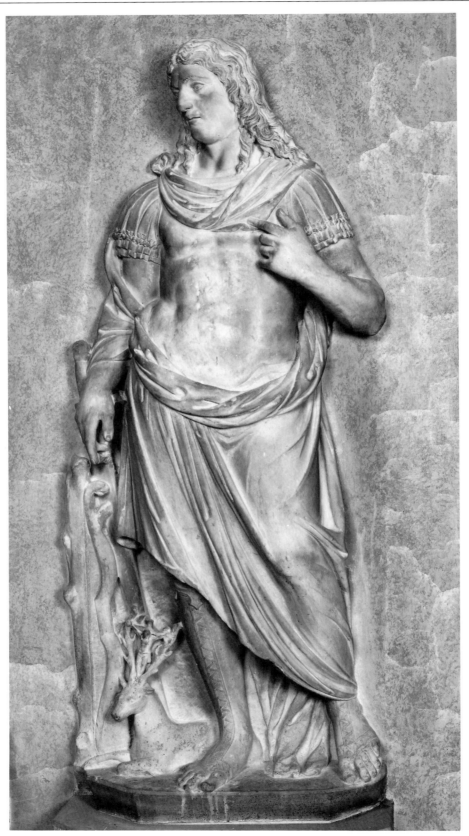

Pl.182. Lorenzo Bregno, *St. Eustace*, Altar of St. Leonard, Duomo, Cesena (Zangheri, Cesena)

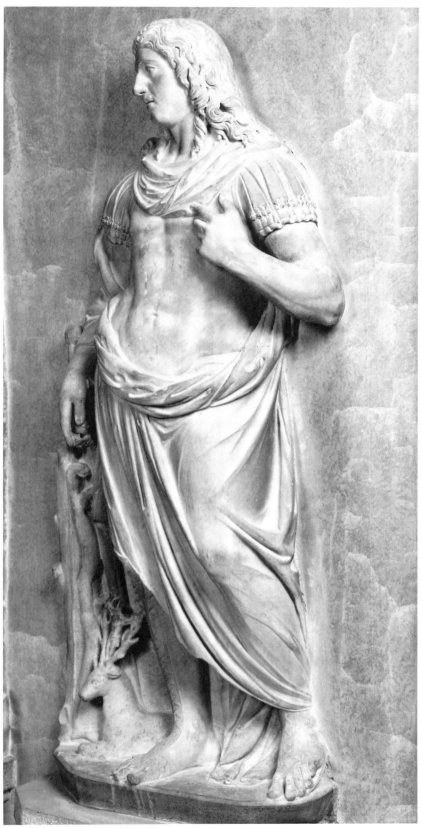

Pl.183. Lorenzo Bregno, *St. Eustace*, Altar of St. Leonard, Duomo, Cesena (Zangheri, Cesena)

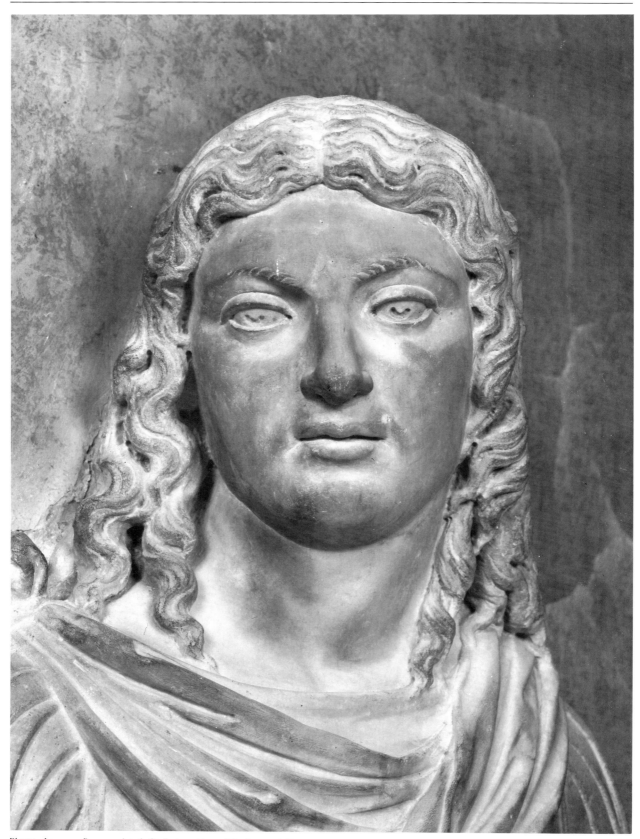

Pl.184. Lorenzo Bregno, detail, *St. Eustace*, Altar of St. Leonard, Duomo, Cesena (Zangheri, Cesena)

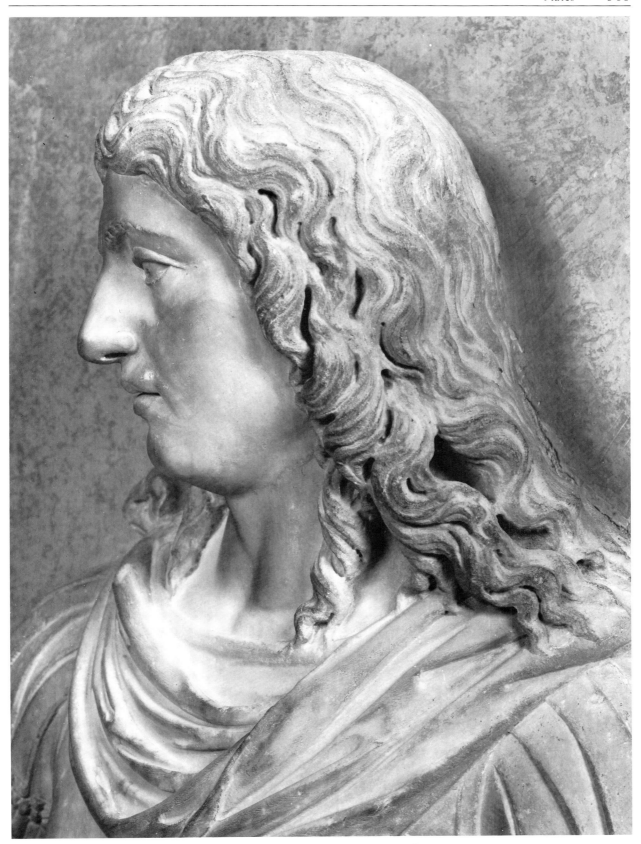

Pl.185. Lorenzo Bregno, detail, *St. Eustace*, Altar of St. Leonard, Duomo, Cesena (Zangheri, Cesena)

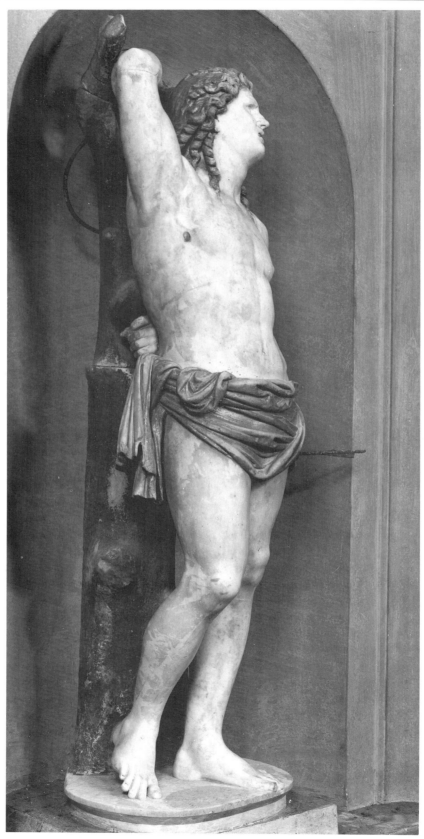

Pl. 186.  Lorenzo Bregno, *St. Sebastian*, Altar of St. Sebastian, Duomo, Treviso (Giacomelli, Venice)

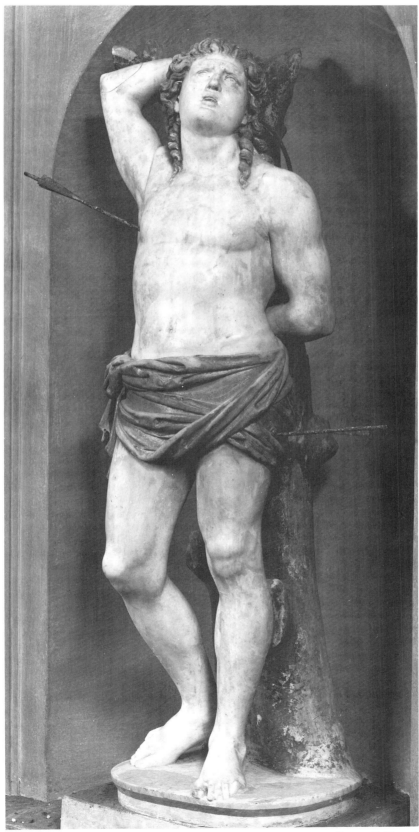

Pl.187.  Lorenzo Bregno, *St. Sebastian*, Altar of St. Sebastian, Duomo, Treviso (Giacomelli, Venice)

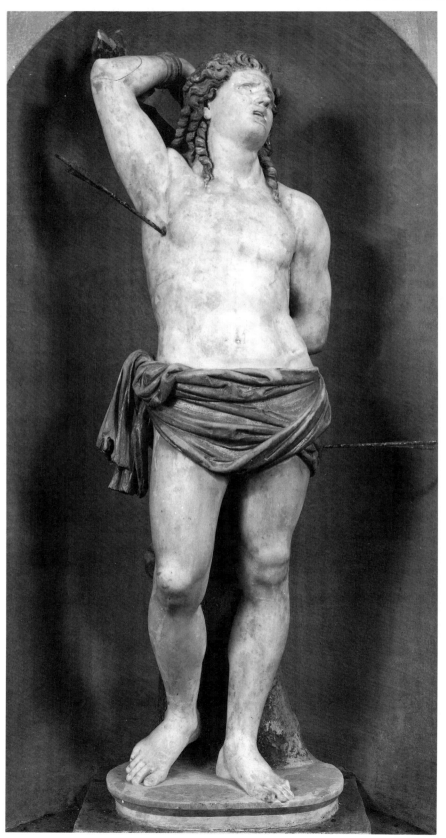

Pl.188. Lorenzo Bregno, *St. Sebastian*, Altar of St. Sebastian, Duomo, Treviso (Giacomelli, Venice)

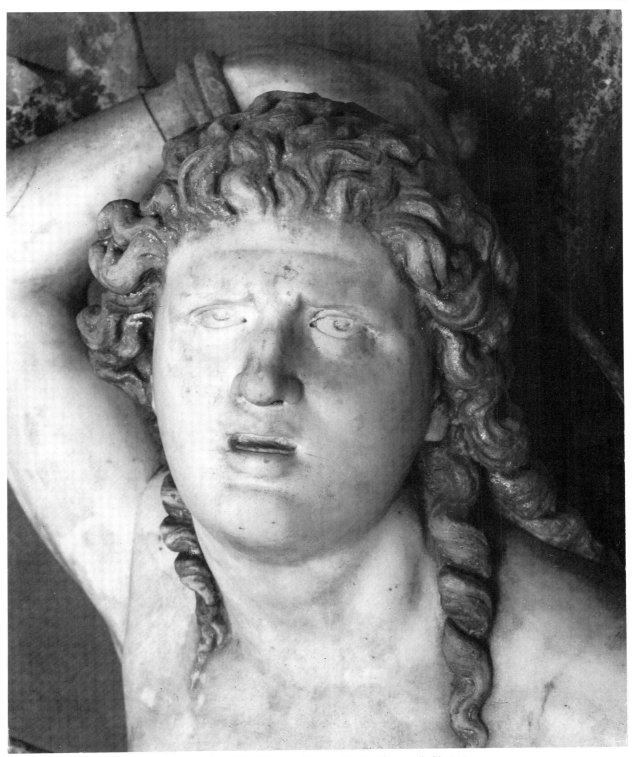

Pl.189. Lorenzo Bregno, detail, *St. Sebastian*, Altar of St. Sebastian, Duomo, Treviso (Giacomelli, Venice)

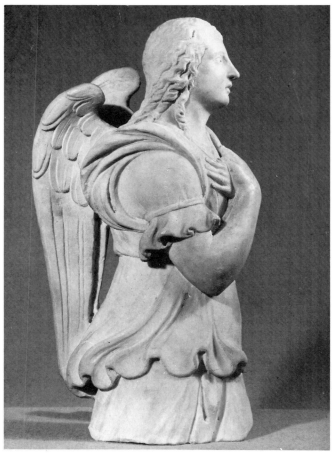

Pl.190.  Assistant of Lorenzo Bregno, left-hand *Angel*, Altar of St. Sebastian,
Szépművészeti Múzeum, Budapest (Szépművészeti Múz., Budapest)

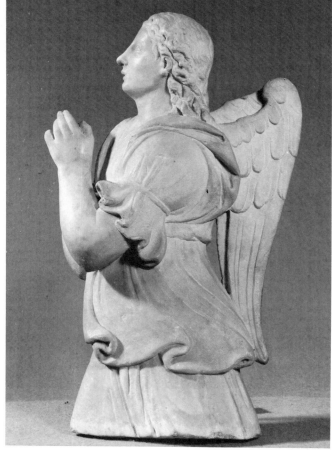

Pl.191.  Assistant of Lorenzo Bregno, right-hand *Angel*, Altar of St. Sebastian,
Szépművészeti Múzeum, Budapest (Szépművészeti Múz., Budapest)

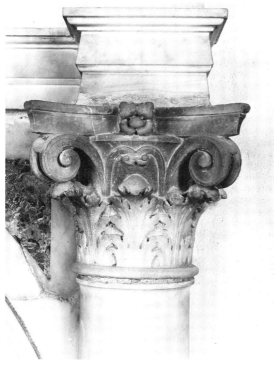

Pl.192. (Opposite) Lorenzo Bregno, capital, Altar of St. Sebastian, S. Leonardo, Treviso (Giacomelli, Venice)

Pl.193 (Below) Assistant of Lorenzo Bregno, *Madonna and Child*, Altar of St. Sebastian, Szépművészeti Múzeum, Budapest (Szépművészeti Múz., Budapest)

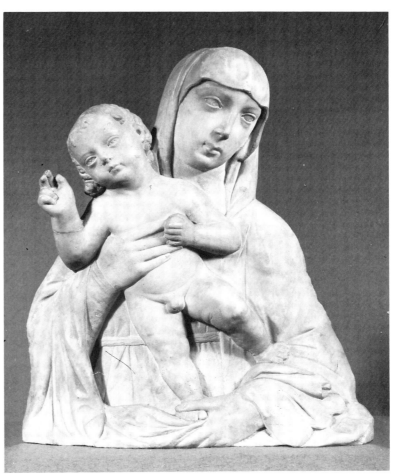

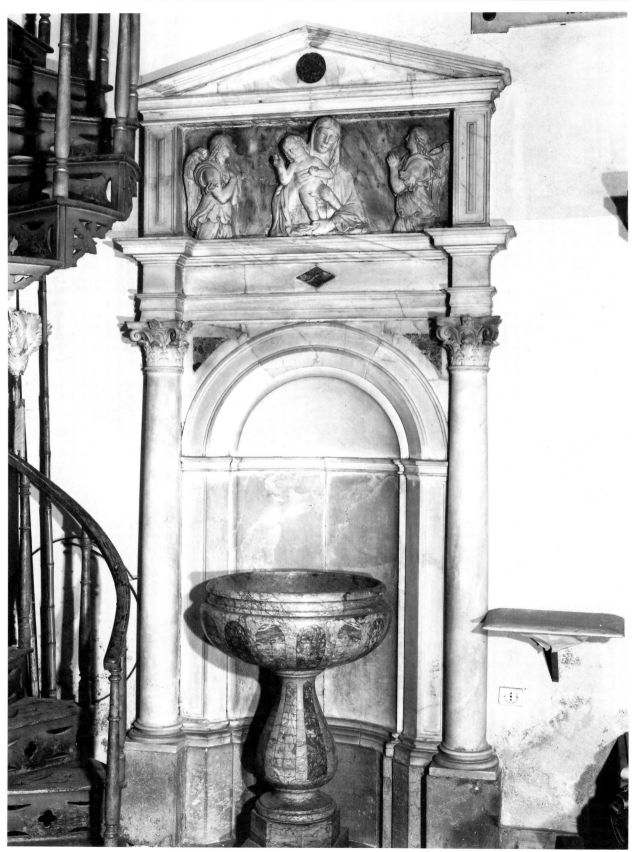

Pl.194. Lorenzo Bregno, frame, Altar of St. Sebastian, S. Leonardo, Treviso (Giacomelli, Venice)

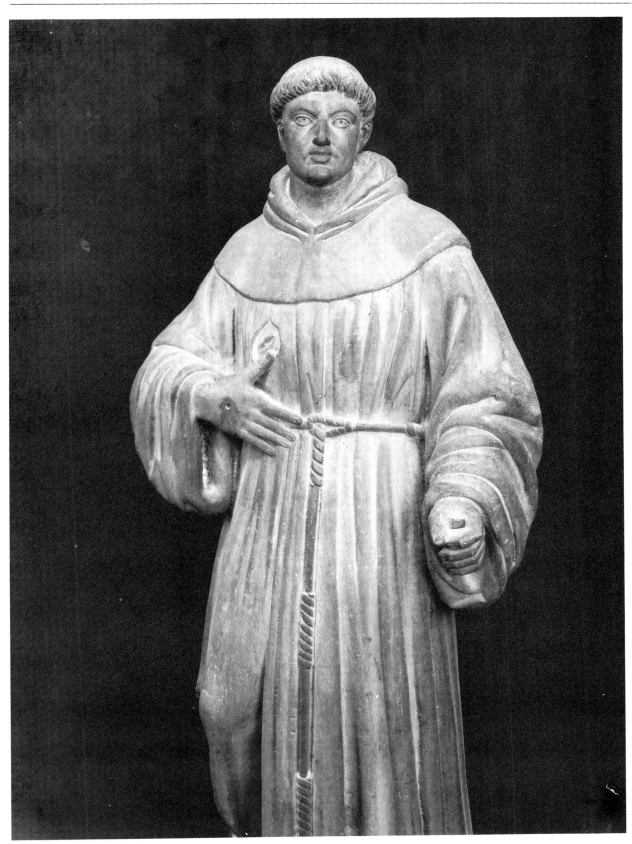

Pl.195. Lorenzo Bregno, detail, *St. Francis*, High Altar, S. Maria dei Frari, Venice (Giacomelli, Venice)

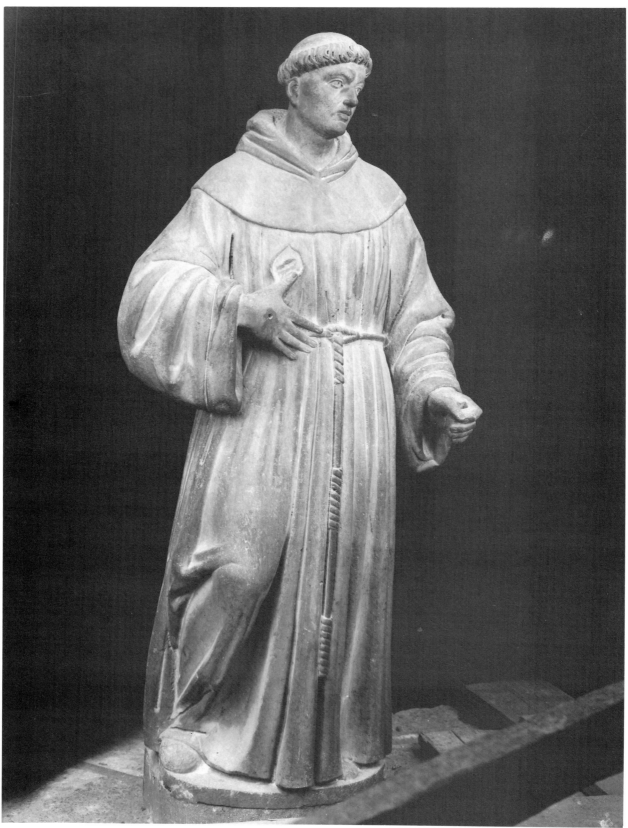

Pl.196. Lorenzo Bregno, *St. Francis*, High Altar, S. Maria dei Frari, Venice (Giacomelli, Venice)

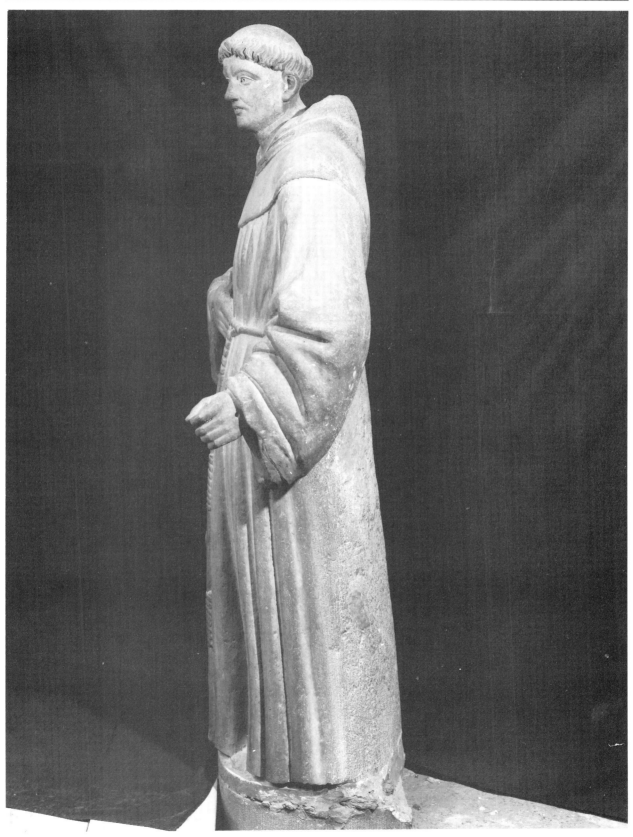

Pl.197. Lorenzo Bregno, *St. Francis*, High Altar, S. Maria dei Frari, Venice (Giacomelli, Venice)

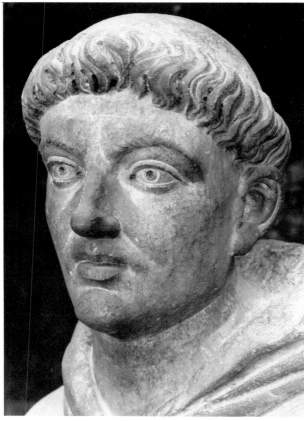

Pl.198. Lorenzo Bregno, detail, *St. Francis*, High Altar, S. Maria dei Frari, Venice (Giacomelli, Venice)

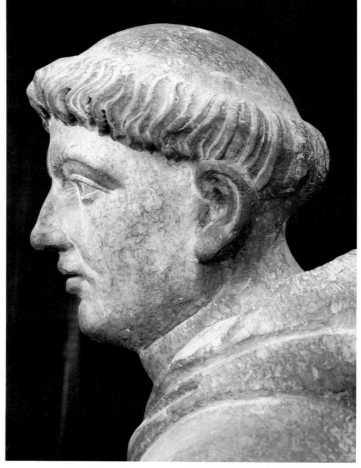

Pl.199. Lorenzo Bregno, detail, *St. Francis*, High Altar, S. Maria dei Frari, Venice (Giacomelli, Venice)

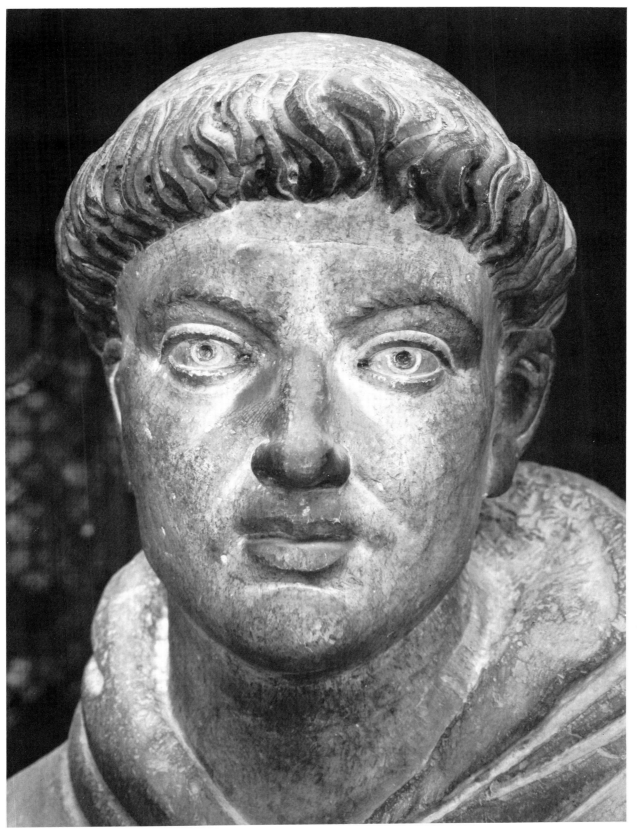

Pl. 200. Lorenzo Bregno, detail, *St. Francis*, High Altar, S. Maria dei Frari, Venice (Giacomelli, Venice)

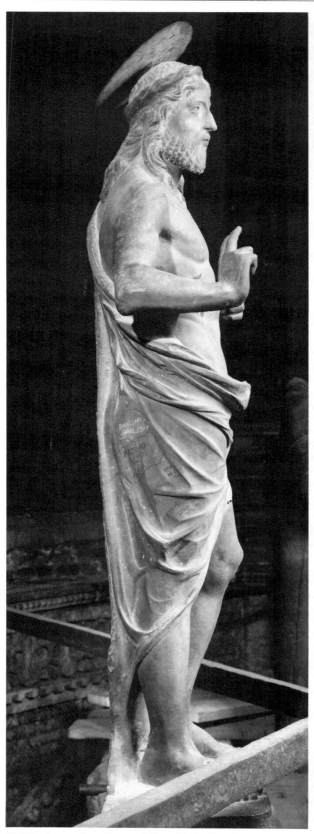

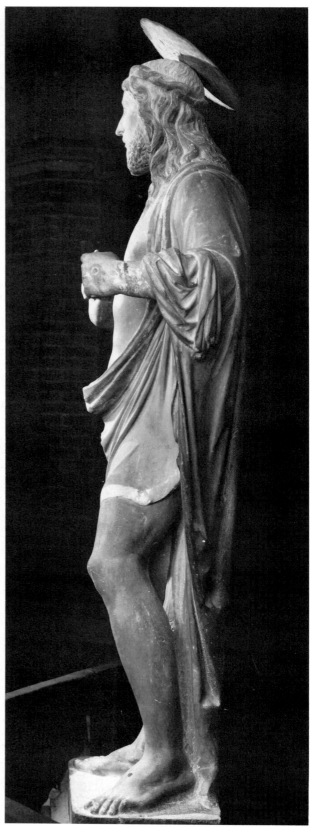

Pl. 201. Bregno shop, *Resurrected Christ*, High Altar, S. Maria dei Frari, Venice (Giacomelli, Venice)

Pl. 202. Bregno shop, *Resurrected Christ*, High Altar, S. Maria dei Frari, Venice (Giacomelli, Venice)

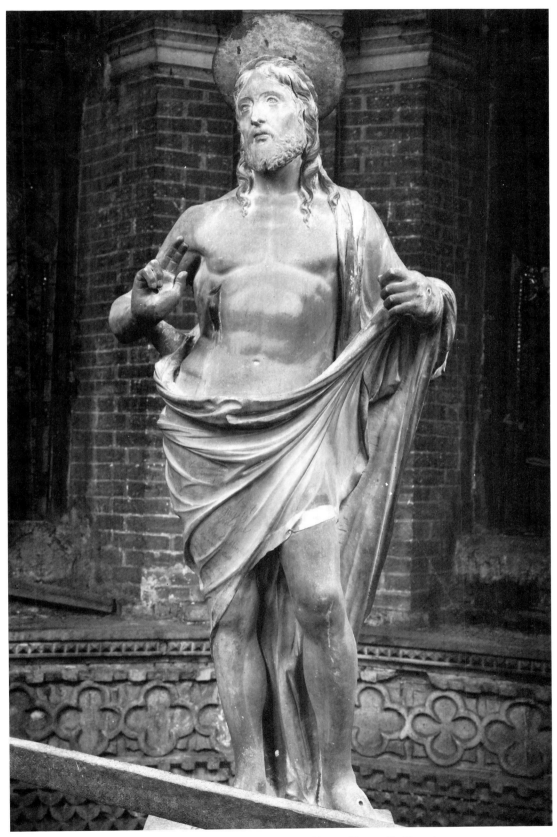

Pl. 203. Bregno shop, *Resurrected Christ*, High Altar, S. Maria dei Frari, Venice (Giacomelli, Venice)

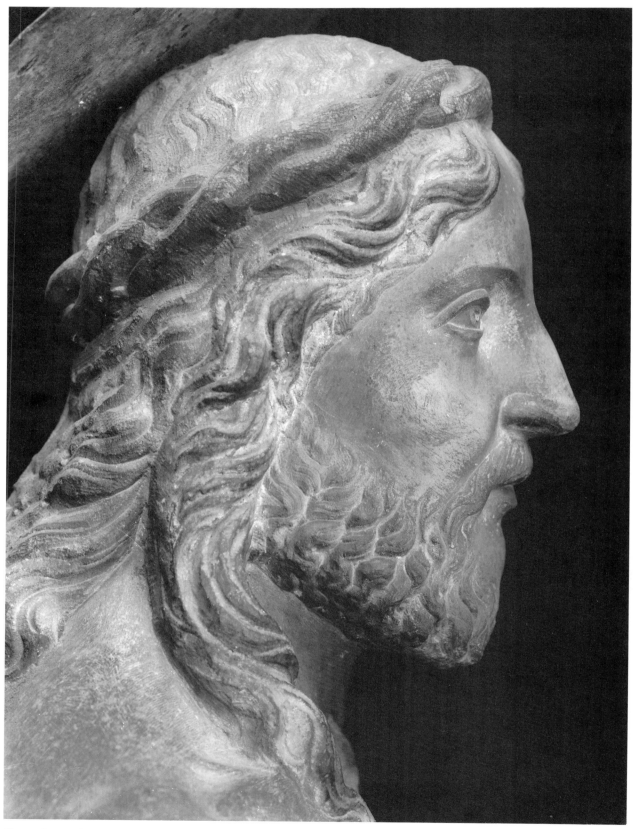

Pl. 204. Bregno shop, detail, *Resurrected Christ*, High Altar, S. Maria dei Frari, Venice (Giacomelli, Venice)

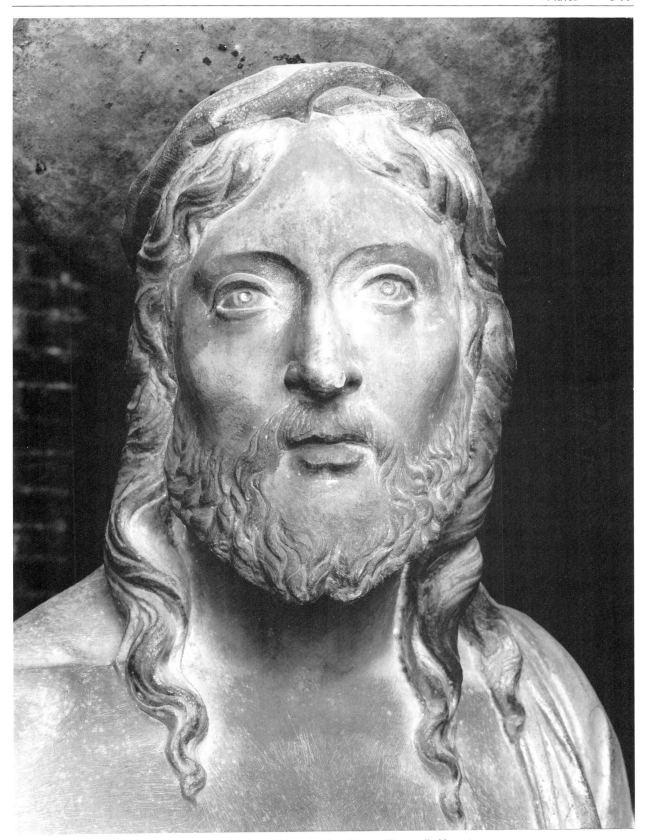

Pl. 205. Bregno shop, detail, *Resurrected Christ*, High Altar, S. Maria dei Frari, Venice (Giacomelli, Venice)

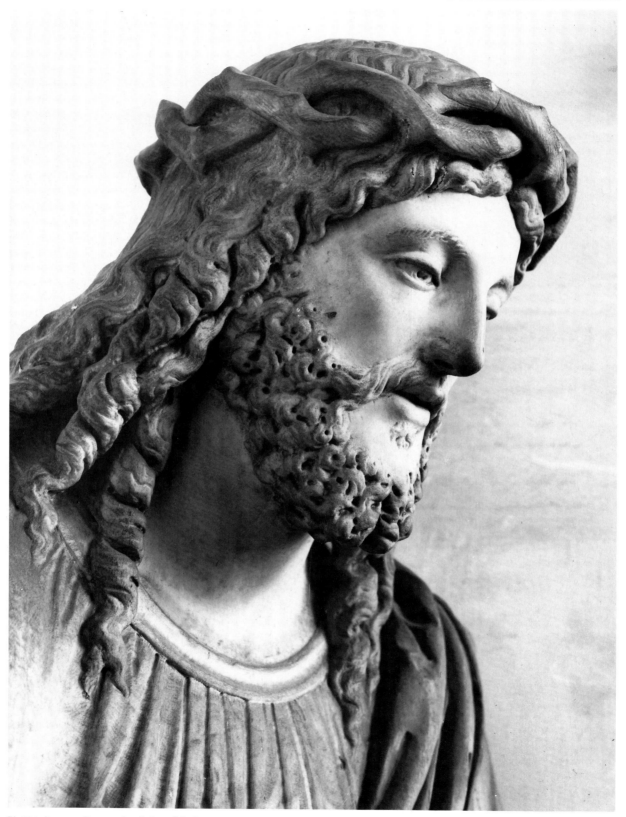

Pl. 206. Lorenzo Bregno, detail, *Bust of the Saviour*, Scuola Grande di S. Rocco, Venice (Giacomelli, Venice)

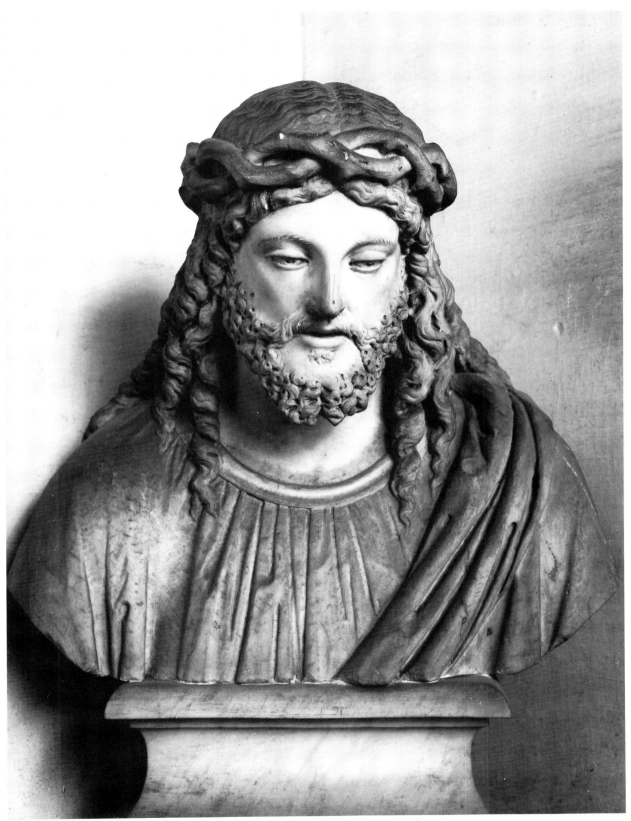

Pl. 207.  Lorenzo Bregno, *Bust of the Saviour*, Scuola Grande di S. Rocco, Venice (Giacomelli, Venice)

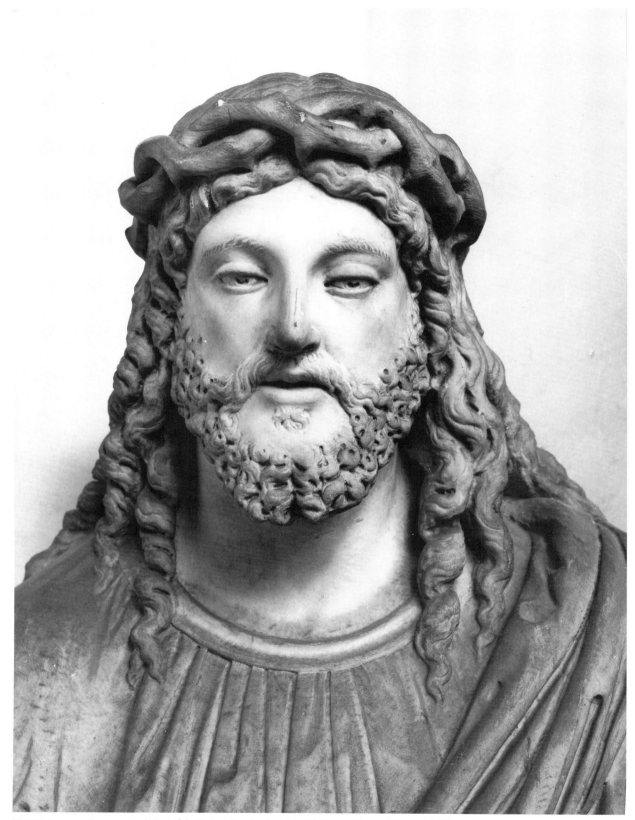

Pl. 208. Lorenzo Bregno, detail, *Bust of the Saviour*, Scuola Grande di S. Rocco, Venice (Giacomelli, Venice)

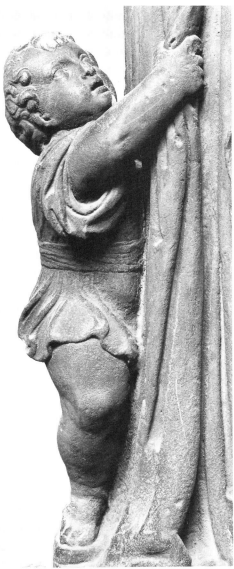

Pl. 209. Lorenzo Bregno, detail, *St. Marina*, High Altar of S. Marina, Seminario Patriarcale, Venice (Giacomelli, Venice)

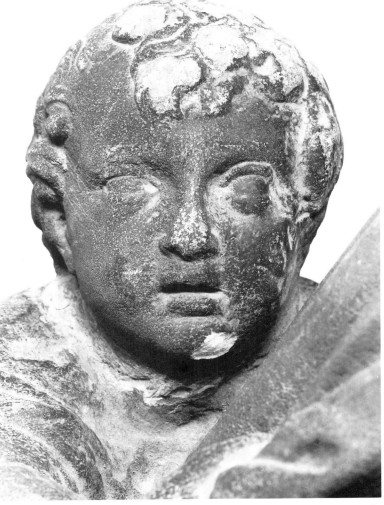

Pl. 210. Lorenzo Bregno, detail, *St. Marina*, High Altar of S. Marina, Seminario Patriarcale, Venice (Giacomelli, Venice)

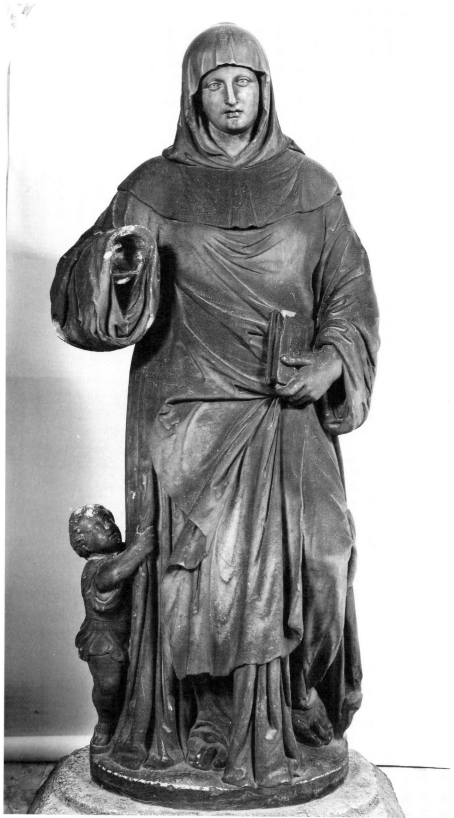

Pl. 211. Lorenzo Bregno, *St. Marina*, High Altar of S. Marina, Seminario Patriarcale, Venice (Giacomelli, Venice)

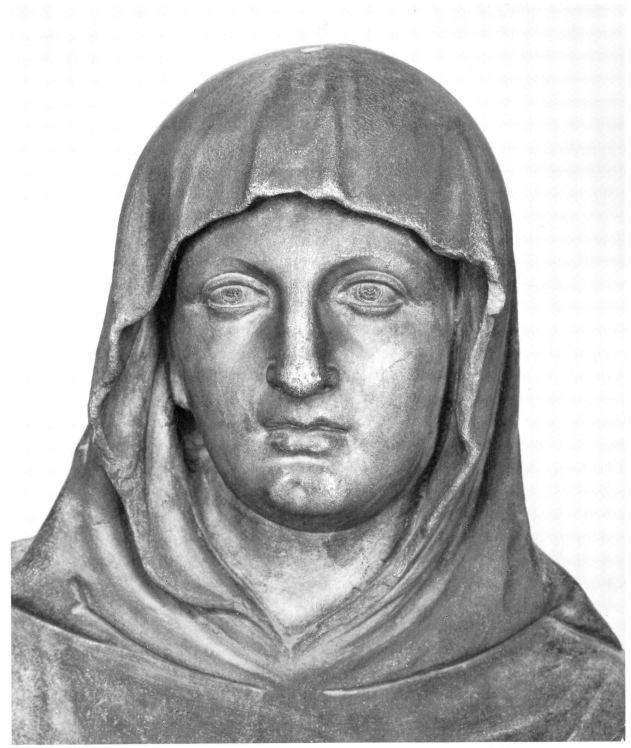

Pl. 212. Lorenzo Bregno, detail, *St. Marina*, High Altar of S. Marina, Seminario Patriarcale, Venice (Giacomelli, Venice)

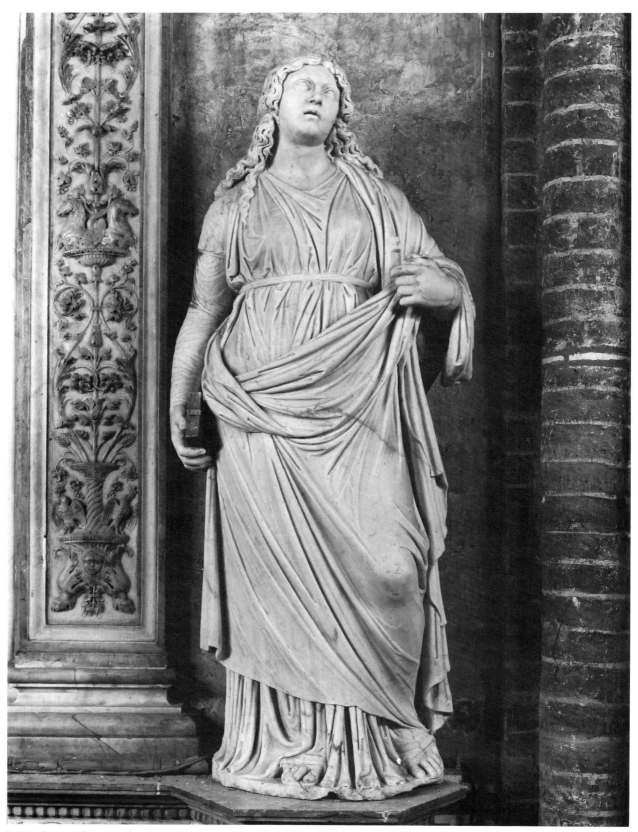

Pl. 213. Lorenzo Bregno and assistant, *St. Mary Magdalene*, High Altar of S. Marina, SS. Giovanni e Paolo, Venice (Giacomelli, Venice)

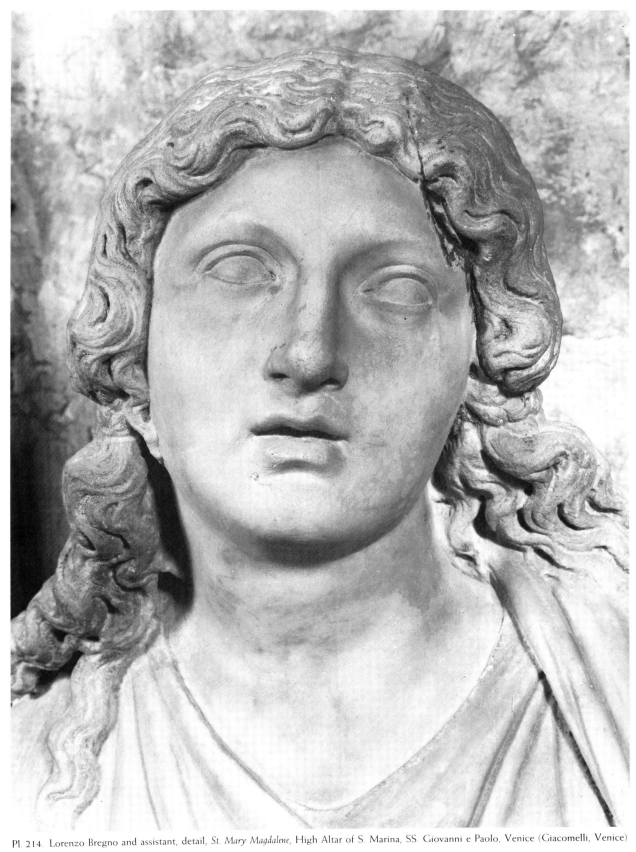

Pl. 214. Lorenzo Bregno and assistant, detail, *St. Mary Magdalene*, High Altar of S. Marina, SS. Giovanni e Paolo, Venice (Giacomelli, Venice)

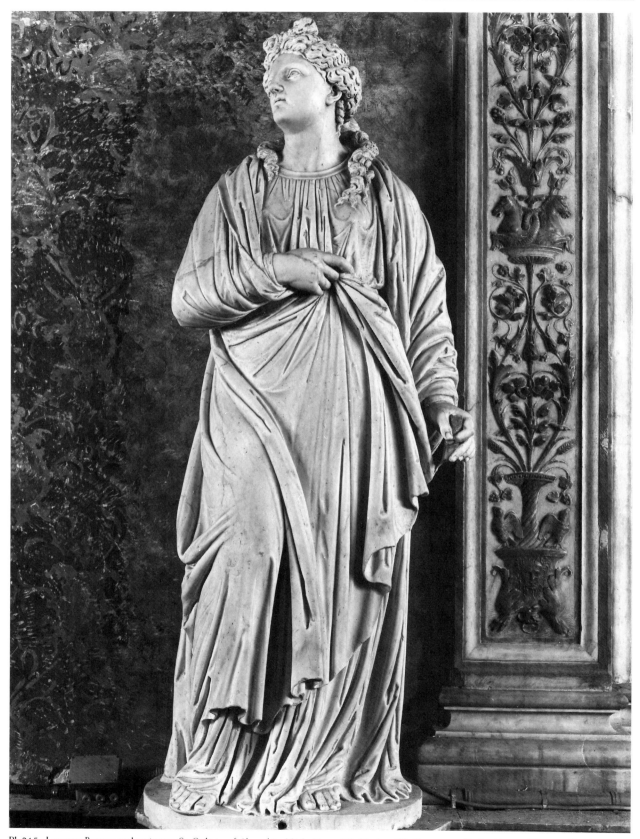

Pl. 215. Lorenzo Bregno and assistant, *St. Catherine of Alexandria*, High Altar of S. Marina, SS. Giovanni e Paolo, Venice (Giacomelli, Venice)

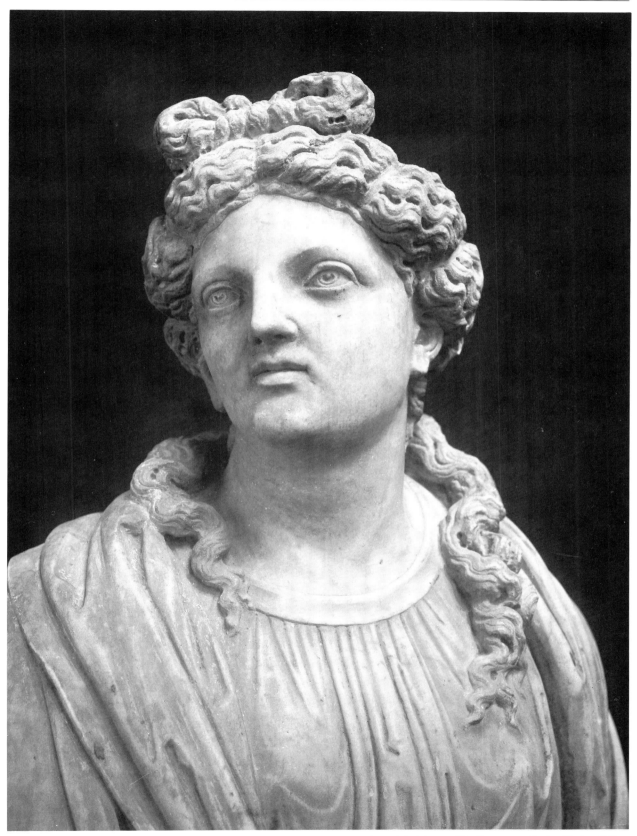

Pl. 216. Lorenzo Bregno and assistant, detail, *St. Catherine of Alexandria*, High Altar of S. Marina, SS. Giovanni e Paolo, Venice (Böhm, Venice)

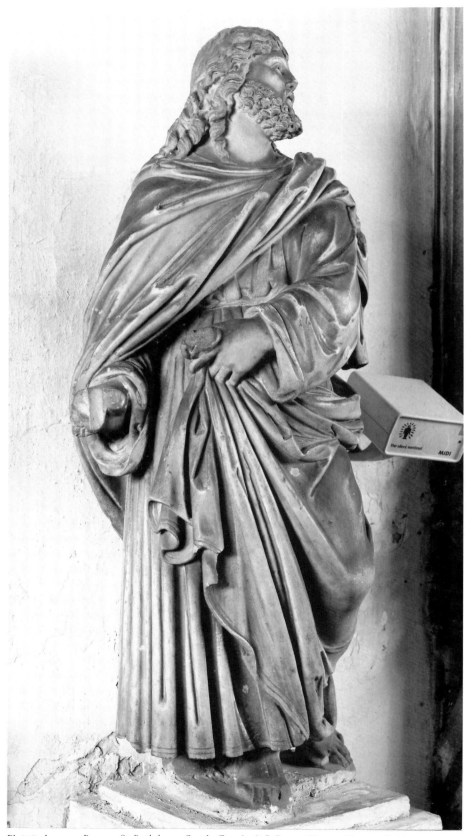

Pl. 217. Lorenzo Bregno, *St. Bartholomew*, Scuola Grande di S. Rocco, Venice (Giacomelli, Venice)

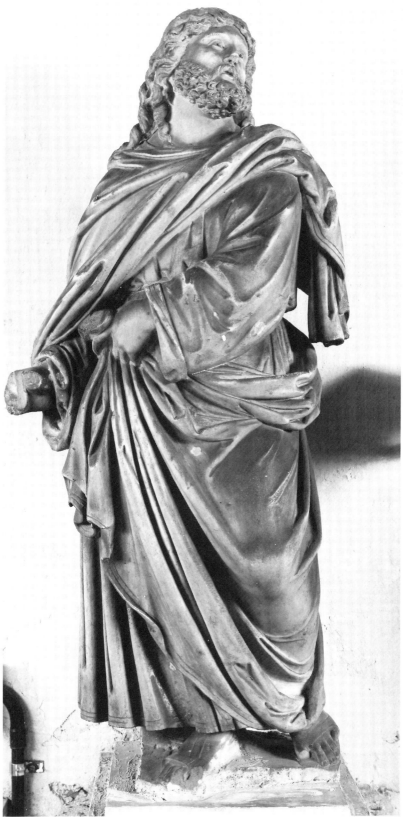

Pl. 218. Lorenzo Bregno, *St. Bartholomew*, Scuola Grande di S. Rocco, Venice (Giacomelli, Venice)

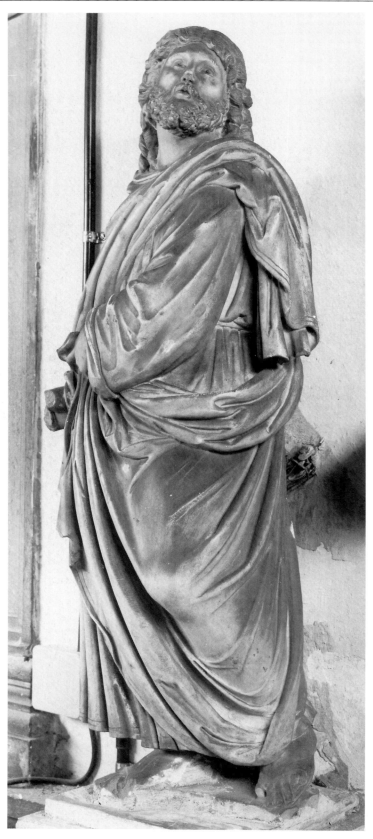

Pl. 219. Lorenzo Bregno, *St. Bartholomew*, Scuola Grande di S. Rocco, Venice (Gia-
comelli, Venice)

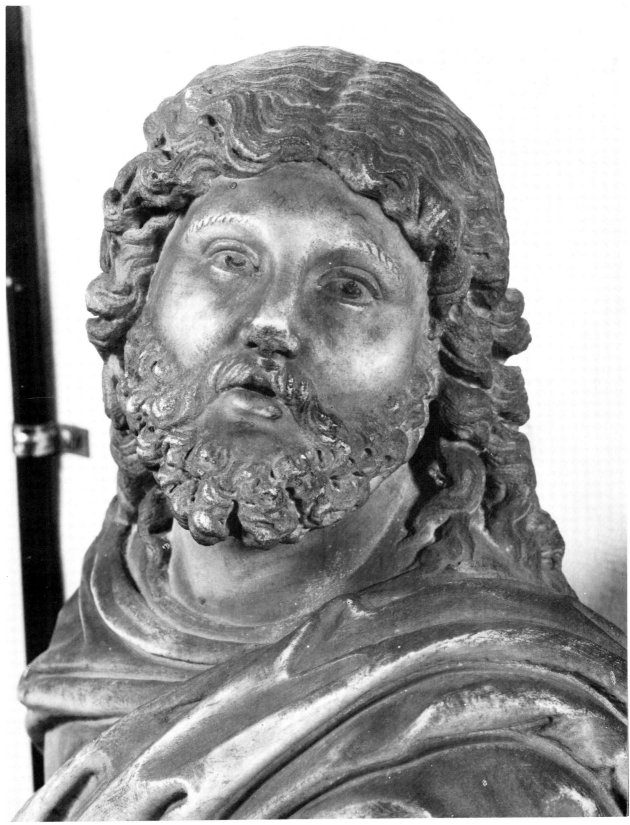

Pl. 220. Lorenzo Bregno, detail, *St. Bartholomew*, Scuola Grande di S. Rocco, Venice (Giacomelli, Venice)

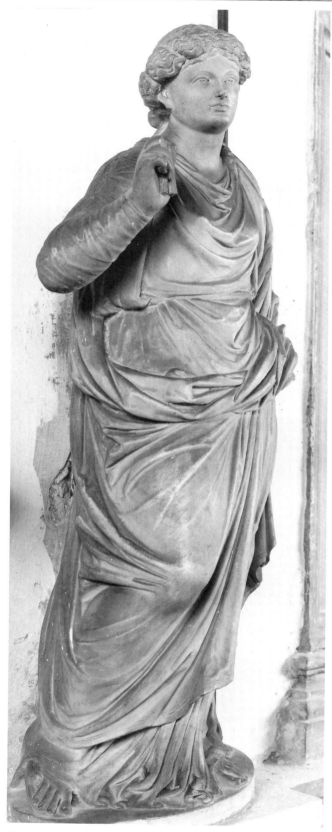

Pl. 221. Lorenzo Bregno, *St. Apollonia* or *St. Agatha*, Scuola Grande di S.
Rocco, Venice (Giacomelli, Venice)

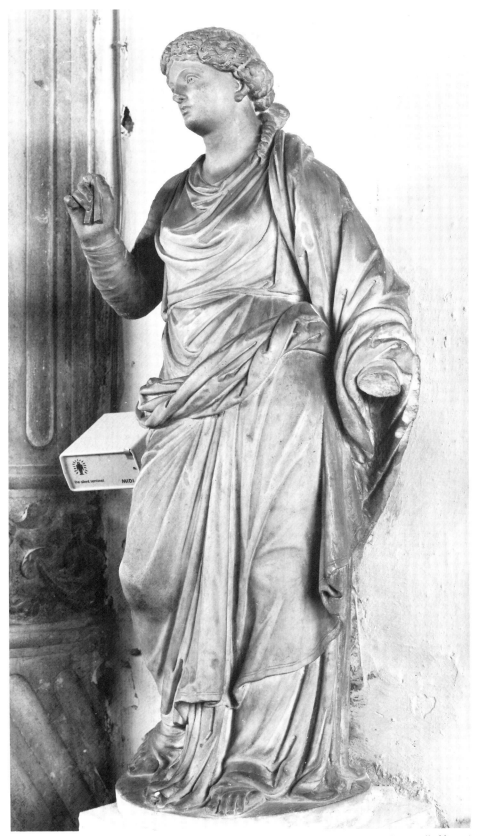

Pl. 222. Lorenzo Bregno, *St. Apollonia* or *St. Agatha*, Scuola Grande di S. Rocco, Venice (Giacomelli, Venice)

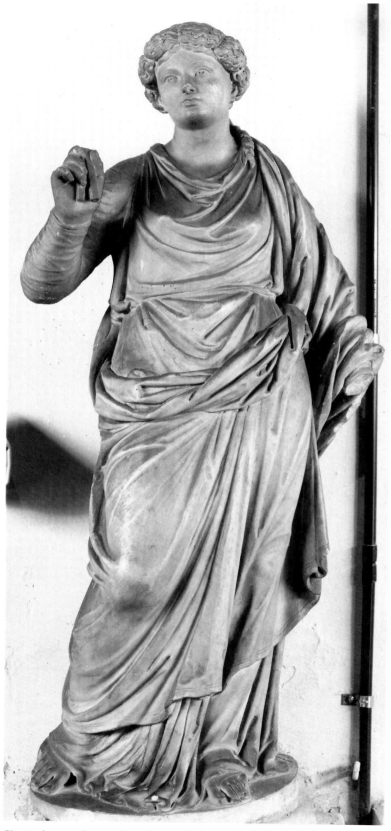

Pl. 223. Lorenzo Bregno, *St. Apollonia* or *St. Agatha*, Scuola Grande di S. Rocco, Venice
(Giacomelli, Venice)

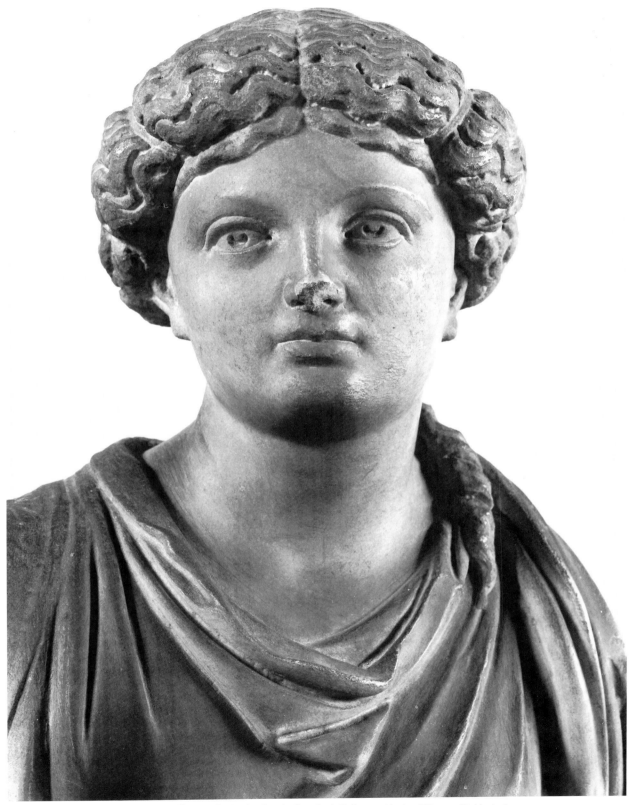

Pl. 224. Lorenzo Bregno, detail, *St. Apollonia* or *St. Agatha*, Scuola Grande di S. Rocco, Venice (Giacomelli, Venice)

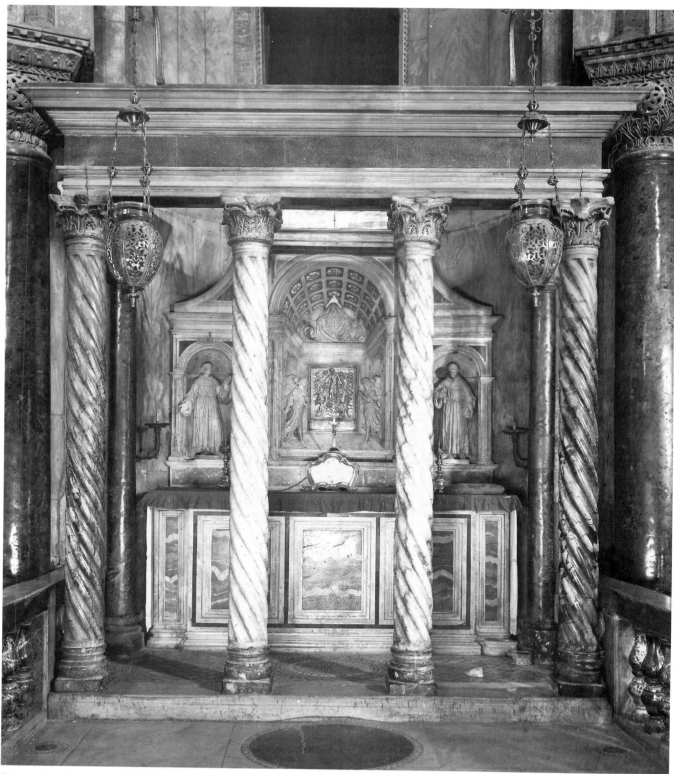

Pl. 225. Altar of the Cross, S. Marco, Venice (Böhm, Venice)

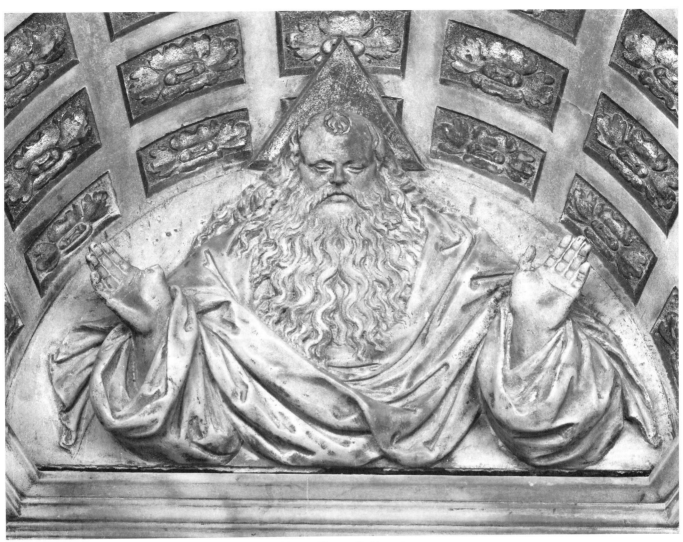

Pl. 226. Lorenzo Bregno, *Trinity*, Altar of the Cross, S. Marco, Venice (Giacomelli, Venice)

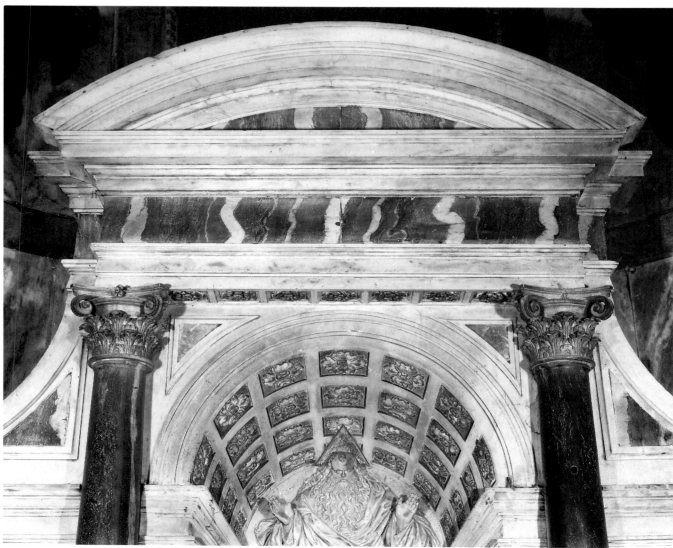

Pl. 227. Lorenzo Bregno, detail, Altar of the Cross, S. Marco, Venice (Giacomelli, Venice)

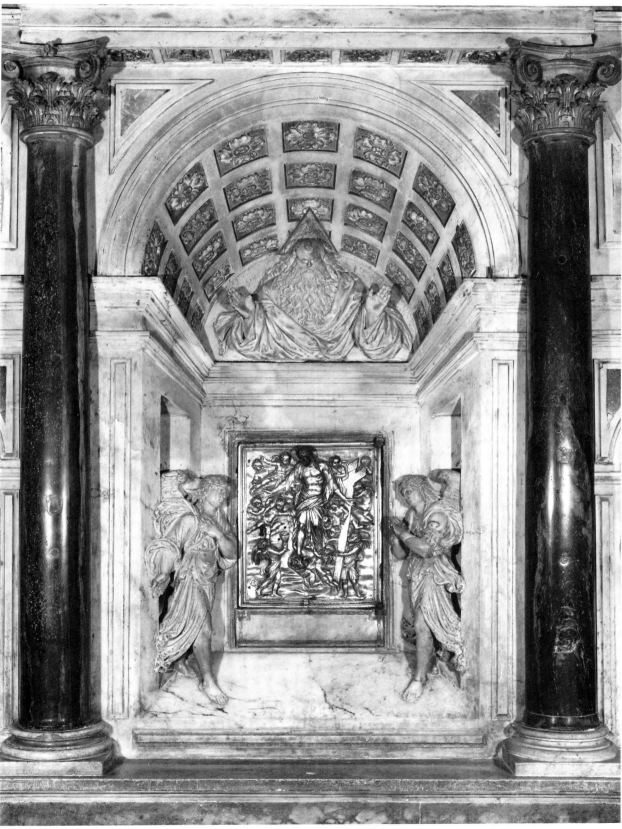

Pl. 228. Lorenzo Bregno, assistant, and Jacopo Sansovino, detail, Altar of the Cross, S. Marco, Venice (Giacomelli, Venice)

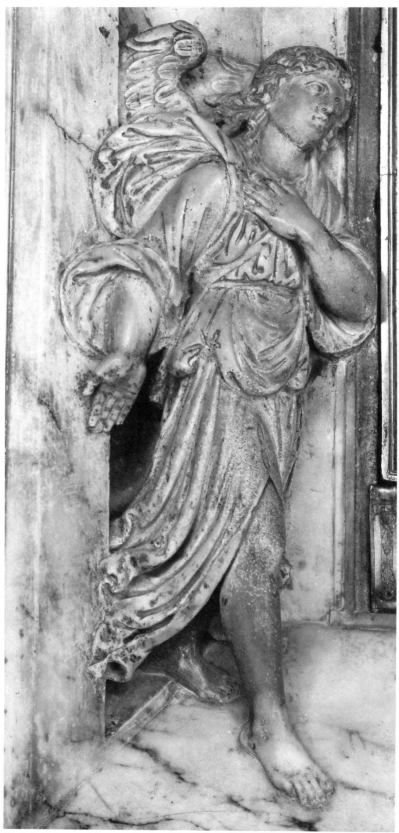

Pl. 229. Assistant of Lorenzo Bregno, left-hand *Angel*, Altar of the Cross, S. Marco, Venice
(Giacomelli, Venice)

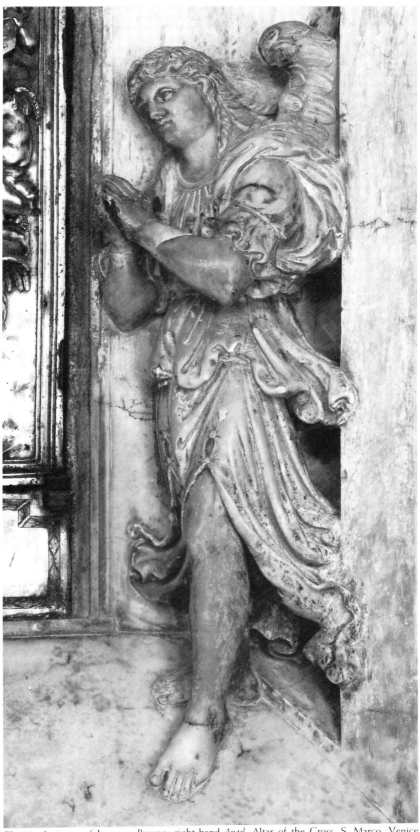

Pl. 230. Assistant of Lorenzo Bregno, right-hand *Angel*, Altar of the Cross, S. Marco, Venice
(Giacomelli, Venice)

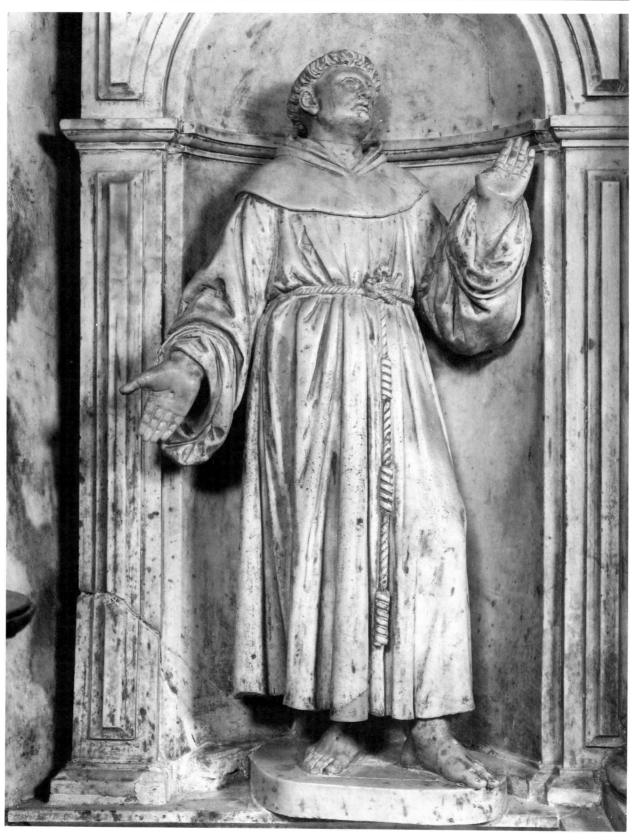

Pl. 231. Lorenzo Bregno, *St. Francis*, Altar of the Cross, S.Marco, Venice (Giacomelli, Venice)

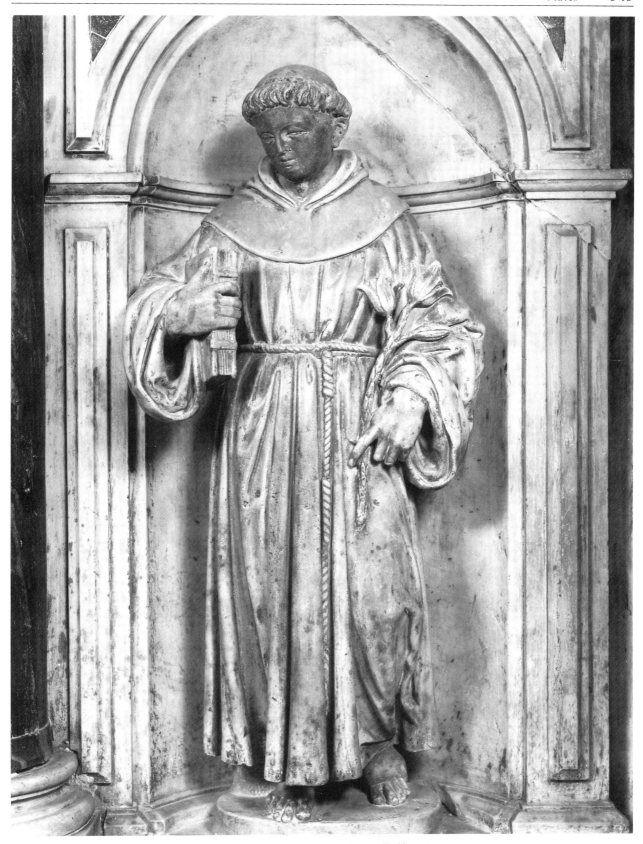

Pl. 232. Lorenzo Bregno, *St. Anthony*, Altar of the Cross, S. Marco, Venice (Giacomelli, Venice)

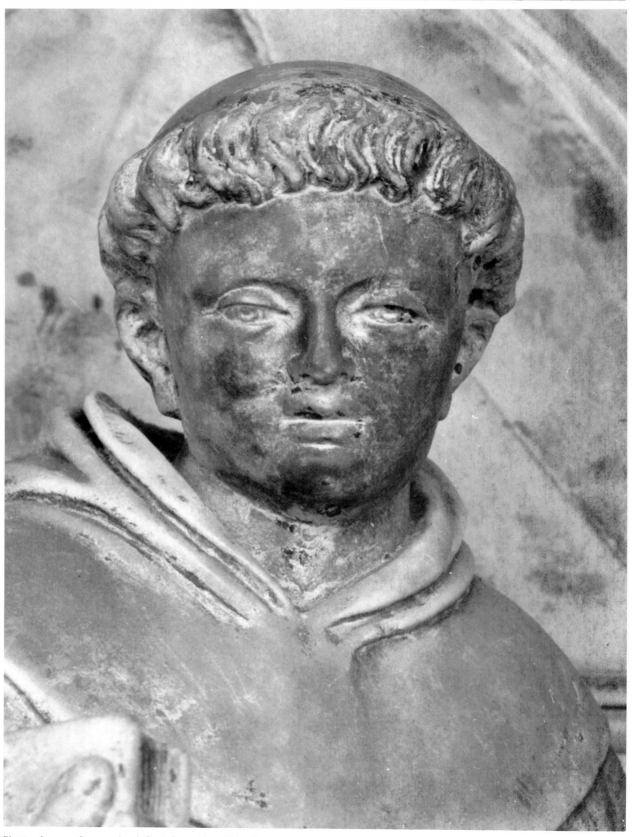

Pl. 234. Lorenzo Bregno, detail, *St. Anthony*, Altar of the Cross, S. Marco, Venice (Giacomelli, Venice)

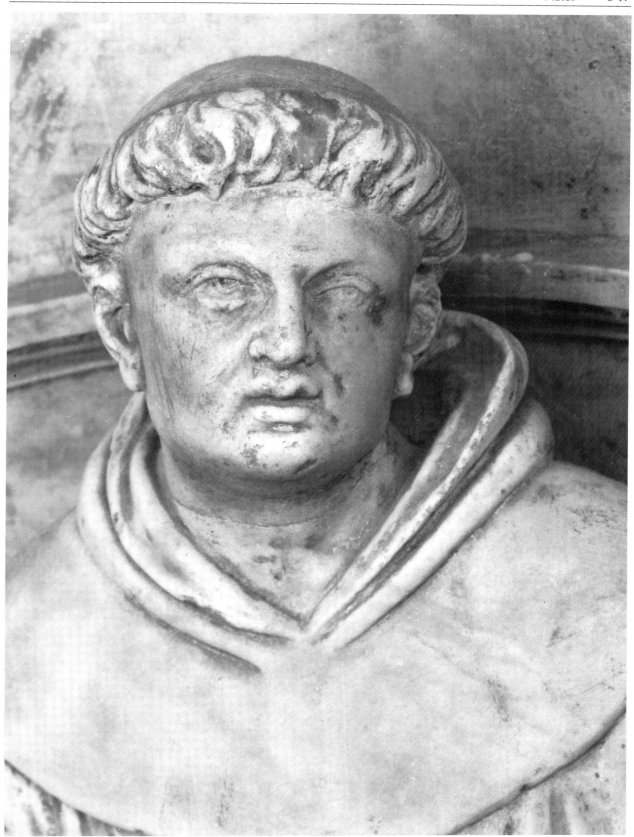

Pl. 233. Lorenzo Bregno, detail, *St. Francis*, Altar of the Cross, S. Marco, Venice (Giacomelli, Venice)

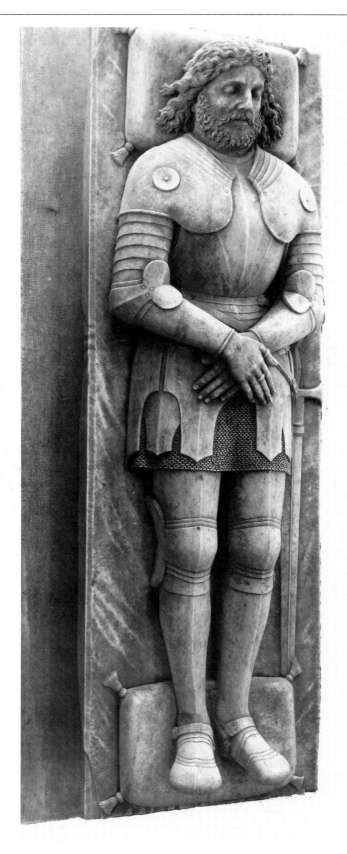

Pl. 235. Lorenzo Bregno, *Effigy*, Tomb of Benedetto Crivelli, S. Maria del Carmine, Creola (Mus. Civico, Padua)

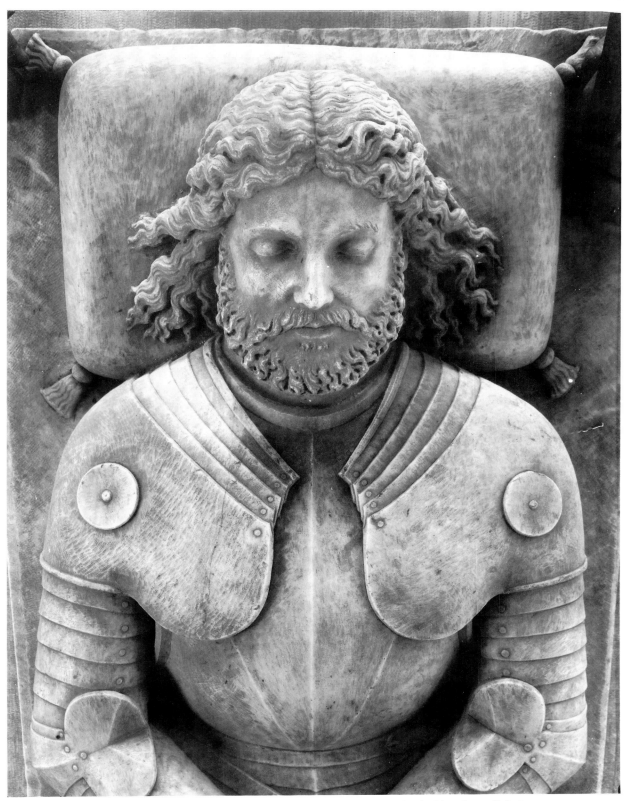

Pl. 236. Lorenzo Bregno, detail, *Effigy*, Tomb of Benedetto Crivelli, S. Maria del Carmine, Creola (Mus. Civico, Padua)

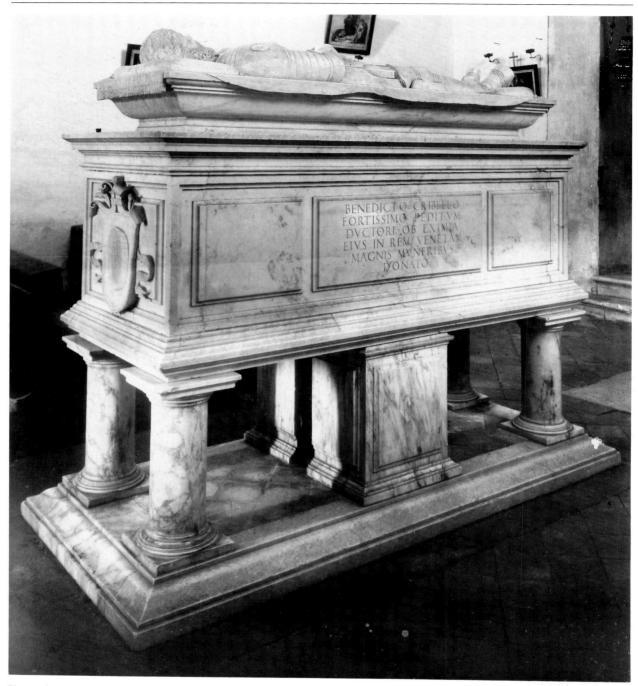

Pl. 237. Lorenzo Bregno, Tomb of Benedetto Crivelli, S. Maria del Carmine, Creola (Mus. Civico, Padua)

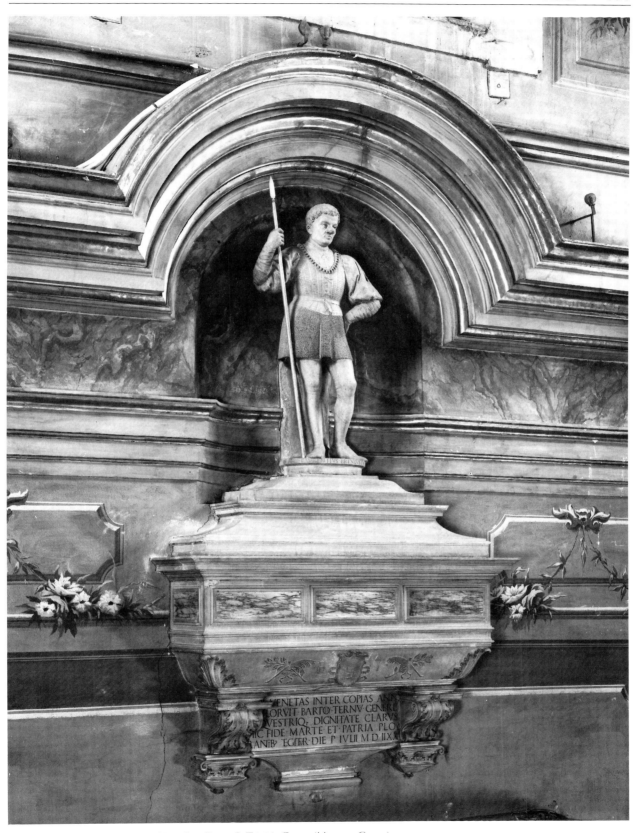

Pl. 238. Lorenzo Bregno, Tomb of Bartolino Terni, S. Trinità, Crema (Marasca, Crema)

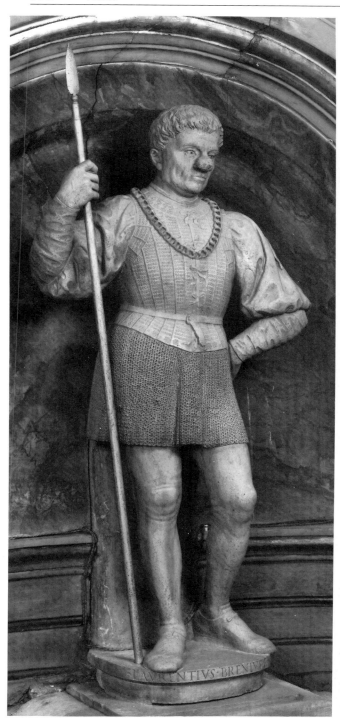

Pl. 239. Lorenzo Bregno, *Effigy*, Tomb of Bartolino Terni, S. Trinità, Crema
(Gamberoni, Bergamo)

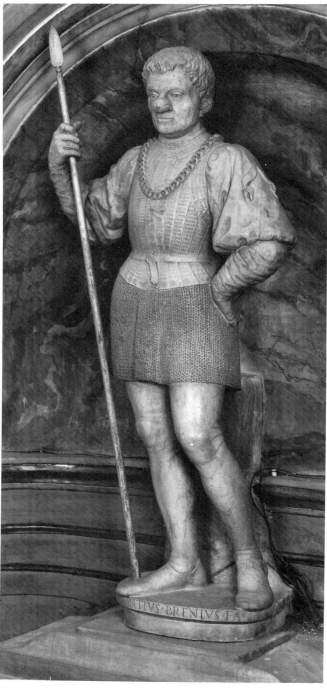

Pl. 240. Lorenzo Bregno, *Effigy*, Tomb of Bartolino Terni, S. Trinità, Crema
(Gamberoni, Bergamo)

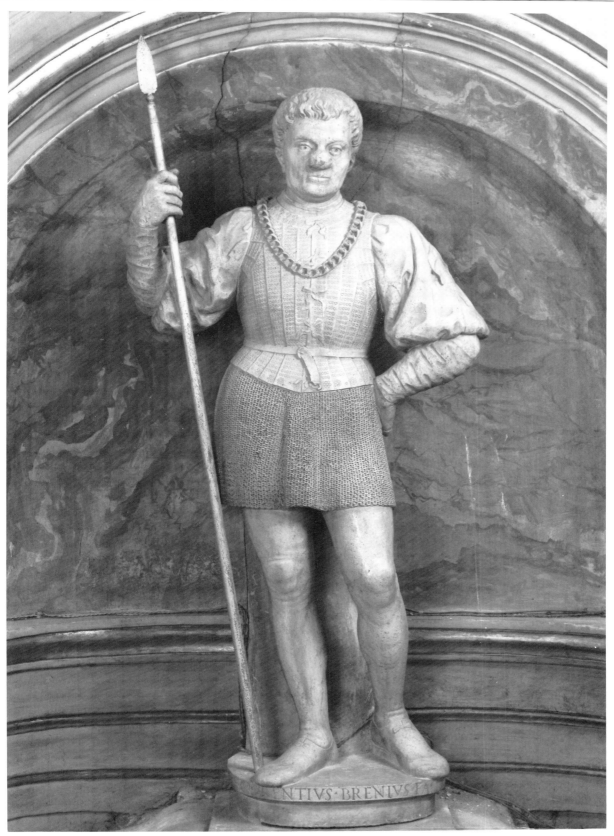

Pl. 241. Lorenzo Bregno, *Effigy*, Tomb of Bartolino Terni, S. Trinità, Crema (Gamberoni, Bergamo)

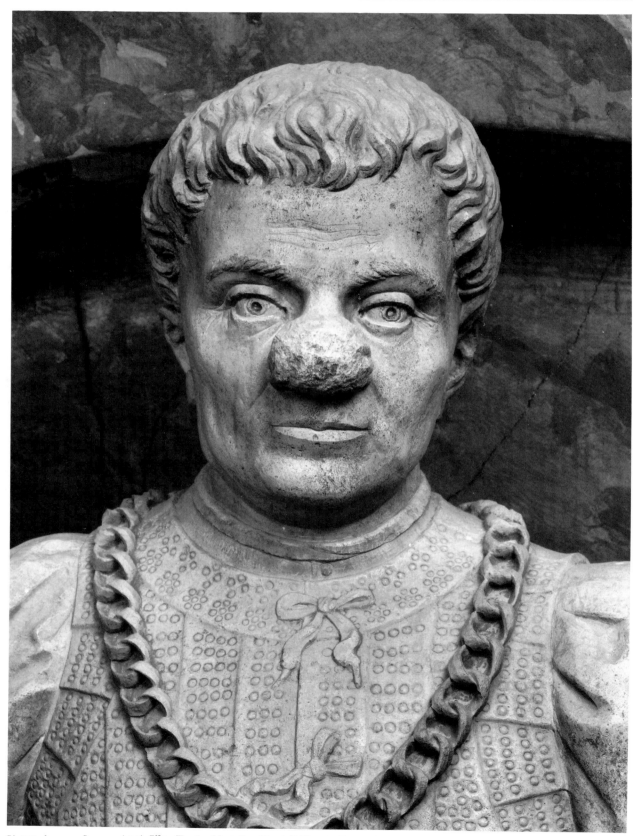

Pl. 242. Lorenzo Bregno, detail, *Effigy*, Tomb of Bartolino Terni, S. Trinità, Crema (Gamberoni, Bergamo)

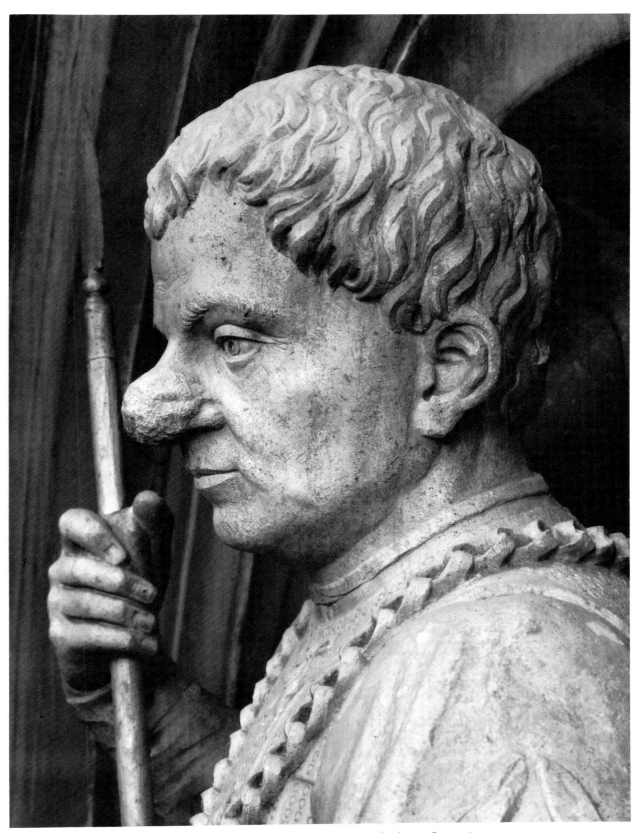

Pl. 243. Lorenzo Bregno, detail, *Effigy*, Tomb of Bartolino Terni, S. Trinità, Crema (Gamberoni, Bergamo)

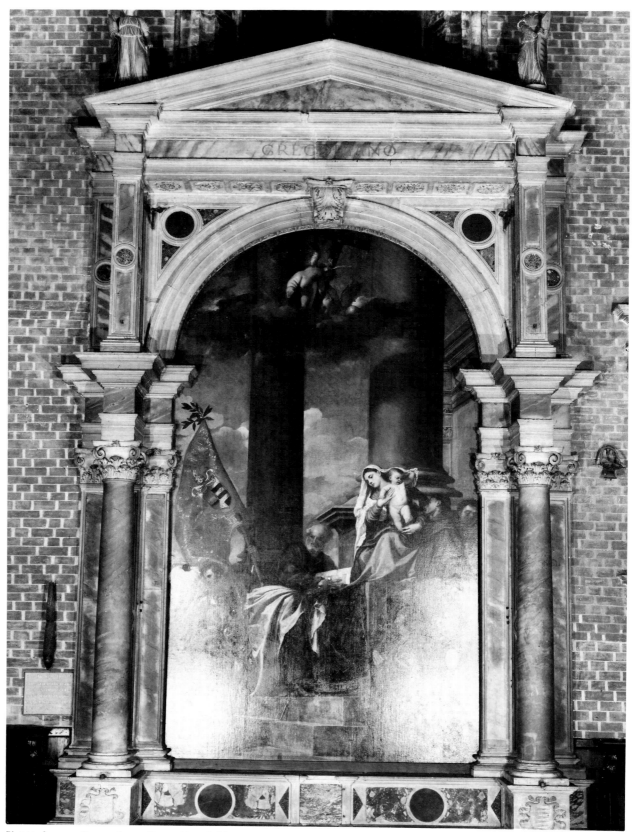

Pl. 244. Lorenzo Bregno, frame, Pesaro Altar, S. Maria dei Frari, Venice (Giacomelli, Venice)

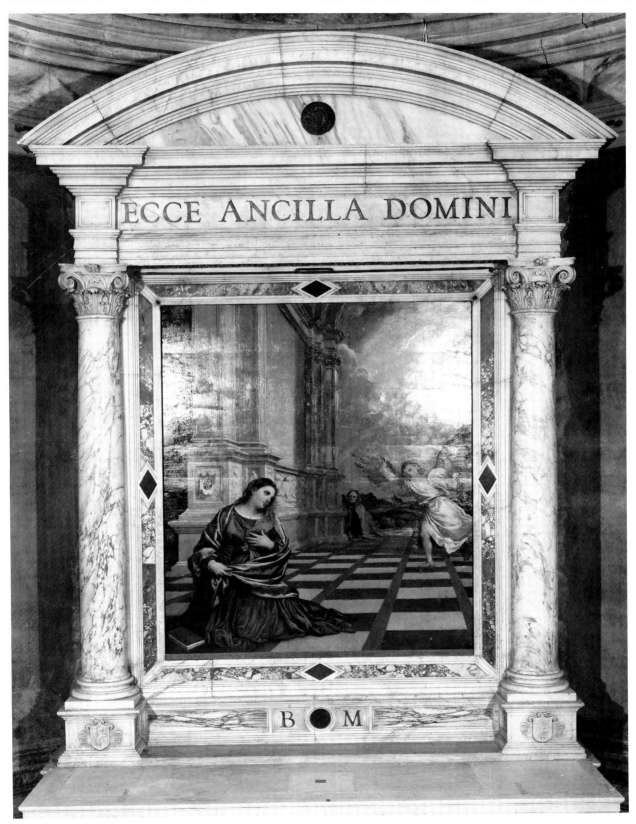

ECCE ANCILLA DOMINI

B ● M

Pl. 245. Lorenzo Bregno, frame, Altarpiece of the *Annunciation*, Cappella della SS. Annunziata, Duomo, Treviso (Giacomelli, Venice)

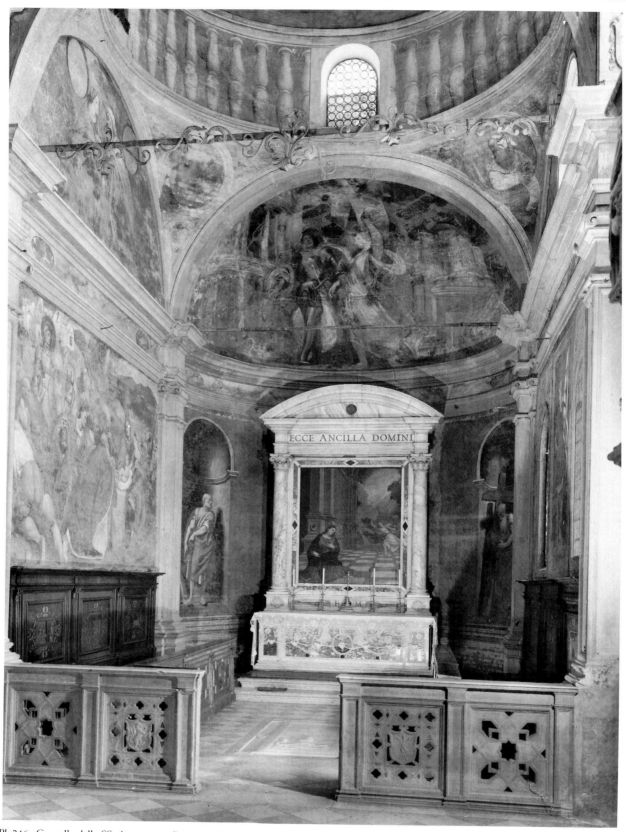

Pl. 246. Cappella della SS. Annunziata, Duomo, Treviso (Alinari, Florence)

Pl. 247. Lorenzo Bregno, capital, Altarpiece of the *Annunciation*, Cappella della SS. Annunziata, Duomo, Treviso (Giacomelli, Venice)

Pl. 248. Bregno shop and an anonymous stonecarver, Tomb of Bertuccio Lamberti, formerly crypt, Duomo, Treviso (Giacomelli, Venice)

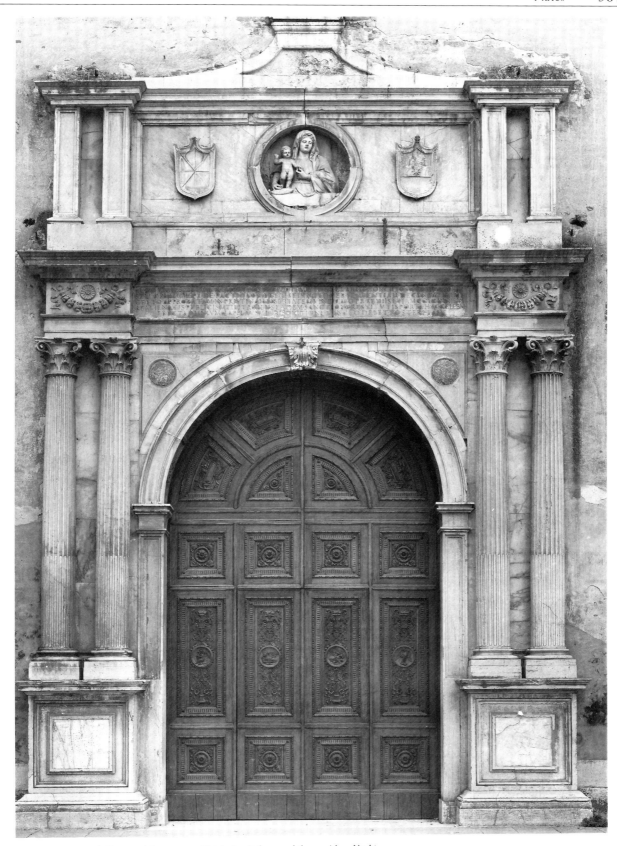

Pl. 249. Main portal, Duomo, Montagnana (Frick Art Reference Library, New York)

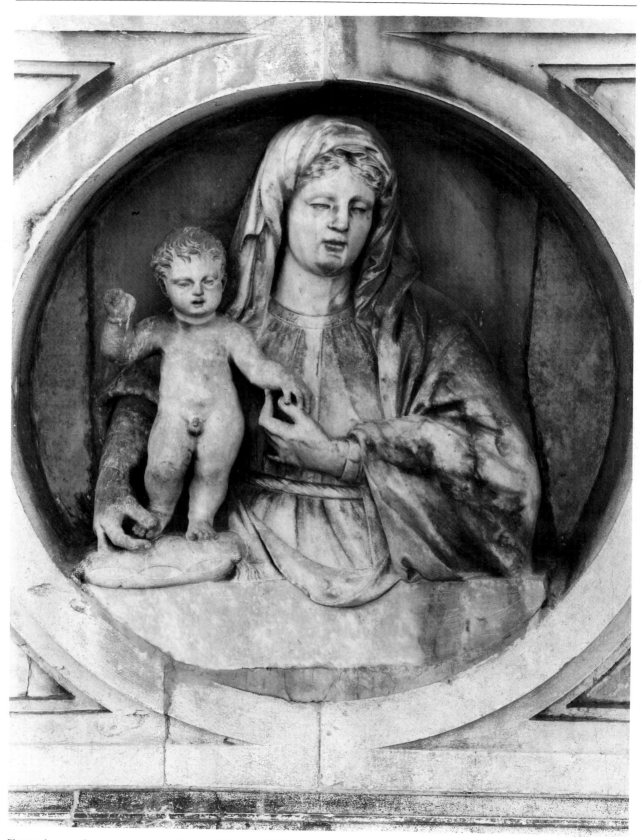

Pl. 250. Lorenzo Bregno and Antonio Minello, *Madonna and Child*, main portal, Duomo, Montagnana (Giacomelli, Venice)

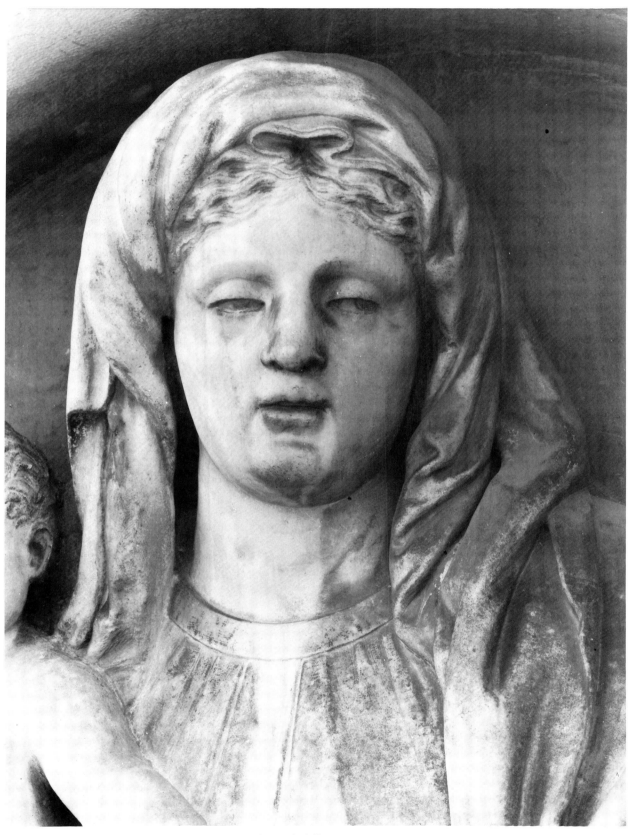

Pl. 251. Lorenzo Bregno and Antonio Minello, detail, *Madonna and Child*, main portal, Duomo, Montagnana (Giacomelli, Venice)

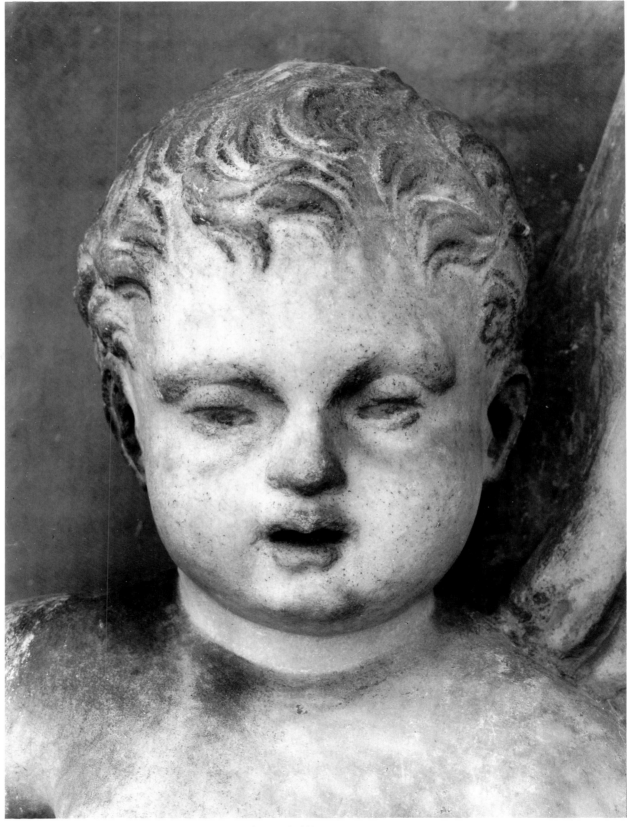

Pl. 252. Lorenzo Bregno and Antonio Minello, detail, *Madonna and Child*, main portal, Duomo, Montagnana (Giacomelli, Venice)